A DICTIONARY OF ARTISTS.

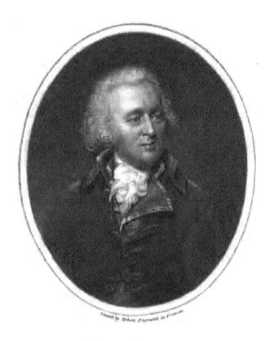

Valentine Green Esq. F.S.A.

A DICTIONARY OF ARTISTS

OF THE

ENGLISH SCHOOL:

PAINTERS, SCULPTORS, ARCHITECTS, ENGRAVERS
AND ORNAMENTISTS:

WITH NOTICES OF THEIR LIVES AND WORK.

BY

SAMUEL REDGRAVE,

JOINT-AUTHOR OF
'A CENTURY OF PAINTERS OF THE ENGLISH SCHOOL.'

New Edition revised to the present date.

'A painfull work it is, I'll assure you, and more than' difficult, wherein what toyle hath been taken, as no man thinketh, so no man believeth, but he that hath made the triall.'—*Ant. à Wood.*

LONDON:

GEORGE BELL AND SONS, YORK STREET,
COVENT GARDEN.

1878.

BIOGRAPHICAL NOTICE

OF

SAMUEL REDGRAVE,

AUTHOR OF

'A DICTIONARY OF ARTISTS.'

SAMUEL REDGRAVE,

THE eldest child of William and Mary Redgrave, was born at No. 9, Upper Eaton Street, Pimlico, on the 3rd of October, 1802. His father was at that time in the office of Mr. Joseph Bramah (the inventor of the Hydraulic press), to whom he was distantly related; but he afterwards engaged in business for himself, in partnership with Mr. Pilton, carrying out their invention of strained wire, or, as it was then called, 'invisible wire fencing.'

A family following in quick succession, Samuel, with his brother Richard, the second child, was sent early to a school at Chelsea. There they were both allowed to follow their inclination for drawing, and, under the instruction of Mr. John Powell, obtained such a knowledge of water-colour painting as was consistent with the time then given to this 'extra,' in a school course. Samuel shewed much taste, careful execution, and love for the art, which he continued to practice for his amusement and solace until late in life. On leaving school at an early age, the brothers entered a night class for the study of architecture, where they continued to practice for

some years, and thus obtained a thorough knowledge of architectural drawing, perspective, construction, and design.

The difficulty of providing for a large family, owing to the hard times caused by the long wars of the beginning of the century, induced his father thankfully to accept for his eldest son, then about fourteen, a small clerkship connected with the Home Office. The place of his labours, however, was not for some years in the Home Department, but in the Old State Paper Office in Scotland Yard, since pulled down. There, alone and employed in the driest duties, his young days were passed in writing during the official hours, often bringing home extra work at which he laboured far into the night. This, however, formed for him habits of steady perseverance and precision, which he never lost; nor did it preclude him from self-improvement, since he found time to perfect the knowledge of French which he had acquired at school, to make himself well acquainted with German, and to obtain enough of the Spanish language to enable him to read and enjoy some of the best Spanish authors, besides which, as a flute player, he frequently joined his father and one or two German friends in a trio or quartet. Mention has already been made of his architectural studies, and when his brother Richard, in spite of many discouragements, determined to follow the profession of art, and in 1826 was admitted a student in the Schools of the Royal Academy, Samuel was stimulated to make an effort to study there also. He prepared a set of drawings, was entered as a probationer, and (during his annual holiday, devoted to this purpose) completed the necessary works. He was, in December 1833, admitted as an architectural student for ten years. At that time, beyond attendance at lectures, and the use of the library, there was little direct architectural teaching (a want since largely remedied), but his studentship brought him into connexion with art and artists, who, to the end of his life, formed his chief companions and friends.

It must not be supposed that these varied labours and studies withdrew his attention from his official duties—far from it. When he obtained an assured place in the Home Office, he at once began to consider how the work confided to him could be improved, or more complete information afforded. Part of his labours had consisted in annually preparing a very feeble register of Criminal

Offences; this he amplified into an annual volume, registering every criminal and criminal offence, and to ensure accuracy he read up our criminal law with great attention. This was at a period when the criminal code was undergoing serious and continuous changes, and he was able to aid the movement by his careful and exact statistics, and to support or suggest alterations which the extreme severity of the English laws against crime so greatly needed. These labours met with encouragement and acceptance by the best statisticians both here and on the Continent, and it was in acknowledgment of the value of his statistical labours connected with criminal offences, that he was made a life member of the Statistical Society.

In 1836 the Constabulary Force Commission was appointed; and Mr. Redgrave was named as its secretary; much valuable information was obtained, from which the secretary drew up a most graphic report as to the many ways in which the public was preyed upon by thieves and vagrants. In May 1839 Lord John Russell appointed him his Assistant Private Secretary, and on his leaving office, he was continued as Mr. Fox Maule's till September 1841. He was also Private Secretary to Mr. Fitzroy from December 1852 to January 1855.

Later in his official life, in 1853, the Home Secretary confided to him the consolidation, with a view to extinction, of the Turnpike Trusts of the United Kingdom. This he did not hesitate to accept, and, in addition, the task of arranging an annual registration of the procedure in civil cases, as he had already done with criminal offences—a duty requiring much previous reading and study; such labour, though wholly distinct from the routine of office, he nevertheless carried out as part of his usual official work.

At the desire of the then Home Secretary, Sir G. Cornewall Lewis, Mr. Redgrave undertook to compile and codify all the duties of the Secretary of State—the authority for such duties, their use and source. This confidential volume he completed, after much research, to the satisfaction of his chief; it is entitled 'Some Account of the Powers, Authorities, and Duties of Her Majesty's Principal Secretary of State for the Home Department.' It was printed for the use of the Home Secretary in 1852. The research incident to this work induced the author to enter upon the larger

field of tracing the origin and duties of all the Government officers. This he completed in 1851; it was entitled 'The Official Handbook of Church and State,' published by Mr. Murray. It was greatly appreciated, and a second edition called for and exhausted; nevertheless, it was wholly unremunerative to its author. These severe and sedentary labours, however, told upon his constitution, and after an attack of congestion of the brain, added to heavy domestic troubles, he was advised to ask leave in 1860 to retire from the office he had held above forty years.

The object of this short memoir, however, is to relate Mr. Redgrave's connexion with art and artists, and his qualifications for the work to which this memoir is appended. We have seen his acquaintanceship with artists by his early studies; and when, in 1842, his brother Richard, who had acted as Secretary to the Etching Club from its foundation in 1837, was obliged, from his own accumulated labours, to resign the office, Samuel succeeded him, and continued to fulfil the duties until the day of his death, this duty bringing him in constant connexion with many of the most rising artists of the day. In the International Exhibition of 1862, Mr. R. Redgrave was entrusted with getting together an historical series of the works of British painters, both in oil and water-colours. He sought the aid of his brother, who undertook the arrangement of the pictures in water-colours. Both were greatly interested in the work, and having accumulated much material as to the history of English art, they determined to embody it in a book which should serve as a continuation to Vertue and Walpole, and they jointly compiled 'A Century of Painters of the British School,' carrying on the history of art to the date of its publication in 1866. In 1867 to Mr. Redgrave was entrusted the due representation of British Art in the Paris International Exhibition, which he carried out successfully. He was for many years an active member of the Council of the Society of Arts, and became one of their Vice-Presidents. The Society appointed him their Trustee (under Sir John Soane's will) of the Soane Museum, a trust which he continued to hold until his death.

Besides these multifarious labours, he submitted, in 1865, to the Lord President of the Committee of Council on Education a proposal to form a Loan Collection of Miniature Portraits, which was

x

accepted, and the Exhibition (opened in the June of that year) was entrusted to him to carry out.

In 1866 he aided the late Earl of Derby in giving effect to his Lordship's idea of a Loan Exhibition of Portraits of British Celebrities, extending from the earliest known pictures to the present time. The series was so ample that the Exhibition continued during three seasons.

When the Royal Academy, in the winter of 1869, determined, in the best interests of art, to continue the Exhibition of the works of deceased masters, which had lapsed with the British Institution, the Council, aware of Mr. Redgrave's administrative abilities, requested him to act as secretary to the committee formed to carry out their intentions. The first exhibition was a decided success, and he continued to fulfil the office until the appointment of a lay secretary to the general body rendered his further assistance unnecessary. All this time he was gathering materials for the 'Dictionary of Painters, Sculptors, Architects, and Engravers,' completed and published in 1874. During that year the Department of Science and Art requested him to compile a catalogue of the 'Historical Collection of British Paintings in Water-Colours,' with a short introductory preface embodying the history and progress of the art. On this work he was engaged till his lamented death, on the 20th March, 1876, and it was published towards the end of that year. Mr. Redgrave married in 1839, but lost his wife after a long illness in 1845. She left two daughters who both died before him, the younger in 1856, and the elder in 1859.

A true-hearted brother and friend, his kindly and modest nature endeared him to all who knew him, by whom his loss will long be felt. It is hoped that this short memoir will suffice to show how diligently he served the public during a life of useful labour.

PREFACE.

THIS work was begun upon an experience of the little inform-
ation readily attainable respecting the Artists of the English School.
For some years several special opportunities which arose have been
diligently used, and every means taken, to collect such facts as
might be obtained; but it was painful to find how little was known,
or could be learnt, of many who, in their own day, if not in ours,
had been distinguished, and how often the few facts which in some
cases still existed were at variance. While it cannot be assumed
that this work is free from errors, or that all who ought to find a
place have been included, it will be a great satisfaction to the author
to correct hereafter any mistakes or omissions that may be kindly
pointed out.

A succession of native artists, many of whose works exist, and are
prized, may be traced from the time of Henry VII.; while of the
artists themselves, the few facts which in some cases have been
preserved, are beyond the reach of ordinary means of reference.
The collected art-biographies we possess are general, and the notices
of our countrymen which are included in them seem rather the
result of chance than of any effort to attain completeness.

The present work appears to be the first to combine, in a dic-
tionary form, some account of the Artists of the English School
exclusively, and to include the Painters, Sculptors, Architects,
Engravers, and Ornamentists; and the number who have been
thought deserving a place is probably ten times greater than will
be found in any other work. The materials have not only been
collected from all the ordinary sources of references, but much

information has been sought in out-of-the-way places, and has been the result of private and personal enquiries.

The aim of the Compiler has been to include the name of every artist whose works may give interest to his memory, whether to the lover of art, the art-collector, or the antiquary. The limitation to the Artists of the English School has not been followed so strictly as to include only those born in this country. Many foreign artists who came to England in their youth, learnt their art here, practised it here, and died here, could not be omitted; nor could, indeed, some others whose title to insertion may not be so clear. But in every case foreign artists who held any public appointment or employment here, or who have been connected with the art institutions of the country, have been included; though, in taking this course, it is not necessarily intended to claim such artists as of the English School.

Regarding the scope of the work, it may be objected that the names of artists have been inserted who have left little by which they merit remembrance. Possibly so. But, on the other hand, it is not the artist alone of whose works and memory there are ample records, so much as the obscure and forgotten, whose works are rarely met with, of whom information is desired, and frequently sought in vain. Also in the scale of the memoirs, of an indifferent artist information may abound; of one of eminence, concerning whom every fact would be valued, the particulars which exist are meagre in the extreme. The time seems past when they could be supplied, and the few facts given are all that in many such cases it appeared possible to save from oblivion.

Of the early architects, the names of the chief of those are included which appear in many documents under the title of ' Devisor,' ' Supervisor,' ' Director,' ' Master Mason,' ' Clerk of the Works,' &c., some of whom held high Church preferment. But the doubts often expressed are fully shared by the Author as to how far such officers may claim the distinction of architect, as the name is now applied, of many of the noble early works which have been attributed to them.

PREFACE.

In the alphabetical arrangement, all names with a prefix have been classed under the initial letter of the prefix. Thus names commencing *Van, Von, Van der, Von der, Le, La, De, Di, Della,* &c., have been subjected to this arrangement. They refer chiefly to foreigners or their descendants, and it will be found that when such names become acclimatised, the prefix is naturally absorbed in the proper name, and no longer maintains its separate form. In the orthography of names, which hardly became settled till nearly the middle of the last century, the most recently accepted spelling has been adopted.

The Author received, in the progress of this work, so much kind assistance, not alone from friends, but from many others of whom he solicited information, that he regrets he is only able to acknowledge generally the valued help given to him, and the great obligations he has incurred.

KENSINGTON,
 November, 1873.

Editor's Note to the Second Edition.

———•———

THE first edition of this Dictionary being exhausted, it has become necessary to publish a second. This has been revised and corrected in many instances by the Compiler himself, who continued to labour upon the work till his death in 1876; since which time it has been carried on by a member of his family. A short Memoir of the Author has been appended, about 150 lives added, and the Dictionary carried down to the date of the present year. Any corrections of errors in this work will be thankfully received, and the help already given by friends is here gratefully acknowledged.

F. M. R.

KENSINGTON,
 October, 1878.

DICTIONARY

OF

ARTISTS OF THE ENGLISH SCHOOL.

NOTE.

Royal Academy of Arts, London : P.R.A., President ; R.A., Royal Academician ; A.R.A., Associate ; A.E., Associate Engraver.

Royal Scottish Academy, Edinburgh : R.S.A., Royal Scottish Academician ; A.R.S.A., Associate ; H.R.S.A., Honorary Scottish Academician.

Royal Hibernian Academy, Dublin : R.H.A., Academician ; A.R.H.A., Associate.

A

ABBOT, J. W., *amateur.* Practised about 1760. He drew landscapes in the manner of Peter de Laer. He also painted insects, and there is a small etching by him of some merit. He was honorary exhibitor of landscapes with cattle and figures at the Academy from 1793 to 1810. A landscape and cattle in oil, exhibited 1794, received great contemporary praise.

ABBOT, HENRY, *landscape painter.* Practised in London. Drew in 1818 views of the chief Roman ruins, with the panoramic environs of Rome, which he published.

ABBOTT, EDWARD, *landscape painter.* Lived many years in Long Acre, where he was eminent as a herald and coach painter. He also painted landscapes in a pleasing manner, and travelled in France and Italy with Wynne Ryland, the engraver. In 1782 he retired to Hereford, where he practised as an artist, and died, after a long illness, November 11, 1791, in his 54th year.

ABBOTT, FRANCIS LEMUEL, *portrait painter.* Born 1760, in Leicestershire. Son of a clergyman in that county. At the age of 14 he became the pupil of Frank Hayman, who dying two years after, he returned to his parents, and by his own perseverance attained the power of taking a correct likeness. About 1780 he settled in London, and gained reputation and employment. He first exhibited his portraits at the Academy in 1788, again in the following year, and then not till 1798. He exhibited the last time in 1800. Lord Nelson sat to him several times ; and his practice greatly increasing, he would not, as was then the custom, employ an assistant. He was overwhelmed with engagements which he could not complete, and that anxiety, added to the domestic disquiet arising from an ill-assorted marriage, brought on insanity, which terminated his life early in 1803. His portraits have been engraved by Valentine Green, Skelton, Walker, and others. There is a half-length portrait of Nelson by him in the gallery at Greenwich Hospital, and a whole-length of Admiral Sir Peter Parker. His merits were limited to the head ; his male portraits, in particular, were perfect in resemblance, and the finish well studied, but his figures were insipid, and his backgrounds weak and tasteless.

ABEL, JOHN, *architect.* Practised with some distinction in the reigns of Charles I. and II. The Town Hall and Market House at Hereford (1618–20), at Brecon, and at Weobly, are from his design, as also the School-house at Kington and at Leominster, 1663. These buildings were handsome erections in wood, showing much constructive ability ; but where they remain, repairs and alterations have deprived them of their original character. He held the appointment as one of Charles I.'s carpenters. He died 1694, aged 97, and was buried at Snaresfield, Herefordshire, where on his tomb he is styled 'architect.'

ABEL, RICHARD, *medallist.* He was a goldsmith, and was in the 27th Henry III. nominated 'to be maker and cutter of the money dies.'

ABERRY, ——, *engraver.* He is only known by an etched portrait of Sir W. W. Wynne, after Hudson, 1753.

ABRAHAM, ROBERT, *architect.* Born 1774. Was the son of a builder, and educated as a surveyor. In the early part of his career he found employment in measuring builders' work and settling their accounts, and later in life was much engaged in valuations. When, following the peace of 1815, some impetus was given to Metropolitan architecture, he was engaged as an architect, and his works, if not of great architectural merit, showed a fitness of character and

B

adaptation of material. Among the chief were the Jews' Synagogue, near the Haymarket, the County Fire Office, and the Westminster Bridewell. He died Dec. 11, 1850, aged 77.

ADAM, WILLIAM, *architect*. Held the appointment of king's mason at Edinburgh, where he practised his profession with much repute. Hopetoun House and the Royal Infirmary in that city are examples of his ability, as also the New Library and University at Glasgow. He died June 24, 1748. The three Adams of the Adelphi were his sons.

ADAM, ROBERT, *architect*. Born 1728, at Kirkaldy, Fifeshire. Son of the above William Adam. He was educated at the Edinburgh University, and formed friendships with several men who became distinguished. In the study of his art he visited Italy about 1754. He took with him Clérisseau, a clever draftsman, and remained some time. On his return he soon rose to professional eminence, and in 1762 was appointed architect to the king, but resigned that office to become candidate for Kinrosshire, for which county he was elected representative in 1768. At this time, in conjunction with his brother James, he commenced the great work on the shores of the Thames with which his name is associated. His plans were unsuccessfully opposed by the Corporation of London, as an encroachment upon their privileges. He raised the shore by a succession of arches, and on them erected three fine streets and a terrace fronting the Thames, naming this work, in memory of himself and his two brothers, the 'Adelphi.' It was not, however, successful as a speculation, and in 1774, under the sanction of an Act of Parliament, he disposed of the whole by lottery. Among his works may be named—The *façade* of the Admiralty, Whitehall; Lansdowne House, Berkeley Square; Luton Hoo, Bedfordshire; Caen Wood House, near Hampstead; Osterley House, near Brentford; Kidleston, Derbyshire; Compton Verney, Warwickshire; and the General Register House, Edinburgh. He was largely employed in the alteration of many fine mansions, and showed great ability in the arrangement and decoration of interiors, displaying a pleasing variety in the form and proportion of his apartments, and a comfort and elegance not studied by his predecessors. He also designed ornamental furniture. His style was original—in taste approaching prettiness, but was highly popular in his day, and has left a character which is still known as his. He painted many good landscape compositions in water-colours. He published a work on the Ruins of Diocletian's Palace, 1764, and, with his brother James, commenced in 1773 'The

Works in Architecture of R. and J. Adam.' He was F.R.S. and F.S.A. He died, from the bursting of a blood-vessel, at his house in Albemarle Street, March 3, 1792, and was buried in the south aisle of Westminster Abbey. His journal of his tour in Italy, 1760–61, was published in the Library of the Fine Arts.

ADAM, JAMES, *architect*. Younger brother of the preceding, and connected with him in most of his works. He held the office of architect to the king, and was himself the architect of the spacious range of buildings named Portland Place. He published a treatise on architecture, and was engaged upon a history of architecture which he did not live to finish. He died, in Albemarle Street, of an apoplectic attack, October 20, 1794.

ADAM, JOHN, *engraver*. He practised in London towards the end of the 18th century, and engraved in the chalk manner portraits for periodical works. The portraits in Caulfield's 'History of Remarkable Characters' are engraved by him, but possess little merit. There are also by him portraits of Queen Elizabeth and Dudley, Earl of Leicester, after drawings by Zucchero.

ADAMS, ROBERT, *architect*. Born in London, 1540. Was surveyor to the Board of Works and architect to Queen Elizabeth. A large plan of Middleburgh by him is extant, dated 1588; also a pen-and-ink drawing, styled 'Tamesis descriptio,' showing how the river may be defended by artillery from Tilbury to London, with representations of several actions while the Spanish Armada was off the British coast. These latter were engraved, and Walpole assumes that they were engraved by him, and styles him an engraver. Dallaway says they were engraved by Augustine Ryther, of which there seems little doubt. He translated from the Italian into Latin Ubaldini's account of the defeat of the Spanish Armada. He died in 1595, and was buried in Greenwich Church, where a tablet describes him as 'Operum regiorum supervisori, architecturæ peritissimo.'

ADAMS, BERNARD, *architect*. Practised in the reign of Queen Elizabeth, when his name often appears, but of his works no particulars are recorded.

ADAMS, FRANCIS E., *engraver*. He received a premium from the Society of Arts in 1760. Produced some portraits in mezzotint about 1774, but did not attain any excellence in his art. A satirical print of a young girl, dressed quite *à la mode*, whose mother does not know her (1773), is well drawn and tolerably finished.

ADAMS, FRANCES MATILDA, *flower painter*. Was water-colour painter extraordinary to Queen Adelaide, and exhibited at the Royal Academy for several years

from 1816. She died October 24, 1863, aged 79.

ADAMS, JAMES, *architect*. Was a pupil of Sir John Soane, and gained the Royal Academy gold medal for an architectural design, 1809. In 1818 he was residing at Portsmouth, and exhibited the view of a Dispensary erected at Plymouth Dock and the additions made to Mount Edgecumbe House. In the following year he exhibited the interior of St. Thomas's Church, Portsmouth, after which the catalogue affords no trace of him.

ADYE, THOMAS, *sculptor*. He was appointed sculptor to the Dilettanti Society in 1737, and between that date and 1744 executed several little commissions for the Society, chiefly for carvings in ivory.

AGAR, D., *portrait painter*. Practised about the beginning of the 18th century. Faithorne engraved after him.

AGAR, JOHN SAMUEL, *engraver*. Produced some excellent works in the stipple or chalk manner, and also drew some portraits. ▪ He exhibited portraits and an occasional subject at the Royal Academy, commencing in 1796 up to 1806, and 'The Tribute Money' at the British Institution in 1810. He was, in 1803, governor of the Society of Engravers, and was living in 1820.

AGASSE, JAMES LAURENT, *animal and landscape painter*. Born at Geneva, and studied there as an animal painter. In 1800 he pleased an English traveller by a portrait of his dog, and was induced by him to come to London, where he settled. In 1801 he appears as an exhibitor, at the Academy, of the 'Portrait of a Horse,' followed by a 'Rustic Repast,' 'Race-ground,' 'Portrait of a Lady,' 'Market-day,' &c. Then, in 1842, after an interval of 10 years, he sent a 'Fishmonger's Shop,' and contributed one work in each of the three following years. Several of his works were engraved, among them six landscapes. He was of independent, unconciliating manners; lived poor and died poor about 1846.

AGGAS, RALPH, *draftsman and surveyor*. Said to have been born in Suffolk about 1540. He practised 1560–89, and was distinguished by his maps of the principal cities of the realm. They are bird's-eye views, representing in the margins the principal structures. Cambridge, published 1578, was the earliest; 10 years later, Oxford, surrounded with the views of the colleges, the arms, and other objects of interest. He also made a survey of London and Westminster, and produced a large plan and view on wood (subsequently repeated on pewter); but he could not obtain permission to publish it—probably from political reasons—till the accession of James I., to whom it is dedicated. He died about 1617. He has been designated

the engraver of the plans, but on one of them he is is called 'Autore,' and the engraving was more probably the work of Ryther. His maps have been many times repeated, and are the authority adopted by all subsequent antiquarian writers.

AGGAS, ROBERT, *landscape and scene painter*. A descendant of the foregoing. Was a good landscape painter both in oil and tempera, and skilled in the introduction of architecture. He was much employed by Charles II., and gained a reputation as scene painter for the theatre at Dorset Garden. He was also employed at the Blackfriars and Phœnix Theatres. In the Painter-Stainers' Hall there is preserved a landscape by him. He died in London in 1679, aged about 60.

AGLIO, AUGUSTINE, *subject painter and decorator*. He was born at Cremona, Dec. 15, 1777, and was educated at the College of St. Alessandro, Milan, where he was one of the most distinguished pupils. He studied the various branches at the Academy Brera, and in 1797 practised landscape painting at Rome, where he was introduced to Mr. Wilkins, R.A., with whom he travelled in Italy, Greece, and Egypt, and employed himself in sketching the antiquities of those countries. In 1802 he returned to Rome, and in December of the following year came to England on the invitation of Mr. Wilkins, whom he at once joined at Cambridge, and whose 'Magna Græcia' he was employed to complete in aqua-tint.

In 1804 he was engaged in the scene-room of the Opera House, and in 1806 at the Drury Lane Theatre, and was then largely employed in the decorations of some important mansions, and visited Ireland, where he painted twelve pictures of Killarney. In 1811 he decorated the Pantheon in Oxford Street, and in 1819, in fresco, the ceiling of the Roman Catholic Chapel in Moorfields, where he also executed the altarpiece. He also drew many works in lithography, and his 'Mexican Antiquities,' which were announced in ten volumes, though only nine were published — 1830 - 48. About 1820 he produced many easel pictures. He exhibited at Suffolk Street between 1825 and 1856, and at the Royal Academy between 1830 and 1846. To the Westminster Hall Exhibition he sent a large landscape, with figures in fresco. In 1844 and in 1847, 'Rebecca,' a large oil picture. One of his last works was the decoration of the Olympic Theatre. He painted two portraits of the Queen, which, with some other works, were engraved. After a long earnest life spent in the pursuit of art he died Jan. 30, 1857, in his 80th year, and was buried in Highgate Cemetery.

AIKIN, EDMUND, *architect*. Son of

Dr. John Aikin. Was born at Warrington, October 2, 1780. He was assistant to General Sir Samuel Bentham, R.E., who was the architect of the General Penitentiary at Millbank. About 1814 he resided some time at Liverpool, while superintending there the erection of the Assembly Rooms, and designed several buildings in that borough, and later the Presbyterian Chapel in Jewin Street, London. He wrote several professional papers and essays, among them the account of St. Paul's Cathedral, published with Britton's engravings of that edifice, and some of the earlier architectural articles in Rees's 'Encyclopædia;' and also, in 1808, published 'Designs for Villas.' He was from 1800 to 1814 an occasional exhibitor of architectural designs at the Royal Academy. He died at Stoke Newington, March 13, 1820.

● AIKMAN, WILLIAM, *portrait painter.* Born at Cairney, Forfarshire, October 24, 1682, only son of a member of the Scotch bar, of good family, who designed him also for the law. But he was attracted to art, and so soon as he was at liberty left the study of law, and turning to art placed himself under Sir John Medina, with whom he continued three years. Then he sold his paternal estate in Forfarshire, and in 1707 went to Rome, where he studied till 1710. He next travelled to Constantinople and Smyrna, and returning by Rome and Florence, reached Scotland in 1712. He succeeded to some employment on the death of Sir John Medina, and practised for about 13 years in Edinburgh with great success. He was induced, in 1723, to come to London, where he settled and became acquainted, among other artists, with Kneller, whose manner he imitated. He was much employed. His works were weak but pleasing, not showing much original invention. Several of his full-length portraits are at Blickling, Norfolk. He had commenced a large picture of the royal family in three compartments, but the third, containing the half-length portrait of the king, was unfinished at his death. This picture is in the collection of the Duke of Devonshire. Many of his portraits have been engraved, and two portrait etchings by his hand are known. He was reputed a good judge of pictures, and while in Italy was employed to purchase for the Duke of Kingston. He died in Leicester Square, June 7, 1731, it is said of excessive grief for the loss of an only son, and both were removed to Scotland together and buried in one grave, in the Greyfriars' Church, Edinburgh. He left two daughters. His friend Mallet wrote his epitaph and Thomson bewailed his loss in verse. He was intimate with many of the most distinguished men of his time.

AIKMAN, JOHN, *draftsman.* Born 1713; only son of the foregoing. He had early shown much promise of future excellence in art. There are a few studies etched by him after Vandyke, two or more on a plate, but they are rare. He died at the age of 18, in 1731.

ALBIN, ELEAZAR, *draftsman and naturalist.* Was of German origin, and changed his family name of Weiss to its latinised translation, Albinus. A student of natural history, he made able drawings, and engraved and coloured them with his own hand. His 'History of English Insects' is a great example of laborious perseverance. It was published in 1720. He explains, in his preface, that teaching to draw in water-colours is his profession, that the beautiful colours of flowers and insects led him to paint them, and that, becoming acquainted with some eminent naturalists, he was much employed by them. He published a 'Natural History of Birds,' comprising 306 plates of birds drawn from life, a work on spiders, and a history of fishes, but in this last work he was assisted in the engraving by Basire, James Smith, and others. His insects are marked by great truth. He does not seem to have received the encouragement he so well deserved, for he says his subscriptions came in slowly, and that having a large family to provide for, his circumstances retarded his work. He practised 1720-40.

ALCOCK, JOHN, D.D., *amateur.* Born at Beverley about 1453. Was educated at Cambridge, was preceptor to Edward, Prince of Wales, and successively Bishop of Rochester, Worcester, and Ely. He was also a privy-councillor, ambassador to the Court of Spain, and filled several high offices in the State. He was distinguished as one of the greatest architects of his time. He designed the spacious hall belonging to the Episcopal Palace at Ely, and made great architectural improvement there and in his other sees. He planned the conversion of the old nunnery of St. Radegund at Cambridge into Jesus College. He was appointed joint surveyor of the royal works and buildings in the reign of Henry VIII. Died at Wisbeach, October 1, 1500.

ALDRICH, HENRY, *amateur.* Dean of Christ Church, Oxon. Born at Westminster 1647. He had much skill in architecture, for which he had cultivated a taste during a long residence in Italy. He designed the quadrangle at Oxford, named Peckwater Square, the chapel of Trinity College, the church of All Saints, and the garden front of Corpus Christi. He wrote a series of lectures called 'The Elements of Civil Architecture,' published many years after his death (1789). He was a man of great knowledge and varied acquirements, a

Aldrich W. Portrait Painter

classic and scriptural scholar, and withal a good musician; the composer of 'A Smoking Catch' and the favourite 'Hark, the bonny bonny Christ Church Bells!' which he published in his 'Pleasant Musical Companion.' He was also the author of several learned works. Died at Oxford, December 14, 1710.

ALEFOUNDER, JOHN, *portrait and miniature painter.* Was a student in the Royal Academy, and in 1782 gained a silver medal. He first exhibited, in 1777, an architectural design, in the following year a portrait in chalk, and then practised in miniature, occasionally in chalk and oil, and in 1784 he exhibited some theatrical portraits and portrait groups. Soon after he went to India, where he realised some property by the practice of his art. He sent a portrait from Calcutta to the Academy Exhibition in 1794, and suffering from the effects of the climate, died there in the following year. A portrait by him of 'Peter the Wild Boy' was engraved by Bartolozzi in 1784, and of 'Edwin the Actor' by C. N. Hodges in the same year. An oil portrait by him of John Shipley is at the Society of Arts.

ALEXANDER, Sir ANTHONY, Knight, *architect.* Son of Alexander, Earl of Stirling. Was master of the king's works in Scotland in the reign of Charles I. He died in London, August 1637, and was buried at Stirling.

ALEXANDER, JOHN, *portrait and history painter.* Was born in Scotland, the son of a minister of the Scotch Kirk, and was the pupil and son-in-law of Alexander Jamesone, a descendant of George Jamesone. He was educated in Italy, spent some time in Florence, and in 1716 was in Rome, where he devoted himself to the study of Raphael's works. On his return to Scotland in 1720, he painted portraits and several historical pictures. The 'Rape of Proserpine,' on the staircase of Gordon Castle, was by him. He copied, or invented, several portraits of Mary Queen of Scots. While in Rome he etched in a coarse but effective manner six plates after Raphael.

ALEXANDER, COSMO, *portrait painter.* Practised in Edinburgh about 1750. A portrait by him of the provost of that city was engraved in 1752. His portrait of General Dalziell is also engraved. In 1766 he was a member of the Incorporated Society of Artists in London. Gibbs, the architect, left him his house, with all his furniture, pictures, busts, &c. He went to America when between 50 and 60 years of age, and in 1772 was painting portraits in Rhode Island, but he eventually returned to Scotland, and shortly after his arrival died in Edinburgh.

ALEXANDER, WILLIAM, *water-colour painter.* Born at Maidstone, April 10, 1767. Son of a coach-maker in the town, and educated at the Grammar School there. Came to London at the age of 15 to study as an artist, and was placed under William Pars, then under Ibbetson, and in 1784 was admitted student of the Royal Academy. In 1792 he accompanied Lord Macartney's mission to China as draftsman, and remaining during the journey to the northern frontier, returned with the mission in 1794. He married in the following year, but the loss of his wife shortly afterwards left a lasting impression on his character. In 1802 he was appointed professor of drawing to the Royal Military College, Great Marlow, an office he resigned in 1808 on his appointment as assistant-keeper of the antiquities in the British Museum, and afterwards was appointed, on the creation of the office, keeper of the prints and drawings. His drawings were engraved for the illustration of Sir George Staunton's account of the Chinese embassy, published in 1797. In 1798 he published himself some drawings made in China, of headlands, islands, and other views; and in the same year he made finished drawings from Daniell's sketches, illustrating Vancouver's voyage to the North Pacific. He also illustrated Barrow's 'Travels in China,' published 1804, and his 'Cochin China,' 1806. In 1805 he published his 'Costumes of China.' He was also employed as draftsman to the department of antiquities, British Museum, and made the drawings for the engravings from the terra cottas and marbles in the Museum, published by the trustees in 1810, 1812, and 1815. He also drew many of the views for the 'Beauties of Great Britain,' and for Britton's 'Architectural Antiquities.' He died of a brain fever at Maidstone, July 23, 1816, and was buried in the neighbouring village of Boxley. He was a good draftsman and colourist. His drawings are minutely finished, and evince great accuracy. His early drawings are executed with the pen, shaded in India ink and tinted; his figures well introduced; his architectural details, as shown in the 'Britannia Depicta,' minutely traced. He published, 1798-1805, a masterly collection of his etchings, illustrative of Chinese life and character; and in 1837 a short journal of a visit he paid to the old seat of Cotton the angler was published in lithograph *fac simile.* He was a man of cultivated tastes, an artist, antiquary, and connoisseur.

ALEXANDER, DANIEL ASHER, *architect.* Was born in London, 1768, and educated at St. Paul's School, London. In 1782 he was admitted a student of the Royal Academy, and on the completion of his professional education was early called into important and responsible practice.

In 1796 he was appointed surveyor to the London Dock Company, the principal buildings of which are by him. He built the military prison at Dartmoor, now used for convicts; the old county prison at Maidstone, the Royal Naval Asylum at Greenwich, the London Docks, several lighthouses, and was employed on additions and alterations to Longford Castle, Wilts; Beddington House, Surrey; Coleshill, Berks; and Combebank, Kent. His designs were marked by appropriateness, his knowledge of construction great, and his work finished with great attention to detail. He had retired from his profession to Exeter, and died there March 2, 1846, aged 78. His eldest son for some time practised as his assistant, but he left the profession in 1820 to enter the Church, and died in 1843.

ALIAMET, FRANCIS GERMAIN, engraver. Brother to the celebrated French engraver. Born at Abbeville 1734. He studied at Lisle and then at Paris, but came to London when young. He received a Society of Arts' premium in 1764, and completing his studies under Strange, settled here, and found employment in engraving portraits for the publishers. He finished with great care and accuracy. He engraved a 'Circumcision' after Guido, on a large scale, for Alderman Boydell; also plates after Caracci, Le Sœur, Watteau, Edge Pine, and others. He was accidentally killed February 5, 1790.

ALKEN, SAMUEL, aqua-tint engraver. Practised his art in London towards the end of the 18th century. He had probably some instruction in architecture, and in 1780 exhibited an architectural design. He produced many views in Great Britain and Ireland, chiefly for the illustration of topographical works, and carried the art of aqua-tint to very high perfection. He designed and etched 'A New Book of Ornaments.' He published, in 1796, 'Views in Cumberland and Westmoreland,' and aqua-tint views in North Wales in 1798.

ALKEN, HENRY, draftsman and engraver. He was well known by his numerous facile delineations, sometimes humorous in character, of field-sports, races, and games. He published 'The Beauties and Defects of the Figure of the Horse,' 1816; 'Scraps from his Sketch-Book,' 1821; 'Symptoms of being Amused,' 1822; 'Illustrations of Popular Songs,' 1823; 'The Art and Practice of Etching,' 1849; 'Jorrock's Jaunts and Jollities,' 1869.

ALLAN, DAVID (called the Scotch Hogarth), portrait and history painter, was born at Alloa, near Edinburgh, where his father held the office of shore-master, February 13, 1744. His childhood was marked by troubles; his genius first shown by chance. In 1755 he was apprenticed to

Messrs. Foulis, and studied his art in their academy at Glasgow. Then, assisted by some friends, he set off for Italy in 1764, and remained in that country nearly 14 years, studying and copying from the old masters. He sent home two historical pictures for exhibition at the Royal Academy in 1771, and at Rome in 1773 he gained the prize medal of the Academy of St. Luke for his historical composition, 'The Corinthian Maid drawing the Shadow of her Lover.' Returning in 1777 he resided in London till 1780, supporting himself by portrait painting. Four drawings which he made at Rome during the Carnival, introducing portraits with much humour and character, were engraved in aqua-tint by Paul Sandby, and published in 1781. He then settled in Edinburgh, where he met with much patronage, and on a vacancy in 1786 was appointed master and director of the Edinburgh Academy of Arts. He etched in a free style the illustrations for Tassie's 'Catalogue of Engraved Gems,' comprising 57 plates, with from seven to nine examples each. They have a frontispiece designed and etched by him, dated 1788. In the same year he illustrated by engravings an edition of the 'Gentle Shepherd,' and in 1798 he etched some characteristic designs, small oval size, for the 'Songs of the Lowlands of Scotland.' He also amused himself with etching, sometimes combined with mezzo-tint, chiefly scenes from cottage life. He was admired for the natural truth of his works and the character and expression of his subjects from low life. His art did not aim at either beauty or grace. He will be remembered by his 'Scotch Wedding,' 'Highland Dame,' 'Repentance Stool,' and his designs for the 'Gentle Shepherd.' He died near Edinburgh, August 6, 1796, leaving a widow with a son and daughter. His portrait, painted by himself, hangs in the National Gallery of Scotland.

ALLAN, Sir WILLIAM, Knt., P.R.S.A. and R.A., subject and history painter, limner to the Queen in Scotland. He was born in 1782, in Edinburgh, where his father held the humble office of macer to the Court of Session, and was educated at the High School. He made little progress in classic knowledge, but showed a fancy for drawing, to gratify which he was apprenticed to a coach painter, and proving to have a taste for decoration was sent for his further improvement to the Trustees' Academy, where, after several years' study, he developed a taste for art, and then came to London and entered the schools of the Royal Academy. Struck with the works of Opie, he imitated his manner, and in 1803 exhibited his first picture, 'A Gipsy Boy with an Ass.' But failing to gain notice, he set off the same year for Russia,

with no other apparent inducement than the love of travel and the desire to seek his fortune. Driven into Memel by a storm, his means were soon exhausted, and he painted a few portraits to enable him to make his way to St. Petersburg, where he found friends, and was assisted by his countryman, Sir Alexander Crichton, then the Court physician.

Having made some study of the language, he visited Tartary and Turkey, sketching the costume and studying the manners of the Cossacks, Circassians, and Tartars. He sent home to the Academy Exhibition of 1809, 'Russian Peasants keeping Holiday,' but his picture did not receive much notice, and, disappointed, he did not exhibit again for several years. In 1812 he had made up his mind to return, but Napoleon's great campaign, the horrors of which he witnessed, prevented him, and he did not reach Scotland till 1814. Then, settling in Edinburgh, he sent to the Academy in London the following spring his 'Circassian Captives,' and in 1816 a work of the same class, 'The Sale of Two Boys by a Chief of the Black Sea,' an incident he had witnessed ; and in 1817 another Circassian subject. But these works were unsold, and he was disappointed beyond hope. He was, however, befriended by Sir Walter Scott, who got up a lottery for the sale of his 'Circassian Captives,' and induced him to remain in Edinburgh. Here he painted 'Tartar Robbers dividing their Spoil,' and then tried another class of subjects, 'The Press Gang,' 'The Parting between Prince Charles Stuart and Flora Macdonald,' 'Jeannie Deans and her Father ;' yet these works did not justify the expectations he had raised among his friends. He again desponded, Sir Walter came once more to his help, encouraged him to paint a sketch he had made of the 'Murder of Archbishop Sharpe,' and found a purchaser for it when finished. With renewed hope he then painted 'John Knox reproving Mary, Queen of Scots,' which was exhibited at the Royal Academy in 1823, followed by 'Ruthven forcing Mary to sign her Abdication,' and 'The Regent Murray shot by Hamilton of Bothwellhaugh,' which last was purchased by the Duke of Bedford for 800 guineas, and gained the artist the distinction of Associate of the Royal Academy in 1825. In 1826 he was appointed master of the Trustees' School, Edinburgh, an office he held till only a few years before his death.

Though he did not want energy, and persevered in his work without flagging, he scarcely maintained the reputation he had gained, and his labours and anxieties began to tell upon him. He was attacked by a complaint which threatened blindness,

and was compelled to take rest. He went to Italy, and after spending a winter at Rome journeyed on to Naples, and from thence to Constantinople, Asia Minor, and Greece. In 1830 he returned to Edinburgh, restored to health, and was successful in a small portrait work of 'Sir Walter Scott in his Study,' now in the National Portrait Gallery, which became a favourite, and was well engraved by Burnet ; as also in a companion picture, exhibited in 1833 under the title of 'The Orphan,' representing Ann Scott on the floor, close to her father's vacant chair in his studio at Abbotsford, which was purchased by Queen Adelaide. In 1834 he again travelled, visiting Spain, and subsequently France and Belgium. On his return in 1835 he was elected a royal academician, and in 1838 the president of the Royal Scottish Academy. In 1841 he succeeded to the office of limner to the Queen in Scotland, which was accompanied, as had been usual, by knighthood.

He had returned to his Siberian subjects, and exhibited yearly at the Academy, when in 1843 he completed a work he had long contemplated, 'The Battle of Waterloo from the French side.' This was admired by the Duke of Wellington, who became its purchaser. His last great completed work was a second picture of this battle from the English side. It was painted in competition for the decorations of the palace at Westminster in 1846, but was unsuccessful, and he had the further disappointment that it remained unsold. He had always retained a pleasant recollection of the kindness of his friends in St. Petersburg, and in 1844 he revisited that capital, and painted for the emperor 'Peter the Great teaching his Subjects the Art of Ship-building.' The effects of hard travel and a life of hard labour and anxiety now began to tell upon him. He suffered from bronchitis, and had been for some time at work upon a large canvas on 'The Battle of Bannockburn.' His weakness increased, but he did not relax, and removing his bed to his painting-room he continued his work ; and here, with his unfinished picture before him, he died in Edinburgh, February 23, 1850. His picture has found an appropriate place in the National Gallery of Scotland, and he will not fail to be remembered among the painters of his country. He represented the costumes and characters of countries then little known, and connected them with kindred subjects of great interest, and painted many subjects and incidents with equal success from the history of his own country. His stories were well told and well composed, his choice of subjects good ; but his pictures were wanting in power, and were crude and weak in colour. His merit

did not find early recognition, and distinctions and honours were delayed till near the end of his active career. He was gifted with much natural humour, a clever mimic, at all times an agreeable companion, and possessed the friendship of many of the most distinguished of his countrymen.

ALLASON, THOMAS, *architect.* Born in London, July 31, 1790. Was placed in an architect's office, and entered as a student at the Royal Academy, where he gained a silver medal, and in 1805 exhibited a design for a college. He studied Grecian architecture, and in 1814 made a tour in Greece. On his return in 1817 he established himself in London, and was much employed both in buildings, furniture, and landscape gardening. Many villas and mansions were erected after his designs—perhaps the Alliance Fire Office, in Bartholomew Lane, may be pointed to as his chief work. He died April 9, 1852, in his 62nd year. He began life dependent upon his own exertions. He was conspicuous for good taste, and independently shaped his own useful career. He published 'Plan of a House of Industry,' 1805; 'Picturesque Views of the Antiquities of Pola, in Istria,' 1819; and a clever etching of Milan Cathedral.

ALLEN, ANDREW, *portrait painter.* Supposed of Scotch origin. Practised with some repute in Edinburgh about 1730. A portrait by him of one of the Lords of Session is engraved, as is also his own portrait.

ALLEN, JAMES B., *engraver.* Born in Birmingham, April 18, 1803. He was apprenticed to his brother, Mr. Josiah Allen, of Colmore Row, Birmingham, to learn his art. He went to London, however, before he had finished his time, and was employed many years in engraving for the Bank of England. He executed many works for the 'Art Journal' and other periodicals. His best engravings are after landscape subjects. He died in London, January 10, 1876.

ALLEN, JOSEPH, *portrait painter.* Born at Birmingham, and early found employment in painting Japanned tea-trays, which it was then the fashion to decorate with pictures. Having some feeling for art, he came to London and obtained admission as student at the Royal Academy, with the resolution to attempt history, but he was compelled to descend to portrait, and in this did not meet with success. He next was induced to try Wrexham, where he settled, and found a lucrative practice by visiting Manchester, Preston, Lancaster, and other large towns in the north, where he established a connection. This last success tempted him again to try the Metropolis, but he again failed to secure notice; and being advanced in life,

8

he broke up his establishment and retired to Erdington, near Birmingham, in easy circumstances, and died there November 19, 1839, aged 70. His portraits were carefully painted, tender and pleasing in character, but not of any high merit.

ALLEN, JOHN, *architect.* He practised in England, with much repute, in the reign of Queen Elizabeth. His descendants settled in Ireland, where his grandson, JOSHUA ALLEN, following his profession, was employed by many of the nobility, became lord mayor of Dublin, and was knighted.

ALLEN, GEORGE, *architect.* Was born at Brentford, April 14, 1798. Studied at the Royal Academy, and was a pupil of James Elmes. He published, in 1828, 'Plans and Designs for the future Approaches to the New London Bridge,' and found much professional employment on the Southwark side of the river. He died June 28, 1847.

ALLEN, JOSEPH W., *landscape painter.* Was born in Lambeth, the son of a schoolmaster, and educated at St. Paul's School. For a time he found employment as an usher in an academy at Taunton, but a love of art prevailing, he came to London to gain a living as an artist. His early practice was in water-colours—views in Cheshire and North Wales—but latterly chiefly in oil. He was first employed by a dealer, afterwards assisted as a scene painter, and many of the scenes at the Olympic during Madame Vestris's first management were by him. He became a member of the Society of British Artists, and was for a time vice-president, and a large contributor of landscapes to the exhibitions, chiefly of views in Surrey, and some compositions. His 'Vale of Clwyd,' 1842, gained him much notice, and was purchased for 300 guineas as an Art Union prize. His works were of some merit, but the anxieties to provide for a large family were hindrances to art; and though his subjects were well chosen, and not without artistic feeling, they were crude and unfinished. He was also engaged as a teacher in the City of London School. He sketched landscapes on copper with some skill. He died in August, 1852, aged about 48, leaving a widow and a large family, to make some provision for whom a subscription was raised among his friends.

ALLEN, JAMES C., *engraver.* Was born in London, the son of a Smithfield salesman, and apprenticed to William Cooke, for whom he worked many years after the termination of his apprenticeship, and was much employed on book illustration. In 1821 he published, with Mr. Cooke, 15 views of the interior and exterior of the Coliseum at Rome, well engraved in the line manner; and in 1831 a spirited plate

of the 'Defeat of the Spanish Armada,' after De Loutherbourg. He excelled very much in his etching, and was devoted to his art. Of eccentric habits, and suffering from ill-health, he died in middle age.

ALLEN, THOMAS, *marine painter.* His subjects were chiefly naval battles. Practised about the middle of the 18th century. He painted the incidents of Queen Charlotte's voyage and arrival in this country, also the 'Great Harry,' from Holbein's design of that vessel. His works were engraved by P. C. Canot.

ALLEN, THOMAS, *topographical draftsman.* An ingenious man, who was engaged in several antiquarian publications. He drew and etched the illustrations for his 'History of the Antiquities of Lambeth' and 'History of the Antiquities of London, Westminster, and Southwark,' and was the author of some other antiquarian works; but his illustrations possessed no higher merit than careful neatness. He died suddenly, of cholera, July 20, 1833, aged 30.

ALLEN, THOMAS JOHN, *architectural draftsman.* Excelled in water-colours. He committed suicide, it was said owing to the death of his sister, September 20, 1846, aged 25.

ALLOM, THOMAS, *architect.* Was born in London, March 13, 1804, and was articled to Francis Goodwin, in whose office he passed about seven years; and was also a student in the schools of the Royal Academy. In 1824 he first appears as an exhibitor at Suffolk Street of designs for a cathedral, and in 1827 at the Academy, contributing a design for Sydenham Church. Soon after he travelled for improvement in his art. He had great skill in finishing architectural drawings, and drew and sketched with great facility, and was soon engaged by publishing firms to furnish them with views of the continental cities. He continued an occasional exhibitor of views and architectural designs. In 1846 he was awarded a premium for his design for the Choristers' Schools at Oxford. He was the architect of the Union Workhouse at Calne and at Kensington; also of Highbury Church, 1850; the Cambridge Military Asylum, Kingston, 1852; St. Peter's Church, Notting Hill, 1856; and other works. But his reputation will rest upon his numerous published views, by which he is so widely known—Cumberland and Westmoreland; Devonshire and Cornwall; Yorkshire, Derbyshire, and the Midland Counties; Surrey, Belgium, Scotland, France, Constantinople, Asia Minor, China. He was one of the founders of the Institute of British Architects. He died at Barnes, October 21, 1872.

ALLPORT, H. C., *water-colour painter.* He lived near Lichfield, and first appears as an 'exhibitor' at the Water-Colour Society in 1813. He continued to exhibit landscape views, but chiefly of well-known buildings, and in 1818 was elected a member of the Society. In 1822 his name disappears from the list of members, but he contributed several drawings, chiefly Italian scenes, in 1823, and is then classed as an 'associate exhibitor.' He does not appear to have again exhibited.

ALLSTON, WASHINGTON, A.R.A., *history painter.* Was born in South Carolina, 1779, and entered Havard College, Massachusetts, 1796. Drawing was his favourite amusement as a boy, and he early tried to design. He first attempted miniature, but without success. In 1800 he graduated and then returned to Charleston, where he devoted himself to art, banditti being his favourite subjects. Then, with a desire for his improvement, in May, 1801, having sold his hereditary property to enable him to study art, he came to England and at once entered the schools of the Royal Academy; was an exhibitor in 1802 and 1803. After three years' study he went to Paris in 1804, copied some pictures at the Louvre, and then set out for Italy, where he passed four years, the greater part of the time in Rome, studying modelling in clay as well as drawing; and there, in 1805, he painted his 'Joseph's Dream,' a work which at once laid the foundation of his fame. In 1809 he went back to America, where he married the daughter of Dr. Channing, and in 1811 brought his wife to England. Soon after he commenced 'The Dead Man touching Elisha's Bones,' but his work was interrupted by a dangerous illness; and when, after a short residence at Clifton to re-establish his health, he finished his picture, it was exhibited at the British Institution, and gained, in 1814, a premium of 200 guineas. It was afterwards purchased by the Pennsylvanian Academy of Fine Arts for 3500 dollars. In the same and the two following years he exhibited at the Academy, chiefly Italian landscapes. He had returned to London, and had hardly settled in his newly-furnished house when his wife died suddenly. The shock produced the deepest melancholy and temporary derangement. But recovering, he visited Paris in 1817, in company with his friend C. R. Leslie, and on his return commenced his 'Jacob's Dream,' which he sent to the Academy from Boston in 1819, his first contribution to that exhibition. He continued in England during the American war; on its termination a home sickness seized him, and with great regret he left his English friends and again crossed the Atlantic, arriving at Boston in 1818. He had the same year been elected an Associate of the Academy, and had gained a premium of 150 guineas at the British Institution for his 'Angel Uriel

9

standing in the Sun.' He had also commenced his 'Belshazzar's Feast,' but he did not complete this work till 1834. Finally settling in his native country, he pursued his art, and wrote on several subjects. In 1830 he married his second wife, a sister of Mr. Dana, the well-known author. He died at Cambridge, Massachusetts, July 8, 1843. He was an excellent artist. His subjects were of the highest aim, and marked by a vivid imagination; his light and shade full of power; his colour good. He was also a scholar. He published—'The Sylphs of the Seasons,' London, 1813. 'Hints to Young Practitioners on Landscape Painting,' 1814; 'Monaldi: a Tale.' Boston, U.S., 1841. After his death his 'Lectures on Art and Poems,' were published at New York, 1850; 'Outlines and Sketches,' at Boston, U.S., 1850.

ALNWYCK, WILLIAM, D.D., *amateur.* Became Bishop of Norwich 1426, and of Lincoln 1436. Besides several works at Cambridge and at Lincoln, he rebuilt the western door of Norwich Cathedral with the window over it, also the principal part of the Tower Gate-house to the Episcopal Palace. He died about 1450.

ALVES, JAMES, *portrait painter.* He practised in London, chiefly in miniature. In 1775 he exhibited two classical subjects; in the following year, with some portraits, a 'St. Cecilia,' in miniature; and in 1777-78 and 1779 small portraits in crayons. After that he does not appear as an exhibitor. He died at Inverness, November 27, 1808, in his 71st year.

AMES, ——, *engraver.* Practised, with no great ability, about 1777. His works consisted chiefly of portraits—many of them in small oval, in the stipple manner—of popular dissenting ministers.

ANDERSON, ALEXANDER, *engraver.* An English artist of the latter part of the 18th century. He engraved some designs for 'Don Quixote,' and some anatomical figures, with great neatness and accuracy.

ANDERSON, DAVID, *modeller.* Native of Perthshire. Made himself locally known by some clever works in statuary, but did not exhibit in London. Died of typhus fever at Liverpool, 1847.

ANDERSON, JOHN, *wood engraver.* Was born in Scotland, where he received a classical education. He was a man of superior attainments; became a pupil of Bewick, and engraved the illustrations to 'Grove Hill,' a poem, and also for an edition of 'The Letters of Junius.' He formed a style of his own, and showed much ability, but did not long follow his profession. He went abroad on some speculation, and was lost sight of. He died early in the century.

ANDERSON, WILLIAM, *marine painter.* Born in Scotland 1757. Originally a shipwright, he cultivated drawing in his leisure hours, and painted some pictures of shipping. He practised in London; first exhibited at the Academy in 1787, and continued to contribute up to 1814, when he exhibited for the last time. His works are usually of small size, and show a practical nautical knowledge; they are usually river scenes—calms, with shipping and boats—neatly painted, low and agreeable in colour, but wanting in vigour. He painted one or two landscapes. A set of five 'Views of the Battle of the Nile,' were well engraved after him in aqua-tint, 1800, by W. Ellis. Died May 27, 1837.

ANDERTON, HENRY, *history and portrait painter.* Born 1630. Practised in the reign of Charles II., by whom he was patronised. He was a pupil of Streater, and made a tour in Italy for his improvement. On his return he was employed by the King and the Court, and in some degree rivalled Lely. He painted a fine portrait of the celebrated Mrs. Stuart, afterwards Duchess of Richmond. His name does not appear to any engraved works, and it has been assumed that the more popular name of Lely may have been attached to his portraits. He died young, soon after 1665.

ANDRAS, Miss CATHERINE, *modeller in wax.* Was born near Bristol about 1775, where she attained some proficiency in her art, and was induced by her success to visit London. In 1799 she first exhibited her portraits in wax at the Royal Academy, and had several distinguished sitters. The Queen appointed her modeller in wax to Her Majesty, and in 1802 she exhibited her model of the Princess Charlotte. She continued an occasional exhibitor up to 1824.

ANDRÉ, Major JOHN, *amateur.* A young officer of much promise, who showed great talent for art. A half-length miniature, which he painted of himself, was engraved by Sherwin. There is also a bold landscape etching by him. He was acting as adjutant-general to the British Army in North America, and, arrested within the American lines, was shot as a spy, October 2, 1780, aged 29.

ANDREWS, H., *subject painter.* He was a contributor to the Academy Exhibitions from 1833, when he sent 'Charade en Action'—exhibiting for the last time, in 1838, 'A Garden Scene' and 'The First Music Lesson.' He had talent and might have acquired reputation, but he fell into the hands of unscrupulous dealers, made copies of Watteau—not sold as copies—and subjects in the style of Watteau, and his art became degraded. He died November 30, 1868.

ANGELIS, PETER, *landscape and figure painter.* Was born at Dunkirk in 1685.

10

After studying there, and in Flanders and Germany, he came to England about the year 1712, was well received, and became a favourite painter. He practised here up to 1728, when he sold his pictures, including many fine copies, and went to Italy, where he remained three years, chiefly in Rome, when he set off, intending to return to England; but, stopping at Rennes, he was so well esteemed there, that he was induced to remain, and died in that city in 1734.

ANGEIR, PAUL, *engraver*. Was taught by John Tinney. Practised in London about the middle of the 18th century, being chiefly employed on small plates for book illustration. There are some landscapes of this class by him neatly executed, but weak in manner. Also ' Roman Ruins,' after Pannini, dated 1749 ; a Landscape, after Moucheron, 1755 ; ' Dead Game,' after Huet, 1757. He never arrived at much excellence, and died at the age of 30.

ANGUS, WILLIAM, *engraver*. Was a pupil of William Walker, and his works highly esteemed. He practised in the line manner, excelled in landscape, and engraved after Paul Sandby and Daynes, as well as from his own designs. One of his principal works was ' The Seats of the Nobility and Gentry,' 1787-1815. He also engraved, chiefly after Stothard, the plates for the small Atlas Pocket-book, and some portraits for the ' European Magazine.' One of his best works is a landscape after Elsheimer. He was improvident and died poor, after two years' painful illness, October 12, 1821, aged 69, leaving a widow without any provision.

ANSELL, CHARLES, *animal painter*. Reputed for his drawing of the horse. He also drew domestic subjects with some elegance. Several of his works are engraved. ' The Death of a Race-horse,' in six aqua-tint plates, published 1784; ' The Poor Soldier,' 1787; also, ' A Dressing-room à l'Anglaise' and ' à la Française,' 1789. He exhibited at the Royal Academy in 1780 and 1781, but his name does not appear afterwards in the catalogues.

ANSLEY, Mrs. MARY ANN, *amateur*. Was a daughter of Gandon, the architect, and married General Ansley, an officer of the Guards. She contributed many clever subject pictures to the British Institution and the Royal Academy. At the latter she first exhibited, in 1814, a classical subject, and continued to send works of this class, with an occasional portrait, up to 1825; and in 1833 exhibited, for the last time, a portrait of Prince Napoleon, for which the prince, then in London, had sat to her. She died at Naples in 1840. Her principal paintings are at Houghton Hall, Huntingdonshire, the family residence.

ANTONY, CHARLES, *medallist*. He was master of the mint to James I. His

relative, THOMAS ANTONY, at the same time held the office of overseer of the stamps. Both were able artists.

ARCHER, JOHN WYKEHAM, *water-colour painter*. Was the son of a prosperous tradesman at Newcastle-on-Tyne, and was born there August 2, 1808. He was sent to London as the pupil of John Scott, the animal engraver. Returning to Newcastle he etched, in conjunction with Collard, after Carmichael's designs, ' Views of Fountains' Abbey,' and some plates for Mackenzie's ' History of Durham.' After passing a short time in Edinburgh, he came again to London about 1830, and was employed by the Messrs. Finden. He engraved a plate after Callcott, R.A., and was then engaged to engrave for the ' Sportsman's Magazine;' but his employment was uncertain, and he was induced to try water-colour painting. He was led by his taste to paint the old buildings in the Metropolis, and in this pursuit he acquired knowledge and repute as an antiquarian, and had a large commission for works of this class, which employed him to the end of his life. He drew occasionally on the wood for Mr. Charles Knight's publications, and made a number of topographical drawings for the Duke of Northumberland. He was an able artist, and a member of the Institute of Painters in Water-Colours, and exhibited there a number of drawings of St. Mary Overy and of Lambeth Palace. He died suddenly in London, May 25, 1864. He published ' Vestiges of Old London,' drawn and etched by himself, 1851—his subjects very pictorially treated, with numerous figures well introduced—and some other etchings. His collection of drawings is in the British Museum. He had some literary taste, and wrote for Douglas Jerrold's Magazine, ' Recreations of Mr. Zigzag the elder,' and some antiquarian papers which he contributed to the ' Gentleman's Magazine.'

ARCHER, THOMAS, *architect*. His father represented Warwick in the time of Charles II. He was a pupil of Sir John Vanbrugh, and was largely employed at the beginning of the 18th century. He built Heythorpe Hall, Oxfordshire, his first work, 1710 ; Harcourt House, Hanover Square ; Cliefden House, long since burned down ; St. Philip's Church, Birmingham ; 1715-19 ; and St. John's Church, Westminster, 1721-28. This work, frequently ascribed to Vanbrugh, is conspicuous by its four belfries, and has been sharply assailed by the critics. He held the office of groom-porter during the reigns of Anne, George I., and George II. Walpole speaks of him as ' the groom-porter who built Hithrop' (Heythorpe). He died May 23, 1743, having accumulated a large property. His works were not without a certain

11

grandeur of proportion, and they may surely claim the merit of originality.

ARLAUD, James Anthony, *miniature painter.* Was born in Geneva, May 18, 1688, and was intended for the Church, but was too poor to continue his studies, and he turned painter. .At the age of 20, he left Geneva, and after working a while at Dijon, where he found employment in art as a painter of small ornamental portraits for jewellers, encouraged by his success, he went to Paris, where he commenced practice as a miniature painter, and, patronised by the Duke of Orleans, gained a great reputation. In 1721 he came to London, and met with much encouragement. He painted the Princess of Wales, afterwards Queen Caroline, and several of the nobility. But he went back to Paris, and after a time, having amassed money, retired to Geneva, where he died May 25, 1743. He was esteemed one of the first artists in miniature of his time. His portraits, which are very numerous, are well drawn and carefully finished; his colour is good, the costume well painted. He painted several historical subjects.

ARLAUD, Benedict, *miniature painter.* He was brother of the foregoing, and, like him, was born in Geneva. He practised for a time in Amsterdam and then in London, where he died in 1719. Some of his portraits have been engraved.

ARLAUD, Bernard (or Benjamin), *miniature painter.* Born in Geneva, he came to London, where he resided, and at two different periods met with encouragement. Between 1793 and 1800 he was frequently an exhibitor at the Royal Academy. He retired to Geneva in 1801, and was living there in 1825, when he sent a miniature to the Royal Academy Exhibition.

ARMSTRONG, Cosmo, *engraver.* He was a pupil of Milton, and remained in his employ for five years. He engraved illustrations for Cook's edition of the Poets, Kearsley's edition of Shakespeare, 1804–5, and after Smirke and Thurston, for an edition of the 'Arabian Nights.' He was a governor of the Society of Engravers, founded 1803, and in 1821 exhibited with the Associated Engravers. His works were greatly esteemed, and examples of his art were shown at the International Exhibition, 1862.

ARNALD, George, A.R.A., *landscape painter.* Born in Berkshire in 1763, he began life as a domestic servant to a lady who, noticing his great ability in drawing, obtained for him some instruction. He became a pupil of William Pether, and first appears as an exhibitor at the Academy in 1788; and was from that time, with few exceptions, a regular contributor. He painted moonlights, storms, effects of light,

the sun breaking through a fog, classical landscapes, architectural compositions; and. later in his career, marines and sea-fights. In 1810 he was elected an Associate of the Academy. In 1825 he was the successful competitor for a commission of 500*l.* offered by the British Institution for a painting of 'The Battle of the Nile.' This work is of large size and well painted, the moment seized being the explosion of the 'L'Orient.' It is now in the gallery at Greenwich Hospital. In 1827 he exhibited 'The "Bellerophon," 74, as a Convict Ship at Sheerness,', and the following year four landscapes, in approval of which 50*l.* were awarded to him. He continued an exhibitor for many years. He died at Pentonville, November 21, 1841. Some of his works were engraved in 'The Border Antiquities of England and Scotland.' His two daughters exhibited at the Royal Academy; one of them was a constant exhibitor of landscapes in oil, 1823–32.

ARNALD, Sebastian Wyndham, *sculptor.* Son of the above. Was student in the Academy schools, and first exhibited, in 1823, bust. of G. Arnald, A.R.A.; in 1827, 'The Death of Abel,' a sketch in plaster; in 1828, a 'Perseus and Andromeda;' and continued to exhibit classical designs and busts. In 1831 he gained the Academy gold medal for his group of 'The Murder of the Innocents.' Afterwards, he occasionally exhibited a drawing or a painting up to the death of his father in 1841, when he ceased to exhibit till 1846, and then sent a painting from 'Pilgrim's Progress,' after which any further traces of his art-career are lost.

ARNOLD, Samuel James, *panorama painter.* Began art as a portrait painter, and first appears in the Academy catalogues as an exhibitor in 1800, and continued to exhibit portraits up to 1806, but was chiefly employed in panorama painting.

ARTAUD, William, *portrait painter.* He was the son of a jeweller, and in 1776 gained a premium at the Society of Arts. He became a student in the Academy schools, and appears first in 1780 as an exhibitor of a 'St. John,' in enamel, followed in 1784 and 1786 by portraits in oil. In the latter year he obtained the Academy gold medal for a painting from 'Paradise Lost,' and in 1795 the travelling studentship. He continued to exhibit portraits, with, occasionally, history—in 1791, 'Potiphar's Wife accusing Joseph;' in 1792, 'Martha and Mary;' in 1795, 'A Weary Traveller in a Storm;' in 1800, four subject pictures—up to 1822, when his name appears in the catalogue for the last time. He was employed on some of the subjects for Macklin's 'Bible,' and several of his portraits are engraved. His portraits were cleverly drawn, and painted with great

power. They have individuality of character, but want expression.

ARUNDALE, FRANCIS, *architect*. Born in London, August 9, 1807. Was a pupil of Augustus Pugin; accompanied him in his tour through Normandy, and made some of the drawings for his 'Architectural Antiquities of Normandy.' In 1831 he went to Egypt to study the architectural remains of that country, and in 1833, in company with Mr. Catherwood and Mr. Bonomi, he visited the Holy Land, resided some time in Jerusalem, and made a large number of sketches and drawings, and a careful measurement of the Mosque of Omar. He remained, altogether, nine years in the East, and then travelled in Greece. Later he visited France and Italy, passing several winters in Rome. He did not practise as an architect; he rather studied the art as a draftsman. He painted several large pictures in oil from his Eastern sketches, and published 'The Edifices of Palladio,' from his own drawings and measurements, 1832; 'Illustrations of Jerusalem and Mount Sinai,' also from his own drawings, 1837; 'Selections from the Gallery of Antiquities in the British Museum,' 1842; 'The Early History of Egypt,' from the same source, did not appear till 1857, and was, with the preceding work, the joint production of Mr. Bonomi. He also commenced a reprint of 'Palladio.' He married a daughter of Mr. Pickersgill, R.A., by whom he had six children. He died at Brighton, September 9, 1853, probably having laid the seeds of his malady by inhabiting a tomb while in Egypt.

ARUNDEL, THOMAS, D.D., *amateur*. Was born in 1353; second son of the Earl of Arundel. He was created Bishop of Ely 1374, Archbishop of York 1388, and of Canterbury 1396; and he filled the office of Lord Chancellor. As an architect, he rebuilt the Episcopal Palace in Holborn, built or superintended the erection of the Palace at York, and the Lantern Tower and part of the nave of Canterbury Cathedral. He died February 20, 1413.

ASHBY, H., *portrait painter*. Was the son of an engraver, who died in 1818. He practised in London, and first appears as an exhibitor at the Royal Academy in 1794, and in the following years was a regular contributor of portraits, and occasionally of domestic subjects. In 1808 he exhibited at the British Institution 'The Attic Artist,' and in 1816 'The Hypochondriac,' at the Royal Academy. He had retired for several years to Mitcham, and he exhibited two portraits in 1821, his last contribution. His portraits possessed some merit, and one or two have been engraved. His domestic scenes showed an appreciation of character.

ASHFIELD, JOHN, *architect*. He was master of the works of Bristol Cathedral from 1472 to 1491, and is believed to have built the tower and south transept.

ASHFIELD, EDMUND, *portrait painter*. Pupil of Michael Wright; painted both in oil and crayons, but excelled in the latter, which were highly and powerfully finished, and gained large prices. He multiplied the number and variety of tints, black and white only being previously chiefly employed, the paper forming the middle tint Vertue speaks with much praise of a small portrait by him of Lady Herbert. He practised about 1680, and died about 1700. There are some portraits by him at Burleigh.

ASHFORD, WILLIAM, P.R.H.A., *landscape painter*. Born in Birmingham, he went to Ireland in 1764 and settled in Dublin. He was at that time about 18 years of age, and for a while held a situation in the Ordnance Department. Fond of landscape painting, he gave up his situation to follow art. He contributed to the early exhibitions of the Incorporated Society of Artists in London, and in 1783 and 1790 to the Royal Academy Exhibitions. At this period he resided some time in London, and in conjunction with Serres, R.A., the marine painter, made a joint exhibition of their paintings. He was one of the three artists to whom his professional brethren confided the election of eleven others to constitute, with themselves, the Royal Hibernian Academy, which was incorporated in 1823, and he was the first president of the new institution, in which he always took the liveliest interest. His works were much esteemed, and he saved, early in his career, a sufficient competence; but for the last 30 years of his life he was neglected. He had retired to Sandymount, near Dublin, where he pursued his favourite art, both in oil and water-colours, with great vigour. He died there April 17, 1824, aged 78, and was buried in the neighbouring old churchyard at Donnybrook. A fine work by him, 'Orlando under the Oak,' is in the Hibernian Academy; and his own portrait, painted by himself, and several of his landscapes, are in the Fitzwilliam collection at Cambridge.

ASHLEY, HECTOR, *mason and architect*. His name frequently appears in the Privy Purse accounts of Henry VII. and Henry VIII. He is also mentioned by Walpole as an architect of the time of Queen Elizabeth, and is supposed to have been engaged in the erection of Hunsdon House.

ASHPITAL, ARTHUR, F.S.A., *architect*. Born December 14, 1807. He was the son of a surveyor and architect; a clever child, he suffered from an accident, and his long confinement led to study. When about 35

13

years of age, regaining his strength, he established himself as an architect and surveyor in the city, where he designed and erected a number of houses. In 1845 he built the new church of St. Barnabas, Homerton, soon after a church at Battersea, and another near Cardigan, followed by a church at Vernham Dean, near Hungerford, and the new church at Blackheath. In 1853 he travelled by Paris and Marseilles to Rome, where he passed the first three months of the next year, and then went to Naples for three months, where he suffered from fever, and returned home in 1854, after twelve months' absence. He had from 1845 been a constant exhibitor, chiefly of his executed works, at the Royal Academy, and after his return from Italy exhibited several restorations and works of great interest—in 1850, 'Selections from Palladio;' in 1851, 'A Design for rebuilding Blackfriars Bridge and throwing open St. Paul's;' in 1858, restorations of 'Ancient Rome;' in 1859, 'Modern Rome,' the last two published works. He was a good scholar and linguist, a clever archæologist, fellow of the Society of Antiquaries, and the writer of several works of art connected with his profession. He was an active fellow of the Institute of British Architects, and a contributor to the 'Dictionary of Architecture' in the course of publication by that body. He also contributed to the 'Encyclopædia Britannica' the articles on Vanbrugh, Wren, the Wyatt Family, and William of Wykeham. He died January 18, 1869, and was buried in Hackney churchyard.

ASHTON, HENRY, architect. Born in London, 1801. He was a pupil of Sir Robert Smirke, and was afterwards employed by Sir Jeffrey Wyattville, and continued in his employ till his death. He was engaged to erect the stables at Windsor and the kennels at Frogmore. In 1828 he first exhibited a 'Roman Street,' a composition; in the following year, 'Strada della Chiesa,' a composition; in 1830, a 'Palladian Villa;' and in 1831 a study in the Tudor style; and then for above 20 years was no longer an exhibitor. He was at this period employed by the King of Holland to erect the Summer Palace at the Hague, and competed, though without success, for some of the most important works of his day. He was engaged as architect for the Victoria Street improvements, and designed the fine thoroughfare connecting Belgravia with the Houses of Parliament, and in 1854 he appears again as an exhibitor, sending a portion of his designs for this street, 'Houses on the Scotch Principle;' in 1855 he exhibited a design for a mansion he was erecting; and in 1856, 'Sketches for enlarging the National Gallery.' His work possessed many good characteristics

14

—good in construction, simple yet tasteful in its design and proportions. Some of his best examples will be found in Victoria Street. He died March 18, 1872.

ASHTON, MATTHEW, portrait painter. Practised his art between 1725–50, both in Ireland and London. His portrait of Boulter, Archbishop of Armagh, is engraved, and also his portrait of Ambrose Philips, the poet.

ASTLEY, JOHN, portrait painter. Born at Wem, Shropshire, about 1730. Son of an apothecary, and educated in the village school. Came to London and studied his art under Hudson; then, about 1749, managed to visit Rome, where Northcote tells he was poor enough, for, reluctantly pulling off his coat to follow the general example of a party of artists one hot evening, he displayed the back of his waistcoat made of one of his own canvas studies. On his return he practised his art some time in London, and afterwards went as an adventurer, in 1759, to Dublin, where in about three years he is said to have realised 3000l. by his pencil. On his way home he was tempted to visit the neighbourhood of his birthplace, and, invited to the Knutsford Assembly, Lady Daniell, a rich widow who was present, was so won by his appearance that she contrived to sit to him for her portrait, and to marry him, we are told, within a week. She settled on him the Tabley estate, producing about 1000l. a year, and by her will left him, on the death of her daughter, the Duckingfield estate, worth 5000l. a year. He had much talent, particularly in portraits. His colouring was agreeable, the composition original, drawing fair, but the finish slight, and character and expression weak. His art was, however, spoiled by his fortune. He passed his time in idleness and dissipation, and obtained the name of 'Beau Astley.' He soon sold the Tabley property. He made two or three charges on the reversion of the Duckingfield estate, and was just on the point of selling his final interest when the heiress died, and he came into possession of the whole. He now purchased Schomberg House, Pall Mall, for 5000l., and spent 5000l. more to convert it into three dwellings; the centre, fantastically fitted up, but not without taste, he inhabited himself, and also a villa on Barnes Terrace. He speculated in a colliery, and sank more money than he raised, and was not more successful in some iron works; but his losses were somewhat replaced by a fortune of 10,000l. he inherited on the death of his brother, a surgeon at Putney, who was accidentally killed. In his youth handsome, vain, and ostentatious, with little sense of morality or propriety; in the decline of life, when not without the apprehension of indigence, he was disturbed by

the remembrance of his early follies. He died at Duckingfield Lodge, November 14, 1787, and was buried in the village church there. He had, when far advanced in life, married a third wife, and left a son and two daughters.

ATKINS, J., *portrait painter*. Born in Ireland. He studied for a time at Rome, and exhibited portraits at the Academy in 1831 and 1833. He was a young artist of much promise, and went to Constantinople to paint the portrait of the Sultan; on his return, and while undergoing quarantine at Malta, he was attacked with fever, and died there 1834.

ATKINS, S., *marine painter*. Exhibited some good paintings at the Royal Academy in 1787—'A Light Breeze,' 'A Calm,' and 'A Fresh Gale,' but did not exhibit again till 1791, when in that year, and up to 1796, he was a contributor. He then went to the East Indies, and on his return in 1804 exhibited 'An East Indiaman passing the Boca Tigris,' and continued an exhibitor to 1808. He painted both in oil and in water-colour. His works are characterised by much neatness and truth of finish.

ATKINSON, Thomas Witlam, *architect and draftsman*. Was of humble origin; born about 1799; and was employed as a mason or stone-carver upon several churches building in the North of England. He for some time taught drawing at Ashton-under-Lyne. Ingenious and observant, he gained knowledge in his work, and drew and published in his 'Gothic Ornaments.' He afterwards settled at Manchester, and commenced practice as an architect, and gave the first impulse towards some taste in building in that city. In 1829 and the succeeding years he exhibited some architectural designs at the Royal Academy. In 1840, after some reverses, which left him in difficulties, he came to London, and eventually went to Hamburg, and from thence to Berlin and St. Petersburg. Then abandoning any practice as an architect, he started as a traveller and an artist, and with the sanction of the Russian Government he visited the most remote parts of Russia in Asia, including the Amoor River, bordering Chinese Tartary. He made a great many drawings and notes upon the condition of this remote territory, and returning to England after many difficulties, he published, with his own illustrations, in 1858, 'Oriental and Western Siberia;' in 1860, 'Travels in the Region of the Upper and Lower Amoor.' The 'Recollections of the Tartar Steppes and their Inhabitants' appeared in 1863. He died at Little Walmer, Kent, August 13, 1861, aged 62.

ATKINSON, John Augustus, *painter and draftsman*. Was born in London in 1775, and in 1784 went with his uncle to St. Petersburg. Fond of art, he was allowed to study in the picture gallery of the royal palace, and gained the patronage of the Empress Catharine, and, on her death, of her son the Emperor Paul. Induced to settle in Russia, he executed there some good paintings. Two in the Michael's Palace represent 'The Victory of the Cossacks of the Don over the Tartars' and 'The Baptism of Count Wladimir.' He was a very skilful draftsman, and made numerous drawings of Russian costume and amusements, and illustrated a Russian edition of 'Hudibras,' published in 1798 at Königsberg. In 1801 he returned to England, and the following year was an exhibitor of a Russian subject at the Royal Academy. Boydell about the same time published a view by him of the Russian metropolis, and a portrait of Suwarrow, engraved by Walker. In 1803-1804 he published 'A Picturesque Representation of the Manners, Customs, and Amusements of the Russians;' the plates, slightly etched in outline, shaded with aqua-tint and coloured, number 100, and were all drawn and etched by himself. In 1807 he published a set of soft-ground etchings to illustrate the miseries of human life; and, in the same year, 'A Picturesque Representation, in 100 coloured plates, of the Naval, Military, and Miscellaneous Costumes of Great Britain.' Later, he published some very spirited lithographic drawings of battles. In 1819 he completed a large picture of the 'Battle of Waterloo,' which was engraved by Burnet. He first exhibited at the Water-Colour Society as an 'Associate,' in 1808, two classic subjects with some others, and the following year was elected a member of the Society, when his contributions were chiefly military. In 1810 and 1811 his works were of the same class. In 1812 he sent Shakespeare's 'Seven Ages.' In 1813, when an alteration was made in the rules of the Society, his name no longer appears as a member, but he continued to contribute under the new class as an 'exhibitor' up to 1818, when his contributions ceased. He was also a frequent exhibitor at the Royal Academy, sending during several years both rustic and classic subjects, with battle-pieces and camp scenes, in oil and water-colours. His last contribution was in 1829. The date of his death cannot be traced. His drawing was vigorous and powerful, his battle-pieces, in which he excelled, very spirited; his representation of character and costume truthful; and his water-colour drawings simple in treatment, and characterised by a masterly hand.

ATKINSON, Frederick, *amateur*. Was a silk-mercer and draper at York; and about the beginning of the 19th

century produced some fair etchings, chiefly portraits, some from the life, with two or three views.

ATKINSON, PETER, *architect.* Was born at Ripon in 1725, and was brought up as a carpenter. He was employed by John Carr, the architect of York, and improving himself he succeeded his master on his retirement from the profession. He built for Sir John V. Johnstone the large mansion at Hackness, near Scarborough, and found much employment in Yorkshire and the adjacent counties. He died June 19, 1805.

ATKINSON, PETER, *architect.* Son of the above. Born about 1776; brought up to his profession under his father, and afterwards his partner. He erected the bridge over the Ouse at York, commenced 1810. He was many years surveyor to the Corporation of York, and built the city prison. He also built several new churches. During the latter part of his life he resided abroad. He died in 1842.

ATKINSON, WILLIAM, *architect.* Was born at Bishop's Auckland, near Durham, about 1773. Began life as a carpenter, and with the assistance of Bishop Barrington was sent to London and became the apprentice of James Wyatt. He entered the schools of the Royal Academy, and first exhibited some architectural designs in 1796, and was for several years an occasional exhibitor. In 1797 he gained the Academy gold medal for his designs for a Court of Justice. He built several large mansions—among them Lord Mansfield's house at Scone—and was both in theory and practice a clever architect; also several churches in Scotland; and holding the office of architect to the Board of Ordnance he made several alterations to the buildings at the Tower and at Woolwich. The offices of the Board of Control in Cannon Row, Westminster, are also after his designs. He was the inventor of Atkinson's cement, and published 'Views of Picturesque Cottages' in 1805. He died at Cobham, Surrey, May 22, 1839, aged 66.

ATSYLL, RICHARD, *gem engraver.* Held the office of gem engraver to Henry VIII., with a fee of 20*l.* a year. It is recorded that he cut the king's head in sardonyx, and this gem is supposed to exist in the Duke of Devonshire's collection.

ATTWOLD, R., *engraver and draftsman.* There is an engraving in the line manner, cleverly designed and engraved by him, published in 1750—'The Military Nurse, or Modern Officer,' and 'The Naval Nurse, or Modern Commander,' two satirical subjects on one plate, in the manner of Hogarth, to whom, in the absence of any knowledge of the artist, they have been erroneously attributed.

ATWOOD, THOMAS, *flower painter.* Exhibited a large flower-piece at the second Exhibition of Artists, 1761, and was a member of the Incorporated Society in 1766; but does not appear to have been a contributor to the Academy Exhibitions.

AUDINET, PHILIPPE, *engraver.* Descended from a French refugee family long settled in England. Born in Soho in 1766, was apprenticed to John Hall, the distinguished line engraver, and worked in that manner. Among his early works were the portraits for Harrison's 'Biographical Magazine' and the 'History of England.' He also engraved for Bell's publications, and there is a plate of 'Louis XVI. and the Royal Family of France' by him. Among his later works may be distinguished a large portrait of Sir Benjamin Hobhouse, and another of Sir William Domville, with the illustrations for an edition of Walton's 'Angler.' He died a bachelor, December 18, 1837, aged 71, and was buried in the vaults of St. Giles's Church.

AUSTEN, WILLIAM, *modeller.* Practised in London in the reign of Henry VI. Executed the model and metal work of the famous monument of Richard de Beauchamp, Earl of Warwick, in St. Mary's Church at Warwick, 1464, the principal figure of a natural size, and a fine work, with 36 small figures in rich Gothic niches. Flaxman praises this tomb highly, and says it equals the work of the great Italian artists of that time.

AUSTIN, GEORGE, *architect.* Was born at Woodstock, and early applied himself to the restoration of Gothic edifices. In 1820 he was appointed the resident architect of Canterbury Cathedral, and carried out very extensive and important restorations and repairs to the fabric. He died October 26, 1842, aged 62, and was buried in the cathedral.

AUSTIN, PAUL, *engraver.* Born in London 1741. He engraved landscape after several masters.

AUSTIN, RICHARD T., *wood engraver.* Was a pupil of John Bewick; and executed small cuts and vignettes in wood at the commencement of the 19th century. In 1802 he obtained the Society of Arts' silver medal. The cuts for Linnæus's 'Travels in Lapland,' published in 1811, are by him. He was a clever artist, and much employed by the booksellers, but he did nothing to promote the art, which in his day began to rise in estimation. He exhibited some landscapes at the Royal Academy in 1803 and 1806.

AUSTIN, SAMUEL, *water-colour painter.* He resided at Liverpool, where he was originally clerk in a bank, and gave up a good salary to pursue professionally an art in which he had excelled as an amateur. He was, in 1824, one of the foundation members of the Society of British Artists,

16

and exhibited in their galleries water-colour drawings till 1827, when he joined the Water-Colour Society, on his election as an associate member, and exhibited with the Society to 1834, and died in July of that year. He contributed landscapes and occasionally rustic figures, but his best works were coast scenes, introducing boats and figures, some of which were from sketches in Holland, France, and on the Rhine.

• AUSTIN, WILLIAM, *draftsman and engraver.* Pupil of Bickham. Practised in London about the middle of the 18th century, but did not attain to much reputation. He engraved several landscapes; 10 plates of the ' Ruins of Palmyra ;' views of Rome, Venice, Athens ; 38 slight etchings after Lucatelli, 1781 ; and ' Windsor Park ' after Thomas Sandby. He for some

time kept a print shop ; was a great humourist, a great supporter of Charles Fox, and published some political caricatures, which were mostly directed against the French. He exhibited at the Academy in 1776 a view on the Rhine, but does not appear again as an exhibitor. He retired to Brighton, and died there in 1820, aged 99.

AYLESFORD, HENEAGE FINCH, Fourth Earl of, *amateur.* Born in London, July 15, 1751. Was a clever draftsman in water-colours, working in a slight, free manner, chiefly in sepia or bistre. He was an honorary exhibitor at the Royal Academy, 1786–90, contributing architectural views. He also produced a few good etchings of cottages and rural scenery, some of which were published. He died October 20, 1812.

autand - willm - pointer

B

• BACON, JOHN, R.A., *sculptor.* Born in Southwark, November 24, 1740. Son of a cloth-worker in Southwark, who was descended from an old Somersetshire family. After a short schooling, he began to learn his father's trade ; but at the age of 15, was apprenticed to Mr. Crispe, a china manufacturer, who had a factory in Lambeth and his shop in Bow Churchyard. Here he was employed in modelling and painting porcelain, gained knowledge from the fine works sent to the manufactory to be burnt, and making rapid progress, early conceived a notion of his art. In 1758 he gained a premium, and altogether, nine premiums from the Society of Arts, including an award of 50 guineas for his emblematic figure, 'Ocean.' During his apprenticeship he matured plans for employing artificial stone for sculpture ; and, by his art, was the means of restoring Coade's manufacture, then falling into disuse. He had hitherto lived in the City, and now removed to the West End, and entered in 1768 as a student of the Royal Academy, then founded. About the same time he began to work in marble, and invented a machine for transferring the design in plaster with mechanical accuracy to the marble. In 1769 he gained the first gold medal given by the Academy for a bas-relief, ' Æneas escaping from Troy.' He had now given proofs of his genius as a sculptor, and in 1770 he was elected an associate of the Royal Academy. He established his reputation by his fine statue of ' Mars,' and gained the favour of the king by a bust of his Majesty, which he executed for the Archbishop of York. He

had for a time lived in Wardour Street. He now married and removed to Newman Street ; but he lost his wife within three years, and married a second time. His talent now gained him full employment, and he was commissioned to execute some important public works ; among them may be pointed out—the monuments to Pitt in the Guildhall, London, and in Westminster Abbey ; to Dr. Johnson and Howard the Philanthropist, in St. Paul's ; the bronze statue of George III. and the two groups and colossal figure of the 'Thames' in Somerset House ; also the monument of Mrs. Draper (Sterne's ' Eliza'), in Bristol Cathedral ; of Judge Blackstone, at Oxford ; of Mr. Whitbread, at Uphill, Bedfordshire ; and of Lord Cornwallis, for India. He greatly improved the sculptor's pointing-machine. He owed much to his natural genius ; in design and execution, though he never acquired the art of using the chisel, he showed an original delicacy, which was neither derived from the study of the antique nor any conventional ideal of beauty. He wrote the article ' Sculpture' in Rees's ' Encyclopædia.' His works, which are almost confined to portrait sculpture, possess great simplicity of treatment. He did not attempt classic subjects. He was, with some interruptions, an exhibitor at the Royal Academy up to his death, which befell at the height of a successful career ; when in the prime of life he was seized with inflammation of the bowels, and died in Newman Street, where he had resided 22 years, August 4, 1799. He was buried at Whitfield's Chapel, known as the Tabernacle, Tottenham

Court Road. Animated by true religious feeling, he had written many epitaphs, in both verse and prose, and the following, upon himself, was placed over his grave— 'What I was as an artist seemed of some importance while I lived; but what I really was as a believer in Jesus Christ is the only thing of importance to me now.' Careful in all his transactions, possibly somewhat avaricious, and judicious in the investment of his gains, he amassed by his art a fortune of 60,000l., which he left to be divided among his five children, two of whom followed his profession. The antique had little influence or share in his art. His chief works were monumental, and for that nature, not the ideal, was his study. His designs were marked by strong good sense. He was not led away by the poetic or the heroic, and the portrait character of his works was well preserved. The pious member of an influential Methodist congregation, he was the writer of some religious disquisitions, and, as connected with his profession, of an article for Chambers's 'Dictionary,' on the characters of painting and sculpture, which is, at least, distinguished by his usual good judgment. A short memoir of him by Richard Cecil, M.A., was published in 1801.

* BACON, JOHN, sculptor. Second son of John Bacon, R.A. He was born in Newman Street, in March 1777; and at 12 years of age entered the schools of the Royal Academy. At 15 he was an exhibitor, contributing in 1792 his first work, a bas-relief of 'Moses striking the Rock.' At the age of 16 he gained an Academy silver medal, and the following year (1794) the gold medal for his 'Cassandra.' In 1796 he exhibited two figures, 'Vigilance' and 'Prudence,' now at the Trinity House. On the death of his father in 1799, he succeeded him in his business and in his studio, completing the works in progress, on which he had been associated. In 1800 he exhibited two monumental works; in 1801, Lord Cornwallis's monument, a work commenced by his father; and in 1802 some portions of monumental works and busts, upon which he was largely employed; and continued to exhibit up to 1824, after which year his name no longer appears in the catalogues. He died in 1859. His monuments, proofs of his genius, will be found both in St. Paul's Cathedral, where there are six, and in Westminster Abbey. The statue of William III. in St. James's Square was by him in 1808.

BACON, T., sculptor. Son of John Bacon, R.A. Was associated with his father in his works. He first exhibited at the Academy, in 1793, 'The Prodigal Son,' in terra cotta; in 1794, 'Christ and the Woman of Samaria;' in 1795, 'Christ in

18

the Garden,' a model, when he ceased to exhibit.

➤ BACON, Sir NATHANIEL, Knt., amateur. Half-brother to Lord Chancellor Bacon. He painted portrait and still-life, had much talent, and studied art in Italy. Some of his works were at Culford, where he lived; and at Gorhambury, his father's seat, there is a 'Cook-maid with Dead Fowls,' and his own whole-length portrait, painted by himself, which is a very good work, and has been justly much praised. He also painted a 'Ceres' and a 'Hercules,' and left some paintings at Redgrave Hall, Suffolk. He died 1615, in his ;69th year, and was buried in the chancel of Culford Church, where a monument to him has been erected bearing his bust, and among other emblems his palette and pencils. A portrait of Sir Nicholas Bacon by him has been engraved.

BADESLADE, THOMAS, topographical draftsman. He practised in London, 1720 –1750. He drew many of the seats of the nobility and gentry, which were engraved by Toms and Harris, and made the drawings for Dr. John Harris's 'History of Kent,' published 1719, and some other publications. Alderman Boydell is said to have been first stimulated to art on seeing Toms' engravings from his drawings.

BAILEY, JOHN, engraver and draftsman. He was self-taught, and early in life drew and engraved for Hutchinson's Histories of Northumberland and Durham, 1781–84; Culley's 'Observations on Live Stock;' and other publications. His works, which were both on wood and copper, are very creditable productions, but better in engraving than in design. Leaving art, he became eminent in Northumberland as a land agent and agriculturist. He was the author of Agricultural Surveys of Northumberland, 1794; Durham, 1810; and an essay on the 'Construction of the Plough,' 1795.

BAILLIE, EDWARD, glass painter. Born at Gateshead. Exhibited at the International Exhibition, 1851, 'Shakespeare reading a Play to Queen Elizabeth.' He died in London September 21, 1856.

BAILLIE, ALEXANDER, engraver. Born in Scotland. Practised about the middle of the 18th century; but his art was indifferent, and his works are but little known. He was at Rome in 1764, and while there engraved a 'St. Cecilia,' and a 'Holy Family,' both after Imperiali. On his return he settled in Edinburgh, and engraved some portraits.

➤ BAILLIE, Captain WILLIAM, amateur etcher. Born at Killbride, county of Carlow, June 5, 1723. Educated at Dublin, and at the age of 18 came to London and entered the Middle Temple to study the law; but, against the wishes of his father

he followed the example of a younger brother and entered the army. He served several years in the 13th Foot, and was at the battle of Culloden and several actions in Germany; afterwards in the 51st Foot, and fought at Minden, and lastly in the 17th Light Dragoons. He then left the army and was made a commissioner of stamps, from which office he retired with a pension after 25 years' service. It is uncertain at what period, though no doubt early in life, he took up art (which his office left him leisure to practise). He said the happiest hours of his life were spent in its pursuit. He, however, exhibited mezzo-tints and etchings at the Spring Gardens Exhibition in 1774, and in 1776 Rembrandt's one hundred guelders print, before and after 'restoration.' He etched in various manners, blending mezzo-tint and etching with great success. He shone most in his imitations of Rembrandt, the original plate of whose hundred guelders etching, 'Christ healing the Sick,' he found in a worn-out condition, and restored. This with the 'Three Trees,' the twilight effect of which he closely copied, with some others of his works, have been placed side by side with the originals in the British Museum. He scraped a portrait of himself, after Hone, and from his own designs, 'The French Fleet overtaken by a Storm,' 1759; 'An Engagement of Cavalry,' 1762; and 'The Sacrifice of Abraham,' 1765, with some portraits. He produced altogether 107 plates, a selection of 50 from which was published by his son in 1774, and the whole collection by Boydell in 1792. He died in December 1810, in his 88th year.

BAILY, J., *engraver*. Practised towards the end of the 18th century. Some good landscapes and views in aqua-tint were executed by him, and some subjects after Morland.

BAILY, EDWARD HODGES, R.A., *sculptor*. Was born March 10, 1788, at Bristol, where his father was noted for his skill as a carver of figure-heads for ships. He was educated at the City Grammar School, and leaving school at the age of 14, was placed in a merchant's office, where he continued two years. As a boy he had amused himself in carving the likenesses of his schoolfellows, and making the acquaintance of a modeller in wax, he soon acquired such facility in the art that he abandoned the counting-house and commenced portraiture in that material. A love of Flaxman's works led him to make some studies from the antique, and gained him an introduction to the great sculptor, who offered him assistance; and coming to London in 1807, he was admitted to Flaxman's studio, where he worked for nearly seven years; and was then employed as chief modeller by Messrs. Rundell, the silversmiths. In 1809 he entered the schools of the Royal Academy, and the same year gained a silver medal, followed in 1811 by the gold medal for his group, 'Hercules rescuing Alcestis.' In 1817 he was elected an associate of the Academy, and produced for the next year's exhibition his 'Eve at the Fountain,' which gave him a wide reputation, and was executed in marble for the Literary Institution in his native city. In 1821 he became a full member of the Academy, and was at this time commissioned to execute the bassi-rilievi for the Marble Arch, now removed to Cumberland Gate, Hyde Park, and some of the decorations in Buckingham Palace. He was a constant exhibitor at the Academy. His art did not derive its inspirations from any classic source. His tastes led him to works founded on the affections, and 'Mother and Child,' 'Group of Children,' 'Sleeping Girl,' were subjects several times repeated. His few sacred subjects, originating in the same feeling, were confined to Adam and Eve. But his chief works—those on which he was mainly employed and became most distinguished — were monumental statues and portrait busts. Of such may be mentioned, in St. Paul's, Sir Astley Cooper, Sir P. Malcolm, Sir W. Ponsonby, and Earl St. Vincent; his Charles James Fox and Lord Mansfield for St. Stephen's Hall, in the Houses of Parliament; Earl Grey, Lord Mansfield, Telford the engineer, and some others. After 1858 his contributions to the Academy Exhibition fell off, and in 1863 he accepted the position of 'honorary retired academician,' and did not again exhibit. He died at Holloway, May 22, 1867, in the 80th year of his age, and was buried in Highgate Cemetery. His talent placed him in the front rank of his profession, and as he was for many years fully employed, should have made him wealthy; but he was extravagant and careless, and in the latter part of his life was always in difficulties.

BAKER, HENRY AARON, R.H.A., *architect*. Was a pupil of Gandon. He practised in Dublin, and was elected teacher of architecture in the Dublin Society's School 1787, and filled that office till his death. He erected the Triumphal Arch at Derry, and gained the first premium for his design for converting the Irish Parliament House into a bank, but was not employed. He was elected a member of the Royal Hibernian Academy on its foundation in 1823. He died in 1838. He had considerable architectural talent, but was not fortunate in opportunity for its development.

BAKER, J., *portrait painter*. Practised about 1700. He assisted Sir Godfrey

Kneller in the draperies and accessories of his portraits. A portrait by him of Sir Stephen Fox is finely engraved in mezzotint by J. Simon. A view of St. Paul's by him was sold at Sir Mark Sykes's sale. Bannerman engraved his portrait on the same plate with Charles Boit, the enamel painter.

BAKER, J., *engraver*. Resided at Islington. Practised towards the end of the 18th century. There are by him some neatly engraved book plates, chiefly portraits. He engraved for the ' European' and other magazines.

BAKER, JOSEPH, *draftsman*. Was originally an actor at York, and master of the ceremonies in that city; but fond of art he became an able draftsman. Walpole mentions his having painted some church interiors. He drew, on a large scale, the cathedrals of York and Lincoln, which were well engraved by Francis Vivares. He died April 25, 1770.

BAKER, JOHN, R.A., *flower painter*. Born 1736. Was bred an ornamental coach painter, and became pre-eminently distinguished for the wreaths and floral decorations by which it was then the fashion to surround the family arms emblazoned on coach-panels. These works by him had considerable merit, though marked by a sharp hardness of finish common to this class of art. Later in life he devoted himself to flower painting, and attained great brilliancy in his colouring. He first exhibited at the Spring Gardens Exhibition in 1762. He was one of the foundation members of the Royal Academy, and exhibited groups of flowers at the three first exhibitions. His presentation picture is a group of flowers. He died in Denmark Street, Soho, April 30, 1771. His widow was long a pensioner of the Royal Academy.

BAKER, THOMAS, *landscape painter*. Born October 8, 1809. He practised in the Midland Counties, where he was known as 'Baker of Leamington,' and his art was patronised and esteemed. His watercolour showed great versatility. He exhibited at the Royal Academy in 1831. He died August 10, 1869.

BAKER, SAMUEL, *engraver*. Practised in London towards the end of the 17th century. There are several engravings by him, but they do not possess much merit. For a series of costumes à la mode he engraved two or three of the plates, 1690.

BALDREY, JOHN K., *engraver and draftsman*. Born about 1750. Practised both in London and Cambridge between 1780–1810, working both in the chalk and dot manners; many of his works are printed in colours. Among his best works are 'The Finding of Moses,' after Salvator Rosa, 1785 ; ' Diana in a Landscape,' after

20

Carlo Maratti ; 'Lady Rawdon,' after Reynolds, 1783; and some subjects after Penny and Bunbury. His chief work is from the East Window of King's College Chapel, Cambridge, which he drew and engraved, and then finished highly in colours. He exhibited portraits at the Academy in 1793 and 1794. He retired to Hatfield, where he was living in 1821.

BALDWIN, THOMAS, *architect*. Practised in Bath, and about 1775 was appointed the architect of the corporation. He designed many of the mansions, the town-hall, the baths, the western front and portico of the king's pump-room, 1796. He also drew the plans of a Roman temple which was discovered in Bath. He died March 7, 1820, aged 70. ROBERT BALDWIN practised in London as an architect about the same period.

BALMER, GEORGE, *water-colour painter*. Was the son of a house painter in North Shields, and intended for that business. He practised for a while as a decorator in Edinburgh, cultivating at the same time a taste for art. About 1831 he sent some water-colour drawings to an exhibition at Newcastle, and afterwards assisted Mr. W. J. Carmichael, the marine painter, in his large work, 'The Heroic Exploit of Admiral Collingwood at the Battle of Trafalgar,' a picture now at the Trinity House, Newcastle. He then visited Holland, the Rhine, Switzerland, and Paris, where he made some good studies at the Louvre. On his return he settled in London, and painted some Rhenish and Dutch shore and coast scenes and some moonlights. In 1836 he suggested to Messrs. Finden, 'The Ports and Harbours of Great Britain,' a publication which they commenced, containing many views, chiefly on the north coast, from his drawings, but the work was not continued. About 1842 he came into possession of some property. He had always been diffident of the merit of his works, and giving up his commissions, he retired to Ravensworth, Durham. Here he lived about four years, amusing himself only with his art, when he was attacked by illness, and died in the prime of life on April 10, 1846.

BAMFYLDE, COPP WARRE, of Hestercombe, Somersetshire, *amateur*. Was conspicuous as a landscape painter towards the end of the 18th century, and was an honorary exhibitor at the Academy. There are some landscape etchings by him and some humorous caricatures on costume, 1776. Benazech, Canot, and Vivares engraved after him.

• BANKS, THOMAS, R.A., *sculptor*. Born in St. Mary's parish, Lambeth, Dec. 22, 1735 (some accounts say 1738). His father was land-steward and surveyor to the Duke of Beaufort. He was sent to school at Ross.

Herefordshire, and at 15 apprenticed in London to a woodcarver, serving his full time of seven years. At 23 he entered the St. Martin's Lane Academy to study from the life. In 1763 he obtained the Society of Arts' medal for a basso-rilievo. He gained a second medal in 1765, and for a life-size model of 'Prometheus' in 1769 a third medal. He had found some employment under Kent, and at the same time entering the newly-established schools of the Royal Academy, he obtained the gold medal in 1770 for his 'Rape of Proserpine,' a bas-relief; and two years later the travelling studentship. He arrived in Rome in August 1772, and by the assistance of his family prolonged his stay beyond the three years of his studentship, and completed some fine works in marble, the chief of which were 'The Death of Germanicus,' a basso-rilievo; 'Caractacus,' a 'Psyche,' and a 'Cupid,' which he brought to London to finish. He returned to England in 1779, having married a lady of some property, and exhibited a group in marble and some designs in plaster. Soon after, not finding his talents appreciated at home, and tempted by an offer from the Court of Russia, he visited St. Petersburg, taking with him his 'Cupid tormenting a Butterfly,' which was purchased by the Empress. His health suffered by the climate, and after executing some works, he returned in less than two years, and in 1781 took a house in Newman Street, and settling in the practice of his profession, he met with considerable encouragement, exhibiting yearly at the Academy. He was employed upon a monument of Bishop Newton, and finished his first great work, a colossal statue of 'Achilles bewailing the loss of Briseis,' which was afterwards presented by his widow to the British Institution, and till the closing of the gallery in 1868, stood in the vestibule. In 1784 he was elected an associate, and in the next year a full member of the Royal Academy. He presented on his election his fine work, 'The Falling Giant.' 'Thetis and her Nymphs,' a small oval alto-rilievo, is also one of his most excellent productions. Of his works in St. Paul's are the monuments of Captains Westcott and Burgess; in Westminster Abbey, where there is a tablet to his memory, the monument of Sir Eyre Coote; and in Pall Mall, the Shakespeare Group in the exterior front of the British Institution. He died in Newman Street, where he had dwelt since 1781, February 2, 1805, and was buried in Paddington Churchyard. His death was hastened by the violent treatment of an ignorant empiric. He takes high rank among England's sculptors, among whom he was the first who attained excellence in the poetic treatment of purely classic subjects, of which he left numerous sketches in clay, full of delicacy in feeling and refined finish. He was a reserved, amiable, religious man—always kind to young artists. In his latter days he found pleasure in instructing his only daughter. He left a handsome provision for his widow.

BANKS, CHARLES, *sculptor*. Brother of the foregoing. Was a student of the Royal Academy, and after receiving several premiums of the Society of Arts, gained the Academy gold medal in 1774 for his group of 'Pygmalion and his Statue.' In the following year he exhibited 'Adonis,' a model, and did not again contribute to the exhibition till 1783, when he sent 'A design for a monument;' in 1784, 'Lot and the Angels,' a model; in 1787, 'Sketch of a Basso-rilievo in Wax;' and after a lapse of four years, in 1792, 'Diana and Endymion,' apparently in wax, which was his last exhibited work.

BANKS, CHARLES, *miniature painter*. Was a native of Sweden, originally spelt his name Bancks, and came to this country when young, in 1746. He practised his art here, and was an occasional exhibitor at the Royal Academy from 1775 to 1792. His miniature of himself is engraved by M'Ardell.

BANNERMAN, ALEXANDER, *engraver*. Born at Cambridge about 1730. He was employed by Alderman Boydell, and engraved for him 'Joseph interpreting Pharaoh's Dream,' after Spagnoletto; 'The Death of St. Joseph,' after Velasquez; and 'Children Dancing,' after Le Nain. He also engraved several of the portraits for Walpole's 'Anecdotes of Painters,' and other portraits, frequently grouping them grotesquely together. In 1766 he was a member of the Incorporated Society of Artists, and in 1770 was residing at Cambridge.

BAPTIST, JOHN GASPARS, *portrait and drapery painter*. Born at Antwerp. Came to England during the Civil War, and was employed by General Lambert. After the Restoration, Lely engaged him as drapery painter, and he was known as 'Lely's Baptist.' He was afterwards employed in the same capacity by Kneller and Riley. There is a portrait by him of Charles II. in the hall of St. Bartholomew's Hospital, and another in the hall of the Painters' Company. His drawing was correct. He excelled in designs for tapestry. He died in London, 1691.

BARBER, CHARLES, *landscape painter*. Was born in Birmingham, and settled in Liverpool, where, and in the neighbourhood, he resided nearly 40 years. When the Liverpool Institute of Art was founded he was appointed the teacher of drawing, and subsequently became the president. He

painted landscape with figures. In 1813–1816 he exhibited with the Water-Colour Society, which was then open to the profession. In 1839 he exhibited at the Royal Academy 'A View of Dovedale.' His name does not appear again in the catalogue till 1849, when he sent—his last contribution—'Evening after Rain: a Luggage Train preparing to Start,' and 'Dawn of Day: Foraging Party returning.' He died at Liverpool, January 1854.

BARBER, CHRISTOPHER, *miniature painter*. Practised with some repute, both in crayons and miniature, and in oil. He was careful in the mediums he used and in the preparation of his colours, and attained much brilliancy. He was a member of the Incorporated Society of Artists in 1763, but was expelled in 1765, having exhibited with the opposing society. In 1770 he was living in St. Martin's Lane, and exhibited for the first time at the Academy miniature portraits in oil, followed by small half-lengths, conversation pieces, and some landscapes, continuing an occasional exhibitor up to 1792. He was a great enthusiast in music, and a man of much ingenuity. He died in Great Marylebone Street, March 8, 1810, aged 74.

BARBER, J., *medallist*. He executed in 1814 a good medal of 'Europa,' and earned a reputation by many fine memorial medals. He exhibited at the Academy, in 1825, 'A Group of Horses,' an impression from a die; and in 1838, 'A Medallic Portrait of the Queen.'

BARBER, JOHN VINCENT, *landscape painter*. Was the son of Joseph Barber, who taught drawing in Birmingham towards the end of the 18th century, and died there in 1811. He exhibited at the Academy, in 1812, 'Cattle and Landscape;' in 1828, 'Lake Lugano' and 'The Golden Age;' in 1829, 'Morning;' and in 1830, 'Gypsies' and 'Evening'—his last exhibited works. He died at Rome a few years after. He made drawings, in conjunction with some of our eminent water-colour painters, for the 'Graphic Illustrations of Warwickshire,' published in 1829.

BARBER, THOMAS, *portrait painter*. He was apprenticed to a house painter in Nottingham, and showing signs of superior ability, he came to London to study, and was assisted to receive some instruction from Sir Thomas Lawrence. He practised at Nottingham about 1810, and in that and the following years was an exhibitor at the Royal Academy. In 1819 he was residing at Derby, and exhibited at the Academy a portrait of Mrs. Siddons; in 1823, two portraits of young ladies; in 1824, 'The Sisters.' In 1829 he was still residing at Derby, and was for the last time a contributor to the exhibition. He

was well known and encouraged in the Midland Counties, and possessed a local reputation; but his portraits, though showing the influence of Lawrence, were weak, and had little character. He also painted several landscape views. He died at Nottingham, September 12, 1843, aged 75, and was buried in the cemetery there. He is said to have made a considerable sum by his profession.

BARBOR, LUCIUS, *miniature painter*. He lived in the Haymarket, and practised in oil, but chiefly in enamel, and gained a reputation by his clever miniatures. He exhibited at the Spring Gardens Exhibitions. He died November 7, 1767, and left a widow in distress, who was assisted by the Incorporated Society of Artists.

BARCLAY, HUGH, *miniature painter*. Born in London in 1797, and practised his art there, and also in Paris, where he was much engaged in making copies in the Louvre from the great Italian masters. He died in 1859.

BARWELL, JOHN, *amateur*. Was born at Norwich, 18 Oct. 1798, and died there 27 Feb. 1876. He painted in oil and water-colour. His portrait of William Taylor of Norwich was exhibited in Lord Derby's loan collection in 1868.

BARDWELL, THOMAS, *portrait painter*. Chiefly employed as a copyist. He painted a picture of 'Dr. Ward (who was caricatured by Hogarth) relieving his Sick and Lame Patients,' which was engraved in 1748–49; and in 1744 a portrait of Admiral Vernon, from which there is a mezzo-tint. In the University Galleries, Oxford, there are full-length portraits by him of the Earl and Countess of Pomfret. His name is remembered by his book, 'The Practice of Painting and Perspective made Easy,' which he published by exclusive licence from the Crown in 1756. He died about 1780.

BARENGER, JAMES, *animal painter*. His father (born 1745, died 1813) was brought up a chaser, and was known by his drawings of insects in water-colours. His mother was a sister of Woollett, the engraver. He was born December 25, 1780, and gained a reputation as a painter of running horses. He also painted park scenery, introducing deer, other animals, and birds. He exhibited at the Royal Academy, and was about 1820, while giving his address at Messrs. Tattersalls, largely employed in painting the portraits of horses and dogs. He continued an occasional exhibitor at the Academy up to 1831.

BARKER, BENJAMIN, *animal painter*. Native of Newark. Was educated for the bar. Ran through a considerable property, and then turned artist. He became known as a horse painter, but his works did not

go beyond portraits of horses. He died at Bristol, June 12, 1793.

BARKER, THOMAS (known as 'Barker of Bath'), *landscape and subject painter*. Born 1769, near Pontypool, Monmouthshire. Son of the foregoing. Removed with his family to Bath, where, showing a talent for art, and assisted in means by a friend, he made some good copies from the Dutch masters; and continuing to improve, at the age of 21 his friend made him a liberal allowance to go to Italy. He was there pursuing his studies in 1793, when his father died. He first exhibited at the Academy in 1791—two landscapes and a 'Moonlight with Banditti;' in 1796, three Italian landscapes and a portrait; and continued an occasional exhibitor up to 1829. He also exhibited at the British Institution for many years. His sketches were truthful, but slight and unfinished in manner. His 'Woodman,' 'Old Tom,' 'The Gipsy,' and other rustic groups, were very popular, and were reproduced on china, pottery, and even the textile fabrics. The 'Woodman,' of which he made two copies life-size, sold for 500 guineas; his 'Woodman's Cottage-door,' in 1819, for 350 guineas. He painted 'The Trial of Queen Caroline,' introducing many portraits, 1821; and a fresco, 30 feet by 12 feet, in his house at Bath, 'The Inroad of the Turks upon Scio,' 1822. He made an exhibition of his works in the great room in Lower Brook Street, where the Water-Colour Society opened their first exhibition. He died at Bath in his 79th year, December 11, 1847. He published, in 1813, 'Rustic Figures after Nature,' in 40 tinted plates; drew also on stone, and published a series of lithographic works.

BARKER, BENJAMIN, *landscape painter*. Brother of the above. Born in 1776. He resided at Bath, and occasionally exhibited at the Academy—in 1800 and 1801, Welsh views; in 1810, two landscapes; in 1813, a scene near Arundel; and in 1821, his last contribution, a Sussex landscape. During the years 1813-20 he was a large exhibitor of views and landscape compositions at the Water-Colour Society. He was also an exhibitor at the British Institution. Though a student from nature, his landscape compositions are often imitations of the old masters. His works, both in oil and water-colour, no less show much taste and feeling, and have considerable merit, but he found little encouragement. His 'English Landscape Scenery' was published in 1843. He died at Totnes, after a lingering illness, March 2, 1838, aged 62. Thales Fielding engraved 48 of his landscapes in aqua-tint.

BARKER, ROBERT, *panorama painter*. Born in 1739, at Kells, in the county of Meath. He set up in business in Dublin, and failing in this, tried miniature and portrait painting; then, quitting Ireland, he settled in Edinburgh, and followed portrait art there. The view from the Calton Hill first suggested the panorama. He had made himself master of the principles of perspective; and in 1787 he determined to execute the half-circle view from the hill, to prove the practicability of his idea. This he completed in water-colours and brought to London in the following year. Sir Joshua Reynolds was greatly pleased with his attempt, but thought his scheme impracticable. He, however, persevered, and patented his plan under the title of 'La Nature à Coup-d'œil.' Then completing a whole-circle view of Edinburgh, he exhibited it in that city, Glasgow, and London; but he did not at first meet with success in the Metropolis. His next work, however, a view of London from the Albion Mills, became popular; and, encouraged by this, he built in 1793 a new exhibition-room at the corner of Leicester Square, and painted the 'Russian Fleet at Spithead,' which was visited by the King and Queen, and became the talk of the town. A succession of his panoramas, among which the Elba, Athens, and Bay of Lisbon, were very fine, were long the favourites of the public. Stothard admired his genius, and spoke of him in high terms. He died in West Square, Lambeth, April 8, 1806, aged 67, leaving two sons.

BARBER, HENRY ASTON, *panorama painter*. Younger son of the above. Was born at Glasgow, 1774. When quite a youth, he made the drawings for his father's first panorama from the Calton Hill, and was for some time a teacher of perspective in Edinburgh. In 1789 he made the drawings of London for the same purpose, and afterwards etching them in six large sheets, published them. He was the chief assistant in the production of his father's panoramas, and on coming to London was admitted a student of the Academy. Succeeding his father, he went to Constantinople to make drawings for the panorama of that city, which he opened in 1802; and on the peace of Amiens, he went to Paris to make sketches for a panorama. He had a good knowledge of shipping. He was at Palermo in 1799, and at Copenhagen in 1801, and made sketches for panoramas of the two naval actions which were fought off those cities. In 1810 he was at Malta. He assisted Messrs. Burford in their panoramas of the Peninsular actions and of Waterloo, and went to Venice in 1819 to make drawings for the panorama of that city. His last work was the Coronation procession of George IV., 1822. In 1826 he retired from his profession, having realised a

handsome competency. He died July 19, 1856, at Bilton, near Bristol, aged 82.

BARKER, SAMUEL, *flower painter*. Was the cousin and pupil of John Vanderbank. He was brought up as a portrait painter, and a portrait by him is engraved; but he was early led to paint flowers and fruit, and in this art promised much excellence, when he died young, in 1727.

BARLOW, J., *engraver*. Practised in London towards the close of the 18th century. Among his works are engravings after Hogarth, to illustrate Ireland's work in 1791; a portrait of Mrs. Siddons as 'Rosalind;' and a considerable number of the illustrations for Rees's 'Encyclopædia,' with other works of that date.

BARLOW, FRANCIS, *animal painter*. Born in Lincolnshire in 1626. He became the pupil of William Sheppard, a portrait painter, and at first himself painted portraits; but his genius inclined him to animals, and he drew horses, dogs, birds, and fish with great spirit and characteristic truth, and embellished his groups with clever landscape backgrounds. Faithorne engraved after him, in 1658, 'Diversæ avium species studiosissime ad vitam delineatæ;' Hollar, in 1671, 'Hunting, Hawking, and Fishing,' from his inventions. He engraved several of his own works himself, and there are many etchings by him. His best work is his illustrations, consisting of 110 plates, to an edition of Æsop's 'Fables.' Symonds records that he lived in Drury Lane, and inherited a large sum of money; yet notwithstanding this and his numerous drawings and engravings, he died in indigent circumstances in 1702. His drawings are usually done with the pen in a very minute, careful manner, and slightly tinted, mostly in brown. He painted some ceilings with birds, and designed several monuments for Westminster Abbey. He painted a portrait of George Monk, Duke of Albemarle, of which there is by his own hand an excellent etching; and he also designed the hearse and made drawings of the duke's funeral pageant, which are engraved in mezzo-tint.

BARNARD, WILLIAM, *engraver*. Practised in mezzo-tint in London about the beginning of this century. Among his works, 'Summer,' and 'Winter,' after Morland, often printed in colours, were much prized. He also engraved a portrait of Nelson. He was for many years keeper of the British Institution, and died Nov. 11, 1849, aged 75.

BARNEY, JOSEPH, *engraver*. Practised about the end of the 18th century. There are some plates by him after Bassano, and in the dot manner after Hamilton and others.

BARNEY, JOSEPH, *fruit and flower*
24

painter. Was born at Wolverhampton in 1751, and at the age of 16 came to London, where he studied under Zucchi and Angelica Kauffmann. In 1774 he gained a premium at the Society of Arts, and early in life was appointed drawing-master at the Royal Military Academy, an office which he held for 27 years. His name first appears as an exhibitor at the Royal Academy in 1786, and his first contributions were chiefly classical subjects from Tasso, from Shakespeare, 'Calypso,' 'Erminia;' in 1791, 'Taking down from the Cross,' followed by domestic scenes, introducing children. Later he resumed history, with occasionally a portrait. He had exhibited one or two groups of flowers in oil, and in 1815 was appointed flower painter to the Prince Regent. He then exhibited some flowers and fruit, with other subjects, and appears for the last time in 1827, when he sent a domestic picture. He lived for a time in Westminster, but the greater part of his life at Greenwich.

BARNEY, JOSEPH, *flower painter*. Son of the foregoing. He practised at Southampton. He exhibited at the Water-Colour Society in 1815 and the three following years, and was an occasional exhibitor in London.

BARNEY, WILLIAM WHISTON, *engraver*. Brother of the above. He was a pupil of S. W. Reynolds, and practised in mezzo-tint. He engraved, among others, the portrait of the Marquis of Blandford, and his brother, after Cosway, R.A.; Sir Arthur Wellesley, after Hoppner, R.A.; and some sporting subjects, after Reinagle, R.A. About 1805, quitting his profession, he purchased a commission in the army, and rose to some distinction in the Peninsular campaign.

BARON, BERNARD, *engraver*. Born in Paris about 1700, and educated there. He came to England in 1712, but returned to Paris for a time in 1729, and while there sat to Vanloo for his portrait. On his return to this country he met with considerable employment. He engraved many fine works after Vandyke—'King Charles I. on Horseback, with the Duke d'Epernon;' 'The King and Queen, with two children;' 'The Nassau Family;' and 'The Pembroke Family.' He engraved also several works after Watteau and Titian, and after Holbein, Allan Ramsay, a portrait after Hogarth, 'King William,' after Kneller; and many other works from the best masters. His chief works were executed in London, where he resided the greater part of his life, and died in Panton Street, Piccadilly, January 24, 1762. He engraved in the manner of Tardieu, a French artist, by whom he was instructed. His manner, though coarse, possessed much merit. He was employed by Hogarth.

BARRA, JOHN, *engraver*. Born in Holland about 1572. He came to England in 1624, and between that date and 1627 he completed several plates, to which his name is attached, with the word 'London.' He is reputed to have died here in 1634. He worked entirely with the graver in a stiff, laboured manner. He is supposed to have occasionally painted on glass.

BARRALET, JOHN JAMES, *water-colour painter*. He was of French descent, and was born in Ireland. He studied under Manning in the schools of the Dublin Academy, and was temporarily employed to teach in the schools. Settling in Dublin he was much sought after as a teacher. Later he was engaged in glass-staining in connection with Hand. Afterwards he became a member of the Incorporated Society of Artists in London, and was an occasional contributor to the exhibitions of the Royal Academy. In 1770 he sent three tinted drawings—'A Storm,' 'Sunset,' and 'Ruins;' in 1771, two historical drawings and a whole-length portrait, followed by 'Women Bathing,' and some subject pieces. He also drew some views of gentlemen's seats, introducing figures and cattle, and was awarded, in 1774, a premium by the Society of Arts for 'A View on the Thames.' In 1795, when advanced in years, he emigrated to Philadelphia. There, though at first a great beau, he is said to have fallen into slovenly habits. He found employment chiefly in book illustration. Many of the drawings for Grose's 'Antiquities of Ireland' and Conyngham's 'Irish Antiquities' are by him, and his works have been engraved by Bartolozzi, Grignon, and others. He died in America about 1812.

BARRALET, J. MELCHOIR, *water-colour painter*. Brother to the above. He was a student of the Academy, and was chiefly employed as a teacher of the figure and of landscape, both in oil and water-colours. He exhibited at the Royal Academy tinted views in 1775–77 and 1788; and in 1789 views of London, but his name does not appear again. His drawings were cleverly and carefully finished in the early tinted manner. Several of his landscapes are engraved.

BARRAUD, WILLIAM, *animal painter*. Was grandson of the well-known chronometer-maker, who was of an old French family. His father held a situation in the Custom House, where, on leaving school, he obtained an appointment, which after a short time he resigned, and became a pupil of Abraham Cooper, R.A. He chiefly painted portraits of horses and dogs, but tried some subject pictures in conjunction with his brother Henry. He first exhibited at the Academy in 1829, and continued to exhibit till his death. He was

also an occasional exhibitor at Suffolk Street. He had attained a power of drawing, but did not reach any eminence in art. Two sentimental subjects by him were engraved, and had an extensive sale. He died, after a short illness, in October, 1850, in his 40th year.

BARRAUD, HENRY, *portrait and subject painter*. Brother of the above. Was born in 1812. He was for many years an exhibitor at the Royal Academy, beginning in 1833, and sending for the last time in 1859. His works are chiefly portraits with horses and dogs, but he also exhibited subject pictures, the more important in conjunction with his brother, such as, in 1842, 'The Pope blessing the Animals.' His most popular works were, 'We praise Thee, O God;' also 'The London Season,' 'Lord's Cricket Ground,' and 'Lobby of the House of Commons,' in 1872. He died June 17, 1874.

BARRET, GEORGE, R.A., *landscape painter*. Was the son of a clothier, and was born in the Liberties of Dublin 1732 (some accounts say 1728). He was apprenticed to a stay-maker, but managed to get employed by a publisher to colour prints, and, self-taught, became drawing-master at a school in Dublin. He was fortunate in gaining the notice and patronage of Mr. Burke, upon whose recommendation he began to study from nature among the fine scenery in the environs of Dublin, and soon after gained a 50*l.* premium from the Dublin Society for the best landscape painting. His success prompted him to seek his fortune in London, where he arrived in 1762, bringing with him two landscapes, which were so extravagantly praised that he thought himself the first landscape painter in Europe. He found a patron in Lord Dalkeith, who paid him 1500*l.* for three pictures. He was a member of the Incorporated Society of Artists, and one of the exhibitors at the Spring Gardens Exhibitions, and in 1764 gained the Society of Arts' premium of 50*l.* for the best landscape.

His success continuing, he settled in the Metropolis, and on the foundation of the Royal Academy in 1768 was nominated one of the members. He resided for several years in Orchard Street, Portman Square, and managed to become reduced to bankruptcy, while he was earning, it is said, 2000*l.* a year by his profession. He suffered from asthma, and then removed to Westbourne Green, Paddington, as more conducive to his health. He was at this time employed by Mr. Lock, on whose commission he painted a large room at Norbury Park, near Leatherhead, and by the friendship of Mr. Burke he was appointed master painter to Chelsea Hospital, an office to which large emoluments, though it does

not appear what duties, were attached. The last 10 years of his life were passed at Westbourne Green. There he had painted some of his best works, and died May 29, 1784, and was buried at Paddington Church. His family endured much distress, and after his death were pensioners of the Royal Academy.

He became a painter by the force of his own genius; he was his own teacher. His pencil was rapid, his touch firm and characteristic. He represented English scenery in its true freshness and richness, excelling in the verdure peculiar to spring. His distances were very successful; his effects good. He painted animals in a spirited manner; sometimes they were introduced into his pictures by Sawrey Gilpin. In his early manner he was heavy, but improved in his later pictures. Some of his works have not stood well from the colours he employed. His studies from nature, made with a black-lead pencil, are excellent, and his drawings in water-colour are painted with great skill. Several etchings by his hand are also known—done in a spirited manner. He enjoyed great reputation in his lifetime, which his works have not since maintained.

BARRET, GEORGE, *water-colour painter.* Son of the preceding. His life commenced under difficulties, which he encountered with patient exertion. He appears as an exhibitor at the Academy in 1800—'Rocky Scene' and 'Morning'— and became celebrated for his water-colour paintings. He excelled in his poetic treatments of sunrise and sunset, the effects of moonlight, and in his truly classic and poetic compositions. He was, on the foundation of the Water-Colour Society in 1804, one of its first members, and was a constant and large contributor to their exhibitions. He laboured incessantly at his art, and striving rather for excellence than gain, only earned enough to meet the daily wants of his family. The long illness and eventual loss of his son added to his troubles and accelerated his own death, which took place in 1842, when a subscription was opened for his family. He published, in 1840, 'The Theory and Practice of Water-colour Painting elucidated in a series of Letters.'

BARRET, Miss M., *water-colour painter.* Was the sister of the foregoing. She was a pupil of Mrs. Mee, and commenced art as a miniature painter, exhibiting at the Royal Academy in 1797 and the two following years. She also painted birds, fish, and still-life, and in 1823 was admitted a member of the Water-Colour Society, and was a constant exhibitor up to 1836, at which time she died. She resided with her brother.

BARRET, J., *landscape painter.*
26

Brother of the above. He practised as a water-colour painter, sometimes in body colour, and was an occasional exhibitor at the Academy from 1785 to 1800.

BARRET, RANELAGH, *copyist.* Was much employed by Sir Robert Walpole and others, and excelled in his power of copying, especially from the works of Rubens. He died in 1768, and his pictures were sold by auction in the December of that year.

BARRON, HUGH, *portrait painter.* Born in London. Son of an apothecary in Soho. He became a member of the Incorporated Society, and a pupil of Sir Joshua Reynolds, and on leaving him practised for some time as a portrait painter in London, exhibiting at the Spring Gardens Exhibitions in 1766-67 and 1768. About 1770 he started for Italy by sea. Stopping some time at Lisbon he painted some portraits there, and in 1771 and 1772 was in Rome. He soon after returned to London, settled in Leicester Square, and exhibited some portraits at the Academy in 1782-83 and 1786. He died in the autumn of 1791, aged about 45. He gave as a boy great promise of future excellence, which he failed to realise. His manner was weak; his paintings but feeble imitations of his great master. He had, however, great musical talent—was esteemed the first amateur violinist of his day—and probably to this talent, and to his gentlemanly manners, owed his employment as a painter.

BARRON, WILLIAM AUGUSTUS, *landscape painter.* Younger brother of the above. Was pupil of William Tomkins, A.R.A. In 1766 he gained a premium at the Society of Arts. He practised landscape painting and taught drawing. He was an exhibitor of landscapes, chiefly views, at the Academy from 1774 to 1777. His view of 'Wanstead House' has been engraved by Picot, and some other of his views in Essex have been engraved. Like his brother, he was distinguished as a musical amateur; and gaining the notice of Sir Edward Walpole, he gave him an appointment in the Exchequer, upon which he quitted his profession.

BARRY, JAMES, R.A., *history painter.* Born at Cork, October 11, 1741. His father was a bricklayer and builder, and afterwards became a coasting trader and the keeper of a small public-house, called 'Cold Harbour,' on the quays at Cork. He was intended for the coasting trade, but became disgusted after two or three voyages. His early education was not deficient, and of drawing he first showed some art talent by painting his father's sign of 'The Neptune,' a ship of that name on one side and the heathen god on the other. Then, permitted to follow his own

bent, he continued the practice of drawing; made acquaintance with two herald painters, from whom he gained some help; copied such prints as he could get, among them the cartoons of Raphael, and decorated his father's house with his attempts. Happily, finding a purchaser for his works, he was enabled to go to Dublin. Here he became the pupil of Mr. West, the well-known able teacher of the figure, and at the age of 22 he painted a large historical subject from a sketch he had made at Cork, The Conversion and Baptism of one of the Kings of Leinster. This work was exhibited at the Dublin Society of Arts, and at once brought him into notice and gained him the friendship of Mr. Burke, who, in 1764, induced him to come to London, introduced him to his friends, and in the next year assisted him by an allowance of 50l. a year to visit Italy. On his way he stayed a while to study, and then went on to Rome, where, as his letters show, he applied himself earnestly to his improvement in art; but, unfortunately, an irritable temper led him into disputes with both the artists and lovers of art in that capital.

In 1770, after an absence of five years mostly spent in Rome, he returned to London, visiting on his way Florence, Turin, Bologna, and other cities, and the following year he exhibited his first picture at the Royal Academy, the 'Adam and Eve,' now in the possession of the Society of Arts, and next year his 'Venus rising from the Sea,' when he gained his election as associate, and in 1773 as royal academician. These pictures, and his 'Jupiter and Juno' exhibited at this time, obtained him much notice but no employment, and he advertised to give lessons twice a week for three guineas per month. He disliked portraiture—indeed, he was by temper and manner most unsuited to its successful pursuit—but devoted to epic art, he was one of the foremost of the artists who proposed to decorate St. Paul's Cathedral, if the plan did not originate with him. In 1776 he completed a 'Death of General Wolfe.' Led away by his love of classic art—and not without high contemporary authority—his figures in this picture were all nude, and provoked criticism which stirred him to unbridled anger, and much bitter feeling ensued. Enthusiastic in his desire to vindicate the genius of his countrymen, he published at this time his reply to the ill-founded opinion of the Abbé Winckelmann, that the English are incapable both from natural defect of genius and an unfavourable climate of attaining excellence in art. His wants were, from his well-known habits, few; yet he must have found a difficulty to supply them by the practice of high art, and he recurred to his proposal to teach, offering to give instruction in the art of design to any nobleman or gentleman who might require such assistance.

Shortly after, he was engaged in the great work of his life. In March 1777 the Society of Arts accepted his offer to decorate their great room with appropriate paintings, on condition that he was provided with canvas, colours, and models for his work. He chose for his subject 'Human Culture,' and thus describes his designs: 'In this series, consisting of six pictures on subjects useful and agreeable in themselves, I have still further endeavoured to give them such a connection as might serve to illustrate one great maxim or moral truth —viz. that the obtaining of happiness, as well individual as public, depends upon cultivating the human faculties. We begin with man in a savage state, full of inconvenience, imperfection, and misery; and we follow him through several gradations of culture and happiness, which, after our probationary state here, are finally attended with beatitude or misery. The first is the story of Orpheus; the second, a Harvest Home, or Thanksgiving to Ceres and Bacchus; the third, the Victors of Olympia; the fourth, Navigation, or the Triumph of the Thames; the fifth, the Distribution of Premiums in the Society of Arts; and the sixth, Elysium, or the State of Final Retribution. Three of these subjects are poetical, the others historical.' These six pictures are each 11 feet 6 inches high, and two 42 feet each in length. All of them are crowded by carefully painted figures, and the Elysium is filled with the portraits of the most distinguished men the world had then known. Barry, unassisted by any one, and in strict conformity with his offer, completed his laborious work—which must have proved a constant strain upon his mental and physical powers —but not in three years as he had proposed, as it was not till April 26, 1783, that the Society of Arts voted him their thanks on accepting his finished work.

Meanwhile, in 1782, he was appointed professor of painting in the Royal Academy, and at the beginning was irritated by some observations of the president on his want of diligence in preparing his lectures. But surely some allowance might have been made for an artist then so earnestly occupied; and there could have been little time lost, as he commenced his first course on March 2, 1784. But the choice of lecturer was injudicious, and should have been avoided. He was not popular in the profession. He had made enemies, and was soon charged with being intemperate in his remarks from the professor's chair, and filling his lectures with invectives against his fellow-academicians. One of the body, Edward Edwards, in a

memoir of Barry tainted by great ill-will, selects as an example of this his remark ' on the contracted and beggarly state of the academical library '—a fact, if coarsely expressed—and his out-of-place tale of his serious loss of money, which he is supposed to have misplaced and afterwards discovered. ' My house was broken open and robbed of a considerable sum, which I had provided to purchase the lease of a house, where I wished quietly and retired to carry on another work for the *public*, about which I had been for some time engaged. What aggravated the matter still more was, that I had good reason to be assured that this robbery was not committed by mere thieves, but by some limbs of a motley, shameless combination, some of whom passed for my friends, who well knew what I was about, and wanted to interrupt and prevent it, by stripping me of the necessary means of carrying it on ; ' and this writer thus sums up Barry's offences : ' His writings, and particularly his lectures, abound with traits of self-consequence and inexplicable attempts at definitions, interspersed with abusive comments upon those persons who did not pay him that high respect to which he thought himself entitled.' There is no doubt the academicians had selected the wrong man for their professor's chair, nor that they wished to remove him; and in 1799 they appointed a committee to enquire into his backslidings, who summoned him to appear before them. It is not stated whether he appeared; but on their report a general assembly of the body resolved—' First, to remove him from the office of professor of painting ; and by a second vote, that he be expelled from the Royal Academy.' The interests of the Academy would warrant the conclusion which was come to in the first vote, but on what grounds can the second vote be justly supported ? Now all personal irritation has long since passed away, Barry is known only as a great painter ; and all must feel regret that, for defects of temper and manners alone he should have been expelled from a body where, as artists, few were his equals.

Barry was now 58 years of age. He was a solitary man, of an unsocial but far from a morose disposition, and rudely independent, living in the greatest discomfort and neglect, without a servant or even an attendant of any kind. His house in Castle Street, Oxford Street, where he lived 20 years and died, was known by its ruinous decayed exterior ; a visitor was rarely admitted, and he became more and more negligent of his person and dress. Yet he was not without means, though his wants were reduced to a very low scale. The Society of Arts, with their gold medal and a present of 200 guineas, had given him

the privilege to exhibit the great works he had painted on their walls. This produced him, in 1783 and 1784, 503*l*., and altogether 700*l*., and he then undertook the drudgery of etching and engraving these works to a large size, which, from his way of working, became a labour requiring the exercise of strength as well as skill, and it is said that he even printed the work himself. He also engraved some of his own designs in aquatint, among them ' Job in his Distress surrounded by his Friends.' The occasional sale of a few copies of these works was an addition to his means, though he ungraciously received the help of those who procured him purchasers. Age had crept upon him. His singular appearance and mode of life naturally led to the conclusion that he was in necessitous circumstances, and his friends at the Society of Arts recognising his persevering pursuit of art, his love of his profession, and his neglect of mere pecuniary gain, called a meeting in May 1805, and resolved to purchase him an annuity. They raised 1000*l*. and purchased of Sir Robert Peel an annuity of 120*l*., to which Lord Buchan added 10*l*., but Barry did not live to receive the first payment.

The circumstances of his death and solitary condition are truly painful. He was seized with an attack of pleuritic fever on entering a dining-house which he usually frequented, on February 6, 1806. Unable to speak or move, some cordial was administered, and he was taken to the door of his house in a coach. It was found impossible to open it. Some mischievous boys had filled the key-hole with dirt and pebbles; shivering under the rapid progress of his disease, he was at last taken to the house of a kind friend, who procured him a bed at a neighbour's. He desired to be left, and locked himself in for 48 hours without medical assistance. He could give no account of himself during that time, and was probably delirious. When medical aid was procured it was too late. He lingered till the 22nd, when he died. Son of a Protestant father, he had early in life been converted to Romanism by his mother, and became a stern and bigoted Catholic, and on his death-bed he was attended by a priest of that communion. He was in principle a republican, which he never failed to avow. Sir Robert Peel defrayed the charge of his funeral. Surrounded by his great epic work, still unsurpassed in the English school, his body lay in state at the Society of Arts, and then, followed only by its members and a few friends—yet not one artist—found its merited resting-place in the crypt of St. Paul's, near the coffin of Reynolds.

His literary works have been published, with a copious memoir of him, by Dr.

Fryer, in 2 vols. 8vo. They comprise 'An Enquiry into the real and imaginary Obstructions to the acquisition of the Arts in England in 1775.' 'An Account of the series of Pictures in the Great Room of the Society of Arts, by James Barry, R.A., 1783.' 'A Letter to the President, Vice-presidents, and Members of the Society, 1793.' 'A Letter to the Dilettanti Society respecting the obtension of certain matters essentially necessary for the improvement of public taste, and for accomplishing the original views of the Royal Academy.' 'Second edition, with matters appended relating to his expulsion from the Academy,' 1799. 'A Letter and Petition addressed to His Majesty, 1799.' His works were sold at Christie's in April 1807. Bidders mounted on the benches. His favourite 'Pandora,' though unfinished, fetched 230 guineas; 'Venus rising from the Sea,' 100 guineas; 'Adam and Eve,' 110 guineas. But the 'Pandora,' when resold in 1846 to pay the expense of warehouse-room, fetched only 11½ guineas! In the 'Edinburgh Review' of 1811 there is an article on his works, attributed to Mr. Payne Knight.

BARRY, Sir CHARLES, Knt., R.A., *architect*. Born May 23, 1795. Son of a stationer in Bridge Street, Westminster. He was articled to a surveyor and architect in Lambeth. About the expiration of his articles his father died, and leaving him a little property, he determined to travel for improvement in his profession. He was a tolerable draftsman, and had exhibited his first drawing at the Royal Academy in 1812. In 1816, in his 22nd year, he started for Italy, and devoted himself to the careful study of the finest edifices of the Italian cities. In 1818 he extended his tour to Greece, and thence to Palestine and Egypt, returning to England in 1820. In 1822 he commenced his professional career, and while yet unknown obtained by competition the erection of St. Peter's Church at Brighton. Some commissions followed from Manchester, where he also erected a church, and at Oldham another in 1822. His works soon made known his abilities, and professional employment increased rapidly. He was appointed architect to Dulwich College; and in 1832 completed his first notable work in London, the Travellers' Club, a building distinguished by the simple elegance of its proportions and of its ornamentations. In 1834 the Houses of Parliament were burnt down, and a new legislative palace was thrown open to competition, an opportunity of distinction which rarely falls to the architects of this country. Barry entered the competition and was successful, and in 1837 commenced this great work, which will for ever give him a memory and a name in our metropolis. In the same year he was appointed to erect the Reform Club, followed by the College of Surgeons. He now stood at the head of his profession, and in 1840 was elected an associate, and in 1842 full member of the Royal Academy. Simultaneously with the great works on which he was engaged, he erected several noble mansions—for Lord Tankerville, at Walton-on-Thames; the Duke of Sutherland, at Trentham, Cliefden, and, in Scotland, Dunrobin Castle; and for the Earl of Ellesmere, Bridgewater House, St. James's. But the greater portion of his active life was devoted to the Houses of Parliament, one of the most extensive and elaborate works of the time, both from its vast proportions and the amount of its decorative details. The House of Lords was completed and occupied for the session of 1847, and the House of Commons, with all the principal parts of the edifice, for the session of 1852, and the architect then received the honour of knighthood. His unremitting labours came to a sudden termination; he was seized with paralysis and died, before medical assistance reached him, at his house at Clapham, May 12, 1860. He was buried in Westminster Abbey, his funeral attended by numerous professional and personal friends. His art will always be measured by his great Gothic work, the Houses of Parliament—a work carried on with successful determination under many vexatious obstructions and difficulties. The noble river *façade*, the grand proportions of the Victoria Tower, the elegant lightness of the Clock Tower, added to the well-proportioned and decorated galleries and chambers of the interior, render this work one of the greatest architectural features of the Metropolis; yet the less pretentious merits of some of his other works no less attest his genius and refined taste. The two fronts of the Travellers' Club—that in Carlton Gardens especially—and the entrance front of Bridgewater House, are notable examples of his true feeling for Italian art. He was a fellow of the Royal Society and of the Institute of British Architects, and was awarded the gold medal of the Institute in 1850. He was also a member of several foreign academies, and in 1855 gained the gold medal for architecture at the Paris Exhibition. His 'Life and Works' has been written by his son, the Rev. Alfred Barry.

BARRY, J., *miniature painter*. He first appears as an exhibitor at the Royal Academy in 1784, and continued for many years. In 1786 he contributed, in miniature, 'The Four Seasons.' In 1788, his health failing, he made a voyage to Lisbon, and on his return, in 1789, exhibited 'Mrs. Crouch in Selima;' in 1792, a 'Bacchante;' and was an occasional exhibitor up to 1819, when his name disappears.

BARTHOLOMEW, ALFRED, *architect.* Was born in Clerkenwell, March 28, 1801. Showing an early taste for architecture, he was placed under an architect, but devoted himself to the literature of the profession. He published 'Specifications for Practical Architecture;' 'Hints relative to the Construction of Fire-proof Buildings;' a 'Cyclopædia of the Metropolitan Buildings Act;' and was the editor of 'The Builder' on its commencement. He died January 2, 1845.

BARTHOLOMEW, ANNE CHARLOTTE, *flower painter.* Born March 28, 1800, at Loddon, Norfolk. In 1827 she married Mr. Tunbull, a musical composer, who died in 1838, and under this name she published —1825, 'It's only my Aunt,' a farce; and in 1840, 'The Song of Azreal,' and other poems. She first exhibited miniature portraits at the Royal Academy in 1829, and continued for several years as an exhibitor of miniatures. In 1840 she married Mr. V. Bartholomew, a flower painter, and then occasionally exhibited flowers or fruit; but her chief works were miniatures for brooches and jewellery. She painted also some miniatures in character. Her last exhibited works, in 1856 and 1857, were flowers and fruit. She died in Charlotte Street, Rathbone Place, August 18, 1862, and was buried in Highgate Cemetery.

* BARTLETT, WILLIAM HENRY, *topographical landscape painter.* Born at Kentish Town, March 26, 1809. In 1823 he was articled to Mr. John Britton, whose architectural publications are well known, and accompanied him on his tour when collecting the materials for his 'Picturesque Antiquities of English Cities.' He soon made great progress in drawing, and was employed in sketching views and buildings in Essex, Kent, Bedford, Wilts, and other counties. He afterwards made drawings of many churches in Bristol, Gloucester, and Hereford. In 1829 he was engaged in making drawings of Fountains, Roche, Rievaulx, and other abbeys. Then he travelled on the Continent, and in 1834–35 extended his journeys to the East, exploring, in a succession of visits up to 1852, Asia Minor, Syria, Palestine, Egypt, Turkey, and the Arabian Deserts. He also took four voyages to America. In these journeys he made numerous sketches and drawings, above 1000 of which have been published, in addition to those comprised in the following works—'Walks about Jerusalem,' 1844; 'Topography of Jerusalem,' 1845; 'Forty Days in the Desert,' 1848; 'The Nile Boat,' 1849; 'The Overland Route,' 1850; 'Footsteps of our Lord,' 1851; 'Pictures from Sicily,' 1852; and 'The Pilgrim Fathers,' 1853. In prosecution of his indefatigable labours, he had started again for the East, when, on his

passage from Malta to Marseilles, he was suddenly attacked by illness, and died on board, September 13, 1854. His drawings were sold by auction at Messrs. Sotheby's in the following January.

BARTOLOZZI, FRANCESCO, R.A., *engraver.* Was the son of a goldsmith in Florence, and born there September 21, 1725. He studied drawing under a master in Florence, and then became the pupil of Joseph Wagner at Venice, by whom he was taught engraving. He afterwards went to Rome, where he established his reputation by his plates from designs for the 'Life of St. Vitus' and the engraved portraits for an edition of 'Vasari.' Dalton, the librarian of George III., who was travelling in Italy, engaged him to engrave a series of Guercino's drawings, and on the completion of this work induced him to come to England, where he arrived in 1764, and was soon after admitted a member of the Incorporated Society of Artists and appointed engraver to the king, with a salary of 300*l.* a year. He was thus brought into rivalry with Robert Strange, who had lost the king's favour; and stimulated by this he produced his fine plate of 'Clytie,' after Caracci, followed by his 'Virgin and Child,' after Carlo Dolci. His skill in drawing the figure and knowledge of the principles of painting were unequalled, and on the establishment of the Royal Academy in 1768, he was nominated a member. As an engraver, he was a complete master of his art, and the diploma of the Royal Academy, engraved by him, is unrivalled; this, with the works mentioned above, the 'Venus and Satyr,' after Luca Giordano; the 'Silence,' after Caracci; and the portraits of Lord Clive and Lord Thurlow, are talented specimens of his art and finest manner. In his boyhood he formed a friendship with Cipriani, R.A., which continued through life, and he became the best engraver of the works of his friend. He engraved several fine plates for Alderman Boydell. He was not less excellent in his lighter productions, which were rapidly executed, than in his exquisitely-finished plates—both bore evidence of character, sweetness, and beauty, while both equally imitated the spirit of the originals. Laborious, working early and late, he was generous and profuse in spending his gains, but he was without prudence, and made no provision for the latter days. His difficulties drove him to expedients to meet his expenses. The chalk manner offered him facilities, and his studio became a mere manufactory of this class of art; plates were executed by many hands under his directions, which received only some finishing touches by him; and his art was further vitiated and his talents wasted by the trifling class of works thus produced. In 1802 he accepted

30

the office of superintendent to the National Academy at Lisbon, and to induce his stay here George III. offered him a pension, but too late; his engagement was made, to which he held or excused himself, and he left England on November 3, 1802, for Portugal, where he was knighted. He died at Lisbon, March 7, 1815, in his 91st year.

BARTOLOZZI, Gaetano Stephen, *engraver*. Son of the foregoing, and of some reputation in the same profession, but was indolent—an enthusiast for music rather than engraving. He was the father of Madame Vestris, of stage celebrity. He engraved a portrait of Madame Recamier, after Cosway, R.A., and of Mrs. Rudd, who was tried for forgery 1775. He died August 25, 1821, aged 64.

BARTON, ——, *portrait painter*. An artist of this name painted a portrait of George I., of which Bromley catalogues an engraving.

BASEVI, George, *architect*. He was educated at the well-known school kept by Dr. Burney at Greenwich, and then entering Sir John Soane's office in 1810, was for six years his pupil. At the end of this time he travelled, and studied during three years, in Italy and Greece; on his return he soon gained notice, and Belgrave Square, the great building speculation of the day, was erected after his designs in 1825. His principal work is the Fitzwilliam Museum at Cambridge, in the florid Italian style, designed in competition in 1835. He built a small church at Twickenham, St. Mary's Church at Greenwich, and also a church at Brompton and at Hove. The Elizabethan Hall at Brighton is by him, and he was the joint architect, with Mr. Sydney Smirke, of the Conservative Club in Pall Mall. His death was accidental. He was engaged to inspect the Bell Tower of Ely Cathedral, then undergoing repair, and while lost in the consideration of its fine construction, he stepped from a beam on which he was standing, and falling to the floor, was killed on the spot, October 16, 1845, aged 51.

BASIRE, Isaac, *engraver*. Born 1704. He lived near St. John's Gate, Clerkenwell, and has been styled a map engraver. He engraved the frontispiece to an edition of Bailey's 'Dictionary,' published 1755. Died August 24, 1768.

BASIRE, James, *engraver*. Son of the foregoing. Born October 6, 1730. Brought up to his father's profession, he was assisted in his studies by Richard Dalton, went with him to Italy, and made drawings in Rome after Raphael. He was appointed engraver to the Society of Antiquaries about 1760, and to the Royal Society about 1770. He was member of the Free Society of Artists, and acted as their secretary. The best specimens of his works are the

beautiful plates in the 'Vetusta Monumenta,' published by the Antiquarian Society, and the royal portraits and other plates in the 'Sepulchral Monuments.' He also engraved 'Pylades and Orestes,' after West; a large plate from 'The Field of the Golden Cloth,' after the painting at Hampton Court; many plates for Stuart's 'Athens;' and some fine portraits of distinguished men. He died in his house in Great Queen Street, Lincoln's Inn Fields, September 6, 1802, and was buried in a vault under Pentonville Chapel. He was noted for the correctness of his drawing and the fidelity of his burin.

BASIRE, James, *engraver*. Son and grandson of the foregoing, and succeeded his father in his art. Born November 12, 1769. He was engraver to the Royal Society and the Society of Antiquaries, and inherited the abilities of his father. His best works are 'The Cathedrals' from Mr. John Carter's drawings. He died at Chigwell Wells, May 13, 1822.

BASIRE, James, *engraver*. Son of the above, and fourth in succession following the same profession. He was born in 1796, and early acquired excellence as a draftsman and engraver. He was much employed by the Society of Antiquaries, and engraved many of the plates for Gough's 'English Cathedrals.' He died in London, May 17, 1869.

BASSETT, Henry, *architect*. Student of the Royal Academy. Gained the gold medal in 1825 for his design for a National Gallery. He was from that time an occasional exhibitor at the Academy, and about 1839 was professionally employed on the Southampton estate. In 1844 he exhibited his last contribution, a 'Model of Italian Villas,' then erecting after his designs.

BASTON, Thomas, *marine painter*. Attained some eminence. Several of his representations of ships-of-war and shipping have been engraved. He etched some of his own designs, and published in 1721 nine plates of sea views.

BATEMAN, James, *animal painter*. He was born in London in 1814, and in 1841 was, for the first time, an exhibitor at the Royal Academy, and continued a contributor till his death. His subjects were the humorous treatment of animals, and were very cleverly chosen, as well as the titles he gave to them. He died at Holloway, March 24, 1848.

BATEMAN, William, *engraver*. Born at Chester. Drew and engraved with much spirit many of the ancient buildings in that city. He died at Shrewsbury, April 27, 1833, aged 27.

BATLEY, ——, *engraver*. He practised in mezzo-tint about 1770, and was chiefly employed upon portraits.

BATLEY, William, *architect*. He is

31

supposed to have built some of the fine old mansions in Northamptonshire and the adjoining counties. He died at Wellingborough in 1674, aged 80, and on his tomb is designated as 'architect.'

BATTLEY, JOHN, *architect.* Was of some local eminence at Leeds, where he erected the theatre and several considerable buildings in the town and neighbourhood. His principal works executed about 1770-80.

BATTY, ROBERT, Lieut-Colonel, *amateur draftsman.* Son of Mr. Batty, of Hastings, M.D. At the age of 15 he accompanied his cousin, Mr. Bickersteth, afterwards Lord Langdale, on a tour in Italy, and had the opportunity of cultivating a taste for art, which belonged to his family. He was educated at Caius College, Cambridge, but his destination in life was balanced between arms and medicine, for after entering the army he returned to Cambridge, and eventually took a degree in medicine. But the events of the day probably determined his career, and entering the Grenadier Guards, he served with them during the campaign of the Western Pyrenees and at Waterloo; and he recorded the services of his corps in a quarto volume, illustrated by his own etchings, under the title of 'The Campaign of the Left Wing of the Allied Army in the Western Pyrenees and South of France in 1813-14.' He also wrote a 'Sketch of the Campaign of 1815.' Afterwards he published several volumes of scenery in various countries—'French Scenery,' in 1822; 'German Scenery,' in 1823; 'Welsh Scenery,' in the same year; 'Scenery of the Rhine, Belgium, and Holland,' 1826; 'Hanoverian, Saxon, and Danish Scenery,' 1828; 'Scenery in India,' and 'Select Views of the principal Cities of Europe,' 1830-33. He had also completed drawings in water-colours of views in Spain and Portugal, and had disposed of them for publication, but they have not appeared. He was occasionally an honorary exhibitor at the Academy from 1825 to 1832. He died in London, November 20, 1848, aged 59, leaving a widow and family. His industry was great, his works carefully and truthfully drawn, his architecture correct in its proportions and outlines; and his merits as a topographical draftsman deserve recognition.

BAUER, FRANCIS, F.R.S., *botanic draftsman.* Was born at Felsberg, Austria, October 1, 1758. He came to England in 1788, and two years after settled at Kew, where he was for 30 years draftsman to the Royal Botanic Gardens, and was appointed botanic painter to George III. A fine collection of his elaborate works is in the British Museum. He died December 11, 1840, aged 82.

BAXTER, THOMAS, *water-colour paint-*

er. Was born in Worcester, where his family were long connected with the china works, February 18, 1782. He was a clever imitator of still life, and rapid in his manner. He excelled in fruit, flowers, and landscape. He also painted some works on porcelain, which were greatly esteemed, especially some miniatures after Reynolds, and a pink service of china, in which the figure was well introduced, 1814-16. He then went to the Swansea works, where he continued three years, returning to Worcester in 1819. Afterwards he went to London, but unable to support himself, he sought employment in the provinces, travelling from place to place; but under his anxieties his health failed, and he died in London, April 18, 1821. He drew the monumental figures, some of which he also etched, for Britton's 'Salisbury Cathedral,' and made two very clever copies of the 'Portland Vase.'

BAXTER, JOHN, *architect.* Born in Scotland, where, after having studied in Italy, he practised with much ability. He died 1796.

BAYNES, JAMES, *water-colour painter.* Born at Kirkby Lonsdale, April 1766, and was assisted to become the pupil of Romney, and a student of the Academy. He married, and was on the point of starting for Italy; but his patron, offended by his imprudent marriage, stopped his assistance. He then obtained employment, with but small pay, from a company who proposed to print in oil-colours the works of the old masters. This soon failed, and he fell back upon his art. He also taught, and had several pupils who gained a name in art. He was from 1796 till his death nearly a constant exhibitor at the Academy. His contributions comprised views in Norfolk, North Wales, Cumberland, and later, in Kent. He occasionally introduced figures and cattle. He died 1837.

BEACH, THOMAS, *portrait painter.* He was born at Milton Abbas, Dorsetshire, and early showed a love of art. In 1760 he became a pupil of Sir Joshua Reynolds, and at the same time a student in the St. Martin's Lane Academy. On leaving his master he established himself in Bath, where he gained employment and repute as a portrait painter, and from that city sent portraits (1772-83) to the exhibitions of the Incorporated Society of Artists, of which body he was a member, and a warm advocate in the squabbles which arose. His works are well known in the West of England, and consist chiefly of small portraits and portrait groups. He painted in 1787 the portraits of Mrs. Siddons and her brother in the Dagger scene in 'Macbeth;' and she describes 'her brother's head as the finest she has ever seen, and the likest of the two.' He first exhibited at the Royal Academy

Baudin Josephus Ruester 1732. 3

in 1785, contributing portraits yearly up to 1790, and did not again exhibit till 1797, when he was living at Strand-on-the-Green, near Kew, and then sent a portrait of the Prince of Wales. He died at Dorchester, December 17, 1806, aged 68. His works are well drawn, carefully painted in a low sober tone, and are by no means without merit. Several of his portraits are engraved. There is a portrait of Woodfall, the parliamentary reporter, by him in the National Portrait Gallery.

♥ BEALE, MARY, *portrait painter*. Born in Suffolk 1632. Daughter of the Rev. Mr. Cradock, minister of Walton-on-Thames. She is said to have been instructed by Sir Peter Lely, but probably only copied his works; and Walpole adds, 'Sir Peter is supposed to have had a tender attachment to her.' She painted in oil, water-colour, and crayons, and was much encouraged; many persons of great distinction, especially Churchmen, sat to her, and she derived a good income from her profession. Her prices in oil were 5*l*. for a head, 10*l*. for a half-length. Pilkington says she married an obscure painter named Beale, but it is stated in a note to Walpole that he succeeded his father in a manor and estate at Walton, Bucks; and it appears he was more of a chemist than an artist, preparing colours, in which he trafficked with painters, and it is clear exchanged with Lely. It appears, too, that he held some employment under the Board of Green Cloth. Mrs. Beale died in Pall Mall, December 28, 1697, and was buried under the communion table in St. James's Church. There is a portrait by her of Charles II. in the National Portrait Gallery, and of Archbishop Tillotson in Lambeth Palace. Her portraits are weakly painted, wanting in expression and finish, hands without drawing, and colour disagreeable. She was in her day reputed as a poet as well as a painter.

BEALE, CHARLES, *miniature painter*. Son of the foregoing. Born May 28, 1660. Studied art under Flatman; then assisted his mother in her draperies and backgrounds, and painted portraits in oil and water-colours, and some few in crayons. But he had weak eyes, which prevented him following his profession more than four or five years, and he never attained any distinction in art.

BEALE, BARTHOLOMEW, *portrait painter*. Another son of the above Mary Beale. He was intended for his profession, and commenced his art under Flatman, and painted portraits in oil and water-colours; but he had little inclination for painting, which he relinquished, and studied physic. He practised medicine for a time at Coventry, and died there.

BEAN, RICHARD, *engraver*. Studied in Paris under Guérin. He was of much promise, and produced a set of anatomical plates and some good portraits; but he was drowned while bathing at Hastings, at the age of 25, June 24, 1817.

BEARD, THOMAS, *mezzo-tint engraver*. Born in Ireland. He engraved several portraits of no great merit, though popular in his day. His best works dated about 1728.

BEARE, GEORGE, *portrait painter*. Practised in the first half of the 18th century. There is a known portrait by him of John, fourth Duke of Bedford, and an engraving, date 1747, of another portrait by him.

BEAUCHAMP, RICHARD, D.D., *architect*. Son of Sir Walter Beauchamp. Was created Dean of Windsor in 1447, Bishop of Hereford 1449, and of Salisbury 1450. He built the great hall, parlour, and chamber of the Episcopal Palace at Salisbury, and was appointed by Edward IV., in 1474, 'master and supervisor of the works' in the erection of St. George's Chapel, Windsor. He died in 1481, and was buried at Salisbury.

BEAUCLERC, Lady DIANA, *amateur*. Daughter of Charles Spencer, second Duke of Marlborough. Born March 24, 1734; married in 1757 Viscount Bolingbroke, and, on the dissolution of this marriage, the Hon. Topham Beauclerc, celebrated as a wit and man of society. She drew, designed, and executed bas-reliefs. Walpole says he built a closet 'expressly for the reception of some incomparable drawings by her for scenes in the "Mysterious Mother;"' but he adds, 'these sublime drawings were the first she ever attempted, and were all conceived and executed in a fortnight.' This smacks of flattery; but she was certainly a clever painter, and though aiming at a loose artistic style, she showed power and invention. She made designs for a translation of Burger's 'Leonora,' and contributed some designs also to a handsome edition of Dryden's 'Fables,' published in folio, 1797. A drawing by her of her two daughters in the characters of 'L'Allegro' and 'Il Penseroso' was engraved by Bartolozzi. She died August 1808, aged 74.

BEAUMONT, Sir ALBANIS, *amateur*. Born in Piedmont, but naturalised in this country. He was an amateur draftsman of great merit, and engraved in aqua-tint. He travelled much; and in 1801 issued his 'Travels in the Alps,' illustrated by his own faithful drawings. Between 1787 and 1806 he published five works on the Alps, and views of the harbours and antiquities of the South of France. He died in England; the date of his death is unknown.

BEAUMONT, Sir GEORGE HOWLAND, Bart., *amateur*. Born at Dunmow, Essex, November 6, 1753. Succeeded to the title 1762. Educated at Eton and New College,

D 33

Oxford. In 1782 he travelled and visited France, Switzerland, and Italy. In 1790 he entered Parliament. His tastes were early devoted to the arts, and he gained distinction as an amateur painter. He enjoyed the friendship of Sir Joshua Reynolds and other distinguished artists, and ruled in the fashionable world as the leader of taste. He was a frequent honorary exhibitor, at the Royal Academy, of landscapes, which did not surpass respectability in manner. He died February 7, 1827, and left by his will 16 pictures—among them some fine works — to the National Gallery, the establishment of which he had zealously promoted.

BEAUMONT, John Thomas Barber, *miniature painter.* Was born in Marylebone, December 21, 1774. He manifested an early taste for art, and in 1791 entered the schools of the Royal Academy, where he gained several medals, and from 1794 to 1806 was an exhibitor. He took up miniature art, soon distinguished himself, and was appointed miniature painter to the Duke of Kent and Duke of York. In his miniatures there is no apparent stippling or hatching—all appears done with a broad, full pencil. Of an active mind, he was not satisfied with the quiet pursuits of art. He published, in 1802, 'A Tour in South Wales.' Soon after, he wrote on the defences of the country, and organised a body of volunteers. He also established the well-known 'Weekly Register.' In 1806 he successfully established a provident institution, and later the County Fire Office, of which he was the managing director. He abandoned art for these pursuits, and does not appear as an exhibitor after 1806. He took the name of Beaumont (added to Barber), and was an active magistrate for Middlesex and Westminster. He died May 15, 1851. Some theatrical miniature portraits by him are engraved.

BEAUVAIS, John, *miniature painter.* A native of France, who settled in England. He gained a Society of Arts' premium in 1765, and practised with success as a miniature painter at Bath in the latter half of the 18th century. He is mentioned in Smith's 'Life of Nollekens' as a constant attendant at Langford's auctions, and was noted for his dirty person, but he nevertheless regularly presented himself at Court. He died in London, date unknown.

BEAZLEY, Charles, *architect.* Formerly of Whitehall and of Walmer, Kent. He was an occasional exhibitor at the Academy, 1787 to 1806. Died at Hampstead, January 6, 1829, aged 69.

BEAZLEY, Samuel, *architect.* The son of an architect; he was born at Whitehall in 1786, and was the pupil of the foregoing Charles Beazley, his uncle.

In early life he served as a volunteer in the Peninsula. He was fond of the drama, and wrote for the stage several dramatic pieces and adaptations. 'The Steward,' played in 1820, and 'The Deserted Daughter,' were his chief productions of this class. His architectural works were mainly in connection with the theatre. He rebuilt the Lyceum in 1807, and again after it was burnt down in 1830. In 1820 he rebuilt the Birmingham Theatre, and in 1821 the Dublin Theatre. He also reconstructed the interior of the Drury Lane Theatre in 1822, and added the external colonnade. To this list must be added the Soho Theatre, built about 1834 ; the St. James's Theatre, in 1836–37 ; the theatre at Leicester, 1836 ; and the City of London Theatre, 1837. After his designs also several mansions were erected, and some stations on the South Eastern Railway ; the Lord Warden Hotel, Dover, 1849 ; and the Pilot House. He exhibited at the Royal Academy for the first time in 1811, and at long intervals up to 1840. He died of apoplexy at Tunbridge, October 12, 1851, in his 66th year, and was buried at Bermondsey Old Church.

BECK, David, *portrait painter.* Born at Arnheim 1621. Came to England as pupil and assistant to Vandyke, and gained the notice of Charles I., who made him drawing-master to the young princes. His facility of execution was so great, that the king is reported to have said : 'Faith, Beck ! I believe you could paint riding post !' He afterwards went to France, Denmark, and Sweden, and in the last country was patronised by the Queen, and gained wealth and reputation. He died at the Hague, 1656.

BECKETT, Isaac, *mezzo-tint engraver.* Born in Kent 1653. He was apprenticed to a calico printer, but becoming acquainted with Lutterell, who was trying the new art of mezzo-tint, he learnt from him the process. He was obliged to abscond for a time in consequence of an intrigue, but was afterwards again connected with Lutterell in the development of mezzo-tint ; and then marrying a woman of some fortune, he set up for himself. He was industrious, completed many portraits, chiefly after Kneller, Lely, and Riley, with some after Vandyke and Murray, and from the life, with some subject plates. In this he was assisted by his former colleague, Lutterell. His drawing was weak, but his plates clear and well scraped, though flat and coarse in the shadows ; and the art owed some progress to him. He died 1719, aged 66.

BECKMAN, Sir Martin, Knt., *landscape painter.* Pupil of John Wyck. He painted sea-pieces and landscapes, and then entering the service of Charles II. as

an engineer, he planned Tilbury Fort and the works at Sheerness.

BECKWITH, THOMAS, *portrait painter.* Was the son of a respectable attorney in the West Riding of Yorkshire, and was apprenticed to a house-painter at Wakefield. Then, showing a taste for drawing, he became locally reputed as a clever portrait painter, and with the feeling of an antiquary drew every church and object of antiquity in the neighbourhood, till his drawings in pencil or water-colour formed an important collection. He was well-known for his antiquarian knowledge. He published 'A Walk in and about the City of York,' and was elected F.S.A. He obtained a patent for a hardened crayon which held a good point. During the latter part of his life he resided in York, and died there February 17, 1786.

BEECHEY, Sir WILLIAM, Knt., R.A., *portrait painter.* Was born at Burford, in Oxfordshire, December 12, 1753. He is said by an early contemporary to have been originally a house-painter; other accounts state that he was articled to a solicitor at Stowe, Gloucestershire, and was transferred to a solicitor in London. Here he became acquainted with some students of the Royal Academy and enamoured with the fine arts. He had been restless in his law studies, and his master being prevailed upon to release him, he devoted himself earnestly to the profession of his own choice, and was admitted a student of the Academy in 1772. In 1775 he exhibited some small portraits, and making some progress he painted for a time in London, and then tried Norwich, where he produced some conversation-pieces in the Hogarth manner. He remained there four or five years, and first tried life-size portraits in 1783, when he painted a whole-length, with some others. He had some distinguished sitters, and he also tried some subject pictures. He then returned to the Metropolis, and took a house in Lower Brook Street, where he soon gained both practice and celebrity. He afterwards removed to Hill Street, Berkeley Square, then to George Street, Hanover Square, and finally to Harley Street. He was elected A.R.A. in 1793, and the same year painted a portrait of Queen Charlotte, who appointed him Her Majesty's portrait painter. He was fortunate to gain the Court favour, and in 1798 he painted a large equestrian portrait of George III., with portraits of the Prince of Wales and the Duke of York at a review in Hyde Park, and the same year received the honour of knighthood, and was elected a royal academician. The above large work has been called his *chef-d'œuvre*, and was much admired at the time. It is, with several other portraits by him, in the Hampton Court

Gallery, and has at least the merit of solid, honest painting; but he has failed to overcome the ungainly military uniforms of that day, and his composition is faulty, and the work stiff and ineffective. He afterwards painted for the Prince of Wales portraits of the princesses, and then whole-length portraits of all the royal family, and for the Queen the entire portrait decorations of a room at Frogmore. Enjoying the favour of the Court, fashion followed him, and many of the most distinguished of his day were among his sitters. In his early career he had painted some subject pictures, but his art was essentially portrait. His chief merit was the accuracy of his likenesses. His colouring was delicate and sweet, particularly in his female portraits, but his draperies were flimsy, his females want grace, and his males character. Yet he was not without much merit, though his works are not likely to sustain the high reputation which he enjoyed in his lifetime. He sold his art collection of pictures, books, and engravings in 1836, and retired to Hampstead, where he died January 28, 1839, aged 86.

BEECHEY, GEORGE D., *portrait painter.* Son of the foregoing. Was brought up as a portrait painter, and followed his father's manner. Commencing in 1817, he was a constant exhibitor at the Academy for several years, and so long as his father continued in active practice he had many sitters, including some persons of distinction. Soon after 1828, his practice having rapidly declined, he went to Calcutta, and his last exhibited portrait, in 1832, was sent from that city. He was for a long time settled in Lucknow, and was Court painter to the King of Oudh. He is believed to have been living there in 1855, but to have died before the Indian Mutiny in 1857.

BEESLEY, ROBERT, *still-life painter.* He was a member of the Free Society of Artists, and exhibited with the Society, 1763-80, fruit, birds, landscapes, and some subjects in oil.

BEHNES, WILLIAM, *sculptor.* Was the son of a Hanoverian, a pianoforte maker, who had settled in London. He was born there, and in 1795 was taken, when in childhood, by his family to Dublin, and was intended to follow his father's business, but entering the schools of the Dublin Academy he showed abilities which led him to art. He, however, returned with his family to London, and settling with them at the East End of the Metropolis, he continued to work with his father. He had no less retained his art tastes, and acquired a great facility in drawing portraits on vellum, and the family moving westward he tried portraiture as a profession, and by his great diligence soon rose into notice. He first exhibited at the

Academy in 1815, and in that and the three following years sent portraits in oil and in crayons ; but gaining some casual instruction in modelling he was led to that art, and in 1819 he exhibited portraits both in oil and modelled in clay.

He now finally adopted the sculptor's profession, and soon found full employment. From 1820 to 1840 he enjoyed a very large practice, and executed some important public works. But he was improvident and involved himself in difficulties, added to which he was of irregular habits. His reputation suffered ; and in 1861 he became bankrupt, and in his old age, living alone in miserable lodgings and afflicted with paralysis, he was taken, after a fall in the streets, to Middlesex Hospital, where he died, January 3, 1864, aged above 70.

His true art was in portrait statues and busts, and from 1822 his exhibited works were of this class. He rendered the grace of childhood with much truth. His ' Child with a Dove,' and his portraits of Lord Mansfield's and Mr. Hope's children are good examples, as is also a bust of the Princess Victoria and of Benjamin West, P.R.A. Of his statues may be named Sir William Follett and Dr. Bell, in Westminster Abbey ; and Major-General Sir T. Jones and Dr. Babington, in St. Paul's—the latter probably his best work. General Havelock, in Trafalgar Square—his last work of this class—is but a weak production. The honours of his profession were barred by his irregularities. Several distinguished sculptors were among his pupils.

BELL, Edward, *engraver.* Was nephew of the publisher of the ' British Poets,' and was known as a mezzo-tint engraver towards the end of the 18th century.

BELL, Lady, *amateur.* Sister of Hamilton, R.A., and wife of Sir Thomas Bell, sheriff of London. She was instructed by her brother, and had some assistance from Sir Joshua Reynolds. She made some good copies of oil paintings : among them, a ' Holy Family ' by Rubens. She appears also to have had some skill in modelling, as in 1819 she was an honorary exhibitor of two busts at the Royal Academy. A portrait by her of her husband is engraved. She died March 9, 1825.

BELL, William, *portrait and history painter.* Born at Newcastle-on-Tyne about 1740. He came to London 1768, and entered the schools of the Royal Academy established that year. In 1771 he gained the gold medal for his picture of ' Venus entreating Vulcan to forge Arms for her Son.' He found a patron in Lord Delaval, and painted two views of his Lordship's mansion, Seaton Delaval, in 1775, and several whole-length portraits of his family, but did not maintain his early promise. He resided for some time at

36

Newcastle, where he subsisted by portrait painting, and died about 1804.

BELLERS, William, *landscape painter* of the latter part of the 18th century. Eight views by him of the Cumberland Lakes were published by Boydell in 1774, and several of his landscapes are etched by Chatelain, Ravenet, Canot, and others. He exhibited with the artists at the Society of Arts in 1761, and continued an exhibitor to 1772, painting moonlights, sunsets, storms, &c., sometimes tinted drawings and crayons, but he does not appear to have contributed to the Academy Exhibitions.

BENAZECH, Peter Paul, *engraver and draftsman.* He was born in England in 1744, and was a pupil of Vivares, and studied some time in Paris. His landscapes evinced much observation of nature and taste, and gained him reputation ; some of them are engraved. Of his own engravings, his best are four large landscapes after Dietrich, 1770-71. He also engraved four landscapes after Vernet, and a subject-piece after Ostade.

BENAZECH, Charles, *portrait and subject painter.* Son of the foregoing. Born in London, but chiefly studied on the Continent. He went to Rome in 1782, and returning by Paris, was in that city at the commencement of the Revolution. He exhibited at the Academy, in 1790 and 1791, subjects from the poets and some portraits. He is known by four pictures, engraved by Schiavonetti, of the last days of Louis XVI. He painted several good portraits, some of which he engraved with his own hand. He was member of the Academy at Florence. Died in London in the summer of 1794, in his 27th year.

BENIÈRE, Thomas, *statuary.* Born in England, of French parents, 1663. He carved portraits in marble from life at two guineas each, and modelled small works, which were much admired. He lived near the Fleet Ditch, and died there in 1693.

BENNET, S, *engraver.* He practised in London at the beginning of the 19th century, and kept a print-shop in Spring Gardens. He engraved after M. Angelo ' Leda ' and ' Venus and Cupid.'

BENNET, William Mineard, *miniature painter.* Born at Exeter. Became a pupil of Sir Thomas Lawrence, and attained reputation in London as a miniature and portrait painter. He exhibited at the Academy in 1812, sending oil portraits and miniatures, in 1813-15-16, and again in 1834-1835. He then settled in Paris, where he gained the esteem of the French Court, and was decorated by Louis Philippe. He attained also proficiency in music, and cultivated a taste for literature. In 1844 he returned to Exeter, and pursuing art only as an amusement, died in his native city, October 17, 1858, aged 80.

Bellin S= mezt engraver ? 1860

BENNET, WILLIAM JAMES, *water-colour painter*. He was in 1808 a member of the 'Associated Artists in Water-Colours,' and was in 1819 an 'exhibitor' at the Water-Colour Society, sending Neapolitan views. In 1821 he was elected an 'associate exhibitor,' exhibiting in 1823 'The Coast of Barbary,' and in 1824 'Mount Vesuvius;' after 1825 his name disappears from the catalogue.

BENNETT, WILLIAM, *water-colour painter*. Born 1811. He is reputed to have been a pupil of David Cox, and to have begun his art career rather late in life. His name as an exhibitor first appears at the Royal Academy in 1842 and 1843, when he sent views in Somersetshire, followed in 1844 and 1845 by subjects in North Wales, continuing at long intervals a contributor till 1854. In 1848 he was chosen a member of the Institute of Painters in Water-Colours, and from that year till his death his chief works were exhibited at the gallery of the Institute. He painted chiefly the scenery of England—her woods, commons, sea-coasts, and ruined edifices. His works were carefully finished, his foliage good, but the general effect sometimes too green. He died at Clapham Park, after a short illness, March 16, 1871.

BENOIST, WILLIAM PHILIP, *engraver*. He was born at Coutances, Normandy, and brought to England by Du Bosc; he early in life settled in London. He engraved portraits in a neat manner, and a print of the 'Mock-masons,' with some other subject works. He was also a teacher of drawing in many families of the higher class. After a residence of about 40 years in London, he died there in August 1770.

BENSON, SIR WILLIAM, KNT., *architect*. His father served the office of sheriff of London, and was knighted. He was born in 1682, and having received a good education he travelled to improve himself in his profession. In 1710 he built a residence for himself at Amesbury. He represented Shaftesbury in the first parliament of George I. He was appointed surveyor-general to the Crown in 1718, superseding by a political intrigue Sir Christopher Wren, and in opposition to his opinion he erected the exterior balustrade over the upper order of St. Paul's Cathedral. On an official survey of the House of Lords, he reported the Peers' Chamber was in a dangerous · state; but other professional opinion being taken, it was, after investigation by a committee of the House, declared in a sound condition, and his report false and groundless. He was removed from his office, for which he was incompetent. He was afterwards convicted of bribery, and expelled the House of Commons; and then, sinking into obscurity, he died at Wimbledon, February 2, 1754. He is stigmatised by Pope in 'The Dunciad.'

BENTLEY, CHARLES, *water-colour painter*. He first exhibited at the Water-Colour Society in 1832 and 1833, and appears as an associate exhibitor in 1834. He was elected a member in 1844, and was from the first a constant contributor to the Society's Exhibitions. His contributions were chiefly coast and river scenes, but extended over a wide range, and included the numerous and varied incidents which belong to such subjects. Though chiefly found on the coasts of the United Kingdom, he sought his subjects in France, Holland, Venice, and painted effects of sunset, evening, storm, and calm. He also painted a few more exclusively landscape subjects. In the hands of picture dealers, he was uncertain in his transactions, and always poor. He died of an attack of cholera, after a few hours' illness, September 4, 1854, aged 48.

BENTLEY, JOSEPH CLAYTON, *engraver*. He was born in 1809, at Bradford, Yorkshire, and commenced art as a landscape painter; but in 1832 came up to London to study engraving, and placed himself under R. Brandard. He practised in the line manner, and was much engaged on Messrs. Fisher's illustrated serial publications. Many of his works were also for the 'Gems of European Art,' published by Messrs. Virtue; and he engraved for 'The Vernon Gallery.' He did not abandon painting, but continued to paint and exhibit, and his knowledge of art enhanced the value of his engravings. In engraving he was rapid, but his work was not of a high class. Some of his best engraved works are after R. Wilson, Gainsborough, Calcott, Creswick, and Linnell. His assiduous labour undermined a weak constitution, his health became precarious, and he died at the age of 42, October 9, 1851, leaving a widow and two children.

BENTLEY, RICHARD, *amateur*. Was the only son of the celebrated Dr. Bentley, master of Trinity College, Cambridge, and an educated man of many accomplishments, but involved in distress and difficulty by his own imprudence. He was intimate with Walpole, with whom he is said to have maintained 'a sickly kind of friendship, which had its hot and cold fits.' He claims a place here by his designs in illustration of an edition of Gray's works, printed at Strawberry Hill, and also as the designer of many Gothic embellishments at that noted residence. He was patronised by Lord Bute, and wrote some political and dramatic works. He died October 23, 1782.

BENWELL, JOHN HODGES, *subject painter*. Born 1764; son of the under-steward to the Duke of Marlborough. Was a pupil of Mr. Saunders, an obscure portrait

painter, and studied in the schools of the Royal Academy, where, in 1782, he gained a silver medal. He then for a time taught drawing in Bath. He executed a few small oval drawings in water-colour, which he united with crayon in a manner peculiar to himself, and was much praised at the time. Several of his works have been engraved—two scenes from 'Robin Gray,' the 'St. Giles's and the St. James's Beauties,' and the 'Children in the Wood.' This latter, by Sharp, has been pointed to as of great merit, but possesses little character—the children unsoiled, trimly dressed, and crisply curled, reclining on a bank of flowers. He exhibited a classic subject at the Academy in 1784. Using the wet crayon, which is so liable to be effaced, his works have not endured. He died prematurely, of consumption, in 1785, and was buried in St. Pancras's Churchyard. He is believed to have been in no way related to Mary Benwell, who practised about the same time.

• BENWELL, Miss MARY, *portrait painter*. She practised in crayons, oil, and in miniature; and was of repute in her profession. She lived in Warwick Court, and exhibited at the Artists' Society in 1761, and continued to exhibit there and at the Royal Academy up to 1782, chiefly crayon portraits and miniatures. A portrait by her of Queen Charlotte was engraved by Houston, and her 'Cupid Disarmed' by Charles Knight. She married an officer named Code, whose promotion she was able to purchase, and retired to Paddington, where she was living in 1800, having long ceased to practise her profession. She was said to have been an aspirant for Academy honours; and Peter Pindar, mistaking her Christian name, alludes to her—

'Thus shall I hurt not any group composers,
　From Sarah Benwell's brush to Mary
　　Moser's.'

BERCHETT, PETER, *history painter*. Born in France 1659. Was a pupil of La Fosse, and made rapid progress in art. He first came to England in 1681, but stayed only a year. He then came again on an engagement, which fulfilled, he went to Holland for a short time to paint King William's palace at Loo, and returned to England, where he finally settled. He practised in the decorations then in vogue. He painted the chapel-ceiling at Trinity College, Oxford, the staircase at the Duke of Schomberg's in Pall Mall, and other works of this class. At the latter part of his life he lived in ill-health at Marylebone, and painted only small pieces from fabulous history. He died in Marylebone, January 1, 1720.

BERRIDGE, JOHN, *portrait painter*.

He was a pupil of Sir Joshua Reynolds. While studying under him in 1766 he received a premium from the Society of Arts. In 1769 he was elected a member of the Incorporated Society of Artists. He exhibited portraits in oil at the Society's Exhibitions and at the Royal Academy in 1785, but there is no further trace of him.

BERRY, WILLIAM, *gem engraver*. Born in Scotland about 1730. Was apprenticed to a seal engraver in Edinburgh, and followed this art with great assiduity. He attained high excellence, and executed some fine intaglios, but very few in a pure style of art—heads and full-length figures, both of men and animals. For these works, both original and from the antique, he was without encouragement; his great abilities were little known, and he modestly followed the lower branches of his art to maintain his family. He passed his life in Edinburgh, and died there June 3, 1783, leaving a large family, for whom his talent and industry had not enabled him to make any savings.

BETTES, JOHN, *engraver and painter*. Was a pupil of Hilliard, and practised miniature painting and engraving in the reign of Queen Elizabeth. He painted a miniature in oil of the Queen, which gave her Majesty great satisfaction. He engraved some vignettes for Hall's 'Chronicle.' An oil head by him was exhibited in 1875 at the Royal Academy Old Masters' Exhibition, dated 1545. It was well drawn and expressed, good in colour, and carefully finished. He died about 1570.

BETTES, THOMAS, *illuminator*. Was brother of the foregoing, and followed, with him, the same profession. He painted the limnings, then much used, in Church books, and drawings in small from the life.

BEWICK, THOMAS, *wood engraver*. He was born August 12, 1753, at Cherryburn, in the parish of Ovingham, Northumberland, where his father held a colliery for many years. Having by his chalk scribblings on a barn-door—a propensity he indulged over the whole village—attracted the notice of Mr. Ralph Beilby, an engraver at Newcastle, he became his apprentice. His master undertook every class of work, and he employed Bewick on the diagrams for Dr. Hutton's great work on Mensuration, which were engraved on wood, that they might be printed with the type; and the beauty and accuracy with which he finished these diagrams induced his master to recommend him to devote himself to wood engraving, then little practised. His apprenticeship ended in 1774–75, he returned to his father's house at Cherryburn, but continued to do piece-work for his master. In 1776 he came to London, and was employed by a wood engraver; but he pined for his native air and rural habits,

and within about twelve months he was again settled at Newcastle, and soon after became the partner of his former master. At this time he engaged to furnish the cuts for an edition of Gay's 'Fables,' published in 1779. The work showed a good knowledge of his art, and 'The Old Hound,' one of these cuts, obtained a premium from the Society of Arts. In 1784, a new edition of 'Select Fables' was published, the wood-cuts for which were entirely the work of himself and his brother, and showed an advance in his art, with improved finish.

From his earliest youth he was a close observer and delineator of animals. He neglected no opportunity of visiting and studying the itinerant collections which were brought to Newcastle, and had long projected a 'History of Quadrupeds.' This he commenced in 1785, and after several years of preparation, in conjunction with his partner, published, in 1790, the first edition, the drawings and engravings for which were entirely by his own hand : and as a proof of its popularity, in each of the succeeding two years printed another edition. During the progress of this work he was employed upon some plates in copper, the natural history illustrations for a 'Tour through Sweden and Lapland,' which are curious specimens of that art, combining the manner both of wood and copper. His 'Quadrupeds' became widely known, and the work was very highly esteemed : the animals themselves, the vignettes and tail-pieces descriptive of their haunts and habits, with quaint bits of humour, satire, and fun, were a great and unexpected charm. His fame was now firmly established, both as an engraver and designer, and he engaged, with his brother John, upon a series of cuts for Goldsmith's 'Traveller' and 'Deserted Village,' and Parnell's 'Hermit,' which were published by Bulmer in 1795, and their success afterwards led to Somerville's 'Chase.'

The 'Quadrupeds' had been the foundation of his fortune, and pursuing the same idea, and jointly with his partner, he began, in 1791, the cuts for a new work, 'The History of British Birds,' and in 1797 published the first volume, containing the land-birds, the finest example of his work. His partner contributed the written descriptions ; but, owing to some misunderstanding, he published in 1804 the second volume, the water-birds, himself, with some assistance in the literary part. This new work increased his reputation ; the minute and characteristic accuracy of the drawing, the natural delicacy of the feathered and furry textures, the truth of the backgrounds and accessories, and the graphic humour of the vignettes, were unsurpassed, and a new scope and value

given to the art of wood engraving. In 1818 he published Æsop's 'Fables,' with his own designs. This was his last work, and had occupied him six years. He was engaged in the latter part of his life, assisted by his son, upon the 'British Fishes.' About 30 cuts of the fishes were completed, with more than 100 vignettes of river and coast scenery, the vagaries of fishermen and fishwomen, birds of prey fishing, and such like ; but the work was not finished. His last project was to improve the morals and taste of the lower classes by a series of prints on a large scale for cottage-walls ; and a cut of an old horse, intended to head an address on cruelty, his last attempt. He died of gout at his house, near the Windmill Hills, Gateshead, November 8, 1828, in his 76th year. He was a man of frank, genial habits, with a strong power of observation and love of nature, and united the talents of the draftsman and engraver with the knowledge of the naturalist—the power of vigorous invention with laborious detail.

The number of his works and his industry are inconceivable. Fine copies of his birds and quadrupeds command large prices. For an impression of his celebrated 'Bull,' dated 1789, 20 guineas have been given ; and the impressions of a zebra, an elephant, a lion, and tiger, which he executed on a large scale for an exhibitor of wild beasts, are now rare. Yet his art is best shown in his smaller pieces. But it must not be said that all had been the work of his own hands. He had the merit of educating several talented pupils, who assisted him. Of them, Robert Johnson designed many of the tail-pieces in the birds and the greater number of the fables published in 1818 ; and Luke Clennell, among other works, the greater portion of the tail-pieces in the second volume of the birds. His own brother, too, was a valuable coadjutor. Several memoirs and notices of him have been published—'A Sketch of his Life and Works,' by his friend Mr. Atkinson ; 'Some Account of his Life, Genius, and Personal Habits,' by another friend, Mr. Doveston ; a memoir in 'Blackwood's Magazine,' 1825, and in the 'Gentleman's Magazine,' 1829 ; a notice in Jackson's 'Treatise on Wood Engraving,' 1839 ; 'A Critical Catalogue of his Works and his Brother's, with Notices of their Lives,' by John Gray Bell, 1851 ; and lastly, a manuscript memoir, which he left with his family, was published in 1862, but it is very discursive, and but little connected with his art.

✔ BEWICK, JOHN, *wood engraver*. Younger brother of the foregoing Thomas Bewick. He was born at Cherryburn in 1760, and was apprenticed to his brother. During five years he assisted in many of

this class. He was one of our earliest political caricaturists. The 'Newmarket Racecourse' and 'Ludicrous Philosopher,' in six plates, are by him. He also engraved the portraits of his father and himself. He died 1758.

BIELBY, W., *topographical draftsman.* He practised in the latter half of the 18th century, and painted some views of Chelsea and Battersea, which were engraved in aqua-tint by Jukes. Several views by him are also engraved in Angus's 'Seats of the Nobility and Gentry,' commenced 1787.

BIERLING, ADAM A., *architectural draughtsman.* Hollar engraved views of Arundel House, in the Strand, after his drawings. He was the publisher of several of Hollar's works.

BIFFIN, Miss SARAH, *miniature painter.* She was born near Bridgewater in 1784, and was from her birth without hands and feet. She was early taught drawing, and making good progress, she had some instruction from Mr. Craig, the miniature painter, and in 1821 was awarded a medal by the Society of Arts. She was patronised by the royal family, and for many years supported herself by her art; but as age grew upon her she was much reduced, and then residing at Liverpool, an annuity was purchased for her by a subscription raised there. She died October 1850.

BIGG, WILLIAM REDMORE, R.A., *subject painter.* Was born in January 1755. He was a pupil of Penny, R.A., and entered the Academy schools in 1778. In 1780 he first appears as an exhibitor of 'Schoolboys giving Charity to a Blind Man,' and in the following year of 'A Lady and Children relieving a distressed Cottager.' In 1782 he exhibited with the Free Society 'Palemon and Lavinia.' He continued to exhibit works of this class and portraits, and in 1787 was elected an associate of the Academy; but his progress must have been slow, for it was not till 1814 that he gained his election as academician. From the commencement of his career to its close he was a constant exhibitor. His whole art, from which he never strayed, was founded upon the simplest incidents of domestic life, and always with a benevolent and moral tendency. Among his later works are, however, some landscapes, into which, no doubt, rustic figures are introduced. His works had not much vigour in execution or subject; his colouring was somewhat feeble and chalky; but his pictures were no less suited to the taste of the day, and were very popular. Many of them were engraved. Leslie, R.A., mentions that he sat to him for the Knight in his painting of 'Sir Roger de Coverley,' and says, 'I thought him an admirable specimen, both in look and manner, of an old-fashioned English gentleman; a more amiable man never

existed.' He died in Great Russell Street, February, 6, 1828.

BILLINGSLEY, sometimes called 'Beeley,' WILLIAM, *china painter.* Born at Derby about 1758. He early found employment in the china works, where he was apprenticed for five years, 1774–9. He left the Derby works about 1785, and became engaged at the Pinxton factory in the same county. He did not stay longer than 1800, when he superintended a small factory at Mansfield, where he remained about five years. In 1811 he emigrated to Worcester, from thence to Nantgarw in 1816, where he remained till his death in 1828. He gained great repute for his skill as a china painter, excelling especially in his flowers, but he changed his employment so often that he failed to maintain the position he deserved.

BILLINGTON, HORACE W., *landscape painter.* He was the brother-in-law of the celebrated singer, and was known by his abilities as an artist. He exhibited some views at the Academy in 1802. Died in London, November 17, 1812.

BINDON, FRANCIS, *amateur.* Was a native of Ireland, and a gentleman of fortune, who made great efforts to promote the fine arts in his country. With this view he visited Italy, to improve his own knowledge of art. He painted many portraits in Ireland in the reign of George II., and had some knowledge of architecture, of which Bessborough House, in the county of Kilkenny, built by him, is an example. There is by his hand a portrait of Dean Swift, engraved 1732; Dean Delany, and Dr. Sheridan; and a full-length of the Archbishop of Armagh, which was mezzo-tinted about 1742 by John Brooks. His portraits are tolerably drawn, but painted thinly, and with very little finish. He died June 2, 1765.

BING (or BYNG), EDWARD, *drapery painter.* He found constant employment in the studio of Sir Godfrey Kneller, to whose portraits he added the wigs, draperies, and other accessories. After Kneller's death, in 1723, he was employed to finish his unfinished works—a task left him by his master's will, with an annuity of 100*l.*

BING (or BYNG), ROBERT, *drapery painter.* Brother of the above, and employed in the same manner, by Kneller. There are portraits by him dated 1716. He practised for a time in Salisbury. There is a portrait of Cave Underhill, the actor, by him in the Garrick Club.

BINNEMAN, WALTER, *engraver.* He practised in the 17th century, and there are some indifferent portraits by his hand.

BIRCH, WILLIAM, *enamel painter.* Born in Warwick. Practised in London. Exhibited at the Academy, first time, in

Binns -J- - Painter 41t 1850

1781, 'A Mother and Child,' enamel; and the following year, 'Portrait of a Child going to Bed,' also in enamel; and continued for several years to exhibit. He received the Society of Arts' medal in 1785 for excellence in his art and improvements in the processes. In 1794 he went to America, and settled in Philadelphia, where he died. He painted a miniature of Washington, which has been engraved. He was also an excellent engraver, and a clever view from Mr. Cosway's room in Pall Mall is a good example of his ability in the use of the graver, 1789. He published, in 1791, 'Délices de la Grande Brétagne'— landscapes after the principal English painters.

BIRCH, HENRY, *engraver*. Practised latter part of 18th century. He engraved two plates after Stubbs—'The Gamekeeper' and 'The Labourer.' His chief works were after contemporary artists.

BIRCH, JOHN, *portrait painter*. Born April 18, 1807, at Norton, Derbyshire. For a time assisted his father, who was a file-cutter, and was then employed by a carver and gilder at Sheffield; but after seven years he was tempted by a love of drawing to try his fortune as a portrait painter, and coming to London, he placed himself under Mr. Bigg, R.A. He practised his art chiefly at Sheffield, where he found full employment; but a portrait by him of Ebenezer Elliott, the poet of the corn-laws, does not give any high opinion of his ability. He also painted some landscape scenery in Derbyshire. In the latter part of his life he resided in the Metropolis. He died at South Hackney, May 29, 1857.

BIRD, Miss E., *miniature painter*. She was an occasional exhibitor at the Academy from 1793 to 1798.

BIRD, EDWARD, R.A., *subject painter*. Was born at Wolverhampton, April 12, 1772; the son of a carpenter. He received a fair education, began to draw as a lad, and was apprenticed to a tea-tray maker, whose productions he embellished with landscapes, fruit, and flowers. His work gave room for taste and skill, and he was soon distinguished above his fellow-workmen. After the end of his apprenticeship he refused advantageous offers to continue with his employers, and removed to Bristol, where he opened a drawing-school, and in the intervals of teaching worked hard to improve himself. Nothing came amiss to him; he painted miniatures and the scenery for a pantomime. He had filled a sketch-book with subjects which showed much originality, and was induced by his friends to send some finished works to the Bath Exhibition, where they found purchasers. His first successful work was 'Good News,' which he exhibited at the Academy in

42

18?9. This was followed by 'Choristers Rehearsing' and 'The Will;' and in 1812 he was elected an associate of the Academy. He exhibited the same year his 'Country Auction,' followed by six subjects representing a Poacher's Career; and in 1814, 'Queen Philippa supplicating the Lives of the Six Burghers of Calais.' In 1815 he was elected a member of the Academy; and in 1816 he exhibited 'The Crucifixion;' in 1817, 'Christ led to be Crucified;' and in 1818, 'The Death of Sapphira,' his last work. His 'Chevy Chase' was esteemed his *chef-d'œuvre*. It was purchased for 300 guineas by the Duke of Sutherland, and gained him the appointment of historical painter to the Princess Charlotte. This was followed by his 'Death of Eli,' for which the British Institution awarded him 300 guineas. His 'Choristers' was purchased by the Prince Regent, who gave him a commission for a companion picture, which he did not live to finish. During the last five or six years of his life he constantly struggled with disease, latterly producing hypochondriacal affection. The death of a son and a daughter added to his trials, and he died November 2, 1819, at Bristol, where he had chiefly resided, and was buried in the cloisters of the cathedral. He left a widow and three children without provision. His art was imitative, without the appearance of labour. His earlier domestic subjects are his best works. He showed great skill in the conception of his higher class pictures, but he had not the power suited to their completion, and his colouring was crude and tasteless.

BIRD, FRANCIS, *sculptor*. Was born in Piccadilly in 1667. Sent to Brussels at the age of 11, he afterwards studied his art there, and then travelled to Rome, where he was instructed by Le Gros. In 1716 he returned to England, and was employed by Gibbons, and next by Cibber, whom he succeeded in his profession, setting up for himself after a second short visit to Italy. He gained the favour of Sir Christopher Wren, and was employed on the decorations of St. Paul's Cathedral. The great alto-rilievo, 'The Conversion of St. Paul,' in the pediment, 64 ft. by 18 ft., contains eight equestrian figures, with many others. It is his chief work, and he was paid for it 1180*l*. His 'Queen Anne,' with four figures round the pedestal, which stands before the portico, is a picturesque work, for which he received 1130*l*. His chief monumental works are—'Dr. Busby,' a fine characteristic work; 'Sir Cloudesley Shovell,' and 'The Duke of Newcastle,' in Westminster Abbey; 'Lord Mordaunt,' in Fulham Church; and 'Henry VI.' in bronze, at Eton College. He died February 20, 1731, after having for many years

monopolised the chief works in the profession. He was unequal in his productions, but hardly deserves the criticism with which he has been assailed. If his works possess little true genius, they cannot be called 'barbarous in taste ;' but Pope's epithet, 'the bathos of sculpture,' applied to his monument of Sir Cloudesley Shovell, sticks to the artist.

BIRD, JOHN, *topographical draftsman.* He was self-taught, and, without the advantages of education, gained some local distinction. He drew some of the views for Augus's 'Seats of the Nobility and Gentry,' and the views for a 'History of Cleveland,' published in 1808. Died at Whitby, February 5, 1829, aged 61.

BISSET, JAMES, *engraver.* He was born in 1760, and was first known in 1785, when he was practising at Newmarket as a miniature painter. At the beginning of the 19th century he was living at Birmingham, and produced there several good medallions. He was a singular character, and at the latter town kept a museum. He was chiefly known by his poetic effusions ; among them by his 'Poetic Survey of Birmingham,' which was illustrated by his own designs, emblematical and topographical. He died at Leamington, August 17, 1832.

BLACK, ALEXANDER, *architect.* Attained eminence by his works in Edinburgh, where he practised. He died there February 19, 1761, aged 60.

BLACK, THOMAS, *portrait painter.* He studied at the St. Martin's Lane Academy. In his day he was well known in London, where he practised for many years as a portrait and drapery painter. His portrait heads were well drawn. He died in 1777.

BLACK, Miss MARY, *portrait painter.* Daughter of the above. She painted a few portraits, but was best known as a copyist and as a fashionable teacher of drawing. She died in London, November 24, 1814, aged 77. Her sister, CLARA BLACK, had some ability. There is a mezzo-tint portrait by her.

BLACKBURN, WILLIAM, *architect and surveyor.* Born in Southwark, December 20, 1750. He was a student of the Royal Academy ; and in 1773 gained the silver medal for an architectural drawing. When the state of our prisons was first forced upon the public notice by the philanthropic Howard, he conduced largely to their improvement by his designs for a mode of construction better suited to the separation and employment of the prisoners ; and in 1782 he received the premium of 100 guineas offered for the best design for a penitentiary prison. He built the county gaol at Oxford, and was appointed architect to St. Thomas's Hospital and to

Guy's Hospital. He was much consulted on plans for the improvement of prisons, but did not live to carry them into execution. On his journey to Glasgow to advise as to the erection of a new gaol in that city, he was attacked by paralysis at Preston, and died there December 28, 1790.

BLACKLOCK, W. J., *landscape painter.* Practised in the North of England, and painted the varied scenery of the Northern Counties. He exhibited oil landscapes at the Academy in 1853–54 and 1855. He died at Brampton, Cumberland, in March 1858, aged 42.

BLACKMORE, JOHN, *mezzo-tint engraver.* Born in London about 1740. He engraved several portraits after Sir Joshua Reynolds: among them Foote, the player, dated 1771 ; and Bunbury, the caricaturist. He also engraved after Frank Hals, Molinaer, and others. Died about 1780. His work was brilliant : the character of his heads well expressed, hands well drawn.

BLACKWELL, ELIZABETH, *botanical painter.* She was born about the beginning of the 18th century. The daughter of a merchant in the city of London, she became the wife of Dr. Blackwell, physician to the King of Sweden. With great perseverance she drew, engraved, and tinted with her own hands a large collection of medical plants, an undertaking in which she was assisted and encouraged by Sir Hans Sloane, Dr. Mead, and the well-known Mr. Thomas Miller ; and for this purpose she resided near the Physick Garden in Chelsea. The first volume of her work was completed in 1737, the second in 1739, and the whole was then published under the title of 'A Curious Herbal, containing five hundred cuts of the most useful Plants which are now used in the practice of Physic, engraved on folio copper plates, after drawings taken from the life.' An edition of her work was published at Nuremberg in 1750, and another at Leipzig in 1794. Her work had much merit. Her drawings were faithful and characteristic, but by no means possessed that accuracy, particularly of the minute parts, which is required in the present day. She commenced this laborious work to relieve the difficulties of her husband, who, though an educated man, was a restless schemer. She died suddenly in 1774. Her husband, who after many speculations had gone to Sweden upon some agricultural undertaking, was involved in a state cabal, and was put to the torture and beheaded at Stockholm, August 9, 1747, on a charge of treason, of which he denied his guilt.

BLAGRAVE, JOHN, *amateur.* He was an eminent mathematician, who, among other works, published, 1582, 'The Mathematical Jewel,' illustrated with neat woodcuts, inscribed, 'By John Blagrave, of

Reading, gentleman, and well-wisher to the mathematics, who hath cut all the prints or pictures of the whole with his own hands.'

BLAKE, Miss C. J., *amateur*. She etched a careful portrait of her uncle, Sir Francis Blake Delaval, which is dated 1775.

BLAKE, B., *still-life painter*. His name first appears in 1807, when he exhibited at the Royal Academy. He was then lodging in London, probably in his student days, and his work was 'The Portrait of an Artist.' In the following year he exhibited a 'Last Judgment,' not necessarily a sacred subject, and a 'View near Dunford, Salisbury.' He did not exhibit again till 1818, and then contributed another view of Dunford, where he was at the time living. In 1812 he was lodging in Westminster, and exhibited another view of the same village and a landscape with figures, and from that time occasionally exhibited landscape subjects till 1821, when he sent 'Dead Game,' and only once more exhibited at the Academy. He was, in 1824, one of the foundation members of the Society of British Artists, and up to 1830 exhibited, usually 'Dead Game,' with the Society. His works were minutely and carefully painted, but hot and monotonous in colour. He was pressed with difficulties, lived in obscurity, and most of his works were painted for the dealers. He made some skilful copies of the Dutch masters, which would mislead an unwary connoisseur. He died about 1830.

BLAKE, WILLIAM, *engraver, painter, and poet*. Born in Broad Street, Golden Square, London, November 28, 1757. His father was a respectable hosier, and carried on his business there for 20 years. He was a strange dreamy boy, who took to wandering away to the fields and country lanes, and was fond of resorting to the picture sales by Langford in Covent Garden. When only 10 years of age he was sent to Pars's school to learn drawing. At 12 he was a poet, and has left verses written at 14, which have merit. Then it was determined that the young genius should be an engraver, and he was apprenticed to James Basire, the second and most talented of the name, and was sent to make drawings for his master from the antiquities in Westminster Abbey, and in the old edifice nourished his dreamy fancies. From 1779 to 1782, and onwards, he was employed engraving book illustrations, some from his own designs, but chiefly after Stothard, R.A. In 1783 he married, and the same year, assisted by his young friend Flaxman, he printed, in 74 pages, his 'Poetical Sketches,' some of which possess much sweetness; yet on the death of his father, in 1784, we find that, stimulated by the necessities of life, he opened a shop as

printseller and engraver with James Parker, who was his fellow-apprentice.

His shop was not a profitable undertaking, for having, in 1788, completed the first part of another poem, 'The Songs of Innocence,' he was without the means to publish it, and we are now first told of his visions. His thoughts were filled with this printing difficulty, when in the night his dead brother Robert stood before him, and revealed to him a process, which he adopted, spending for the materials half the few pence he possessed. This revealed process was not very recondite, and simply consisted in leaving in relief, by means of nitric acid, the letters written on a copper plate, so that they might be printed by a copper-plate printing-press, though the result was a very blurred, blotted work. By this original process, however, he multiplied the copies of his illustrated poem, and with the help of his wife, truly a helpmate, the songs were printed, tinted, and stitched into a book of 27 pages, and their occasional sale found the means of subsistence for the contented couple. This work was followed by the 'Books of Prophecy,' produced in the same manner. He contributed some few works to the Academy Exhibitions—in 1780, 'The Death of Earl Godwin;' in 1784, 'A Breach in a City the Morning after Battle;' and 'War unchained by an Angel: Fire, Pestilence, and Famine;' in 1785, three subjects from the history of Joseph; in 1799, 'The Last Supper;' and in 1808, 'Jacob's Dream' and 'Christ guarded in the Sepulchre by Angels.' In 1793 Blake removed to Hercules Buildings, Lambeth, and in the same year published his 'Gates of Paradise,' a small book for children, and the next year the 'Songs of Experience,' a sequel to the 'Songs of Innocence,' the two comprising 54 engraved plates; and 'America, a Prophecy;' followed by 'Europe, a Prophecy.' Resuming his graver, in 1797 he commenced an illustrated edition of 'Young's Night Thoughts,' of which every page was a design, but he only published one number containing 43 plates.

In 1800 a new life opened to Blake; he was induced by Hayley, the poet, who became known to him through the instrumentality of Flaxman, to come and live near him at Felpham, a small village on the Sussex coast; and here for a time he was happy, indulging in dreamy rambles, assisting Hayley as his 'illustrator,' and painting a few portraits. But Hayley's projects had no success, and his society became burdensome. Blake had at this time a vexatious quarrel with a soldier who trespassed upon his premises, and from some angry words he used, was charged with sedition, and tried at the Quarter Sessions, where the charge could not be

sustained. His visions then began to fail him, and in disgust he quitted his cottage, and returning after three years' absence to the Metropolis, lived nearly 17 years in South Molton Street. At Felpham he had illustrated some ballads by Hayley, and he afterwards designed 40 illustrations of Blair's 'Grave,' which were neatly engraved by Schiavonetti, and were greatly admired. Yet at this time he is said to have subsisted with his wife upon a few shillings a week.

His 'Canterbury Pilgrims,' a large sheet engraving, full of character and talent, led to a bitter feud with his friend Stothard, R.A., who painted the same subject, the works of both showing some points of similarity, and both claiming the original conception. He also published his 'Jerusalem,' 'Milton,' and 'Job,' his last and best work, elaborately finished with the graver, and full of fine original thought. His latter days were passed in a back room in Fountain's Court, leading from the Strand. Here, surrounded by his books, his sketches, and manuscripts, his copper-plates and his materials, in poverty, but not, it is believed, in want, simple in mind and conduct, he died tranquilly, August 12, 1827, in his 70th year. He was laid in a common grave in the great Bunhill Fields Burial-ground, near the north wall, the more exact situation of which is now lost. His works comprise his engravings, showing a fair knowledge of his art; his water-colour drawings, ranging from mere rude sketches to the most careful and elaborate finish; but all, like his writings, combining occasional ideas of great sweetness with wild and incomprehensible imaginings, incompatible with a sane mind. He early said he 'acted by command. The spirit said to him, Blake, be an artist, and nothing else;' also, 'I wish to do nothing for profit. I wish to live for art. I want nothing whatever. I am quite happy.' And at another time, 'I should be sorry if I had any earthly fame, for whatever natural glory a man has is so much taken from his spiritual glory.' His 'Life,' by Alexander Gilchrist, was published in 1863, and by A. C. Swinburne in 1868.

BLAKE, JOHN, *engraver*. Brother of the foregoing; drew and engraved for several literary works. He engraved, in 1817, Flaxman's outlines for Hesiod's 'Theogony.'

BLAKE, NICHOLAS, *engraver and designer*. Was born in Ireland. Studied in Paris, and resided much there. He was of some celebrity about the middle of the 18th century, and worked both as painter and engraver. He was one of the first who began to design for engravers. He designed and engraved the illustrations for an edition of Pope's works, and for Jonas Hanway's 'Travels in Persia,' published 1753; and jointly with Frank Hayman he designed some prints in illustration of English history, which were published by subscription. He died in Paris. His daughter was living in London in 1809.

BLONDEAU, PETER, *medallist*. Was, in 1649, invited to London from Paris, and upon a favourable report upon his improved method of coining by a committee of the Mint was appointed by the Council of State to coin their money; but, it is stated by Ruding, the opposition of the moneyers of the Mint for some time impeded his progress, and eventually succeeded in driving him out of the country. On the Restoration he returned, was appointed engineer to the Tower Mint, when he brought into use his new machinery for coining; his occupation here being rather as a machinist than as a medallist. The dies of the so-called Blondeau's pattern pieces of 2*s.* 6*d.*, 1*s.*, and 6*d.* were the work of Thomas Simon.

BLYTH, ROBERT, *engraver*. Born 1750. Was a pupil of Mortimer, A.R.A., from whose drawings he produced some clever etchings. His works showed great spirit and feeling; but he had lived a loose life, ruined his constitution, and committed suicide on January 19, 1784. His best works are his slight etchings, after Mortimer, and his engravings of 'The Soldier's Courtship,' with a companion plate.

BOADEN, JOHN, *portrait painter*. He first exhibited at the Academy in 1812. His art was limited to portraiture, occasionally a portrait group or a theatrical portrait in character. His portraits were generally pleasing, but did not rise above respectability in art. His contributions to the Academy fell off after 1825, and his last work was exhibited in 1833; but he exhibited at the Society of British Artists up to 1838, and died in 1839.

BOBBIN, TIM, pseudonym. *See* COLLIER, JOHN.

BOCKMAN, R., *portrait pointer and mezzo-tint engraver*. Practised in the first half of the 18th century. There are several portraits by him of the Duke of Cumberland, and a life-size half-length of Admiral Russell, Earl of Orford, in the Gallery of Greenwich Hospital; also copies in half-length after Kneller of the naval heroes of the early part of Queen Anne's reign, in the Hampton Court Gallery. He also engraved in mezzo-tint portraits after Vanloo, Dahl, Worsdale; and, after his own painting, 'St. Dunstan holding the Devil with a pair of Tongs by the Nose.' His widow applied to the Society of Artists for relief in 1769.

BODDINGTON, HENRY JOHN, *landscape painter*. He was born in 1811, and was a member of the 'Williams Family,' of

whom so many were painters, and changed his name as a means of better identification in his art. He first exhibited at the Royal Academy in 1837. In 1842 he became a member of the Society of British Artists, and contributed to their exhibitions; but he contributed more largely to the Academy, where he continued an exhibitor till his death. His subjects were chiefly found on the Thames and the Welsh rivers. He painted the effects of spring and autumn, of morning and evening, of sunshine and shower, and treated all with much ability, in a facile manner. He died at Barnes, after a long illness, April 11, 1865, in his 54th year.

BOGDANI, JAMES, *flower painter.* Native of Hungary. His father was deputy from the States to the Emperor. He was not brought up as an artist, but by his natural abilities he acquired much power. He painted fruits, flowers, and especially birds, with great excellence. He came early to England. Several of his works were purchased by Queen Anne, and well patronised he made a competence by his art, but an extravagant son reduced him to poverty. After a residence of between 40 and 50 years in England, he died in 1720, at his house in Great Queen Street, Lincoln's Inn Fields, and his pictures and remaining property were sold there by auction.

BOGLE, JOHN, *miniature painter.* He practised his art in Glasgow, and afterwards in Edinburgh, sending miniatures from thence in 1769 and the following year to the Spring Gardens Exhibitions. In 1772 he was settled in London, and from that time to 1792 exhibited miniatures at the Royal Academy. His works were beautifully finished, and possessed great merit. He died in great poverty. Allan Cunningham says 'he was a little lame man, very poor, very proud, and very singular.'

• BOIT, CHARLES, *enamel painter.* He was born at Stockholm, the son of a Frenchman, and was brought up a jeweller. About 1683 he came to London, to follow that trade here; but, not succeeding, he went into the country as a teacher of drawing. Following this occupation, Walpole says that he had engaged one of his pupils, the daughter of a general officer, to marry him; and that the intrigue being discovered he was thrown into prison, where, during two years' confinement, he studied enamel painting. This art he afterwards practised in London with very great success, and was paid very high prices for his work. He undertook an unusually large plate for Queen Anne, representing her Majesty, the Prince, and the chief officers of her court, and received large advances for the work; but, though he built a furnace for the purpose, he was unable to lay an

enamel ground over the large surface. During his many experiments the Queen died; and Boit, who had run into debt, fled to France, where his works were greatly admired, and he obtained the Court favour and a large pension. He died suddenly at Paris, about Christmas, 1726.

BOITARD, LOUIS P., *engraver.* Born in France, where he was a pupil of La Farge. He was brought to this country by his father; and in the reigns of George I. and George II. was chiefly engaged in book illustrations, engraved in a neat, light style. There is a plate by him of the 'Ranelagh Rotunda;' one of 'Apollo and Venus' for Spence's 'Polymetis,' which has much merit, and some portraits. He frequently engraved from his own compositions, was a member of the Artists' Club, and a humorist; occasionally with his pencil burlesquing the eccentricities of his time. He married an Englishwoman, and died in London some time after 1760, leaving a daughter, and a son who followed his profession.

BOLTON, WILLIAM, *architect.* Was prior of the monastery of St. Bartholomew, Smithfield, about 1506. He was 'maister of the works' of Henry VII.'s Chapel, which was completed in 1519; and the design, with other works, has been attributed to him. He died at Harrow 1532.

BOLTON, JAMES, *flower painter.* He was apprenticed to B. Clowes, the engraver, but became known in the North of England for his skill as a painter of flowers in water-colours. His works do not appear to have been exhibited in London. He died near Halifax, January 24, 1799.

BOND, JOHN DANIEL, *landscape painter.* Resided chiefly at Birmingham, where he conducted the decorative branch of some large manufactory. He obtained the Society of Arts' premiums for landscape— in 1764, 25 guineas; in the following year, 50 guineas. He worked with a bold pencil, in the manner of Wilson, R.A.,; tried effects of light and shade, but was black; neglected detail. He died near Birmingham, December 18, 1803, aged 78. His pictures and other works were sold in London a few months after his death.

BOND, JOHN SINNELL, *architect.* Born about 1766. He was a student of the Royal Academy, and probably a pupil of Malton. He gained the Academy gold medal in 1786 for his design for a mausoleum, and was an occasional exhibitor at the Academy from 1783 to 1797. In 1818 he set out upon his travels in Italy and Greece to study their architectural remains, and returned in 1821. Then, commencing the practice of his profession, he was employed in the erection of several large mansions, and made the architectural design for Waterloo Bridge. He was a good

classic scholar, and left behind him a translation of Vitruvius, the work of nearly 20 years. He was also a writer on professional subjects in the 'Literary Gazette.' He died in Newman Street, after a long illness, November 6, 1837.

BOND, WILLIAM, *engraver*. His works, after Reynolds, Shee, Westall, and others, deserve especial notice. He was a governor of the Society of Engravers, founded 1803.

• BONE, HENRY, R.A., *enamel painter.* He was born at Truro, February 6, 1755, and was the son of a cabinet-maker there, who was also reputed as a clever carver. When 12 years of age he came with his family to Plymouth, and showing a disposition for art, was apprenticed in 1771 to a china manufacturer, with whom he shortly afterwards removed to Bristol, where his master established the celebrated porcelain works. His apprenticeship terminated in 1778; and on the failure of his master in the following year, he came to London with a few pounds lent to him by a humble friend, and found employment in enamelling watches and jewellery in the manner then fashionable. Then, fashion changing, this device painting began to fail, and he tried miniature painting in water-colour, and with higher aims in enamel. After much study of his colours and the necessary fluxes, he completed an enamel portrait of his wife, which he exhibited at the Royal Academy in 1780, and gained much notice. Continuing to execute such device painting as offered, his thoughts were bent on enamel, and he completed 'A Muse and Cupid' after his own design, and of a size far exceeding any hitherto executed in that material. His 'Sleeping Girl,' after Sir J. Reynolds, exhibited 1794, and a portrait of Lord Eglintoun, 1797, pleased the Prince of Wales, and in 1800 he was appointed enamel painter to the Prince, who for several years was the purchaser of his best works.

Rising rapidly in public estimation, in 1801 he was elected associate of the Royal Academy, and was appointed enamel painter to George III. He then engaged upon several large enamels after Sir Joshua, and completed a very fine work after Lionardo da Vinci. In 1811 he was elected a royal academician, and soon after produced an enamel copy, 18 in. by 16 in., of the 'Bacchus and Ariadne' after Titian, for which he received 2200 guineas. His industry led him to undertake a series of portraits of illustrious persons, 85 in number, commencing with the reign of Elizabeth, but with little pecuniary reward; also portraits of the Russell family from the reign of Henry VII., and of the Royalists distinguished in the Civil War. His eye-sight failing, he retired to Somers Town. He had brought up and educated a large family, and was compelled to receive the Academy pension. He was greatly esteemed, yet he complained that his artist-friends neglected him in his old age. He died of paralysis, December 17, 1834, and his works were then sold, though they were far from realising their real value. He possessed the power of correct drawing and fine colour, with great richness, force, and chastity, free from the glare and china-looking surface of enamel.

BONE, HENRY PIERCE, *enamel painter.* Son of Henry Bone, R.A. Born November 6, 1779. Was brought up under his father and assisted him. He also practised in oil, and first exhibited at the Academy in 1799, his early works being portraits in that medium. In 1806 he exhibited two classic subjects, and continued, with an occasional portrait, to paint from sacred and profane history, the poets and dramatists, till 1833, when he commenced enamel painting; and from that year to 1855—the last year he exhibited—his works were exclusively in enamel, comprising portraits from the life after contemporary painters and the old masters, with one or two subject pictures, also in enamel. He was enamel painter to Queen Adelaide and to the Queen and Prince Consort. He died in London, October 21, 1855.

BONE, ROBERT TREWICK, *subject painter.* Born in London, September 24, 1790. Son of Henry Bone, R.A. Was taught by him, and for the first 20 years of his art career lived in his house. He exhibited at the Academy, in 1813, 'A Nymph and Cupid;' in 1815, a portrait of his sister; and at the British Institution, in 1817, 'A Lady with her Attendants at the Bath,' for which the directors awarded him a premium of 100*l.* He continued to contribute to the exhibitions at the Academy, and also at the British Institution, classic and sacred subjects, with occasionally a portrait, and later in his career some domestic subjects; but gradually falling off in his contributions, he ceased to exhibit after 1838. He died from the effects of a hurt, May 5, 1840. His works were small in size, tasty and clever in composition, broad and sparkling in effect, the landscape accessories and costume pleasing; but his art did not find the encouragement it merited. He was a member of the Sketching Club.

• BONINGTON, RICHARD PARKES, *landscape and subject painter.* Born October 25, 1801, at Arnold, a village near Nottingham. His grandfather was the governor of the gaol of that county, and was succeeded by his father, who lost the appointment through his irregularities, and then practised as a portrait painter, and published a few prints of little merit in aqua-tint, while his wife kept a school.

The son's early talents were divided between art and the drama, and his future career seemed balanced between the two. But the father's love of low company, his indiscreet conduct, and his violent political opinions, broke up his wife's school, which was probably the chief support of the family, and they fled to Paris. Here, at the age of 15, and with the most limited means, young Bonington obtained admission to the Louvre, and commenced seriously the study of art as his future profession. He took great pains to improve, became a student at the Institute, and drew in the atelier of Baron Gros, and his improvement was rapid; his studies were in a bold, masterly style, and he gained the gold medal in Paris for one of his marine subjects.

About the year 1822 he went to Italy. His works, both in oil and water-colours, had already met with patronage, and had made him a reputation in Paris, but were unknown here; when, in 1826, he exhibited at the British Institution two views on the French Coast, which surprised the English painters, and gave him at once a name among his own countrymen; and in the next year a similar subject at the Academy, followed in 1828, when he was still residing in Paris, by 'Henry III. of France' and the 'Grand Canal, Venice.' He had always been greatly esteemed in France, and now commissions flowed upon him from both countries. Devoting himself to his art, he was imprudently sketching in the sun at Paris, when he was attacked by brain fever, followed by a severe illness. He came to London for advice, and fell into a rapid consumption, which ended his short yet promising career, September 23, 1828. He was buried in the vaults of St. James's Church, Pentonville. His works were marked by great originality and a rich feeling for colour. His art was picturesque and dramatic. He painted landscape and marine; and master of the figure, genre subjects with much grace. His drawings were sold by auction, and realised 1200*l.* In 1870, his 'Henry IV. and the Ambassador' is stated to have fetched 3320*l.* at a sale in Paris. A series of his works was lithographed by Harding, and his 'Picturesque Journey' was published, but its true appreciation was confined to the artists.

BONNAR, WILLIAM, R.S.A., *portrait and subject painter*. Born in Edinburgh in June 1800. He was the son of a house painter, and was apprenticed to a decorator. In 1822 he fitted up the Assembly Rooms at Edinburgh for the State ball given to George IV. on his visit to Scotland. His friends advised him to try art, and in 1824 he painted 'The Tinkers,' a work which at once gave him rank as an artist. On the foundation of the Royal Scottish Academy

in 1830, he was chosen one of the members, and painted many good pictures, some of which have been engraved; but he was chiefly engaged in portraiture. He died in Edinburgh, February 1853, in his 53rd year.

BONNEAU, JACOB, *landscape painter*. He is believed to have been the son of an indifferent French engraver, who, about 1741, practised in London, and was employed by the booksellers. He was a member of the Incorporated Society of Artists, and exhibited landscape views at the Spring Gardens Exhibitions—1765–1778, and at the Academy between 1770 and 1784 — chiefly landscapes, in water-colours, with occasionally a figure subject. But he was principally engaged as a teacher of drawing and perspective. He died at Kentish Town, March 18, 1786.

BONNER, GEORGE WILLIAM, *wood engraver*. Was born at Devizes, May 24, 1796, and educated at Bath. He came to London, and, apprenticed to a wood engraver, he became a good draftsman and skilled engraver, and was distinguished by his ability in producing gradations of tint by a combination of blocks. He engraved for the 'British Cyclopædia.' Died January 3, 1836.

BONNER, THOMAS, *topographical draftsman and engraver*. Was a native of Gloucestershire, and drew and engraved the churches of that county. He was a pupil of Henry Roberts, and in 1763 received a premium from the Society of Arts. The views also for Polwhele's 'History of Devonshire,' published 1797, and the numerous illustrations for Collinson's 'History of Somersetshire,' published 1791, were both drawn and engraved by him. He published also the 'Copper-plate Perspective Itinerary,' which consisted of well-executed topographical engravings, and, with the drawings and descriptive letter-press, were by his own hand. He was the designer of some illustrations to the works of Richardson, Smollett, and Fielding. In 1807 he exhibited at the Academy drawings of architectural remains. He died before 1812.

BONOMI, JOSEPH, A.R.A., *architect*. Born at Rome, January 19, 1739. Studied architecture there, and was induced, in 1767, to come to London by the Brothers Adam, with whom he for many years found employment, especially in the interior decoration of their buildings. He married, in 1775, the cousin of Angelica Kauffmann, who, when she went to reside in Rome, in 1783, persuaded him to return to Italy, with his wife and family. He did not remain there above one year, but, hastened by the death of his son, came back again to London, where he finally settled in the practice of his profession. In 1789 he was elected

associate of the Royal Academy, and the failure of his election to the full membership, which was espoused by Sir Joshua Reynolds, was the cause of his resignation of the office of president. He was an occasional exhibitor at the Royal Academy from 1783 to 1806, and was distinguished for his architectural knowledge and his great taste as an architectural draftsman. He made additions to Langley Hall, Kent, 1790; designed the chapel of the Spanish Embassy, 1792; Eastwell House, Kent, 1793; Longford Hall, Shropshire, and Laverstoke, Hants, 1797; Roseneath, Dumbarton, N.B., for the Duke of Argyle, 1803; and in 1804 was appointed honorary architect of St. Peter's, Rome, and made designs for the new sacristy. He died in London, March 9, 1808, in his 69th year, and was buried in the Marylebone Cemetery.

BONOMI, JOSEPH, F.R.S.L., and F.R.A.S., *sculptor.* Son of the foregoing Joseph Bonomi, was born in London in 1796. He studied at the Royal Academy, and gained two silver medals. In 1822 he went to Rome, intending to devote himself to sculpture, but was persuaded to go to Egypt instead. He remained 15 years in the East, visiting Sinai, Damascus, and Baalbek, and became one of the most distinguished authorities on Egyptology and hieroglyphics. He returned to Egypt a second time in 1842. In 1853, he helped Owen Jones in the works at the Egyptian Court of the Crystal Palace. He was appointed Curator of Sir John Soane's Museum, in Lincoln's Inn Fields, in 1861, which office he held till his death. This occurred at Wimbledon Park, April 3, 1878, in his 83rd year.

BOON, DANIEL, *subject painter.* Born in Holland. He came to England, and practised here in the reign of Charles II. He painted drinking and debauchery, with nothing to relieve the vulgarity of his subjects. He died in London 1698.

BOOTH, WILLIAM, *miniature painter.* He was born at Aberdeen in 1807. He practised in London with much success, and was a constant exhibitor at the Royal Academy from 1827 to 1845. He painted female portraits well, and groups with children. He died 1845.

BOOTH, JOSEPH, *miniature painter.* Was born and studied in England; but about 1770 practised in Dublin with great success. He was a clever man, and possessed also some mechanical genius.

BOSSAM, JOHN, *subject painter.* Hilliard speaks of this painter in the reign of Edward VI., describing him 'As a most rare English drawer of story works in black and white;' and he adds that 'he was poor, and growing yet poorer by charge of children, and gave painting clean over—

unfortunate being English born;' and it is said that in the reign of Elizabeth he entered the Church, and became a reading minister.

BOTT, THOMAS, *china painter.* Born near Kidderminster in 1829. He was brought up as a mechanic, and employed his leisure in drawing. He gained employment in a glass manufactory, and then went to Birmingham; and for two or three years he subsisted by painting portraits. Returning to Worcester he was employed there in porcelain painting; improved himself in the art, and became reputed for his very successful imitation of the Limoges enamels on china, for which he was distinguished at Paris in 1855, London 1862. He fell into ill-health, and died December 13, 1870.

BOURDE, JOHN (of Corfe Castle), '*marbler.*' Was employed as mason, and carved upon the fine tomb of the Warwick family in Warwick Church, in the time of Henry VI., the figures upon which are well composed, the action good.

▶BOURGEOIS, Sir FRANCIS P., Knt., R.A., *landscape painter.* His father, descended from a Swiss family, was a watchmaker in London, where he was born 1756, and was intended for the army; but a taste for drawing, and some instructions which he had received from an obscure painter, led him to art, and he became the pupil of De Loutherbourg, with whom he continued some time, and early attained reputation. In 1776 he travelled in France, Holland, and Italy; and on his return his works made him known and found him patrons. He exhibited at the Academy from 1779 to 1810. His subjects were chiefly landscapes, with cattle and figures; but among them were 'Hunting a Tiger,' 'A Young Lady as a Shepherdess,' 'Mr. Kemble as "Coriolanus,"' 'A Friar before the Cross,' 'A Detachment of Horse, costume of Charles I.' In 1791 he was appointed painter to the King of Poland, and received from him at the same time the honour of knighthood. In 1787 he was elected an associate, in 1793 a full member, of the Royal Academy, and the following year was appointed landscape painter to George III., who sanctioned the use of the title conferred by the King of Poland. His friend, Noel Desenfans, on his death in 1804, left him, with his other property, a valuable collection of paintings, which it was said he had purchased by remittances made to him for the purpose by Stanislaus, King of Poland, and which, upon that monarch's misfortunes, remained in his hands. This fine collection, comprising, with some modern works added by Sir Francis, 350 paintings, he bequeathed to Dulwich College, with 10,000l. to provide for its maintenance and 2000l. to fit up a gallery for its reception,

49
Boughton . painter !1046

besides legacies to the officers of the College. He died in Portland Street, in consequence of a fall from his horse, January 8, 1811, and was buried in the chapel of Dulwich College. His works, with a strong feeling for art, are crude and sketchy, his drawing of figures and animals weak, and his attitudes extravagant and mannered; but he had an influence on the art of his day, which his works would not now earn for him.

BOURNE, JAMES, *water-colour painter*. Practised in London at the beginning of the 19th century, and was an occasional exhibitor of landscape views at the Academy up to 1809. He was afterwards much employed by Sir Thomas Gage, and made numerous drawings for him in a pleasing, easy style. Some of the drawings for 'Views in Lincolnshire,' published 1801, are by him.

BOWEN, EMANUEL, *engraver*. There is no other information of him than that he was appointed engraver to George II. and to Louis XV. His son, THOMAS BOWEN, a map engraver, died in Clerkenwell Workhouse 1790.

BOWER, EDWARD, *portrait painter*. Practised in the reign of Charles I. He painted 'The King seated at his Trial,' now possessed by Mr. Pole Carew; an equestrian portrait of Lord Fairfax, 1647, which was engraved by Marshall; and a small oval portrait of Lord Finch, 1640, also engraved; and some other portraits by Hollar.

BOWER, GEORGE, *medallist*. Produced several large medals of Charles II., with the head of his Queen on the reverse; also a medal of the Duke of York's shipwreck, of James II., his Queen, the Dukes of Albemarle, Ormond, and Lauderdale, and the Earl of Shaftesbury. He was employed in the Mint as an assistant to Henry Harris during the reign of James II.

BOWLER, THOMAS WILLIAM, *landscape painter*. He showed an early attachment to art, but was led to accept the appointment of assistant-astronomer at the Cape of Good Hope. At the end of four years, the love of art prevailing, he resigned his office, and commenced at Cape Town his career as a painter and teacher of drawing. He published views of Cape Town and the neighbourhood, and 20 scenes illustrating the Caffre War. In 1866 he visited Mauritius, where he made some drawings, but caught a fever which prevailed there, and in bad health came to England to publish some of his works, and died October 24, 1869.

BOWLES, THOMAS, *draftsman and engraver*. Born about 1712. He is chiefly known by the publication of 30 views of the principal buildings in London, drawn, and some of them engraved, by himself.

But he was also esteemed for his skill as a scene painter. He engraved some portraits after several masters. His principal works are dated about the middle of the century.

BOWNDE, RICHARD, '*glazier*,' of St. Clement Danes. One of four contractors, in the reign of Henry VIII., for 18 painted windows of the upper story of King's College Chapel, Cambridge.

BOWNESS, WILLIAM, *portrait painter*. He was born at Kendal in 1809, and commenced his art career there. He afterwards came to London, where he found employment as a portrait painter. He was an exhibitor at Suffolk Street and at the Academy from 1841 to 1855, sometimes sending a subject—'Girl at her Devotions,' 1841; 'Maternal Solicitude,' 1844; 'Captivity,' 1853; and his last work, 'Monday Morning: Conning the Lesson,' 1855. He died in London, aged 58, December 27, 1867.

BOWRING, BENJAMIN, *portrait painter*. Practised in London both in oil and in miniature. He first exhibited at the Academy in 1773, and continued to contribute up to 1781, sending in 1777 a miniature, 'Apollo and Diana.'

BOWYER, ROBERT, *miniature painter*. Was probably a pupil of Smart. He first exhibited miniatures at the Academy in 1783, and continued an exhibitor up to 1797. He had many sitters of distinction, and his works were greatly esteemed. He was appointed painter in water-colours to George III. and miniature painter to the Queen. He was the projector and publisher of an illustrated 'History of England,' which bears his name, with some other works of the same class. He died at Byfleet, Surrey, June 4, 1834, aged 76.

BOYCE, SAMUEL, *engraver*. A portrait of the Earl of Oxford bears his name. He died 1775.

BOYDELL, Alderman JOHN, *engraver and publisher*. Born January 19, 1719, at Dorington, near Ower, Shropshire. His grandfather was vicar of Ashbourne and rector of Mapleton, Derbyshire; his father a land surveyor, for which profession he was himself intended. But he took a fancy to engraving, and at the age of 21 walked up to London, and apprenticed himself to Mr. Thoms, at the same time entering himself as a student at the St. Martin's Lane Academy. He worked steadily for six years, and then, purchasing the remaining year of his term, became his own master, and was admitted a member of the Incorporated Society of Artists. At this time he published six small engravings from designs of his own, which, from each containing a bridge, was called his 'Bridge-book;' followed in 1751 by a book of 152 prints of views in England and Wales, also engraved by himself. The

profits of this work enabled him to employ some of the best engravers of that time in producing specimens of the old masters, and to commence a career which raised the engraver's art to a high eminence in this country; and while treating the profession with great liberality, gained a fortune for himself. Having achieved this, he commissioned artists to paint subjects for the engraver, and in 1786 he adopted the scheme of a 'Shakespeare Gallery.' He alone found the funds, and employing every English artist of distinction to paint subjects from the works of the great poet, he exhibited them in a gallery he had built for the purpose in Pall Mall (now converted to other uses), and then engaged engravers to produce the whole series, and published it by subscription. He had ventured an extensive capital, but the French Revolution deranged his large ordinary transactions with the Continent, and he was bankrupt. Parliament empowered him to dispose of his gallery of paintings, which he had purposed to present to the nation, and also his stock, by lottery, and he was enabled to discharge the whole of his debts. He died soon after, December 12, 1804, at his house in Cheapside, and was buried at St. Olave's, Coleman Street. As an engraver he never made much progress himself; but the art owed to his enterprise a pre-eminence it had never before known. He filled the office of sheriff in 1785, and lord mayor in 1790.

⁂ BOYDELL, JOSIAH, *portrait and history painter.* Born at Stanton, Shropshire, about 1750. Nephew of the foregoing; bred in his counting-house, and eventually his partner and successor. He had a professional training both in painting and engraving, and painted some portraits and several of the subjects in the Shakespeare Gallery. The latter are by no means poor works—compositions with many figures, and a little in the manner of Westall, R.A. —though his uncle, in the preface to the engraved work, makes an apology for him, which seems hardly needed. He exhibited at the Academy from 1772 to 1799, his works consisting of some portraits, a 'Juno,' 'Gipsy Girl,' and—apparently his most aspiring contribution—'Coriolanus taking leave of his Family.' He published, in 1803, 'Suggestions towards forming a Plan for the Improvement of the Arts and Sciences.' He succeeded his uncle in his alderman's gown, and was master of the Stationers' Company. Died at Halliford, Middlesex, March 27, 1817.

BOYDEN, WILLIAM, *architect.* His name is recorded, as the chief architect of the chapel of the Virgin, in the Abbey Church of St. Alban's, 1308-26.

BOYFIELD, JOHN, *architect.* Com-

pleted, towards the end of the 14th century, the works commenced in 1350 for the improvement of Gloucester Cathedral.

BOYNE, JOHN, *caricaturist and engraver.* He was born in the County Down about 1750. He was the son of a joiner, who was afterwards employed in the Victualling Office at Deptford, and brought his son, then about 9 years of age, with him to England. The boy was apprenticed to William Byrne, the engraver, and for a time followed that employment; but, falling into bad habits, he sold his tools and joined a company of strolling players, among whom he became distinguished. Leaving them in 1781 he returned to London, set up a drawing school, made some literary attempts, and both sketched and engraved. He excelled in caricature. 'The Muck-worm' and the 'Glow-worm' are by him, as is also 'The Meeting of the Connoisseurs,' the original drawing of which is exhibited at the South Kensington Museum. Reckless in his habits and always poor, he died June 22, 1810.

BRADBERRY, THOMAS, *architect.* Student of the Royal Academy. Gained the gold medal, 1823, for an architectural design for 'A Hospital for Sailors.' He does not afterwards appear as an exhibitor at the Academy.

BRADLEY, WILLIAM, *portrait painter.* Born at Manchester, January 16, 1801. Left an orphan at 3 years of age, he commenced life as an errand boy, but early began to try his hand at drawing, and was soon able to produce profile portraits, for which he received 1s. each. He also added to his means by teaching. When 21 years of age he got some little instruction from Mather Brown, then practising in Manchester, and soon after made his way up to London. Establishing himself in the Metropolis he paid frequent visits to his native town, and was induced to return and settle there in 1847; but his health had given way, he became misanthropic, his mind was affected, and he died of typhoid fever, July 4, 1857. He achieved a local reputation, and many distinguished men were among his sitters. His heads were well drawn and intellectual, his likeness good.

BRADSHAW, LAWRENCE, *architect.* His name is mentioned as practising in the reign of Queen Elizabeth, but his works are now unknown.

BRAGG, THOMAS, *engraver.* He was a pupil of W. Sharp, and practised at the beginning of the 19th century. In 1821 he exhibited his works with the Associated Society of Engravers. He died 1840.

BRAGGE, FRANCIS, *engraver.* Practised in the reign of James II.

BRANDARD, ROBERT, *landscape en-*

graver. Was born in Birmingham 1805. He came to London in 1824, and placed himself for one year under Mr. Edw. Goodall. Then, working on his own account, he engraved some plates for Brockedon's 'Passes of the Alps' and Captain Batty's 'Saxony.' Gaining power, he was next employed upon Turner's 'England' and 'English Rivers,' and upon many plates after Turner, Callcott, and Stanfield. He published, in 1844, a series of etched scraps from nature, very well etched, but having more of the character of the engraver's than the painter's art. At the International Exhibition, 1862, two works by him were exhibited after Turner 'Crossing the Brook'—esteemed his best work — and 'The Snow Storm.' He occasionally exhibited a small oil painting at the British Institution, and excelled as a painter in water-colours. He died Jan. 7, 1862.

BRANDON, ——, *portrait painter.* Practised in the reign of William and Mary. A portrait by him of the Queen is engraved by Gunst.

BRANDON, JOSHUA ARTHUR, *architect.* He built, jointly with John R. Brandon, his brother, the New Corn Exchange at Colchester, and Portswood Chapel, Southampton; and published, also in conjunction with him, 'An Analysis of Gothic Architecture' and 'Views of Parish Churches.' He died in Beaufort Buildings, Strand, December 11, 1847, aged 25.

BRANDON, J. RAPHAEL, *architect.* Brother of the above, was born in 1817, and was a Fellow of the 'Royal Institute of British Architects.' He was the architect of the Catholic Apostolic Church, in Gordon Square, and other buildings. In conjunction with his brother, Mr. J. A. BRANDON, he wrote many works upon their own branch of art, which both the brothers practised with success. Among other publications may be mentioned 'Norfolk Churches,' 'Parish Churches,' 'The open timbered roofs of the Middle Ages,' and 'An Analysis of Gothic Architecture'; some of these passed through more than one edition. He fell into a state of despondency and bad health, chiefly arising from what he considered professional disappointment, and died by his own hand, at his chambers in Clements Inn, October 8, 1877, aged 60.

BRANSTON, ALLEN ROBERT, *wood engraver.* Born 1778, at Lynn, Norfolk. Apprenticed to his father, a general copper-plate engraver, and when in his 19th year settled at Bath, and practised both as a painter and an engraver. He then undertook some woodcuts for a work describing that city, but not finding encouragement he came to London in 1799, and for a time supported himself by engraving music. Then he engraved some woodcuts

for lottery bills, and determined to apply himself to wood engraving. He soon became distinguished. He formed a style of his own, engraved the figure well, and excelled in the gradations of light in indoor scenes. His best works are in 'The History of England,' published by Scholey, 1804–10; Bloomfield's 'Wild Flowers,' 1806; and 'Poems' by George Marshall, 1812. He had several pupils, and many clever artists were indebted to his teaching. He died at Brompton in 1827.

BRANWHITE, NATHAN, *engraver.* A very good stipple engraver, the particulars of whose life are not known. He made an excellent engraving of Medley's picture of the Medical Society of London. A curious fact about this work was that Jenner came into great notice during the painting of the picture, and after it was finished it was decided to add his portrait. The plate was partially engraved before the decision to put him in was arrived at, and a piece of copper had to be let in, as back-ground details had been worked over the spot upon which his head and shoulders were subsequently placed. Branwhite was a pupil of Isaac Taylor's, and the son of a schoolmaster at Lakenham, in Suffolk.

BRAY, Sir REGINALD, *architect.* He was a distinguished statesman, holding the highest offices in the reign of Edward IV. He was high steward of the University of Oxford in the reign of Henry VII., and the architect of the large additions then made to St. Mary's Church. He built Henry VII.'s Chapel at Westminster, and, it is supposed, St. George's Chapel at Windsor, two of the finest Gothic structures. He was eminent both as an architect and a statesman. He died in 1503, and is buried at Windsor.

BRENTWOOD, JOHN, *ornamentist.* Citizen and *steyner* of London. Was one of the artists engaged upon the Warwick tomb, in the chapel of Warwick Church, in the time of Henry VI. He painted the west wall and the dome with all manner of devices and imagery, with the finest colours and fine gold, 1439.

BRETHERTON, JAMES, *engraver.* He was born about the middle of the 18th century. He etched and aqua-tinted after Bunbury and others, and some works after his own designs. Of those after Bunbury, whose works he published, were 'Susannah and Blouzelinda,' 1781; 'Snip Français and Snip Anglais,' 1773; 'A Tour in Foreign Parts.' His chief productions date between 1770 and 1790.

BRETHERTON, CHARLES, *engraver.* Son of the foregoing. He engraved views, landscapes, and portraits, and was employed by Walpole on the portrait illustrations for his 'Anecdotes of Painters.' There is by him an etching after Samuel

Cooper's fine head of Cromwell, at Sidney Sussex College. He was also a designer; and 'Kate of Aberdeen,' by him, is engraved by Tomkins. He died young, of decline, in July 1783.

BRETT, JOSEPH WILLIAM, *history painter*. Son of a clergyman of the Church of England. He was an unsuccessful competitor for the premiums offered for cartoons for the decoration of the Houses of Parliament. The subject he submitted was 'King Richard forgiving the Soldier who shot him.' He was found dead at Chelsea, with his throat cut, supposed his own act, January 12, 1848. He was aged 34.

BRETTINGHAM, MATTHEW, *architect*. He built, in 1742, North House, St. James's Square (now No. 21), in which George III. was born; the north and east fronts of Charlton House, Wilts; the Duke of York's house in Pall Mall (now part of the War Office), a well-proportioned elevation, but with little attempt at design; and some other mansions in London. In 1748 and 1750 he travelled in Italy. He published, in 1761 and 1773, plans drawn by himself of Lord Leicester's house at Holkham, but omitted to state that it was designed by Kent. He died August 19, 1769, aged 70, and was buried at St. Augustine's, Norwich. His son, MATTHEW BRETTINGHAM, was also an architect. He died March 18, 1803, aged 78.

BRETTINGHAM, ROBERT FURZE, *architect*. Nephew of the foregoing, and grandson of Matthew Brettingham, senr.; was born about 1750, and early in life travelled in Italy, returning about 1781. He had a large practice, and built and altered several fine mansions. He was from 1783 to 1799 an exhibitor of his designs at the Royal Academy. In 1790 he exhibited the design for a bridge he had erected at Benham Place, Berks, in the previous year; and he is supposed to have been the architect of Maidenhead Bridge, in the same county. He held an office in the Board of Works, from which he retired in 1805.

BRIDELL, FREDERICK LEE, *landscape painter*. Was born of respectable parents at Southampton, in November 1831. He was very early attached to art, and when very young tried to maintain himself by portrait painting. Then falling in the way of a picture dealer, he made an engagement to copy for him, and he passed some time in Munich and other art cities; and afterwards, following his own impulses, resided several years on the Italian hills, studying the grand poetry of the scenery by which he was surrounded. In 1851 he was living at Maidenhead, and in that year was first an exhibitor at the Royal Academy of 'A bit of Berkshire.' In 1856 he sent 'Moun-

tains in the Tyrol,' which at once made him known. He afterwards travelled in Italy, and was married at Rome in 1858 to a lady of much ability in art. In 1860 he passed the winter in Rome. He was of delicate and declining health, but laboured with unabated energy. Consumption ensued, and he died in August 1863. 'The Coliseum by Moonlight,' his last and best work, was exhibited at the International Exhibition, 1862. His art was poetic and of much promise, his colour and composition good and vigorous; but he had not met with much encouragement, and after his death about 40 of his works were sold at Christie's.

BRIDGES, CHARLES, *portrait painter*. He practised in the first half of the 18th century. There is a portrait by him in the collection of the Society of Antiquaries.

BRIDGMAN, CHARLES, *ornamental gardener*. He practised towards the middle of the 18th century, and about 1735 was the fashionable designer of gardens. He first used the sunk fence, or 'ha-ha.' He banished the formal Dutch style, and what Walpole called 'the verdant sculpture' that had prevailed, and introduced the more natural and picturesque manner, and was so far the predecessor of Kent. He held the appointment of gardener to the King, and was a member of the St. Luke's Artists' Club.

BRIGGS, HENRY PERRONET, R.A., *subject and portrait painter*. Born at Walworth in 1791, of a very old Norwich family. He was a cousin of Amelia Opie. his father held a lucrative situation in the Post-office, and intended him for a commercial life; but he showed an early love for art, and in 1806, while at school at Epping, sent to the 'Gentleman's Magazine' two small, well-executed engravings of Epping Church. He entered as student of the Royal Academy in 1811, and in 1813 went to Cambridge, where he painted the portraits of several members of the colleges, and the following year exhibited a portrait at the Royal Academy. In 1818 he produced an historical composition, 'Lord Wake of Cattingham setting fire to his Castle to prevent a Visit from Henry VIII., who was enamoured of his Wife;' and next year a subject from Boccaccio, followed by 'Othello relating his Adventures to Desdemona.' He next exhibited his 'First Interview between the Spaniards and Peruvians,' a picture which gained him much notice, and is now in the National Gallery. In 1823 he exhibited at the British Institution 'Scenes from Shakspeare,' and the directors awarded him a premium of 100*l.* In the following year he exhibited there 'Colonel Blood's Attempt to Steal the Regalia;' and in 1827 a large painting of 'George III. presenting the Sword to Earl

Howe on board the "Queen Charlotte," 1794,' which the directors purchased for 500 guineas, and presented to Greenwich Hospital, where it finds an appropriate place: He was elected an associate of the Royal Academy in 1825, and a full member in 1832; and from this time devoted himself chiefly to portraiture, not from his own free choice, but as more remunerative of his talents. His subject pictures are well constructed, the action of his figures original, and his story well told; but his colour is not agreeable, and his flesh-tints hot. He painted some fine portraits, among them 'The Earl of Eldon receiving the Degree of D.C.L. at Oxford, on the Installation of the Duke of Wellington.' He died in Bruton Street, January 18, 1844, in his 51st year. His wife had died six or seven years previously, and he left two orphan children.

BRIGHT, HENRY, *water-colour painter.* Was born at Saxmundham in 1814, though he early showed a talent for art, was apprenticed to a chemist and druggist, and afterwards became dispenser to the Norwich Hospital. Here a self-taught student from nature, he found time to improve himself in art, and to gain a place on the walls of the London exhibitions. In 1839, he was elected a member of the Institute of Painters in Water-Colours, and in this year, in 1841, and 1844, contributed to its exhibitions. He then seceded from the Institution, and from that time to 1850, was an exhibitor of landscapes in oil to the Royal Academy Exhibitions. Painting the passing effects of nature, his art was bold and vigorous, his skies full of feeling and beauty. After a career of above 20 years in the Metropolis, his health failing, he retired to Ipswich, where he died September 21, 1873. He has been classed as of the Norwich School.

BRIGHTWELL, Miss CECILIA LUCY, *amateur.* She lived in Norwich, and excelled in her etchings. These comprised copies from the old masters, the figure spiritedly drawn, and from nature, landscape, and marine subjects. She is more widely known by her writings. She died at Norwich, April 17, 1876.

BRIOT, NICHOLAS, *medallist.* Native of Lorraine. Was employed in the French mint, and invented a process of coining by the press, instead of hammering. Foiled in his endeavours to introduce his invention in France, he came to England, probably in the reign of James I. Gaining the notice of Charles I., he was employed to engrave a medal of him in 1628, and was engaged to work for both the English and Scotch mints, holding the office of graver from the 3rd to the 8th Charles I. In 1631 a commission was issued to report upon his invention for coining. He executed

the coronation medal of Charles I,, when inaugurated at Edinburgh in 1633, which was the first medal that bore a legend engraved on the edge. It is said that he was removed from the Mint, and made a Poor Knight of Windsor; but some authorities state that he returned to France about 1642. Thomas Simon was his pupil.

BRISTOWE, EDMUND, *still life and subject painter.* Was born in 1787. He was well known in the neighbourhood of Windsor, and there are some pictures by him in the Royal Collection there. They are of little merit. He died at Eton, February 12, 1876, at the age of 89.

BRITTON, JOHN, F.S.A., *architectural draftsman.* Was born in 1771, at Kingston St. Michael, Wilts, where his father kept a general shop. In 1787 he came up to London, and was employed for many years as cellarman at a tavern, and then by a hop-factor. Fond of reading and actively intelligent, he made acquaintance with men engaged in the book-trade and literary pursuits, and then found employment in a printing-office, where he became afterwards connected with Mr. Brayley in some of his publications. In 1799 he took an engagement, at three guineas a week, to write, recite, and sing at a theatre in Panton Street, Haymarket, and about the same time found his true vocation as a draftsman, and exhibited some drawings of architectural antiquities at the Royal Academy in 1799, 1800, and 1801. He then undertook with Mr. Brayley 'The Beauties of Wiltshire' and 'The Beauties of England and Wales.' These were followed by works of much learning on the cathedrals of Norwich, Winchester, York, Litchfield, Oxford, Canterbury, Wells, and Exeter. He began, in 1802, a series of articles on British topography for Rees's 'Encyclopædia.' In 1805 he commenced his 'Architectural Antiquities of Great Britain;' in 1814, his 'Cathedral Antiquities of England;' in 1825, in conjunction with Augustus Pugin, 'The Architectural Antiquities of Normandy;' in 1829, a 'Dictionary of Architecture and Archæology of the Middle Ages.' These were his chief works. From 1845 he was engaged upon his autobiography, which he had nearly completed, when he died in London, January 1, 1857.

BROCAS, HENRY, *landscape painter.* He was born in Dublin, and practised there. He painted chiefly in water-colours, and drew well in chalk. There are some engravings by him. He was appointed teacher of landscape in the Dublin Society's School in 1801. He died in 1838, aged 72, and was succeeded in his office by his son Henry.

BROCAS, SAMUEL F., *landscape painter.* Son of the above. He practised

both in oil and water-colours, and painted in a broad, free manner. Among his water-colours are a series of street views in Dublin, dated 1817, well drawn and filled with figures and animals, in which latter he excelled.

BROCAS, WILLIAM, R.H.A., *portrait painter*. He was the brother of the foregoing, and practised in Dublin, both in oil and water-colours. He was also much engaged in teaching. He left a large collection of prints and etchings.

BROCKEDON, WILLIAM, *subject and history painter*. Born October 13, 1787, at Totnes. Son of a watchmaker there, whose family had been known in the county from the time of Henry IV. His father died early, and for five years he managed to carry on the business. Having a love of art, he then came to London, and gained admission, in 1809, as student of the Royal Academy. He studied assiduously, and in 1812 exhibited two portraits, and the next year a portrait of Miss Booth, the actress, as 'Juliet,' which obtained him notice. In 1814 he exhibited a painting of a higher class, and also sent in a plaster model of 'Adam and Eve,' in competition for the Academy medal. He took the opportunity in 1815 to visit the galleries in Paris, then temporarily so rich, and the Belgian cities; and in 1818 was again, in sculpture, a competitor for the Academy medal; and the same year painted 'The Resurrection of the Widow's Son,' for which he received a premium of 100*l.* from the British Institution; and for the following seven years was led to engage in large historical works, an attempt which he then abandoned. He had in this period married, and had visited the chief Italian cities in the summers of 1821–1822, spending a winter in Rome.

On his return in 1822 he settled in London, and painted pictures of a smaller size, and of subjects more suited to the public taste—'Pfifferari,' 'Psyche borne by Zephyrs,' 'L'Allegro,' 'Galileo visited in Prison by Milton,' 'Burial of Sir John Moore,' 'Raphael and the Fornarina,' some of which were engraved. Between 1828–30 he published 'Illustrations of the Passes of the Alps,' followed by 'Journals of Excursions in the Alps.' He edited Finden's 'Illustrations of the Life of Byron,' 1833–34; 'The Road-book from London to Naples,' 1835; 'Italy, classical and picturesque,' 1842–43; 'Egypt and Nubia, from drawings by David Roberts, R.A.' 1846–49. He was clever and of active invention, and in his latter years devoted himself to science rather than art. He contrived a rest for painters engaged in minute works, also a support for a weak knee-joint; he made improvements in steel-pens, and utilised the waste of black-lead in the manufacture of pencils. He patented some chemical processes in caoutchouc, a method of drawing gold and silver wire, and arrangements for warming buildings; and is reputed to have amassed property by his inventions. He was the founder of the Graphic Society, and was F.R.S. and member of the academies of Florence and Rome. He died August 29, 1854, in his 67th year, and was buried in the cemetery of St. George-the-Martyr, Bloomsbury.

BROCKY, CHARLES, *portrait and subject painter*. He was born in 1808, of peasant parents, at Banat, in Hungary. The son of a hair-dresser, and early an orphan, he commenced life with some strolling players. He endured many vicissitudes—was servant in a cook's-shop and assistant to a barber. Eventually he was placed in a free drawing school in Vienna, and, while undergoing sad privations, managed to acquire some knowledge of art. He then found his way to Paris, and became a student in the Louvre; and from thence, when about 30 years of age, he came to London, and in 1839 first appears as an exhibitor of portrait studies and heads at the Royal Academy. Making friends, he continued to exhibit portraits in pencil, and some miniatures on ivory, and settled in the Metropolis. In 1850 he exhibited a 'Nymph' in oil; in the following year a 'Psyche' and 'Venus and Phaon;' in 1852, 'Spring,' 'Summer,' 'Autumn,' and 'Winter,' four pictures; and in the next two years, classic and subject pictures. He was also successful in his portraits, and reckoned the Queen among his sitters. He died July 8, 1855. A sketch of his life, by Norman Wilkinson, was published in 1870.

BRODIE, ALEXANDER, *sculptor*. Born 1830. Was the brother of W. Brodie, R.S.A., and commenced life as a brass finisher. Having a taste for art, he tried modelling, and was rising into reputation in his practice at Aberdeen when he died suddenly there, May 30, 1867, at the age of 36. He exhibited at the Royal Academy, in 1864, 'The Mitherless Lassie' and 'Cupid and Mask.' The statue of Queen Victoria in Aberdeen is by him, and also the statue of the Duke of Richmond at Huntly, Scotland.

BROME, CHARLES, *engraver*. Son of a linen-draper. Was a pupil of Skelton, and a good draftsman. He engraved a portrait of Pitt, after Owen; and was engaged upon Romney's picture of 'Contemplation' when he was accidentally drowned bathing in the Serpentine, April 23, 1801, aged 27.

BROMLEY, WILLIAM, A.E., *line engraver*. Born at Carisbrooke, Isle of Wight, in 1769. He was apprenticed to Wooding, an engraver in London, and soon gaining

notice, he enjoyed a considerable reputation at the commencement of the 19th century for the excellence of his engravings in the line manner. Among his early works may be mentioned those for Macklin's 'Bible;' and after Stothard, 'Illustrations of the History of England;' also 'The Death of Nelson,' after Devis; 'The Attack on Valenciennes,' after De Loutherbourg; and 'The Woman taken in Adultery,' after Rubens. He was elected an associate engraver of the Academy in 1819, and was for several years engaged in engraving for the trustees the 'Elgin Marbles' in the British Museum. He died 1842.

BROMLEY, JOHN CHARLES, *mezzo-tint engraver*. Born in 1795, at Chelsea. Second son of the foregoing. Distinguished by his many important works—among them, 'Spanish Girl and Nurse,' after Murillo, 1831; 'The Trial of Lord William Russell,' after Hayter, 1830; 'The Lady Jane Grey refusing the Crown,' after Leslie; 'The Trial of Algernon Sydney,' after Stephanoff, 1835; 'Monks preaching in Seville,' after Lewis, 1836; 'The Reform Banquet,' after B. R. Haydon; and the portraits of many eminent men. His figures were well drawn, the expression well preserved; his tints and gradations of light and shade excellent —powerful, yet refined in his manner. He died of water on the chest, April 3, 1839, aged 44. He left a large family. His son Frederick followed his profession as an engraver.

BROMLEY, JAMES, *mezzo-tint engraver*. Born in 1800. Third son of the above William Bromley, A.E. He engraved several well-known portraits—the Princess Victoria, the Duchess of Kent, and Lord John Russell, after Hayter; the Marchioness of Londonderry, after Sir W. Ross, R.A.; and many others. He was of a weakly constitution, and died unmarried, December 12, 1838, in his 38th year.

BROMLEY, VALENTINE WALTER, *history and genre painter*. Was born in London, Feb. 14, 1848, and was the great-grandson of the above William Bromley, A.E. He was trained in art under his father, and at nineteen elected an associate of the Institute of Painters in Water-colours. Shortly afterwards he became an associate of the Society of British Artists. He travelled with Lord Dunraven in America, and painted about twenty large pictures for that nobleman, depicting the country and people of the Far West. Besides this he worked as a book illustrator, and was on the staff of the *Illustrated London News*. He exhibited at the Royal Academy in 1872, 'The False Knight;' in 1876, 'The Great Scalper;' in 1877, 'The Fairy Ring.' An artist of great promise, he was suddenly cut off in

his 30th year, and died at Fallows Green Harpenden, April 30, 1877.

BROMLEY, HENRY, *engraver*. He was born at Wigan in 1750, and was intended for the profession, but is only known by his useful 'Catalogue of Engraved British Portraits,' published in 1793. The name under which he published is believed to have been assumed, and his real name to have been Anthony Wilson.

BROMPTON, RICHARD, *portrait painter*. Was a pupil of Benjamin Wilson, and afterwards studied at Rome under Mengs. While there he became acquainted with the Earl of Northampton, and accompanied his lordship to Venice. There he painted a small conversation-piece, with whole-length portraits of the Duke of York and of some English gentlemen, which were exhibited at Spring Gardens in 1763. He had a few months previously returned to England, and settled in George Street, Hanover Square. He painted a whole-length portrait of the Prince of Wales in the robes of the Garter, 1772, and of his brother, Prince Frederick, in the robes of the Bath—both of which are engraved in mezzo-tint by J. Saunders; also a good portrait of the first Earl of Chatham—the face quietly expressive and the robes excellent. His abilities would not have failed to secure him considerable employment, but his folly and vanity in a few years brought him into the King's Bench. From this he was released by the Empress of Russia, who appointed him her portrait painter, and he went to St. Petersburg. Here he was well received and encouraged, but he launched into a pompous style of living, and after a few years died there in 1782. His widow married an English merchant, and returned to London. His colour was gaudy, his drawing frequently hard, and he prided himself upon his laborious finish. There is a portrait by him of Admiral Saunders in the gallery of Greenwich Hospital. He was employed to repair Vandyke's celebrated portrait-group of the Pembroke family at Wilton, which suffered grievously under his hand.

BROOKE, WILLIAM HENRY, *portrait painter*. Was nephew of the author of 'The Fool of Quality,' and began life in a banker's office. Afterwards he became a pupil to S. Drummond, A.R.A., and making rapid progress, he established himself in the Adelphi as a portrait painter. He first exhibited at the Academy in 1810. His early works were sketches only, the subjects—'Anacreon,' 'Murder of Thomas à Becket,' 'Musidora.' From 1813 to 1823 his name does not appear in the catalogues; but in the latter year he contributed a portrait and two Irish landscapes with figures; and in 1826, 'Chastity,' the last work he exhibited at the Academy. In

1812 he undertook a series of designs for 'The Satirist,' a monthly publication, which led to his employment to make drawings on wood for the publications of the day. The vignettes for Moore's 'Irish Melodies,' published in 1822, are by him; also some of the vignettes for Major's edition of 'Izaak Walton,' and the outline figures and gems from the antique for Keightley's 'Greek and Roman Mythology,' published 1831. His best designs were characteristic, and were well drawn. He died at Chichester, after a long illness, January 12, 1860, aged 88.

BROOKE, HENRY, *history painter.* Was born in Dublin 1738. He came to London in 1761, and by the exhibition of his pictures gained both a reputation and money. In 1767 he married and settled in Dublin, where he lost his money in an unfortunate speculation. He then found employment in the decoration of some Roman Catholic chapels. He died in Dublin 1806.

BROOKING, CHARLES, *marine painter.* Born 1723. Was bred in some department of the dockyard at Deptford, and practised as a ship painter. He acquired great skill as a marine painter, but he was in the hands of the dealers, and lived in obscurity. He painted sea-views and sea-fights, which showed an extensive knowledge of naval tactics; his colour was bright and clear, his water pellucid, his manner broad and spirited. He promised to become eminent, but died under 36 years of age from consumption, induced by mistaken medical treatment, at his lodging in Castle Street, Leicester Square, in the spring of 1759, just as he was getting into repute. His works have been engraved by R. B. Godfrey, Ravenet, Canot, and Boydell. There is a very fine sea-piece of large dimensions by him in the Foundling Hospital. The records of the Royal Academy show that 'William Brooking, the son of a painter'—and doubtless his son—was apprenticed to a peruke-maker, with a fee of 11 guineas out of the proceeds of his first exhibition; and from other documents it is clear that his widow and children were left in extreme distress, and that another son was an inmate of St. Luke's Workhouse.

BROOKS (or BROOKES), JOHN, *mezzo-tint engraver.* Was born in Ireland, and was a very popular engraver towards the middle of the 18th century. He discovered a method of printing in enamel to burn on china, which was applied in a manufactory at Liverpool and some other places, and then at Battersea, where appropriate buildings were erected for the purpose, at which Gwinn, a clever designer, and John Hall, the engraver, then very young, were employed. Their designs were popular, and the enterprise might have succeeded but

for the dissipated conduct and bad management of Brooks, which led to the ruin of Sir Stephen T. Jansen, then (1755) lord mayor of London, who had embarked in it. On this failure, Brooks, who had resided at Battersea till 1756, when he was bankrupt, took up his abode with a congenial friend, a publican in Westminster, and never for years quitted his room, except to accompany his friend on his removal to Bloomsbury, where he then continued in the same conclusion till his death. In his younger days he had been industrious. He worked chiefly on portraits; but there is a plate by him, after Wyck, of 'The Battle of the Boyne;' but it is very doubtful whether several plates which bear his name are not by his pupils. He is distinguished as the master of McArdell and Houston.

BROOKSHAW, RICHARD, *draftsman and mezzo-tint engraver.* Born about 1736. For many years he practised unnoticed in London, earning only 25s. a week while engraving after the most celebrated masters. He then went to France, where his talents were recognised, and he was admitted a member of several societies and well remunerated. Among his works, which are not numerous, the best are—'The Flight out of Egypt,' after Rubens; portraits of Louis XVI. and Marie Antoinette; a sea-piece; 'Moonlight,' and 'A Storm,' after Kobell; 'A Lady,' half-length; and 'The Earl of Radnor,' after Reynolds. He also engraved for the 'Pomona Britannica,' a costly work, published 1804.

BROWN, CHRISTIAN, *botanical painter.* He was chiefly employed upon the illustrations for botanical works. Died in Marylebone, May 7, 1803.

BROWN, DAVID, *landscape painter.* Was brought up a house and sign painter. He became so infatuated with George Morland's art that, at the age of 35, he parted with a good business to become his pupil. He was a man of persevering, steady habits, and learned to make respectable copies of his master's works; but could not bear his excesses, and was obliged to leave him. He exhibited landscape views and landscapes with figures at the Academy in 1792, and up to 1797. He retired into the country to gain his livelihood as a teacher of drawing.

BROWN, JOHN, *serjeant painter to Henry VIII.* He received a pension of 10l. a year. He built Painters' Hall for the Company 1553, and his portrait is preserved there. Edward VI. appointed him, or an artist of the same name, surveyor of the coins.

BROWN, JOHN, *engraver.* He practised as a draftsman and copper-plate engraver in London about 1676, and is known by several portraits from his hand.

Brown. F. M. 57

• BROWN, JOHN, *portrait painter*. Born at Edinburgh 1752. He was the son of a jeweller and watchmaker. He received a good education, was early destined for an artist, and was a pupil of Alexander Runciman. In 1771 he went to Italy; and at Rome, from whence he sent two drawings to the Academy Exhibition in 1774, became acquainted with Mr. Townley and Sir William Young, who were pleased with his drawings; and he accompanied them to Sicily, where he made many highly-finished pen drawings of the antiquities. He was absent above 10 years, and on his return to Edinburgh was much esteemed for his taste and acquirements. He exhibited a portrait and a frame of miniatures at the Academy in 1786, and the same year came to London and engaged in portraiture. He excelled in small portraits in pencil, which were always correct in drawing and character; but his health had suffered by his incessant application, and taking a sea-voyage to Scotland, he was sea-sick, lay without attention in his hammock, and on landing at Leith died there on September 5, 1787. He was a great enthusiast for his art. His works were marked by delicacy and taste. He left some highly-finished portraits in pencil, many sketches of Italian scenery in the same manner, and one or two careful etchings. He was also passionately fond of music, and his 'Letters on the Poetry and Music of the Italian Opera' were published in 1789 for the benefit of his widow, edited by Lord Monboddo. His friend, Alexander Runciman, about 1782 painted his portrait grouped with his own.

• BROWN, LAUNCELOT (called 'Capability Brown'), *architect*. He was born in 1715 at Kirkhall, Northumberland, and was brought up in the kitchen-gardens at Stowe. He came into Lord Cobham's service when a lad, in 1737, and was employed in the gardens till 1750, and afterwards from 1751 at Croome Court, Worcestershire, where he built the mansion and offices and a Gothic church. He made additions to Burleigh, Northamptonshire, and Broadlands, Hampshire; and built Redgrave Hall, Suffolk. But the successful formation of a fine lake for the Duke of Grafton at Wakefield Lodge laid the foundation of his fortunes, and he was largely employed in landscape gardening, and engaged on the improvement of the grounds at Blenheim, Luton, Corsham, Trentham, Nuneham, Caversham, and the formation of Kensington Gardens; and on the alteration of the mansion and grounds at Claremont, at a cost of 100,000*l*. He held the appointment of head-gardener at Windsor Castle and Hampton Court. In 1770 he was chosen high sheriff of Cambridge and Huntingdon, and his son

58

afterwards represented the latter county. He died suddenly in the street in London, February 6, 1783. Hannah More extols his great conversational powers.

BROWN, MATHER, *history painter*. Was born in America; it is supposed at Boston, and that his father was a loyalist. He came to England young, and was the pupil of Benjamin West, P.R.A., whose pictures were the objects of his intense admiration. He pursued the study of his art with great devotion, and shared the public patronage as a portrait painter. From 1782 up to 1831 he was an exhibitor at the Royal Academy, and at the latter part of the time an occasional contributor to Suffolk Street. He occupied a large house in Cavendish Square, and among his sitters numbered George III. and his queen, and some distinguished officers of both services. He painted Holman and Miss Brunton as 'Romeo' and 'Juliet,' was consulted by Alderman Boydell on his scheme of the 'Shakespeare Gallery,' and painted for that collection 'Bolingbroke offering the Crown to Richard II.' He painted some other subjects, which were engraved, the best known of which is 'The Marquis Cornwallis receiving as Hostages the Sons of Tippoo Saib.' Later in life he finished a 'Resurrection,' probably one of his best works. He, however, never attained excellence, though in the height of his career he occasionally produced a portrait possessing some good art, and he was prudent then to make some provision for the future. In his latter days he became careless in his dress and person, poverty-stricken in his appearance, and lost to the customs of society. But he continued to labour at his art, though without reward, accumulating historical pictures and portraits of all classes, amused in happy self-satisfaction in spite of surrounding critics. Leslie, R.A., says that at this period he visited him, and never saw a more miserable display of imbecility. 'I thought,' he adds, 'of Gay's lines—

"In dusty piles his pictures lay,
 For no one sent the second pay."'

He died in Newman Street at an advanced age, June 1, 1831. He held the appointment of principal painter to H.R.H. the Commander-in-Chief and to the Duke of Clarence.

BROWN, PETER, *botanical painter*. In 1766 he was a member of the Incorporated Society of Artists, and the following year was assisted from the Society's funds. He first exhibited at the Academy in 1770, and was for several years a constant exhibitor. He tried several styles of art, but after painting animals, birds, shells, and insects, and even a 'Holy Family' in miniature, he settled down as a flower

Brown - n painted J. Matlock -

painter about 1781, and was appointed botanical painter to the Prince of Wales. His last contribution to the Academy Exhibition was in 1791.

BROWN, RICHARD, *architectural draftsman.* He devoted himself to the theory and teaching of his profession. He first exhibited at the Academy an architectural drawing in 1793, and continued to exhibit works of this class. In 1811, 'Interior of Chester Cathedral;' in 1826, 'Interior of Exeter Cathedral;' the following year an exceptional work, 'The Angel delivering St. Peter out of Prison;' and in 1828 his last contribution was, 'A View of Exeter Cathedral.' He published, in 1815, 'The Principles of Practical Perspective;' in 1822, 'Rudiments of Drawing,' 'Cabinet and Upholstery Furniture;' in 1841, 'Domestic Architecture;' and in 1845, 'Sacred Architecture.'

BROWN, ROBERT, *decorative painter.* Born in London. Was the pupil and assistant to Sir James Thornhill, working under him upon the cupola of St. Paul's. He was also assistant to Verrio and La Guerre, and afterwards set up for himself, and found employment in the decoration of the City churches and as a sign painter. The altar-piece of St. Andrew, Undershaft, is by him; as also some original paintings in St. Botolph, Aldgate, and St. Andrew's, Holborn; but much of his work consisted in painting crimson curtains and religious emblems, which were then common. He painted some portraits, and there are two mezzo-tint engravings by McArdell after children painted by him. He was the master of Frank Hayman, R.A. He died December 26, 1753.

BROWNE, ALEXANDER, *limner and mezzo-tint engraver.* He practised in the reign of Charles II., and was also a dealer in paintings. He engraved both in mezzotint and with the needle. He painted, among other portraits, Charles II., the Countess Stewart, and the Prince of Orange. He published, in 1669, 'Ars Pictoria; or, An Academy treating of Drawing, Painting, Limning, and Etching,' illustrated with 31 etchings by his own hand; and in 1677, 'A Compendious Drawing-book.'

BROWNE, JOHN, A.E., *landscape engraver.* Erroneously stated by Bryan to have been born at Oxford 1719, was born at Finchinfield, Essex (of which parish his maternal grandfather was vicar), April 26, 1741, six months after the death of his father, who was rector of Booton, Norfolk. He was educated at Norwich, and in 1756 was apprenticed to Tinney, the engraver and printseller, in London, with whom he continued till 1761, completing his time with Woollett, who had been his fellow-apprentice, and remaining with him three years after as his assistant. In 1768 he finished a fine plate of 'St. John' after Salvator Rosa, the figures by Hall, which at once gave him distinction; and in 1770 he was elected associate engraver of the Royal Academy, where he was an exhibitor from 1771 to 1783. On leaving Woollett he commenced a series of fine works after Rubens, Poussin, Paul Brill, Both, Swannevelt, and also executed two large works after Hodges, R.A.; all of which plates were published by Alderman Boydell between 1768 and 1795. In 1796-98 he engraved and published from his own drawings four plates—'Morning,' 'Evening,' 'After Sunset,' and Moonlight.' His other chief works were from sketches by Gainsborough, R.A., and a forest scene after Sir George Beaumont. He was the friend and neighbour of his great rival in art William Sharp, while residing in Lambeth, and died after a long illness in West Lane, Walworth, October 2, 1801, leaving a widow with three sons and a daughter. He was distinguished as an etcher and engraver of landscapes; his style was bold and beautiful in its variety—particularly in his foregrounds; but his distances had a tendency to be heavy and black—wanting gradation and air.

BROWNE, WILLIAM, *gem engraver.* In early life he was much employed by the Empress of Russia, who appointed him her 'gem sculptor.' He then resided for a time in Paris (was there in 1788), and was patronised by the Court of Louis XVI. On the Revolution he quitted France and followed his art in London, where he failed to receive due appreciation. He exhibited at the Royal Academy at intervals from 1770 to 1811, and then for the last time in 1823. His contributions were classic heads, impressions, and gems—'Venus,' 'Hebe,' 'Dying Gladiator,' 'Piety of Æneas,' and later in his career, a series of portraits of illustrious persons, cut with spirit and feeling, many of which are in the royal collection; but his best works were sent to Russia, are of a high order, and are mostly distinguished by his initials. He died in John Street, Fitzroy Square, July 20, 1825, in his 77th year. CHARLES BROWNE, who lived with him, exhibited works of the same class from 1780 to 1789. Died June 1, 1795, aged 46.

BROWNE, J. C., A.R.S.A., *landscape painter.* He was born in 1805, at Glasgow, where he commenced his art studies. He visited Holland, Flanders, and Spain, and on his return spent several years in London. He then settled for a time in Glasgow, and finally removed to Edinburgh. He usually painted Scotch scenes —'The last of the Clan Glencoe, Dawn Morning of the Massacre,' 'The Ferry

Rock,' 'The Desolate Glen.' He died at Edinburgh, May 8, 1867.

BROWNOVER, T., *portrait painter.* He practised about the beginning of the 18th century. A portrait of Locke by him is engraved.

BRUCE, Sir WILLIAM, Bart., *architect.* Was born in Scotland; the second son of the third Baron of Blairhill. He was, in 1671, his Majesty's surveyor and master of the king's works, and enjoyed a high reputation. He was engaged on the restoration of Holyrood Palace after the fire of 1674. He built Hopetoun House, 1698–1702—a noble mansion, engraved in the 'Vitruvius Britannicus,' the elevation showing both originality and taste. He died 1710.

BRYER, HENRY, *engraver.* He was a pupil of W. Wynne Ryland, and afterwards entered into partnership with him in the shop opened on Cornhill. He received, in 1762, the Society of Arts' premium for a plate—'Mars discovered with Venus by Vulcan;' but his engraved works are few—some plates after Angelica Kauffmann and a 'Bacchus and Ariadne.' He died 1799.

BUBB, J. G., *sculptor.* The monument to William Pitt in the Guildhall, erected 1813, is by him. He carved the sculptures for the front of the Custom House, and modelled the terra cotta basso-rilievo in the Haymarket front of the Opera House. He exhibited at the Royal Academy, 1831, 'A Nymph leaving the Bath;' and there are several busts by him.

BUCHAN, HENRY DAVID STEWART, Earl of, *amateur.* Born 1699. He was fond of engraving. There is a south view of the cathedral at Icolmkill in aqua-tint by him, dated 1761; and among his later works are some portraits. These attempts are respectable. He died December 1, 1767.

BUCK, ADAM, *portrait painter.* Born in Cork. Believed to have been self-taught, but is said to have studied under Minasi. He practised for several years in Dublin, and first exhibited at the Academy in 1795, contributing two marine drawings; but his subsequent works were all portraits, and he continued an exhibitor, with little intermission, to 1833, when he appears for the last time. His portraits were chiefly drawn, small size, in wax crayons, and slightly tinted; but he also painted in oil and miniature. His portraits evince no power of grouping or composition, are mostly in profile, and hard and without feeling. He published, in 1811, a collection of 100 Greek vases, drawn and engraved from the originals by himself. His brother, FREDERICK BUCK, practised at the same time as a miniature painter in Cork.

60

• BUCK, SAMUEL, *engraver and topographical draftsman.* Drew and engraved a very large number of views, consisting of churches, abbeys, castles, and other ruins; also views of the principal towns in England and Wales, with a large plate of London and Westminster. His works were finished with the graver in a stiff manner; the backgrounds slightly etched; his drawings hasty and slight; but in some few instances, elaborately finished with pen and ink, and tinted. He exhibited drawings at the Spring Gardens Exhibitions in 1768, 1774–75, and two topographical views at the Academy in 1775. He was in his latter days in distress, and a liberal subscription was made for him; but he died a few months after, on August 17, 1779, aged 83. He was buried in St. Clement's Churchyard, Strand. His works are known as 'Buck's Views,' and are records of places long since destroyed; they are in three volumes, and comprise 420 views of noted ruins in England and Wales.

• BUCK, NATHANIEL, *engraver.* Brother to the foregoing Samuel Buck, and his partner and assistant in his topographical works. Died many years before him.

• BUCKLER, JOHN CHESEL, *topographical draftsman.* Born at Culbourne, Isle of White, November 30, 1770. He was articled to an architect and surveyor in Southwark, and on the expiration of his articles commenced business for himself, and practised for some years as an architect; but is chiefly known as a topographical draftsman. In 1797 he published two aqua-tint engravings of Magdalen College, Oxford, and in 1729 a south-east view of Lincoln Minster; and in these beginnings originated his laborious and valuable work—'The English Cathedrals,' and contemporaneously the finest of our collegiate and abbey churches. He was confirmed in this pursuit by a commission from Sir Richard Colt Hoare to make drawings of the churches and other ancient buildings in Wiltshire; and in the latter part of his life he was similarly employed by antiquarians in Buckinghamshire, Yorkshire, Oxfordshire, and Hertfordshire. He exhibited at the Royal Academy, from 1796 to 1840, drawings of cathedrals and colleges, chiefly of an antiquarian character; and from 1815 to 1820 drawings of the same class with the Water-Colour Society. He published, in 1809, aqua-tint engravings from his drawings of some of the chief cathedrals and abbey churches; in 1822, his 'Views of the Cathedral Churches in England;' in 1826, 'Views of Eaton Hall, Cheshire;' in 1827, 'Sixty Views of Endowed Grammar Schools;' in 1828, 'Historical and Descriptive Account of the Royal Palace at Eltham;' in 1843,

'Remarks upon Wayside Chapels;' in 1847, 'History of the Architecture of the Abbey Church of St Alban.' He died at Rockingham Row, New Kent Road, December 6, 1851, aged 81.

BUCKSHORN, JOSEPH, *drapery and portrait painter*. Born in the Netherlands. He settled in England in 1670; and was the pupil and assistant of Lely, painting his draperies and accessories, and copying his works with great skill. He also painted portraits, imitating Lely's manner, with much ability. He died in London in his 35th year, and was buried in St. Martin's Churchyard. Bardwell, in his work on painting (1756), says, 'Buckshorn was one of the last good copyers we have had in England.' The copy of 'The Stafford Family,' at Wentworth Castle, after Vandyke, is by him.

BUDD, GEORGE, *portrait and landscape painter*. He was bred a hosier, but left that business and became a teacher of drawing. He also painted landscapes, still-life, and portraits. A portrait by him of the so-called 'Patriotic Shoemaker,' who maintained the right of way through Bushey Park, was mezzo-tinted by McArdell in 1756. A painting by him is also engraved, representing the execution of Lords Balmerino and Kilmarnock in 1746, with a background of the Tower and surrounding buildings, and the whole picture crowded by a dense mass of small figures.

BULL, SAMUEL, *medallist*. Was engraver to the Mint in the reigns of Anne and of George I.

• BUNBURY, HENRY WILLIAM, *amateur*. He was the second son of the Rev. Sir W. H. Bunbury, Bt., of Mildenhall, Suffolk, and was born in 1750. Educated at St. Catherine's Hall, Cambridge, he was a good classic scholar. He was colonel of the West Suffolk Militia, and was in 1787 appointed one of the Duke of York's equerries, and constantly attended him at Court. Early distinguished by his taste for drawing, he became celebrated as a caricaturist, and was occasionally an honorary exhibitor at the Royal Academy. His drawings are marked examples of harmless humour. His 'Long Minuet at Bath,' 'Propagation of a Lie,' 'Barber's Shop,' 'Country Club,' 'Hints to bad Horsemen,' and 'Academy for grown Horsemen,' are among his best productions. He made 40 drawings illustrative of Shakespeare, which were engraved by Bartolozzi and others, and Macklin's 'Poets;' but his art was essentially caricature, and his higher attempts were weak sentimentalities only. He was an accomplished performer in private theatricals, and wrote an epilogue in verse spoken by Mrs. Jordan in 1791. Died at Keswick, May 7, 1811.

BUNK, JAMES, *landscape and orna-*

mental painter. An obscure painter of landscapes, still-life, candle-light effects, and figures for the decoration of clocks, giving to them mechanical movement. He exhibited in the Free Society of Artists from 1766 to 1769, and is supposed to have died soon after.

BUNNING, JAMES BUNSTONE, *architect*. Born October 9, 1802. He was the son of a surveyor in London, was self-taught, and began early in life to practise on his own account. He was fortunate, on the commencement of his career, in gaining the appointment of surveyor to the Foundling Hospital Estates. He first exhibited at the Royal Academy in 1819, and continued to be an occasional exhibitor. In 1837 he gained, in competition, the erection of the City of London School. In 1839 he was appointed surveyor to the City Cemetery Company, and afterwards to several other institutions. In 1843 he gained the lucrative office of architect to the Corporation of London, 'clerk of city works,' and during the 20 years he held the appointment he carried out many extensive improvements. Of his principal works may be named—the City School, the Orphan School, Billingsgate Market, the Coal Exchange, the City Prison, Holloway, Islington Cattle Market, Rogers' Almshouses, Brixton; the City Lunatic Asylum. He had amassed a considerable property, and died November 2, 1863.

BURCH, EDWARD, R.A., *sculptor and medallist*. He was born in London, and originally studied in the St. Martin's Lane Schools. In 1769 he was admitted a student of the Royal Academy, where he became noted for the great delicacy, truth, and finish shown in his studies. He exhibited at Spring Gardens, in 1765, 'Heads from the Antique,' and first at the Academy in 1770; and from that time continued a contributor of models in wax, casts from gems, intaglios, classical heads, and portraits in wax. He was elected an associate of the Academy in 1770 and a full member in 1771, and was afterwards appointed librarian. As a gem engraver he was unrivalled in his day. Early in his career he married a lady of great beauty, and from that time he devoted himself to miniature painting, and exhibited for the first time a miniature enamel in 1792. He painted a portrait of Mrs. Fitzherbert, the last for which she sat; and of Mary, Duchess of Gloucester. George III. sat to him for a bust. He lived to an advanced age, became nearly blind, and died at Brompton sometime before 1840.

BURCHETT, RICHARD, *subject painter*, and teacher of art, was born at Brighton, Jan. 30, 1815. He studied drawing in the classes of the Birkbeck Mechanics' Institution, in Chancery Lane, and after-

BUR

wards aided in establishing art classes in Maddox Street; thence he entered the Government School of Design at Somerset House, where he became an assistant-master. On the formation of the Department of Practical Art in 1852, he was appointed head-master of the Normal School for training teachers, and materially aided in carrying out the course of instruction laid down by the Art Superintendent for these schools. For the use of the masters in training he published in 1855 a treatise on 'Practical Geometry,' and in 1856, on 'Practical Perspective.' He first exhibited at the Royal Academy, in 1847, 'The Death of Marmion,' and at intervals other pictures, until 1873, 'The Making of the New Forest.' He painted some large figures to decorate the domes of the 1862 Exhibition buildings, a window for Greenwich Hospital, and other decorative works elsewhere : but his reputation will rather rest on his labours in the Art Training Schools than on his other works. He died while on a visit to Dublin, May 27, 1875, and the students of the School of Art at South Kensington erected a monumental tablet there to his memory.

BURFORD, ROBERT, *panorama painter*. He was known as the painter and proprietor of the panoramas exhibited in Leicester Square and in the Strand. He commenced these works in 1827, visited several of the European capitals to make sketches for them, and was engaged upon them for the greater part of his life. He died January 30, 1861, aged 69.

BURFORD, THOMAS, *mezzo-tint engraver*. Born about 1710. His best works are portrait, and were executed towards the middle of the 18th century, some of them from the life; but he also engraved some landscapes and hunting subjects. He was a member of the Incorporated Society of Artists, and died in London about 1770.

BURGESS, JOHN CART, *flower painter*. Grandson of William Burgess, the portrait painter. He painted, in water-colours, flowers, and occasionally a landscape, and exhibited at the Royal Academy and at Suffolk Street; but the necessities of a large family compelled him to devote much of his time to teaching. He published 'The Art of Flower-painting' and a 'Treatise on Perspective.' He died at Leamington, Feb. 20, 1863, in his 65th year.

BURGESS, THOMAS, *portrait painter*. Was a student in the St. Martin's Lane Academy, and in 1766 a member of the Incorporated Society, and contributed to its exhibitions portraits, academy studies, conversation-pieces, &c. In 1778 he was living in Kemp's Row, Chelsea, and for the first time exhibited at the Royal Academy, 'William the Conqueror dismounted by

his eldest Son,' 'Hannibal swearing enmity to the Romans,' and 'Our Saviour's Appearance to Mary Magdalen.' He afterwards sent a portrait of himself, some landscapes, and, in 1786, 'The Death of Athelwold,' his last contribution to the Academy. He for some time kept an art academy in Maiden Lane, and was reputed for his teaching.

BURGESS, WILLIAM, *portrait painter*. Son of the foregoing. In 1761 he gained a premium at the Society of Arts. He exhibited portraits and conversation-pieces with the Free Society of Artists in 1769 and 1771, and at the Academy, commencing in 1774, portraits in chalk, small whole-lengths, groups, 'Gipsy Boy and Girl,' and occasionally landscape views. He last exhibited in 1799. His principal occupation was, however, as a teacher of drawing. He died in Sloane Square, Chelsea, May 11, 1812, aged 63, and was the father of H. W. BURGESS, landscape painter to William IV.

BURGESS, THOMAS, *landscape painter*. First appears as an exhibitor at the Academy in 1802, when he contributed 'Market Gardener's House at Walham Green;' in 1803, 'Landscape and Flowers;' in 1804, 'Ruins of a Fire in Soho;' and in 1805 and 1806, 'Derbyshire and Devonshire Views.' His works were of much promise. He died at the age of 23, in Sloane Square, Chelsea, November 23, 1807.

BURGESS, WILLIAM, *engraver*. He practised about the end of the 18th century. There is by him a set of prints of the Lincolnshire churches, and of Lincoln and Ely Cathedrals. While following his profession as an artist, he was for 20 years the pastor of a Baptist congregation. He was also the writer of a controversial pamphlet on the works of Dr. Adam Clark. He died suddenly, at Fleet, Lincolnshire, December 11, 1813, in his 59th year.

BURGESS, WILLIAM OAKLEY, *mezzo-tint engraver*. Son of the parish surgeon of St. Giles-in-the-Fields. Pupil of Lupton, under whom he continued till his 20th year, and acquired by his earnest application much delicacy in his art. He engraved a fine portrait of the Duke of Wellington, after Sir Thomas Lawrence, P.R.A., and had commenced a series of Lawrence portraits, giving great promise of excellence, when he died prematurely, December 24, 1844, aged 26, from an abscess in the head, attributed to a blow from a cricket-ball some years before.

BURGH, H., *engraver*. Practised in London about the middle of the 18th century. He was principally employed by the booksellers in engraving portrait frontispieces.

BURGHERS, MICHAEL, *engraver and draftsman*. Born in Holland. Came to

62

England on the taking of Utrecht by Louis XIV., and settled at Oxford. He engraved the first Oxford almanack, 1676, and the greater part for the first 47 years. He drew and engraved the illustrations for Dr. Plot's 'History of Staffordshire,' 1686, and for Dr. White Kenett's 'History of Ambroseden,' and engraved many portraits. He worked almost wholly with the graver, and with great neatness, but in a dry, stiff manner.

BURKE, THOMAS, *engraver.* Born in Dublin 1749. Was pupil of Dixon, the mezzo-tint engraver, and practised both in that and in the chalk manner. He principally engraved after contemporary painters, and his works were highly esteemed. Among his best are those after Angelica Kauffmann, R.A.: 'Telemachus at the Spartan Court,' 1778, and 'Andromache at Hector's Grave;' 'The Battle of Agincourt,' after Mortimer; 'The Nightmare,' after Fuseli, R.A., 1783; and 'Lord North,' after Dance, R.A. He died in London, December 31, 1815.

BURLINGTON, RICHARD BOYLE, Earl of, *amateur.* Born April 25, 1695. He early and enthusiastically studied architecture. At the age of 20 he visited Rome, and was distinguished for his genius and the zeal he displayed in the patronage of art, as well as for the sums he expended on publications more particularly tending to the improvement of architecture. The Bath-house at Chiswick, commenced about 1717, was his first work. The *façade* of Burlington House, Piccadilly, and the colonnade within the court, both now pulled down, were said to have been from his own designs, though the centre gateway, the principal feature in the *façade*, is described in the 'Vitruvius Britannicus' as designed by Colin Campbell. He built in 1729 an Italian villa at Chiswick, in imitation of a Palladian design, to which James Wyatt added two wings; also the dormitory of the Westminster School; the Assembly Rooms at York—two large, handsome rooms, in the Corinthian order, without any variety in form, and of very inconvenient access. Lord Harrington's house at Petersham; the Duke of Richmond's house at Whitehall, which occupied the site of Richmond Terrace; and General Wade's house in Cork Street, Saville Row, were also designed by him. Lord Chesterfield wittily said of this house, which was not celebrated for its interior arrangements, that 'as the owner could not live in it with comfort, he had better take a house opposite and look at it.' He died December 4, 1753.

BURLOWE, HENRY BEHNES, *sculptor.* Was the brother of Behnes, the sculptor, and following the same art took the name of Burlowe, as distinctive. He exhibited busts at the Academy in 1831-32-33. He afterwards went to Rome, where he was much employed as a bust modeller. On the memorable outbreak of cholera he resolved to take his chance in the city, and was found in his solitary lodgings, unattended, unassisted, and dying, by a kind artist friend, whose hurriedly sought help was all too late. He died of that terrible scourge in August 1837. He was original in his art and of much promise.

BURMAN, THOMAS, *sculptor.* Practised in the reign of Charles II. Did not attain any excellence, and is chiefly known as the master of Bushnell. He died March 17, 1673-74, aged 56, and was buried at St. Martin-in-the-Fields.

BURN, WILLIAM, *architect.* He was born in Edinburgh, December 20, 1789. He was the son of a builder and surveyor, who sent him to London in 1808, as a pupil of Sir Robert Smirke. Returning to Scotland, his earliest commission of any importance was the Custom House at Greenock. He settled in Edinburgh, and devoting himself to domestic architecture, became reputed for the comfort and convenience of his designs. After 28 years' practice there, his connections gradually extended to England, and he came to reside in London in 1844. During a long career he executed a long list of works in various styles of art, in both England and Scotland, including several churches, hospitals, and county buildings, the Theatre Royal, Edinburgh, and the residence of the Duke of Buccleugh at Whitehall, one of his last works. He died in London, February 15, 1870, and was buried in the Kensal Green Cemetery.

BURNET, JOHN, F.R.S., *engraver and painter.* He was born near Edinburgh, March 20, 1784; the son of the surveyor-general of excise for Scotland. It has been said that he was descended from a brother of Bishop Burnet, but this is proved to be an error. A passion for drawing led to his apprenticeship to Robert Scott, a landscape engraver, practising in Edinburgh, and he improved himself as a student in the Trustees' Academy. Here his tastes led him to painting, and incited by the success of his friend and fellow-student Wilkie, he worked early and late during his apprentice years, and gained a knowledge of the figure; and then seeking distinction in a wider field, having completed his term of apprenticeship, he set out in a Leith smack for London in 1806, and arriving with only a few shillings in his pocket, he was warmly received by Wilkie. He first found employment as an engraver on the illustrations for Britton and Brayley's 'England and Wales,' Mrs. Inchbald's 'British Theatre,' and Cooke's 'Novelists.'

63

But he desired to be employed on some more ambitious work ; and in 1810 made a successful engraving, the size of the picture, of Wilkie's 'Jew's Harp.' This was the foundation of his reputation, and was followed by the same painter's 'Blind Fiddler,' which was highly popular ; and encouraged by the notice he had gained, he visited Paris at the peace of 1815, and for nearly five months was a constant student in the Louvre. Soon after he engraved for Foster's 'British Gallery,' Metzu's 'Letter Writer,' and Rembrandt's 'Salutation of the Virgin.' Anxious to support the school of line engraving, he joined the Associated Engravers, and executed for the Association Rembrandt's 'Jew,' 'Nativity,' and 'Crucifixion.' He also engraved, after Atkinson, 'The Battle of Waterloo,' and the same subject after Devis. His best works were, however, after his friend Wilkie, who was fortunate in his clever renderings of 'The Reading of the Will,' 'The Rabbit on the Wall,' 'Chelsea Pensioners reading the Gazette of the Battle of Waterloo,' 'The Letter of Introduction,' 'The Death of Tippoo Saib,' 'The Village School'—in which the character and humour of the painter were admirably maintained. Yet his work was defective in beauty of line ; had an appearance of blackness ; was heavy ; wanting in sparkle and brilliance.

His repute does not, however, rest alone on his engraving ; he was a painter and a writer on art. He first exhibited at the Royal Academy, in 1808, 'The Draught Players ;' in 1818, 'The Humorous Ballad ;' in 1823, 'A Windy Day ;' and on some few occasions at the British Institution, sending there in 1837 his 'Greenwich Hospital and Naval Heroes,' painted on a commission from the Duke of Wellington as a companion for Wilkie's 'Chelsea Pensioners'—a difficult task, which resulted in his best picture. The above work he engraved, and also, from his own paintings, 'Christmas Eve,' 1815 ; 'The Valentine,' 1820. He was a fellow of the Royal Society. His writings on art are numerous, and he will probably be remembered by his criticisms and opinions rather than his art. He published, in 1827, 'A Practical Treatise on Painting, in Three Parts : Composition, Chiaroscuro, and Colouring ;' in 1837, 'An Essay on the Education of the Eye, with reference to Painting ;' in 1848, 'Practical Essays on various Branches of the Fine Arts, and an Enquiry into the Practice and Principles of Sir David Wilkie, R.A. ;' in 1849, 'Landscape Painting in Oil-Colours Explained' and 'Rembrandt and his Works ;' in 1850, 'Practical Hints on Portrait Painting ;' in 1852, 'Turner and his Works, illustrated by Examples ;' and in 1854, 'The Progress of

a Painter in the 19th Century.' In 1860 he was granted a pension on the Civil List, and retired to Stoke Newington, where he passed the last six years of his life, in straitened circumstances, and died on April 29, 1868, aged 84.

BURNET, JAMES M., *landscape painter*. Brother to the above. He was born at Musselburgh 1788. He early showed a taste for art, and was placed under a wood carver, studying also at the Trustees' Academy ; but was soon tempted to art, and sending some specimens of his drawings to his brother, then in London, without waiting for a reply he started for the great metropolis in 1810, determined to devote himself to art. Charmed with Wilkie's 'Blind Fiddler,' which he found his brother then engraving, he was led by it to the study of the Dutch masters, and the art which he afterwards followed. Taking up his residence at Chelsea, he haunted the neighbouring pasture-lands at Battersea and Fulham, devoting himself to the study of rural nature. In 1812 he first appears as an exhibitor at the Royal Academy of 'Evening : Cattle returning Home ;' in 1813 he sent 'Mid-day' and 'The Return in the Evening ;' in 1814, 'Early Morning' and 'The Ploughman returning Home ;' in 1816, two works of the same class, his last contributions. Of weak health, he was attacked with consumption, and removing for purer air to Lea, in Kent, died there July 27, 1816, and was buried in the adjacent churchyard at Lewisham. He was of great promise ; he had a true feeling for the rural and picturesque ; his pictures were rich and brilliant in colour, luminous and powerful in effect.

BURNEY, EDWARD FRANCIS, *portrait and subject painter*. He was born near Worcester, of a good family, in September 1760. Sent to London to study in 1776, he was admitted to the schools of the Royal Academy, and gained the friendship of Sir Joshua Reynolds. He first appears as an exhibitor at the Academy in 1780, contributing three sketches from 'Evelina,' and from that time exhibited portraits, with occasionally a domestic subject ; but, of retired habits, he did not continue portraiture, and after 1793, when he sent some illustrations for 'Telemachus,' he ceased to exhibit. He made, in conjunction with Catton, jun., some designs for Gay's 'Fables,' and devoting himself to book illustration he became popular, and his designs were inlaid in work-boxes and other feminine trifles. His designs were clever and imaginative, made with the pen, and slightly tinted. He painted a good half-length portrait of his relative, Madame d'Arblay, which is engraved as a frontispiece to her works. He continued till late in life to visit the schools of the Academy.

He died in Wimpole Street, London, December 16, 1848, in his 89th year.

BURROUGH, Sir JAMES, Knt., LL.D., *amateur*. Was master of Gonville and Caius College, Cambridge, in 1747, and applying himself to architecture, he attained some proficiency. He was consulted upon the designs of the University buildings erected during his time. The chapel at Clare Hall is reputed to have been built after his designs, but it has not much claim to originality. He designed the Corinthian altar-screen erected in Canterbury Cathedral in 1720, and since removed. Died August 7, 1764.

BURT, ALBIN R., *engraver*. Was a pupil of Thew, and was turned over to Benjamin Smith, but not excelling as an engraver, he became an itinerant portrait, or rather face, painter—for his art did not go farther—and by his industry saved money. He painted many persons of eminence, but took persons of all classes, and associated with all without loss of self-respect. His mother had known the celebrated Lady Hamilton when a barefooted girl in Wales, and he produced a great ugly print of her as 'Britannia unveiling the Bust of Nelson,' for which she secured him a good list of subscribers. He died at Reading, March 18, 1842, aged 58.

BURY, T. TALBOT, *architect and designer*. Was born in 1815. Was a pupil of Augustus Pugin, and helped his son, Mr. A. Welby Pugin, in the production of some of his published works. He also aided the younger Pugin in some of the work in the Houses of Parliament under Sir Charles Barry. He became an Associate of the Society of British Architects in 1839, and a fellow in 1843. He exhibited at intervals at the Royal Academy from 1846 to 1872. He erected New Lodge, Windsor Park, for M. Van de Weyer, various schools and almshouses, the new market at Weymouth, St. Barnabas at Cambridge, and several other churches. He died in London, February 23, 1877, aged 63.

BUSBY, CHARLES A., *architect*. He was a successful student in the schools of the Academy, and in 1807 gained the gold medal for an architectural design. He had been an exhibitor from 1801. He appears to have gained employment, and about 1823 to have settled at Brighton, where he was engaged in the design and erection of the buildings at Portland Place and West Cliff. After 1814 he only exhibited at the Academy at long intervals, and for the last time in 1830.

BUSHE, LETITIA, *amateur*. She was skilled as a miniature painter. There is a good miniature of her, painted by herself, engraved for Lady Llanover's 'Mrs. Delany.' She died in Ireland about 1757.

BUSHELL, THOMAS, *medallist*. An excellent die engraver of the 17th century. He is supposed to have produced the die for the remarkable medal bearing the likeness of the Lord Chancellor Bacon.

BUSHNELL, JOHN, *sculptor*. He was a pupil of Burman, and left England in disgust, his master having frightened him into marrying a servant girl whom he had himself seduced. After studying two years in France he travelled to Italy, and resided some time in Rome and Venice. On his return to England he executed statues for the Royal Exchange of Charles I., Charles II., and Sir Thomas Gresham, works which gained him credit for much proficiency in art. The kings introduced in Temple Bar are by him, also Cowley's and Sir Palmer Fairbourn's monuments in Westminster Abbey. His statue of Lord Mordaunt in Roman costume at Fulham was looked upon as a classic performance. He was capriciously jealous, and refused to complete a set of kings for the Guildhall, though he had begun several, because Cibber, his rival, was also employed. To confute the opinion that he could not model undraped figures, he undertook a nude statue of Alexander the Great, which was a failure, and he commenced a large model in wooden-frame work, to be covered with stucco, to demonstrate the probability of the Trojan Horse, but his unfinished work was blown down by the wind, and so far damaged that he had not courage to recommence it. He had purchased an estate in Kent, which he lost by a law suit; and this, with the failure of other schemes, overset his disordered brain, and he died insane 1701. He was buried in Paddington Church. He left a daughter and two sons. Walpole tells that his sons, to whom he had bequeathed a sufficient maintenance, shut themselves up in an unfinished house and saw no one, grumbling that the world had not been worthy of their father.

BUSS, ROBERT WILLIAM, *subject painter*. Was born in London, August 29, 1804. His father, to whom he was apprenticed, was an engraver and enameller. He early showed a talent for art, and was placed under Mr. Clint, A.R.A. He was much engaged in theatrical portraiture at the beginning of his career, and was employed for the Illustrations of 'Cumberland's British Drama.' He exhibited chiefly with the Society of British Artists, commencing in 1826. Escaping from portraiture his art took a humorous character. In 1830, he exhibited 'The Spasmodic Attack;' in 1832, 'The Musical Box;' in 1838, 'Satisfaction;' in 1841, 'Hint to Novel Readers;' in 1859, 'The Antiquaries' Room.' He exhibited at the Westminster Competition in 1844–45. In the latter year, 'Prince Henry acknowledges the authority of Justice Gascoigne.'

He was for a time editor of the 'Fine Art Almanack.' He printed for private circulation in 1874, 'English Graphic Satire,' the illustrations etched by himself. He died at Camden Town, Feb. 26th, 1874.

BUTLER, WILLIAM DEANE, *architect.* He was a pupil of Beazley and settled in Dublin, where he practised nearly 40 years. He built the Roman Catholic Church at Roscrea and at Monasteverin, two important Gothic edifices; the new cathedral at Kilkenny; the railway stations at Dublin and Drogheda; and the market-place in Sackville Street, Dublin. He held the appointment of architect to the Lord Lieutenant. His art was much esteemed in Ireland. He died suddenly at Dublin, November 28, 1857, well advanced in years.

BUTTS, JOHN, *landscape painter.* He was born at Cork, where be was brought up, and early in life took to landscape painting, without much help in the pursuit of his art. He painted compositions in the manner of Claude, introducing figures, but far from mere imitations. For a time he was a scene painter, and suffering many distresses, did anything, even signs and coach-panels, to supply the wants of a large young family. Barry, R.A., his friend and fellow-citizen, writes of him from Rome: 'I am, indeed, sensibly touched with the fate of poor Butts, who, with all his merit, never met with anything but cares and misery, which, I may say, hunted him into his very grave.' His works showed great breadth and harmony of colour. His cares may be accounted for—he fell into the hands of a dealer in Dublin when about 30 years of age, shared an attic with him, spent his gains in whisky, and his vices soon terminated his career. He died 1764.

BYER, NICHOLAS, *portrait painter.* Born at Drontheim, Norway. Painted both history and portrait. Was employed for three or four years by Sir William Temple, at Sheen, Surrey. Several persons of distinction and some members of the royal family sat to him, and he was reputed a good painter. He died at Sheen in 1681, and was the first person buried at St. Clement Danes after the rebuilding of the church.

BYFIELD, EBENEZER, *wood engraver.* Executed the fine woodcuts for Dibdin's 'Decameron,' a costly work, published in 1817, and died before its publication.

BYFIELD, JOHN, *wood engraver.* Brother of the above Ebenezer. He attained much reputation as a wood engraver, and, assisted by Mary Byfield, his sister, engraved the woodcuts for an edition of Holbein's 'Icones Veteris Testamenti,' published 1830; and, in conjunction with Bonner, 'The Dance of Death,' published

1833. He also engraved for an illustrated edition of Gray's 'Elegy,' published 1835.

BYFIELD, GEORGE, *architect.* From 1780 till his death he was a constant exhibitor at the Academy, his designs and the works on which he was employed seldom going beyond a villa, a country seat, or a park entrance. He died in Craven Street, Strand, August 9, 1813, in his 58th year.

BYRES, JAMES, *architect.* He was established at Rome about 1770, and promoted the inclination of his countrymen to purchase antique sculpture.

BYRNE, WILLIAM, *landscape engraver.* Born in London 1743. He was educated at Birmingham under his uncle, a native of Ireland, an engraver of arms on plate. He attempted an engraving of the 'Villa Madama,' after Wilson, R.A., for which, in 1765, he gained the Society of Arts' medal. Thus encouraged, he studied landscape engraving, and went to Paris, then the chief school of engraving, and was the pupil of Aliamet, and afterwards of Wille. On his return to England he became a member of the Incorporated Society of Artists. He studied from nature, and formed his own style. His larger works are after Zuccarelli and Both; but his best examples will be found in 'The Antiquities of Great Britain,' after Hearne; 'Views of the Lakes,' after Farington, R.A.; and 'The Scenery of Italy,' after Smith. His chief excellence was in his aërial perspective and the general effect of his light and shade. His skies were put in by hand, and were noted for their beauty of finish. His pupils—in his later years his own son and daughters — were employed in the etching, and he occupied himself more in the finishing of his plates. He died in Titchfield Street, September 24, 1805, and was buried at Old St. Pancras's Church.

BYRNE, ANNE FRANCIS, *flower painter.* Eldest daughter of the foregoing William Byrne. She was born in London in 1775, and in her early life was chiefly engaged in teaching; but renouncing this more lucrative practice, she devoted herself to painting, and acquired great skill in water-colours. In 1806 she was elected an associate exhibitor of the Water-Colour Society, and in 1809 to full membership. On the change made in the constitution of the Society in 1813 she withdrew from it; but in 1820 was an exhibitor, and in the following year she rejoined the Society as a member. She occasionally exhibited a flower-piece at the Academy, commencing in 1796, and sent her last work in 1820. Her flowers were well grouped, and with great richness of colour combine a charming freshness; but, with the exception of a bird exhibited on one or two occasions,

her art was confined to fruit and flowers. She died January 2, 1837.

BYRNE, ELIZABETH, engraver, youngest daughter of the foregoing William Byrne. She was distinguished by the beauty of her engravings of flowers. She etched views of the colleges for 'Cantabrigiæ Depictæ' in 1809, and also some groups of flowers after Van Os. and Van Huysam.

BYRNE, LETITIA, engraver. Third daughter of the foregoing William Byrne. Born November 24, 1779. She exhibited landscape views at the Academy, commencing 1799. Her last work exhibited was 'From Eton College Play-fields,' 1822. She etched the illustrations for 'A Description of Tunbridge Wells,' 1810; and engraved four views for Hakewill's 'History of Windsor.' She also engraved for 'White - Knights,' the Duke of Marlborough's seat; but was best known by her skilful etchings. She died May 22, 1849, and was buried at the Kensal Green Cemetery.

BYRNE, JOHN, water-colour painter. Was born in 1786; the only son and youngest child of William Byrne, the engraver, whose profession he followed at the commencement of his career, some of his best engravings being produced for Wild's 'Cathedrals.' He exhibited at the Academy, in 1822, 'A Scene in Moor Park,' and the following year 'London from Hampstead Heath,' and afterwards turning to landscape art, practised as a water-colour painter; and from 1826 to 1846 was an 'associate exhibitor' of the Water-Colour Society and a constant contributor to the Society's Exhibitions. He also, from 1830 to 1833, contributed views in Wales to the Academy Exhibitions. Setting off about 1832, he travelled in Italy for three years, passing that time in a careful study both of nature and the great Italian painters; on his return he exhibited, in 1838 and up to 1843, Italian views at the Royal Academy, in the latter year two Welsh views in oil. His works at the Water-Colour Society during the same period comprised many views of the ancient Welsh border castles and ruins. His 'View of Twickenham, on the Thames,' exhibited in 1830, and now in the Water-Colour Gallery at the South Kensington Museum, is a good example of his art. He was a careful imitator of nature, finishing his works with great power and truth, introducing animals with good effect, and pleasing in his tone of colour. He died March 11, 1847, and was buried at the Kensal Green Cemetery.

BYRNE, CHARLES, miniature painter. Was born in Dublin about 1810, and for some time practised his art in London. He was constitutionally eccentric, and capricious, and his infirmity ended in confirmed insanity. He died in Dublin.

BYRON, WILLIAM, Lord, amateur. He was a pupil of P. Tillemans, and excelled as an etcher. He copied Rembrandt closely, and there is a good imitation of 'The Three Trees' by him. His portrait of the first Earl de la Warr is engraved. He died August 8, 1736.

C

CABALIERE, JOHN, miniature painter. Began life as a wine merchant in Bond Street, but had a talent for art, and was distinguished by his skill as a miniature painter. He died June 12, 1780.

CABANEL, RUDOLPH, architect. Was born at Aix-la-Chapelle in 1762. He came to England early in life, and settled in London, where he was employed in the construction of several theatres. He designed the arrangements of the stage of the old Drury Lane Theatre, the Royal Circus, afterwards called the Surrey Theatre, 1805 (since burnt down), and the Coburg Theatre, 1818. He died February 4, 1839.

CALDWALL, JOHN, miniature painter. Born in Scotland, where he practised with much reputation, and died February 1819.

CALDWALL, JAMES, engraver and draftsman. Brother of the above. Born in London 1739. Was a pupil of Sherwin. He is chiefly known by his portrait engravings, the dates of which extend to 1780. He engraved also 'The Camp at Coxheath,' after Hamilton; Mrs. Siddons as the 'Grecian Daughter;' the 'Apotheosis of Garrick;' and some fine portraits; also some of the plates for Cook's 'Voyages' and Boydell's 'Shakespeare.' He survived his brother. He practised in the line manner, and used the etching needle largely. His drawing was good, his work powerful, the drapery beautifully and brilliantly treated. He exhibited engravings with the Free Society of Artists from 1769 to 1776.

• CALLCOTT, Sir AUGUSTUS WALL, Knt., R.A., landscape painter. Was born at Kensington, February 20, 1779. He was brother to the distinguished musician, Dr. Callcott, and commenced life himself in the choir at Westminster Abbey; but, tempted to try his hand at portrait painting, his

success induced him to take up that art, though for some time he pursued music and painting together. He was a student of the Academy, and under the tuition of Hoppner, R.A.; and in 1799 he exhibited at the Royal Academy his first portrait, and thenceforth followed art. In 1801 he exhibited two portraits and a landscape view of Oxford, and soon found the true bent of his genius, for after 1803 his exhibited works were for many years exclusively landscapes. In 1806 he had fully confirmed the expectations raised by his first works. He was looked upon as a very rising painter of the landscape school, and in that year was elected an associate of the Royal Academy. He continued to paint English landscape, chiefly river and coast scenery, with increasing reputation ; and in 1810 he gained his election as full member of the Academy.

Commissions came freely upon him, but he was not a rapid painter ; his work was conscientiously and studiously laborious, and in the 10 years—1813-22—he only exhibited seven of his works at the Royal Academy. In 1827 he married the widow of Captain Graham, R.N., a lady well known by her literary abilities, and with his wife set off for a Continental tour. His subjects up to this time had continued of the same class, with one or two Dutch coast scenes, but in 1830 he commenced his Italian landscapes. In 1837 he painted a life-size subject picture of 'Raphael and the Fornarina,' and the same year received the honour of knighthood. In the following year he produced another large work, 'Milton dictating to his Daughters.' In 1844 he was appointed surveyor of the royal pictures, an office for which he was well fitted, but which he did not long enjoy. His health had been for some time failing. His wife died in 1842, and he then showed increased feebleness and marks of suffering, and died at Kensington, November 25, 1844, aged 65. He was buried at the Kensal Green Cemetery.

His early English and Dutch landscapes were among his best works. They show great richness and purity of tone and colour, with a thorough feeling for English nature. His Italian landscapes charm by their tasteful composition and classic rendering. Claude-like they have been called, but are purely original. He will always rank as one of the eminent landscape painters of the English school, representing with much refinement and poetry Nature in her most placid and gentle moods. In his private life he was amiable and greatly esteemed, generous and unprejudiced in all that related to his profession.

CALVERT, FREDERICK, *topographic draftsman.* Published, in 1815, four of his own drawings, of the Interior of Tin-

tern Abbey, and 'Lessons on landscape colouring, shadowing, and pencilling ;' in 1822, a series of lithographic drawings, 'The Forest Illustrated ;' in 1830, 'Picturesque Views in Staffordshire and Shropshire'—39 plates. He also contributed some papers in the 'Archæological Journal.'

CALVERT, CHARLES, *landscape painter.* Born September 23, 1785, at Glossop Hall, Derbyshire, where his father was agent for the Duke of Norfolk's estate. He served an apprenticeship in Manchester, and commenced business as a cotton merchant, but soon relinquished this to follow the more genial pursuit of art. He devoted himself to landscape painting, practising both in oil and water-colour, and was instrumental in founding the Royal Manchester Institution, from which he gained the Heywood gold medal for the best oil picture, and the silver medal for a 'Landscape by a Manchester Artist.' His time was much occupied in teaching ; but when released from that he studied among the lake scenery of the North of England. His bad health had for some time removed him from notice. He died at Bowness, Westmoreland, Feb. 26, 1852, aged 66.

CAMDEN, SAMSON, *portrait painter.* Lived in the Old Bailey, and painted there about 1540. He was the father of William Camden, the antiquarian, who is said to have drawn a portrait of Queen Elizabeth, which is now in the British Museum.

CAMERON, CHARLES, *architect.* Practised in the latter half of the 18th century. He published, in 1772, a large folio work on the 'Roman Baths,' many of the numerous illustrations to which were etched by himself. He died at the beginning of the 19th century.

CAMPBELL, COLIN, *architect.* Born in Scotland. He enjoyed much reputation in his day, and was largely employed. He built Wanstead House in 1715 (pulled down in 1822), a work—the front extending 260 feet—which united in a great degree grandeur of design with convenience in arrangement. He also built the Rolls House in Chancery Lane, 1717, and Mereworth, in Kent—the latter an imitation of Palladio ; Drumlanrig Castle, a poor mixture of the classic and grotesque ; and several other mansions. He carried out Lord Burlington's designs for the improvement of his mansion in Piccadilly, and designed himself the *façade.* With Woolfe and Gandon he published, in three large folio volumes, with 30 plates, the 'Vitruvius Britannicus,' a work originally projected by Lord Burlington. He was appointed architect to the Prince of Wales in 1725, and in 1726, surveyor of the works of Greenwich Hospital. He died 1734. His least pretentious designs are the best, his

attempts at originality leading him into inharmonious combinations.

CAMPBELL, THOMAS, *sculptor.* Was born in Edinburgh, May 1, 1790, of parents in very humble circumstances. He was apprenticed to a marble-cutter, and though without education, soon showed a taste and intelligence which raised him above the mechanic; and occupied on a class of works by which he gained knowledge, he made good progress, and was enabled to come to London and study in the schools of the Royal Academy. In 1818 he was assisted to visit Rome; and there, devoted to his art, he soon made friends, and received commissions for busts. One of his first works was a sitting statue of the Princess Pauline Borghese, which is now at Chatsworth. He continued at Rome for many years, and his chief associates were the Italian and German artists. In 1827 he sent from thence his first work, the bust of a lady, for exhibition in the Royal Academy; and the next year a classic group—'Cupid instructed by Venus to assume the form of Ascanius.'

Having at this time large commissions to execute in England, he returned in 1830, but retained his studio in Rome, and exhibited at the Academy a marble statue of 'Psyche,' with other works. He established himself chiefly by his busts—some of which were colossal—and portrait statues, and continued to exhibit his works at the Academy up to 1857, though only occasionally in the latter years. He frequently during this period visited Rome to make arrangements for works commenced there; but during the last 25 years of his life his residence was in London, where he died February 4, 1858. He was painstaking and elaborate in the completion of his works, and amassed a large property by his profession. One of his most important groups is the monument to the Duchess of Buccleuch at Boughton. At Windsor Castle there is a statue of the Queen by him; at St. Paul's, Sir William Hoste, one of the public monuments.

CAMPBELL, J., *engraver.* He practised about the middle of the 18th century. He engraved some plates after Rembrandt, successfully rendering that master's style and manner.

CAMPION, GEORGE B., *water-colour painter.* He was elected a member of the Institute of Water-Colour Painters in 1837, and was an occasional, and sometimes a large, contributor of views, but slightly finished, to the exhibitions of the Institute. His chief art was topographical, and many of his views have been published. He wrote some contributions on German art for the 'Art Journal.' Reputed a good sportsman, he was the author of 'The Adventures of a Chamois Hunter.' He died

at Munich, where he had long resided, April 7, 1870.

CANOT, PETER CHARLES, A.E., *engraver.* Born in France 1710. He came to England in 1740, and found employment in engraving marine subjects and landscapes. He engraved after Backhuysen, Vandevelde, Gaspar Poussin, and Claude; also views of London and Westminster Bridges, after Scott; a series of sea-views and sea-fights, after Monamy; and four battle-pieces, after Paton, his over-exertions on which are said to have led to his death in 1777, at Kentish Town. He was a member of the Incorporated Society of Artists in 1766, and was elected associate engraver of the Royal Academy in 1770, where he was one of the early exhibitors. His engravings, particularly the sea-pieces, have much merit, and were very popular in their day.

• CAPON, WILLIAM, *scene painter and architect.* He was born at Norwich, October 6, 1757. His father was an artist of some ability, and under him he commenced portrait painting, but his taste led him to architecture, and he was placed under Novozielski, the architect and scene painter, and assisted him in the erection of the Italian Opera House and the buildings and scenery for the Ranelagh Gardens. On the completion of the new Drury Lane Theatre in 1794, he was engaged by Mr. Kemble as the scene painter, and materially assisted him in his great reform of the stage. This he was well qualified to do by his antiquarian knowledge, which enabled him to give his works historic interest by their accuracy. He was appointed draftsman and painter of architecture and landscape to the Duke of York. He first exhibited at the Academy in 1788, next in 1792, and from that time was an occasional exhibitor. His subjects were chiefly views of buildings and architectural remains, with some landscapes. He made many drawings of the old dwellings and buildings in the Metropolis, and careful plans of the old palace at Westminster, and of the substructure of the Abbey, priding himself upon the accuracy of his drawings and measurements. His plan of the Westminster Palace was purchased by the Society of Antiquaries for 120 guineas, and was engraved by Basire. He made finished drawings of the interior of both Covent Garden and Drury Lane Theatres, exhibited 1800 and 1802; and erected a theatre at Kildare, painting also the scenery, for Lord Aldborough. He left some views which he had drawn of the theatre in Goodman's Fields, burnt down in 1802; and had made an extensive collection of topographical drawings. He died suddenly at his house in Norton Street, Westminster, September 26, 1827, aged

70. He was of a conceited nature, and Sheridan gave him the name of 'Pompous Billy.'

CARDON, ANTHONY, *mezzo-tint engraver.* The son of an engraver, by whom he was instructed in his art. He was born at Brussels in 1773 ; and on the insurrection in 1790 he fled to England, where he placed himself under his friend Schiavonetti for three years. He soon found employment, and became known by his engravings for book illustration. He engraved 'The Battle of Alexandria' (for which he received the Society of Arts' gold medal in 1807) and of 'Maida ;' 'The Marriage of Catharine of France with Henry V. of England,' after Stothard, R.A. ; 'The Rustic Minstrel,' after Singleton ; and 'George III.,' after A. Chalon, R.A.; and portraits of Mr. Pitt, Madame Recamier, and others. He died, from too close an application to his profession, in London Street, Fitzroy Square, February 17, 1813, in his 40th year. He engraved chiefly in the stipple manner. His style was pretty, but wanting in drawing ; the parts ill-defined and hard.

CARDON, PHILIP, *engraver.* Was the son of the above, and educated as an engraver. He was a clever draftsman, but died young, about 1817.

CAREW, JOHN EDWARD, *sculptor.* Was born at Waterford about 1785. A student in the Society's Drawing Schools at Dublin, he afterwards became a pupil of Sir R. Westmacott, and first appears as an exhibitor at the Royal Academy in London in 1830, when he sent 'Model of a Gladiator,' 'Bear in the Arena,' and 'Theseus and Minotaur.' In 1832–34–35 he was living at Brighton, and in each of these years he sent two busts to the Academy. He did not exhibit again till 1839, when he sent 'The Good Samaritan,' a marble bas-relief ; in 1842 an 'Angel,' part of a monumental group, and in the years 1843, 1845, and 1848 some busts. In these latter years he was living in London. He was employed by Lord Egremont at Petworth House, but his best known statue is 'Whittington listening to the London Bells.'

● CARLINI, AGOSTINO, R.A., *sculptor and painter.* He was a native of Geneva, and came early in life to this country, where he settled in the practice of his art, and obtained the reputation of the best sculptor of his day. He was one of the original members of the Royal Academy, and in 1783 succeeded Moser as the keeper. He executed the model of an equestrian statue of George III., which he exhibited in 1769, and in the following year an emblematical figure of 'Maritime Power ;' in 1776 he exhibited the portrait in oil of a nobleman, and in 1783 a model of 'Plenty.'

In the hall of the Society of Arts there is by him a marble statue of the renowned Dr. Ward, strutting in dignity and drapery. At Somerset House three of the key-stones of the Strand front, representing the rivers Tyne, Dee, and Severn, are by him, as also the two centre statues against the same edifice. He died in Carlisle Street, Soho, August 16, 1790.

CARLISLE, MISS ANNE, *portrait painter.* She practised in the reigns of Charles I. and Charles II. She was much esteemed and patronised by the former, who, it is recorded, made her a valuable present of ultramarine. She was celebrated for her copies of the great Italian masters, and also for her miniature copies in the manner of the Olivers. She died about the year 1680.

CARLISLE, ISABELLA, Countess of, *amateur.* She was the daughter of William, fourth Lord Byron, and married in 1743 the Earl of Carlisle. She was known as a clever etcher, and made some good copies of Rembrandt's etchings. Her second husband was Sir William Musgrave. She died January 22, 1795.

CARLON, ——, *engraver.* He was born in England, and practised at the beginning of the 19th century. He engraved for Thornton's 'Temple of Flora,' a costly work, published in 1805.

CARLSE, JAMES, *engraver.* Was born in Shoreditch in 1798, and apprenticed to an architectural engraver. On the expiration of his term, he took up landscape and figure engraving, and attained much proficiency. In 1840 he commenced a work on Windsor Castle, which he discontinued from the absence of support. He was then employed to engrave for the annuals and the 'Art Journal,' and upon some architectural plates for Mr. Weale's publications. He died in August 1855.

CARMICHAEL, JAMES WILSON, *marine painter.* He was born at Newcastle-on-Tyne. His name first appears as an exhibitor in 1838, when he contributed an oil picture to the Society of British Artists —'Shipping in the Bay of Naples.' In 1841 he exhibited at the Royal Academy a drawing of 'The "Conqueror" towing the "Africa" off the Shoals of Trafalgar ;' and in 1843 two drawings—'The Royal Yacht, with the Queen on board, off Edinburgh,' and 'The Arrival of the Royal Squadron.' In 1845 he exhibited both in oil and water-colours. He had up to this time lived at Newcastle, and now came to reside in London, and continued to exhibit marine subjects, chiefly in oil, up to 1859. Shortly after this he retired to Scarborough, where he died very suddenly, May 2, 1868, in his 68th year. There is a large painting by him in the Trinity House, Newcastle, 'The heroic Exploit of Admiral Colling-

wood at the Battle of Trafalgar.' He published 'the Art of Marine Painting in Water-colours' 1859, and in 'Oil-colours' 1864.

CARPENTER, RICHARD CROMWELL, architect. He was born October 21, 1812, and was educated at the Charter House, and then articled to Mr. Blyth, under whom he studied Gothic architecture with great industry. He first exhibited at the Academy, in 1830, 'Design for a Cathedral Transept;' in the next year, 'A Cathedral Shrine;' in 1832, 'An Italian Villa.' His earliest executed works were the churches of St. Stephen and St. Andrew at Birmingham, erected about 1841. His later works —St. Paul, Brighton; St. Mary Magdalene, Munster Square, London; and the restorations at Chichester Cathedral, Sherborne Abbey, and St. John's College, Hurstpierpoint, Sussex; the last probably his most important work. He died in Upper Bedford Place, Russell Square, March 27, 1855, in his 43rd year.

CARPENTER, Mrs. MARGARET SARAH, portrait painter. She was the daughter of Captain Geddes, who was of an Edinburgh family, and was born at Salisbury in 1793. She was instructed in art by a drawing-master who practised in that city, and greatly improved herself by the study, to which she was admitted, of the fine collection of paintings at Longford Castle; and for one of her copies was awarded a gold medal by the Society of Arts. In 1814 she was induced to come to London, where she soon established herself as a portrait painter. She exhibited a portrait of Lord Folkestone at the Academy in that year, and at the British Institution, 'The Fortune Teller.' In 1817 she married Mr. Carpenter, of the British Museum, and from that time to 1866 was a constant contributor of portraits, with occasionally a subject picture, to the Academy Exhibitions. Among her exhibited portraits were Sir H. Bunbury, 1822; Lady Denbigh, 1831; Lady King, 1835; Lord John Manners, Gibson, R.A.; and, her last work, Dr. Whewell. Her portrait of Gibson is in the National Gallery, and three of her works in the South Kensington Museum. Upon the death of her husband in 1866 she was granted a pension of 100l. a year—a graceful recognition of her own merits as well as of her husband's valued services. She died in London, November 13, 1872, in her 80th year.

CARPENTIERS, or CHARPENTIÈRE, ADRIEN, portrait painter. Born in Switzerland. Came to London about the year 1760, and settled here in the practice of his profession. In 1763 he was a member of the Free Society of Artists, and was a constant exhibitor at the Spring Gardens Exhibitions. From 1770 to 1774

he sent portraits and portrait-groups to the Academy Exhibitions. A half-length portrait of 'Roubiliac, the sculptor, modelling Shakespeare's bust,' which has been well engraved both in mezzo-tint and line, is mentioned as one of his best works; it is now in the National Portrait Gallery. His own portrait is in Salter's Hall, St. Swithin's Lane. In the latter part of his life he lived in Pimlico, and he died there far advanced in years, but the date is unknown. He ceased to exhibit in 1774.

CARR, The Rev. WILLIAM HOLWELL, amateur. Born in 1750. He painted landscapes, and was an occasional honorary exhibitor at the Royal Academy from 1797 to 1820 of landscape views. He died in 1830, and bequeathed several good works, by the old masters, to the National Gallery.

CARR, JOHN, of York, architect. Was born at Horbury, near Wakefield, in May 1723. He commenced life as a working man, and settling in York, found full employment. By his intelligence and industry he improved his position, and practised with reputation as an architect. He built the Court House at York; Harewood House, near Leeds, 1760; Thoresby of Nottinghamshire; Oakland House, Cheshire; Burton Park, Constable, Yorkshire; Lytham Hall, near Preston; the east front and gallery of Wentworth Castle, near Beverley; York Castle and Gaol; Basildon Park, 1780, and Farnley Hall, 1790—both in Yorkshire. At his own expense, nearly 10,000l., he built the parish church of his native village, and was buried there. He died at Askham Hall, near York, February 22, 1807, aged 84. He was lord mayor of York in 1770, and again in 1785. His buildings were symmetrical and well planned, his elevations marked by simplicity and good taste, and he enjoyed considerable merit in his profession, amassing a very large property.

CARR, JOHNSON, landscape painter. Was descended from a respectable family in the North of England, and became the pupil of Richard Wilson, R.A. He obtained premiums from the Society of Arts for his landscape drawings in 1762 and 1763. His drawings were something in the manner of his master, drawn on tinted paper in black and white chalk, and showed great promise. He died of rapid consumption, January 16, 1765, in his 22nd year.

CARR, R., engraver. Practised in the latter part of the 17th century. He imitated Hollar, but with little success. He etched a map of England, which is dated 1668.

CARRICK, THOMAS, miniature painter. Was born at Carlisle, and was entirely self-taught in art, and unsupported in his self-advancement. He came to London,

and in 1841 first exhibited seven miniatures at the Royal Academy, painted on marble. He at once gained good employment, and had many sitters of distinction. About 1848 he shared in the general decline of miniature art, and his name only appears occasionally up to 1860. He died in 1874.

CARSE, A., *topographical draftsman.* Drew views and buildings towards the end of the 18th century, which appear literally accurate as their chief merit. Many of his drawings were engraved in 'The Scots' Magazine.'

CARSE, W., *subject painter.* He practised in Edinburgh, and at the time of the first exhibition there in 1808 enjoyed a high reputation. His pictures showed much humour, but they were coarse and ill drawn. He is said to have died early in the century.

CARTER, ELLEN, *book illustrator.* Her maiden name was Vavaseur. Educated in a convent at Rouen, she formed a taste for drawing, drew the figure tolerably, and made careful copies of antiquarian subjects. She drew for the 'Gentleman's Magazine,' the 'Archæologia,' and other works. An engraving was published from a drawing by her, called 'The Gardener's Girl.' She married the Rev. John Carter, and died September 22, 1815.

CARTER, FRANCIS, *architect.* He was clerk of the works under Inigo Jones, and carried out several of his designs after his death. He is mentioned in Evelyn's 'Sculptura' as one of the draftsmen of that day, and as then in Italy. He resided some time in Covent Garden, and during the Commonwealth was made a justice of the peace and 'surveyor of the works.' He died soon after the Restoration.

CARTER, GEORGE, *portrait and subject painter.* Practised in the second half of the 18th century. Several of his works are engraved. His 'Death of Captain Cook' has been engraved by Hall, Thornthwaite, and Cook; his 'Apotheosis of Garrick,' with portraits of contemporary tragic actors and actresses, by Caldwall. His 'Fisherman going Out' and 'Fisherman returning Home' were popular. He died 1786.

CARTER, GEORGE, *subject painter.* Was born at Colchester, of humble parents, and educated at the Free School there. He came to London as a servant, afterwards became shopman to a mercer, and then entered into the same business; but failing after a few years he set up as a painter, and ingratiating himself with the artists, gained their assistance. He then travelled, visiting Rome, St. Petersburg, Gibraltar, and the West Indies. In 1775 he sent from Rome to the Academy Exhibition

'A Wounded Hussar on the Field of Battle,' and a small size portrait-group. In the following year he was in London, and exhibited 'A Weary Pilgrim on his Journey to Rome' and 'The Dying Pilgrim, with a View of the Sybils' Temple.' In 1778 he exhibited 'The Adoration of the Shepherds,' a poor work, which he afterwards presented to St. James's Church, Colchester. In 1785 he exhibited in Pall Mall, admission 1s., a collection of his pictures, 35 in number, including 'The Siege of Gibraltar,' but nearly all portraits, and described them with ignorant pomposity in his catalogue. He says: 'These pictures were all painted without commission; the motive, to celebrate good men and brave actions. They are now at the disposal of any nobleman or gentleman who may wish to possess either the whole or a part of them.' He published several engravings from his works. He styled himself 'historical painter,' and affected also to be an author, having published 'A Narrative of the Loss of the "Grosvenor," East Indiaman.' He contrived, however, to realise a fortune, and retired to Hendon, where he died in 1795.

CARTER, H.B., *water-colour painter.* He was a native of Scarborough, and removed to the West of England. He exhibited at Suffolk Street in 1827-28-29, and in those years was living in the Metropolis. He died in the West of England. His son CARTER, J. R., also dead, was known as a painter in water-colours.

CARTER, JAMES, *engraver.* Was born in Shoreditch 1798. He was articled to an architectural engraver, but his taste led him to landscape. He worked in the line manner, and in 1840 he commenced a work on Windsor Castle which did not succeed. He then found employment on plates for the annuals, working successfully after Prout; and engraved for the 'Art Journal,' after Ward and Goodall. He was also engaged upon some architectural plates for Weale's publications. He engraved some works after his own sketches and designs. He died August 1855, and left a large family without provision.

CARTER, JOHN, *architectural draftsman.* Born in Ireland, June 22, 1748. He was the son of a carver in marble, in Piccadilly, and was early employed in making drawings for architects and builders. From 1774 to 1786 he drew for 'The Builders' Magazine,' a serial publication, and gave evidence of his correct antiquarian taste. In 1780 he was employed by the Society of Antiquaries, of which he became a member, and was their draftsman for above 20 years. He was also employed by Richard Gough, for whose 'Croyland Abbey' and 'Sepulchral Monuments' he made drawings. In 1782-

84 he published his 'Specimens of Ancient Sculpture and Painting' and 'Views of Ancient Buildings in England; and in 1786 he published some small etchings, followed by 'The Ancient Architecture of England,' and some small architectural works of a monumental character. He was passionately fond of music, and wrote and composed two operas, painting also the scenery and adapting them to the stage. He was an enthusiastic writer on Gothic architecture, and the author of a series of communications to the 'Gentleman's Magazine,' commencing 1798, under the title of 'Pursuits of Architectural Innovation.' As a draftsman he was faithful, but wanting decision; his light and shade were put in with Indian ink, and touched slightly with local colour; groups of figures, sometimes humorous, are well introduced. He was an occasional exhibitor at the Royal Academy. He was of the Roman Catholic religion, a recluse in his habits, and a bachelor. He died in Eaton Street, Pimlico, September 8, 1817, and was buried at Hampstead. His drawings and antiquities—his sketches alone filling 28 large folio volumes — were sold by Sotheby in February 1818, and realised 1,695l.

CARTER, OWEN BROWNE, architect and draftsman. He lived at Winchester, and in addition to his practice as architect made some good drawings of cathedrals and churches. He died March 30, 1859, aged 53.

CARTER, THOMAS, sculptor. Was a statuary at Knightsbridge, whom Jervas, the painter, noticed industriously employed early and late on tombstones, tablets, and such works. At last he made acquaintance with him at his labour, and greatly surprised him by the question if 100l. would be of service to him. 'One hundred pounds!' exclaimed the young workman. 'Lord love me! why, it would be the making of me for ever.' Jervas at once asked his new friend, who did not even know his name, to breakfast, lent him the money, recommended him, and thus laid the foundation of his fortune. The bas-relief on Lord Townshead's monument in Westminster Abbey was modelled by him. Carter was member of the first artist committee formed in 1755 to found a Royal Academy. He was the first employer of Roubiliae. He died January 5, 1795.

CARTER, WILLIAM, engraver and draftsman. He was born about 1630, was a pupil of Hollar, and the most successful imitator of his style, and probably assisted him in his larger works. His own engravings are mostly vignettes and ornamental plates for books. The illustrations for an edition of Ogilvy's 'Homer' are engraved by him. He practised about 1660.

CARTWRIGHT, JOHN, portrait painter. Exhibited at the Academy from 1784 to 1808. His contributions were portraits in oil, including some small whole-lengths, and at the commencement of his career one or two classical subjects. When Fuseli, R.A., returned to London in 1779, he resided with him in St. Martin's Lane.

CARTWRIGHT, JOSEPH, marine painter. He was attached to the army in a civil capacity, and was for some time paymaster-general at Corfu. Called to Greece in the course of his duties, he made many sketches of the country, and on his return to England he devoted himself to art. He painted some good marine subjects; and was appointed in 1828 marine painter to the Lord High Admiral. He exhibited at the Academy in 1824-25, and in 1826 was elected a member of the Society of British Artists, exhibiting with the Society in that year 'The Burning of Admiral Bruey's Ship at the Battle of the Nile;' in 1827, 'Venice from the Public Gardens;' in 1828, 'Vesuvius and the Bay of Naples;' and in 1829, 'Dover Pier.' He died in the spring of 1829.

CARTWRIGHT, THOMAS, architect. He practised in the latter part of the 16th century as an architect and builder. A plan of the Royal Exchange is said to have been engraved by him about 1571.

CARTWRIGHT, WILLIAM, engraver. He was one of the early engravers of portraits and book plates. His name is affixed to a portrait of Thomas Cranmer, Archbishop of Canterbury. He engraved also after Holbein.

CARTWRIGHT, WILLIAM, engraver. He practised as a landscape engraver at the beginning of the 19th century. He engraved four views of the Isle of Wight, after Walmsley.

CARVER, RICHARD, history and landscape painter. He was born in Ireland, and practised there about the middle of the 18th century. In 1775 he was in London, and was then a 'director' of the Incorporated Society of Artists, and contributed to their exhibition in Spring Gardens a large oil landscape with ruins and figures, also two landscapes in water-colours. He exhibited again, in 1778, some large landscapes; and in the newspapers of the day was spoken of as 'the celebrated Mr. Carver.' There is an altar-piece in a church at Waterford painted by him. He was weak both in drawing and colour, but his landscapes showed some taste.

CARVER, ROBERT, scene painter. Son of the above. Born in Ireland, where he gained a reputation by his small water-colour drawings, and as a scene painter. He was invited to London to paint for Drury Lane Theatre, but followed his friend Barry, the actor, to Covent Garden

Theatre, where he continued till his death. He was a member of the Incorporated Society of Artists, and his landscapes contributed to their exhibition in 1777 were much noticed. His landscape scenery was grand, with great beauty of execution, particularly in his early pictures; his colouring warm, with depth of middle tint, giving a great tranquillity of light and shade. He painted coast scenes, with the waves breaking on the shore, with great truth and force; and a drop-scene of this character is described as of terrific excellence. He was a fast liver and generous host, and for several years afflicted with gout. Died in Bow Street at the end of November 1791.

CARWARDINE, Miss J., *miniature painter*. Born in Herefordshire. She was an exhibitor up to 1761, when she married Mr. Butler, organist of St. Martin's and St. Anne's, Westminster, and quitted the practice of her profession.

CARWITHAM, J., *engraver*. Born in England. Practised in the first half of the 18th century, and worked chiefly upon book plates. He largely employed etching, but some plates are worked with the graver only, and retouched in the manner of Picart, after whom he engraved an emblematical frontispiece dated 1723. He engraved the 'Laocoon' from the antique, 1741.

CASALI, Andrea, The Chevalier, *history painter*. Born at Civita Vecchia 1720. He came to England before 1748, as in that year he was employed to paint the transparencies which formed part of the decorations used in St. James's Park on the celebration of the peace of Aix-la-Chapelle —works which were afterwards engraved. He painted some ceilings at Fonthill, and was one of the first candidates for the Society of Arts' premiums, obtaining in 1760 the second premium of 50 guineas for a subject from English history; in 1762, the first premium of 100 guineas; and in 1766, a third premium of 50 guineas. He painted an altar-piece for the chapel of the Foundling Hospital, which was afterwards removed, to make place for West's 'Wise Men's Offering;' and about 1758 the figures of St. Peter and St. Paul for the altar of St. Margaret's Church, Westminster. His works were carefully and neatly painted, but tawdry in colour and theatrical in style. He completed some etchings, among them from the pictures for which he gained the Society of Arts' premiums. In 1763 he sold his collected works by auction, and soon after 1766 quitted England, and lived several years at Rome.

CASANOVA, Francis, *landscape and battle painter*. Born in London, of Italian parents, 1730. Settled in Paris, where he was admitted a member of the Academy of Painting in 1763. He was employed by

the Prince of Condé, and also by Catherine II., who engaged him to paint the Russian victories over the Turks. He died near Vienna 1805.

CASSELS, Richard, *architect*. He was born in Germany, and invited to Ireland, came and settled there in 1773. There was little talent to oppose him, and he was soon successful. He built the mansion of Hazlewood, Co. Sligo; Powerscourt, Co. Wicklow; Carton House, Kildare; Bessborough House, Kilkenny; Leinster House, and several other fine mansions, in Dublin; also the Lying-in Hospital, 1757, and the Printing-office in the College Park. The design for the Parliament House has been attributed to him. He died suddenly, aged 60, and was buried at Maynooth. He was very eccentric and addicted to intemperance, but Ireland owes to him the introduction of a better style of architecture.

CASTELLS, Peter, *painter and engraver*. Born at Antwerp 1684. He came to England in 1708, and in 1716 revisited his native city, but soon returned to this country. He painted birds, fowls, fruit, and flowers—mostly the latter, but in an inferior manner. His engravings had more merit. Lord Burlington published, at his own expense, Castells' 'Villas of the Ancients,' giving him the profits. In 1726 he published himself 12 plates of birds and fowls, which he etched from his own designs; also some plates from his pictures, which have much merit. In 1735 he removed to Tooting, as designer for some calico works there, and afterwards followed the manufactory to Richmond, where he died May 16, 1749.

CATESBY, Mark, F.R.S., *amateur and naturalist*. Born 1679; and in 1712 visited America, where he remained seven years, studying the botany of the country. On his return he was induced by some scientific friends to revisit America, and taking up his quarters at Charleston, he made incursions into Georgia and Florida, collecting specimens. On his return to England he studied etching, and engraved his own work, 'The Natural History of Carolina, Florida, and the Bahama Islands,' published 1741-43, comprising 165 plates, all drawn and etched by his own hand. The birds, animals, plants, and insects are of large size, are well drawn, and expressed with much character, and must have been the fruit of great industry and labour, whilst its sale was the chief support left for his widow and two children. He died Dec. 24, 1749, aged 70.

CATTERMOLE, George, *water-colour painter*. He was born at Dickleburgh, near Diss, in August, 1800, and at the age of 16 began his career as a topographical draftsman, and drew for Britton's 'English

Cathedrals.' In 1822 he was elected an associate exhibitor of the Water-Colour Society, but was only an occasional contributor to the Society's Exhibitions up to 1833, when he became a member, and for the next few years was a more constant contributor—sending, among others, 'After the Sortie;' 'The Gallery of Naworth Castle;' 'The Murder of the Bishop of Liège;' 'Pilgrims at a Church-door;' 'The Armourer relating the Story of the Sword;' and at this period produced some of his best works; then his contributions fell off, and in 1850 he withdrew from the Society. He afterwards tried some subjects in oil, and exhibited in that medium at the Royal Academy in 1862, 'A Terrible Secret.' He was unsettled in his habits and uncertain in his engagements, and died July 24, 1868. Versatile in his power, learned in costume, his art was dramatic and pictorial. He was largely employed by the publishers. He designed for the annuals and for the 'Waverley' novels, with some other works of the same class. The 'Historical Annual,' devoted to the scenes of the Civil War, is his best work of this character. At the Paris Exhibition, 1855, he received a first-class gold medal in water-colour painting. He was a member of the Academy at Amsterdam, and of the Belgian Society of Water-Colour Painters.

CATTERMOLE, RICHARD,' *water-colour painter.* He was, between 1814 and 1818, an 'exhibitor' at the Water-Colour Society, in the latter year contributing 'The State Bedchamber, Hampton Court,' and 'The Cupola Room, Kensington Palace,' painted for Pye's 'Royal Palaces,' on which work he was at that time employed. He afterwards went to Cambridge, and entered the Church.

CATTON, CHARLES, R.A., *landscape and cattle painter.* Born at Norwich 1728; and said to have been one of 35 children by his father, who was twice married. He was apprenticed to a coach painter in London, improved himself as a student in the St. Martin's Lane Academy, and became a member of the Incorporated Society of Artists, with which body he exhibited, 1760-64, landscapes, cattle, and subject pictures. He obtained a good knowledge of the human figure, which, with his natural taste, raised him above others following this branch of the profession. He designed and painted the ornamental panels of carriages, flowers, and allegorical subjects in an artistic manner, and greatly improved the style of herald-painting and sign-painting. He was appointed the king's coach-painter, and was one of the foundation members of the Royal Academy. He served the office of master of the Company of Painter-Stainers in 1784.

He had a knack for humorous designs, and drew and etched in 1786 'The Margate Packet,' a very clever work of this class. At the Royal Academy he chiefly exhibited landscapes, but occasionally compositions and animals. His last works were a 'Jupiter and Leda' and a 'Child at Play.' He also painted some whole-length portraits and an altar-piece, 'The Angel delivering St. Peter,' for the church of St. Peter's Mancroft, Norwich. He had for several years retired from the active pursuit of his profession, and died rather suddenly at his house in Judd Place, August 28, 1798, in his 70th year, and was buried in Bloomsbury Cemetery, Brunswick Square.

CATTON, CHARLES, *animal painter.* Son of the foregoing; was born in London, December 30, 1756. He was taught by his father, and studied in the schools of the Academy, where he acquired a good knowledge of the figure. He travelled in most parts of England and Scotland, making sketches, some of which were engraved and published. He was a good scene painter, and had a reputation for his topographical views. In 1775 he exhibited at the Academy a 'View of London from Blackfriar's Bridge,' and of 'Westminster, from Westminster Bridge.' In 1793 he exhibited his designs, conjointly with Burney, for Gay's 'Fables,' which were afterwards published; as was also a collection of animals, drawn from nature and engraved by him, 1788. He exhibited for the last time in 1800, and was then living at Purley, near Reading; and in 1804, having acquired wealth, he emigrated to America with his two daughters and a son, and took a farm upon the Hudson, where he lived many years, occasionally painting landscapes and animals. He died in America, April 24, 1819.

CAVE, HENRY, *topographical draftsman.* He resided at York, and drew and etched the ancient building in that city. He exhibited an oil-painting at the Academy in 1814, and again in 1822. He published, in 1813, 'The Antiquities of York,' with 40 plates, which are very well drawn and etched with spirit; and several other etchings. He died at York, August 4, 1836, aged 56.

CAVE, JAMES, *topographical draftsman.* He practised his art at Winchester. He exhibited at the Academy, in 1802, views of the Interior of Winchester Cathedral; in 1806, of St. Cross; and in 1812 and 1817, of the Cathedral again. He made the drawings for the illustration of Milner's 'History of Winchester,' 2nd edition, published 1809.

* CAWSE, JOHN, *portrait and subject painter.* He first exhibited at the Royal Academy in 1802. His early works were

portraits and sketches for pictures, and he was much engaged as a teacher. In 1814, and some following years, he exhibited portraits of race-horses; and in 1818–19, subjects from Shakespeare's 'Henry IV.,' introducing Sir John Falstaff. He last exhibited at Suffolk Street in 1845. He died January 19, 1862, aged 83. In 1840 he published 'The Art of Oil-Painting.' Several of his pictures are engraved.

CECIL, Thomas, *engraver and draftsman.* Practised in the first half of the 17th century, working from 1628 to 1635 in London, where he maintained a high rank among his contemporaries. Some of his best works are dated 1627–28 and 1631, and are portraits—many of them from his own designs—executed entirely with the graver. His 'Queen Elizabeth on Horseback' is much esteemed. His works are neat in finish, but stiff and wanting in taste; his drawing of the figure weak and incorrect, the extremities bad; yet Evelyn speaks of his art in high terms.

CERACCHI, Giuseppe, *sculptor.* Was born at Rome about 1740. He came to England in 1773, and was employed by Carlini, R.A. He modelled in basso-relievo, for Mr. R. Adam, a 'Sacrifice of Bacchus,' 14 ft. by 6 ft., and also a bust of Sir Joshua Reynolds, which was popular. He exhibited at the Royal Academy, in 1776, a group of 'Thetis and Jupiter;' in the following year, a 'Castor and Pollux;' and in 1779, 'A Design for Lord Chatham's Monument in St. Paul's;' and other works. The Hon. Mrs. Damer was his pupil, and the statue of her in the hall of the British Museum was modelled by him. In 1791 he crossed the Atlantic, to propose the erection of a statue to Liberty in the United States, but returned disappointed to Europe about 1795. He was then for a time at Rome, and afterwards went to Paris. He was a republican fanatic, and was one of the conspirators in a plot to assassinate Napoleon in 1801. Charged with this crime, he called in his defence David, with whom he had lived in intimacy, to speak to his character; but the great painter declared he knew nothing of him beyond his fame as a sculptor. He was condemned and guillotined in 1801; and it is said that he was dragged to the scaffold, in the habit of a Roman Emperor, on a car which he had designed.

CHALMERS, W. A., *water-colour painter.* Practised in London towards the end of the 18th century. His works appear to have been in water-colours, and his subjects show him to have been an artist of some pretensions. In 1790 he exhibited a 'View in the Collegiate Church, Westminster,' and 'Mrs. Jordan as "Sir Harry Wildair;"' in 1791, two Interiors of Westminster Abbey; in 1792, 'The Interment

of the late President at St. Paul's;' in 1793, 'The Interior of Henry VII's Chapel, with the Ceremony of the Installation;' the next year, 'West Front of the Abbey, Bath;' and then, after a lapse of three years, he exhibited, in 1798, 'Mr. Kemble as the "Stranger,"' and the 'Tomb of Henry VII.,' the last work he exhibited. He probably died young.

CHALMERS, Sir George, Bart., *portrait painter.* He inherited a title without fortune, which was forfeited from a connection with the exiled Stuart family. He was born in Edinburgh, and studied under Ramsey, and afterwards travelled, making some stay in Rome. Returning, he resided a few years at Hull, where he painted portraits; and, commencing in 1775, exhibited at the Royal Academy up to 1790. One or two of his portraits have been engraved in mezzo-tint. He died in London in the early part of the year 1791.

CHALMERS, George Paul, R.S.A., *portrait, genre, and landscape painter.* Was born at Montrose in 1836, and was educated at the Burgh School of that town. He began to draw at an early age, and though he was first apprenticed to an apothecary, and afterwards served as clerk to a ship-chandler, he finally resolved to become a painter. For this purpose he went to Edinburgh, and studied drawing in the Trustees' School there, while he maintained himself by portrait painting. His first exhibited picture in this city was a 'Boy's Head' in chalk. In 1863 he contributed a portrait of J. Pettie, R.A., and the next year, 'The Favourite Air,' to the exhibitions. He was elected an Associate of the Royal Scottish Academy in 1867, and a full member in 1871. He seldom exhibited in London. Latterly he devoted himself rather to landscape than figure subjects. These were remarkable for their richness of colour. He was very fastidious in his work, and took a high rank among Scottish artists. He was robbed on coming away from the Scotch Academy dinner, and found by the police thrown down an area with his skull fractured and his pockets rifled. He never recovered consciousness, and died 28 Feb. 1878. aged 42.

CHALON, John James, R.A., *landscape and genre painter.* Was of an old French family, who left France on the revocation of the edict of Nantes, and long resided in Geneva, where he was born March 27, 1778. His grandfather served as a volunteer in a French Protestant regiment in Ireland, under King William III., and was wounded at the battle of the Boyne. On the reverses which followed the French Revolution in 1789 the family came to England, and the father was appointed professor of the French language and literature at the Royal Military Col-

* Chalon: John. Engraver &c 1738–1795
" - Maria Painter

lege, Sandhurst, and afterwards settled with his family at Kensington. The son was placed in a large commercial house; but he had a natural genius for art, and in 1796 entered as a student at the Royal Academy, and there, in 1800, he exhibited his first picture, 'Banditti at their Repast,' followed by 'A Landscape' and 'Fortune Telling;' and then, in 1804 and 1805, several works—all landscapes. Up to this time his art had been in oil; but in 1806 he became an exhibitor, and in 1808 a full member, of the Water-Colour Society, and then produced works which gave him a distinguished position as a water-colour painter. On the alterations which took place in the Society in 1813 he was among the seceders.

He had continued to send an oil-painting to the Academy—his secession was probably influenced by the desire to seek Academy honours; and in 1816 he exhibited his 'Napoleon on board the "Bellerophon,"' a fine work, which he presented to the gallery at Greenwich Hospital. In 1819 he exhibited a work of great power, now in the South Kensington Museum—'A View of Hastings.' He continued to exhibit both landscape and genre subjects of great merit and interest, original both in their conception and treatment. It was not till 1827 that he gained his election as associate, and his election as academician was deferred till 1841. Among his later works were, 'Gil Blas in the Robbers' Cave,' 1843; and 'Arrival of the Steam-packet at Folkestone,' in the following year.

In 1847 he was suddenly seized with paralysis, his powers and health gradually declined, and a long and wearisome illness terminated fatally on November 14, 1854. During a career of nearly 50 years he painted few pictures. His art met with little encouragement, and he was engaged part of his time in teaching. With his brother Alfred he was the centre of a group of distinguished men of their profession. He published, in 1820, 'Sketches from Parisian Manners'—humorous in their treatment, but not caricatures.

CHALON, ALFRED EDWARD, R.A., *portrait and subject painter.* Was the younger brother of the above, and was born at Geneva, February 15, 1780. Like him, he was intended for a commercial life, but the drudgery was distasteful, and with the consent of his father he commenced the study of art, for which his talents eminently fitted him, and entered the schools of the Academy in 1797. He became a member of the short-lived Society of Associated Artists in Water-Colours in 1808; and in the same year, with his brother and a few friends, founded 'The Sketching Society,' for the study and

practice of composition. In 1810 he exhibited his first picture at the Royal Academy. He was elected an associate of the Academy in 1812 and a full member in 1816. He then, and for many years afterwards, was the most fashionable portrait painter in water-colours. His full-length portraits in this manner, usually about 15 inches high, were full of character, painted with a dashing grace, and never commonplace; the draperies and accessories drawn with great spirit and elegance, imitations of all the vagaries that fashion can commit in lace and silk. He also painted, among his earlier works, some good miniatures in ivory. Many of his drawings of the celebrated operatic singers and dancers of his day were engraved. He held the appointment of painter in water-colours to the Queen.

But his genius was not limited to water-colours or to portraiture. He painted many fine subject pictures in oil. Among others, he exhibited, in 1831, 'Hunt the Slipper,' a large composition, filled with well-grouped figures in action; in 1837, 'John Knox reproving the Ladies of Queen Mary's Court,' which was engraved; in 1847, 'Serena;' and in 1857, 'Sophia Western;' with many others. He had a great power of imitating the styles of the great painters, particularly of Watteau, whose works he greatly admired. In 1855 a collection of his works, together with his late brother's, was exhibited in the rooms of the Society of Arts in the Adelphi. He had made a large collection of drawings and sketches by himself, and he possessed the chief of his brother's works, which had found no purchasers, all of which he proposed in 1859 to give to the inhabitants of Hampstead, with some endowment for the maintenance of the collection; but they were unable to provide a suitable building for its exhibition. He then offered the collection to the Government, but no arrangement was come to, when he died suddenly, though he had been sometime unwell, on October 3, 1860.

He had retired to an old house at Campden Hill, Kensington, with his brother, where both died, and after passing a long unmarried life inseparably together, were buried in the same grave in the Highgate Cemetery. French in his manner, he was a true Englishman at heart; an active host, a witty companion, full of the gossip of his profession; and an accomplished musician.

CHALON, HENRY BERNARD, *animal painter.* Born 1770. His father was a native of Amsterdam, in no way related to the foregoing two painters of the same name. He came early in life to London, where he practised and was living in 1793.

77

The son was a student of the Academy, and first appears as an exhibitor there of a landscape with cattle in 1792, which was followed by a ' Lion and Lioness' and some other wild animals. He was appointed in 1795 animal painter to the Duchess of York, and from that time was exclusively devoted to animal portraiture, chiefly of horses and dogs. He appears to have met with much patronage. He also received the same appointment from the Prince Regent, and afterwards from William IV. He was a frequent exhibitor at Suffolk Street, and continued an exhibitor at the Academy up to 1846, when, at the age of 76, he met with an accident in the street, which deprived him of the use of his limbs. His conduct had not been unimpeachable ; he fell into severe distress, and a subscription was raised for him in 1846. He died in 1849. He published a lithographed work on the Horse, 1827. His daughter, Miss M. A. CHALON, was miniature painter to the Duke of York and an exhibitor at the Academy. She married a Mr. H. Moseley, and died in 1867.

CHAMBERLAIN, HUMPHREY, *china painter.* He was the son of the senior proprietor of the Worcester porcelain works. He was self-taught, and copied many subjects on china. He had no original inventive power, but was celebrated for his exquisite finish. He died in 1824, aged 33.

CHAMBERLAIN, WILLIAM, *portrait painter.* Was born in London, and was a student of the Royal Academy. Afterwards he was a pupil of Opie, R.A. He showed much talent in portraiture, and followed that branch of the profession. He first exhibited at the Academy in 1794, and in the following year sent 'A Fortune Teller' and ' An Old Man Reading,' and did not exhibit again till 1802, when he sent his last contribution, the portrait of a Newfoundland dog. He practised for a short time at Hull, where he died in the prime of life, July 12, 1807.

CHAMBERLIN, MASON, R.A., *portrait painter.* He commenced life as a clerk in a merchant's counting-house, and then turning to art became the pupil of Frank Hayman, R.A. In 1764 he gained the Society of Arts' second premium of 50 guineas for an historical painting. He resided chiefly in the vicinity of Spitalfields, and practised there as a portrait painter with some success. His likenesses were faithful, very carefully drawn and painted, but his colouring was thin, monotonous, and unpleasant. He was a member of the Incorporated Society of Artists, and when the Royal Academy was founded he was nominated one of its members ; and is distinguished by a few words addressed to him by Peter Pinder in his first ode to that body. He exhibited at Spring Gardens in 1763, and at the Academy from 1770 to 1786. His works were exclusively portraits, several of them whole-lengths. Late in life he removed to Bartlett's Buildings, Holborn, and died there, January 26, 1787. A portrait by him of Dr. Hunter, his presentation picture, is in the Royal Academy, and a portrait of Dr. Chandler in the Royal Society, both of which have been engraved. His son was an occasional exhibitor of landscape views at the Academy from 1786 to 1821.

CHAMBERS, THOMAS, A. E., *engraver.* He was of Irish extraction, and was born in London about 1724, and studied drawing and engraving both in Dublin and in Paris. When residing in the latter city in 1766, he was awarded a premium by the Society of Arts. He engraved several large plates for Boydell — 'St. Martin dividing his Cloak,' after Rubens ; 'A Concert,' after Caravaggio, considered his best work. He also engraved Mrs. Quarrington as 'St. Agnes,' after Reynolds, and the 'Death of Marshal Turenne,' two excellent works ; and after Raphael, Vandyck, Murillo, and others. He occasionally assisted Grignon. In 1761 he was an exhibitor and member of the Incorporated Society of Artists, and was elected associated engraver of the Royal Academy in 1770. He worked with the graver ; his manner was vigorous, but hard. He was not successful in his profession, and being pressed by his landlord for the over-due rent of his apartments, he quitted the house in distress of mind, leaving a note desiring the landlord, if he did not return, to sell his effects and pay himself. Some days afterwards his body was found in the river Thames, near Battersea. This happened in 1789.

CHAMBERS, GEORGE, *marine painter.* Born at Whitby 1803. He was the son of a seaman of that port, and when 10 years old was sent to sea in a small coasting vessel, and was afterwards apprenticed to the master of a brig trading to the Mediterranean and the Baltic. He showed his ingenuity by sketching the different classes of vessels, and his master was so pleased with his attempts, that in furtherance of the lad's wishes he cancelled his indentures, that he might devote himself to becoming a painter of shipping. Returned to Whitby, he thought himself in the right direction by commencing as a house-painter, and devoting his spare time in taking drawing lessons. This he continued for three years, and, then being ambitious to try his fortune in London, he worked his way to the Metropolis in a trading vessel. Here he tried to make a livelihood by painting portraits of ships, and then gained employment under Mr. T. Horner, and for seven years assisted him in painting his great

panorama of London. This work completed, he became the scene painter at the Pavilion Theatre. Self-taught, relying upon himself, struggling with difficulties, he attained success. His painting gained the notice of Admiral Lord Mark Kerr, who introduced him to William IV. Fortune seemed to look favourably upon him, and he was rapidly improving in his art, when his constitution, impaired by the hardship of his boyhood and never naturally strong, gave way, and he fell a victim to disease on October 28, 1840. Late in his career he drew in water-colours, and rapidly mastering the technicalities of the art, he was admitted an associate exhibitor of the Water-Colour Society in 1834, and in 1836 elected a member of the Society, and exhibited up to his death many clever works founded on the interesting incidents of our river and coast scenery. His best works were his naval battles. In Greenwich Hospital there is by him a large painting of the 'Bombardment of Algiers in 1816' and the 'Capture of Portobello;' but though truthful and correct, his works have a tendency to coldness in manner and colour. He left a family, for whom a subscription was raised. His 'Life and Career,' by John Watkins, was published in 1841.

CHAMBERS, Sir WILLIAM, Knt., R.A., *architect*. Was descended from a Scotch family, and was born at Stockholm, in 1729, where his grandfather was an eminent merchant, and his father supplied the armies of Charles XII. with stores and money. In 1728, when 2 years of age, he came with his father to England. He was educated at Ripon, and at 16 commenced life as supercargo to the Swedish East India Company, and made one voyage to China, where his previous acquirements enabled him to make some sketches of their peculiar architecture. But when 18 he quitted that service to follow the bent of his own inclination as a draftsman and architect, and went to Italy, where he made a considerable stay, assiduously studying to improve himself in his adopted profession, and at Paris studied under Clérisseau. On his return in 1755 he had the good fortune to be employed by the Princess Dowager of Wales in the improvement of Kew Gardens, and was also employed to teach the Prince of Wales drawing, which secured him the royal favour for the rest of his life, and by his own merits and ability as a draftsman he early enjoyed a great reputation.

He was also distinguished as an author. In 1759 he published his 'Designs for Chinese Buildings' and a 'Treatise on Civil Architecture,' upon which his fame as an author rests ; in 1765, in a costly form, the result of his labours at Kew, 'Plans,

Elevations, Sections, and Perspective Views of the Gardens and Buildings at Kew ;' in 1771, 'A Dissertation on Oriental Gardening,' founded on his own observations in China, a work which was much ridiculed at the time. The King of Sweden in 1771 created him a Knight of the Polar Star, and his own sovereign allowed him to assume the title. In 1775 he was appointed the architect of the great national palace in the Strand, Somerset House, and maintained for many years the highest rank of his profession. He was architect to the King and the Queen, and surveyor-general of the Board of Works. He was largely instrumental in the foundation of the Royal Academy, and was one of the first members, and the treasurer. He was also a fellow of the Royal Society and the Society of Antiquaries, a member of the Academy of Fine Arts at Florence, and of the Royal Academy of Architecture at Paris. He died, after a long and severe illness, at his house in Norton Street, March 8, 1796, aged 69, and was buried in Poet's Corner, Westminster Abbey. He left a son and three daughters married, and had amassed a considerable fortune. Somerset House is his greatest work—the terrace is boldly conceived, the distribution of the interior good, the staircases masterpieces. Among his best works may be mentioned Charlemont House, Dublin, a noble mansion ; the Marquis of Abercorn's mansion at Duddingstone, near Edinburgh ; Milton Abbey, near Dorchester ; Lord Bessborough's Italian villa at Roehampton ; and the 'Albany,' Piccadilly. Mr. Hardwick, R.A., published in 1825 a memoir of his life.

CHANDLER, J. W., *portrait painter*. He was a natural son of Lord Warwick, and practised in London towards the end of the 18th century ; and about 1800 was invited to Aberdeenshire, where he painted a good many portraits, and afterwards settled in Edinburgh. He was a freethinker, of a morbid disposition, and attempted suicide. His life was spared, but he died in confinement about 1804-5, when under 30 years of age. He was considered of great promise. His works are little known, and such as may be seen are stiff, weakly painted, and do not sustain the character of talent. He does not appear to have exhibited at the Academy. William Ward, A.R.A., mezzo-tinted after him a portrait of Lord St. Helens.

CHANTREY, Sir FRANCIS LEGATT, Knt., R.A., *sculptor*. He was born at Norton, near Sheffield, April 7, 1781. His father was a carpenter, and also rented some small fields, and his family had long followed humble employments in that neighbourhood. Educated in the village school, he was then employed by a grocer

at Sheffield, where his imagination was strongly attracted by the display in the shop windows of a carver, and he became the carver's apprentice for seven years. Raphael Smith, the mezzo-tint engraver, found him some time after precariously employed in drawing portraits and landscapes in black-lead pencil, in which he displayed great taste and skill. The engraver noticed and encouraged his talent, and a statuary of the town helped him in the mechanical part of the art of stone-carving. All this time he continued with his master, who did not encourage his predilections for art; and in 1802 he made a composition with him, and left him, though some accounts say that he ran away and was advertised as a run-away apprentice; but this can hardly be correct, as he advertised in the 'Sheffield Iris' of April 22, 1802, to paint portraits at two guineas each; and no less than 72 portraits of this class by his hand have been catalogued.

Soon after this time he came up to London, and was allowed to study for a limited time in the schools of the Royal Academy, though he was not regularly admitted as a student; and it is told that for the first eight years of his London life he did not make 5l. by his profession, yet it appears that in 1804 he advertised to take models from the life, and in the same year exhibited his first portrait at the Academy. He married a cousin in 1809, with whom he received a little property, which assisted him in 1810, when making way in his profession, to establish himself in Pimlico, and to build a studio and large workshops. The merit of his busts was recognised, and in that year he was the successful competitor for a statue of George III. for the city of London, his first work of that class. His reputation continued to increase, and about 1813 he raised his price for a bust from 120 to 150 guineas. In 1816 he was elected an associate of the Royal Academy, and in the following year he completed his simple and affecting group of 'The Sleeping Children,' now in Lichfield Cathedral. He was elected a full member of the Academy in 1818, and in 1819 visited France and Italy, and after his return produced some of his finest works; and then, at the head of his profession, with more commissions than he could execute, in 1822 he raised his price for a bust to 200 guineas.

Of his most important statues should be mentioned—The Sir Joseph Banks, 1827, now in the hall of the British Museum; George Canning, in the Town Hall, Liverpool, 1832; Sir John Malcolm, in Westminster Abbey, 1837; Bishop Bathurst, in Norwich Cathedral, 1841; also in Westminster Abbey, Francis Horner, a work of great simplicity, truth, and sweetness, the modern costume treated in a masterly style; James Watt and Sir Stamford Raffles, and the three bronze statues of William Pitt, one of which is in Hanover Square; the equestrian figure of George IV., in Trafalgar Square; and of the Duke of Wellington, in front of the Royal Exchange. In 1835 he was knighted by William IV. He died suddenly, in his own house, of a spasm of the heart, November 25, 1842, and was buried in a vault he had prepared in his native village. His works were distinguished by great refinement and taste. They consist almost exclusively of busts and portrait statues, treated in a simple natural style, never wanting in character or dignity. His invention did not lead him to allegory, or to those classic compositions to which the sculptor loves to give life. About 25 of his sketches from nature are engraved in his friend Rhodes' 'Peak Scenery,' published 1818-23. He was childless, and he left the reversionary interest of the bulk of his property, after the death of his widow, to the Royal Academy, to make some provision for the president, and for the purchase of the most valuable works in sculpture and painting by artists of any nation residing in Great Britain at the time of their execution, for the purpose of establishing a national collection. He is reputed to have died worth 150,000l. 'Recollections of his Life, Practice and Opinions,' written by his friend George Jones, R.A., was published 1849; and, 'Memorials of Sir F. Chantrey, sculptor in Hallamshire,' by John Holland, of Sheffield, was published there 1851.

CHANTRY, JOHN, *engraver.* He practised in the reign of Charles II. His chief works were portraits and ornamental frontispieces for the booksellers. He used the graver only in a hard, stiff manner, and his fingers were very indifferent. He resided some time at Oxford, and died about 1662. Vertue enumerates several plates by him.

CHAPMAN, CHARLES, *decorative painter.* Was the son of an eminent comedian. He was the pupil of Frank Hayman, and was employed by him in the decorations at Vauxhall; but, losing this engagement, he sunk into indigence, and died soon after 1770.

CHARPENTIÈRE, ADRIEN, *statuary.* Was much employed at Canons, under Van Nost, by the Duke of Buckingham. He afterwards set up for himself in Piccadilly, and manufactured the leaden statues used in the decoration of gardens, and grew rich upon the bad taste of the day. Died in 1737, in Piccadilly, aged above 60.

CHARRETIE, ANNA-MARIA, *miniature painter.* She was married young, and first exhibited 'Flowers' in the Royal Academy in 1843. From that time she was a constant exhibitor, but rarely of

80

more than one miniature till about 1868, when her practice increased, and later she sent one or two portraits in oil. She exhibited miniatures till the year of her death, and was one of the few who continued that failing branch of art. She died at Kensington on the 5th October, 1875, aged 56.

CHATELAINE, JOHN BAPTISTE CLAUDE, *draftsman and engraver.* Was born in London, of French Protestant parents, in 1710. His real name was Phillippe — the name of Chatelaine assumed. He held a commission in the French army, and served a campaign in Flanders. He then tried art, and became an eminent draftsman and engraver. His drawings were chiefly from nature, sketched with great spirit, either in black chalk or with pen and ink slightly washed. He engraved landscapes with great freedom, many from his own designs, some after Gaspar Poussin and Marco Ricci. He used to work for Vivares, and was employed by Alderman Boydell; but he only worked when impelled by necessity, and it was his custom to hire himself by the hour, working as long as the fit lasted, and bargaining for instant payment; when he had earned a guinea he would spend half upon a dinner. He lived in an old house, near Chelsea, that had belonged to Oliver Cromwell, which he took from having dreamt he should find there a hidden treasure, and spent much time in idle attempts to discover it. It is much to be regretted that his great talents were obscured by his depraved manners and irregularities. He was famed for his etchings. Fifty views by him of churches and other buildings in the environs of London, which he had devoted four years to making the sketches for, were published. He died at the White Bear Inn, Piccadilly, in 1771, after eating a too hearty supper. His friends raised a subscription to defray the cost of his funeral. Dussieux, in his 'Artistes Françaises à l'Etranger,' says that he was born and died in Paris.

CHATFIELD, EDWARD, *portrait painter.* He was of a respectable family, and was placed as a pupil under B. R. Haydon. He tried portraiture, and was an exhibitor of portraits at the Royal Academy, commencing in 1827. He also tried a 'Death of Locke,' 1833; 'The Battle of Killiecrankie: two Highlanders stripped to Fight,' 1836; and in 1837, 'Ophelia.' But he had not powers equal to such works, and did not do justice to the talent he really possessed. He died January 21, 1839, aged 36. He wrote some able papers for 'Blackwood' and the 'New Monthly' magazines.

CHEERE, Sir HENRY, Bart., *sculptor.* He was a pupil of Scheemakers, and prac-

tised about the middle of the 18th century. He was in 1755 a member of the Artists' Committee which in that year attempted to found a Royal Academy; and in 1757 he offered to the Society of Arts a plan of his own for that object. In 1770 he lived in Piccadilly, where he manufactured the leaden figures then used for garden decoration. The bronze busts of the eminent Fellows of All Souls College, Oxford, and the large statue of the founder, are by him, as is also the equestrian figure of the Duke of Cumberland in Cavendish Square. In 1798 he was an honorary exhibitor at the Royal Academy of a drawing from nature. He was knighted in 1760, and created a baronet in 1766. He died at an advanced age in 1781.

CHEESMAN, THOMAS, *engraver and draftsman.* Born in 1760, was placed under Bartolozzi, R.A., and was esteemed one of his best pupils. He engraved in the dot manner, and practised about the end of the 18th century. He was an exhibitor of drawings at the Royal Academy. He contributed, in 1802, 'Plenty;' in 1803, 'Spring and Summer;' in 1805, 'Erminia;' in 1806, a portrait; in 1807, 'Nymphs Bathing;' followed by an occasional portrait up to 1820, when he exhibited for the last time. Among his engraved works may be mentioned—a portrait of General Washington, printed in colours; 'The Two Apostles,' after Giotto; some subjects after Romney; and 'The Lady's last Stake,' after Hogarth.

CHENEY, BARTHOLOMEW, *modeller.* He was employed by Sir Robert Taylor towards the middle of the 18th century. Among other works, the figures of Fame and Britannia, for Captain Cornwall's monument in Westminster Abbey, were modelled and carved by him.

CHENU, PETER FRANCIS, *sculptor.* He studied in the schools of the Royal Academy, and in 1786 gained the gold medal for 'An attempt to perfect the Torso.' He first exhibited at the Academy in 1788, 'Mercury instructing Cupid;' and in 1790, 'Genius Weeping;' but in succeeding years, whether from inability or want of means, he exhibited at intervals only, and his works did not rise above those of a decorative class—designs to support lights, candelabra, and such, but usually embodying the figure. In 1822, returning to his early art, he sent a 'Model of Time for a Monument,' his last exhibited work.

CHERON, LOUIS, *designer.* Born in Paris, 1660. He was the son of an enamel painter. After studying in Italy, he came to England, on account of his religion, in 1695, and was employed in the decoration of Boughton, Burleigh, and Chatsworth. His work was not, however, much esteemed, and he tried small subjects in history, and

found employment as a designer, the book illustrations of the time being largely from his designs. He etched from his own designs 22 small histories for the 'Life of David,' published with a French version of the Psalms, 1715, and made the designs for an edition of 'Paradise Lost,' published in 1720. He died of apoplexy in Covent Garden in 1723, and was buried in the porch of Covent Garden Church.

CHESHAM, FRANCIS, *draftsman and engraver*. Born 1749. He engraved after his own drawings 'Moses striking the Rock,' and several other works. He also engraved 'Britannia,' after Cipriani, R.A.; 'Admiral Parker's Victory of 1781;' and many views after Paul Sandby. He died in London 1806.

CHICHELEY, HENRY, Archbishop of Canterbury. Born 1362. One of the chief ecclesiastical architects of the time of Henry V., and died in 1443.

CHILD, JAMES WARREN, *miniature painter*. He was, during many years, an exhibitor of miniature portraits at the Royal Academy. Among his sitters were many of the principal and most popular actresses of the day, and some actors; and they formed from 1832 the chief of his exhibited works. He exhibited for the last time in 1853, and died September 19, 1862, aged 84.

CHILDE, ELIAS, *landscape painter*. He was an exhibitor of some views at the Water-Colour Society in 1820, and in 1824 with the Society of British Artists; and was in the following year elected a member. From that time his contributions were very numerous—landscapes, many with moonlight effects, and introducing figures with the incidents of country life. At the same time he exhibited works of the same class at the Royal Academy, with river scenes. He exhibited for the last time in 1848.

CHINNERY, GEORGE, R.H.A., *portrait painter*. Practised both in oil and water-colours. He first appears as an exhibitor of crayon portraits with the Free Society in 1766, and of miniature portraits at the Royal Academy in 1791. He was then living in London, and in the following years made rapid progress. In 1798 he was practising in Dublin, and was elected a member of the Irish Academy. In 1802 he had returned to London, and exhibited a family group in oil; and from that time his name does not appear as an exhibitor till 1830, when he sent a portrait to the Academy from Canton, where he was then living. He was again, in 1831, a contributor of four, and in 1835 of five, portraits. In 1846 he exhibited his own portrait—his last work exhibited in London. He spent nearly 50 years of his life in the practice of his art in India and China, and died at Macao. There are some etched portraits

by him — works of great ability. He sketched in pencil, and tinted with much spirit, boats and river scenes in China, and was greatly esteemed as a portrait painter, excelling in every style of art; but in his life eccentric, irregular, and uncertain.

CHIPPENDALE, THOMAS, *ornamentist*. He was a native of Worcestershire. Came to London, where he first found employment as a joiner, and by his own industry and taste was in the reign of George I. most eminent as a carver and cabinet-maker. He published, in 1762, the third edition of his 'Gentleman's and Cabinet-maker's Director,' comprising 200 designs drawn by himself of household furniture, full of fancy and taste, but with a leaning to the French style. Messrs. Weale published, in 1858–59, his 'Interior Decorations in the Old French Style.' No particulars of his life could be ascertained.

CHISHOLM, ALEXANDER, *portrait and subject painter*. Born at Elgin, N.B., in the year 1792 or 1793. He was apprenticed to a weaver at Peterhead, but had a great dislike for his trade and a predilection for drawing. He drew on the cloth in his loom, and resorting to the seashore, amused himself by tracing forms on the smooth sand. Nourishing his love for drawing he strolled to Aberdeen; at the age of 19 or 20 came to Edinburgh, and had improved himself so far as to gain the appointment of teacher in the schools of the Scottish Academy. Here he married one of his pupils, and in 1818 came to London, and practised history and portrait painting—the latter with much success. He first exhibited at the Royal Academy in 1820, his earliest works being portraits, with an occasional subject picture, not rising higher than 'Boys with a Burning-glass,' 1822; 'The Cut Foot,' 1823; and from that year to 1836 he only exhibited thrice, and his contributions were portraits. In 1837 he exhibited more pretentious subjects—'The Baptism of Ben Jonson's Daughter,' for whom Shakespeare stood godfather, with portraits of Shakespeare, Jonson, Beaumont, Fletcher, Raleigh, and others; followed, in 1842, by 'The Lords of the Congregation taking the Oath of the Covenant;' in 1844 and 1845, by other important works; and in 1846, by his last work, 'The Minister and his Wife concealing in the Church the Scottish Regalia.' He had, in 1829, become an 'associate exhibitor' of the Water-Colour Society, and from that year to his death exhibited works of the same class in water-colours as those he contributed to the Academy. After having suffered from severe illness for nearly nine years, he died at Rothesay, N.B., October 3, 1847, while he was engaged in painting some portraits for a

picture of the Evangelical Alliance. He left six orphan children.

CHRISMAS, Gerard, *architect and carver.* He enjoyed a reputation in the reign of James I. He designed Aldersgate (pulled down in 1761), and carved on it in bas-relief the figure of James I. on horseback. He designed also the *façade* of Northumberland House, and had much ingenuity in his inventions for pageants.

CHRISMAS, John, } *modellers and*
CHRISMAS, Gerard, } *carvers.* Sons of the above, who continued his business. They executed a fine tomb at Ampton, in Suffolk; another at Ruislip, Middlesex; and the carved decorations for the great ship built at Woolwich by Peter Pett in 1637.

CHRISTIE, Alexander, A.R.S.A., *portrait and subject painter.* Was born at Edinburgh 1807. Served an apprenticeship to a writer to the signet, and was for some time engaged in the business of the law; but he had from his youth indulged a great feeling for art, to pursue which he at last gave up the law. He entered as a pupil in the Trustees' Academy in 1833, and afterwards studied a short time in London. He then returned and settled in Edinburgh, and was in 1843 appointed an assistant, and in 1845 director of the ornamental department of the Trustees' School. In 1848 he was selected an associate of the Scottish Academy. He exhibited at the Royal Academy in London only once, sending in 1853 'A Window-seat at Wittenburgh, 1526, Luther, the married Priest.' He died May 5, 1860.

CHURCHMAN, John, *architect.* He built the first custom-house for the port of London, which stood upon the site of the present building. He was sheriff for the City 1385.

CHURCHMAN, John, *miniature painter.* He was of some ability. Died in Russell Street, Bloomsbury, August 5, 1780.

CIBBER, Caius Gabriel, *sculptor.* Born at Flensburgh, in Holstein, 1630; son of the cabinet-maker to the Danish Court. He evinced an early talent for modelling, and was sent at the expense of his sovereign to Rome to pursue his studies. Shortly before the Restoration he came to England and found employment under John Stone, and was afterwards largely engaged in monumental art and the production, or rather manufacture, of gods and goddesses for the decoration of groves and gardens. He carved most of the statues of the kings round the old Royal Exchange; the figures of 'Faith' and 'Hope' in the chapel at Chatsworth, where he was much employed, both on the mansion and in the gardens; the large bas-relief in the western front of the pedestal of the Monument;

the 'Phœnix' in bas-relief over the southern door of St. Paul's; and a fine vase at Hampton Court. But he is popularly known by his figures of 'Melancholy Madness' and 'Raving Madness,' which in 1680 were placed over the entrance-gate of Bethlehem Hospital, at that time in Moorfields. These figures, though original and characteristic, attained a notoriety beyond their art merits. They are said to have been the portraits of two remarkable patients then in Bethlehem, one of whom had been the porter to Oliver Cromwell. Pope says of them in his 'Dunciad,' referring to Cibber's son, the well-known Laureate—

'Where o'er the gates, by his famed
 father's hand,
Great Cibber's brazen brainless brothers
 stand.'

But they neither stood, nor were brazen. They are recumbent and carved in Portland stone; were repaired by Bacon, R.A., in 1815, and were placed in the South Kensington Museum. Cibber was appointed 'carver to the king's closet,' whatever that office may be. He was twice married; his second wife, a Miss Colley, of a Rutlandshire family, bringing him a fortune of 6000*l.* He died in 1700, at the age of 70, and was buried in the Danish Church, Wellclose Square, of which, in 1696, he was the architect.

• CIPRIANI, John Baptist, R.A., *historical painter.* Was born in Florence in 1727, of an ancient Tuscan family of Pistoja. His first instruction was by an English painter named Heckford, who was settled in Florence. In 1750 he went to Rome, where he studied three years, and was then induced by Sir William Chambers and Wilton, the sculptor, to accompany them to England in 1755. His reputation had preceded him. He found here his countryman Bartolozzi, whose engravings from his works gave him at once a widespread reputation. He was appointed in 1758 one of the visitors to the Duke of Richmond's gallery at Whitehall, was a member of the St. Martin's Lane Academy, and in 1768 one of the foundation members of the Royal Academy, and an exhibitor of classic subjects from that year up to 1779. He painted a few large pictures in oil, some of them at Houghton, but they were feeble and gaudy, wanting in expression, colour, and chiaroscuro. His art is to be found in his drawings, full of graceful invention and fancy; his females exquisitely elegant, his children unrivalled. Fuseli praises his invention, his graceful compositions and elegant forms, and also his simple manners and unaffected benevolence. The English school is indebted to him for the improved drawing of the figure

and more correct taste. He painted the allegorical designs on the panels for the new state-coach first used by George III. in November 1762, and still used by our sovereign. Designed the diploma of the Royal Academy in 1768. He repaired the paintings by Verrio at Windsor, and the fine Rubens' ceiling in Whitehall Chapel in 1778. He etched some portraits for Hollis's 'Memoirs.' He married in 1761 an English lady of some fortune, and had two sons, and a daughter who died young. He lived many years next the Royal Mews, in Hedge Lane (now Whitcombe Street), Charing Cross, but later in life removed to Hammersmith, where he died of rheumatic fever, December 14, 1785, and was buried in the Chelsea Burial-ground, King's Road, where his friend Bartolozzi erected a monument to his memory. In March 1786 no less than 1100 drawings by him were sold, many of them highly finished, and among them a composition of six figures, 'The Death of Dido,' which fetched 54 guineas. In the following year a collection of his drawings made by Mr. Locke was also sold by auction.

* CIPRIANI, Captain Sir HENRY, Knt., *copyist.* Was the youngest son of the foregoing, and was brought up as an artist. He made a careful drawing in water-colours of Copley's 'Death of Chatham,' from which Bartolozzi executed his engraving. His copy was much praised, and the 100 guineas he received was deemed only a small sum. In 1781 he exhibited a 'Portrait of a Young Nobleman' at the Academy. But he did not meet with the encouragement he deserved, and he accepted a commission in the Huntingdonshire Militia, forsaking art. Then he held a clerkship in the Treasury, and the appointment of exon in the Corps of Gentlemen Pensioners, and was knighted. He died September 17, 1820.

CLACK, RICHARD AUGUSTUS, *portrait painter.* He was the son of a Devonshire clergyman, and studied in the schools of the Royal Academy. He exhibited at the Academy—commencing in 1830, when he resided in London—domestic subjects and portraits. In 1845 he practised at Exeter, and continued to send portraits to the Academy Exhibitions from that city up to 1856; and the following year, when he was living at Hampstead, sent his last contribution to the Academy Exhibition.

CLARET, WILLIAM, *portrait painter.* Was a pupil of Sir Peter Lely, whose style he successfully imitated. Several of his portraits, dated 1670–80, were engraved by R. White and R. Thompson. He died at his house in Lincoln's Inn Fields in 1706. His portraits are carefully finished and tolerably drawn, hands good, but the expression weak.

CLARK, W., *aqua-tint engraver.* He
84

was a corporal in a light dragoon regiment, but was a clever draftsman, and produced some good plates in aqua-tint. He died at Limerick in December 1801.

CLARK, HENRY, *china painter.* He was an apprentice in the Water Lane Pottery, Bristol, where he was employed nearly 50 years. He painted flowers and landscapes, and attained considerable ability. He died about 1862.

CLARK, JOHN, *landscape painter.* Was known as 'Waterloo Clark,' from his scenes drawn on the field immediately after the battle. He published, in 1827, 'Practical Illustrations of Landscape Painting in Water-colours,' with 55 well-executed coloured views from nature. He was an ingenious man, and invented the toys called 'The Myriorama' and 'Urania's Mirror.' He was also engaged in book illustration. He died in Edinburgh in October 1863, in his 92nd year.

CLARK, THOMAS, *portrait painter.* He was born in Ireland, and educated in the Dublin Academy. Then, about 1768, he came to London, and on the introduction of Oliver Goldsmith became the pupil of Sir Joshua Reynolds. He exhibited an oil portrait at the Academy in 1769 and again in 1770. He drew well, particularly the head, but had no notion of colour or practice in painting, and he soon left Reynolds, to whom he was of little use. Neglected and in difficulty, he died young.

CLARKE, GEORGE, *sculptor and modeller.* He practised at Birmingham in 1821, and then sent his first work, a bust of Dr. Parr, to the Academy. In 1825 he had settled in London, and was then an occasional exhibitor of busts in marble, among them one of Dr. Maltby. He was of much promise, which he did not live to realise. He died suddenly at Birmingham, March 12, 1842, aged 46, leaving a large family without provision. He modelled a colossal bust of the Duke of Wellington and the statue of Major Cartwright, in Burton Crescent, which may be referred to as his best work.

CLARKE, Dr. GEORGE, LL.D., *amateur.* Was educated at Oxford University, and became eminent in architecture, with which science Walpole says, 'he was classically conversant.' He designed the library at Christ Church, and jointly with Hawksmoor the new towers in the quadrangle of All Souls College. Walpole says also that he built the three sides of the square called Peckwater, at Christ Church, and the gate of the Church of All Saints, in the High Street. But Dallaway ascribes these works to Dean Aldrich. He represented the University in Parliament for 15 sessions, and in the reign of Queen Anne was one of the Lords of the Admiralty. He died in 1736, aged 76. He bequeathed his valuable col-

lections of architecture to the library of Worcester College.

CLARKE, THEOPHILUS, A.R.A. *portrait painter*. He was born in 1776; was a pupil of Opie, and student in the schools of the Royal Academy. He first appears as an exhibitor in 1797. His works were chiefly portraits and domestic subjects, with some marines and landscapes. He was elected an associate of the Academy in 1803, and last exhibited in 1810. The date of his death is unknown. His name was continued on the list of associates till 1832.

CLARKE, BENJAMIN, *sculptor*. He was born in Dublin 1771. An artist of promising ability; he was idle and neglected to study, but was held in much estimation. He died 1810.

CLARKE, JOHN, *engraver and draftsman*. Born in Scotland about 1650. Practised in Edinburgh with much reputation; but Strutt says he worked chiefly with the graver in a style which does him little credit as an artist. He executed profile heads of William and Mary, Prince and Princess of Orange, dated 1690; seven small heads, on one plate, of Charles II., his Queen, Prince Rupert, the Prince of Orange, Duke of Monmouth, and General Monk; and portraits of some of the chief persons in the three kingdoms. He also engraved, after his own designs, 'The Humours of Harlequin.' He died about 1697.

CLARKE, JOHN, *engraver*. Lived in Gray's Inn, and practised the latter part of the 17th century. He engraved a portrait of Rubens and a picture of 'Hercules and Dejanira,' but did not attain any eminence.

CLARKE, WILLIAM, *engraver and draftsman* of the time of Charles II. He engraved chiefly portraits, and mostly for frontispieces—one of which for a book of devotion, published in London 1635. There is a small mezzo-tint by him of John Shower, from a portrait by himself. His works are dated as late as 1680.

CLARKSON, NATHANIEL, *portrait painter*. He practised in the latter half of the 18th century, but commenced art as a coach-panel and sign painter, and it is said painted the elaborate Shakespeare sign, for which Edward Edwards gives Wale, R.A., the credit. He was a member of the Incorporated Society of Artists. He resided at Islington, and died there September 26, 1795, aged 71. He painted and presented to the new church at Islington, finished 1754, an altar-piece, 'The Annunciation.'

CLATER, THOMAS, *subject painter*. He was from 1820 a constant exhibitor at the Royal Academy. He first contributed some portraits, and then took up subjects from domestic life. In 1824, 'The Morning Lec-

ture;' in 1827, 'Christmas in the Country;' in 1829, 'Scandal—only think;' in 1839, 'The Music Lesson;' in 1849, 'Sunday Morning.' Clever in their quiet humour and pleasing in colour, his works did not find purchasers, and after a long career he fell into difficulties. He exhibited for the last time in 1858, and was assisted from the funds of the Royal Academy. He died February 24, 1867.

CLAY, ALFRED BARRON, *history painter*. He was born June 3, 1831, at Walton-le-Dale, near Preston, and was the second son of the Rev. John Clay, who was distinguished as the chaplain of Preston Gaol. He was educated at the Preston Grammar School, and, intended for the legal profession, was articled to a solicitor in that town. Towards the latter part of his term he became strongly attached to the study of art, and though discouraged by his parents, he managed quietly to persevere in the pursuit, and when the question arose of further arrangements for his continuance in the law, he was resolutely opposed, anxious that some test should be made of his pretensions in art; and with this view he painted his mother's portrait, and upon the favourable opinions expressed he was sent to Liverpool, where he commenced his studies in the spring of 1852, and in the autumn of the same year came to London, and was admitted to the schools of the Royal Academy. In 1855 he first exhibited at the Academy, sending portraits of his father and his sister, and their success decided his career. From that time he was a regular contributor. He painted several subjects from Scottish history, thrice exhibiting 'The Imprisonment of Mary Queen of Scots.' In 1864 he exhibited 'Charles IX. and the French Court at the Massacre of St. Bartholomew;' in 1865, 'The Huguenot;' and in 1867, his most important work, 'The Return of Charles II. to Whitehall in 1660.' His health gave way at this time, in spite of every effort, and he gradually sunk, dying at Rainhill, near Liverpool, at the beginning of a career of much promise, October 1, 1868. His 'Mary, Queen of Scots, when a Prisoner, mending an old Tapestry,' was exhibited at Suffolk Street in the spring of that year.

CLAYTON, JOHN, *still-life painter*. He was brought up as a surgeon, but left that profession for the arts. He was a member of the Incorporated Society of Artists, and known as a painter of fruit and still-life in oil and water-colours at the exhibitions which preceded the establishment of the Royal Academy. He has left no remembrance of his works, some of the chief of which were destroyed by fire in 1769. He retired from the practice of art, and died at Enfield, May 23, 1800, in his 73rd year.

CLAYTON, JOSEPH, *architect*. He

Claxton In. painter ?/1820

practised at Hereford, where he built some railway stations and residences, but is better known by his published works— 'The Churches of London and Westminster built by Sir Christopher Wren,' 1848–49; 'The Ancient-timbered Houses of England.' He was a fellow of the Institute of British Architects, and read some papers at their meetings. He died 1861.

CLENNELL, LUKE, *subject painter*. Born at Ulgham, near Morpeth, the son of a farmer there, April 8, 1781. He was placed at an early age with a relative who was a grocer, and assisted in the shop till he was 16. Then his friends were induced by his love of drawing and some attempts at caricature, which led him into scrapes, to apprentice him for seven years, in 1797, to Bewick, the wood engraver; but, between the grocer and the artist, he was for a short time with a tanner, with whom it was purposed to place him. With Bewick he made great and rapid progress; he soon drew correctly and well, and was employed to copy on the wood the designs of his fellow-pupil, R. Johnson, for the tail-pieces of the 'Water Birds,' and to cut them; and to these he added some beautiful little sea-pieces and shore-views of his own design. At this time his parents fell into difficulties, and to assist them and provide himself with a little pocket money, he disposed of some drawings he had made by a raffle. In 1804, shortly after the termination of his apprenticeship, he came to London, and there married the daughter of Charles Warren, the engraver. He soon found full employment in wood engraving. Among his works are the illustrations of Falconer's 'Shipwreck;' Rogers' 'Poems,' from Stothard's designs, perhaps his best work, and full of the very spirit and character of the painter; the diploma of the Highland Society, from a design by West, P.R.A., for which the Society of Arts gave him their gold medal. All these works were eminently distinguished by their free and artist-like execution, and by their excellent effect.

But he now resolved to abandon wood engraving. He had formed friendships with artists of celebrity, and his ardent genius led him to painting as a larger field. He already drew beautifully in water-colours, and had made the designs for Walter Scott's 'Border Antiquities.' When the Water-Colour Exhibition was thrown open to the profession, he sent several works in 1813–14 and 1815, and commencing in 1812, was a contributor at the same time to the Royal Academy Exhibitions, sending for the last time, in 1816, 'Baggage Waggons in a Thunder Storm' and 'The Pedlars.' He entered into competition for the premium of 150 guineas offered by the directors of the British Institution for the best sketch of the Decisive Charge

made by the Life Guards at Waterloo, and was successful. In 1814 he received from the Earl of Bridgewater a commission for a large picture to commemorate the dinner to the allied sovereigns at the Guildhall, London. He had great difficulty, as all painters of such works have, in obtaining the portraits of the distinguished guests, and suffered from many anxieties in the commencement of the work; but when he had succeeded, and was going on vigorously with his picture, his mind suddenly gave way, and in April 1817 he was found to be insane, without any previous symptoms of his sad malady. After two or three years' confinement in a lunatic asylum in London, his mind so far recovered that restraint became unnecessary. He was sent to his friends in the North, with whom he lived in a state of harmless imbecility, and amused himself with attempts at drawing and wood engraving, and even poetry and music, for he had a fine voice, and had known Burns and sang his songs. But in 1831 his malady returned; he was again sent to a lunatic asylum, and continued to amuse himself at intervals in the same way. He never recovered his reason. He died at Newcastle-on-Tyne, February 9, 1840, aged 59. When seized with his insanity his family were assisted by the Artists' Fund; a subscription was also made for them, and Bromley engraved his 'Charge of the Life Guards,' which was published for their benefit; but the sufferings of his young wife produced the same malady in her, soon followed by her death. Clennell had great talent as a landscape painter, readiness of composition—spirited, truthful, and powerful—his rustic groups admirable, full of character and nature.

CLÉRISSEAU, CHARLES LOUIS, *architectural draftsman*. Was born in Paris in 1722. He painted chiefly in water-colours, and was remarkable for extrordinary facility of execution. He studied many years at Rome, and his drawings of architecture and ruins are highly esteemed, and are well known here. He was induced by Robert Adam to come with him to England, and made many of the drawings for his 'Ruins of Spalatro,' published in 1764. On the bankruptcy of Adam he returned to France, and published in 1778 his 'Antiquités de France,' followed by the 'Monumens de Nîmes.' In 1783 he was appointed architect to the Empress of Russia. He exhibited stained drawings, architectural compositions, ruins, &c., at the Spring Gardens Rooms in 1775–76 and 1790. He died at Paris, January 20, 1820, in his 99th year. He was chevalier of the Legion of Honour and member of the Academy at St. Petersburg.

CLERK, JOHN, Lord Eldin (one of the Scotch Lords of Session), *amateur*. He

painted some clever landscapes, introducing figures. Some of his works have been engraved. He published a work on Naval Tactics. He died in July 1812.

CLERMONT, ——, *decorative painter.* Born in France. Came to England and resided here many years. He painted ceilings and decorations for buildings, with grotesques, foliage, birds, and animals. He returned to France in 1754.

CLEVELEY, JOHN, *marine painter.* He was born in London about 1745, and was brought up in the dockyard at Deptford, where early in life he held some appointment. He showed an early taste for drawing, and acquired considerable skill in painting shipping and sea views. He became acquainted with Paul Sandby, R.A., who then taught at the Royal Military School at Woolwich, and learnt from him the practice of water-colour painting. Continuing to reside at Deptford, he drew the shipping which floated past with every tide, and acquired great facility and truth as a marine painter. After exhibiting with the Free Society of Artists from 1765, he first exhibited at the Royal Academy in 1770, and was a constant contributor to the year of his death, and up to 1782 appears in the catalogues as 'John Cleveley, junr.' Commencing with views on the Thames, his exhibited works comprised drawings of Iceland, 'The King reviewing the Fleet at Spithead,' views on the Tagus and of Gibraltar, 'A Gale off Dover,' 'Greenland Fishery,' one of the Friendly Islands, with many others. He was appointed draftsman to Capt. Phipps's (afterwards Lord Mulgrave) expedition of discovery to the North Seas in 1774, and made the drawings to illustrate the 'Journal of the Voyage,' which in the engravings bear his signature, 'John Cleveley, junr.' This would lead to the assumption that his father was an artist—possibly a naval draftsman in the dockyard. He also accompanied Sir Joseph Banks on his tour in Iceland. He was awarded a premium for his drawings by the Society of Arts. He never held any commission in the Navy. He resided some time in Pimlico, and died in London, June 25, 1786. He painted occasionally in oil, but chiefly in water-colours, in which he excelled. His drawings are finished with much skill and taste, spirited in execution, and in colour almost in advance of his day.

✲CLEVELEY, ROBERT, *marine painter.* It cannot be traced that he was any relation of the above. He first appears as an exhibitor with the Free Society of Artists in 1767, and afterwards at the Royal Academy, where he was a contributor of works both in oil and water-colours from 1780 to 1803. Up to 1788 he was classed as an 'honorary exhibitor,' but he early attained distinction as a painter of naval actions, and after that year took his place among the artists. In 1782 his name appears in the catalogue as 'R. Cleveley, of the Navy,' and he is spoken of as a lieutenant; but a careful search of the records of the Admiralty makes it quite clear that he never held a commission in the Royal Navy. In 1783 he exhibited 'The Relief of Gibraltar;' in 1784, 'The "Ruby" engaged with the "Solitaire,"' and 'The "Solitaire" striking to the "Ruby;"' in 1788, 'A Calm' and 'A Breeze on the Elbe;' in 1790, 'The Reception of the Duke of Clarence in Portsmouth Harbour;' in 1797, 'Commodore Nelson boarding the "San Nicolas" and the "San Josef."' He had previously painted the Morn and Eve of Earl Howe's Victory of June 1, pictures each 12 feet by 8 feet, which were much admired at the time. There is a good portrait of him painted by Beechey, and engraved by Freeman, in the dress of a civilian, inscribed 'Robert Cleveley, Esq., marine painter to H.R.H. the Prince of Wales, and marine draftsman to H.R.H. the Duke of Clarence.' While on a visit to a relative at Dover, he fell from the cliff September 29, 1809, and died in a few hours. His paintings and drawings of marine subjects possess much merit, and he also painted a few good landscapes.

✲ CLEYN, FRANCESCO, *ornamental painter.* Was born at Rostock, in Mecklenburg-Schwerin, and in the latter part of the 16th century was retained in the service of Christian IV., King of Denmark. He travelled in Italy and studied there for four years; and then, on the recommendation of the English minister at Venice, was invited here by Charles I. when Prince Charles. He arrived while the Prince was in Spain, and was received by James I., who, with the King of Denmark's permission, retained him in his service. He was first employed in designing for the manufactory of tapestry at Mortlake, which he assisted in carrying to great perfection, and was granted an annuity of 100*l.*, which he held till the rebellion. But he was not employed exclusively on tapestry designs. He painted some ceilings and decorations at Somerset House, Bolsover; Carew House, Parson's Green; and at Holland House. He designed Charles II.'s Great Seal and illustrations engraved by Hollar for Virgil and for Æsop's 'Fables,' for which he was paid 50*s.* each. He also designed some small books of ornamental foliage, and for goldsmith's work, and etched some plates in the manner of Hollar. He died in London in 1658. He is styled on a small drawing by him, 'Il famosissimo pittore F. C., miracolo del secolo e molto stimato del re Carlo della Gran Britannia.'

✲ CLEYN, FRANCIS, ⎫ *miniature painters.*
CLEYN, JOHN, ⎬ Sons of the above,

and brought up by him to his profession, were distinguished as draftsmen and miniature painters. Evelyn, in his 'Sculptura,' speaks of them as 'hopeful but now deceased brothers,' and greatly praises their drawings from the cartoons. FRANCIS, born in 1625, died October 21, 1650; and JOHN, the youngest brother, also died young. They both died in London. Their sister PENELOPE is said to have been a miniature painter; and some miniatures, like Cooper's in manner, with the initials P.C., have been thought possibly her work.

CLINT, GEORGE, A.R.A., *portrait painter and engraver.* Was born in Brownlow Street, Holborn, where his father kept a hair-dresser's shop, April 12, 1770. He was apprenticed to a fishmonger, but left that trade in disgust and found some employment in an attorney's office. Then his conscience revolting against his work, he tried house painting, and soon after married. He next tried his hand at art, and finally abandoning house painting, he with a young family underwent acute privations; but he made rapid progress as a miniature painter, and at last succeeded, his works possessing great skill in execution, with a delicate feeling for beauty. After this he took up engraving in mezzo-tint, and tried both the chalk manner and outline. He engraved 'The Frightened Horse,' after Stubbs, an entombment, many portraits, some prints for Sir Thomas Lawrence, which resulted in a disagreement, and in 1807, 'The Death of Nelson,' after Drummond, A.R.A. But he did not find full employment, and to eke out his means he made for sale copies by the dozen from popular subjects by Morland and others. About this time he engaged to mezzo-tint Harlow's 'Kemble Family,' and produced a successful plate, which was so popular that it was re-engraved three times. He had painted a portrait of his wife, and was greatly encouraged by the kind opinion of Sir William Beechey, R.A.; and the completion of Harlow's picture bringing him into connection with many players and lovers of the drama, he commenced a series of dramatic scenes and portraits of favourite actors, which gained him so much reputation and were so popular that they led to his election as associate of the Royal Academy in 1821. Of these we may point to his 'Hamlet and Ophelia,' 'Paul Pry,' and the 'Honeymoon,' in the Sheepshanks Gallery; and his 'Falstaff and Mrs. Ford' in the Vernon Gallery at South Kensington. He also painted the portraits of several persons of distinction; but he did not attain the higher rank of academician. Young men pressing on passed over his head—he thought himself slighted, and in 1835 he resigned his position of associate, and became an angry

opponent of the Academy. Not long after this he retired from his profession and lived at Peckham, on the savings from his works and some property derived from a second marriage. Later he removed to Pembroke Square, Kensington, where he died May 10, 1854, in his 85th year. He was successful as a portrait painter, and in his subject pictures has perpetuated a generation of dramatic celebrities, cleverly grouped and expressed. His colour was tame and lacked richness and variety, and there was a character of feebleness in his art. His mezzo-tint was good, bold—perhaps wanting in finish, but artistic.

CLINT, SCIPIO, *medallist.* Son of the foregoing. He gained a medal at the Society of Arts in 1824, and the following year exhibited for the first time at the Academy. In 1830 he exhibited his dies for a medal of Sir Thomas Lawrence. He was appointed medallist to the King, and was attaining distinction in his art, when he died on August 6, 1839, at the age of 34, just as employment was beginning to promise a successful career.

CLOOS, NICHOLAS, 'surveyor,' a term synonymous with architect. Was of Flemish extraction, and held the cure of the church of St. John the Baptist, Cambridge, which was pulled down to make room for King's College Chapel. Of this great example of English art he was the architect; and was in 1443 one of the six fellows originally placed on the foundation. He was also for his services as architect empowered to bear arms by a grant from the King. In 1449-50 he was apointed to the see of Carlisle, and in 1452 was translated to Lichfield.

CLOSE, SAMUEL, *engraver.* He was born in Dublin, and was deaf and dumb from his birth. Of intemperate habits, he was employed at small pay by others, whose names were affixed to his works. He died 1817.

CLOSTERMAN, JOHN, *portrait painter.* Was born at Osnaburgh in 1656. In 1679 he went to Paris, and from thence, in 1681, came to this country, and was employed by Riley to paint his draperies; and afterwards painted portraits in conjunction with him, Riley usually finishing the heads. After Riley's death he finished many of his uncompleted portraits, and obtaining much notice, set up as a rival to Kneller. In 1696 he went by invitation to Spain, and painted the portraits of the King and Queen. He also went twice to Italy, and brought back some good pictures which he purchased there. He painted a whole-length of Queen Anne, now in the Council Chamber, Guildhall; a family group of the Duke and Duchess of Marlborough, with their children; and a portrait of the Duke of Rutland. His colour-

ing was heavy, but not without power; his works entirely without grace; yet, in the low state of the arts which then prevailed, he might have realised wealth. But he became infatuated with a young Englishwoman, an artful girl, and it is said married her. When made poor by her extravagance, she robbed him and left him; then falling into a state of dejection of body and mind, he died in 1713, and was buried in Covent Garden Churchyard. He resided some years in Piccadilly. His portraits have been engraved by Faithorne, Smith, and Sherwin.

CLOWES, BUTLER, *engraver*. Practised in the latter half of the 18th century. He scraped some portraits in mezzo-tint, which have little claim to merit, and engraved after Hemskirk, Stubbs, Collet, and others; and also both designed and engraved some theatrical and genre subjects of his own. He died 1782.

COCHRAN, ROBERT, *architect*. A native of Scotland. He was employed by James III. of Scotland in the erection of several large structures, and created Earl of Mar, and treated with so much favour by that monarch that the jealous nobles seized him and hung him on the Bridge of Lauder in the year 1484.

COCHRAN, WILLIAM, *portrait painter*. He was born at Strathern, in Clydesdale, N.B., on December 12, 1738, and commenced his art education in Foulis's academy at Glasgow in 1754. About the end of 1761 he went to Italy, where he remained for five years, chiefly at Rome, and studied under Gavin Hamilton. On his return he settled at Glasgow as a portrait painter. He was successful in his likenesses, and his drawing was accurate. While at Rome he painted 'Dædalus and Icarus,' 'Diana and Endymion,' and some other historical pictures; but he was unambitious, and satisfied to follow his art in Glasgow, where his relatives dwelt. He died there October 23, 1785, aged 47, and was buried in the Cathedral Church.

COCKBURN, JAMES PATTESON, Major-General, *amateur*. He was of much ability, and drew and published many views of foreign scenery, but is reputed to have made use of the camera lucida in sketching—'The Route of the Simplon' and views of Mont Cenis, 1819–22; views of the Coliseum, 1821; views in the Valley of Aosta, 1822–23; and he also contributed some drawings for 'Pompeii Illustrated,' 1819–27.

COCKE, HENRY, *decorative painter*. He practised about the middle of the 17th century. He travelled in Italy, and was some time the pupil of Salvator Rosa; on his return he accompanied Sir Godfrey Copley to Yorkshire, and decorated the panels of his newly-built mansion. He

afterwards went again to the Continent, where he remained seven years, and on his return gained much employment. By William III.'s orders he repaired the cartoons at Hampton Court, and some other paintings in the Royal Palaces. He painted the equestrian portrait of Charles II. at Chelsea College, the choir of the New College Chapel at Oxford, and a staircase at Ranelagh House.

COCKERELL, SAMUEL PEPYS, *architect*. He was born about 1754, and was a pupil of Sir Robert Taylor. In 1792 he was first an exhibitor at the Royal Academy, and from that year was a constant contributor, chiefly of designs for mansions and churches, up to 1803. In 1796–98 he rebuilt the church of St. Martin's Outwich, London. He built several handsome residences, and was employed upon some large alterations. He held the appointment of surveyor to the East India House, and filled some other important professional offices, and had an extensive practice towards the end of the century. He died July 12, 1827.

COCKERELL, CHARLES ROBERT, R.A., *architect*. He was the son of the foregoing, was born in London, April 28, 1788, and was educated at Westminster School. He studied his profession under his father, with whom he continued about five years, becoming a good draftsman, and about 1809 was engaged to assist Sir Robert Smirke in the rebuilding of Covent Garden Theatre. He was well fitted by his studies for the pursuit of classic architecture, and in 1810 he commenced his travels to mature and improve his knowledge. He sailed direct to Constantinople, and finding there many objects of study, he stayed several months, and then went to Athens, where he passed the winter; in the spring visiting the Morea and other parts of Greece, and then returning to Athens. In 1811–12 he travelled in Ionia, Lycia, and Cilicia, and went from thence to Malta and Sicily, where he remained some time, visiting the ancient temples and remains at Girgenti and Syracuse. In 1813 he returned to Greece, and after two years' more study there—during which he discovered the fine reliefs from the temple of Phigalia, now in the British Museum—he went to Naples in 1815, devoted his chief attention to Pompeii, then passed the winter in Rome, and after seeing the other great Italian cities, returned to England in 1817.

His reputation had preceded him, and with the great advantages which he had enjoyed, he commenced the practice of his profession. In 1818 he first exhibited at the Royal Academy, contributing in that and the following years his restorations of some of the great edifices of the ancients.

In 1825 he completed Hanover Chapel, Regent Street; and in 1829, St. David's College, Lampeter, a Gothic design; and was in that year elected an associate of the Royal Academy. About the same time he was a competitor for the erection of the Cambridge University Library, and was eventually employed, but only one wing of his design was built. His next large work was the Westminster Fire Office, in King Street, Covent Garden.

In 1833 he was appointed architect to the Bank of England, and he erected the Dividend Office, and made some other alter-ations, which were in his best manner, but they have chiefly been since pulled down to provide for some necessary enlarge-ments. In 1836 he was elected a member of the Academy, and in 1840 was ap-pointed professor of architecture. He competed for the erection of the Houses of Parliament, the National Gallery, and the London University, and later for the Royal Exchange; and failure was, in such strong contests, no dishonour to any artist. In 1840 he designed the Taylor and Ran-dolph Buildings at Oxford, a noble work; and in 1845 was presented with the hon-orary degree of D.C.L. He was engaged during seven years in completing, on the death of their designer, Mr. Elmes, the Assize Courts and St. George's Hall, Liver-pool, which the latter had commenced. In 1848 he was awarded the first gold medal given by the Institute of Architects, of which he was the president. In 1857 he completed at Liverpool, after his own designs, the London Insurance Company's offices, his last work. He had gained European reputation, was a member of several foreign orders and academies, and after a long and active life died at his house in Regent's Park, September 17, 1863, and was buried in St. Paul's Cathedral.

He was only an occasional exhibitor at the Academy, and then not of the works he was executing, but rather his classic restorations and dreams of the great works of antiquity, rendered valuable by his great knowledge and study. Thus, in 1830 and 1831, he exhibited restorations of the Parthenon and of the theatre at Pom-peii; in 1838, 'A Tribute to the Memory of Wren,' comprising a group of his chief works; in 1849, 'The Professor's Dream,' a composition including the principal archi-tectural monuments of ancient and modern times; in 1859, his last contribution to the Academy Exhibitions, 'Study of the Mau-soleum of Halicarnassus,' from the ancient texts and fragments, with the then recent measurements. He was also distinguished as a lecturer and writer on his art. He published, in 1830, his 'Antiquities of Athens,' and 'The Temple of Júpiter Olympus at Agrigentum;' in 1851, 'The

Iconography of the West front of Wells Cathedral;' and, in 1860, 'The Temples of Jupiter Panhellenius and Apollo Epi-curius.'

COCKSON, THOMAS, *engraver and draftsman*. He worked exclusively with the graver, in a neat, finished, stiff manner, and engraved a great variety of portraits; among them, of 'James I. sitting in Parliament;' his daughter, the Princess Elizabeth; 'Charles I. in Parliament;' Louis XIII.; Mary de Medicis; also the 'Revels of Christendom,' and some sea-pieces, with shipping. His best works are dated between 1620–30.

COLE, HUMPHREY, *engraver, drafts-man, and goldsmith*. Was born in the North of England about 1530. He was an officer of the Royal Mint, in the Tower. He engraved a frontispiece for Parker's 'Bible,' published in 1572, in which he has represented a portrait of Queen Elizabeth, with the Earl of Leicester as 'Goliath' and Lord Burleigh as 'David.'

COLE, PETER, *portrait painter*. Prac-tised in the reign of Queen Elizabeth, and was some time director of the Mint. He is mentioned by Meres in his 'Wits' Com-monwealth,' 1592, and is supposed to have been the brother of the above Humphrey Cole.

COLE, JOHN, *engraver*. He was much employed by booksellers on works of a low class, which he produced entirely with the graver. He etched 136 plates for a 'His-tory of Canterbury Cathedral and West-minster Abbey,' published in 1727.

COLE, B., *engraver*. Practised in the first half of the 18th century. He en-graved chiefly portraits, among them Lords Kilmarnock, Cromarty, Balmerino, and Frazer of Lovat.

◆ COLE, Sir RALPH, Bart., *amateur*. Was the son of Sir Nicholas Cole, of Brancepeth Park, Durham, who was created a baronet in 1640. When young he studied paint-ing under Vandyke. He retained several Italian painters in his own service, and spent his fortune in his love for art. His friend, Francis Place, executed a good por-trait of him in mezzo-tint. He painted, in 1677, a half-length portrait of Thomas Wyndham, F.R.S., which is now in the library at Petworth, and has been mezzo-tinted by R. Tompson.◆

COLEBURN, KRISTIAN, '*paynter*.' Practised in London, and was engaged to paint 'in most fine, fairest and curious wise four images of stone—Our Ladye, St. Gabrielle, St. Anne, and St. George, for the tomb of the Warwick family in Warwick Church.' Time of Henry VI. (1439).

COLECHURCH, PETER of, *architect*. He was chaplain of St. Mary, Colechurch, and practised as an architect in the 12th

century. He rebuilt London Bridge of timber in the year 1163. He died 1205.

COLEMAN, EDWARD, *still-life painter*. He practised at Birmingham about 1830. He exhibited at the Royal Academy, in 1819 and 1820, 'Dead Game;' and in 1822 a portrait, his last contribution. His pictures were well and rapidly painted, but do not possess much merit as works of art.

COLEMAN, WILLIAM, *engraver*. He was one of the early engravers on wood, and was distinguished by several premiums which he received from the Society of Arts, 1775–77. He died in Duke's Court, Bow Street, December 1807.

COLLET, JOHN, *portrait painter*. Little is known of him. He retired from his profession to Chelsea, where he died, January 17, 1771. He was distinguished as 'John Collet, senior.'

COLLET, JOHN, *subject painter*. He was born in London about 1725. Was a pupil of George Lambert, and studied at the St. Martin's Lane School. He was of a respectable family, his father filling a public office, and possessing a small independence, and was by some styled an amateur. He painted humorous subjects and plagiarised Hogarth, but missed his deep moral. He was a shy man, of grave habits and conversation, yet his pictures were sometimes displeasingly vulgar. His 'Female Bruisers' is of this class. He painted 'The Love Match,' a series of designs; 'The Recruiting Sergeant,' a servile imitation of Hogarth, some of the principal figures actually copied from him; 'Picquet, or Virtue in Danger;' and 'The Tailor riding to Brentford,' by which he was best known in his day. From 1765 to 1775 he exhibited with the Free Society of Artists. Several of his works were engraved by Goldar and published by Carington Bowles and by Sayer, of Fleet Street, and are not of the most pure character. He acquired a considerable addition to his property on the death of a relative, and retired to Chelsea, where he lived several years, and died in Cheyne Row, August 6, 1780. He etched some of his own designs, among others two caricatures of antiquaries, and published a Drawing-book, containing some academy figures.

COLLIER, JOHN (known as 'Tim Bobbin'), *comic draftsman*. He was born near Warrington, where his father held a small curacy and kept a school. He was intended for the Church, but his father becoming blind, he was put out apprentice to a Dutch loom-weaver. Eccentric and full of spirits, he managed to obtain a release from his master, and though very young, was able to support himself as an itinerant teacher, going from one small town to another, generally keeping both a

day and a night school for reading, writing, and accounts, and then found a place with a pay of 20*l.* a year as usher in a school, to which he eventually succeeded. He learned to play on the hautboy, drew landscapes, attempted some heads, and made some enemies by his satirical verses. He added to his means by painting signs in his vacant hours, and, it is said, altar-pieces for chapels. At last he found a more profitable employment in drawing faces with grotesque expression, of which he sold large numbers, leaving them at inns, when the landlord disposed of them; so that with teaching, painting, and his writings, he managed to live to the age of 80. He published 'Shude Hill Fight,' a poem, 1757; 'The Cobbler's Politics;' 'The Human Passions,' 25 plates; 'The Lancashire Dialect,' 1775, with seven rudely clever copper-plates, apparently from his own designs. Richard Townley wrote 'The Life of Tim Bobbin, Esq.,' 1806.

COLLINGS, S., *subject painter*. He is best known as a caricaturist, whose works were engraved in the 'Wits' Magazine,' 1784. But he was also an exhibitor at the Academy, contributing, in 1784, 'The Children in the Wood,' followed by 'The Chamber of Genius,' 'The Triumph of Sensibility,' and in 1789, when his name appears for the last time in the catalogue, 'The Frost on the Thames, sketched on the spot.'

COLLINS, CHARLES, *still-life painter*. He painted birds, game, and works of this class early in the 18th century. He has introduced his own portrait, wearing his hat, in a group with a hare and birds. He died 1744.

COLLINS, JACOB, *engraver*. He practised in obscurity till the end of the 17th century. He engraved portraits and frontispieces for books.

COLLINS, JAMES, *engraver*, chiefly of views of buildings. Among his works is a large-sized view of Canterbury Cathedral. He practised about 1715.

COLLINS, JOHN, *engraver*. Practised towards the end of the 17th century. There are some indifferent portraits by him—'The Funeral Procession of George, Duke of Albemarle'—and some etchings.

COLLINS, JOHN, *landscape painter*. Some landscapes with figures by him, in a scenic manner, from the 'Jerusalem Delivered,' were finely engraved by Sandby and Rooker.

COLLINS, RICHARD, *topographical draftsman*. Was the son of a painter at Peterborough. He studied under Dahl. He was an antiquarian, and made many topographical drawings. A drawing by him of the front and grand vestibule of Peterborough Minster was engraved by Vander Gucht. Two drawings by him

are also engraved in Buck's 'Lincolnshire Views.' He died 1732.

COLLINS, SAMUEL, *miniature painter.* He was born at Bristol, the son of a clergyman, and was educated as an attorney. There is no trace of the circumstances under which he was led to art or of his artteaching. But about the middle of the 18th century he was in practice at Bath as a miniature painter; and shortly after Ozias Humphrey, afterwards so distinguished in the profession, was articled to him as his pupil. About 1762 he removed to Dublin, and there enjoyed a very high reputation. He practised both on ivory and in enamel. The Royal Academy was founded shortly after; but if he then survived, he never appears as an exhibitor.

COLLINS, RICHARD, *miniature painter.* He was born in Hampshire, January 30, 1755, and commenced art as the pupil of Meyer, R.A. In 1777 he was an exhibitor of portraits at the Royal Academy, and continuing to exhibit, he was in 1787 appointed principal enamel and miniature painter to George III. He attained great excellence, and his miniatures are estimable in all the finest qualities of the art. He had a large share in the practice of his day, and gaining a competence, gradually ceased to exhibit about 1806, and retired to Pershore, in Worcestershire, about 1811; but missing the companionship of his art friends in his old age, he returned to London about 1828, where he died August 5, 1831, aged 77.

COLLINS, CHARLES, *draftsman.* He published, in 1736, 12 large-sized folio plates of British Birds, drawn by himself. Each plate contains about 10 birds, fair representatives both of the birds and their natural action, with a background, and tolerably grouped. An attempt has been made to colour them, but the artist of that time was sadly in want of the requisite materials.

COLLINS, WILLIAM, *engraver.* He engraved some of the plates for 'The British Theatre,' and was of much repute in his day. He died May 31, 1793.

COLLINS, WILLIAM, *sculptor and modeller.* Was one of the first members of the St. Martin's Lane Academy, and a member of the Incorporated Society of Artists. He modelled rustic subjects for the friezes of chimney-pieces, many of them taken from Æsop's 'Fables,' which were much in vogue, and his works were widely known and admired. He modelled a prototype bust for Frank Hayman's 'Don Quixote.' He exhibited a bas-relief at the Society of Artists in 1761, and was one of the directors of the Incorporated Society in 1765. Gainsborough was his friend. He resided in Tothill Fields, and died there May 24, 1793.

COLLINS, WILLIAM, R.A., *subject painter.* Was born September 18, 1788, in Great Tichfield Street, London, where his father, a native of Wicklow — who among other works wrote, 'A Life of George Morland, the Painter'—was settled as a picture-cleaner and dealer. He stood by the easel of Morland, his father's friend, and early imbibing a taste for drawing, in 1807 he was admitted a student of the Royal Academy, and exhibited two landscapes. In 1809 he gained a medal in the life-school, and in the same year exhibited his first work. Though occasionally painting portraits, he chose for his subjects rustic groups and landscape — 'Boy at Breakfast,' 'Boy with a Cat;' in 1810, 'Cottage Children blowing Bubbles;' in 1811, 'Country Kitchen;' in 1813, 'The Sale of the Pet Lamb,' a work which added greatly to his growing reputation; but about 1816 he commenced painting coast scenes, which he treated with great freshness and truth; his 'Coast of Norfolk,' 1818, finding a purchaser in the Prince Regent. In 1814 he was elected an associate, and in 1820 a member, of the Royal Academy. He continued a constant exhibitor of such subjects; they were carefully painted, his colouring and composition of rustic groups pleasing, and his art popular. In 1836 he produced two of his best works—'Sunday Morning' and 'Happy as a King;' and then, in order to vary his subjects, he went to Italy, where he travelled for two years, and on his return commenced his pictures from Italian life, followed, in 1840, by attempts at a higher style—'Our Saviour with the Doctors in the Temple,' 'The Two Disciples at Emmaus,' and contemporaneously with such works gradually returned to his first manner, seeking his subjects on our own coasts. His art was feeble, wanting in vigour and power; his best works will be prized, but the high reputation which he enjoyed will hardly be maintained, though from his happy choice of subjects his pictures will always be popular, and many of them have been engraved and have had a large sale. He sketched in water-colour, using tinted paper with body colour for the high lights. Some of his earlier sketches, which are of small size, have much truth and brilliancy. He etched some of his coast scenes, combining mezzo-tint largely and effectively. He married, in 1822, Miss Geddes, the sister of Mrs. Carpenter, the portrait painter. When in Italy he laid, by exposure, the foundation of an illness which undermined his constitution. He died in Devonport Street, Hyde Park Gardens, February 17, 1847, and was buried in the cemetery of the church of St. Mary, Paddington. He left two sons, one of whom followed his profession; the other, a well-known popular writer, published a life of his father in 1849.

COLLINS, CHARLES ALLSTON, *subject painter.* Younger son of the above. He was born at Hampstead, January 25, 1828, and was brought up under his father, whose wish it was that he should be an artist, studying at the same time in the schools of the Royal Academy. He first exhibited at the Academy, in 1847, and in 1851 sent 'Convent Thoughts,' followed in the next year by 'May in the Regent's Park,' with two others; in 1853, by a subject from 'The Christian Year;' and in 1855, 'The Good Harvest.' He had commenced art rather as a duty than from choice, and he then turned to literature. He contributed to Dickens's 'Household Words' and 'All the Year Round,' and became the husband of Dickens's daughter. He wrote a clever account of his wanderings, 'A Cruise upon Wheels,' 1863; 'Stathearne,' a novel, and the 'Bar Sinister,' in 1864; and 'At the Bar' in 1866. His health had been for some time failing, and he became a confirmed invalid, and for several years quietly bore sad paroxysms of pain, and died April 9, 1873. He was buried in the Brompton Cemetery.

COLLINS, ELIZABETH JOHANNA, *designer.* She practised in the middle of the 18th century. Six designs by her from 'Jerusalem Delivered' were engraved.

COLLYER, JOSEPH, A.E., *engraver.* Born in London, September 14, 1748. His father, who was an eminent bookseller, and his mother had both literary tastes. The latter translated Gesner's 'Death of Abel,' which became very popular. Showing an early love for art he was apprenticed to Anthony Walker, who dying shortly after, he is supposed to have continued with Walker's brother. He was awarded in 1761 a premium by the Society of Arts, and in 1771 was admitted a student of the Royal Academy, and soon pursued his profession on his own account. He had acquired a neat manner, which was well suited to book illustration, in which he was chiefly employed. In 1779 he exhibited with the Free Society of Artists. He engraved some of the portraits belonging to the Royal Academy, and gaining the notice of Sir Joshua Reynolds, he allowed him to engrave his 'Venus' and 'Una.' These he executed in the chalk manner, and produced an excellent imitation of the master, which was much praised. He also engraved, after Reynolds, 'The Girl with a Cat,' 'Miss Palmer,' and a portrait of the painter by himself. In the line manner he engraved for Boydell 'A Flemish Wake,' after Teniers, and 'The Irish Volunteers,' after Wheatley, R.A., which are good examples of his manner. In 1786 he was elected associate engraver of the Royal Academy. He was appointed portrait engraver to Queen Charlotte, and was master

warden of the Stationers' Company. He died December 24, 1827, in his 80th year. His works were delicate, finished, and accurately drawn.

COLMAN, ——, *water-colour painter.* He was a Norwich artist, and exhibited there in 1824 some good water-colour drawings—'Yarmouth Bridge after Sunset,' and some other coast scenes.

COLONI, ADAM, *landscape and figure painter.* Was born at Rotterdam in 1634. He came to England early, and passed the greater part of his life in London. He was reputed for his paintings of country wakes, cattle-pieces in the manner of Berghem, effects of firelight, and for his copies after Bassan. He died in London 1685, aged 51, and was buried at St. Martin's Church.

COLONI, HENRY ADRIAN, *landscape and figure painter.* Son of the foregoing. Was the pupil of his father and of Vandiest, his brother-in-law, into whose landscapes he often painted the figures. He drew well, and is known by his landscapes in the manner of Salvator Rosa, whom he imitated. He died in London 1701, aged 33, and was buried near his father.

COLTE, MAXIMILIAN, *architect and sculptor.* He was master sculptor to James I., and was of some eminence. He lived in St. Bartholomew's Close, and his wife was buried in the church there. He is reputed the architect of Wadham College, Oxford.

COMBES, PETER, *engraver.* Practised in mezzo-tint about 1700. His works are chiefly portrait.

COMER, JOHN, *portrait painter.* He practised about 1760, and was an exhibitor at the Free Society's Rooms, in the Strand.

COMERFORD, JOHN, *miniature painter.* Was the son of a flax-dresser at Kilkenny, where he was born. He came early in life to Dublin, and studied in the Society's schools. He settled in the practice of his art at Dublin, and in 1809 sent two miniature portraits to the Academy Exhibition, though he did not subsequently exhibit. He attained a high reputation in Dublin, and made money by his art. His miniatures had much merit, particularly his male portraits. They were low in colour, carefully finished, and well expressed, but without elevation of character. He drew many slight sketch portraits, which were both popular and profitable. He died, of a second attack of apoplexy, in Dublin about 1835, at the age of nearly 62. He strenuously opposed the establishment of the Royal Academy of Arts in Dublin.

CONDY, NICHOLAS MATTHEWS, *marine painter.* He was a native of Plymouth, where he practised about the early part of the 19th century. He first painted some miniatures, and afterwards some landscapes

and marines in oil. In the years 1842–43 and 1844 he was an exhibitor at the Royal Academy. Some views on the Thames by him were published. He died at Plymouth, May 20, 1851, aged 52.

CONEY, JOHN, *draftsman and engraver.* Was born at Ratcliff Highway in 1786. He was apprenticed to an architect, but did not follow that profession, though at an early age he distinguished himself as an architectural draftsman. He exhibited a 'View of Lambeth Palace' at the Academy in 1805, and continued to exhibit from time to time, always views of old edifices. In 1815 he published his first work, consisting of eight views of the exterior and interior of Warwick Castle, drawn and etched by himself. He was soon afterwards engaged in making drawings of the cathedrals and abbey churches of England, for a new edition of Dugdale's 'Monasticon,' a work which was his chief occupation during 14 years. In 1829 he commenced a series of engravings of ancient cathedrals, hôtels de ville, and other public buildings of celebrity in France, Holland, Germany, and Italy, which he drew on the spot and engraved himself; and in 1831 this was followed by a similar work, only less in size, 'Architectural Beauties of Continental Europe,' also from drawings made on the spot and engraved by himself. He was some time engaged by Cockerell, R.A., to engrave a large general view of Rome; and he also engraved some drawings of the new Law Courts at Westminster for Sir John Soane. He drew in pencil and water-colours, but with all his labours does not appear to have done more than earn a subsistence. He died of an enlargement of the heart, in Leicester Place, Camberwell, August 15, 1833, in his 47th year. He was twice married, but had no children. Some of his drawings were sold by Messrs. Sotheby soon after his death, and his view of the 'Interior of Milan Cathedral' was published for the benefit of his widow. His drawings were careful and elaborate, but do not show that accurate knowledge of the details of Gothic tracery which has been ascribed to him.

CONSTABLE, JOHN, R.A., *landscape painter.* He was born at East Bergholt, in Suffolk, June 11, 1776, and was the son of a miller, the owner of several mills, who had inherited a considerable property. Originally intended for the Church, he soon showed a preference for art. His father then tried to make a miller of him, but after a year left him to follow his own bent. He sketched the scenery of his own picturesque neighbourhood, and his desire to pursue art gaining strength, he came to London for the purpose in 1795. But unsettled as to his future he returned home, and the love of art still holding the

94

mastery, he came again to the Metropolis, and was in 1799 admitted a student of the Royal Academy. Devoting himself then to study, he received some assistance both from Farrington, R.A., and R. R. Reinagle, R.A. He commenced his profession as a portrait painter, then the only profitable branch of art, and for several years occasionally painted portraits, and made one or two attempts at history; but his art was landscape. In 1802 he exhibited 'A Landscape,' his first; and early gaining a consciousness of his own power, resolved upon the necessity of studying nature. He wrote, in 1803, 'I feel now, more than ever, a decided conviction that I shall some time or other make some good pictures; pictures that shall be valuable to posterity, if I do not reap the benefit of them;' and he now finally settled down as the painter of the class of rural scenery in which he was born. In 1816, after a long attachment, he married. He then resided in Charlotte Street, Fitzroy Square, but in 1820 his love of nature led him to take also a house at Hampstead. In 1819 he exhibited his large picture, 'A View on the River Stour,' and was elected associate; but he did not till 1829, when in his 53rd year, gain his election as a member of the Royal Academy.

Leslie, R.A., his friend and graceful biographer, speaks most highly of his works at this period. 'I cannot but think,' he says, 'that they will attain for him, when his merits are fully acknowledged, the praise of having been the most genuine painter of English landscape that has yet lived;' yet at the same time he said of himself—and the expressions are characteristic of the man—in reference to the publication of his works, mezzo-tinted by Lucas, 'The painter himself is totally unpopular, and will be so on this side the grave; the subjects nothing but art, and the buyers wholly ignorant of that.' Again, 'My art flatters nobody by imitation, it courts nobody by smoothness, tickles nobody by petiteness, it is without either fal-de-lal or fiddle-de-dee; how can I then hope to be popular?' He yearned for the appreciation he so truly merited. His house was filled with his unsold pictures, and courting notice he advertised, 'Mr. Constable's Gallery of Landscapes, by his own hand, is to be seen *gratis* daily, by an application at his residence.' He was first widely esteemed in France; some of his works purchased by the French made a sensation in Paris, and the king of the French sent him a medal. His health had been for some time uncertain, when on April 1, 1837, he died very suddenly, and the reputation he sought in life soon ensued. His admirers purchased his picture of 'The Cornfield,' and presented it to the National Gallery; 'The Valley Farm,' his father's

house, is in the same collection. The Sheepshanks Gallery contains six of his works, and purchasers now eagerly give large prices for his paintings. His works were purely original, his manner entirely his own. He depicted with great truth and power the freshness and variety of English landscape. His reputation as one of our first painters is now firmly established, and is not likely to decrease. He made many fine drawings in water-colour, one of which, of a large size, 'Stonehenge,' was exhibited in 1836.

COOK, HENRY, *portrait painter.* Practised about 1640, and appears to have found employment in the City, but at low prices. The Ironmongers' Company possess some portraits by him, for which the records of the company show that, disputing his charge of 5*l.* each, they paid him the reduced sum of 3*l.* 5*s.*; but some of these are supposed to be copies.

COOK, HENRY, *history painter.* Son of the above. Born 1642. Travelled in Italy to study the works of the great history painters, and was for a time the pupil of Salvator Rosa. On his return he was employed to paint the altar-piece for the new College Chapel at Oxford, but met with little encouragement, and lived for several years in want and obscurity. He was at last obliged to fly from England for the murder of a man who courted his mistress, whom he afterwards married. When this affair was forgotten he came back, and his talents gained him notice. He was commissioned by William III. to repair the cartoons. He finished the equestrian portrait of Charles II. in the hall at Chelsea Hospital. As a decorative artist, he painted the staircase at Ranelagh House and at Lord Carlisle's in Soho Square. He also tried portrait painting, but could not put up with the caprice of his sitters. His collection of pictures and drawings was sold March 26, 1700. He died Nov. 18 in that year, and was buried in St. Giles's Church. Faithorne engraved after him.

COOK, ROBERT, *portrait painter.* He also filled the office of Clarencieux in Henry VII.'s reign. He painted the portrait of that King, and of Henry VIII., Queen Catherine, Charles Brandon, Duke of Suffolk, Sir Anthony Wingfield, Sir Robert Wingfield and his lady, with their seven or eight sons. This latter painting was, when Walpole wrote, at Boughton.

COOK, RICHARD, R.A., *history painter.* Was born in London 1784, and entered the schools of the Royal Academy in 1800. In 1832 he received the Society of Arts' gold medal. He first appears as an exhibitor at the Academy in 1808, and in that and the succeeding years, up to 1811, sent landscapes—chiefly compositions; but he also, in 1808, sent two historical paintings to the British Institution—'The Agony of Christ' and 'Hector reproving Paris,' in which latter the Helen introduced was treated with great beauty. In 1812 and the following year his works exhibited at the Academy were portraits; in 1814 he sent 'Acis and Galatea;' in 1816, 'The Lady of the Lake,' and was in that year elected an associate of the Academy. His remaining works were classic—'Ceres disconsolate for the loss of Proserpine;' and, in 1819, after two years' absence from the walls of the Academy, another 'Lady of the Lake;' and though he was elected a full member of the Academy in 1822, he was not again an exhibitor. He possessed an independence, and for many years before his death had relinquished the practice of his profession. He died in Great Cumberland Place, Hyde Park, March 11, 1857. There is by him an illustrated edition of the 'Lady of the Lake' and of 'Gertrude of Wyoming.'

COOK, THOMAS, *line engraver.* He was a pupil of Ravenet, of great merit, and rose to the very top of his profession. In 1771 he received a premium from the Society of Arts. He was employed by Boydell, and executed many works which are much esteemed, both historical and architectural, engraving the figure and landscape. He spent many years of his life in repeating the works of Hogarth, the same size as the originals, which were published under the title of 'Hogarth Restored.' He afterwards reduced these engravings, comprising 160 plates, for Nichols and Stevens's edition of 'Hogarth's Works,' in two volumes 4to. In the 'Gentleman's Magazine' for May 1818 he is stated to have died lately, aged 74.

COOK, J., *engraver.* Practised in the latter part of the 18th century. He engraved some of the illustrations for the editions of Bell's 'Shakespeare,' published in 1774 and 1787. There are also many portraits by him. He was chiefly employed by the booksellers.

COOK, SAMUEL, *water-colour painter.* Was born 1806, at Camelford, where his mother kept a bakehouse. He was taught at the village school, and at the age of 9 was employed in a woollen factory. He was the cause of some annoyance in the factory from his propensity for scribbling, which he afterwards developed into sign painting and scene painting for travelling peep-shows. He then went to Plymouth, where he engaged himself to a painter and glazier, and afterwards commenced business on his own account, devoting all the time he could spare to sketching on the coast and the quays. Gaining notice in the neighbourhood, though of a timid nature, he was encouraged to submit his drawings to the Committee of the New

Water-Colour Society on its foundation in 1830, and was admitted a member. But he continued to carry on his trade, not caring to depend on art alone, though he had attained much excellence. His works were chiefly coast scenes in the neighbourhood of Clovelly and Plymouth—expressed with much quiet, simple truth, and not without some power. His seas were good and well in motion. He died June 7, 1859.

COOKE, GEORGE, engraver. He was born in London, January 22, 1781. His father was a native of Frankfort-on-the-Maine, and burgomaster of the free city, who, coming to London, realised a competency as a large manufacturer of wholesale confectionery. The son was apprenticed at the age of 14 to James Basire; and on the conclusion of his apprenticeship, among much work of a miscellaneous character, he executed many of the plates for Brewer's 'Beauties of England and Wales,' a publication then commenced. He was afterwards engaged on a series of plates illustrating Pinkerton's 'Collection of Voyages and Travels,' a laborious task, which did not lead to much reputation. He contributed three plates to 'The Thames,' a publication commenced by his brother William, which led to their joint publication of 'The Southern Coast of England,' commenced in 1814, completed 1826—a work which was alike memorable from the distinguished painters engaged upon it, its influence upon the art and taste of the day, and its well-merited success. He then published an improved edition of his 'Thames,' for which he engraved himself 'The Launch of the Nelson,' 'The Fair on the Thames,' after Clennel; and 'The Opening of Waterloo Bridge,' after Reinagle. Among works of less importance, he was next engaged upon 'The Iron Bridge at Sunderland,' for Surtees's 'History of Durham;' Bacon's statue at St. Alban's for Clutterbuck's 'Hertfordshire;' and 'Gledhouse, Yorkshire,' after Turner, R.A.—works which may be referred to as specimens of his art. He also engraved some plates for Hakewell's 'Italy,' and for 'The Provincial and Picturesque Scenery of Scotland;' and in the latter work his 'Edinburgh from the Castle Hill,' after Turner, R.A., took a high rank. Among his works of this period may be mentioned five plates and the frontispiece for Allason's 'Pola;' some plates for the Dilettanti Society, and for D'Oyly and Mant's 'Bible.' In May 1817 he commenced, in connection with Messrs. Loddiges, of Hackney, 'The Botanical Cabinet,' for which, up to December 1833, he produced monthly 10 small plates, slight, but accurate and tasteful. In 1825 he finished a fine plate of 'Rotterdam,' after Callcott, R.A., but by the failure of his agent he lost all the profit

96

of this work. He now began a work which he had long projected—'London and its Vicinity;' but he was disappointed by the appearance of a cheaper publication of the same kind on steel, which admitted of larger, though inferior, impressions. In 1833 he engraved the 'Old and New London Bridges' from drawings by his son (Edward W. Cooke, R.A.), who also took a part in the engraving. After a life so actively spent, he died at Barnes, of fever, February 27, 1834, aged 53, and was buried there.

COOKE, WILLIAM BERNARD, line engraver. Was born 1778. Elder brother of the foregoing, and engaged with him in several of his more important undertakings. Was a pupil of Angus, and showed great ability and enterprise. He published several of his own plates, but did not succeed; among them a work on the Isle of Wight. He died of heart complaint, August 2, 1855, aged 77.

COOKSON, THOMAS, engraver. Practised in England. His works bear dates from 1609 to 1624.

COOLEY, THOMAS, architect. Was born in England in 1740, and was apprenticed to a carpenter. In 1763 he received a premium from the Society of Arts. On a competition in 1769 he was selected to build the Royal Exchange in Dublin, a fine work, which he completed in 1779, and then settled there. He was also employed to erect a tower at Armagh Cathedral, but his foundations were bad and it was taken down. He was not more fortunate in the erection of Newgate Prison in Dublin, which was not only defective in construction, but badly planned. He also built the Record Office, the Marine School, the Chapel in the Park, and commenced the erection of the Four Courts, but had only completed the western wing when he died in Dublin, of bilious fever, in 1784, aged 44.

COOPER, ALEXANDER, miniature painter. He was brought up under Hoskins, his uncle. He painted miniatures both in oil and water-colours, and was a good draftsman. He chiefly excelled in water-colour landscapes. He followed his profession in the Low Countries, principally at Amsterdam, and was invited from that city to Sweden, where he was appointed limner to Queen Christina. He practised about 1650–1660.

* COOPER, SAMUEL, miniature painter. Born in London 1609. He was instructed by his elder brother Alexander, and assisted by Hoskins, his uncle. He also improved himself by the study of Vandyck, and reached an eminence in miniature art which has not yet been surpassed. Tender in execution, well drawn and coloured, graceful and expressive, his miniature heads were known extensively on the Con-

tinent, and greatly prized in his own day as in ours. He was an excellent musician and linguist—a man of many attainments. He lived much in France and Holland, and was acquainted with the most eminent men in those countries and in England. He drew Charles II., his Queen, the Duke of York, and most of the Court; also several portraits of Oliver Cromwell. His works are numerous, and eagerly sought after by collectors. He lived, in 1645, on the south side of Henrietta Street, Covent Garden, then very fashionably inhabited. He died May 5, 1672, aged 63, and was buried in 'Pancras Church in the Fields,' where a monument was set over him. His widow, who was the sister of Pope's mother, received a pension from the Crown. Pepys, in his 'Diary,' enlarges upon his friend Cooper's many excellent qualities.

COOPER, EDWARD, *portrait painter*. He practised both as a painter and engraver. He was successful in his portraits, and known also as a dealer. He engraved after Albano and Kneller. A portrait, both painted and engraved by him, is dated 1779. The time of his death is unknown.

COOPER, GEORGE, *architect*. First exhibited at the Academy, in 1792, a design for a villa; in 1794, a design for a church, followed by similar designs in 1795 and 1799. He last exhibited in 1807. Published, in 1805, 'Architectural Reliques,' from drawings made on the spot by himself, and both drew and etched the principal plates for Wade's 'Walks in Oxford.'

COOPER, RICHARD, *engraver*. He was born in Yorkshire, and about 1730 practised in Edinburgh, and was then the only engraver beyond the Tweed. He lived for many years in the Canongate, and in a newspaper of the day is called 'Dick Cowpar.' He had a good knowledge of his art, and practised both as a draftsman and an engraver. His known works are few, chiefly contemporary portraits. He is remembered as the master of Sir Robert Strange, who was apprenticed to him in 1735, and served out a term of six years. He died in Edinburgh in 1764, and was buried in the Canongate Churchyard.

COOPER, RICHARD, *landscape painter*. Son of the foregoing. He is stated to have been born in London. He originally studied under his father in Edinburgh, and was then a pupil of R. Edge Pine. Having inherited some property he went to Italy, where he passed several years in the study of the great masters, and acquired considerable skill as a draftsman and painter. In 1783 he exhibited views of Italy, tinted drawings, and other work at the Spring Gardens Rooms. He afterwards settled in Edinburgh, where he followed

his profession of landscape painter with great success, and built for himself a handsome residence. In 1789 he appears to have returned to London, and in that year exhibited at the Academy 'A View from Richmond Hill,' followed by landscape compositions and drawings. In 1800 he exhibited 'Ruins of Vespasian's Amphitheatre, Rome;' in 1802, 'Solitude;' in 1808, 'Landscape, with Banditti;' and the next year sent his last contribution to the Academy. During this latter period he held the office of drawing-master at Eton School, and was teacher of drawing to the Princess Charlotte. His landscapes are clever—chiefly Italian scenes—loosely, but vigorously handled. He died some time after 1809.

COOPER, RICHARD, *engraver and draftsman*. Born in London about 1730. Studied under Le Bas in Paris, and gained great repute there as an engraver. He signed his name to his works, 'Riccardus Cooper.' They are much esteemed for their correct drawing, grandeur, and brilliancy. Among them are—'The Children of Charles I., with a large Dog,' 1762; 'King William III. and Queen Mary,' 'Frederick, Prince of Wales, and his Sisters,' 'The Virgin and Infant Jesus,' after Coreggio, 1763; 'Rembrandt's Mistress,' 1777. He was living in 1814.

COOPER, ROBERT, *engraver*. Employed in the portrait illustration of Scott's novels; and there are some interesting and characteristic portraits by him for 'Old Mortality,' and some others. He engraved also for Lodge's portraits, and also several private plates for the Duke of Buckingham. He exhibited with the Associated Engravers in 1821, and was living in 1836.

COOPER, WILLIAM, *portrait painter*. He was known as a painter in the first half of the 18th century. An old oil painting on canvas, by a painter of this name, 'Philadelphia from the River,' 7 ft. 9 in. long, was the subject of a communication to the Society of Antiquaries about 1750.

*COOPER, ABRAHAM, R.A., *animal painter*. Was born September 8, 1787, in Red Lion Street, Holborn. His father was a tobacconist, and afterwards an innkeeper. At the age of 13 he was taken from school, and under many hardships began life as an assistant at Astley's Theatre, where he was much employed among horses. When about 22 years of age he made his first attempt in art, and painted with great success a favourite horse belonging to Sir Henry Meux. This encouraged him to continue. He was employed to draw portraits of horses for the 'Sporting Magazine,' and in 1812 was an exhibitor at the British Institution. In 1814 he sent his 'Tam O'Shanter,' and on a competition in 1816 the directors awarded him a premium of 150 guineas

for his finished sketch of 'The Battle of Ligny;' at the same time he was also a contributor to the Water-Colour Exhibition. He had now gained an assured position in art, and in the following year he was elected an associate of the Royal Academy. In 1819 he exhibited his 'Battle of Marston Moor,' which greatly increased his reputation. He was esteemed the best battle-painter of the day, and in 1820 reached his full honours as a member of the Academy. He was from this time a constant exhibitor at the British Institution and the Academy, contributing his last work to the latter in 1868, when he accepted the newly created distinction of 'honorary retired academician,' but did not long survive the practice of his art. He died at Greenwich, December 24, 1868, and was buried in Highgate Cemetery. He had studied carefully the horse and its anatomy, and had a good antiquarian knowledge of arms of offence and defence. His works were of small size, spirited and truthful in their composition and execution, but flat and leaden in colour. They were very popular, and many were engraved.

COPLEY, JOHN SINGLETON, R.A., *history painter*. Born July 3, 1737, at Boston, United States, then a British Colony, of Irish parents, immediately after their arrival there. He showed an early love for drawing, and, out of the reach of instruction, was self-taught. His first works were portraits and domestic groups. In 1760 he sent a picture—his 'Boy with a Squirrel'—to London for exhibition, and for several years continued to send his works to the exhibitions of the London artists. In 1767, while living at Boston, he was, on the proposal of Benjamin West, elected a fellow of the Society of Artists in Great Britain, and in expressing his great sense of this honour, he said: 'I cannot but reflect upon my present situation, which utterly deprives me of every opportunity (but what nature has furnished me with) of aiding in this laudable work, the promotion of the arts.' Zealously pursuing his art, he found good employment in portraiture at Boston, and was saving money; but restlessly desired to visit Europe, and in 1774 set sail for England, and from thence started for a Continental tour, his first aim being to see Rome, which he reached about the end of the same year. Towards the end of 1775 he returned to London, where he eventually settled. He first resided in Leicester Fields, and in 1776 exhibited 'A Conversation' at the Academy; the following year, 'A Family,' whole-length, with some other portraits; and in 1778, 'A Boy attacked by a Shark,' and a whole-length family-group.

He was now in the full practice of his art, which was essentially portrait. He

had been elected an associate of the Academy in 1776, and in 1779 gained his full membership. He had just completed his great work, 'The Death of Chatham,' a fine composition, which added largely to his growing reputation. His next work was 'The Death of Major Pierson,' again finding his subject in a great incident of the day, and confirming the fame he had already acquired. In both these works the principal figures were portraits, and with all the accessories were rendered with great truth. They both happily find a place in our National Gallery. He then attempted an historical incident, 'Charles I. demanding in the House of Commons the five Impeached Members.' In this he grouped no less than 58 of the most celebrated personages of the Revolution, and took great pains to portray them after the best authorities. These three pictures were highly popular, were engraved, and large numbers of impressions immediately sold.

Another recent event of great historical importance was then the subject of his pencil. He was commissioned by the Corporation of London to paint to a large scale 'The Repulse and Defeat of the Spanish Batteries at Gibraltar.' In this he introduced the portrait of Lord Heathfield, and also the portraits of the principal officers who commanded at the siege, and with his love of accuracy he went to Hanover to sketch the heads of the German officers who formed part of the garrison. Of his other works of an historical character the principal are—'King Charles signing Strafford's Death-warrant,' 'The Assassination of Buckingham,' 'The Battle of the Boyne,' 'King Charles addressing the Citizens of London,' 'The five Impeached Members brought back in Triumph,' and 'The King's Escape from Hampton Court.' Of his portrait compositions, a group of the 'Royal Children playing in a Garden,' which is now at Windsor Castle, must be mentioned as one of the most attractive.

In his historical subjects, little influenced by his study in Italy, Copley was original and simple in composition and treatment; his drawing was good and intelligent, and the scene treated with great nature and individuality. In his best portraits his action, colour, and expression were appropriate, and he showed a nearer approach to Reynolds and Gainsborough than any of his contemporaries. He had, soon after 1780, removed to George Street, Hanover Square, and there, after a long residence, he died, on September 9, 1815. He was buried at Croydon Old Church. He was the father of Lord Chancellor Lyndhurst.

CORBETT, ——, *portrait painter*. Born in Cork, he was a pupil of Barry, R.A., and practised portrait painting for a time

in London. On his return to his native city he found good employment. His portraits showed some power. He died, in neglect and indigence, at Cork, February 20, 1815.

CORBOULD, RICHARD, *portrait and landscape painter*. He was born in London, April 18, 1757. His genius gave a wide range to his art. He painted, both in oil and water-colours, portraits and landscape, with a few historical subjects. His time was divided between painting on porcelain and miniatures in enamel and on ivory. He was also much employed on book illustration, in which he excelled. His style of painting varied greatly, and he showed great ability in imitating the manner of the great masters, both of the old school and our own. He first appears as an exhibitor of 'Fruit' in 1776, at the Free Society of Artists, followed by a miniature at the Royal Academy in 1777. He was then living in Moorfields, and from that year continued to exhibit at the Academy, his contributions being chiefly landscape views and landscapes with figures, and occasionally a portrait. In 1793 he sent to the exhibition 'Cottagers gathering Sticks;' in 1797, 'A Subject from a Sonnet;' in 1802, 'Eve caressing Adam's Flock' and 'The Angel Michael;' in 1806, 'Ulysses's descent into Hell;' in 1808, 'Hannibal passing the Alps' with his Soldiers,' with, in most of these years, landscapes also. In 1811 he exhibited for the last time. He died at Highgate, July 27, 1831, and was buried in the parish ground of St. Andrew's, Holborn, Gray's Inn Road.

CORBOULD, GEORGE JAMES, *engraver*. Second son of the above. He was born April 27, 1786, and was a pupil of James Heath, A.E. He practised in the line manner. Some of Smirk's 'Illustrations of Shakspeare,' which he engraved, are fair representations of his art. He died November 5, 1846.

CORBOULD, HENRY, *historical painter and draftsman*. Third son of the above. Was born in London, August 11, 1787. Studied under his father and in the schools of the Royal Academy, where he gained a silver medal. He commenced as an exhibitor in 1807; his first contributions were classic. In 1808, 'Coriolanus;' in 1809, 'The Parting of Hector and Andromache,' 'Thetis comforting Achilles,' with other designs. In 1811 he exhibited designs from the 'Lady of the Lake,' followed by designs from 'Rokeby,' and was at this time engaged in designing for book illustration. But, having attained great purity of drawing, his chief occupation was in drawing from antique marbles. He was selected, on the highest authority, as the artist most competent to be employed in

making the drawings, for the purpose of engraving, of the Elgin and other marbles in the British Museum. This work, upon which he was employed nearly 30 years, was placed entirely in his hands, as was also the nomination of the engraver for each plate. He drew also, for engraving, from the Duke of Bedford's collection and Lord Egremont's collection, and likewise occasionally for the Dilettanti Society, and the Society of Antiquaries. He continued to exhibit from time to time at the Academy up to 1840. Suddenly attacked with apoplexy, when riding up from St. Leonard's, he died at Robertsbridge, December 9, 1844, and was buried in Etchingham Church, Sussex.

CORBUTT, CHARLES, *mezzo-tint engraver. See* PURCELL, RICHARD.

CORDEN, WILLIAM, *china painter*. Was born at Ashbourne in 1797, and was employed in the Derby China Works. He excelled in portraits and flowers. He was sent to Rosenau, Coburg, by the Queen, to copy some portraits for her Majesty. He died at Nottingham in 1867.

CORNELIS, LUCAS, *portrait painter*. Was born at Leyden 1495, and came with his family to England on the invitation of Henry VIII., who appointed him his painter. His art had great merit, and was much esteemed. He is reputed to have taught Holbein, when in England, to paint in water-colours. He died in England, it is supposed, in 1552.

CORNER, JOHN, *engraver*. He engraved in line and published, in 1825, 'Portraits of Celebrated Painters.' This work was rather tastefully arranged, grouping in a small medallion the most celebrated work of each painter with his portrait; but the heads were ill drawn, weak, and ineffective, and the work, intended to be a serial, only extended to 25 portraits.

CORNER, PETER, *portrait painter*. Practised in the beginning of the 18th century. Some of his works are engraved.

COSTELLO, LOUISA STUART, *miniature painter*. She was of an old family, the daughter of Colonel Costello, and born 1799. For many years she lived in France, and about 1820 came to London to practise miniature painting, which she had studied. She exhibited at the Academy in 1822–23 and 1825, and does not appear again till 1833, continuing yearly an exhibitor to 1839. She was so far successful as to be able to assist her mother and to maintain a brother at Sandhurst College; but she at the same time tried literature, and became best known as an author. She published, in 1825, 'Songs of a Stranger;' then 'Specimens of the Early Poetry of France,' followed by several works on France and French manners; and the 'Rose Garden of Persia,' for which she herself drew the

illustrations. She retired to Boulogne upon a small literary pension, and died there of virulent cancer, April 24, 1870.

* COSWAY, RICHARD, R.A., *miniature painter.* Was born 1740, at Tiverton, where his family had been long settled, and his father was master of the public school. He early showed great ability in drawing, and was sent to London as the pupil of Hudson, and also became a student in Shipley's school. He received a premium for drawing in 1755 at the Society of Arts. He began his career by drawing heads for the shops and fancy miniatures—sometimes licentious in character—for snuff-boxes, and soon made himself known as a portrait miniaturist. He was a member of the Incorporated Society of Artists in 1766, and was admitted a student of the Royal Academy in 1769. In the following year he was elected an associate, and in 1771 a full member of the Royal Academy. His career was rapid; he had obtained a good knowledge of the figure, and was a refined and powerful draftsman. His miniatures were not only fashionable, but the fashion itself. He drew small whole-lengths of the courtly beauties of his day in black-lead pencil, in an elegant easy style quite his own—the faces painted in miniature, and frequently highly finished. His miniatures on ivory are exquisite for their beauty and grace, and are highly esteemed. He painted the lovely Mrs. Fitzherbert, and gained the favour and even the intimacy of the Prince of Wales. The beauties of the prince's coterie sat to him, and he enjoyed the full tide of royal favour and good fortune which his art truly merited. He occasionally produced a work in oil. Some angels' heads in this medium are admirable for their pure ideal beauty. He was only an occasional exhibitor at the Academy, and sent his last work in 1806. He gave one of his best works in oil to the parish church of his native town. His portraits have been engraved by Bartolozzi, R.A., and by Valentine Green and others.

Cosway was mean in person. He assumed great airs; his vanity led him to deck his portrait, *ipse pinxit*, in the most extravagant costume. His studio was most interesting, filled with the choicest specimens of art and virtu—in which he was not unwilling to deal—and he was in the habit of purchasing old pictures, which he repaired and sold. He left a very large collection of drawings. He married, at St. George's, Hanover Square, 1781, Maria Hadfield, a handsome, clever woman, and an artist. Together they kept a sumptuous house, lived in great style on the verge of Carlton House Gardens, and afterwards in Stratford Place. They affected high society; the prince was their visitor, and they made themselves the wonder and whisper of the

100

town—the bitter mark for satirists and caricaturists. Cosway's eccentricities and vanities were increased by his success. He believed in Swedenborgianism and in animal magnetism; and whether he played the charlatan, or felt himself inspired—most probably the former—he professed his ability to raise the dead; and asserted to Miss Coombe, his niece, that the Virgin Mary had appeared to him, and had sat to him several times for a half-length figure of the Virgin which he had just finished. He had for some time retired from the practice of his profession. He died while taking an airing in his carriage, July 4, 1821. He desired to be buried near Rubens, at Antwerp, but rests in the vaults of the new church, St. Marylebone, where there is a tablet to his memory.

COSWAY, MARIA CECILIA LOUISA, *subject painter.* Wife of the foregoing. She was the daughter of an Irishman named Hadfield, who kept an hotel at Leghorn, and was born in Italy. She was educated in a convent and studied art in Rome; on her father's death she came to England, and, for a time at least, painted miniatures professionally. She also painted many subject pictures, and was a contributor both to Boydell's 'Shakespeare Gallery' and Macklin's 'Poets.' She drew in chalk 'The Progress of Female Dissipation' and 'The Progress of Female Virtue.' Her 'Going to the Temple' was engraved by Tomkins. She etched some figures after Rubens. In early life she had been betrothed to Dr. Parsons, the composer, but in 1781 she married Richard Cosway, R.A. In the same year she was first an exhibitor at the Royal Academy, and continued to exhibit up to 1801. Her subjects were mostly of a classic character, with now and then a portrait. She is reputed to have maintained her own family by her art.

She was in her day a notoriety, and was the subject of much hostile remark. She is said to have run away from her husband. She was certainly long separated from him, and at the beginning of the century was living apart at Paris in much luxury, while she was copying some works at the Louvre for engraving. She made a pilgrimage to the Shrine of the Virgin at Loretto in fulfilment of a vow to do so if blessed with a living child. Walpole mentions, in an unpublished letter, her great grief and her avoidance of all society on the loss of her daughter, which was probably the cause of her retiring in 1804 to a religious seminary at Lyons, of which she became the superior, and is described as occasionally preceding her pupils to the Cathedral with a long ivory cross in her hand, and draped in a sky blue robe spotted with velvet stars. She was living in 1821, and was in London in that year on the death of her husband;

Cousins. Samuel. Mezzotinto Engraver b1801-d1887
 " Henry - - - Do - - -

but returning again to Lyons is believed to have died there. Nagler gives a long description, in the most stilted language, of her personal charms, her works, and her talents, and says the English galleries are full of her exquisite works. She certainly possessed great talent as a musician, and excelled as an artist. There are some etchings by her, but in outline only, of a number of her husband's works. 'The Progress of Female Virtue' by her was published in 12 plates, 1800. *at Jools 1823*

• COTES, FRANCIS, R. A. *portrait painter.* He was the son of the mayor of Galway, who, on some political dispute, came to settle in London about 1720, and practised as an apothecary in Cork-Street, Burlington Gardens. Here the painter was born in 1726, and commenced the study of art as the pupil of George Knapton. He became eminent for his portraits in crayons, and also painted in oil with much ability. He was a member of the Incorporated Society of Artists, and one of the foundation members of the Royal Academy. He painted, in 1767, 'Queen Charlotte with the Princess Royal' on her lap' — a pleasing portrait which was well engraved by Ryland. He was in considerable practice, and for a time had so great a run that fashion followed him from London to Bath, and back again. He drew well, sketched his subject freely, and was agreeable in his colouring. He occupied the house 32 Cavendish Square, afterwards tenanted by Romney, and then by Sir Martin Shee, P. R. A. He died there on July 20, 1770, in his 45th year, having imprudently taken soap-lees as a cure for stone, to which he was a martyr, and was buried at Richmond. His presentation picture to the Royal Academy—a portrait of his father—is a good specimen of his abilities. There is a full-length portrait by him of Admiral Lord Hawke in the gallery of Greenwich Hospital ; but a portrait-group of Mr. and Mrs. Joah Bates, in the possession of the Sacred Harmonic Society, is one of the best examples of his art in oil—well grouped, and solidly and carefully painted. His prices for portraits were —three-quarters, 20 guineas ; half-length, 40 guineas ; whole-length, 80 guineas. His draperies were mostly painted by Toms.

COTES, SAMUEL, *miniature painter.* Younger brother to the foregoing. He was brought up to medicine, but quitted that profession, stimulated by his brother's success in art, and was assisted by him in the study of painting. He was a member of the Incorporated Society of Artists. His works in crayons were much esteemed, and in miniature, both enamel and on ivory, he ranked among the first of the day. He exhibited miniatures at the second Royal Academy Exhibition in 1769, and continued an occasional exhibitor. He married

a Miss Shepheard, who had great talent for painting, and who died 1814. He had quitted the profession for many years, when he died in Paradise Row, Chelsea, March 7, 1818, aged 84.

• COTMAN, JOHN SELL, *landscape and marine painter.* Was the son of a silk-mercer at Norwich, and born there June 11, 1782, and educated at the City Free School. He was intended for his father's business, but his early love of art prevailed, and he came to London, where he remained from 1800 to 1806, and during that time he was an exhibitor, chiefly of Welsh views, at the Academy, and frequented the well-known artists' meetings at the house of Dr. Monro. In 1807 he was living at Norwich, and became a member and the secretary of the Norwich Society of Artists. He then styled himself a portrait painter, and in that and the following years was a large contributor to the Society's Exhibitions, sending no less than 67 works in 1808. He afterwards lived for some time at Yarmouth, and having now a wife and young family, he added to his means by teaching drawing. In 1811 he commenced a publication by subscription of his 'Architectural Etchings ;' and in 1816 his 'Specimens of Norman and Gothic Architecture, Norfolk Churches,' &c. ; and in 1817 he accompanied Mr. Dawson Turner, the antiquary, on a tour to Normandy, and again visited that country in 1818 and 1819. In these two years he completed his 'Etchings illustrating the Architectural Antiquities of Norfolk,' and his 'Engravings from Sepulchral Brasses, Norfolk'—works which had been for several years in progress, and which are more antiquarian than artistic in their character. The result of his visits to Normandy appear in the illustrations to Dawson Turner's 'Architectural Antiquities of Normandy,' published in 1822.

Though at that time residing in Norwich, he was in 1825 elected an associate exhibitor of the Water-Colour Society ; and was from that year a constant contributor to the Society's Exhibitions. His works were—'Views in France and Normandy,' 'Fishing-boats off Cromer,' 'Vessels off Yarmouth' (where he found many of his favourite subjects), landscape compositions, and some sketches of figure subjects. In 1834 he was appointed drawing-master to King's College School, and then removed to London. Here his health began to decline. He had long been subject to great nervous depression, which became more severe, and gradually terminated in loss of reason. He died in London, July 28, 1842. He painted in water-colour and oil, excelling in both. His light and shade were good, the masses broad and simple ; the details in water-colours frequently added with a reed pen ; his colour

rich, but a hot yellow predominates; his figures were well placed, and the details of his architecture well understood; his treatment of the subject highly artistic; but many of his works are only slightly or half finished. His son JOHN COTMAN, who also practised art, died in Norwich in 1878.

COTMAN, MILES EDMUND, *water-colour painter*. He was the eldest son of the foregoing, and was brought up an artist. He exhibited at Suffolk Street, in 1835–38 and 1841, river and sea views, both in oil and water-colours, and at the Academy in 1850 and 1851. He succeeded his father as drawing-master to King's College, and was chiefly occupied as a teacher. He died January 23, 1858, aged 47.

COTTINGHAM, LEWIS NOCKALLS, *architect*. Born October 24, 1787, at Laxfield, Suffolk, of a highly respectable family. He was apprenticed to a builder at Ipswich, and after several years, feeling a talent for art, he came to London, and placed himself under a skilful architect and surveyor. In 1814 he commenced his professional career. He gained the appointment of architect to Rochester Castle in 1825, and carried out some extensive works, including a new central tower. In 1829 he was the successful competitor for the restoration of the exterior of the chapel of Magdalen College, Oxford; and in 1833 he was entrusted with the repair of St. Alban's Abbey Church. The successful execution of these works gave him a reputation as a Gothic architect, and he was employed to restore the cathedral of Armagh, the greater part of which he rebuilt, an undertaking which occupied several years, and gave room for his constructive and mechanical skill. He zealously promoted the restoration of the Lady Chapel of St. Saviour's, Southwark; and in 1840 he promoted and afterwards assisted in the restoration of the Temple Church. He made important restorations at the church of St. James's, Louth; St. Mary's, Bury St. Edmund's; Ashbourne, Chelmsford, and many other churches. He was also employed on works at several country mansions. His last work was upon the restorations of Hereford Cathedral. He published several works on Gothic architecture, of which the chief are 'Plans, Elevations, and Sections of Henry VII.'s Chapel at Westminster,' 1822–29; 'Working Drawings for Gothic Ornaments,' and 'The Smiths and Founders' Directory: Designs for Ornamental Metal-work,' 1824. He made a valuable collection of architectural antiquities at his residence in the Waterloo Road, Lambeth, where he died October 13, 1847. He was buried at Croydon Church.

COUSE, J., *engraver*. Supposed born in England. Practised here about 1750. His works are but little known. Strutt says

some views which he engraved prove him to have been no indifferent artist.

COUSE, KENTON, *architect*. Was one of the surveyors of the Board of Works. He designed Botley House, Chertsey; the church of St. Paul, Clapham Common; and the bridge over the Thames at Richmond. Died October 10, 1790, aged 70.

COWEN, W., *landscape painter*. His name first appears as an exhibitor of some clever Irish landscapes at the British Institution in 1823. In the following year he was living in London, and then sent to the Academy some Swiss and Roman views in oil. He continued to exhibit Swiss and Italian scenes up to 1836, and in 1839 exhibited a view in Normandy, after which he ceased to exhibit. He published, in 1824, six views of Italian and Swiss scenery made 1819–22.

COWPER, DOUGLAS, *subject painter*. His father was a merchant at Gibraltar, where he was born May 30, 1817. He showed an early talent for drawing. His family disapproved, but, out of the reach of instruction or examples, he persevered, and on his 17th birthday set out for London, and after a short study was admitted to the schools of the Royal Academy, and gained the silver medal for the best copy in the painting school. In 1837 he exhibited —his first time—'The Last Interview' and a portrait; in 1838, 'Shylock, Antonio, and Bassanio;' and in 1839 his best work, 'Othello relating his Adventures,' and a 'Capuchin Friar.' In the same years he exhibited in Suffolk Street 'Ailsey Gourlay and Lucy Ashton,' 'The proposed Elopement,' 'The Last Farewell,' 'Kate Kearney,' and at the British Institution a subject from 'Taming the Shrew.' At this time his health failed; he was consumptive. He visited his family, who were at that time in Guernsey, and then tried the South of France; but his malady increased, and he only was able to reach Guernsey to die there on November 28, 1839; an artist of great promise prematurely cut off.

* COX, DAVID, *water-colour painter*. Was born April 29, 1783, at Birmingham, where his father was a blacksmith, and owed much to the early religious training of his mother. He was of too delicate a constitution to follow his father's trade; and laid up by an accident, a box of colours given for his amusement was the source of unceasing pleasure, and led to his being placed for instruction under an artist in the neighbourhood. He was afterwards apprenticed to a locket painter, and was attaining much proficiency, when at the end of 18 months, he lost his master, and not readily finding other employment in art, to which he clung, he engaged to prepare the colours for the scene painters at the Birmingham Theatre, and from his habits of observation

gained a knowledge of their art and its processes, and was soon employed to carry on the less important parts of the scene painters' work. He remained four years with the Birmingham company; travelled with the manager to Leicester and other places, coming on the stage when required in a subordinate character. Meanwhile, this employment aroused in him a love for landscape, and laid the foundation for some of the finest qualities of his future art.

Moving from place to place with the company, the unsettled life had become very distasteful to him, and he came in 1803 to London, where he gained employment in the scene-loft of Astley's Theatre. Attracted by the sight of some water-colour drawings, he determined to try that art, which was then making great progress. He fortunately made the acquaintance of John Varley, who gave him access to his studio, and he soon made such progress in the new art as to enable him to leave the scene-loft. He added to his means by teaching, and during his long art career was distinguished as a teacher. In 1805 he made his first visit to Wales, and on his return exhibited some drawings from Welsh scenery. Residing on Dulwich Common, he improved in his art by the diligent study of the surrounding scenery, and learnt to render the varied effects of nature and the aspects of morning, noon, and close of day. In 1813 he was elected a member of the Society of Painters in Water-Colours, and was a large contributor to the Society's Exhibitions. He was in the following year appointed a teacher at the Military College, Bagshot, but the duties were unsuited to his disposition, and he resigned after a few months, and in 1815 went to reside at Hereford, where he lived till 1829, usually visiting the Metropolis in the spring to keep up his acquaintance with art and his brother artists.

From his admission to the Water-Colour Society to the year of his death he was a constant exhibitor, contributing a very large number of works. His drawings were chiefly from the scenery of his own country. He was fond of the Thames, and painted many views on that river—the vessels and the scenery of its banks; also views of the Metropolis from the surrounding heights, the operations of husbandry, ploughing being a favourite subject. He painted the mountain scenery of Wales and Scotland, and the grand gloom of their passes, with great effect; and in 1829 extended his range of subjects to the Continent, choosing his subjects on the coasts and in the market-places of Antwerp, Brussels, and the crowded bridges of Paris, which he peopled with clever groups. At this time he returned to the Metropolis, and taking a house at

Kensington, resided there till 1840, when he retired to Harborne, a village near his native town; and tired of teaching and exhibitions, devoted himself almost entirely to painting in oil. He died June 7, 1859.

He will always take very high rank as a water-colour painter. His manner was peculiar to himself. His fluent brush and liquid tints gave great richness. He was intent upon obtaining the exact tone and colour of nature rather than in defining form, and his drawing is loose. His light and shade are good, his keeping excellent, and his figures and cattle admirably placed. He produced a highly artistic generalised treatment of nature, with great breadth, luminous freshness, and breezy motion. Many of his works are highly imaginative, and impressed with the truest sentiment. His sparkle of our English summer in shower and sunshine has never been surpassed. His latter works in oil were little seen in London. He published, in 1816, 'A Treatise on Painting in Water-Colours,' and had prepared 100 drawings in sepia for publication, but the work was not proceeded with.

COZENS, ALEXANDER, *water-colour painter*. He was a natural son of Peter the Great, by an Englishwoman from Deptford, who accompanied the Czar on his return to Russia, where he was born. He was sent by the Czar to Italy to study painting; and some studies he then made, and lost during his journey, are now possessed by the British Museum. They are of much interest, drawn with the pen with great minuteness and care, excellent in taste and composition. From Italy he came to England in 1746, and settled here as a landscape painter, but was chiefly occupied in teaching. He was a member of the Incorporated Society of Artists, a contributor of landscape drawings to the Spring Gardens Exhibitions; from 1763 to 1768, he held the office of drawing-master at Eton School, and gave some lessons to the Prince of Wales. He practised some time at Bath, where his teaching was popular. He affected a plan of splashing a china-plate with colour, and then instructing his pupils to work the chance blot impressed from it into a landscape composition, and published a small tract explaining this method. He also published 'The Principles of Beauty, in relation to the Human Head,' with engraved illustrations by Bartolozzi, 1778; 'The various Species of Composition in Nature,' and 'The Shape, Skeleton, and Foliage of Thirty-two Species of Trees,' 1771, reprinted 1786. He was a frequent exhibitor at the Royal Academy between 1772 and 1781; and Banks, R.A., the sculptor, exhibited, in 1783, 'Head of a majestic Beauty, composed on Mr. Cozens's Principles.' He

married a daughter of Robert Edge Pine, the painter, by whom he left one son. He died in Duke Street, Piccadilly, April 23, 1786.

COZENS, JOHN ROBERT, *water-colour painter*. He was the son of the foregoing, and was born in England in 1752. Little is known of his early teaching, but he probably learnt his art from his father. He first exhibited at the Spring Gardens Exhibition in 1767, and sent his only contribution to the Royal Academy in 1776, when he was in Italy studying—'A Landscape, with Hannibal, in his March over the Alps, showing his army the fertile plains of Italy.' He was taken to Italy by Mr. Beckford, who employed him, and was the first British artist who successfully painted in water-colours the romantic scenery of that country. He returned in 1783, having while there made many studies and acquired qualities and modes of treatment which peculiarly belong to water-colour art. Thus he was the immediate predecessor of Turner and Girtin, and the first who produced those atmospheric effects which are the charm of his works as of theirs. His works are little more than tinted chiaroscuro, thinly washed with colour. He compounded his cloud tints and those for his distant mountains of Indian red; for his middle distance he used a small portion of lake with indigo and yellow ochre; his foregrounds principally of black and burnt umber; his distant trees were tinted with warm washes, which he used for the sky, and those nearer with yellow ochre and indigo, enriched with burnt sienna, using the same with greater power in the foreground. With these simple materials, which were all that could be procured by the water-colour painter of his day, he produced works of the highest poetry and beauty. Constable, R.A., said 'his works were all poetry,' and in enthusiastic admiration pronounced him 'the greatest genius that ever touched landscape.' Leslie, R.A., said 'he had an eye equally adapted to the grandeur, the elegance, and the simplicity of nature, but loved best her gentlest and most silent eloquence;' and again, 'pensive tenderness forms the charm of his evening scenes.' It is sad to tell of one so gifted that he became deranged in 1794. He was generously attended by Dr. Monro, and supported by Sir George Beaumont; and in this state he died in 1799. The drawings he made for Mr. Beckford—chiefly views in the neighbourhood of Rome and in other parts of Italy—were sold at Christie's in 1805. They were 94 in number, and produced 510*l.*, then considered a large sum.

CRADOCK, LUKE, *still-life and animal painter*. Was born at Sumerton, near Ilchester, about 1660, and was apprenticed to a house-painter in London with whom

he served his time. Self-taught, he became a skilful painter of still-life, birds and animals, his works possessing great freedom and spirit. He was not appreciated in his lifetime, but after his death his pictures realised greatly enhanced prices. He died in London in 1717, and was buried at St. Mary's, Whitechapel.

CRAFT, WILLIAM, *enamel painter*. He practised in enamel towards the end of the 18th century, and was employed in the Porcelain Works at Bow. He first exhibited at the Royal Academy, in 1774, a portrait in enamel, with several subject pieces. In 1778 he exhibited, in enamel, 'Boy on a Lion' and 'Cupid Meditating,' and continued an exhibitor till 1781. He produced some large works in enamel, which were very good in the manipulation of his material, but very weak in art.

CRAIG, JAMES, *architect*. He was a pupil of Sir R. Taylor, and practised with much reputation in Edinburgh. He designed Princes Street and George Street, parts of the new town, the Physicians' Hall, and some other public buildings. He was a nephew of Thomson, the author of 'The Seasons.' He died June 23, 1795.

CRAIG, WILLIAM MARSHALL, *miniature painter*. Said to have been brother to the above. He was painter in water-colours to the Queen, and miniature painter to the Duke and Duchess of York. He first exhibited at the Academy in 1788, and was then residing in Manchester. About 1791 he had settled in London, and in that year exhibited two figure subjects. In the following year he commenced as a miniature and portrait painter, occasionally exhibiting rustic figures, landscape views, and domestic scenes. In 1814 he exhibited a collection of his water-colour drawings in Lower Brook Street. After 1821 his contributions were few, and ceased in 1827. He made much of the engraver's drawings for 'The British Gallery of Pictures,' a serial publication commenced in 1808, and is well known as a draftsman on wood and book illustrator. His drawings in water-colour have much careful finish, and though frequently tame and mannered, some of his illustrations are not without merit. He published, at the beginning of the 19th century, 'A Wreath for the Brow of Youth,' for which he designed the illustrations; 'An Essay on the Study of Nature in Drawing,' 1793; 'The Complete Instructor in Drawing,' 1814; 'The Sports of Love,' in six poems, 1818; and 'Lectures on Drawing, Painting, and Engraving,' 1821.

CRANCH, JOHN, *amateur*. Was born at Kingsbridge, Devon, October 12, 1751. Self-taught, as a boy he made great progress in drawing, writing, and music. He first found employment as a clerk at Axminster, and received some kind instruc-

tion from a Catholic priest. He then went into the office of an attorney, who on his death left him 2000l. With these means he came to London, where he was noticed and befriended by Sir Joshua Reynolds. He painted portraits and sometimes tried history, but was unable to secure a place on the walls of the Academy, often suffering the rejection of his works; but a 'Death of Chatterton' gained him some notice, and gave a promise which was not fulfilled. He excelled in what were called 'Poker pictures.' He lived many years at Bath, and died unmarried in that city in February, 1821, aged 70. He published a work—'On the Economy of Testaments,' 1794; and wrote 'Inducements to Promote the Fine Arts of Great Britain.'

CRANE, FRANCIS. A skilful artist, founded a manufactory of tapestry at Mortlake in Surrey, in the reign of James I. This manufactory was patronised by the King, and afterwards by Charles I., for whom were wrought a great number of hangings, remarkable for the beauty of their execution. He died in 1703.

CRANE, THOMAS, portrait painter. Born at Chester 1808. Assisted by some friends he came to London in 1824, and was admitted to the schools of the Royal Academy. After two years' study he returned to Chester, and at the age of 18 commenced practice as a miniature painter. In 1832 he exhibited his first work at the Liverpool Academy, and was soon after made an associate, and in 1830 a member of that society. Then marrying, he came to London, but was compelled by weak health to leave the Metropolis, and he tried Leamington and some other places. Improved in health, he came again to London in 1844, and again compelled to leave, he settled at Torquay, where he remained 12 years; and in 1857 he removed to Bayswater, but his health again failed, and gradually sinking, he died there in July 1859. He painted some domestic subjects—'The Deserted Village,' 'The Cobbler,' 'Masquerading'—and was an occasional exhibitor at the Academy. Though successful in his portraits, both in oil and water-colours, his reputation was only provincial, and his works were little known in the Metropolis.

CRANKE, JAMES, portrait painter. He practised in London, where he enjoyed some repute, about 1750; and was from 1775 to his death an occasional exhibitor at the Royal Academy. He died at Urswick, near Ulverston, in 1780, aged 73.

CRAWFORD, WILLIAM, A.R.S.A., portrait and subject painter. He was born at Ayr, N.B. He studied his art at the Trustees' Academy, Edinburgh, where he was a pupil of Sir William Allan, made good progress, and gained a travelling studentship, which enabled him to continue his study for several years in Rome. On his return to Scotland, he conducted the drawing classes in the Trustees' Academy till 1835. He painted portraits and small subject pictures, and his small crayon portraits were much esteemed. He was elected an associate of the Royal Scottish Academy in 1862. Settled in Edinburgh, he was from 1853 a frequent exhibitor almost exclusively of portraits, at the Royal Academy in London. He is best remembered by his 'Highland Keeper's Daughter,' 1865; 'More Free than Welcome,' 1867; and 'Return from Maying.' He died, after a short illness, August 2, 1869.

CREED, CAREY, engraver. He drew and etched a number of plates, in a slight but clever manner, in illustration of the statues and busts at Wilton, which he published in 1731.

CREED, Mrs. ELIZABETH, amateur. Was the only daughter of Sir Gilbert Pickering, Bart., and cousin to the poet Dryden. She was born in 1642. She married a county gentleman of Oundle, and on his death employed herself in painting, and gratuitously instructed young females in fine needlework and other elegant arts. Many churches in the neighbourhood of Oundle were decorated with altar-pieces and other works by her hands. There is a portrait by her of the first Earl of Sandwich at Drayton; and her descendants possessed many other portraits and some pictures painted by her. She died in May 1728. Her daughter, who became Mrs. Steward, had like artistic tastes, and decorated the hall of an Old Tudor house near Oundle, but her work no longer remains.

CREGAN, MARTIN, R.H.A., portrait painter. He was one of the members of the Royal Hibernian Academy on its incorporation in 1823. He practised both in Dublin and in London. He was residing in London in 1812, and in that year, and yearly up to 1821, when he contributed a portrait of Miss Dance as 'Mrs. Haller,' was a constant exhibitor at the Royal Academy. In the following year he returned to Dublin, where he had some sitters of distinction.

CRESWICK, THOMAS, R.A., landscape painter. He was born at Sheffield, February 5, 1811, and gained some early knowledge of art in Birmingham, where he was a pupil of Mr. J. V. Barber. In 1828 he came up to London, where he settled, and at once commenced as an exhibitor at the British Institution and the Royal Academy. His first works were chiefly Welsh scenes, followed by some views in Ireland. After 1840 he found his best subjects in the North of England, selecting with great taste the many beautiful passages which

Crane - Walter - b 1845

occur in the domestic scenery, and realising their details with great truth. His art early became popular. In 1842 the directors of the British Institution awarded him a premium of 50 guineas for the general merit of his works, and in the same year he was elected an associate of the Royal Academy. The subjects he loved to paint may be conceived by the titles he gave them. Thus, on his election he exhibited, 'The Old Foot Road;' in 1846, 'The Hall Garden' and 'The Pleasant Way Home;' in 1849, 'A Glade in the Forest;' in 1851, when he was elected to his full membership, 'The Valley Mill' and 'Over the Sands;' in 1854, 'The Blithe Brook;' in 1859, 'The Village Bridge;' in 1861, 'In the North Countrie;' in 1864, 'Across the Beck.' He painted several works in conjunction with his friend R. Ansdell, R.A. His health and vigour had been for some time failing, but he continued to exhibit, usually three or four pictures, each season. He had for many years lived in Linden Grove, Bayswater, but his house being disturbed by a new railway line, he built himself a residence in the Grove, which his rapidly declining health scarcely permitted him to enjoy, and he died there December 28, 1869. He was buried at the Kensal Green Cemetery. He painted the homely scenery of his country, especially its streams, in all its native beauty and freshness; natural, pure, and simple in his treatment and colour, careful and complete in his finish, good taste prevailing in all his works, and conspicuously so in his charming contributions to the works of the Etching Club, of which he was a valued member, and also in his many designs on wood.

CRISTALL, JOSHUA, *water-colour painter.* Was born at Cambourne, in Cornwall, in 1767. His father was a native of Scotland, and the master of a small trading vessel. An early love of art, which he secretly pursued, was opposed by his father; and on the family coming to settle in Rotherhithe, he was apprenticed to a china-dealer. Hating this business he left it, and also his home, before the completion of his apprenticeship, and began a life of great hardship. He found some employment as a china painter, and for a time worked in the Potteries. But the work was too mechanical; he returned to London, and seriously injured his health by attempting to subsist for a year solely on potatoes and water. Then, secretly assisted by his mother, he continued to study his art, gained admission to the schools of the Academy, and made rapid progress. Here his classic tastes, which he imbibed from his mother's teaching, were developed by his diligent study of the antique; and he formed a style which he retained through life, and which added a grandeur even to

106

common forms and rustic figures. He also frequented the house of Dr. Monro, which became a school for many of the rising water-colour painters of the day.

He does not appear to have been an exhibitor at the Academy, and it was not till the foundation of the Water-Colour Society in 1805 that his works were publicly seen. Of this society he was one of the foundation members, was several times president, and an earnest supporter. He had established himself in art, and during a long life was a constant exhibitor. His subjects were chiefly classic or rustic figures with landscape backgrounds, his figures well grouped and drawn with great refinement and taste, but with a tendency to too great height in their proportions. At the commencement of his career he lived first at Kentish Town, then at Chelsea and at Lambeth, and later at Paddington, where, in 1813, he was fortunate in marrying a lady of cultivated mind, whose lively manners and talents made his house the resort of many friends. About 1821, his health failing, he purchased a cottage at Goodrich on the Wye, and removed there in 1822; but after some happy years, the death of his wife after a lingering illness rendered the neighbourhood distasteful; and in 1840 he returned to London, and took up his abode in Robert Street, Hampstead Road, and afterwards in Circus Road, St. John's Wood, where he died, October 18, 1847. He was, at his own request, buried near his wife at Goodrich.

Among his early works, and fresh from the schools, his classic tastes predominated, and his exhibited works comprised, with others, 'Lycidas,' 'The Judgment of Paris,' 'Hylas and Nymphs,' 'Diana and Endymion;' followed by rustic figures, fishermen, gleaners and cottage groups, with landscapes. Soon after his marriage he tried portrait painting for a while, usually small whole-lengths, introducing landscape backgrounds. His art was simple, he used no body colour, and was free from all trick. Original in manner and character, entirely without insipidity and prettiness, his works will always hold a high rank in the water-colour school. He added some classical figures to Barret's landscapes, and some groups to Robson's Scotch scenery. He was an early member of the Sketching Society.

CROKER, JOHN, *medallist.* Was bred a jeweller, and afterwards became medallist and engraver to the Mint. Commencing with the accession of Anne, he engraved all the medals of her reign, and also one large medal of King William's reign. He also engraved all the medals of George I., and many of George II. He died in 1740. His works have considerable merit, and he was one of the chief medallists. The

original drafts of his medals are preserved in the manuscript department of the British Museum.

CROLL, FRANCIS, *engraver.* Was born in 1827, at Edinburgh, and served his apprenticeship there. He became a good draftsman in the schools of the Scottish Academy, and attained proficiency in engraving. He engraved 'The Tired Soldier,' after Goodall, A.R.A., for the Art Union, and several portraits. His last work was an illustration for the 'Cottar's Saturday Night,' after Faed, a commission by the Scottish Association for the Encouragement of Art. When on the road to distinction in his art, he died of heart-disease, at the age of 27, February 12, 1854.

* CROME, JOHN (known as 'Old Crome'), *landscape painter.* Was born at Norwich, December 22, 1768. He was the son of a poor weaver, and began life as a doctor's boy, carrying out the medicine. When of a suitable age, moved by some love of drawing, he became the apprentice of a house and sign painter, and soon began to sketch from nature, while following his trade, the picturesque scenery which surrounds his native city. He was poor, very poor, but he persevered, and his perseverance gained him friends. He found some resource as a teacher of drawing, yet he was but an awkward and uninformed country lad, gifted, indeed, with great natural shrewdness. He married early, and his efforts were doubly taxed to provide for a family rapidly increasing. He had the good fortune to obtain admission to a neighbouring collection, where there were some good examples of the Dutch school; and he paid some hasty visits to London, and thus gained greater art knowledge. He earned after a time at least a local reputation, and his works found occasional purchasers, but at low prices.

In February 1803 he gathered round him the artists of his native city for their mutual improvement, and from this beginning the Norwich Society of Artists arose, founded in 1805. The Society held their annual exhibitions, to which Crome was a large contributor, rarely sending his pictures to the Metropolis for exhibition. His pupils and associates, among whom Vincent, Stark, and Cotman were distinguished, formed what is known as the 'Norwich School,' whose art inspiration was derived from Crome. He visited Paris in 1814, and there made sketches. He was not tempted to the Metropolis, but continued to reside in his native city, where he died, April 22, 1821, after only a few days' illness.

Crome's art was founded on the Dutch school, to the esteemed masters of which some of his best works closely approximated. He chose his subjects in the lanes, heaths, and river-banks surrounding Norwich, and was easily satisfied. They were painted in his studio, from sketches, and were the result of careful study and observation. They charm by their sweet colour and tone, their true rustic nature and fine sense of generalised imitation. Little known and unduly esteemed in his lifetime, his works have now greatly increased, and will continue to increase, in repute and value. His picture of 'Mousehold Heath,' in the National Gallery, is a good example of his style and art. In 1834 a series of 31 etchings by him was published under the title of 'Norfolk picturesque Scenery;' and in 1838 a second issue appeared, with some additional plates.

*CROME, JOHN BERNAY, *landscape painter.* Eldest son of 'Old Crome,' was born in 1793. He was educated at the Free School, Norwich, and afterwards under Dr. Valpy. Brought up to art, he first exhibited at Norwich, and in 1811 appears as an exhibitor at the Royal Academy. In 1814 he exhibited there 'Old Buildings on the Norwich River,' and continued to exhibit occasionally up to 1843. Several of his later works were moonlight scenes. He resided for several years at Great Yarmouth, where he died, September 15, 1842, in his 49th year. His works were very unequal, and he never took any place in art. His brother was also brought up as an artist, and exhibited at Norwich, but did not succeed, and left the profession.

CROMEK, ROBERT HARTLY, *engraver.* Was born at Hull, June 1771. He was intended for the law, but allowed to follow his own inclination. Fond of literature and art, he passed some time in study at Manchester, and showing a taste for engraving, he was sent to London, and became a pupil of Bartolozzi. He engraved many book-plates after Stothard, but he was constitutionally unfitted for the close application required by his profession, and being of an active disposition, took up the trade of printseller and publisher. He induced Blake to illustrate Blair's 'Grave,' and this publication was his first venture. He lies under the accusation of having seen Blake's 'Canterbury Pilgrims,' and of then engaging Stothard to paint the same subject for him as an engraver's speculation—a charge which was refuted by his son. He certainly had a violent quarrel with Blake, and probably gave him some grounds for his epigrammatic scorn—

'Cromek loves artists as he loves his meat;
He loves the art, but 'tis the art to cheat!'

He died of consumption, in Newman Street, London, March 12, 1812, aged 42.

CRONE, ROBERT, *landscape painter.*

Born in Dublin, where he was educated under a portrait painter named Hunter. He afterwards turned to landscape art, went to Rome, and studied there for a time under Wilson, R.A. He exhibited at the Royal Academy in 1772 'Morning' and 'Evening'—two landscapes in oil—and two landscape drawings, and continued in the succeeding years to exhibit compositions of the same class up to 1778, but his progress was impeded by his bad health. He was subject to epileptic fits, which at last caused his death in London in the early part of 1799. His landscapes were much esteemed, but are scarce. There are some specimens in the royal collection. He executed some of his drawings in the manner of Wilson, in black and white chalk upon a bluish-grey paper.

CROSS, JOHN, *history painter*. Was born May 1819, at Tiverton, where his father superintended the works of a lace factory, and on his father's removal to St. Quentin, France, where a similar employment was offered him, he accompanied the family there; and admitted to the School of Design in that town, he was distinguished by his progress, and gave so many proofs of his ability, that he was induced to set off for Paris, where he became a pupil of M. Picot, a painter of the old French classic school. Here he gained several of the medals which are open to the students in Paris. He was just completing his studies when the competition was opened in 1843 for the decoration of the Legislative Palace in Westminster; and he sent a cartoon of 'The Assassination of Thomas à Becket' to the first exhibition, but his work gained little notice. With better success he was again a competitor in the second exhibition, sending an oil painting of 'Richard Cœur de Lion,' which gained a first premium of 300*l.*, and was purchased by Her Majesty's Commissioners for 1000*l.* He at once gained a reputation, but the labour and anxiety he had undergone brought on a serious illness, from which he only slowly recovered. In 1850 he exhibited at the Academy—his first contribution—'The Burial of the Young Princes in the Tower;' in the next year, 'Edward the Confessor leaving his Crown to Harold,' followed by 'The Death of Thomas à Becket,' 1853; 'Lucy Preston's Petition,' 1856; and 'The Coronation of William the Conqueror,' 1859. He proved, however, quite unable to maintain the high position his 'Cœur de Lion' had given him. His subsequent attempts were feeble and weak; he seemed unable to complete them. His two pictures sent to the Academy in 1860 were rejected. He fell again into ill-health, and died in London, February 26, 1861. The paintings he left were exhibited at the Society of Arts, and an attempt was made to raise a subscription for his family. His

108

friends purchased his 'Murder of Thomas à Becket,' and placed it in Canterbury Cathedral, and a small civil list pension was granted to his widow in consideration of his merits as a painter.

CROSS, MICHAEL, *copyist*. Practised in the reign of Charles I., who employed him as a copyist in Italy. He is alleged to have copied a celebrated 'Madonna' by Raphael, in St. Mark's at Venice, and to have substituted his copy for the original, which he stole, and contrived to bring to England; and, it is added, that on the sale of Charles I.'s pictures this work was bought by the Spanish ambassador. He was living in the reign of Charles II.

CROSS, THOMAS, *engraver*. He was chiefly employed upon portraits and small illustrations for booksellers, which he both designed and engraved himself. His chief works are dated between 1646 and 1680. They are executed almost entirely with the graver, and are in a hard, tasteless style.

• CROSSE, RICHARD, *miniature painter*. He was born in Devonshire, and his name first appears in 1758, when he received a premium at the Society of Arts. He was in 1763 a member of the Free Society of Artists. He had been an exhibitor at the two previous exhibitions, and continued to exhibit up to 1769. In 1770 he exhibited at the Royal Academy, and continued to contribute his miniatures, and occasionally a small whole-length in water-colours, in which manner he exhibited a portrait of Mrs Billington in 1788. In 1790 he was appointed painter in enamel to the King, but he painted very little in the latter part of his practice, and did not exhibit after 1795. He died at Knowle, near Collumpton, in 1810, aged 65. He appears to have been the artist whom B. R. Haydon describes in his memoirs as a dumb miniature painter who made his fortune by his art early in life, and lived many years at Wells, having retired from society on the marriage of Haydon's mother, to whom he was a disappointed suitor. His portrait, engraved by Thew, was published in 1791.

CROSSE, LEWIS, *miniature painter*. He flourished in the reign of Queen Anne, and painted many distinguished persons. He also excelled in small copies in water-colour from the old masters. He is reputed to have painted a small portrait of Mary, Queen of Scots, belonging to the Duke of Hamilton, who ordered him to make Mary as handsome as he could. His work was for many years believed to be original, and many copies made from it. He possessed a valuable collection of the works of our early miniaturists, which he sold in 1722. He died October 1724.

CROWLEY, NICHOLAS J., R.H.A., *portrait painter*. Born in Ireland, and in 1838 elected a member of the Irish Academy;

the last 20 years of his life were passed in London. In 1835 he was living at Belfast, and in that year, for the first time, exhibited at the Royal Academy in London 'The Eventful Consultation.' In 1838 he came to reside in the Metropolis, and from that time was a constant contributor to the Academy Exhibitions—chiefly portraits—and he became esteemed for his portrait-groups. He died in 1857, or early in 1858.

CRUIKSHANK, ISAAC, *caricaturist.* Born at Edinburgh in 1756-7. His father was one of the followers of the Pretender in 1745; was impoverished, and came to London with his son, whom he soon left an orphan. Isaac tried his hand as a caricaturist, and in 1796 published his first print in defence of Pitt, then attacked by the pencil of Gillray. Following this manner, he was the author of the greater part of the humorous designs published by Messrs. Lawrie & Whittle, illustrating Dean Swift, Joe Miller, John Browne, and other works of this class. Some of his water-colour drawings are well finished, and are not without merit. He exhibited at the Academy in 1789-90 and 1792. He engraved some works in the stipple manner. He died in London from the effects of a severe cold in 1810 or 1811. He was the father of the well-known artists, George and Robert Cruikshank.

• CRUIKSHANK, GEORGE, *subject designer and etcher.* Was born in London, September 27, 1792, and was the youngest son of the above Isaac Cruikshank. He early showed a taste for art, but never studied at the Royal Academy Schools. His father dying while George was still young, he turned his attention to illustrating children's tales, and gradually extended his practice, working largely as a book-illustrator for many of the publishers of the day. From his strong inclination for satire and caricature, he became the contributor of a monthly design to 'The Scourge,' and to 'The Meteor,' which he published conjointly with the literary editor. To ridicule the follies of the fast young men of London, he etched a series of plates, to which Pierce Egan added letter-press, and it was published under the title of 'Life in London.' It became widely popular, was dramatised at more than one theatre, and its characters became heroes to imitate rather than avoid. Political Squibs and other works too numerous to mention now flowed from his unwearying etching point. When Dickens began to write, he illustrated 'Sketches by Boz,' and there can be no doubt that his illustrations to 'Oliver Twist' and 'Nicholas Nickleby' added much to the popularity of those novels. In his latter days the aged designer worked

himself into the belief that little Oliver and Smike were created by him. He sought in all his works to combat vice and folly, and vigorously attacked in temperance, etching many plates against this sin. He became a convert to the total abstinence movement, and published a series of 8 plates, entitled 'The Bottle,' which with its sequel, 'The Drunkard's Children,' gave great aid to the cause he had adopted, as did his large picture of 'The Worship of Bacchus,' now in the National Gallery. His life was a life of unending toil, and the number of his works is enormous. His art was essentially grotesque and humorous, but it was now and then conjoined with true pathos, rendered more touching by its intense reality. He had, however, no sense of beauty. Many of his etchings have race qualities simply as etchings, yet he took no rank as a painter, and his pictures are lower than mediocre. In his own art, however, as an illustrator, he takes high rank. His abstinence was accompanied by fine spirits and cheerfulness up to a great age, and he enjoyed good health to the last. He died in London, February 1, 1878, aged 86.

CRUIKSHANK, ROBERT ISAAC, *designer for book illustration.* Was the eldest son of the above Isaac Cruikshank. He commenced life as a midshipman in the East India Company's ship 'Perseverance,' and early quitted the service, tempted possibly by the rising fame of his brother George, to follow the arts, and practised as a designer in water-colours. His best works are for the illustration of Cumberland's 'British and Minor Theatres.' For this he was in some measure qualified by a long familiarity with the stage both before and behind the scenes. He was for many years employed on the illustration of the comic publications of the day; but his designs, full of extravagant drollery, did not rise above mediocrity. He had known the vicissitudes of life, and died March 13, 1856, in his 66th year.

CUETT, JOHN. There is by him in the South Kensington collection a clever drawing in pure Indian ink, a composition of classical architectural ruins, powerfully shaded with figures introduced. It is legibly signed, and dated 1710.

CUITT, GEORGE, *landscape painter.* Was born at Moulton, near Richmond, Yorkshire, in 1743, and was the son of a builder. Showing an early taste for drawing, he was sent to Italy in 1769 by Sir Lawrence Dundas, who had employed him to draw the portraits of his family. He vigorously pursued his studies at Rome, but was tempted to pursue landscape art, which was most congenial to him. He returned to England in the latter part of 1775, and in the following year exhibited

at the Royal Academy 'The Infant Jupiter fed with goat's-milk and honey.' He also exhibited some portraits, most elaborately finished but very thinly painted. Later his exhibited works were landscape views, his last contribution being in 1798. He painted some of the scenery of Moor Park, intending to settle in London. He, however, suffered from attacks of low fever, which compelled him to return to his native air, and he finally settled at Richmond. Here, secluded from the companionship of artists, he found employment in making drawings in the neighbourhood, and during 40 years' practice there was scarcely a park or a residence which he had not been commissioned to paint. He frequently worked in body colours; his works degenerated into mere imitations, with no attempt at light and shade or composition. He died February 3, 1818, in his 75th year.

CUITT, GEORGE, *etcher*. Only son of the foregoing. Was born at Richmond, Yorkshire, in 1779. With the help of his father, he devoted himself to his profession from his earliest years, and was led to etching by the works of Piranesi. About 1804 he removed to Chester, where he found an opening to teach drawing. Here he resided some time, and in 1810–11 he published his first etchings—'Six Etchings of Saxon and other Buildings remaining at Chester;' followed by 'Six Etchings of old Buildings at Chester,' and 'Six Etchings of picturesque Buildings at Chester.' At the age of 40, by teaching and the sale of his etchings, he had realised a small independence. He then gave up the more laborious part of his profession, and retired to Masham, near Richmond, where he built himself a house. Here he published his 'Yorkshire Abbeys,' and in 1848 his collected works, under the title of 'Wanderings and Pencillings amongst the Ruins of Olden Times;' and here he died July 15, 1854, in his 75th year. His etchings are well and vigorously drawn, and have much spirit and truth.

CUMING, WILLIAM, R.H.A., *portrait painter*. He practised at Dublin early in the 18th century, and was highly esteemed, especially for his female portraits. In 1823 he was one of the three artists selected to elect 11 others to form with themselves the members of the body then incorporated.

CUNDY, JAMES, *sculptor and modeller*. He was employed by Messrs. Rundell and Bridge, the silversmiths. He had a good knowledge of anatomy, and drew and modelled the figure well. He also executed some good monumental works. He was run over and died a few days after, on May 2, 1826.

CUNDY, THOMAS, *architect*. Was born 1790, in Pimlico, where his father carried on an extensive business as a builder, to
110

which he was brought up, and about 1826 succeeding to the connection, from that time he practised only as an architect. He erected several large mansions, and the house and gallery, with the *façade*, in Upper Grosvenor Street, for the Marquis of Westminster; also several churches—the Holy Trinity, Paddington; St. Paul's, St. Michael's, and St. Barnabas's, Pimlico. He died 1867.

CUNNINGHAM, EDWARD FRANCIS, *portrait painter*. He was born of a good family about 1742, it is said, in Kelso. After the defeat of the Pretender in 1745, his father fled from Scotland and took his son with him, who, as he grew up, studied art sedulously at Parma, then at Rome, and in 1764 at Venice, afterwards at Paris. Soon after this he inherited the family property, and then laid down his pencil; but his inheritance and a second property which fell to him were soon dissipated. He was then induced to go to Russia in the train of the Duchess of Kingston. Soon quitting her Grace he found employment as a painter at the Russian Court. Restless and unsettled in habit, in 1788 he was well employed in portrait painting at Berlin. At length he returned to London, where he earned large sums; but he was improvident and always in difficulties; he squandered his gains, and died very poor in London in 1795. His portraits, which had merit, were many of them engraved. He also painted some historical subjects. He is said to have assumed the name of 'CALZE.'

CUNYNGHAM, Dr. WILLIAM, *amateur*. Born at Norwich, and there practised as a physician. He engraved many illustrations on wood, chiefly emblematical figures, with a large bird's-eye map of Norwich, for his work called 'A Cosmographical Glass,' published in 1559.

CURE, WILLIAM, *architect*. He was master-mason to James I. He built the tomb to Queen Mary, erected by James in Westminster Abbey, and the monument with seven kneeling figures at Cranford, Middlesex, to Sir Roger Aston, 1611.

CURRAN, Miss, *amateur*. Was daughter of the Irish statesman. She painted some portraits in oil. A portrait by her of Percy Bysshe Shelley was exhibited at the National Portrait Exhibition in 1868.

CURTIS, JOHN, *landscape painter*. He was a pupil of William Marlow. He first exhibited at the Royal Academy in 1790 'A View of Netley Abbey,' and sent some views in the following years; but in 1797 he contributed a naval subject—'Sir Edward Pellew's Action with the French Seventy-four, "Les Droits de l'Homme,"' which appears to have been the last work he exhibited.

CURTIS, SARAH, *portrait painter*. She was a pupil of Mrs. Beale, and esteemed

as a portrait painter; but her art is weak, heavy in expression and colour. There is a portrait of Whiston by her, and another by her husband. She quitted her profession on her marriage with Dr. Hoadly, who became Bishop of Winchester. She died in 1743. Her portrait of Bishop Burnet is engraved by Faithorne.

CURTIS, CHARLES M., *draftsman.* Practised in London, and was chiefly engaged on subjects of natural history, which he rendered with much accuracy. He died October 16, 1839, aged 44. He was brother to the author of 'British Entomology.'

D

D'AGAR, JACQUES, *portrait painter.* Born at Paris in 1640, he came early to England. He followed Kneller, was contemporary with Dahl, and was largely employed as a portrait painter in the reign of George I. He was afflicted with gout, and died at Copenhagen in 1716. His portrait is placed in the gallery at Florence. He left a son, whom he had brought up to his profession, and who visited England and painted many distinguished persons in the reign of Queen Anne, but did not settle here.

DAGLEY, RICHARD, *subject painter.* Was an orphan, and was educated at Christ's Hospital. He began life as an apprentice to a jeweller, whose daughter he married, and was employed in enamelling the miniatures and allegorical subjects with which jewellery was then ornamented. In this he showed much taste; and also became a good painter in water-colours and a tolerable medallist. He first exhibited at the Academy in 1784, and continued a contributor of domestic subjects up to 1806.

In 1804 he published a work on Gems, and subsequently made the designs for 'Flimflams,' a production of the elder D'Israeli. But all these pursuits did not yield him a living, and he was induced to go to Doncaster, where he hoped to find employment as a teacher of drawing; and for nearly 10 years his name disappears from the Exhibition catalogues. He had, however, no better pecuniary success, and after a long struggle he returned to London in 1815, and resided at Brompton. He then resumed his contributions to the Academy, and up to 1833 was a constant exhibitor of domestic subjects and portraits, some of them in character. He also designed for several publications, wrote reviews on art, and in 1822 published a second volume of his 'Select Gems from the Antique,' followed, in 1826, by a set of designs styled 'Death's Doings;' and so he managed to live, struggling on for 25 years. He died 1841.

A DAHL, MICHAEL, *portrait painter.* He was born at Stockholm in 1656, and educated there in art. He came to England at the age of 22, remained here about twelve months, and then travelled, staying a year in France, and about three years visiting the chief cities in Italy. In 1688 he returned to London, where he settled, and acquired considerable reputation as a portrait painter. He became a competitor of Kneller, and gained the favour of Queen Anne, whose whole-length portrait and the portrait of Prince George were painted by him. He left many good portraits in the royal collections and the mansions of the nobility. At Petworth there are eight whole-length portraits of ladies by him. He died October 20, 1743, aged 87, and was buried in St. James's Church, Piccadilly. He had acquired property by his art, which was exclusively limited to portraiture. If he excelled, it was only in the mediocrity by which he was surrounded. His likeness was good, and so was his colouring; but his draperies were tasteless and his art without refinement or grace. He left two daughters. His son, who was brought up to art, but was a very inferior painter, died about three years before him.

DALL, NICHOLAS THOMAS, A.R.A., *landscape painter.* He was by birth a Dane, and came to London, where he settled about 1760, and the following year exhibited 'A Piece of Ruins' at the Society of Artists, of which body he was a member. He probably had some instruction from Vivares. In 1768 he obtained the first premium of the Society of Arts for landscape painting. In 1771 he was elected an associate of the Royal Academy, and from that year till his death was an exhibitor. He was chiefly employed as the scene painter to Covent Garden Theatre, but after his election he exhibited some landscape views in Yorkshire, where he was employed by the Duke of Bolton, Lord Harewood, and some others. He died in Great Newport Street, in the spring of 1777, leaving a widow and a young family,

for whom the managers of the theatre gave a benefit.

DALTON, RICHARD, *draftsman and engraver.* Born about 1720, at Deane, in Cumberland, of which place his father was the rector. He was apprenticed to a coach painter in Clerkenwell. After quitting his master he went to Rome to study art, with the intention to practise as a portrait painter. Here meeting Lord Charlemont, he agreed to accompany him to Greece in 1749. Upon his return he was appointed librarian to the Prince of Wales. In 1763 George III. sent him to Italy to make a collection of drawings, medals, &c., and on his return appointed him keeper of the royal drawings and medals, an office for which he was well fitted. On the death of Knapton in 1778 his Majesty appointed him surveyor of the royal pictures. He never possessed much power as an artist or contributed to the Academy Exhibitions, though he was an exhibitor with the Society of Artists at Spring Gardens. He drew and engraved some views to illustrate his travels, and made some engravings from the Holbein drawings in the royal collection. He published a collection of prints from the antique statues, a few of which, some dated 1744, he etched himself. He also published the 'Ceremonies and Manners of the Turks,' and there is by him an etching *ad vivum* of Sir Joshua Reynolds when young. He was an active, but not, it is said, an estimable man. He was a member of the Artists' Committee appointed in 1755 to establish a royal academy. He was also treasurer and director of the Society of Artists in 1765, but did not long hold that office. He died at his apartments in St. James's Palace, February 7, 1791.

DAMER, The Hon. ANNE SEYMOUR, *amateur.* She was the only child of Field-Marshall the Right Hon. Henry Seymour Conway, brother to the first Marquess of Hertford, and was born 1748. She married, in 1767, the Hon. John Damer, the eldest son of the first Lord Milton, but her marriage proved unhappy. Her eccentric, restless husband shot himself in 1776, and from that time his childless widow devoted herself to the study of art, to which she became enthusiastically attached, and was distinguished by her attainments as a sculptor. She was taught by Ceracchi—who was afterwards guillotined in Paris as an accomplice in a plot to assassinate Buonaparte—and by the elder Bacon, and travelled in France, Italy, and Spain for her improvement. She was a frequent honorary exhibitor at the Royal Academy from 1785 to 1818. She modelled her designs herself, and also, it is admitted, worked on the marble with her own hands; but the finish of her work in this material

112

shows that she must have been assisted by a skilled artist. Her best works are a statue of George III., 8 ft. high, at the Register Office, Edinburgh; her own statue, and a bust of Sir Joseph Banks, at the British Museum; and the colossal heads of the 'Thames' and 'Isis' at Henley Bridge. She executed also many clever busts—that of the Countess of Aylesbury, her mother, in Sundridge Church, Kent, and of Viscountess Melbourne, at Panshanger. She was mistress of the French and Italian languages, and had some knowledge of Latin; and was distinguished by her talent as an amateur actress. She was also a determined politician of the Liberal school. She died in Upper Brook Street, in her 80th year, on May 28, 1828, and by her own desire was buried at Sundridge, with her sculptor's tools and apron and the ashes of a favourite dog in her coffin. Lord Orford, her cousin, left her Strawberry Hill, where she resided till 1810, with a legacy of 2000*l.* a year for its maintenance. In her early travels she had made notes of what she had seen, with the intent to publish them; but on her death these, her correspondence with Lord Orford, and her other papers and correspondence, including her father's letters — which she had also purposed to publish—were, by her order, destroyed.

DANBY, FRANCIS, A.R.A., *landscape painter.* Was born November 16, 1793, near Wexford, the son of a small proprietor and farmer in that neighbourhood. When he was of an age to be trained to some occupation his family had removed to Dublin, and he had lost his father. He became a student in the Royal Dublin Society's Schools, and, showing a great desire to follow art, he obtained the approval of his widowed mother. He studied for a time with O'Connor, and in 1812 exhibited at Dublin his first picture, 'Landscape, Evening.' In 1813, accompanied by George Petrie, the future president of the Hibernian Academy, both having made some small savings, determined to visit London. O'Connor was also of the party; but their means were soon exhausted, and they started on foot, penniless, for Bristol, on their way home. By the sale of some drawings there he enabled his friend O'Connor to return to Dublin; but he determined to remain, and up to 1824 appears to have resided at Bristol.

He exhibited in 1817 his first work at the Royal Academy; in 1821, his 'Disappointed Love;' in 1822, 'Clearing up after a Shower;' and in 1824, his 'Sunset after a Storm at Sea.' His 'Upas, or Poison-tree of Java,' a highly poetic work, appeared in the British Institution in 1820, and is now in the South Kensington Museum. In 1825 he exhibited at the Academy 'The

Delivery of the Israelites out of Egypt;' and the same year was elected an associate of the Academy, and came to reside in the Metropolis. His 'The Opening of the Sixth Seal,' exhibited at the Institution in 1828, gained him a premium of 200 guineas, and was followed at the Academy in 1829 by two pictures from the Revelation — fine works, fully maintaining his reputation in the grand style of landscape art which he had made his own. But in this latter year a rupture took place between him and the Academy, which unhappily never healed, and was one among other causes which led him to leave England for the Continent.

During the next 11 years he resided principally in Switzerland, boat-building and yachting on the Lake of Geneva, making small studies and drawings, and painting some few works on commission. We lose sight of his works in the London Exhibitions, with the exception of his 'Golden Age,' which appeared in the Academy in 1831, and his 'Rich and rare were the gems she wore,' in 1837; and it is not till 1841, when he returned to England, that his name occurs as an exhibitor; and from that year, with the omission of 1852 and 1856, he was a contributor to the Academy Exhibitions, and occasionally to the British Institution; the 'Evening Gun,' exhibited at the former in 1848, ranking among his best works. He had resided at Exmouth since 1847, and died there February 9, 1861, his life no doubt saddened by a long exile and the loss of many art friendships. He left two sons, James and Thomas, who follow the profession of landscape painters.

Danby will always take high rank with the lovers of art and genius. His imagination was of the highest class, his landscapes of the truest poetry; he studied the grandest and saddest aspects of nature, combining her largest truths in his ideal creations, avoiding all mere imitative littleness, and conjuring up scenes of voluptuous beauty. Several of his finest works have been well engraved.

DANBY, JAMES FRANCIS, *landscape painter*. Son of the above Francis Danby, was born at Bristol in 1816. He was a member of the Society of British Artists, and a constant exhibitor at the Royal Academy. His sunset effects always attracted attention by their brilliant colouring and poetic treatment. Amongst other works he contributed to the Academy in 1849, 'Dover from Canterbury Road'; in 1851, 'Wicklow Mountains, Sunset'; in 1854, 'Dumbarton Rock'; 1860, 'View on the Thames'; and in 1867, 'Carrickfergus Castle.' He died suddenly from apoplexy, October 22, 1875, in London, aged 59.

DANCE, GEORGE, *architect*. He was appointed surveyor and architect to the city of London. He built the Mansion House in 1739; the church of St. Botolph, Aldgate, which has little merit, in 1741-44; St. Leonard, Shoreditch; and the old Excise Office in Broad Street, finished in 1768. He died January 11, 1768, and was buried at St. Luke's, Old Street. There is a collection of his drawings in the Soane Museum.

• DANCE, GEORGE, R.A., *architect*. Son of the foregoing. He was born 1740, and was brought up in his father's office. In pursuit of his art he travelled in France and Italy, studying some time in Rome. He was a member of the Incorporated Society of Artists, and in 1761 sent to their exhibition his design for Blackfriars' bridge. In 1768 he succeeded, by purchase, his father in the office of city architect. In 1770 he commenced the rebuilding of Newgate, and distinguished himself by the characteristic appropriateness of its exterior. He also built the Giltspur Street Prison, St. Luke's Hospital — a very creditable work,—and the front to the Guildhall. He was one of the foundation members of the Royal Academy, and in 1798 was appointed the professor of architecture, but he resigned the office in 1805, having never fulfilled his duty as lecturer. He was also a poor contributor to the Academy Exhibitions. He sent architectural designs in 1770 and 1771; again in 1785 and 1795. He next sent, in 1798 and 1800, small chalk portraits—probably part of his work published in 1808-14—72 portraits in profile of eminent men, drawn from the life, which he said had formed a great relaxation from his severer studies. These portraits are slightly sketched in chalk, life-like, but exaggerated, wanting in drawing and refinement. In 1815 he resigned his office of city surveyor, and after a lingering illness of many years, died January 14, 1825, in his 84th year, and was buried in St. Paul's Cathedral. He was the last survivor of the foundation members of the Royal Academy.

DANCE, NATHANIEL, R.A. (afterwards Sir Nathaniel Dance-Holland, Bart.), *portrait and subject painter*. Brother of the above. He was born in 1734, and, brought up to art, studied for some years under Frank Hayman; afterwards he spent eight or nine years in Italy, and while there, hopelessly enamoured of Angelica Kauffmann, followed her, it is said, from place to place. He was in 1761 a member of the Incorporated Society of Artists, and in 1763 sent to their exhibition from Rome his 'Dido and Æneas.' On his return to England he commenced portrait painting, occasionally producing an historical subject. In 1768 he was one of the foundation members of the Royal Academy, and contributed to the first exhibition some good portraits, including two fine whole-lengths of George III. and his young Queen, now at Up Park,

Sussex. In 1770 he exhibited 'The Interview between Helen and Paris after his Combat with Menelaus,' with some portraits; in 1771, a full-length of 'Garrick as Richard III.;' in 1774, 'Orpheus lamenting Eurydice;' in 1776, 'Death of Mark Antony;' and then for the next 13 years he was not an exhibitor. In 1790 he resigned his academic distinction, on his marriage with Mrs. Dummer, a widow lady, who possessed a life-interest in estates valued at 18,000l. a year, and took the name of Holland. He represented the borough of East Grinstead in Parliament for many years, and was created a baronet in 1800. He died suddenly at Carnborough House, near Winchester, October 15, 1811. He had amassed above 200,000l., of which he left 30,000l. to his relatives and the remainder to his widow. He drew the figure well; his likenesses were good, but stiff; his colouring agreeable. There is by him a portrait of Captain Cook at Greenwich Hospital; 'Timon of Athens,' a subject picture, in the royal collection. His 'Garrick as Richard III.' has been engraved in mezzo-tint by Dixon; and a 'Death of Virginia,' which he exhibited at the Society of Artists in 1761, by Gottfried Haid, and some other of his works have been engraved. It is said that after his marriage he collected and destroyed his works; but this seems very improbable, especially as he was an honorary exhibitor of landscapes, which showed much skill, in 1792–94 and 1800.

DANCKERS, HENRY, landscape painter. Born about 1630, at the Hague, where he was bred an engraver, but taught painting. He then turned landscape painter, and studied some time in Italy. He was invited to England by Charles II., who employed him to paint views of the seaports, the royal palaces, and the Welsh coasts, some of which subjects he afterwards engraved. Hollar also engraved after his designs. Pepys records having commissioned him to execute some works of this class, which were painted in distemper. Some of his works are in the royal collections. He followed his profession for many years in London, but being a Roman Catholic, he left England at the time of the Popish plot, and soon after died at Amsterdam. His works are marked by their neat execution and finish.

DANDRIDGE, BARTHOLOMEW, portrait painter. He was the son of a house painter, but turning to art, he practised in the reign of George II., and gained much reputation and employment in portraiture from his great facility in taking likenesses and the merit of his small conversation-pieces, which aimed much both at power and colour. Some good portraits, painted by him about 1750, were engraved by McArdell and others. His portrait of

Hook, the historian, is in the National Portrait Gallery. He died in the vigour of his age.

DANIELL, THOMAS, R.A., landscape painter. Was son of an innkeeper at Chertsey, and was born at Kingston-on-Thames in 1749. He served his time to a herald painter. In 1773 he was admitted a student of the Royal Academy and practised landscape painting. He first exhibited at the Academy in 1774, and continued to contribute flower-pieces and landscape views up to 1784. He then went to India, accompanied by his nephew William Daniell, and during 10 years they pursued their profession, gathering stores in a region then unvisited by artists. At Calcutta they published a series of views of that city. They returned together to England, and commenced the publication of their 'Oriental Scenery,' which was completed in six volumes in 1808. In 1795 Thomas renewed his contributions to the Academy Exhibitions, and his works now consisted almost exclusively of Indian views, temples, tiger hunting, and sports. In 1796 he was elected an associate, and in 1799 a full member, of the Royal Academy. He was also distinguished as a fellow of the Royal Society and of the Asiatic Society and the Society of Antiquaries. He had secured a competency by his Oriental works, and after the completion of his publications he led a quiet and retired life, occasionally contributing a picture to the Academy Exhibitions up to 1828. He died, unmarried, at Earl's Terrace, Kensington, March 19, 1840, aged 91, and was buried at the Kensal Green Cemetery. His works are characterised by great Oriental truth and beauty; the customs and manners of India are well rendered. His painting was firm, but sometimes thin; his colouring agreeable. He seldom painted any but Oriental subjects. His publications were—'Oriental Scenery,' 144 views, 1808; 'Views in Egypt,' 'Hindoo Excavations at Ellora,' 24 plates; and 'Picturesque Voyage to China by Way of India.'

DANIELL, WILLIAM, R.A., landscape painter. Born in 1769. At the age of 14 he accompanied his uncle Thomas to India, as described above, and assisted in making drawings and sketches. On their return he worked zealously in preparing for publication the materials they had collected, and of the six volumes in which they were comprised, five were engraved in aqua-tint by his own hand, or under his superintendence. He first exhibited at the Royal Academy in 1795, and for several years his pictures were Indian views; but in 1802 and the following five years he sent some clever views in the Northern counties of England and Scotland. He continued an exhibitor to the year of his death. He

114

published 'A Picturesque Voyage to India,' 'Zoography,' 'Animated Nature,' 1807; 'Views of London,' 1812; and 'Views of Bhootan,' from the drawings of Samuel Daniell. He then planned and commenced, in 1814, another extensive work, 'A Voyage Round Great Britain.' He spent his summers in making the drawings and collecting his materials, and completed the work, entirely with his own hands, in 1825. In 1826 a sum of 100l. was awarded to him by the British Institution for his sketch of the 'Battle of Trafalgar.' He painted, in 1832, in conjunction with Mr. E. T. Parris, a Panorama of Madras, and afterwards, without assistance, 'The City of Lucknow and the mode of Taming Wild Elephants.' He had entered the Royal Academy as a student in 1799, and in 1807 was elected an associate, gaining his full membership in 1822. He died, after severe suffering, in New Camden Town, August 16, 1837. His engraved views of 'Oriental Scenery,' his drawings for 'The Oriental Annual,' and his panoramas, made his art widely known. 'A View of the Long Walk, Windsor,' in the royal collection, is one of his best pictures.

DANIELL, SAMUEL, landscape painter. Was the brother of William Daniell and nephew of Thomas Daniell, the two foregoing painters. He first appears as an exhibitor at the Academy in 1792 and 1793, and was then probably a pupil of Medland. He went to the Cape early in life, and after some stay there travelled into the interior of Africa, and made many drawings, which he afterwards published in his 'African Scenery.' In 1804 he returned to England with a large collection of drawings of the natives, the animals, and the scenery. In 1806 he sent to the Academy 'African Animals and Scenery,' and the same year he took an opportunity which was offered to him of visiting Ceylon, and in a residence there of six years he added greatly to his collection of drawings, part of which he now published under the title of 'The Scenery, Animals, and Native Inhabitants of Ceylon.' But his constitution had suffered by his travels, his residence in forests and swamps in pursuit of his art, and he died at Ceylon, after a few days' illness, in December 1811, aged 36. He had sent home a painting of 'The Talipot Tree of Ceylon,' which was exhibited in the following year. In his drawings he showed great fidelity and taste, and as an intelligent traveller and naturalist he was indefatigable.

DANIELL, ABRAHAM, miniature painter. He practised at Bath in the latter part of the last century, and died there, after a long illness, August 29, 1803. He does not appear to have exhibited at the Royal Academy. His miniatures are

marked by great simplicity and truth, and were justly much esteemed.

DANLOUX, H. P., portrait painter. Born in Paris in 1745. He practised in London, and was an occasional exhibitor at the Royal Academy in 1792-1800. His works were chiefly in chalk, small size, and well drawn. He had many sitters, including two members of the Royal Academy. He died in his native city in 1809.

DARCEY, ——, miniature painter. He is mentioned as one of the youthful companions of Stothard. In 1778 he lived at Portsmouth, and had begun successfully to practise his profession there. He was afterwards induced to accompany the embassy to China, and brought home with him a large collection of drawings illustrating the Court and manners of the country.

DARLY, MATTHEW, engraver. He kept a shop in the Strand in the latter part of the 18th century, and was better known as a caricaturist than an engraver. In the early part of his career he advertised to teach ladies and gentlemen the use of the dry needle, engraving, &c., and was then living in Cranbourne Abbey, Leicester Square. He was also one of the first who sold prepared artists' colours and materials. He published some of the earliest of Henry W. Bunbury's humorous sketches, and two numbers of 'Caricatures by several Ladies, Gentlemen, and Artists,' also some marine and other subjects, and is known to have produced altogether about 300 caricatures, and to have thriven upon the personalities of the day. In 1778 he advertised his 'Comic Exhibition,' admittance 1s. For a time he resided in Bath. Anthony Pasquin was apprenticed to him to learn the art of engraving.

DASSIER, JAMES ANTHONY, medallist. Was the nephew of the celebrated medallist, John Dassier, of Geneva, and the son also of a medallist working in steel. He came to this country some time before 1740, and was in that year appointed second engraver to the Royal Mint. He is mentioned as filling the office of engraver on that establishment in 1755; but Walpole states that he returned to Geneva in 1745. He engraved, while in England, a fine series of medals, 36 in number, of the English kings, showing great taste and spirit; also some good medals of illustrious men.

DAVENPORT, ——, portrait painter. Was a pupil of Sir Peter Lely, and arrived at some eminence in his art, his works showing much feeling for colour; but he did not depart from the manner of his master, and had no claim to originality. He had also a talent for music. He died about 1695, at the age of 50.

DAVENPORT, SAMUEL, line engraver. Was born December 10, 1783, in St. John's

parish, Bedford. Came with his family in infancy to London, where his father then practised as a land surveyor and architect. On completing his education he was articled to Charles Warren, then in much repute, and from him gained a good knowledge of the art of engraving on copper. His early works were chiefly for book illustration, from the designs of Shenton, Corbould, and others; but he subsequently became especially known as an engraver of portraits, from the large number which he produced in outline for biographical works, having engraved no less than 700 for one publication alone. On the introduction of steel plates, he was one of the first to practise in that metal. He was largely engaged engraving on steel for the annuals, and among the illustrations for these and some other publications the best examples of his careful finish and refined art will be found. He died July 15, 1867.

DAVIDSON, J., *portrait painter.* Practised in Edinburgh in the middle of the last century. Roubiliac modelled, after a portrait by him, the statue of President Duncan Forbes, now in the Parliament House, Edinburgh.

DAVIS, RICHARD BARRETT, *animal painter.* Born at Watford in 1782. His father was huntsman to the royal harriers. King George III., who was pleased with some of his drawings, placed him under Sir William Beechey, R.A., and at the age of 19 he was admitted to the schools of the Royal Academy. He first exhibited there in 1802 a landscape, but in 1806 sent 'Mares and Foals from the Royal Stud at Windsor' and 'The Portrait of an Old Hunter.' Continuing to exhibit, he sent, in 1814, 'Going to Market;' in 1821, a 'Horse Fair;' in 1831, 'Travellers attacked by Wolves,' and was in that year appointed animal painter to William IV., and painted for his Majesty the cavalcade which formed his coronation procession. He joined the Suffolk Street Society in 1829, and became one of its influential members and exhibitors. He died in March 1854.

DAVIS, EDWARD, *subject painter.* He was born at Worcester in 1833, and studied at the School of Design in that city, where he gained several prizes. He first exhibited at the Academy, in 1854, 'Meditation,' a small domestic subject, and continued an exhibitor of works of that class; in 1858, 'Granny's Spectacles;' in 1859, 'Doing Crochet Work;' in 1861, 'Words of Peace;' in 1867, 'The Little Peg-top.' He died at Rome, June 13, 1867.

DAVIS, J. P. (called 'Pope Davis'), *portrait painter.* He first exhibited at the Academy in 1811, and in that and the next 10 years his contributions were exclusively portraits in oil. In 1824 he went to Rome,

and while there painted a very large picture of 'The Talbot Family receiving the Benediction of the Pope,' from which his cognomen arose, and the following year he was awarded 50l. by the directors of the British Institution. In 1826—he had then returned to London—he exhibited at the Academy 'Canova Crowned by the Genius of Sculpture' and 'A Trasteverina Pandora;' and after that a portrait in 1827, and again in 1830; in 1842, an 'Infant Bacchus;' and the following year a portrait, his last contribution. He was a great friend of B. R. Haydon, and joined with him in bitter animosity to the Academy. He published in 1858, 'The Royal Academy and the National Gallery. What is the State of these Institutions?' After his death his friends published, in 1866, his 'Thoughts on Great Painters.'

DAVIS, JOHN SCARLETT, *subject painter.* Was the son of a shoemaker at Hereford. He took early to art, studied for some time in the Louvre, and was remarkable for his great facility. He made his first contribution to the Academy Exhibition in 1825, 'My Den.' In 1830 he sent 'Interior of a Library.' He then went to the Continent. He painted the interior of the gallery at Florence in 1834, a successful interior of the Louvre, and afterwards became noted for his interiors of libraries, galleries, and works of that class. In 1841 he was at Amsterdam, and sent to the Academy 'Jack, after a successful Cruise,' visiting his old Comrades at Greenwich.' He married early in life, became drunken and of demoralised habits —got into prison and died before the age of 30. His works were of much promise, but wanted completeness and finish. He lithographed and published 12 heads from sketches by Rubens; also, in 1832, some views of Bolton Abbey, drawn by him from nature on the stone. In 1831 Lord Farnborough gave him a commission to paint an interior of the Vatican and of the Escurial, but it does not appear that these works were executed.

DAVIS, W. H., *animal painter.* He appears in 1835 as an exhibitor at the Royal Academy of 'A Heath Scene with a Group of Asses,' and in the succeeding years exhibited 'A Group of celebrated Greyhounds,' 'Girl with Cows,' 'Shepherd Boy,' and continued a contributor up to 1849, when his name no longer appears in the catalogues.

DAVIS, M., *wood engraver.* Was well known as an engraver of woodcuts for printers. Resided in Salisbury Court, Fleet Street, where he practised nearly 50 years, and died January 28, 1784, aged 74.

DAVIS, WILLIAM, *landscape painter.* Born in 1812, in Dublin, of an old family, he studied in the Dublin Academy. He

afterwards practised during the greater part of his life at Liverpool, and was a member of the Liverpool Academy, and the professor of painting. From 1851 he was an occasional exhibitor at the Royal Academy of landscapes and still-life. His subjects, drawn from rural nature, were marked by truth of character and highly finished. He died in London, April 22, 1873.

DAVISON, JEREMIAH, *portrait painter*. He was born in England, of Scotch parents, in 1695, and was a pupil of Lely, and afterwards employed by Van Haken. He became noted for his power of imitating the texture of satin. He was patronised by the Duke of Athol, whose portrait, with the portrait of the Duchess, he painted. He accompanied his patron to Scotland, and then practised in Edinburgh, where he met with great encouragement as a portrait painter. He painted the portrait of Frederick, Prince of Wales, in 1730. He died at the latter part of 1745, aged about 50. His works are weak both in drawing and colour. In the gallery of Greenwich Hospital there is a full-length by him of Admiral Byng, the first Lord Torrington, who died 1733.

DAVY, ROBERT, *portrait painter*. Was born at Collumpton, Devon. He began art as a portrait painter, and went early to Rome for his improvement. On his return, about 1760, he settled in London, and was admitted a member of the Incorporated Society of Artists. He painted chiefly portraits, but met with little success. He obtained the appointment of under drawing-master at the Woolwich Academy, and also taught in other schools. He was knocked down and robbed in the street, brought home speechless, and died September 28, 1793.

DAVY, HENRY, *architect*. He published at Southwold, in 1827, 'Etchings illustrating the Antiquities of Suffolk,' comprising 70 large-sized folio plates, drawn and etched by himself. They are carefully and artistically executed, and form an important work. He afterwards published 'Views of the Seats of the Noblemen and Gentlemen in Suffolk;' but this work is weakly *engraved*, and of a very different character.

DAWE, PHILIP, *mezzo-tint engraver*. Was the natural son of a City merchant, and was articled to Henry Morland. He was the intimate friend through life of George Morland, and wrote his life. He about 1760 worked under Hogarth as an engraver, and at the same time was an unsuccessful competitor for the premium offered by the Society of Arts for the best historical painting. He exhibited some subjects of a humorous class at the Society of Artists in 1761, and also exhibited at the first Royal Academy Exhibition in 1768.

Among his paintings were the Cavern scene in 'Macbeth,' 'Captain Bobadil cudgelled,' and perhaps his best work, 'The Drunkard reproving his disorderly Family.' As a mezzo-tint engraver, he produced several plates after his master, Henry Morland, and some portraits after Gainsborough, Reynolds, and Romney. He is said by most authorities to have died about 1780; but from the date of his son's birth, and some other circumstances, he probably died later. His pictures were common and vulgar in their humour, and he is best known as a mezzo-tintist.

DAWE, GEORGE, R.A., *portrait and history painter*. Son of the above Philip Dawe; born in London, February 8, 1781. He was brought up as an engraver, and several engravings by him were published. Entering the Academy Schools in 1794, he was an assiduous student. He also studied anatomy; and aspiring to higher things in art, he abandoned engraving on attaining the age of 21. In 1803 he gained the Academy gold medal for his 'Achilles frantic for the loss of Patroclus.' In the following year he exhibited 'Naomi and her two Daughters-in-law;' and in 1809, at the British Institution, 'A Scene from Cymbeline,' for which he was awarded by the directors a premium of 50*l*., and in 1811 a second premium of 122*l*. for his 'Negro overpowering a Buffalo.' But he did not continue historical subjects; from 1809 to 1818 his exhibited works were chiefly portraits. In 1816 he painted a whole-length of Miss O'Neill as 'Juliet,' which he exhibited by lamplight, to produce the usual scenic effect. He had, in 1809, gained his election as associate of the Royal Academy, followed by full membership in 1814.

His chief art was portraiture, at which he laboured carefully, requiring numerous sittings. After the battle of Waterloo, he travelled in the suite of the Duke and Duchess of Kent, and painted several of the officers distinguished in the battle. On the marriage of the Princess Charlotte with Prince Leopold, he painted their portraits several times, and engravings of them became very popular. While travelling he was engaged by the Emperor of Russia to paint, at St. Petersburg, his officers who had been prominent in the wars with Napoleon, and after a short visit to London he started for Russia in January 1819, and during a residence there of nine years he is said to have painted for the Emperor 400 portraits, which decorate a large gallery in his palace called 'The Hermitage,' besides some other works. He paid a visit of several months to England early in 1828, and set out again for Russia in September, staying at Berlin to paint the portrait of the King. On the journey he caught a

violent cold, which undermined his health, and determined him to return home. He left St. Petersburg in the spring of 1829, travelled slowly back, reached London at the end of August, and died on October 15. He was buried in St. Paul's Cathedral. He was reputed to have amassed 100,000*l.* by his art, but his gains were dissipated by his greed in money-lending, which was followed by litigation and losses, and his property dwindled to 25,000*l.* From expressions in his will, he appears to have been disgusted with the Russian character and the Catholic religion. There is a biography of him in Arnold's 'Library of the Fine Arts,' 1831.

DAWE, HENRY, *engraver and painter.* Younger brother of the foregoing. He was born in Kentish Town, September 24, 1790; was taught engraving by his father, and studied in the schools of the Royal Academy. On the foundation of the Society of British Artists, he became an exhibitor, and in 1830 was elected a member of the Society. Practising in mezzo-tint, his engravings were much esteemed; among them were a large number of Russian officers, from his brother's portraits; John Kemble, after Sir Thomas Lawrence, 1828; Mrs. Siddons as the 'Tragic Muse,' after Sir Joshua Reynolds. He also contributed to the 'Liber Studiorum;' and Turner, R.A., entrusted him with the superintendence of the plates, which were re-engraved. He was an exhibitor of portraits and subject pictures—'Christmas Fare,' 'The Philanthropist,' 'Holiday, or Granny in a Rage.' Some sensational subjects by him were engraved, and had a large sale. He retired to Windsor about 1845, and died there December 28, 1848.

DAY, ALEXANDER, *miniature painter.* Resided in Italy during his early life, and there imbibed a love of art, and pursued both painting and sculpture, excelling in the former. He was settled at Rome in 1794, and during the war with Naples he was detained by the French for some years, which he employed in the practice of his art, and produced some good medallions. He had meanwhile been lost sight of by his countrymen—his works were unknown, his early associates believed him dead. On his return to England he brought with him some of the finest works which now enrich our National Gallery; and his judgment of art will always rank very high. Among these works were—'The Descent of Bacchus,' the 'Ganymede,' and the 'Venus and Adonis,' by Titian; the 'St. Catherine' and portrait of Pope Pius, by Raphael; the 'Ecce Homo,' by Coreggio; 'The Flight of St. Peter,' by Carracci; 'The Land Storm,' by Salvator Rosa; 'Abraham and Isaac,' by Gaspar Poussin; and the 'St. Ambrose and the Emperor Theodosius,' by Vandyck. He died at Chelsea, in his

69th year, January 12, 1841. His miniatures, particularly of females, were painted with great grace and sweetness of execution, but rarely went farther than the head. He does not appear to have been an exhibitor at the Royal Academy.

DAY, THOMAS, *miniature painter.* Was a constant exhibitor at the Royal Academy between 1772 and 1778, when he contributed for the last time. In 1777 he sent 'Cupid,' a miniature; 'Musidora,' in crayons. He also exhibited occasionally some water-colour landscapes and views, and some crayon portraits.

DAYES, EDWARD, *water-colour painter.* Was a pupil of William Pether. He painted in miniature in a graceful, simple, finished manner, scraped a little in mezzo-tint, and afterwards practised landscape drawing. He first exhibited at the Royal Academy in 1786, sending miniature portraits and views, and continued to exhibit with little intermission till his death. In 1798–99 he sent some classic and scriptural subjects, with views, and the same in 1803. His works were in water-colours, chiefly topographical, well drawn, neatly laid in with Indian ink, and tinted. He drew the figure well. His 'Royal Procession to St. Paul's on the Thanksgiving for the King's Recovery in 1789' is a work crowded with figures; also, of the same class, 'The Trial of Warren Hastings in Westminster Hall,' both of which were engraved; and there is by him an interesting drawing of old Buckingham House, with large, well-executed groups in the foreground. He mezzo-tinted several works—'Rustic Courtship' and 'Polite Courtship,' after Hogarth; 'A Landscape,' after J. R. Smith. He wrote an 'Excursion through Derbyshire and Yorkshire,' 'Instructions for Drawing and Colouring Landscapes,' 1808; and 'Professional Sketches of Modern Artists.' After his death his works were published for the benefit of his widow, edited by E. W. Brayley. He was also a teacher of drawing. He is best known by his topographical views, which are of much merit. He died by his own hand, at the end of May 1804. His wife painted miniatures, and during his life was several times an exhibitor at the Academy.

DEACON, JAMES, *miniature painter.* He was gifted with great talent both for drawing and music. He took Zincke's house in Covent Garden, and painted miniatures professionally. He produced some masterly portraits. In the print-room of the British Museum there are by him miniature portraits of Samuel Scott, the marine painter, and his wife. They are well drawn and tinted with Indian ink, elaborately careful, full of expression and character—the faces only finished. He had scarcely embarked in his profession, when

attending the Old Bailey as a witness, he caught the gaol fever, and died young, May 1750.

DEAN, JOHN, *draftsman and mezzotint engraver*. Born about 1750. Was a pupil of Valentine Green. Engraved both portrait and historical subjects. There are good plates by him after Reynolds, Gainsborough, Ramsey, Hoppner, Morland, and one or two after the old masters. He exhibited at the Academy, in 1789, 'Lavinia,' and some others ; in 1790, 'Journey to the Watch-house ;' and, for the last time, in 1791, 'Dutiful Children.' He died in London 1798.

DEAN, HUGH PRIMROSE, *landscape painter*. Born in Ireland. He was called the 'Irish Claude.' He was very poor and unprincipled. Of insinuating address and of some ability in art, he was assisted by Lord Palmerston to visit Rome, where he settled, abandoning his wife and child. He had exhibited landscapes at the Free Society in 1765 ; and at the Spring Gardens Exhibition, in 1768, a 'View of the Danube.' In the following year he was elected a member of the Society, and in 1775 he sent from Rome to the same exhibition a view of Naples. In 1776 he was at Florence, and was elected a member of the Academy in that city ; in the same year his wife and child were sent out to him, and surprising him there, he ran away from them. In 1777 he was at Naples, and sent a picture to the Academy. In 1778 he sent for exhibition from Rome, where he then was, two landscapes,' Morning' and 'Evening ;' and the next year returned to London ; but he did not meet with much encouragement, from his misconduct, and lost the support of Lord Palmerston. He exhibited at the Academy, in 1779, an 'Eruption of Mount Vesuvius,' and the following year—his last contribution—'The Banks of the Tiber.' He produced at the same time his 'Eruption of Mount Vesuvius,' treated as a transparency, which he exhibited in a large room in Great Hart Street, Covent Garden. It is not supposed that this speculation was very successful, for a year or two after he appeared in a new character, as a Methodist preacher ; but he did not long survive. He died about 1784.

DEAN, RICHARD, *gem engraver*. He practised in the last quarter of the 18th century, and in 1777-78 was an exhibitor at the Royal Academy, but he did not attain any eminence.

DEANE, Sir THOMAS, Knt., *architect*. Born 1792. He was the son of a builder at Cork, whose father's death managed to carry on the business for his family, and eventually to realise a fortune for himself. He became mayor of Cork, and was knighted in 1830, the year of his mayoralty, by the lord-lieutenant of Ireland. He then commenced practice as an architect, and in his native city built the Bank of Ireland, the Savings' Bank, and the Queen's College, and added a well-conceived classic portico to the Court House. Extending his practice, he built the lunatic asylum at Killarney, and made a good addition to Trinity College, Dublin. He was for some years in partnership with Mr. B. Woodward. With the assistance of his son, THOMAS DEANE, who had succeeded him in his profession, he built the museum at Oxford. He was for several years president of the Institute of Irish Architects. He died near Dublin, aged 80, September 2, 1871.

DEANE, WILLIAM WOOD, *water-colour painter*. He was educated as an architect, and was in 1844 admitted to the schools of the Royal Academy. In that and the following year premiums were awarded to him by the Institute of British Architects. About this time he travelled in Italy, and in 1853 exhibited at the Academy a view of St. Peter's, Rome, followed in 1854 and 1855 by views of churches in Capri and Venice, and continued an occasional exhibitor of works in which architecture pictorially treated formed the prominent feature. In 1863, turning more exclusively to art, he was chosen an associate of the Institute of Water-Colour Painters, and in 1867 a full member, exhibiting with the Society till 1870, when he resigned, and was in 1871 elected an associate of the old Society of Painters in Water-Colours, and exhibited in that year a view of Santa Maria della Salute, Venice, and of the north porch of Chartres Cathedral, and a number of works in each of the two following years. He died prematurely, on January 18, 1873, aged 47.

DEARE, JOHN, *sculptor*. Was born at Liverpool, October 18, 1760. He showed early proofs of genius, and at 10 years of age, carved a human skeleton with his pen-knife. He was articled to a carver in London, and at 16 produced works of so much ability that he was induced to turn his attention to art. He was admitted a student of the Royal Academy, and in 1780 obtained the gold medal for a model of 'Adam and Eve.' He continued to work for his master ; his reputation meanwhile rapidly increasing, he left him in 1783, and was then employed by Bacon, R.A., and by Cheere. Commissions now crowded upon him, and he worked till far into the night. In 1785 he was elected travelling student of the Academy, and in May set out for Florence on his route to Rome. For the exhibition in the following year he had completed a large bas-relief— 'The Judgment of Jupiter,' containing 30 figures, but it does not appear to have been

Dean. J. a engraver : 1830.

exhibited. At Rome, where he was joined by Flaxman and Howard, he studied closely from the antique marbles, and made a large collection of careful drawings. He sent from Rome to the Academy Exhibition in 1788 his 'Edward I. and Queen Eleanor.' He was fortunate in receiving commissions, and in the midst of success was suddenly cut off. He was eccentric. He thought it right to say his prayers stripped of all clothing; and his death is attributed to his having slept all night on a block of marble he was about to carve, that he might receive inspiration in his dreams. He died at Rome, of bilious fever, August 17, 1798, and was buried in the Protestant Burial-ground. He left a young widow, an Italian, of poor origin, *enceinte*, and a daughter about 3 years of age. He was of much promise, and a great loss to art. He drew with great power and correctness, had much fertility of invention, and possessed unflinching application.

DEARE, JOSEPH, *sculptor*. Nephew of the above John Deare. He studied in the schools of the Royal Academy, and in 1825 gained the Academy gold medal for a very original group of 'David and Goliah,' which was much admired at the Academy Exhibition in the following year, when he was for the first time a contributor. In three succeeding years he exhibited portrait busts, and in 1831 a group in marble of 'Virginius and Virginia,' and in that year also and the following year two male busts. He had changed his dwelling four times in the last four years. After 1832 he ceased to exhibit at the Academy, and the traces of him disappear.

DEARMAN, J., *animal painter*. He was an exhibitor at the Royal Academy from 1842 to 1856. He painted landscapes, which formed the backgrounds to groups of cattle and figures. His works were well coloured and strong in their imitation of nature. He lived at Shiere, near Guildford, and died in 1856 or 1857.

DE BRIE, THEODORE, *engraver*. Was born at Liège in 1528, and for several years practised in London. While here he engraved 'The Grand Funeral Procession and Obsequies of Sir Philip Sydney, 1586,' in 34 plates, and the illustrations for Hariot's 'Newfoundland of Virginia.' He had two sons, John Theodore and Israel, who assisted him in his art. He died 1595.

DE BRUYN, THEODORE, *landscape painter*. Born in Switzerland; settled in England about 1760, and practised his art here. He painted in a variety of styles, but chiefly landscapes with cattle and figures, and was for about 20 years an occasional exhibitor at the Royal Academy. He is principally known as an imitator of bassi-rilievi in monochrome, and by his

decorations in this manner in the chapel at Greenwich Hospital. He died in London, in the early part of 1804, leaving a son, who was then a student at the Academy, and was afterwards two or three times an exhibitor.

DE CAUX or CAUS, SOLOMON, *architect*. He was a Gascon, and practised in England in the reign of James I., and in 1612 designed a picture gallery at Richmond Palace for Prince Henry, whom he taught drawing.

DE CAUS, ISAAC, *architect*. Supposed to have been a brother of the above. He assisted Inigo Jones in building the front of Wilton, and also conducted the works in the erection of the portico and loggias at Gothambury, and for part of Campden House, Kensington.

DECKER, JOHN, *medallist*. Was graver to the Mint in the reign of James I.

DE CORT, HENRY, *landscape painter*. He was born at Antwerp in 1742, and studied his art there, Ommeganck frequently painting his figures. He was induced to come to London, where he settled. He first exhibited at the Royal Academy in 1790, and continued for several years an exhibitor, chiefly of English landscape views. After many years' practice in London, he died here, June 28, 1810. His early landscapes were chiefly compositions of cities and ruins in the Italian manner, agreeably coloured, not possessed of any high merit.

DE CRITZ, JOHN, *decorative painter*. He was sergeant-painter to James I. and Charles I., and enjoyed a great contemporary reputation. Walker, the painter, said he was the best painter in London. He is reputed to have painted scenes for the masques then in fashion, ceilings, and many of the decorations of the time, of which only, and of some few portraits, the record remains. He speculated largely in purchases on the sale of Charles I.'s collections. He died 1642.

DE CRITZ, EMANUEL, } *decorative* DE CRITZ, THOMAS, } *painters*. Brothers of the foregoing, practising at the same period, and both painters, though inferior, of the same class. Emanuel succeeded to the office of sergeant-painter to Charles I., and Thomas was probably the officer of that name who was mace-bearer to the Parliament.

DEERING, JOHN PETER, R.A., *architect*. His paternal name was Gandy. He was younger brother of Joseph Gandy, A.R.A., and was born in 1787. In 1805 he was admitted a student of the Royal Academy. He first contributed to the Academy Exhibition in 1806—'Leading to the Apartments of the Dead ;' in the following year, 'A Design for a Royal Academy ;' in 1810, 'An Ancient City' and

'The Environs of an Ancient City.' His early designs were of a highly imaginative character, and proved his power as a draftsman. He began life under the patronage of the Dilettanti Society, for which, in 1811, he undertook a mission to Greece, where he obtained the friendship of Lord Elgin, and afterwards built Broom Hall, his lordship's seat in Scotland. During the years 1811–13 he continued his researches in Greece, and on his return he exhibited at the Academy, in 1814, 'The Mystic Temple of Ceres,' and then for the following 10 years his name disappears as an exhibitor. He designed, in conjunction with Wilkins, R.A., a tower 280 feet high, to commemorate the victory at Waterloo, which, though it appears an extravagant design, was adopted by the Committee of Taste, but was never executed. In 1826 he was elected an associate of the Royal Academy, and in 1827 he changed his name to Deering, on acquiring a large estate in Buckinghamshire. Though fond of his art, he from this time devoted himself chiefly to the care and improvement of his property. The works he exhibited were designs for buildings he was erecting; and though elected a full member of the Academy in 1838, he did not again contribute to the Academy Exhibitions. He was elected member for Aylesbury on the passing of the Reform Bill, and in 1840 served as high sheriff for Bucks. He had gained a high place in his profession. His chief works are—Exeter Hall, Strand; St. Mark's Chapel, North Audley Street; the Phœnix Fire Office, Charing Cross; part of the University College, London; and jointly with Wilkins, the University Club, Pall Mall East. He died at Lee, near Missenden, Bucks, March 22, 1850. He published, in 1805, 'The Rural Architect;' and in 1817, 'Pompeiana,' in conjunction with Sir William Gell. He was well studied in the architecture of Greece, an excellent draftsman, and his works were marked by great refinement.

DE ESSEX, John, 'marbler.' Was the architect and mason employed, in the reign of Henry VI., upon the great tomb of the Warwick family in Warwick Church, the architectural portions of which display great variety, richness, and delicacy of design and execution.

DE FARLEIGH, Richard, architect. He is styled 'builder,' and is supposed to have designed, if not executed, the spire and part of the tower of Salisbury Cathedral, 1334. He was also employed on certain works at the Priory Church, Bath, and at Reading Abbey.

DE HEERE, Lucas, portrait painter. Was born at Ghent in 1534, of a family noted for their skill in art. He was placed under Francis Floris, and made great progress. His first employment was in designing for tapestry and for the glass painters. From Ghent he went to France, where he was employed as a designer by the Queen and Queen-mother, and resided some time in Fontainebleau, where he married. He then returned to his native city, and was employed in painting for several churches. His inducement to visit England, or the time of his coming, is not known, but it was probably soon after the accession of Elizabeth, whose favour he gained. He painted many portraits in this country, and several of the Queen. He returned to Ghent, and died there in 1584. He was not only a clever painter, refined and delicate in his finish, but a poet. He wrote 'The Orchard of Poesie.' He translated from the French the 'Temple of Cupid,' and had begun, in verse, the 'Lives of the Flemish Painters.'

DE LA MOTTE, William, watercolour painter. Born in 1780. He studied at the Royal Academy, and was for a time a pupil of West, P.R.A., but eventually devoted himself to landscape art, and towards the end of the century made himself a name by his Welsh landscapes in water-colours. His early works were in the manner of Girtin. Later, his landscapes were chiefly drawn with the pen and tinted, and were peculiar in style. He was a contributor to the Academy Exhibitions from 1796 to 1848. He drew architecture with accuracy, and landscape and marine views, introducing animals and cattle, but he never attained a thorough mastery over his art. He resided at Oxford in 1798–99, and repaired Streeter's work in the theatre there. He was, in 1803, appointed drawing-master at the Royal Military Academy at Great Marlow. In 1806 he contributed, as 'fellow exhibitor,' of the Water-Colour Society, and also in the two following years, but not longer. He died at St. Giles's, Oxford, February 13, 1863, aged 83. His collection of drawings were sold at Sotheby's in the following May. There is a large drawing by him — a fine example of his early manner — in the South Kensington Museum. He published 'Thirty Etchings of Rural Subjects,' 1816.

DE LANE, Solomon, landscape painter. Was born in Edinburgh in 1727. He studied landscape, and, self-taught, worked from nature. He travelled in France and Italy, and painted many of their finest scenes. In 1771 he sent from Rome two large landscapes to the Academy Exhibition. He continued in Rome till 1777, and about 1780 was residing near Augsburg. In 1782 he was living in London. He was an exhibitor at the Royal Academy from 1777 to 1784, after which his name is lost sight of. He had a correct knowledge of

perspective, was a good colourist, and much esteemed as a landscape painter.

DELANY, Mrs., *amateur. See* GRANVILLE, MARY.

DÉLARAM, FRANCIS, *engraver.* Practised in London in the reigns of Elizabeth and James I. He was contemporary with William and Simon de Passe and Elstracke, and engraved in the stiff, neat manner of that day. His works are chiefly portraits, among them Henry VIII., Queen Mary and Queen Elizabeth, James I., Henry, Prince of Wales, and many of the notables of that day. His works are rare, and command high prices. At Sir Mark Sykes's sale, in 1824, a print by him of Charles, when Prince of Wales, with Richmond Palace in the background, fetched 46*l*. 4*s*., and a portrait of James I., with a view of London, 34*l*. 13*s*.

DELATTRE, or DELATRE, JEAN MARIE, *engraver.* Was born at Abbeville in 1745. He worked some time in Paris, and then, in 1770, came to London, where he practised in the chalk manner, and was employed under Bartolozzi. He engraved many historical subjects and portraits—'Penelope,' 'Dido,' and 'Beauty led by Prudence,' after Angelica Kauffman ; and also after Wheatley, Stothard, and Hamilton, and for Bell's 'British Poets.' A 'St. Cecilia,' after Guercino, is esteemed one of his best works. He brought an action against Copley, R.A., in 1801, for a plate which he had executed for him, and gained the full amount of his claim, 600 guineas. He was one of the governors of the Society of Engravers, founded in 1803, to assist infirm members of the profession. He was, in 1836, a pensioner on Peter Hervé's Society. He died at North End, Fulham, in his 95th year, and was buried at Fulham, June 30, 1840.

DE LOUTHERBOURG, PHILIP JAMES, R.A., *landscape painter.* Was born at Strasburg on October 31, 1740. His father, who was of a noble Polish family, practised as a miniature painter. He was educated at the college at Strasburg for the Lutheran Church, but his genius made him a painter. Following his own strong inclinations, after some previous study, he went to Paris and became the pupil of Carl Vanloo. His works, exhibited at the Louvre, gained him a reputation, and in 1762 he was, at the age of 22—thirty being the prescribed age—elected a member of the French Academy. He then visited Switzerland, Germany, and Italy, and painted portraits, landscapes, and battle-pieces. About 1771 he came to England. His fame had preceded him, and he was engaged by Garrick, at a salary of 500*l*. a year, to superintend the scenery and machinery of Drury Lane Theatre. Here he was employed many years, and

showed surprising powers and invention. He painted with his own hand the whole of the scenery of 'The Christmas Tale,' and introduced so much novelty and effect as formed a new era in scene painting. At the same time he painted easel pictures, and on canvases of a large size commemorated some of the naval and military victories of Britain—'Lord Howe's Victory of the 1st of June,' 'The Siege of Valenciennes,' and 'The Review of Warley Camp.'

He first exhibited at the Academy in 1772, and from that year till his death was a constant and large contributor. His subjects were always of a stirring character. His landscapes and marines chiefly treated of the storms and violence of nature ; his figure subjects, of battles and the attacks of banditti. He was never tame. There are also some theatrical groups by his hand. He was elected an associate of the Royal Academy in 1780, and a full member in the following year. At this time Sheridan who had succeeded to the management of the theatre, attempted to reduce his pay, and he quitted the scene-loft. He now planned his '*Eidophusicon,*' which all the world went to see, and were astonished by the illusion—his effects of calm and storm, sunset and moonlight, the accurate imitation of nature's sounds, the approaching thunder, the dash of the waves on the pebbly beach, and the distant minute-gun. His charges for admission were 5*s*. and 2*s*. 6*d*. He had used music to entertain during the shifting and preparation of his scenes, and he was proceeded against before the justices, who, refusing to convict, granted him a licence.

Soon after his arrival in London he took a house at 45, Titchfield Street, where he lived 12 years, and then removed to Hammersmith Terrace. Here his eccentricities broke out. He was the dupe of a German charletan in the search for the philosopher's stone ; but a female relative broke in upon their nocturnal studies and destroyed their crucible. He was a disciple of the prophet Brothers, and, like him, fancied himself inspired by faith to heal the lame and the blind ; but his patients, who received no relief, mobbed his house and broke his windows. In 1789 some zealous friend published 'A List of a few Cures performed by Mr. and Mrs. De Loutherbourg without medicine ; by a lover of the Lamb of God.' The writer says 'that Mr. De L. has received a most glorious power from the Lord Jehovah, viz. the gift of healing all manner of diseases—deafness, lameness, cancer,' with many others, of which he gives some very miraculous details ; and in the same year a popular clergyman advertised a meeting to debate the question, 'Is it consistent with reason

or religion to believe that Mr. De Louther-
bourg has performed any cures by a divine
power, without any medical application?'
He died March 11, 1812, and rests in
Chiswick Churchyard, under these pomp-
ous lines—

'De Loutherbourg, repose thy laurelled
 head,
While art is cherished thou canst ne'er
 be dead.
Salvator, Poussin, Claude, thy skill com-
 bines,
And beauteous nature lives in thy designs.'

De Loutherbourg's art was peculiarly suited
to the stage. He was a good draftsman. He
painted from sketches, rarely from nature.
His colouring is bad, his manner conven-
tional; but he had great vigour and in-
vention. In his battle-pieces the various
incidents are well conceived, painted with
fire and animation, and have great sem-
blance of truth. His subjects were noble
and grandly treated, and he deserved the
reputation he enjoyed. He etched a few
plates, chiefly of a humorous character.

DELVAUX, LAURENT, sculptor. Came
to this country from the Continent, and was
assistant to Bird in the reign of George II.
He then went to Italy with Scheemakers
in 1728, and returning with him after an
absence of four or five years, they found em-
ployment together on monumental works.
The monument of Dr. Chambers, and that
to the Duke of Buckingham, both in West-
minster Abbey, are their joint work. The
bronze lion on Northumberland House,
now removed to Sion House, Isleworth, is
by Delvaux, who was the abler of the two;
and there is a 'Venus,' in bronze, after the
antique, by him at Holkham. He also
copied some other antique statues in bronze.
He returned to the Continent, to enjoy
the property he had earned here.

DE MAYNE, JOHN, gem engraver.
Practised in England in the reign of Henry
VIII., cutting heads and engraving seals.

DENBY, WILLIAM, art teacher and
subject painter. Was born at Great Book-
ham, Surrey, in the early spring of 1819.
He studied in the Government School of
Design under Mr. Dyce, R.A., and was
appointed an assistant master in 1847.
He was afterwards a student in the Royal
Academy, and assisted Mr. Horsley, R.A.,
in his work at Westminster. He first ex-
hibited at the Royal Academy 'St. John'
in 1847, and from time to time other Scrip-
ture subjects until 1868. He visited Italy
in the summer of 1863, and unfortunately
contracted the Roman fever, from which he
never entirely recovered. He died in
London, July 15, 1875, and was buried at
his native village.

DENHAM, Sir JOHN, K.C.B., architect.
Born at Dublin 1615. His father, one of

the barons of the Exchequer in Ireland,
was in 1617 appointed to the same office
in England, and in that year brought his
son to London with him. He received a
good education, took his bachelor's degree
at Oxford, and then studied the law in
Lincoln's Inn. In 1641 he gained celebrity
by his tragedy of 'The Sophy,' which was
confirmed by his poem of 'Cooper's Hill,'
by which he is now best known. In 1647
he performed some important services for
Charles I., then a prisoner, which becoming
known, he fled to France, but in 1652 re-
turned to England, and on the restoration
of Charles II. was appointed surveyor-
general of his Majesty's buildings, and
created a Knight of the Bath. It does not
appear what qualification he possessed for
this office, in which he was for a time
associated with Wren, who was appointed
assistant surveyor-general in 1661. He
had charge of the repair of old St. Paul's
after the great fire in 1666. He designed
part of Burlington House, Piccadilly, and
after the designs of Inigo Jones, part of
the river front of Greenwich Hospital. He
also made some additions to Windsor
Castle. His mind had been for some time
impaired by domestic troubles, when he
died March 19, 1687-88. He was buried
in Westminster Abbey. His name survives
as a poet rather than as an architect.

DENNING, STEPHEN POYNTZ, minia-
ture painter. Born in 1795; and was a
pupil of Mr. J. Wright, portrait painter.
He first exhibited at the Royal Academy
in 1814. In 1821 he was appointed curator
of the Dulwich Gallery, but he continued
without much intermission to exhibit
miniatures up to 1851. He died at Dul-
wich College in June 1864.

DERBY, WILLIAM, miniature painter.
Was born at Birmingham, January 10, 1786.
He was taught drawing in that town. In
1808 he tried to establish himself in London,
and engaged to make the reduced drawings
of the Stafford Gallery for the engravers.
He at the same time practised portrait
and miniature painting, occasionally making
water-colour drawings of portraits and pic-
tures. In 1825 he undertook to make the
drawings for Lodge's 'Portraits of Illus-
trious Persons,' and he also made for Lord
Derby copies, in water-colour, of all the
known portraits of his family from the time
of Henry VII. which are to be found in
the different collections. He was an occa-
sional exhibitor at the Royal Academy,
commencing in 1811. In 1838 he was
attacked with paralysis, but rallied and
resumed the pencil with his usual vigour.
He died in Osnaburgh Street, Regent's
Park, January 1, 1847, leaving a widow
and eight children. His copies were ex-
ecuted with extreme minuteness; careful
imitations of the original, both in manner

and spirit. ALFRED T. DERBY, his son, who practised miniature painting and had assisted him in his works, died, after a long illness, April 19, 1873, aged 52.

DE REYNE, JOHN, *history and portrait painter.* He was born at Antwerp, about 1610, and when young became the pupil of Vandyck, whom he accompanied to England, and was content to work for, unknown and unnoticed. His copies from Vandyck's works were so good that these repetitions have often passed for the originals. He continued in Vandyck's employment till his death in 1641, when he went to France and settled in Dunkirk. Here he was principally employed in painting subjects for churches, but he painted some portraits, which were much admired. He died 1678.

DERICK, ANTONY, *medallist.* Was granted a patent as graver to the Mint, 6th Edward VI., and held the same office from the 2nd to the 18th of Elizabeth.

DERYKE, WILLIAM, *history painter.* Born at Antwerp in 1635; he was bred a goldsmith and jeweller, became a pupil of Quellin, and then tried history painting. He came to England in the reign of William III. and settled here. His historical subjects were painted life-size, and in a large, bold manner; but he never attained any eminence in his profession. He died in London in 1697. He left a daughter, Katherine, who had been brought up to art, in which she excelled.

DE TABLEY, Lord, *amateur.* Was born April 4, 1762, and was well known as Sir John Fleming Leicester, one of the first who made a collection of the works of English painters. He had instruction from several eminent artists, and sketched in water-colours with much freedom and ability. He also painted a few slight sketches in oil. He executed a set of lithographic prints from his own drawings. He was created Baron De Tabley in 1826, and died June 18, 1827.

DEUCHAR, DAVID, *seal engraver.* He practised in Edinburgh, and in 1803 published three volumes of 'Etchings from Masters of the Dutch and Flemish Schools,' with some after original designs by himself.

DEVIS, ARTHUR, *portrait painter.* Was born at Preston about 1711, and was the pupil of Peter Tillemans. He painted portraits and small conversation-pieces. He lived for some time in Great Queen Street, Lincoln's Inn Fields, and was considered a respectable artist. In 1761 he exhibited at the Free Society's Rooms in the Strand, and became a member of the Society in 1763. A few years before his death he was employed to restore Sir James Thornhill's paintings in the Hall at Greenwich, and was paid for this work 1,000*l.* He painted a small group of 'The Pretender and his Friends,' and is said to have
124

borne so remarkable a likeness to the prince that, in a period of political excitement, he found it prudent to leave Preston in disguise. He died at Brighton, July 24, 1787, leaving a daughter and two sons.

DEVIS, ANTONY T., *landscape painter.* Brother to the above. Was born March 18, 1729. He received a premium at the Society of Arts in 1763, and appears as an exhibitor at the Academy in 1772, and again in 1781. He retired to Albury, near Guildford, in 1780, and died there unmarried in 1817, aged 87. He was much reputed as an artist, and was a teacher of drawing. His manner was in the very early style of water-colour art. Some of his drawings were made in black chalk, tinted with a gay prettiness of colour. His figures were weak in drawing.

DEVIS, ARTHUR WILLIAM, *portrait and history painter.* Son of the foregoing Arthur Devis. Was born in London, August 10, 1763. He showed an early genius for art, was educated by his father and studied in the schools of the Royal Academy, where he gained a silver medal. When about 20 years of age he was appointed draftsman on a voyage projected by the East India Company, and was wrecked in the 'Antelope' on the Pelew Islands. There the crew took part in the wars of the natives—in which he was twice wounded—and finally built themselves a vessel, which they were enabled to navigate to Macao. He passed one year in China, then sailed to Bengal, from whence he sent a portrait for exhibition at the Academy in 1791, and arrived in England in 1795. He resumed his profession with much zeal, and produced several works which gave him a reputation. He painted 'The Conspiracy of Babington, in the reign of Queen Elizabeth,' 'Cardinal Langton and the Barons forcing King John to sign Magna Charta,' 'Lord Cornwallis receiving the two Sons of Tippoo Saib as Hostages,' 'Miss O'Neill as "Belvidera."' After the Battle of Trafalgar, he went out to meet Nelson's ship, the 'Victory,' and made a facsimile of the cockpit, with portraits of the officers and attendants who surrounded their dying admiral. From these studies he painted the 'Death of Lord Nelson,' a fine work, which hangs appropriately in the gallery at Greenwich Hospital. On the death of the Princess Charlotte he painted a commemorative picture. From 1796 to 1821 he exhibited at the Academy. His contributions were chiefly portraits. His works were many of them engraved, and he enjoyed a large reputation. His colour, composition, and finish were good, but his works do not hold a first place in art. He was a generous, thoughtless man, and his life was marked by many vicissitudes. He died of apoplexy, February 11, 1822, and

was buried in St. Giles's Churchyard. He left two orphan daughters without provision. His brother, THOMAS ANTONY DEVIS, followed his profession, and was an occasional exhibitor of portraits between 1776 and 1789.

DE WALSINGHAM, ALAN, *architect.* He was sub-prior of Ely in 1321 and prior in 1341. On his first appointment he is assumed to have made the designs for St. Mary's Chapel in Ely Cathedral, and to have subsequently commenced the choir. On the fall of the tower he erected the elegant octagon tower and lantern, a work of great constructive skill. He was originally an ingenious 'fabricator' in gold and silver; and has been styled 'vir venerabilis et artificiosus frater.'

DE WESTON, WILLIAM, *architect.* He built St. Stephen's Chapel, Westminster, 4th Edward III.

DE WILDE, SAMUEL, *portrait painter.* He was chiefly devoted to dramatic portraiture, practising both in oil and water-colours. He contributed some small portraits to the Spring Gardens Exhibitions in 1776–77–78, and first exhibited theatrical portraits at the Academy in 1788. He contributed a 'Scene from the Children in the Wood,' 1794; from 'The Village Lawyer,' in 1795; and in the following year, from 'The Way to get Married.' He continued to exhibit chiefly theatrical portraits in character up to 1821. There are a number of his portraits in the Garrick Club. There are also some early portraits etched by him, among them John Lord Byron, to which he signed the assumed name of 'Paul.' Many of his works were also exhibited with the works of the deceased masters at Suffolk Street in 1833. He died January 19, 1832, aged 84.

DE WINT, PETER, *water-colour painter.* Was descended from an old and wealthy merchant family at Amsterdam, some members of which emigrated to America. His grandfather resided near New York, and his father was sent to the University at Leyden, where he studied as a physician and took his degree; but having, contrary to his father's wishes, married a young English lady of good family, he was disinherited and left to his own resources. He came to England, and settling at Stone, in Staffordshire, practised there as a physician. Here Peter, his fourth son, was born, January 21, 1784. He was intended for his father's profession, but disliking the study of medicine, he was permitted to follow art, his own choice; and in 1802 was placed under John Raphael Smith, the crayon painter and engraver, where he was a fellow-pupil with Hilton, R.A., with whom he formed a life-long friendship, and whose sister he married. In 1807 he entered the schools

of the Royal Academy, and was an exhibitor at the Academy in the same year, sending three landscapes, and continuing at some intervals an exhibitor up to 1828. In 1810 he first appears an an 'associate exhibitor' at the Water-Colour Society, his contributions showing the early bent of his art—'A Hay Field' and 'A Corn Field.' In 1812 he was elected a member. For nearly 40 years he contributed almost exclusively to its exhibitions, and was also distinguished as a teacher, making many true friendships among those who had been his pupils. He loved to paint direct from nature, and was never so happy as when in the fields. His subjects are principally chosen in the Eastern and Northern counties, and though often tempted to extend his studies to the Continent, the love of home and home scenery was so strong that, except a short visit to Normandy, he never left England. He formed a style of his own; his colouring was good and harmonious, his light and shade broad and simple, his figures well introduced; but he was an indifferent draftsman, deficient in executive handling. His works have much freshness and purity. He objected to the use of body colours, and was of the middle period of water-colour art. He died of disease of the heart, June 30, 1849, and was buried in the ground of the Royal Chapel in the Savoy. Good specimens of his art will be found in the galleries of the South Kensington Museum. His views in the South of France and the Rhone were published in 1830.

DE WITTE, ——, *portrait painter,* classed by Walpole as a Scottish painter. He was the painter of the apocryphal Holyrood portraits, having been engaged in 1684 to paint 'the pictures of the haill kings who have reigned over Scotland from King Fergus, the first king, to King Charles II., to completely finish and perfect them, and to make them like the originals, which are to be given to him.'

DIBDIN, CHARLES, *amateur.* Born at Southampton 1745. Educated at Winchester, and intended for the Church, but seduced by a love of music, he came to London. He played at the Richmond Theatre in 1762, and afterwards in London in 'The Maid of the Mill.' He was well known as the writer and composer of popular sea-songs. He had a taste for painting, and produced some pleasing views of Lake scenery, which were engraved in aqua-tint by John Hill, an artist who afterwards emigrated to America. He is said also to have assisted in scene painting. He wrote above 1,300 songs and 30 dramatic pieces. For the inspiriting influence which his songs had on the navy, he was granted a Government pension, which he lost on a

change of ministry. He was saved from indigence by an annuity purchased by public subscription. He died July 25, 1814.

DICKINSON, WILLIAM, *mezzo-tint and dot engraver*. Born in London in 1746. He was awarded a premium at the Society of Arts in 1767, and engraved after West, Morland, Angelica Kauffman, Stubbs, Bunbury, and numerous portraits after Reynolds, which he rendered with great truth and power. He was a good draftsman, greatly distinguished in his art ; his colour good, his engraving like the master. His best works are purchased at large prices. He retired to Paris, where he died in 1823.

DICKINSON, WILLIAM, *architect*. He was surveyor to Westminster Abbey in the early part of the 18th century ; and the design for the Rose Window of the north porch, the glass of which is dated 1722, has been ascribed to him. He superintended, 1671–80, the erection of St. Bride's Church, London, designed by Sir Christopher Wren.

▪ DIEPENBECK, ABRAHAM, *painter and draftsman*. Was born at Bois-le-Duc in 1607, and was the pupil of Rubens, under whom he studied with much industry, and then went to Italy, returning to work in his master's *atelier*. He first devoted himself to glass painting, completed some fine windows for the Antwerp churches, and gained the reputation of the first glass painter of the day, but his process in the furnace often failed. In the reign of Charles I. he came to England and painted some windows here. He was chiefly employed, however, by the Duke of Newcastle. He drew the Duke's managed horses for his Grace's book on Horsemanship. Also views of Welbeck and Bolsover, and the portraits of the Duke and Duchess, and of their children. He returned to Antwerp before 1641, and died there 1675.

▸ DIGHTON, ROBERT, *portrait painter and drawing-master*. Was a man of many talents — painter, actor, dramatic writer, singer, and withal a great humorist. He styled himself 'drawing-master.' He first appears as an exhibitor with the Free Society of Artists in 1769, and in that year and up to 1773 contributed small portraits in chalk. At the Royal Academy in 1775 he exhibited a frame of stained drawings ; in 1777 he sent 'A Conversation,' small whole-lengths, and 'A Drawing of a Gentleman from Memory.' In 1799 he published a 'Book of Heads,' satirical portraits of the leading counsel then at the bar—a work full of character ; and afterwards gained a sort of celebrity by his portraits and comicalities of this class. He also painted some scenery. He died at Spring Gardens in 1814, aged 62. Some very early caricatures have been attributed

126

to RICHARD DIGHTON, but it seems most probable that the Christian name is an error.

DIGHTON, DENIS, *battle painter*. Son of the foregoing. Was born in London in 1792. He was admitted a student of the Royal Academy, and drew some caricatures in his father's manner, yet better drawn ; but gaining the notice of the Prince of Wales, the Prince gave him a commission in the 90th Regiment. This he soon resigned and married, settling in London. He was in 1815 appointed military draftsman to the Prince, and continuing to study art, found in his Royal Highness a purchaser for his pictures. He was a constant exhibitor at the Royal Academy, where his works attracted notice. Commencing in 1811, he sent one picture annually up to 1825. His works were almost exclusively battles or military subjects. When changes took place at the palace, he lost his access to his royal patron, and the sale of his works, the chief souce of his income, was stopped. This, combined with other misfortunes, affected his health, and by degrees his reason. His wife took him to Brittany, where at St. Servan he was assisted from the Artist's Fund till his death there, August 8, 1827, aged 35. There is a 'Death of Nelson' by him in the Bridgewater collection, a clever watercolour drawing ; 'A Cavalry Skirmish' at the South Kensington Museum ; and a 'Battle of Waterloo' in the Queen's collection. His wife painted fruit and flowers, and between 1824 and 1835 was a frequent exhibitor at the Academy. She was appointed flower painter to the Queen.

DIGHTON, W. EDWARD, *landscape painter*. He exhibited English scenes at the Royal Academy from 1844 to 1850, and afterwards visited the East. On his return he exhibited, in 1853, 'Ruins of the Temple of Luxor' and 'Bethany,' and died in the September of that year. He was a young artist of promise.

DIXEY, JOHN, *sculptor*. Born in Dublin. Came to London at an early age, and studied at the Royal Academy. He exhibited there in 1788, and was on the point of leaving for Italy, when prospects, which were opened to him in America, induced him to emigrate there in 1789. He assisted greatly to promote art in that country. Resided many years in New York, and then removed to Pennsylvania on being elected vice-president of the Academy of Fine Arts in that city. He died 1820.

DIXON, CORNELIUS, *architect*. Was of some repute. He resided at Pimlico, London, in 1770. He designed the Royalty Theatre in Wellclose Square, which was completed in 1787, and destroyed by fire in 1826.

DIXON, JOHN, *miniature and crayon painter.* He was a pupil of Lely, and painted in water-colour with much skill nymphs, satyrs, cupids, and pictorial subjects. A great number of these works exist. He painted chiefly in miniature, and also drew in crayons. He was appointed by William III. 'keeper of the king's picture closet.' In 1698 he was concerned in a bubble lottery, which turned out ill; he fell into debt and retired to a small property near Bungay, where he died in 1715.

DIXON, JOHN, *mezzo-tint engraver.* Was born in Dublin about 1740, and came to London in early life, but not till he had dissipated a small patrimony. Originally a silver engraver, he studied under West in Dublin, and was well grounded in anatomy, and sketched and drew with correctness. He was a member of the Incorporated Society of Artists in 1766, and was early distinguished. Some of his best mezzo-tint portraits date soon after 1770, and are excellent in their execution and artist-like in their treatment; brilliant, but occasionally rather black. His most numerous and best works are after Reynolds, and have never been excelled; but he also engraved after Gainsborough, Zoffany, Stubbs, Dance, and others. He was a handsome man, and married a young lady of ample fortune, with an understanding that he should only thenceforth follow his profession as an amusement, to which he was unfortunately only too well disposed. He retired to Ranelagh, kept his carriage, and entertained his friends. He afterwards removed to Kensington, where he died in 1780.

DIXON, ROBERT, *landscape painter.* Published, in 1810-11, 'Norfolk Scenery,' comprising 36 views drawn and etched by himself. He was also an exhibitor at the Norwich Exhibitions—re-appearing, after some lapse, in 1818. His subjects were varied—compositions, landscapes, architecture, rural scenes, cottage-doors—and his manner had some resemblance to Westall, R.A.

DOBBS, ARTHUR, *architect.* He was appointed, in 1733, surveyor-general in Ireland, and completed the Parliament House, which had been commenced by his predecessor in that office.

DOBSON, ALEXANDER R., *architect.* Was the son of an architect in Newcastle-on-Tyne, and was brought up in his father's office. At the age of 21 he came to London, and studied under Mr. Sidney Smirke. In 1852 he returned to Newcastle, where he lost his life in attempting to save the lives of others from fire. He died in his 2th year, on October 6, 1854. He was favourably known in his profession by some clever drawings, and was a member of the Institute of British Architects.

DOBSON, WILLIAM, *portrait painter.* Was born in St. Andrew's parish, Holborn, 1610. His father was a gentleman of some consideration at St. Alban's, who, having squandered his estate, was appointed master of the Alienation Office, probably by Lord Bacon, who was his friend. Necessity made the son a painter. He was apprenticed to Sir Robert Peake, and soon gave proofs of his genius in portraiture. He also had some instructions from Francis Cleyn. He appears to have worked in obscurity till Vandyck chanced to see his work, generously befriended him, and introduced him to Charles I., with whom he found favour. On the death of Vandyck he was appointed the king's serjeant-painter and groom of the Privy Chamber. He followed the Court to Oxford, and painted there the King's portrait, the Prince of Wales's, also Prince Rupert's, but the decline of the royal cause and the disordered state of the country were a bar to his fortunes. At Lord Craven's, Coombe Abbey, there is a portrait of Charles II. by him; at Mr. Howard's, Gatton, a portrait of Milton; at Wilton, a large work, the 'Beheading of St. John;' at Hampton Court, a portrait-group of himself and his wife. His best works are carefully drawn and painted, though his colour is sometimes hot and crude, his hands very good, expression weak, drapery well studied, and altogether his portraits are life-like and characteristic. Sir Joshua Reynolds bestowed much praise upon his works. Dobson was careless to avail himself of his opportunities of saving money. He was a man of ready wit and pleasing conversation, but of a loose and irregular way of living, and when the impending unhappy times came to a climax he was in debt. Eventually he was thrown into prison, and when released by a friend, he enjoyed his freedom only a short time. He died in poverty at the age of 36, on October 28, 1646, and was buried at St. Martin's Church.

DOBSON, JOHN, *architect.* Was born at Chirton, North Shields, December 9, 1787, and was articled to a builder at Newcastle. He afterwards studied for a time under John Varley, and commencing practice in Newcastle, was the only architect then in the county. He soon gained employment, and in the intervals of his labour travelled in England and France. He erected several fine mansions and some churches in his locality, and gradually extended his practice to the neighbouring counties. His works showed good constructive ability, and he was employed upon some of the railway works in Newcastle. The Central Railway Station there is perhaps one of his most important erections, and the design, exhibited in Paris in 1855, gained him a 'médaille d'honneur.' He died in January 1865.

127

DODD, ROBERT, *marine painter*. He lived, early in life, at Wapping Wall, and beginning art as a landscape painter when only 23 years of age, had produced some good works. He then commenced marine subjects, storms, sea-fights, and in these he attained much excellence. In 1781 he painted 'Admiral Parker's Naval Victory;' in 1782, 'The Jamaica Fleet and Convoy in the Great Storm;' in 1785, 'The Loss of the "Centaur,"' followed by, 'The Action between the English ship "St. Margaret" and French "Amazon,"' 'The English Frigate "La Magicienne" encountering two French Frigates,' 'Rodney's Naval Victory;' in 1796, on an immense canvas, 'The British Fleet at Spithead getting under sail to escape the Ship-of-the-line "Boyle,"' which had caught fire; and in 1806, 'The Commencement of the Battle of Trafalgar.' Between 1782 and 1788 he was a constant exhibitor of naval subjects at the Royal Academy, and occasionally up to 1809, when his name cannot be traced farther. His storms at sea were highly impressive. His works had great truth and reality, and were extensively engraved and very popular. A view of the Royal Dockyard, Woolwich, in 1789, was both painted and engraved by his hand.

DODD, DANIEL, *miniature and subject painter*. Practised in the last half of the 18th century. He was an influential member of the Free Society of Artists in 1763, and a contributor of oil and crayon portraits to their exhibitions. For several years his works were of a small size. He painted 'The Royal Procession to St. Paul's,' a composition crowded with figures; and there is by him a good 'Representation of the Royal Academy, Somerset House,' the figures well drawn, which is engraved by Angus. His portraits of Leveridge, the actor, and of Buckhorse, a noted boxer, are also engraved. He also designed many of the illustrations for Harrison's Novelists, and for some other works.

DODWELL, EDWARD, *topographical draftsman*. Travelled in Greece in 1801 and 1805, and made drawings of some of the most memorable places. He published, in 1811, a classical and topographical 'Tour in Greece,' and in 1819 a larger work on the same subject, illustrated by 30 views from his own drawings, which, though careful and not badly drawn, cannot lay claim to much art merit.

DOLLE, WILLIAM, *engraver*. Born in England about 1600. He engraved chiefly portraits for the booksellers. They are in a weak, stiff manner, and most probably from his own designs. Among such portraits are Sir Henry Wootton, George Villars, Duke of Buckingham, and Robert, Earl of Essex.

DONALDSON, ANDREW, *water-colour painter*. Born at Comber, near Belfast.
128

His father was an operative weaver, and brought him in childhood to Glasgow. Here he was employed in a manufactory as a *piecer*, but meeting with an accident, which caused a weak state of health, he was apprenticed to a haberdasher, and seized opportunities for developing a love of art by sketching the picturesque buildings by which he was surrounded in the old city. He then found employment as a teacher of drawing and improvement in sketching the scenery of the neighbouring country, and eventually took high rank among the Scottish landscape painters in water-colours. He afterwards studied in the most picturesque parts of Great Britain and Ireland, where he found subjects for his pencil. He died at Glasgow, August 21, 1846.

DONALDSON, JOHN, *miniature painter*. Born in Edinburgh in 1737, where his father was a glover, and but in narrow circumstances. He was fond of drawing as a child, and while yet very young supported himself by miniature portraits in Indian ink. After some years he came to London, where he gained a premium at the Society of Arts in 1764, and again in 1768, when he was living at Edinburgh, for an historical painting of Hero and Leander. In 1764 he was a member of the Incorporated Society of Artists, and had tolerable success as a portrait painter. He also painted some vases sent to him in London from the Worcester china works, and his art in china is well-known and prized by collectors. But he had imbibed notions that the world was going wrong in religion, morals, and politics, and in his abstraction he wandered aside, dreaming that he could set all things right. His friends fell off, he lost his facility of execution, and then became disgusted with his art. He etched some small plates of beggars in the manner of Rembrandt; but withal he wanted perseverance, was of unsettled habits, and tried many schemes. He cultivated chemistry, and patented a mode of preserving vegetables and meat. He published a volume of Poems in 1786, which are not without some merit; and an 'Essay on the Elements of Beauty,' 1780. Yet, notwithstanding his many endowments, the last 20 years of his life were full of suffering, and he was sometimes without necessaries. At last, however, some friends made such provision as preserved him from destitution. He died October 11, 1801, and was buried in Islington Churchyard.

DONOWELL, JOHN, *architectural draftsman*. He was a member of the Incorporated Society of Artists in 1776. He exhibited views and designs in the Academy 1778-86. He built Lord Le de Spencer's house at Wycombe, the designs for which were printed in Wolfe and Gandon's work. His elevation is but mean and poor. Several

other engravings after his designs were published in 1753, and there is an excellent plate by him of the well-known Marylebone Gardens, published in 1761, full of well-drawn and characteristic figures.

DORIGNY, Sir NICHOLAS, Knt., *engraver*. Born at Paris 1657. He was brought up to the bar, which at the age of 30 his deafness compelled him to abandon. Having a brother a painter, he turned to art, and went to Rome, where for several years he studied painting. He then tried etching, and produced some plates after Raphael, the success of which tempted him to use the graver, and after lesser works he engraved Raphael's 'Crucifixion'—a work of great excellence. Some English travellers, with whom he was acquainted, then induced him to come to England to engrave the cartoons, and after nearly 25 years' residence in Rome, he left that city and arrived in London in the summer of 1711. He applied himself at once to raise the funds for this undertaking, which he commenced in the following Easter, upon a subscription of four guineas for the set, and with the patronage of Queen Anne, who assigned him an apartment at Hampton Court. He was in his 55th year, and hopeless of completing the work with his own hand, he availed himself of the assistance of two engravers whom he brought over from Paris, and with this help he was enabled, in April 1719, to present a complete set of the work to George I., who, in the following year, conferred on him the honour of knighthood. He had passed his best days before he even began the work. He must have been much helped by inferior assistants, and his cartoons do not rank with his earlier productions. While in England he painted some portraits, but did not meet with much success. His eyesight had failed. In 1723 he sold his collection of drawings, and in the next year returned to Paris, where he died in 1746, aged 89.

DORRELL, EDMUND, *water-colour painter*. Born at Warwick in 1778, and was brought up by his uncle, who had a good medical practice there, and intended him for his own profession, but yielded, however, to his love for drawing and etching, and assisted him to study art. He soon attained some proficiency, and for many years practised in London as a water-colour painter. He was an occasional exhibitor at the Academy from 1807 to 1828. He contributed to the Water-Colour Society in 1809 as 'fellow exhibitor,' and the following year as a member. In 1814 he seceded from the Society, but sent some drawings, 1815–18, as an outside exhibitor. He painted landscape scenes, sometimes with effects of storm. Among his contributions was a view of Ranelagh Gardens.

He died in London in 1857, in his 80th year.

DOUGHTY, WILLIAM, *painter and engraver*. Was born at York, and in 1775 became, on the introduction of the poet Mason, the pupil of Sir Joshua Reynolds, with whom, and in his house, he continued for three years. He then went to Ireland, and though possessed of good ability and recommended by Sir Joshua, did not succeed. He returned to London greatly dispirited, and in 1779 lived in Little Titchfield Street, Cavendish Square. He practised for a short time in his native city, and in 1780 set sail for Bengal, accompanied by a servant girl he had just before married from Reynolds's house. The vessel was captured by the combined French and Spanish squadrons, and he was carried into Lisbon, where he died in 1782. He exhibited a good three-quarters portrait of Reynolds in 1778, and in the following year a 'Circe,' but is best known by his mezzotints after Reynolds, and some others, which are very effective and artist-like. He also left a few etchings.

DOUGLAS, WILLIAM, *miniature painter*. He was brought up in Edinburgh, and was a pupil of Robert Scott, the engraver. He practised with great ability as a miniature painter about 1825.

DOWNES, BERNARD, *portrait painter*. He practised in London, and occasionally in the provinces. He was a member of the Incorporated Society of Artists in 1766, and appears as an exhibitor at the Royal Academy in 1770, continuing till 1775, when he ceased to exhibit, and died shortly after. He tried landscape as well as portraits, but his works were without merit.

DOWNMAN, JOHN, A.R.A., *portrait and subject painter*. He was born in Devonshire, and coming early to London, was the pupil of Benjamin West, P.R.A. He studied in the schools of the Royal Academy. He first exhibited with the Free Society of Artists in 1767, and in 1770 sent to the Academy Exhibition a kit-cat portrait of 'A Lady at Work,' followed by another portrait in 1772, and in the next year by 'The Death of Lucretia.' In 1777 he was practising as a portrait painter at Cambridge, and in the two succeeding years exhibited small portraits and subject pictures. He then returned to London, and up to 1802 continued to contribute a large number of portraits, with an occasional domestic subject, to the exhibition. In 1795 he was elected an associate of the Academy. He then visited, in 1806, Plymouth. In 1807–8 he practised at Exeter, and after some years' stay in London, was for about two years, 1818–19, at Chester, continuing to exhibit the same class of subjects. He died at Wrexham, Denbighshire, December 24, 1824.

Dowling J. painter

His portraits, which are very numerous, are drawn with the pencil, and a little tint used. They are frequently in profile, correct, but hard. His compositions were in water-colours, and though weak, were much esteemed. He painted 'Rosalind' for the Shakespeare Gallery. His portrait-group of Miss Farren and Mr. King, in character, is engraved, as are some other of his works.

DOYLE, JOHN, *caricaturist* (known as 'H. B.'). Was born of a respectable family in Dublin, 1797. Fond of art, he became a student in the Dublin Society's Schools. He soon gained notice as a portrait painter, and about 1822 came to London, and between 1825–35 occasionally exhibited a portrait at the Academy, but from the difficulty which he experienced in making a connection as a portrait painter, he was led to lithograph and publish likenesses of some of the most prominent of the public characters of the day. They became popular, and gaining thus a power of seizing with his pencil the prominent peculiarities of face and action, he was led to caricature. His drawing was stiff and formal, wanting in vigour and *abandon*. His subjects were political, always treated with a gentlemanly feeling of propriety, never descending to any approach to vulgarity. He was, for the eventful period from 1829 to 1840, recognised as the caricaturist of the day, the events of which he doubtless in some way influenced by his graphic comments. He died January 2, 1868, aged 70.

DRAKE, NATHAN, *portrait painter.* He was son of a vicar of the Cathedral at York, in which city and at Lincoln he chiefly practised. He exhibited with the Society of Artists, of which he was a member, between 1760–80, and among his contributions were — 'A Family in little,' views of Seats in Yorkshire, subjects from Thomson's 'Seasons,' a 'Madonna and Child.' He published in 1751, a 'View of the Town of Boston,' engraved by Muller.

DRAPENTIERE, JOHN, *engraver.* Supposed to have been born in France. He resided in London towards the end of the 17th century, and practised as an engraver. There are some neatly engraved portraits and frontispieces by him, but they are badly drawn. He also etched some portraits, one of which is dated 1691. A satirical print of a lady shaving a gentleman is also his work.

DRAX, Miss, *subject painter.* Made some drawings and designs in the last quarter of the 18th century. One of her designs is engraved by Tomkins, and printed in colours.

DROESHOUT, JOHN, } *engravers.*
DROESHOUT, MARTIN, } They resided in London about the middle of the 17th century, and were employed by

the booksellers, chiefly upon portraits and frontispieces, which have little merit, though the well-known portrait of Shakespeare by Martin is probably an authentic likeness.

DRUELL, JOHN, *architect.* Brought up to the Church. He was the joint architect of All Souls College, Oxford, commenced in 1437, and was employed as surveyor and architect by Archbishop Chicheley. He afterwards became archdeacon of Exeter.

DRUMMOND, JAMES, R.S.A., *subject and history painter.* Was born in Edinburgh in 1816, and was a student of the School of Design there under Sir William Allan. He was elected an Associate of the Royal Scottish Academy in 1846, and a full member in 1852, while in 1857 he became Librarian. His pictures, 'The Porteous Mob' and 'Montrose on his way to Execution,' are now in the Scottish National Gallery, of which Gallery he was elected principal curator in 1868. He was very fond of Scotch antiquities, and his studies in this direction are very evident in his pictures. He was an active member of the Antiquarian Society of Scotland. He was an occasional exhibitor at the Royal Academy in London, the last time being in 1865, when he sent 'Claverhouse and the Duke of Gordon.' Two of his paintings, 'Peace' and 'War,' are the property of the Queen. He died in Edinburgh, after a long illness, August 12, 1877.

DRUMMOND, SAMUEL, A.R.A., *portrait and history painter.* He was born in London, December 25, 1763. His father fought for the Pretender in 1745, and was for some time obliged to leave England. The son, at the age of 14, ran off to sea, and was in the service for six or seven years. Then, having fostered some love of art, he determined to try painting. He first drew portraits in chalk, afterwards in oil, but without having had any instruction. Gaining some facility, he was engaged to draw for the 'European Magazine,' on which he was employed for several years. He first exhibited at the Academy in 1791. In 1793 he sent two sea-views, with portraits; in 1801, 'The Woodman;' in 1804, 'The Drunken Seaman Ashore' and 'Crazy Jane.' These works gained him some repute, and in 1808 he was elected an associate of the Royal Academy, and was afterwards appointed curator of the painting school. He painted a 'Battle of Trafalgar' and a 'Death of Nelson,' which were engraved; and on a large canvas, 'Admiral Duncan receiving the Sword of the Dutch Admiral De Winter,' a commission from the directors of the British Institution, who presented it to Greenwich Hospital. He continued to exhibit both at the Academy and the British Institu-

tion, where he received a premium of 50l. in 1827. His later works were chiefly sacred subjects and from the poets. He died in August, 1844. His early manner was marked by a neat execution, but he grew careless in his finish, and his colour was crude and chalky. In the National Portrait Gallery the portraits of Mrs. Fry and Sir Isambard Brunel are by him.

DRURY, SUSANNAH, *landscape painter*. Practised about the middle of the 18th century. Vivares engraved 'The Giant's Causeway' after her.

DUBOIS, EDWARD, *landscape painter*. Was born at Antwerp in 1622, and studied there under a landscape painter. He passed eight years in Italy, and was employed by the Duke of Savoy. He then came to England in the reign of William III., and settled here, practising landscape, and occasionally history. He died, aged 77, in 1699, and was buried at St. Giles's Church, London.

DUBOIS, SIMON, *portrait painter*. Younger brother of the foregoing. Was a pupil of Philip Wouvermans. He came to England in 1685, and commenced practice as a portrait painter. He excelled in battle-pieces, and afterwards painted with great minuteness figures, horses, and cattle. He was an imitator of the manner of others, and sold his pictures under assumed names, several of them as originals by the Italian masters. He lived in Covent Garden, with his brother, in a miserly way, both heaping up their gains together. On his brother's death he became acquainted with Vandevelde, and married his daughter. He died in May 1708, the year after his marriage, and was buried at St. Giles-in-the-Fields. He left his hoarded money and a large collection of pictures to his widow. He painted the portrait of the Lord Chancellor Somers, and many distinguished persons sat to him. There is a whole-length portrait by him of Archbishop Tenison at Lambeth Palace.

DU BOSC, CLAUDE, *engraver*. Was born in France, and brought to England by Dorigny in 1712, to assist in engraving the cartoons, but left him upon some difference, and engaged to engrave them himself for the publishers. He also undertook to engrave the Duke of Marlborough's battles, and, with the assistance of Baron and Beauvais, whom he brought from Paris, completed them in 1717. He then set up as a printseller, and in 1733 published an English translation of Picart's 'Religious Ceremonies,' with illustrations, part of which he engraved himself. He also engraved some plates after eminent masters, the best of which was 'The Continence of Scipio,' after Nicholas Poussin. His drawing of the figure, particularly the nude

form, was weak and incorrect; his style black and heavy.

DUDLEY, THOMAS, *engraver*. He was born about 1634, and was esteemed one of Hollar's best pupils. In style he closely imitated his master. He etched some good plates, and his best work was a set of etchings, after Barlow, for the 'Life of Æsop.'

DUFFIELD, WILLIAM, *still-life painter*. He was born and educated at Bath, where his father was the proprietor of the Royal Union Library. When a boy he was fond of drawing, and was placed as a pupil with George Lance, and studied in the schools of the Royal Academy. For a time he practised portrait painting at Bath, sending from thence, in 1849, a fruit-piece, his first contribution to the Academy Exhibition, and in 1856 a similar work. He then studied for a season at Antwerp, and in 1857 settled at Bayswater, and continued with increasing reputation to exhibit at the Academy and in Suffolk Street. He painted dead game, flowers, and still-life with great ability, and was of much promise. He had lost the sense of smell, and painting in his room from a dead deer, was insensible to its dangerous state of putrefaction, which caused an illness, of which he died September 3, 1863, aged 46.

DUFFIN, PAUL, *portrait painter*. His father kept a mad-house in Chelsea. He for some time towards the middle of the 18th century practised as an itinerant artist, and painted several portraits in the neighbourhood of Canterbury; afterwards he became a picture-cleaner and dealer. There is a 'Country Wake' painted and etched by him, but it is entirely founded upon Teniers. He was living about 1755.

DU GUERNIER, LEWIS. *engraver and draftsman*. Born at Paris in 1677. Was a pupil of De Châtillon. He came to England in 1708, and greatly improved by his studies in the Artists' Academy, of which he was chosen the director, and continued in that office till his death. His chief employment was in engraving book frontispieces. He assisted Du Bosc in engraving the Duke of Marlborough's battles; engraved the portrait-heads of the Duke and Duchess of Queensberry, after Kneller, and a 'Lot and his Daughters,' after Caravaggio. He never attained much skill with his graver, but he was a good draftsman, and some small figures engraved by him are of great merit. He died of small-pox at the age of 39, on September 19, 1716.

DUNCAN, THOMAS, R.S.A., A.R.A., *history and portrait painter*. Was born at Kinclaven, Perthshire, May 24, 1807. While at school he painted the scenery for the play of 'Rob Roy,' which was got up by his schoolfellows, and had a desire to be

an artist, but his parents placed him in the office of a writer to the signet, whose profession they deemed more advantageous. When he had finished his engagement, and was in his 20th year, his desire still prevailed, and he went to Edinburgh, and entering the Scottish Academy made rapid progress in his elementary art studies. His early works—'Sir John Falstaff' and 'Sweet Anne Page'—having gained him a reputation in Edinburgh, he was chosen a member of the newly-founded Royal Scottish Academy in 1830. He exhibited at the Royal Academy, London, in 1840, his picture of 'Prince Charles Edward and his Highlanders entering Edinburgh after the Battle of Preston Pans;' in 1841, his 'Auld Robin Gray;' in 1842, his 'Deerstalkers;' and in 1843 he was elected an associate of that Institution. He afterwards painted 'Prince Charles asleep, concealed, after Culloden.' The above two pictures of Prince Charles, which are his best productions, were well engraved, and confirmed his reputation. His last exhibited works were in 1844—a 'Cupid' and 'The Martyrdom of John Brown of Priesthill, 1685.' He was attacked by a tumour affecting the brain, of which he died at Edinburgh, May 25, 1845, aged 38, leaving a widow and family without provision. His works show considerable ability in drawing, composition, and colour, but his premature death prevented the full development of talents which promised still higher things.

DUNCANNON, FREDERICK, Viscount, *amateur*. Born in 1758, and became 3rd Earl of Bessborough. Painted in watercolours. Four views by him are engraved in Angus's 'Views of the Seats of the Nobility and Gentry in Great Britain,' commenced in 1787. He died in 1844.

DUNKARTON, ROBERT, *mezzo-tint engraver*. Born in London in 1744. He was a pupil of Pether, and in 1762 was awarded a premium by the Society of Arts. He first commenced as a portrait painter, and exhibited portraits at the Spring Gardens Exhibitions in 1768–69, and at the Royal Academy, commencing in 1774—portraits in crayons, small whole-lengths, theatrical portraits, and others, discontinuing to exhibit after 1779. But his chief art was as a mezzo-tintist, in which he was rarely surpassed. He engraved portraits after Reynolds, West, Mortimer, Pether, and some historical subjects—'The Disciples at Emmaus,' 'Joseph's Cup found in Benjamin's Sack,' 'Joseph sold by his Brothers,' 'The Interpretation of the Dream.' He died towards the end of the century.

DUNSTALL, JOHN, *engraver*. He practised in the reign of Charles II., and lived in the Strand, where he taught drawing. He designed, engraved, and etched a

set of prints on natural history — birds, beasts, flies, worms, fruit, and flowers, which is dated 1662. He engraved, in the manner of Hollar, portraits and frontispieces for books, and portraits of Mary of Modena and of King William and Queen Mary.

DUNTHORNE, JOHN, *portrait painter*. Practised as a painter and draftsman at Colchester in the latter part of the 18th century, and exhibited a portrait at the Academy in 1784. Several of his works were engraved, among them 'Stella' and the companion 'Rosina,' and a 'Catherine.'

DUNTHORNE, JOHN, *subject painter*. Son of the above ; practised at Colchester. He first exhibited at the Academy in 1783, and continued an exhibitor up to 1792. His works were 'Death Preaching,' 'A Smithfield Bargain,' 'The Hypochondriac and the Lunatic,' 'Rustic Dinner,' 'A Farmer and his Family of the last Century,' 'Ague and Fever,' and others of the same class. He died young and almost unknown though his works showed much ability.

DUPONT, GAINSBOROUGH, *portrait-painter*. Was born in 1767, and was the maternal nephew of Gainsborough, R.A., in imitation of whom he painted some landscapes. He exhibited for the first time at the Royal Academy, in 1790, a 'Cottage Girl,' with five portraits, and continued an exhibitor up to 1795. His chief employment was in portraiture. His principal work is a group of the masters of the Trinity House, for which he received 500*l.*, now in the court-room of that corporation. His portraits partook of the manner of his uncle. He died at his house in Fitzroy Square, after a few days' illness, January 20, 1797. He was buried in the same grave with Gainsborough in Kew churchyard.

DUPONT, PETER, *engraver*. Born in 1730, in Paris, and completed his study there. He then came to London, where he settled. He engraved, after Gainsborough, a portrait of General Conway and of Colonel St. Leger, and other works. He signed his plates 'Paul Pontius,' by which name he was known. He died in London about the end of the century.

DUPPA, RICHARD, *draftsman and copyist*. Practised in London. Towards the end of the 18th century studied some time in Rome, and copied some of the finest heads in Michael Angelo's 'Last Judgment.' These he published under the title of 'Twelve Heads from the Last Judgment of Michael Angelo ;' and afterwards, in 1803, 'Heads from the Fresco Paintings of Rafaello in the Vatican.' In 1807 he published the 'Life of Michael Angelo,' with 50 etched plates, and in 1816 a 'Life of Rafaello Sanzio d'Urbino.' He also published several works unconnected with art.

DURANT, J. L., *engraver.* Practised in London towards the end of the 17th century. He was chiefly employed upon portraits and ornamental frontispieces for books. There is a portrait by him of Mary, Queen of William III.

DURANT, Miss Susan, *sculptor.* She was of a respectable Devonshire family, and first practised art as an amateur, but her success led her to take it up as a profession. She was a frequent exhibitor of busts at the Royal Academy, commencing in 1847, and occasionally sent also a group—in 1850, 'Statue of a Girl;' in 1856, 'Statue of Robin Hood;' in 1858, 'Negligent Watchboy catching Locusts;' in 1863, 'The Faithful Shepherdess,' commissioned by the corporation of London; in 1866, 'Constance,' from Chaucer's 'Man of Lawe's Tale.' She was much employed by the Queen, and modelled busts and medallions of the royal family. The Princess Louise was her pupil. She was a pupil of Baron H. de Triqueti, and died in the prime of life, after a few days' illness, when on a visit at his house in Paris, January 1, 1873.

DURHAM, Joseph, A.R.A., F.S.A., *sculptor.* Was born in London in 1814. He early shewed a taste for art, and was apprenticed to Mr. John Francis, a decorative carver. He afterwards worked for three years in the studio of E. H. Bailey, R.A. He first exhibited in the Royal Academy in 1835, and from that time forward worked hard and produced many busts; of these, his portrait of Jenny Lind exhibited in 1848, and that of Her Majesty the Queen which was in the Royal Academy in 1856, are perhaps the most celebrated. Among his other works must be mentioned his statue of Sir F. Crossley, designed for Halifax, four sitting statues for the portico of the London University, and several effigies in stone of the Prince Consort, the first and best of which was placed in the Royal Horticultural Gardens, London, in 1863. His best classical works are 'Hermione' and 'Alastor,' now in the Mansion House, and 'Leander and the Syren,' exhibited in 1875 at the Royal Academy. He also produced many groups of boys engaged in various sports. He was elected an Associate of the Academy in 1866. He suffered under many disorders and died in London, October 27, 1877, aged 63.

DURNO, James, *history painter.* Born about 1750. Was the son of a brewer at Kensington. He was pupil of Casali, an Italian painter who visited England; and he also received some instruction from West, P.R.A., whom he assisted in preparing duplicates of his works. He was a member of the Incorporated Society of Artists in 1766, and contributed classic subjects to the Spring Gardens Exhibitions

in 1768–69 and 1772. Commencing his art as a history painter, he gained premiums at the Society of Arts in 1766, 1770 and 1773, the last of 100 guineas. He assisted Mortimer in painting the ceiling at Brocket Hall. In 1774 he went to Rome, where from that time he chiefly resided, and died of putrid fever, September 13, 1795. He painted at Rome two pictures for Boydell's 'Shakespeare,' but they are very poor productions, saying little for his art.

DUSIGN, ——, *portrait painter.* His father held the rank of colonel in the regular army. He became a pupil of Sir Joshua Reynolds, and for a time practised portrait painting at Bath, where his family dwelt. He went to Rome for his improvement in art, and soon after died there of consumption in 1770.

DUVAL, Philip, *history painter.* Born in France; was a pupil of Charles Le Brun. Settled in England in the reign of Charles II. and practised several years in London. He was much encouraged, and painted in 1672 the celebrated Mrs. Stuart, afterwards Duchess of Richmond, as 'Venus receiving from Vulcan armour for her son.' He had some knowledge of chemistry, and lost his small fortune in its pursuit. His art falling off at the same time, he was allowed 50*l.* a year by Mr. Boyle, on whose death he fell into great distress, and his mind gave way. He died in London in 1709, and was buried at St. Martin's Church.

DUVAL, C. A., *portrait and subject painter.* He practised at Manchester, where he was known and esteemed. From 1836, when he first exhibited a portrait at the Royal Academy, he was with some intermissions an exhibitor till his death. In 1842 he exhibited 'The Giaour;' in 1855, 'Columbus in Chains;' in 1858, 'The Dedication of Samuel to the Lord;' in 1861, 'The Morning Walk;' at the same time also sending portraits. He died suddenly, June 15, 1872, aged 64.

DWYER, John, *architect.* He had from 1845 exhibited occasionally at the Academy designs for interior arrangements and fittings, and was at once distinguished as one of the successful competitors in the designs for the Government offices in 1857. But he died suddenly of sea-sickness, on landing at Dover, August 31, 1858, aged 39.

DYAS, Edward, *wood engraver.* He was a clever, self-taught artist, who lived near Madeley, Shropshire. He executed the woodcuts for the illustration of 'Alexander's Expedition,' a poem by Dr. Beddoes, printed in 1792, but not published.

DYCE, William, R.A., *history painter.* He was the son of a physician at Aberdeen, where he was born in 1806; educated at the Marischal College, he took there his M.A. degree, and early distinguished himself by his attainments. Led by a love of art,

when in his 17th year he entered the schools of the Royal Scottish Academy; afterwards he came to London and became a probationary student at the Royal Academy, but did not like the course of study, and before the age of 20 went to Italy and studied the works of the great masters at Rome and Florence. In 1826 he returned to Scotland, and in 1827 exhibited his first picture at the Royal Academy, 'Bacchus nursed by the Nymphs.' He soon after revisited the Continent to mature his earlier studies. He sent home for exhibition a 'Madonna and Child,' which gained much notice, and after about two years returned and settled in Edinburgh. Here he continued about eight years, devoted in spirit to historic art, in which he did not find encouragement, and practising chiefly as a portrait painter. In 1835 he was elected an associate of the Royal Scottish Academy.

He had paid much attention to ornamental design, which he had studied in the palaces and churches of Italy; and in 1837 published a pamphlet on 'Schools of Design as a part of State Education.' The consideration of the president of the Board of Trade was at the time directed to the subject, and he was offered and accepted the superintendence of the schools established by the Government; and was in the first place commissioned to investigate and report upon the Continental systems of art education. He made a satisfactory report, which was printed as a parliamentary paper. In 1842 his office was changed to that of inspector of Provincial Art Schools, which he resigned in 1844, and was then made a member of the Council of the Government Schools, and gave his useful aid till 1848, when he finally resigned. He had failed to carry out his views for the establishment of schools of design, and the successful completion of his work was left to others.

While engaged in such matters he had continued to exhibit, chiefly portraits, at the Academy; but in 1836 his 'Descent of Venus' attracted much notice, and in 1844 he was elected an associate of the Academy. He had also been one of the successful competitors in the Fresco Exhibition in Westminster Hall, and employed by the Royal Commission he completed in 1845 the first fresco, 'The Baptism of St. Ethelbert,' on the walls of the palace of the Legislature. For this style of decoration he was peculiarly fitted by his previous studies and the character of his art, and was deemed very successful. In 1848 he received the important commission to decorate the Queen's Robing-room with designs from the legend of King Arthur. Of these he only lived to complete five, one principal and four lesser subjects, of unequal dimensions. The first, 'The Admission of Sir Tristram to the Fellowship of the Round Table,' typifies

134

Hospitality; the second, 'The Vision of Sir Galahad and his Company,' Religion or Faith; the third, 'Sir Gawain swearing to be merciful, and never to be against the Ladies,' Mercy; the fourth, 'King Arthur unhorsed, spared by Sir Launcelot,' Generosity; the fifth, 'Sir Tristram harping to La Reine Isonde,' Courtesy. He was elected an associate of the Royal Academy in 1844, and a full member in 1848.

During the whole of his career he had continued to exhibit easel pictures at the Royal Academy. Of these, his peculiar art will be best remembered by his 'King Joash shooting the Arrow of Deliverance,' 1844; and his sketch for the fresco, 'Neptune assigning to Britannia the Empire of the Sea,' 1847, painted for the Queen at Osborne House; and of his later works, by his 'Jacob and Rachael,' 1853; 'St. John leading Home the Virgin,' 1860; and 'George Herbert, of Bemerton,' 1861. He also painted a series of frescoes in the church of All Saints, Margaret Street, Cavendish Square, completed in 1859, in which he has strictly followed out the theories of his art. It is greatly to be lamented that he did not live to complete his great epic legend of King Arthur, the delay upon which, and the controversy to which it gave rise, no doubt accelerated his death, which happened on February 15, 1864. He had passed the latter part of his life at Streatham, and was buried at the parish church.

He drew the figure correctly and with grace, but without much originality of style, founding himself rather on the old masters he had made his study. His colour was positive, not graced by the refinements of tint, but was well suited to the character of his art. His works were more learned than original, marked rather by refinement of taste than an appeal to the feelings. To his great attainments in art he added the accomplishments of a scholar and of a musician well skilled in the science of music. He published, in 1842–43, 'The Book of Common Prayer, with the Ancient Music set to it at the Reformation,' for which the King of Prussia sent him a gold medal; 'An Essay on Magnetism,' which gained him the Blackall prize at Aberdeen; in 1844, 'The Theory of the Fine Arts;' in 1851, 'Notes on Shepherds and Sheep: a Letter to J. Ruskin;' in 1853, 'The National Gallery, its formation and management;' in 1858, 'On the Connection of the Arts with General Education' and 'On the Position of Art in the proposed Oxford Examinations.'

DYER, JOHN, amateur. Was born at Aberglasney, in Carmarthenshire, in 1700. He was the son of a lawyer, and was educated at Westminster School, and intended for the law; but his inclinations led him to the arts, for which he was professionally instructed, and wandered through South

Wales and the adjacent counties, painting the ancient ruins and picturesque features of the scenery. In 1727 he distinguished himself as a poet by his beautifully descriptive poem of ' Grongar Hill,' and about that time went to Italy, and again his studies of nature were described with his pen, instead of his pencil, in his poem of ' The Ruins of Rome,' 1740. Yet he spent much time in sketching in the environs of Rome and Florence. On his return to England he entered the Church, and held the living of Calthorpe, in Leicestershire, which he exchanged for Belchford, in Lincolnshire,

and was afterwards presented to Coningsby, where, in 1757, he published ' The Fleece,' his last work. He died of consumption, July 24, 1758. Several of his landscapes exist.

DYER, CHARLES, *architect.* Was born 1794, the son of a surgeon at Bristol. His principal works are at Clifton, where he built the Victoria Rooms, the Bishop's College, and the Female Orphan Asylum. He was also the architect of several churches in the West of England, and in London of the hall of the Dyers' Company. He died January 13, 1848.

E

EAGLES, The Rev. JOHN, *amateur.* He was a clever painter of water-colour landscapes, who resided in Bristol, and was in 1809 an unsuccessful candidate for admission in the Water-Colour Society. He had the reputation of being a good etcher, and was the author of a paper, ' The Sketcher,' published in ' Blackwood's Magazine.' He also wrote ' Felix Farley's Rhymes,' a macaronic satire on the inhabitants of Bristol, and ' The Bristol Riots: their Causes, Progress, and Consequences.'

EARLE, A., *marine and landscape painter.* He practised in London, and first exhibited at the Academy, in 1806, ' The Judgment of Midas;' in the following year, ' The Battle of Poictiers;' in 1811 and 1812, ' Banditti;' in 1814, ' Man-of-war's Boats cutting out a French Barque.' In 1815 he exhibited for the last time, his subject ' The Harbour and Town of Calais.' Two views by him have been engraved—' Malta, with the Harbour,' and the ' City and Harbour of Valetta.'

EARLE, THOMAS, *sculptor.* Was born at Hull in 1810, and gained the Royal Academy gold medal and books for the best historical group of sculpture in 1839. He was between twelve and fourteen years with Sir F. Chantrey, as designer or lead modeller, and it is well known that the equestrian statue of George IV. in Trafalgar Square was Earle's work in Chantrey's studio. He exhibited from time to time in the Royal Academy Exhibitions very artistic works such as ' Sin Triumphant,' ' L'Allegro,' ' Hyacinthus,' ' Ophelia,' ' Miranda,' and ' Flower Girl of Capri,' in 1873. A portrait of Her Majesty in his studio at his death proves him to have been great in his portrait busts. He died of valvular disease of heart, brought on by professional disappointment in London, 28 April, 1876.

EARLOM, RICHARD, *engraver.* He was son of the vestry clerk of St. Sepulchre, London, and born there 1743. In 1757 he was awarded a premium by the Society of Arts. He showed an early taste for art, and made copies of Cipriani's allegorical designs on the panels of the lord mayor's State carriage. This led to his becoming the pupil of Cipriani. He soon acquired a power of drawing, and mastered the technicalities of engraving. Alderman Boydell employed him to make drawings from the Houghton collection, and afterwards to engrave the chief of them in mezzo-tint. In this branch of his art he was self-taught, and introduced many improvements in the mode of execution.

He produced some etchings and some plates in the chalk manner, but his chief excellence is as a mezzo-tint engraver. His works show great technical skill, and are marked by brilliancy, spirit, and truth; powerful, yet delicate in a high degree, the drawing good, and the imitation of the master accurate; yet, possessing these high qualities, they want keeping, the lights being too much scattered; and they fail in the textures, which are not in all cases natural. He engraved subjects, landscapes and portraits, both after the old masters and after his contemporaries, and was noted for his groups of flowers after Van Huysum and Van Os. His ' Liber Veritatis,' comprising mezzo-tint engravings after 200 drawings by Claude, published in 1777, is well known.

He possessed a moderate property, yet he quietly pursued his profession, retiring only from practice towards the end of his long life. He died in Exmouth Street, Clerkenwell, on October 9, 1822, in his 80th year, and was buried in the lower burial-ground of St. Mary, Islington. His son, WILLIAM

EARLOM showed great talent for art, but died at the age of 17, in 1789.

EARLOM, RICHARD, *engraver.* He is said to have been born in 1728, in Somersetshire, and to have died in 1794. He is mentioned both by Joubert and Basan as distinct from the foregoing Richard Earldom.

EAST, THOMAS, *die engraver.* He was a pupil of Thomas Simon, the great medallist. He was appointed engraver of the seals to James II., and practised in London in the latter half of the 17th century.

EASTLAKE, Sir . CHARLES LOCKE, P.R.A., *historical painter.* He was the son of a lawyer of good standing at Plymouth, who filled the office of judge advocate and solicitor to the Admiralty, and was born in that town November 17, 1793. He commenced his education at the Borough Grammar School, and was then removed to the Charter House, where he acquired a sound education. While here he made up his mind to be a painter, and wrote a boyish but grave letter to his father explaining his fixed intentions, which were probably influenced by the career Haydon was then entering upon. He had received some early instructions from Prout, and in 1809 became a student in the Academy Schools, where he worked industriously; attended Sir Charles Bell's anatomical lectures, and early cultivated a sound judgment. Supported by an adequate allowance from his father, he visited Paris, where he studied industriously for some months. He then settled at Plymouth, where he painted some portraits, and when the deposed Emperor Napoleon was brought into port there on board the 'Bellerophon,' he managed to paint a portrait of him, surrounded by his officers, which gained him notice, and by its sale assisted him in 1816 to set off for Italy and to extend his tour to Greece. Taking Malta and Sicily on his way home, he returned after nearly twelve months' absence.

After only a temporary stay at Plymouth, he visited the Low Countries and Germany, and then went again to Rome, purposing only to make a short stay; but more and more attracted by the love of Italian art, and the facilities for study, from time to time protracting his stay, he continued there about 12 years. In 1823 he sent from Rome his first contribution, comprising three views in that city, to the Academy Exhibition; in 1825, 'A Girl of Albano leading a Blind Woman to Mass,' and at once made himself known. In his next work, exhibited in 1827, aiming at the highest style in art, he represented 'The Spartan Isadas rushing undraped from the Bath to meet the Enemy,' and was elected the same year an associate of the Academy. This was followed in 1828 by another im-

136

portant work, 'Pilgrims arriving in sight of Rome,' which, with slight alterations, he repeated several times. In 1829 he exhibited 'Byron's Dream;' in 1830, 'Una delivering the Red Cross Knight;' and in this and some works that followed he aimed to attain a richer style in his colour.

In 1830 he was elected a full member of the Academy. During his long residence at Rome he had become used to the customs of the city, and had always been received into the best society; but on his election a feeling of duty to his colleagues induced him, though with great reluctance, to return to England, and in the following year he had settled in London, and exhibited two Italian subjects, with his 'Haïdée, a Greek Girl.' In 1833 his 'Greek Fugitives' was his principal work; and in 1834, 'The Escape of Francesco di Ferrara,' with 'The Martyr' and some portraits. He was at this time, and for the next few years, entirely devoted to his art, painting chiefly Italian subjects, with a few portraits. In 1839 he exhibited his 'Christ blessing little Children,' and in 1841, 'Christ weeping over Jerusalem.' But he was now led to undertake some public employments of high responsibility, but of great interest and utility in the cause of art, for which his varied acquirements, good judgment, and kindly impartiality rendered him peculiarly well fitted.

He was, in 1841, appointed secretary to the Royal Commission for the decoration of the Houses of Parliament; in 1842, the librarian of the Royal Academy; in 1843, keeper of the National Gallery; and in 1850 he was elected the president of the Royal Academy and received the honour of knighthood. He had been subjected to some groundless attacks, and had resigned his appointment at the National Gallery in 1847; but on the reorganisation of the management of that Institution in 1855, he was appointed to the newly-created office of director, with an annual salary of 1,000l. In fulfilling this invidious trust, he year by year journeyed on the Continent to acquire pictures, and added 139 to the Gallery, including many fine works of the early Italian school. While occupied with these onerous engagements, and with his literary works and investigations on the principles of his art, he had little thought or leisure for its practice. He exhibited in 1850 a replica of his 'Escape of Francesco di Ferrara,' which combines some of the finest qualities of his art, and has happily found a place in the National Gallery. In the following years he contributed only three unimportant works, and after 1855 did not again exhibit.

His constitution had long been weakly, and broke down at Pisa, where he died December 24, 1865. His body was brought to England. A public funeral, which the Royal

East Alfred (1890)

Academy proposed to give him, was declined by his widow, and he was carried to his grave in the Kensal Green Cemetery, surrounded by his friends. He received the honorary degree of D.C.L. at Oxford, was a chevalier of the Legion of Honour, and an honorary member of some foreign academies. As a painter, he fell short in his maturity of the early promise of his youth. His works have great refinement of feeling and idea, beauty of expression and graceful arrangement, but were over-finished, and did not exhibit any largeness of manner or execution. He seemed unable to realise the promptings of his cultivated genius. In office he was a painstaking and conscientious administrator, anxious to adapt the usefulness of the Academy over which he presided to the wants of the time. As a writer and critic, he was earnest in the promotion of art and the interests of its professors. His chief published works are—'Materials for a History of Painting,' 1847; 'The Schools of Painting in Italy,' translated from Kugler, 1851; 'Kugler's Handbook of Painting,' edited with notes, 1855; and to these may be added some writings on subjects of passing interest, with reports and addresses to the students of the Academy.

EBDON, CHRISTOPHER, *architect and topographical draftsman.* He was one of the early painters of *tinted* views, and a member of the Incorporated Society of Artists in 1766. He contributed to the Society's Exhibitions in 1767 and 1770. An interior view of Durham Cathedral by him was engraved and published in 1769.

ECCARDT (or ECKHARDT), JOHN GILES, *portrait painter.* Born in Germany. Came to England when young, and was the pupil of J. B. Vanloo. He settled in London, where he gained some reputation as a portrait painter. He painted Sir Robert Walpole and his first wife, Catherine Shorter; Peg Woffington, in 1745; Dr. Middleton; and others. There were several whole-lengths by him in the Strawberry Hill collection. His works were carefully painted, but showed little of the genius of a master. Walpole addressed to him, in 1746, 'The Beauties,' a little poem. His collection was sold by auction at Langford's in 1770, and he retired to Chelsea, where he died in October 1779.

ECKSTEIN, JOHN, *modeller and portrait painter.* Was born in Germany; studied art in this country, and was a pupil of the Royal Academy. In 1762 and in 1764 he gained a premium at the Society of Arts for a basso-rilievo in Portland stone. In 1770 he exhibited at the Academy portraits modelled in wax, and in 1780 was an unsuccessful competitor for the Academy gold medal for a model of 'Adam and Eve.' He was employed by Mr. Carter, and carved the two figures in basso-rilievo, which were greatly admired by Flaxman, R.A., for the Townshend monument on the south wall of Westminster Abbey. He practised for a time in Birmingham, and sent from thence in 1792 portraits for exhibition at the Academy. In 1796 he resided in London, and then exhibited 'The Soldier's Return' and a portrait-group of a lady and children, both paintings in oil. In 1798 he exhibited both models and paintings, and these were his last contributions.

● EDEMA, GERARD, *landscape painter.* Born at Friesland (or, as some state, at Amsterdam) in 1652. He was a pupil of Everdingen, and came to England in 1670. He then made voyages to Norway, Newfoundland, and the British Colonies in America, collecting subjects for his pictures. He delighted in the wild scenery of rocks and waterfalls. He could not paint the figure, and was assisted by Wyck. He lived some time at Mount Edgecumbe, and painted many views in that neighbourhood. He was intemperate in his habits, by which his early death, which took place at Richmond in 1700, was accelerated.

EDMONSTONE, ROBERT, *subject painter.* Was born at Kelso, N.B., in 1795, of respectable parents, and was apprenticed to a watchmaker, but he was so attached to art, that under many difficulties he found means to pursue it. He brought his first works to Edinburgh, and received such encouragement that he was induced to come to London, as a larger field in which to pursue his studies, determined to follow art as his profession. He became a student at the Academy, and also received some assistance from Harlow. He exhibited some portraits at the Academy in 1818, and again in 1819, when he managed to visit the Continent. He remained abroad some years, diligently following his studies in Rome, Naples, Venice, Florence, and other cities. He returned to London and commenced practice as a portrait painter, exhibiting from 1824 to 1829 portraits and portrait-groups, but his chief thoughts were directed to subject pictures, works of imagination, into which he introduced children with great truth and grace. In 1830 he exhibited 'Italian Boys playing at Cards.' He was in Italy a second time in 1831-32, and on his return exhibited in 1833, 'Venetian Water-Carriers,' and in 1834, some portraits of children. His works were marked by a refined sentiment; the composition and action of the figures treated with much simplicity. His career seemed one of much promise, but his constitution had suffered under a severe attack of fever at Rome. His health gave way. He tried his native air, but without relief, and died at Kelso,

in his 40th year, on September 21, 1834. He painted at Rome, ' Kissing the Chains of St. Peter.' His last work was ' The White Mouse.'

EDRIDGE, HENRY, A.R.A., *miniature painter.* He was born at Paddington in August 1769, the son of a tradesman in St. James's, Westminster, who died young, leaving a widow and five children with scant provision. He showed an early attachment to art, and at the age of 14 became the pupil of William Pether, the mezzo-tint engraver and landscape painter. Two years after the expiration of his apprenticeship he was admitted a student of the Royal Academy, and in 1786 gained the silver medal, and with it the notice of Sir Joshua Reynolds, who permitted him to make miniature copies from his works. From this time he laid aside engraving, and studying miniature successfully, established himself as a portrait painter, and marrying, settled in Dufour's Place, Golden Square. He first exhibited at the Academy, in 1786, ' The Weary Traveller,' a miniature ; in 1803, portraits of the King and the Queen. His earliest works were on ivory, afterwards on paper drawn with black-lead or Indian ink. Then later he abandoned this method, and drawing the figure in a slight, spirited manner, finished the face of his sitter elaborately in water-colour. He had a great feeling for landscape art, which he acquired from a study of Hearne, whom he surpassed in colour and power. In 1817, and again in 1819, he visited France and sketched many picturesque subjects in Paris and the Norman cities. In 1820 he exhibited some of these drawings at the Royal Academy, and was elected an associate the same year. There are by him two small landscapes in oil. He lost his daughter when in her 17th year, and soon after his remaining child, a boy of the same age. His constitution gave way under this last blow ; he died in Margaret Street, Cavendish Square, where he had resided during the previous 20 years, on April 23, 1821, and was buried by his friend Dr. Monro, in Bushey Churchyard.

EDWARDS, EDWARD, A.R.A., *portrait and subject painter.* Was the son of a chairmaker and carver, and born in Castle Street, Leicester Square, March 7, 1738. He had some ability for drawing, and in 1764–65 received premiums at the Society of Arts. He became a student in the Duke of Richmond's Gallery and the St. Martin's Lane Academy, and a member of the Incorporated Society of Artists. For some time he taught drawing in an evening school to support himself and his widowed mother, with a brother and sister. He was successful in gaining three of the Society of Art's premiums, and was employed by

Alderman Boydell in making drawings for his publication of engravings from the old masters. In 1770 he resigned his membership with the Incorporated Society, and first exhibited at the Academy, in 1771, ' The Angel appearing to Hagar and Ishmael ; ' in 1773, ' Bacchus and Ariadne,' followed by portraits, landscape and Shakespeare subjects, continuing to exhibit to the year of his death. In 1773 he was elected an associate of the Royal Academy, and in 1788 was appointed teacher of perspective. In 1775 he managed to visit Italy, it is said with the assistance of Mr. Udney, by whom he had been employed, and on his return settled down in the practice of his profession. He painted a subject from the ' Two Gentlemen of Verona,' for the Shakespeare Gallery, but his works were not of a character to attract notice, and such success as he had was due to persevering labour rather than to genius. He possessed some knowledge of architecture, and was a tolerable musician and violin player. He published ' A Treatise on Perspective ' in 1803, and ' Anecdotes of Painters,' a sort of supplement to Walpole's work, by which alone he is now remembered ; also, in 1792, a series of 52 etchings on various subjects. Weakly in frame and in constitution, he died December 10, 1806, and was buried in old St. Pancras's Churchyard. A memoir of him is prefixed to his ' Anecdotes of Painters,' published after his death.

EDWARDS, GEORGE, *draftsman.* Born at Stratford, Essex, 1694. Was apprenticed to a tradesman in London, but having a distaste for his business, he managed to get to Holland in 1716, and to improve a feeling for art. Two years after he made a voyage to Norway, and explored the rocks and precipices, the haunts of numerous birds in that arid region. He passed through Paris on his return to London, and now, with the materials he had collected, applied himself to the study of natural history, and made coloured drawings of birds and animals. In furtherance of this study he went, in 1731, to Holland and Brabant. His abilities led to his appointment, in 1733, as librarian to the College of Physicians, and he became, by means of the valuable collections placed in his charge, one of the most eminent ornithologists of his day. His drawings give him a claim to a place in this work ; of these, above 900 were sold to Lord Bute, about 1759, for 300*l.* In 1764 he completed a history of birds and animals, and then in his 70th year, his sight failing, he retired to Plaistow, in his native county, and died there July 23, 1773, in his 80th year.

EDWARDS, SYDENHAM, *draftsman.* Born about 1768. He was an accurate botanical and animal draftsman, his works highly finished. He exhibited at the Aca-

138

demy, in 1792, a pair of goldfinches, and continued to exhibit, but at distant intervals, up to 1813, dogs, horses, birds, and flowers. He attracted notice by his work 'Cynographia Britannica,' coloured engravings of the various breeds of British dogs, with observations on their properties and uses, and became the first botanical draftsman of the time, constantly resorting to nature. He drew for Rees's 'Encyclopædia,' the 'Flora Londinensis,' the 'Botanical Magazine,' the 'Sportsman's Magazine,' and in 1809 published, himself, 'Representations of 150 Rare and Curious ornamental Plants.' He died at Queen's Elm, Brompton, February 8, 1819, in his 51st year.

EDWARDS, W. H., CAMDEN, *engraver.* Born at Monmouth about 1780. He engraved in the line manner chiefly portraits, practising in Norfolk and Suffolk, and died about 1840.

EDWARDS, WILLIAM, *bridge builder.* Born at Eglwysilan, Glamorganshire, in 1719, the son of a farmer, who died when he was only 2 years old. He lived with his mother on a small farm till he was about 16, and showed a natural skill in repairing the stone fences which are used in that county; built some workshops and mills, and then, with great reliance upon his untaught skill, undertook the difficult task of throwing a bridge over the Taaf, a river that is subject to violent floods. His first bridge, constructed in three arches, was soon after its completion carried away by a furious flood. He commenced a second with one arch of 140 feet span, which in the progress of the work sprung on the crown, forcing out the key-stones; not daunted, however, he lightened the pressure on the haunches of the arch by cylindrical openings. It was completed in 1753, and stands to our day a proof of the self-reliant skill of the builder. At the time the arch had the greatest known span, and introduced its able constructor at once to notice and employment. He built some other bridges in Wales, and greatly improved the art of construction. He was called in his own locality 'the bridge builder.'

He did not learn English till he had passed his 20th year. He studied the manner of hewing and dressing his stones from the masonry of the old Welsh castles. He was a man of great probity, was of the sect of Calvinistic Independents, and about 1750 was ordained their minister. He had six children, and his son David was skilful in bridge building, and erected several fine bridges. He died near Caerphilly, August 7, 1789.

EDWARDS, FRANCIS, *architect.* Was born in Southwark, September 3, 1784. He was apprenticed to a cabinet-maker, and cultivating his taste for drawing, was employed in Sir John Soane's office in 1806,

and gained admission to the schools of the Royal Academy. In 1809 and 1810 he exhibited at the Academy architectural designs, and in 1811 was successful in competition for the Academy gold medal for architecture in his design for a theatre. At this time he left Sir J. Soane's office and was employed as a draftsman, continuing to exhibit at the Academy. He sent in 1813 a design for a theatre, and in 1816 a design for a cathedral. About 1823 he formed some connection, and was employed in valuations and arbitrations, and did not exhibit after 1830. He built one or two mansions, but had little opportunity to realise his early ability in design. He died in Bloomsbury, August 15, 1857.

EGAN, JAMES, *mezzo-tint engraver.* Was born in 1799, in the county of Roscommon, of humble parents. In 1825 he was employed by Mr. S. W. Reynolds, and was little better than his errand boy. Being set by his master to prepare his mezzo-tint grounds, he learnt the first step in his future art. Quitting this service he commenced his career by laying grounds for engravers, and without money, or indeed friends, he relied for success upon his own industry and ability. His application and desire to improve interested all to whom he became known. He worked hard, suffered many privations, but concealed his necessities, while he educated himself in his art. Then, when he was about to reap the fruits of his perseverance, his health failed under the great exertions he had undergone, and he sunk gradually, labouring to the end. His latest work, finished under such trying difficulties, was 'English Hospitality in the Olden Time,' after Cattermole. He died at Pentonville, October 2, 1842, aged 43, and left a family, to assist whom a subscription was raised by his friends.

EGERTON, D. T., *landscape painter.* He was one of the foundation members of the Society of British Artists, and exhibited with the Society some landscape views and compositions in 1824 and 1829. He was next a contributor, in 1838 and the following year, of landscapes in Mexico, introducing characteristic groups of figures, which gained him great notice. In 1840 he exhibited his last work, 'Niagara.' He was murdered in Mexico, at a village a few miles from the capital, in 1842.

• EGG, AUGUSTUS LEOPOLD, R.A., *subject painter.* He was the son of an eminent gunsmith in Piccadilly, and was born there May 2, 1816. Showing considerable ability in drawing, he entered Sass's Art School in 1834, and the following year was admitted a student of the Royal Academy. In 1837 he exhibited, at the Suffolk Street Gallery, his first picture; in the following year his 'Spanish Girl,' at the Royal Academy, and from that time he became a

constant exhibitor. His 'Buckingham Rebuffed,' in 1844, gained him much notice. His 'Wooing of Catherine,' in 1846, and 'Lucretio and Bianca,' in 1847, gave him a high rank as a painter; and in 1848 he was elected an associate of the Academy. In 1850 he produced his 'Peter the Great and Catherine;' and in 1857, 'The Knighting of Esmond,' a work of very great grace and feeling; in 1858, a painful subject, in three parts, representing a seduction and its sad consequences.

He was never a robust man, and his health had been seriously affected so early as 1852 or 1853, but he continued busily engaged in his art. In 1860 he exhibited 'The Dinner Scene' from 'Taming the Shrew,' a favourite subject, from which he painted an excellent picture, and the same year was elected a full member of the Academy. His health was at this time declining; for its re-establishment he was advised to winter at Algiers, where he found so much benefit that he was soon able to resume his work. Perhaps with renewed health he was too confident, for imprudently taking a long ride in the face of a bleak wind, all his unfavourable symptoms returned, and he died of an attack of asthma on March 25, 1863. He was buried at the top of a high hill near Algiers, a spot which his friends chose in preference to a crowded cemetery. He had married unhappily a few years before his death, and it was a great pain to him—perhaps an aggravation of his ill-health—that his wife was not received by his friends. His father left him a good property, which he had increased by his art. His works were sold at Christie's in May 1863. His early pictures were painted with a broad, free pencil, marked by great ease and facility—later by more laborious completion, his execution in either case excellent. His sense of colour showed a refined and delicate appreciation of tint. His subjects were well conceived, his story well told, but too often representing sadness and sorrow.

EGGINTON, FRANCIS, *typographical engraver.* Was born in 1781. He engraved many plates in Straw's Staffordshire and a large plate of Pont-y-cypte aqueducts. He died at Newport in Staffordshire, October 22, 1823.

EGINTON, FRANCIS, *glass painter.* Brought up at Handsworth, near Birmingham, he was celebrated for his improvements in glass painting, of which art he has been called the reviver. He executed numerous works, of which above 50 are known. In 1794 he restored the great west window at Magdalen College, Oxford, and put up eight windows in the ante-chapel, containing whole-length portraits of the bishops, painted in bistre. Reynold's 'Resurrection' at Salisbury is

by him, and a 'Resurrection' at Lichfield. 'Solomon's Banquet to Queen Sheba,' at Arundel Castle, and a window at Stationer's Hall, were also his works. He died at Handsworth, March 25, 1805, in his 68th year.

EGINTON, WILLIAM RAPHAEL, *glass painter.* Was known by his numerous works in painted glass. He died near Worcester, September 17, 1834.

EGINTON, HARVEY, *architect.* Son of the foregoing. Studied Gothic architecture in Worcester, where he resided, and was engaged in the restoration of several parish churches. He died at Worcester, aged 40, February 21, 1849.

EGINTON, J., *engraver.* There is a 'Hebe' engraved by him, after Hamilton, R.A., in 1791.

EGLETON, WILLIAM HENRY, *engraver.* Practised in London. Engraved landscape illustrations for the Waverley novels, 1833, and illustrations for Heath's 'Book of Beauty,' 1836.

EGLEY, WILLIAM, *miniature painter.* He was born in 1798, at Doncaster, where his family had removed from Nottingham. He was first employed in the house of a London publisher, but soon determined to try his fortune as an artist, and entirely self-taught, had to contend for several years with many difficulties. He first exhibited miniatures at the Academy in 1824, and improving in his art and his connection had an extensive practice, and was for many years a large contributor to the exhibition up to 1869. His works were almost exclusively miniatures, which were marked by careful finish, truth, and simple purity of colour. He died in London, March 19, 1870.

EHRÉT, GEORGE DIONYSIUS, *flower painter.* Born at Baden in 1710, the son of a gardener. He early became celebrated for his ability as a botanical draftsman. He visited France, and was employed by Jussieu. After this he came to London, but not succeeding here, he returned to the Continent. About 1740 he again came to London, settled in England, and married the sister of the well-known gardener and botanist, Philip Miller. He was much esteemed and employed by our eminent botanists. He made drawings for Trew's 'Plantæ Selectæ' and Brown's 'History of Jamaica,' and was chosen F.R.S. in 1757. He painted for the Duchess of Portland above 300 English and 500 exotic plants. By these labours, and by teaching, he realised a moderate independence. He died September 1770.

ELDER, WILLIAM, *engraver.* Was born in Scotland, but practised chiefly in London towards the end of the 17th century. He worked mostly with the graver in the mechanical manner of that

time, and was employed by the booksellers. He engraved Archbishop Sancroft, Bishop Pearson, Dr. Mayerne, Dr. Morton, Ray, the naturalist, Ben Jonson, his own portrait, and many others, with several of the heads for Rycaut's 'History of the Turks.' Faithorne drew his portrait.

ELDER, CHARLES, *history painter.* His exhibited works prove him to have attempted the higher branches of art. He first contributed to the Academy a 'Sappho' in 1845; 'Florimel Imprisoned,' in 1846; 'The Death of Mark Antony,' in 1847; 'Ruth Gleaning,' with other works, in 1848; and continued to exhibit till his death, December 11, 1851, aged 30.

ELFORD, Sir WILLIAM, Bart., *amateur.* He was of a Devonshire family, and was created a baronet in 1800. For many years, commencing in 1784, he was an occasional honorary exhibitor at the Royal Academy, contributing landscape views and effects of sunset and shower up to his death at Totnes, in his 90th year, November 30, 1837. There is at Windsor Castle a landscape by him, very good in effect, which he presented to the Prince Regent in 1819.

ELIZABETH, The Princess, *amateur.* Daughter of George III.; born May 27, 1770. She drew with much correctness and taste. Her 'Birth and Triumph of Cupid' was engraved by Tomkins, in 24 plates; and a companion work, 'Cupid turned Volunteer,' was engraved by Gardiner in 1804. She also designed 'The Progress of Genius,' published in 1816. She married the Prince of Hesse-Homburg in 1818, and died January 10, 1840.

ELLIOT, WILLIAM, *engraver.* Born at Hampton Court in 1727. He engraved with the point some landscapes in a free and graceful manner. His best works are after Cuyp, Rosa da Tivoli, and Polemberg, but he engraved largely after the Smiths of Chichester. He also engraved a portrait of Helena Forman, after Rubens. He died in Church Street, Soho, in 1766, aged 39.

ELLIOT, WILLIAM, *marine painter.* He painted marine subjects and sea-fights, a little in the manner of Serres. 'The Loss of the Andromeda,' 1770, and some other of his works, are engraved. There are some landscapes by his hand. Two tame-looking sea-pieces by him at Hampton Court Palace. He died towards the end of the 18th century.

ELLIOT, ARCHIBALD, *architect.* Born in Roxburghshire, and brought up as a joiner. He made his way up to London, where he found employment as a designer of cabinet work. While employed at Douglas Castle, a difference arose between the owner and the architect, and he undertook to complete the work. He was next the contractor for building Mona Castle, Isle of Man, and his success was the be-

ginning of his career. He designed London Castle, erected in .Ayrshire, 1804; the Regent's Bridge, an imposing work, in Edinburgh, 1815-19; followed by the City Prison on the Calton Hill; St. Paul's Chapel, and other edifices. He died at Edinburgh, June 16, 1823, aged 62.

ELLIOTT, Capt. ROBERT, R.N., *amateur.* He was, from 1784 to 1789, an honorary exhibitor of marine subjects of some pretension, painted in oil. In 1784, 'A Frigate and a Cutter in Chase;' in 1785, 'The Fleet in Port Royal Harbour;' in 1786, 'View of the City of Quebec;' in 1787, 'Breaking the French Line, Lord Rodney's Action;' in 1788, 'Fire at Kingston, Jamaica;' and in 1789, three naval actions. He sketched during his travels many landscape views, from which Prout, Stanfield, and others made drawings —chiefly views in the East, in India, Canton, and the Red Sea. These were engraved and published in parts, 1830-33.

ELLIS, JOSEPH F., *marine painter.* He was born in Ireland, and came to London about 1818. He was only twice an exhibitor at the Royal Academy—in 1819, 'Entrance to a Harbour;' and in the following year, 'Morning, the Departure.' One of his early works was exhibited at the British Institution, and was sold for 60l., but he never found such patronage again. He was duped out of several of his best pictures, and, following this loss, a series of reverses left him in the hands of unscrupulous men. For them he laboured at endless views of Venice, which found their way to the auction room, under the name of Canaletti. During the last seven years of his life he resided with a house-agent, who dabbled in pictures; and in an ill-ventilated bed-chamber, living on a weekly pittance, he worked incessantly in manufacturing copies of Canaletti and Vernet, from originals brought to London for the purpose; and these, when dried and doctored, were placed in the market. His best pictures, the fruits of his own study from nature, are original in manner, and are rarely met with. He was frugal in his habits, unassuming, and notwithstanding his trials, full of good humour and good nature. He died at Richmond, Surrey, in his 65th year, May 28, 1848.

ELLIS, JOHN, *scene painter.* He was born in Dublin, and was apprenticed to a cabinet-maker there. Towards the end of the 18th century he practised as a scene painter in Dublin, and for a time in London, and was noted for his valuable knowledge of perspective. He also produced some good landscapes in body colours.

ELLIS, WILLIAM, *engraver.* Born in London 1747. Son of a writing engraver. Was a pupil of Woollett. Engraved many fine plates, chiefly landscapes, and worked

in conjunction with his master. He is known by his plates after Sandby and Hearne, and a set of five 'Views of the Battle of the Nile,' 1800, admirably aquatinted, after Anderson.

ELLYS, JOHN (called 'Jack Ellys'), *portrait painter.* Born 1701. At the age of 15 he was placed under Sir J. Thornhill, and afterwards for a short time under Schmutz. He was an imitator of Vanderbank, and became eminent among the portrait painters of the middle of the century, and one of the few remaining painters of the Kneller school. Several of his portraits in George II.'s reign are engraved. He took Vanderbank's house, succeeded him in his connection, and was allowed to purchase his office of tapestry-weaver to the Crown. He also obtained the post of master-keeper of the lions in the Tower, and in these easy circumstances did not do much at his profession. He is said to have called upon Reynolds, P.R.A., to see his works on his return from Italy, and to have advised him, 'Ah, Reynolds! this will never answer. Why, you don't paint in the least degree in the manner of Kneller;' and on Reynolds's expostulations to have flounced out of the room in a great rage, exclaiming, 'Shakespeare in poetry, and Kneller in painting, d—— me!' His portraits are well drawn, solidly painted, and quiet in character. There is a good life-sized portrait-group by him of Lord Whitworth and his Nephew, and also a portrait, engraved, of 'Figg, the mighty Combatant.' He was a member of the Artists' Committee appointed in 1755 to frame the plan of a royal academy.

ELMER, STEPHEN, A.R.A., *painter of still-life.* He resided at Farnham, where he dealt as a maltster, but not much is known of his early life. He tried art, and painted dead game and some rural subjects, in which he said he found more pleasure than profit. His work was painted in a bold, free manner, and with great truth to nature. In 1763 he was a member of the Free Society of Artists. He first exhibited at the Royal Academy in 1772, sending nine paintings, and was in the same year elected an associate. From that year he was a constant exhibitor. In 1775 he sent 'The death of a Fox;' in 1784, 'An Alarmed Poacher.' He continued to exhibit up to his death, at Farnham, in 1796. He left (with other property) a large collection of paintings to his nephew, who made an exhibition of them for sale at the great room in the Haymarket, in the spring of 1799. This exhibition, which was called 'Elmer's Sporting Exhibition,' contained 148 of his own works, with some others he had collected. They consisted of dead game and still life, and many of them realised very good prices. In 1801 a number of

his works were destroyed by fire, and an insurance of 3,000*l.* was recovered for them. Some partridges by him were well engraved by J. Scott. His son was an artist. He painted fruit and game, and practised in Dublin and other parts of Ireland about the end of the 18th century. He exhibited at the Academy in 1783–84 and 1799.

ELMES, JAMES, *architect.* Born in London 1782. He was educated at the Merchant Taylors' School. Was pupil of George Gibson and a student of the Royal Academy, where he gained the silver medal for an architectural design in 1805. He exhibited some designs at the Academy between 1808–14, and designed and erected several buildings in the Metropolis. He was vice-president of the Royal Architectural Society in 1809, and was appointed surveyor of the port of London, but is better known as a writer on the arts. He died at Greenwich, April 2, 1862, aged 79. He published 'Lectures on Architecture,' 'Memoirs of the Life and Works of Sir Christopher Wren,' 1823; 'The Arts and Artists,' 1825; 'Bibliographical Dictionary of the Fine Arts,' 1826; with some others, more or less connected with the art; and was a large contributor to the periodical art-literature of his day.

ELMES, HARVEY LONSDALE, *architect.* Was the son and pupil of the foregoing James Elmes, and was afterwards placed with a surveyor at Bedford, and then with Mr. Goodridge, who practised as an architect at Bath. He was early looked upon as of great promise, and in 1836, in competition with 85 candidates, was selected to erect St. George's Hall for the Corporation of Liverpool, and afterwards the Collegiate Institution and the Assize Courts in that town; and the County Lunatic Asylum for West Derby. With reputation and fortune before him, he died of consumption in Jamaica, November 26, 1847, at the early age of 34. His designs were left to the completion of others; his great hall at Liverpool, to the care of C. R. Cockerell, R.A., who said the work surpassed every architectural production of this country in the century. He had commenced this fine work in 1838, and the Prince Consort was so pleased with it, on his visit to Liverpool in 1846, that he presented him with his gold medal as a mark of esteem. He left a widow and one child, for whom a subscription of 1,400*l.* was raised, which, on their decease, was to be invested to found two 'Elmes Scholarships' for architectural students.

ELSTRACKE, REGINALD, *engraver.* Born in England; he flourished in the reigns of Elizabeth and James I. He engraved chiefly for booksellers, after his own designs. His best works are portraits, which, though neat in execution, are hard

and tasteless in manner. Portraits of some of the most important persons of the time are from his graver, and these works are greatly prized for their rarity by collectors. At Sir Mark Sykes's sale in 1824, his plate of Lord Darnley and Queen Mary, two whole-length figures, sold for 81l. 18s., and single heads fetched 10l. 15s. each. One of his later plates is dated 1611. His 'True and lively Effigies of all our English Kings' was dated 1618.

ELVINS, THOMAS, *architect.* Practised with some reputation at Birmingham, and died there, August 23, 1802.

EMES, JOHN, *engraver and draftsman.* He engraved Jefferey's large picture of 'The Destruction of the Spanish Batteries before Gibraltar,' exhibited in 1783. There are also some clever water-colour drawings by him, broadly treated and pleasing in colour. He exhibited some tinted views of gentlemen's seats at the Academy in 1790, and some views of the Cumberland Lakes in the following year.

EMLYN, HENRY, F.S.A., *architect.* He practised in the latter part of the 18th century. George III. confided to him some alterations in St. George's Chapel, Windsor, which were executed entirely after his designs, and preserved a due harmony with the original work. He published drawings for a new order of architecture, founded on the idea of a twintree, connecting a double pillar on a single pedestal. He died at Windsor, in his 87th year, December 10, 1815.

EMMET, WILLIAM, *sculptor.* The only record of him is that he succeeded his uncle, one Philips; and was sculptor to the Crown in the *reign* of Charles II. A very poor mezzo-tint portrait of him by himself is known to collectors.

EMMETT, WILLIAM, *engraver.* He practised in London at the beginning of the 18th century, and worked with the graver in a neat manner. He engraved an interior and an exterior of St. Paul's Cathedral, and two views also of the western exterior bear his name.

ENGLEHEART, THOMAS, *sculptor and modeller in wax.* He was a student of the Royal Academy, and gained in 1772, in competition with Flaxman, the Academy gold medal for a bas-relief, 'Ulysses and Nausicaa.' He exhibited at the Academy, in 1773-74, busts, portraits modelled in wax, and continued to exhibit medallions and portraits in wax up to 1780, and once again in 1786, when his name disappears from the catalogues.

ENGLEHEART, GEORGE, *miniature painter.* Was an early exhibitor, commencing in 1773, of miniature portraits at the Royal Academy, and in 1790 was appointed 'miniature painter to the King.' He sometimes painted in enamel, but his chief works are on ivory, and are marked by very great character—well drawn and coloured, and full of power. He occasionally exhibited a group, but rarely any fancy subject. He is said to have made a fortune by his art, and to have died at the end of the 18th century, but he certainly exhibited as late as 1812.

ENGLEHEART, FRANCIS, *engraver.* Born in London 1775; was the nephew of the above George Engleheart. He was apprenticed to Joseph Collyer, and was afterwards assistant to James Heath. He commenced by some plates after Stothard, R.A., but first gained notice by his works after R. Cook, R.A. About the beginning of the 19th century he engraved the portraits for a collection of the English poets. He then engraved after Smirke, R.A., including nearly 30 of his designs for 'Don Quixote.' His most important works are his 'Duncan Gray,' after Wilkie, and his 'Sir Calepine rescuing Serena,' after Hilton. Several of the small plates for the annuals are by him. After practising nearly half a century, he died February 15, 1849, in his 74th year.

ENGLEHEART, J. D., *miniature painter.* He first exhibited at the Royal Academy in 1802, and continued with little intermission to exhibit, enjoying a good practice, up to 1828, after which year there is no further trace of him.

ENGLISH, JOSIAS, *amateur.* He was a gentleman of easy fortune, who lived at Mortlake, and was fond of etching. He imitated the works of Hollar, but without much success, and etched several small plates after Francis Cleyn, to which his name, *fecit* 1654, is attached. He also etched the 'Four Seasons,' a portrait of Dobson, the painter, and a 'Christ and the Disciples at Emmaus,' after Titian, reputed his best production. He died at Mortlake in 1718.

ENNIS, W., *history painter.* He was born in Ireland and studied in Dublin under the elder West. About the year 1754 he was assisted to visit Italy and made some stay in Rome; on his return to Dublin he practised both in history and portrait, but his art was weak. He was master in the Dublin Art School for teaching the figure, and held that office till his death in 1771, in the county of Wicklow, caused by a fall from his horse.

ENSOM, WILLIAM, *engraver.* There are by this graver some historical subjects. He died at Wandsworth, September 13, 1832.

ESSEX, JAMES, *architect.* Was the son of a builder at Cambridge, and born there in 1723. He early distinguished himself by his knowledge of the principles of Gothic architecture, and was engaged in 1757 to make drawings for Bentham's 'Ely Cathedral.'

He was entrusted with extensive repairs of King's College Chapel, Cambridge, the additions to Corpus Christi and Emmanuel Colleges, and the repairs of several of the colleges there. He also repaired the chapel of Ely Cathedral, Lincoln Minster, and the tower of Winchester College Chapel. He designed, in the Italian style, the Shire Hall, Cambridge, 1774, and the Guildhall, 1782. He published 'Remarks on the Antiquity of different Modes of Brick and Stone Buildings in England,' 'Observations on Lincoln Cathedral,' 'On the Origin and Antiquity of Round Churches, and in particular of the Round Church at Cambridge,' 'On Croyland Abbey and Bridge,' and 'Designs for the new building of Benet's, Kings, and Emmanuel Colleges, Trinity Hall, and the Public Library at Cambridge.' He ranks among the earliest of the practical revivers of Gothic. He died of paralysis at Cambridge, aged 61, September 14, 1784, and was buried in St. Botolph's Churchyard.

ESSEX, JOHN, 'marbler.' Was employed to make the figures for the tomb of the Earl of Warwick, in Warwick Church, temp. Richard II.

ESSEX, RICHARD HAMILTON, water-colour painter. He was elected an associate exhibitor of the Water-Colour Society in 1823, and from that year to 1836 was a constant contributor to the Society's Exhibitions. His works were all of an architectural character, almost exclusively Gothic, with some few architectural designs ; among them were, in 1823, 'The Quadrangle of Magdalen College, Oxford,' and the 'Interior of Beauchamp Chapel, Warwick ;' in 1825, 'Views of the Interior and Exterior of Ely Cathedral ;' in 1831, of some Belgian edifices ; about 1835, drawings of several churches. He was also an occasional exhibitor at the Royal Academy of works of the same character, his last contributions being some interiors of Canterbury Cathedral in 1853. He died at Bow, February 22, 1855, aged 53.

ESSEX, WILLIAM, enamel painter. His name first appears in the Academy catalogues in 1818. He was then living in Clerkenwell, and exhibited a 'Dog's Head' in enamel, and in the two following years some animals in enamel. In 1824 he exhibited a head of the Empress Josephine, after Isabey ; and the next year some groups of flowers and a landscape, also in enamel. In the succeeding years, continuing to paint in enamel, he exhibited portraits after Jackson, R.A., Lawrence, P.R.A., with an occasional scripture or history subject after the old masters. In 1839 he was appointed enamel painter to the Queen (by whom he was much employed), and in 1841 to Prince Albert. In the latter part of his career he painted one or two

144

miniature enamels from the life. He exhibited for the last time in 1862, and died at Brighton, December 29, 1869, aged 85. He improved the texture of his art, and his works were greatly esteemed. He was one of the last of several well-known and eminent enamel painters who flourished in the present century. His son, WILLIAM B. ESSEX, was brought up in the practice of his father's art. He died at Birmingham in 1852, aged 29.

ETHERIDGE, WILLIAM, architect. He practised about the middle of the 18th century, and among other public works he is distinguished as the designer of the bridge at Walton-on-Thames, 1767. The credit of this work gained him the appointment of surveyor of Ramsgate Harbour. He died October 3, 1776.

★ ETTY, WILLIAM, R.A., history painter. He was born March 10, 1787, at York, where his father, a respectable man, carried on the business of a miller, and also made gingerbread, which his mother sold. He early showed a predilection for drawing, and scribbled over every plain surface that fell in his way. He learnt little more during his short schooling than to read and write, but picked up what he could among an intelligent family at home, and was piously taught by his parents, who were Methodists. Of a reserved, shy, and affectionate disposition, he was sent from home in his 12th year, and apprenticed to a letter-press printer in Hull, where, notwithstanding hard work and long hours, he found time to cherish his love of drawing and otherwise to gain knowledge—for seven years drudging conscientiously on, all the while dreaming of becoming a painter. Then, his prentice work done, an uncle in London, moved by his entreaties, invited him to the Metropolis, where he arrived in 1805, and after two or three weeks' work as a journeyman printer, was assisted by his uncle to study as an artist. He drew from prints and everything that came in his way, and having finished from the round a drawing of 'Cupid and Psyche,' he took it to Opie, who gave him an introduction to Fuseli, and he gained admission as a student of the Royal Academy in 1807, and was a most diligent attendant in the schools.

He first thought to paint landscape, then inclined to heroic subjects, and then to devote himself, as he said, to 'God's most glorious work, Woman.' In this uncertainty of aim he was attracted by the works of Lawrence, then at the head of his profession, and became, in 1808, by the liberal help of his uncle, his indoor pupil for one year ; after a hard struggle, but with little assistance, he acquired a power of handling and some of the technical manner of his master. He is an example of that perse-

verance which long waited its reward. He was an unsuccessful competitor for the Academy medals, and his works sent for exhibition were rejected year after year; yet he continued a constant worker in the life-school, his art was slowly developed by his unremitting study; and in 1811 his 'Sappho,' the first of his works exhibited, found a purchaser at the British Institution for 25 guineas; and the same year one of his pictures, 'Telemachus rescuing Antiope,' was hung at the Royal Academy; and from that time his works found a place both at the Academy and at the British Institution. In 1816, assisted by his brother, he set out on a long contemplated journey to see the Continental schools. He reached Paris, and crossed the Alps to Florence. But ill-health and spirits, depressed by home-sickness, sent him home in less than three months.

His works now gained some notice, and his genius, aided by so many years' hard study, began to develop itself. In 1820 his 'Pandora' at the British Institution, followed by his 'Coral Finders' and 'Venus and her youthful Satellites arriving at the Isle of Paphos,' at the Royal Academy, gave him a name; and his 'Cleopatra's Arrival in Cilicia,' in the following year, added to his reputation, and found a purchaser. Then his temporary success revived his desire to see the works of the great Italian schools, and in 1822 he visited Rome, Naples, Florence, and Venice, and copied some of the works of the great masters, especially of the Venetian school. Seduced by the love of the fine works by which he was surrounded, he tarried in Italy about 18 months, and then returned reluctantly home, bringing with him about 50 studies. He had hitherto lived in Lambeth; he now removed to Buckingham Street, Adelphi, and here he began and ended his great career.

In 1824 he was elected an associate of the Royal Academy, and then commenced the first of his long-contemplated series of large pictures, 'Woman pleading for the Vanquished,' 1825. But he painted before the second of the series, 'The Judgment of Paris,' for which he had accepted a commission, and then commenced his 'Judith,' the story of the delivery of the Jewish people, a triptych, commenced in 1827 and completed in 1831, of great grandeur, both in conception and execution, and full of poetry. While engaged in this great work, which was a commission from the Royal Scottish Academy, he was in 1828 elected a royal academician. In 1830 he again visited Paris. He painted away at the Louvre, boasting that he was a true Englishman: was present during the Revolution, and on his return gave a vivid description of the scenes he had seen,

saying he had had enough of the Continent, and hoped never to leave England again. From this time he vigorously pursued his art and his art-studies, constantly attending the life-school of the Royal Academy till 1848, when his health declining, he retired to York, where he died of congestion of the lungs, November 13, 1849. In the previous June of that year 130 of his paintings were collected and exhibited at the Society of Arts. He was present at the opening of the exhibition, but in very depressed spirits, and was quite overcome by the congratulations of his friends. He was of a gentle, amiable nature, and lived a long bachelor life, though always falling in love. He had realised about 17,000l. of funded property, and the sale of his paintings and studies produced about 5,000l. more. He left the bulk of his property to his niece and the remainder to his brother Walter. His life by A. Gilchrist was published in 1845; and a simple, unassuming autobiography appeared in the 'Art Journal,' 1849.

His evenings were always spent, when in the height of his career, in the Academy Life-School, his whole life in the continuous study of his art. His earnest study from the nude gave him an unequalled power of imitating flesh, both in colour and texture. His progress was slow, and he waited long for the hope of encouragement—but his love of art was enduring and his perseverance at last crowned with well-earned fame. He delighted in painting the beauty of the female form, and while it cannot be denied that his subjects were of a voluptuous character, pure-minded himself, he was hurt that they should be so deemed by others. Though a close student from nature, his imitation was general rather than individual. His colour and tone were fine, marked by a peculiar grandeur, and well in harmony with his noble conceptions. His landscape backgrounds never fail to be well in character with his subjects.

EVANS, DAVID, *glass stainer.* Born in Montgomeryshire in 1793. He came early in life to Shrewsbury, and was apprenticed there to Mr. (afterwards Sir John) Betton, who in 1815 admitted him into partnership. He painted the windows, which were of elaborate design and execution, for Lord Hill's mansion, Hardwicke Grange, near Shrewsbury; and restored some fine windows in Lincoln Cathedral and the east window in Winchester College. He died at Shrewsbury, aged 68, on November 17, 1861. He was a clever student of his art, and attained a prominent place in his profession.

EVANS, GEORGE, *portrait painter.* Was a student in the St. Martin's Lane Academy. He painted portraits occasionally, and was known in his day. He exhibited

in 1764 and 1766 with the Incorporated Society of Artists, of which body he was a member, and died some time before 1770.

EVANS, RICHARD, *copyist.* He was for awhile an assistant to Sir Thomas Lawrence, and painted drapery and backgrounds, and also painted a few portraits. He lived many years in Rome, where he was chiefly employed in copying. The Raphael arabesques in the South Kensington Museum are his copies. Retiring from art, he resided at Southampton, where, after several years, he died in November 1871, aged 87.

EVANS, WILLIAM, *water-colour painter.* Was born at Eton, December 4, 1798, and was the son of W. Evans, a teacher at Eton College. He succeeded his father as drawing-master in 1818. He was elected an associate of the Society of Painters in Water-colours in 1828, in which year he contributed a fine drawing of Windsor, with others of Llanberris, Eton, Thames fishermen, and Barmouth. He gained his membership in 1830, and died December 31, 1877, in the college where he had been born and educated. His art was eclectic rather than original, and his landscape painting produced no marked or original result in the school of water-colour painting.

EVANS, WILLIAM, *engraver and draftsman.* About 1800 he assisted Benjamin Smith. He engraved 'The Grandmother's Blessing,' after Smirke. About 1805 he finished some works for Alderman Boydell, and in 1809 engraved with much ability part of the 'Specimens of Ancient Sculpture.' He soon after sank into a state of morbid melancholy, impressed with doubts of his future state, and traces of him disappear.

EVANS, WILLIAM, *water-colour painter.* Known as 'Evans of Bristol.' He lived for many years in North Wales, and painted the mountain scenery, the cottages, and their interiors, with great originality and success. He afterwards visited Italy, and made many fine sketches of the mountain and lake scenery of that country, wintering successively in Genoa, Rome, and Naples. He was from 1845 till his death an associate member of the Water-Colour Society. His first contributions to its exhibitions were exclusively Welsh scenes, but after 1852, for the next six years, as exclusively Italian; but at all times his contributions were few. He died in Marylebone Road, London, after a long illness, December 7, 1858, aged 49.

EVELYN, JOHN, *amateur.* He was born at Wotton, Surrey, where his family had settled in the reign of Elizabeth, on October 31, 1620. He was educated at the Free School, Lewes, afterwards at Balliol College, Oxford, and then became a student of the

law in the Middle Temple. On the outbreak of the Civil War he joined the King at Oxford, but, with his Majesty's consent, travelled abroad, and went to Rome, where he made some sketches, which were engraved by Hoare. On his return in 1651, he became by marriage possessed of Sayes' Court, near Deptford, where he lived in close retirement, and was the author of several works. In 1660 he published his 'Sculptura,' after that his 'Sylva.' He introduced Gibbons, the carver, to the notice of the King, and from Hollar having etched several views in the vicinity of Wotton, is supposed to have befriended him. He was a distinguished lover of the fine arts. He etched five small plates from his own drawings made on his journey from Rome to Naples, which bear his cypher, 'J. E., ft.' He died February 27, 1706, aged 86, and was buried at Wotton.

EVESHAM, EPIPHANIUS, *sculptor.* Was the pupil of Steevens, a Fleming, and practised in the reign of James I. He is mentioned as the first native sculptor whose name has been rescued from oblivion, but his works are unknown.

EWBANK, JOHN W., R.S.A., *landscape painter.* He was born at Gateshead about 1779, and was adopted by a wealthy uncle. Intended for the Roman Catholic ministry, he absconded from his college, and in 1813 engaged himself as apprentice to an ornamental painter in Newcastle. He removed with his master to Edinburgh, and showing a talent for art, was allowed to study under Alexander Nasmyth, and soon distinguished himself both as a teacher and a painter. His sketches from nature showed much freedom and truth; and a series of views of Edinburgh by him were engraved in 1823 by Lizars. He painted the banks of rivers, coast scenes, and marine subjects of a cabinet size. About 1829 he tried works of greater pretensions, and was nominated in 1830 one of the foundation members of the Royal Scottish Academy. He painted 'The Visit of George IV. to Edinburgh,' 'The Entry of Alexander the Great into Babylon,' and 'Hannibal crossing the Alps,' and was at this time at the height of his reputation. Fame and wealth were before him, but he gave way to habitual intoxication—his wife and family were reduced to penury, and during the last 12 years of his life, he worked in the most abject misery, selling his pictures wet and unvarnished for a few shillings, to be spent in sensual gratification. He died of typhus fever in the Infirmary at Edinburgh, November 28, 1847. His works are little known in London. He made the drawings, 51 in number, for James Browne's 'Picturesque Views of Edinburgh,' published in 1825.

EXSHAW, ——, *history painter.* Born in Dublin; studied some time in Rome.

About 1758 he was in London and attempted to establish a drawing-school, but he had no success either as an artist or a teacher. He painted, in competition for the Society of Arts' premium, 'The Black Prince entertaining the captive French Monarch after the Battle of Cressy.' He died early in 1771, and his studies and pictures were sold by auction in the April of that year.

EYRE, JAMES, *landscape painter.* He was born at Derby in 1802, and was brought up for the profession of the law, but was led by his inclination to art. He had some assistance from Creswick, R.A., and De Wint, and studied both in oil and water-colour. He excelled in cottage and lane scenes, and his works were of some promise, but he died prematurely in 1829.

F

FABER, JOHN, *engraver.* Born in Holland, where he drew portraits from the life on vellum, and also practised mezzo-tint engraving. He came to England about 1687, some accounts say later, and settled in London, residing for a long time in Fountain Court, Strand. His engraved portraits were many of them drawn from the life, and his works, though not distinguished by taste or execution, are no less held in some estimation by collectors. Among them are 25 portraits of the Founders of the Oxford Colleges, the Heads of the Philosophers, after Rubens, and many portraits of the time. He died at Bristol in May 1721.

FABER, JOHN, *engraver.* Son of the foregoing. Born in Holland in 1684, and when only 3 years old, brought to London by his father, by whom he was instructed. He was also a student in Vanderbank's Academy. His art was confined to mezzo-tint engraving, in which he greatly excelled, his manner being at once bold and free, with great finish and beauty. He was patronised by Kneller, and his works are very numerous. Among them are the 48 portraits of the Kit-Cat Club, published in 1735 by Jacob Tonson; the 'Hampton Court Beauties,' 'Charles II. in his State Robes,' 'The Taking of Namur.' His collected works, comprising 165 plates, were published in two folio volumes. He died of gout, May 2, 1746, at his house in Bloomsbury.

FACIUS, GEORGE SIGMUND, } *engravers.*
FACIUS, JOHN GOTLIEB, } Two brothers, who were born at Ratisbon about 1750. Their father was the Russian consul at Brussels, and both studied engraving in that capital. They were induced by Alderman Boydell to come to London in 1766, and settling here in his employment, they executed a great number of plates, chiefly etched, which were much esteemed. Among these works are a set of plates from Sir Joshua Reynolds's window at New College, Oxford. They both died, it is said, at the latter part of the last century; but there is

an engraved plate after Reynolds, dated 1802, which bears their name.

FAGAN, ROBERT, *portrait painter.* Studied for some years in Rome, and was in that capital 1794-98. He purchased the celebrated Altieri Claudes, and on the entry of the French troops he suffered imprisonment on this account, but he assisted in getting the pictures out of Rome, and brought to this country, where one of them is now an ornament of the National Gallery.

FAIRAM, JOHN, *portrait painter.* Practised in London in the first half of the 18th century. Many of his portraits are engraved.

FAIRFIELD, CHARLES, *copyist.* He imitated with great skill the works of the Flemish and Dutch schools, and practised in London during the latter part of the 18th century. He was of a retired, diffident temperament, and during a needy and laborious life, passed in seclusion, was in the hands of dealers, who availed themselves of his powers, and purchased his exquisite copies for small sums, which by their means found their way into many collections, where they are esteemed as originals. He, however, left behind him some few original works, which are evidence of his ability. He died in Brompton in 1804, aged about 45

FAIRHOLT, FREDERICK WILLIAM, F.S.A., *antiquarian draftsman.* Was born in London of German parents in 1818, and brought up in the heart of the city to his father's trade as a tobacco manufacturer. He had, however, a taste for literature, and when about 15 years of age contributed two papers to Hone's 'Every Day Book.' He then tried art, and commenced his career as a teacher of drawing, also gaining some employment in scene painting. He was next engaged in book illustration, and made some of the designs for the 'Pictorial Bible,' 'Palestine,' 'The History of England.' and an edition of Shakespeare. From 1839 he was engaged as an antiquarian draftsman,

and is better known as an antiquary than as an artist. The Percy Society published his 'History of the old City Pageantry.' He also wrote 'A History of Costume in England,' 'A Dictionary of Terms in Art,' and several other works, and contributed the drawings in illustration of some important publications. In the latter part of his life he suffered from spasmodic asthma, which ended in consumption, of which he died April 2, 1866, at Brompton, and was buried in the cemetery there. He left to the Society of Antiquaries a collection of books on pageants, and an unfinished manuscript by himself on the pageants of the middle ages; to the Stratford Museum a Shakesperian collection, a few scarce books to the British Museum, and to the Literary Fund the proceeds of the remainder of his library.

FAIRLAND, THOMAS, *engraver, lithographer, and portrait painter.* As a boy he was fond of drawing, and practised from nature in Kensington Gardens. He afterwards entered as a student at the Royal Academy, and obtained the silver medal in the antique. He first tried line engraving, and became a pupil of Warren, and then, taking up the new art of lithography, produced some very good works after the painters of that time, but from the competition in this art was induced to turn his attention to portrait painting, and had many sitters. His perseverance did not, however, meet with success, and though he was employed by the Queen, he was unable to secure for his family more than the wants of the day. Ill-health could not overcome his resolute application, and he died prematurely in October 1852, aged 48.

FAIRLESS, THOMAS KERR, *landscape painter.* Was born at Hexham, Northumberland, and was a pupil of Nicholson, a wood engraver at Newcastle, but he was unsettled, and eventually came to London, determined to study art as his profession. From 1848 to 1851 he was an exhibitor at the Royal Academy. He painted landscape in a free, bold manner, and was a teacher of drawing. He died in his native town in his 28th year, on July 14, 1853, before he had time to develop his art.

Senr ♦ FAITHORNE, WILLIAM, *engraver and draftsman.* Was born in London in 1616, and was brought up under Robert Peake, the well-known engraver. After working with him for three or four years, on the outbreak of the Civil War, he was induced by his master to join the royal army, and was one of the defenders of Basing House, and on its surrender became the prisoner of the Parliamentarians. He was for a time imprisoned in Aldersgate, and during his confinement resumed his profession, till the solicitations of his friends obtained his release on condition of leaving the

148

country, and he made his way to Paris. Here he is said to have been assisted in his art by both Nanteuil and Champagne, but this is doubtful.

About 1650 he obtained permission to return to England, and soon after married and set up a print-shop near Temple Bar. He at the same time followed his art, and was much employed by the booksellers upon the portrait frontispieces in vogue at that time. About 1680 he left his shop, and devoted himself more exclusively to drawing and engraving portraits, the former chiefly in crayons from the life. At this time he removed to Printing House Square, and here he died, when well advanced in life, in May 1691, and was buried at St. Anne's Church, Blackfriars. His early manner was founded on the Dutch and Flemish schools, but he made considerable improvement while in France. His best portraits are finished with the graver in a free and delicate style, with much force and colour. He did not draw the figure well, and confined himself chiefly to the head; but there are some historical plates from his graver, among them four subjects engraved for Taylor's 'Life of Christ.' Of his numerous portraits, Lady Paston, probably after Vandyke, is considered his *chef-d'œuvre;* an impression sold at Sir Mark Sykes's sale in 1824 for 54*l.* 12*s.* He published his 'Art of Graving' in 1662. His friend Flatman says of him—

'A Faithorne sculpsit, is a charm can save
From dull oblivion and a gaping grave.'

FAITHORNE, WILLIAM, *engraver.* Son of the preceding; born in London 1656, and instructed by his father. He practised solely in mezzo-tint, and produced a few works of some merit; but Walpole tells that 'he was negligent and fell into distress, involving his father in much care.' He died prematurely in 1686, and was buried in St. Martin's Churchyard. About 30 plates by him are known; of these, perhaps the most prominent are 'Mary, Princess of Orange,' after Hanneman; 'Sir William Reade, the Oculist;' and 'Thomas Flatman showing a Drawing of Charles II.'

FALCONET, PETER, *portrait painter.* Was born in Paris, the son of Falconet, the sculptor, who executed the largest equestrian statue of Peter the Great at St. Petersburg. He came to London, where he practised some years as a portrait painter. He was a member of the Incorporated Society of Artists in 1766, and found considerable employment between 1767–73, exhibiting in the latter year two small whole-lengths in the Academy. He drew the portraits of the 12 most reputed artists in London, which were engraved,

and the portrait of Granger, which forms the frontispiece to his 'Biographical Dictionary.' Several of his portraits were also engraved by Val. Green, Dixon, Earlom, and others. He composed some historical subjects, which were extravagant in their manner, and painted the decorations of a Chinese temple for the Baroness de Grey at her seat in Bedfordshire. He is said to have returned to France soon after 1773, but probably not much before 1780.

FANELLI, FRANCIS, *modeller and sculptor.* Was a Florentine artist and came to this country before 1640, in which year he called himself 'Sculptor to the King.' He was celebrated for his works in metal, which were finely finished. There is by him in Westminster Abbey a bust of Lady Cottinton, one of Charles I. at the Bodleian, and several of his works are at Welbeck.

FANSHAWE, CATHERINE MARIA, *amateur.* Born in London about 1775. She etched about 20 historical and figure subjects with much ability. She died about 1834.

FARINGTON, GEORGE, *history painter.* He was of an ancient Lancashire family. His father was rector of Warrington, where he was born in 1754. In 1770-71 he gained premiums at the Society of Arts for landscape views. He received his first instructions in art from his brother Joseph, and then became the pupil of Benjamin West, P.R.A., and an industrious student of the Royal Academy, where he gained the silver medal in 1779, and the gold medal for 'Macbeth' in 1780. He exhibited a portrait at the Academy in 1773, and again in 1783. He was employed by Alderman Boydell, for whom he made some excellent drawings from the Houghton collection. In 1782 he was induced to visit the East Indies, where he painted many pictures, and while engaged on a large work representing the *Durbar* of one of the native princes, he imprudently exposed himself to the night air, and was seized with an illness which terminated his life in a few days in 1788.

FARINGTON, JOSEPH, R.A., *landscape painter.* Was the elder brother of the foregoing, and was born at Leigh, Lancashire, on Nov. 21, 1747. He chose the profession of a painter, and in 1763 was placed under Richard Wilson, with whom he continued for several years, and was esteemed one of his best pupils. He gained several premiums at the Society of Arts, and at the age of 21 he was elected a member of the Incorporated Society of Artists. He worked with his brother upon the drawings of the Houghton collection, and on the completion of this work he returned to his own county, and studied the landscape scenery of the lake districts

of Cumberland and Westmoreland. He returned to London in 1781, where he then settled. He was one of the first students of the Royal Academy, and from 1778 to 1813 was a constant exhibitor there of landscapes and landscape views. He was elected associate in 1783, and full member in 1785, and then gave much time and exercised great influence in the Academy councils. On the suspension of the five members of the council in 1804, Copley, R.A., says 'he was the avowed and active member of the confederacy which led to this schism.' In his landscapes he has not shown much poetry or grandeur; his composition is poor; his colouring is better, often possessing power and brilliance; his pencilling is free and firm, but with a tendency to hardness. He made numerous topographic drawings, using the reed pen with much spirit, and slightly washing in the breadths with sepia or Indian ink. Many of his views of the English lakes were engraved by Byrne, Medland, Pouncey, and others, and published in 1816; and 76 views by him, in illustration of the history of the River Thames, were published in 1794. He died of a fall from his horse in returning from church, December 30, 1821.

FARNBOROUGH, AMELIA, Lady, *amateur.* Daughter of Sir Abraham Hume, Bart. Was born January 29, 1772, and married in 1793 Sir Charles Long, who was in 1826 created Lord Farnborough. As an amateur, she was distinguished by her very clever water-colour drawings, works of great truth and feeling. She exhibited 'The Boulevards of Paris' at the Royal Academy in 1819, and had from 1807 been an honorary exhibitor of many drawings of considerable merit. She died June 15, 1837.

FARRER, NICHOLAS, *portrait painter.* Born at Sunderland in 1750. He studied art under Robert E. Pine and in the schools of the Society of Artists, and was admitted to the friendship of Reynolds and Northcote. He practised as a portrait painter, and imitated the manner of Reynolds. He was much patronised by the Duke of Richmond, and painted the portraits of the Duke and his family. He died 1805.

FAULKNER, JOSHUA WILSON, *portrait painter.* Was a native of Manchester, and practised in that city. He exhibited at the Royal Academy in 1809 the portrait of a lady in character, and two other works. Soon after he became a member of the Liverpool Academy, and exhibited at that Institution. He settled in London about 1817, and in that and the two following years exhibited portraits at the Academy. In 1820 he exhibited there for the last time, sending some portrait-groups and 'A Boy with a Butterfly.'

FAULKNER, BENJAMIN RAWLINSON,

portrait painter. Brother of the above. Was born in 1787, at Manchester, and in early life engaged in a commercial house, and had charge of a branch establishment at Gibraltar, where he lost his health from an attack of the plague, and returned to England about 1813. During his convalescence he developed a taste for drawing, and, assisted by his brother, devoted himself to study from the antique. He then came to London and established himself in Newman Street. In 1821 he first exhibited at the Academy, and continued an exhibitor, exclusively of portraits, till his death. His works were distinguished by quiet taste and finish, but he did not gain much patronage. Some of his best portraits are at Manchester. He died October 29, 1849, aged 62. With great musical talent, he had the gift of a fine voice, and was for some time organist at Irving's church in Hatton Garden.

FAYRAM, J., *landscape painter.* He practised about the middle of the 18th century. One of his landscapes is engraved by Major, and there are some etchings by him of views about Chelsea and Battersea, and one of the Hermitage in Kew Gardens.

FEARY, JOHN, *landscape painter.* Practised in London. He gained a premium at the Society of Arts in 1775, and painted views of gentlemen's seats and parks. He exhibited at the Academy, first time, in 1772, and continued, with little intermission, an exhibitor up to 1788.

FELLOWES, JAMES, *portrait painter.* Practised with some repute in the reigns of George I. and George II. He was the reputed painter of 'The Last Supper,' an altar-piece, at St. Mary's, Whitechapel, which gave great offence from the assumed representation of Judas by the portrait of Dean, afterwards Bishop Kennet. This work, which has also been ascribed to Sir James Thornhill, was said to have been removed to the Abbey Church at St. Alban's. It was engraved, and the Society of Antiquaries possessed a print of it.

FERG, FRANCIS PAUL, *landscape painter.* Born in Vienna 1689, the son of an obscure artist. He studied under several masters in that capital, and gained a name by his small landscapes with figures, which he painted chiefly on copper. Invited by the Court to Dresden, he passed several years there, and after a short stay at Brunswick, he came to London in 1718, and at once found employment and settled. His circumstances became depressed by an imprudent marriage, and he was always poor, not from excess but from indolence. His works, though sought after by purchasers, were no sooner hurriedly finished than they were taken to the pawnbroker, and were rarely redeemed. He is said to have died in the street, near the door of his lodging,

150

and to have been in want of common necessaries. This happened in 1740, at the age of 51, and he was buried by a subscription raised for the purpose. His landscapes were pleasing, combining picturesque ruins and small figures well drawn. His 'Four Seasons' were engraved by Major in 1754, and Vivares and others engraved after him. He etched eight plates, which he inscribed 'Capricci fatti, per F. P. F.'

FERGUSON, WILLIAM G., *still-life painter.* Born in Scotland, he learned the rudiments of art there, and then greatly improved himself by travel in France and Italy. He painted still-life with great skill, his composition good, and light and shade effective. His principal subjects were dead birds, particularly pigeons and partridges, sometimes hares, rabbits, and other objects. He died in London about 1690.

FERGUSON, JAMES, *portrait draftsman.* He was born in Banffshire, of very poor parents, in 1710, and learned to read by hearing his father teach his elder brother. He had no other instruction, no books; and servant to a farmer he discovered a peculiar aptitude for mathematics, and studied the stars while he minded his master's sheep, gaining a knowledge of astronomy by his own contemplation of the heavens. He had also cultivated some power of drawing. Finding at last some friends, he was sent by them to Edinburgh to study, and there, and afterwards in England, supported himself for several years by drawing miniature portraits in black lead while pursuing his more serious studies, which have given him a well-known name as an astronomer. Several of these portraits existed at Bristol. He died in 1776, aged 66.

FERNELEY, J. E., *animal painter.* Was born in 1781, and brought up as a wheelwright; but, urged by a desire to try art, he abandoned his trade and studied, with some success, to paint animals. He settled among the sporting men at Melton Mowbray, and his first sitter was Mr. Assheton Smith, of fox-hunting celebrity. Others soon followed, and from 1818 to 1849 he exhibited at the Royal Academy portraits of Huntsmen and their horses, dogs and fox-hunting, and hunting-groups. He died June 3, 1860, aged 79.

FERRERS, BENJAMIN, *portrait painter.* He was deaf and dumb, and practised about the middle of the 18th century. There is a portrait by him of Bishop Hoadly, said to have been his kinsman, which is painted with a good deal of rude vigour, and in the Bodleian Library a small oval portrait of Bishop Beveridge. Several of his portraits are engraved.

FERRIÈRE, F., *miniature painter.* He is believed to have been a native of Switzerland. He came early to this country, and practised both in oil and water-

colours. He first exhibited at the Academy in 1793, and continued an exhibitor up to 1822. In 1819 he was appointed portrait painter to the Dowager Empress of Russia. His water-colour miniatures were executed with much power, and were greatly esteemed.

FERRIÈRE, L., *miniature painter.* Lived in the same house with the foregoing, and was probably his son. He exhibited miniature portraits at the Academy in 1817, and again in 1826–27–28, when there is no further trace of him.

FIELDING, THEODORE NATHAN, *portrait painter.* Resided near Halifax; painted in oil, and enjoyed a considerable local reputation about the middle of the 18th century. His works were marked by an elaborately minute finish, and he was much patronised by the gentry of Yorkshire and Lancashire. He was the father of four artist sons — Theodore, Copley, Thales, and Newton.

FIELDING, THEODORE HENRY ADOLPHUS, *water-colour painter.* He was the eldest son of the above, and was educated in art by his father. He exhibited a 'View on the River Tyne' at the Academy in 1779, and continued an occasional exhibitor, chiefly of landscape views, for some years. He was appointed teacher of drawing and perspective at the Military College at Addiscombe, and resided in the neighbouring town of Croydon, where he died July 11, 1851, aged 70. He published a 'Treatise on the Ancient and Modern Practice of Painting in Oil and Water-Colours,' with some other works on art-teaching.

FIELDING, Mrs. T. H., *water-colour painter.* Wife of the above. She was elected a member of the Water-Colour Society in 1821, and from that year to 1835 was a constant contributor to the Society's Exhibitions. She painted flowers, birds, and insects.

FIELDING, ANTHONY VANDYKE COPLEY, *water-colour painter.* Was the second and most distinguished son of the foregoing Theodore Nathan Fielding. He was born in 1787, and became early in life the pupil of John Varley, and was one of the talented party of young men who were accustomed to meet at Dr. Monro's. He devoted himself to water-colours, and his name is first met with as an associate exhibitor of the Water-Colour Society in 1810, from which time he became a regular exhibitor, and occasionally also sent a painting in oil to the Royal Academy. In 1813 he was elected a member of the Society; in 1817, treasurer; and in the following year, secretary. In 1831 he was elected the president, and held this office till his death. His works are very numerous; for several years his contributions to the Water-Colour Society's Exhibitions averaged between 40 and

50. He was at the same time a fashionable teacher, largely employed.

Such an amount of labour, added to his teaching, naturally produced mannerism—slight dexterous works, in which execution prevailed over individuality and truth; yet his art was very popular, his style agreeable and pleasant, and his works fetch high prices. Some of his early drawings possess great breadth and space, with good colour; and with them his marine drawings, effects of clouds and storm, may be classed as his best works. He exhibited some Italian views on several occasions, which were from the sketches of others. It does not appear that he ever visited the Continent. His career was successful, and he amassed some property. He had been in the habit of visiting Brighton, where latterly he chiefly resided. He died at Worthing, on March 3, 1855, in his 68th year, and was buried at Hove.

FIELDING, THALES, *water-colour painter.* He was a younger brother of the foregoing. He drew the figure well, and was a clever artist. In the years 1816–20, when the Water-Colour Exhibition was open to the profession, he was a contributor, sending classic compositions, which were well grouped and coloured, and landscapes, introducing cattle in the foreground, with some well-known line of scenery or buildings in his background. He was for many years teacher of drawing at the Woolwich Military Academy. He died in Newman Street, London, December 20, 1837, aged 44.

FIELDING, NEWTON, *engraver and water-colour painter.* He was the youngest of the four brothers. He was an exhibitor of some views at the Water-Colour Society in 1815, and of some cattle in 1818. He chiefly painted animals, but without much ability. He produced some works in aquatint, and is best known as an engraver. He engraved Sir Humphrey Davy, after Lawrence, 1829, and worked also as a lithographer. He published many works on art. He taught the family of Louis Philippe, and was well esteemed in France. He died June 13, 1856.

FIELDING, JOHN, *engraver.* Was born about 1758, and was the pupil of Ryland and also of Bartolozzi. He worked so much for Ryland, that the plates which bear his own name are very few; of these are 'Jacob and Rachael,' after Stothard, and 'Moses saved by Pharaoh's Daughter;' also some plates after Angelica Kauffman. His best works are between 1780–90.

FILLANS, JAMES, *sculptor.* Was born in Lanarkshire in 1808, and was apprenticed to a stonemason at Paisley. He was afterwards employed there in modelling small groups, by which he eventually made himself known, and by his ability as a bust

modeller found employment. In 1835 he was enabled to visit Paris, where he studied for a time in the Louvre. On his return he exhibited at the Royal Academy in 1837, was a contributor up to 1850, and became successful as a portrait sculptor. He visited Vienna, and from thence Italy, and maturing his art he produced some good groups — 'Blind Girls reading the Scriptures,' 'Rachael weeping for her Children;' but his forte was as a bust modeller. He died of rheumatic fever at Glasgow, September 27, 1852, leaving a widow and a large family, for whom in his short career he had been unable to make provision.

FILLIAN, JOHN, *engraver*. He was a pupil of Faithorne, and practised towards the latter part of the 17th century, but died young, about 1680. Evelyn speaks of him as a hopeful young man. There are a few portraits by him—a head of his master, Faithorne; of Thomas Cromwell, Earl of Essex; and of Paracelsus. He imitated the manner of Faithorne, and had he lived might have attained some excellence.

FINCH, FRANCIS OLIVER, *water-colour painter*. Was born November 22, 1802, the son of a merchant in Cheapside. A weakly child, he passed his boyhood at Stone, a little village near Aylesbury. When of a proper age he was articled to John Varley for three years, but continued with him for five years. He then made a sketching tour in the Highlands. For a time he painted portraits and made some study of the figure. He also painted some landscapes in oil, but returning to his first art, he was in 1822 elected an associate, and in 1827 a member, of the Water-Colour Society. The profits of art were at that time small, and he regretted being so much drawn aside from his art by the necessities of teaching. He was frequently depressed by a want of confidence in his abilities, and was slow in his execution. His landscapes were chiefly compositions, palaces, gardens, and stately terraces, painted in the early pure manner, but laboured in their execution and following too much the style of Barret. His love of twilight and moonlight scenes, in which he excelled, was acquired by his rambles when a young man, frequently extended through the night, with some fellow-student, sketch-book in hand. He exhibited at the Water-Colour Society from 1820 till his death; but between 1817 and 1828 he was also an occasional exhibitor at the Royal Academy. He died August 27, 1862, after a lengthened illness. He possessed a fine voice, and was a good musician. He had also some poetical tastes, and printed a small collection of sonnets and 'An Artist's Dream.' His widow wrote an affectionate memoir of him, published in 1865.

152

FINDEN, EDWARD FRANCIS, } *engravers.*
FINDEN, WILLIAM, } Two brothers, both pupils of James Mitan, who practised their art together, and were largely assisted in their work by their pupils. They first engaged in the illustrations for the 'Arctic Voyages' published by Murray. Next they projected and published the landscape illustrations of Byron, followed by 'The Landscape Bible,' 'Beauties of the Poets,' and some others. Realising a profit by these undertakings, the brothers commenced their most important work, 'The Gallery of British Art,' which, by its failure, involved them in difficulties they hardly ever surmounted, though the work was both well planned and ably executed. Their next attempt was 'The Beauties of Thomas Moore,' and this too was unhappily unsuccessful. Edward, the younger brother, died, after a long illness, February 9, 1857, aged 65. He worked chiefly in conjunction with the pupils and assistants, and did not complete any important plates with his own hand. William died in his 65th year, September 20, 1852. The best works from his own graver are, 'The Highlander's Return' and 'Naughty Boy,' after Edwin Landseer, R.A., and 'The Village Festival,' after Wilkie, R.A.

FINLAYSON, JOHN, *draftsman and mezzo-tint engraver*. Was born about 1730, and practised his art in London. He was a member of the Free Society of Artists in 1763, and in 1764 and 1773 was awarded a premium by the Society of Arts. He engraved a considerable number of portraits after Hone, Cotes, Zoffany, and Reynolds, and died about 1776. He also engraved two or three subject pictures, one of them, 'Candaules showing his Wife as she is leaving the Bath,' after his own design.

FINNEY, SAMUEL, *miniature painter*. He was born in Cheshire, of an old county family, and practised his art, both on ivory and in enamel, with much success in London. He exhibited his miniatures with the Society of Artists, of which he was a member, 1761-66. He was appointed portrait painter to Queen Charlotte, and exhibited a portrait of Her Majesty in 1765. He quitted his profession on inheriting some family property, and retired to his native county, where he died in 1807, aged 86.

FISCHER, JOHN GEORGE PAUL, *miniature painter*. Was born at Hanover, September 16, 1786, and was the youngest of ten sons. His father, a line engraver, dying the year after his birth left the family in very straitened circumstances. At 14 years of age he became the pupil of Heinrich Bamberg, court painter in Hanover to George III. The youth showed so much talent that he was employed by his master to paint portraits, theatrical scenery, and frescoes, and on leaving the

studio was able to support his mother in the long sickness of her last years. In 1810 he fled to England to escape the French Conscription, and was by friends here introduced to royalty, and painted in miniature Queen Charlotte and all the younger members of the Royal Family. These are now at Windsor. In 1819, he painted the infant Princess Victoria in her cradle, and another large miniature of her in 1820. He occasionally painted landscapes in water-colour. He was an exhibitor at the Royal Academy from 1811 to 1871. For the Prince Regent he painted 20 examples of miniature costumes, his last miniature was executed in his 81st year. He died on December 12, 1875, leaving behind him a devoted widow who herself practised art.

FISHER, JONATHAN, *landscape painter*. He was born in Dublin, and was originally a draper in that city. Self-taught in art, he was patronised by Lord Portarlington. His works did not go beyond the mechanical imitation of nature, were cold in colour, and wanting in all the higher qualities of art; nor did they enable him to gain a maintenance. This he owed chiefly to a situation in the Stamp Office, Dublin, which he held till his death, in 1812. He published, in 1782, a set of views of the Lake of Killarney, aqua-tinted, from his paintings, by Mazell, and some illustrations of Irish scenery.

FISHER, EDWARD, *mezzo-tint engraver*. Born in Ireland in 1730; he was originally apprenticed to the trade of a hatter. He then took to engraving, and was distinguished by his plates, after Reynolds, which were brilliant, and the expression well rendered. Some of his best are Lady Elizabeth Keppel, Lady Sarah Bunbury, and Lord Ligonier. His works are distinguished by great breadth and delicacy of finish. Reynolds said of him that he was 'injudiciously exact,' and wasted as much time in giving the precise shape to every leaf as he bestowed on the features of a portrait. He was a member of the Incorporated Society of Artists, 1766, and resided in London, where he died about 1785.

FISHER, THOMAS, *amateur*. Was born at Rochester in 1782, and was a clerk in the India Office. He made numerous drawings of antiquarian and other subjects, which he etched himself. His best known works are his Bedfordshire antiquities, and that from the paintings in the church of Stratford-upon-Avon. He died at Stoke Newington, July 20, 1836.

FISK, WILLIAM H., *portrait and history painter*. He was born 1796-97, at Thorpe-le-Soken, Essex, in which county his family, a long race of yeomen, had possessed some property in land. Educated at Colchester, he came to London at the age of 19, and for 10 years had some mercantile employment. He had always felt a desire towards art, and when past 30 he turned earnestly to its study. He first gained a place on the Academy walls in 1829, and then, and for several years, exhibited portraits; but from 1835, with a higher aim, he exhibited historical works—in 1836, 'The Coronation of Robert the Bruce;' in 1838, 'Lionardo da Vinci expiring in the arms of Francis I.;' in 1839, 'Attempt to Assassinate Lorenzo de Medici,' for which he was awarded, in 1840, the gold medal at the Manchester Exhibition. In 1842 he exhibited 'The Trial of Charles I.;' and in 1843, 'Charles I. on his Way to the Scaffold.' From that time his subjects were of a more domestic character, and he was only an occasional exhibitor; but towards the end of his career he exhibited two or three subjects from Scripture. He purchased some property in Essex, to which he had for some years retired, and died at Danbury, in that county, November 8, 1872. Several of his works are engraved.

* FITTLER, JAMES, A.E., *engraver*. He was born 1758, in London, and in 1788 entered the Academy Schools, where he studied his art and attained much distinction. He engraved portraits, landscapes, marine subjects, and topographical views, and was appointed marine engraver to George III. He was employed on the illustrations for Bell's 'Theatre' and Dibdin's 'Ædes Althorpianæ.' His 'Lord Howe's Victory' and 'Battle of the Nile,' both after De Loutherbourg, are his most important works. He published 'Scotia Depicta,' from drawings by Claude Nattes, and an 'Illustrated Bible.' He was elected an associate engraver of the Royal Academy in 1800. He died at Turnham Green, December 2, 1835, aged 79, and was buried in Chiswick Churchyard. He worked in the line manner; was powerful in light and shade, hard and not agreeable in manner.

FITZ-OTHO, THOMAS, } *medallists*.
FITZ-OTHO, HUGH, } They were engravers to the Mint in the reign of Edward I. Thomas was styled 'Die graver in fee.'

FITZ-OTTO, WILLIAM, *medallist*. He is styled 'goldsmith,' and was engraver of the dies for the Royal Mint in the reign of Henry I., having been confirmed to that office, 'the mystery of the dyes,' which his father, in Domesday-book, is described to have held, and which it appears was at that time hereditary.

* FLATMAN, THOMAS, *miniature painter*. He was the son of a clerk in Chancery, and born in London about 1633. Educated at Winchester School, he went from thence to New College, Oxford, where he was elected

a fellow in 1654, but left, without taking his degree, to study the law in the Inner Temple, and was called to the bar, but it does not appear that he ever followed the profession. He early took up the study of art, and distinguished himself as a miniature painter. His works are somewhat larger in scale than those of his predecessors, and he used more body colour. They are a little after Cooper's manner, but deficient in his refinement of drawing expression, and finish, and are greatly behind him in grace, though they are far from wanting in merit, and are highly esteemed. Some portraits in oil by him also exist. They are pleasing in colour, well painted, with no appearance of littleness in manner. He was also a poet, and a small volume of 'Poems and Songs' by him, published in 1674, reached a third edition in 1688. His miniatures were, however, preferred to his writings by his contemporaries, for Lord Rochester says of him:

' Flatman, who Cowley imitates with pains,
 And rides a jaded muse whipt with loose
 reins.'

And Granger, 'One of his heads is worth a ream of his pindarics;' and it is said also that his art was highly esteemed by Vertue. He lived in Three-leg Alley, St. Bride's, London, where he died, December 8, 1688, and was buried in the parish church. He possessed a small estate at Tishton, near Diss.

FLAXMAN, JOHN, *modeller.* He was of an old Buckinghamshire race, originally from Norfolk, and four brothers of the family fought on the side of the Parliament at Naseby. He was descended from the youngest son, who settled in Buckinghamshire. Roubiliac and Scheemakers both employed him as a modeller. He kept a shop for the sale of plaster casts in Covent Garden, and afterwards in the Strand, where he died about 1795.

FLAXMAN, WILLIAM, *modeller.* He was the eldest son of the above, and practised towards the end of the last century. He exhibited a 'Venus' with the Free Society of Artists in 1768, and at the Academy for the first time in 1781, sending a portrait of his brother in wax, and contributed a portrait in wax to three subsequent exhibitions, the last in 1793. He is said to have been distinguished as a carver in wood.

•• FLAXMAN, JOHN, R.A., *sculptor.* Second son of the above John Flaxman. Was born in York city, July 6, 1755. He was a delicate boy, in very weakly health, and finding his amusement at home, probably received his first inspirations in art from the classic models in his father's shop. For this his taste had been quickened by a fair knowledge of Latin and Greek. He
154

exhibited at the Free Society of Artists, as early as 1767, 'Models from the Antique;' in the next year, busts; and in 1769, 'The Assassination of Julius Cæsar,' a model; probably the first idea of his completed work in 1781. In 1769 he was admitted a student of the Royal Academy. He had acquired the technicalities of his art from his father, and was diligent in his studies. In 1770–71 he exhibited portraits in wax at the Royal Academy; and in 1772 was an unsuccessful competitor for the gold medal, and could not refrain from tears when the decision was announced. The same year he exhibited a 'Figure of History;' the following year, 'A Figure of Grecian Comedy,' with, at the same time, some wax portraits. Continuing to exhibit with little intermission, in 1777 he contributed a clay model of 'Pompey' and of 'Agrippina;' in 1778, 'Hercules tearing his hair after having put on the poisoned Shirt;' in 1781, 'The Death of Julius Cæsar' and 'Acis and Galatea,' two bas-reliefs; in 1782, a bust of Venus; in 1784, 'Prometheus;' followed in 1785–86 by some monumental groups, including that to the poet Collins at Chichester Cathedral and to Mrs. Morley at Gloucester Cathedral; and in 1787, 'Venus and Cupid.' During these years he was largely employed by Messrs. Wedgwood, and added greatly to his means by his designs for their celebrated pottery, and then for the next seven years he sent no work to the Academy Exhibitions.

His early art companions were Stothard, R.A., and Blake, and at this time, leaving his home, he lived in Wardour Street, where he worked zealously, modelling in wax and clay, and occasionally making a study in oil. In 1782 he married Anne Denman, an accomplished young lady of a family in the City, and in 1787, taking his wife, his helpmate ever by his side, as the companion of his travels, visited Italy, where he pursued his studies for seven years. At Rome, while he had to support himself by his work, he attracted great notice. He executed for the Earl of Bristol, but for a price which proved very inadequate, a marble group of four figures above life-size from Ovid's 'Metamorphosis,' representing the fury of Athamas. He began his designs in illustration of the great poets—the 'Iliad' and 'Odyssey,' 80 designs, 1793; from Æschylus, 1795; and Dante, 1797; and these works were engraved at Rome under his supervision by Piroli. On his return home, he was presented with the diplomas of the academies of Florence and Verona, and later he made the designs from 'Hesiod,' which were engraved in 1816.

He reached England in 1794, and in the following year took a house in Buckingham Street, Fitzroy Square, where he resided

till his death. His first work was his monument to Lord Mansfield, in Westminster Abbey—a fine monumental group—the great judge represented seated in his full robes, with figures of Justice and Mercy, and an emblematic figure, said to be of Death. Following this work, he was elected in 1797 an associate, and in 1800 a full member, of the Academy. He afterwards completed his monument to Captain Montague, in St. Paul's, and the monuments to Sir Joshua Reynolds, Earl Howe, and Lord Nelson ; and anxious to distinguish himself, proposed to erect a statue of Britannia, 200 feet high, on Greenwich Hill, as a naval trophy.

Weakly in frame and constitution, and of a gentle spirit, he quietly pursued his art during a long career. Of the numerous works from his chisel, these should be specially noticed — 'Michael and Satan,' executed for Lord Egremont ; a monument to the Baring family at Micheldever Church, Hants ; to Mary Lushington, at Lewisham, Kent ; Earl Howe, in St. Paul's ; and his drawings and model for the 'Shield of Achilles,' completed in 1818, comprising upwards of 100 figures, besides animals. He was elected, in 1810, professor of sculpture to the Royal Academy, and delivered from the professor's chair 10 lectures, which are published. Simple in all his tastes and habits, his art was founded on the highest Greek examples. His imaginative genius is shown in his numerous drawings and designs, full of poetry and sentiment in their conception, but never sensual ; classic and poetical, religious and monumental, his grouping was distinguished by its grandeur of style. Skilled in the use of his modelling tool, he was weak and ineffective when he took his chisel in hand. He was of some reputation as a writer on art subjects. He published, in 1799, 'A Letter to the Committee for raising a Monument to the Duke of Gloucester.' He contributed a sketch of Romney's career to 'Hayley's Life.' He wrote for Rees's 'Encyclopædia' the articles 'Armour,' 'Basso-rilievo,' 'Beauty,' 'Bronze,' 'Bust,' 'Composition,' 'Cast,' and 'Ceres.' His health declined gradually towards the end of his life, and a bad cold caught at the beginning of December terminated in a few days in his death. He was buried in the ground belonging to St. Giles-in-the-Fields, adjoining the old church of St. Pancras, where his tombstone tells that 'his angelic spirit returned to the Divine Giver, December 7, 1826, in the 72nd year of his age.' He was a disciple of Swedenborg. His wife, who died in 1820, and his sister rest in the same grave. His property was sworn under 4,000l. Miss Denman, his wife's sister, and his adopted daughter, founded the Flaxman Gallery at the London University College.

FLAXMAN, Miss MARY ANN, amateur. Sister of the above. Her name first appears in art as an exhibitor at the Royal Academy, both of models and drawings. In 1786 she was an 'honorary' contributor of 'Turkish Ladies ;' in 1789, of 'Ferdinand and Miranda playing Chess' and a portrait in wax ; in 1790, of a drawing from Miss Burney's 'Cecilia ;' and then, after an absence of six years, she again contributes—1797-1800, designs from the poets : in 1802, a portrait of Mrs. Billington. She was, probably at this time, governess in a family, with whom she travelled in Germany. In 1810 she had returned to London and was living with her brother, and then resumed her contributions to the Academy, exhibiting in that year 'Sappho ;' in 1811, portrait of her friend, Miss Porden ; in 1817, designs for the old ballad, 'The Beggar's Daughter ;' in 1819, 'Maternal Piety,' her last exhibited work. She died April 17, 1833, in her 65th year. Her designs for 'Robin Goodfellow' were engraved ; and six illustrations by her for Hayley's 'Triumphs of Temper,' engraved by Blake, were published in 1803. They are very simple in design, with much original feeling, and though weakly, are not badly drawn.

FLETCHER, HENRY, engraver. Practised in London in the second quarter of the 18th century. He was chiefly employed upon portrait heads for frontispieces, but is best known as the first engraver of flowers in this country. Of these his 'Flowers of each Month' (some copies of which were coloured) are good examples. There is a plate by him of the story of 'Bathsheba,' after Sebastian Conca.

FLETCHER, HENRY, engraver. Born at the beginning of the 18th century, and about 1750 engraved several views of Ancient Rome, after Canaletti.

FLITCROFT, HENRY, architect. Born September 3, 1697. His father was gardener to William III. at Hampton Court. He began life as a carpenter, but falling from a scaffold at Lord Burlington's about 1717-18, the accident gained him the notice of that nobleman, by whose patronage and his own merit he attained celebrity and wealth. He held several offices at the Board of Works, succeeding to the appointment of comptroller in 1758. He built the church of St. Giles-in-the-Field, opened 1734, and rebuilt St. Olave's, Southwark and also, about 1745, the church at Hampstead, where he built a house for himself, and dwelt some time. He also made some extensive alterations at Woburn Abbey, almost rebuilding the mansion, and adding an elevation of much pretension. He was elected sheriff for London and Middlesex in 1745, but declined to serve, and paid the fine. He died March 5, 1769, and was

buried at Teddington. He was nicknamed 'Burlington Harry.'

FLOWER, BERNARD, *'glazier.'* He contracted to paint the windows of Henry VII.'s Chapel, Westminster Abbey, but died about the 4th Henry VIII., before the completion of the work.

FLYNTE, NICHOLAS, *die sinker.* Was sculptor of the irons for the Royal Mint. 'Sculptor de et pro Ferris,' 2nd Henry VII.

FOGGO, JAMES, *history painter.* Was born in London, June 11, 1790. His father was a warm advocate for the emancipation of the negroes, and during the suspension of the Habeas Corpus Act in 1799 thought it prudent to leave England, and went with his family to Paris. The son was educated in the schools of the French Academy, and adopted art as his profession. In 1815, on the return of Napoleon from Elba, he hastily left Paris and came to London with small means, which were soon exhausted. But he did not want perseverance. He painted his 'Hagar and Ishmael,' which was exhibited at the British Institution, and gained favourable notice. He was also fortunate in obtaining some teaching, which proved his chief means of support. In 1819 he was joined by his brother George, who was educated in art with him, and from that time they worked together, their pictures being the effort of their combined talent. In 1822 they completed their large work, ' Christians at Parga preparing to Emigrate ;' in 1824, 'Christ healing the Impotent Man at the Pool of Bethesda ;' in 1826, 'The Entombment of Christ ;' but they exhibited very few works, and those generally at the British Institution. In 1840–43 they were competitors in the Westminster Hall Exhibitions for the decorations of the Houses of Parliament, but were not successful. The works they produced were chiefly Scripture subjects, and from their unusually large dimensions and treatment, were hardly of a class to find purchasers ; but the two brothers, working harmoniously together for nearly 45 years, followed the bent of their own genius, undeterred by the want of public appreciation, while they found by teaching their chief means of living. James died in London, September 14, 1860, and was buried in the Highgate Cemetery.

FOGGO, GEORGE, *history painter.* Born April 14, 1793. He was younger brother of the above, and was associated with him in his principal works, and, like him, drew the figure well. He was an energetic, active man, and was associated with many plans for the advancement of art. He drew and lithographed the Raphael cartoons, and was the author of 'A Letter to Lord Brougham on the History and Character of the Royal Academy,' 1835; the 'Report of

a Meeting to promote the free Admission to St. Paul's and Westminster Abbey,' 1837; 'Results of the Parliamentary Inquiry on the new Schools of Design and the Royal Academy,' 1837 ; 'A Catalogue of the National Gallery, with Critical Notes,' 1847. He died September 26, 1869, aged 76.

FOLDSONE, JOHN, *portrait painter,* also styled himself *history painter.* He practised in the latter half of the 18th century. He painted small heads in oil; rapid in his execution, his practice was to attend his sitters at their own houses early in the morning, generally to dine with them, finish his work in the day, and to retire with his honorarium. He exhibited portraits at the Spring Gardens Exhibition in 1769, and small whole-length portraits, with two portrait-groups, at the Academy, in 1771, a classic subject in 1773, and continued to exhibit up to 1783. He died, early in life, soon after. His daughter (Mrs. Mee) was a successful miniature painter.

• FOLEY, JOHN HENRY, R.A., *sculptor.* Was born in Dublin, May 24, 1818, and at the age of 13 entered the art schools of the Royal Dublin Society, where he studied the figure, architecture, and ornamental design. In 1834 he came to London, and the following year was admitted to the schools of the Royal Academy. In 1839 he first appears as an exhibitor, contributing two groups. In the following year he sent his 'Ino and the infant Bacchus,' when his abilities were at once recognised. 'Lear and Cordelia' followed in 1841, 'Venus rescuing Eneas from Diomed' in 1842, 'Prospero and Miranda' in 1843. His attention was then directed to the National Competition in Westminster Hall, where he exhibited in 1844 ' A Youth at a Stream,' and in 1847 his model for a statue of Hampden. In 1849 he was elected an associate of the Academy, but at this time his contributions to the exhibition were few, a bust or a statuette chiefly. In 1854 he exhibited his design for the Wellington Memorial, and in 1858 was elected a full member of the Academy. Subsequently he contributed in 1859 ' Egeria,' in 1860 'The elder brother in Comus,' his diploma work, in 1861 his 'Oliver Goldsmith' and a part of 'General Nicholson's Monument.' This was the last year in which he exhibited. Some difference with the member charged with the arrangement of the sculpture at the following exhibition, led to his persistent refusal to ,exhibit, which, it is believed, was only overcome just before his death. Among his chief works are ' Selden and Hampden' for St. Stephen's Hall, Westminster, 'Goldsmith and Burke' for Trinity College, Dublin, 'Lord Herbert,' 'Lord Hardinge,' 'Sir James Outram,'

two equestrian statues for India. 'The group of Asia' for the Prince Consort's Memorial, Hyde Park, and the seated figure of the Prince, which he did not live to see completed. He had been long in declining health, and died at Hampstead after a short illness, August 27, 1874, and was buried in St. Paul's Cathedral. His work was always graceful and dignified in its proportions, his conceptions are original and marked by true talent, while his works show great beauty and finish. His 'Ino and Bacchus' is purely classical in its style, but perhaps his equestrian portraits will be remembered as amongst his most noteworthy productions. He possessed much musical talent, and was the writer of several songs published anonymously.

FOLEY, EDWARD A., *sculptor*. Was born in Dublin, and was brother to the above, with whom he came to London and resided from 1834 to 1843. From the former year he was an occasional exhibitor of portrait busts at the Royal Academy up to 1860, when he sent 'Helen of Troy,' in 1869 'The Nymph Ænone,' in 1870 'Penelope,' in 1873 'The Morning Star.' To the Westminster Hall Exhibition in 1844 he sent 'Canute reproving his Courtiers.' He was an artist of talent, and reputed an expert carver. He committed suicide early in the summer of 1874.

FOOTTIT, HARRISON, *miniature painter*. He exhibited at the Royal Academy in 1772 and the two following years, and practised till towards the end of that century, though he does not appear again as an exhibitor.

FORD, M., *mezzo-tint engraver*. Produced several fine portrait plates early in the latter half of the 18th century.

FORD, RICHARD, *amateur*. He was the son of Sir Richard Ford, chief magistrate of Bow Street, and was born in London in 1796. Educated at Winchester School and at Trinity College, Oxford, he was called to the bar at Lincoln's Inn. He then travelled, visiting the chief of the great European capitals. He cultivated the arts, was a very able sketcher, and had a knowledge and judgment of pictures, of which he made a good collection. His sketches were used in the illustration of Lockhart's 'Spanish Ballads' and several other works. He etched several fac-similes of plates by Parmegiano and Meldolla. He wrote a 'Handbook for Travellers in Spain,' 1845; 'Gatherings from Spain,' 1846; and 'Tauromania; or, The Bull-fights of Spain,' 1852; and contributed several articles to the 'Quarterly Review' on the art and literature of Spain. He died September 1, 1858.

FORD, SAMUEL, *history painter*. He was born at Cork, April 8, 1805. Weak in constitution, he was by his father's improvidence early inured to privation, and with his pencil and books passed many a sad day in want; yet persevering, he acquired a knowledge of Latin, French, and Italian, and studied drawing in the Cork School, where he was a fellow-student with Maclise. In 1828 he was chosen the master of the Cork Mechanics' Institute. He had often been without the means to procure materials for his work, and full of dreamy aspirations of great poetic subjects, he now tried to realise them. He finished and exhibited 'The Genius of Tragedy,' and in 1827 commenced a large cartoon of the 'Fall of the Angels' (purchased by the Earl of Shannon), by which he hoped to establish a name; but he took cold, which led to consumption, of which he died, July 28, 1828.

FORREST, ——, *glass painter*. Was the pupil of Jarvis, whom he assisted in the completion of the window in St. George's Chapel, Windsor, after West's design of 'The Resurrection;' and was afterwards engaged there, from 1792-96, on three other windows by West—'The Angel's Appearance,' 'The Nativity,' and 'The Wise Men's Offering.' Later, he painted several windows with Eginton, of Birmingham.

FORREST, ROBERT, *sculptor*. Born in Lanarkshire, and bred a stonemason in the Clydesdale quarries. He was self-taught in art. In 1817 he cut a statue of Wallace, and was subsequently employed to cut a colossal figure of Lord Melville for the pillar in St. Andrew's Square, Edinburgh. He also executed the 'John Knox' in the Glasgow Necropolis, and in 1843 completed a good portrait statue of Mr. Ferguson, of Raith. He does not appear to have exhibited in London; but in 1832 he opened an exhibition of about 30 groups, executed by himself, which attracted much notice. His works were original, and had merits both of proportion and conception. He died at Edinburgh, December 29, 1852, in his 63rd year.

FORREST, THEODOSIUS, *amateur*. He was the son of a solicitor, and followed his father's profession. In early life he was a pupil of Lambert, and from 1769 to 1775 was a yearly exhibitor of tinted drawings at the Royal Academy, views of buildings and landscapes, with one or two attempts at classic subjects, but he is distinguished as one of the party who left a record of their 'Five Days' Peregrinations,' with illustrations by Hogarth. He was wealthy, was a member of the Beef-steak Club, and universally known by the artists of his day—a jovial companion, who wrote and sang his own songs. He wrote 'The Weathercock' for the Covent Garden stage. He died November 5, 1784.

FORRESTER, ALFRED HENRY (pseudonym 'Alfred Crowquill'), *comic draftsman*. He was born in London in 1805, of

Forbes - Stanhope. A. b. 85

a family long members of the Stock Exchange, and was educated with a view to that business. He was, however, more attached to literature than to the money transactions of the City, and at the age of 16 he made a beginning as an anonymous periodical writer. Under his assumed name he first wrote in the 'New Monthly Magazine,' and in 1828 he became a permanent contributor; and from that time he took a large share in the periodical literature of the day, but did not retire from the Stock Exchange till 1839. His writings were illustrated by his own comic designs, executed with great facility and power, and his works were among the most popular. In 1845–46 he was an exhibitor at the Royal Academy—'The Huntsman's Rest,' 'The Picnic,' and some other of his designs. He was a constant contributor to the 'Illustrated London News,' and published 'Alfred Crowquill's Sketch-book,' 'Eccentric Tales,' 'Leaves from my Memorandum-Book,' 'Wanderings of the Pen and Pencil,' 'Comic Arithmetic,' and 'Comic Grammar.' He died in May 1872, and was buried in the Norwood Cemetery.

FORRESTER, JAMES, *engraver.* Practised about 1760. He resided some time in Italy, and in 1761 sent a large landscape from Rome to the Academy Exhibition. He etched some Italian scenes, whose chief merit is their neat execution.

FORSTER, THOMAS, *miniature draftsman.* He practised at the beginning of the 18th century. He drew on vellum with the black-lead pencil, and many well-finished miniatures in this manner, carefully drawn and expressed, are known. They are dated and signed with his name, which is well worthy of record, though no other particulars respecting him can be traced.

FOSTER, THOMAS, *portrait painter.* Born in Ireland. Came to England at the age of 15 or 16, and entered as a student of the Royal Academy in 1818, and the next year, and in each succeeding year to 1825, contributed to the Academy Exhibitions. He copied several of Lawrence's portraits, and made rapid advance as a portrait painter. He painted a portrait of 'Mazeppa,' which gained him notice; and in 1823 exhibited 'Domestic Quarrels' and a portrait of Miss Tree and of Mr. J. Wilson Croker, in whom he found a friend and patron. In 1825 he exhibited 'Paul and Virginia.' His connections were respectable, his manners and person agreeable, but his love of society interfered with his art, in which he no less continued to make good progress. He is said, however, to have desponded over an ambitious work he had commenced, or, as was hinted, to have fallen hopelessly in love with a young lady whose portrait he was painting. From whatever cause, he unhappily committed suicide in

158

March 1826, in his 29th year. He left a note saying that his friends had forsaken him, that he knew no cause, and that he was tired of life.

FOULIS, ANDREW, } *amateurs.* Two
FOULIS, ROBERT, } brothers, who were eminent printers in Glasgow, remarkable for the beauty and elegance of their editions of the classics. Their taste for the fine arts induced them to establish an academy of painting and sculpture in Glasgow, and to undertake, at their own charge, the instruction of young artists, and even to provide for the continuance of their studies in Italy. This generous undertaking partially succeeded, mainly in the branches of drawing and engraving, but for want of support the efforts of the two brothers were unsuccessful, and the fortunes which they had realised by printing were swallowed up by the charges of their academy which led to their ruin. Andrew died September 15, 1775, Robert in the following year. Mention will be too frequently made in this work of eminent artists who studied in Foulis's Academy to permit the omission of their names.

FOULSTON, JOHN, *architect.* Was born in 1772, and was a pupil of Thomas Hardwick. In 1796 he commenced practice for himself, and in 1811 was a successful competitor for a large building at Plymouth, comprising the Royal Hotel, Assembly Rooms, and Theatre. This induced him to settle in Plymouth, and establishing a reputation there, he was the architect of several public and private buildings of great merit in the West of England. He died near Plymouth, January 13, 1842. He published his chief designs, 'Public Buildings erected in the West of England,' 1838.

FOUNTAIN, ——, *portrait painter.* There are engravings of portraits painted by him in the reigns of George I. and of George II.

FOURDRINIER, PETER, *engraver.* Born in France. He came to this country and settled in London. He was chiefly employed upon plates for the illustration of books, and engraved the 'Four Ages of Man,' after Lancret; also the plates for a folio volume of 'The Villas of the Ancients,' published in 1728, and the plans and elevations of Houghton Hall. These architectural plates are carefully executed, but his manner was weak and black. He died in London, February 3, 1758, leaving many descendants.

FOURDRINIERE, PETER, *engraver.* Born in England. He excelled in architectural engraving, and was also largely employed upon illustrated frontispieces by the booksellers. He died about 1769.

FOURNIER, DANIEL, *engraver.* He is believed to have been originally an engraver by profession, but eventually he

was of many occupations. He was shoemaker, kept an à-la-mode beef shop, painted, engraved, modelled in wax, and taught drawing. He published, in 1764, 'The Theory and Practice of Perspective, on the Principles of Brooke Taylor,' which he illustrated by movable diagrams and 50 plates. With all his undertakings he was seldom free from difficulties. He died about 1766.

FOWKE, Captain FRANCIS, R.E., *architect*. Was born at Ballysinnin, near Belfast, July 7, 1823. When about 12 years of age he was sent to Dungannon College, where he gained a gold medal for mathematics in a competition open to the whole school. In 1839, at the age of 16, he entered the Woolwich Academy, and passed his probationary examination in 1840, his theoretical in 1841, and his practical examination, coming out sixth, in 1842. The great ability he had shown, added to his talent in drawing, secured him the third out of the four engineer commissions only which were given in that year, and he was at once sent to Chatham. In December 1843 he returned to Woolwich, and in the following April was quartered at Limerick, from whence, in April 1845, he sailed for Bermuda, and was stationed at Ireland Island, and was soon after employed in designing the Bermuda Barracks in St. George's Island. In 1849 he returned to England, and, quartered at Devonport, he designed the Raglan Barracks there, in the construction of which great regard was paid to the health and comfort of the men. In 1853 he was attached to the South Kensington Museum, as inspector of science and art; and in the following year was charged with the machinery of the English department at the Paris Exhibition of 1855, and subsequently appointed secretary to the British Commission. He was made chevalier of the Legion of Honour in recognition of his services. He wrote two able reports in connection with this duty—one on Civil Construction, the other on the Strength of Materials, including the results of valuable experiments upon colonial woods. He was afterwards appointed the architect of the South Kensington Museum, and built the fine picture galleries, which are admirably constructed with regard to light and convenience; the great north court, whose wide-spread roof is suspended without support from the floor; and the south court, with its elegant metal galleries. He was also the architect of the National Gallery of Ireland (interior), a work most pure and unpretentious in its style, and of the Edinburgh Museum of Science and Art.

In 1858 he was appointed a member of the International Technical Commission, and made a separate report on the scheme for the navigation of the Danube. He planned the arcades and conservatory of the Horticultural Gardens, the latter highly decorative and original in its design; and the Prince Consort's Library at Aldershot. The building for the International Exhibition of 1862, a work of great constructive power, was also designed by him, the permanent galleries connected with which were admirably adapted for the exhibition of paintings. One of his last designs was for a Natural History Museum, and was unanimously adopted, in an open court competition, by the judges appointed by the Government; but, from changes with regard to the intended site, has not been carried out. He was charged with the original design for the Albert Hall, but did not live to complete his plans.

He was a man of great invention and constructive power. He invented the collapsing pontoons, made improvements in drawbridges and conical shot and shell, and in gun-carriages. He constructed on a metal framework the large canvas tent used in the Horticultural Gardens; introduced with great skill terra cotta in his architecture, and other new material, with many other useful inventions. After a short illness, he died suddenly, December 4, 1865, and was buried in the Brompton Cemetery. He wrote in the 'Cornhill Magazine,' No. 3, 'The National Gallery Difficulty solved,' and No. 6, 'London the Stronghold of England.'

FOWLER, CHARLES, *architect*. He was born in May 1792, at Collumpton, Devon, where his family had lived for many generations, and was apprenticed for five years to a surveyor and builder at Exeter. On the completion of his apprenticeship in 1814 he came to London, and was employed in the office of Mr. D. Laing, where he remained three or four years, and then commenced practice for himself. His first work was the Court of Bankruptcy in Basinghall Street, finished 1821. In the following year he competed in the designs for the new London Bridge, and gained the first premium, but was not employed to carry out his design. He afterwards made some designs for other bridges, and in 1826 was the architect of the bridge over the Dart, at Totnes. He built Covent Garden Market, 1830, and Hungerford Market, 1831, a work of great skill, both in design and in the arrangement of the plan on two levels, but since pulled down; also Exeter Lower Market, 1835, and in the same year Charmouth Church and Honiton Church, and in 1838, Brickley Church; also the Devon Lunatic Asylum, 1848, and the London Fever Hospital, 1852. He was for many years honorary secretary of the Institute of British Architects, and afterwards vice-president. In 1862, his health

failing, he retired into the country, and died at Great Marlow, September 26, 1867, in his 76th year.

FOWLER, WILLIAM, *portrait painter.* Was born in 1796. He is best known by a portrait of Queen Victoria when young, from which an engraving was taken.

FOWLER, WILLIAM, *draftsman and engraver.* He was brought up as a carpenter at Winterton, in Lincolnshire; and was, by his ingenious and laborious perseverance, a self-taught and trustworthy draftsman. He drew and engraved 'The principal Mosaic Pavements discovered in Britain,' 'The Stained Glass in York Minster,' published in 1805, and some other architectural antiquities. He lived at Winterton during a long life, and died there September 22, 1832, aged 73.

FOX, CHARLES, *modeller.* Executed from nature groups of animals, modelled with fidelity and taste. In 1847 he gained the Society of Arts' medal for a 'Group of Children.' He resided at Brighton, and died there in 1854.

FOX, CHARLES, *engraver.* He was born March 17, 1794, at Cossey Hall, Norfolk, where his father was steward to Lord Stafford, and was brought up in the gardens at Cossey. He was then apprenticed to an engraver at Bungay; on the completion of his term he came to London and engaged himself as an assistant to John Burnet, with whom he remained some time. His best plates are—'Village Recruits,' after Wilkie, R.A.; Sir George Murray, after Pickersgill, R.A.; and 'Queen Victoria's first Council,' also after Wilkie. He engraved for the annuals, and to illustrate Cadell's edition of Walter Scott's works. He left an unfinished plate of Mulready's 'Fight Interrupted.' He engraved in the line manner. He was a man of refined tastes, and painted some water-colour portraits, chiefly of his friends, which have great merit. He died at Leyton, Essex, where he was on a visit, in his 55th year, on February 28, 1849.

* FOX, CHARLES, *landscape and portrait painter.* Born at Falmouth in 1749. Devoted to literature from a child, he also showed a taste for drawing. He began life as a bookseller, but losing all his possessions by a fire, he then tried art, and travelled on foot through Norway, Sweden, and a part of Russia, sketching the wild scenery of those countries. On his return he painted pictures from his sketches, and also had recourse to portraiture as a means of subsistence, but he never was much known as a painter. Later in life he studied the oriental languages, and in 1797 published a volume of poems from the Persian, 'The Plaints, Consolations, and Pleasures of Ahmad Ardabéli, a Persian Exile.' In 1803 he had prepared for the

press two other volumes of translations from the Persian, and a Journal of his Travels, but these two latter works have not found a publisher. He died at Bath in 1809.

FRADELLE, HENRY JOSEPH, *history painter.* He was born at Lisle about 1778, and came early to England, where he studied in the Academy Schools. He painted subject pictures, and occasionally portraits. He exhibited at the Academy, in 1817, 'Milton dictating "Paradise Lost" to his Daughter,' and continued an occasional exhibitor up to 1855; but he principally exhibited at the British Institution. His art was not of a high class, but was popular, and his 'Mary Queen of Scots and her Secretary,' 'Rebecca and Ivanhoe,' 'The Earl of Leicester's Visit to Amy Robsart,' and some other subjects of this class, were engraved. He died March 14, 1865.

FRAMPTON, RICHARD, *illuminator.* The name of this artist is only known as having illuminated a fine manuscript in the time of Henry V.

FRANCIA, FRANÇOIS LOUIS THOMAS, *water-colour painter.* Was born at Calais, December 21, 1772, and came early in life to London, where he settled in the practice of water-colour art. He first exhibited at the Royal Academy in 1795, and continued to exhibit, with some intermission, up to 1822. He attained much excellence, painting landscape, but chiefly marine subjects. He was appointed painter in water-colours to the Duchess of York, for whom he made a great many drawings. In 1816 he was a candidate for the associateship at the Royal Academy. The following year he returned to France, settled at Calais, and died there on February 6, 1839. His marine subjects were treated with great poetry. His works possessed power, breadth, and an harmonious simple richness of colour. He published 'Lessons on Sketching and Painting trees in water-colour,' 1835. His son, A. Francia, sent a picture to the Academy Exhibition in 1841, and again in 1842.

FRANCIS, JOHN, *sculptor.* Was born September 3, 1780, in Lincolnshire, and brought up to farming. He made some early attempts at carving, and his success led his friends to advise him to try the study of art in London. In the Metropolis he became the pupil of Chantrey, and received much friendly assistance from him. He succeeded as a bust modeller, and had very distinguished sitters—among them, William IV., the Queen and the Prince Consort. He exhibited at the Academy a bust of Mr. Coke in 1820, his first contribution, and was then living in Norfolk. He continued an occasional exhibitor of busts, never trying any higher subject, up

to 1857. He died, aged 81, at Albany Street, Regent's Park, August 30, 1861. There is a bust of the Duke of Wellington by him in the National Portrait Gallery. Mrs. Thornycroft, the well-known sculptress, is his daughter.

FRASER, ALEXANDER, A.R.S.A., *subject painter.* He was born in Edinburgh, April 7, 1786, and studied his art under John Graham, at the Trustees' Academy. In 1810 he sent his first picture, 'A Green Stall,' to the Royal Academy, followed by two domestic subjects in 1812 ; and in 1813 he came to reside in London, and was from time to time an exhibitor ; and trusting to his profession for his support, soon gained a fair position. He then engaged as an assistant to Wilkie, R.A., who had been his fellow-pupil in Edinburgh, and for 20 years painted the details and still-life into Wilkie's pictures, working usually in his studio. The engagement did not, however, preclude his painting pictures of his own ; he continued to exhibit at the Academy and the British Institution, and at the latter received in 1842 a donation of 50 guineas for the general merit of his works. He was elected an associate of the Royal Scottish Academy. His pictures were chiefly founded on Scottish incidents, and he could scarcely avoid imitating Wilkie, yet his story was well told and his work well painted. For the last 10 years of his life the state of his health prevented him practising his profession. He died at Wood Green, Hornsey, February 15, 1865. His 'Interior of a Highland Cottage' is in the South Kensington Museum. His 'Robinson Crusoe reading the Bible to Friday' has been engraved, as have some of his designs in illustration of the Waverley novels.

FREEBAIRN, ROBERT, *landscape painter.* Born in 1765. He was Richard Wilson's last pupil, and on his master's death went to Italy to pursue his studies in landscape art. He continued there for 10 years, studied in Rome 1789–91, and formed his art upon the scenery and effects of the country, returning to London in 1792. He painted in oil. His subjects were almost exclusively Italian, and from 1782 to 1807, he was, with little intermission, an exhibitor at the Royal Academy. He was also a 'fellow exhibitor' in 1806 and 1807 at the then newly-formed Water-Colour Society. His works were carefully and neatly finished, his colour brilliant and pleasing, yet they never reached excellence. They were not numerous, and were chiefly painted on commission. He published, in 40 plates, 'English and Italian Scenery.' He died of decline, in Buckingham Place, New Road, January 23, 1808, aged 42, leaving a widow and four children.

FREEBAIRN, ALFRED ROBERT, *engraver.* He was a student at the Royal Academy. His chief work, which he only just lived to finish, is an engraving from Flaxman's 'Shield of Achilles.' He died suddenly, August 21, 1846, aged 52, and was buried in Highgate Cemetery.

FREEMAN, JOHN, *history painter.* He practised in the latter half of the 17th century, and was a rival of Isaac Fuller. He went early in life to the West Indies, and on his return was much employed. In the latter part of his life he was scene painter to the playhouse in Covent Garden. There are five paintings attributed to him in the gallery of the Louvre.

FREEMAN, SAMUEL, *engraver.* He practised chiefly in portrait and history. He engraved Corregio's 'Holy Family' and Raphael's 'Madonna,' 'Infant Christ and St. John,' also Vandyck's 'St. Ambrose refusing the Emperor Theodosius admission to the Church,' works of second class merit. He died February 27, 1857, aged 84.

FREESE, N., *miniature painter.* Artist to the Duke of Cambridge. He exhibited miniatures at the Royal Academy from 1797 to 1813, occasionally contributing a landscape in oil.

FRENCH, THOMAS, *scene painter.* Practised towards the end of the 18th century as an antiquarian draftsman and scene painter. He resided chiefly at Bath, and painted the scenery for the Bath Theatre. He died there in September 1803.

FRENCH, HENRY, *history painter.* Born in Ireland. He went to Italy early in the 18th century, and studied many years in Rome, where he gained a medal in the Academy of St. Luke. Returning to England, he painted some historical subjects, but found no encouragement, and went back to Italy. In 1725 he came again to England, but was attacked by illness, and died the following year.

FROST, GEORGE, *amateur.* He was born at Barrow (some accounts say Ousden), Suffolk, where his father was a builder. Brought up to this business, he was afterwards employed in the office of the Ipswich Coach, a connection which he continued till within a few years of his death, and in which he gained a competence. He early showed a love of drawing, and without instruction acquired by his own perseverance an artist-like love of nature. He drew picturesque buildings and landscape in a masterly manner, finding his subjects in Ipswich and its neighbourhood. He was an ardent admirer and imitator of Gainsborough, and possessed some good drawings and paintings by him. In a note by Constable, R.A., he speaks of him as 'my dear old friend Frost.' He died at Ipswich, June 28, 1821, aged 77, and was buried in St. Matthew's Churchyard.

● FROST, WILLIAM EDWARD, R.A., *figure painter*. Was born at Wandsworth in September 1810. He studied at Sass's, and became a student of the Royal Academy in 1829, at a time when Etty was a constant attendant there. He adopted kindred subjects, though his first contribution to the exhibition was a portrait in 1836. He obtained the Academy gold medal for his picture of ' Prometheus bound by Vulcan,' and a third class medal at the Westminster Hall competition in 1843 for ' Una alarmed by the Fauns.' He painted many portraits, but will be better remembered by his figure pictures of Nymphs, illustrations of Milton, Spenser, &c. He exhibited in 1845 ' Sabrina,' in 1846 ' Diana and Acteon,' in 1847 ' Una and the Wood Nymphs,' which was bought by the Queen, in 1850 ' The disarming of Cupid,' in 1851 'Hylas,' &c., &c. He was chosen an associate of the Royal Academy in 1846, but was not elected a full member till 1871, and entered the retired list in 1877. His female figures are well drawn and coloured, but possess none of the vigour of those by Etty, though they have a chaste and graceful character. He was a simple, modest man and passed a quiet, uneventful life. Worn out by constant attacks of the gout, he died June 4, 1877, aged 67.

FRY, WILLIAM THOMAS, *engraver*. Born in 1789. He engraved after 'Annibale, Caracci, Parmegiano, and Flaxman, R.A., but his works did not attain distinction. He died in 1843.

● FRYE, THOMAS, *portrait painter*. He was born near Dublin in 1710, and was but poorly educated. He came to London early in life with Stoppelaer, the artist, and commenced painting portraits. In 1734 he painted a full-length portrait of Frederick, Prince of Wales, for the Saddlers' Hall. Some years later he took the management of the china manufacture established at Bow. In 1749 he took out a patent for making porcelain, and devoting himself to this work, spent 15 years among the furnaces, to the great injury of his health. His ability was shown in the improved elegance of form and ornamentation, but the manufacture did not succeed. He then journeyed to Wales to restore his health, painting portraits with success on the way ; and returning much invigorated and with some money in his pocket, he took a house in Hatton Garden, and resumed the practice of his art. He painted portraits in oil, crayons, life-size, in black and white chalk on coloured paper, and miniatures. He was happy in his likeness, and enjoyed contemporary reputation, particularly for his miniatures, some of which were highly finished in black lead, and some very small in water-colours, for the decoration of jewellery. He engraved several portraits life-size and *ad vivum* in

mezzo-tint. These works are of great power, the light and shade excellent, the face finely moulded and well drawn, but the hands, when introduced, are indifferent. Of these works, the portraits of George III. and his Queen, with Miss Pond and the artist's own, are the most esteemed. A portrait by him of Leveridge, the singer, exhibited in 1760, is mezzo-tinted by Pether. He was very corpulent and subject to gout, and confined himself to such a spare diet that, added to his close application to his art, a complication of disorders ensued, ending in consumption. He died April 2, 1762, in his 52nd year, it is said insolvent. He left a son and two daughters, who died in obscurity.

FRYER, LEONARD, *serjeant-painter to Queen Elizabeth*. He held the office till his death.

● FULLER, ISAAC, *history and portrait painter*. Born 1606. Little is known of his early life, except that he studied art in France under Perrier. He practised in the reign of Charles II., and painted ' wall-pieces,' which were rather ornamental than artistic, decorating thus several London taverns, as was then the custom ; and both in this manner and in portraiture, it appears, he found much employment, more especially at Oxford. In the chapel at Wadham College he painted his ' Children of Israel gathering Manna.' An altarpiece by him at Magdalen was praised by Addison ; but Walpole speaks slightingly of a similar work at All Souls, which he attributes to him, though it is, in fact, by Thornhill. He also painted, in five large pictures, ' The King's Escape after the Battle of Worcester.' They were presented to the Irish Parliament, and finally came into Lord Roden's possession. His own portrait of himself at Queen's College is a vulgar painting of a vulgar man, but not wanting in power and rich in colour. He etched a set of prints from his own designs, which have little merit. He died in Bloomsbury Square, July 17, 1672. He left a son, who was brought up to his art, and was clever but idle, and died young.

FULLER, CHARLES F., *sculptor*. Born in 1830, son of General Francis Fuller. At the age of 17 he entered the 14th Foot, and soon afterwards exchanged into the 12th Lancers. In 1853 he unexpectedly left the army, and going to Florence, placed himself under Hiram Powers, the American sculptor. In 1859 his works first appear in the Royal Academy Exhibition. In that year, 1860, and 1861 he sent some portrait busts in marble. In 1863 ' Launcelot of the Lake ' and ' Queen Guinevere,' in 1865 ' Dalilah,' in 1867 ' Europa, a marble statue,' in 1868 ' The blind flower-girl of Pompeii.' Up to this time he had resided in Florence. In 1870 and 1871 he was in

Rome, and sent from thence 'The Peri and her Child' for exhibition; about this time also he visited Constantinople. He died at Florence, March 10, 1875. His works, though technically incomplete and sometimes meretricious, showed nevertheless considerable ability.

● FUSELI, HENRY, R.A., *history paint-er*. Was born at Zurich, February 7, 1741. The second son of John Caspar Füessli, who was himself a painter of landscapes and portraits, a man of learning and a writer on art. Henry Fuseli was educated for the Church, took his M.A. degree and entered into holy orders in 1761, and it is recorded preached his first sermon at Zurich from St. Paul's text—'What will this babbler say?' His strong early predilection for art had probably only been stifled, yet he might have continued in the Church had he not united with his friend Lavater in exposing some peculation by the chief magistrate of the canton, who proved eventually too strong for him, and he was, with his friend, compelled to quit Zurich. Then he travelled, visiting several German cities, and at Berlin contributed eight designs to a work which was published there. He had, while pursuing his theological studies, among other acquirements, learnt English and read Shakespeare, whose 'Macbeth,' with 'Lady Mary Wortley Montagu's Letters,' he translated into German. He was induced by the British Minister to the Prussian Court to come to London, where he arrived at the close of the year 1765, his object being to promote some scheme of literary union between England and Germany. He first found employment in translating, occasionally making some designs for book illustration, and then accepted the office of tutor to travel with a nobleman's son, for which he was little suited, and soon resigned.

On his return to England in 1767, intending to devote himself to literature, he gained an introduction to Sir Joshua Reynolds, whose warm appreciation of his drawings induced him to devote himself at once to art. He was now nearly 26 years of age. He had not attained even the rudiments of his adopted profession, which require great application; but he looked to Italy as the source of all art inspiration, and set out for that country, arriving at Rome in the spring of 1770. There he studied earnestly from the antique, and from the works of Michael Angelo, whose great manner he appears to have followed, but not by devoting himself to that laborious attendance at the schools which is essential to excellence. He was absent nearly nine years from England. From Rome he sent to the Spring Gardens Exhibition, in 1775, 'Hubert and Prince Arthur;' in 1778, 'Caius Gracchus;' and

in 1783, 'The Pangs of Mona.' Meanwhile, he had sent to the Royal Academy, in 1774, his 'Death of Cardinal Beaufort;' and in 1777, his 'Scene from Lady Macbeth.' He set off on his return in 1778, visited Zurich on his way, where he stayed some time with his father, and reached London early in 1779, having made both friends and a reputation in Italy.

In 1782 he exhibited his 'Nightmare,' which was multiplied by engravings, and soon became very popular, the publisher having, it is said, realised 600l. from the plate. Zealously following art, he did not abandon literature. He edited the English translation of Lavater's work on Physiognomy, and contributed an occasional paper to the 'Analytical Review.' In 1786 Boydell's scheme of the Shakespeare Gallery was set on foot. Fuseli's co-operation was thought important, and he entered warmly into the undertaking, painting no less than eight large and one small subject for the gallery. He was elected an associate of the Royal Academy in 1788, and a full member in 1790; and the same year married a discreet young woman, who had sat to him as a model. About this time he projected his own Milton Gallery. In this he persevered under some difficulties during nine years; and though assisted both by the purses and the influence of his friends, his scheme proved, when opened to the public in 1799, in a pecuniary sense at least, a sad failure; yet it was a great undertaking, comprising 47 pictures by his own hand, most of them of large dimensions.

His knowledge and literary attainments made him well fitted for the office of lecturer on painting; and to this post he was elected in 1799. He compiled twelve lectures: viz. on Ancient Art, on Modern Art, Invention (two), Composition, Chiaroscuro, Design, Colour (two), Proportions of the Human Frame, History Painting, and the Modern State of Art. These he delivered with great effect, and they have since been published. He vacated the office in 1804, when he was elected keeper of the Royal Academy, but was subsequently re-elected to the professorship by the suspension of the bye-laws of the Academy, which made the two offices incompatible; and he then produced three additional lectures, completing the above series. In 1802 he visited Paris, and collected some materials for a work on the art-treasures in the Louvre, which was not gone on with, probably interrupted by the outbreak of war; and in 1805 he prepared for publication an enlarged edition of Pilkington's 'Dictionary of Painters.' He had also commenced a 'History of Modern Art,' and had completed between 500 and 600 pages in manuscript, bringing his subject down to Michael Angelo; and he left many frag-

mentary papers connected with art and artists. Among his acquirements are reckoned the Greek, Latin, French, English, German, Dutch, Danish, and Spanish languages.

He died while on a visit to the Countess of Guildford, at Putney Heath, April 16, 1825, and was buried in St. Paul's Cathedral. As a teacher he was a great favourite with the students, and had considerable influence over them. His energetic manner, his wild enthusiasm, his caustic wit, and the irritable cynicism with which even his instruction was conveyed, took deep hold upon their young minds; and tales of him are still, and will long continue, rife in the schools. His pupils presented him on his retirement with a handsome silver vase, designed by Flaxman. That his instruction was not only appreciated by them, but was sound, is evidenced by the many very distinguished men who passed through the antique school during his keepership. The enthusiastic poetry of his art was hardly for the multitude, though he was made largely popular by the many engravings from his works. He was a congenial student of Michael Angelo; terrible often in his bold energetic style and the wild originality of his inventions—never tame or commonplace—the action of his figures violent and overstrained, very mannered, yet often noble and dignified. His females were without beauty—all framed on the same model—unfeminine and coarse. The critics did not spare him, nor he them. Dayes said 'he had no conception of female beauty; his women were the devil;' and Peter Pindar, that 'he was the fittest artist on earth to be appointed hobgoblin painter to the devil;' while Barry criticising his art, said, 'Talk of the beau ideal—it is the beau frightful you mean.' Yet as an illustrator of Shakespeare he stands far before all his contemporaries. Wanting in elementary knowledge and the proper training of his profession, he has no refinement or accuracy in drawing, and in some cases his attitudes are impossible. He is equally defective with regard to the laws of colour and the processes of painting, and many of his works are fast going to decay.

G

GAHAGAN, SEBASTIAN, *sculptor.* He was born in Ireland, and coming to England was an assistant to Nollekens, R.A. From 1802 he was an occasional exhibitor at the Royal Academy. His contributions were chiefly monumental designs; among them, in 1816, the 'Victory,' which forms part of Sir Thomas Picton's monument, by him, in St. Paul's; in 1819, 'The Cradle Hymn,' portraits with sometimes a bust. He last exhibited, 1835, the model of a statue to Earl Grey. In 1810 the directors of the British Institution awarded him a premium of 50 guineas for his model, 'Samson breaking his Bonds.' The figures of 'Isis' and 'Osiris,' in the front of the Egyptian Hall, Piccadilly, and the Duke of Kent's statue, at the top of Portland Place, are by him. He was one of a family of modellers. One of his brothers, an assistant to Westmacott, R.A., was killed by the fall of Canning's statue, on which he was working.

• GAINSBOROUGH, THOMAS, R.A., *portrait and landscape painter.* He was born in 1727 (the day unknown, but baptized May 14), at Sudbury, Suffolk, where his father, a clothier, possessed a small property, which was soon lessened by a liberal disposition and the charges of a large family. He was early addicted to sketching from the rustic scenery of the neighbourhood, and at the age of 15 came to London for instruction, and gaining an introduction to Gravelot, the engraver, was assisted by him in his early studies, and entered the St. Martin's Lane Academy. He afterwards became the pupil of Frank Hayman, with whom he continued nearly four years, and having acquired some skill in drawing and the technical processes of his art, he found nothing more to be gained in the insipid conventionalities which then prevailed, and returned to his native town, where he began practice as a portrait painter, and occasionally painted a small landscape, for which he usually found a purchaser, at a low price, among the dealers.

At the age of 19 he married, in London, a young lady who possessed an annuity of 200*l.*, and then with his wife took up his residence at Ipswich. After practising there some time he was induced to visit Bath, where the fashionable world then used to congregate, and settling there he commenced, about 1758, painting three-quarter portraits at five guineas, which he was soon enabled to raise to eight. In his day he was chiefly employed and esteemed as a portrait painter, while his landscapes were disregarded. Later, it may be eclipsed by the reputation of Reynolds, his landscapes were deemed his chief works. It is said that Sir Joshua at an Academy dinner gave, 'The health of Mr. Gainsborough, the

greatest landscape painter of the day,' to which Richard Wilson, R.A., probably nettled, retorted, 'Ay, and the greatest portrait painter, too'—an assertion which has now become the opinion of many. Gainsborough's portraits, particularly of females, possess some of the sweetest qualities, fresh in colour, pure and silvery in tone, graceful without affectation, the backgrounds excellent. His rustic figures no less delight by their charms of simple nature; and his landscapes, into which cattle and figures are introduced with great art, are filled with nature's truths by a clever, facile generalisation which, while far from individualised imitation, satisfies by his purely original view and rendering. He has the great merit of having discarded all the conventionalities of the schools, and devoted himself to the study of nature—of the scenery of his own country, beyond which he never wandered.

In 1766 he was a member of the Incorporated Society of Artists, and occasionally sent his pictures to London for exhibition. He was chosen one of the foundation members of the Royal Academy; and in 1774, increased in reputation and confidence, he came to London and first lived in Hatton Garden, but from 1777 till his death he resided in the western wing of Schomberg House, Pall Mall. He had never shown much interest in the affairs of the Royal Academy, but had been a constant contributor of portraits and landscapes to the exhibitions from 1769 to 1784 (except in the years 1773 to 1776), sending in 1783 portraits of the King and Queen and 13 of their children (probably the beautiful series of small portraits arranged in the Queen's private apartments at Windsor). Upon some disagreement with the council as to hanging his portrait-group of the three Princesses, a full-length, but now unhappily cut down, he withdrew that picture, with 17 others he had sent to the exhibition, and did not again exhibit or take any share whatever in the Academy business.

Northcote, R.A., says : 'He was a natural gentleman, and with all his simplicity he had wit too.' His own portrait has perpetuated his prepossessing countenance; his sprightly conversation and humour made him a welcome favourite in all society. He was surely a genius; possessed of great taste, passionately fond of music, which, with art, formed his favourite topic. Dr. Wolcott, a good judge, was once in an adjoining room, and hearing him play, exclaimed, 'That must be Abel' (at that time a distinguised musician), 'for, by God, no man besides can so touch the instrument!' He had gained both fame and fortune when a complaint in the neck, to which he had paid little attention, developed itself into a cancer, which baffled the skill of his

physicians, and settling his affairs, he composed himself to meet death. He expired August 2, 1788, and by his own desire was buried as privately as possible in Kew Churchyard, where a plain, flat stone simply records his name, age, and date of death. Reynolds, P.R.A., was one of the pall-bearers. He had visited him on his death-bed, and some coolness having existed, the dying man, who wished to be reconciled to his brother painter, said, ' We are all going to heaven, and Vandyck is of the party.' After his death his paintings were exhibited for sale by private contract, at his house in Pall Mall. The admission was at first 2s. 6d., afterwards 1s. His elder brother showed a talent for the arts ; a younger brother was a Dissenting Minister at Henley-upon-Thames, and possessed much mechanical genius. His daughter Margaret died unmarried, at Acton, in 1820. He will always occupy one of the highest places in the English school, and his works now command almost fabulous prices. Some fine examples of his art will be found in the National Gallery ; among them his portrait of Mrs. Siddons and the 'Watering-Place ;' at the National Gallery, Edinburgh, portrait of Mary Graham ; at the Dulwich Gallery, portrait-group, 'Mrs. Addison and Mrs. Tickell ;' in the Westminster Gallery, the portrait of a youth, 'The Blue Boy,' and Mrs. Siddons as the ' Tragic ;Muse ;' at Windsor Castle, the lovely collection of the family of George III., head size. A 'Sketch of his Life and Paintings,' by Philip Thicknesse, was published in 1788. ' His Life,' by Fulcher, 2nd ed., 1856 ; and a Life of him is included in Cunningham's ' Lives of the Painters.'

GAMMOM, JAMES, *engraver and draftsman.* He practised in London about 1660. His works are tame and poorly engraved ; among them is a portrait of Catherine of Braganza and of Richard Cromwell. The latter is supposed to have been drawn by him from the life, and to have been the portrait from which Samuel Cooper painted the well-known miniature.

GANDON, JAMES, *architect.* He was born in London, February 29, 1742, and was descended from a good French refugee family. He was well educated in classics and mathematics, and developed an early taste for drawing. A loss of property by his father led him earnestly to adopt the study of art, and entering the St. Martin's Lane Academy, he became a constant attendant. In 1757 he was awarded a premium by the Society of Arts, and on the arrival of Sir William Chambers in London, he found employment in his office, and afterwards became his articled pupil ; and about 1765 he commenced practice on his own account, and was a member of the

Free Society of Artists. Soon after, he proposed to publish a continuation of Campbell's 'Vitruvius Britannicus,' and associating himself with Mr. Woolfe, of the Board of Works, he undertook the greater part of the labour, engraving many of the plates himself. He contributed to the Spring Gardens Exhibitions in 1765 and the succeeding years. On the foundation of the Royal Academy he entered as a student, and was a successful competitor for the first gold medal awarded in architecture (1769), and from 1774 to 1780 was a contributor to the Academy Exhibitions.

He sent in designs in 1769 for the Dublin Royal Exchange, and gained the second premium ; and in 1776 the first premium for a lunatic asylum in London, but to his great disappointment he was not employed in its erection. He continued to labour in his profession in London up to 1781, when he went to Dublin on an invitation to erect the new Custom House and docks, relinquishing an offer of Court employment in Russia ; and under many difficulties and vexatious interruptions, he at once commenced his extensive undertaking, which occupied him during 10 years. At the same time he was engaged upon a new gaol and court-house at Waterford, and upon the erection of the east portico and ornamental circular screen to the Parliament House. In 1788 he commenced the Dublin law courts, still harassed by an opposition, which was carried into the Irish Parliament. Continuing to reside in Dublin, he commenced his last great work in that city, laying the first stone of the King's Inns, 1795.

In 1797 he came to London, warned by the treasonable dangers which were then impending, and did not return till 1799 to complete his Inns of Court. He did not find less difficulties than before, and about 1806, Lord Chancellor Redesdale expressing dissatisfaction at the progress of these works, he wrote a justificatory letter of explanation, and resigning his employments he retired, in 1808, after an arduous career of nearly 60 years, to Lucan, near Dublin, where he had purchased some property, and passed the remainder of his days. He was a martyr to gout, and died December 24, 1823. He was buried in Drumcondra Churchyard, it is said, in the same grave with his friend Grose, the antiquary. His great public buildings and the street improvements which he carried out in Dublin with great skill and ability, will always perpetuate his name in that city. He etched several plates, after landscapes by Wilson, R.A., and wrote an ' Essay on the Progress of Architecture in Ireland' and ' Hints for erecting Testimonials.' His ' Life,' by his son, was edited by T. J. Mulvany, R.H.A., 1846.

166

GANDY, JAMES, *portrait painter*. Born at Exeter in 1619. He received some instruction from Vandyck, made many copies from his works, and imitated his manner. His portraits possessed much merit. He was retained in the service of the Duke of Ormond, whom he accompanied to Ireland, where many of his portraits are much prized. Sir Joshua Reynolds owned that, at the commencement of his career, Gandy's works made a great impression on him. He died in Ireland in 1689. His chief works will be found in that country ; a few in the West of England.

GANDY, WILLIAM, *portrait painter*. Son of the foregoing. Said to have been instructed by 'Magdalen Smith.' He settled in Exeter about 1700, and travelled in Devonshire and Cornwall, painting portraits. Some good portraits by him exist in these counties, but there are many more which are very loosely finished. He rarely indeed finished more than the head and the hands. His best works possessed great force and power, and have been deemed like Reynolds's.* He was of a proud, intractable disposition, careless of his reputation, in his latter days only painting when pressed by necessity. He was at Plymouth in 1714. He affected to be too deep in the confidence of the Duke of Ormond, who was implicated in the rebellion of 1715, to render it safe to venture up to London. He is supposed to have died at Exeter, but the date is unknown.

GANDY, JOSEPH M., A.R.A., *architect*. Born in 1771. Was a student of the Royal Academy and a pupil of James Wyatt. He gained the Academy gold medal in 1790 for his design for a triumphal arch. He went to Rome in 1794, and the following year received the Pope's medal in the first class for architecture. He was a frequent exhibitor at the Academy, and was much employed by Sir John Soane ; a man of great imagination and genius, an excellent draftsman, he was elected an associate of the Academy in 1803. He made the drawings for Britton's architectural publications, and some others, and built the Assembly Rooms at Liverpool and some mansions. He published ' Designs for Cottages, Farms, and other rural Buildings,' 1805 ; 'The Rural Architect,' 1806 ; and was connected with Sir William Gell in his ' Pompeiana,' published 1817. He was brother to Gandy Deering. Odd and impracticable in disposition, his life was one of disappointment and poverty, and is said to have ended in insanity. He died in December 1843.

GANDY, MICHAEL, *architect*. Was born in 1778, and was the younger brother, and for some time the pupil, of Joseph M. Gandy. Afterwards he was employed in James Wyatt's office, which he left to enter

the Indian Navy, and served in India and China. On his return he was employed in the office of the civil architect to the Navy. From that service he became assistant to Sir Jeffrey Wyattville, remaining with him till his death, or nearly 30 years. He only appears to have been an exhibitor at the Academy in 1795-96-97. In 1842 he published 'Architectural Illustrations of Windsor.' He died in April 1862.

GANDY, JOHN PETER, R.A., *architect.* See DEERING, which name he afterwards assumed.

GARDELLE, THEODORE, *miniature painter.* Was born in Geneva 1722, and was apprenticed to an engraver there. He ran away at the age of 16 and went to Paris, but, persuaded to return, he came back and served out his time. In 1744 he again went to Paris, and studied painting there till 1750, when, returning to Geneva, he practised for a while in his native city, but his immoral conduct was a bar to his success, and in 1756 he was again in Paris. From thence he went to Brussels and to London, arriving probably in the winter of 1759. Here, practising as a miniature and portrait painter, his career was short. He lodged on the south side of Leicester Fields. His landlady was a woman of light character, and on her resisting his advances and violence he murdered her, and after robbing her, cut her body in pieces and burnt it. Convicted, he attempted suicide in prison. He was executed in the Haymarket, April 4, 1761. Hogarth is said to have made a sketch of him on the day of his execution.

GARDINER, WILLIAM NELSON, *engraver.* He was born at Dublin, June 11, 1776. His parents were of the lower class, but he managed to get a good education. Some friends enabled him to pursue an early taste for art, and he studied for three years at the Dublin Academy, where he gained a medal. After a while he made his way as an adventurer to London, and supported himself by taking in black shade profile miniatures, but was ill-paid, and he then associated himself with some strolling players, and became their scene painter, yet with little better success. Meeting accidentally with Captain Grose, he was befriended by him and placed with an engraver. Afterwards he worked for Bartolozzi, whose manner he imitated, and made great progress in the art. He executed some good plates, several of which bear Bartolozzi's name, among them a portion of Lady Diana Beauclerc's illustrations of Dryden's 'Fables.' He was employed on the illustrations for Harding's edition of Shakespeare and De Grammont's 'Memoirs,' and might have gained independence; but he left his business and went to Dublin, where he spent all the money he

possessed. Returning to England, he was seized with a conscientious desire to enter the Church, and was admitted to Emmanuel, and afterwards to Corpus Christi College, Cambridge. He remained about five years, with a view of qualifying for holy orders, and was candidate for a fellowship, and then again turned to art. He copied portraits in water-colours with much skill, yet with small gains. Possessing a considerable knowledge of books, he next set up as a bookseller in Pall Mall. There, plagued with ailments and a restless spirit, and afflicted with the loss of his wife and child, he wrote some sophistical reflections on the pains of life and the sweetness of death, and committed suicide on June 21, 1814.

GARDNER, THOMAS, *engraver.* Practised in the early part of the 18th century, and was chiefly engaged for the booksellers. He engraved a set of plates for the Book of Common Prayer, 1735.

GARDNER, DANIEL, *portrait painter.* Born at Kendal. Came to London early in life, and was admitted a student of the Royal Academy. Was noticed and assisted in his art by Reynolds, P.R.A., and became fashionable for his small portraits, both in oil and crayons. He exhibited at the Academy in 1771, but rarely afterwards. Thomas Watson engraved 'Abelard and Héloïse' after him, 1776, and there are several mezzo-tint engravings after his portraits. He had a nice perception of beauty and character, and composed with elegance. He realised some property by his art and retired from its practice. He died in Warwick Street, Golden Square, July 8, 1805, aged 55. Hayley did not think his talents beneath his verse—

'Nor, Gardner, shall the muse in haste forget
Thy taste and ease, tho' with a fond regret.'

GARDNOR, The Rev. JAMES, *amateur.* He was for many years vicar of Battersea, and both drew and engraved with some ability. In 1767 he received a Society of Arts' premium of 25 guineas. He was a frequent contributor to the Academy Exhibitions, but is not classed with the honorary exhibitors. He exhibited from 1782 to 1796 landscapes in oil and water-colours, views, and at the latter part of the time, subjects on the Rhine. He also painted some portraits. He died at Battersea in January 1808, aged 79. He contributed some of the illustrations for Williams's 'History of Monmouthshire,' and published, in 1788, 'Views on the Rhine.'

GARNER, THOMAS, *engraver.* Was born in Birmingham 1789, and was apprenticed to an engraver in that town, where he practised during the greater part of his life. His chief works were in the line manner and on a small scale, some of

Gardelle. Robᵗ ᵍ Geneva ₤52-1766

the best for the annuals, and generally for book illustration. He died at Birmingham, July 14, 1868.

* GARRARD, MARC, *portrait painter.* Son of an animal painter at Bruges, and born there 1561. He practised history, landscape, portrait, and architecture; also engraved, illuminated, and designed for glass painting. His etchings for Æsop's 'Fables' and a view of Bruges are still esteemed. He came to England soon after 1580, and was appointed painter to Queen Elizabeth and Queen Anne of Denmark, and passed the rest of his life here. His works are numerous, and exist in the mansions of our old families. They are painted with a neat, facile pencil—the draperies formal, and enriched with carefully finished jewels and ornaments. His drawing is good, his flesh tints thin and silvery, but pleasing in colour. His 'Procession of Queen Elizabeth to Hunsdon, or, as lately described, to a wedding, surrounded by her Officers of State and Ladies,' was engraved, as was also his 'Procession of the Queen and the Knights of the Garter, 1584,' the former by Vertue. He painted both Prince Henry and Prince Charles. He died in England in 1635.

GARRARD, J., *topographical draftsman.* He practised towards the latter part of the 18th century. R. Pollard engraved after several of his drawings. He does not appear to have exhibited his works. He is believed to have died suddenly, in October 1815.

GARRARD, GEORGE, A.R.A., *animal painter and modeller.* He was born May 31, 1760. Was a pupil of Gilpin, R.A., and in 1778 a student of the Academy. In 1781 he first exhibited at the Royal Academy, his earliest works being portraits of horses and dogs. In 1784 he exhibited a 'View of a Brewhouse Yard,' with which Reynolds, P.R.A., was so much pleased that he gave him a commission to paint another picture of the same class. Continuing to exhibit such works, in 1793 he sent 'Sheep-shearing;' in 1796, some models; in 1800, models of 'Fighting Bulls' and an 'Elk pursued by Wolves.' In 1802, with other paintings, he exhibited 'A Peasant attacked by Wolves in the Snow,' and was in that year elected an associate of the Academy. About this time his works were largely composed of models, portrait-busts, and some medallions, but he also continued to paint both in oil and water-colours. In the Woburn collection there is a clever picture by him, 'An Agricultural Show,' full of portrait figures and animals, luminous and powerful in colour; and in Sir Walter Fawkes's collection some good examples of his water-colour art. He died at Brompton, October 8, 1826.

168

GARRET, WILLIAM, *wood engraver.* Lived in Newcastle. He cut on wood, and published 13 very small designs. They are in the rudest manner; the last of the series, 'Death leading a Female to the Grave on a Star-lit Night,' has a wild originality. They are without date, but were probably executed towards the end of the 18th century.

GARVEY, EDMUND, R.A., *landscape painter.* At the commencement of his career he exhibited at the Dublin Exhibitions, and is supposed to have been of Irish parentage. He painted landscapes, both in oil and water-colour, in a hard, dry manner. His early works were hot in colour, his later have more imitation of nature. He exhibited views in Italy with the Free Society of Artists in 1767, and was a constant exhibitor at the Royal Academy from its foundation up to 1808. He gained a Society of Arts' premium of 20 guineas in 1769, and from that year to 1777 he lived at Bath, and then came to London, where he settled. He was elected an associate of the Academy in 1770, and a full member in 1783, when his preference gave great offence to Wright, of Derby. He painted chiefly views, and, on a small scale, scenes from Rome, the Alps, and of gentlemen's seats. He died in 1813. Many of his works were sold by auction in 1816.

GASCAR, HENRY, *portrait painter.* He also engraved indifferently in mezzotint. Was born in France, but came to this country, and was patronised by the Duchess of Portsmouth in the reign of Charles II. He left England about 1680, having made here, it is said, above 10,000*l.* At the commencement of the 18th century he was residing in Rome, where it is believed he died.

* GASPARS, JOHN BAPTIST, *portrait painter.* Born at Antwerp, and studied his art there. He came to England during the Great Civil War, and was patronised by General Lambert, who was himself known as an amateur. He afterwards became assistant to Lely, and then to Kneller. He was a good draftsman, possessed much taste, and was employed in designing for tapestry. He painted a portrait of Charles II. for Painters' Hall, where it still hangs, and a second for St. Bartholomew's Hospital. There is also a portrait of Hobbes by him at the Royal Society. He died in London in 1691, and was buried at St. James's Church, Piccadilly.

GASTINEAN, HENRY, *water-colour painter.* Was a student in the Royal Academy. He became an associate of the Society of Painters in Water-colour in 1818, and was elected a full member in 1824. He excelled chiefly in landscapes chosen among wild and romantic scenery, rocks, cataracts,

and rushing streams. He was much engaged in teaching. He died at Camberwell January 17, 1876, in his 86th year.

GATLEY, ALFRED, *sculptor.* Was descended from an old Cheshire family. He studied under Baily, R.A., and first exhibiting at the Academy in 1841, continued an exhibitor of busts, monumental designs, and some other works, for several years. He exhibited some fine works at the International Exhibition in 1862—a noble basrelief in marble of 'Pharaoh and his Host,' and 'Night' and 'Echo.' He had studied in Rome for several years, and unknown in England, he came here during the Exhibition, but was unappreciated, and finding his works little noticed he returned to Rome, disappointed and depressed. He was attacked with dysentery in July 1863, and died there after a short illness, aged about 40. He expressed a wish that a fine lion which he had carved should be placed over his grave. His statues of 'Night' and 'Echo,' with some African and Nubian lions, were sold at Christie's in February 1871.

GATTY, MARGARET, Mrs., *amateur.* Born at Burnham parsonage in 1809. She was the daughter of Dr. Scott, chaplain to Lord Nelson, and married the Rev. Alfred Gatty in 1839. She etched some clever landscapes, chiefly wood scenes, between 1837 and 1843. Her trees are well drawn and show a feeling for nature, but she is better known as the writer of many interesting tales for children, which combine scientific knowledge with religious teaching. She died October 4, 1873.

GAUGAIN, THOMAS, *engraver.* Born at Abbeville, France, 1748. Came very young to London, and was the pupil of Houston. He engraved many plates in the dot and line manner, chiefly after Reynolds, Northcote, Cosway, Henry Morland, and Hoare. Died at the beginning of the 19th century.

GAWDIE, Sir JOHN, Bart., *amateur.* Born in 1639, the second son of Sir William Gawdie, of West Harling, Norfolk. He was deaf and dumb, and became a pupil of Lely, intending to follow portraiture as a profession; but, on the death of his elder brother, succeeding to the family inheritance, he continued art only as an amusement. He died 1708. Evelyn, in his diary, speaks of him as a 'fine painter,' praises his many courteous qualities, and adds, 'that it was not possible to discern any imperfection in him.'

GAYFERE, THOMAS, *architect.* His father was the master mason employed in the erection of Westminster Bridge. He was appointed, in 1802, jointly with his father, master mason to Westminster Abbey, and was charged with the restorations of Henry VII.'s Chapel, commenced

in 1809, a work requiring great skill and ingenuity, and for which he made the whole of the drawings. He also restored, 1819-22, the north front of Westminster Hall. He retired from his employments in 1823, and died at Burton-upon-Trent, October 20, 1828.

GAYWOOD, RICHARD (or ROBERT), *engraver.* Born about 1630. Pupil of Hollar. His works are chiefly portrait—Mary, Queen of Scots; Drummond of Hawthornden, Sir Bulstrode Whitelocke, Holbein, and many others. He also engraved Titian's 'Crouching Venus,' a set of animals and birds after Barlow, and of lions and leopards after Rubens. A view of Stonehenge, drawn by him, was published in 1664 by Camden. His birds and animals are engraved with much spirit, but his manner was hard and laboured. He died about 1711.

GEDDES, ANDREW, A.R.A., *portrait and subject painter.* Was born about 1789, in Edinburgh, where his father, a man of taste, was an auditor of assize. He was sent to the High School, and afterwards to the University of Edinburgh, and was then taken into his father's office. An early love of art had been checked, but on the death of his father it prevailed. He had risen with the sun to draw, and he now resigned an employment he had held nearly five years, and coming to London, was admitted in 1807 to the schools of the Royal Academy. After a few years' close study, he returned to Edinburgh and commenced practice. He exhibited for the first time at the Royal Academy in 1808, while he was residing in Edinburgh, and in 1810, when pursuing his studies in London, his 'Draught Players.' In 1813, having commenced practice, he sent four portraits from Edinburgh for exhibition.

In 1814 he returned to London, where from that time he annually spent several months. In 1815 he visited Paris, and in that and the following three years exhibited portraits in the Academy, followed in 1821 by 'The Discovery of the Scottish Regalia, with portraits of the Commissioners,' a work which made him known and was engraved. About this time he put down his name for the associateship of the Academy, but, disappointed, he did not renew it for many years. He was for several seasons an occasional contributor to the exhibition, but exclusively of portraits. In 1828 he visited Italy, and remaining some time in Rome he painted the portrait of Gibson, R.A., Cardinal Weld, and a young lady in Italian costume, which with others, he sent home to the Academy Exhibitions.

He returned to London in January 1831, and the following year was elected an associate of the Academy. At this time he

169

painted 'Christ and the Woman of Samaria,' an altar-piece, for the Church of St. James, Garlick Hill, and with a subject picture, 'Devotion,' continued to exhibit portraits at the Academy. In 1839 he visited Holland. Soon after, his health began to give way, and symptoms of consumption appeared in 1843, which recurred, and he died in London, May 5, 1844, aged 55. His small full-length portraits, several of which were engraved, are his best works. He was a good etcher, and some etched portraits by him showing much power were exhibited at the International Exhibition, 1862.

GEIKIE, WALTER, R.S.A., *subject painter*. Was the son of a perfumer, and born in Edinburgh, November 9, 1795. He became deaf and dumb when a child, yet he managed to acquire much useful knowledge, and he betook himself to a pencil for his amusement. He was educated in the Trustees' Academy, and painted scenes of every-day life with much truthful humour. He first exhibited in 1815, was elected an associate of the Royal Scottish Academy in 1831, and a member in 1834. He had no feeling for colour, but was a clever draftsman, and made drawings in Indian ink, filled with small figures animated with character. He also etched the same subjects, and he published, in 1829-31, a series of 'Etchings illustrative of Scotch Character,' to which a short memoir of him is prefixed. He died August 1, 1837, and was buried in the Grey Friars' Churchyard, Edinburgh.

GELDORP, GEORGE, *portrait painter*. Was born at Antwerp. He practised in this country, but did not show much ability. He became keeper of the pictures to Charles I. When Lely first arrived in England he was employed by him. His works are not known, but a portrait by him of the Earl of Lindsay was engraved 1642, and also one of the Duke of Richmond. There are, however, several notices of him. He rented a large house and garden in Drury Lane, which Walpole hints was used for assignations and intrigues. Rubens was his guest in 1637, and Vandyck, on his first arrival in England, lodged in his house. He lived till after the restoration, and was buried at Westminster.

GELL, Sir WILLIAM, Knt., *architect and draftsman*. Born 1774. He studied in the schools of the Royal Academy, then travelled in Greece, and made drawings of some of the celebrated antiquities. In 1804 he published 'Topography of Troy and its Vicinity,' with illustrations; in 1807, 'Geography and Antiquities of Ithaca;' in 1810, 'Itinerary of Greece;' in 1817, 'Attica;' in 1818, 'Itinerary of the Morea;' in 1817-19, in conjunction with Gandy, 'Pompeiana;' in 1823, 'Narrative of a
170

Journey to the Morea;' and in 1834, 'The Topography of Rome and its Vicinity.' He does not appear to have exhibited at the Royal Academy, and is best known as an archæologist and a scholar. He resided in Italy from 1820, and was for some time chamberlain to Caroline, Princess of Wales. He died in Naples, February 4, 1836.

GEMINUS, THOMAS, *amateur*. An early English writer and illustrator of his own works. He published, in 1545, a translation of Vesalius's 'Anatomy,' and copied the wood-cuts on copper. He also published a book on the Weather, the phenomena of the heavens, &c., which he ornamented with a number of plates engraved by himself; and a book on Midwifery, similarly illustrated, is attributed to him.

GENDALL, JOHN, *landscape painter*. He practised, commencing about 1820, and was largely engaged in the picturesque publications and views then published— 'Picturesque Views of the Seine,' in conjunction with A. Pugin, 1821; 'Views of Country Seats,' with Westall and T. H. Shepherd, 1823-28. He painted many oil and water-colour ruins in Devonshire, where he was well known, and of these he was a constant exhibitor at the Royal Academy from 1846 to 1863. He resided chiefly at Exeter, and died there March 1, 1865, aged 75, when a large collection of his works were sold by his executors.

GENTILESCHI, HORATIO, *history painter*. Was born at Pisa in 1563, and studied at Rome under the best masters. He was invited to England by Vandyck to paint the ceilings and wall decorations then in fashion. King Charles I. assigned him apartments and a considerable salary, and employed him in the decoration of Greenwich and his other palaces. He also painted a ceiling at York House and at Cobham House, Kent. There is a picture by him, at Hampton Court, of 'Joseph and Potiphar's Wife.' He attempted portrait painting, but with little success. He resided in England about 12 years, and died here in 1647, at the age of 84. He was buried in the chapel in Somerset House.

GENTILESCHI, ARTEMESIA, *portrait painter*. Daughter of the above. Born in 1590. She came to England and painted both history and portrait, excelling in the latter. She drew some of the royal family and several distinguished persons. Graham says 'she was as famous for her amours as for her painting.' Charles I. possessed several of her works. Her portrait, painted by herself, is at Hampton Court, and at Althorp. She died about 1642.

GERBIER, Sir BALTHASAR, Knt., *painter and architect*. He was born at Antwerp about 1591, and came to England in 1613 as a retainer of the Duke of Buckingham.

He practised miniature painting, but styled himself 'painter and architect,' visited Italy and gave himself airs of importance, attended the young prince and the duke to Spain in 1623, ostensibly as a miniature painter, and painted the portrait of the Infanta, but was employed in the marriage negotiations. On the accession of Charles I. he was employed in Flanders to negotiate a treaty with Spain. In 1628 he entertained the King and Queen at supper, and was knighted the same year. In 1641, continuing in favour at Court, he was appointed master of the ceremonies. He is said subsequently to have been neglected at Court, and to have gone to Surinam with the intention to settle there, but to have been arrested and sent to Holland by the Dutch. During the Commonwealth he appears again in London. He was a purchaser of some of the King's pictures which were then sold, and next the founder, in 1648, of a short-lived sort of universal academy, opened the following year at Bethnal Green, where he proposed to teach everything—an expedient probably in his days of poverty. On the restoration of Charles II. he was again in the ascendant, and prepared the triumphal arches to welcome the King's return. He was appointed to succeed Inigo Jones as the surveyor of the royal palaces, and was naturalised by statute in 1641. He commenced Hempstead Marshall, a large mansion, for Lord Craven, which was burnt down, and before the completion of his work died, and was buried there in 1667. His miniatures are well drawn and finished, his ornamental and architectural drawings not without merit. He wrote an 'Encyclopædia of Art,' and treatises and suggestions, but of a superficial character, on several subjects, and published, in 1662, 'The Three chief Principles of magnificent Building;' in 1663, 'Caution and Advice to all Builders.' Walpole calls him architect, author, lecturer, diplomatist, quack. He styled himself 'Baron d'Ouvilly,' and appears to have been an unscrupulous, clever schemer.

GESSNER, SOLOMON, *subject painter.* Born in Switzerland in 1730. Practised in England with some reputation, chiefly for the illustration of books, and was in advance rather of the manner of the time. He died in 1788. His son Conrad also practised for a while both in England and Scotland.

GIBB, ROBERT, R.S.A., *landscape painter.* Was born in Dundee. His landscapes are truthful and carefully finished. On the foundation of the Royal Scottish Academy in 1830, he was chosen one of the first members. He died, after a short career, in 1837. Some of his works are in the Royal Academy and Royal Institution in Edinburgh.

GIBBON, BENJAMIN PHELPS, *engraver.* Born in 1802. Son of the vicar of Penally, Pembrokeshire. He was educated in the Clergy Orphan School, and apprenticed to Scriven, an engraver in the chalk manner. On the completion of his time he placed himself with J. H. Robinson, under whom he soon attained great proficiency as a line engraver. He worked both in the line and in a mixed manner. His style is simple, refined, and finished, but wanting in power. He engraved, after Landseer, 'The Twa Dogs,' 'Jack in Office,' 'Shepherd's Chief Mourner;' after Mulready, 'The Wolf and the Lamb.' He also engraved some portraits, among them a full-length of the Queen. He died unmarried in London, July 28, 1851, in his 49th year.

GIBBONS, GRINLING, *carver in wood.* The accounts of his birthplace are conflicting. He is said to have been born at Rotterdam, April 4, 1648; of Dutch parents, at Spur Alley, in the Strand; and of English parents, in Holland. Evelyn tells that he lived in Belle Sauvage Court, Ludgate-Hill, and afterwards removed to Deptford, where he accidentally met with him, discovered his great talent, and made him known, in 1671, to Charles II. The King employed him in decorating several of the royal palaces, and gave him an office under the Board of Works. Fine examples of his work in wood, finished with the greatest truth, refinement, and skill, will be found at Windsor, St. Paul's Cathedral, Chatsworth, Petworth, Burleigh, and Trinity College, Oxford. In the later part of his career he produced some fine works in marble. The pedestal of Charles I.'s statue at Charing Cross in stone is by him, and is a rich and tasteful work. The statue of James II. in bronze at the back of Whitehall Chapel cannot be placed among his successful works. He was master carver to Charles II., James II., William III., and George I. He lived in Bow Street, Covent Garden, from 1678 till his death, August 3, 1721, and was buried in St. Paul's, the parish church. His carvings, paintings, and art works were sold by auction in the November following. He married and had five daughters.

GIBBS, JAMES, *architect.* Born 1674, near Aberdeen, the son of a merchant of repute in that city. He was educated in the Marischal College, had a strong inclination to mathematics, and took his M.A. degree. His father, who was a Roman Catholic, sold his property in 1688, and dying early, his son's education was continued by an uncle and aunt. There was probably little to induce him to stay in his native town, and resolving to seek his fortune abroad, about 1694 he left Aberdeen, to which he never returned. He went to Holland, where he spent some years in the

service of an architect and builder, and there, about 1700, he was introduced to the Earl of Mar, who had a great taste for architecture, and assisted him with money and introductions to enable him to visit Italy, where he pursued his studies, including sculpture and architecture, under the best masters for nearly 10 years.

About 1710 he came to England. His patron, who was then in the ministry, and high in Court favour, recommended him to the trustees under the Act for Building new Churches, but he was not employed by them till 1720-21, when he commenced the parish church of St. Martin-in-the-Fields, and soon after the church of St. Mary-le-Strand, completed in 1726. He also built and repaired several other churches, and rose to much professional distinction. He built at Oxford the Radcliffe Library, his greatest work, and the Gothic quadrangle of All Souls; and at Cambridge, the King's College Library and the Senate House. He also built St. Bartholomew's Hospital; Dytchley House, Oxfordshire; East Antony House, Cornwall; Braemar, Scotland; and the mansions of many other families of distinction. The monument to the Duke of Newcastle in Westminster Abbey is after a design by him. He fell upon an opportune time, and with much work to be done, had few rivals. His works are marked by a propriety of character, heavy in their outline and details, and wanting in genius. His St. Martin's Church, which occupies a very commanding site, has perhaps been over-praised, but though marked by heaviness, is not without grandeur. St. Mary's, though lighter in outline, is over-ornamented. He published 'The Book of Architecture,' a large folio of his designs, 1728; 'Rules for Drawing the several Parts of Architecture,' 1732; and a 'Description of the Radcliffe Library, with plans,' &c. 1747.

He was afflicted with gravel and stone, and went to Spa in 1749, but without finding much relief. He died in London, August 5, 1754, and was buried in St. Marylebone Church. He lived a Roman Catholic and a bachelor. He left about 15,000*l.* among his friends, and an estate of 280*l.* per annum, with his plate and 1,000*l.*, to Lord Erskine, the only son of his patron, who had plunged into the Civil War and was ruined. His books he bequeathed to the Radcliffe Library.

• GIBSON, RICHARD (known as 'The Dwarf'), *portrait painter.* Born 1615, it is supposed in Cumberland. He was originally page to a lady at Mortlake, and showing a taste for drawing was placed under F. Cleyne, who had the management of the tapestry works established there. He afterwards studied Lely's works and imitated his manner. His water-colour drawings

172

were well esteemed, but he was best known as a copyist of Lely. His works were good in colour, spiritedly painted, yet wanting in finish and refinement. He gained the notice of Charles II., who appointed him one of his pages. He married Ann Shepherd, the Queen's dwarf, the height of each being the same—3 ft. 10 in. She was given away by the King. Lely painted their portraits hand in hand, and Waller wrote some verses on the occasion. He drew Cromwell's portrait several times. He instructed Queen Anne in drawing, and went to Holland to teach her sister Mary, when Princess of Orange. He died July 23, 1690, in his 75th year, and was buried in Covent Garden Church. The little couple had nine children, five of whom lived to maturity and attained the natural size.

GIBSON, EDWARD, *portrait painter.* Kinsman of Gibson the Dwarf, Walpole says his son. Instructed by him. He painted portraits in oil and in crayons, and found encouragement, particularly in the latter manner. He was of some promise, but died in his 33rd year.

GIBSON, SUSAN PENELOPE, *miniature painter.* Daughter of Gibson the Dwarf. Painted miniatures and in water-colours. A portrait of Bishop Burnet, in his robes as chancellor of the Order of the Garter, is one of her most reputed works. She died in 1700, in her 48th year.

GIBSON, WILLIAM, *miniature painter.* Nephew of Gibson the Dwarf, by whom and also by Lely he was taught. He attained eminence as a miniaturist, and some eminent persons sat to him. He was an excellent copyist of Lely, part of whose collection he purchased after his death. He also brought into this country a number of fine works from the Continent. He died in 1702, aged 58.

GIBSON, THOMAS, *portrait painter.* Born about 1680. Practised in the first part of the 18th century. He had for many years full employment, but his health failing, he disposed of his pictures about 1730, and retired to Oxford. Probably regaining health, he returned to London, where he died April 28, 1751, aged about 71. His portraits are well drawn and painted, the expression good, and also the hands and drapery. Highmore said that when Sir James Thornhill had a figure in difficult action he always applied to Gibson, who sketched it in for him. There is a portrait by him of Vertue, the engraver, dated 1723, at the Society of Antiquaries, and of Flamstead, the astronomer, at the Royal Society. Many of his portraits are engraved by C. White, J. Faber, Johnston, J. Simon, and one of Sir Robert Walpole, by Bockman.

GIBSON, DAVID COOKE, *subject paint-*

er. Was born in Edinburgh, March 4, 1827, the son of a portrait painter, by whom he was first taught. Left by his father's death to early struggles, he visited the neighbouring towns and painted portraits. Of industrious habits, he entered the schools of the Scottish Academy, where he gained a medal in 1845, and then by his savings was·enabled to come to London, and to visit Belgium and the galleries in Paris. His first work which gained notice was 'The Little Stranger,' which with 'Rustic Education' were his first exhibited works at the Royal Academy in 1855. The following year he sent 'Un Corrillo Andaluz,' and in 1857, after his death his 'Gypseys of Seville' appeared on the walls of the Academy. His work was of much promise, careful in finish and strong in character. In 1855 he went to Spain to recruit his declining health, but died in London, to which he had returned, October 6, 1856. His life with some of his poetry was published by a brother artist in 1858, and Miss Brightwell has included a short memoir of him in her 'Men of Mark.'

GIBSON, GEORGE, *architect.* Studied his art in Italy, and practised in the middle of the 18th century. James Elmes was his pupil.

GIBSON, JESSE, *architect.* Practised in London towards the end of the 18th century. He designed the church of St. Peter-le-Poor, City, a mediocre erection, finished in 1792 ; and rebuilt, 1822, the hall of the Saddlers' Company. He held two or three district surveyorships. Died June 24, 1828, aged 80.

GIBSON, THOMAS, *glass stainer.* He is chiefly known as a glass stainer, though he showed some talent as an artist. His works on glass decorate several of the churches at Newcastle-on-Tyne and in the surrounding parishes. He was a member of the Town Council, and served the office of sheriff. He died at Newcastle, November 25, 1854, aged 60.

GIBSON, JOHN, *sculptor.* Was born at Gyffin, near Conway, in 1790. His father, poor but honest, lived by his daily labour as a gardener. As a child he spoke only the Welsh language. When 9 years of age the family purposed to emigrate to America, and with this object went to Liverpool, but there his mother's resolution failed, it is said under the influence of a dream. The family settled in Liverpool and he was put to school. His first attention was attracted by the printsellers' windows. He was fond of drawing, and for his inveterate habit of scribbling in school he was punished. At 14 he was apprenticed to a cabinet-maker, and at the end of a year managed to get transferred to a carver, whose trade he thought somewhat allied to art. Then still unsettled, and

moved by some marble works he saw on the premises of Samuel Francis, he tried, at the end of another year, to get his indentures transferred to him, and by his dogged resolution at last succeeded.

He was now on the right road. Some works he had designed gained him the notice of Mr. Roscoe, whose patronage assisted him in every way. He studied anatomy and the works of the great Greek sculptors, and under their influence modelled a life-size 'Psyche,' which was exhibited at Liverpool, and his dawning talent brought him many friends. His ambition was inflamed by a desire to study in Rome, and he made a *drawing* of 'Psyche borne by Zephyrs,' which he exhibited at the Royal Academy, with two busts, in 1816. Early in 1817 he came to London, and with his introductions again found friends. He exhibited two busts that season ; but haunted by the idea of Rome, he set out for that capital in the September of the same year, and managed to reach his destination, travelling by Paris and Florence, in the following month. Introduced to Canova, he was kindly received and admitted to study with his other pupils. Hitherto he had been without any instruction, and did not know how to set about his work ; but getting over the first difficulties, he was admitted to the life academy, where, both assisted and depressed by the works of his fellow-students, who had attained a masterly style of drawing, he never flagged ; while in his lonely lodgings he thought of home.

By the advice of Canova he tried a figure life-size from his own design, which he called 'The Sleeping Shepherd ;' and in 1819 he began a large group, 'Mars and Cupid,' and was, after some months' labour, commissioned by the Duke of Devonshire to execute his group in marble. The work is now at Chatsworth, but he had named so low a price that he was barely remunerated for his materials. In 1821 he commenced his model for 'Psyche borne by Zephyrs,' and when his group was well advanced, Sir George Beaumont gave him a commission for it in marble, and the Duke of Devonshire a second commission for a basso-rilievo, 'The Meeting of Hero and Leander.' Other commissions followed. In 1826 he commenced his 'Hylas surprised by the Nymphs,' now in the National Gallery ; and established and happy in his art, was daily inspired with fresh enthusiasm.

In 1827 his 'Psyche borne by Zephyrs' was exhibited at the Royal Academy, and his friends urged his return to England, but the temptation of becoming rich did not weigh with his ambition for fame, which he thought would be best gained in Rome. In 1830 he exhibited a 'Nymph seated,' and a monumental statue, his first

portrait work; and afterwards, from the 'Aminta' of Tasso, modelled 'Love disguised as a Shepherd,' of which he produced no less than seven repetitions. Next, meeting with a beautiful boy, he conceived and modelled after him, 'Cupid tormenting the Soul,' which he deemed one of his best works. Thus pursuing his art, in which all his thoughts were centred, and sending his works home to the Academy Exhibitions, that they might be known to his countrymen, though they were the constant subject of hostile criticism by the press, he was in 1833 elected an associate of the Academy, and that year exhibited 'A Sleeping Shepherd Boy' and a 'Paris.' In 1838 he contributed a 'Narcissus,' and in 1840 was elected a full member of the Academy, exhibiting that year two bassi-rilievi. His powers were now at their height, and enjoying the fame of which he was ambitious, his days passed happily in the pursuit of art, by which he was surrounded.

After a long sojourn at Rome, with little relaxation, his whole thoughts bent on his own art—for he had little sympathy with the painters—he passed several successive summers at Innsbruck, and on his first visit there said that 'he felt as if he were new modelled.' On the death of Mr. Huskisson in 1831, he was asked to compete for the erection of a statue to him at Liverpool, but declining to do so, the commission was unreservedly given to him; and a second statue, not a replica, was commissioned for the custom-house there, by Mrs. Huskisson, who induced him, after 24 years' residence abroad, to return to England in the summer of 1844 to superintend the erection of his work, and in 1847 he came again for the same purpose, and from that time was almost a yearly visitor. On his first visit the Queen sat to him for the statue of her Majesty, now in Buckingham Palace. In his endeavours to give the highest finish to this work, he first employed a little colour, using slight tints of blue and yellow. He met the clamorous critics with, 'Whatever the Greeks did was right,' and submitted his tinted statue at the Academy Exhibition to the opinion of the public. But he only exhibited again on two occasions—in 1851 sending his marble statue of George Stephenson, and in 1854 his bust of the Prince of Wales.

The effects of the tumultuous period of 1848-49 did not fail to reach him. The successful English sculptors in Rome, and their exemption from enrolment, were the subject of dangerous remarks. When the French troops neared Rome he fled to Florence, returning in 1850, when the Pope again took possession of his palace. He was then engaged to model a group of the Queen for the new palace at Westminster, into which he introduced the typical figures of Wisdom and Justice. About the same time he commenced his 'Venus,' which he deemed his most ideal and highly-finished work, and carrying out his idea of colour, he gave the flesh the tint of warm ivory, made the eyes a pale blue and the hair blonde, enclosed in a golden net. This was evidently his cherished work. On the tortoise at the feet he inscribed, 'Gibson made me at Rome;' and he tells how long and often he sat in contemplation of his 'Venus,' and asks how he was ever to part with her. This figure was itself a replica, and was followed by three more. He was in apparent health, though his power was declining, and was in Rome, where he had dwelt for 48 years, when he was suddenly attacked by paralysis, and died January 27, 1866. His affections were with the arts and artists of his own country, and by his will he left to the Royal Academy the models both of his executed and his unfinished works, including several in marble, with the earnings of his life (32,000l.), for he had outlived his two brothers, his only relations. He passed a quiet and equable life in the pursuit of an art on which his happiness was fixed, unwearied in his earnestness and activity. He was entirely without knowledge of the classic languages, and had little intellectual cultivation, yet he made the works of the great Greek sculptors his life-long models, and to approach them was the object of his most earnest study. While Flaxman imbibed the spirit of the Greeks, he is accused of having imitated them. He did not seek invention or aim at novelty. He said, 'It is the desire of novelty that destroys pure taste. What is novel diverts us; truth and beauty instruct us.' He was a member of the principal European art academies, and also of the French Legion of Honour and the Prussian Order of Merit. The son of a Welsh gardener, he rose to the highest honours in art. His life, in which an autobiography is embodied, was edited by Lady Eastlake, and published 1870.

GIBSON, BENJAMIN, sculptor. He was born at Liverpool, and was brother to the foregoing, and chiefly employed as his assistant. He was also his inseparable companion, and having studied the classics, was the authority to whom he constantly referred. He wrote some papers on the antiquities of Italy, and sent to the Society of Antiquaries communications on the 'Ionic Monuments of Zanthus' and on 'Fresco Painting.' He died at the Baths of Lucca, August 13, 1851, aged 40.

GIBSON, PATRICK, R.S.A., landscape painter. Was born in Edinburgh in December 1782. His parents were respectable, and he received an excellent classical education. He showed an early taste both for literature and art, and wishing to follow

the latter he was placed under Alexander Nasmyth, and at the same time studied in the Trustees' Academy. He also extended his studies to architecture, mathematics, and other branches of knowledge connected with the fine arts. By these acquirements he fitted himself for a critic and writer on art, and came to London early in his career for further improvement. In 1805 and the two following years he exhibited landscape views at the Academy. He contributed to the 'Encyclopædia Edinensis' an article on 'Design,' and to the 'Edinburgh Encyclopædia' the articles 'Drawing,' 'Engraving,' and 'Miniature Painting.' For the 'Edinburgh Annual Register,' 1816, he wrote a 'View of the present State of the Art of Design in Britain,' and afterwards for the 'New Edinburgh Review' an article 'On the Progress of the Fine Arts in Scotland.' In 1818 he published 'Etchings of select Views in Edinburgh,' with letter-press descriptions; and in 1822 a remarkable *jeu d'esprit* on the works of the artists then exhibiting in Edinburgh, but the publication was anonymous, and he remained silent under the indignant remarks of his brother artists. In 1824 he left Edinburgh, accepting the office of teacher at Dollar. He found this sphere a very narrow one, but he remained there till his death, after three years' illness, on August 26, 1829, in his 46th year. His landscapes were chiefly compositions introducing architecture, and much in the style of the early masters.

GIFFORD, GEORGE, *engraver.* He practised about 1640, and engraved, chiefly for the booksellers, small portrait heads, which have little merit.

GILBERT, JOHN GRAHAM, R.S.A., *portrait painter.* Born at Glasgow in 1794, he was the son of a West India merchant, and was for a time placed in his father's counting-house, but was determined to be an artist. In 1818 he came to London, and was admitted into the schools of the Royal Academy, where in 1821 he gained the gold medal for his original painting of 'The Prodigal Son.' He afterwards travelled in Italy, where during two years he pursued his studies of the old masters, especially of the Venetian school. On his return he practised portrait painting in London, and was an exhibitor at the Academy. In 1827 he went to reside in Edinburgh, where he was very successful, had many sitters, and in 1833 was elected a member of the Scottish Academy. In 1834 he married and settled in Glasgow, adding the name of Gilbert to his paternal name of Graham, which he had borne hitherto. Possessed of ample means he continued the practice of his art, and in 1843 renewed his contributions to the Academy Exhibitions in London, sending

in that year 'The Pear-tree Well,' a romantic well near Glasgow, with a portrait; in 1845, 'Females at a Fountain;' in 1846, 'Christ in the Garden;' in 1853, 'The Young Mother,' with occasionally a portrait up to 1864, when 'A Roman Girl' was his last contribution. His fine portrait of Sir J. Watson Gordon, P.R.S.A., is in the National Gallery of Scotland. He died at Glasgow, June 5, 1866. He was greatly distinguished as a portrait painter; his drawing good, the pose of his figure natural, and the expression characteristic; his colour rich but sober, his backgrounds simple, and the whole carefully and conscientiously finished.

GILBERT, JOSEPH FRANCIS, *landscape painter.* Born 1792. In the midst of many family difficulties, he took up art and was an occasional exhibitor at the Royal Academy and the British Institution. He resided for many years at Chichester. Several of his early works were engraved—his 'Goodwood Racecourse,' 'Priam winning the Gold Cup,' and 'View of the Ruins of Cowdray.' He was a competitor at the Westminster Hall Exhibition. He died September 25, 1855, in his 64th year.

GILES, JAMES WILLIAM, R.S.A., *landscape painter.* He was born in 1801, at Glasgow, and in his boyhood was taught by his father, who was an artist. He early settled in Aberdeen and devoted himself with much success to portraiture. At the commencement of his career he passed a short time in Italy, and then painted chiefly landscape. In 1830 he was chosen a member of the Scotch Academy, and in that and the following year sent for exhibition at the Royal Academy in London 'The Errand Boy' and some landscapes, and on some other occasions, at long intervals, was an exhibitor. He is best known by his 'Highland Scenery,' in which sporting subjects are prominently introduced; and, a keen angler, the result of a good day's sport often proved a tempting subject. He lived principally at Aberdeen, where he died October 6, 1870.

GILL, CHARLES, *portrait painter.* Son of a pastry-cook at Bath. In 1749 he became a pupil of Reynolds, P.R.A. He exhibited portraits at the Royal Academy in 1772, two in 1774, a whole-length and two others in 1775, but does not appear again as an exhibitor. He suffered an injury to the leg, which deprived him of the use of the limb.

GILLRAY, JAMES, *caricaturist.* His father was born in 1720, in Lanarkshire, entered the army, lost an arm at Fontenoy, and was for many years an out-pensioner of Chelsea Hospital. He was born about 1757, and was apprenticed to an heraldic engraver on plate, but ran away and joined a company of strolling players. Disgusted

with this life, he returned to London, and soon after was admitted as a student of the Royal Academy, and acquired a power of correct drawing. His first attempts were as an engraver. In 1784 he published some engravings, after his own designs, in illustration of Goldsmith's 'Deserted Village,' and among other works of this period he engraved a portrait of Dr. Arne, after Bartolozzi, whose pupil, but more probably assistant, he is said to have been. He also engraved some plates after Lady Spencer's drawings. Several of his known plates have fictitious names to them.

His genius, however, led him to caricature. His first known essay was in 1779, and straying more and more from the higher branches of art, in which his knowledge, taste, and feeling qualified him to succeed, he devoted himself entirely to the graphic satire of the politics and morals of the day. He attacked the 'No Popery' rioters in 1780; in 1784, Pitt and his Government; then the Westminster election and the attendant riots, followed by the doings of the Prince of Wales, with numerous hits at the lesser follies of the time. His political partisanship led to an attack upon his house in 1794. His works were the amusement of the day. He seized with ready wit and great power of delineation the points he attacked, and, however grotesque his caricature, preserved the features and character of those he represented, frequently etching his designs at once upon the copper. Upwards of 600 of his engraved works have been collected. Mr. Bohn has published a large selection from them.

He was a man of intemperate habits, and the vice grew upon him. For many years he lived in the house of Mrs. Humphreys, his publisher, in St. James's Street, who supplied all his wants on condition that he should not work for any other publisher. Gossip said there was a more tender connection between them, but this scandal had no foundation. His latest work is dated in 1811. Soon after this his excesses brought on imbecility, with fits of delirium, during an attack of which he threw himself out of the window. He died June 1, 1815, aged 58, and was buried in St. James's Churchyard, Piccadilly.

GILPIN, SAWREY, R.A., *animal painter.* He was a descendant of Bernard Gilpin, the eminent English divine, called the 'Apostle of the North,' and was born at Carlisle, November 11, 1733. He was intended for business, and with that view sent to London, but a predilection for art led to his engagement, in May, 1749, as a pupil of Samuel Scott, the marine painter, who then lived in Covent Garden. Here he was diverted from his master's art to sketch the horses bringing supplies to the

176

market and the groups assembled there. In 1758 he left Mr. Scott to devote himself to animal painting, and went to Newmarket to acquire a knowledge of the horse and of animal anatomy. He was patronised by the Duke of Cumberland, then ranger of Windsor Park, who gave him apartments, with every facility for his improvement. He was for a time president of the Incorporated Society, and exhibited at the Society's Rooms, in 1763-64, portraits of horses; and in 1770, an oil sketch of 'Darius obtaining the Persian Empire by the neighing of his Horse;' and in the next year, 'Gulliver taking leave of the Houyhnyms,' followed by other subjects of the same class.

These works gained him a reputation. From 1786 to 1807 he was an exhibitor at the Royal Academy, and was elected an associate in 1795, and a full member in 1797. His horses were well drawn, his wild animals spirited and truthful. He painted in conjunction with Barret, R.A.; and Zoffany, R.A., painted some figures into his pictures. He etched a small book of horses, a set of etchings of oxen, some heads for his brother's 'Lives of the Reformers,' and the examples of his 'Forest Scenery.' His own 'Death of the Fox,' an excellent work, was well engraved by John Scott. He lived many years at Knightsbridge. On the death of his wife, he gave up his house and went to live with his generous friend Mr. Samuel Whitbread, at his seat in Bedfordshire. His health declining, he returned to pass the remainder of his life with his daughters at Brompton, where he died March 8, 1807, aged 73.

GILPIN, The Rev. WILLIAM, M.A., *amateur.* Brother of the foregoing. Was born in 1724, near Carlisle. He entered Queen's College, Oxford, in 1740, and was ordained in 1746. He was better known as a writer on landscape beauty than as an artist. Though his sketches are by no means without merit, they are, however, mere vigorous tintings of picturesque nature, with little drawing or topographical correctness. He for many years kept a large school at Cheam. In addition to several religious works, he published the following on art-subjects—'Tour down the Wye,' 1782; 'An Essay on Prints,' last edition, 1792; 'Northern Tour,' 1792, dedicated to the Queen; 'Scotch Tour,' 2nd edition, 1792; 'Forest Scenery,' 1794; 'Three Essays on picturesque Beauty,' 1794; 'Western Tour,' 1798. And the following were published after his death: 'Tour on the Coasts of Hants, Sussex, and Kent,' 1804; 'Two Essays on the Author's Mode of Sketching,' 1804; 'Observations on parts of Cambridgeshire, Norfolk,' &c., 1809. For the chief of these publications the illustrations were both drawn and en-

graved by himself. His works were at the time very popular, and passed through several editions. He was vicar of Boldre, in the New Forest, and appropriated a large collection of his sketches, which, sold by Christie in 1802, realised 1,560*l.*, to the endowment of his parish school. He died at Boldre in his 80th year, April 5, 1804, and is buried in the churchyard there.

GILPIN, WILLIAM SAWREY, *water-colour painter.* He was the son of the foregoing Sawrey Gilpin, R.A. His name first appears as an exhibitor at the Academy in 1797, when, and in 1799 and 1801, he contributed some landscape views. On the foundation of the Water-Colour Society in 1804, he was elected the Society's first president, but resigned the office in 1806, on his appointment as drawing-master at the Royal Military College at Great Marlow, and his necessary residence in the neighbourhood. Though very weak in art, he appears to have made the Society a useful president. He was a teacher of drawing, and his connections had insured him a great practice, which was seriously injured by his poor appearance on the walls of the exhibition. He continued a member of the Society, and exhibited up to 1814, when he removed with the establishment of the college to Sandhurst, and in 1816 his name is no longer in the catalogue.

GIRLING, EDMUND, *amateur.* Clerk in the Bank at Yarmouth. He produced some good imitations of Rembrandt's etchings, 'The Three Trees,' 'Goldweigher,' 'Descent from the Cross,' and other works. He also etched after Crome and the Dutch school, and was an exhibitor with the Norwich Society of Artists. His first work is dated in 1817, and he practised towards the end of the first quarter of the 19th century. His brother, RICHARD GIRLING, was also an etcher, and made some good copies.

, GIRTIN, THOMAS, *water-colour painter.* Was born February 18, 1773, in Southwark, where his father was an extensive rope and cordage manufacturer. He received some instruction from a drawing-master in Aldersgate Street, and was then for a short time the pupil of Dayes. He commenced art as a water-colour painter, and first studied subjects in the neighbourhood of London—the Savoy ruins, the water-gate of the palace, the picturesque shores and potteries of Lambeth; and on the opposite bank of the Thames, the bowered road, old church and hospital at Chelsea. He then made a tour in Scotland, and visited York, Durham, Cumberland, and Westmoreland. Afterwards he rambled to Ely, Peterborough, Lichfield, and Lincoln, sketching their grand cathedrals and ruins. He first exhibited at the Academy in 1794, and in that and the following year sent

views of Ely, Peterborough, and Lincoln Cathedrals, Warwick Castle, and some others. In 1797-98 he was a large exhibitor, sending four views of the city of York, an interior of St. Alban's, and afterwards views in Devonshire, Scotland, and Wales. In 1801 he exhibited for the last time — one work only — a view in oil of 'Bolton Bridge, Yorkshire.' He visited France about twelve months before his death, and his last and best drawings were views in Paris. From two of these views he painted scenes for Covent Garden Theatre. He also painted a panorama of London, which was on view when he died.

His name will be for ever associated with the progress of water-colour art in this country. His manner was bold and vigorous; suppressing details by his clever generalisation, he gave a gloomy grandeur to his picture. He chose for his subjects the picturesque ruins of our old abbeys and castles, and the hilly scenery of the North, to which, by his skilful treatment, he gave both sentiment and power. Using a full and flowing pencil, he appreciated the tones which truly harmonise with each other and were best suited to his subject, which was wrought with the greatest ease and mastery. A good example of his art is exhibited in the South Kensington Museum—'Rivaulx Abbey,' painted 1798. His death, which has been attributed to his irregularities, took place at his lodgings in the Strand, at the early age of, his gravestone says, 27, on November 9, 1802. He was buried in the churchyard of St. Paul, Covent Garden. Twenty of his views in Paris were published. He etched the outline himself on soft ground, and the effects were slightly put in in aqua-tint from his drawings.

GISBRANT, JOHN, *history painter.* An English artist of the 17th century. He passed many years of his life at Lisbon, where he was living in 1680. He painted an altar-piece for the church of St. Mary Magdalen in that city.

GLOVER, GEORGE, *engraver.* Born about 1618, he practised in the middle of the 17th century. He was chiefly employed for the booksellers upon portraits, frontispieces, and emblematical subjects. His portraits are produced entirely with the graver, and in a bold, powerful manner; the face often finely rendered in line. He apparently engraved from his own designs; his heads are larger than was usual at the period. Many of his portraits of eminent persons are of much interest.

GLOVER, JOHN, *water-colour painter.* Born at Houghton-on-the-Hill, Leicestershire, where his father was a small farmer, February 18, 1767. He received a plain education. As an artist he was self-taught, when a child scribbling his designs over

every scrap of paper he could appropriate. In 1786 he was chosen master of the Free School at Appleby; and besides combining the study of art, cultivated music with great success. In 1794 he removed to Lichfield, and gave himself up to drawing and art teaching. He had hitherto only used water-colours, but now began to practise in oil, and made many etchings. His style pleased, his works became known and appreciated, and he was induced to come to London, where he settled.

He was one of the promoters and first members of the Water-Colour Society, and a large contributor to their first and the following exhibitions, and was in 1815 elected president of the Society, filling the office only for the twelvemonths. The same year he visited Paris, and afterwards Switzerland and Italy, returning with his sketch-book stored with the scenery of those countries. At this time he painted some large works in oil. His 'Durham Cathedral' sold for 500 guineas, and his 'Loch Katrine,' and some other large works of the same class, were sold for liberal prices. In 1818 he withdrew from the Society to become a candidate for admission to the Royal Academy, but did not succeed; and in 1824 was one of the founders and a member of the Society of British Artists. He exhibited with the Society from that year to 1830, but not afterwards, though he continued a member up to 1849. In 1820 he made an exhibition of his works, both in oil and water-colours, in Old Bond Street; and for several years continued in the pursuit of his profession, contemplating his retirement to Ulswater, where he had purchased a house and some land.

This scheme was never realised. He suddenly adopted the intention to emigrate —on what inducement does not appear— and starting for Australia, he arrived at the Swan River Settlement in March 1831, and there, in scenery new alike to him and to art, he set vigorously to work, and sent home some of his colonial pictures, but they did not find a ready sale. For several of his latter years he painted little, passing his time in reading, chiefly religious works. He died at Launceston, Tasmania, Dec. 9, 1849, aged 82.

Glover's art, which was exclusively landscape, including views and an occasional marine, was mannered, and the style his own. His execution was rude and blotted, his foliage produced by splitting the hair of his brush, giving great apparent facility of handling; his atmospheric effect and general aerial perspective were good, his colour pleasing. His oil pictures are less satisfactory than his water-colour, and have not improved with age, but appear smooth and painty. He was in his early career a fashionable teacher, and gave lessons, 178

amongst others to Mrs. Somerville. He received very large sums for his lessons.

GLOVER, MOSES, architect and painter. He practised in the time of James I. He was associated with Gerard Christmas in rebuilding (1605) the Charing Cross front of Northumberland House (then called Northampton House), and between 1604–13 was much employed at Sion House. A plan, dated 1615, for rebuilding Petworth is preserved at that mansion, which is attributed to him. His name is attached to a survey of Syon, Middlesex, with views of the neighbouring royal palaces and mansions.

GODBY, JAMES, engraver. Practised in London at the beginning of the 19th century. In 1812 he engraved the illustrations for 'The Fine Arts of the English School,' also 'The miraculous Draught of Fishes,' after Raphael.

GODDARD, JOHN, engraver. Practised about the middle of the 17th century. He produced some book portraits and other works for book illustration.

GODFREY, RICHARD B., engraver. Born in London in 1728, he practised towards the latter half of the 18th century. His chief works were views, antiquities, and some few portraits. He engraved for the 'Antiquarian Repository' and for Bell's 'British Theatre.'

GODFREY, ROBERT S., glass painter. Practised in the last half of the 18th century. His colours were brilliant and well arranged, and he claimed to have revived and rivalled the art of the old painters.

GOLD, Captain CHARLES, R.E., amateur. An officer of the East India Company's Service. He was a tolerable draftsman, and in 1806 published, in folio, an interesting collection of 'Oriental Drawings, sketched between the Years 1791–98,' representing the costume and customs of the different castes in Coromandel and the neighbouring coasts; but his drawing is very rude and weak.

GOLD, JAMES, architect. He built St. Botolph Without, Bishopsgate, London, 1725-28.

GOLDAR, JOHN, engraver and draftsman. Born at Oxford 1729. He was employed by Boydell, and exhibited with the Free Society of Artists a proof engraving in 1765. His works, which are little esteemed, are chiefly of a humorous character. He engraved a series of four plates, called 'Modern Love,' after Collet; and 'Ships after an Engagement,' after Wright. He died suddenly, of apoplexy, in Hyde Park, August 16, 1795.

GOLDICUTT, JOHN, architect. Born 1793. He was a pupil of J. Hakewill, and studied in the schools of the Royal Academy, and afterwards in Paris. He then travelled in Italy, studied in Rome in

1817, and on his return in 1819 exhibited at the Academy a coloured drawing of the interior of St. Peter's, made from measurement, for which he had received the Pope's gold medal. He was active in his competitions for public buildings—in 1820, for the new Post Office, when he gained the third premium; in 1823, for the new buildings at King's College, Cambridge; in 1829, for the Middlesex Lunatic Asylum, gaining a premium; in 1830, for Fishmongers' Hall; and in 1839, for the Royal Exchange. He was one of the secretaries of the Institute of British Architects and a member of the academies of Rome and Naples. He died October 3, 1842, aged 49. He published, in 1825, 'An Account of the ancient Paintings and Mosaics discovered at Pompeii.'

GOLDING, RICHARD, *engraver.* He was born in London, of humble parents, August 15, 1785, and apprenticed to an engraver in 1799; but on some disagreement he arranged to leave him at the end of five years, and his indentures were transferred to James Parker, who, dying in 1805, he completed his master's unfinished plates. Gaining by his art an introduction to West, P.R.A., who employed him to engrave his 'Death of Nelson,' he was soon after engaged to engrave, after Smirke, R.A., some of the illustrations for 'Gil Blas' and 'Don Quixote,' and completed these plates with great power and delicacy. In 1810 he assisted William Sharp in some of his works, among which were two fine portraits. His reputation continued steadily to increase, and in 1818 he produced, after 30 retouchings by the artist, his fine plate of Sir Thomas Lawrence's portrait of the Princess Charlotte, which was greatly admired both here and on the Continent. Commissions were offered to him on all sides, among them Lawrence's portrait of Sir William Grant, which he executed, with some other good works, for which he neither asked nor received a sufficient price; and he was then engaged upon some plates which were not from subjects worthy of his art.

From this cause, probably, he became apathetic, and fell into a desponding state. At the latter end of 1842 he had been induced to commence a work after Maclise, R.A., for the Irish Art Union. He had at this time, he said, 'been without work for several years, and had given up all further thoughts of practice.' He commenced the work unwillingly, his powers and eyesight diminishing, and at the end of 10 years it was still unfinished. Of shy and reserved habits, unmarried, able to subsist upon small earnings, there was nothing to rouse him from his desponding indolence. He found some amusement in angling, a solitary sport suited to his secluded habits, but seems to have neglected

all friendly advances. He died in an upper floor in Lambeth, where he had for some months cooked and performed all domestic offices for himself; and here, though he was not without the means to provide himself with all proper comforts, he ended his days in neglect and dirt, December 28, 1865. He was buried at Highgate Cemetery, and in the following September his body was exhumed, and an inquest held on some entirely unfounded allegations that he had been improperly treated by his medical attendant, who had possessed himself of his property. His art was of a high class, his line free and powerful. Proofs of his works are extremely scarce, and of great value.

GOOCH, T., *animal painter.* He chiefly painted portraits of horses and dogs, occasionally grouping them with a portrait of their owner. He exhibited at the Spring Gardens Exhibitions, and first appears at the Academy in 1781. In 1783 he exhibited, with other works, 'The Life of a Racehorse, in six different stages,' from the birth to the death. He continued an exhibitor, with some intermissions, up to 1802, when he left the Metropolis and retired to Lyndhurst, in Hampshire. His art, with small exception, did not extend beyond the mere portraiture of animals.

GOOD, JOSEPH HENRY, *architect.* Was born November 13, 1775, at Sambrook, Somersetshire, of which place his father was rector, and was a pupil of Sir John Soane. He early entered into several public competitions, and in 1803 gained both the first and second premiums for his designs for the conversion of the Dublin Parliament House into the uses of the Bank of Ireland. In 1810, in conjunction with Mr. Lochner, he gained the first premium for a design for Bethlehem Hospital. In 1829 he was appointed surveyor to the Pavilion at Brighton, and made several additions to that palace; and in 1826 the Commissioners for Building new Churches selected him for their architect. He afterwards held the offices of clerk of the works to the Tower of London, the Royal Mint, and Kensington Palace. He died November 20, 1857, and was buried at the Kensal Green Cemetery.

GOOD, THOMAS SWORD, *subject painter.* Was a native of Berwick-upon-Tweed, and was born in 1789. He first appears as an exhibitor of 'A Scotch Shepherd,' at the Royal Academy in 1820, and coming up to London in 1822, was for fifteen years an exhibitor. His early works were carefully finished, clever and with a leaning to humour. In 1823 he sent to the Academy 'Practice,' a boy trying his prentice hand in shaving a sheep's head; in 1829, 'Idlers;' in 1830, 'The Truant;' in 1831, 'Medicine,' with occasionally a coast scene

introducing fishermen. In 1833 he exhibited for the last time. He died in 1872, having for nearly forty years abandoned his art in which he was gaining distinction. His widow bequeathed three of his works to the National Gallery.

GOODALL, EDWARD, *engraver*. He was born at Leeds, September 17, 1795, and was early attached to art. He first tried landscape painting, and in 1822-23 exhibited a landscape in oil at the Royal Academy. He was, however, induced by Turner, R.A., to devote himself to engraving, and in this art was self-taught, and was eminently successful. He was largely employed by Turner in engraving his works, and from him must have received much valuable advice. Among the works of Turner which he engraved are the 'Florence,' 'Cologne,' 'Tivoli,' 'Caligula's Bridge,' 'Oxford,' 'Richmond Hill,' and 'Old London Bridge.' He also engraved after Turner for his 'England and Wales' series, his 'South Coasts,' Rogers's 'Italy,' and Campbell's 'Poems;' and after Stanfield, R.A., 'Views in Italy, Switzerland, and the Tyrol,' with some landscapes after Cuyp and Claude. Later in his career he executed several works for the 'Art Journal.' But his fame will surely rest upon his fine rendering of the great landscape works of Turner. He died at his house in the Hampstead Road, April 11, 1870.

• GOODALL, FREDERICK TREVELYAN, *subject painter*. He was the son of Mr. Goodall, R.A., and was a student in the schools of the Royal Academy. He exhibited some studies at the Academy in 1868-69, and at the close of that year gained the gold medal of the Academy for his original picture, 'The Return of Ulysses.' He then went to Italy, and unhappily lost a life of much promise by an accident at Capri, April 11, 1871, when he had only attained his 23rd year. HOWARD GOODALL, his brother, a *subject painter* of much promise, died at Cairo, January 17, 1874, aged 24. He had exhibited at the Academy in 1870 'Nydia in the House of Glaucus,' and in 1873 'Capri Girls winnowing.'

GOODRIDGE, H. E., *architect*. He practised at Bath, where some of his works show him to have possessed both invention and taste. He erected for Mr. Beckford the well-known Lansdowne Tower at Fonthill. He died at Bath in 1863 or 1864, aged 63.

GOODWIN, FRANCIS, *architect*. He was born at King's Lynn, May 23, 1784, and gained much employment on public buildings in the early part of the 19th century. He built new churches at the following places: Bordesley, near Birmingham, 1820-23; Hulme, 1822-24; Derby, Walsall, Ashton-under-Lyne, Kiddermin-

180

ster, Bilston, Burton-on-Trent, Portsea, Oldham, and West Bromwich; and rebuilt and made extensive repairs to several other churches. He also erected the town hall at Manchester and at Macclesfield; the market at Leeds and at Salford; the exchange at Bradford; the county prison at Derby, and several mansions. He was the architect for Hungerford Bridge (of which Captain Browne, R.E., was the engineer), a very elegant work, which has been lately removed. He exhibited at the Royal Academy, between 1820-30, the designs of many of his executed works. He published 'Rural Architecture,' and 'Cottage Architecture,' and the designs which he prepared in competition for the new Houses of Parliament. He died in London, suddenly, of apoplexy, August 30, 1835.

GOODWIN, EDWARD, *landscape painter*. He practised chiefly in water-colours, and painted with some ability, in the early tinted manner, at the beginning of the 19th century. He exhibited at the Royal Academy, from 1802 to 1808, chiefly views in Wales, and was in 1806 an unsuccessful candidate for admission to the Water-Colour Society, but contributed to its exhibitions in 1814-15-16, when they were open to painters generally.

GOODYEAR, JOSEPH, *engraver*. He was born at Birmingham, and for many years found employment there as an engraver on plate. He was encouraged to come to London, where he found employment, and in 1802 placed himself under Charles Heath for three years, and was soon competent to work upon book plates. Continuing to improve by the zealous practice of his art, his last and best work was 'Greek Fugitives' for Finden's 'Gallery of British Art.' His health failed over this work, and after a lingering illness, he died in Camden Town, October 1, 1839, aged 41, and was buried in Highgate Cemetery.

• GORDON, Sir JOHN WATSON, Knt., R.A., P.R.S.A., *portrait painter*. Was born in Edinburgh in 1790, the son of Captain Watson, R.N., of an old Berwickshire family. Interest was made to gain his admission to the Military Academy at Woolwich, and he was meanwhile placed in the Trustees' Academy, Edinburgh, under John Graham, to improve himself in drawing. Here he remained four years, and having made some progress in his art, and perhaps disappointed in his expectation of a soldier's career, he tried history painting, but found his true place as a portrait painter. Settled in Edinburgh, he painted most of the eminent men in that capital, and on the death of Raeburn in 1823, monopolised the chief practice; and in 1826 became a member of the Royal Scottish Academy, then recently founded. His works and his reputation were,

however, mainly confined to Scotland, and it was not till 1827 that he began to exhibit at the Royal Academy in London. Continuing to improve in his art, in 1841 he was elected an associate, and in 1850 a full member, of that body, and the same year succeeded to the presidency of the Scottish Academy. He was at the same time appointed the Queen's limner for Scotland, and knighted. Enjoying the society and friendship of many distinguished men, he lived a single life in his native city, where he died rather suddenly on June 1, 1864. His portraits are vigorous and manly. He seized with great success the character of his sitters, uniting frequently great intellect and expression; his aim was rather tone than colour; his compositions simple, with no attempt at making up or backgrounds. He succeeded best with his male heads. His works were greatly admired when exhibited at Paris in 1855, and won for him a medal.

GORE, CHARLES. Probably an *amateur.* Drew in pen and ink marine subjects with much freedom, well coloured, and not without power. His shipping is well understood and very spirited. There are many of his drawings in the Cracherode collection at the British Museum, chiefly dated between 1790–94.

GOSSET, ISAAC, *wax modeller.* Descended from a French Huguenot family who took refuge in Jersey. He invented a composition of wax, in which he modelled portraits with much ability. He was a contributor to the first Artists' Exhibition in 1760, and was a member of the Incorporated Society of Artists. His works are numerous, and include the royal family and many distinguished persons from the reign of George II. to 1780. He died at Kensington, in his 88th year, November 28, 1799.

GOTT, JOSEPH, *sculptor.* He was a student of the Royal Academy, and in 1819 gained the gold medal for his group of 'Jacob wrestling with the Angel,' which he exhibited with two other works the following year; and in 1821, his sketch for 'Babes in the Wood,' a 'Fawn and Nymph,' and 'Sisyphus.' He did not exhibit again till 1826, when he sent to the Academy a 'Sleeping Nymph,' and 'A Gleaner.' By the kindness of Sir Thomas Lawrence, and assisted by a gentleman of his own name, but unconnected with him, he was enabled to go to Rome, from whence he sent to the exhibition, in 1830, 'Devotion,' and in 1831 his finished work, 'Babes in the Wood,' in marble. He next appears in 1837, with a marble group, 'Sylvia and the wounded Stag;' and continued an occasional contributor of a work from Rome, where he had settled, up to 1848, when he exhibited, for the last time,

'Mary Magdalene,' a marble group. He died at Rome soon after, leaving to his son, who took up his residence there, a competence he had secured by his art. Several of his chief works are at Armley House, Yorkshire; and in the village church there two life-size statues, 'Resignation' and 'Grief,' and a recumbent figure of Mr. B. Gott. At Chatsworth and at Wentworth there are some of his works.

GOUGAIN, T. *engraver.* Lived in London and engraved some of Sir Joshua Reynolds's works in mezzo-tint.

GOUGH, ALEXANDER D., *architect.* He was born November 3, 1804. Was at the age of 19 a pupil of Mr. B. Wyatt; on leaving him, joining a partner, he commenced practice. He erected several schools, 12 churches, of which the chief are, St. Saviour's, Camberwell, and St. John's, with a parsonage at Tunbridge Wells. He died September 8, 1871.

GOULDSMITH, HARRIET, *landscape painter.* She first appears as an exhibitor at the Royal Academy in 1809, and with some long intervals continued to exhibit up to 1854. In 1813 she was elected a member of the Water-Colour Society, and contributed to the Society's Exhibitions up to 1820. She also exhibited on one or two occasions in Suffolk Street. Her works were chiefly landscape views, but she painted two or three portraits, and one subject picture from 'Don Quixote.' Her landscapes were pleasing and well esteemed. She published in 1819 four landscape etchings of Claremont, and in 1824 four lithographic views, drawn on stone. About 1839 she married Captain Arnold, R.N., and from that time exhibited in her married name. She died January 6, 1863, aged 76.

GOUPY, LOUIS, *miniature painter.* He was a nephew of Bernard Lens, to whom he probably owed his instruction in his art. He practised several years in London early in the 18th century, and painted some clever miniatures. He was also a good copyist.

GOUPY, JOSEPH, *water-colour draftsman.* He was a relative of the foregoing, and was born at Nevers, France. He came to England when very young and settled here. In conjunction with Tillemans he painted a set of scenes for the opera. He was a clever copyist of the Italian masters, and was very fashionable as a drawing-master. He taught Frederick, Prince of Wales, who employed him at Kew and at Clieveden House. George III., whom he had also taught, on his accession allowed him a small pension. He drew small figure subjects and miniature portraits in body colours with great truth and fidelity. He also drew landscapes and etched some spirited plates, both from his

own drawings and the old masters. Among the latter, a set of eight landscapes, after Salvator Rosa. He quarrelled with Handel, and drew a caricature of him with a pig's snout, playing an organ. He died in London, at an advanced age, in 1763. His collection was sold by auction in 1765. His brother, BERNHARD GOUPY, practised in London about the same period, and was a clever miniature painter.

GOWER, GEORGE, *portrait painter.* He was appointed, 26th Elizabeth, her Majesty's serjeant-painter in oil for life, the patent granting to him or his deputy the sole privilege ' to make or cause to be made purtraictes of Our person, phisiognomy and proporcon of our body in oyle cullers on bourdes or canvas, or to grave the same in copper or to cutt the same in woode, or to printe the same, beinge cutt in copper or woode or otherwise ; ' making an exception in favour of Nicholas Hilliard in respect to portraits ' in small compasse in lymnynge only, and not otherwise.'

• GRACE, Mrs., *portrait painter.* She was the daughter of a shoemaker ; her maiden name Hodgkiss. She was uninstructed in art, but gained much skill and considerable employment as a copyist, and also painted portraits. She exhibited with the Society of Artists, and in 1767 sent an historical subject, ' Antigonus, Seleucus, and Stratonice.' Two years afterwards, her husband dying, she left off practice with the enjoyment of a competency she had made, and removed to Homerton, where she died, well advanced in years, about 1786. There is an engraved portrait of her, published in 1785.

GRAFTON, WILLIAM, *mezzo-tint engraver.* He practised in the first half of the 18th century.

GRAHAM, G., *engraver of portraits and other works.* Practised in the last half of the 18th century, in the dot manner ; and some of his works, as was then the custom, are printed in colours. He engraved several of the illustrations of ' The Pleasures of Hope,' published in 1799 ; and also some of Rowlandson's works.

GRAHAM-GILBERT, JOHN, R.S.A., *portrait and subject painter.* Was born at Glasgow in 1794, and was originally intended for his father's business, which was that of a West India merchant. His inclination and taste, however, led him to prefer art, and in 1818 he came to London, and entered as a student in the Royal Academy, where in 1820 he took the gold medal, and afterwards studied for two years in Italy. In 1827 he set up in Edinburgh as a portrait painter, and became quite fashionable. His female portraits were justly distinguished by their great feeling for beauty. In 1830 he was elected a member of the Royal Scottish Academy,

182

and was through life a firm supporter of that body. Though a man of considerable property he always remained firmly devoted to his art. Four of his pictures, two portraits, ' An Italian Nobleman,' and ' The Bandit's Bride,' his last work, are in the Scottish National Gallery. He died in Glasgow, June 5th, 1866.

GRAHAM, JOHN, *history painter.* He was an English artist, but passed the greater part of his life in Holland. After studying there for some time he travelled to Paris, London, and afterwards visited Italy to complete his studies. He then returned to the Hague, and practised there about the middle of the 18th century, painting, we are told, historical subjects.

GRAHAM, JOHN, *history painter.* He was born in 1754, and was apprenticed to a coach painter in Edinburgh. He afterwards came to London, where he followed the same trade, but aiming at higher things he gained admission to the schools of the Royal Academy, and about this time managed to visit Italy. In 1780 he appears as an exhibitor of ' Daniel in the Lions' Den,' and from that year he was a regular contributor. His subjects, with occasionally a portrait, were, in 1783, ' Una,' from Spenser ; in 1786, ' Ceres in Search of Proserpine ; ' in 1788, ' The Escape of Mary, Queen of Scots, from Lochleven Castle,' which was presented by Alderman Boydell with a portrait of himself, also by Graham, to Stationers' Hall. In 1792 he exhibited ' Mary, the Morning before her Execution ; ' and in 1797, his last contribution, ' King David instructing Solomon,' and is said to have used young Mulready (afterwards R.A.) as his model for the boy. In 1788 he was appointed the joint master, and soon after, master of the Trustees' Academy at Edinburgh, and went to reside there. He was most successful in his office of teacher, which he held till his death, several of the painters who became most distinguished in the next generation having studied under him. He died in Edinburgh in November 1817.

GRAHAM, JAMES GILLESPIE, *architect.* He was born about 1777, at Dumblane. He practised in Edinburgh, and erected many fine mansions in Scotland, where he was extensively employed. He designed a Roman Catholic chapel, erected in Edinburgh 1813, and another in Glasgow. He built Murthley House, Perthshire ; the halls for the General Assembly in Edinburgh ; and made the designs for Hamilton Square, Birkenhead. In conjunction with Mr. A. W. Pugin he was a competitor for the erection of the Houses of Parliament at Westminster, and they were united in some other designs. He died March 21, 1855, aged 77, and was buried at the Greyfriars, Edinburgh.

[handwritten annotations:]
Gower. Andrew. †1848.
Gower Thos --- Herald Painter 879

GRANGER, DAVID, *engraver.* Practised in London about the beginning of the second quarter of the 17th century. There is by him a 'St. George,' after Raphael, and a companion plate.

GRANGER, ROBERT, *architect.* Born at Newcastle-on-Tyne. He was educated in a charity school, and by his own energy and industry raised himself in the world, and his marriage with a lady of property enabled him to enter into a large building scheme in his native town, much in advance of the provincial street architecture of that day. He also designed and built there the new market, the exchange, the theatre, dispensary, and some other edifices, which were of much merit. His works gave a character to the town, but it is most probable that he was not without assistance in the architectural character of his buildings. He died July 4, 1861, in his 63rd year.

GRANT, WILLIAM JAMES, *history painter.* Was born at Hackney in 1829, and in 1844 was admitted into the schools of the Royal Academy. In 1847 he exhibited his first work, 'Rabbits,' and in the following year, with higher aim, 'The Black Prince entertaining the French King after the Battle of Poictiers.' This work was followed, both at the Academy and at the British Institution, by some sacred subjects. In 1852 he exhibited at the Academy a 'Samson and Delilah,' a work of large size and much pretension; and in 1858 his 'Eugène Beauharnais refusing to give up his Father's Sword,' and 'The last Trial of Madame Palissy,' attracted much notice. In 1860 he exhibited 'The Morning of the Duel,' a work of painful interest. His works continued of much promise. He exhibited for the last time in 1866, and died on June 2 in that year, aged 37.

GRANVILLE, MARY (Mrs. DELANY), *amateur.* She was born May 14, 1700, and was a descendant of Sir Bevil Granville. She was first married to Mr. Pendarves, of Roscrow, and after his death, to Dr. Delany, Dean of Down, in 1743. She copied in oil very cleverly many portraits, and some original portraits by her are very good, among them the Duchess of Queensberry, Prior's 'Kitty, beautiful and witty.' She completed a Flora, comprising 980 plants. She was much in favour with George III. and his Queen. She died in 1788. Lady Llanover published her 'Autobiography and Correspondence,' 1862. There is a portrait of her by Opie, R.A., at the Hampton Court Galleries.

GRANVILLE, ——, *engraver.* Practised early in the second half of the 18th century. He engraved some landscapes after Thomas Smith, of Derby.

GRATTON, GEORGE, *subject painter.* The Dublin Society awarded to him, in 1807, 100 guineas for the purchase of his 'Beggar Woman and Child,' painted in the Society's Schools. He exhibited in Dublin again in 1809. In 1812 he was residing in London, and that year exhibited three pictures at the Royal Academy—'The Guard Room,' 'The Gathering,' and 'Noontide.' But he does not again appear as an exhibitor.

GRAVE, THOMAS, *architect.* Practised in London in the reign of Elizabeth, and though his name frequently appears, no reference can be made to his works.

GRAVELOT, HENRY, *engraver and draftsman.* He is known in England by his assumed name of Gravelot. His real name was D'Anville, and he was the brother of the well-known geographer D'Anville. He was born in Paris, March 26, 1699. After receiving his art education in that city, he obtained employment in the suite of the French ambassador at Rome, but loitered at Lyons on his way, and then returned to Paris, where he spent in dissipation the money given to him for his journey. He then went with the governor to St. Domingo, at that time a French colony, and assisted in making a map of the island. A ship in which a remittance was made to him by his father was lost. Sickness and trouble followed, and he got back to Paris destitute. He tried painting for his support, and afterwards designing and etching. In 1733 he was invited to England by Claude Du Bosc to assist him in the plates for Picart's 'Religious Ceremonies,' and was on his arrival here suspected as a spy.

He was at once employed by the booksellers, and gained some repute by a 'Treatise on Perspective' which he published. He was the first who noticed the talent of Gainsborough, R.A., and taking him as his pupil, he employed him in designing the ornamental borders to Houbraken's engraved portraits. In 1745, on the breaking out of the war, he returned to France, where he chiefly employed himself in drawing, but after a time was induced to come again to England, and assisted Hogarth in some of his early plates. He drew for Vertue the 'Monuments of the Kings,' and was also engaged in Gloucestershire in drawing the churches and antiquities of the county. He both designed and etched the plates for Theobald's 'Shakespeare.' He is also known as one of the earliest caricaturists—the attacks on Sir Robert Walpole and Lord Burlington, 'The State Coach,' 'The Funeral of Faction,' and some others are by him. He attempted small compositions and conversation-pieces, and is said to have been a designer by choice, an engraver by necessity. He for a time kept a drawing school in the Strand. During a second residence here of several years he had saved some money, and in 1754 he returned to settle

183

in Paris, and was employed there in illustrating some of the best works at that time published. He died in Paris, April 20, 1773. He was gifted with great facility and taste, and finished his drawings with much minuteness, but his numerous illustrations are not of a character to maintain his reputation in the present day.

GRAVES, ROBERT, A.E., *engraver*. He was born in St. Pancras, May 7, 1798, and was a member of the oldest established family of printsellers in London. He became, in 1812, a pupil of John Romney, the engraver, and studied in the life-school, then held in Ship Yard, Temple Bar, and gained a thorough knowledge of his art, practising in the line manner. Among his first works he engraved for the illustration of the Waverley novels, and was soon largely employed. In 1836 he was elected, it is said by a unanimous vote, an associate engraver of the Royal Academy, and commenced a series of important works, among which may be distinguished, 'The Abbotsford Family,' after Wilkie, R.A. ; 'The Highland Whisky Still,' after Edwin Landseer, R.A. ; 'The Slide,' after Webster, R.A.; 'The Children of George III.,' after Copley, R.A.; 'The Sisters,' after Eastlake, P.R.A. Latterly, he was engaged upon engraving from the portraits of Reynolds, P.R.A., and Gainsborough, R.A. Of industrious habits and zealously working to the end, his engravings are very numerous and are highly esteemed. He died at Highgate Road, February 28, 1873, and was buried in the cemetery at Highgate.

GRAY, PAUL, *wood engraver and designer*. Was born in Dublin, May 17, 1842. He came to London in 1863 or 1864, and found employment as a draftsman on wood. He designed some book illustrations, but is best known by his cartoons for 'Fun,' a comic weekly periodical. His health failing, he was sent to Brighton in the hope to restore it, but died there of consumption, Nov. 14, 1866.

GREEN, BENJAMIN, *mezzo-tint engraver*. Was born at Hales Owen, Shropshire, of poor parents, about 1736. He was a member of the Incorporated Society of Artists in 1766, and exhibited with the Society for several years. He was appointed engraver to George III. He also held the appointment of drawing-master to Christ's Hospital. He possessed a considerable knowledge of drawing, and his engravings are vigorous and powerfully executed. Some of his plates after Stubbs, A.R.A., are good examples of his art— 'The Horse before the Lion's Den,' 1768 ; 'The Lion and Stag,' 1770 ; 'The Horse and the Lioness,' 1774. He also engraved the illustrations for Morant's 'Essex,' and published many plates of antiquities, both drawn and etched by himself; and he was
184

a painter as well as an engraver. He died in London about 1800.

GREEN, AMOS, *flower painter*. Brother to the above. Born at Hales Owen. He practised in the latter half of the 18th century. Though he chiefly excelled in flowers, there are some landscapes by him which are brilliant in colour and well composed, and some engravings which he executed at the commencement of his career. He retired about 1757 to Bath, where he lived with a friend, and then did little more in art. He died at York in June 1807.

GREEN, JOHN, *engraver*. Another brother of the above. Born at Hales Owen. About 1724 was pupil of the elder James Basire. He excelled both in landscape and portrait. He engraved some of the plates for Borlase's 'Natural History of Cornwall,' including the seats of the principal nobility and gentry ; and was for many years employed on the plates for the Oxford almanacs. He died young, about 1757.

GREEN, JOHN, *draftsman and picture dealer*. He was well known as 'Johnny Green.' Practised 1749—63.

GREEN, JAMES, *engraver*. He was born in 1755. He practised in mezzo-tint. His works are beautifully drawn and expressed, his tints excellent. He produced some fine engravings after Reynolds, P.R.A., in which the character of the painter is well imitated. He died about 1800.

GREEN, JAMES, *portrait painter*. He was born March 13, 1771, at Leytonstone, Essex, where his father was a builder. He was early distinguished by his water-colour portraits, and later more especially by his paintings in oil. In 1808 he was a member and the treasurer of the short-lived 'Associated Society of Artists in Water-Colours.' He was also for several years, up to 1826, an exhibitor at the British Institution, and in 1808 the directors awarded him a premium of 60l. Lately he frequently exhibited at the Royal Academy, and in 1820 sent a good subject picture of large size, 'A Lady preparing for a Masked Ball.' His works are graceful and harmonious in colour ; they possess a characteristic originality, of which his portrait of Stothard, R.A, in the National Portrait Gallery, is a fair example. He died at Bath, March 27, 1834, and was buried in Wolcot Church. Several of his portraits are engraved. There is a memoir of him in Arnold's 'Magazine of the Fine Arts' for May 1834.

GREEN, Mrs. MARY, *miniature painter*. Born in 1776 ; she was the second daughter of William Byrne, the landscape engraver, and married in 1805 to the above James Green. She was a pupil of Arlaud, and became eminent as a miniature painter, regularly exhibiting her works at the Royal Academy, from 1796 till her husband's

death in 1834, when she retired from her profession. She made some excellent studies after Reynolds and Gainsborough; faithfully rendering the great qualities of both. A portrait by her of Queen Adelaide is engraved, and also one of Lady Alicia Peel. She died October 2, 1845, and was buried at the Kensal Green Cemetery.

GREEN, BENJAMIN R., *water-colour painter.* Son of the above, Mrs. Mary Green, was born in London, and studied at the schools of the Royal Academy. He painted both figure and landscape subjects, and was much engaged in teaching. He was a member of the Institute of Painters in Water-colour, and for many years secretary of the 'Artists Annuity Fund.' He died in London October 5, 1876, aged 68.

◆ GREEN, VALENTINE, A.E., *mezzo-tint engraver.* Born at Hales Owen, Salop, 1739. Intended for the law, he was placed under a solicitor at Evesham, but after two years he was led by his taste for drawing to abandon the law, and, unknown to his family, to place himself with an obscure line engraver at Worcester. Making little progress and dissatisfied, he came to London in 1765, and without further help attempted mezzo-tint. He exhibited two mezzo-tint works at Spring Gardens in 1766, and, self-taught, was original in his treatment in that style of engraving, and attained eminent success. Hitherto mezzo-tint had chiefly been practised for portraiture, and he was among the first who used it for historical subjects. He gained a great reputation by his plates after Benjamin West's 'Return of Regulus to Carthage' and 'Hannibal swearing Enmity to the Romans;' and engraved some good plates after R. Morton Paye—'The Sulky Boy,' the companion picture, 'The Disaster of the Milk-Pail,' and 'The Child of Sorrow,' 1783.

He was a member of the Incorporated Society of Artists in 1767, and was from 1774 an occasional exhibitor of drawings and engravings at the Royal Academy, and in 1775 was elected an associate engraver, and appointed engraver to George III. In 1789 he was granted the exclusive privilege of engraving and publishing from the Dusseldorf Gallery, and by 1795 he had completed and published 22 plates from that collection; but the disturbances caused by the Continental war, added to the want of support which the undertaking met with, involved both him and his son, ROBERT GREEN, an engraver, who also painted some miniatures, in serious loss; they were nearly ruined. Probably this and advancing years induced him, on the foundation of the British Institution in 1805, to accept the office of keeper, which he held till his death.

His works are very numerous. During a practice of nearly 40 years he produced about 400 plates, many of them subject pictures. He engraved after West, Reynolds, Romney, Zoffany, Mortimer, and after Vandyck, Rubens, and the Italian masters. He died in London, July 6, 1813, in his 74th year. He published, in 1782, a 'Review of the Polite Arts in France, as compared with their present State in England,' addressed to Sir Joshua Reynolds; a 'History of the City of Worcester,' 1796; and some other writings of an antiquarian character.

GREEN, WILLIAM, *engraver and draftsman.* Born at Manchester in 1761, he was in early life engaged to a surveyor practising there, but dissatisfied with his occupation, he came to London, where he studied aqua-tint engraving, and produced some good plates. His health failing, he settled in the North of England, and made innumerable drawings from the beautiful lake scenery, which are distinguished by their careful finish and fidelity. For these works, which he exhibited at Keswick and Ambleside, he found a ready sale among the tourists till the peace opened the Continent to them. He published, in 1809, 78 studies from nature in Cumberland, Westmoreland, and Lancashire, drawn and engraved by himself; and in the following year 60 studies of the same localities, etched on soft ground; also, in 1822, 'The Tourist's new Guide.' He died at Ambleside, April 28, 1823, aged 62.

GREENBURY, ——, *portrait painter.* He was employed by Charles I. as a copyist; and Walpole mentions two of his copies after Albert Dürer as much admired. He died about 1670. There is at New College, Oxford, a half-length portrait by him of Lake, Bishop of Bath and Wells, dated 1626. Sir Theodore de Mayerne named him among the distinguished painters to whom he dedicated his MSS. on painting and other arts, 1620.

GREENE, EDWARD, *die engraver.* He held the office of graver to the Mint 5th Charles I., and was a good medallist. He engraved the Irish seals of office for Lord Strafford.

● GREENHILL, JOHN, *portrait painter.* He was born at Salisbury, of a good family, in 1649, and was a pupil of Sir Peter Lely, whose style he imitated, both in oil and crayons; but was jealously, it is said, kept from the knowledge of some of his master's methods. He at first followed his art with great devotion, and has left a few portraits, which will maintain his reputation; but he became of dissolute habits, and returning from a tavern he fell into the kennel, and, carried home, died in his bed the same night, May 19, 1676. Graham says, 'He was the most excellent of the disciples of Lely. He was finely qualified by nature

for both the sister arts, painting and poetry, but death, taking advantage of his loose and unguarded manner of living, snatched him away betimes, and only suffered him to leave us enough by his hand to make us wish that he had been more careful of a life likely to do great honour to his country.' He left a young widow, reputed of great beauty, with several young children, who were assisted by an annuity of 40l. a year from Lely; but she died soon after, insane. There is a good portrait of him, painted by himself, at Dulwich, and also by him a portrait of Bishop Seth Ward, in the town hall at Salisbury. An etching by him of his brother is known to collectors.

* GREENWOOD, JOHN, *engraver.* He was born in 1729, at Boston, America, and was self-taught in art. He was for some time in Surinam, where he practised painting, and collected some objects of natural history. He afterwards went to Holland, where for a time he dealt in works of art. From thence he came to England and practised as a mezzo-tint engraver and painter. He was a member of the Incorporated Society of Artists, and exhibited with the Society from his arrival in 1763 to 1773, when he abandoned art and became an auctioneer. He died at Margate, September 16, 1792, aged 63. He engraved portraits after Hone and others, and some subject pictures after Rembrandt, Teniers, Metzu. he engraved 'The curious Maid,' from a picture by himself, 1768.

GREENWOOD, THOMAS, *scene painter.* Son of the foregoing. Was a scene painter and artist of much eminence. He was for many years the head scene painter to Drury Lane Theatre. He died October 17, 1797.

GREGAN, JOHN EDGAR, *architect.* Was born at Dumfries, December 18, 1813. He settled at Manchester, and built in that neighbourhood several churches, school-houses, and residences, with some public buildings, including Messrs. Heywood's bank, deemed one of his best works. His designs contributed to the improvement of Manchester. He died there April 29, 1855, and was buried at Dumfries. He was the honorary secretary to the Manchester Royal Institution, and a fellow of the Royal Institute of British Architects.

GREIG, G. M., *water-colour painter.* Practised in Edinburgh. There are some good interiors by him of the old buildings in that city picturesquely treated. He exhibited some interiors of Holyrood Palace at the Royal Academy in 1865, and held an acknowledged place among the artists of Scotland. Died at Edinburgh, May 3, 1867.

GRELLIER, WILLIAM, *architect.* Was born at Peckham, May 24, 1807. He was articled to his profession and studied in the schools of the Royal Academy. He gained
183

an Academy silver medal, and in 1829 the gold medal for his design for a 'British Senate House.' He was awarded the first premium for his design for the new Royal Exchange, London, 1839, but was not employed. In 1846–48 he built the Royal Exchange Insurance Offices in Liverpool—his most important work. He died January 7, 1852, and was buried in the cemetery at Norwood.

GRENVILLE, JONES, *engraver.* Born in Dublin 1723. He engraved landscapes after several masters. Two by him, after Poussin, were published in London.

GRESSE, JOHN ALEXANDER, *water-colour painter.* Born in London 1741. Son of a Genevese. He commenced drawing under Gerard Scotin, engraver, and in 1755 received a Society of Arts' premium for a drawing in chalk. He was afterwards under Major, and then for several years worked for Cipriani, during which time he received some instruction from Zuccarelli. He also studied in the Duke of Richmond's Gallery and the St. Martin's Lane Academy, and in both these schools he gained premiums. But with all this, and with ood ability, he wanted perseverance to succeed in the higher branches of art. He was a member of the Incorporated Society of Artists in 1776, and in that and several following years exhibited some miniatures and drawings. He became a teacher and the most fashionable drawing-master of the day. In 1777 he was appointed to teach the princesses, and George III. often found some amusement in his gossip. He was corpulent, and his companions called him 'Jack Grease.' He executed several drawings for Boydell, and etched the figures for Kennedy's account of Wilton and four other plates. He was a collector as well as an artist, and his effects were sold by auction, occupying six consecutive days, in 1794. His father, after whom Gresse Street, Rathbone Place, is named, left him a comfortable property. He died February 19, 1794, in his 53rd year, and was buried at St. Anne's, Soho.

GREVILLE, Lady LOUISA AUGUSTA, *amateur.* She was sister to the ninth Baron and second Earl of Warwick, and made some good etchings after Salvator Rosa, Annibale Caracci, and others. She was awarded three gold medals by the Society of Arts in 1758 and 1759 for a landscape drawing, and in 1760 for a coloured figure subject after Guercino.

GRIBELIN, SIMON, *engraver.* Born at Blois 1661. He came to England 1680, but was for nearly 20 years with little employment. He attracted notice by his engraving of 'The Tent of Darius,' published in 1707, and then executed with great success the first set published of engravings after Raphael's cartoons. He afterwards

published six historical subjects from the Kensington Palace collection, and, in three large plates, Ruben's 'Ceiling of the Banqueting House,' also several portraits and small plates for books. He died in England in 1733, aged 72. He left a son, who practised as an engraver. His own works were executed entirely with the graver in a cold, neat style, weak in drawing and expression.

GRIEVE, JOHN HENDERSON, *scene painter.* His family had been distinguished in the art from the time of De Louther-bourg, and he formed another distinguished link. He died of apoplexy, April 16, 1845, aged 75.

GRIEVE, WILLIAM, *scene painter.* Son of the above. He was born in London in 1800, and as a boy began his career in the scene-loft at Drury Lane Theatre, and both at that house and at the Italian Opera House he made great improvements in scenic effects and arrangements. He raised the reputation of the Opera House by his scenery. The ballet of 'Masaniello' was greatly indebted for its success to his inventive talent ; and on the performance of 'Robert le Diable' in 1832, the audience called him before the curtain—an unprecedented event—to receive their approving testimony to his success. His moonlights were excellent and his delusions marvellous in effect. He died at South Lambeth, October 24, 1844, aged 44. He left some small pictures and water-colour drawings, but his art shone only on the stage.

GRIFFIER, JOHN (called 'Old Griffier'), *landscape painter.* He was born at Amsterdam 1645, and apprenticed to a carpenter, but learning to paint on earthenware, he was allowed to follow his own inclination, and placed himself with a flower painter. He came to England about 1667, and his landscapes were much esteemed. His colour and execution are good, his figures well introduced, and, with his cattle, correctly drawn. Excelling in his views on the Thames, he purchased a vessel, in which his whole family passed their time between Gravesend and Windsor. Having amassed some money, he sailed in his vessel from Rotterdam, was wrecked, and lost all his possessions, and but for a few guineas his daughter had sewed up into her girdle, would have been reduced to beggary. Then, after 10 or 12 years' stay, returning to England, he took a house on Millbank, where he died in 1718. His collection was sold by auction after his death. He etched several small plates of birds and animals after Barlow, and five large half-sheet plates of birds.

GRIFFIER, ROBERT, *marine painter.* Son of the foregoing. Was born in London in 1688, bred under his father, and made good progress in art. He painted river

and marine subjects, and in some of his sketches excelled his father. His colour and drawing was very good. When, after his shipwreck, his father returned to London, he went to Amsterdam, where he settled, and died at a good old age.

GRIFFIER, JOHN, *landscape painter.* Younger son of 'Old Griffier.' He was noted for his great power as a copyist of Claude. He practised in London as a landscape painter, and died in Pall Mall about 1750.

✻ GRIFFITH, MOSES, *topographical draftsman.* He was born in Carmarthenshire, April 6, 1749, and became the servant of Pennant, the antiquarian. Travelling with his master he picked up some knowledge of drawing, and, improved by study in the school of the Artists' Society in 1771, was ultimately employed by his master, first as draftsman, later as an engraver also. He made some of the drawings for Pennant's 'Journey from Chester to London,' 1782, and ornamented the margins of his 'Tour in Wales,' 2nd volume. His works have little art merit. They are washed in rather heavily with Indian ink, and very slightly tinted. He accompanied his master on all his journeys, and on receiving his 'manumission' retired to Wales, where he published, in 1801, some etchings, his first attempts, as supplemental plates to the 'Tour in Wales.' He was living in 1809.

GRIGNION, CHARLES, *portrait and history painter.* He was born in 1754, in Russell Street, Covent Garden, where his father was a watchmaker of some celebrity. Was pupil of Cipriani and a student of the Royal Academy. At 15 he gained the Society of Arts' premium for a drawing from the human figure, and in 1776 the Academy gold medal for his 'Judgment of Hercules.' In 1782 he was sent to Rome with the Academy pension. He painted at Rome a large picture of the 'Death of Captain Cook,' and made a number of drawings, some of which were engraved, and was residing in Rome in 1794. Later in life he devoted himself to landscape and produced some works of much excellence. Lord Nelson sat to him for his portrait at Palermo in 1798. On the French entering Rome he was compelled to leave, and retired to Leghorn, where he died of a bilious fever, November 4, 1804, and was buried in the ground of the English Factory there. He was an exhibitor of portraits and classic subjects at the Academy from 1770 to 1784. He purchased several fine pictures in Italy during the French invasion, and sent them to London, among others the Altieri Claudes. Two drawings by him, 'A Roman Assassination' and 'A Dancing Group,' were engraved.

GRIGNION, REYNOLDS, *engraver.* He

was much employed by the booksellers. He engraved, from Hayman's designs, the illustrations for Baskerville's edition of Addison's works, some of Frederick the Great's battles and sieges, and was employed upon Pennant's 'Scotch Tour' and a 'History of England,' for which he engraved a series of full-length portraits, mostly fictitious, of the Kings and Queens, with many other works of this class. He does not take much rank in his profession. He died in the King's Road, Chelsea, October 14, 1787.

GRIGNON, CHARLES, engraver. He is reputed to have been born in Covent Garden, of foreign parents, in 1716. In early life he studied in Paris under Le Bas for a short time. He was a member of the St. Martin's Lane Academy. He was employed by Hogarth, and engraved his 'Garrick in the Character of Richard III.,' and assisted in engraving the four election pictures. He also engraved many of Gravelot's illustrative designs. In 1755 he was a member of the Committee of Artists appointed to establish a royal academy. There are some good examples of his art in the illustrations to Bell's 'Poets,' particularly those after Stothard, about 1778. Though not engaged on works of large size or high importance, his art is distinguished by a masterly ease of style and purity of execution. But as he advanced in years he was superseded by the more finished and powerful manner of the school which then grew up, and after nearly 50 years' labour, was subjected to poverty, with its sufferings and trials. He had arrived at the great age of 90 years, past the practice of his art, and had a wife with a daughter nearly blind dependent upon him, when in 1808 subscriptions for his relief were solicited by advertisement, and some provision was made for his few remaining days. He died at Kentish Town, November 1, 1810, aged 94, and was buried in the churchyard of St. John the Baptist.

GRIMALDI, WILLIAM, enamel and miniature painter. He was born in Middlesex in 1751, and claimed descent from the great Genoese family whose name he bore. He studied his art under Worlidge, and afterwards in Paris. He first exhibited at the Free Society of Artists in 1768–69, and afterwards at the Academy in 1786, and then as De Grimaldi, but soon omitted the prefix. He practised at Portsmouth, Southampton, Gloucester, Worcester, Chester, and Shrewsbury; from 1777 to 1785 in Paris, and in this latter year settled in London. He painted both in enamel and on ivory, had many sitters of distinction, and was largely employed. He was miniature painter to George III., to the Duke and Duchess of York, and in 1824 to George IV., but did not continue

188

to exhibit after that year. He resided many years at Albemarle Street, but died in Pimlico, May 27, 1830.

GRIMBALDSON, WALTER, landscape painter. He practised early in the 18th century. There was a sale of his works, which do not appear to have been much esteemed, in 1738.

GRIMM, SAMUEL HIERONYMUS, water-colour draftsman. Born at Burgdorf, Berne, the son of a clever miniature painter there, of whom he learnt his art. He came to London, where he settled, about 1778, and in that and the following year exhibited some views in the Spring Gardens Rooms. He drew with the pen and in water-colours, was much employed in topographical works, and sketched numerous views in Sussex, Derbyshire, Nottinghamshire, and other counties. He made above 100 sketches in Northumberland and Durham for Sir R. Kaye, and the drawings for Sir William Burrell's 'Sussex.' He was occasionally employed by the Society of Antiquaries, and the Society published his views of Cowdray House for their 'Vetusta Monumenta.' Above 500 of his drawings were sold by auction in July 1795. They were chiefly executed with the pen and shaded with bistre, but some were tinted and more highly finished. His buildings were correct, his skill in architecture and perspective respectable, but his trees and foliage stiff and weak. He also was known by his caricatures and humorous subjects, many of which were published by Carrington Bowles. He exhibited at the Royal Academy in 1769 and several following years. His subjects were 'Falstaff Recruiting,' 'A Swiss Fair,' 'Mortlake Fair,' and several from Shakespeare. There are also some etched plates by him. He died April 14, 1794, aged 60, in Tavistock Street, Covent Garden, and was buried in the parish church.

GROGAN, NATHANIEL, landscape painter. Was born in Cork, and apprenticed to a wood turner. Was fond of art, gained some assistance from John Butts, and then taught drawing in Cork. He served in the army during the American War, and afterwards returned to Cork, where he tried to gain a livelihood as an artist. He painted landscapes and humorous subjects illustrating Irish character. His best known works of this class are an 'Irish Fair' and an 'Irish Wake.' He published views in the neighbourhood of Cork, aqua-tinted by himself, and a large plate of the 'Country Schoolmaster.' He died at Cork about 1807. Though highly extolled by his countrymen, his works are coarse, and have not much art merit. He left two sons, who practised as artists, struggling to earn the means of living.

GROOMBRIDGE, WILLIAM, water-

colour painter. He practised in the tinted manner in the last quarter of the 18th century, when his works were well esteemed. He painted landscapes and moonlight scenes, introducing figures and cattle, and was from 1777 to 1790 an exhibitor at the Royal Academy. In the latter part of his career he resided at Canterbury.

GROSE, Captain FRANCIS, *amateur,* He was born in 1731 at Richmond, where his father, who left him an independent fortune, was a jeweller, and was employed to fit up the coronation crown of George II. His brother became a judge of the Court of King's Bench. He received a good classical education, but was never at college. He studied art in Shipley's drawing school, and was in 1766 a member of the Incorporated Society of Artists, and in 1768 exhibited with the Society, 'High Life below Stairs,' a stained drawing. Early in life he devoted himself to sketching the ruins of the old edifices in England. He afterwards visited Scotland and studied the ancient architecture of that country, where he made the acquaintance of Burns. He was 'the chiel amang ye taking notes' of the poet, who wrote some verses upon him, concluding—

'Now by the pow'rs o' verse and prose,
Thou art a dainty chiel, O Grose!
Whae'er o' thee shall ill suppose,
They sair misca' thee.'

He next carried his antiquarian researches into Ireland, visiting several parts of that country in 1790, to collect the materials for a work on Irish Antiquities, returning again in 1791. He was noted for his corpulency, it was a constant theme, and the hospitality of Dublin was too much for him. He had, as he said, 'been going it too hard for three or four days,' when after a convivial dinner he died suddenly, on May 18, 1791. He had a good taste, drew well, and the figure very creditably. He was an honorary exhibitor at the Academy of tinted drawings, chiefly of architectural remains, in 1769 and for several following years. But he was eminent as an antiquary, and is well known by his able researches. His chief published works are — 'The Antiquities of England and Wales,' 1773–87; 'The Antiquarian Repertory,' 1775; 'Advice to Officers of the British Army,' a satire, 1782; 'Guide to Health,' 1783; 'Military Antiquities,' 1786–88; 'Treatise on Ancient Armour and Weapons,' 1786–89; 'The Antiquities of Scotland,' 1789–91; 'The Antiquities of Ireland,' 1791; 'Rules for drawing Caricatures,' 1791. He held a captain's commission in the Surrey Militia and was paymaster to the regiment, also from 1755 to his resignation in 1763 the office of Richmond herald.

GROVES, JOHN THOMAS, *architect.* Was one of the contributors to the Academy's first exhibitions. He travelled in Italy, and on his return in 1791, exhibited the 'Sibyls' Temple.' In 1794 he was appointed clerk of the works to St. James's Palace, and in 1807 architect to the General Post Office. The baths at Tunbridge Wells were designed by him. He died in Great Scotland Yard, August 24, 1811. There is a good drawing by him of the exterior of Westminster Abbey, which was engraved to a large scale in 1779.

GROZER, JOSEPH, *engraver.* Born about 1755. Practised in London the greater part of the last half of the 18th century. His works were well drawn and effectively finished in mezzo-tint. He engraved, after Sir Joshua Reynolds, 'Dido,' 'Shepherds with a Lamb,' 1784; 'Innocence,' 1788; 'Miss Johnson, as a girl, Dancing,' 1792; and some others.

GRUBB, EDWARD, *stone carver and painter.* He executed some busts in a rude manner, but with ability. His figures of a boy and a girl at the Bluecoat School, Birmingham, are examples of his art. He had a local reputation, and painted some family portraits, of which the family of the Cannings, at Stratford, possess several. He died at Stratford-upon-Avon, April 8, 1816, aged 76.

GRUNDY, THOMAS LEEMING, *engraver.* Born at Bolton, Lancashire, January 6, 1808, the son of Lieut. Grundy. He was apprenticed to a writing engraver at Manchester, but, aspiring to higher work, at the end of his apprenticeship he came to London, and was employed upon some plates for the annuals, after Liversege and Stanfield, R.A. Having attained some power in the line manner, he was then employed by Mr. Doo, and afterwards by Mr. Goodall, the landscape engraver. He possessed great taste, and was of some promise in his art, when he was attacked by inflammation, and died in Camden Town, March 10, 1841. He engraved the portraits of several clergymen, and produced some clever etchings.

GUEST, DOUGLAS, *history painter.* He studied in the schools of the Royal Academy, and first appears as an exhibitor of a portrait in 1803. In 1804 he sent 'A Madonna and Child;' in the next year he gained the Academy gold medal for his 'Bearing the dead body of Patroclus to the Camp, Achilles's Grief;' in 1806 he exhibited 'Penelope unravelling the Web;' in 1811, 'Cupid and Psyche.' He had at the same time occasionally exhibited a portrait, and he contributed a portrait in 1816–17, and then he ceased to exhibit up to 1834, when he sent two works to the Academy—'The second Appearance of the Messiah' and 'The Judgment of Hercules.'

189

He exhibited once more in 1838, ' Phaeton driving the Chariot of the Sun,' his last exhibited work. He painted, 'The Transfiguration,' an altar-piece 40 feet high, for St. Thomas's Church, Salisbury. In 1829 he published an 'Inquiry into the Causes of the Decline of Historical Painting.'

GULSTON, ELIZABETH, amateur. Daughter of Joseph Gulston, Esq., of Ealing Grove, Middlesex, who possessed a good collection of English portraits. Of these she reproduced several by her etchings, which are enumerated in Bromley's 'Catalogue.' She was an honorary exhibitor at the Academy in 1801, but her name does not appear subsequently. She died before 1840.

GWILT, GEORGE, architect. Appointed in 1770 surveyor of the county of Surrey. Built Horsemonger Lane Gaol, completed 1790, and later the Sessions House, Newington, since pulled down. In 1800 he was appointed architect of the West India Dock Company, and built the Company's warehouse in the Isle of Dogs. Died Dec. 9, 1807, in his 62nd year.

GWILT, GEORGE, architect. Son of the foregoing. Born May 8, 1775. Brought up to his father's profession. Restored, between 1822–25, the choir and tower of St. Mary Overy's Church, Southwark, and after a visit to Italy in 1825, the Lady Chapel, which he completed in 1834. He also designed the first 10 of the almshouses of 'Cure's College,' in that parish. His restorations were made with skill and accuracy. He communicated some interesting papers to the Society of Antiquaries. Died May 26, 1856. He had two sons, who gave promise of ability in his profession, but died young.

GWILT, JOSEPH, architect. Born January 11, 1784. Younger brother of the foregoing. Studied in his father's office and in the schools of the Academy. He travelled in Italy during 1816–18, on his return was engaged in the erection of some residences. The rectory at East Woodhay, Hants; Mackree Castle, Sligo; and a church at Charlton, are his principal works. He exhibited at the Academy on one or two occasions only. He was much employed as a surveyor, and is chiefly known by his professional writings. He is the author of the 'Encyclopædia of Architecture' and some other useful works.

GWINN, JAMES, designer and engraver. Was born in the county of Kildare, and is believed to have been self-taught. He was originally a coach painter. He came to London about 1755, and lodged at a public-house in the Broad Sanctuary, Westminster. He painted some marine subjects and was a neat draftsman. He gained his livelihood by his designs for the lids of snuff-boxes for the Battersea manufactory of enamels.

But he was an eccentric man, worked at his art only for a mere subsistence, and secluding himself from everybody, devoted every spare hour to the study of the occult sciences. He fell into great distress, was so absent as often to forget his food, and was found dead in his chamber, probably, it was thought, the victim of a rude joke, April 26, 1769.

GWYNN, JOHN, R.A., architect. Was born at Shrewsbury, but the date of his birth is unknown. He was distinguished as a well-educated man. It is not known that he was originally brought up as an architect, but his name first appears as a writer on subjects connected with that profession. In 1734 he published an 'Essay on Harmony in Situation and Building;' in 1742, 'The Art of Architecture, a Poem,' followed by two non-professional works; and in 1749, his 'Essay on Design.' In this essay, which is the work of a scholar, he vindicates the genius of his countrymen, shows the necessity that drawing and design should be extensively taught, and suggests the foundation of a public academy. In 1752 he published, in conjunction with Samuel Wale, a clever transverse section of St. Paul's Cathedral. While engaged in measuring outside on the top of the dome for this section, and intent upon his work, he missed his footing and slid down the vast convex surface until he was arrested by a small projecting piece of lead, where he remained until he was discovered and rescued by his assistants. He was an unsuccessful competitor in 1759 for the proposed new bridge at Blackfriars, and on the controversy that ensued as to the use of circular or elliptical arches, he was supported by the influence of his steady friend Dr. Johnson. He travelled in the Northern counties, and made numerous drawings. He was a contributor to the first Artists' Exhibition in 1760. In 1764 he published his ingenious work, 'London and Westminster Improved,' and at that time projected several main lines of streets, since carried out. He was in 1768 nominated one of the foundation members of the Royal Academy, having been one of the members of a small committee who, 12 years before, had attempted to found an institution of the same kind. He was a contributor to the early exhibitions, sending, in 1771, 'Designs for erecting the British Museum opposite the Horse Guards by adding to Whitehall Chapel.' He built two bridges over the Severn, one near Shrewsbury in 1774, the second at Worcester in 1781. He carried out many improvements at Oxford, and built the new bridge over the two arms of the Cherwell at Magdalen Hall; also the market and the workhouse. He passed the latter part of his life at Worcester, where he died February 27, 1786, and was buried.

190

He left his property to a natural son, and in case of his death, to the Royal Academy and the Royal Society. Many of his designs are preserved in the British Museum. Mr. Wyatt Papworth contributed a very interesting memoir of him to 'The Builder,' 1863.

GYFFORD, EDWARD, *architectural draftsman.* He studied in the schools of the Royal Academy, and in 1792 gained the Academy gold medal for his design for a 'House of Lords and Commons.' He exhibited some drawings at the Academy, the last in 1799, when he appears to have held a commission in the West London Militia. He published, in 1807, 'Designs for small picturesque Cottages and Hunting-boxes.' He was a rapid, clever draftsman, but

managed only to gain a poor subsistence by his profession. He died about 1834. His son was a gold medal student and painted general subjects.

● GYLES, HENRY, *glass painter.* Practised chiefly at York, where he resided from 1640 to 1700. He painted the east window at University College, Oxford, in 1687, and some other windows at Oxford. He also painted some historical subjects and landscapes. His own portrait in crayons, by himself, in the print-room of the British Museum, shows a power of drawing and some taste for colour. He established a school of glass painters at York, which maintained a reputation for nearly a century. There is a letter by him in the Ashmolean collection.

H

HABERSHON, MATTHEW, *architect.* He was born in 1789, of a Yorkshire family, and was articled to an architect. He built a church at Belper, Derbyshire, in 1824, with two other churches in the same county, and a church at Kimberworth, Yorkshire. At Derby he built the town hall, since burnt down, the county courts and the market, and Hadsor House at Droitwich. He was an occasional exhibitor at the Royal Academy from 1807 to 1827. He published 'The Ancient Half-timbered Houses of England,' with 36 plates, in 1836, and several works on the prophetical Scriptures and on the prophecies. He died in London in 1852.

HACKERT, JOHANN GOTTLIEB, *landscape painter.* Born 1744, in Germany, of a family of painters. Was pupil of Le Sœur in Berlin, and studied some time in Rome. In 1766 he was in Paris, and in 1771 again at Rome, when he sent some views in water-colours to the Spring Gardens Exhibition. In 1772 he accompanied some English gentlemen to London, where, finding encouragement, he settled. In the following year he exhibited some Italian views in oil and water-colours—his first and only contributions to the Royal Academy—and a picture of four hounds, which was engraved and published by Boydell. His constitutional weak health soon after failed. He went to Bath for his recovery, and died there, in his 29th year.

HACKETT, DAVID, *architect.* An Irish architect of this name is reputed to have designed the great church of Batalha,

erected by King John of Portugal in 1430, a work of the pure Gothic of that era.

HADFIELD, GEORGE, *architect.* Was the brother of Maria Cosway. He studied in the schools of the Royal Academy, and in 1784 gained the Academy gold medal for his 'Design for a *National* Prison,' a strange subject. Elected in 1790 to the travelling studentship, he went to Rome in that year, accompanied by Mrs. Cosway, and was studying there in 1794. He made drawings of the temples of Palestrina, Mars, and Jupiter Tonans, which he exhibited at the Academy on his return in 1795. A drawing by him of the interior of St. Peter's was much praised at the time. He was soon after invited to America to assist in the erection of the capitol at Washington, and arrived in that city about 1800. He did not long continue in this employment, but leaving it, practised on his own account, and erected several buildings there. He died in America in 1826.

HAID, JOHANN GOTTFRIED, *engraver.* Born in Wurtemburg in 1730, the son of an artist, by whom he was taught. He painted portraits, but chiefly practised as a mezzo-tint engraver. He came to London when young and was much employed by Alderman Boydell, engraving after Reynolds, Dance, and, among others, 'Foote as Major Sturgeon,' after Zoffany. He afterwards returned to Germany. Died 1776.

HAINES, WILLIAM, *miniature painter.* He was born in 1778, and was from 1808 to 1830 a constant exhibitor at the Royal Academy. Among his numerous sitters

'Hacken. Arthur - 6·1858'

'Haden . F. Seymour - Physician & Etcher (1890)'

were many military officers. A notable work by him in water-colour was a full-length portrait of Earl Stanhope, which was engraved to the same size by S. W. Reynolds. He succeeded to a considerable property and retired to East Brixton, where he resided several years, and died July 24, 1848.

HAKEWILL, JOHN, *landscape and portrait painter*. His father was foreman to James Thornhill, son of Sir James. He commenced art as a pupil of Wale, R.A., and was a student in the Duke of Richmond's Gallery. In 1763 he gained the Society of Arts' premium for a landscape painting, and in 1764 for a figure from the antique. He exhibited at the Spring Gardens Rooms, in 1769 and the two following years, portraits and landscapes. He painted many designs in arabesque, and though continuing to paint an occasional landscape or a portrait, he found his chief employment in designs for house decoration. He died September 21, 1791, aged about 50.

HAKEWILL, HENRY, *architect*. Born October 4, 1771. Son of the above. He was a pupil of Yenn, R.A., and a student in the Academy Schools. Was a frequent exhibitor at the Academy. He was the architect of Rendelsham, Suffolk, 1801, and of Cave Castle, Yorkshire, 1804, and was employed upon alterations and additions to several fine mansions. He was architect to the Society of the Middle Temple, and was in 1809 appointed architect to the Rugby Schools, where he designed the new chapel and residences, which he exhibited at the Academy in that year. He built the church at Wolverton, and St. Peter, Euston Square, since burnt down. He published an account of a Roman villa discovered at Northleigh, Oxfordshire. He died March 13, 1830, and was buried at North Cray, Kent.

HAKEWILL, JAMES, *architect*. Younger brother of the foregoing. Born November 25, 1778. He was brought up as an architect, and exhibited some designs at the Academy on one or two occasions, but preferred painting, and is best known by his publications on art, which are chiefly of an architectural character. In 1813 he published a 'History of Windsor and its Neighbourhood,' the illustrations of which, including the plans of the castle, were drawn by himself. On the peace he travelled in Italy, and during 1816–17 collected the materials for his ' Picturesque Tour in Italy,' published in parts, 1818–20 ; in 1825, a ' Picturesque Tour in the Island of Jamaica.' In 1828 he published 'Plans of the Abattoirs of Paris,' with a proposal for their adoption in London, and in 1835 a small tract on 'Elizabethan Architecture.' He was one of the competitors for the erection of the new Houses of Parliament. He exhibited at the Royal Academy in

192

1826–27 some architectural designs, and in 1833–34 the drawings of some works he was then executing. He was engaged in collecting materials for a work on the Rhine, which was interrupted by his death, in London, May 28, 1843, in his 65th year. In addition to his art writings, he was the author of ' Cœlebs Suited.'

HAKEWILL, Mrs. JAMES, *portrait painter*. Wife of the above. She accompanied her husband to Italy, and passed there the greater part of the years 1816–17. She exhibited some studies at the Royal Academy in 1808–9, and from that time, with a lapse from 1816 to 1825, was an exhibitor of small portraits in oil up to 1838, when she exhibited for the last time. She also exhibited on one or two occasions at Suffolk Street. Her portraits were pleasing and well painted.

HAKEWILL, ARTHUR WILLIAM, *architect*. Eldest son of the above. He was born in 1808. Was educated under his father, and in 1826 became a pupil of Mr. Decimus Burton, and at this time exhibited two or three designs at the Royal Academy. But he preferred literature to his professional studies, which became distasteful to him, and his spirits giving way he went for a time to Italy, but returned without much permanent benefit. He had much professional taste and judgment, and his inclination led him to employ his knowledge in literature. In 1848 he was appointed lecturer to the Architectural Society. He published ' An Apology for the Architectural Monstrosities of London,' 1835 ; 'Modern Tombs, Gleanings from the Cemeteries,' 1851 ; 'Illustrations of Thorpe Hall, Peterborough,' 1852 ; ' Thoughts on the Style to be Adopted in rebuilding the Houses of Parliament,' 1836 ; ' The Architecture of the 18th Century,' measured, drawn, and etched (with a weak hand) by himself, 1856 ; and some other professional works. He died June 19, 1856.

HAKEWILL, HENRY JAMES, *sculptor*. He was a younger son of the foregoing James Hakewill, and was born at St. John's Wood, April 11, 1813. His early love of art tempted him to that profession in preference to another, to which he had been destined. He was admitted a student of the Royal Academy in 1830. In 1832 he exhibited a statue in armour of the time of Richard I., and in the following year a basso-rilievo from ' Mazeppa.' He also modelled a design for a proposed statue to Earl Grey, and was engaged on other works, when a career of some promise was cut off by his death, March 13, 1834, in his 21st year.

HAKEWILL, EDWARD CHARLES, *architect*. He was a student in the schools of the Royal Academy, and in 1831 was placed under P. Hardwick, R.A. Practis-

ing for himself, he built several churches—Stonham, Aspall, and Grandsburgh. He was appointed one of the metropolitan district surveyors, but resigning the office in 1867, he retired and settled in Suffolk, where his professional assistance was sought. He was a fellow of the Institute of British Architects. Died October 9, 1872.

HALES, ——, *portrait painter*. Practised in the middle of the 17th century. Pepys sat to him in 1666, and this portrait, answering to Pepys's description, was sold by auction in 1848 at Christie's for 50s., and is now in the National Portrait Gallery.

HALFPENNY, WILLIAM, *architect*. Practised in London in the first half of the 18th century. He published 'The Marrow of Architecture,' 1722; 'The Art of sound Building,' 1725; 'Practical Architecture,' 1730-48; 'Twelve Designs for Farm Houses,' 1750; 'Useful Architecture,' 1760; and also a work on Rural Architecture, 1752.

HALFPENNY, JOSEPH, *topographical draftsman*. Was born in Yorkshire, at Bishopsthorpe, where his father was the gardener, October 9, 1748. He was apprenticed to a house painter, and followed that trade in York for several years. Then he became a teacher of drawing, and made himself known as a draftsman. He published, in 1795-1800, his 'Gothic Ornaments,' drawn and etched by himself from the cathedral at York; in 1807, his 'Fragmenta Vetusta.' He died July 11, 1811.

HALL, ——, *glass painter*. He practised in London in the early part of the 17th century, and was much esteemed for the rich brilliancy of his colour. The stained glass window of Lincoln's Inn Chapel, consecrated 1623, is by him.

HALL, CHARLES, *engraver*. Born about 1720. He was brought up a letter engraver, but improved himself in art, and found employment in engraving portraits, medals, coins, and other antiquities. His portraits are his best works, respectable in execution, and faithful copies. He engraved after Holbein, Passe, Hertocks, and others. He practised in London, where he died, February 5, 1783.

HALL, JOHN, *engraver*. Born near Colchester, December 21, 1739. He came to London early in life, but not being designed to follow art, he was led to its pursuit by his own tastes. In 1756 he was awarded a premium by the Society of Arts. He was a pupil of Ravenet, was employed for a time in painting on enamel for the works at York House, Battersea, and soon became distinguished. He engraved after West, P.R.A., 'The Battle of the Boyne' and 'Oliver Cromwell dissolving the Long Parliament,' and employed then by Boydell,

he engraved for him the same artist's picture of 'Venus relating to Adonis the story of Hippomenes and Atalanta,' in which he succeeded by a new method in giving great softness and flexibility to the flesh—the difficulty of the engraver's art. His principal works are after Carlo Maratti, Reynolds, Gainsborough, West, Hoare, and Dance. On the death of Woollett he succeeded to his place in the profession, and also as historical engraver to the King. He was a member of the Free Society of Artists in 1763. He ranks among our best historical engravers: his line is good, his work careful, but has a tendency to blackness. He died in Berwick Street, Soho, April 7, 1797, and was buried in Paddington Churchyard.

HALLIDAY, MICHAEL FREDERICK, *amateur*. His father was a captain in the Royal Navy. He held an appointment in the House of Lords, and when past middle life cultivated a taste for painting. He exhibited at the Royal Academy in 1853 a landscape, and in 1856, 'The Measure for the Wedding Ring,' which was engraved and brought him into notice. In 1857 he exhibited 'The Sale of a Heart;' in 1864, 'A Bird in the Hand;' and in 1866, his last work, 'Roma vivente e Roma morta.' He died after a short illness, June 1, 1869. His works were sold at Christie's in January 1871.

HALLS, J. J., *portrait and history painter*. He lived for some time at Colchester, of which town he was probably a native. He first appears as the exhibitor of a landscape at the Academy in 1791, and again in 1798, when he exhibited 'Fingal assaulting the spirit of Loda.' In the following year he came to London, and from that time was a constant exhibitor of portraits, and had many distinguished sitters. He also occasionally contributed a subject picture; in 1802, 'Lot's Wife turned into a Pillar of Salt;' in 1808, 'Hero and Leander;' in 1811, 'Danae.' In 1813 he gained at the British Institution a premium of 200 guineas for his 'Raising of Jairus's Daughter.' But from this time he exhibited only portraits, and was a large contributor. His last exhibited work was in 1827.

HALPEN, PATRICK, *engraver*. Practised in Ireland in the line manner 1778-86, and was the only engraver of his class then in Ireland. He was principally employed on vignette illustrations for books.

HALPEN, ——, *portrait painter*. Son of the above. Studied in the Dublin Academy, and then commenced art as a miniature painter. Not succeeding, he tried the stage, and appeared at the Crow Street Theatre in Dublin. But again unsuccessful he came to London, and in a new field resumed his art.

HAMILTON, Sir JAMES, Knt., *architect*. He was a natural son of James, first Earl

o

of Arran, and received letters of legitimation 1512. He was comptroller of the household and the favourite of King James V. of Scotland, and was afterwards appointed the master of the king's works, and employed in the repairs and alterations of the palaces at Stirling and Linlithgow, and some other works of importance. He was charged in 1539 with inventing engines to assassinate the King, and with embezzlement in his office, treasons which he could not be brought to confess, and was after a trial beheaded at Edinburgh, in September 1540.

• HAMILTON, GAVIN, *history and portrait painter.* He was descended from the Hamiltons of Murdieston, Fifeshire, an ancient Scotch family, but was born in the town of Lanark in 1730. There is no account of his education. He went early in life to Rome, where he spent the greater part of his days, and was looked up to in all matters of art. He was for a short time resident in London about 1752, and was in 1755 a member of the Artists' Committee appointed to establish a royal academy. He was devoted to the study of historic art, but was persuaded to try portrait, and about this time painted the Duchess of Hamilton and her sister, the Countess of Coventry, two celebrated beauties. These portraits are engraved in mezzo-tint ; and his portraits of Dawkins and Wood, the discoverers of Palmyra, are engraved by Hall. Soon after he went back to Rome, only returning to England, after many years' absence, to take possession of a considerable family estate, which he inherited in 1783 on the death of his elder brother. His tastes were pure and founded on classic study, his drawing good but timid ; his colour and light and shade weak. He painted several large historical subjects, among them—'Achilles dragging the body of Hector at his chariot wheels,' 'Andromache weeping over the body of Hector,' both pictures engraved ; and an 'Apollo,' presented to the city of London by Alderman Boydell, a single figure, above life-size, well and solidly painted, but heavy in colour, which was exhibited at the International Exhibition, 1862. He also painted, about 1794, an apartment in the Villa Borghese at Rome, in compartments, representing the story of Paris. While residing at Rome he sent classical subjects for exhibition at the Royal Academy in 1770-72-76, and for the last time in 1788. He was engaged at Rome in excavating for antiquities, commencing the diggings at Hadrian's villa, about 1769, and was fortunate both there and in other places to find some fine specimens of antique sculpture, which for some time graced the Townley and other galleries, and are some of them now in the collections at the British Museum. He published a
194

volume containing 40 prints, 'Schola Italica Pictura,' from the works of the great Italian masters. Many of his own pictures are also engraved. He died at Rome in the summer of 1797, his death occasioned, it is said, by anxiety on the entry of the French.

HAMILTON, JAMES, *still-life painter.* Born at Murdieston, Fifeshire, and probably of the same family as Gavin Hamilton. He practised in the time of Charles I. and excelled in still-life, painting birds and fruit. On the usurpation of Cromwell he left this country and settled at Brussels, where he lived till nearly 80 years old. He had three sons, born and educated on the Continent, who were painters. JOHN GEORGE was an animal painter of great ability, whose works will be found in the Berlin Gallery and the galleries of the Belvidere Palace at Vienna. PHILIP FERDINAND, a painter of cattle and still-life, whose works are also in the Belvidere Palace ; and CHARLES WILLIAM, several of whose paintings are in the royal collections of the King of Bavaria. In the Vienna catalogues these artists are distinguished as 'Von Hamilton.' They cannot be claimed as of the English school.

HAMILTON, HUGH DOUGLAS, R.H.A., *portrait painter.* He was born in Dublin about 1734, and studied under James Manning in the art schools of the Dublin Academy. He commenced practice there early in life, and was successful in his crayon portraits, drawn in a slight but pleasing manner. Tempted by his success he came to London, took lodgings in Pall Mall, and was extensively employed, the King and the Queen sitting to him. His portraits were of small size, oval, the prevailing tone grey, finished with red and black chalk, and distinguished by the clever expression of the eyes ; his usual price nine guineas. In 1765 he gained a Society of Arts' premium of 60 guineas, was admitted a member of the Incorporated Society of Artists, and exhibited 12 chalk portraits at their gallery in Spring Gardens. After a very successful practice in London, he went to Rome in 1778, and settling there, painted many of the English and Irish visitors to that city. While there, by the advice of Flaxman, R.A., he tried oil, and from that time confined his art to that material, which he soon mastered. In 1787 he was in Florence, and sent home two portraits, which were exhibited at the Academy, and in 1791 a portrait from Rome. On his return, soon after, he settled in Dublin, where he was elected a member of the Academy, and practised there as a portrait painter up to 1800. He had many eminent sitters, and in oil maintained his early reputation. His works were marked by truth of outline, agreeable expression and good grouping,

yet were feeble and wanting in effect. 'Dean Kirwan Preaching,' in the Dublin Royal Society, is a good example of his art. His best portraits were of females, some of them treated historically. Of his historical attempts, a colossal head of 'Medusa,' 'Prometheus,' and 'Cupid and Psyche' are mentioned as his best. He died in Dublin in 1806. Earlom and Houston engraved after him, the latter his portrait of Mrs. Hartley.

HAMILTON, Thomas, R.S.A., *architect.* Was born in 1785. He practised in Edinburgh; designed the Burns's Memorial, Ayr, 1820, and erected there the Edinburgh High School, 1825-29, a clever adaptation of Grecian art; and planned the grand lines of approach on the north side of the town; also the *façade* of the Physicians' Hall, 1845, and several churches and mansions. He was one of the foundation members in 1830, and treasurer of the Royal Scottish Academy, and received a gold medal at the Paris Universal Exhibition, 1855. He died February 24, 1858. He was the author of 'A Letter on the present state of the Fine Arts in Scotland,' 1850.

HAMILTON, John, *amateur.* He painted some landscapes, and in 1766 was a member of the Incorporated Society of Artists. About 1773 he was secretary to the Society, and later became vice-president. He etched in a painter-like manner the illustrations for his friend Grose's 'Treatise on Ancient Armour and Weapons,' 1785.

HAMILTON, David, *architect.* Born in Glasgow, May 11, 1768. He was brought up as an artificer, but he distinguished himself early by his superior abilities, and in 1804 was employed as the architect of the Queen Street Theatre in that city. In 1806 he designed the monument erected there to Nelson, and afterwards several churches; in 1830 the Royal Exchange, in the Corinthian order; and in 1835, St. Paul's Church, in the Ionic order. He was also the architect of several mansions and other important works in Scotland. On the competition for the Houses of Parliament in 1830, he was awarded the third premium. He died at Glasgow, December 5, 1843.

HAMILTON, William, R.A., *history and portrait painter.* He was born at Chelsea in 1751, the son of a Scotchman, who was employed by R. Adam, the architect, who early in life assisted him to visit Italy, where he studied under Zucchi, but was too young to take full advantage of this opportunity. On his return he entered, in 1769, as a student at the Royal Academy. He practised in history, and sometimes painted subject pictures and portraits. He designed for Boydell's 'Shakespeare,' and

for Macklin's 'Bible' and edition of the Poets; also for Tomkins' edition, in 4to, of Thompson's 'Seasons;' and was generally much employed in book illustration. He was popular in his day, and many of his paintings were engraved. Some of his water-colour drawings possess much brilliancy and merit. His style was light and pretty, but wanting in all the essential characteristics of historic art. His male figures were effeminate and tall; his females, dolls draped in the costume of the stage, and tawdry. His Shakespeare pictures possessed little of the character of the poet or his time. He received 600 guineas for painting the panels of Lord Fitzgibbon's state carriage, now in the South Kensington Museum; and painted some antique decorations for the Marquis of Bath's seat in Wiltshire. He was elected associate in 1784, and R.A. in 1789. He was a constant exhibitor at the Academy, commencing in 1774, and took a wide range of subjects. From 1783 to 1789 he exhibited portraits; and, at the latter part, theatrical portraits. He died in Dean Street, Soho, of fever, after a few days' illness, December 2, 1801, and was buried in the parish church of St. Anne. His widow became a pensioner of the Academy.

HANCOCK, J. G., *medallist.* Towards the end of the 18th century he executed several good medals. He excelled in his portrait dies. There is a fine medal by him of Lord Nelson.

HANCOCK, Robert, *engraver.* Was born in Staffordshire. He studied under Ravenet and was first engaged at Battersea, and later in the pottery works of his native county, where he was chiefly employed as an engraver, and saved about 6,000*l.* The Worcestershire printed porcelain owed to him much of its excellence. Losing his savings by the failure of a bank, he commenced as an artist, and practised, in the latter part of the 18th century, in mezzo-tint. His works are chiefly after Sir J. Reynolds, Wright, of Derby, Miller, and some others. He resided some time at Worcester, and the latter part of his life at Bristol, where he drew in crayons some small portraits, several of which, among them Samuel Taylor Coleridge, dated 1796, are engraved in Cottle's 'Early Recollections.' He died October 1817 in his 87th year.

HAND, Thomas, *landscape painter.* He was a pupil of George Morland, and became one of the companions of his excesses. He acquired his master's free manner, and was a facile copyist of his works, to which he did not scruple to add his master's name. He exhibited a small landscape at the Spring Gardens Gallery in 1790, and at the Royal Academy, commencing in 1792, rustic and sporting subjects,

and continued from time to time an exhibitor. He died in September 1804.

HAND, RICHARD, glass painter. He was born in Warwickshire, and for a time practised in Ireland, painting landscapes and fruit, and was also employed in copying pictures. About the end of the 18th century he learnt the art of staining glass from a clever chemist in Dublin, and he then applied himself to glass painting. He was an ingenious artist, and succeeding, he made many improvements in his art. He practised at the early part of the 19th century, and had then settled in England, and was residing in Belgrave Place, Pimlico. He painted some glass for Carlton House, Arundel Castle, and Donnington Hall. He died shortly before 1817.

HANDASYDE, CHARLES, miniature and enamel painter. Practised towards the end of the 18th century. In 1765 he received a Society of Arts' premium for an historical painting in enamel. He lived in Covent Garden between 1770-80. He exhibited with the Society of Artists in 1761 and at the Royal Academy in 1776, but not subsequently. He etched and mezzo-tinted his own portrait.

HANNAN, WILLIAM, decorative painter. Born in Scotland. Commencing life as an apprentice to a cabinet-maker, he encouraged a love of drawing, and was employed by Lord Le de Spencer at West Wycombe, where he painted several ceilings, which were chiefly copies from the designs of others. He, however, produced some original works, and some drawings made by him in the gardens at West Wycombe were engraved by Woollett, and published in 1757. His name appears in the Exhibition catalogue of 1769 and the following years. He died at West Wycombe about 1775.

• HANNEMAN, ADRIAN, portrait painter. Born at the Hague in 1611. He painted portraits and occasionally history. Studied the manner of Vandyck, and came to England in the reign of Charles I., and during a residence here of 16 years, part of which he was employed under Mytens, he painted many persons of distinction, whose portraits are preserved in family collections. He returned to the Hague, and there became the favourite painter of Mary, Princess of Orange, and was in 1665 director of the Academy. He died in 1680. His heads were very well drawn, coloured and expressed, his hands good, and his portraits generally agreeable. Sanderson speaks of him as the first who vamped up copies of the old masters and passed them off as the originals.

HANNEMAN, WILLIAM, portrait painter. Son of the foregoing. Was esteemed as a portrait painter in the reign of Charles I. He died young, and was buried in the church of St. Martin-in-the-Fields.

196

HARDING, J. W., engraver. Practised in the latter half of the 18th century, working in the dot manner, and was chiefly employed upon the works of Angelica Kauffman and some of her contemporaries. Six plates of 'Sketches in North Wales,' coloured to represent drawings, and published in 1810, are probably by him.

• HARDING, SYLVESTER, miniature painter. He was born at Newcastle-under-Lyme, July 25, 1745. Sent to an uncle in London at the age of 10 years, he was placed by him to a trade which he disliked —it is said to a hair-dresser—and at 14 he ran away and was not heard of for several years. He had joined a company of strolling players, and under an assumed name had played at Edinburgh, Glasgow, and London, but without any hope of success. His first attachment had been to art, and he left the players in 1775, began practice as a miniature painter, and came to London to follow that branch of the profession. From 1777 to 1787 he exhibited his miniatures at the Royal Academy. He was also a copyist in water-colour of old family portraits. A drawing by him, 'Portraits of Printsellers,' was engraved. He then entered upon a publication of some portraits in illustration of Shakespeare, 1793, many of which he engraved, and establishing himself in Pall Mall, he published, in 1795, 'The Biographical Mirror,' a work entirely got up by himself and his brother (who was afterwards appointed librarian to the Queen at Frogmore). He also published the 'Memoirs of Count de Grammont,' and made the designs for 'The Economy of Human Life.' He was well known to the collectors of his day. He died in Pall Mall, August 12, 1809.

HARDING, EDWARD, engraver. Son of the above. He engraved some of the works published by his father, and was rising in his profession, when, at the age of 20 years, he died September 11, 1796.

HARDING, GEORGE PERFECT, water-colour painter. Another son of the foregoing Sylvester Harding. He commenced art as a portrait painter, and from 1811 to 1840 was an occasional exhibitor of portraits at the Royal Academy. But he was distinguished by his minute and faithful copies in water-colours of many portraits in our public and private collections, which possess historical and antiquarian interest; of these, some were published by the 'Granger Society,' and the publication was continued, by subscription, by him for five years after the expiration of the Society. He also copied portraits for several historical publications, the series of portraits of the 'Deans of Westminster,' also for Neal and Brayley's 'History of the Abbey,' 1822-23; and 'The Sepulchral Brasses in Westminster Abbey,' 1825. He married

late in life and had a large family. Much reduced in means, his chief resource was in the disposal of his accumulated works, which were sold by auction. He died in Lambeth, December 23, 1853.

HARDING, JAMES DUFFIELD, *water-colour painter.* Was born at Deptford in 1798. His father was an artist, and had been a pupil of Paul Sandby. He was articled to an attorney, but he very early connected himself with art, and was an exhibitor of some views at the Royal Academy. In 1818 he gained the Society of Arts' medal for an original landscape, and the same year first appears as an exhibitor at the Water-Colour Society, sending 'Greenwich Hospital, Sunset,' and 'Windsor from the Great Park.' Continuing to exhibit, he was in 1821 elected an associate exhibitor, and the following year a member of the Society. He had begun life as a teacher of drawing, and at this time found full employment. In connection with his teaching he published 'Lessons on Art,' a 'Guide and Companion to Lessons on Art,' and 'The Principles and Practice of Art.' In 1830 he visited Italy, and on his return exhibited some Italian scenes. In 1836 he published 'Sketches at Home and Abroad;' and in 1842, 'The Park and the Forest.' He had painted in oil, and commencing in 1843, was for several years an exhibitor of landscapes in oil at the Academy, contributing also to the exhibitions of the Water-Colour Society up to 1847, when he withdrew from the Society to become a candidate for Academy honours ; but failing in this, he was re-elected a member of the Water-Colour Society in 1857. In 1861 he published 'Selections from the Picturesque.' He also lithographed a series of sketches after Bonington, an excellent work. He died at Barnes, December 4, 1863, and was buried at the Brompton Cemetery. He was a skilful and rapid draftsman, but mannered and feeble, with a tendency to a meretricious style. He was much connected with lithography, which his many publications stimulated and improved.

HARDWICK, THOMAS, *architect.* Was born June 1752, at New Brentford, where his father carried on the business of a builder. He studied architecture under Sir William Chambers and in the schools of the Royal Academy. He exhibited at the Royal Academy 1772-76, and in the latter year visited the Continent, being absent about three years and passing some time in Rome. On his return in 1799, he commenced the practice of his profession, and resuming his contributions to the Academy, which continued to the end of the century, he exhibited many important designs — among them, for a palace, a senate house, a public museum, and a public library. In 1790 he was employed to build the church of St. Mary, Wanstead. In 1795 he rebuilt, after the original design by Inigo Jones, the Tuscan church of St. Paul, Covent Garden, which had been destroyed by fire ; and was afterwards engaged in the erection and repair of several churches, among which the new church of St. Marylebone, a classic structure, was conspicuous. It cost 60,000*l.*, and was built 1813-17. In 1810 he was appointed clerk of the works for Hampton Court Palace. He died January 16, 1829, and was buried at Brentford.

HARDWICK, PHILIP, R.A., *architect.* He was born in St. Marylebone, June 15, 1792, son of the above, was brought up in his office, and in 1808 was admitted a student in the schools of the Royal Academy. He was an exhibitor in 1812-13-14, his principal works being a design for the lodge entrance of the Millbank Penitentiary and for a royal palace. In 1815 he visited the Continent, and after three years' study returned to England in 1818, and at once commenced the active practice of his profession. One of his first works was the large warehouses, with the dock house, for the St. Katherine's Dock Company, the designs for which he exhibited at the Academy in 1825 and 1830. This was followed by his works for the North-Western Railway Company, including the principal station in Euston Square and in Birmingham. One of his best works was commenced soon after—the new hall of the Goldsmiths' Company, a fine piece of Italian architecture. Of this he exhibited a portion of the interior in 1839 and 1842. He was then engaged upon the erection of a new hall and library at Lincoln's Inn, which his failing health compelled him to leave to the charge of his son Mr. P. C. Hardwick. Among his other works may be mentioned the Euston and Victoria Hotels, the Globe Insurance Office, and the City Club. He was elected an associate of the Academy in 1840, and a full member in 1841. He received the gold medal of the Institute of British Architects, and a gold medal at the Paris Exhibition of 1855. He was the architect of Bridewell and Bethlehem Hospitals, of the Goldsmiths' Company, and of the Commissioners of Greenwich Hospital. His infirm health had long precluded him from any active duty, when he died December 28, 1870, and was buried in the Kensal Green Cemetery.

HARDY, J., *portrait painter.* He practised in London towards the end of the 18th century. Several of his portraits are engraved, among them 'Lady Cavendish, when a child, playing with her Dog.'

HARGRAVE, JOHN, *sculptor.* Was one of the assistants to Nicholas Stone, the master-mason to James I.

197

HARGRAVE, ——, *mezzo-tint engraver.* He practised early in the second half of the 18th century.

HARGREAVES, Thomas, *miniature painter.* He was born at Liverpool in 1775, the son of a woollen draper. He early attempted miniature painting, and Sir Thomas Lawrence being shown one of his works advised him to come to London, and he was the president's articled assistant for two years, from May 1793, at a small weekly pay. He worked in oil and continued his employ for several years after the termination of the original engagement. But his health failing he returned to Liverpool, and devoting himself to miniature met with great encouragement. He sent some of his works to the Academy Exhibitions in 1808 and 1809. In 1811 he was a member of the Liverpool Academy, and from that year a large contributor to its exhibitions. He joined the Society of British Artists on its foundation, and was an influential member and one of its exhibitors. After many years of weak health he died December 23, 1846. His miniatures were well and carefully drawn and finished, but, imitations of the Lawrence manner, were without any marked character. Three of his sons succeeded him as miniature painters at Liverpool. One of them, G. Hargreaves, joined the Society of British Artists.

HARLOW, George Henry, *portrait painter.* He was born in St. James's Street, June 10, 1787, the posthumous son of an English merchant residing at Canton. His mother, a young and handsome widow, left with a competence, spoiled her good-looking boy. He had an early inclination for art, and was first placed under De Cort, then with Drummond, A.R.A., and finally, for about 18 months, in the studio of Sir Thomas Lawrence. Here he quarrelled with the mechanical art to which he was set and the cold courtesy of his master, and on leaving him (it is said he was dismissed) had to depend upon his own industry and ability. He painted at a low price small portraits of many of the actors of the day, and thus fell into their society, and being of an easy, careless disposition, soon became embarrassed in his affairs.

He first appears as exhibitor of a portrait at the Royal Academy in 1805, and from that time till his death was a constant contributor, his exhibited works, with three exceptions, being portraits. He met with full encouragement, and gradually raised his price to 40 guineas for a three-quarters portrait. In June 1818 he set off for Italy, and stayed some time in Rome, where he was much noticed and flattered. He arrived in England on January 13, 1819, and a few days after was attacked by the mumps, which having been checked and neglected, swelling and ulceration of the glands of the

198

throat ensued, followed by mortification. He died on February 4, and was buried in a vault at St. James's Church, Piccadilly. After his death a collection of about 150 of his works was exhibited.

Harlow's chief excellence will be found in his portraits. In 1815 he commenced a series, of small size, of the eminent painters and some of the notorieties of the day; they are refined yet broadly finished, and full of character. He also made portrait-sketches in chalk, slightly tinting the face, many of them admirable in taste and manner. Several of his portraits were engraved; of these, Miss Stevens, the singer, Mathews in character, and Northcote, R.A., were very popular. Two small groups of a portrait character, 'The Proposal' and 'The Congratulation,' were also engraved, and had an extensive sale. Of his historical attempts, the best known is his 'Trial of Queen Catherine,' in which the portraits of the members of the Kemble family are introduced, a work which was finely produced in mezzo-tint by Clint, A.R.A. This painting is clever, but more a tableau than a picture, reminding rather of the stage, the persons represented addressing an audience, than an historical event. His colouring and execution were good, but his drawing weak, owing to a neglect of early study. It is probable that his art would not have improved or his reputation have been increased had his life not been prematurely closed. There is a memoir of him in Arnold's 'Library of the Fine Arts,' 1831.

HARPER, John, *architect.* Born near Blackburn, Lancashire, November 11, 1809. He practised for some years at York, where he resided, and then travelled in Italy for his improvement. At Rome he was attacked with fever, and rallied sufficiently to set out for Naples, but he suffered so much from sea-sickness on the voyage that he died on reaching that city, October 18, 1842. He was a skilful draftsman, and left many clever sketches of architecture, antiquities, and landscape scenery. During his short career he built the Roman Catholic chapel at Bury, Lancashire, the Freetown church and Elton church in the same town, the York Collegiate School, and several mansions.

HARRADEN, R. B., *draftsman and engraver.* He produced very finely, in aqua-tint, several of Girtin's views of Paris, published 1802, and made the drawings for the 'Cantabrigia Depicta,' published in 1809 by his father, a bookseller at Cambridge. He became a member of the Society of British Artists, and exhibited there on two or three occasions. He continued a member up to 1849.

HARRIS, J., *water-colour painter.* He was one of the early artists who practised

water-colours in the tinted manner. He made some designs illustrating a Bible published by Reeves in 1802, and from that year to 1813 was an exhibitor at the Royal Academy of birds, insects, and rural and domestic subjects. He died 1834.

HARRIS, J., *engraver*. Practised towards the end of the 17th century. Works by him bear date from 1686 to 1700. His best plates illustrate a volume of 'Vitruvius Britannicus,' published in 1739. He was engaged with John Kip in engraving some views of gentlemen's seats.

HARRIS, Moses, *amateur*. Born in 1731. He was a member of a society of entomologists called the 'Aurelians,' and was engaged for 20 years, as a labour of love, in drawing, engraving, and colouring insects, chiefly moths and butterflies, which he published under the title of 'The Aurelian; or, Natural History of English Insects,' 1766. The insects were all drawn by him from the life, the engraving was his first attempt with the graver, and the colouring is very brilliant. The work is exceedingly well done, and considering the date is remarkable for its art. He afterwards published 'An Essay intended as a Supplement to the Aurelian,' 1766; 'The English Lepidoptera,' 1775-78; 'An Exposition of English Insects,' 1776; and a 'Natural System of Colours,' 1811. He exhibited a frame of English insects at the Academy in 1785.

HARRIS, Henry, *medallist*. He was employed in the Mint in the latter part of the reign of Charles II., and on the accession of James II. was appointed one of the die engravers. He was distinguished by his ability as an artist, but Walpole, confounding·him with Joseph Harris, an actor and dramatic writer at the Royal Theatre, says he was ignorant of art and incompetent. He died 1690.

HARRIS, W., *gem sculptor*. He exhibited at the Royal Academy, 1788-92, engraved gems. 'The Parting of Achilles and Briseis,' 'The Judgment of Paris,' 'The Entrance of Alexander into Babylon.' He was appointed gem sculptor to the Dukes of York and Clarence.

HARRISON, Mrs. Mary, *flower painter*. Was one of the original members of the new Society of Painters in Water-Colours, now called the Institute. Her fruit and flower pieces, unfailingly exhibited year after year, bore unmistakable marks of taste, feeling, and close observation of nature. Her first works, executed at the beginning of the century, followed the trim fashion of the time. Born in Liverpool in 1788, the daughter of Mr. Rossiter, a hat manufacturer, she married in 1814 Mr. Harrison, a gentleman in easy circumstances; he unfortunately, as his family increased, was induced to enter into a partnership which proved disastrous. He became a broken-spirited invalid, and the duty of providing for twelve children devolved upon Mrs. Harrison. This duty she bravely performed, and many of her loveliest works are pot boilers. Her husband died in 1861. She herself breathed her last on November 25, 1875, without a struggle, having previously ascertained that her pictures had been safely despatched to the winter exhibition of the Institute.

HARRISON, George H., *water-colour painter*. Son of the above. Was born at Liverpool in March 1816. He was early taught in art, and at the age of 14 came up to London, with some unsettled notions of being an engraver, and for a time supported himself by the sale of his drawings to the dealers. Afterwards he was engaged in making anatomical drawings and illustrations, and studied at the Hunterian Museum in Windmill Street. At this time he gained the notice of Constable, R.A., who advised him to sketch from nature. He was also a teacher, leading his pupils into the open fields. He was an exhibitor at the Royal Academy, chiefly in water-colours, from 1840 till his death. His works were chiefly landscape and domestic scenes. He had tried most subjects and many mediums, and was settling down to landscape. His foliage was luxurious and true, his figures well introduced. He was elected an associate of the Water-Colour Society in 1845, and was improving as an artist when, after much suffering, he died of aneurism, October 20, 1846.

HARRISON, Thomas, *architect*. Was born at Richmond, Yorkshire, 1744. He early showed a taste for drawing, and about 1769 was assisted by Lord Dundas to visit Italy, and studied for several years at Rome. While there he made some designs for the embellishment of the Square of Santa Maria del Popolo, for which the Pope presented him with a gold and a silver medal. He was also elected a member of the Academy of St. Luke. He travelled home through Italy and France, arriving in 1776, and was at that time an occasional exhibitor at the Royal Academy. Soon after he engaged to build a bridge of five arches over the Lune, a Lancashire river, and constructed the first level bridge erected in England. Having settled at Lancaster, he was employed to execute several extensive alterations at the old castle in that town, and afterwards built, on the panopticon principle, the gaol at Chester, and the court-house. He designed the bridge over the Dee, with an arch of 200 feet span, a dimension then unequalled. He also designed the Athenæum and the St. Nicholas's Tower in Liverpool, and the theatre; and in 1809 the Exchange Buildings in Manchester, the latter an early

attempt at classic design in this country. He built several mansions in Scotland, among them Broomhall, in Fifeshire, for Lord Elgin, then minister to the Porte, to whom he suggested to obtain casts of the marbles now in the British Museum, and known as the 'Elgin Marbles,' not supposing that the originals could be removed. After attaining much local reputation, he died at Chester, on March 29, 1829, aged 85.

HARRISON, STEPHEN, *architect.* He held the appointment of architect to James I. Some triumphal arches, which he erected on the entry of that king into London, have been engraved; but there is no record of any work by which he is distinguished.

HARRISS, D., *water-colour draftsman.* He practised in the early tinted style, imitating the manner of Malton, and his works possessed much merit. He exhibited a 'View of a Country Seat' at the Academy in 1799, and was then residing at Oxford.

HARTLEY, Miss M., *amateur.* She is remembered as having produced some clever etchings, among them a landscape dated 1761, and a portrait, from the life, of Buxton, an arithmetician, dated 1764.

HARVEY, Sir GEORGE, P.R.S.A., *subject and landscape painter.* Born at St. Ninian's, near Stirling, in 1805. He was early apprenticed to a bookseller, but soon evinced talents for drawing and a love of art. In 1823 he obtained admission to the Trustees' School in Edinburgh, where he worked diligently and made rapid progress, so that when the Scottish Artists, in 1826, determined to form themselves into a body on the model of the Royal Academy of London, they invited him to join them as an associate, and his contributions to their annual exhibitions won him his election as a full member in 1829. The wild scenery of his native land, and the struggles of its stern religionists with the Church and State, supplied Harvey with some of his best subjects, and the union of figures and landscape well suited his powers; such were 'Covenanters preaching,' 1830; 'Covenanters' Baptism,' 1831; 'The Battle of Drumclog' in 1835, etc. Some of these works were at once well engraved, and aided by the feeling which the writings of Scott (from which some of the subjects were chosen) had aroused, speedily gained great popularity. He exhibited for the first time in London in 1843, the subject being 'An Incident in the life of Napoleon.' Two of his pictures are in the Scottish National Gallery, 'Dawn revealing the New World to Columbus,' and 'Quitting the Manse.' On the death of Sir T. Watson Gordon, he was elected President of the Scottish Academy, and knighted by her Majesty in 1867. His pictures, though somewhat heavy in execution, are picturesque in com-

bination and rich in tone of colour. He died in Edinburgh, January 22, 1876.

HARVEY, WILLIAM, *wood engraver and designer.* Born at Newcastle-on-Tyne, July 13, 1796. He was apprenticed to Thomas Bewick at the age of 14, and chiefly employed during his apprenticeship upon common trade-work on copper and wood. He also assisted on his master's woodcuts for Æsop's 'Fables.' For his improvement he came to London in 1817, and placed himself under B. R. Haydon, continuing to work all the time as a wood engraver. In 1821 he cut Haydon's 'Dentatus,' a work which at once, from its ability and unusual size, gave him a reputation. Later he devoted himself to designing for illustrations both on wood and copper; and in 1824 abandoned wood engraving and at once found full employment in designing, his drawings on wood being especially adapted to the wood engraver's art. He designed for the illustration of the 'Babes in the Wood,' 'The Blind Beggar of Bethnal Green,' Hood's 'Eugene Aram,' and many other works. In 1840 he became largely employed for the illustration of works published by Charles Knight. Among his best designs may be cited his 'Arabian Nights' and the tasteful vignettes for Northcote's 'Fables.' He died at Richmond, where he had long resided, on January 13, 1866.

HASSEL, WILLIAM, *portrait painter.* Practised in miniature and oil towards the end of the 17th century. One of his portraits is engraved by Peter Vanderbank; and John Smith mezzo-tinted a portrait painted by him in 1707. He sat to Kneller for his own likeness. George Lambert was his pupil.

HASSELL, J., *draftsman and engraver.* He practised about the end of the 18th century. He drew and engraved 16 tinted aqua-tints for a 'Picturesque Guide to Bath and Bristol Hotwells,' 1793. To several of them Ibbetson added the figures and cattle, giving some spirit to an otherwise tame performance. He published, 1790, a 'Tour of the Isle of Wight,' with many aqua-tint plates, engraved by himself; in 1806, 'Life of George Morland;' in 1801, 'Callographia, or the Art of Multiplying Drawings;' and in 1820 a 'Progressive Drawing-Book,' in water-colours.

HASSELL, EDWARD, *landscape painter.* He was the son of an engraver. For several years he was an exhibitor at the Society of British Artists, chiefly of interiors of Gothic edifices. In 1841 he was elected a member of the Society, and exhibited the 'Interior of Gloucester Cathedral' and the 'Interior of Winchester Cathedral, William and Mary returning from the Altar.' In 1842 he contributed 'The Mountain Torrent;' in 1843 and 1844 he was a large exhibitor;

in 1850, 'Thames Craft, Moonlight,' and 'Winter Evening;' in 1852, 'Rochester, from Stroud.' This was his last exhibited work. He died shortly after. For some time he filled the office of secretary to the Society.

HASTINGS, Captain THOMAS, *amateur*. He was an associate of the Liverpool Academy. He held the office of collector of customs, and amusing himself as an etcher produced some good plates. In 1813 he published his etchings from St. Augustine's and other buildings at Canterbury, under the title of 'Vestiges of Antiquity;' and in 1825 his collection of etchings (39 in number) from the works of Richard Wilson, R. A.

HAUGHTON, MOSES, *enameller*. He was born at Wednesbury, Staffordshire, in 1734, and brought up as an enameller. Employed in ornamental work at a manufactory in Birmingham, he was led by his abilities to try art, and produced some good works, excelling in his still-life, dead game, &c., which were chiefly in water-colours, and close imitations to nature. He resided the greater part of his life at Wednesbury, and died at Ashted, near Birmingham, December 23, 1804.

HAUGHTON, MOSES, *portrait and subject painter*. Nephew of the foregoing. Was born at Wednesbury about 1772. Came to London, where he was the pupil of Stubbs, and, admitted a student of the Royal Academy, he gained there a competent knowledge of the figure. He exhibited two small subject pictures in 1792. He commenced his art as a portrait painter, chiefly practising in miniature. In this manner he showed much vigour and power, and his likenesses were marked by great character. He was an early friend of Fuseli, of whom he painted and engraved a portrait in 1808. He attempted some scriptural and rural subjects in oil. Two of his works, 'The Love Dream' and 'The Captive,' were engraved. He engraved himself (but it does not appear how far he practised this art) Fuseli's 'Death and Sin,' 'Eve's Dream,' 'The dismissal of Adam and Eve from Paradise,' and some other plates. He was a large exhibitor of miniatures at the Royal Academy, and continued to contribute to the Academy Exhibitions till 1848.

HAVELL, WILLIAM, *landscape painter*. One of 14 children, he was born at Reading, February 9, 1782. His father was a drawing-master there, and to make some addition to his professional gains kept a small shop. The son gained a good classical education at the well-known grammar school in the town. His father wished him to pursue the more certain gains to be made in the shop, but he longed to follow art, and seizing every opportunity to improve, surprised his father by his ability. Then allowed to take his own course, he made his way to Wales, and returned with a well-filled sketch-book. He first exhibited at the Royal Academy in 1804, and in the same year was one of the foundation members of the Water-Colour Society. To study mountain scenery he went to Westmoreland in 1807, where he remained for nearly two years, gathering rich stores for his future works.

He had now attained distinction as a water-colour painter, and practised his art with success, exhibiting at the Water-Colour Society, notwithstanding his secession on the alteration of the constitution of the Society in 1813, and also occasionally, sometimes in oil, at the Royal Academy. During this time he resided awhile at Hastings, going to Reading to assist his father when his uncertain health prevented his professional teaching, till 1816, when he was appointed draftsman to Lord Amherst's embassy, and sailed for China in the 'Alceste.' But he did not continue long in this office; an unfortunate quarrel led him to accept the opportunity of going, in 1817, to India, where he continued in the practice of his profession up to 1825, and realised a small property.

On his return he rejoined the Water-Colour Society, and in 1827 visited Florence, Rome, and Naples. But during his long absence in the East, added to his Italian travel, his art had become forgotten, his place filled by younger men, and after three years we miss his name in the Society's catalogues. Probably to regain his place in art he tried oil, and became a constant exhibitor at the Royal Academy of works in that medium, his subjects chiefly Italian, with occasionally one of his old English hill scenes in Wales or Westmoreland, or a Chinese subject. He had, however, to struggle hard to maintain his position; he was obliged to trench upon his small savings, and his trials were aggravated by the failure of an Indian bank in which they were invested. He, however, gained some relief as a recipient of the Royal Academy 'Turner Fund.' His long declining health gave way at last, and he died at Kensington, December 16, 1857.

Havell was one of the real founders of our water-colour school; his manner original, true to nature and characteristic, grand and massive in treatment, his colour powerful and good, his figures and cattle well drawn and grouped. His oil pictures show much excellence, and though rather yellow in tone and monotonous, the effect of sun and sunshine is admirably expressed.

HAVELL, JOHN, *engraver*. He was born and practised in London. His works evinced much talent, but when gaining a rank in his profession he suddenly suffered a loss of his reason some years before his death, which took place in 1841.

HAVELL, ROBERT, and HAVELL, DANIEL, *aqua-tint engravers.* They published in 1812 a series of 'Picturesque Views on the River Thames,' aqua-tinted by them jointly, from the drawings of W. Havell. Robert also engraved 'Views in India,' published in 1837; and Daniel published in 1826, 'Historical and descriptive accounts of the Theatres of London,' illustrated by views of each theatre, drawn and engraved by himself.

HAVENS, THEODORE, *architect and painter.* Practised in the reign of Charles II. There is in Caius College, Cambridge, a portrait of him painted by himself, and another portrait by him which bears the date 1653.

HAWARD, FRANCIS, A.E., *engraver.* He was born April 19, 1759, and in 1776 was admitted to the schools of the Royal Academy. He first exhibited in 1783, and from that year was an occasional exhibitor. His early and best works were in the mezzo-tint manner, but led aside by the popularity of Bartolozzi, R.A., he adopted the mixed style of that artist. He engraved chiefly after Reynolds, P.R.A., and Angelica Kauffmann, R.A. His 'Mrs. Siddons as the Tragic Muse,' 'Cymon and Iphigenia,' and 'Infant Academy,' are fine works, in the stipple manner. He died in 1797, in Marsh Street, Lambeth, where he had dwelt many years. His widow received the Academy pension during 42 years.

HAWKER, EDWARD, *portrait painter.* He succeeded to Sir Peter Lely's house and studio, but never enjoyed much reputation as an artist. A portrait by him of Titus Oates is engraved in mezzo-tint, as is also a full-length of the Duke of Grafton, and some others. He was admitted a Poor Knight of Windsor, and died about 1723, aged above 80.

HAWKSMOOR, NICHOLAS, *architect.* He was born at Nottinghamshire 1661, and at the age of 17 became the domestic clerk and assistant to Sir Christopher Wren, who employed him during the whole time of the building of St. Paul's, and in the erection of the many churches rebuilt at that time. He was also deputy surveyor at the building of Chelsea College, 1682–90, and clerk of the works of Greenwich Hospital, 1698. He overlooked the works at Kensington, Whitehall, and St. James's. Under George I. he was chief surveyor of the new churches then building, and on the death of Wren, of the works at Westminster Abbey.

Several of Queen Anne's intended 50 new churches were designed by him—St. Mary, Woolnoth; Christ Church, Spitalfields; St. George, Middlesex; St. Anne, Limehouse (1724)—one of his best works, unfortunately destroyed by fire in 1850; and St. George, Bloomsbury. In this latter

he aroused the critics by placing the King's statue on the apex of the steeple—an eccentric piece of originality, surely—which gave rise to a contemporary epigram:

'When Henry the Eighth left the Pope in the lurch
The Protestants made him the head of the Church;
But George's good subjects, the Bloomsbury people,
Instead of the Church, made him head of the steeple.'

He also built the library and quadrangle at Queen's College, Oxford: the towers and quadrangle of All Souls' College, Oxford, 1734; and several noble mansions, among them Easton Neston, in Northamptonshire.

He was an able constructor, learned in every science connected with his art; his buildings not without dignity; but in striving to be original, his novelty was scarcely architectural. He died at Westminster, March 25, 1736, and was buried at Shenley, Herts.

HAWTHORNE, HENRY, *architect.* Was appointed clerk of the works at Windsor Castle in 1575, and designed, in the Italian style, the gallery now forming the library. He also planned alterations on the terrace, and made some other improvements.

HAY, JAMES, *sculptor.* Was originally a pupil of President West, but showing a stronger inclination to sculpture than painting, he placed himself under Flaxman, R.A., and during two years made great progress in art. He also studied anatomy. He became the prey of a lingering illness, and died prematurely at Portsea, April 26, 1810, aged 28. A good portrait-group, believed to be by him, is engraved as the frontispiece to the 8th volume of Nichols's 'Anecdotes.'

HAY, RAMSAY DAVID, *ornamental painter.* He was born at Edinburgh in March 1798, and was apprenticed there to a heraldic and decorative painter. He tried some pictures, but was advised to confine his practice to ornamental art, which he adopted and followed all his life. He gained notice by his work 'On the Laws of harmonious Colouring,' 1828, which went through several editions. He afterwards published several other works on the Principles of Harmony, Form and Colour, and upon the Science of Beauty. He died at Edinburgh, September 10, 1866.

• HAYDON, BENJAMIN ROBERT, *history painter.* Was born at Plymouth, January 26, 1786, the son of a bookseller and publisher there, who claimed descent from an old county family. He was educated at the grammar school of the borough and at Plympton, and gained some small share of classical learning. He early attached himself to drawing, for which he showed some

ability and great enthusiasm, and disliking bookselling, his father at last consented that he might come up to London to study as a painter, and in May 1804 he entered as a student at the Royal Academy. His aims were high art, his views inflated, his nature self-willed and obstinate. In 1807 he exhibited his first picture, 'Joseph and Mary.' Then visiting Plymouth for a time, he made a purse by painting portraits among his friends.

Returning to London, he gained permission, which he used most vigorously, to study from the Elgin Marbles, and inspired by those great works, produced his 'Dentatus,' a commission from Lord Mulgrave. He believed that his picture was to produce a new era in art, and the place assigned to it in the Exhibition of 1809, with the subsequent rejection of his works, led to his quarrel in 1812 with the Academy. In 1810 he began his 'Lady Macbeth,' a commission from Sir George Beaumont, which he forfeited; and irritated, in debt, and refused further assistance by his family, he was plunged into difficulties, when he was partially relieved by a prize of 100 guineas awarded to him for his 'Dentatus' by the British Institution, and he commenced his 'Judgment of Solomon,' which he finished under great privations, and sold for 700 guineas, the Institution again awarding him 100 guineas for this work.

He now (1814) paid a visit to Paris, to study the great works in the Louvre. No commissions awaited him on his return; but not cooled in his enthusiasm, he commenced his great picture, 'Christ's Entry into Jerusalem,' to which he earnestly devoted himself, but was compelled to solicit assistance to enable him, under great privations, to continue his work. He had, in 1817, established a painting school at his residence in Lisson Grove, and had several pupils who rose to eminence. Resolutely presuming on the sensation created by his works, his ambition was to obtain distinction as a great historical painter; but he failed to gain the appreciation of the public. His 'Christ's Entry into Jerusalem' was completed in 1820, and its exhibition, at the Egyptian Hall, Piccadilly, produced him 1,700l. Though the picture did not find a purchaser, he at once commenced another great work, 'The raising of Lazarus,' comprising 20 figures, on a scale 9 feet high. This picture was exhibited in 1823, and attracted considerable attention. The composition is imposing, the incidents and grouping well conceived, the effect of colour good, in some parts excellent; but he had been arrested for debt during its progress, and the money received from day to day for its exhibition barely supplied each day's wants.

He was not yet 40 years old. He had produced his greatest works under painful difficulties, and the future offered no better prospect. In 1826 he finished his 'Venus appearing to Anchises,' followed by 'Alexander taming Bucephalus' and 'Euclus,' the latter a very good, pleasing work. But his difficulties again overcame him. He was thrown into a debtors' prison, and he appealed to the public for help. He said, 'My "Judgment of Solomon" is rolled up in a warehouse in the Borough; my "Entry into Jerusalem," once graced by the enthusiasm of the rank and beauty of the three kingdoms, is doubled up in a back room in Holborn; my "Lazarus" is in an upholsterer's shop in Mount Street; and my "Crucifixion" in a hay-loft in Lisson Grove.' His appeal produced a subscription which restored him to his art and his family. He commenced portrait painting, for which he was ill-suited both in art and character, and was reduced almost to actual want; and he painted his 'Mock Election' from a burlesque scene which occurred in the prison; and then, as a companion picture, his 'Chairing the Member.'

He had grown apathetic, his enthusiasm was damped, his misfortunes beginning to tell upon him, when the King purchased his 'Mock Election;' and the exhibition of that and the companion picture produced him a good sum; nevertheless he was, in 1830, a second time in prison for debt. On his release the excitement of the Reform Bill prevailed, and he fell in with the public feeling by painting 'Waiting for the Times,' and then 'The Reform Banquet,' a large portrait subject, a commission by Earl Grey. In 1835 his difficulties seem to have culminated; and in the following year he was, for the third time, a prisoner. He was assisted by the proceeds of a raffle for his 'Zenophon,' and took a prominent part before the committee upon the Royal Academy, of which Institution he was a bitter opponent. About the same time he commenced a series of lectures on art, and for the next two or three years by this means gained some help for the maintenance of his family.

He had been long a claimant for State patronage; and, as a means, had persistently advocated the decoration of our public buildings. When, therefore, a royal commission was issued for the decoration of the Houses of Parliament, he dreamt that his plans would be realised; and he eagerly entered into the cartoon competition in 1842. But he was doomed to disappointment, and as one young artist after another received some employment, and he was passed by, his spirits sank. He struggled to complete six designs for the House of Lords, as a sort of appeal; but the effort was too much for him; his mind gave way,

and on June 22, 1846, he died by his own hand, after making this sad notice in his journal, 'God forgive me! Amen. Finis. —R. R. Haydon. "Stretch me no longer on the rack of this rough world."—Lear.'

Haydon was from the first an enthusiast; he aspired to the first place in the highest walks of historic art; his attempts were unchilled by the severest trials. His works are marked by great merits and many faults. Commenced without due study, in the fervour of a first conception, and truly original, they are often wanting in composition and arrangement. With much knowledge of anatomy, his figures are frequently defective in proportion and drawing. His colouring was powerful and harmonious, sometimes brilliant; his execution hurried and incomplete, yet rapid and powerful. All must no less admit his great merits as a painter. He was a frequent contributor on matters connected with art. He wrote an essay on painting, in 1848, for the 'Encyclopædia Britannica,' which cannot claim the merit of a well-considered theme; and lectures on Painting and Design, which were published. His diary shows much of the excitement of an erratic genius and a painful record of trials and sufferings: it was evidently a record intended for the world, and was published in 1853. His widow was granted a pension by the Crown, and some additional provision made for his family by a public subscription.

HAYES, MICHAEL ANGELO, R.H.A. Was born in Waterford, July 25, 1820, and was the son of Edward Hayes, R.H.A., a clever water-colour painter of landscapes, figures and small portraits, and an exhibitor of works in oil of marine subjects for several successive years at the Royal Academy in London. His first contribution to the R.H. Academy was 'The Deserter' in the year 1840, and he became celebrated for military subjects in water-colour, though he subsequently painted in oil. He was an Associate of the Institute of Painters in Water-Colours in London, and was elected a member of the Royal Hibernian Academy in 1854, and fulfilled the duties of its secretaryship between 1856—1870. Some of his principal works are 'Charge of the 3rd Light Dragoons at Moodtree,' 'St. Patrick's Day at Dublin Castle,' and 'Installation of the Prince of Wales as Knight of St. Patrick,' in 1871. His death was the result of an accident, he was found drowned in a tank into which he had fallen from giddiness, and in falling had been stunned so that he could not struggle out. As an artist he showed considerable ability, and he was a conscientious student of nature. He died December 31, 1877.

HAYES, WILLIAM, animal painter. An industrious artist of the latter part of the 18th century. He published, in large folio, 1775, 'The Natural History of British Birds, accurately drawn and coloured from Nature;' and in 1794, 'Portraits of the rare Birds in Osterley Park,' in 41 numbers, containing 81 plates; but he never realised enough to keep a large family, and lived in much distress and difficulty.

HAYES, JOHN, portrait painter. He had considerable employment, and from 1820 was a constant exhibitor of portraits at the Academy. In his latter years he exhibited some subject pictures. He died June 14, 1866, aged 80.

HAYLEY, ROBERT, animal painter. He was born in Ireland, and was a pupil of the elder West in the Dublin Schools. He drew in black and white chalk in an original manner, having the appearance of mezzo-tint, both cattle and the human figure. His animals were freely and correctly drawn, and had much spirit. He died in Dublin about 1770, from a cold caught while sketching out of doors.

• HAYLEY, THOMAS, sculptor. The natural, or adopted son, of Hayley, the poet, who styled him 'his poetic child,' 'his youthful Phidias.' He was the pupil of Flaxman, and showed much ability, but died young, at Eartham, Sussex, May 2, 1810.

• HAYLS, JOHN, portrait painter. Born in England. He was the contemporary, and in some degree the rival, of Lely. He practised both in oil and in water-colours. Some of his best known portraits are of the Bedford family, and in the Woburn collection. He was an excellent copyist of Vandyck, and was employed by Pepys, who was pleased with his work. He died in Bloomsbury, 1679, and was buried in St. Martin's Church.

HAYMAN, N., portrait painter. There is a portrait by an artist of this name, of Tallis, the musician, who died 1585. It is engraved.

• HAYMAN, FRANCIS, R.A., history painter. Born in Exeter in 1708; he was descended from a respectable family. He commenced his art education as a pupil of Robert Brown, a portrait painter; came to London while young, and was employed by Fleetwood, the manager of Drury Lane, as scene painter. He was also much employed in the illustration of books, and designed for Sir Thomas Hanmer's edition of Shakespeare, 1744, and for editions of Milton, 1749, Pope, and Cervantes. He painted a series of historical designs for Vauxhall Gardens, which gained him a great reputation, and he was considered the first historical painter of his day. He was a tolerable draftsman, but was quizzed for his long noses and shambling legs. His colour was weak and ineffective. He was a member of the St. Martin's Lane Academy, for a short time president of the Incorporated

Society of Artists, and a contributor to their exhibitions in 1760–61 and 1764. On leaving that body he became one of the foundation members of the Royal Academy, contributing Scripture subjects to the exhibitions from 1769 to 1772, and was in 1771 appointed librarian. He was a member of the Beef-steak Club, the Old Slaughter's Club, and several other clubs; the friend of Hogarth and companion of the fast men of the day—a *bon vivant*, esteemed a good fellow, fond of athletic exercises. In his latter days he was a martyr to gout. He died in Dean Street, Soho, February 2, 1776, and was buried in the parish church. There is a painting of the 'Finding of Moses' by him at the Foundling Hospital, which he presented to the Institution; and in the National Portrait Gallery, a portrait of himself painting the portrait of Sir R. Walpole. He etched a few small plates.

HAYNES, WILLIAM, *engraver.* Born in Sussex; he was about 1800 in practice as an engraver in London. He engraved after Romney 'The Introduction of Slop into Shandy's Parlour,' and there is also a good plate by him of Louis XVI. and of Marie Antoinette. He afterwards painted some tolerable pictures.

HAYNES, JOHN, *engraver.* Many of the illustrations for Drake's 'Eboracum,' published 1736, are by him; but they are most faintful in their treatment and without merit.

HAYNES, JOHN, *painter and etcher.* Born at Shrewsbury in 1760. He came to London early in life, studied under Mortimer, A.R.A., and on his death was some time engaged in etching from his works, among them, 'Paul preaching to the Britons' and 'Robbers and Banditti.' He was afterwards known to Sir Joshua Reynolds, who allowed him to copy from his paintings. Later, he made an unsuccessful visit to Jamaica, and on his return retired to Shrewsbury, and afterwards to Chester, where he found his chief employment in teaching, and died December 14, 1829.

HAYNSWORTH, WILLIAM, *engraver.* Practised in the time of the Commonwealth, working with the graver. His manner was dark and stiff. An impression of his, 'Richard, Lord Protector of the Commonwealth,' a large whole-sheet print, sold for 42l.—rather from its rarity than its art—at Sir Mark Sykes's sale in 1824.

HAYTER, CHARLES, *portrait painter.* Practised about the beginning of the century in crayons and miniature, and was esteemed for the correctness of his likeness. His portraits were pleasing, but weak in drawing. He was teacher of perspective to the Princess Charlotte, and in 1813, published 'An Introduction to Perspective.' He was for many years an exhibitor of miniatures at the Royal Academy, contributing for the last time in 1832.

HAYTER, Sir GEORGE, Knt., *portrait and history painter.* Son of the above. He was born in London, December 17, 1792, and when very young was admitted a student of the Royal Academy. In 1808 he was rated as a midshipman in the Navy, but in the following year he returned to his art, and made rapid progress. For his picture of the 'Prophet Ezra,' in 1815, the directors of the British Institution awarded him a premium of 200 guineas. He practised miniature, and in 1815 was appointed painter of miniatures and portraits to the Princess Charlotte and the Prince of Saxe-Coburg; and the same year he went to Italy, and studied at Rome nearly three years. In 1820 he exhibited the portraits of some distinguished persons at the Academy, with a classic subject, 'Venus, supported by Iris, complaining to Mars;' and in 1825, his 'Trial of Lord William Russell, 1683,' a work full of figures, carefully grouped and painted, which was engraved, and made his art widely known. He afterwards painted 'The Trial of Queen Caroline' and 'The Meeting of the first reformed Parliament,' both pictures filled with portrait-groups, the latter is in the National Portrait Gallery. In 1826 he went a second time to Italy, returning in 1831, when he again appears as the contributor of portraits to the Academy Exhibitions. On the accession of Queen Victoria in 1837, he was appointed her portrait and history painter, and painted a large picture of her coronation in Westminster Abbey. The following year he exhibited her Majesty's portrait at the Academy, his last exhibited work, and in 1842 he was knighted. During his career he had a long list of very distinguished sitters. His portraits were pleasing and carefully painted, but did not possess any high art qualities. He was member of the academies of Rome, Florence, Bologna, Parma, and Venice, but did not gain admission to the Royal Academy. He died in Marylebone, January 18, 1871. He wrote an appendix to the 'Hortus Ericæus Woburnensis' on the classification of colours.

HAYTLEY, E., *portrait painter.* Practised in the middle of the 18th century. He exhibited some three-quarters portraits with the Society of Arts in 1761. There is by him at the Foundling Hospital a view of Greenwich Hospital and a view of Chelsea Hospital, which he presented. These works, dated 1746, are of small size, powerful in light and shade, agreeable in colour, and with figures well introduced. A very good whole-length portrait by him of 'Peg Woffington as Mrs. Ford' was mezzo-tinted by J. Faber in 1751.

205

HAYWARD, RICHARD, *statuary*. He was much employed towards the end of the 18th century, and exhibited some bas-reliefs with the Society of Arts in 1761. He died August 11, 1800.

HAYWARD, J. S., *amateur*. He was an occasional honorary exhibitor at the Royal Academy from 1805 to 1812, sending 'Diana and Actæon,' 'Breaking up the Camp, Southsea Common,' 'Mounts Bay, Evening, Fisherman preparing to go out;' and many views in Italy. His works were in water-colours, sketchy and powerful; his figures well drawn.

HAZLEHURST, THOMAS, *miniature painter*. He practised at Liverpool in the last half of the 18th century. Some of his earliest works are dated in 1760, and he continued to practice up to 1818, and exhibited at the Liverpool Exhibition. His miniatures are cleverly and highly finished, and are frequently signed with his initials, 'T. H.'

HAZLITT, JOHN, *miniature painter*. He was born at Wem, in Shropshire, the son of a Unitarian minister. He came to London shortly before 1788, and exhibited at the Royal Academy from that year to 1819. His works were confined exclusively to miniature. Some few of his latter works were in oil, and there is an oil miniature by him of Joseph Lancaster in the National Portrait Gallery. He did not attain to much excellence in his art. He died at Stockport, May 16, 1837, in his 70th year.

HAZLITT, WILLIAM, *artist and critic*. Younger brother of the above. He was born in 1778, and educated at the Unitarian College, at Hackney. He commenced life as an artist, and in some of his early studies showed much ability. He appears at the Academy in 1802 as an exhibitor of a portrait of his father, but he early renounced art for literature. He was distinguished by his numerous critical writings. Of those bearing upon art the chief were—'The Conversations of Northcote, R.A.,' 'Criticisms on Art,' 'A Translation of Quatremère de Quincy's work on the Madonnas of Raphael,' and Duppa's 'Lives of Michael Angelo and Raphael.' He died in Frith Street, Soho, September 18, 1830, and was buried in St. Anne's Churchyard, where a monument is erected to him.

HEAD, GUY, *portrait painter*. Born at Carlisle, where his father was a house painter. He was instructed in drawing, and showing much ability, he came to London and entered as a student of the Royal Academy, where he was noticed by Reynolds, and assisted by a friend to study in Italy. He contributed to the Spring Gardens Exhibition, in 1780, 'The Fire at London Bridge Waterworks,' and some small whole-length portraits. He resided many years at Rome, where he was settled

206

in 1794, and was employed largely in copying; but he painted some original works, which are not without merit. He returned home shortly after the breaking out of the French Revolution, and exhibited at the Academy two classic works and a portrait. He died suddenly in London, December 16, 1800. He is best known as a copyist. His works were sold by auction in 1805, but did not attract much notice. C. Turner engraved a horse's head after him.

HEAPHY, THOMAS, *water-colour painter*. He was born in London, December 29, 1775. His father was descended from a French family. He commenced life as an apprentice to a dyer, disliking which trade, he was transferred to an engraver, but his inclination was rather to painting, he employed his extra hours in its pursuit, and attended an art school of some repute in Finsbury. He married before his apprenticeship expired, had recourse to colouring prints to assist his young wife's maintenance, and tried his hand at portrait painting. In 1800 he exhibited at the Academy, for the first time, two portraits, and became a student in the schools. He continued an exhibitor, chiefly of portraits, till 1804, when he produced a subject picture, 'The Portland Fish Girl.'

He had made some successful attempts in water-colours, and was already popular in that art. In 1807 he was admitted an associate exhibitor of the Water-Colour Society, and in the following year a member. His 'Hastings Fish Market,' exhibited with the Society in 1809, was sold for 500 guineas, and raised him to the first rank in his art. He was appointed portrait painter to the Princess of Wales, whom he painted in miniature, and also many other distinguished persons; but his subject pictures gained less attention, and many remained unsold. He soon after (1812) left the Water-Colour Society, and, giving himself up to portraiture, he quitted England for the British camp in the Peninsula, where he was employed in painting the portraits of the officers, and continued with the army till the end of the war. On his return to England he painted a large picture of the Duke of Wellington and his Staff, a portrait composition, which was engraved, and had great success.

For some time after this he occupied himself in a building speculation at St. John's Wood, and his art was only practised occasionally. When he wished to resume it more actively, he was aware that his long absence had quite severed him from the Water-Colour Society, and he began to agitate most actively to found the Society of British Artists, and when formed was elected its president. He contributed nine works to the first exhibition in 1824, but from some misunderstanding left the Society in

1829. In 1831 he paid a short visit to Italy, and on his return he engaged actively in the formation of the new Water-Colour Society, and was one of its first members, but he did not long survive. He died November 19, 1835.

Heaphy was restless and intractable; always a zealous opponent of the Academy, though friendly with several of its members. His paintings were appreciated from their direct reference to nature, which he represented as it appeared to him. Though his subjects were not always agreeable, they never failed in character and expression. His colouring was good, his works sweetly and highly finished. Miss HEAPHY was an exhibitor of miniatures at the Royal Academy from 1822 to 1845; and Miss ELIZABETH HEAPHY, from 1838 to 1844.

HEAPHY, THOMAS F., *portrait and subject painter*. Son of the foregoing T. Heaphy. He began life as a portrait painter, and first exhibited at the Royal Academy in 1831, and in that and the following years his contributions were portraits. For the next ten years he did not exhibit, but in 1846 sent 'Mary Magdalene going to the Sepulchre,' and from that year was a constant exhibitor. In 1850 he sent the 'Infant Pan educated by the Wood Nymphs;' in 1854, 'Sketch from a fancy ball at the Tuileries;' but up to 1858 his works continued to be chiefly portraits and portrait groups. In 1863 he exhibited 'Kepler in poverty taken for a fortune-teller,' and then followed a series of the peasant girls of various countries. He was a member of the Society of British Artists, and possessed much literary ability as an art-critic in the periodical publications of his day. He died August 7, 1873, aged 60.

• HEARNE, THOMAS, *water-colour painter*. Born at Brinkworth, near Malmesbury, in 1744. He came to London young, and was intended for a trade, but an early taste for art gained him a premium at the Society of Arts in 1763, and led to his being apprenticed, in 1765, to Woollett, the engraver, with whom he continued six years, and assisted in many of his works. In 1771 he engaged to accompany the newly-appointed governor to the Leeward Islands, and during three years and a half was employed in making drawings of the islands under his government, their harbours, forts, and other characteristic features, and for nearly two years after his return was engaged in the completion of the work.

This employment gave a new direction to his art. He entirely gave up engraving, and devoted himself to water-colour painting. He was eminently a topographic draftsman. In 1777 he engaged with Wm. Byrne on their well-known work, 'The Antiquities of Great Britain,' and for this purpose made an extensive tour in England and Scotland, and exhibited his drawings for the work at the Spring Gardens Rooms. The drawings are 52 in number, and are dated from 1777 to 1781; the latter drawings exhibiting more artistic feeling, and all are of the highest interest. From this time, but at intervals, he contributed up to 1802 many drawings of views and antiquarian remains to the Academy Exhibitions. Following Sandby and Rooker, and next in succession to them, he greatly advanced the new art in water-colours. Though weak in colour, his truth and correctness of drawing, his tasteful finish and composition, added a new charm to the art. He used the pen, but less obtrusively than his predecessors, sometimes so tenderly in tint that, while adding greatly to the minute beauty of his architectural forms, it gives a most delicate sharpness and completion. He died at Macclesfield Street, Soho, April 13, 1817, aged 73, and was buried by his friend, Dr. Monro, in Bushey Churchyard.

• HEATH, JAMES, A.E., *engraver*. Born in London, April 19, 1757. Was articled to Collyer, then an engraver of eminence. His first works were several portraits to illustrate Lord Orford's Works and Correspondence. He was afterwards engaged upon the illustrations for Bell's 'Poets,' the designs of Stothard for the 'Novelist's Magazine,' and other works; and making this artist his especial study, he gained a great reputation, and by his talent and tasteful execution gave a great impulse to book illustration. He also engraved many small plates after Smirke. Among his larger works are 'The Death of Major Pierson,' after Copley; 'The Riots of 1780,' after Wheatley; 'The Dead Soldier,' after Wright, of Derby; and 'The Death of Nelson,' after West, P.R.A. In 1780 he exhibited engravings at the Spring Gardens Rooms. He was elected an associate engraver of the Royal Academy in 1791, and appointed engraver to the King in 1794. He lost a large property by fire in 1789, and nearly his own life in rescuing his infant child. He had long retired from his profession, when he died in Great Coram Street, November 15, 1834, in his 78th year. He left two sons, one of whom rose to the head of his profession; and a daughter, Mrs. Hamilton, who had some skill as an engraver.

HEATH, CHARLES, *engraver*. Youngest son of the foregoing. Excelled in his small plates, and was well known by his 'Annuals' and 'Book of Beauty.' He was one of the early members of the Society of British Artists, but soon left the Society. In his latter years he was chiefly engaged in arrangements connected with publications of the above class, in which his own graver had only a small share. He

engraved after Newton, R.A.; Lady Peel, after Lawrence; and 'Europa,' after Hilton, R.A. Mr. Doo and Mr. Watt were his pupils. He died November 18, 1848, in his 64th year, leaving a large family. One son was brought up as an engraver.

HEATH, WILLIAM, *draftsman.* Many humorous domestic subjects by him are published, with some military costumes, and he drew and etched the illustrations for Sir John Bowring's 'Minor Morals,' 1834, but his works were of a very mediocre class. He died at Hampstead, April 7, 1840, aged 45.

HEAVYSIDE, JOHN SMITH, *wood engraver.* Was the son of a builder at Stockton-upon-Tees. He did not try art till in his 26th year, and then after practising a short time in London he settled in Oxford, and was chiefly employed in the illustration of archæological works, especially those published by Mr. Parker. He died in Kentish Town, October 3, 1864, aged 52. His two brothers practised as wood engravers.

HEBERT, WILLIAM, *engraver.* He was a pupil of Vivares, gained a premium at the Society of Arts in 1760, and practised in London in the latter half of the 18th century. Six small landscapes, with buildings, by him were published in 1750.

HEIGHWAY, R., *miniature painter.* He was an occasional exhibitor at the Royal Academy between 1787 and 1793. He sent some miniatures and some rustic subjects. Some very clever miniatures on glass, painted on the reverse, are attributed to him. He used the reverse of the glass for an apparently rude painting, which had a good effect on the other side. During the above period he practised in London, Lichfield, and Shrewsbury.

HEINS, D., *portrait painter.* A native of Germany, who settled in Norwich, and practised there towards the middle of the 18th century. He painted the portraits of several members of the Corporation, and scraped some mezzo-tint plates, but without much merit. There are also some etchings by him. There was in the National Portrait Exhibition, 1868, a small, carefully-finished miniature in oil by him of the mother of Cowper, the poet.

HEINS, JOHN, *portrait painter.* Son of the foregoing. Born at Norwich about 1740; apprenticed to a stuff manufacturer, but led by his inclination, he followed his father's profession. He painted portraits both in oil and in miniature, but his chief excellence was in etching. His plates were executed entirely in dry point, without the use of aqua fortis, and were etched directly from nature. The views and monuments for Bentham's 'History of Ely' were by him, also a 'Cat and Kittens,' after Collet, and some portraits. He died of a decline

208

at Chelsea early in 1771. His art collection was sold by auction at Exeter Change in May of that year.

HEKEL, AUGUSTIN, *chaser and painter in water-colours.* Born at Augsburg. Was the son of a chaser, and brought up to that art. After working in several of the Continental cities he came to London, where he settled. He understood the figure, and had the reputation of being one of the best chasers of his time. Having acquired a competence he retired to Richmond, and amused himself by painting landscapes and flowers in water-colour, and occasionally sold these works, some of which were engraved for Bowles and Sayer. He also etched eight plates of Richmond and its environs, a 'Horse,' after Wootton, and a 'Book of Flowers.' A drawing of the 'Battle of Culloden' by him was engraved by Sullivan. He died at Richmond in 1770, at nearly 80 years of age. His sister, who was unmarried, drew the figure correctly, and engraved in a neat style many of the plates for Kilian's 'Bible.'

HEMSKIRK, EGBERT, *subject painter.* Born at Haerlem in 1645. Studied there and came early to England, where he was patronised by Lord Rochester. He painted pieces of Dutch humour, fairs, drunken scenes and the like. He died in London 1704, leaving a son, who followed the same profession, but turned a singer at Sadler's Wells, and became a dissolute fellow.

HENDERSON, JOHN, *architect.* He was born at Brechin 1804, and was a pupil of T. Hamilton. He was much connected with the revival of church building in Scotland. He built St. Mary's Chapel, Dumfries, 1837, three churches at Edinburgh, and St. John's, Glasgow, 1848. His best work is Trinity Church, Glenalmond. He died at Edinburgh, June 27, 1862, aged 58.

HENDERSON, JOHN, *engraver.* Was born in London in February, 1746, and was the son of an Irish Factor. He commenced life as an artist. He was a student in Shipley's School, and for a time a pupil of the eccentric Daniel Fournier, for whose 'Theory of Perspective' he etched many of the illustrations. In 1762 he gained, for a drawing, the Society of Arts' medal. But soon after abandoning his art, he went upon the stage, and became one of the most distinguished tragedians of the day. He died 1785. His brother was also apprenticed to an engraver, but died young.

▶HENNING, JOHN, *sculptor.* Was the son of a carpenter at Paisley, where he was born May 2, 1771, and was brought up to that trade. He cultivated a love of art, and in 1799 went to Glasgow, where he met with encouragement, and then removed to Edinburgh. Here he studied in the Trustees' Academy under Graham, and made many distinguished friends, of whom his

busts and medallions are remembrances. In 1811 he came to London, where his admiration of the Elgin Marbles gained him permission to copy them, and determined his stay in the Metropolis. After a diligent labour of 12 years he completed a restoration of the Parthenon and Phigalian friezes. He afterwards modelled in relief, in the same manner, the cartoons of Raphael. He was one of the founders, and for many years an influential member, of the Society of British Artists. He died in 1851, and was buried in the Cemetery of St. Pancras at Finchley. His works are plaster miniatures, modelled with great skill and minute accuracy.

HERBERT, ALFRED, *water-colour painter*. He was the son of a Thames waterman, and as a boy began life in his father's boat. He was appenticed to a book-binder, but an early love of art prevailed, and he cast in his lot as an artist. He drew vigorous coast scenes, with groups of figures and vessels under the influence of calm and storm, but his works only found a sale at a very small price, through a friendly dealer, who was almost his sole purchaser. Yet he was a frequent exhibitor. He first appears in 1844 and 1845 as a contributor of water-colour drawings to the Suffolk Street Exhibition, and in 1847 exhibited at the Royal Academy. His favourite subjects were found on the Thames—hay-barges, smacks, tugs. Woolwich Reach, Barking Reach ; and fishing boats on the Dutch and Norfolk coasts. His last contribution to Suffolk Street was in oil, ' French Boats Mackerel fishing,' in 1855 ; but he continued a yearly exhibitor at the Academy up to 1860, and died in 1861. Though he worked earnestly, and under the influence of true genius, he was unknown, and never made an income exceeding 50*l.* a year ; and it was not till his illness, which was followed by his death, that any brighter prospect opened to him. In the last year of his life his income rose to 200*l.*

HERBERT, ARTHUR JOHN, *subject painter*. Son of J. R. Herbert, R.A. Studied under his father and in the schools of the Academy, where he first exhibited, in 1855, ' Don Quixote's first impulse to lead the life of a Knight-Errant ;' and in the next year, ' Philip IV. of Spain knighting Velasquez.' He was a young artist of much promise. Died of fever in Auvergne, September 18, 1856, aged 22.

HERNE, WILLIAM, *serjeant painter*. He was appointed to that office by Patent of 14th Elizabeth, July 12, 1572.

HERRING, JOHN, FREDERICK, *animal painter*. He was the son of American parents, who had settled in London, where his father followed a trade. Born in Surrey in 1795, he began his art on signboards and the heraldry of coach panels ; and after a

time tried his fortune in Yorkshire. Led by his love of animals to Doncaster, he was employed in a stable, and afterwards, while still a young man, drove the coach between Wakefield and Lincoln, and then between York and London. All this time he devoted his leisure to painting, and the horses he drove were often his subjects. He soon gained notice, and then painted the hunters of the gentry and their racehorses. After receiving some help in the studio of A. Cooper, R.A., he established himself as an animal painter. For many years he painted the winner of the Doncaster St. Leger and Derby, and combining some subject with his art, painted ' Returning from Epsom on the Derby Day,' ' Market Day,' ' The Horse Fair,' and other works of the same class, several of which were engraved and were very popular. From 1826 his works, chiefly portraits of horses, found at intervals a place in the exhibitions of the Royal Academy. He was also an occasional exhibitor with the Society of British Artists, and in 1841 was elected a member of the Society, and exhibited with them ' A Mail Coach in the time of George IV.,' ' Bait Stables,' ' Country Stables,' and continued to exhibit up to 1852, when he ceased to be a member. He published ' The Horse ' in a series of 12 plates. He died at Tunbridge Wells, September 23, 1865, aged 70. He held the appointment of animal painter to the Duchess of Kent.

HERTOCKS, A., *engraver*. Born in the Netherlands. He practised in London towards the middle of the 17th century, his chief works being dated between 1626 and 1659. He engraved for the booksellers portrait frontispieces. His best works are portraits produced with the graver, but in a hard, stiff manner. There are also some miniatures by him. He was very weak in the figure. His works, known to collectors, are valued for their rarity alone.

HEWITSON, CHRISTOPHER, *sculptor*. He was born in Ireland, and went to Rome to complete his studies. He sent a bust to the Academy Exhibition in 1786, and again in 1790 ; and continued to reside in Rome in 1794, but did not exhibit further in London. There is a fine monument by him to Dr. Baldwin, at Trinity College, Dublin.

HEWLETT, JAMES, *flower painter*. He practised at Bath at the beginning of the 19th century. His works were esteemed in his day. He exhibited flowers and fruit at the Royal Academy from 1802 to 1807. His colour was good, his flowers well drawn, and botanically correct.

HEYWOOD, ——, *portrait painter*. Practised in the time of the Commonwealth, and painted the portraits of the distinguished men of that time ; among them General Fairfax.

HIBBART, WILLIAM, *portrait painter*

He practised chiefly at Bath, about the middle of the 18th century. There are several heads by him etched in the manner of Worlidge, and a very fine head of Lawrence Delvaux in Walpole's 'Anecdotes,' excellently treated.

HICK, ROBERT. 'The only *outer* and beginner of tapestry within this realm.' Employed at William Skelton's tapestry works at Barcheston, in Warwickshire : see his will, dated 1570.

HICKEY, NOAH, *sculptor*. Born in Dublin 1756. He was apprenticed to an eminent wood carver. After practising some time in Dublin, he gained the patronage of Mr. Burke, came to London, and was admitted a student of the Royal Academy. In 1778 he gained the gold medal for a bas-relief, 'The Slaughter of the Innocents.' In 1780 he exhibited for the first time at the Academy, and the same year was appointed sculptor to the Prince of Wales. He was greatly lauded by Burke, was of much promise, and had nearly completed a model for the Garrick monument, when he died, from the effects of intemperance, at his lodgings in Oxford Street, January 12, 1795.

HICKEY, THOMAS, *portrait painter*. Brother to the above. Born in Dublin. Studied in the Academy there, and afterwards visited Italy. Returning to London in 1771, he was appointed to accompany Lord Macartney's embassy to China. He practised in London in the latter part of the 18th century. He exhibited at the Academy, in 1775, a small whole-length of the Duke of Cumberland, and was a constant exhibitor at that time. There is a portrait of Mrs. Abingdon by him at the Garrick Club, and a good whole-length at the Magdalen Hospital. J. Watson mezzo-tinted a portrait after him.

HICKFORD, ——, *an English artist*, who resided in Florence about 1730-40, and was the first teacher of Cipriani, R.A. He was the brother of a well-known dancing-master, who built a large music-room in Brewer Street, Golden Square.

HIGHMORE, THOMAS, *engraver*. He was born in Suffolk, and was brought up as an engraver. His chief works were of an architectural character. He was employed upon a portion of the plate of 'The Coronation of Queen Victoria.' He died at Islington, January 3, 1844, aged 48.

HIGHMORE, THOMAS, *serjeant-painter to William III*. He was connected with the Thornhill family, and Mr. (afterwards Sir James) Thornhill served his apprenticeship to him, and succeeded him as serjeant-painter, 1719-20.

❧ HIGHMORE, JOSEPH, *portrait painter*. He was the son of a coal merchant and nephew to the preceding, and was born in London, June 13, 1692. He had an early

210

taste for the fine arts, which was discouraged by his family, who placed him, in 1707, with a solicitor ; but at the age of 17 he abandoned the law, and marrying the following year, trusted to art for the future. He was for 10 years a student in the Painters' Academy in Great Queen Street, and attended the lectures of Cheselden, the great anatomist, and made the drawings for his 'Anatomy of the Human Body,' published in 1722. He resided at first in the City, and was much employed in painting family groups. Then, his practice increasing, he removed to Lincoln's Inn Fields.

Upon the revival of the Order of the Bath in 1725, on a commission from Pine, the engraver, he painted the portraits of several of the knights, some of them whole-lengths ; and a portrait of the Duke of Richmond, attended by three Esquires, which is now at Goodwood. He also painted, for the King, a portrait of the Duke of Cumberland, which was mezzo-tinted by Smith. In 1732 he visited the principal galleries in Holland, and in 1734 made an excursion to Paris. In 1742 the Prince and Princess of Wales sat to him. He also produced some subject pictures, 'Hagar and Ishmael,' which he presented to the Foundling Hospital ; 'The Finding of Moses,' 'The Good Samaritan,' and others. He made the designs for the original edition of his friend Richardson's 'Pamela,' published in 1745, and painted the portraits of the author and his wife, which hang in Stationers' Hall. They are good specimens of his art ; in the Jervas manner, they are better in colour and more powerful, less hard in the face painting, the hands good, and well drawn.

He continued in practice as a portrait painter for 46 years, painting many persons of distinction, and in 1761 retired from the profession. His art collection was sold in the following year. He lived in his retirement at Canterbury, never revisiting the Metropolis, and died there March 3, 1780, in his 88th year ; he was buried in the south aisle of the cathedral. He was a keen geometer, and had some distinction as a writer. He published 'A Critical Examination of Rubens's Paintings at the Banqueting House, Whitehall.' 1754 ; 'Observations on Dodswell's Pamphlet against Christianity,' 'The Practice of Perspective,' 'Moral and Religious Essays,' and a translation 'On the Immortality of the Soul.'

HIGHMORE, ANTHONY, *landscape painter*. Was the son of the foregoing, and educated by his father for his profession, but his works are now unknown. Some views by him of Kensington and Hampton Court were engraved by John Tinney.

HILL, THOMAS, *portrait painter*. Born in 1661. Was taught drawing by Faithorne, and practised in London as a portrait painter about the beginning of the 18th century. There is a good portrait by him in the Bodleian Library, and a full-sized three-quarters portrait of Humphrey Wanley, dated 1711, in the possession of the Society of Antiquaries. He died at Mitcham in 1734. Many of his portraits are engraved; they are well coloured and painted, full of character and expression, but not elevated. His work has been attributed to Hogarth.

HILL, JOHN, *engraver*. He was a clever artist, and produced some good plates in mezzo-tint, among them some lake views, after Charles Dibdin. He emigrated to America, where he was living in 1822.

HILL, DAVID OCTAVIUS, R.S.A., *land-scape painter*. He was born in 1802, at Perth, where his father was a bookseller, and showing a taste for art was sent to Edinburgh to be the pupil of Andrew Wilson. Here he settled in the practice of his art, and painted the scenery of his own country. In 1830 he was one of the foundation members of the Royal Scottish Academy, and was elected to the office of secretary, which he filled till shortly before his death. His early pictures were illustrative of the manners of the Scottish peasantry. In 1843 he painted a large picture containing 470 portraits—'The Establishment of the Free Kirk.' His works were chiefly exhibited in Edinburgh, and were little known in London. He exhibited at the Royal Academy for the first time in 1852, 'Edinburgh, from Mons Meg, on the Queen's Birthday;' in 1861, 'The Castle of Dunure, Ayrshire Coast;' in the following year, 'The River Tay, with the Lower Grampians, Evening;' and for the last time, in 1868, 'The Vale of the Forth.' He took an active share in the warm controversy which arose as to the body by whom the Government art-patronage should be dispensed in Scotland. He published, in 1841, 'The Land of Burns,' a series of 60 landscapes. He had long been in failing health, and died at Edinburgh, May 17, 1870, aged 68.

• HILLIARD, NICHOLAS, *miniature painter*. Was born at Exeter 1547. His father was high sheriff of that city and county in 1560, and was reputed to have been descended from an old Yorkshire family, though his father and grandfather resided in the West of England. He was a younger son, and was apprenticed to a goldsmith; and carrying on that business he studied miniature painting, especially from the works of Holbein. He was appointed goldsmith, carver, and portrait painter to Queen Elizabeth, to make pictures of 'her body and person in small

compass in lymnynge only,' and the same office was continued to him by the patent of 15th James I., who also gave him during 12 years the exclusive privilege 'to mint, make, grave, and imprint any pictures of our image or our royal family.' This right he was empowered to sell and to enforce. He employed Simon Passe as his assistant in these works. He painted several portraits of Queen Elizabeth, one, we are told, a whole-length, in her state robes; a portrait of Mary, Queen of Scots, at the age of 18; and many of the notables of his time. He engraved the Great Seal of England in 1587. He died January 6, 1619, and was buried at St. Martin in-the-Fields. He was the first English painter whose contemporary reputation has been maintained to our day. His drawing was minutely careful and true, his colouring—the flesh tints particularly—was feeble, but has probably faded. He used opaque pigments largely, and gold occasionally in his draperies and jewelled ornaments, which were exquisitely finished and truthful.

HILLIARD, LAWRENCE, *miniature painter*. He was the only son of the above, and followed the same profession. That he was of good ability appears from a warrant of the Council in 1624, ordering the payment to him of 42*l.* for 'five pictures by him drawn.' He was living in 1634, and had three children born to him after that date. He enjoyed the exclusive patent granted to his father till the expiration of its term.

• HILLS, ROBERT, *water-colour painter*. Was born at Islington, June 26, 1769. He received some instruction in drawing from John Gresse; but little is known of him till he appears as an exhibitor at the Royal Academy in 1791, when he contributed 'A Wood Scene, with Gipseys,' and the following year a landscape. His name is next mentioned as one of the six artists who met in 1804, at Shelley's Rooms, to establish the Water-Colour Society. Of this body he was one of the first members, and for many years the secretary. To its exhibitions he was a constant contributor till 1818, when his name disappears in the catalogue for five years, during which time he exhibited six or seven drawings yearly at the Royal Academy. Then resuming his membership with the Society, he continued an exhibitor till his death.

Hills was most industrious in his labours. He exhibited at the Water-Colour Society alone 599 drawings. He made numerous etchings of animals, of which there is a collection in the print-room of the British Museum amounting to 1,240. He published, in 1816, in quarto, 'Sketches in Flanders and Holland,' with some account of a tour through those countries, illustrated by 36 aqua-tinted engravings, etched

by himself. He died at 17 Golden Square, May 14, 1844, and was buried in Kensal Green Cemetery.

He was an animal painter, confining himself exclusively to water-colours, but he placed his animals in sweet bits of appropriate scenery. He was a most painstaking sketcher of animals from nature, chiefly in pencil, with frequent indications of surrounding park or rural scenery. Many of his sketches are covered with hieroglyphic notes, apparently a sort of shorthand. From these stores he made his pictures, seldom painting direct from nature. This deprives his work of that clear, vigorous execution, the freshness, and the incidents, which no amount of knowledge can give in the studio. Yet there is great merit in the composition, character, and careful finish of his works. His later drawings, however, became woolly in appearance and over-wrought, hot, and disagreeably foxy in colour. His etchings show great character, but do not usually extend beyond the outline, with some slight indications of light and shade. He often worked in connection with Robson and sometimes with Barret.

HILTON, WILLIAM, *portrait painter*. Born at Newark. He painted the scenery for a company of actors who played at the chief towns in the Eastern counties, and afterwards practised as a portrait painter at Norwich, and for a time at Lincoln and in London. He exhibited portraits at the Academy in 1776 and 1783. He died 1822.

HILTON, WILLIAM, R.A., *history painter*. Son of the above. Was born at Lincoln, June 3, 1786. His father purposed to apprentice him to a trade, but he showed an early attachment to art, and upon his earnest entreaties, and by the assistance of friends, he was taught drawing, and became the pupil of Raphael Smith, the mezzo-tint engraver. In 1806 he entered the Academy Schools, and at the same time studying anatomy, he soon mastered the figure. His first known works are a series of well-finished designs in oil for an edition of 'The Mirror,' and for 'The Citizen of the World.' He painted the portraits of one or two friends, but did not seek to eke out his means by portraiture, though they were evidently straitened.

He first appears as an exhibitor as early as 1803, and continued to contribute a classic or historic work up to 1811, when he appears with an 'Entombment of Christ,' for which he was awarded a second premium by the British Institution, having received a premium of 50 guineas in the previous year. This work was followed by 'Christ restoring sight to the Blind,' and 'Mary anointing the feet of Jesus,' and for this latter work he was fortunate to

find a sale to the directors of the Institution, who in 1825 purchased also his fine work, 'Christ crowned with Thorns.' Though his art was not of a class to be popular, his great merit was early recognised by his professional brethren. In 1813 he was elected an associate of the Academy. In 1818 he visited Italy, saw the Art of Rome, and in 1820 gained his full membership. At this time he produced some of his best works, exhibiting one picture annually—in 1821, 'Nature blowing Bubbles for her Children;' in 1823, 'Comus, the Lady in the Enchanted Chair;' in 1825, 'Christ crowned with Thorns;' in 1827, 'The Crucifixion.'

He was, both by his acquirements and disposition, well fitted as a teacher, and in 1827 was selected for the office of keeper, and continuing to paint great works, he exhibited, in 1831, his 'Sir Calepine rescuing Serena' and 'The Angel releasing St. Peter from Prison;' in 1832, his 'Una' (engraved for the Art Union); in 1834, his 'Editha seeking the dead body of Harold,' for which the directors of the Institution awarded him a complimentary sum of 100*l.*; and in 1838 his last work, 'Herod.' He had in 1828 married the sister of his friend and pupil, Peter de Wint, but had the misfortune to lose his wife in 1835. Naturally reserved and silent, shunning all notoriety, the loss fell heavily upon him; it aggravated an asthmatic complaint from which he suffered. He lost vigour and spirits, and though eager to work, he became unable to finish anything; and wasting away, he died December 30, 1839, in his 54th year. He was buried in the yard of Savoy Chapel, Strand.

The neglect and want of appreciation of his works must have weighed heavily upon him, and it is probable prevented the full development of his powers. On his death several of his finest works remained unsold, and the students of the Academy expressed their regard for him by purchasing and presenting to the National Gallery his 'Sir Calepine.' This, and other works, will not fail to maintain his reputation if they will endure; but they are suffering from the unfortunate pigments, chiefly asphaltum, which he employed. The 'Sir Calepine' and his 'Editha,' also in the National collection, are falling into hopeless decay. His great triptych, 'The Crucifixion,' at Liverpool, is also in a state of dilapidation. It is a noble work, grand in its conception and treatment; the action of his figures fine, the drawing good, and more original than his Scripture subjects generally, which have a leaning to precedent.

HINCHLIFFE, JOHN ELLEY, *sculptor*. Was for the 20 years preceding the death of Flaxman, R.A., his chief assistant, and after his death completed several of his

unfinished works; among them the statue of John Kemble, in Westminster Abbey. He exhibited at the Academy, commencing in 1814, many groups in high art—'Christ fighting with Apollyon,' 'Leonidas at Thermopylæ,' 'Venus and Aurora as the Morning and Evening Stars.' About 1818 he tried a few busts, but after 1820 his contributions, which ceased about 1850, were entirely monumental figures or bas-reliefs for monuments. He died, aged above 90, about 1867.

HINCKS, WILLIAM, *engraver and painter.* He was born at Waterford, and was apprenticed to a blacksmith. Self-taught, he tried art, and practised towards the latter part of the 18th century. While in Ireland he drew and engraved in the dot manner a series of designs representing the progress of the linen manufacture, published in 1782. On coming to London, he designed some illustrations for an edition of 'Tristram Shandy.' He first exhibited at the Academy in 1781, and was an occasional exhibitor, sending in 1784 an allegorical painting. He tried both history and portrait, and from 1785 to 1790 exhibited miniatures. He exhibited for the last time in 1797, and was living in London at the close of the century.

HINDE, T., *engraver.* He practised about the middle of the 17th century, chiefly in portraits.

HIORNE, FRANCIS, *architect.* Was born at Warwick in 1741, and was reputed one of the early students of Gothic. His church at Tetbury, Gloucestershire, is an instance of his ability. He also built, 1776, the church at Stony Stratford. The mansion at Foremark, Derbyshire, and the gaol, sessions house, and town hall, at Warwick, are designed by him. He died December 9, 1789, at Warwick, and was buried there.

HIXON, JAMES THOMPSON, *water-colour painter.* He was in 1866 elected an associate member of the Institute of Water-Colour Painters, and in the following year, whilst residing at Algiers, he sent six Algerine scenes to the Society's Exhibition. He was of promising abilities, but died of pulmonary consumption, at Capri, July 30, 1868, aged 32, and was buried in the Protestant Cemetery at Naples.

HOADLY, Mrs., *portrait painter.* See CURTIS, SARAH.

• HOARE, WILLIAM, R.A., *portrait and history painter.* Was born at Eye, in Suffolk, 1706. He received a liberal education, and then studied art under Grisoni, an Italian, practising in London. He afterwards went to Rome, where he availed himself of the opportunities for improving in art; and, after nine years spent on the Continent, returned to England and settled at Bath, where he established himself as a

portrait painter, practising both in oil and in crayons, and finding among his sitters some of the most distinguished visitors. He wished to follow the grand style, but met with no encouragement. He painted, however, an altar-piece for St. Michael's Church, Bath, and also for the Octagon Chapel in that city, as well as a picture for the hospital there; but these works, if they still exist, do not possess much merit. He was one of the foundation members of the Royal Academy, and contributed to its exhibitions portraits (full-lengths) and groups, with some classic designs in crayons, exhibiting for the last time in 1779. He died at Bath in December 1792. There are a few known etchings by him.

• HOARE, PRINCE, *portrait and history painter.* Son of the foregoing. Was born at Bath in 1755, and studied art there under his father. In 1772 he gained a Society of Arts' premium, and at the age of 17 came to London and entered the schools of the Academy. In 1776 he was sent to Rome, where he was the pupil of Mengs, and was diligent in copying the great works. He returned to London in 1780, and for a time practised his profession, exhibiting at the Royal Academy in the following year; and in 1782, a classical attempt, 'Alceste, devoted to death, recommends her children to Vesta.' He also painted a portrait of Sir Thomas Lawrence, when a child, which was engraved by Sherwin; and up to 1785 exhibited a portrait and a subject picture at the Academy. But it seems his return had been heralded by expectations he did not fulfil. He ceased to exhibit, and ill-health, probably added to want of success, induced him to make a voyage to Lisbon. He returned in 1788, and when he again settled in London, he tried literature, and wrote some successful comic operas, producing, between 1788 and 1799, 20 plays, chiefly musical farces, one of which at least, 'No Song, no Supper,' continues to hold its place on the stage.

In 1799 he was appointed to the honorary office of foreign corresponding secretary to the Royal Academy. He wrote several works connected with the fine arts—'Academic Annals,' 'Inquiry into the present State of Arts of Design in England,' 1806; 'The Artist,' a collection of essays, 1809; and in 1813, 'The Epochs of the Fine Arts.' He died at Brighton, aged 80, December 22, 1834.

HOARE, Sir RICHARD COLT, Bt., *amateur.* Born in 1758, and succeeded to the baronetcy in 1787. He drew many of the views to illustrate Coxe's 'Historical Tour in Monmouthshire,' published in 1801; but was known by his landscapes as early as 1780. He went to Rome with Lord de Tabley, and with him sketched the antique ruins and scenery. He died 1841.

213

HOARE, ——, *engraver*. He practised in the time of Charles I. He engraved some of the sketches made in Italy by Mr. Evelyn, and was of some repute.

HOBDAY, WILLIAM ARMFIELD, *miniature and portrait painter*. He was born in 1771, at Birmingham, where his father had realised a good property in manufacture. An early talent for drawing was encouraged, and he was placed under an engraver; but he did not like the art, and left his master in the sixth year of his time, and at once commenced painting small portraits in water-colours and miniatures, which he exhibited at the Academy in 1794-95-96. He came to London, and though he met with good encouragement, and added considerably to the allowance made to him by his father, yet he rushed into society and expense, to the neglect of his art, and in his falling fortunes married, and increased in extravagance. He went yearly to Bristol and to Bath, where he found much employment, and eventually, about 1802, settled at Bristol. where he painted during 14 years, was well supported, and made large gains. But in 1818 he returned penniless to London, and took a large house. His art could not, however, maintain his extravagance; he sold pictures by commission, and engaged in other speculations, finishing by bankruptcy in 1829; but his property did not realise a dividend, and, ruined in fortune and in spirit, he died February 17, 1831. He painted many portraits and portrait-groups of large size, and some subject pictures, and he received large prices for his pictures. Several of his works were engraved.

HODGES, CHARLES HOWARD, *portrait painter*. Born in England in 1774. He passed the greater portion of his life in Holland, and did not exhibit his works at the London Exhibitions. His portraits were life-like, well-drawn, and possessed much merit in tone and colour. He was also a good mezzo-tintist, and imitated Reynolds with great tenderness and expression. He produced some clever plates, vigorously treated, after the Dutch masters. He died at Amsterdam in 1837, aged 63.

HODGES, JOHN, *engraver*. He was a mezzo-tint engraver, and excelled in that art. His best plates are after Sir Joshua Reynolds's 'Beggar Boy, Boy with a book,' 1794; and 'Hercules strangling the Serpents.' He died in August 1802.

HODGES, WILLIAM, R.A., *landscape painter*. Born in London 1744, the son of a blacksmith, who kept a small shop in Clare Market. He gained some instruction in Shipley's drawing school, where he was originally employed as errand boy, and was noticed by R. Wilson, R.A., who took him to be his assistant and pupil. He made rapid progress, and quitting his master he found some employment as scene painter to the theatre at Derby, where he continued some time. He exhibited at the Spring Gardens Rooms in 1770 and 1772, and in the latter year was appointed the draftsman to Captain Cook's second expedition; returning after three years' absence, he was engaged by the Admiralty in completing his drawings and superintending their engraving. In 1776 he first exhibited at the Royal Academy, and then and in the two following years sent views in Otaheite and New Zealand, with some English views. About this time he married, but losing his young wife he was induced to go to India under the patronage of Governor Hastings. Here he acquired some money, and in 1784, on his return, he exhibited views in India, to some of which Gilpin added the animals. He also married a second time, and again, after a few months, losing his wife, he married a third time.

In 1786 he was elected an associate, and the following year a full member, of the Royal Academy. He made a tour on the Continent in 1790, collected some sketches on the Rhine, and also visited St. Petersburg. When the Pantheon was converted into a theatre for operas, on the destruction of the Opera House by fire, he was appointed the scene painter, but did not show much ability for this art. His works are mostly from nature; with some appearance of power, they are loose and unsatisfactory in their execution, and monotonous in colour. His best productions are the views he brought from India, and a view of Windsor from the Great Park. He painted several subjects for Boydell's 'Shakespeare,' but they are mere landscapes, with Shakespeare incidents introduced. Two of his pictures of this class — 'The Effects of Peace and War,' are in the Soane Museum. He continued to exhibit many works up to 1794, when his contributions to the Academy ceased. He published four views of India, engraved by different artists; a collection of views in India, in great part aqua-tinted by himself; and his travels in India, illustrated by his drawings. A collection of 25 of his paintings were exhibited in Bond Street, which did not meet with support, and on its close he retired from the profession. His works were then sold by auction, but produced only an inconsiderable sum.

He endeavoured to retrieve his fortune, which had become impaired, it was said by his publications, by establishing a bank at Dartmouth, where he settled in 1795, but completely ruined himself in this undertaking. His losses impaired his health, and he died at Brixham, February 27, 1797, leaving a wife and family without any provision.

HODGINS, HENRY, *scene painter*.

Hodgetts Thos. painter & Engraver — 1830

Born in Dublin. Was a pupil of Robert Carver, and was for many years engaged at Covent Garden Theatre as one of the principal scene painters. Died at Maidstone, September 11, 1796.

HODGSON, CHARLES, *draftsman.* An artist of the Norwich School, who was principally occupied in teaching early in the 19th century. He was a contributor, chiefly of interiors, by which he is best known, to the exhibitions of the Norwich Society, as was also his son David.

HODGSON, THOMAS, *wood engraver.* He gained a premium at the Society of Arts in 1775, and was employed in 1776 by Bewick, who was then in London. His name appears to one of the plates to Hawkins's 'History of Music.' He was also a publisher.

HODGSON, EDWARD, *flower painter.* Born in Dublin. He practised in London, painting with much ability both fruit and flowers, in the last half of the 18th century. He exhibited with the Free Society in 1782 and 1783, also at the Royal Academy in 1781 and 1782, and again in 1788. He was treasurer to the Associated Artists of Great Britain. He died in Great Newport Street, London, in 1794, aged 75.

HOFLAND, THOMAS CHRISTOPHER, *landscape painter.* Was born at Worksop, Nottinghamshire, December 25, 1777. His father was a cotton manufacturer there, and removed with him to Lambeth about 1790, and soon after failed. He was then in his 19th year, and self-instructed, tried landscape. Devoting himself to the study of his art, he was assisted for a few months by Rathbone, and then had recourse to teaching as a means of existence. He was a volunteer in the King's Own Company at Kew, where he resided from 1799 to 1806, and having attracted his Majesty's notice, he gave him a commission to make drawings of the rare plants in the royal collection; and afterwards made some other attempts to promote his interests. He had during the above period exhibited at the Royal Academy; and about this time he went to the North of England, and then became a member of the Liverpool Art Academy. An opening for a teacher at Derby led him to that town, where he resided for some short time. But coming up to London to copy as a student at the British Institution, his love of art prevailed, and in 1811 he returned to the Metropolis at the close of that year, resumed his contributions to the Academy Exhibitions, and was successful in his works.

In 1814 he received the award of 100 guineas by the governors of the British Institution for his painting, 'A Storm off the Coast of Scarborough,' which was purchased by the Marquis of Stafford; and the copies he made from the great masters

in landscape found ready purchasers. About 1815 he removed to Richmond, and in 1817 to Twickenham. At this time he received a commission from the Duke of Marlborough to paint a series of pictures of his seat of White Knights. To this he devoted himself for several years, and also made himself responsible to the engravers employed upon the work, to his sad disappointment and loss. Driven back to London by this in 1823, he again engaged in teaching, but not leaving his easel he painted several pictures carefully from nature, and produced some of his best landscapes — 'A Lake view of Windermere,' 'Jerusalem at the time of the Crucifixion,' with some moonlight and lake views; 'Windsor Castle by Moonlight,' 1823; 'Llanberris Lake,' 'Twilight,' 1833. He was now in his 63rd year, and was enabled by the sale of his works to visit Italy. He made some good sketches, but unfortunately attacked by fever at Florence, he hastened home, quite broken in health. He was a foundation member and active supporter of the Society of British Artists, and a large contributor to the Society's Exhibitions. He lived successively at Kensington, Hammersmith, and Richmond, where he lingered for about two years, then went to Leamington, and died there January 3, 1843, aged 65. His art was peculiar. His aim was to convey poetical impressions, but he never rose to the first rank, probably kept back by the many struggles and difficulties which he had to encounter. An enthusiastic angler, he wrote, 'The British Angler's Manual,' 1839; and was generally a well-read man. His widow, who did not long survive him, was well known by her literary abilities.

HOGAN, JOHN, *sculptor.* He was born in October 1800, at Tallow, Co. Waterford, where his father was a builder. His mother was a descendant of the Irish Lord Chief Justice Cox. He was placed in 1812 in an attorney's office at Cork, but he had found means to draw in the Academy there, and at the end of two years he quitted his employment and gained admission to an architect's office. Almost untaught in art, he produced at this time a wood carving in basso-rilievo, 'The Triumph of Silenus,' a group of 15 figures. Studying anatomy he improved in his power, and executed several other carvings, both in wood and stone. In 1823 he modelled a 'Minerva' of so much promise that his friends in Ireland attempted to raise a fund to take him to Rome. The subscription was headed by the Royal Irish Institution and the Dublin Society, and 250*l.* were raised, to which Sir John Fleming Leicester added an allowance of 50*l.* a year for three years. He set off for Rome in November of the same year. His first production there was his 'Eve picking up a dead Bird,' which was

215

followed by his monumental group to the memory of Dr. Doyle, a fine work, which gained him admission as an associate of the College of Art at Rome. He next completed his statue of O'Connell, now in the Exchange at Dublin, and 'The Drunken Faun.' After some stay his funds failed him, and he was again, and unsolicited, assisted by his Irish friends and Sir John Fleming Leicester. On his return he practised in Dublin. Irish in all his associations, he was called 'The Irish Sculptor.' He only exhibited at the Royal Academy on two occasions, in 1833, when he sent a 'Marble figure of the Redeemer after Death,' and in 1850 two busts and the model of a mural monument. He died in Dublin, March 27, 1858, in his 57th year, and was buried in the Glasnevin Cemetery. He left an Italian lady, whom he had married, unprovided for, a widow with 11 children. The Queen granted her a pension of 100l. on the Civil List.

• HOGARTH, WILLIAM, *subject painter.* His father, Richard Hogarth, was educated at St. Bees, Durham, and kept a school in that county. He was a man of some learning, came to London early in life, and opened a school in the Old Bailey. He was also employed as a corrector of the press. He published, in 1712, 'Grammatical Disquisitions,' styling himself 'Schoolmaster;' compiled a Latin Dictionary, and some other works. He died about 1721. Of his son William's early life only scant particulars exist. He was born in London, Dec. 10, 1697, and was baptized at the Church of St. Bartholomew, Smithfield, and apprenticed to a silversmith, to learn the art of engraving arms and cyphers on plate. But he was a youth of a strong and original mind, and soon showed indications of a genius above such work.

On his completion of his apprenticeship, he became a student in the St. Martin's Lane Academy, where he gained such a knowledge of drawing as enabled him to express his ideas. About 1720 he engaged in business for himself, which at first was confined to his master's trade; but in 1723 he both designed and engraved 12 plates for De la Mottraye's 'Travels.' This work was followed by seven small plates for Apuleius's 'Golden Ass,' and in 1725, by the head-pieces for Beaver's 'Military Punishments of the Ancients.' He also designed and engraved the illustrations for an edition of 'Hudibras,' with a portrait of Butler. At the same time he painted portraits, for which he had shown an aptitude by his power of seizing a graphic likeness, and gave a novelty to his work by producing small characteristic groups, which obtained the designation of 'conversation pieces.' The spirit of art was soon aroused in him, and, self-reliant and determined in 216

his pursuits and opinions, he was destined to produce an entirely original art, and casting aside all the old traditions, to lay the broad foundations of the English school.

His disposition is shown in the incidents of his life. He ran away, in 1730, with Sir James Thornhill's daughter, when in her 19th year. He resolutely maintained his own original style of painting against his professional brethren — even influencing them to turn to nature for their art. He successfully asserted his rights in a court of law, and was the means of obtaining from Parliament a copyright act, to defend the property of art. He did not fear to aim his graphic attacks at Wilkes, Churchill, Pope, Warburton, Kent, and others who could retaliate. He is said to have drawn his brush across his friend Garrick's portrait on some dispute about the likeness; and there is another well-known portrait, through which, on some similar provocation, he had run his knife. Steevens says he had not received a liberal education, yet it is hardly probable that his father, who was both a scholar and a teacher, left him without such knowledge as could be gained before his prentice days. Opposed to academies and to the foundation of a Royal Academy, he became a member in 1760 of the Society of Artists, which, on his motion, was entitled 'The Free Professors of Painting, Sculpture, and Architecture.' But it does not appear that he showed any further interest in the young society, and his name does not continue on the list of members in the following year.

At the time of his marriage, Hogarth had commenced his 'Harlot's Progress,' and the work, which was completed in 1733, is said to have appeared his wife's father. The painter here invented his own story, and first carried out, as he tells us he wished, his design 'to compose pictures on canvas, similar to the representations on the stage, and that they should be tried by the same test and criticised by the same criterion.' This truly original work, both in conception and execution, he followed up by another story of the same class, 'The Rake's Progress;' and in 1745 he completed his 'Marriage à la Mode,' in which his art culminated. Divided into six acts or tableau, the story of youth sacrificed to rank, with its sad moral, is well and touchingly depicted. Every incident tends to the climax; every accessory, even the smallest, contributes its share to the story; the background itself studiously combines to fill its part in the drama.

Such was Hogarth's true art, on which his imperishable fame will surely rest. But he was tempted to enter into competition with the other painters of his day, and to try subjects of high art. For this he was unsuited, and brought upon himself much

severe criticism by his 'Paul before Felix,' 'Moses brought to Pharaoh's Daughter,' 'The Good Samaritan,' 'Sophonisba,' and some others, which possess none of the qualities of this class of art, and into which some marring incident was sure to creep. Hogarth found his engravings more saleable than his pictures. He was from his education used to the graver, and assisted by others he published many plates, which had deservedly a large sale, and spread the knowledge of his art. The serial pictures before mentioned were engraved, so also 'A Midnight Modern Conversation,' 'Southwark Fair,' 'The Four Times of the Day,' 'Strolling Actresses in a Barn,' 'The enraged Musician,' 'Industry and Idleness,' 12 plates; 'the March to Finchley,' four election prints, and many others.

Hogarth's power of drawing, though it did not qualify him for high art, enabled him admirably to imitate the forms within his own range of art—to seize their expression and character—and to endow them with truth and nature. In this he was surely a master. His colour was simple and pleasing, not wanting in harmony; his works well and carefully finished. He died childless at his house in Leicester Fields, October 26, 1764, and was buried in Chiswick Churchyard. That he had not amassed money by his art, appears from the fact that the Royal Academy, founded after his death, at once granted his widow a pension of 40l. a year. When his tomb was opened to receive her, November 21, 1789, his coffin was not to be seen, which led to some conjectures; but it was afterwards remembered that he was buried in a grave, and the tomb subsequently erected over him.

HOGENBERGH, REMIGIUS, *engraver.* There are only scant accounts of him. He was one of the engravers who was employed at Lambeth Palace about the middle of the 16th century, by Archbishop Parker, of whom there exist by him two engraved portraits. He worked with the graver only, and the rarity of his works forms their chief value.

HOGG, JACOB, *engraver.* Practised in the last half of the 18th century, usually in the dot manner. He engraved several works after Angelica Kauffman, R.A. after Kirk for the Shakespeare Gallery, and some others of the English painters of his time.

• HOLBEIN, HANS, *portrait and subject painter.* He was of an artist family, and was the son of an artist. Born at Augsburg, authorities have differed as to the time of his birth, which has been variously placed between 1495 and 1498, but the first year seems most consistent with the ascertained date of some of his earliest works. Taught by his father, and imitating his

manner, he painted some portraits and other works in his native city; and about 1515 removed to Basle, where, in 1520, he was invested with the freedom of the city, and was induced to settle, probably from the greater liberty enjoyed there. There also he gained the friendship of Erasmus. He very early attained great technical skill, and evinced a rare power of drawing—lifelike, full of character, and truthful. He painted the 'Meier Madonna,' one of his finest works, in 1522; the 'Passion of Christ,' in eight compartments; with many portraits, among them his patrons, Amerbach and Erasmus, and the frescoes in the town hall. At Basle he also made many of his inimitable designs for wood engraving, his satirical marginal sketches, full of humour, to Erasmus's 'Praise of Folly,' his 'Alphabet of Death,' 'Initial Letters,' and 'Dance of Death.'

While at Basle also he had visited and executed some works at Lucerne and Altorf. But the disorders which befell in 1525 at Basle, followed by the plague, must have rendered art stagnant. Poverty possibly urged him to listen to overtures made to him to try his fortune in England, and in 1526 he came to this country, bringing his portrait of Erasmus, with a letter of introduction from that renowned scholar to Sir Thomas More, who at once received him into his house at Chelsea. He had begun as a portrait painter, and this was the class of art in which he now found employment. He was in the full vigour of life and of his art. One of his first works was a portrait of his patron, followed by Archbishop Warham, 1527; Fisher, Bishop of Rochester, Sir Henry Guildford, and his large picture of the More family.

He had come to England with small means, possibly ill-provided even for his journey, and had left his wife and children at Basle. Neither country had in the mean while been without serious troubles, times were hard in both, and in the autumn of 1529 he returned to Basle, were he remained for about two years, and in that time completed his frescoes in the town hall. On coming back to England he found his friend Sir Thomas More removed from his high office, and Archbishop Warham dead. He had satisfied the claims upon him as a citizen of Basle, and with the intention to settle in England had probably made some provision for his family, whom he had left behind. He had gained a reputation here, saw a career open to him, and between this time and 1535 painted many fine portraits, of which may be mentioned the so-called 'Ambassadors,' at Longford Castle; John Reskemer, at Hampton Court; Sir William and Lady Butts, at Antony.

It has been generally stated circumstan-

217

tially, that he was introduced to Henry VIII. by Sir Thomas More, but there is no confirmation of this, nor of the date at which he entered the King's service, other than that the first payment made to him by the Crown was in March 1538, and from that year must be dated many of the works by him in the royal collections—several portraits of Henry VIII., the Duke of Norfolk, Sir Henry Guildford, Edward VI. when a child, a number of fine miniatures, and a large collection of drawings, including 86 portraits. The British Museum also possesses several of his drawings. Many of his works will also be found in private collections. A very fine full-length portrait of the Duchess of Milan is at Arundel Castle ; a large painting of 'The King presenting the Charter' in the possession of the Barber Surgeons' Company, but much injured ; a cartoon of part of the large picture of Henry VII. and Henry VIII., with the two Queens, destroyed at Whitehall, is at Hardwick Hall ; and at Longford Castle, the 'Ambassadors' already mentioned, and the portraits of Egidius and Erasmus.

Unsurpassed in many of the highest qualities of portrait art, especially in his life-like character, he was no less so in the originality, variety, and power of his designs, whether drawings for the wood engraver, for jewellery and ornament, or for works of an architectural character. He has been generally stated by his biographers to have died in England, of the plague, in 1554, in his 56th year. But the discovery in 1861 of the will of 'John Holbeine, servaunte to the Kynge's Magestye,' with some other corroboratory circumstances, have led to the adoption of 1543 as the year of his death.

HOLDERNESSE, ——, *portrait painter.* Practised in the time of Charles I. His works are now unknown, but they did not bear any reputation.

HOLDING, HENRY JAMES, *landscape painter.* He was of an artist family, and practised both in oil and water-colours at Manchester, where he exhibited and enjoyed a local reputation. He died of consumption, in Paris, August 9, 1872, aged 39. An exhibition was formed at Manchester for the benefit of his widow.

HOLE, HENRY, *wood engraver.* He was a pupil of Bewick, for whose 'British Birds' he engraved some of the blocks. He also engraved some of the illustrations for McCreevy's poem, 'The Press,' and for Felicia Browne, Mrs. Hemans' 'Poems.' He resided at Liverpool, was a member of the Liverpool Academy, and at the exhibition there, in 1814, contributed 'An Attempt to restore the Old Method of Cross-lining on Wood,' engraved by himself. But

succeeding to an estate early in life, he abandoned engraving.

HOLE, WILLIAM, *engraver.* Practised, but without much ability, in the early part of the 17th century. He was chiefly employed upon portrait frontispieces for the booksellers. His works find a place in the folios of collectors. He published a copy-book called 'The Pen's Excellencie.'

HOLL, WILLIAM, *engraver.* Was a pupil of Benjamin Smith. His works are chiefly in the chalk manner. He engraved several portraits and historical subjects, and was engaged in the engraving of the antique marbles in the British Museum. In 1816 he ran the risk of severe penalties by concealing, without any sympathy with his opinions, young Watson, one of the leaders of the Spa Fields rioters, for whose apprehension a large reward was offered by the Government. He died in London, December 1, 1838, aged 67. His sons William and Francis were brought up to his profession.

HOLL, WILLIAM, *engraver.* He was the eldest son of the above, and was born at Plaistow, in Essex, February 1807. He studied his art under his father, and became eminent as a portrait engraver, attaining great excellence in the stipple manner. He engraved for Lodge's 'Portraits of illustrious Personages,' Knight's 'Portrait Gallery,' and some portraits published by Messrs. Finden ; also after Frith, R.A., 'An English Merry-making,' 'The Village Pastor,' and 'The Gleaner and his Wife,' with a number of portrait drawings after G. Richmond, R.A. He died in London, after a long illness, January 30, 1871.

HOLLAND, HENRY, *architect.* Was born about 1740. One of his first works was the erection of Claremont House, Esher, 1763–64, followed by some large alterations at Trentham Hall, Staffordshire. He was afterwards much employed in the Metropolis. He designed Brooks's Club, St. James's Street, 1778 ; added the portico and vestibule to Dover House, Whitehall, 1786 ; and the fine Corinthian portico and Ionic colonnade to Carlton House, Pall Mall, since removed. He rebuilt, in 1794, Drury Lane Theatre, which was burnt down 1809. He designed the Pavilion, Brighton, 1800, and the Albany, Piccadilly, 1804. He also made some alterations at Woburn Abbey and Althorp, and built Lord Spencer's mansion at Wimbledon. He held the appointment of surveyor to the India House. Died in Hans Place, June 17, 1806. His nephew, RICHARD HOLLAND, was brought up to his profession, and exhibited some architectural designs at Spring Gardens 1770, and at the Academy in 1771.

HOLLAND, JOHN, *amateur.* Practised

in London in the reign of Queen Elizabeth, and is mentioned by Walpole as an ingenious painter.

HOLLAND, JOHN, *engraver*. Practised in London in the second half of the 18th century. He engraved some caricatures, but was chiefly engaged on portraits.

HOLLAND, JAMES, *water-colour painter*. Born October 17, 1800, at Burslem, where his father was employed in the pottery works, and his family had long been engaged; he was very early set to work as a flower painter on porcelain and pottery, and in 1819 came to London, where he tried flower painting, and supplemented his small earnings by teaching, extending his art to landscapes, in which he introduced architecture, and to marine subjects. Making some progress, he first exhibited a group of flowers, in 1824, at the Royal Academy, and continued to exhibit flowers up to 1829. About 1830 he visited France, where he made some architectural studies, and on his return produced some works of greater pretension, exhibiting at the Academy, in 1833, his 'London, from Blackheath.' In 1835 he first appears as an 'associate exhibitor' at the Water-Colour Society. In 1843, leaving that Society, he was elected a member of the Society of British Artists, and remained a member till 1848, but continued to exhibit occasionally at the Royal Academy. In 1856 he was re-elected an associate of the Water-Colour Society, and then exhibited with them, and was in 1858 a full member. He was largely employed upon illustrations by publishers, and produced many works for the Annuals; for this purpose, in 1836, he visited Venice, returning by Milan, Geneva, and Paris. In 1838 he made a journey to Portugal, and in 1839 exhibited at the Royal Academy a fine painting of Lisbon. He afterwards visited Holland and Normandy, and again Venice. He died February 12, 1870. His works were marked by great delicacy and poetry, his views of Venice glowing with tender colour.

HOLLAND, Sir NATHANIEL, Bart., R.A., *portrait and history painter*. See DANCE, NATHANIEL.

⁕ HOLLAR, WENCESLAVS, *engraver*. Was born July 15, 1607, at Prague. His family were of the higher order of gentry; as Protestants they had suffered in fortune, and their ruin was completed by the confiscations which followed the battle of Prague in 1619. He was educated for the law, but having a love for drawing, he began to study art as a means of maintenance at Frankfort, where he had found a refuge, and afterwards at Strasbourg. In 1625 he published a 'Virgin and Child' and an 'Ecce Homo,' his two first plates. He then travelled to Antwerp, Cologne, and some of the German cities, returning to Cologne. Here the Earl of Arundel saw some of his drawings, took him under his protection, treated him with great respect, and brought him, on his return, to England in 1637.

His first works in England were his plates of Greenwich and a portrait of his patron, the earl, on horseback. He had apartments in Arundel House, studied uninterruptedly from the noble collection there, was liberally remunerated, and had the good fortune to marry a young gentlewoman, who was under the protection of the countess. His merits were soon recognised, and in 1640 he was appointed to teach the prince drawing. In the same year appeared his fine work, in 28 plates, 'Ornatus Muliebris Anglicanus,' small full-length figures of the costume of women in England, followed in 1642-43-44 by similar works on the Dresses of Women of other European countries. The Civil War now broke out. He was, from his connections, obnoxious to the Parliamentarians, and entered the ranks of the royal army under the Marquis of Winchester. Made prisoner on the surrender of Basing House, he escaped to Antwerp, where his patron had already fled, and settled there in 1645. Here he laboured for some years, but not meeting with much encouragement after Lord Arundel left, he was again in difficulties, and in 1652 he returned to England.

He now found full employment in engraving heads and title-pages for book illustrations. In 1654 he was employed by Faithorne, who took him into his house, his wife having died, and employed him upon plates for Dugdale, Virgil, and other publications. The Restoration, however, brought no brighter prospects for him. He wanted enterprise, was most inadequately paid for his labour, and was content to remain in quiet obscurity, while others gained the profit of his laborious work. The times were unfortunate for art. The Fire of London and the Great Plague added to the perplexities of all, and he fell into absolute want, when about this time (1669) he was sent to Tangiers by the King to make drawings of the forts and defences, and of the surrounding country. For his two years' labour and his valuable drawings, some of which are now in the British Museum, he only received 100*l.* after many supplications and long delay; and on his return his vessel had to encounter a serious attack by Algerine corsairs.

His life had been one long series of trials, and things did not now mend. He lost his only son, a youth of much promise, and his sorrows were full. He died a Roman Catholic, March 28, 1677, in his 70th year, in Gardiner's Lane, Westminster, now a most miserable place, and was disturbed on his death-bed, which he prayed to retain

for the few hours he had to live, by bailiffs, who entered his apartment, to seize his only remaining piece of furniture. He was buried in the churchyard of St. Margaret hard by. That he was laboriously industrious his etchings and engravings testify. They have been calculated to number 2,400—costumes, portraits, history, antiquity, views, and landscapes, and a catalogue has been made of his works, which extends to 132 quarto pages. He worked with the point with extraordinary minuteness of finish, yet with an almost playful freedom. His drawings are equally truthful and finished; many of his views of our cathedrals and antiquities are excellent. Walpole feelingly says of him, 'To have passed a long life in adversity, without the errors to which many men of genius have owed it, and to have ended that life in destitution of common comforts, merely from the insufficient emoluments of a profession, and with a strictly moral character, such was the fate of Hollar!' Vertue published, in 1745, a description of Hollar's works, with some account of his life. Gustav Parthey's descriptive catalogue, published at Berlin in 1853, enumerates 2,733 prints by him.

HOLLINS, JOHN, A.R.A., *portrait and subject painter.* Born at Birmingham, where his father was a glass painter, June 1, 1798. He was early devoted to art, and first exhibited portraits in 1818. In 1822 he came to London, where he practised painting in oil and occasionally in miniature. In 1825 he travelled to Italy, and studying there two years, returned in 1827. He resumed portrait painting, contributed largely to the Academy Exhibitions, and from this time till his death was a constant exhibitor of portraits, portrait-groups, and subjects, chiefly from the poets and novelists. His likenesses were accurate, his drawing and grouping good, and he excelled in colour. He was elected an associate of the Royal Academy in 1842. He died, unmarried, in Berners Street, March 7, 1855, in his 57th year.

HOLLINS, WILLIAM, *architect and sculptor.* Cousin of the above. Was a self-taught man, and for above half a century practised at Birmingham. He exhibited at the Royal Academy, commencing in 1821, some busts, a head of Thetis and of Christ. His last contribution to the exhibition was in 1824, 'Model of the Garden of Gethsemane.' He erected in Birmingham the public office and prison, the old library, and dispensary. He also made some alterations in the mansion at Alton Towers. He designed the Royal Mint at St. Petersburg, but declined to go to Russia to superintend its execution. He died in 1843, in his 80th year.

HOLLIS, GEORGE, *engraver.* Born at Oxford in 1793. He was a pupil of George
220

Cooke, and was largely employed on topographical works — Hoare's 'History of Wiltshire,' Warner's 'Glastonbury Abbey,' Ormerod's 'Cheshire,' &c. In 1818 he published six views of Chudleigh, from drawings by De Cort. He also engraved a series of plates of the Oxford colleges and halls, some of them from his own drawings. He practised in the line manner, and contributed some of the plates on steel for the 'Oriental Annual,' 1834. In 1837 he finished a large plate after Turner, R.A., which was exhibited at the Academy the following year. He died at Walworth, January 2, 1842, aged 49.

HOLLIS, THOMAS, *draftsman.* Only son of the foregoing. Entered the schools of the Academy in 1836, and became a pupil of Pickersgill, R.A. In 1839 he commenced, in conjunction with his father, who etched the greater number of the plates, a work on Sepulchral Effigies, on the plan of Stothard's, for which he made the drawings. The first part was published in 1840. Some of the etchings were by him, and showed much spirit. His health gave way soon after, and he died October 14, 1843, aged 25.

HOLLOWAY, THOMAS, *engraver.* Born in London 1748. His father was in easy circumstances, and gave him a useful education; of a Dissenting family, he was himself a Baptist. He was apprenticed to a steel engraver, and soon showed his ability in the ornaments in that material which were then worn. But this fashion passed away, and after trying several branches of engraving he adopted the copper-plate, and produced some portraits and embellishments for magazines. He was at the same time a student, both drawing and modelling, at the Royal Academy. He first made himself known by the engravings for Lavater's 'Essays on Physiognomy,' an extensive work, containing 700 illustrations. He was also employed on the publications of Boydell, Macklin, and Bowyer, and on editions of the British classics. He painted some portraits in oil and miniatures, which were exhibited, with some life-size crayon portraits. But he is chiefly known as the engraver of the cartoons of Raphael. He desired to produce a more finished series than those of Dorigny, and having obtained from the King the exclusive use of the cartoons, he removed to Windsor, where they were then deposited, to commence his work, of which he had scarcely considered the full magnitude. Here, with the assistance of two former pupils and of Joseph Thompson, he worked for many years, the labour and expense of his undertaking becoming more and more apparent; and as his work proceeded, his original inadequate price of 3 guineas for the set was increased to 10 guineas. The cartoons, during the

Progress of the work, were removed to Hampton Court, and, with his assistants and family, he followed them. After many more years' labour, careful drawings being completed, the artists moved in a body to Edgefield, in Norfolk; and then, not finding sufficient convenience, to Coltishall, near Norwich. Here the sixth plate was in advanced progress, and the seventh and only remaining plate commenced, when Holloway died, in February 1827, aged 79. George III. felt much interest in the work, and appointed him his historical engraver. He had suffered an early disappointment, and never married. A brief memoir of him, in small octavo, was published in 1827, but contains little of interest connected with his art. His careful drawings for the cartoons were sold by auction in 1862. His engravings were neatly and carefully finished, but lack the drawing and spirit of the ruder works of Dorigny.

HOLMAN, FRANCIS, marine painter. He exhibited yearly at the Royal Academy, commencing in 1774, and enjoyed a contemporary reputation. He painted storms and sea-fights. In 1778, 'Action between the French and English Fleets in 1759;' in the following year, 'The Attack upon Rhode Island' and 'A Storm at Sea;' in 1782, 'Admiral Parker's Fight with the Dutch Fleet,' from a sketch made during the action; in 1783, Lord Rodney's Engagement with the French Fleet under the Count de Grasse;' and in 1784, a naval action, his last exhibited work.

HOLME, ARTHUR, architect. He practised in Liverpool, where he enjoyed a local reputation. He built St. Paul's Church, St. Matthew's Church, All Souls' Church and Schools, St. Andrew's Church and Schools, St. Aidan's Church and Schools, All Saints' Church, some warehouses, and other buildings in that borough. He died early in December 1857.

HOLMES, JAMES, miniature painter. Born 1777. He showed an early talent for drawing, and was apprenticed to an engraver, with whom he made rapid progress, but on the termination of his apprenticeship he turned to the practice of water-colours, and in 1813 joined the Water-Colour Society. He exhibited, with some portraits, rural subjects, generally treated with humour—'Hot Porridge,' 'Cinderella,' 'Michaelmas Dinner,' 'Going to School,' 'The Doubtful Shilling'—which was engraved, and was very popular—'Girl protecting Chickens from a Hawk,' 'The unskilful Carver' (purchased by the King). In 1822 he left the Society. He had in 1819 first exhibited at the Royal Academy, and was soon after led to attempt oil painting, and in this medium, as well as in water-colour, was for many years an occasional exhibitor of portraits and portrait groups. He was an active promoter of the foundation of the Society of British Artists, and in 1829 became a member and an exhibitor, sending a portrait of George IV. in water-colours, with, from time to time, a portrait up to 1850, when he resigned his membership. Soon after he retired from London, and spent the greater part of his latter years in Shropshire. He died February 24, 1860. His chief practice was in miniature, and he met with great encouragement, and had many distinguished sitters, among them several members of the royal family and Lord Byron, who preferred his work to any other. He was clever in the choice of a subject, and his works were always most carefully finished and good in colour. Genial and buoyant in spirit, he was gifted with great musical talent. He became a favourite with George IV., and was in the habit of joining both in singing and playing with his Majesty.

HOLMES, P., engraver. Practised in London at the end of the 17th century. He worked with the graver only, but never attained any excellence. The greater part of the illustrations of Quarles's 'Emblems' are engraved by him.

HOLTE, THOMAS, architect. Was a native of York. Practised in the time of James I. The revival of Gothic architecture at Oxford is greatly due to him. He built in that city, the square of the public schools, which is of some grandeur and fine in its proportions. The groined vault under the eastern wing of the Bodleian Library is an example of his skill, as is also the quadrangle of Merton College. The whole of Wadham College is attributed to him. He died at Oxford, September 9, 1624, and was buried there in Holywell Churchyard.

HOLWORTHY, JAMES, water-colour painter. He was an occasional exhibitor at the Royal Academy about the beginning of the 19th century, and made himself known by his Welsh views. He was in 1804 one of the foundation members of the Water-Colour Society, and from that time to 1813 a constant contributor to its exhibitions, sending views chiefly in Wales, the Lake districts of England, and in Yorkshire. He continued to practise in London up to 1822. He married in 1824 a niece of Wright, of Derby, who was also known as an artist, and then retired to reside upon some property, the Brookfield estate, which he purchased, near Hathersedge, in that county. He died in London in June 1841, and was buried in Kensal Green Cemetery.

HOME, ROBERT, portrait and subject painter. Was the son of an apothecary in London. He studied under Angelica Kauffman, R.A., and for a time in Rome. He first appears in the Academy catalogue as the exhibitor of a portrait in 1770. He went early to practise in Dublin, and exhi-

bited there in 1780 no less than 22 portraits and an allegorical picture. He also sent portraits from thence for exhibition at the Royal Academy in 1781–82, and returned to London in 1789, from whence, at an early age, he went to India. He first settled at Lucknow, and was appointed portrait and historical painter to the King of Oude. He afterwards resigned that office and retired to Cawnpoor, having realised a considerable fortune by the practice of his profession. When a picture pleased by the recognised fidelity of the likeness or the faithful rendering of the costume, with the jewellery and the rich accoutrements, the generosity of the royal sitter frequently knew no bounds. In some of his groups of large ceremonials he had to encounter great difficulties from the ignorance of the King, and had frequently, when his Majesty deposed his minsters or beheaded them, to make corresponding changes in his pictures. In 1797 he sent home for exhibition at the Academy, 'The Reception of the Mysore Princes as Hostages by the Marquis Cornwallis,' and 'The Death of Colonel Morehouse at the Storming of Bangalore.' He died about the year 1836. There is a large picture of 'The King of Oude receiving Tribute,' by him, at Hampton Court. His pictures were carefully and accurately painted, his colouring rich and harmonious. He prepared his colours himself, and his pictures stand well. Several of his works are engraved. He published a 'Description of Seringapatam,' 1796, and 'Select views in Mysore,' which represent the chief scenes of the campaign against Tippoo Sultan in 1797. His two sons were in the Indian army, and one of them was killed at the head of his regiment at the battle of Sobraon. Sir Everard Home, Bt., was his brother.

HONDIUS, JODOCUS, *engraver.* Born at Ghent about 1563. Studied there the classics and mathematics, and when about 20 years of age fled to England, where he made mathematical instruments and engraved charts and maps. Besides these, he engraved some portraits, among them Queen Elizabeth, Thomas Cavendish, famed as a sailor, a large print of Sir Francis Drake, &c. He married in London in 1586, and had a family. Removed to Amsterdam, he died there in 1611.

HONDIUS, HENRY, *engraver.* Was born in London about 1588. The son of the above, by whom he was instructed. There are many known portraits by him, neatly but stiffly executed. Among them, portraits of Queen Elizabeth, James I., and Charles I. He died about 1658.

• HONDIUS, ABRAHAM, *animal painter.* Son of the foregoing. He was born, according to some authorities, at Rotterdam in 1638, and came to England in the reign

of Charles II. He painted hunting-pieces and animals, and greatly excelled in his vigorous and characteristic treatment of dogs. There are a few good etchings by him. He died in London 1695.

* HONE, NATHANIEL, R.A., *portrait painter.* Born in 1718, at Dublin, where his father was a merchant. He early acquired a love of painting, and (self-taught) practised portraiture. He came to England when young, and followed his profession in several parts of the country, particularly at York, where he married a lady of some property. Shortly after he came to London and settled in St. James's Place. For some years, with increasing reputation, he painted both in oil and miniature, and more especially in enamel, in which he excelled, and became the first artist of his day. He was a member of the Incorporated Society of Artists and one of the foundation members of the Royal Academy, but some pique against the president, Reynolds, led him into collision with that body.

He painted a picture of 'The Conjurer,' which was considered, though not very apparent, a covert attack upon Reynolds, and a second work attacking (it was so construed) Angelica Kauffman. These works the academicians refused to exhibit, and, angry at their rejection, he made in 1775 an exhibition of his own works, about 60 or 70 in number, including the two which had given offence. He was a constant exhibitor of portraits at the Academy from its foundation to his death. Sometimes he sent a portrait in character, as 'A Fair Penitent,' 'St. Cecilia,' 'Hebe,' and one or two subject pictures, 'David when a Shepherd,' 'A Spartan Boy,' 'Nathan and David.' He died at Rathbone Place, London, August 14, 1784, in his 67th year, and was buried at Hendon. His portraits were good, but hot and unpleasant in colour. He drew occasionally in crayons, and scraped some good mezzo-tints from his own pictures, particularly from his own portrait, painted in 1782, which is in the Royal Academy collection. There are also a few etchings from his hand. He had collected many prints and drawings, which he distinguished by the mark of a human eye. These he sold during his lifetime. His pictures and the materials of his art were sold in 1785.

HONE, CAMILLUS, *portrait painter.* Younger son of N. Hone, R.A. He was an exhibitor at the Royal Academy from 1777 to 1780, and then practised his art with success for several years in the East Indies. On his return he settled in Dublin, and was appointed to a situation in the Stamp Office there. He died in 1837, at a very advanced age.

* HONE, HORACE, A.R.A., *miniature painter.* Son of the above. He practised

both in water-colour and in enamel, and occasionally in oil. From 1772 to 1782 he exhibited at the Royal Academy, and was in 1779 elected an associate. He then went to Dublin, where he settled, and was residing in 1791, when his reputation brought him more commissions than he could execute. In 1795 he was appointed miniature painter to the Prince of Wales, and that year exhibited a number of miniatures at the Academy. But on the Union his fashionable sitters fell off, and he soon followed them to London. He resided then in Dover Street, Piccadilly, had a large practice, and resuming his contributions to the Academy, he continued to exhibit up to 1822. He died after a short illness, May 24, 1825, in his 70th year, and was buried in St. George's Chapel Yard, Oxford Road. Many of his miniatures are engraved.

HOOD, THOMAS, *humorous draftsman.* Was born in the Poultry, a 'Cockney,' as he said, May 23, 1799; the son of a bookseller, and apprenticed to his uncle as an engraver, by whom he was transferred to one of the Le Keux. He early abandoned this art for literature, in which his first attempts had been made. But he had much ability of drawing, and the quaintness of his illustrations to his writings added to their just celebrity. His chief works so embellished were his 'Whims and Oddities,' 'Hood's Magazine,' and 'The Comic Annuals.' He also etched and published a large plate full of humour and character, called 'The Progress of Cant.' His memory, however, belongs to literature. He was a most original and powerful genius; a poet, serious and comic; a novelist, a humorist, writing under the pressure of pecuniary difficulties and of bodily suffering. As he desired, it was recorded on his tomb in the Kensal Green Cemetery, 'He wrote the Song of the Shirt.' This song consisted of a few painfully serious verses, of which the moral effect was inconceivable. After a lingering illness of several years, aggravated by many trials, he died in the Adelphi, May 3, 1855. A pension of 100*l.* a year granted by the Queen to his wife just before his death, then fast approaching, was his last solace.

HOOD, JOHN, *marine painter.* He was a shipwright, living at Limehouse, and practised in water-colours soon after the middle of the 18th century. In 1765 he exhibited 'Shipping' at the Spring Gardens Rooms. Houston engraved after him, in mezzo-tint, 'A Naval Engagement.'

HOOKE, Dr. ROBERT, *architect.* He was born July 18, 1635, at Freshwater, Isle of Wight, of which parish his father was the minister. He was for a short time a pupil of Sir Peter Lely, but was early removed to Westminster School, and from there to Christ Church, Oxford, where he took his

M.A. degree about 1662. A good mechanician, he tried many astronomical and mechanical inventions, and was one of the promoters of the foundation of the Royal Society; and became the curator in 1662 and the secretary in 1677, and read many philosophical papers at the Society's meetings. He was also Gresham professor of geology. For some time he was an assistant to Sir Christopher Wren, and after the Great Fire in 1666 was his competitor, having submitted a model for rebuilding the City. He was appointed one of the commissioners for surveying and adjusting the sites of the different owners; and was the designer of several well-known buildings, the chief of which have been taken down to make way for modern improvements. He built, in 1663, the Duke of Montague's house in Bloomsbury, which was burnt down in 1686; part of the old College of Physicians, Warwick Lane; Aske's Hospital, Hoxton; and Bethlehem Hospital, on its removal to Moorfields, in 1675. After a life of great activity, he died, quite worn out, March 3, 1702-3. His works, and a record of his inventions, with a memoir of him, were published 1705. In his own day he was known as a great astronomer and miser.

HOOPER, S., *topographical draftsman.* He practised in the latter part of the 18th century, and made many of the drawings used by Gough in his 'Monumental Antiquities,' but they are of an inferior character.

HOPKINS, THOMAS, *enameller and engraver.* He was chiefly employed in enamelling and chasing watches and jewellery at a time when such work was fashionable, and when Bone, R.A., found the same employment. He died in London, August 4, 1794.

HOPLEY, EDWARD W. J., *subject painter.* He practised at Lewes in the early part of his life, but in 1850 came to London, and from that year to his death was a frequent exhibitor at the Academy. In 1851, 'Psyche;' in 1853, 'A Little Bit of Scandal;' in 1860, 'Sappho;' in 1863, 'The Spanish Coquette.' His last exhibited work was a portrait of Professor Owen. He was also an exhibitor at the British Institution. He died in London, April 30, 1869, in his 53rd year.

HOPPER, THOMAS, *architect.* Was the son of a surveyor, and was brought up under him. He gained the notice of Walsh Porter, who enjoyed the reputation of a man of taste, and was introduced by him to the Prince Regent, who became his patron. He built Slane Castle, Ireland, altered and added largely to Penrhyn Castle, Bangor, and was engaged in the alteration or erection of several other fine mansions. In the Metropolis he built Arthur's Club-house, St. James's Street; the Atlas Fire Office, in Cheapside; the Legal and General Fire

Office, in Fleet Street ; and St. Mary's Hospital, Paddington. He was for nearly 40 years surveyor of the county of Essex, and adapted the large county gaol at Springfield to the cellular system. He made designs for a national gallery for works commemorative of British victories ; competed for the erection of the General Post Office, and published his designs ; and also for the new Houses of Parliament. From the year 1833 he was a frequent exhibitor at the Royal Academy. He died August 11, 1856, aged 79.

HOPPER, HUMPHREY, *sculptor*. Studied in the schools of the Royal Academy, and in 1803 gained the Academy gold medal for his original group, 'The Death of Meleager.' He was, commencing in 1799, an occasional contributor to the Academy Exhibitions. His first works were of an ornamental character, but in 1807 he exhibited designs for the Pitt and Nelson Monuments ; then some classic figures, 'Venus,' 'Bacchus,' 'A Bacchante.' In 1815 and the following years he was an exhibitor of busts, with sometimes a monumental figure. He exhibited for the last time in 1834. The public monument in St. Paul's to Major-General Hay, a group of three figures, is by him.

HOPPNER, JOHN, R.A., *portrait painter*. Was born at Whitechapel, April 4, 1758. His mother was one of the German attendants at the palace, and his father, notwithstanding some mystery had been made with respect to his parentage, also a German, had for some time been settled here. He commenced life as a chorister in the Chapel Royal ; afterwards showing a strong inclination for art, the King made him some small allowance, and in 1775 he was admitted a student of the Royal Academy. Continuing to study diligently, he gained the gold medal in 1782 for an original painting from ' King Lear,' and the same year married Miss Wright, whose mother was celebrated for her small portraits modelled in wax.

His early devotion was to landscape, but he soon adopted portrait as his profession, and had many sitters. In 1780 he first appears as an exhibitor at the Academy, and for some years he continued to send portraits of ' A Lady' or ' A Gentleman,' it not then being the custom to give the name of the person represented. He retained some friends in the palace, for in 1785 he exhibited the portraits of three of the princesses, and in 1789 is distinguished as portrait painter to the Prince of Wales, and then painted the portraits of the Prince and the Duke and Duchess of York. He had attained a high position in his profession, and rank and fashion surrounded his easel. His contributions to the Academy Exhibitions were numerous. Lawrence recognised in him his most powerful competitor, and the public

224

looked upon the two as rivals. His art was confined to portraiture ; he made few higher attempts. He was elected in 1793 an associate, and in 1795 a member, of the Royal Academy.

Hoppner succeeded best in his portraits of ladies and children. His handling was free, his execution unlaboured, but his drawing often faulty. His colouring was deemed brilliant by his contemporaries ; it has become hard and horny by time, and from the use of defective materials many of his pictures have fallen into a sad state of decay. The best examples of his art are in the State apartments at St. James's Palace. He was an imitator of Reynolds, to whom some of his best works owe their inspiration. He continued to exhibit, but later with some intermission, up to 1807. A chronic state of ill-health, aggravated by restless irritability, shortened his days. He died January 23, 1810, aged 51, and was buried in the cemetery of St. James's Chapel, Hampstead Road. He published, in 1803, ' A Select Series of Portraits of Ladies of Rank and Fashion,' painted by him ; and in 1806, 'Oriental Tales translated into English Verse.'

HOPPNER, LASCELLES, *subject painter*. Son of the above. He was a student in the Royal Academy, and in 1807 gained the Academy gold medal for his painting, ' The Judgment of Solomon.' He exhibited portraits at the Academy from 1811 to 1815. There is a spirited picture by him, 'The Market-place, Seville,' at Holland House, Kensington, and a fine crayon sketch of ' The Apotheosis of Santa Clara,' after Murillo.

HOPWOOD, JAMES, *engraver*. Born about 1752, at Beverley. He was without any help to knowledge in his profession, but was found surrounded by a family of six children, and was then, at the mature age of 45, making a second attempt on copper, having already by great industry engraved and published a plate by subscription. By the sale of these two plates, which he had finished under great privations, he was enabled to make his way to London. Mr. Heath kindly permitted him to work in his house, and, struggling with difficulties, by his great assiduity he made up for the deficiency of his early training. In 1813 he was elected secretary to the Artists' Fund, and held this office till 1818, when he resigned, and during illness was assisted from the Fund. He died September 29, 1819.

HOPWOOD, JAMES, *engraver*. Son and pupil of the foregoing. He was born in 1795. He engraved in the dot manner, chiefly portraits, a collection of which was published in Paris. He both designed and engraved some clever book illustrations.

HORNE, GALYON, *glass painter*. Described as of the parish of St. Mary

Magdalen, glazier. He was one of four contractors in Henry VIII.'s reign for completing 18 of the painted windows of the upper story of King's College Chapel, Cambridge.

HORNEBAND, GERARD LUCAS, *portrait painter*. Born at Ghent in 1498. He came to London, where he practised as a portrait painter, was employed by Henry VIII., and died in 1544. His sister, SUSANNAH HORNEBAND, a miniature painter, also came to England, and is said to have married an English sculptor named Whorstley, and to have died at Worcester.

HORSBURGH, JOHN, *engraver*. Was born at Prestonpans, near Edinburgh, November 16, 1791, and lost his father early in life. He studied drawing at the Trustees Academy, and when fourteen years of age was apprenticed to Robert Scott the engraver, with whom, after serving his full time, he continued for several years longer, and then began his own professional career. He practised in the line manner and was much engaged in book illustration. His chief works are 'Mackie the actor, as Baillie Nicol Jarvie' after Sir William Allan, 'Prince Charles reading a despatch' after William Simson, a portrait of 'Sir Walter Scott' after Sir Thomas Lawrence, and 'Italian Shepherds' after McInnes. He also engraved some fine plates after Turner, R.A., with some vignettes by him to illustrate Sir W. Scott's works. For the last fifteen or twenty years of his life he may be said to have retired from his profession. For nearly forty years he filled gratuitously the office of pastor in the Scotch Baptist Church. His pastoral addresses, preceded by a brief memoir, was published in 1869. He died in Edinburgh, September 24, 1869, aged 79.

HORWELL, CHARLES, *sculptor*. He was a student in the Royal Academy, and in 1788 gained the gold medal for his group, 'The Grief of Achilles at the Death of Patroclus.' He had previously exhibited at the Academy, and in 1789 sent a 'Cupid and Psyche,' with some other designs; in 1791, 'The Murder of Duncan, King of Scotland.' He did not exhibit again till 1799, when, trying portrait art, he exhibited busts of his son and daughter. In 1807 he exhibited a design for Nelson's monument, and from that time the trace of his art is lost.

HOSKING, WILLIAM, *architect*. He was born in 1800, at Buckfastleigh, Devon, and was taken when young to New South Wales, where he was apprenticed to a builder and surveyor. He returned to England in 1819, and the following year articled himself to an architect, and subsequently spent a year in Italy to improve in his profession. He exhibited, but on one occasion only, a drawing at the Royal Aca-demy. In 1834 he was appointed engineer to the West London Railway, and in 1840 to a professorship of construction and architecture at King's College. In 1844 he was appointed one of the referees under the Metropolis Building Act. He built Trinity Chapel, Poplar, and the chapels and other edifices in the Abney Park Cemetery; but he is little known in the actual practice of his profession. He published, in 1827 (in connection with J. Jenkins), 'A Selection of Architectural and other Ornaments;' in 1842, 'Abstract of Reports concerning the Restoration of St. Mary's, Redcliffe, Bristol,' 'A Treatise on the Principles and Practice of Architecture;' and his 'Lectures at King's College;' in 1848, 'A Guide to the proper Building of Towns;' and in 1849, 'Healthy Homes.' He wrote the articles 'Architecture,' 'Buildings,' 'Masonry,' and some others, for the 7th edition of the 'Encyclopædia Britannica.' He died in London, August 2, 1861, and was buried in the Highgate Cemetery.

» HOSKINS, JOHN, *miniature painter*. Commenced the practice of his art in oil, afterwards took to miniature, in which his chief excellence lies. Charles I., his Queen, and many of the nobility sat to him. His works are truthful and well drawn, but his flesh tint has a tendency to hotness. Sir Kenelm Digby, in his 'Discourses,' says 'that by his paintings in little he pleased the public more than Vandyck.' Samuel and Alexander Cooper were his pupils. He affixed his initials to his works, grouping the I within the H. He died in February 1664, and was buried in Covent Garden Church.

HOSKINS, JOHN, *miniature painter*. Was a son of the foregoing, and excelled in the same art. His works are greatly prized. He painted a portrait of James II. in 1686, for which he was paid 10*l.* 5*s.* He signed the initials 'I. H.' separately.

HOUGHTON, ARTHUR BOYD, *subject painter*. Was the son of Captain Houghton of the Indian Navy, and born in 1836. He became first known by his very clever illustrations of books, and was perhaps one of the most skilful draftsmen on wood of the time. His illustrations to the 'Arabian Nights' are marked by their spirited character and richness of incident. He was elected an associate of the Society of Painters in Water-Colours in 1871, and sent to their exhibitions many works of high merit. He also painted in oil, and his first contribution to the Royal Academy was 'A Fisher' in 1860, and 'Here i' the Sands,' 'The Mystery of Folded Sleep' in 1864, and 'John the Baptist rebuking Herod' in 1870, besides other works. He was cut off in the midst of a career of great promise at the early age of 39. He died at Hampstead, November 23, 1875.

Houbraken. Arnold. Engraver

HOUSTON, RICHARD, *engraver*. He was born in Ireland, and was apprenticed to John Brooks, in Dublin. He settled in London when a youth, and practised in mezzo-tint with great success. His works are highly esteemed. They are chiefly portrait, and those after Reynolds, P.R.A., have rarely been excelled. His 'Duchess of Marlborough and Child' is a fine work, and his plates after Rembrandt and some running horses are excellent. He also painted a few miniatures. He was of very dissipated habits. Sayer, the printseller, advanced him some money, and was then avoided by him. Sayer then arrested him, and confined him in the Fleet Prison, that he might, as he said, have him under his own eye and know where to find him, and in this state he continued for many years. He was released on the accession of George III. He died August 4, 1775, in his 54th year.

• HOWARD, HENRY, R.A., *history and portrait painter*. Born in London, Jan. 31, 1769. He received an average education, and intended for the arts, at the age of 17, he became the pupil of Philip Reinagle, R.A. In 1788 he was admitted a student of the Academy, and in 1790 gained the first two medals of the year—the first silver medal in the life school, and the gold medal for his original painting of 'Caractacus recognising the dead body of his Son.' Thus distinguished, he set off for Italy in the following year, visited the principal cities, and sent home, in competition for the travelling studentship, a large painting of 'The Death of Abel,' but was unsuccessful. Returning home by Vienna and Dresden, he reached London in 1794.

He had, while in Italy, made many careful drawings of the antique sculptures, and was, on his return, employed by the Dilettanti Society upon a series of similar drawings for their publications. His tastes led him to the poetic and the classic rather than to the more severe style, and his works were chiefly from the poets. From 1795 he was a large contributor to the Academy Exhibitions, sending classic, and exceptionally sacred subjects, with, from 1798 to 1824, a considerable number of portraits. But from the latter year his exhibited works were more of his own peculiar class. He continued an exhibitor till his death. He married, in 1801, Miss Reinagle, the daughter of his old master, and the same year was elected an associate, and in 1808 a member, of the Academy. In the latter year he exhibited his 'Christ blessing little Children,' which now forms the altar-piece of the chapel in Berwick Street, St. James's. He made some designs for book illustration, and for the ornamentation of Wedgwood's pottery. In 1811 he was appointed secretary to the Academy. In 1814 he gained

226

the premium for designing a medal for the Patriotic Fund. He also prepared the designs for the Great Seals and other medals. About this period he produced some of his best works—'Sunrise,' for which the British Institution awarded him 100 guineas; in 1815, 'The Birth of Venus,' 'The Story of Pandora;' his 'Lady in a Florentine Dress,' exhibited 1824. He was elected professor of painting in 1833, but as a lecturer he showed little originality of thought, and his manner and matter both failed to interest the student. In 1843 he was awarded one of the 100*l.* premiums at the Westminster Hall competition. He died at Oxford, when on a visit to his son, October 5, 1847.

Distinguished at the outset of his career by the highest Academy honours to be gained by a student, Howard fills only a second rank in art. His works are graceful and pretty, pleasing in composition, correct in drawing, but cold and feeble in style. Painted to a small scale, and suited to the taste of the day, they have found a place in many collections. His art did not, however, meet with much encouragement, and he was glad to add to his income by portraiture and as a designer. His lectures were published, with a short introductory memoir, by his son.

HOWARD, FRANK, *designer and draftsman*. Son of the above. Born 1805. He showed an early love of art, and was his father's pupil and a student in the Academy. He commenced his career as an assistant in the studio of Sir Thomas Lawrence, and afterwards painted a number of small-sized portraits, and designed for work in gold and silver. He first exhibited at the Academy in 1825, and in that year and up to 1833 sent subjects from the poets and from Scripture. From that time he only exhibited in 1839, 1842, and 1847. He was gifted with some ability as a lecturer. About 1842 he went to Liverpool, where he settled, but managed to gain only a scanty livelihood by painting and making drawings, which he sold for a small price, added to teaching and lecturing, and some trifling pay as theatrical critic for one of the local newspapers. He died at Liverpool in much distress, June 30, 1866. He published 'Lessons on Colour;' 'The Spirit of the Plays of Shakespeare,' a series of outline designs, 1827; 'The Sketcher's Manual,' 1837; 'Colour, a means of Art,' 1838; 'The Science of Drawing,' 1839; 'Imitative Art,' 1840; 'A Course of Lectures on Painting,' and his father's Lectures, with a memoir, 1848.

• HOWARD, HUGH, *portrait painter*. Born in Dublin, February 7, 1675. His father practised there as a doctor, and driven from Ireland by the political troubles which followed the Revolution, he brought his son with him to England. The young

Howell. Sam.? painter (1800).

lad showed a talent for drawing, which he improved by a journey through Holland to Italy, in the suite of the Earl of Pembroke, in 1697. He returned home in 1700, and after passing some years in Dublin, settled in England, and practised portrait painting; but his friends obtaining for him the office of keeper of the State Papers and paymaster of the Royal Palaces, he abandoned the professional practice of his art, and amused himself by making a collection of books, prints, and medals. He died in Pall Mall, March 17, 1737, and was buried at Richmond. He bequeathed his collection to his brother, the Bishop of Elphin, whose eldest son was created Baron Clonmore and Earl of Wicklow. There are one or two etchings by him. His collection of prints and drawings was sold in 1853 and produced nearly 5000*l.*, but a very important selection had been previously made for the British Museum, and a considerable portion was retained and sold subsequently.

HOWARD, WILLIAM, *engraver.* Practised in the latter half of the 17th century. There is a set of sea-views, with shipping, by him, dated 1665. His works, though very inferior in merit, are in Hollar's manner.

HOWES, JOHN, *miniature and enamel painter.* First exhibited at the Royal Academy in 1772, and continued a contributor of portraits for several years. In 1780 he exhibited 'The Death of Lucretia,' an enamel, and occasionally a classic subject in the same material, ' Cleopatra sailing down the Cydnus,' 1789 ; ' Imogen discovered in the Cave,' 1790 ; and in 1793, ' Venus attended by the Graces,' his last exhibited work.

HOWISON, WILLIAM, A.R.S.A., *engraver.* Born at Edinburgh in 1798. He was educated at Heriot's Hospital and apprenticed to an engraver. He worked in comparative obscurity for many years after the termination of his apprenticeship. He first gained notice by his plate of ' The Curlers,' after Harvey, R.S.A. He then undertook ' The Polish Exiles,' after Sir William Allan, followed by the ' Covenanter's Communion,' after Harvey, works which gave him a reputation. He was elected an associate of the Scottish Academy. He died at Edinburgh, December 20, 1850.

HOWITT, SAMUEL, *animal painter.* Born about 1765. He was self-taught in art, but there is little record of his early life. He first exhibited at the Spring Gardens' Rooms in 1783, and at the Royal Academy in 1793, ' Jaques and the Deer ' and ' A Fox Hunt ;' and in the following year, ' Smugglers Alarmed.' His name then disappears as an exhibitor. He went to India and passed many years in Bengal, where he made numerous drawings, particularly of

the wild hunting of that country. From these he published 50 engravings in 1801 ; ' The British Sportsman,' 70 coloured plates, 1812 ; in 1814, his groups of animals in illustration of Æsop's ' Fables,' and ' Foreign Field Sports,' 100 plates ; in 1827, ' British Preserves,' 36 plates, etched by himself from his own drawings. In 1814–15 he was again an exhibitor at the Academy, but only in these two years. He died suddenly, in Somers Town, in 1822. His drawing was marked by spirit and character ; his etchings are carefully finished and truthful. His works almost entirely relate to animals and the sports connected with their pursuit.

HOWLETT, BATHOLOMEW, *engraver and draftsman.* He was born at Louth, and came to London, where he was apprenticed to Heath. He was much employed in topographical and antiquarian works. He engraved, in 1805, a selection of views in Lincolnshire, a work of some note, and was engaged on Wilkinson's ' Londina Illustrata,' Bentham's ' Ely,' Frost's ' Notices of Hull,' and other works. In 1817 he commenced a topographical account of Clapham, for which he had made the drawings, but only one number was published. He left a series of drawings of the church of St. Katharine, near the Tower, which he had completed, and above 1,000 finished drawings from the seals of the monastic and religious houses in his kingdom. His latter days were embittered by pecuniary distress. He died at Newington, December 18, 1827, aged 60.

HOWSE, G., *water-colour painter.* He painted landscape, views of towns, and coast scenes. He was from 1837 a member of the Institute of Water-Colour Painters, and a large contributor to their exhibitions. He died about the end of the year 1860.

HUDSON, THOMAS, *portrait painter.* Born in Devonshire in 1701. He was the pupil of Richardson, and became a member of the Incorporated Society of Artists. He drew the face well, and his unaffected representations pleased the gentry of his time, but he had little ability to paint more than the face, the rest was left to the drapery man. He lived for many years, in Great Queen Street, Lincoln's Inn Fields, and, succeeding Jervas, became the fashionable portrait painter of his day, and was the first English painter who gained that distinction. He was soon, however, eclipsed by Reynolds, who had been his pupil, and he retired contentedly to Twickenham. Celebrated in his own day, scant justice has been done him in the present. He is only spoken of as the master of Reynolds. His first wife was the daughter of Richardson, who had been his teacher ; and towards the close of his life he married a second time, a lady of good fortune. There is a portrait

of Handel by him in the National Portrait Gallery. He had a large collection of drawings, many of them probably came into his possession from Richardson. He died at Twickenham, January 26, 1779.

HUDSON, HENRY, *engraver*. Born in London. He practised in mezzo-tint about the end of the 18th century, but little is known of him. He engraved 'Belshazzar's Feast,' after Rembrandt; 'David and Bathsheba,' after Castelli; and Sir William Hamilton and some other portraits, after Sir Joshua Reynolds. He died abroad in 1762.

HUGFORD, IGNATIO, *history painter*. Born in England. He settled early in life at Florence, where he practised as an historical painter. Some of his works are in the Ducal collection, and the altar-piece of Sta. Felicità, in that city, is by him. His works have not much merit. He is chiefly remembered as the master of Bartolozzi, R.A. He died 1778, aged 75.

HUGGINS, WILLIAM JOHN, *marine painter*. Began life as a sailor, and passed his early days at sea in the service of the East India Company. Of the circumstances and opportunities which made him an artist little is known, but he was early in life settled in Leadenhall Street, painting the portraits of ships, some of his first being those in the East India Company's service. In this he found remunerative employment, and gradually improving his work was admitted to the Academy Exhibition, and he continued for several years an occasional exhibitor. In 1834 he was appointed marine painter to William IV., who esteemed his work rather for its correctness than its art. He painted for his Majesty three large pictures of the 'Battle of Trafalgar,' which are now at Hampton Court. His works are tame in design, skies bad in colour, seas thin and ;poor. He died May 19, 1845, aged 64. Several of his paintings are engraved.

HUGHES, HENRY, *wood-engraver*. Born about 1796. He practised his art in London, and engraved the illustrations for many works, among others, 'The Beauties of Cambria,' the landscape views of which are cut with much ability.

HUGHES, ROBERT BALL, *sculptor*. Student of the Academy. Gained the gold medal in 1823 for his group of 'Mercury and Pandora.' He exhibited a bust at the Academy in 1822, his gold medal group in 1824; in 1825, 'Achilles;' in 1826, two busts; and in 1828, his 'Shepherd Boy;' after which he went to America, and his name no longer appears in the catalogues.

HUGHES, WILLIAM, *wood-engraver*. Was a native of Liverpool, and apprenticed to Henry Hole. His earliest works were for the illustration of Gregson's 'Fragments of Lancashire;' some of his most finished
228

for Rutter's 'Delineations of Fonthill.' He also engraved for Dibdin's 'Decameron,' 1817, and Johnson's 'Typographia,' 1824. He had great power of imitation, and two blocks after Holbein and some of his illustrations for Ottley's 'History of Engraving' are excellent. He died in Lambeth, February 11, 1825, aged 32. His works are neat in finish, and though dry and hard possess much merit.

HUGO OF ST. ALBAN'S. He is recorded as the master painter of St. Stephen's Chapel, Westminster, *temp.* Edward I.

HULETT, J., *engraver*. He practised in London in the reign of Charles I., and found his chief employment with the booksellers. There is, both drawn and engraved by him, a portrait of Robert Devereux, Earl of Essex, and of Sir Thomas Fairfax.

HULETT, JAMES, *engraver*. Towards the middle of the 18th century he practised in London, and was chiefly employed by the booksellers. He executed the cuts for an edition of 'Joseph Andrews,' and many of the plates for Coetligon's 'Dictionary of Arts and Sciences,' and for a 'Life of Queen Anne.' He died in Red Lion Street, Clerkenwell, January 1771.

HULL, THOMAS H., *miniature painter*. First exhibited at the Royal Academy in 1775, and continued to contribute up to the year 1800.

HULLMANDEL, CHARLES JOSEPH, *lithographer*. Son of a German musician. He was born in London, and devoted himself to art; travelled, and made on the Continent many sketches and studies. In the year 1818 he tried lithography, and printed many of his own drawings. He was so successful that his instruction was sought both by artists and amateurs; and he determined to devote himself to the new art, which was indebted to him for great improvements. He succeeded in producing a graduated tint, and in the use of white for the high lights. He was engaged in the fine folio works of Stanfield, Roberts, Harding, Nash, Haghe, and others. After many experiments, he invented the litho-tint process, the use of liquid ink on the stone with a brush, and in this manner published the works of Cattermole, and afterwards gave greater variety in the art by the use of the *stump* on the stone. He died in Great Marlborough Street, November 15, 1850, in his 62nd year.

HULSBERG, HENRY, *engraver*. Was born at Amsterdam. He practised in London many years, but the time of his arrival here is not known. His chief works are portraits. Some architectural plates by him in the 'Vitruvius Britannicus' and a large view of St. Peter's, Rome, are well engraved; but his works, though neat, are tasteless in manner. He was paralysed for two years before his death, and was assisted

by a Dutch club, and by the community belonging to the Lutheran Church in the Savoy, where, on his death, in 1792, he was buried.

HUMBERT, ALBERT J., *architect.* Began his career in partnership with Mr. Reeks, who is now in the Office of Works. They made drawings for the New Government Offices, which obtained a premium at the Exhibition of Westminster Hall. In 1854 he rebuilt the chancel of Whippingham Church, and when in 1860 the old church was entirely re-built, he furnished the designs. He also designed the mausoleum of the late Duchess of Kent at Frogmore, near Windsor, in 1860, and in 1862 the mausoleum for the Prince Consort, though the decorations were the work of Professor Grüner. He subsequently rebuilt Sandringham House for the Prince of Wales. He died at Castlemona, Isle of Man, December 24, 1877, aged 55.

• HUMPHREY, OZIAS, R.A., *miniature painter.* Born at Honiton, September 8, 1742, and educated at the Grammar School there. He was the representative of the ancient family of Homfrey mentioned by Holinshed. His love of drawing induced his parents to send him to London, and under the advice of Reynolds, P.R.A., he studied at the St. Martin's Lane School and the Duke of Richmond's Gallery. At the end of about two years the death of his father led to his return home, and he was then placed under Samuel Collins, the well-known miniature painter at Bath, and on his master's removal to Dublin he succeeded to his Bath connection. In 1764, encouraged by Reynolds, he settled in London, and in 1766 a miniature, which he exhibited in the Spring Gardens' Rooms, was purchased by the King, who gave him a commission to paint the Queen and other members of the royal family. He was a member of the Incorporated Society of Artists, and now occupying an eminent place in his profession, he continued to practice with success till, in 1772, his system suffered severe injury from the effects of a fall from his horse, and he sought relaxation and relief by a visit to Italy. He left England in March 1773, accompanied by Romney, and made his way to Rome, where he studied the works of the great masters and drew in the French Academy established in Rome. He also visited Naples, Florence, Venice, and Milan.

He returned in 1777, reaching London in September. He settled in Newman Street, and hoping to profit by his earnest studies in Italy, where he had practised in oil, he tried the higher walks of art, but without encouragement. He exhibited portraits at the Academy in 1779–80, whole-lengths and others, and again in 1783. His attempts on large canvases did not, however, realise

the hopes promised by his early miniatures; and with some sense of his disappointment he went to India, to find a competence at the native courts. He embarked for Bengal in the beginning of 1785, and there, and subsequently at Calcutta, Moorshedabad, Benares, and Lucknow, he painted the miniatures of the native princes and persons of distinction, and realised some property.

In 1788 ill-health compelled his return, and he resumed miniature painting in St. James's Street. He had been elected in 1779 an associate, and in 1791 was made a full member, of the Academy. He found plenty of employment, and among other engagements he undertook to ornament a cabinet, for the Duke of Dorset, with miniatures from the portraits at Knole. He had finished 50, when, from the excessive application, added to his weak health, his sight failed. He then directed his attention to crayon portraits, and was in 1792 appointed portrait painter in crayons to the King. His success in this manner gained him sitters, and he exhibited many portraits at the Royal Academy. In 1797 the Prince and Princess of Orange sat to him. But these were nearly his last works; he did not exhibit after that time. His sight suddenly and entirely failed, and he retired to Knightsbridge. He died in Thornhaugh Street, Bedford Square, March 9, 1810, aged 67. As a miniaturist he was eminently successful. Though without loss of originality, he possessed more of the character of Reynolds than any other painter. Simply composed, well drawn, sweetly coloured, and graceful, not wanting in character or resemblance, his miniatures possess a charm which will always maintain for them a high place among works of art. He signed his initials in Roman capitals, H. within the O.

HUMPHREYS, WILLIAM, *engraver and draftsman.* Born about 1740. He obtained, in 1765, the Society of Arts' premium for an engraving after Rembrandt. He practised towards the end of the 18th century, and excelled in mezzo-tint, but used also the graver and the needle. His mezzo-tints after Reynolds, P.R.A., possess very high merit, and were esteemed among the best of the time.

HUMPHREYS, WILLIAM, *line-engraver.* Born at Dublin. He went early in life to America, and was much employed in Philadelphia on vignettes for bankers' notes, adopted for their art excellence as a security against imitation and forgery. On his return to London he had some similar employment, and engraved the head of Queen Victoria for our postage stamps. Among his more important works are Leslie's 'Sancho and the Duchess,' the Dresden 'Magdalen,' after Correggio;

Reynolds's 'Coquette;' and Lawrence's 'Master Lambton.' He also engraved for 'The Bijou,' 'Forget-me-not,' and some other of the annuals. He died at Genoa, where he had gone for the restoration of his health, January 21, 1865, aged 71.

HUNNEMAN, CHRISTOPHER WILLIAM, *miniature painter.* He had a good practice in London in the last quarter of the 18th century, and was from 1777 till his death an exhibitor of portraits at the Academy in oil and crayons, but chiefly in miniature. He died November 21, 1793.

HUNT, H., *engraver.* Practised in the latter part of the 17th century. He worked for the booksellers, and there are some slight engravings of natural history by him, dated 1683.

HUNT, THOMAS F., *architect.* He was the labourer in trust attached to Kensington Palace, and was an exhibitor on one or two occasions at the Royal Academy. He designed the Burns Mausoleum at Dumfries. He published 'Hints for picturesque Domestic Architecture,' 1825; 'Designs for Parsonage Houses, Almshouses,' &c., 1827; 'Architettura Campestra, Lodges, Gardeners' Houses,' &c.; 'Exemplars of Tudor Architecture, adapted to Modern Habitations,' 1829. He died at Kensington, January 4, 1831, aged 40.

* HUNT, WILLIAM, *water-colour painter.* Born March 28, 1790, in Belton Street, Long Acre, where his father kept a shop as a tin-plate worker. His education was but scanty. A sickly child, he amused himself by drawing, and, overcoming his father's objections, he was apprenticed to John Varley, and in 1808 was admitted a student of the Royal Academy. He had the previous year exhibited there three oil pictures, and continued an exhibitor yearly to 1811. He became a visitor to Dr. Monro's, and the associate of the rising water-colour painters of the day. He often stayed with the doctor for a month at a time, and was paid by him 7s. 6d. per day for the drawings he produced. In 1814 he first connected himself with the Water-Colour Society as an exhibitor, and contributed occasionally to the exhibitions. In 1824 he was elected an associate, and in 1827 a member, of the Society.

From 1824 he was a large and constant exhibitor, for many years his contributions ranging between 20 and 30 works. He will always maintain a very high place in the school of water-colour art. Commencing his practice when that art was in its infancy, his early drawings are in the tinted manner, some of them drawn in with the reed pen; yet in these the original qualities of his matured art may be traced. As this was developed, all the resources and methods are employed to give texture, brilliancy, and power, and in all these he excelled. His best works are wonders of colour and imitative execution—his fruit and flowers unrivalled in truth and completeness of finish; his rustic groups well drawn, full of life and humour, the real children of the soil, redolent of country nature; his landscapes no less truthful and excellent.

Sickly from infancy, he was during his long life more or less an invalid, and lived much at Hastings. Always indefatigable in his art, he continued to work to the last, and his numerous drawings from their varied and life-like character and artistic excellence will never fail to be esteemed and valued. He caught cold, which terminated in apoplexy, and died in Stanhope Street, London, February 10, 1864, in his 74th year.

HUNTER, WILLIAM, *portrait painter.* Practised in London the latter part of the 18th century. He made some attempts at history.

HUNTER, ROBERT, *portrait painter.* Was born in Ulster, and studied under Mr. Pope, senior. He practised in Dublin about the middle of the 18th century. He had a large and profitable practice. His likenesses were good, his colouring studied and harmonious, and his art generally respectable. He was deemed the first portrait painter in Ireland, and maintained that position till the arrival of Mr. Home, about 1780. He had great knowledge of all matters of interest relating to the fine arts in his country, and readily concurred in the plan for founding the Dublin Society's Art School. His portrait of the Rev. L. Madden, 1745, is mezzo-tinted by R. Purcell.

HUQUIER, JAMES GABRIEL, *portrait painter.* Son of a French painter, who came to England late in life. He practised his art in London, and obtained some celebrity as a painter of small portraits in crayons. He exhibited occasionally at the Academy from 1770 to 1786, and about 1783 resided for a time at Cambridge. He died at Shrewsbury, far advanced in years, June 7, 1805.

HURDIS, JOHN HENRY, *amateur.* Descended from an old Warwickshire family. He finished his education in France, and then, by his own wish, became a pupil of James Heath, the engraver. His property did not necessitate his following art professionally, but he was well known by his etchings as an amateur. He long resided near Lewes, and both by his portrait and topographical etchings has left many memorials of that neighbourhood. He died at Southampton, November 30, 1857, aged 57.

HURLSTON, RICHARD, *portrait painter.* Practised in London the latter part of the 18th century. In 1764 he was awarded a premium at the Society of Arts. He contributed portraits to the Royal Aca-

Hunt Holman b1827.

demy Exhibitions in 1771-72-73, and in the latter year went to Italy with Wright, of Derby. Immediately after his return to England he was killed by lightning, while riding across Salisbury Plain in a storm. He was an artist of some promise. A portrait by him was mezzo-tinted by Dean. His picture of Sterne's 'Maria' was also engraved.

HURLSTONE, FREDERICK YEATES, *portrait and history painter.* He was the grand-nephew of the above, and was born in London in 1800. He was early engaged in the office of the 'Morning Chronicle,' of which paper his father was one of the proprietors, but attached himself to art, and was admitted to the schools of the Royal Academy in 1820. He became a pupil of Sir William Beechey, and also received some instruction from Sir Thomas Lawrence and B. R. Haydon. He first exhibited at the Academy, in 1821, 'Le Malade Imaginaire;' and the following year, 'The Prodigal Son,' with a portrait; in 1823, portraits; in 1824, portraits, with 'The Contention between the Archangel Michael and Satan for the body of Moses,' a work which had gained the Academy gold medal in the competition of the preceding year, and from that time to 1830 he exhibited several portraits yearly. In 1824 he was also an exhibitor at the newly-founded Society of British Artists, and continuing an occasional exhibitor, was in 1831 elected a member of the Society, and for the following 14 years exhibited exclusively with its members, sending a large number of portraits and occasionally a subject picture. In 1835 he was elected president of the Society, and in that year he first visited Italy. In 1844 he resumed his contributions to the Academy Exhibition, sending his 'Prisoner of Chillon,' with some portraits, and exhibiting there again in the following year, but then for the last time.

He visited Spain in 1851-52, and in 1854 Morocco; and at this time, greatly influenced by the art of Spain, he painted some Spanish subjects, boys half-clad, in the manner of Murillo, and some Moorish scenes. He became much opposed to the Royal Academy, and was one of the party who gave evidence against the constitution and management of that institution in the parliamentary enquiries instituted in 1835. He filled the office of president of the Society of British Artists nearly 30 years. He had a knowledge of foreign literature, made several visits to Italy, and studied in Spain the works of the great Spanish painters. He was in 1855 awarded a gold medal at the Paris Exhibition, but his latter works did not maintain his reputation. Of those most esteemed may be mentioned 'Armida,' from Tasso; 'Eros,' 'Constance and Arthur,' 'Card-players in a Posada in Andalusia,' 'Boabdil el Chico, mourning over the Fall of Granada, reproached by his mother,' and 'Monks at the Convent of St. Isidore distributing Provisions.' He died June 10, 1869, in his 69th year, and was buried in Norwood Cemetery.

HURTER, JOHN HENRY, *miniature painter.* Was born at Schaffhausen, September 9, 1734. He was induced to visit this country by Lord Dartrey, and was much employed here practising in enamel, and chiefly as a copyist. He exhibited at the Academy about 1782. He returned to Switzerland. J. F. C. HURTER, believed to have been his brother, worked with him.

•HUSSEY, GILES, *portrait painter.* Was descended from an old Dorsetshire family, and was born at Marnhull, in that county, February 10, 1710. Educated at Douai and St. Omer, where he acquired a taste for drawing, he was, in opposition to the wishes of his family, permitted to follow art, and placed with Richardson, the portrait painter, as his pupil. But he soon left Richardson, and placed himself under Damini, a Venetian painter then in England, and after four years' study went with him to Italy. On their arrival at Rome the master decamped, robbing his unsuspecting pupil of all his money and the best of his clothing. Assisted by the English Minister, he remained several years in Italy, chiefly at Bologna, and returned to England in 1737.

He did not, however, settle in London till 1742. He then was obliged to submit to what he called the drudgery of portrait painting for his subsistence, and worse than that, he for some time earned his scanty meals by making copies of a likeness of the Pretender, which he had painted at Rome. He imagined that, after having long sought the unerring principles of art, they had been mysteriously revealed to him in Italy; that the drawing of the human race, on a ruling principle of concord in nature, should be corrected by the musical scale, and that after the key-note had been obtained, the proportions of the face should be determined by it. He was wounded by the jealousy, as he deemed it, with which his discovery and his art were received, and he complained that his spirits were depressed, his ardour cooled, and he conceived a disgust for the world and a dislike for his profession. His temper was soured, and in October 1768 he retired into the country, to recover the wounds inflicted on a too sensitive mind. In 1773, his elder brother dying, he succeeded to the family estate at Marnhull, where he amused himself with his favourite studies and in gardening, till 1778, when, from religious motives, he resigned all his worldly possessions to a near relative, and retired to Beeston, near Ashburton, where

he died suddenly in June 1788. There is a memoir and portrait of him in the 8th volume of Nichols's 'Literary Anecdotes.'

His portraits are simple and characteristic, and have much elegance. His drawings are chiefly in pencil, pure and free in line; many of them are preserved in the Academy at Bologna. Reynolds praised his pure, classic taste. Barry, who defended him against what he called his mean detractors, said few could conceive the perfections that were possible in him; and he placed his portrait behind that of Phidias in his 'Elysium' at the Society of Arts. West also possessed some of his chalk heads, which he declared had never been surpassed.

HUSSEY, PHILIP, *portrait painter.* He was born at Cork, and beginning life as a seaman, he was five times shipwrecked. ·He commenced art by drawing the figure-heads of ships' sterns, and, self-taught, was in time able to gain a practice in Dublin as a portrait painter. He painted some fair whole-lengths. He was a clever man, and made himself a tolerable florist, botanist, and musician, and his house was the rendez-vous of the artists and literary men of Dublin. He died there at an advanced age in 1782.

HUSSEY, ——, *animal painter.* He is said to have been a surgeon and apothecary, practising in Covent Garden, to have left that profession for the arts, and to have excelled particularly as a painter of race-horses; but there appears no known trace of these works. He died in Southwark, August 26, 1769.

HUTCHINSON, HENRY, *architect.* He was of some promise, and designed and executed the additions to St. John's College, Cambridge; but his career was short. He died at Leamington, November 22, 1831, aged 31.

HUYSMANN (or HOUSEMAN), JACOB, *portrait painter.* Born at Antwerp in 1656, he came early in life to England, and practised portrait painting, and occasionally history, in the reign of Charles II. He painted several portraits of Catherine of Braganza, one of which, a work of much pretension — a full-length seated figure, surrounded by cupids and a lamb—is at Buckingham Palace. The altar-piece at the German Chapel, St. James's, is by him, as is also a portrait of Isaac Walton, in the National Portrait Gallery. He died in London in 1696, and was buried at St. James's Church, Piccadilly. His heads are well drawn and coloured, the character and expression good.

I

• IBBETSON, JULIUS CÆSAR, *landscape and figure painter.* His father was one of the first who joined the Moravian fraternity at Fulneck, Yorkshire, but, marrying, was expelled the society. His mother, in consequence of a fall, died in premature labour, and he was brought into the world December 29, 1759, by the Cæsarian operation, hence his Christian name. He was educated for a time by the Moravians, and then sent to a Quaker school at Leeds. Showing an early inclination for art, he was apprenticed to a ship-painter, and though he could only learn from him the mechanical part of his art, his invention soon showed itself in his appropriate ornaments. When only 17 years of age he painted the scenery for a piece acted at the York and Hull Theatres, which gained him a local celebrity. He says: 'Having from my earliest youth had a most violent propensity for art, without ever meeting with instruction or encouragement, I at last, on making my way up to London, found myself safely moored in a picture-dealer's garret.' This was in 1777, and without money or friends he laboured unknown and in durance for several years. In 1785 he first appears as an exhibitor at the Academy, contributing in that and the two following years views in the suburbs of the Metropolis.

He had in the interim married, and managed to remove to Kilburn, where he devoted himself to the study of nature, painting both cattle and rustic figures. Many of these works were of much merit, but were sold at very inadequate prices to the dealers. But while so employed he acquired knowledge, particularly of the Dutch and Flemish masters, as well as of the tricks of the picture-dealing trade, as then carried on. He became acquainted, too, with Captain Baillie, the well-known amateur, formed a better connection, and improved his fortunes; and as he was a man of extensive reading and of acute observation, he found his way into much good society. In 1788 he accompanied, as draftsman, Colonel Cathcart's embassy to China, but the ambassador dying on the

voyage the vessel returned to England. He had been arrested by his quondam master on arranging to accompany the embassy, and a long delay arising before only a part of his claim was settled, he was in great difficulties, and he had gained little by his voyage but a knowledge of sailors and ships, which appears in his works from this time. On his return he was for many years a large contributor in oil and water-colours to the exhibitions at the Academy. His works at first were chiefly coast scenes, but later, landscapes, introducing cattle and figures, with rustic incidents.

He found employment in painting for a publisher the animals for the 'Cabinet of Quadrupeds,' which are rendered interesting by their characteristic incidents and picturesque backgrounds. In 1794 he lost his wife; he had previously lost eight children in succession, and his excessive grief brought on brain fever, on recovering from which he found he had been robbed of everything that could be removed; and, disposing of the little that was left, he put his three remaining children to school and broke up his household. Then, led into convivial society and increasing embarrassments—driven to seek his amusement in doubtful company, he accepted bills and became surety for payments far beyond his means, and at last, as the only means of escape, left London in 1798 for Liverpool, where an art commission was procured for him, and from thence visiting Westmoreland, Hull, and Edinburgh, returning to London in 1800.

In June 1801 he married a second time, and a few months later was attacked by his old creditors, whith whom he believed a friend had settled, and he was again plunged into hopeless embarrassments. He had, however, many commissions to execute, and managed to escape to his own quiet native village of Masham, in Yorkshire, where, out of the way both of duns and parasites, who had preyed upon him, he was, by pinching economy, enabled to live. From thence he sent some pictures to the Academy Exhibition—his last in 1812; and there he died, from the effects of a cold which settled on the lungs, October 13, 1817, aged 58. He painted both in oil and water-colours. His works possess considerable merit, but did not find purchasers. His manner was clear and firm, his colouring subdued, having a tendency to a clayey hue; his landscape pleasing, with cattle and figures well introduced. He published, in 1803, 'An Accidence or Gamut of Painting in Oil and Water-Colours,' treating solely of the mediums and colours to be used, exemplified by examples; but in a short introduction, illustrated by some clever head and tail pieces etched by himself, he shows himself a humourist and a clever writer. He advises artists to avoid picture-dealers as

serpents; says they are to living painters as hawks to singing-birds, and he proposes to publish a work, for which he says he has collected a prodigious quantity of materials, to be entitled 'Humbuggologia'—anecdotes of picture-dealers, picture cleaning, and pictures; but this, like a promised second part of his 'Gamut of Painting,' has never appeared. The boon companion of George Morland, his follies and failings were of the same class.

ILLIDGE, THOMAS HENRY, *portrait painter.* Descended from a highly respectable Cheshire family, he was born at Birmingham, September 26, 1799. His father removed to Manchester when he was a child, and dying early left his family with only scanty provision. He was educated at the Manchester Grammar School, and showing a taste for art, was taught drawing, and afterwards became successively the pupil of Mather Brown and William Bradley. His inclination would have led him to landscape, but he had married early, and with a young family he thought it more prudent to try portraiture. His abilities were assisted by many kind friends, and he found full employment in the manufacturing districts of Lancashire. He was an exhibitor in Liverpool in 1827; and from 1842, when he came to reside in London, he was a constant exhibitor at the Royal Academy. On the death of H. P. Briggs, R.A., in 1844, he purchased the lease of his house in Bruton Street. Of a cultivated mind and refined manners, in the middle of a career of great promise, he died there of fever, after a short illness, May 13, 1851. A portrait of Colonel Clayton by him hangs in the court-house at Preston; of Sir Joshua Walmesley, at the Collegiate Institution, Liverpool, presented by the artist; and one of the late Earl of Derby, in the board-room of the college.

IMBER, LAWRENCE, *master carver.* Was employed in that capacity in the erection of Henry VII.'s Chapel, Westminster.

INCE, JOSEPH MURRAY, *water-colour painter.* He was born about 1806. His parents resided at Presteign. In December 1823 he became a pupil of David Cox, and continued with him until early in 1826. He then came to reside in London, and exhibited landscapes at the Royal Academy. About 1832 he was living at Cambridge, where he made many drawings of the architecture of the place, for which he found purchasers there; and then, about 1835, resided for a time at Presteign. He continued an occasional exhibitor at the Academy of landscapes, both in oil and water-colours, up to 1847, and up to 1858 at the Society of Artists. He inherited some property on the death of his parents, and died shortly before 1860, probably at Presteign. His small drawings were well and

carefully coloured, and are among his best works.

INGALTON, WILLIAM, *subject painter.* He was born at Worplesdon, Surrey, in 1794, and was the son of a shoemaker. He painted domestic and rustic scenes, which showed great ability, living the greater part of the time at Eton. He exhibited at the British Institution, 1818, 'Preparing for the Fair' and 'The Vestry;' and yearly, from 1816 to 1823—after which his name no longer appears — he contributed to the exhibitions at the Royal Academy subjects of a domestic character — 'The Wedding Ring,' 'Skittle Players,' 'Bargaining for China,' and 'The Battle Interrupted.' When about 30 years of age, owing to extreme ill-health, he ceased to practise as an artist, and became an architect and builder at Windsor. He resided in the latter part of his life at Clewer, where he gained much good will, and died in 1866.

INGLIS, HESTER, *ornamental designer.* She was celebrated for her great skill in caligraphy, but has claims to a place among the artists for her embellishments and clever head and tail pieces. She practised in the reigns of Elizabeth and James I. To the Queen she presented a copy, in French, of the Psalms of David in her own writing, now in the Library of Christ Church, Oxford. Her manuscripts are highly curious. She wrote 'Les Proverbes de Salomon' in 1599, every chapter of which is in a different hand. There are two manuscripts by her in the Bodleian Library, Oxford. In the Royal Library there is a collection of 50 emblems by her, finely drawn and written.

INGRAM, JOHN, *engraver.* Born 1721, in London, where he learnt his art. In 1755 he went to Paris, and settling there greatly improved his style. He produced several plates after Boucher, but was chiefly employed on small plates for book illustration, most of them vignettes, engraved in a neat, formal manner.

INSKIPP, JAMES, *subject painter.* He was originally in the Commissariat Service, from which he retired with a pension, and then resided in Soho, where he practised as an artist. He was from 1820 a constant contributor, with one or two periods of absence, to the Academy Exhibitions. His first works were landscapes, followed by some portraits and domestic subjects. He was also, from 1825, an exhibitor with the Society of British Artists of works both in oil and water-colours, and up to 1835 was a large contributor; but from that time he exhibited at the Academy only, sending in 1839 'An Italian Vineyard;' in 1840, 'A Hencoop,' which was highly spoken of at the time; and in 1841, 'Zingarella,' his last exhibited work.

234

Of an irritable temper, he was ill-fitted to contend with the trials of portrait painting, and is said to have dismissed a distinguished sitter, on the second sitting, telling him with an oath that he hated him and would not paint him. About this time he retired to Godalming, where he did not altogether lay aside his art, practising for his amusement. He died there, March 15, 1868, aged 78, and was buried in the Godalming Cemetery. He published 'Studies of Heads from Nature,' in 1838.

INWOOD, WILLIAM, *architect and surveyor.* Was born about 1771, near Highgate, where his father was bailiff to Lord Mansfield. He designed several country mansions, and in 1819–22, assisted by his sons, he designed and erected the fine new church at St. Pancras. In 1821 he planned the new galleries for St. John's Church, Westminster, and in 1832–33 the new Westminster Hospital. From 1813 he was for several years an exhibitor of architectural designs at the Royal Academy. He died in London, March 16, 1843. He published 'Tables for purchasing Estates,' 1819, which has run through 18 editions.

INWOOD, HENRY WILLIAM, *architect.* Born May 22, 1794. Son of the above. He was educated under his father, and in 1819 travelled in Greece, where his studies are evinced by the classic church at St. Pancras, the joint work of his father and himself. He was also connected with his father in the erection of St. Martin's Chapel, Camden Town, 1822–24; Regent's Square Chapel, 1824–26; Somer's Town Chapel, 1824–27. He sailed for Spain in March 1843, and the vessel was lost with all on board. He was for many years, commencing in 1809, an exhibitor at the Royal Academy. He published 'The Erechtheion at Athens,' 1827, and commenced 'The Resources of Design in the Architecture of Greece, Egypt, and other countries,' but of this two parts only appeared.

INWOOD, CHARLES FREDERICK, *architect.* Born November 28, 1798. Younger brother of the above. He was brought up in his father's office, and was his special assistant. He designed All Saints' Church, Great Marlow, opened 1835, and the St. Pancras National Schools. He exhibited some designs from time to time at the Royal Academy. He died June 1, 1840.

IRELAND, SAMUEL, *engraver and draftsman.* Was originally a mechanic in Spitalfields. He commenced dealing in prints and drawings, and in 1760 he gained a Society of Arts' medal, and soon attained some skill in drawing and engraving. He exhibited at the Royal Academy in 1782— the only occasion—some water-colour landscapes and a drawing of 'Children,' and was able, never having travelled, to compile and publish, in 1790, 'A Picturesque

Ingham. C-painter

Tour through Holland, Brabant, and part of France.' Encouraged by this fiction he produced, in 1792, ' Picturesque Views on the River Thames ;' and in 1793, ' Picturesque Views on the River Medway,' followed by ' Picturesque Views on the River Severn.' These works were produced in mezzo-tint by his own hand, from his own sketches, and pleased the taste of his day. In 1794 he published an ingenious work, ' Graphic Illustrations of Hogarth,' which must not be confounded with the work ' Hogarth Illustrated,' edited by John Ireland, with whom he was in no way connected. His last work, published after his death, was ' Picturesque Views, with an Historical Account, of the Inns of Court.' His son has a bad reputation for his Shakespeare forgeries, and he was unable to defend himself successfully from the suspicion of complicity in this daring fraud.

He published two angry, ill-judged pamphlets on the subject. He died in Norfolk Street, Strand, in July 1800. His daughter, JANE IRELAND, painted some clever miniatures.

IVORY, JAMES, *architect.* Was self-educated in his profession. He practised in Dublin, and on the foundation of the Dublin Society's School was the first professor of architecture, and held the office till his death in 1786. He built the Blue-Coat Hospital, Dublin, commenced in 1773, an important, well-proportioned Ionic structure, and the only monument of his ability.

IVORY, THOMAS, *architect.* Practised at Norwich about the middle of the 18th century. He built the Assembly House in that city, and the Octagon Chapel in Colegate Street, surmounted by a dome supported by Corinthian columns, 1754-56, and the theatre, 1757. He died 1780.

J

JACKSON, ROBERT, *engraver.* There are some early mezzo-tint portraits and a woodcut by an artist of this name in the reign of James II.

JACKSON, JOHN, R.A., *portrait painter.* Was the son of the village tailor at Lastingham, in the North Riding of Yorkshire, where he was born, May 31, 1778, and was apprenticed to his father, who could not for some time be induced to let him follow his strong predisposition for art, saying, ' He is as good a tailor as ever sat on a shop-board, and how can he do better?' He soon, however, made himself known by his attempts to draw the likenesses of his companions, and was rescued from his apprenticeship by the contributions of some friends when he had still two years to serve. His portraits had been slight attempts in pencil, weakly tinted, but a portrait by Reynolds was lent him to copy in oil, in which his success led to his going to London, in 1804, to study art as his profession. In this he was assisted by the generosity of Sir George Beaumont, and in 1805 he was admitted a student of the Royal Academy. The following year he exhibited a portrait-group of Lady Mulgrave and the Hon. Mrs. Phipps, and continued to exhibit his works at the Academy for several years, the names of his sitters showing how largely he was supported by Lord Mulgrave's family.

He pursued his studies with assiduity, but his portraits in oil did not afford much promise. His water-colour portraits were however, as he gained power, greatly admired—they were faithful in resemblance, well drawn, and carefully finished. Many of the heads in Cadell's ' Portraits of Illustrious Persons of the 18th Century' were drawn by him in this manner, and his practice in water-colour was extensive, and produced him a handsome income. But he aimed at distinction in oil, and soon attained complete success. In 1815 he was elected an associate of the Academy, and travelled through Holland and Flanders, studying the works of the Dutch and Flemish masters. In 1817 he became a full member, and the same year the directors of the British Institution awarded him a premium of 200*l.* for the general merit of his pictures. In 1818 he visited the chief cities of Northern Italy and Rome, and was elected a member of the Academy of St. Luke. He continued to exhibit at the Academy, but exclusively portraits, up to 1830. He had many men of great distinction as sitters, and several of his most eminent contemporaries in the Academy.

As a portrait painter he occupies a high rank. His works are faithful in resemblance, but wanting in elevation of character ; solidly and powerfully painted, avoiding meretricious graces. He particularly excelled in subdued richness of colour, and had great facility of execution. He was of the Methodist persuasion, and of deep religious feeling. In the two last years of his life he fell into a low despond-

ing state of health. He died at St. John's Wood, June 1, 1831. He was twice married, and though his professional earnings had been large, he left his second wife, the daughter of James Ward, R.A., and three infant children, without any provision. There is a memoir of him in the 'Library of the Fine Arts,' 1831.

JACKSON, JOHN, *wood-engraver.* He resided for many years in Smithfield, and was much employed, in the latter part of the 18th century, in engraving illustrations for children's books. He was a man of eccentric habits, of whom little can now be learnt.

JACKSON, JOHN BAPTIST, *wood-engraver.* Was born in 1701, and was apprenticed to Kirkall, from whom he learnt his art. From want of employment at home, he went to Paris about 1726, where he applied to Papillon, then eminent as a wood-engraver, who says, in his 'Traité de la Gravure en Bois,' that he gave him a few things to execute to supply him with the means of subsistence, and charges him with ungratefully attempting to sell a duplicate, which he had dishonestly made, of a design entrusted to him to execute. For some time he finished works on speculation, and was glad to sell them for what he could get, till, disgusted with his position, and almost destitute, he was induced to accompany a painter to Rome about 1731, and from thence to Venice. He resided there till 1742, and in 1745 published 17 large woodcuts in chiaroscuro, chiefly from the great Venetian masters. After 20 years spent in France and Italy he returned to England, and finding no employment, he engaged himself in a paper-hanging manufactory at Battersea, where he continued in 1754, after which time no further record of him appears. He was employed upon vignettes and ornamental cuts for books, produced a fine 'Descent from the Cross,' after Rembrandt, and published six landscapes, printed in colours, of which process he claimed to be the inventor.

JACKSON, JOHN, *wood-engraver.* Was born at Ovingham, April 19, 1801. He was a pupil of Armstrong, and afterwards of Bewick; but, disagreeing with his master, after about twelve months he came to London, and was for a time under Harvey. He soon commenced on his own account, and was largely employed on Mr. Charles Knight's publications, especially upon his 'Shakespeare.' He employed many assistants, and his works, if not of the first class, were suited to the publications for which they were required. Some of his engravings of cattle, after Harvey, may be referred to as among his best works, as also some of his blocks for Northcote's 'Fables.' He published, with Chatto, 'A Treatise on Wood Engraving, Historical

236

and Practical'—a work which is due to his enterprise. After four years of declining health and suffering, he died March 27, 1848. He was buried in Highgate Cemetery.

JACKSON, JOHN RICHARDSON, *mezzotint engraver.* Was born at Portsmouth, December 14, 1819, and was the second son of Mr. E. Jackson, banker. In 1836 he became the pupil of the late R. Graves, A.R.A., and at first practised line-engraving, but before long he abandoned this method in favour of mezzo-tint. His first work of importance was 'The Otter and Salmon,' after Sir E. Landseer, engraved in 1847; but he subsequently confined himself almost entirely to portraits. Among them may be mentioned 'Lord Lansdowne,' after Sir F. Grant, P.R.A.; 'Archbishop Trench,' 'Duke of Buccleugh,' 'Bishop Wilberforce,' and many others, after G. Richmond, R.A.; 'Sir A. Fairbairn,' after G. F. Watts, R.A.; 'The Queen,' after Fowler; 'The Princess Royal and her Sisters,' after Winterhalter, etc., etc. His drawing was careful and his execution refined and delicate, and his best works are characterised by much richness of colour. He died at Southsea of relapsing fever, May 10, 1877.

JACKSON, SAMUEL, *water-colour painter.* He was born at Bristol, where his father, a merchant, brought him up in his office. He travelled in Scotland and Ireland, and made a voyage to the West Indies to establish his failing health. In his travels the contact with nature developed a love of art, and at the age of 30 he commenced its study as a profession, and was the pupil of Danby, A.R.A., who was then residing at Bristol. He formed a friendship with Prout, Pyne, and some others; and gaining a footing in art, was in 1832, while still residing at Bristol, elected an associate exhibitor of the Water-Colour Society, and from that time was a yearly contributor of views in Wales and landscape compositions up to 1848, when he withdrew from the Society. In 1853 he exhibited at the Royal Academy a 'Roadstead after a Gale, Twilight,' and 'Towing a dismasted Vessel into Port,' both in water-colours; and the following year a 'Coast Scene, a Calm.' When well advanced in life, he made a tour in Switzerland, and painted some of his most successful pictures. Well versed in the technicalities of his art, he successfully studied the treatment of landscape, which he rendered with much poetry and effect. He died in 1870, aged 75. His son, Mr. S. P. JACKSON, is a member of the Water-Colour Society.

JACKSON, WILLIAM, *amateur.* He was born in 1730, at Exeter, the son of a tradesman in that city, and became distinguished as a musician and teacher of

music. He was a friend of Gainsborough, had a good taste for art, and was known in his day by his clever landscapes. In 1771 he was an honorary exhibitor at the Academy; but his chief merit was as a copyist, particularly of the works of Gainsborough, of whose life he wrote an interesting sketch. He also published some works on music and on some miscellaneous subjects. He died July 12, 1803.

JACOBSEN, THEODORE, architect. Was descended from a family who possessed considerable property in London at the time of the Great Fire. He built the Foundling Hospital, London, and the Royal Hospital at Gosport. He was a fellow of the Royal Society and of the Society of Antiquaries. He died in May 1772, and was buried in Allhallows' Church, Thames Street. His portrait is in the Foundling Hospital, of which institution he was a governor.

JAGGER, CHARLES, miniature painter. Practised at Bath, and does not appear to have exhibited in London. His works are marked by peculiar breadth and character, and are esteemed for their ability. A portrait by him of the Duke of Clarence is engraved. He died at Bath, after two days' illness, in 1827, aged 57.

JAMES, ISAAC, statuary. He practised in London in the reign of Charles I. Nicholas Stone was his pupil, and was afterwards connected with him in some monumental work.

JAMES, JOHN, architect. He was, in 1705, appointed clerk of the works, and afterwards surveyor, of Greenwich Hospital, and being much employed at Greenwich, he settled there in 1718, and built the parish church. In 1710 he built Orleans' House, Twickenham, and in 1713-15 added a new body to the church, leaving the ancient tower standing. In 1721 he built a large mansion at Blackheath for Sir Gregory Page, since pulled down. He also built Canons for the Duke of Chandos, and the church of St. George, Hanover Square, finished in 1724, and St. Luke's, Middlesex. He was partner in Ged's scheme of block printing, and sunk a considerable sum of money, which he lost. He translated Perrault's 'Ordonnance des cinque Espèces de Colonnes selon la Méthode des Anciens,' 1712, and wrote 'The Theory and Practice of Gardening,' 1737, and a pamphlet on the schemes for rebuilding Westminster Bridge. He died early in 1746.

JAMES, GEORGE, A.R.A., portrait painter. Was born in London, and went early to Rome to study art. On his return he settled in Dean Street, Soho, to practise his profession, but did not meet with much encouragement, and then removed to Bath, where he had little better success. He was a member of the Incorporated Society of Artists, and in 1764 exhibited with them the 'Death of Abel,' a large picture, followed, in the succeeding years, up to 1768, by portraits. He exhibited portraits at the Royal Academy, some of them whole-lengths, from 1770 to 1777; and in 1771, 'Cupid stung by a Bee.' He afterwards resided at Bath, from whence he sent some small subject pictures to the Academy Exhibition in 1789 and 1790. His works, though carefully painted and designed, possess little merit. He was elected an associate of the Academy in 1780. His grandfather built Meard's Court, Soho, and he inherited this property. He also married a lady of some fortune, so that he was independent of his profession. He had the reputation of being a bon vivant, a clever comic singer, and a good mimic. He went to reside at Boulogne, and was thrown into prison by Robespierre. His constitution suffered, and he died early in 1795.

JAMES, WILLIAM, landscape painter. Practised in the latter part of the 18th century, and was in 1766 a member of the Incorporated Society of Artists. He also dealt in pictures. When Canaletti was in London he was his pupil, or rather, perhaps, his assistant, and an imitator of his manner. He exhibited at Spring Gardens, from 1761 to 1768, views of London from the bridges and in the parks; and at the Royal Academy some Egyptian temples and Oriental scenes in 1769 and 1770; and in the following year (after which his name disappears) two views of London and Westminster. There are some views by him in the Hampton Court Galleries. They are very literal, and entirely without art.

JAMESON, Mrs. ANNA, amateur. She was born in Dublin in 1796, and was the eldest daughter of Mr. Murphy, an artist of some repute, who filled the appointment of painter in ordinary to the Princess Charlotte. She married, in 1823, a gentleman who held the office of vice-chancellor of Canada, but the marriage was not a happy one, and a separation soon followed. In 1834 she published anonymously her 'Diary of an Ennuyée,' which was written during a tour in Italy; and from that time, encouraged by the success of her work, commenced a literary career. She visited Germany in 1837, and America in 1839. She died at Ealing, after a few days' illness, March 17, 1860. Among her numerous publications, those more immediately referring to art are, 'Sketches of Germany, Art, Literature,' &c., 1837; 'Handbook of the Public Galleries of Art in and near London,' 1842; 'Memoirs of the Early Italian Painters,' 1845; 'Memoirs and Essays, illustrative of Art, Literature,' &c., 1846; 'Decorations to the Garden Pavilion,

Buckingham Palace,' 1846; 'Sacred and Legendary Art,' 1848; 'Legends of the Monastic Orders, as represented in the Fine Arts,' 1850; 'Legends of the Madonna, as represented in the Fine Arts,' 1852; 'Hand-book to the Art of Modern Sculpture, Crystal Palace,' 1854; 'History of Our Lord, as exemplified in Works of Art,' 1864. Several of these works are profusely illustrated by careful drawings, made, and some of them etched, by herself.

JAMESON, ALEXANDER, *engraver*. He was a descendant of the above, and engraved the family group of 'Jameson, with his Wife and Son,' in 1728. He is supposed to have practised as an engraver at Edinburgh, but nothing is known of him.

• JAMESONE, GEORGE, *portrait painter*. He was the son of an architect and member of the guild at Aberdeen, and was born there in 1586. He was sent—it is not known under what influences—to study art under Rubens, at Antwerp, where he was a fellow-pupil of Vandyck. He returned to Aberdeen in 1620, married there in 1624, and his continued residence in that city may be traced up to the end of 1630. In 1635 he is described as dwelling in Edinburgh, and later, as a burgess of the city. On settling in Aberdeen he applied himself to portraiture, practising in oil, but there are some historical subjects and landscapes in his hand. He also painted some miniatures. His portraits are usually rather under life-size. His oil-paintings are delicately finished and well coloured, remarkable as the works of a native painter of his time. We are told that when Charles I. held a parliament in Edinburgh, in 1633, and rode with his nobles from the palace to the Parliament House, the magistrates, to please the King's well-known love of art, collected all the paintings by Jamesone they were able, and hung them on either side the Nether Bowport, through which the King had to pass; and that the King's attention being attracted, he stopped his horse a considerable time, and admired the paintings and the fidelity of the likenesses. This introduced the painter to the King, who sat to him for a full-length portrait. He died at Edinburgh in 1644, and was buried in the Greyfriars' Church, but without a memorial stone. Walpole tells, that by his will, dated in July 1641, 'he provided for his wife and children.' Other authorities state that his sons met early deaths, and that one daughter alone survived him. She inherited some of her father's genius, and executed several large Scripture subjects in worsted-work for the decoration of the church of St. Nicholas, Aberdeen.

JANSEN, BERNARD, *architect*. Little is known of his early life. He is believed to have been a Fleming. He lived in South-

wark in the reign of James I., and was employed on several extensive works. He built Audley Inn, 1616; the Lord Treasurer Howard's palace in Essex, an enormous pile, near Saffron Walden, also attributed to Thorpe; Northumberland House, Charing Cross, except the Strand front; and other mansions; but the best information respecting him and his works is scarcely authentic.

• JANSSEN, VAN CEULEN, CORNELIUS, *portrait painter*. Born in 1590, at Amsterdam, but some writers say in England, of Flemish parents. His first works in England are dated in 1618, and at that time he lived at Blackfriars, and was fully employed. Between 1630–40 he resided much in Kent, near Barham Down. He was engaged in the service of James I., and painted several fine portraits of him and the royal family. Industrious by habit, during a residence of nearly 30 years in this country, many eminent persons were his sitters. His reputation faded on Vandyck's arrival, and the Civil War breaking out he left England in October 1648, and died at Amsterdam in 1665. His works will be found in many old family collections. He is distinguished by the careful finish and calm truth of his portraits. His tints are quiet and delicate; his draperies frequently black, and relieved by some tasteful bit of colour. He painted sometimes to a small size, and occasionally copied his own works in that manner. He sometimes signs his pictures Jonson. His son Cornelius was bred to his profession, and followed him to Holland, where he died poor.

JARMAN (or JERMAN), *architect*. Was surveyor to the city of London at the time of the Great Fire in 1666. He rebuilt the Exchange, destroyed by fire in 1638, at a cost of 58,962*l*.; also the Drapers' Hall, the Fishmongers' Hall, since pulled down, and Merchant Taylors' Hall. He died 1668.

JARVIS, THOMAS, *glass painter*. He was born in Dublin, and originally practised there. Advised to try his fortune in London, he was on his arrival employed by Lord Cremorne upon some small works for his house at Chelsea. He made an exhibition in 1776 of his works in stained glass, comprising effects of moonlight, firelight, frost, &c. In 1777 he commenced the west windows for New College, Oxford, and introduced 'Two Shepherds' from Reynolds's 'Nativity' and several allegorical figures. He also painted West's 'Resurrection' (lately removed) for St. George's Chapel, Windsor. He is said to have introduced great improvements in his art, but he tried effects and a realistic manner, which are quite unsuited to glass painting. He died at Windsor, after some years'

retirement from his profession, August 29, 1799.

JARVIS, JOHN, *glass painter*. Born at Dublin about 1749. He was engaged with the foregoing Thomas Jarvis in most of his works, and was probably his brother. He commenced his art in Dublin, where he was assisted in his chemical studies by Dr. Cunningham. He came early in life to London, where he gained some distinction, and died in 1804.

JEAN, P., *miniature painter*. Was born at Jersey, and brought up in the Navy. On the peace which followed the American War he studied miniature painting, and practised with much skill. He also painted in oil, and executed a whole-length of the Queen, but it was without any original merit. He exhibited miniatures, with, on one or two occasions, an oil portrait, at the Royal Academy from 1787 to 1802. He died at Hempstead, in Kent, September 12, 1802, aged 47.

JEAVONS, THOMAS, *engraver*. He was born in 1816, and became of some repute as a landscape engraver, working in the line manner. 'Dutch Boats in a Calm,' 1849, is a good work by him, after E. Cooke, R.A. He retired to Welshpool, where he resided many years, and died November 26, 1867.

JEFFEREYS, JAMES, *marine painter*. Born at Maidstone 1757, the son of a painter there of coach panels, and occasionally landscapes. He was placed under Woollett, the engraver, but became a student of the Royal Academy, and studied painting. In 1773 he obtained the Academy gold medal for the best historical painting; the following year the gold palette at the Society of Arts; and in 1775 was selected to go to Rome by the Academy, on the allowance provided by the Dilettanti Society. He returned at the end of four years, but was careless of himself, and died of a decline, January 31, 1784, aged 27. His picture of the 'Destruction of the Spanish Batteries before Gibraltar,' his only contribution to the Academy, was exhibited in 1783, and was engraved by James Emes.

JENKINS, D., *engraver*. Practised in London towards the end of the 18th century. He engraved several plates after Angelica Kauffman. There are two plates by him of horse races, dated 1786.

JENKINS, THOMAS, *history painter*. Born in Devonshire, he studied in London under Hudson, and accompanied Richard Wilson to Rome, where he was residing in 1763. He studied historical painting, but does not appear to have ever exhibited; and not succeeding, he became a dealer in antiquities, and also the chief English banker in Rome, where he amassed a considerable fortune. He was instrumental to the purchase of many works of antique sculpture brought home by his countrymen. On the

occupation by the French, they confiscated his property, and he escaped to England. He died at Yarmouth in 1798, immediately upon landing after a storm at sea.

JENNER, ——, *engraver*. Practised in the latter part of the 18th century. He engraved Sir J. Reynolds's 'Girl with a Muff,' 1777.

JENNINGS, ROBERT, *master mason*. Was employed in the erection of Henry VII.'s Chapel, Westminster.

JERVAS, CHARLES, *portrait painter*. Born in Ireland about 1675. He received a good education, and showing a decided taste for art, was placed under Sir Godfrey Kneller, in London, for about a year. He copied the cartoons in little, and sold his copies to Dr. Clark, of Oxford, who assisted him to visit Paris and Italy. At Rome, when 30 years old, he studied art—Walpole says 'drawing.' On his return, he found full employment, married a widow lady with a fortune of 20,000*l.*, and was appointed principal painter to George I., and afterwards to George II. He was the head of the art of his time, and was a gentleman, a man of letters, and a wit; the intimate friend of Pope and Addison, by whom his natural vanity was inflamed. The former addressed a complimentary epistle to him; but he was sadly wanting in all the art qualities for which he was so unmeaningly praised. His portraits are slight, both in drawing and character, but his art has been unjustly depreciated. That he was not without merit will be evident from his portrait of the Duchess of Queensbury, recently added to the National Portrait Gallery, and his other portraits in that collection. He affected to be violently in love with Lady Bridgewater, and after finding a fault in her ear, as the only feature short of perfection, pointed to his own as a perfect model. He is known by his English Edition of 'Don Quixote;' but his friend Pope, evidently referring to him, says he translated this work without understanding Spanish. In 1738 he visited Italy a second time for his health, but only survived a short time, dying November 2, 1739, at his house at Cleveland Court. Here, in the following year, his collections, the fruits of 40 years, were sold by auction. His paintings, statues, china, Raphael-ware, and other works of art, occupied nine days; his drawings followed, in 2,275 separate lots, and occupied 25 more days. There is a portrait of Pope by him in Lansdowne House, and of Newton at the Royal Society.

JEWITT, THOMAS ORLANDO SHELDON, *wood-engraver*. He was born in Derbyshire, of a family known in literature, in 1799, and as a boy attempted wood-engraving. In his 16th year he illustrated in wood his elder brother's 'Wanderings of Memory;' and later 'The Northern Star;

or, Yorkshire Magazine,' which was published by his father. He then devoted himself to the pursuit of art, and becoming known, he connected himself with Mr. Parker, of Oxford, in his architectural publications, producing the illustrations for the 'Memorials of Oxford,' the first editions of the 'Glossary of Architecture,' 'Domestic Architecture of England,' and some other works. In 1838 he removed to Oxford, and gaining a name by his architectural engravings, was employed upon Murray's 'Cathedrals,' Scott's 'Westminster Abbey,' Street's works on Spain and on Venice, and many other publications of the same class. He was a good naturalist, and illustrated Harvey's 'Sea Weeds,' Bentham's 'British Flora,' Reeve's 'Land and Fresh-water Mollusks,' and in the latter drew many of the specimens himself from nature. He died at Camden Town, May 30, 1869.

JOHNS, AMBROSE BOWDEN, *landscape painter*. Was born at Plymouth in 1776, and was apprenticed there, as a bookseller, to the father of B. R. Haydon. He withdrew from that business early in life, to seek success in the neighbourhood as a landscape painter, residing there, and but little known beyond the locality. His works possessed some originality, both in their composition and treatment. He was an exhibitor at the Royal Academy in 1822, when he contributed 'Evening, Pirates landing their Cargo and a Female Captive,' and exhibited views in the neighbourhood of Plymouth in 1828, 1836, and 1838. Some of his landscapes are in Lord Morley's collection at Saltram, and in several other Devonshire mansions. He died at Plymouth, December 10, 1858.

JOHNSON, C., *engraver*. He was one of the few who early practised the art in England. His works, which are chiefly portraits, have little merit. There is by him a head of the queen of James I.

JOHNSON, GERARD, *modeller*. A Hollander, who lived in the parish of St. Thomas the Apostle, London, and is stated, in Dugdale's 'Diary,' to have made the monumental bust and tomb of Shakespeare at Stratford-upon-Avon.

JOHNSON, ISAAC, *antiquarian draftsman*. Was a resident at Woodbridge, and practised as a surveyor. He made many drawings of antiquities, which were esteemed for their fidelity, and between the years 1799 and 1816 drew nearly every church in the county. Some of his drawings are engraved in Gough's 'Monumental Antiquities' and in Loder's 'History of Framlingham.'

JOHNSON, JAMES, *engraver*. Practised in London about the middle of the 18th century. His works, both portrait and history, are chiefly in mezzo-tint. He

engraved after Coreggio, Le Brun, Rubens and others.

JOHNSON, JOHN, *architect*. Born at Leicester in 1754. He left his native town early in life, and by his strong natural abilities made himself known in his profession. He was for 26 years architect and surveyor to the county of Essex. He built, at Chelmsford, in 1787, the handsome one-arch stone bridge, and in 1792 the county hall. He enlarged and improved the county prison, and in 1806 built the new house of correction. He died in 1814, aged 60.

JOHNSON, JOHN, *wood-engraver*. Was a pupil of Bewick. He showed much taste for drawing, but died at Newcastle about 1797, shortly after the termination of his apprenticeship. A few of the tail-pieces to the 'British Birds' are by him. He was cousin of the following Robert Johnson.

JOHNSON, LAWRENCE, *engraver*. Practised at the beginning of the 17th century. Engraved the heads for 'The General History of the Turks,' 1603. He worked entirely with the graver, but was without merit.

JOHNSON, MARTIN, *medallist*. Practised in the first half of the 17th century. He began art as a painter of English views, and his works showed much taste, freedom of execution, and colour. He then turned medallist, and was an assistant and a worthy rival of Simon. He died about the beginning of James II.'s reign. Evelyn mentions him in his 'Sculptura' as excelling in medals and intaglios.

JOHNSON, ROBERT, *painter and engraver*. Was born at Shotley, a village in Northumberland, in 1770, and was apprenticed to Bewick as a copper-plate engraver. He was led aside from this laborious art, in which he did not excel, by his love of sketching from nature in water-colours. During his apprenticeship he made, in water-colours, with admirable finish, the designs for some of the tail-pieces in Bewick's 'Water Birds,' and for most of the wood-cuts in his 'Fables.' Some of these were copied on the block by William Harvey, the rest by Bewick himself. A number of the original drawings were purchased by the Earl of Bute. On the completion of his apprenticeship, he left his work on copper, and devoted himself to water-colour drawing. In 1796 he was employed to copy the portraits by Jamesone at Taymouth Castle; and neglecting a severe cold caught there, it terminated in fever, under which his delicate constitution sank, and he died at Kenmore, Perthshire, October 26, 1796, in his 26th year.

JOHNSON, THOMAS, *architect*. Was born at Stone, Staffordshire, December 24, 1794. He had a talent for drawing, and after an apprenticeship in Lichfield, he came

to London, and was employed in the office of Mr. Shaw, the architect. Returning in 1825 to Lichfield, he established himself there, and was the architect of churches at Longton and Stoke, and of a club-house in Manchester. In Lichfield he built Christ Church, the corn exchange and market, and some other public edifices. He died May 7, 1865, at Lichfield, and was buried there.

JOHNSON, Thomas, *draftsman and engraver.* Practised in London in mezzo-tint in the latter part of the 18th century. There are several good mezzo-tint portraits by him, some from the life; also, after his own drawing, 'A View of Canterbury Cathedral,' in Dugdale's 'Monasticon.' Strutt says that Faber adopted Johnson's name to engravings to which he did not choose to affix his own.

JOHNSTON, Andrew, *engraver.* There are a few mezzo-tint portraits by this artist. A portrait of Henry Sacheverell, after Gibson, is by him.

JOHNSTON, Francis, R.H.A., *architect.* Born in Ireland. Practised at Armagh 1786–93, and superintended the erection of the cathedral tower. He resided afterwards for some time in Dublin, and completed there the Castle Chapel, St. George's Church, 1802, a good example of the Ionic order, the steeple, elegant and original in its design. The cashier's office of the Bank of Ireland, 1804; the Post Office, 1817; and the Richmond General Penitentiary, are also by him. In 1824 he commenced, at his own expense, the erection of the Royal Hibernian Academy, including the exhibition rooms, schools, and keeper's residence, which he completed in 1826, at a cost of 14,000l., and presented to that institution in perpetuity. He was the same year elected the president. He held the office of architect to the Dublin Board of Works. Died March 14, 1829.

JOHNSTON, Richard, *architect.* Born in Ireland. Practised with some repute in Dublin in the latter half of the 18th century. He built the Dublin Assembly Rooms, a fine suite of apartments.

JOHNSTONE, William Borthwick, R.S.A., *landscape and history painter.* Was brought up as a solicitor, but allured by a love of art, he at last turned to its study with great enthusiasm. He tried both history and landscape, and in 1843 went to Rome, and, led by the art which surrounded him, tried some works in the early Italian style. In 1840 he was elected an associate, and in 1848 a member, of the Scottish Academy. Here his chief works were exhibited, and he became the curator of the National Gallery for Scotland on its establishment in 1858, an office for which he was well fitted by his knowledge of the history of his art and of archæology. After his first manner he tried an elaborate finish,

and later relapsed into a more free and larger treatment. He does not appear as an exhibitor at the Royal Academy in London. He died in Edinburgh, June 5, 1868, in his 56th year.

JONES, Charlotte, *miniature painter.* She was an exhibitor at the Royal Academy, commencing in 1801, and held the appointment of miniature painter to the Princess of Wales, and her portrait of the princess is engraved. She continued to exhibit until 1823, when her name appears for the last time in the catalogue. She died September 21, 1847.

JONES, Emma (Madame Soyer). Born in London in 1813. She is reputed to have drawn likenesses with great fidelity before the age of 13 years, and devoted herself to the study of art. She painted portraits and groups of children, and was a frequent contributor to the Suffolk Street Exhibition; one of her groups is engraved in mezzo-tint. In 1836 she married M. Soyer, the well-known *chef de cuisine* of the Reform Club. She died in child-bed, August 29, 1842, and was buried in the Kensal Green Cemetery. Her works are hard and black, with little feeling for colour or light and shade, but are not ill-drawn, and are good in their expression.

JONES, Inigo, *architect.* Was born near St. Paul's, London, about 1572, the son of a citizen and cloth-worker, a respectable man, in religion a Catholic. He was apprenticed to a joiner, early distinguished himself by his pencil, and gained notice for his landscape skill and his designs. He was evidently well educated for his station in life. His talents introduced him friends, and the Earls of Pembroke and Arundel, it is said, though doubtful, assisted him to visit Italy. He studied some time at Rome, and then for several years at Venice. Here the reputation he had acquired gained him the notice of Christian IV., King of Denmark, who appointed him his architect, and employed him at Copenhagen. It seems most probable, that he accompanied the King on a visit to this country in 1606, and that soon after his arrival Queen Anne, the sister of the King of Denmark, appointed him her architect, and he was granted the office of surveyor-general in reversion; Prince Henry also appointed him his architect. He first shewed his ingenuity and skill in the preparation of the Court masques, then the fashion.

On the untimely death of the young prince in 1612 he again went to Italy, where he remained some years, maturing his powers by study. Then his reversionary office fell vacant and he returned to England. He commenced the Banqueting House in Whitehall in 1619, and designed for James I. the magnificent palace of which it was

R

to form a part; but the time passed, James died, and the great designs, which his son inherited, were set aside in the sad times which followed. They are, however, preserved by Kent in the volumes published by Lord Burlington. He was appointed in 1620 one of the commissioners for the repair of St. Paul's, but did not commence the work till 1633. He renewed the sides with the bad Gothic which then prevailed, adding to the western entrance a Roman Corinthian portico, which must have possessed much stately grandeur, but was no less incongruous and unsuited to the ancient parts of the building. At Winchester, in the same manner, he introduced into the Gothic cathedral a Roman screen. On the accession of Charles I., who esteemed him a man of genius, he was continued in his office of Crown surveyor, and as architect to the Queen. Meanwhile his restoration of old St. Paul's went on, including the erection of the far-famed stately Corinthian portico. Among his other chief works are—the quadrangle of St. John's College, Oxford; the Queen's Chapel, St. James'; the Piazzas and Church, Covent Garden; Lincoln's Inn Chapel; the Queen's House, Greenwich; and Surgeons' Hall. To these works must be added several fine mansions — Gunnersbury pulled down in 1802, Coleshill, Cobham Hall, Kent; The Grange, Hants; and others imputed to him, but of which little certain is known.

He also designed the movable scenery and contrivances for the Court masques, and was thus associated with Ben Jonson, with whom a quarrel arose, which ended only with life; and the poet satirised him without mercy as 'Lantern Leatherhead' and 'Inigo Marquis Would-be.' He had made a handsome fortune, but was a great sufferer at the Revolution. In November 1640, upon the complaint of the parish of St. Gregory, London, he was brought before the House of Lords, for damages which the church of that parish. He was not only a favourite of his deposed royal master, but also a Roman Catholic, and in 1646 he was compelled to pay 545l. for his delinquency and sequestration. He had buried his accumulation of ready money in Scotland Yard, but on a proclamation encouraging informers, he removed it to Lambeth, where he again concealed it. On the Restoration, Charles II. continued him in his post. He did not long survive; grief, misfortune, and old age ended his life, and he died at Somerset House, July 21, 1651. But the accounts of the date both of his birth and death are very conflicting. He was buried at St. Bennet's, Paul's Wharf. His only daughter and heiress married John Webb, his pupil and executor.

JONES, JOHN, *engraver.* Born about 242

1740. He devoted himself to mezzo-tint and the dot manner. He practised in London, and his mezzo-tint plates have gained him much reputation both in portrait and history. He engraved many fine works after Reynolds, Gainsborough, Romney, Hone, Mortimer, and others. His works are dated between 1774 and 1791. They are powerful, but black; his flesh defective in colour. He died 1797.

JONES, GEORGE, R.A., *battle and subject painter.* Son of the foregoing. He was admitted a student of the Royal Academy, and was an exhibitor for the first time in 1803. During the Peninsular War he joined the South Devon Militia, afterwards held a lieutenantcy in the Staffordshire Militia, and was promoted to a company in the Montgomeryshire Militia. He likewise, with his company, volunteered for active service, and in 1815 joined the Army of Occupation in Paris. On the termination of the war he resumed the practice of his art, and in 1820 was elected an associate of the Royal Academy, in 1824 a full member. In 1820, and again in 1822, he received premiums from the British Institution. He was appointed the librarian to the Academy in 1834, which he resigned to fill the office of keeper in 1840, and continued to hold the latter appointment till 1850. He painted the picturesque towns of the Continent, filling them with characteristic groups and incidents. Later he painted several battles. His 'Battle off Cape St. Vincent, Nelson Boarding,' was purchased by the directors of the British Institution and presented to the gallery at Greenwich Hospital. The directors also commissioned him to paint the 'Battle of Waterloo,' which they presented to Chelsea Hospital. Several other of his works are in the Vernon Gallery, now in the South Kensington Museum. He died in London, September 19, 1869, aged 83. He was one of the executors of the will of Turner, R.A. He wrote 'Recollections of the life of Francis Chantrey, R.A.'

JONES, OWEN, *architect and ornamental designer.* Was of an old Welsh descent, and his father, a fur merchant, gained a well-merited distinction by his collection of Welsh poetic literature. He was born in Thames Street, London, February 15, 1809. Losing his father when young, he was placed by his guardian at the Charterhouse, but was afterwards removed to a private school, and it was intended that he should be brought up for the Church. Instead of this he became, at 16, the pupil of Louis Vulliamy for six years, whom he served with great zeal, studying at the same time at the Royal Academy; yet though he became a good draftsman he did not master the figure.

On the completion of his pupilage he travelled, and setting out in the autumn of 1830, visited Paris, Milan, Venice, and Rome. After a short return to France, he started in 1833 for the East, and saw parts of Greece, Alexandria, Cairo, Thebes, and Constantinople. In this journey his mind received, while in Egypt, that strong impression of Arabic form and ornament which founded the ideal of his future art, and led him in 1834 to Granada, where he was allured by the great Moorish work, the Alhambra, which he made the object of his study. Returning to England in 1836, he began his work on 'The Alhambra,' and revisiting Granada in 1837, spent another year on the work, which was not completed till 1845. He devoted himself entirely to it, and not only drew the details, but trained artists to assist him in the best use of gold and silver for their reproduction; and further, sold a property his father had left him in Wales, and also incurred liabilities in the undertaking, which was unsuccessful, and caused him much difficulty and anxiety. He then illustrated Lockhart's 'Spanish Ballads,' followed by some other works of the same class. In 1842 he issued his designs for 'Mosaic and Tesselated Pavements;' in 1846, 'The Polychromatic ornament of Italy;' in 1851 he was appointed to superintend the works of the Great Exhibition, and took an active part in the decoration and arrangement of the building; in 1852 he published an 'Attempt to define the principles which regulate the employment of Colour in Decorative Arts,' and afterwards lectured on the principles he had adopted. In the same year he was joint-director for the decoration of the Crystal Palace, and specially designed the Egyptian, Greek, Roman, and Alhambra Courts; in 1856 he published his 'Grammar of Ornament;' in 1867 his 'Examples of Chinese Ornaments.' He exhibited at the Royal Academy in 1831 his design for the 'Town Hall, Birmingham;' in 1840, for 'St. George's Hall, Liverpool;' in 1845, 'Mansions in the Queen's Road, Kensington,' and some designs for shop decoration. His works, the result of fifty years earnest labour, were founded upon the true principles of structural ornamentation and symmetry in harmony with harmony of colour. Possessing great fertility of invention, his art tended greatly to the decorative improvement of our manufactories, such as wall-papers, carpets, and furniture. He received the gold medal of the Institute of British Architects, of the Paris International Exhibition of 1867, and of the Vienna International Exhibition of 1873. He died in Argyll Place, April 19, 1874, and was buried in Kensal Green Cemetery.

JONES, THOMAS, landscape painter. Was born about 1730, and practised in London. In 1750 he was studying in Rome, where he appears to have continued till 1768, when he was awarded a premium at the Society of Arts. He first exhibited at the Royal Academy in 1784, and continued to exhibit Italian and Welsh views up to 1788, but did not exhibit again till 1798, when he contributed four Italian views. His name does not again occur. Woollett engraved after him, in 1776, the 'Merry Villagers;' and Bartolozzi and others engraved his works. Mortimer, A.R.A., painted the figures in some of his landscapes.

JONES, JOHN E., sculptor. Was born in Dublin in 1806. He studied in that city as a civil engineer, but having a taste for sculpture, he came to London to study for that profession, and practised here. He first exhibited at the Royal Academy in 1844, his contributions in that year being busts of 'Daniel O'Connell' and other eminent Irishmen; and settling in London, found great encouragement, and had many eminent sitters — the Queen, the Prince Consort, Lord Brougham, the Emperor of the French, the Duke of Cambridge, Duke of Wellington, Louis Philippe, the King of Holland, and others. He died in Dublin, July 1862. His art was confined to busts, and was well esteemed.

JONES, WILLIAM, landscape painter. He was a native of Ireland, and practised there in the latter part of the 18th century. His views of the 'Waterfall' and the 'Salmon Leap,' county of Wicklow, have been engraved.

JONSON, VAN CEULEN, CORNELIUS. See JANSSEN.

JOSEPH, GEORGE FRANCIS, A.R.A., portrait and history painter. He was born November 25, 1764, and in 1784 entered the schools of the Royal Academy. He first appears as an exhibitor in 1788, and then contributed a portrait family group and 'A Bacchante,' an impression from a gem, and, on a subsequent occasion, a work of the same class. He continued to exhibit portraits, with, in 1792, a subject picture 'Eve met by Adam,' and in that year gained the Academy gold medal for his original painting, 'A Scene from "Coriolanus."' Shortly after he exhibited miniatures, and for some time continued a large contributor of them, with sometimes an oil portrait or a subject picture. In 1797 he painted 'Mrs. Siddons as the Tragic Muse;' in 1808, 'Flora dispensing her Sweets to Zephyr.' He was also an exhibitor at the British Institution, and was awarded by the directors two premiums —in 1811, 122l., for 'The Return of Priam with the dead body of Hector;' and the next year, 100 guineas, for his 'Procession to Mount Calvary.' This success was followed by his election, in 1813, as an

R 2 243

Jopling - Mrs Louise Goode & Fred Romer

associate of the Academy. He drew the Ilustrations for a serial publication of Shakespeare's works, commenced in 1824. But his practice was as a portrait painter, and he found his chief employment in that branch of art. There is a portrait by him of Mr. Spencer Perceval in the National Portrait Gallery. He retired to Cambridge in 1834, and died there in 1846, having continued an occasional exhibitor at the Academy up to that year. He was buried in St. Michael's Churchyard.

JOSEPH, SAMUEL, R.S.A., *sculptor.* He was a son of the treasurer of St. John's, Cambridge, and cousin to the foregoing. Commenced as a pupil of P. Rouw, and studied at the Academy, in 1815 obtaining the gold medal for his group of 'Eve supplicating Forgiveness.' After practising for some time in London, exhibiting yearly at the Academy busts and portrait medallions, he removed in 1823 to Edinburgh, where he met with great encouragement, and was elected a member of the Royal Scottish Academy. He was induced in 1828 to return to London, and settled in Great George Street, but did not meet with the support he had been led to expect. After the first year his contributions to the Academy were few, and ceased altogether after 1846. He died in London in 1850. He found his chief employment as a modeller of busts, and executed by command in 1830 a bust of George IV. His likenesses were accurate, and his work tasteful and well finished. There is a fine full-length characteristic statue by him of Wilberforce, in Westminster Abbey, and a statue of Sir David Wilkie, R.A., in the vestibule of the National Gallery.

JOSI, CHRISTIAN, *engraver.* Was born in Holland, and coming early to this country, he studied his art under J. R. Smith. He engraved and published many fac-similes of Dutch drawings, but early abandoned the more active pursuit of art, and possessing great knowledge, found profitable employment as a restorer and dealer in engravings and drawings. He died in London about 1825. His son, HENRI JOSI, was appointed keeper of the prints and drawings in the British Museum, and held that office till his death, in 1845, in his 43rd year.

JOY, THOMAS MUSGRAVE, *subject painter.* Was born in 1812, at Boughton, Minchelsea, Kent, where his father possessed property. An only son, fond of art, and allowed to choose for himself, he came to London, and was the pupil of Drummond, A.R.A. He first exhibited at the Society of British Artists in 1832, and at the Academy in 1833, and continuing to exhibit at both these institutions, he early made himself known. In 1841 he received some commissions from the Queen, and painted

for her Majesty portraits of the Prince and Princess of Wales. With occasionally a portrait, in 1842 he exhibited at the Academy, 'Le Bourgeois Gentilhomme;' in 1853, 'A Medical Consultation;' in 1863, 'Prayer;' and among his last works—an important attempt — 'The Meeting at Tattersall's before the Race,' 1864. He died of bronchitis, after a short illness, April 7, 1866.

JOY, WILLIAM, } *marine painters.*
JOY, JOHN CANTILOE, } Their father was guard to the Yarmouth coach. William was born in 1803, John Cantiloe in 1806. They practised for many years in Yarmouth, working almost invariably together, and painting both in oil and water-colours, but chiefly in the latter. Self-taught and independent, they thoroughly understood the trim and rigging of vessels, and their works are deservedly esteemed. In 1824, and again in 1832, William was an exhibitor at the Royal Academy. Leaving their native town, where many of their works are treasured, they lived some time in London, and then removed to Chichester, where they both died, within a short time of each other, in 1857.

JUDKIN, The Rev. T. K., *amateur.* He was for many years minister of the Episcopal Chapel at Somers Town, and was known in art by his clever landscapes, usually painted direct from nature. He was an occasional exhibitor at the Academy from 1822 to 1848. He died in October 1871, aged 83.

JUDKINS, ELIZABETH, *mezzo-tint engraver.* Practised in London in the second half of the 18th century. She engraved some fine works after Reynolds—'Mrs. Abington,' 1772; 'The careful Shepherd,' 1775; and also after Cotes.

JUKES, FRANCIS, *painter and engraver.* Born at Martley, Worcestershire. He began art as a topographical landscape painter, but by great perseverance raised himself to much distinction as an aqua-tint engraver. This art he brought to great perfection; and by tinting his impressions, gave them the effect of drawings. His works, which are principally sea-pieces and landscapes, are very numerous. He died in 1812, in his 66th year. He engraved Walmesley's 'Views in Ireland,' Nicholson's 'Views in England,' and was employed on Gilpin's works.

JUNE, JOHN, *engraver.* Practised about the middle of the 18th century. He engraved some portraits and portrait frontispieces for books, also some landscapes after Collett, and some scenes after Hogarth; and in 1770, 'Race-horses,' after Sartorius.

JUPP, RICHARD, *architect.* He was appointed architect to the East India Company, and designed the new *façade* to the

India House in Leadenhall Street, since pulled down; a work simple in its proportions, with an Ionic portico well introduced. He also added the front to the Skinners' Hall. In 1762 and 1763 he exhibited with the Society of Artists, and also contributed to the early exhibitions of the Royal Academy. He was one of the original members of the Architects' Club, founded in 1791. He died in London, April 17, 1799.

JUPP, WILLIAM, *architect*. Brother of the foregoing. He was a member of the Incorporated Society of Artists. He rebuilt the 'London Tavern,' Bishopsgate Street, 1765, and designed the entrance hall and staircase of the Carpenters' Company's Hall, 1780. He died 1788.

JUPP, WILLIAM, *architect*. Son of the foregoing William Jupp. Was an occasional exhibitor at the Academy, 1794–1804. Held the appointment of architect to the Skinners' Company, and designed the exterior of their hall, Dowgate Hill, 1808. He was also architect and surveyor of the Merchant Taylors', Ironmongers', and Apothecaries' Companies. He died at Upper Clapton, April 30, 1839.

JUTSUM, HENRY, *landscape painter*. He was born in London in 1816. Sent to school in Devonshire, he imbibed a love of landscape, and on his return made Kensington Gardens a place of study. He first exhibited at the Academy in 1836, and in 1839 became a pupil of James Stark. Then trying water-colour painting, he was in 1843 elected a member of the new Water-Colour Society; but he continued a contributor to the Academy Exhibitions, and in 1847 left the Society, determined to devote himself to painting in oil. He was also an exhibitor at the British Institution. He painted exclusively the scenery of his country, and was distinguished by his pleasing style. He died at St. John's Wood, March 3, 1869.

K

KAUFFMAN, JOHN JOSEPH, *portrait painter*. He was born in Switzerland, and practised in this country for several years, but was a very indifferent painter. He contributed sacred and poetic subjects, with an occasional portrait, to the exhibitions of the Royal Academy, from 1771 to 1779, and in the following year retired with his daughter to Rome.

• KAUFFMAN, ANGELICA MARIA CATHERINE, R.A., *history and portrait painter*. She was daughter of the above, and was born October 30, 1740, at Coire, the capital of the Grisons. She very early developed a talent for music and drawing, and when between 10 and 11 years of age drew portraits in crayons. Brought up to art from a child, she was taken by her father to the Academy in boy's clothes, to improve in drawing. In 1754, when in her 15th year, she went with him to Milan, and there painted the portraits of some eminent persons. She afterwards spent about a year in Florence, and then, in 1759, accompanied her father to Rome. She had made herself complete mistress of the German, French, Italian, and English languages, and highly excelled both in vocal and instrumental music. With these advantages she had many sitters, and her reputation as a painter greatly advanced.

In 1764 she removed to Venice, and there became acquainted with the wife of the English ambassador, whom she accompanied to England in 1765. Learned, refined, and amiable in manner, she was introduced to the young Queen, and her talents, joined to her elegant person, attracted general notice. In 1769 she was nominated one of the foundation members of the Royal Academy, and the same year she was unhappily deceived into a secret marriage with the valet of Count de Horn, who contrived to pass himself off as his master. Ill-treated by this fellow, he was at last induced by a payment of 300*l*. to take himself off to Germany, and she was relieved of him for ever. She contributed to the first and every subsequent exhibition of the Academy up to 1782, sending in that year a work catalogued from 'Abroad.' She usually exhibited three or four classic subjects and one or two portraits. After settling at Rome she exhibited a classic picture in 1788, 1789, 1796, and in 1797 a portrait of a lady of quality, her last contribution. She decorated a room for the Queen at Frogmore, still called the 'Flower Room,' where some of her flower-groups remain. She married a second time, in 1780, Signor Antonio Zucchi, a Venetian painter, who had long resided in England, and retaining her maiden name, after travelling with him in Italy, and making some stay in Naples, she retired with him in 1782 to Rome, accompanied by her father. Here she resided 25 years in the full enjoyment of her popularity, and died after a long and painful illness, November 5, 1807, in her 67th year.

Her works are numerous, and will be found in many of the collections which date from her time, though they are now held in little esteem. Her reputation was widely spread by the numerous engravings from her paintings. Ryland, Bartolozzi, and Schiavonetti engraved after her, and Alderman Boydell published no less than 60 of her works. Yet, though her paintings were gay and pleasing in colour, they are weak and faulty in drawing, and lack life and originality. They are chiefly taken from the classics and her own poets, and all partake of the same effeminate stamp. There are some slight etchings by her.

° KAY, JOHN, *miniature painter and caricaturist.* He was born near Dalkeith, in April 1742. His father was a stonemason, and destined him for the same business, but dying early, he was placed with some relatives, who treated him with much cruelty. At the age of 13 he was apprenticed to a barber in Dalkeith, and after serving with him six years came to Edinburgh and set up for himself. The trade was a lucrative one in those days, and he throve in his shop. He had, as a boy, made some attempts at drawing, and he now in his leisure tried some miniatures. His likenesses were faithful, and a wealthy customer assisted him to pursue art, and dying in 1782, his son settled upon him an annuity of 20*l.* a year; and with this help he abandoned his trade, and depended upon his limning, to which he added etching.

His principal employment was as a miniature painter. His works were minutely finished, and he managed to seize a likeness strong in the peculiarities of his sitter —full of individuality, but without art, of which he was ignorant, or flattery. In 1784 he published an etched caricature of a well-known crazed individual, which attracted notice, and led him to attempt others. These possessed the same qualities as his miniatures—caricatures, but extreme in their resemblance, humorous, exaggerating, and intensifying little points of character, they gave offence. Many were bought and destroyed. The artist was cudgeled and charges brought against him before the magistrates. Yet his works are only the exaggeration of truths, and are not offensive. They are highly interesting, elaborately minute in finish, but, like his miniatures, make no attempt at art—the offspring of great natural, but untaught genius. He died 1830.

He etched nearly 900 plates, perpetuating the characters, during nearly half a century, of persons of every class in Edinburgh, and his small shop-window was filled with these productions. His etchings are published in two quarto volumes, under the title of 'Kay's Edinburgh Portraits.'

KAY, JOSEPH, *architect.* Was born in 246

1775, and was a pupil of Cockerell, R.A. About 1802 he went to Italy, and studying some time in Rome returned in 1805. The east side of Macklenburgh Square was designed by him in 1812. He was appointed architect to the General Post Office in 1814, and designed the new Post Office in Edinburgh. In 1823 he received the appointment of architect to Greenwich Hospital, and designed several alterations which have greatly improved the hospital approaches. He was also architect to the Foundling Hospital. He died in Gower Street, December 7, 1847.

KEAN, MICHAEL, *miniature painter.* He was born in Dublin, and studied in the Dublin Academy, where he gained the gold medal in 1779. He was originally a pupil of Edw. Smith, the sculptor, but he turned to miniature painting, practising at the same time in crayons. He came to London, and between 1786–90 exhibited crayon portraits at the Royal Academy. At the early part of the 19th century he became a partner in the Derby China works. He died in London in 1823.

KEANE, JOHN B., *architect.* He held an appointment in the Dublin Office of Works, and practised for many years in Dublin. He sent a 'Design for a Temple' to the Academy Exhibition in London in 1840, but was not again a contributor. He designed two large Roman Catholic churches, and in 1846–50 the Queen's College Galway. He died October 7, 1859.

KEARNEY, WILLIAM HENRY, *water-colour painter.* His works were chiefly landscape, though he sometimes tried figures. He was one of the foundation members and a vice-president of the Institute of Painters in Water-Colours. His works, which were well esteemed, were careful, simply coloured, and painted in the early pure manner. One of his last exhibited works was 'Love's young Dream.' He died June 25, 1858, in his 58th year.

KEARSLEY, T., *portrait painter.* He practised in London with some repute about the end of the 18th century. He exhibited at the Royal Academy from 1792 to 1802. He painted several theatrical portraits, some of them whole-lengths.

KEATE, GEORGE, *amateur.* He was born at Trowbridge, of a good family, about 1729. Educated for the Bar, he travelled, became fond of art, and was admitted a member of the Incorporated Society of Artists. He was an honorary exhibitor at the Academy from 1770, with some intermission, to 1789, his contributions being chiefly coast views. He published his 'Sketches from Nature, taken and coloured in a journey to Margate,' in two volumes, 1779. The illustrations were on wood, and the writing a weak imitation of Sterne's

style. He was a F.R.S. and F.S.A. He died June 28, 1797.

KEATING, GEORGE, *engraver.* Born in Ireland in 1762, he was a pupil of William Dickenson, and practised in London towards the end of the 18th century, both in the mezzo-tint and the dot manner, and was well esteemed. He worked after Reynolds, Gainsborough, Henry Morland, and others.

KEEBLE, WILLIAM, *portrait painter.* Practised in London about the middle of the 18th century. He was a member of the St. Martin's Lane Academy in 1754. A whole-length portrait by him of Sir Crisp Gascoyne, lord mayor of London in 1753, was mezzo-tinted by McArdell.

KEEFE, DANIEL, *miniature painter.* He practised in London, and exhibited miniatures at the Royal Academy from 1771 to 1783.

KEELING, MICHAEL, *portrait painter.* He practised his art in Staffordshire, where his works were well esteemed. He exhibited portraits on two or three occasions at the Royal Academy, 1800-1809. He died near Stone, Staffordshire, in 1820.

KEENAN, J., *portrait painter.* He first appears as an exhibitor at the Royal Academy in 1792, and was then residing at Bath. From 1794 to 1799 he was practising in Exeter, and was a regular exhibitor, and in 1801 he came to London. He had several sitters of distinction, and was esteemed for his portrait-groups of children. In 1806 he went to reside at Windsor, and about that time painted many miniatures. In 1809 he was appointed portrait painter to Queen Charlotte, and continued to live at Windsor and contribute to the Academy Exhibitions up to 1815, when further trace of him is lost. His wife was an occasional exhibitor of landscapes.

KEENE, HENRY, *architect.* Practised about the middle of the 18th century, and was surveyor to the Dean and Chapter of Westminster. He was also for about 20 years the architect to Magdalen College, Oxford. He designed the new building at Balliol College, which forms a handsome front of street architecture, 1769; also the hall, chapel, and quadrangle of Worcester College, and was much employed in Oxford. He died 1776.

KELLY, RICHARD, *architect.* He built Hill Hall, Essex, a large quadrangular edifice, commenced in 1548, for Sir Thomas Smith, who was principal secretary to King Edward VI. and to Queen Elizabeth.

KELSEY, RICHARD, *architect.* He was a student of the Royal Academy, and in 1821 gained the Academy gold medal for his 'Design for a Theatre.' He became principal assistant to Mr. D. Laing, who built the custom-house. But his name does not appear as an exhibitor, and there is no further trace of his art career.

KEMP, GEORGE MEIKLE, *architect.* He was born in 1794, the son of a shepherd on the Pentland Hills, and was apprenticed to a joiner. He had acquired a knowledge of construction, and, of an unsettled disposition, his love of Gothic buildings led him to visit the great cathedral towns of Scotland and England, finding the means by working at his trade. He then returned to Glasgow, and after a time removed to Edinburgh in 1817, and continued there, still working as a mechanic, till 1824, when he made his way to London, and visited France and Belgium, where, gaining employment, he managed to remain during two years, sketching and measuring the ecclesiastical edifices and antiquities. He afterwards settled in Edinburgh, and commenced business as a master joiner, but being unsuccessful, he was compelled to return to journey work.

He also gained some employment as an architectural draftsman, and was engaged for two years in making a model of Dalkeith Palace. This led to other engagements. He made the drawings for the 'Ecclesiastical Antiquities of Scotland;' among these were included Glasgow Cathedral, and on the question of the restoration of this edifice, he made, 1837-39, a careful model, representing his project and design for its repair. While so employed, and unknown, the proposal for Sir Walter Scott's monument afforded him an opportunity of distinction. Among numerous competitors his design was selected. He was appointed the architect, and his work was rapidly rising, when the career which had just opened to him was suddenly closed. Returning home on a dark night from a professional engagement, he was accidentally drowned, March 6, 1844, in his 50th year. He left a widow and children, for whom a subscription was raised.

KENDAL, JOHN, *engraver and draftsman.* Practised in the first half of the 18th century. His works are mostly portraits in mezzo-tint.

KENDALE, JOHN, *architect.* Was supervisor of all the King's works throughout the realm in the reign of Edward IV.

KENDALL, JOHN, *architect.* He was engaged from 1805 to his death upon the new works at Exeter Cathedral, where he made several important restorations, which brought him much repute. He died at Exeter in October 1829, aged 63. He published 'An Elucidation of the Principles of English Architecture, usually denominated Gothic,' 1818.

KENDRICK, JOSEPHUS, *sculptor.* He was a student in the Royal Academy Schools, and in 1813 gained the gold medal for his group of 'Adam and Eve lamenting over the dead body of Abel,' and from that time was a contributor to the Academy

Exhibitions. In 1815 he sent a 'Model for a National Monument in St. Paul's;' in 1817, 'Prometheus Chained;' in 1819, 'Adam and Eve;' and in that and the following year a 'Model for a National Monument.' With these works he exhibited busts, and was a frequent competitor for public works. Two of the public monumental tablets in St. Paul's are by him, but he appears to have met with little encouragement. He exhibited for the last time in 1829.

KENDRICK, Miss EMMA ELEONORA, *miniature painter*. Daughter of the above. She first exhibited at the Academy in 1811, and became successful as a miniature painter, and was a large contributor to the Academy Exhibitions for many years. She was also, between 1815 and 1820, an 'exhibitor' at the Water-Colour Society, sending with her miniatures 'Cupid and Psyche,' 'Cleopatra dissolving the Pearl,' 'Dido expiring on the Funeral Pile.' In 1831 she was appointed miniature painter to the King. After 1835 she exhibited only on two or three occasions, the last in 1840. She also occasionally exhibited classic subjects and portraits at the Society of British Artists down to 1841. She published, in 1830, a work on Miniature Painting. She died April 6, 1871, aged 83.

KENNEDY, WILLIAM DENHOLM, *landscape and figure painter*. Was born at Dumfries, June 16, 1813. He went to Edinburgh early in life, and was well educated there. In 1830 he came to London, and in 1833 entered the schools of the Royal Academy, where he gained the friendship of Etty, R.A., by whom his future art was influenced. In 1835 he was a successful competitor for the Academy gold medal—the subject 'Apollo and Idas,' and in 1840 he was elected to the travelling studentship. He went at once to Italy, where he studied about two years, returning with a large collection of studies and sketches. He first exhibited at the Academy in 1833, commencing with domestic subjects, and was a regular contributor up to 1841, when he went to Rome. In 1844, after his return, he exhibited some landscape compositions with figures, and thenceforth the influence of his Italian studies was apparent. With the exception of the years 1855, 1856, and 1857, he was an unwearied contributor to the Academy Exhibitions up to his death. He tried every class of subject, except portraiture, but his chief works were classic landscape compositions, founded upon Italian scenery —freely painted, rich in colour, and with groups of figures well introduced. But he was unable to maintain his early promise, and did not gain good places on the walls of the exhibition. His health also failed, and he fell into a state of despondency

and neglect. He had suffered about two years from dropsy, and was also tried by the loss of his brother, when on June 2, 1865, having the previous evening been left in his usual state of health, he was found dead in his bed. On an inquest, he was shown to have died from natural causes.

KENT, WILLIAM, *architect and painter*. He was born of poor parents in Yorkshire, in 1685. After receiving the rudiments of a common education, he was apprenticed to a coach-painter, but ran away from his master and came to London about 1704. He had at least learnt the use of his colours, and tried to support himself as a portrait painter, making some attempts at history. It is said his genius gained him friends, who made a purse and sent him to Rome in 1710. There he studied painting, and gained a second-class medal: Continuing to devote himself to his studies, his first resources became exhausted, and one of his countrymen allowed him 40*l.* a year for seven years. Afterwards he gained the notice of Lord Burlington, who assisted and patronised him. He returned to England for a short time and made a second journey to Rome, and then coming back in 1719 he settled in London, and had an apartment in Lord Burlington's house. He first, through his patron's influence, found employment as a portrait painter, but his likenesses had no individuality, and were in every respect meretricious. He painted an altar-piece for St. Clement's Church in the Strand, which Hogarth, who did not spare him on other occasions, caricatured; and the bishop ordered its removal in 1725. He ventured to design the conceited monument of Shakespeare in Westminster Abbey. He then undertook ornamental design, to which his tastes were better suited. He decorated Wanstead House, Rainham, and several ceilings for Sir Robert Walpole at Hampton, in the usual allegorical style of the period, and the praises bestowed upon some of the architecture in these painted designs induced him to try that art, with which he combined landscape gardening, but his chief works are in architecture. He assisted Lord Burlington, who was an amateur in that art. He built Devonshire House, Piccadilly; the Earl of Yarborough's house in Arlington Street; the Horse Guards, Whitehall; and altered and decorated Stowe, Houghton, and Holkham, his favourite work—the elevation of which is mean and poor in its parts. He made another journey to Italy in 1730.

He had great influence on the taste of his day, and was consulted on every description of furniture, utensil, and even dress. He designed some of the illustrations for an edition of Gay's 'Fables,' Pope's Works, and Spenser's 'Faerie Queen,' all of them very poor. As an ornamental gardener he

enjoyed great repute. Following the first attempts of Bridgman, he introduced a new style of gardening, and quitting the clipped forms, the prude lines, the trim terraced and walled gardens, which had till then prevailed, he displayed the natural and picturesque beauty which had since characterised English gardens; grouping the fine varieties of trees, and instead of the formal canal and basin, produced streams and lakes in their own true forms. By the patronage of his friends he was appointed master carpenter, architect, keeper of the pictures, and principal painter to the Crown. He died at Burlington House, April 12, 1748, in his 64th year, and was, in compliance with his wish, buried in Lord Burlington's vault at Chiswick. He left about 10,000*l.* which he had accumulated.

KERRICH, The Rev. THOMAS, *amateur.* He was born in 1747, and educated at Magdalen College, Cambridge, where he held the office of librarian to the University. He had a talent for art, and in 1776 received the gold medal of the Academy of Painters, at Antwerp. He drew in black and red chalk many of the distinguished members of the University. These works possessed much character, and were highly finished. Many of them were engraved. He also etched a few plates of monuments. He was one of the four residuary Trustees of Nollekens, R.A. He died May 10, 1821.

KERSEBOOM, FREDERIC, *portrait and history painter.* Was born at Solingen, Germany, in 1632. He studied painting at Amsterdam, and in 1650 went to Paris, and for several years worked under Le Brun. He then went to Rome, where he was maintained for 14 years by the French Chancellor. He came to London to practise as a history painter, but not meeting with encouragement he tried portraiture, with more success; but his colour was black and his drawing weak and loose. He died in London in 1690, and was buried at St. Andrew's, Holborn. There is a portrait by him of Robert Boyle at the Royal Society.

KETEL, CORNELIUS, *portrait painter.* He was born 1548, at Gouda. When about 18 years of age he went to Delft, and studied there and at Fontainebleau, where he worked some time, and then returned to Gouda. In 1573 he came to England, where he married a Dutch woman, and found good employment as a portrait painter. He gained an introduction to Court by an allegorical picture of 'Strength vanquished by Wisdom,' and then painted Sir Christopher Hatton, the portrait now at Ditchley; Lord Pembroke, Lord Arundel, and in 1578, the Queen. He practised in England till 1581, when he went to Amsterdam, settled, and painted several important works. Then he laid aside his brushes, and painted only

with his fingers; and Walpole says that, increasing in his folly, he next tried his toes. He died 1602.

KETTLE, TILLY, *portrait painter.* He was born in London about 1740, the son of a coach-painter, from whom he learnt the first rudiments of his art. He studied in the Duke of Richmond's Gallery and the St. Martin's Lane Academy, and for some years practised in London as a portrait painter. In 1762 he repaired Streeter's great ceiling picture in the theatre at Oxford. He was a member of the Incorporated Society of Artists in 1765, and a constant contributor to the Society's Exhibitions. Afterwards he went to the East Indies, where he stayed from 1772 to 1776, and acquired a fortune in the practice of his art. He returned to London about 1777, where he settled and married, and the same year he first appears as an exhibitor of portraits at the Royal Academy. In 1781 he exhibited 'The Mogul of Hindostan reviewing the East India Company's Troops,' with some portraits; and in 1783 exhibited for the last time. He built himself a large house in Bond Street; but, unsuccessful in his art, he became bankrupt. He then left London for Dublin, but did not remain long in that city. He resolved to revisit the East Indies, the scene of his first success; but, taking the overland journey, he died at Aleppo, on his way to Bengal, in 1786. His portraits, though weak in drawing, are agreeable in colour, and the likeness good.

KEYES, ROGER, *architect.* He practised early in the 15th century, and was the joint-architect of All Souls' College, Oxford, and was employed as surveyor and architect by Archbishop Chicheley.

KEYL, FREDERICK WILLIAM, *animal painter.* Was born September 17, 1823, at Frankfurt am Main, and began his art career in the atelier of Verboekhoven. He arrived in London in May 1845, having come to England expressly to study under Sir Edwin Landseer. He was a great favourite with his master and remained his sole pupil, and was introduced by him to the favourable notice of the Queen and Prince Consort in 1847. He frequented the Zoological Gardens, and made many drawings and studies there. He first exhibited at the Royal Academy in 1847, 'Fidelity,' and for the last time in 1872, 'Waiting' and 'Lambs,'—these two works were exhibited after his death. He painted many pictures of her Majesty's dogs, ponies, and other pets for the Royal Collection. In 1852 he sent four works to the Academy; in 1854, 'Halt on the Road;' in 1858, 'Sheep;' in 1859, 'Companions;' in 1863, 'Setters' and a 'Hillside Flock.' He was very fastidious about his work, and was of a nervous and irritable disposition, so that

he had a great dislike to exhibiting his pictures. He died in London, December 5, 1871, of inflammation of the lungs with typhoid symptoms, and was buried in Kensal Green Cemetery.

KEYSE, THOMAS, *still-life painter.* He contributed to the first exhibition in 1760, and was in 1763 a member of the Free Society of Artists, continuing an occasional exhibitor. He was for 30 years keeper of the Bermondsey Spa, a sort of tea-garden, and had great repute as a painter of still-life. In 1768 the Society of Arts awarded him a premium of 30 guineas for a method of setting crayon drawings. He showed a gallery of his own works, in which the master-piece was a butcher's-shop, with its contents admirably imitated. He boasted of a visit from Sir Joshua Reynolds, and a critic wrote of him—

'Keyse's mutton
Show'd how the painter had a strife
With nature, to outdo the life.'

He died at his tea-gardens, February 8, 1800, in his 79th year.

KIDD, WILLIAM, R.S.A., *subject painter.* Was born in Scotland, and was apprenticed to a house-painter and decorator in Edinburgh. He came to London early in his career and practised as an artist, painting numerous subjects embodying the pathos, but more frequently the humour, of Scottish life, several of which have been engraved. He first exhibited at the Royal Academy in 1817, and for many years was a constant contributor. About 1840 his contributions fell off. In 1849 he was elected an honorary member of the Scottish Academy, and only exhibited again at the Royal Academy in 1851 and the two following years. He was also an occasional exhibitor at the Society of British Artists. He was a genius, quite incapable of managing his worldly affairs, was never well off at any period of his life, lived from hand to mouth, and towards the end of his days fell into hopeless difficulties. He was assisted by his friends, and was a pensioner of the Royal Academy. He died in London, December 24, 1863.

KIDD, JOHN BARTHOLOMEW, R.S.A., *landscape painter.* He was a pupil of Thomson, of Duddingstone, and one of the original members of the Royal Scottish Academy. He resided at Edinburgh for a while, and left that city about 1836, and then settled as a teacher of drawing at Greenwich. He resigned his membership of the Scottish Academy in 1858. There are a few etchings of highland scenery by him.

'KILLIGREW, ANNE, *amateur.* Was born in 1660. Her father, Dr. Henry Killigrew, was master of the Savoy, and one of the prebendaries of Westminster.
250

She painted landscapes and portraits in the manner of Lely, and drew James II. and Mary of Modena, and some pieces of still-life and history. She died in London of smallpox, June 16, 1685, and was buried in the Savoy Chapel. Her portrait, after a painting by herself, was engraved by Becket, the early mezzo-tintist. Three pictures by her were sold at Admiral Killigrew's sale in 1727. She was maid of honour to the Duchess of York, and is highly praised by Antony Wood, who said 'she was a Grace for beauty, and a Muse for wit;' and Dryden celebrated her genius in poetry and painting. Her poems were published after her death, in 1686.

KING, DANIEL, *amateur.* Practised about the middle of the 17th century. He worked in the manner of Hollar, and probably learnt his art from him. He executed some works for the 'Monasticon' of Dugdale, who called him an ignorant, silly knave. He wrote 'Miniatura; or, The Art of Limning,' and published, in 1656, a thin folio of 'The Cathedral and Conventual Churches of England and Wales,' drawn by himself, comprising 50 plates, of which three or four are by Hollar. He also published, in 1656, 'The Vale Royal of Cheshire,' illustrated by engravings from his own drawings. He etched, besides many views of castles, churches and ancient buildings.

KING, Captain JOHN DUNCAN, *amateur.* Painted landscapes with much ability, and was an occasional honorary exhibitor at the Royal Academy between 1824 and 1851—his subjects, views on the coasts of Spain and Portugal, and later, of Ireland. He had seen much service in the early part of his life, and was for many years of his latter life a military knight of Windsor. He died there August 21, 1863, aged 74.

KING, GILES, *engraver.* Was born in England, but settled in Dublin, and practised there for many years about the middle of the 18th century. He engraved views of the 'Salmon Leap' and 'Waterfall,' Wicklow, 'The taking of Cape Breton,' and some other works.

KING, GEORGE, *engraver.* Practised in the reign of Queen Anne. His works were chiefly for book ornamentation. He engraved a few portraits, some from the life, but they are poor in manner.

KING, JOHN, *history and portrait painter.* Was born at Dartmouth in 1788, and showing talent for drawing, he came to London at the age of 20 and gained admission to the schools of the Academy. He first exhibited at the Royal Academy in 1817. He aimed to excel in history, and under much difficulty and discouragement painted several pictures—'Christ in the Garden,' 'Christ Bound,' 'Abraham and Isaac,' 'Lear and Cordelia,' 'Ferdinand

King -Gerard -Landscape painter 6-1855

and Miranda,' but he met with no encouragement. About 1826 he tried portrait, and might have succeeded better, but he disliked this branch of art. He continued to exhibit up to 1845, and died at Dartmouth, July 12, 1847. His works, most of which remained on his hands, were sold by auction the same year, and produced only small sums.

KING, MARGARET, portrait painter. Practised in the latter part of the 18th century. She exhibited crayon portraits at the Royal Academy in 1779, and continued an exhibitor up to 1786.

KING, THOMAS, portrait painter. Was a pupil of Knapton, and attained considerable ability, but was eccentric, restless, and dissipated. He died about 1769, and was buried in Marylebone Churchyard. There is a mezzo-tint of his portrait of Matthew Skeggs playing on a broomstick; and Houston engraved after him the portrait of Maddox, a celebrated rope-dancer.

KING, THOMAS, antiquarian draftsman and engraver. He lived at Chichester, and published a series of plates of the cathedral and other antiquities of the city. He died August 9, 1845.

KINSBURY, HENRY, draftsman and engraver. He practised in London between 1750-80, engraving in the mezzo-tint and dot manner, chiefly subject plates.

KIP, WILLIAM, engraver. Practised in London at the beginning of the 17th century. There are some triumphal arches engraved by him, dated 1603.

KIP, JOHN, engraver. Was born at Amsterdam, and came to England soon after the Revolution. He was employed to engrave views of the Royal palaces and the mansions of the nobility and gentry for the 'Britannia Illustrata,' published in 1714. He engraved the architectural and topographical views in Strype's edition of 'Stowe's Survey,' 1720; and also, on a large scale, the mansions of Gloucestershire, for Atkyns's history of that county. These are bird's-eye views, most minutely and curiously executed. He also engraved some portraits, birds after Barlow, and other plates. He died in Westminster in 1722, when nearly 70 years of age, leaving a daughter, whom he had brought up to painting.

KIRBY, RICHARD, architect. Built Hill Hall, Essex, a stately structure, in the latter part of the 17th century, for Sir Thomas Smith.

KIRBY, JOHN, amateur. Was originally a schoolmaster at Orford, in Suffolk, and afterwards occupied a mill at Wickham Market, his native place. He then resided some time at Ipswich, where he published, 1735, 'The Suffolk Traveller,' a road-book with antiquarian notices, from an actual survey he made of the whole county in the years 1732-33-34. He died December 13, 1753, aged 63, and was buried at Ipswich.

KIRBY, JOSHUA, F.R.S., topographical draftsman. Son of the foregoing. Was born at Parham, Suffolk, in 1716, and settled at Ipswich as a coach and house painter about 1738. He was induced by an early friendship with Gainsborough to try landscape painting. He made a number of drawings for an intended county history, and of these he published 12, with some descriptive letter-press, in 1748, the plates etched by himself, followed by a series engraved by J. Wood. He also studied linear perspective, and lectured on that science at the St. Martin's Lane Academy. He was appointed teacher of architectural drawing to the Prince of Wales, afterwards George III., whose favour he enjoyed, and by whom he was appointed clerk of the works at Kew Palace. He edited, in 1754, a second edition of Brook Taylor's 'Perspective;' and in 1761 published 'The Perspective of Architecture,' which was printed at the expense of the King. He was secretary, and was in 1770 elected president, of the Incorporated Society by the faction which had excluded Frank Hayman from that office; but the same year, on the plea of ill-health, he resigned the post, which he had little claim to occupy. He exhibited with the Society, 1765-70, views in Richmond Park, Kew, &c. His views of Kew Palace were engraved by Woollett in 1763. He died June 20, 1774, aged 58, and was buried in Kew Churchyard. WILLIAM KIRBY, probably his son, who was in 1766 a member of the Incorporated Society of Artists, died suddenly at Kew in 1771.

KIRK, JOHN, medallist. He was a pupil of Dassier, on whose death he was much employed. In 1762 and 1763 he received premiums from the Society of Arts. He was a member of the Incorporated Society of Artists, and exhibited medals of the King, Queen, &c., 1773-75-76. He died in London, November 27, 1776.

KIRK, THOMAS, painter and engraver. Studied under Cosway, R.A., and practised during the last half of the 18th century. He was an eminent artist. He painted well-chosen subjects in history with great fancy and vigour, the drawing good and the colour agreeable. His vignette illustrations to Cooke's 'Poets' are excellent. He first exhibited at the Academy, in 1785, 'Venus presenting love to Calypso,' and continued to exhibit in alternate years up to 1791. Then, after two years' interval, he exhibited, in 1794, some scriptural subjects, a portrait and a frame of fancy miniatures; and in the following year 12 subjects, evidently designed for book-illustration. In 1796 he exhibited, for the last time, 'Evening' and 'A Dream.' Some few miniatures which

251

he painted are full of feminine elegance, his children also sweet and well-coloured. His engravings were in the chalk manner, and of great merit. Supported in his chair to touch a proof the day before he died, he was cut off by consumption, November 18, 1797, and was buried at St. Pancras. Dayes said, 'He passed like a meteor through the region of art.' 'Titus Andronicus,' for the Shakespeare Gallery, was both painted and engraved by him.

KIRK, THOMAS, R.H.A., *sculptor.* Was born in Cork in 1784, and studied in the schools of the Royal Dublin Society. He practised his art in Dublin, and was an exhibitor at the Dublin Exhibition in 1810. On the foundation of the Royal Hibernian Academy in 1823 he was one of the first members. One of his earliest public works was the colossal statue of Nelson for the memorial pillar erected to him in Sackville Street, Dublin. The statue of George IV. and of the Duke of Wellington are also by him, as are the figures of Justice and Clemency in the court-house, Londonderry; the statue of Lord Monteagle, Limerick; and several of the busts in the library of Trinity College, Dublin. His 'Orphan Girl' and 'Young Dog Stealer' were much esteemed in Ireland; and his marble statue of Admiral Sir Sidney Smith in the Painted Hall, Greenwich Hospital, was one of his last works. He exhibited at the Royal Academy in London, in 1825, busts of Mr. Wilson Croker and his daughter, and was also an exhibitor in 1839, 1845, and 1846. He died in Dublin in 1845.

KIRKALL, EDWARD, *engraver.* Was the son of a locksmith at Sheffield, and born there about 1695. He was instructed in drawing in his native town, and came to London, where he found employment as an engraver of arms, stamps, and ornaments for books. He is supposed by the initials to have engraved the plates, which have much merit, for an edition of 'Terence,' published in 1713. In 1722 he published by subscription 12 mezzo-tints, produced by a method he had invented—a combination of etching and mezzo-tint with wood blocks—the outlines and darks printed from copper, the tints printed afterwards from wood blocks; but though the process had merit, he does not appear to have been able to perfect it. In 1724 he published 17 tinted engravings after Vandevelde. He engraved on copper the illustrations to Rowe's translation of 'Lucan's Pharsalia,' 1718; and to Inigo Jones's 'Stonehenge,' 1725. In mezzo-tint he engraved the seven cartoons of Raphael.

KIRKALL, L., *engraver.* Practised about the beginning of the 18th century. There are by him three large engravings—'A Bear Hunt,' 'Wild Boar Hunt,' and 'Stag Hunt.'

252

KITCHEN, GEORGE, *engraver.* He practised about the middle of the 18th century. There are some clever heads, elaborately engraved, by him, and some views; he also engraved some maps. He was chiefly employed upon book-illustration. THOMAS KITCHEN practised about the same time, but was mostly engaged on map-engraving.

KITCHINGMAN, JOHN, *miniature painter.* He was a pupil of Wm. Shipley, and was admitted a student of the Academy, where he gained a good knowledge of the figure. He obtained several premiums at the Society of Arts. He exhibited miniatures at the Free Society of Artists 1766–68, and from the year 1770 at the Academy, some of these being theatrical portraits in character. He also painted in oil some genre subjects, marines, and landscapes. Fond of the water, he gained in 1777 the silver cup at the Thames sailing match; and he painted four pictures, which were engraved by Pouncey, to illustrate the progress of a cutter. These he exhibited at the Academy, his last contribution, in 1781. He married early in life a girl as young as himself, and separated from her after a few years. He then fell into habits of intemperance and irregularity, and died, aged about 40, December 28, 1781, immediately after the amputation of his leg, the bone of which was diseased.

KNAPTON, GEORGE, *portrait painter.* Born in London in 1698, the son of a bookseller. He was the pupil of Richardson, and his early works were in crayons. In 1740 he went to Italy, and wrote an interesting account of the discoveries at Herculaneum. He held the office of painter to the Dilettanti Society, and in 1765, of keeper of the King's pictures. He was associated with Arthur Pond in engraving and publishing engravings from the drawings of eminent masters. At Hampton Court there is a large and pretentious group by him of the family of Frederick, Prince of Wales. The widowed princess forms the centre, with the child born after its father's death in her lap, surrounded by her four other daughters and four sons, and in the background a full-length portrait of her late husband. All the figures are life-size and in action, the portraits, dresses, and draperies carefully painted, and every part defined with a scrupulous care that defied art. The grouping is formal and unpleasant, all the figures cut out from the background. But some of his portraits in the Dilettanti Society give a better opinion of his art, which is by no means without merit. He died in 1778, aged 80, and was buried at Kensington.

KNAPTON, CHARLES, *engraver and publisher.* Brother of the foregoing. Published, in 1734–35, some aqua-tint imita-

tions of drawings in bistre; and a number of other works are ascribed to him. He died in 1760, aged 60.

KNELL, WILLIAM ADOLPHUS, *marine painter*. Began to exhibit in the Royal Academy in 1835, when he sent 'Folkestone from the Dover Road;' in 1838 he contributed 'The Port of Leith;' in 1846, 'Vessels off the Flemish Coast.' He was a constant contributor to the annual exhibition of the Royal Academy down to 1866. The Queen has one or two of his pictures in her collection which are cleverly painted. He died July 10, 1875, and was buried in the Abney Park Cemetery.

KNELLER, Sir GODFREY, Bart., *portrait painter*. Was born of an ancient family, at Lubeck, in 1648. Designed for the army, he was sent to Leyden to study mathematics and fortification; but a love of art predominated, and he was for a time the pupil of Bol, at Amsterdam, and had some instruction from Rembrandt. In 1672 he went to Italy, visited Rome, made some stay at Venice, and in 1674 came to England. He did not purpose to remain here, but gaining the patronage of the Duke of Monmouth, who introduced him to Charles II., he was engaged to paint the King's portrait, and the work pleased so well that he was induced to stay. Charles was interested in him, sat to him several times, and sent him to Paris to paint the portrait of Louis XIV. He was equally in favour with James II., and the death of Lely left him without a rival. He painted the portraits of all who were most eminent in his day—the 43 celebrities of the Kit-Cat Club, the ten 'Beauties,' at Hampton Court; and no less than ten sovereigns, were his sitters. He held the office of state painter to Charles II., James II., William III. (who knighted him in 1692), Queen Anne, and George I., by whom, in 1715, he was created a baronet. He was lauded in the verse of Pope, Dryden, Addison, Steele, Tickell, and Prior; and though he lost 20,000*l*. in the South Sea scheme, he left an estate of 2,000*l*. a year. He lived in Covent Garden from 1681 to 1705, and afterwards at Kneller Hall, near Twickenham. He died from the effects of a violent fever, November 7, 1723, and was buried at Twickenham Church. There is a monument to him in Westminster Abbey.

His portraits have great freedom, and are well drawn and coloured, but are slight, and have much sameness and want of completeness. The great number of his works was a bar to their excellence. Their chief fault is the absence of all simplicity and nature—steeped in a vicious, common-place allegory, which deprives them of truth and character. Yet to him is due, during a practice of 30 years in England, the remembrance of our greatest men of his time.

KNELLER, JOHN ZACHARY, *ornamental painter*. Born at Lubeck in 1635. Was the elder brother of the foregoing, and came with him to England in 1674. He painted architectural decorations in fresco, and still-life in oil, and copied some of his brother's portraits in water-colours. He died in Covent Garden in 1702, aged 67, and was buried in the church there.

KNIGHT, CHARLES, *engraver*. Practised in London in the second half of the 18th century. There are many works by him after Kauffman, Wheatley, Bunbury, Singleton, Hoppner, and others. He was one of the governors of the Society of Engravers, founded in 1803 for the relief of members of the profession.

KNIGHT, MARY ANNE, *miniature painter*. Was born in 1776, and was a pupil of Andrew Plimer. She was a good miniaturist. She first exhibited at the Academy in 1807, and from that time was for many years an occasional exhibitor. She was unmarried, and died in 1851.

KNIGHT, WILLIAM HENRY, *subject painter*. Born September 26, 1823, at Newbury, where his father kept a school. He was placed under a solicitor, but he had an early love of drawing, and encouraged by the exhibition of two pictures at the Society of British Artists, and disliking his profession, he came up to London in 1845 to try his fortune as a portrait painter, and entering the schools of the Academy, just managed to live. In 1846 he exhibited for the first time at the Academy, 'Boys playing at Draughts;' and getting over his first difficulties, continued to exhibit at the Academy and the British Institution till his death. His chief painting are—'Boys Snow-balling,' 1853; 'The Young Naturalist,' 1857; 'The Lost Change,' 1859; with 'Peace versus War,' and 'A Troublesome Neighbour,' 1862. His works are of small size, truthfully painted, usually introducing children. He died July 31, 1863, leaving a widow and young family.

KYSELL, EDWARD, *engraver*. Practised in London, chiefly in portraits, about the middle of the 17th century. There is an equestrian portrait of Oliver Cromwell by him.

KYTE, FRANCIS, *mezzo-tint engraver*. He occasionally painted portraits, and there are several by him rather loose and unfinished, but agreeable for tone and colour. He was convicted in 1725 of uttering a forged bank-note, and sentenced to the pillory; from that time he assumed the translated name of Milvius. He engraved two portraits of Gay, the poet; to the first is attached his real, to the second his assumed name

L

LABELYE, Charles, *architect*. Was a native of Switzerland, and naturalised in England. He is said to have first gained his living as a barber. He had no less a great skill in geometry and architecture, and was for a time employed by Hawksmoor, the architect. He built Westminster Bridge, upon which he was occupied from 1739 to 1747. In 1744 he planned a harbour between Sandwich Town and Sandown Castle, a scheme which was brought under the consideration of Parliament. He afterwards retired to France for his health, and died at Paris, February 18, 1762. He published an account of the method he used in laying the foundations of the bridge.

LACON, ——, *portrait painter*. He painted water-colour portraits, and set up a puppet-show at Bath, which was much the fashion. He died about 1757.

LADBROOKE, Robert, *landscape painter*. Was apprenticed to a printer, but turned to art, which he began by painting portraits at 5s. each. He lived at Norwich, was early associated with old Crome, and the two painters married sisters. He was a member of the Norwich Society of Artists from its foundation in 1805, and a contributor to its exhibitions, his works comprising the picturesque localities in Norwich, and views in North Wales. Between 1809 and 1816 he exhibited several landscapes in oil at the Royal Academy. He gained a small competence, and died at Norwich, October 11, 1842, in his 73rd year, leaving sons who followed the arts.

LADBROOKE, Henry, *landscape painter*. Second son of the above. He was born at Norwich, April 20, 1800. He was well educated and intended for the Church, but at the desire of his father he reluctantly turned his energies to the study of art, to which by degrees he became attached, and pursued with unflagging energy. He painted landscape with great truth to nature, quiet in harmony of colour. He excelled in his moonlight scenes, and enjoyed a local reputation, but does not appear to have exhibited at the Royal Academy. He died November 18, 1870. His brothers, E. Ladbrooke and J. B. Ladbrooke, exhibited landscape views at the Academy on one or two occasions, about the year 1820.

LADD, Anne. Painted portraits and fruit-pieces. She died unmarried, of small-pox, in London, February 3, 1770, aged 24.

• LAGUERRE, Louis (called 'Old Laguerre'), *history painter*. Born in 1663, at Paris, where his father was master of the Royal Menagerie. He was godson of Louis XIV. and intended for the Church, but having an impediment in his speech, was allowed to follow the bent of his own inclination, and was placed under Le Brun, with whom he studied art for some time, as also in the academy at Paris. In 1683 he came to England, and was engaged by Verrio, for whom he painted a large part of the work Verrio was then engaged upon at St. Bartholomew's Hospital. He soon rose into great esteem, and was employed on his own account to decorate the halls, staircases, and ceilings of many fine mansions. King William gave him lodgings at Hampton Court, where he painted the 'Labours of Hercules,' and injured by his repairs Mantegna's great work, 'The Triumph of Cæsar.' He also painted the ceilings and staircases at Burghley; Devonshire House, London; Petworth; Marlborough House, St. James's; Whitton; and others. He was chosen by the Commissioners for repairing St. Paul's to decorate the interior of the cupola, but was set aside by the influence of Thornhill. Queen Anne commissioned him to design tapestry in commemoration of the Union, and he made the drawings, but the intention was carried no further. In 1711 he was elected the director of an academy of painting, then established in London. There is an etching by him of 'Midas sitting in Judgment between Pan and Apollo.' He died suddenly in Drury Lane Theatre, where he had gone to be present at his son's benefit, April 20, 1721, and was buried in St. Martin's Churchyard. As an artist he must take high rank with his cotemporaries. His compositions are good, his drawing vigorous; his tone of colour subdued, but pleasing. His large works on the staircase of Marlborough House, which have just been released from the coats of paint under which they have so long been hidden, are proofs of his great ability.

• LAGUERRE, John (called 'Jack Laguerre'), *decorative painter*. Was the son of the above. He was born in London, and educated as an artist under his father. He worked for a time for Hogarth, but having a good voice he tried the stage. He was engaged as a singer both at Lincoln's Inn Fields and Covent Garden Theatres, and he also painted some of the scenes. He assisted Verrio in the plafonds at Windsor Castle. He engraved some plates himself, and published a set of plates from the farce of 'Hob in the Well,' which, though indifferently executed, had a large sale. He wanted application, not talent. He was a know-

ing fellow, known to everyone worth knowing, a great humourist, singer, mimic, and wit, the founder of a school of caricaturists; but withal he died in indigent circumstances, in March 1748. It is not known where he was buried.

LAING, JOHN JOSEPH, *wood-engraver.* Born in Glasgow, and practised for some time there. Later he came to London, where he found employment. His chief works were architectural subjects for 'The Builder.' He died at Glasgow in December 1862, aged 32.

LAING, DAVID, *architect.* Was born 1774, the son of a London merchant, and became the pupil of Sir John Soane. In 1810 he was appointed surveyor of buildings to the Custom House, and soon after was commissioned to prepare designs for a new custom-house, which was just commenced west of the old building, when that edifice was destroyed by fire. The new building, erected after his designs, was completed between 1814-17, when a few years after the centre failed, either from a defect in the foundation or the construction, and the repair and necessary alteration were transferred to Sir Robert Smirke. Some litigation followed, and Laing retired from practice. He exhibited at the Royal Academy from 1814 to 1822, chiefly designs for the custom-house, exterior and interior, and views of St. Dunstan-in-the-East, which he was at that time rebuilding. He died at Brompton, March 27, 1856, at the age of 82. He published, in 1800, a small work, 'Hints for Dwellings;' and in 1818, his 'Plans of Buildings, Public and Private, including the New Custom-house.'

LAMB, EDWARD BUCKTON, *architect.* He was very early an exhibitor of designs at the Academy, commencing in 1824, and about 1830 found active employment in his profession. He gained a reputation for the correct propriety of his Gothic designs, but does not appear to have been engaged in any works of magnitude. The design for the Smithfield Martyrs' Memorial Church in Clerkenwell was one of his last works. He died August 30, 1869, aged 63.

• LAMBERT, General JOHN, *amateur.* He was of a good family, was born in 1619, and was brought up to the Bar. On the breaking out of the Civil War he entered the army of the Parliament, and gained great distinction; was a personal friend of Cromwell, and the first president of his council. He had been instructed in art by Baptiste Gaspars, and when banished for life to Guernsey on the Restoration, he found a solace in flower-painting, in which he excelled. There is at Goodwood a small portrait of Cromwell at an ale-house door, which is traditionally said to be after an original by General Lambert; a portrait of him, *se ipse pinxit*, is mezzo-tinted by

J. Smith. After a residence of nearly 30 years in Guernsey, he died in the Roman Catholic faith in 1692. He left some fruit and flower pieces which he had painted.

LAMBERT, JOHN, *amateur.* Son of the above. He painted portraits and left several, which are said to be known in some English collections. Lord Ribbesdale exhibited two portraits by him at the Leeds Exhibition. He died at his estate in Yorkshire.

• LAMBERT, GEORGE, *landscape and scene painter.* He was born in Kent in 1710, and was the pupil of Hassel and Wootton. In his art he was an imitator of Gaspar Poussin, and his landscapes have much grandeur, excelling those of his contemporaries. He did not succeed in his figures, some of which are attributed to Hogarth, with whom he was a convivial friend. He was a mannerist, and his manner was scenic, some of his best works being painted for the stage. He was first employed as a scene painter at the Lincoln's Inn Fields Theatre, and so early as 1736 was engaged as the principal scene painter at Covent Garden Theatre, an office he held many years, and assisted Manager Rich in carrying out great scenic improvements. He was the first president of the Incorporated Society of Artists, and was one of the jovial party at Old Slaughter's, a merry companion at all times, and the founder of the 'Beefsteak Club,' which first held its meetings in the scene-room at Covent-Garden, called the 'Thunder and Lightning' loft. His portrait was engraved in mezzo-tint by the younger Faber. He died November 30, 1765. In conjunction with Samuel Scott he painted some views of the Indian settlements for the East India Company's house in Leadenhall Street, now pulled down. There is a good landscape by him at the Foundling Hospital. Vivares and Mason engraved after him; and two etchings by him are known, one an upright landscape and ruins, with three small figures, coarse in execution. Some of his best scenery was destroyed when Covent Garden Theatre was burnt down in 1808.

LAMBERT, JAMES, *landscape painter.* He practised in the latter part of his life at Lewes. He gained a premium of 25 guineas at the Society of Arts in 1770, and was an exhibitor at the Royal Academy in 1774, and continued to exhibit landscape views till his death. He died near Lewes in 1779. His son, JAMES LAMBERT, during the same period exhibited still-life, fruit, and flowers.

LAMBERT, MARK, *engraver.* Apprenticed at Newcastle-on-Tyne, and became an assistant to Thomas Bewick. He was distinguished for the truth and carefulness of his drawings. In the latter part of his

255

life he was employed chiefly in ornamental engraving of a mechanical character. He died at Newcastle, September 28, 1855, aged 74.

LAMBORNE, PETER SPENDELOWE, *engraver and miniature painter.* Born in London 1722. He practised at Cambridge about the middle of the century, and was employed in drawing and engraving architectural and other antiquities. He also painted miniatures and etched portraits. He etched a head of Cromwell after Samuel Cooper, and of Dr. Johnson from his own drawing. He engraved many of the plates for Bentham's 'History of Ely Cathedral,' printed at the Cambridge University Press in 1771. His architectural drawings and views are elaborately careful, washed in with Indian ink, and tinted. He was a member of the Incorporated Society of Artists in 1766. He died at Cambridge in November 1774.

LANCASTER, HUME, *marine painter.* He exhibited at the Academy in 1836, and about the same time with the Society of British Artists, of which body he was elected a member in 1841. He continued to exhibit with both Institutions up to 1849, contributing scenes chiefly on the French and Dutch coasts, with some landscapes in Normandy, and views on the Scheldt. His abilities were checked by his domestic troubles, which were a bar to his progress in art. He had lived for some time at Erith, Kent, and died there July 3, 1850.

• LANCE, GEORGE, *still-life painter.* He was born at Little Easton, near Colchester, March 24, 1802. His father was then adjutant of the Essex Yeomanry, and afterwards for many years an inspector of the Bow Street horse patrol. He was intended for manufacture, and was placed with a relative at Leeds, but he disliked his occupation, and came to London, where he tried art, and became the pupil of B. R. Haydon and a student of the Royal Academy. He first exhibited with the Society of British Artists in 1824 — 'The Mischievous Boy' and two fruit-pieces. In 1828 he sent his first work, 'Still-life,' to the Academy, but did not exhibit there again till 1835, in the interim exhibiting, in 1830 and 1831, with the Society of British Artists. Continuing to paint still-life, in 1839 he also sent to the Academy 'Rolando showing Gil Blas the Treasures of the Cave;' but in this and some succeeding subject pictures the motive was found in the rich accessories to which they lent themselves. Soon after 1845 he returned exclusively to still-life, exhibiting principally fruit, and for the last time in 1862. His imitation of fruit, flowers, with the varied accessories of plate and rich textures, was excellent, as was the skill with which they were grouped. His feel-

256

ing for colour was good, but rather gay. He died at Sunnyside, near Birkenhead, June 18, 1864.

LANDELLS, EBENEZER, *wood-engraver.* Born at Newcastle-on-Tyne in 1808, where his family carried on a draper's business. He was a pupil of Bewick. Came to London when 21 years of age, and was employed in the illustration of several of the periodical publications. He was connected with 'Punch' from its origin. In 1842 he was commissioned to sketch and engrave the Queen's visit to Scotland for the 'Illustrated London News,' and afterwards several of her Majesty's visits, both at home and on the Continent. He originated the 'Illuminated Magazine.' He worked in a broad, clever manner, but wanted delicacy and refinement both in his line and his drawing. He died at Brompton, September 1, 1860, aged 51.

LANDELLS, ROBERT THOMAS, *illustrator and designer.* Was for many years the special artist of the 'Illustrated London News,' and in this capacity was present in all the recent campaigns, from the Crimean War to the Franco-German War. In this latter he contracted the illness which caused his death. He received four medals from foreign governments in recognition of his services and courage, and his war-sketches were much esteemed. The Queen has several commemorative drawings by him. He died at Chelsea, July 5, 1877, aged 43.

LANDSEER, JOHN, A.E., *engraver.* Was born at Lincoln in 1769, the son of a jeweller. Was apprenticed to William Byrne, the landscape engraver, and, through him, was connected by pupilage with a long line of eminent engravers. Among his first works were his vignettes after De Loutherbourg for Macklin's 'Bible' and Bowyer's 'History of England,' which were of great merit. In 1795 he engraved 20 views of the South of Scotland. He was an active supporter of his profession by his pen also; and in 1806 lectured at the Royal Institution upon engraving, and asserted the high position of the art. An opponent of the Royal Academy, on the ground of the exclusion of the engravers, he was, in 1806, elected an associate engraver, but did not cease to complain of the unfair position in which the engravers were placed by being deemed ineligible for the full membership, and he never ceased to agitate upon this question; and since his death this honour has been conceded to them. He commenced a 'Periodical Review of the Fine Arts,' which lived only to the second volume, and at a later period he published 'The Probe,' a weekly periodical, in which the artists were sharply handled, but it did not continue above half a year. He engraved in a large, bold manner,

making much use of the needle. His works were highly esteemed. He died February 29, 1852, in his 83rd year, leaving three sons, who had become eminent in art. In addition to the two periodical works above mentioned, he published, in 1807, 'Lectures on the Art of Engraving;' in 1817, 'Observations on the engraved Gems brought from Babylon;' in 1823, 'Sabæan Researches: Essays on the engraved Hieroglyphics of Chaldea, Egypt, and Canaan;' in 1833, 'Engravings illustrating the Holy Scriptures;' in 1834, 'A Descriptive Catalogue of Fifty of the earliest Pictures in the National Gallery,' and 'Some Account of the Dogs and the Pass of St. Bernard.'

LANDSEER, Sir Edwin Henry, Knt., R.A., *animal painter*. He was the third and youngest son of the foregoing, and is stated to have been born in Queen Anne Street, London, 7th March, 1802, the date which was placed on his coffin, though there is some question, even in his family, as to the year of his birth. Surrounded by art associations, he seemed destined to be an artist: his young genius was very early developed under his father's teaching, and he received a premium for his drawing of 'A Horse for Hunting' from the Society of Arts. Fond of animals and of the sports to which this attachment naturally led, as a boy he haunted the itinerant wild beast shows, and, sketch-book in hand, watched the action of dogs when matched to fight or at rat-killing. So trained, at the age of 14 he was admitted to study in the Academy schools, and was also an exhibitor at the Academy Exhibition, sending 'The Heads of a Pointer Bitch and Puppy;' and in 1817, to the Water-Colour Society, which then admitted works in oil, his 'Mount St. Bernard Dogs;' and in 1818, 'Fighting Dogs getting Wind;' and at the same time he exhibited at the Academy, 'Brutus,' the portrait of a dog, with the portrait of an 'Old Horse.'

Up to this time his studies had been chiefly from nature, and his father now introduced him to B. R. Haydon, who superintended his progress, though he did not become his pupil, and advised him to dissect and make anatomical studies of animals. In this course, taking advantage of the death of a lion in one of the menageries, he studied carefully its anatomy, which gave him a power in the drawing of that animal notable in his future works. Making rapid progress, in 1820 he exhibited at the British Institution 'Alpine Mastiffs reanimating a Distressed Traveller;' in 1821, at the Academy, a 'Prowling Lion;' in 1822, a 'Lion Disturbed;' and at the Institution, the same year, 'The Larder Invaded,' for which the directors awarded him 150*l.*; and in 1824, 'The

Cat's Paw,' a monkey seizing the cat's paw to take the roasting chestnuts from the fire, one of the first of his paintings in which a well-known moral was so happily combined with humour.

By these works he had already established a reputation. In 1825 he exhibited at the Academy a 'Portrait of Lord Cosmo Russell,' a boy on his rough little pony scampering over the heather, followed, in 1826, by the 'Interior of a Highland Cottage' and 'Chevy Chase;' and having reached the prescribed age of 24 years, he was at once elected an associate of the Academy, and now commenced the exhibition of a series of fine works, addressed to the comprehension and tastes of all, fully confirming the high opinion so early formed of his art, and highly popular—in 1827, he exhibited at the Academy 'The Monkey who had seen the World,' a careful work, full of genius and sly humour; in 1832, 'The Pets,' a sweet picture of a child feeding a fawn. At the British Institution, in the same year, 'Lassie Feeding Sheep;' and in 1833, at the Academy, a 'Jack in Office,' and 'The Hunted Stag.'

As he matured his art, the field before him widened, and attracted by the talk of Highland sport and the allurements of deer-stalking, he was led to visit the Highlands, where, in his yearly succeeding visits, he found so many attractive subjects for his pencil. In 1834 he exhibited at the Academy a 'Highland Breakfast,' a young mother suckling her babe, with a group of eager dogs, one with a litter of pups at its teats, feeding at her feet, and 'Bolton Abbey in the Olden Time.' In 1835 he sent to the Institution 'The Sleeping Bloodhound,' a simple but probably one of his best coloured and most vigorous works; and to the Academy, in 1835, a 'Highland Drover's Departure for the South,' a fine and elaborate work, crowded, perhaps over-crowded, with his fertile conceptions, incidents so full of feeling that not one would willingly be spared. In the mean time he had been elected a full member of the Academy in 1831, and had now reached the highest rank in his profession. His works were justly esteemed by all, the theme of popular admiration, yet, receiving only very inadequate prices for them, and even these not promptly paid, he suffered pecuniary inconveniences painful to his susceptible nature.

Of the works which he now exhibited at the Academy, maintaining the high reputation he had gained, the following may be mentioned:—In 1837, 'The Return from the Chase,' with 'The Old Shepherd's Chief Mourner,' with his faithful dog watching beside the coffin, its action, and the whole of the accessories of the picture, forming a work of almost human pathos; 1838, 'A Dis-

tinguished Member of the Humane Society,' represented by a noble Newfoundland dog; and 'There's Life in the Old Dog yet;' 1839, 'Tethered Rams;' in 1841, 'Peace,' and the companion picture, 'War;' 1842, 'The Highland Shepherd's Home;' 1847, 'The Drive, Shooting Deer on the Pass,' one of his largest works, purchased by the Queen; 1848, 'Alexander and Diogenes,' two dogs; 1850, 'A Dialogue at Waterloo,' the aged Duke of Wellington with his daughter-in-law visiting the field; 1851, 'Scene from the Midsummer Night's Dream,' which may be esteemed his last great work; 1856, 'Highland Nurses;' 1858, 'The Maid and the Magpie;' 1860, 'Flood in the Highlands;' 1861, 'The Shrew Tamed' and the 'Fatal Duel.' During the whole of these years, while as a member of the Academy he sent his chief works to their exhibitions, he continued to exhibit at the British Institution, and probably from early associations supported that body by the contribution of his works till nearly its final collapse.

Up to this time his deserved prosperity and success had, to the world, appeared unclouded, but it was not so. A lively companion, gifted with all that made his company desirable, he was admitted and esteemed in the first society, even the Queen's. But from his youth painfully sensitive, nervously alive to censure, he had suffered occasionally from long periods of mental depression, and then felt most acutely the slights, no doubt purely imaginary, of his distinguished friends. In 1851–52 he was attacked by illness, arising from these causes, and in those years he did not exhibit. He had when so young reached, and so long maintained, such great excellence in his art that his friends, seeing now some falling off, feared, after his 40 years' practice, they must be prepared to find his place on the Academy walls a blank; but it was not yet. He happily rallied, and again his works appeared, yet in faded excellence. In 1864 he exhibited, with other works, his 'Piper and Pair of Nutcrackers;' in 1866, 'The Stag at Bay,' a model; in 1868, 'Rent-day in the Wilds,' the concealed tenants paying their rents for their exiled chief; in 1869, two 'Studies of Lions,' with 'The Swannery,' a work which had long lain unfinished in his studio; and continuing to send two or three pictures in the following years, in 1873 he exhibited his last work, 'An Unfinished Sketch of the Queen.' He produced a number of etchings which are highly prized, and modelled the four noble lions which ornament the base of the Nelson column in Trafalgar Square, a commission which he kept many years in hand.

Towards the end of his life his nervous state of health was aggravated by a rail-

way accident in the north, in November 1868, which left a scar on the forehead visible in his coffin. From this time his failing memory became more affected, and for the last two or three years he was a great sufferer. He had lived, since 1825, in the same house at St. John's Wood Road. He was unmarried, but was surrounded by the members of his family, and also by his many dogs and animals, whose natures, faculties, and actions, were his amusement and the object of his continual, almost unconscious, study; and here he died on October 1, 1873, and was buried in St. Paul's Cathedral, his funeral attended by his family and friends, the president and members of the Royal Academy, with many persons of distinction and eminence, nor was it unaccompanied by many marks of public sympathy. His art will fill a permanent place in the memories of all. His skill endowed animals with something more than instinct — sometimes highly pathetic, sometimes of the most subtle humour. His fertile invention and happy incidents were unrivalled, the titles of his works so cleverly, sometimes wittily, chosen; his drawing truthful and correct; his power of execution dexterous and rapid in the extreme; the facile treatment of his textures—wool, fur, skin, or feathers—unsurpassed, and all that the Dutch painters reached by the most elaborate skill; his composition without effort, yet always good. But his colour was often heavy, and latterly grey and leaden. His portraits, of which he painted several, when his subject was evidently his own choice and his own taste, bore all the successful impress of his art; not so, however, when he was oppressed with the sense of an uncongenial task, perhaps too good-naturedly undertaken.

His works have been so largely circulated by the numerous excellent engravings of them, including almost without exception all those mentioned here, that they have become known and have found a place in the affections of all. Eminently happy in the engravers employed, his 'Bolton Abbey,' and 'Midsummer Night's Dream,' are especially distinguished by the happy talent with which they are rendered; and 'The Mothers,' a collection of small designs admirably etched, are tributes no less to the engraver than the painter.

He was fortunate in receiving all the honours which art could give him. He was knighted in 1850, was awarded the large gold medal at the Exposition Universelle in Paris, 1855, and on the death of Sir C. Eastlake, in 1865, was formally offered, but refused, the office of President of the Royal Academy. He realised, in the latter part of his life, largely from the sale of the copyrights of his pictures, a handsome fortune, his personal property being sworn under

160,000*l.* The Queen, his gracious patron, possesses many of his works. The nation is fortunate in the number of his best paintings, which were bequeathed to it by the munificence of Mr. Sheepshanks, Mr. Vernon, and Mr. Jacob Bell, and are now open to the public in the galleries of the National Gallery and the South Kensington Museum. A large collection of his works was exhibited at the Royal Academy Winter Exhibition in 1874. *d 1873.*

LANE, JOHN BRYANT, *history painter.* He was born in Cornwall, and brought up to the medical profession, but turning to art he was noticed and assisted by Lord de Dunstanville. He exhibited some sacred and classic subjects at the Royal Academy —in 1808, an 'Altar-piece;' in 1810, 'Artemesia preparing to Drink the Ashes of her Husband;' in 1811, 'Christ mocked by Pilate's Soldiers;' in 1813, 'Eutychus restored to Life by St. Paul.' He then went to Rome, and after a time it was known that he was engaged upon a large and important work. Year after year passed away. He was continually increasing the size of his canvas, and continuing his labours, refused all requests to see his work. Then, at the end of 14 years, he announced the completion of his picture, 'The Vision of Joseph.' The work was crowded with figures, full of errors, and when seen by his artist friends, pronounced an utter failure. It was also offensive to Roman Catholic prejudices, and the artist had to leave Rome with his work. He went to Dresden to study Coreggio, and sent his great picture to London, and in 1828 it was exhibited at Charing Cross in a part of the Royal Mews. He exhibited some portraits of his patrons at the Academy in 1831–32 and 1833, and for the last time in 1834, when his name disappears. His picture was deposited at the Pantechnicon in Belgravia, till the rent exceeded its value, and it was destroyed by dust.

LANE, SAMUEL, *portrait painter.* Was born at King's Lynn, July 26, 1780, of a respectable Staffordshire family. From an accident when a child he became deaf, and nearly dumb also. This misfortune, added to a taste for art, determined his profession. He was placed for a time under Farrington, R.A., and afterwards under Sir Thomas Lawrence. He became known as a portrait painter chiefly from the accuracy of his likenesses, and though wanting in the higher qualities of his art, he had some distinguished sitters. He first exhibited at the Academy in 1804, and for nearly 50 years was a constant and large contributor of his portrait works. Soon after 1853 he retired to Ipswich, and sent from thence, in 1856, his last contribution to the Academy Exhibition. He died at Ipswich, July 29, 1859.

LANE, THEODORE, *subject painter.* Was born in 1800, at Isleworth, where his father, a drawing-master, had retired. He was apprenticed to an engraver, and studied assiduously, but his genius tempted him to original design. He exhibited at the Academy, as early as 1816, the portrait of a dog; and in 1819, 1820, and 1826, female portraits. Then, in 1827, finding the true bent of his genius, 'The Christmas Present, or Disappointment;' and the following year, 'Disturbed by the Nightmare.' This latter picture, and 'The Enthusiast,' two humorous works, which are well known, are engraved, and he was rising into notice, when, falling through a skylight, he was killed on the spot, May 21, 1828. He left a widow and three children, for whose benefit his 'Enthusiast'—a gouty old man fishing in a tub in his chamber—was published. There are also some caricatures drawn and etched by him.

LANE, WILLIAM, *portrait painter.* He commenced art as a gem engraver, and from 1778 to 1784 exhibited at the Academy classic heads on cornelian and other precious stones. In 1785 he exhibited a head of Mrs. Siddons in crayons, and from that year occasionally sent a portrait, but from 1797 established himself as a popular portrait draftsman. His works were slight, and cleverly drawn in hard coloured chalks. He was a large contributor of portraits and portrait-groups up to 1815. He died at Hammersmith, January 4, 1819, in his 73rd year. ANNA LOUISA LANE, apparently his wife, also exhibited some portrait drawings in 1778–81 and 1782.

LANE, RICHARD JAMES, A.E., *engraver.* He was the son of the Rev. Dr. Lane, prebendary of Hereford. His mother was the niece of Gainsborough, R.A. Born in 1800, he was at the age of 16 articled to Charles Heath, the line engraver, and made good progress in his art; but on the completion of his pupilage, the higher branches of engraving suffered great discouragement from the attempts to widen its diffusion by greater cheapness, and in 1824 he was tempted to try the new art of lithography, to which, after many struggles, he finally devoted himself, and soon attained great excellence, standing foremost in delicacy of finish and perfection of style. Among his first works were a charming series of 'Sketches by Gainsborough,' 1823; followed by 'Imitations of British Artists,' among which are works that stand unrivalled in lithography. His imitations of 'Sketches by Sir Thomas Lawrence, P.R.A.,' are no less distinguished by their extreme tenderness and delicacy, and are quite deceptive in their imitative power. He executed for the Queen, who appointed him her lithographer, many prints of the members of the Royal family after Winterhalter, and

Landseer – Thomas Painter & Engraver - . . . d 1880.

also some excellent prints after his friend, Alfred Chalon, R.A. In 1827 he was elected an associate engraver of the Royal Academy. In 1864 he was appointed director of the etching class at the South Kensington Museum, an office for which he was peculiarly fitted by his large knowledge of art, and his patient, gentle temper. He died at Kensington, November 21, 1872. He wrote 'Life at the Water-cure.'

LANGLEY, BATTY, *architect.* Was the popular architect of his day. He pretentiously attempted to adapt the proportions of the Gothic to the Roman, and invented five orders of his new style. These he published, also 'An accurate Description of Newgate,' 1724; and a 'Design for a new Bridge at Westminster,' 1736. He also published a useful 'Builders' Price-book,' successive editions of which have continued to the present time; and a 'Survey of Westminster' which he had made; and on some squabble with the city authorities, who preferred the Swiss architect (Labelye) to him, in a vignette to his work, introduced his foreign rival hung by the neck under an arch. He had sufficient assurance and influence to corrupt the taste of the time. He died March 3, 1751. Walpole calls him a 'barbarous architect;' but he was one of those who, in his day, helped to keep alive a taste for Gothic architecture. THOMAS LANGLEY, brother of the above, engraved many of his plates, and was joint author of several of his works.

LANGTON, JOHN, *glass painter.* He was originally a writing-master at Stamford, and presented to Queen Anne specimens of his penmanship. He made some experiments in glass painting, and painted the east window of the church at Stamford, 'Christ blessing the Elements,' in 1700; and claimed to have revived the art of painting on glass.

' LANIERE, NICHOLAS, *portrait painter.* Was one of the sons of Jerome Laniere, an Italian, who came to England with his family in the latter part of Queen Elizabeth's reign, and belonged to her Majesty's band. He was painter and musician, and skilled in both these arts. Charles I. employed him as his agent in the purchase of pictures, and sent him to Italy, where he laid out large sums on the commission given by his Majesty. When the royal collection was sold by the order of Parliament, he was a large purchaser, and deposited his acquisitions in his father's apartments at Greenwich, and, taking care to remove them before the Restoration, none could be recovered. He wrote the music and painted the scenes for a masque by Ben Jonson, which was performed in 1617; also a vocal composition for a funeral hymn on his royal master. As a musician, he had a pension of 200*l.* a year for life, and he also held the office of closet-

keeper to the King. His portrait by himself, in the music school at Oxford, proves him to have possessed great powers as an artist; it is well drawn and coloured, the composition and expression excellent. He died November 4, 1646, and was buried at St. Martin-in-the-Fields. He published a Drawing-book, in which the examples were engraved by himself, and there are also some etchings by him.

LANKRINK, PROSPER HENRY, *landscape painter.* Born in Antwerp in 1628. He was the son of a German soldier in the Dutch service. His mother had devoted him to the Church, but showing a talent for painting, she sent him to the academy at Antwerp, were he made rapid progress. On his mother's death, he came to England in the reign of Charles II., after having visited the chief galleries in Italy. He had copied much from Salvator Rosa, and was an able imitator of his works. His own landscapes, into which he introduced small figures, were much admired; and Sir Peter Lely employed him on his landscape backgrounds. Many of his works were lost in a fire. As he advanced in life he became idle and dissipated. He resided several years in Piccadilly, and dying in Covent Garden in 1692, was buried in the Church there. J. Smith mezzo-tinted 'Nymphs Bathing' after him.

• LANT, THOMAS, *amateur.* He was portcullis pursuivant to Queen Elizabeth, and a gentleman in the service of Sir Philip Sydney. He drew the funeral procession and obsequies of his master, which were engraved in 34 plates by De Brie.

LAPIDGE, EDWARD, *architect.* He was the son of the gardener at Hampton Court Palace. He exhibited some designs at the Academy in 1808 and following years, but was rarely an exhibitor. He was the architect of Kingston Bridge, completed in 1828, and in the following year built St. Peter's Church, Hammersmith; also a chapel on Ham Common. He was a competitor, sending in a set of designs, for the new Houses of Parliament in 1836. He exhibited at the Academy, in 1850, a design for a suspension bridge on a new principle. He died in March 1860.

LAPORTE, G. H., *animal painter.* He was an occasional exhibitor at the Suffolk Street Exhibition from 1825, and at the Royal Academy from 1827. On the foundation of the Institute of Painters in Water-colour he became a member and a constant exhibitor, but his yearly contributions did not exceed two or three works, chiefly animals and figures, military and Arab groups, and some hunting subjects. He was appointed animal painter to the Duke of Cumberland. He died October 23, 1873.

LAPORTE, JOHN, *water-colour painter.* He first appears as an exhibitor at the

Royal Academy in 1785, and from that year, with few exceptions, was a constant contributor of landscape scenery. He was one of the masters at the Military Academy at Addiscombe, and was greatly engaged also in private teaching. He painted landscapes, introducing cattle, with effects of sunset and morning, of rain and showers, and some views of lake scenery. There are some attempts by him in oil, which he exhibited at the British Institution. 'Characters of Trees' was published by him in 1799, followed by 'Progressive Lessons sketched from Nature.' He died in London, July 8, 1839, aged 78.

LARGILLIÈRE, NICHOLAS, *portrait painter*. Was born at Paris in 1656, and was intended for commerce, but showing a love for art he studied at Antwerp. At the age of 18 he came to England, and was employed by Lely to repair some of the royal pictures at Windsor. There he gained the notice of Charles II., who commissioned him to paint several pictures, but he soon left England and settled in Paris, where he was patronised by Louis XIV. On the coronation of James II. he was invited to return to London, when he painted the King's portrait in armour, wearing an immense wig, also the Queen's with a profusion of lace and brocade. He afterwards went back again to Paris, and was a third time tempted to come to London by the large prices paid for his works, but the hostility of the artists, it is said, drove him back to Paris, where, having been appointed Director of the Academy and treated with much distinction, he died in 1746. His works are very numerous. They include several portraits of the exiled Stuarts and some large historical works, among which 'The Crucifixion' for the Church of St. Geneviève, Paris, is specially mentioned.

LAROON, MARCELLUS (known as 'Old Laroon'), *subject painter*. He was born at the Hague in 1653, and taught by his father, who was an artist. With him he came, when young, to England, where he studied closely from nature, and formed a style of his own. He lived several years in Yorkshire, and on returning to London was employed by Sir Godfrey Kneller as his drapery painter. He drew correctly, and painted history, subject and conversation pieces, and landscape. He had great power in imitating the styles of the great masters, and both engraved in mezzo-tint and etched. He drew and engraved Tempesta's well-known 'Cryes and Habits of London' and 'The Coronation Procession of William and Mary.' There is also a book upon Fencing by him. He resided in Bow Street, Covent Garden, from 1680 till his death, of consumption, March 11, 1702, which took place at Richmond, where he was buried.

LAROON, MARCELLUS (known as 'Captain Laroon'), *subject painter*. Son of the above. He was born in Bow Street, Covent Garden, April 2, 1679. He early gained power as a rapid draftsman. At the age of 18 he went as a page to Sir Joseph Williamson, one of the plenipotentiaries to the Congress at Ryswyck; and from thence travelled in the suite of the Earl of Manchester, the ambassador to Venice, being absent altogether about a year. He had studied both painting and music, and quarrelling with his father, went on the stage as an actor; and at the end of two years turned again to his painting till 1707, when he obtained a commission and joined the army in Holland, where he fought at the battle of Oudenarde and the sieges of Ghent and Tournay. In 1710 he was with the army in Spain, served a campaign as deputy quartermaster-general, marched with the army to Madrid, and, taken prisoner, was detained till 1712. On the Rebellion, in 1715, he was again on service with the royal army at Preston. There he was placed on half-pay till 1724, when he was appointed to a troop of dragoons, in which he served till 1734. His art is now known by his drawings—music parties, groups in conversation, sometimes introducing portraits and camp sketches. These are freely drawn with a reed pen, with sometimes a slight shadow washed in. About 1740 he was living at Worcester. He died at York, some accounts say Oxford, June 2, 1772. He had a great genius both for painting and music. He sold a collection of his own works, with many of his father's, in 1725.

LATHAM, JAMES, *portrait painter*. Born in Tipperary. Studied his art at Antwerp, and practised in Ireland about 1725–40. He was one of the earliest of Ireland's painters, and was greatly esteemed. He practised for a time in London. He painted in a pure style, and among his works left an excellent portrait of Peg Woffington. His portraits are frequently met with in the old Irish mansions, and some of them are engraved. He died in Dublin about 1750.

LATILLA, EUGENIO, *subject painter*. After exhibiting for several years with the Society of British Artists, he was in 1838 elected a member, and in that and the two following years was a large contributor to their exhibitions. In 1842 he went to Rome, and sent from thence a Pfifferaro, 'Abraham dismissing Hagar and Ishmael,' 'Preparing for the Carnival,' and other works. In 1847–48 he was at Florence, and returning to London in 1849, he exhibited 'Jane Shore's Penance,' and some others. In 1851 he resigned his membership and went to America, where he died.

LATOMUS, HENRY, *architect*. Prac-

tised at the beginning of the 14th century. In 1319 he rebuilt the church at Evesham.

LAUDER, JAMES ECKFORD, R.S.A., *subject painter.* He was born in 1812, at Silvermills, near Edinburgh, and was younger brother of the following, by whose help his early love of art was rapidly developed. He studied at the Trustees' Academy, and in 1834 joined his brother in Italy, where he studied zealously nearly four years. On his return he settled in Edinburgh, where he was a yearly contributor to the exhibition, sending among other works, 'The Unjust Steward' and 'The Ten Virgins,' which latter was engraved. His works yearly attracted much notice, and in 1839 he was elected an associate of the Scottish Academy, and in 1846 a full member. He was also an occasional exhibitor at the Royal Academy in London, where he exhibited, in 1841, 'A Scene from The Two Gentlemen of Verona;' followed by, in 1842, 'Cherries;' in 1843, 'Hop-Scotch;' in 1845, 'Night and Day;' making his last contribution in 1846. In 1847 he was awarded, in the competition at Westminster Hall, a premium of 200*l.* for his 'Parable of Forgiveness.' He had continued to practise in Edinburgh, and died there March 27, 1869. He enjoyed a reputation in Scotland, and for a long period his works filled an important place on the walls of the Scottish Academy.

LAUDER, ROBERT SCOTT, R.S.A., *subject painter.* He was born at Silvermills, near Edinburgh, in 1802. Stirred by an early love of art, on leaving school he gained admission to the Trustees' Academy in Edinburgh, and after three years' study there he came to London, and for about three years drew at the the British Museum and in a private life academy. In 1820 he returned to Edinburgh and renewed his studies at the Trustees' Academy, and was elected an associate of the Royal Institution, and on the foundation of the Royal Scottish Academy in 1830 he became one of the first members. At this time he painted a number of small portraits, and in 1833 visited the Continent, where he remained for five years, chiefly studying at Rome, and at Bologna, Florence, and Venice. He returned in 1838, and from that time resided mostly in London. In 1839 he exhibited at the Royal Academy his 'Bride of Lammermuir' and 'Rose Bradwardine;' in 1840, 'The Trial of Effie Deans;' in 1842, 'Ruth,' and 'Meg Merrilies and the dying Smuggler;' in 1845, 'Hannah presenting Samuel to Eli;' and in 1848, 'Mother and Child,' with, during the same years, occasional portraits. In 1847 he exhibited at the Westminster Hall competition, 'Christ walking on the Sea.' He afterwards returned to Edinburgh, and painted his 'Christ teaching Humility,'

262

which was purchased' by the Society for promoting the Fine Arts in Scotland. Struck with paralysis in 1861, he was unable to continue his art, and died at Edinburgh, April 21, 1869. His colour and light and shade are rich and powerful, his expression and character good, his aspirations lofty and original.

LAURIE, ROBERT, *engraver.* Was born in London about 1740, practised in mezzotint, and was also a printseller. He was awarded a Society of Arts' premium in 1771, and one in 1776 for an invention in mezzo-tint engraving, which facilitated working the plates in colours. There are some good plates by him after Rembrandt, Rubens, Vandyck, Ostade; and portraits after the English artists of his own day, including George III. and his Queen. He died about 1804.

LAWLESS, MATTHEW JAMES, *subject painter.* He first appears at the Royal Academy as an exhibitor in 1858. In 1860 he exhibited 'The King's Quarters at Woodstock;' in 1861, 'Waiting for an Audience;' in 1862, 'The Widow of Hogarth selling her Husband's Prints;' and in 1863, his last contribution, 'A Sick Call,' the visit of a priest, probably suggested by his own failing health. He died at Bayswater, in the autumn of 1864, in his 28th year. His works were carefully finished, and his latest works showed an improvement in character and refinement. He made many designs for wood engraving, which have great merit.

LAWRANCE, RICHARD, *amateur.* He was a veterinary surgeon, and a friend of B. R. Haydon. He published, in 1818, 'Fifty Outlines from the Elgin Marbles,' drawn and etched by himself.

LAWRANSON, THOMAS, *portrait painter.* An Irish artist, of whom little is known. He practised in London about the middle of the 18th century, and was a member of the Incorporated Society of Artists, exhibiting with them portraits, whole-lengths, and some miniatures, in 1764–73. He painted chiefly in oil, and drew and published a large engraving of Greenwich Hospital. There is a portrait of O'Keefe by him in the National Portrait Gallery. He died after 1778.

LAWRANSON, WILLIAM, *portrait painter.* Son of the foregoing. He painted subject pictures and portraits in London in the latter part of the 18th century. He gained premiums at the Society of Arts in 1760 and 1761. He was a member of the Incorporated Society of Artists, and exhibited with them crayon portraits 1765–70, and first appears as an exhibitor of crayon portraits at the Royal Academy in 1774, and continued to contribute in the succeeding years. His portrait of 'Nan Catley as Euphrosyne,' is engraved by Dunkarton,

and there are many fine mezzo-tints after his works; of these are 'Palemon and Lavinia,' 'Rosalind and Celia,' 'Cymon and Iphigenia,' 'Lady Haymaking,' 1780, his last contribution to the Academy Exhibition.

LAWRENCE, ANDREW, *engraver*. He was born in Westminster in 1708, and was the natural son of Andrew Lawrence, apothecary to Queen Anne. He learnt drawing under Mons. Regnier, who then taught in Soho. He became a good linguist and musician. He also drew in crayons and painted in oil. On the death of his father he tried alchemy, and soon lost the fortune left him. Then a ruined man, he made his way to Bologna and from thence to Paris, where he was employed by Le Bas, and etched for him many plates, receiving about a franc and a half a day. Among the works so executed are the 'Halte d'Officiers,' 'Les Sangliers forcés,' after Wouvermans; 'Le Soir,' after Berghem; and some others. Afterwards he worked for A. Pond. Salvator Rosa's 'Saul and the Witch of Endor' is engraved wholly by him, as are also some plates after De Loutherbourg and Wouvermans. His engravings, published in Paris, have the name A. Laurent under them. He etched with great taste, was also a clever painter, and possessed much professional knowledge. He died at Paris, July 8, 1747.

LAWRENCE, MARY, *flower painter*. She first exhibited at the Academy in 1794, and continued with small exception a yearly contributor up to 1814, when she became, by marriage, Mrs. Kearse, and in that name exhibited up to 1830. She published, in 1797, 'The Various Kinds of Roses cultivated in England,' which she drew and coloured from nature, and engraved with great tenderness.

* LAWRENCE, Sir THOMAS, Knt., P.R.A., *portrait painter*. Was born at Bristol, May 4, 1769. His father, the son of a clergyman, tried many means to gain a livelihood. At the time of his son's birth he kept the 'White Lion Inn,' and his business failing there about three years after, he took another inn at Devizes. Young Lawrence was a handsome boy, and both repeated poetry and drew likenesses with a very precocious taste: two years' schooling and a few lessons in French were the sum of his education. His family removed successively to Oxford, Weymouth, and Bath, where he received some art-help from Wm. Hoare, R.A., and commenced his career by drawing chalk heads in ovals at one guinea and one and a half guinea each. He gained a premium from the Society of Arts in 1785, and his sitters increasing he doubled his prices, and he made some attempts at historical subjects, though probably only in chalk.

In 1787 he came with his family to London, and was admitted a student of the Royal Academy. He exhibited there in that year four female portraits — 'Mad Girl,' 'A Vestal Virgin,' and 'Mrs. Esten as Belvidera;' in the following year, six portraits; in 1789, 13 portraits, one of them of the Duke of York; and in 1790, the Queen, the Princess Amelia, and 11 other portraits. He was not long in gaining public patronage and royal favour. In 1791, though under the academic age, he was elected an associate of the Academy, and with 10 portraits, exhibited a classic subject, 'Homer reciting his Poems.' In 1792, when in his 23rd year only, he was appointed by the King his painter in ordinary, on the death of Sir Joshua Reynolds; that year exhibited his Majesty's portrait, and in 1794 was admitted to his full honours as member of the Academy. Reynolds's death had left the profession open; he soon distanced his competitors, and stood first in the front rank, enjoying the chief honours and profits of his profession. In 1801 an incident occurred which, for a short time, diminished the number of his female sitters. He was required to paint the portrait of the Princess of Wales, and for a time occupied a room at her Royal Highness's residence, which was made a subject of scandal and of inquiry before the Commission of 1806, then called 'The Delicate Investigation,' but no allusion whatever was made to Lawrence in the report.

On the opening of the Continent in 1814, he hastened to Paris to see the great art collection in the Louvre, but was recalled to receive an important commission from the Prince Regent, who had not before employed him. He was appointed to paint the portraits of the eminent statesmen and soldiers who had aided in the restoration of the Bourbons (many of whom were then expected to visit London), to form a commemoration gallery at Windsor. In 1815 the Prince Regent sat to him and conferred on him the honour of knighthood, and in 1818 he visited Aix-la-Chapelle, where the Congress sat, and afterwards Vienna and Rome, for the completion of the Prince's commission, returning in 1820, after an absence of 18 months, during which he had seized the opportunity to visit the principal Italian cities.

The president of the Academy had died during his absence, and on the very day of his arrival in London he was unanimously elected the new president. Fortune seems invariably to have favoured him. He continued to paint the portraits of the most distinguished of his countrymen and countrywomen. In 1825 he went to Paris to paint for the King, Charles X., and the Dauphin, and had the Legion of Honour conferred upon him. At the height of his fame,

Lawrence S. Painter. 19

favoured in every respect, and not in the least anticipating the termination of his career, after only a few days' illness, he died, of ossification of the heart, on January 7, 1830, and after lying in state at the Royal Academy, was buried with great ceremony in St. Paul's Cathedral. In the spring of the same year a fine collection of his works, which included 91 pictures, was exhibited at the British Institution, and the proceeds, which amounted to 3000l., were presented to his nieces by the directors.

Lawrence had never married; an early engagement to the daughter of Mr. Siddons was broken off by the lady's father, on the ground of the inadequacy of the young painter's income; and fond of female society, on one or two other occasions he is said to have entered into engagements, which, however, still left him a bachelor. The profits of his profession must have been large. His last list of prices was—head, 210l.; kit-cat, 315l.; half-length, 420l.; Bishop's half-length, 525l.; full-length, 630l.; extra full-length, 735l. For the portrait of Lady Gower and child he received 1500 guineas, and for his Master Lambton 600 guineas. Upon a fine collection of drawings which he made, he is estimated to have expended 60,000l. On his death they did not realise 20,000l. He could not resist the temptation of a fine drawing, if he could command the money. But he was during his whole career needy, and sometimes compelled to seek payment for his works before they were finished. His only extravagance was in the purchase of works of art, and he had a family of sisters and brothers, who depended largely upon him.

Lawrence early adopted a style of his own, and made little change in his manner, seeking no new methods of execution. Beside his great predecessor's works, his appear thin and weak, his colouring tinty and artificial; his drawing, though refined, effeminate; and his works marked by an artificial look approaching insipidity. His compositions want variety, and his backgrounds were too frequently merely commonplace. He painted some large historical subjects—in 1797, his 'Satan,' which was severely criticised; next 'Coriolanus,' which he called a half-history picture; followed by 'Rolla,' 'Cato,' and 'Hamlet,' which he placed above all his works, except the 'Satan.' His art was highly esteemed by his contemporaries; and as much as he had risen above his true rank in his lifetime, on his death he fell beneath it. But time, which has failed to place him in the position he once enjoyed, has now assigned to him his true place; yet this is not in the front rank. A life of him by D. E. Williams was published in 1831, but it is a verbose performance.

LEA, RICHARD, architect. Practised

with much reputation in the reign of Henry VIII. He is said to have mixed the Gothic and the classic in a strange manner, which probably refers to what is now termed the 'Tudor style.'

LEADER, WILLIAM, engraver. Practised in London, in mezzo-tint, about the middle of the 18th century, working chiefly after the old masters.

LEAHY, EDWARD DANIEL, portrait painter. He was born in London, and first appears as an exhibitor at the Academy in 1820, when he contributed 'Mrs. Yates as Meg Merrilies;' and continued an exhibitor of portraits, with an occasional subject picture, up to 1853. In 1830, 'Jacques and the wounded Stag;' in 1837, 'Escape of Mary, Queen of Scots, from Lochleven Castle;' in 1844, 'Lady Jane Grey summoned to Execution;' in 1852, 'Un piccolo Pfifferaro.' He died at Brighton, February 9, 1875, aged 77.

LEAKE, HENRY, portrait painter. He was the son of an eminent bookseller at Bath, and a pupil of Hoare, R.A. He came to London about 1764, and exhibited portraits in 1765–66, remaining about two years. He then went to the East Indies, but did not long survive.

LEAKEY, JAMES, portrait and miniature painter. Was born at Exeter in 1773; and early in the present century painted with much success portraits and miniatures in oil, which were well coloured and finished with great care. He was established at Exeter, and, well known, was employed in the Western counties, where his miniatures were held in esteem. He resided in London in 1821–22, and in those years exhibited at the Royal Academy 'The marvellous Tale,' 'The Fortune Teller,' and two Devonshire landscapes. In 1838, while residing at Exeter, he sent to the Academy three portraits, with two landscapes. He died at Exeter, February 16, 1865, aged 92.

LEBANS, JOHN, master mason. Was employed in this capacity in the erection of Henry VII.'s chapel at Westminster.

LE BLOND, CHRISTOPHER JAMES, engraver. Was born at Frankfort in 1670. Studied in Italy under Carlo Maratti, and afterwards practised as a miniature painter in Amsterdam. He was fond of mechanics, and discovered a process of printing mezzo-tint plates in colours. He came to England, and executed several plates by this process, but they were not much esteemed, and he disposed of them by lottery. He published his process under the title of 'Coloretto.' He then set on foot a project for working the Raphael cartoons in tapestry, made the drawings and erected looms for the work at Chelsea, but he did not meet with support, and suddenly disappeared. He went to Paris, where he died in a hospital in 1740. His coloured prints, though the colours were

fist and dirty, had some merit. Among them were the portraits of George II., Louis XIV., and Vandyck.

LE BLUND, RALPH, *die engraver.* Was presented to the office of 'cutter of the king's dies,' 52nd Henry III.

LE CAPELAIN, JOHN, *water-colour painter.* Was born in Jersey about 1814. He was a self-taught man, and came to London in 1832 to make art his profession. He painted upon the wrong side of veneered paper in a wet condition, which made the colours run together, and blend in a very harmonious manner. His works had but little outline, which caused Stanfield to speak of him as the 'foggy painter.' He made the drawings for the Jersey Album, presented to the Queen after her visit there, and this led to her Majesty's giving him a commission to paint the scenery of the Isle of Wight. While executing these drawings he caught cold, and died of rapid consumption in Jersey in 1848. His works were collected after his death, and preserved in the Jersey Museum. His sketches met with a ready sale, and he had many pupils.

LE CAVE, P., *water-colour painter.* He practised in the early tinted manner, painting landscapes with cattle and figures, pleasing but weak imitations of Berghem, and was employed in teaching. There are also by him some small works of the same class in oil. In 1769 he was an applicant for assistance to the Incorporated Society of Artists, and he is again heard of in 1803, when, much in debt, he left his lodgings, promising to return, but no further trace of him could be gained.

LE DAVIS, EDWARD, *painter and engraver.* Born in Wales about 1640. He was apprenticed to Loggan, but soon left him, and entered service as a domestic. Accompanying his master to Paris, he found there the means of pursuing his art, and practised both as a painter and engraver, but is best known by his engraved works, which are chiefly portraits. He died about 1684.

LEDBEATER, S., *architect.* He practised in the early part of the 18th century. The mansion of Nuneham Courtenay, Oxfordshire, was erected by him, the elevation plain and well proportioned. It is engraved in Woolfe and Gandon's work.

LEE, ANNA, *botanical painter.* Was a pupil of Parkinson, and practised in London with much repute in the latter part of the 18th century. She painted and drew plants, shells, and insects with great perfection. She died in the prime of life about 1790.

LEE, J., *wood engraver.* Between 1794-98 he engraved the cuts for 'The cheap Repository,' which, though coarsely executed, had great merit.

LEE, JAMES, *wood engraver.* Son of the

foregoing. When young he practised some time in Paris, returning 1786. He executed the portraits in Hansard's 'Typographia,' 1805; also, after Craig's designs, the illustrations to a reading-book, 'A Wreath for the Brow of Youth,' for the Princess Charlotte of Wales, and was largely employed in the illustration of books for children. He died 1804.

LEE, A., *portrait painter.* Practised in the reign of George II. Some of his works are engraved.

LEE, JOSEPH, *enamel painter.* He was an occasional exhibitor of enamel miniatures from the life, as well as copies, at the Academy, commencing in 1809. In 1818 he was appointed enamel painter to the Princess Charlotte, and that year exhibited her portrait, and again exhibited her Royal Highness's portrait in 1823, after Dawe. In 1832 he was appointed enamel painter to the Duke of Sussex, whose portrait, after Phillips, R.A., he exhibited, and also George IV.'s, after Lawrence, P.R.A. After a career of 44 years, which does not appear to have been successful, he exhibited for the last time in 1853. There is a clever example of his art at the South Kensington Museum. He died at Gravesend, December 26, 1859, aged 79.

LEE, WILLIAM, *water-colour painter.* His chief subjects were English rustic figures, and later, French coast figures. He was elected in 1846 a member of the Institute of Water-Colour Painters, and continued a contributor to the Society's Exhibitions up to his death. Among his last works were 'The Long Sermon,' 'The Drinking Fountain,' 'The Rustic Beauty,' 'Thoughts of the Future.' He died in London, January 22, 1865, aged 55.

LEECH, JOHN, *humorous designer.* Of Irish descent, he was born in the city of London in 1817, and sent very early to the Charter-house, where he remained eight years. He drew in his childhood, and had only a school-boy teaching in drawing. On leaving the Charter-house, he studied medicine and surgery, and entered St. Bartholomew's Hospital. Though qualified for the practice of medicine, the love of art grew too strong, and upon the commencement of 'Punch' he was among its first graphic contributors, and for 20 years continued to be the life of its weekly illustrations. Then the unceasing nature of the work proved too much for him, his system fell into a state of exhaustion and nervous irritability, and he died suddenly, without any alarming premonitory symptoms, at Kensington, October 29, 1864. He was buried at Kensal Green Cemetery. His humour was universal, without the least taint of ill-will, and was enjoyed by all—amiable, aiming at truth and goodness, and illustrating every phase of life; his females incomparably ladies,

and his children inexpressibly childlike. His landscape backgrounds, fresh and charming, were evidences that he was an ardent horseman and fisherman; his sketch-book was filled with notes from the life while the objects were before him, and was a mine for *bits* of every description.

LEFEBVRE, CLAUDE, *portrait painter*. He was born at Fontainebleau in 1633, and studied in the gallery there. He painted flowers, history, and portraits, in which latter he chiefly excelled. He came to England, and settled here in the reign of Charles II., and was well esteemed, but little is known of his works. He practised for some years in London, where he died in 1675, aged 42. He etched his own and his mother's portraits, and some other plates.

LEFEVRE, ROLAND (known as ' Lefevre of Venice '), *portrait painter*. Was born at Anjou in 1608. He painted portraits and small historical groups, and came to England, where he was patronised by Prince Rupert. He is known by a method of staining which he adopted, and was not much esteemed as a painter. He died in Bear Street, Leicester Fields, in 1677, and was buried at St. Martin's Church.

• LEGAT, FRANCIS, *engraver*. Born in Scotland in 1755, he was educated in Edinburgh under Alexander Runciman. He came to London in 1780, when about 26 years of age, and was employed by the publishers, but chiefly by Boydell. He engraved the ' Continence of Scipio,' after Poussin, in 1784; and ' Mary, Queen of Scots, resigning her Crown,' after Hamilton, in 1786; followed by Northcote's ' Children in the Tower.' About the end of the century he engraved ' Ophelia before the King and Queen,' which procured him the appointment of engraver to the Prince of Wales. Wishing to try a plate on his own account, he bespoke Stothard's ' Sir Ralph Abercrombie;' but when far advanced he was unable to publish it successfully, and his spirits gradually gave way under the disappointment. He died soon after, on April 7, 1809, in his 55th year, and was buried in old St. Pancras's Churchyard, leaving behind him debts, which a friend discharged. He engraved in a finished style, imitating the manner of Strange, and was distinguished by his correct drawing.

LEGREW, JAMES, *sculptor*. Was born in 1803, at Caterham, Surrey, of which place his father was the rector. He was well educated; had a knowledge of Latin, Greek, Hebrew, and Syriac, as well as of French, Italian, and German, and to these acquirements he added a love for the arts, which led to his being placed under Sir Francis Chantrey, R.A. He at the same time entered the schools of the Academy,

and, after gaining the silver medal in 1824, was awarded the gold medal in 1829 for his group of ' Cassandra dragged from the Altar of Minerva.' He had exhibited some groups at the Academy, commencing in 1824; in 1830 exhibited his gold medal group; and in the following years contributed busts, with an occasional group. Between 1840 and 1842 he travelled in Italy, studying for a time in Rome. On his return, after first living in Pimlico, he settled in Kensington, and produced 'Samson breaking his Bonds,' ' The Murder of the Innocents,' ' Rachael mourning for her Children,' ' Milton dictating to his Daughters,' a ' Sea Nymph,' ' Musidora,' ' Venus,' with several monumental works. In 1844 he sent to the Westminster Hall competition ' The last Prayer of Ajax,' a work of great merit. He had been for some time affected with mental delusions, which, though mitigated, he had never recovered from, and on the loss of his father and a brother, he suffered a succession of attacks, under which, in spite of medical assistance and the affectionate watching of his relations, he committed suicide at Kensington, September 15, 1857.

LEICESTER, Sir JOHN FLEMING, Bart., *amateur*. Born in 1762. He was taught both by Vivares and Paul Sandby, and travelled in Italy with Sir R. Colt Hoare. He drew in Indian ink, and tinted with bistre, and is described as an occasional honorary exhibitor at the Royal Academy; but his name does not appear in the catalogues, unless he exhibited under initials. He was distinguished for his knowledge and patronage of English art, and was one of the earliest to form a collection of the works of his countrymen, to whom he readily threw open his gallery. He was one of the originators of the British Institution in 1805, of the Calcographic Society 1810, and of the Irish Academy 1813. He was created Baron de Tabley in 1826, and died June 18, 1827.

LEIGH, T., *portrait painter*. He practised with some repute about the middle of the 17th century. There is a portrait by him of Robert Davis, of Gwysaney, a distinguished royalist, dated 1643.

LEIGH, JARED, *amateur*. He was a proctor in Doctors' Commons, who painted for his amusement—chiefly landscapes and sea views. He exhibited at the rooms of the Incorporated Society in Spring Gardens. He died about 1769, in the prime of life.

LEIGH, JAMES MATHEWS, *history painter*. Was born in 1808, the son of a publisher in the Strand, and the nephew of the elder Matthews, the well-known actor. He showed a taste for art, and in 1828 became a pupil of Etty, R.A., and was from 1830, when he exhibited ' Joseph presenting

his Brethren to Pharaoh' and 'Jephthah's rash Vow,' an occasional exhibitor at the Academy. He early made a visit to the Continent, seeing the principal art galleries in France, Italy, and Germany. On his return he was occupied more with literature than art, and then he travelled again, principally to see Spain. In 1840 he resumed his contributions to the Academy, and continued to exhibit chiefly sacred subjects, and in the later years some portraits, up to 1849. He made many good sketches in a vigorous style, and, establishing an art school, became well known as a teacher. He died in London, April 20, 1860. He wrote 'Cromwell: a Drama,' 1838; and 'The Rhenish Album.'

LE KEUX, JOHN, engraver. Was born in Bishopsgate, June 4, 1783, and was apprenticed to his father, a large pewter manufacturer. At about 17 years of age he tried engraving on copper, and being encouraged by Basire, he was turned over to him for the remaining term of his apprenticeship. Under Basire he imbibed his master's taste for architectural subjects, and working in the line manner, refined upon his style, attaining both greater minuteness and freedom. 'Easby Abbey' and 'Rome,' after Turner, R.A., are probably his best works. He contributed, by his ability and taste, to the success of many of the publications of his day, and was largely engaged with Britton. He engraved for his 'Architectural Antiquities,' 'Cathedrals,' and other works; for Pugin's 'Antiquities of Normandy,' 'Gothic Specimens and Gothic Examples;' for Neale's 'Memorials of Oxford;' and other works of this class. His works are distinguished by great truth and refinement of finish. He died April 2, 1846. His eldest son, J. H. Le Keux, followed his art.

LE KEUX, HENRY, engraver. Younger brother of the foregoing. Was born in 1787, and was articled to James Basire. He was first engaged upon Basire's large plates for the Society of Antiquaries and the 'Oxford Almanacs,' and afterwards on the illustrations for the 'Beauties of England and Wales;' and took a part with his brother in Britton's 'Cathedrals.' Later, with Blore, he produced the 'Monumental Remains.' He also engraved for the 'Forget-me-not,' and some other of the annuals, after Martin and Prout, and after Turner for Rogers' 'Poems.' He was a member of the Associated Society of Engravers, and one of his last works was Claude's 'Embarkation of St. Ursula' for that Society. He left his profession about 1838, and retired to Bocking, in Essex, where he joined in a crape manufactory; and after 30 years died there, October 11, 1868. He worked in the line manner, was unassisted

by pupils, and his productions are models of industrious painstaking.

• LELY, Sir PETER, Bart., portrait painter. Was born 1617, at Soest, in Westphalia, the son of a captain of infantry, who changed the name of Van der Vaas to Lely, and studied art under Peter de Grebber at Haerlem. He came to England at the age of 24, and painted history and landscape; but Vandyck had just then died, and he soon found there was a place open for him, and much better encouragement, as a portrait painter. He was introduced to Charles I., whose portrait he painted. He also painted Cromwell's portrait; and on the Restoration was favoured by Charles II., who appointed him his principal painter, made him a baronet in January 1679–80, and was pleased by his conversation. For more than 30 years he stood alone as the popular painter, and all that were eminent and distinguished sat to him. By this great practice he acquired a considerable fortune. He married an English lady of family, but her name cannot now be traced. He had a town house and a house at Kew, where he had purchased an estate. He kept a handsome table, and is described by Pepys as 'a mighty proud man, and full of state.' His society was sought by men of the greatest eminence. He lived for some years in Drury Lane, and from 1662 to 1680 in the Piazza, Covent Garden. Here he died of apoplexy, November 30, in the latter year, and was buried in the adjoining church of St. Paul. His monument, with a bust by Gibbons, was destroyed by fire when the church was burnt down in 1795. He left a son and a daughter, who died under age. His large collection of pictures and drawings were sold by an auction which lasted 40 days, and produced 26,000l. The drawings in his collection were all marked 'P. L.' His estate was worth 900l. a year, and went to a nephew in Holland. From the records of the Free Society of Artists, it appears that the widow of JOHN LELY, his grandson, who died November 25, 1728, and who was a face-painter, fell into great distress, and solicited the charity of the Society; and that she afterwards found a refuge in Megg's Almshouses, Mile End.

His portraits, though meretricious and slight, had many good qualities. They are pleasing in colour, freely executed, and well drawn, particularly the hands; but they want individuality and character, are affected, and too frequently revel in unmeaning allegory. The eyes of his females have a drowsy languor, which became quite a mannerism. He designed in Indian ink, touching in the high lights with white. There are some drawings by him in crayons and a few in water-colour. His 'Beauties' at Hampton Court are well known, and are good examples of his art. There are some

historical subjects by him—a 'Magdalen' and a 'Sleeping Venus,' at Windsor; 'Susanna and the Elders,' at Burghley; a 'Judgment of Paris,' engraved by Lens; and some others.

LENEY, WILLIAM S., *engraver.* Was born in London, and apprenticed to Tomkins. He established himself as a stipple engraver, practised towards the end of the 18th century, and produced a large plate of 'The Descent from the Cross,' after Rubens. He also engraved after Downman and Smirke for the Shakespeare Gallery, and after Westall and De Wilde. His work was but indifferent, and afterwards he emigrated to America, where he made some money by engraving bank-notes, and purchased a farm up the St. Lawrence, to which he retired, and was living there in 1808.

LENS, BERNARD, *enamel painter.* He did not attain much excellence, and little is known of him. He died February 5, 1708, aged 77, and was buried in St. Bride's Church, Fleet Street.

· LENS, BERNARD, *mezzo-tint engraver and draftsman.* Son of the foregoing. Born in London 1659. He was instructed in art by his father, and made many drawings for other engravers, and also taught drawing. He excelled in mezzo-tint, and engraved in this manner Lely's 'Judgment of Paris' and a number of portraits, landscapes, and historical subjects. There are also some good etchings by him. He drew, in Indian ink, views and topographical sketches. Died April 28, 1725, aged 66. He published, in 1697, in connection with the well-known J. Sturt, a broad-sheet prospectus of their drawing-school in St. Paul's Churchyard, which sets forth, quite in the style of the present day, the value which drawing will prove to all classes—mechanics, professional men, and others.

, LENS, BERNARD, *miniature painter.* Born in London 1680. Son of the above, and taught by him. He was considered one of the best miniaturists of his day, and was appointed enameller and miniature painter to George II. He excelled also in his water-colour copies from Rubens, Vandyck, and other great masters. He was drawing-master to William, Duke of Cumberland, and the Princesses Mary and Louisa, and to Horace Walpole. He also held the appointment of drawing-master to Christ's Hospital. His 'New and Complete Drawing-book' (published after his death) 'for curious young Gentlemen and Ladies that study and practise the noble and commendable Art of Drawing, Colouring,' &c., contains 62 plates etched by himself, with full instructions and recipes. He also scraped some mezzo-tint plates. He died at Knightsbridge, December 30, 1740, leaving three sons; two followed his

profession, one of whom was living in 1780. He made two sales of his pictures and works.

LENS, ANDREW BENJAMIN, *miniature painter.* He was the son of a miniature painter—most probably of the above. He exhibited with the Incorporated Society of Artists from 1765 to 1770, and in the latter year was in Antwerp. His collection of miniatures by himself and his father was sold in 1777. He used the monogram 'A.B.L.' PETER PAUL LENS, a miniature painter practising in London in 1747, may be assumed to have been his brother.

LEONI, GIACOMO, *architect.* Born in Venice. He was for some time architect to the Elector Palatine, but came to this country, where he settled in the practice of his profession, in the early part of the 18th century. He built the Duke of Queensbury's house in 1726, on the site now occupied by the branch of the Bank of England in Burlington Gardens; the mansion in Moor Park, Herts, which has great pretensions to magnificence; Lyme Hall, Cheshire, and Bodecton Park, Sussex. He superintended Lord Burlington's edition of 'Palladio,' published 1725, and afterwards published Alberti's 'Architecture,' to which he added many of his own designs. He died June 8, 1746, aged 60, and was buried in old St. Pancras's churchyard.

, LE PIPER, FRANCIS, *designer and etcher.* Of Flemish extraction. His family settled at Canterbury in the reign of Elizabeth, and he was born in Kent about 1698. His father was wealthy, gave him a good education, and he was intended for commerce; but idle and fond of pleasure he rambled on foot over the greater part of Europe. He sketched landscapes and humorous groups; and, a jovial fellow, his performances were done in taverns, where he etched droll figures on his friends' snuff-boxes. Having dissipated his patrimony, he tried in the latter part of his life to turn his abilities to some account, and made some drawings for Becket to execute in mezzo-tint, and designs for Rycaut's 'History of the Turks;' but on the death of his mother, who left him a fortune, he relapsed into his old ways, fell again into a life of dissipation, and bled for fever by an ignorant surgeon, who pricked an artery, he died in 1740. He was buried at St. Mary Magdalen, Bermondsey. Faithorne drew his portrait in crayons, and Lutterel engraved a good portrait of him.

LERPINIERE, DANIEL, *engraver.* He was a pupil of Vivares and practised in London, working after the manner of his master, both with the needle and the graver. He engraved many fine landscapes, views, sea-fights, which have much merit, and some historical subjects. Among

Le-Piper - or Piper Francis Le

his works are three landscapes after Claude, six sea-fights after Paton, and after Vernet a 'Calm' and a 'Storm.' He exhibited in 1778 some architectural engravings with the Free Society of Artists. He died in 1785, aged 40.

LESLIE, CHARLES ROBERT, R.A., *subject painter*. Was born in Clerkenwell, of American parents, October 11, 1794. The family left England for Philadelphia in 1799, and settling there, the future artist, the eldest of a young family, was at the age of 10 years left to the charge of a widowed mother. His earliest wish was to be a painter, but his mother's straitened means led to his apprenticeship to a bookseller and publisher. His wish, though repressed, clung to him; a likeness he sketched from recollection showed so much ability that a fund was raised by his friends to enable him to visit Europe to improve himself, and provided with letters of introduction, he arrived in London in 1811.

He was in 1813 admitted a student of the Academy, and devoting himself to the study of his profession, the same year appears as an exhibitor of 'Murder,' with a quotation from Macbeth, and the following year of the 'Witch of Endor.' He next exhibited, in 1816, 'The Death of Rutland.' He added to his means at this period by painting the portraits of his friends, and in 1817 visited Paris, Brussels, and Antwerp, and after enlarged study he found the true bent of his genius in humorous comedy, and painted his 'Slender and Anne Page.' In 1819 he exhibited 'Sir Roger de Coverley,' which made a great impression, and was induced to follow this walk in art, apparently determined to settle in England. He was fortunate to make, about this time, the friendship of Lord Egremont, for whom he painted 'Sancho Panza in the Apartment of the Duchess,' a work which led to numerous commissions, and enabled him to marry in 1825.

He had been elected an associate of the Academy in 1821, and in 1826 was admitted to his full membership. In 1831 he exhibited a large group, upon which he had been for some time engaged, 'The Dinner at Page's House,' from the 'Merry Wives of Windsor,' one of his finest works. In 1833 his brother, without his knowledge, asked and obtained for him the appointment of teacher of drawing at the American Military Academy at West Point, on the Hudson, and induced him to accept it and remove with his family to America; but it was a mistake, the regret at leaving his art and art friends in England could not be overcome, and he returned early in the following year, in the full vigour of his powers, and resumed his art and his old friendships. He painted from Shakespeare,

Cervantes, Sterne, Goldsmith. In 1838 he painted, by command of her Majesty, 'The Coronation of the Queen;' and in 1841, 'The Christening of the Princess Royal.' He was a constant exhibitor at the Academy, and his works never failed to please and attract the public. A family and a happy household surrounded him. He had been appointed the professor of painting in 1847, but resigned the office in 1852 on the ground of delicate health. The loss of a daughter, shortly after her marriage, was a shock too great for him; he gradually declined, and died May 5, 1859.

Leslie entered into the true spirit of the writer he illustrated. His characters appear the very individuals who have filled our minds. Beauty, elegance, and refinement, varied and full of character, or sparkling with sweet humour, were charmingly depicted by his pencil, while the broader characters of another class, from his fine appreciation of humour, are no less truthfully rendered, and that with an entire absence of any approach to vulgarity. The treatment of his subject is so simple that we lose the sense of a picture, and feel that we are looking upon a scene as it must have happened. He drew correctly, and with an innate sense of grace. His colouring is pleasing, his costume simple and appropriate. Leslie was also a pleasant, intelligent, and kindly writer. He published, in 1845, 'The Memoirs of John Constable, R.A.,' and the substance of his own lectures in his 'Handbook for young Painters' in 1855. Some 'Autobiographical Recollections' of him, edited by Mr. Tom Taylor, were published in 1860, and his materials for a life of Reynolds, on which he was engaged, continued and concluded by the same writer, were published in 1865. A collection of 30 of his works was exhibited with the works of the old masters at the Royal Academy in 1870.

LE SUEUR, HUBERT, *modeller and sculptor*. Born in France. He studied under John of Bologna. Was a Huguenot refugee, and settled in England, where he was much employed by the Court and the nobility. He was living in St. Bartholomew's Close in 1630, when his son Isaac died, who was buried in the adjacent church of that name. The bronze statue of William, Earl of Pembroke, in the picture gallery at Oxford, is by him, as is also the fine statue of Charles I. at Charing Cross. The latter was cast in 1633, for the space in front of the church in Covent Garden, and was removed to Charing Cross in 1678. In Westminster Abbey, the figure of Sir George Villiers and the bust of Sir Thomas Richardson, dated 1635, are also by his hand. Many of his works, particularly these in bronze, have disappeared. He died in England about 1652.

269

LE STRANGE, HAMON, *amateur*. He was born at Hunstanton Hall, Norfolk, January 25, 1815, and was the representative of an old family in that county. He undertook to decorate with his own hand the nave of Ely Cathedral. As a labour of love he devoted himself for several years to this self-imposed task, and had painted on the vault some of the subjects of the 'History of Man,' but died suddenly in London, when in the prime of life, July 27, 1862. His work has been carried on in the same spirit by Mr. Gambier Parry.

LETHBRIDGE, W. S., *miniature painter*. He practised in London for many years, and was from 1801 to 1829 an exhibitor at the Royal Academy. Several popular actresses sat to him, some in character; and in 1817 he exhibited a miniature of Dr. Wolcot, which is now in the National Portrait Gallery.

LEVERTON, THOMAS, *architect*. He had a considerable practice in the last quarter of the 18th century, residing in the Metropolis, and building many villa residences in the adjoining counties. Between 1771 and 1803 he was a constant exhibitor of his designs at the Royal Academy. In 1783, when the improved construction of our prisons was under the consideration of the Government, he received a premium for his designs for penitentiary houses. Grocers' Hall may be mentioned as one of his chief works.

LEWIN, WILLIAM, *amateur*. He does not appear to have been professionally an artist, but in 1789 he published, drawn and engraved by himself, seven quarto volumes of the 'Birds of Great Britain,' exceedingly well delineated; followed, in 1795, by the 'Insects of Great Britain,' executed in the same manner.

* LEWIS, CHARLES, *still-life painter*. Was born at Gloucester in 1753, and was apprenticed to a Birmingham manufacturer, in whose employ he excelled in the decoration of japanned tea-boards. In 1776 he went to Dublin, where, on the failure of an engagement, he went upon the stage; but not succeeding, again tried the arts. In 1781 he visited Holland, and from thence came to London, where he practised for a time, painting fruit and birds, which were well finished and grouped. He was then invited by a kind patron to Scotland, and died in Edinburgh, July 12, 1795.

LEWIS, GEORGE ROBERT, *portrait painter*. Born in London, March 27, 1782, he entered the schools of the Royal Academy, where he studied under Fuseli. In his early days he was an ardent and patient student of the figure, as well as of outdoor nature. In 1818 he accompanied the Rev. Dr. Frognall Dibdin on his 'Bibliographical and Picturesque Tour through France and Germany,' for which work he made all the

270

illustrations, combining in them a very wide range of subject, which subsequently gained him the eulogium of all connoisseurs. He also executed some of the illustrations to Dr. Dibdin's 'Decameron,' and was the author of a series of 'Groups of the people of France and Germany.' He was, commencing in 1820, an exhibitor of portraits at the Academy, and had some distinguished sitters, and sent also, occasionally, a subject picture. Among the latter were some connected with his tour—in 1820, 'Pilgrimage to the Monastery' and a 'View in the Temple Gardens;' in 1825, 'Baby with Playthings;' in 1845, 'Austrian Pilgrims, Tyrol;' in 1850, 'Boulevard des Italiens;' and his last works in 1854, 1856, and 1859, landscapes. He also published his work on the 'Muscles of the Human Frame,' the plates engraved by himself, after drawings made from his own dissections; 'Illustrations of Kilpeck Church, with an Essay on Ecclesiastical Design;' 'Shobden Church,' 'The Early Fonts of England,' 'British Forest Trees,' and some other works. He had resided the last six years of his life at his son's, at Hampstead, and died there, May 15, 1871, in his 90th year. His works are evidence of his varied powers and his great devotion to art.

LEWIS, FREDERICK CHRISTIAN, *engraver and draftsman*. Brother of the above. Born in London, March 14, 1779, he was apprenticed to Stadler, a German engraver, settled in London, and studied in the schools of the Royal Academy. He was first employed to make the engravings for Mr. Young Ottley's 'Italian School of Design,' and during the five years he was so employed he lived at Enfield, and sketched early and late from nature. Soon after Sir Thomas Lawrence engaged him to engrave, in the stipple manner, some of his chalk portrait drawings, and until the death of Sir Thomas in 1830, he was almost wholly employed on this work, for which he was especially fitted by the refinement and delicacy of his art. He had studied landscape, which he painted with great ability, and was a frequent exhibitor from 1815 to 1820 at the Water-Colour Society, and up to 1853 at the Royal Academy. He was also a contributor to the British Institution. His first exhibited works were his studies made in the neighbourhood of Enfield; his more matured works, scenes from the valleys and streams of Devon; while engaged on which he made the acquaintance, ending in friendship, with Mr. Calmady, of Langdon Hall; and on his introduction, Sir Thomas Lawrence painted his favourite portraits of 'The Calmady Children.' In 1821 he published, sketched and engraved by himself, 'Picturesque Scenery of the River Dart;' in 1823, 'Scenery of the Tamar and Tavey;' in

1827, his 'Scenery of the Exe.' Almost his last large work was from the drawings by Claude in the British Museum, comprising 100 plates. He held the appointment of engraver to the Princess Charlotte; to Leopold, King of the Belgians; to George IV., William IV., and Queen Victoria. He died at Enfield, December 18, 1856. Two of his sons are distinguished in art, one a member of the Royal Academy, the other eminent as an engraver.

LEWIS, WILLIAM. Brother of the above. He held some office in the Carpenters' Company, and from 1815 to 1838 was an exhibitor at the Royal Academy of landscapes and cottage scenes in oil and water-colours.

LEWIS, JOHN FREDERICK, R.A., *figure painter*. Was born in London, July 14, 1805, and was the eldest son of F. C. Lewis, the engraver, under whom he studied the elements of his art. His first efforts were devoted to animal painting, and he exhibited at the British Institution as early as 1820, and at the Royal Academy in 1821, 'Puppies, a study from Nature.' There is, in the Royal Collections, a portrait by him of 'Old Clark of the Sandpit gate,' in which deer are introduced, a very early work. In 1825 he published a collection of etchings. He early turned his attention to water-colours, and was elected an associate of the Society of Painters in Water-Colours in 1828. In pursuit of his art he visited Italy and Spain, where he remained nearly two years, returning in 1835. His visit produced a series of pictures painted in water-colours, in a large and bold manner, rich in colour, and varied in character, the picturesque costume of Spain contributing greatly to their attractions, and the incidents of the Civil War providing him with interesting subjects, such as 'A Christian Spy brought before Zama,' &c. In 1836 he published 'Sketches in Spain,' lithographed on stone, which was very successful. He again visited Italy in 1838, and painted a large picture of 'Easter Day in Rome,' exhibited in 1841. In 1843 he went to Cairo, and remained in the East until 1851, in which year he married and settled at Walton-on-Thames. While in Cairo he completed a picture of the 'Interior of a Harem,' a work of most elaborate and minute finish, great purity of colour, and careful and learned drawing. It was selected for exhibition at the first Paris International Exhibition in 1856. Numerous Eastern subjects followed, his manner being much changed from his earlier Spanish pictures, much more minute in detail, and brighter in colour. He became President of the Society of Painters in Water-Colours in 1857, and was also elected an honorary member of the Scottish Academy. He recommenced painting in oil

about 1854, and in 1858 was elected an associate of the Royal Academy, and a full member in 1865. His failing health caused him to withdraw on to the retired list in the Spring of 1876, but he did not long enjoy repose, he died at Walton, August 15, 1876.

LEWIS, F. C., brother of the above, resided in India for many years, and painted the large pictures of the Durbars, Nautches, &c., held there, and which were engraved by his brother, Charles C. Lewis.

LEYLAND, JOSEPH BENTLEY, *sculptor*. He was the son of a well-known naturalist at Halifax, where he was born March 31, 1811. He showed a talent for modelling, and exhibited at Manchester a greyhound and a colossal statue of 'Spartacus.' In 1843 he sent to London for exhibition a colossal head of 'Satan;' and soon after came to reside in the Metropolis, and studied under B. R. Haydon. He next produced the 'Sinless Maiden' from Hogg's 'Queen's Wake,' which was purchased by the Literary Society of Halifax. His latest works were a statue of Dr. Beckwith, of York, and an 'Anglo-Saxon Chief.' He does not appear to have been an exhibitor at the Royal Academy; but in 1834, and again in 1839, he sent a group of hounds, modelled from life, to the Suffolk Street Galleries. He died at Halifax in his 40th year, January 26, 1851.

LIART, MATTHEW, *engraver*. Was born about 1736, in Compton Street, London (not, as is usually said, in Paris). He was of French extraction, but both his grandfather and his father were shopkeepers in Soho. In 1764 he received a premium from the Society of Arts. He was the pupil of Ravenet, and a student in the schools of the Society of Artists and of the Royal Academy, gaining the silver medal in the life school of the latter. He engraved after the old masters, but his two best works are the 'Venus and Adonis' and 'Cephalus and Procris,' after West. He died about the year 1782, and was buried at Paddington.

LIGHTFOOT, WILLIAM, *engraver and draftsman*. Practised in the latter half of the 17th century. He was a good perspective draftsman, and painted some landscapes in oil. Wren employed him in the decorations for the Royal Exchange. He also engraved some plates; and Evelyn, in his 'Sculptura,' speaks of his special talent for this art. He died 1671.

LILLY, HENRY, *limner*. In James I.'s reign he was rouge dragon and pursuivant of the College of Arms, and possessed great skill in limning and illuminating. He completed a fine genealogy of the Howard family, enriched with portraits, armorial bearings, and tasteful compositions. Died 1638.

271

LILLY, E., *portrait painter.* There is by him at Blenheim a large full-length portrait of Queen Anne. It is an indifferent work, weak in drawing and expression, cold and grey in colour. It is dated 1703.

LINCOLN, ANNA MARIA, Countess of, *amateur.* Daughter of the Earl of Harrington, married the Earl of Lincoln, afterwards Duke of Newcastle. She painted about 1780, and C. White engraved after her, in the dot manner, a plate representing two females placing a wreath on the bust of Diana. She died in 1807.

LINDSAY, THOMAS, *water-colour painter.* He was from 1837 till his death a member of the new Water-Colour Society. His pictures were chiefly of Welsh scenery, feeble in colour, and, though pleasing, not of a high character. He resided from about 1848 at Hay, near Brecon, and died there January 23, 1861.

LINES, SAMUEL, *landscape painter and designer.* Was born near Coventry, February 28, 1778, and was brought up on his uncle's farm. When 14 years of age he showed a taste for art, which led to his being placed, in 1794, with a clock dial enameller at Birmingham, and on the completion of his apprenticeship he found employment there as a designer for the manufacturers; and in 1809 established a life Academy, in which several young men, afterwards known in art, were students, and during forty years he was always active in promoting the interests and advancement of art in Birmingham, where he died November 22, 1863.

LINES, SAMUEL RESTELL, *landscape painter.* Third son of the above, was born at Birmingham, January 15, 1804, and studied under his father. He attained great skill in sketching, particularly trees, and in 1828 he was engaged to assist in a series of lithographic drawing-books. In 1831 he undertook to bring out a work exclusively on trees. He drew well in water-colours, and some of the old wood-timbered houses at Coventry and in the Midland counties are memorials of his ability. He died prematurely at Birmingham, November 9, 1833. He was one of the founders of the Birmingham School of Art.

LINNEL, ——, *wood carver.* Was a member of the St. Martin's Lane Academy. He practised about the middle of the 18th century, and excelled in his art.

LINTON, J., *portrait painter.* Practised in the reign of William III. Several of his portraits are engraved; among them one of Sir William Ashurst, lord mayor in 1694.

• LINTON, WILLIAM, *landscape painter.* Was born in Liverpool in 1788, and was articled to a merchant in that city, but feeling little inclination for mercantile pur-

suits, he turned to the study of art, and after a tour in Wales, repaired to London in pursuit of it. In 1821 he exhibited at the British Institution 'The Morning after a Storm,' which obtained him several commissions. In visiting the Continent he returned with a store of sketches suited to the style of classic landscape, which he adopted. At that period, the realistic school, painting directly from nature, had not arisen, and the painters of the day produced as a rule, compositions founded upon sketches made on the spot. He took part with the Society of British Artists, and for years exhibited there, and only occasionally at the Royal Academy. He was a competitor in the Westminster Hall competition. In 1842 he made an exhibition of his sketches in Sicily, Colchis, and Greece, at the gallery of the Society of Painters in Water-Colours. In 1858 he published a pamphlet on painters' pigments, and an illustrated work, entitled 'The Scenery of Greece and the Islands.' He died September 18, 1876, in his 88th year.

LINWOOD, Miss MARY, *ornamentist in needlework.* She was born at Birmingham in 1755, and early in life removed to Leicester. She opened an exhibition of her work in worsted at the Hanover Square Rooms in 1798, which she removed to Leicester Square, and afterwards to Edinburgh, Dublin, and the chief provincial towns. Her collection comprised above 100 works from originals by the great masters. She enjoyed a great reputation and popularity in her lifetime, and died in her 90th year, March 2, 1845. Her collection, sold by auction, fetched only a trifling sum.

• LIOTARD, JOHN STEPHEN, *miniature painter.* Born at Geneva in 1702. Was intended for a merchant, but had a desire for art, and when in Paris in 1725 he found the means of study, and drew portraits in chalk and in miniature. In 1738 he accompanied the Neapolitan ambassador to Rome, and while there was induced by two English noblemen to visit Constantinople with them. He adopted the Eastern dress, grew a long beard, and was called 'the Turk.' After a stay of four years, he travelled by Jassy to Vienna, where Maria Theresa and the imperial family sat to him. He then went to Paris, and from that city came to London with powerful introductions, and painted the Princess of Wales and her sons. About 1756 he went to Holland, where he married; and in 1772 he came again to London, bringing with him a collection of pictures, which he sold by auction. He exhibited at the Royal Academy crayon portraits in 1773 and in the following year. He returned to Switzerland in 1776, and is said to have died about 1790. He painted miniatures well, both in water-colour and

Linnell painter ? 1820

enamel, but his best works are in crayons. His likenesses are exact and literal, yet very stiff and graceless in manner; his miniatures laboriously finished, the colour good. He met with great encouragement in England, and was for a time deemed no mean rival of Reynolds, a proof of the false taste of the day. He etched his own portrait and some others. He taught drawing in many families of rank. He was the convivial associate of our artists, and his name repeatedly occurs in connection with the art of this country. His brother, JOHN MICHAEL LIOTARD, practised as an engraver in Paris and in Venice.

LISTER, MARTIN, M.D., amateur. Born at Radcliffe, Bucks, about 1638, he originally practised at York, but removed to London in 1683. He became physician to Queen Anne, and was a learned naturalist. He published, among other scientific works, a 'Historia Conchyliorum,' the drawings for which were made by himself, and, with the assistance of his daughters, engraved also. He died February 2, 1711.

LISTER, ANNA, } amateurs. Two LISTER, SUSANNA, } sisters, daughters of the above, whose etchings are not without merit. Some of their etchings are published in his 'Historia Conchyliorum,' 1688.

LITTLE, THOMAS, architect. Born in February 1802. Was the pupil of Robert Abrahams. He exhibited at the Royal Academy in 1832, and again in 1840, after which he continued an occasional exhibitor, his designs being chiefly residential. In 1844 he was successful in a competition for the chapels at the Nunhead Cemetery, which he erected, and was then employed upon several churches. He built All Saints', St. John's Wood, 1845; St. Mark's, Regent's Park, 1852; St. Saviour's, Paddington; Fairlight, near Hastings; also the parochial schools of St. Marylebone and Bishop Duppa's Almshouses, Richmond. He died December 20, 1859.

* LIVERSEEGE, HENRY, subject painter. Was born in 1803, at Manchester, where his father held some employment in a cotton mill. He was fond of drawing as a child, and early employed himself in painting portraits for a very small remuneration. He then tried some compositions, which showed a feeling for romance and poetry, and exhibited at Manchester, in 1827, three small pictures of Banditti, which gained him notice. He came about the end of the same year to London, and in 1828 exhibited at the Academy 'Wildrake presenting Col. Everard's Challenge to Charles II.' Making rapid progress, he exhibited, in 1830, his 'Black Dwarf,' from Sir Walter Scott's romance. His practice was to come to London occasionally for three or four months, when he studied at the British Museum and the British Institu-

tion. He exhibited the 'Grave Diggers,' from 'Hamlet;' 'Catherine Seyton,' 'Hamlet and his Mother,' with other compositions. He also exhibited occasionally at Manchester, and painted several subject pictures in water-colours. He was of a weakly constitution from an organic defect in the chest, always ailing, despondent in temperament, and died suddenly at Manchester, January 13, 1832. His style was dramatic, his colouring brilliant and powerful, but his works wanted refinement and beauty. He had no conception of landscape. His works, 'Recollections of Liverseege,' were published in mezzo-tint, in 12 parts, 1832-35.

LIVESAY, RICHARD, portrait painter and engraver. He practised in London towards the latter part of the 18th century, and about 1781 lodged some time with Hogarth's widow in Leicester Fields. He was a pupil of President West, who employed him in copying some pictures at Windsor Castle, and subsequently in assisting on his own works. This induced him to remove to Windsor, where he settled and was residing in 1790. He was appointed to teach George III.'s family drawing, and many of the Eton boys sat to him for their portraits. There is by him a group of 'Eton Boys going to Montem,' containing many portraits, and also a group of George III. with his Queen and family, to whom the Duchess of Gloucester is being introduced; and his portrait of the Earl of Charlemont, not a good specimen of his art, is in the National Portrait Gallery. His portraits, some of them whole-lengths, are usually of small size, and he also painted some miniatures in oil and some domestic scenes. He was appointed drawing-master to the Royal Naval College at Portsmouth, and removed to Portsea in 1796. He exhibited at the Academy in 1802, and about this time painted the six prize ships taken by Admiral Lord Howe from the French, with some other marine subjects. He died at Southsea about 1823. There are several portraits by him, engraved by himself, and 16 plates after Hogarth.

LIZARS, WILLIAM HOME, engraver and subject painter. He was born in 1788, in Edinburgh, where his father, Daniel Lizars, was well known as an engraver and copperplate printer. Brought up under him he also studied from 1802 to 1805 in the Trustees' Academy, was industrious and soon showed marks of talent. He engraved, about 1807, 'The Escape of Queen Mary from Lochleven Castle,' and soon after painted some portraits and subject pictures, 'Reading the Will' and 'A Scotch Wedding,' exhibited at the Royal Academy in 1812, where they gained favourable notice, and were engraved. The loss of his father at this time, left a widow and large family dependent upon the business, and he

sacrificed his higher hopes in art to carry it on. He died in Edinburgh, March 30, 1859.

LLOYD, Mrs. MARY, R.A., *flower painter.* See MOSER, MARY, R.A.

LOAT, SAMUEL, *architect.* Was a student at the Royal Academy, and in 1827 gained the gold medal for his design for a National Gallery. He was awarded the travelling studentship, and went to Rome in the following year; returning in 1832, he exhibited that year a design for an Italian palace, after which there are no traces of his art.

LOCHNER, W. C., *architect.* He studied in the Royal Academy Schools, and first exhibited some designs at the Academy in 1803 and 1804, and in 1805 gained the gold medal for his 'Design for a Villa.' In 1808 he exhibited a design for a 'Triumphal Building;' and in 1810, in conjunction with J. H. Good, he was awarded the first premium for his design for Bethlehem Hospital, in St. George's Fields, which he exhibited in that year, his last contribution to the Royal Academy.

LOCKE, WILLIAM (of Norbury Park), *amateur.* He was distinguished as a collector and the associate of artists. He was at Rome in 1760, and brought to this country the 'Discobulus,' 'Alcibiades's Dog,' and the 'St. Ursula,' by Claude, now in the National Gallery. He died October 5, 1810, aged 78.

LOCKE, WILLIAM (of Norbury Park), *amateur.* Son of the foregoing, educated at the Rev. W. Gilpin's school at Cheam. He painted several allegorical subjects. He is best known by a 'Death of Wolsey,' which is engraved. Madame d'Arblay records in her Diary — 'Mr. W. Locke, ma'am,' said Mrs. Delany (addressing the Queen), 'I understand is now making the same wonderful progress in painting that he has done before in drawing.' 'I have seen some of his drawings,' said the Queen, 'which were charming.' This was in 1785, when he was 18 years old. There is by him a good allegorical design, the nude figures well drawn, engraved by Legatt, as a frontispiece to Webb's 'Memorials,' 1802. Fuseli, R.A., inscribed to him his 'Lectures on Painting.' Captain LOCKE, of the same family, an amateur of much talent, was drowned on the Lake of Como, April 15, 1832, aged 28.

LOCKEY, ROWLAND, *portrait painter.* He practised at the end of the 16th century. He was a pupil of Hilliard, 'was skilful in limning, and in oil-works and perspectives,' and is reputed (see Nichols's 'History of Leicestershire)' to have painted in one table, 'portraits of Sir John More, a judge of the Court of King's Bench, *temp.* Henry VIII., and of his wife, and of Sir Thomas More, lord chancellor, his son and his wife, and of all the lineal heirs male descended from them, together with each man's wife, unto that present year living,' a description which appears to resemble the well-known group generally attributed to Holbein.

LOCKIE, NICHOLAS, *portrait painter.* Practised in the reign of Queen Elizabeth. A portrait by him of King, bishop of London, who died in 1621, is engraved by Simon Passe.

LOCKLEY, DAVID, *engraver.* Practised early in the 18th century, but did not attain any excellence. There is a large plate by him of the new church in the Strand. He also engraved portraits.

LODGE, JOHN, *engraver.* Practised in the last half of the 18th century, and both drew and engraved with some spirit, but in a slight, unfinished manner. He died April 4, 1796.

LODGE, WILLIAM, *amateur.* Was born at Leeds, July 4, 1649, the son of a merchant, from whom he inherited an estate of 300*l.* a year. He was educated at Jesus College, Cambridge, and was afterwards a law student at Lincoln's Inn. He accompanied Lord Bellasis on his embassy to Venice, and translated there Barri's 'Viaggio Pittoresco,' published in 1679, with portraits etched by himself. He also etched several drawings of views which he had made in his travels, and some views of London, York, and other places. On his return to England he etched some portraits, and also assisted Dr. Lister in drawings of natural history, which were presented to the Royal Society, among them 34 different species of spiders. He was the friend of Francis Place, with whom he made long sketching excursions. He died at Leeds, August 27, 1689. On carrying him to the grave, the hearse broke down near Harewood, and so he was buried in the church there.

LOGGAN, DAVID, *draftsman and engraver.* Was born at Dantzic about 1630. He had some instruction there from the younger De Passe, and afterwards in Holland, under Hondius. He came to England before the Restoration, and made himself known in London by his drawings. Later, he went to Oxford, where he matriculated as University engraver, and published in 1672, drawn and engraved by himself, 'Habitus Academicorum Oxoniæ a Doctore usque ad Servientem;' and in 1675, 'Oxonia Illustrata,' in 44 plates. This latter work the University granted him a license for selling for 15 years. He then went to Cambridge, where he stayed some time, drew the colleges, and published, in 1688, 'Cantabrigia Illustrata.' He appears to have had a little dealing in pictures. He drew portraits in black-lead with great delicacy and truth, and was the best portrait engraver of his time. He engraved the illustrations for Morrison's 'History of

Plants,' which was not published till 1715. An excellent portrait by him of Bishop Mew belongs to the see of Worcester—well painted, the finish and expression in the best manner. He married an English lady of good family, and left a son, who was fellow of Magdalen College, Oxford. He lived the latter part of his life in Leicester Fields, where he was settled in 1675, and let his lodgings to persons of quality. He died there in 1693. There is a half-length portrait in oil by him of Sheldon, archbishop of Canterbury, in the Earl of Home's collection.

LOMBART, PETER, *engraver*. Born in Paris 1612. A Huguenot refugee, he came to England some time before the Revolution, and found employment chiefly in book frontispieces. His 12 half-lengths after Vandyck, known as 'The Countesses,' are considered his best works. He engraved 'Charles I. on Horseback,' after Vandyck; afterwards he erased the face and substituted Cromwell's, and, as times changed, again inserted the King's. The latest known work by him is dated 1672. He returned to Paris, where he died.

LONG, J. ST. JOHN, *engraver*. He was born in Ireland and claimed a high descent, but was believed to have been the son of a poor basket-maker, named O'Driscoll. On the introduction of an Irish nobleman, he received some kind assistance from John Martin, who formed a poor opinion of his art abilities. He for a while assisted in the studio of W. Young Ottley, and though brought up as an engraver, he did not follow that profession. A mere sketcher, he tried painting, and in 1825 exhibited at Suffolk Street, 'Elijah comforted by an Angel,' 'The Temptation in the Wilderness,' and 'Abraham entertaining an Angel;' and in the following year, at the British Gallery, 'His Majesty's Entrance into Cowes Castle;' essays perhaps of some merit, which attracted notice. He soon after took up the profession of a chiropodist, and then professed to cure consumption, but a patient dying under his care, he was tried for manslaughter at the Old Bailey in February 1831, but was acquitted. Not depressed by this adventure, he continued to reside at his house in Harley Street and to keep his carriage. He died of the complaint he had professed to cure, July 2, 1834, aged 37. He had managed to save a property, surely not by his art, and he directed by his will that 1000l. should be expended upon his tomb. He is buried in Kensal Green Cemetery, where a handsome temple of Greek design, decorated with Esculapian emblems, covers his remains, and sets forth that it is intended to record the benefits derived from his 'remedial discovery.'

LONGMATE, BARAK, *engraver*. Born

in Westminster. He engraved some topographical drawings, but he was particularly distinguished as a heraldic engraver. He edited an edition, in eight volumes 8vo., of 'Collins's Peerage' in 1779, and the supplemental volume in 1784. Died July 23, 1793, in his 56th year. His son BARAK LONGMATE succeeded him in his profession, and died in 1836, aged 68.

LONSDALE, JAMES, *portrait painter*. Was born in Lancashire, May 16, 1777. Tried art there and then came early in life to London. He was received into Romney's house as his pupil, and entered the schools of the Academy. On the death of Opie, R.A., he purchased his house in Berners Street, and resided there the rest of his life. He was largely employed in portraiture, and had many distinguished sitters, chiefly gentlemen. He was appointed portrait painter in ordinary to the Duke of Sussex. He exhibited a fine picture of 'Talma as Hamlet,' at the Royal Academy in 1818, and painted for the Duke of Norfolk a large historical subject —'King John signing the Magna Charta.' He was one of the founders of the Society of British Artists, where he exhibited from 1824, with some intervals, to 1837. He died in Berners Street, January 17, 1839, aged 62. His art was bold and natural, his portraits made little attempt at flattery.

LOTEN, JOHN, *landscape painter*. Born in Switzerland (some writers say Holland), he came early in life to England in the reign of Charles II. Settled here, he studied landscape from nature with great success. He painted, frequently of a large size, cloudy effects, storms, and rocky subjects. His colouring was cold, and had a tendency to blackness; his light and shadow well mastered; his execution spirited, yet well finished. He died in London 1681.

LOUGH, JOHN GRAHAM, *sculptor*. Was born at Greenhead, near Hexham, in Northumberland, in 1806, and is said to have followed the plough in his youth. He was apprenticed to a stone-mason named Marshall, and subsequently worked at Newcastle. The captain of a collier befriended him and gave him a free passage up to London, where he at once devoted himself to the study of the Elgin Marbles, at the British Museum. Here amongst his fellow students it was understood that he had been a blacksmith. He first exhibited at the Royal Academy in 1826, when he sent a bas-relief of the 'Death of Turnus.' In the following year he contributed an ideal statue, 'Milo,' which procured him the notice of B. R. Haydon, and which, together with a companion statue, 'Samson,' was bought by the Duke of Wellington. In 1832 he exhibited 'Duncan's Horses,' and two years afterwards he went to Italy to study, and spent the time

between 1834-38 in Rome. There are ten full-length statues by him at Sir M. White Ridley's house in Carlton Terrace, portraying characters from Shakespeare. The statue of her Majesty, executed for the Royal Exchange in 1845, and that of the Prince Consort for Lloyds in 1847, together with the colossal statue of the Marquis of Hastings for Malta in 1848, are among his best known works. He also produced the monument to Southey in Keswick Church, and the statue of Dr. Broughton in Canterbury Cathedral, with many other portrait statues and busts. He received in the first instance the commission to execute the lions at the base of the Nelson Monument in Trafalgar Square. His works shew a broad manner and are large in style. He was much beloved in private life, and married a sister of Sir James Paget, the eminent surgeon. He died April 8, 1876.

LOUND, THOMAS, *amateur.* He was engaged in a large brewery at Norwich, but was devoted to art and excelled as a landscape painter both in oil and watercolours, painting with great freedom and power. From 1846 to 1855 he was a frequent contributor to the Academy Exhibitions, chiefly of works of oil, river and coast scenes. He died at Norwich, January 18, 1861, aged 58.

LOVELACE, FRANCIS, *amateur.* Held a commission as colonel in the army. He painted a portrait of his brother Richard Lovelace, the poet, who died 1658; a good head, which Hollar engraved in 1660, and is prefixed to the poet's 'Lucasta.'

LOVELL, PEREGRINE, *engraver.* Practised his art about the middle of the 17th century. There are some spirited heads etched by him in Della Bella's 'Drawing-book,' published in 1634; and some small engravings of Flemish soldiers are by his hand. He etched in Hollar's manner, and is said to have imitated him.

LOVER, SAMUEL, R.H.A., *miniature painter.* He was born February 24, 1797, at Dublin, where his father was a member of the Stock Exchange. He began art at an early age, and both sang and wrote songs professionally. He practised miniature painting in Dublin, and had some distinguished sitters; and in 1822 was elected a member of the Royal Hibernian Academy. In 1832 he first exhibited at the Academy in London, sending a miniature of Signor Paganini, and continued to contribute yearly up to 1843, when, tempted by the success of his 'Irish Evenings,' which had become a popular entertainment, he visited the United States, returning in 1848. At this time he appears to have devoted himself chiefly to literature, and only was an occasional exhibitor at the Academy. In 1851 he sent a 'Drawing on the Ohio;' in 1852, 'Rapids and Falls of the Niagara,'

276

followed by some paintings in oil; in 1858, 'The Thames at Chiswick;' in 1861, 'The Chesil Beach;' and in 1862, 'The Kerry Post on Valentine's Day.' But he will be best remembered by his writings—his novels 'Rory O'More,' 1841, and 'Handy Andy,' 1842, both illustrated by designs etched by himself; and his tender and graceful songs, 'The Angel's Whisper,' the 'Four-leaved Shamrock,' 'Molly Carew,' and some others. He was granted a pension of 100*l.* a year on the Civil list, and during the last four years of his life resided at Jersey, where he died July 9, 1868. He was buried in Kensal Green Cemetery. In addition to the above works and some ballad poetry, he published 'Legends and Tales of Irish Character,' 1832; 'Irish Sketches,' 1837; 'Treasure Trove,' 1844; 'Lyrics of Ireland,' 1858. His life by Bayle Bernard was published in 1874.

LOW, WILLIAM, *portrait painter.* Practised in Edinburgh about the middle of the 18th century.

LOWE, MAURITIUS, *history painter.* He was reputed a natural son of Lord Sunderland, from whom he had a small annuity, and was a student of the Royal Academy and a pupil of Cipriani, R.A. He exhibited miniatures at the Spring Gardens' Rooms in 1776 and 1779, and in the latter year a 'Venus' also. He gained the first gold medal awarded by the Academy for his historical painting, 'Time discovering Truth,' and was elected to receive the Academy travelling pension for three years. He went to Rome, but was indolent and spent his time in dissipation, and not sending home a picture to the Academy, as required by their laws, forfeited his pension in the second year. He exhibited historical works at the Academy, and in 1783 sent his 'Deluge,' 'There were Giants on the Earth in those Days,' a large picture, which was rejected, and subsequently admitted at the solicitation of Dr. Johnson, and placed alone in the Antique Academy. The Doctor said of the picture, 'It is both noble and probable.' Northcote, 'that the manner of painting was execrable,' and that the painter 'was too idle and inattentive to attain any excellence.' The picture was in 1835 in the hall of Sutton Place, near Guildford. His best work was a drawing, exhibited 1777, of 'Homer singing his Iliad to the Greeks.' He married a servant girl, by whom he had a large family. Dr. Johnson stood godfather to one of his children, befriended him, and left him a small legacy. Some of his conversations are recorded by Boswell; but Fanny Burney, in her diary, tells most about him: 'There is a certain poor wretch of a villainous painter, one Mr. Lowe, who is in some measure under Dr.

Southebourgh - P. James de 6 at Strasbourg beteen 1720-41
died in Chiswick 1812
Lovatt - painter ? 1030

Johnson's protection, and whom therefore he recommends to all persons he thinks can afford to sit for their pictures.' Among these he made Mr. Seward, and then applied to Mr. Crutchley, who was also obliged to go to the painter's. He says, 'I found him in such a condition! A room all dirt and filth, brats squalling and wrangling, up two pair of stairs, and a closet of which the door was open, that Seward well said was Pandora's box. It was the repository of all the nastiness and stench and filth and food and drink, and —— Oh! it was too bad to be borne! And "Oh!" says I to Mr. Lowe, "I beg your pardon for running away, but I have just recollected another engagement;" so I poked three guineas in his hand and told him I would come again another day, and ran away with all my might.' He was living, in 1778, in Hedge Lane, now Whitcombe Street, and died in an obscure lodging in Westminster, September 1793. He was the reputed writer of the 'Ear-Wig,' an abusive art periodical, published in 1787.

LOWRY, STRICKLAND, *portrait painter.* Was born at Whitehaven, and about 1768 went to Ireland, where he practised and then returned to his native town, where he lived by painting portraits. He also practised in various parts of Shropshire, Staffordshire, and Worcestershire. He had some local repute, and his portraits were simple and broadly treated. There are 13 views of churches engraved by him for a 'History of Shrewsbury,' published 1779.

LOWRY, WILSON, *engraver.* Born January 24, 1762, at Whitehaven. Son of the above, when a child was taken by his parents to Ireland, and some years later returned with them. While yet a boy he removed to Worcester, found some employment as a house painter, and commenced engraving. When 17 he came to London, and was admitted to the schools of the Royal Academy. Persevering, but poor, he worked hard. His early plates do not bear his name. He engraved most of the machinery for the illustrations to Rees's 'Encyclopædia,' Crabbe's 'Technological Dictionary,' and the 'Philosophical Magazine.' His art was purely mechanical, but his great scientific attainments eminently fitted him for this class of work. He was a good mathematical draftsman, had a knowledge of anatomy, surgery, mineralogy, and geology, and was learned in the qualities and values of precious stones. About 1790 he invented his celebrated ruling machine, and etched with the diamond and other hard stones, instead of the steel point, which gave an unexampled beauty to his ruling. Some of his best specimens as an architectural engraver will be found in the illustrations of Murphy's 'Batalha,' Nicholson's 'Architecture,' and Gandon's

'Designs for the Dublin House of Commons.' He died in London, June 22, 1824, after a lingering illness, during which he was assisted by the Artists' Fund. His son, JOSEPH LOWRY, was brought up to his profession.

LOWRY, ROBERT, *engraver.* See LAURIE, ROBERT.

LUARD, JOHN DALBIAC, *subject painter.* Was born in Lincolnshire in 1830, the son of an officer in the army, and was educated at the Royal Military School, Sandhurst. He obtained a commission in the 82nd Foot, and served five years in the regiment. Then led by a love of art, he left the army to study painting as a profession, was for a time a pupil of Phillip, R.A., and exhibited his first picture at the Academy in 1855. Later in the same year he joined his brother, who was serving in the Crimea, returning to England in February 1856. In 1857 he exhibited a Crimean subject, 'The Welcome Arrival;' the following year, 'Nearing Home' and 'The Girl I left behind Me;' and in 1859 commenced another work, but his health failed. He tried a voyage to America and back, which had only a temporary effect, and retiring to the house of a relative near Salisbury, died there in August 1860, leaving much promise of a reputation in art.

LUCAN, MARGARET, Countess of, *amateur.* Was well known as a clever copyist of the early miniature painters— Hoskins, the Olivers, and Samuel Cooper. She also painted some good original miniatures, low in colour, with landscape backgrounds well introduced. She undertook the illustration of Shakespeare's historical plays by means of portraits, tombs, landscapes, heraldic devices, flowers, birds, and insects. This work, in five vols., which occupied her 16 years, is preserved in the library at Althorp. She died in 1815, aged 66. Walpole, who flattered her, is thus addressed by Peter Pindar:

'Do not to Lady Lucan pay such court,
 Her wisdom will not surely thank thee
 for't;
Ah! don't endeavour thus to dupe her,
By swearing that she equals Cooper.'

LUCAS, JOHN, *portrait painter.* Born in London, July 4, 1807. He was a pupil of S. W. Reynolds and began life as a mezzo-tint engraver; but he early turned to the practice of painting, and met with encouragement as a portrait painter. In 1828 he first exhibited at the Royal Academy, and from that time was a constant contributor. Several ladies of distinction were among his sitters, also the Prince Consort and the Duke of Wellington. About sixty of his portraits have been engraved. He died at St. John's Wood, April 30, 1874. His pictures and sketches

277

were sold at Christie's the following February.

LUCY, C., *portrait painter*. Was born in London in 1692. He commenced the study of art when 13 years of age. Was for eight years the pupil of Cignani, and studied at Rome and Bologna. His portraits are graceful and well drawn. Dr. Pepusch and Farinelli, by him, are engraved by Van Hacken.

LUCY, CHARLES, *historical painter*. He was born at Hereford, and was apprenticed to his uncle, a chemist there; but he turned to art, and became a student in the École des Beaux Arts at Paris. He exhibited a portrait at the Royal Academy in 1838, and was then living at Hereford; followed, in 1840, by the 'Interview between Milton and Galileo,' and from that time he devoted himself purely to historical art. In 1844 he exhibited 'The Good Samaritan' with 'Burns and his Mary;' and for the Westminster Hall competition he commenced a series of large historical works, which first made him known, exhibiting there, in 1844, 'Agrippina interceding for the Family of Caractacus,' for which a premium of 100*l.* was awarded to him; in 1845, 'Religion supported by Faith, Hope, and Charity;' and in 1847, 'The Departure of the Pilgrim Fathers.' In 1848 he exhibited at the Royal Academy 'The Landing of the Pilgrim Fathers in America;' in 1849, 'Mrs. Claypole's Death-bed at Hampton Court;' in 1850, 'The Parting of Charles I. and his Children;' in 1852, 'The Parting of Lord and Lady Russell in 1683;' and continued an exhibitor of subjects chiefly connected with the history of his country up to the year of his death. He had for many years taught in a drawing-school established in Camden Town, and had visited France in 1858-60, and again in 1862. His health had long been failing. Devoted to the highest branch of art, his works, important by their subject and the scale on which he painted, failed to gain the attention they merited, yet many of them have been engraved—'The Pilgrim Fathers,' 'The Death of Mrs. Claypole,' 'Shakespeare before Sir Thomas Lucy,' 'Nelson in the Cabin of the Victory.' He died at Notting Hill, May 19, 1873, aged 59.

LUMLEY, GEORGE, *amateur*. Was a solicitor settled at York, where he was born. He was a friend of Francis Place, and produced in mezzo-tint several portraits towards the middle of the 18th century. He died at York, October 12, 1768, aged 60.

LUNDGREN, EGRON, *water-colour painter*. Received his art education in Paris, where he resided about four years, but he was a Swede by birth. He lived

also four years in Italy and five in Spain, and he travelled in Egypt and in the East. His first introduction to England was due to J. Phillip, R.A., whom he met at Seville in 1851. He came to London in 1853, and was in 1864 elected an associate of the Society of Painters in Water-Colours, and a year or two later, a full member. He was a frequent and successful exhibitor, and his works were noted for their rich colour and full tones. A specially fine one is 'Dominican Friars in the Library of Seville.' In 1874 he exhibited 'Lent in Spain,' 'Dolores,' 'No cares,' and other works. Among his numerous pictures are several executed for the Queen which have not been exhibited. The sketches he made in India by command of Lord Clive were sold at Christie's in 1875. The King of Sweden made him a knight of the order of Gustavus Vasa in 1861. Two books by him were published at Stockholm, 'Letters from Spain' and 'Letters from India.' He was a good linguist and an accomplished man. He died at Stockholm, December 16, 1875, in the 60th year of his age.

LUNY, THOMAS, *marine painter*. Practised in London in the second half of the 18th century, and for some time lived in Ratcliffe Highway. He first exhibited at Spring Gardens in 1777-78, and at the Academy in 1780, continuing to exhibit naval actions, coast scenes, and views of the dockyards, up to 1793; after which he only exhibited again in 1802, when, stirred by the battle of the Nile, he exhibited a painting of that victory. Four pictures by him of the 'Essex,' East Indiaman, on her stormy passage to Bombay, are engraved in aqua-tint. His 'Burning the Spanish Batteries before Gibraltar' and 'Admiral Rodney's Action' are also engraved. He died at Teignmouth, September 30, 1837, aged 79. At the Foundling Hospital there is a painting by him of 'Vessels attacking Land Batteries,' which is carefully painted and truthful, but without any attempt at effect. In 1863, 17 paintings by him were sold at Christie's—sea-pieces and coast scenes, with 'Lord Exmouth's Bombardment of Algiers,' and a companion picture, 'The British Fleet leaving Algiers.'

LUPTON, THOMAS GOFF, *engraver*. He was the son of a working goldsmith in Clerkenwell, and was born in 1791. He became the pupil of G. Clint in 1805, and on the completion of his articles he was able to establish himself in his profession. He produced some good plates after Sir T. Lawrence and the most esteemed portrait painters of his day. In 1822 he received the gold Isis medal of the Society of Arts for his application of soft steel to the process of mezzo-tint engraving. He was

successful in establishing the use of steel, and worked both in that metal and copper. Among his more notable works are the 'Infant Samuel,' after Sir J. Reynolds; 'Belshazzar's Feast,' after John Martin; with many fine plates after Turner, R.A.; 'Newcastle-on-Tyne,' 'Warkworth Castle,' and 'Dartmouth,' for the 'Rivers of England.' He re-engraved a selection of 15 plates for the 'Liber Studiorum,' 1858. He died May 18, 1873.

LUTTEREL, HENRY, *engraver and painter.* Was born at Dublin about 1650, and came early in life to London. He studied the law at New Inn, but the love of art tempted him to change his profession. He became the pupil of Ashfield, and applied himself to portraiture in crayons, in which he excelled. He designed a series of heads for Kennet's 'History of England,' which were engraved by Vanderbank. On the invention of mezzo-tint, he took up the new art, and joining Isaac Becket, they were the earliest English engravers in that manner. But Becket soon left him, and he brought out a print which had a large sale, and forming an acquaintance with Vansomer, by his help soon mastered the whole process. He tried a method of laying the ground with a roller, and discovered a means of drawing crayon portraits on copper. He finished many heads, and assisted Becket, his former colleague, in giving better completeness to his work. He died about 1710.

LYNCH, GERMAN, *die engraver.* Was master of the Mint in Ireland and graver of the puncheons 39th Henry VI.

LYNE, RICHARD, *engraver.* Was eminent in his day as a painter, and was also a good engraver. He was engaged by Archbishop Parker, about 1570, as one of his engravers at Lambeth Palace.

LYNN, SAMUEL FERRES, A.R.H.A., *sculptor.* Was born at Belfast in 1836. He at first studied architecture under his brother, Mr. W. H. Lynn, but having determined upon becoming a sculptor, he came to England and entered the schools of the Royal Academy, where he obtained a silver medal for the best study from the life in 1857, and in 1859 the gold medal.

He first exhibited at the Royal Academy 'The Peri's Daughter' in 1856 ; in 1857 he sent 'The Silent Thought;' in 1859, 'Psyche;' and in 1860, 'Achilles and Lycaon.' While a constant contributor to the Royal Academy exhibitions, he was also much employed on ornamental sculpture for public buildings in Dublin. Between 1863–66 he assisted the late J. Foley, R.A., in his studio. His last work at the Royal Academy was 'Lord Lurgan's Master McGrath,' exhibited in 1875. His latter habits were intemperate, and he died suddenly, at Belfast, April 20, 1776.

LYSARDE, NICHOLAS, *history painter.* He had been in the service of Henry VIII. and Edward VI., and was appointed serjeant-painter 2nd and 3rd Philip and Mary, and afterwards to Queen Elizabeth. He was a painter of historical subjects, and as the custom then was, presented a picture to the Queen on her birthday. He died in 1570, and was buried at St. Martin's on April 5.

LYSONS, The Rev. DANIEL, *amateur.* He was born in 1760. He drew and etched many of the illustrations for his 'Environs of London,' published 1792–96, and for his 'Magna Britannica.' He died January 3, 1834.

LYSONS, SAMUEL, *amateur.* Brother of the above. He was born at Rodmarton in Gloucestershire in 1763, studied at the Middle Temple, and was called to the Bar. Between 1785 and 1796 he was an occasional exhibitor at the Royal Academy of views of old buildings. He etched the plates for his 'Account of the Roman Ruins discovered at Woodchester,' 1797, and for his 'Reliquiæ Britannica Romanæ,' 1813. He assisted his brother on the 'Magna Britannica.' He was distinguished as an antiquarian, and was appointed keeper of the records in the Tower of London. His studies were principally directed to the Roman antiquities in Britain. He died June 29, 1819.

LYTTELTON, Lady, *amateur.* Second wife to the third Lord Lyttelton. She both painted and drew in crayons the portraits of her friends, and between 1774–80 was an honorary exhibitor at the Spring Gardens' Rooms and the Royal Academy.

Lynch J. H. Lithographer

M

McALISTER, GEORGE, *glass painter.* Was born in Dublin 1786, and brought up as a jeweller, but devoted himself to study and experiment in glass painting, and at the age of 21 his great ability in this art was recognised by the diploma of the Dublin Society. He finished a fine window for the cathedral at Lismore, and had commenced another of larger dimensions for Tuam, but anxiety and the heat of the furnace at which he worked produced inflammation of the brain, of which he died, June 14, 1812, in his 26th year. This last work was completed from his designs by his three

sisters, to whom he had communicated his processes.

McARDELL, JAMES, *mezzo-tint engraver*. Was born about 1710, in Dublin, and apprenticed in that city to John Brooks. At the age of 17 he came with his master to London. He attained great excellence in his art, and has left numerous fine works from his hand. His portraits are admirable for expression, accuracy, and force. He engraved many after Reynolds, with whom he was a great favourite; also after Hogarth, Hudson, Zoffany, and Cotes, R.A. Reynolds, whose fame has been so widely spread by his works, is said to have exclaimed that he should be immortalised by him. His historical works, after Rubens, Vandyck, Rembrandt, Murillo, and others of the great masters, are admirable. He was also a publisher, a jolly companion at the artists' clubs, and well known in the green-room; a sworn brother of Quin, whom he painted in the character of Falstaff, and engraved after his own painting. He died in London, June 2, 1765, and was buried at Hampstead.

* McCULLOCH, HORATIO, R.S.A., *landscape painter*. Was born in November 1806, at Glasgow, where his father was a weaver. He managed to gain a good education, and was instructed in art by a painter settled in his native city, in the neighbourhood of which he painted for some time. When in his 20th year he was first an exhibitor, and continuing the successful practice of his landscape studies, he was in 1834 elected an associate, and in 1838 a member, of the Scottish Academy, where he was a constant exhibitor. He only appears to have exhibited at the Royal Academy in London, where his art was too little known, in the year 1844, when he contributed two of his native landscape scenes. He devoted his art to the fine scenery of his own country, and painted with great brilliancy, freshness, and truth its characteristic lochs, forests, and mountainous wilds, with their mists and poetic effects of light and shadow, spring and autumn. For the last 20 years of his life he resided in Edinburgh, and died there June 24, 1867.

MACDONALD, LAWRENCE, *sculptor*. Was born in Perth in 1799, and went to Rome in 1822. He was with Gibson, Eastlake, Penry-Williams, Severn, Bonomi, etc., one of the founders of the British Academy of Arts in Rome in 1823, and was a trustee of the Institution at the time of his death. He devoted his time principally to portrait busts, and during the fifty years that he was in Rome produced a very large number of works. He contributed a very fine statue, 'Ulysses and his Dog,' to the Paris Exhibition of 1855, which is now the property of Lord Kilmorey. He first exhibited at the Royal Academy, in 1828, a marble bust

of 'Sir David Baird,' and from that time till 1855, when he contributed three busts, was a constant exhibitor. In 1835 he sent a marble statue of 'A Girl and Carrier Pigeon;' in 1837, 'Female Suppliant,' also a statue, besides portraits; in 1840, 'Lord Crewe;' in 1844, 'Marble Group;' in 1849, 'Eurydice;' in 1853, 'Lady Pakenham.' He died in Rome, March 4, 1878, in his 79th year.

McDOWELL, PATRICK, R.A., *sculptor*. He was born August 12, 1799, the son of a tradesman at Belfast, who died while he was an infant, leaving his family with very limited means. His schoolmaster had been an engraver, and encouraged his love for drawing. When about 12 years old, his mother came to England, and he was placed for two years under a schoolmaster in Hampshire. He was then apprenticed to a coachmaker in London, and his master becoming bankrupt at the end of four years, his indentures were cancelled. He found lodgings in the house of Peter Chenu, a well-known sculptor, and in his leisure hours strove to acquire a knowledge of the art, and was fortunate in selling some reduced copies which he made. He exhibited at the Royal Academy, in 1822, a posthumous bust, and in 1826 six busts and a model for a monument, and in the three following years was an exhibitor, sending in 1829 a 'Bacchus.'

He had thus, self-taught, found himself a profession, and in 1830 was admitted a student in the Academy Schools. He continued to get employment upon busts, but his first ideal work which gained notice was from Moore's 'Loves of the Angels,' and found a purchaser in a fellow townsman at Belfast. In 1837 his 'Statue of a Girl reading,' which was greatly admired, was also purchased by a gentleman who became a liberal patron, for whom, in 1840, he finished another work, 'Girl going to Bathe,' which he exhibited in that year; in the next year 'Prayer;' and in 1841 he gained his election as an associate of the Academy. In 1842 he exhibited 'Cupid' and his 'Girl going to Bathe' in marble. In 1844, 'Love Triumphant,' a marble group. In 1846 he completed a monumental statue of Viscount Exmouth for Greenwich Hospital, and was elected a full member of the Academy.

Continuing to exhibit a bust from time to time, he sent, in 1847, 'Early Sorrow,' a marble statue, and 'Virginius and his Daughter,' an important work, which he executed in marble in 1850. In 1849 he exhibited 'Cupid and Psyche' in bassorelievo, and an 'Eve;' in 1853, 'The Day Dream;' in 1856, a fine statue in bronze of the Earl of Belfast; and in 1858, a bronze figure of Viscount Fitzgibbon, for the city of Limerick. He executed also for the palace at Westminster some bronze statues

and a marble statue of William Pitt and of the Earl of Chatham. He continued to exhibit, but for the latter years chiefly busts, up to 1869, and, having completed his 'Europe' for the Albert Memorial, had just accepted the position of retired academician when he died in London, December 9, 1870. His works are carefully studied and masterly in execution, graceful in their form and composition, his female forms full of delicacy and beauty. His busts were simple in their design and truthful in their portraiture.

MACDUFF, ARCHIBALD, *amateur.* Born in England about 1750. There are by him some drawings, and plates produced by the union of etching and aqua-tint, but he is supposed to have worked only as an amateur. Of his etchings there are, after Barry, R.A., 'The Temptation of Adam,' 'Job and his Friends,' 'The Birth of Venus,' 'King Lear,' dated in 1776 and 1777, and a 'Holy Family,' after Raphael.

McIAN, ROBERT ROLAND, A.R.S.A., *subject painter.* Was born in Scotland in 1803, of an ancient Highland race. His early life was passed on the stage, and after having been for some years a member of the Bath and Bristol company, he appeared in London in 'Rob Roy,' and gained a reputation for his clever performance of the 'Dougal Creature.' But he was cultivating a love for the arts, and during his engagement at the English Opera House he was, in 1835 and 1837, an exhibitor at Suffolk Street; and in 1836 and 1838 at the Academy. In 1839 and 1840, when engaged at Drury Lane, he exhibited a 'Highland Cateran' and the 'Covenanter's Wedding.' About this time he retired from the stage to try his fortune in art, and painted, 1842, 'Harold the Dauntless;' 1843, 'Highlander defending a Pass,' 'The Battle of Culloden,' 'An Encounter in Upper Canada,' and other works, treated with great earnestness and vigour, and founded almost exclusively on incidents of Highland courage and character. He died at Hampstead, December 13, 1856, in his 54th year, and was buried in the cemetery at Highgate. His widow, an artist, was for many years mistress in the Government School of Design.

MACKENZIE, ALEXANDER MACDONAL, *architect.* Was for more than 30 years architect to the city of Perth, and designed and executed many churches, public buildings and mansions. He died near Perth, February 15, 1856.

MACKENZIE, FREDERICK, *water-colour painter.* Was a pupil of John A. Repton, and became distinguished by his careful drawings of our ancient edifices, in which the architecture and perspective are well understood. He exhibited at the Royal Academy in 1804 and 1809, and with the Water-Colour Society in 1820, and was elected an associate exhibitor in 1822, when he contributed 'The Coronation of George IV. in Westminster Abbey.' In 1823 he was chosen a member of the Society, and in 1835 the treasurer. He continued an exhibitor till his death. His contributions were usually only one or two each year; his subjects the interiors of cathedrals and ancient churches, which had almost entirely their inspiration from the Gothic ecclesiastical edifices. He published, 1812, 'Etchings of Landscapes,' intended as progressive lessons for students; 'Specimens of Gothic Architecture,' 1825, selected from the ancient buildings at Oxford; and in 1844, 'Architectural Antiquities of St. Stephen's Chapel, Westminster.' He made all the drawings for Britton's 'Salisbury Cathedral.' He died April 25, 1854, aged 67, and was buried in Highgate Cemetery.

MACKENZIE, SAMUEL, R.S.A., *portrait painter.* He was a native of Cromarty, North Britain, and commenced life as a stone carver. Coming to Edinburgh, he was struck with the works of Sir Henry Raeburn, and was inspired with the desire to be himself a portrait painter; and devoting himself zealously to art he succeeded, and gaining a reputation, was in 1830 chosen a member of the newly-formed Royal Scottish Academy. His female heads, though deficient in force, were generally very successful, and his art popular. He died in 1847, aged 62.

McKEWAN, DAVID HALL, *water-colour painter.* He was an occasional exhibitor of drawings at the Royal Academy from 1837 to 1849, and at Suffolk Street from 1840 to 1844. In 1848 he was elected a member of the Institute of Painters in Water-Colours, and from that time exhibited with this society, being always a large contributor. He died in his 56th year, August 2, 1873. He published 'Lessons on Trees in Water-Colours.'

MACKLIN, THOMAS, *engraver.* He undertook in 1793 the publication of Bunbury's 'Shakespeare,' illustrated by 48 plates, for which Bunbury made the drawings. He engraved 'Peace and War,' after Guercino, in 1779, and some other plates.

MACLEAN, ALEXANDER, *subject painter.* First exhibited at the Royal Academy in 1872. In 1874, his picture of 'Covent Garden Market, 1873,' attracted great attention, and this success he followed up by contributing 'Looking Back,' in 1876; and 'At the Railings, Covent Garden,' 1877. His health had been failing for some time, and he died at St. Leonard's-on-Sea, October 30, 1877. He was a very promising young painter.

MACLEOD, JOHN, *animal painter.* He practised in Edinburgh, and painted with

281

much success portraits of favourite horses, dogs, &c. He died February 17, 1872.

' MACLISE, DANIEL, R.A., *subject and history painter.* Born at Cork, January 25, 1811, he was the son of an officer of the Elgin Fencibles, a Scotchman of an old race. His mother was the daughter of a Cork merchant, whom his father first met while serving in Ireland. This statement has been generally received; the date is that given by the artist himself, and the whole has been adopted by his biographer and friend. But, on the contrary, it is stated, and supported by public documents, that 'Alexander McLish, a soldier in the Elgin Fencibles, was married in the Presbyterian Church, at Cork, to Rebecca, daughter of Mrs. Buchanan, Almshouse, December 24, 1797,' and the birth of their son, Daniel McLish, is recorded February 2, 1806; and this child, who afterwards spelt his name McClise, is identified with the artist. On an inquiry, the Secretary of State for War says, and so far verifies the latter statement, 'that no *officer* of the name of Maclise or McLish can be traced as having served in the Elgin Fencibles about the period referred to.' Brought up in his native city, he received a plain education. He had an early desire to be an artist, but his father thought him better placed as a clerk to a banker in Cork. At the age of 16 he managed to leave this employment, and gained admission to the Cork School of Art; he att he same time made a practical study of anatomy, and had the character of an intelligent and industrious student. The 14th Dragoons were then stationed in the city, and making some friends among the officers, he first found profitable employment in sketching their portraits. In 1826 he made a sketching tour in Wicklow, and then resuming his portrait practice in Cork, he saved a purse of his own, and was enabled in July 1827 to make his way to London, where in 1828 he entered the schools of the Royal Academy, and rapidly improving in his power of drawing, he gained successively the silver medals in the life school and in the painting school, and in 1831 the gold medal for his ' Choice of Hercules.'

He had brought to London some friendly introductions, and made the acquaintance of influential men engaged in literature. On his first arrival he produced a happy sketch in the theatre of Charles Kean, which was published, and brought him a handsome sum. And his talents, aided by his friends, opened to him a career in that branch of art. But he was not anxious to devote himself to portraiture. In 1829 he first appears on the walls of the Academy with his 'Malvolio affecting the Count.' In the following year he exhibited several portraits, among them one of his friend

282

Miss L. E. Landon; and at the same time he visited Paris, with the intention of reaching Madrid, but when near the Pyrenees he was attacked by illness, and obliged to return. In 1831 his exhibited works were portrait drawings, and the same in the next year, with his 'Puck disenchanting Bottom.' In the autumn he visited Ireland, and enjoyed All Hallow Eve at the house of the parish priest, where he sketched the scene for the picture he exhibited in 1833, so well known by the popular engraving.

Arising out of a dispute with Sir John Soane, R.A., who was annoyed by Maclise's portrait of him—afterwards destroyed by a friend—there appeared an etched full-length sketch of Sir John in 'Fraser's Magazine,' by 'Alfred Croquis' (a name assumed by Maclise), which was so popular that it was followed by a series extending to 72 numbers of the magazine, of which it became a feature, representing the eminent literary and scientific men of the day. From his connection with the magazine he was led to contribute a clever poem, which occupies nine pages, 'Christmas Revels,' an epic rhapsody. Continuing to find employment in portraiture, he exhibited, in 1834, his 'Installation of Captain Rock;' and in 1835, his great work, 'The chivalric Vow of the Ladies and the Peacock,' which fully established his power as an artist, and gained him his well-deserved election as an associate of the Academy in the same year. From this time his exhibited works were confined to subject pictures, his portraits to an occasional oil picture of a literary friend, with some scenes from 'Gil Blas' and the 'Vicar of Wakefield.' He exhibited, in 1838, 'Merrie Christmas in the Baron's Hall;' in 1840, when he was elected a member of the Academy, the 'Banquet Scene in "Macbeth;"' in 1841, 'The Sleeping Beauty;' in 1842, the 'Play Scene in "Hamlet,"' now in the South Kensington Museum; in 1844, 'A Scene from "Comus"' and 'A Scene from "Undine;"' in 1846, 'An Ordeal by Touch;' a succession of works by which his art will be best known.

At this time he entered the lists as a competitor for the great works offered in the decoration of the palace at Westminster, for which his art and his powers of execution eminently fitted him. He was, with others, selected by her Majesty's Commissioners, and after many wearying delays received a commission for two frescoes—the 'Spirit of Justice' and the 'Spirit of Chivalry.' His chief thoughts from this time must have been occupied with these engagements; his contributions to the Academy fell off; but in 1850, while engaged on the above two works, he exhibited there the 'Gross of Green Spectacles;' in

1851, 'Caxton showing his Printing-press to Edward IV.;' in 1854, 'The Marriage of Strongbow and Eva,' an important picture, which the commissioners wished him to repeat on the walls of the palace, but proposed a very inadequate remuneration. He had visited Paris again in 1844, and he now (1855) made his third visit, and extended his journey to Turin, Genoa, Florence, Naples, and Rome.

He had in 1851 expressed a wish to undertake the decoration of the Royal Gallery, which resulted in the commissioners offering, as a commencement of that work, two subjects—'The Meeting of Wellington and Blucher after the Battle of Waterloo' and 'The Death of Nelson.' The spaces these two pictures were to occupy were each 48 ft. long; and he commenced his designs for them in 1858, and in the following year he completed an elaborate cartoon of the first, full of the most careful detail, which is now possessed by the Royal Academy. But on commencing the work in fresco he found so many insurmountable difficulties that he resigned the task in that material, yet was willing to make a trial of it in oil. To remove this difficulty, at the request of Prince Albert, the president of the commission, he went to Berlin in 1859 to inform himself of the waterglass process, and consented to commence his subject on this principle. Working incessantly in the gloomy gallery it was to occupy, utterly abstracted from all else, depressed and plagued, he finished his great work in December 1859, representing accurately even the smallest details of portrait, costume, and the minor accessories; and was then commissioned to commence the companion picture, which, under the most discouraging and depressing circumstances, he completed in 1864, abandoning all claim to the amount of remuneration which he might justly have claimed. These two large water-glass paintings have been engraved in line for the Art Union of London.

Between 1857, when he completed an outline series of designs, 'The Story of the Norman Conquest,' for the Art Union, and 1865, while engaged on the works of the Royal Commission, he had only exhibited one unimportant picture at the Academy. In each of the following years, including the year of his death, he exhibited, his pictures chiefly from Shakespeare; but his energies, great as they were, had been exhausted, and he succumbed after a short illness, dying at his house in Cheyne Walk, Chelsea, on April 25, 1870. He was buried at the Kensal Green Cemetery, his grave surrounded by his friends. He illustrated Moore's 'Irish Melodies,' Lord Lytton's 'Pilgrims of the Rhine,' and some other works, and designed the Swiney Cup for the Society of Arts, the Medal for the International Exhibition, 1862, and the Turner Medal for the Royal Academy.

Of a high and generous nature, fertile in invention, of great power of execution, and an excellent draftsman, but deficient in colour, he was always original and pleasing in his art. As a man he was modest, gentle, and frank-hearted. Wedded to his art, he died unmarried. Indifferent and almost careless in money matters, his will was proved under 40,000l. personalty. A memoir of him was published in 1871 by his friend Justin O'Driscoll.

MADDEN, THOMAS, *sculptor.* There is a fine tomb to Sir Hugh Hammersley by this unknown artist in the Church of St. Andrew Undershaft, London. The knight is represented kneeling under a canopy, and behind him his wife, with two finely-conceived cavalier figures on each side, 1636.

MADDEN, WYNDHAM, *portrait painter* of the last half of the 18th century. Dickinson mezzo-tinted a portrait by him.

MADDOX, GEORGE, *architect.* He was an exhibitor at the Royal Academy in 1796, 1807, and 1819, afterwards he became a member of the Society of British Artists, and contributed to their exhibitions classical compositions in architecture, fragments of sculpture, and ornaments in the antique taste. Cockerell, R.A., Decimus Burton, and Professor Hosking were his pupils. He died October 9, 1843, in his 83rd year.

♦ MADDOX, WILLIS, *portrait and history painter.* Was born at Bath in 1813. Was noticed by Mr. Beckford, of Fonthill, for whom he executed several works—'Christ's Temptation on the Mount' and 'Agony in the Garden.' And from him he probably received an impulse towards oriental subjects. He first exhibited at the Academy in 1844, his early contributions being still-life. He painted the portraits of several distinguished Turks, and was invited to Constantinople, where he painted the Sultan. He exhibited at the Academy, in 1849, a portrait of Risk Allah; and in 1850, of Aina Felleck, the 'Light of the Mirror.' The chief subject picture which he exhibited is his 'Naomi, Ruth, and Orpah,' 1847. There is a portrait of the Duchess of Hamilton by him, painted in 1846, and at Bath many of his portraits, which are truthful and vigorous. He died of fever, at Pera, near Constantinople, June 26, 1853.

MAINWARING, WILLIAM, *medallist.* Practised in England towards the end of 18th century.

MAJOR, THOMAS, A.E., *engraver.* Born in 1720. In the early part of his life he resided several years in Paris, and was eventually imprisoned there, as a reprisal for some French troops captured at Culloden. He engraved, while in Paris, several plates after Berghem, Wouvermans, and others.

On his return to England he engraved portraits, landscapes, and subject pictures. He united a free style of etching to a more finished manner than had been practised in landscape engraving. His foliage is graceful. He held for 40 years the office of seal engraver to the King, and in 1770 was elected associate engraver of the Royal Academy, and was the first engraver who received that distinction. He published, in 1768, a set of 24 plates of the 'Ruins of Pæstum.' He lived many years in St. Martin's Lane, and afterwards in Tavistock Row, Covent Garden, where he died December 30, 1799, in his 80th year, and was buried in Camberwell Churchyard.

MALCOLM, JAMES PELLER, *draftsman and engraver.* Was born in Philadelphia, August 1767. He came to England, to improve himself in art, some time in 1788 or 1789, and entered the schools of the Academy, where he studied three years. He was assisted by Benjamin West, P.R.A., and by Wright, of Derby, but did not succeed as a painter, and then tried engraving, in which he was self-taught. He is supposed at this time to have gone back to America, but to have returned shortly to England. He found employment in connection with the 'Gentleman's Magazine,' in which work a well-etched design appeared in 1792, and was engaged in works chiefly of a topographical character. Some of his best and most finished productions will be found in his 'Excursions through Kent,' and in Nichols's 'History of Leicestershire,' to which he devoted himself both as draftsman and engraver for nearly 20 years. He engraved also for Granger's 'Biographical History of England' and a 'History of Caricaturing,' which he published in 1808; 'Anecdotes of the Manners and Customs of London during the 18th Century,' with 50 views, chiefly of buildings, drawn and etched by himself. He died in London, April 5, 1815, after a long illness, leaving a destitute wife and family, for whom a subscription was raised.

MALTON, JAMES, *architect and draftsman.* Practised towards the end of the 18th century, his topographical drawings showing great accuracy and merit. He published 'Picturesque Views of the City of Dublin,' from drawings taken 1791–95; in 1798, an 'Essay on British Cottage Architecture;' in 1800, 'The Young Painter's Maulstick,' being a practical treatise on perspective. He died of brain fever, in Norton Street, Marylebone, July 28, 1803.

MALTON, THOMAS, *architectural draftsman.* Born in 1726. Originally kept an upholsterer's shop in the Strand. In 1769 he was in Dublin, and is said to have left London under some pecuniary embarrassments. Here he continued several years,

teaching perspective for a living, in great poverty. He was one of the early exhibitors at the Royal Academy, contributing, in 1772, a drawing in water-colour of 'The Queen's Palace from St. James's Park;' and in 1774, 'The Interior of Walbrook Church.' In the same year he published 'The Royal Road to Geometry;' and in 1775, 'A Treatise on Perspective on the Principles of Dr. Taylor.' His drawings were finished in Indian ink, slightly tinted. He lived for some time in Porter Street, Newport Market, and afterwards in Poland Street, where he advertised, in 1775, a course of lectures on Perspective. He died in Dublin, February 18, 1801, in his 75th year.

MALTON, THOMAS, *architectural draftsman.* He was born in 1748, the son of the above. He received a premium at the Society of Arts in 1774, and a student in the schools of the Royal Academy, he gained the gold medal in 1782 for his 'Design for a Theatre.' He was for a time in Dublin with his father, and for three years was employed in the office of Gandon, the architect, who was satisfied with his ability, but was compelled to dismiss him for his irregularities. He exhibited at the Academy, in 1774, some stained drawings, views on the Thames from the Adelphi; in 1780, views of Bath, where he was then living; in 1790 and 1798, views of St. Paul's; and in 1803, three views of Oxford. He painted several successful scenes for Covent Garden Theatre. In 1792 he published 'A Picturesque Tour through the Cities of London and Westminster,' with 100 illustrations drawn and aqua-tinted by himself; and in 1802, 'Picturesque Views of the City of Oxford.' There are also many aqua-tint engravings by him of some of the chief buildings of the city of London. He died in Long Acre, March 7, 1804. His brother, WILLIAM MALTON, was also a draftsman.

MANBY, THOMAS, *landscape painter.* He painted in the reign of Charles II. He paid several visits to Italy, and his best works are in the Italian manner. Several notices of him appear; he is mentioned by Beale as putting in the background to a portrait, and that a good collection of pictures which he brought from Italy were sold about 1672. He died in London about 1691.

MANNIN, JAMES (frequently spelt MANNING), *flower painter.* He was born and educated in France, and came over to Dublin, where he settled, and was appointed in 1746 to fill the office of master in the class of ornament and flower painting in the Dublin Society's Schools then established. Several artists, who afterwards distinguished themselves, were trained under him. He died 1779.

MANNIN, Mrs., *miniature painter.*

She exhibited at the Academy from 1829 to 1832 in her maiden name as Miss Millington, and from that year, under her married name, she was a constant exhibitor up to 1859. She died at Brighton in October 1864. A clever artist, she was largely employed, excelling in her portraits of children.

MANNING, SAMUEL, *sculptor* Was a pupil of Bacon, R.A., and studied in the Academy Schools. He first exhibited a bust in 1819, and the next year a statue of the Princess Charlotte; followed in 1821 by a marble bust of Warren Hastings for his monument in Westminster Abbey; in 1825, a model of a statue of Charles Wesley, and from that time occasionally busts and a portrait statue. In 1845 he exhibited 'Prometheus,' his only classic work; and in 1846, a bust, his last contribution. Three of the small tabular public monuments in St. Paul's are by him. He died December 7, 1847.

MARCHANT, NATHANIEL, R.A., *gem engraver and medallist*. Was born in Sussex in 1739, and was a pupil of Burch, R.A. In 1766 he was a member of the Incorporated Society of Artists. He visited Rome for his improvement, was there in 1773, and studied there during several years, both from the antique gems and the most celebrated antique groups in marble, sending impressions from intaglios to the Royal Academy from 1781 to 1785. On his return to London some time before 1789, he gained great reputation, especially for his gems, which have rarely been excelled. He was appointed probationary engraver to the Royal Mint in 1782, and afterwards first engraver, holding the office till 1815, when he resigned. He was also gem engraver to the King. He was elected an associate of the Royal Academy in 1791, and academician in 1809, and continued an exhibitor up to 1811. Died in Somerset Place, London, in April 1816, aged 77. He was a member of the Academy at Stockholm and at Copenhagen. He published a catalogue of 100 impressions from gems, engraved by himself.

MARCHI, GIUSEPPE FILIPPO LIBERATI, *portrait painter*. Born in Rome. Brought to England in 1752, when about 15 years of age, by Sir Joshua Reynolds, he studied for a time at the St. Martin's Lane Academy, and was in 1766 a member of the Incorporated Society of Artists. He was employed by Sir Joshua to set his palette, paint draperies, and forward his numerous copies and duplicates — being his ready assistant in all matters connected with his studio. About 1770 he attempted to establish himself as a portrait painter in the Metropolis, and then in Wales, but not succeeding, he returned, and continued with Sir Joshua till his death. Reynolds painted a fine portrait of him in an oriental dress. From his knowledge of his master's manner of painting he was skilful in repairing and restoring his works, after several of which he executed mezzo-tint plates of some merit. He had saved enough while with Reynolds to provide for his old age. He died in London, April 2, 1808, aged 73.

MARCUARD, ROBERT SAMUEL, *draftsman and engraver*. Was born in England 1751. Was the pupil of Bartolozzi, and esteemed one of his best scholars. He practised in the dot manner, but occasionally in mezzo-tint, and chiefly from the works of his contemporaries — Cipriani, Angelica Kauffman, W. Hamilton, Hoppner, Flaxman, Reynolds, and Stothard. He died about 1792.

MARLOW, M., *engraver*. He practised towards the last quarter of the 17th century, and was chiefly employed by the booksellers, but his works are little known or esteemed.

MARLOW, WILLIAM, *landscape painter*. Was born in Southwark in 1740. Studied under Scott, the marine painter, and at the St. Martin's Lane Academy, and became a member of the Incorporated Society of Artists. Exhibited at the Spring Gardens' Rooms 1762–63–64. He painted several noblemen's seats in England, and then, by the advice of the Duchess of Northumberland, who admired his works, he travelled in France and Italy from 1765 to 1768. On his return he again exhibited at the Spring Gardens' Rooms, and established himself in London, living several years in Leicester Square. In 1788 he was residing at Twickenham, and that year exhibited at the Royal Academy for the first time, and continued to exhibit yearly to 1796. In 1807 he exhibited again, and for the last time, contributing 'Twickenham Ferry by Moonlight.' He painted from his Italian sketches, some of which he etched, and also views of London, chiefly on the Thames. His landscapes are pleasing, his colour good, but he aimed little at picturesque effect, and his trees, which are rarely introduced, are weak. His Italian sketches are slight and weakly tinted, but his works possess a quiet truth. Some of his works are at the Foundling Hospital, and have also a place in several collections. He realised a moderate competence, and died at Twickenham, January 14, 1813, in his 73rd year. His 'View of Westminster Bridge' and of 'Blackfriar's Bridge,' with some other of his works, are engraved.

MARMION, Sir EDMUND, *amateur*. He etched in the time of Charles I. and Charles II. There are some portraits by him, in the manner of Vandyck, etched with much freedom, and some slight etchings of domestic scenes, after his own designs.

MAROCHETTI, Baron CHARLES, R.A., *sculptor*. Was born at Turin, of French parents, in 1805, and in early life went with

his family to Paris, where his father practised as an advocate. He was educated in the Lycée Napoléon; and at the age of 17 went to Rome, where he studied about eight years. In 1829 he returned to Paris, and exhibited there 'A Girl playing with a Dog,' which gained him a medal at the Beaux Arts. He afterwards went to Turin, and produced several statues and smaller works, which made him widely known. He also presented to the City his noble equestrian statue of Emmanuel Philibert, and the King conferred upon him the title of Baron. An equestrian statue by him of Charles Albert also decorates his native city. Going back again to Paris, he was employed there on many fine works, and was made a chevalier of the Legion of Honour in 1839. On the death of his father he inherited a mansion in the suburbs of Paris, where he resided till 1848, when, on the Revolution, he came to England. Here he was at once noticed by the Queen, and was employed upon several public works, and completed an equestrian statue of her Majesty, erected at Glasgow. He exhibited for the first time at the Academy in 1840, 'Sappho,' a statue in marble, and in the following year, a bust of Prince Albert; and continuing to exhibit, chiefly busts, sent in 1856 a bust of the Queen. His last exhibited work was a bust of Sir Edwin Landseer, presented, as his diploma work, to the Academy. In 1851 his equestrian statue of 'Richard, Cœur de Lion,' made him widely known; and this group has been since executed in bronze, and placed on the west front of the Houses of Parliament. Before coming to England he executed an equestrian statue of the Duke of Wellington for the city of Glasgow, and afterwards completed a second for Strathfieldsaye. He also designed the Scutari Monument for the Crimea and the monument to the Guards' Officers at Inkerman; Lord Melbourne's tomb in St. Paul's; and Lord Clyde's statue (his last work) in Waterloo Place. He was elected an associate of the Royal Academy in 1861, and a full member in 1866. He died suddenly at Passy, near Paris, December 28, 1867.

MARQUIS, ——, portrait painter He practised in the reign of James I. His portraits were in oil, but on a small scale.

MARRABLE, FREDERICK, architect. He was the son of the secretary of the Board of Green Cloth. Articled to Mr. Blore, upon the termination of his pupilage he pursued his studies on the Continent, and then set up in his profession, competing for such works as offered. In 1856 he was appointed architect to the Metropolitan Board of Works, and designed and carried out the great plan of the Holborn

286

Viaduct, which unfortunately proved defective in its construction. He was also the architect of the new churches, St. Mary Magdalen, at St. Leonard's; and St. Peter, Deptford; of the Garrick Club and the adjoining dwelling-houses; of the offices of the Metropolitan Board, at Spring Gardens; and of Archbishop Tenison's School, in Leicester Square. In 1862 he resigned his appointment under the Metropolitan Board. He died suddenly, June 22, 1872. He was a frequent exhibitor at the Royal Academy of designs for works he was executing.

MARSHAL, ALEXANDER, water-colour painter. Practised in the latter half of the 17th century. He drew some of Mr. Tradescant's choicest flowers and plants, and made very careful copies after Vandyck.

MARSHAL, EDWARD, sculptor. He practised towards the middle of the 17th century. There is a monument by him at Derby, dated 1628, of William, Earl of Devonshire, and his countess; another at Tottenham, dated 1644, of Sir Robert Barkham, his wife, and eight children; and at Chatham a third, of Sir Dudley Digges, consisting of an Ionic column supporting an urn, with four females, life-size, representing the cardinal virtues. There is also a monumental work by him at Stavesey, Cambridgeshire.

MARSHAL, JOSHUA, sculptor. Probably the son of the above, with whom he was for some time employed. Was master mason to Charles II., the successor of Stone, and was much employed at the time of the Restoration. There is a monument by him at Campden, in Gloucestershire, dated 1664, to Edward, Lord Nevil, and his lady. The figures are of white marble, life-size, and are represented standing in their winding-sheets within a cabinet, with folding doors of black marble thrown open.

•MARSHAL, BENJAMIN, animal painter. He practised both at Newmarket and in London, and drew the portraits of horses for the 'Sporting Magazine.' There are several portraits of horses by him in the Stud Park. He was an occasional exhibitor at the Academy, commencing in 1801, of horses, and from time to time of a portrait. Two celebrated race-horses were carefully engraved after him by George and William Cooke. He died in 1835, aged 68.

MARSHALL, GEORGE, portrait painter. Was a native of Scotland, and a pupil of the younger Scougal; also studied under Kneller. He painted awhile in York, and after a long practice in Scotland, at the beginning of the 18th century he went to Italy, but did not much improve by travel. He died about 1732.

MARSHALL, THOMAS FALCON, subject painter. Was born in Liverpool, Decem-

ber 18, 1818, and early showed a wish to become a painter. He first exhibited at the Royal Academy at the age of 18, and was constantly represented upon its walls until his death. At 21 he gained the silver medal for an oil-painting, awarded by the Society of Arts. At the beginning of his career he painted several portraits. His works are well known in Manchester and Liverpool. He died in Kensington, April 2, 1878, aged 59.

MARSHALL, WILLIAM, engraver. His early works date in the reign of James I., and he appears to have practised for 50 years. His works are very numerous; they are chiefly portraits, many of them of great interest from the persons represented, and are probably executed by him from the life; among these is a portrait of Milton at the age of 21. They are stiff and poor in style. The dates of his works range from 1591 to 1646.

MARSHALL, WILLIAM, engraver and dealer in art. He edited in 1771 Desgodet's fine work, 'The Ancient Edifices of Rome.'

MARSHALL, PETER. He practised as an artist, and is remembered as the inventor of the peristrephic panorama. He died in Edinburgh, January 27, 1826, aged 64.

MARTEN, JOHN, water-colour painter. He practised about the end of the last century and the beginning of the present. He exhibited at the Royal Academy, in 1794, 'A view of St. Augustine's Monastery,' and in 1808 was again an exhibitor. He lived at Canterbury. His drawings possess some merit. MARTEN, R. H., practised in water-colours about the same time.

MARTIN, DAVID, portrait painter and engraver. Born at Anstruther, Fife, in 1736, was pupil of Allan Ramsay, and when very young went with him to Rome. On his return he studied in the St. Martin's Lane Academy, and gained premiums for his drawing from the life. He was a member of the Incorporated Society of Artists, and in 1773 the Society's treasurer. About 1775 he was in Edinburgh, and had the chief practice in that city. He was appointed principal painter to the Prince of Wales for Scotland, and was held in repute. He practised also as an engraver, and scraped some mezzo-tint plates, among them a good portrait of Roubiliac, the sculptor; and from his own painting, a full-length of Lord Mansfield. He married a lady of some property, was living in 1779 in Dean Street, Soho, and resided there some years. On her sudden death he retired to Edinburgh, where he died in 1798.

MARTIN, ELIAS, A.R.A., subject and landscape painter. Was born in Sweden about 1740, and having gained some skill in drawing, he travelled to improve himself. He was in England in 1769. In that year he gained admission to the schools of the Academy, and also contributed to the exhibition a 'View of Westminster Bridge, with the King of Denmark's Procession,' and a water-colour view in Sweden. In 1770 he was elected an associate of the Academy. He painted portraits, several of which are engraved in mezzo-tint, subjects and landscapes, and practised both in oil and water-colours. He has also been styled an engraver, in support of which it appears from the catalogue that he exhibited at the Academy in 1773, 'The tender Mother educating her Daughter from her Birth to her Marriage,' six prints in imitation of red chalk. After having passed 14 years in England, he is said to have returned to Stockholm in 1780, on the invitation of the King, who appointed him his Court painter. His contributions to the Academy cease in that year. But he appears again, and for the last time an exhibitor, in 1790, when he gave his address at Bath, and sent eight pictures, chiefly subjects. His reputation is founded on his early works; he became, later, vain and careless. He died in 1804, but his name was not removed from the list of associates till 1832. His brother, JOHANN FRIEDRICH MARTIN, an engraver, passed 10 years in London, and then returned to Stockholm. He engraved after his brother, in 1787, a 'Group of Elias Martin and his Family.'

MARTIN, F. B., engraver. Practised in the second half of the 18th century. There is by him a portrait of Maria Cosway, after Cosway, R.A., and of Sophia Western, after Hoppner, R.A.

*MARTIN, JOHN, landscape painter. Was born at Haydon Bridge, near Hexham, July 19, 1789. Having a taste for drawing, he was intended for a herald painter; and he says of himself 'he began as a coach painter, then as a china painter.' After running away from coach painting, he was placed by his father under an Italian at Newcastle (the father of Charles Muss, the well-known enamel and miniature painter), and, a few months after, came to London in September 1806. He supported himself for a time by painting on china and glass and by teaching, and meanwhile he was a diligent student of perspective and architecture. At 19 years of age he married, and necessitated to work and ambitious for fame, he produced, in 1812, his first picture, 'Sadak in search of the Waters of Oblivion,' which at once found a purchaser; followed in 1813 by 'Adam's first Sight of Eve;' and in 1814, by his 'Clytie.'

The exhibition of this last picture, which he thought inadequately hung, was the

commencement of his rupture with the Royal Academy, of which he was through life an angry opponent; but it did not prevent his continuing to exhibit on the Academy walls. In 1816 he sent his 'Joshua commanding the Sun to stand still,' which gained him great notice, and in the following year, at the British Institution, a premium of 100*l.* He was at the same time appointed 'historical landscape painter to the Princess Charlotte and Prince Leopold.' In 1819 he sent his large picture, 'The Fall of Babylon,' to the British Institution; and in 1821, his 'Belshazzar's Feast,' which gained the premium of 200 guineas, and is by many deemed his best work. On the foundation of the Society of British Artists he became a zealous supporter of that body, and exhibited at their rooms in Suffolk Street, from 1824 to 1831, and again in 1837-38; but in the latter year he withdrew from them, and from that time his best and more important works were sent to the Academy, though he did not abate his opposition. There he exhibited his 'Deluge' in 1837, his 'Eve of the Deluge' in 1840, his 'Pandemonium' in 1841, and continued to exhibit regularly till 1853.

He painted many clever views in watercolour, in which his peculiar manner is apparent. The valley of the Thames, the Wandle, and the Brent, the Surrey Hills, and the eminences round the Metropolis, were the subjects of his pencil. Many of his works are engraved, some by his own hand. Of these are the 'Belshazzar's Feast,' the 'Ascent of Elijah,' 'Christ tempted in the Wilderness,' the 'Joshua,' 'Marcus Curtius,' 'The Fall of Nineveh,' 'The Fall of Babylon,' and some others. The popularity of his works also led to his being engaged in the illustration of books. In 1832-33 he received 2000*l.* for his designs for 'Paradise Lost,' which show great poetic grandeur; and in 1833 commenced, with Westall, the illustrations of the Bible. He was active, too, in schemes for the improvement of the Metropolis—the water supply, the sewage, and the docks.

In the midst of his occupations, and while at his easel, he was attacked by paralysis. He thought a remedy might be found in abstinence, and refusing nourishment, except in the smallest quantities, he at last gradually sank, and died on February 17, 1854, in the Isle of Man, where he had gone for the restoration of his health. The public were surprised by Martin's works, which they were unable to judge; the artists were disposed to call them meretricious, tricky, scenic; but it must be admitted that they were highly original and full of poetic imagination, embodying visions of art not hitherto displayed, though the manner became tedious by its repetition; but his colouring was hot and disagreeable, his

288

figures sadly wanting in drawing. He was a knight of the order of St. Leopold of Austria. The unfortunate lunatic who set fire to York Minster was his brother.

MARTIN, WILLIAM, *history painter.* He was a pupil of Cipriani, and in 1766 was awarded a gold palette by the Society of Arts. His name first appears in the Academy catalogue in 1775, when, and in several succeeding years, during which he continued to exhibit, he was living with Cipriani, R.A., to whom he was a pupil. The works which he exhibited up to 1784 were almost exclusively classic—'Antiochus and Stratonice,' 'Perseus and Andromeda,' 'Thetis comforting Achilles,' 'Venus attended by Iris,' with an occasional portrait. Then for the following seven years he did not exhibit, but in 1791 he contributed 'Lady Macbeth surprised in her Castle;' in 1800, sketches for paintings he was executing at Windsor Castle. Among his latter works he exhibited, in 1810, 'Celadon and Amelia,' a sketch; in 1812, 'Serena falls into the Hands of the Savages;' and in 1816, an 'Allegorical sketch for a Picture in memory of Nelson,' his last work. He held the appointment of history painter to George III. Bartolozzi engraved after him 'Edward and Eleanor,' 'Lady Jane Grey,' 'Imogen's Chamber;' and J. Watson, 'The Confidants,' 'Colibert,' 'Louise and the Gardener.'

MARTINEAU, ROBERT BRAITHWAITE, *subject painter.* Was born in London, January 19, 1826. He was educated in the London University School, and in 1842 adopted the law for his profession, but after four years' study under articles, he gave it up and devoted himself to art. During two years he laboured in a drawing school, and then gained admission to the schools of the Academy, and was for a short time the pupil of Mr. Holman Hunt. He first exhibited, in 1852, 'Kit's Writing Lesson,' and although some lesser works occupied him in the interval, his mind was chiefly engaged upon his 'Last Day in the old House,' exhibited at the International Exhibition in 1862. This work was a highly laboured production, a drama of the artist's own invention, and attracted great notice; but he was unable to produce another work of equal importance or power. He died February 13, 1869, of heart disease, after only a short illness.

•**MASCALL, EDWARD,** *portrait painter.* He practised during the Commonwealth, and there is a portrait of Cromwell by him. His portrait of himself is engraved by James Gammon. He made some of the drawings for Dugdale's 'Monasticon,' and there is an etching of Viscount Falconberg by him, dated 1643.

MASON, ABRAHAM JOHN, *wood-engraver.* Born in London, April 4, 1794. He lost both his parents early in life. Edu-

Martineau. Clara

cated in Devonshire, he was articled to Robert Branston in 1808, and at the end of his seven years' apprenticeship was employed by him for five years further. In 1821 he commenced on his own account. He also gave some lectures on his art at the London Mechanics' Institution, the Royal Institution, and the London Institution. In November 1829 he sailed for New York, and settling there was elected an associate of the New York Academy of Design and professor of wood engraving. George Cruikshank's 16 illustrations to 'Tales of Humour and Gallantry,' 1824, are engraved by him.

MASON, GEORGE HEMMING, A.R.A., *subject painter.* He was born at Witley, in Staffordshire, of a good family, possessing property in the county, and was intended for the medical profession, for which he studied during five years at Birmingham. But he was attracted to art, and quitting his profession he travelled on the Continent in 1844, visited France, Germany, Switzerland, and Italy, and finally settled at Rome, where he resided several years. He sent his first picture, 'Ploughing in the Campagna,' to the Academy in 1857, and returned to England in the following year, when he exhibited 'In the Salt Marshes, Campagna;' in 1862, 'Mist on the Moors;' in 1864, 'Returning from Ploughing;' in 1865, 'The Gander' and 'The Geese;' in 1867, 'The Unwilling Playmate;' in 1868, 'The Evening Hymn,' which was followed by his election as an associate of the Royal Academy. Then in 1869 he exhibited his 'Dancing Girls' and 'Only a Shower;' in 1871, 'The Milkmaid' and 'Blackberry Gathering;' and in 1872 his last and greatest work, 'The Harvest Moon.' He had for many years suffered from heart disease, to which he fell a victim October 22, 1872, aged 54. His early Roman scenes are powerful and full of rich colour, the climate finely studied. His English scenes are equally fine as studies of climate, tender in mists; his 'Dancing Girls' and 'The Gander' lovely bits of nature; his 'Harvest Moon' full of sweet poetry.

MASON, WILLIAM, *animal painter.* He practised in the latter half of the 18th century. J. Jenkins and R. Pollard engraved horse-races after him; and Val. Green produced in 1783 a fine mezzo-tint of his 'Scene in a Country Fair at Race Time.'

MASON, JAMES, *engraver.* Born in 1710. He gained a reputation as a clever artist, and particularly in landscape — to which his art was almost confined—representing the effect of colour with much skill. He was in 1766 a member of the Incorporated Society of Artists. Employed by Boydell, he produced for him some plates jointly with Vivares, Canot, and others.

He engraved after Claude, Poussin, and some of the Dutch masters; and after George Lambert and several of his own contemporaries. He died about 1780.

MASQUERIER, JOHN JAMES, *portrait painter.* Was born at Chelsea, of French Protestant parents, in October 1778, and returned with them in 1789 to Paris, and studied art in that capital. He became a favourite pupil of Vernet, and was a witness of the frightful scenes of the revolution of 1792. He then found the means of getting to England, and was admitted a student of the Academy. In 1796 he first exhibited a portrait, with 'The Incredulity of St. Thomas,' which is still the altar-piece of the chapel in Duke Street, Westminster; and was from that time a frequent contributor to the Academy Exhibitions at the commencement of the 19th century. His works were almost exclusively portraits, but in 1800 he exhibited 'The Fortune Teller;' in 1803, 'The First Meeting of Petrarch and Laura;' in 1808, 'January and May;' with, occasionally, a portrait in character. In 1800 he visited Paris, and was enabled to make a sketch of the First Consul: this work he exhibited in London in the following year, and being the first genuine likeness of Buonaparte seen here, produced him a profit of 1000*l.* He then commenced a successful career as a portrait painter, and in 1812 married a lady of good connections. He had in 28 years' practice painted about 400 portraits, and in 1823 he retired upon a competence he had earned by his profession to Brighton. But he continued an occasional exhibitor of portraits at the Academy, and in 1831 exhibited 'A Marriage in the Church of St. Germain l'Auxerrois, Paris;' followed in 1838 by 'Buonaparte and Marie Louise viewing the Tomb of Charles the Bold at Bruges,' his last exhibited work. He died at Brighton, after 30 years' residence, March 13, 1855. Baroness Burdett Coutts has a full-length portrait by him of Miss Mellon as 'Mrs. Page' in the 'Merry Wives of Windsor,' which he exhibited in 1804.

MASSON, ANDREW, *landscape painter and drawing master.* Was born near Edinburgh in 1750. In 1824 he resided for six weeks in the Bell Rock Lighthouse, making studies of the action of the waves from thence, for J. M. W. Turner, R.A. He made a spirited drawing of the lighthouse in a storm, engraved by J. Horsburgh as a frontispiece to Robert Stephenson's account of the peculiarities of structure, and details of erection. He died in November 1825.

MATHESON, ROBERT, *architect.* Was born at Tain in Rossshire, in 1808. He came early to Edinburgh, and entered the office of Mr. Reed, the King's architect, and afterwards that of Mr. Nixon, and on the death of the latter he was appointed

289

Masterman — ; a Painter

his successor as architect to the Scottish Board of Works. During his tenure of office, he designed 'The Palm House,' in the Botanical Gardens, and the 'General Post-Office' at Edinburgh, and many additions to public buildings, both in that city and other towns of Scotland. He died in Edinburgh, March 4, 1877.

MATHIAS, GABRIEL, *subject painter.* Was long a student in art. He exhibited in 1761 and during the two or three following years. One of his pictures, 'A Sailor splicing a Rope,' is engraved by McArdell. But he was unsuccessful in art, and retired from his profession on obtaining an appointment in the office of the Keeper of the Privy Purse. He afterwards became deputy paymaster to the Board of Works. He resided chiefly at Acton, where he died, at a very advanced age, in 1804.

MAUBERT, JAMES, *portrait painter.* Was a pupil of 'Magdalen Smith,' and practised in the reign of George II. He painted small portraits, and there are by him portraits of the English poets, copied in small ovals and surrounded with flowers ; and in the National Portrait Gallery a portrait of Dryden. He did not attain to much excellence. He died 1746.

MAUCOURT, CHARLES, *portrait painter.* Born in Germany. Practised portrait painting in London for several years, both in oil and water-colours, and also in miniature. He was a member of the Incorporated Society of Artists, and an exhibitor from 1761 to 1767, sending in the former years full-length portraits. He also practised in mezzo-tint. Some of his works have much merit. He died in London in January 1768, leaving a child quite destitute.

MAURER, J., *draftsman and engraver.* Practised in the first half of the 18th century. He drew several views and occurrences of the time, usually with the pen, in a careful manner, and engraved them on copper. There is by him a view of Rosamond's Pond and the Parade, St. James's Park, 1742 ; a view of Vauxhall Gardens, 1744 ; Tower Hill and place of execution of Lords Kilmarnock and Balmerino, 1746 ; with other views of London.

MAWLEY, GEORGE, *landscape painter.* Was born in London, November 1838, and received his art education at Cary's School of Art and the schools of the Royal Academy. He first exhibited at the Royal Academy in 1858, and continued to do so till the year of his death. He was also a constant contributor to the Dudley Gallery water-colour exhibition, to which he sent 'A Pine Wood,' 'Storm clearing off North Wales,' 'Hambledon Lock,' etc. His best known oil pictures are 'The way across the Marsh,' 'Autumn,' 'A deserted Sand-pit.' He died prematurely in London, March 24, 1873.

290

MAXWELL, GEORGE, *landscape painter.* Was born in 1768. He exhibited in the Royal Academy in 1787–88–89, when his pictures obtained the favourable notice of Sir Joshua Reynolds. He died December 28, 1789.

MAY, HUGH, *architect.* He was the brother of 'Bab May,' keeper of the Privy Purse to Charles II., and practised in that reign. He built, about 1665, Berkeley House, Piccadilly, which was greatly lauded by Evelyn, and occupied the site where Devonshire House now stands. He was the architect of Cashiobury, and surveyor of the works at Windsor Castle. He is introduced in Verrio's picture of 'Christ healing the Sick,' costumed in a long periwig, as one of the spectators of the miracle.

MAYNARD, JOHN. An English painter of this name practised in the reign of Henry VIII., and was employed upon the tomb of Henry VII. in Westminster Abbey.

MAYNARD, T., *portrait painter.* He practised in London, was well employed, and exhibited portraits in oil at the Royal Academy from 1780 to 1812.

MAYOR, BARNABY, *engraver and painter.* He was a member of the Incorporated Artists' Society, and practised early in the last half of the 18th century. A picture of Wenlock Abbey by him is engraved by Valentine Green. He died July 8, 1774.

MAZELL, PETER, *engraver.* Practised his art during the last half of the 18th century. He was a member of the Incorporated Society of Artists 1774, and exhibited with them his engravings during several years. He was employed in the illustration of some scientific publications ; and by Pennant, who calls him his engraver. He produced some plates for Boydell, after G. Smith, of Chichester, published 1763 ; and engraved all the illustrations for Cordiners's 'Remarkable Ruins and Romantic Prospects in North Britain,' published 1792.

MEADOWS, J. KENNY, *designer.* Was born in Cardiganshire, November 1, 1790, and was the son of a retired naval officer. He first became known in art by his designs on wood for book illustration. Some of his earliest works of this class were for children, such as 'Granny's Wonderful Chair,' 'Jack Ketch,' 'Swift's hints to Servants ;' but he is best esteemed for his 'English heads of the People' and 'Illustrated Shakespeare ;' the latter published between 1842–45, and probably his best work. He exhibited some drawings on three occasions, the last in 1834, with the Society of British Artists, and also sent twice or thrice to the Royal Academy. His illustrated works published, exceed twenty in number. Though his designs have some claim to grace, they are too often trivial and affected. He was the companion of the humourists of his day. For the last ten years of his

life, he received a pension from the civil list. He died in August 1874, and was buried in the St. Pancras Cemetery at Finchley.

MEADOWS, ROBERT MITCHELL, *engraver.* Practised his art chiefly in the latter half of the 18th century, engraving in the stipple manner, and attained much distinction in his profession. He engraved for Boydell's 'Shakespeare Gallery,' and after Westall, Hamilton, and others. He published, in 1809, three lectures on Engraving, and died some time before 1812.

MEDINA, Sir JOHN BAPTIST, Knt., *portrait painter.* Was the son of a captain in the Spanish service, and born in 1660, at Brussels, where he studied painting. He married young, and came to England in 1686. After practising portrait painting in London for several years, he was induced to visit Edinburgh, where he settled, and painted the portraits of many of the Scotch nobility and of the professors in Surgeons' Hall, Edinburgh. He occasionally painted history, and he designed the illustrations for an edition of Milton's 'Paradise Lost,' folio, 1688. There are also some landscapes by him, but he found his best encouragement in portraiture. His manner was firm and bold, better suited to his male than his female sitters; the expression and character good. He worked with great facility and industry. He was knighted by the Lord High Commissioner to the Scotch Parliament. He died in Edinburgh in 1711, and was buried at Greyfriars. Some of his portraits are engraved.

MEDINA, JOHN, *portrait painter.* Grandson of the foregoing. Practised his art in Edinburgh, where he is supposed to have been born, and for a time in London, where he exhibited in 1772 and 1773. Little is known of his works, but he was much employed as a copyist and a picture cleaner. He repaired the collection at Holyrood Palace, and made many copies of a valued portrait of Mary, Queen of Scots. He died at Edinburgh, in his 76th year, September 27, 1796.

MEDLAND, THOMAS, *engraver.* Practised in the latter half of the 18th century, and excelled in the delicate truth and finish of his landscape engravings. He exhibited some topographical views of the Metropolis, in water-colours, in 1777–78–79, and was an occasional exhibitor for many years. He engraved several plates in conjunction with William Byrne—'Mount Etna,' in 1788; 'Views in Cumberland and Westmoreland,' published in 1789; 'Cities and Castles of England,' 1791. He engraved with much spirit Stothard's illustrations to 'Robinson Crusoe,' which were afterwards engraved by Heath; the illustrations to Barrow's 'Embassy of Lord Macartney to China,' 1804; two of Lord Howe's sea-fights, after R. Cleveley; 45 plates to Sir W. Gell's 'Topography of Troy.' About 1808 he appears to have been appointed an art teacher at the East India College, Hertford, and went to live in that neighbourhood, and from thence sent his works occasionally to the Academy Exhibitions up to 1822.

MEDLEY, SAMUEL, *portrait and animal painter.* He was born about 1748, and commenced art by attempts at historical painting. He exhibited 'The Last Supper' at the Academy in 1792, followed by some historical and classical subjects. About 1797 he tried portraiture, and settled in the practice of a portrait and animal painter, in which he became known as a clever artist. He exhibited at the Academy, with some intermission, up to 1805. A good group of portraits by him, 'The Medical Society of London' was engraved in 1801 by Branwhite (see this life for a curious account of the plate). He was living in 1853. Being tired of his profession he went on to the Stock Exchange, where he made a comfortable independence, and was one of the founders of University College, London. He was the maternal grandfather of Sir H. Thompson, the celebrated surgeon.

MEE, Mrs. ANNE, *miniature painter.* She was the eldest daughter of John Foldsone, an artist, who died young. She received a good education in a well-known school kept by a French lady, in Queen's Square, Westminster, and was deemed clever as a musician, poetess, and painter. She must have commenced practice very early as a miniature painter, to assist in the wants of the family, and had formed a large and influential connection. Miss Berry, in her memoirs, says of her, 'She has a mother and eight brothers and sisters to support,' and intimates that it is dangerous to pay for her portraits before they are finished. She began an engraved work, 'Beauties of the time of George III.' The Prince of Wales, afterwards George IV., gave her many commissions, and a number of miniatures she painted for him are in the royal collection at Windsor. She married a man who pretended to family and fortune, and had neither. Her name first appears in the Academy catalogues in 1815, and then as Mrs. Mee. From that year she continued an occasional exhibitor up to 1836, about which time she retired from practice. She died at a very advanced age, May 28, 1851.

MEEN, MARGARET, *flower painter.* She practised in water-colours, and first appears as the exhibitor of a small landscape at the Royal Academy in 1775, and from that year to 1785 was a contributor of flowers and groups of flowers. She painted with much ability in a large, vigorous manner.

MEHEUX, FRANCIS, *engraver.* Born at Dover in 1644, and practised till the end of that century, both with the graver and in mezzo-tint.

MEHEUX, JOHN, *painter.* Practised in the second half of the 19th century. William Blake engraved after him 'Clorinda' and 'Robin Hood.'

MELLISH, THOMAS, *marine painter.* He practised about the middle of the 18th century, painting seaside scenes with figures, shipping, &c.

MERCIER, PHILIP, *portrait painter.* Was born at Berlin, of a French refugee family, in 1689, and educated in the Academy of that city. He studied in France and Italy, and afterwards went to Hanover, where Frederick, Prince of Wales, appointed him his portrait painter and brought him to England, retaining him in his service. After nine years he lost the prince's favour, and was dismissed. He then talked of abandoning his profession, and bought a small property in the country, but he soon returned to London, and took a house in Covent Garden, where he painted portraits and subjects of familiar life. He afterwards went to York, where he met with encouragement, and for a short time to Portugal and Ireland. There is a portrait by him of Queen Anne, and at the Garrick Club of Peg Woffington. Houston mezzo-tinted his 'Avarice' and 'Innocence,' and Faber and McArdell also engraved after him. He died July 18, 1760.

MERCIER, CHARLOTTE, *painter and engraver.* She was the daughter of the above, and, brought up to art, was skilled both as a painter and engraver. Her 'Four Ages: Childhood, Youth, Womanhood, and Decrepit Age,' were engraved by Ravenet. She was unmarried, and abandoning herself to a vicious life, she died in the workhouse of St. James', Westminster, February 21, 1762.

METZ, Miss CAROLINE M., *subject painter.* She was the daughter of Conrad Metz, a German artist, who came to London. She first exhibited flowers and fruit at the Academy in 1773–74, and in 1780 contributed drawings, and from that time finished designs in chalk—in 1781, 'Antony and Cleopatra;' in 1782, 'Boadicea;' in 1783, 'A Spartan Youth charged with Intemperance;' in 1788, 'The Feast of the Gods;' and continued to exhibit subjects of the same class, with occasionally a portrait or a landscape, up to 1794. Her 'Country School' is engraved by C. Turner. In 1772 Miss GERTRUDE METZ exhibited fruit and flowers at the Spring Gardens' Rooms.

MEVES, AUGUSTUS, *miniature painter.* He practised early in the 19th century, but does not appear to have exhibited. He died suddenly at Shoreditch, where he was

292

living, in 1818; and founded on some ambiguity in his will, and the statements of his widow, his son, then 33 years of age, assumed to be the Dauphin of France, probably with less ground of claim than other pretenders.

MEYER, JEREMIAH, R.A., *miniature painter.* Was born at Tubingen, Wurtemberg, 1735, and came to this country with his father at the age of 14. He entered as a student in the St. Martin's Lane Academy, of which he was for many years a member. He studied under Zincke 1757–58, paying 200*l.* for the two years' pupilage. In 1761 he gained the Society of Arts' premium for a profile of the King, to be used for a die. In 1762 he was naturalised, and was in 1764 appointed miniature painter to the Queen and enameller to the King. In 1769 he was one of the foundation members of the Royal Academy, and was a constant exhibitor, his works including several portraits of the King and Queen, the Prince of Wales and Duke of York. He last exhibited in 1783. He painted in oil and water-colours, and also in enamel, but his miniatures on ivory were unrivalled in his day. By his study of Reynolds he attained great power and elegance, and his works please by their life-like truth and expression, added to a quiet refinement of colour. He married Barbara Marsden, a young lady of great art talent, who gained several premiums from the Society of Arts. He lived many years on the south side of Covent Garden. At the latter part of his life he retired to Kew, where he died (January 20, 1789, in his 54th year) and was buried. Hayley complimented his art—

'Though small its field, thy pencil may presume
To ask a wreath where flowers eternal bloom.'

MEYER, H., *landscape painter.* Was a native of Holland, and obliged to leave his country, being involved in the revolution of 1788. He came to London, and gained a reputation as a landscape painter in water-colours, exhibiting at the Academy, chiefly Dutch scenes, 1790–91 and 1792. His works are usually of a small size, painted in the manner of Ostade, and highly finished. He introduced figures into his landscapes, which were drawn with great care and neatness. Some of his works are in tempera. He died in Berners Street, February 1793.

MEYER, HENRY, *engraver.* Was born in London about 1783, and was the nephew of Hoppner, R.A. He was the pupil of Bartolozzi, and following his style, his chief works are in the dot manner, but he also worked in mezzo-tint. He was principally engaged upon portraits, and engraved many. They are worked in the dot man-

ner, the drawing good, and the expression and likeness well preserved. Latterly he occasionally drew portraits, and was very successful in his likeness. He was active in the foundation of the Society of British Artists, one of the foundation members, a large contributor to their first exhibition in 1824, and an occasional contributor up to 1831. Among other works, he engraved the 'Princess Charlotte and Prince Leopold,' after A. Chalon, R.A.; 'Miss O'Neill as Belvidera,' after Devis; 'Sir Roger de Coverley,' after Leslie, R.A. He died May 28, 1847, aged 64.

MIDDIMAN, SAMUEL, *engraver and draftsman.* Was a pupil of Byrne. He appears as an exhibitor of landscape drawings at the Free Society in 1771, and at Spring Gardens in 1773 and 1775. In 1780 he exhibited 'stained drawings' at the Royal Academy, and continued an occasional exhibitor of views up to 1797. He practised his art in London, and was employed as an engraver by Alderman Boydell. He was greatly distinguished for his etching, and was engaged by Pyne, content to receive a weekly wage without ambition; but his great skill and taste soon made him known. He engraved after the old masters, and after Smirke, Farington, Gainsborough, Barret, Hearne, Cipriani, and finished his numerous works with scrupulous care. He excelled in landscape, and engraved 'Select Views in Great Britain,' published 1784-92; 'Picturesque Views and Antiquities of Great Britain,' published 1807-11. He died in Cirencester Place, December 18, 1831, aged 81.

MIDDLETON, JOHN, *landscape painter.* He was born at Norwich in 1828, and developed a love of art. He had some instruction from Crome, and was also assisted by Stannard. Practising in his native city, he first appears as an exhibitor at the Royal Academy in 1849, and from that year was a constant contributor. He painted effects of the seasons, particularly the early spring. He died at Norwich, of consumption, November 11, 1856.

MIDDLETON, CHARLES, *architectural draftsman and engraver.* He was in 1766 a member of the Incorporated Society of Artists, and on the establishment of the Royal Academy, and up to 1790, contributed to its exhibitions. He made many designs for country residences and garden decorations, and published some professional works—'Designs in Architecture, Cottages,' &c., 'Designs for Park Gates, Fences,' &c., 'Design for Coldbath Fields Prison,' 1788; and the same year, 'Design for the Pavilion at Brighton.' He was appointed architect to George III. He engraved several of his own designs. Died about 1818.

MIDDLETON, J. J., *draftsman and landscape painter.* He practised at the

beginning of the 19th century, his subjects being chiefly architectural views and views of towns. He was also engaged in panorama painting. His views of the remains of ancient buildings in Rome were published in 1820.

MILBOURN, JOHN, *portrait painter.* Pupil of F. Cotes, R.A. He gained a Society of Arts' premium in 1764, and practised in the latter half of the 18th century. He exhibited small whole-length and crayon portraits at the Royal Academy in 1773-74. A picture of 'Matrimony and Courtship,' by him, was engraved by Gaugain in 1789.

MILES, EDWARD, *miniature painter.* He was a native of Yarmouth. He practised in London in the latter part of the 18th century, and exhibited at the Royal Academy yearly, from 1786 to 1797. He was miniature painter to the Duchess of York and to Queen Charlotte. He died at Yarmouth.

MILLER, JAMES, *water-colour draftsman.* He was one of the early painters in water-colour and there are some good works of the time by him. He practised in the last half of the 18th century, and exhibited at the Academy landscapes, introducing figures and cattle, 1773-75.

MILLER, ANDREW, *mezzo-tint engraver.* He was born in London, it is believed, of Scotch parents, and was taught his art under Faber. He practised many years in Dublin, and was in that city in 1740. He is erroneously stated by Strutt to have been born there. He engraved, in mezzo-tint, Dean Swift, 1743; Robert Boyle, the chancellor of Ireland, 1747; and other works. He engraved Frank Hayman's designs, was one of his boon companions, and was much addicted to drinking, which accelerated his death. He died in Dublin about the middle of the century.

MILLER, WILLIAM, *history and portrait painter.* Born about 1740. Had much reputation in his day as a painter of historical subjects, and was engaged on Boydell's 'Shakespeare Gallery.' He also painted some portraits, which were solidly and faithfully executed. He was an exhibitor at the Academy from 1790 to 1803. He contributed whole-length portraits occasionally. In 1792, 'Ariadne;' in 1801, 'Death of Adonis,' and subjects of a lower class. Many of his works are engraved, among them—'Mrs. Jordan as The Romp,' by Carey; Scenes from 'Werther,' by Laurie; 'Last Moments of Louis XVI.,' by Schiavonetti; and 'Louis XVI. at the Bar of the Convention,' by Gaugain. He died about 1810.

MILLER, JOHN, *engraver.* He gained a premium from the Society of Arts in 1764, and practised about the middle of the 18th century. He had considerable

merit, and among other works by him are portraits of George III. and his Queen from the life.

MILLER, John, *architect.* He had studied in Italy, and practised in London in the last half of the 18th and the beginning of the 19th century. He exhibited at the Royal Academy, 1781–87, some drawings of London houses and architectural views in the Metropolis. He published 'Elements of Architecture restored to its original Proportion' and 'The Country Gentleman's Architect,' 1787. He designed in the Palladian style.

MILLER, John, *flower painter and engraver.* Born in London about 1750. He practised as a flower painter, and in 1766 received a premium from the Society of Arts. His flowers are natural, careful, and correct in their botanical details. He published, 1770–77, 'Illustratio systematis sexualis Linnæi,' the plates for which are drawn, etched, and coloured by himself.

MILLER, J., *miniature painter.* In the middle of the 18th century he practised in London, with some reputation. He died in Southampton Street, Bloomsbury, Jan. 8, 1764.

MILLINGTON, James Heath, *miniature and subject painter.* Was originally from Cork, though not of Irish parentage. He became a student of the Royal Academy in 1826, and gained most of the Academy prizes, though unsuccessful in his attempts to obtain the gold medal. He last exhibited at the Royal Academy 'A Magdalene,' in 1870. He was curator of the School of Painting for a short time till his death in 1873.

MILLNER, Thomas, *architect.* His designs for 'Gregories,' a mansion in Buckinghamshire, erected in 1712, is engraved in Campbell's 'Vitruvius Britannicus.'

MILLS, Alfred, *wood-engraver.* He was for above 40 years engaged in designing and cutting works for the illustration of children's books, in which he showed much ability. He died at Walworth, December 7, 1833, aged 57.

MILLS, George, *medallist.* He received three gold medals from the Society of Arts, and was distinguished by his medals of General Moore, Watt, West, Admiral Duckworth, George IV., and Sir F. Chantrey, R.A., his last work. He was an exhibitor at the Royal Academy from 1816 to 1823, and died at Birmingham, January 28, 1824, aged 31.

MILN, Robert, *engraver.* There are by him some plates, in a weak manner, of Scottish antiquities, published at Edinburgh in 1710.

MILTON, William, *engraver.* Practised in London, and was chiefly employed by the booksellers on illustrations. He died in 1790, and was buried at Lambeth.

MILTON, John, *medallist.* He was one of the engravers of the Royal Mint and medallist to the Prince of Wales. He was an exhibitor at the Academy from 1785 to 1802, but his contributions do not seem to have been works of a high class.

MILTON, Thomas, *landscape engraver.* Was born about 1745. He practised his art in London, and for several years in Dublin. He gained a great reputation. He engraved for 'Views of Gentlemen's Seats,' 1799; 'The Stafford Collection of Pictures,' 'Views of Castles in Ireland,' 1787; and 'Views in Egypt.' His grandfather was brother to the author of 'Paradise Lost.' He was a governor of the Society of Engravers. Died at Bristol, February 27, 1827, aged 84.

MILTON, John, *marine and landscape painter.* Practised in the last half of the 18th century as a painter of landscapes, marine views, and animals, excelling in dogs. He exhibited with the Free Society of Artists, 1769 to 1771, shipping, storms, rocks, &c. Several of his works were engraved—'A Strong Gale,' in mezzo-tint, by R. Laurie, 1774; 'The English Setter,' by J. Cook; six dockyard views, by J. Canot.

MITAN, James, *engraver.* Born in London, February 13, 1776. He was apprenticed in 1790 to a writing engraver, and was assisted in drawing by Agar, then by Cheeseman, and aspiring to be an artist, entered as a student in the Royal Academy. On the expiration of his apprenticeship he gained employment with some of the best engravers, and became distinguished by his ability as a line engraver. His best works are the illustrations of Inchbald's 'Theatre,' Stothard's vignettes to the 'Irish Melodies,' Smirke's 'Don Quixote,' Dibdin's 'Bibliographical Tour,' and a plate of Leslie's 'Anne Page.' He made some attempts at architectural design, produced an elaborate drawing for a chain bridge over the Mersey, and was a competitor for the proposed Waterloo monument. His health became impaired. He suffered an attack of paralysis, and died August 16, 1822.

MITAN, S., *engraver.* Was brother and pupil of the above. He engraved for Batty's 'Views of France,' and was employed upon Messrs. Ackerman's publications.

MITCHELL, John, *engraver.* Born in 1791. He practised in Edinburgh, and was distinguished by the finish and style of his works in the line manner. He engraved, after Wilkie, 'Alfred in the Neatherd's Cottage,' 1829; 'The Ratcatchers,' 1830. He died 1852.

MITCHELL, Robert, *architect.* He was an exhibitor at the Royal Academy from 1782, contributing in that year designs for a church, and in 1798, the last occasion of his exhibition, 'Design for the

Front of a Cathedral.' He erected several fine residences—Selwood Park, Berkshire; Moor-place, Herts; Heath-lane Lodge, Twickenham; Cottesbrooke, Northamptonshire; Preston Hall, Edinburghshire; and published, 1801, plans and views of the buildings he had erected.

MITCHELL, EDWARD, *sculptor*. He exhibited at the Academy in 1854 a medallion bust; in 1863, 'Venus surprised,' a marble bas-relief; followed, in 1864, by two busts. He was employed upon two colossal figures for Sir Arthur Guinness—'Erin' and the 'Archangel Michael,' when, owing to depression, caused by the loss of his wife, he committed suicide, April 17, 1872, aged 41.

MITCHELL, THOMAS, *amateur*. He was Master Shipwright's assistant at Chatham dockyard, and afterwards became Assistant Surveyor of the Navy. He was a good sailor and ship-builder, added to which he was a clever painter of marine subjects. He was an occasional honorary exhibitor at the Royal Academy from 1774—when he exhibited 'his Majesty's yacht coming to anchor in the Downs'—to 1789, and his exhibited works include 'The Burning of the French Fleet at La Hague,' 'A Storm, with shipwreck,' etc.

MOGFORD, THOMAS, *portrait painter*. He was a native of Devonshire, and practised for many years in that county, residing at Exeter. From 1838 to 1854 he was an occasional exhibitor of portraits, with sometimes a subject picture, at the Royal Academy—in 1838, 'Caught in the Fact;' in 1844, 'The Sacrifice of Noah;' in 1846, 'Loves of the Angels.' He had been for several years in failing health, and died at Guernsey in 1868.

MONAMY, PETER, *marine painter*. Born about 1670 in Jersey. His parents were poor, and he was sent to London when a boy and apprenticed to a house-painter on London Bridge. He was clever, and gradually improving himself in art, became a good painter of marine subjects, exhibiting his paintings in his windows to the many seafaring men who congregated in the neighbourhood. He was an imitator of the Vandeveldes, his execution good, his vessels well drawn, and his knowledge of art considerable. There is a large picture by him in Paper Stainers' Hall, dated 1726, and a sea-fight at Hampton Court, luminous and carefully painted, the colour good, but tame in its treatment of the subject. He is reputed to have excelled in calms. There are some pen drawings by him in Indian ink. He decorated a carriage for the unfortunate Admiral Byng with ships and naval trophies. He died at Westminster in the beginning of the year 1749.

MONOYER, JOHN BAPTISTE, *flower and ornamental painter*. Born at Lille, 1635; educated at Antwerp, where he studied as a history painter. But returning to Lille he applied himself to flower painting, and with so much success that he was employed by Le Brun in the ornamental part of his work at Versailles, and in 1663 made a member of the French Academy. He was brought to England by the Duke of Montague to embellish his house in Bloomsbury, and was afterwards employed by several of the nobility, and by Queen Mary. He commenced the publication of a large collection of flowers and fruits, which he etched himself in a bold, free style. He died in London in 1699, aged 64. ANTONY MONOYER, his son and pupil, painted flowers and fruits with much skill.

MONRO, HENRY, *portrait and subject painter*. Born in London, August 30, 1791. Was the son of Dr. Monro, who was well known as a physician and by his friendship with the early painters in water-colours. He was educated at Harrow, and entered the navy, which he quitted before he was formally placed on the books of the frigate he had joined. For a short time he had a wish to enter the army; but he at last decided upon art, and in 1806 was admitted a student of the Royal Academy. When a little advanced he attempted portraiture, chiefly in crayons, and there is a portrait by him of his father in this manner at the College of Physicians of more than ordinary merit. He then vigorously commenced painting in oil, making studies for some great works which he projected, and occasionally sketching from nature. In 1811 he exhibited at the Academy 'A Laughing Boy,' 'Boys at Marbles,' and some portraits and works of the same class in the following year. In 1811 he visited Scotland, and falling from his horse was seriously injured, and from this and subsequent neglect suffered a dangerous illness. On his restoration to health in 1812, he painted 'Othello, Iago and Desdemona,' exhibited at the Academy in the following year; and at the British Institution, 'The Disgrace of Wolsey,' for which the directors awarded him a premium of 100 guineas. These were the only pictures of a high class he painted; but he left some clever drawings on grey paper in black and white chalk, and some etchings. In January 1814 he was seized with a fatal malady, of which he died on March 5 following, in his 23rd year.

MORE, Sir ANTONIO, Knt., *portrait painter*. Was born at Utrecht in 1525, and studied under Schoreel and at Rome. In 1552 he went to Spain, and painted a portrait of Philip II. in the same year. He became a favourite with this prince, and was sent by him to take the portrait of Donna Maria Infanta of Portugal, his

first wife. He afterwards came to England and painted the Princess Mary, Philip's second wife. He stayed in this country till her death, and painted the portraits of many distinguished persons here, as he held the office of painter to their Majesties. He returned to Spain with Philip after the Queen's death, but having offended this monarch by an ill-timed familiarity, retired to the Netherlands, where he practised both at Antwerp and Brussels. He was a very handsome man, and was accustomed to live in great state. His works are marked by their correct drawing and rich tone of colour, and by their breadth of treatment in light and shade. The exhibitions of the old masters at the Royal Academy and Lord Derby's portrait exhibitions, brought many fine pictures by this painter before the public which have hitherto been hidden in private collections. He died at Antwerp in 1581, aged 56.

MOORE, JACOB, landscape painter. Born 1740, in Edinburgh, where he was apprenticed, and studied art under Alexander Runciman. He went to Rome about 1773, and acquired his reputation in landscape there. He laid out for Prince Borghese the grounds adjoining his villa on the Pincian Hill, giving the Romans the first specimen of an English garden; and decorated a room in the prince's villa. He painted, in the manner of Claude, subjects from the Campagna and in the suburbs of Rome; and though of much repute in his day, was weak and poor in manner and colour. But the ambitious character of his art is evidenced by the works which, between 1784 and 1789, he sent from Rome to the Royal Academy for exhibition. For instance, in the former year, 'The Eruption of Mount Vesuvius, in which the elder Pliny lost his life;' in 1788, 'The Deluge,' and other works of this class. He resided chiefly in Rome, where he died of bilious fever in 1793. Miss Berry mentions in her journal having visited his studio there in 1783; and Goethe, in 1787, speaks with high praise of the works then in his studio. He left some property; and some plates of his works, with other effects, were sold in London after his death. John Landseer engraved after him, in 1795, 20 views of the South of Scotland.

MOORE, GEORGE BELTON, architectural draftsman and teacher. Was a frequent exhibitor of pictures at the Royal Academy, and a teacher of drawing at the Military Academy, Woolwich, and University College, London. He wrote 'Perspective, its principles and practice,' and 'The Principles of Colour applied to decorative Art,' both published in 1851. He is said to have drawn out the perspective in the Railway Station by W. Frith, R.A. He died

296

early in November 1875, in his 70th year.

MOORE, ALEXANDER POOLE, architectural draftsman. He was an accurate and faithful draftsman, and from 1793 till his death a constant exhibitor at the Royal Academy. His first contributions were drawings of the City churches. About 1797 he was employed in the office of the Surveyor of Christ's Hospital. In 1801 he exhibited the elevations of St. Paul's, and of St. Peter's, at Rome. He died young, July 11, 1806.

MOORE, MARY, amateur. Mentioned by Walpole as having painted some portraits about the middle of the 17th century. There is a portrait by her, in the Bodleian Library, of Cromwell, Earl of Essex, but believed to be a copy only.

MOORE, FRANCIS JOHN, sculptor. Born in Hanover; settled in London. In 1766 he was awarded a premium by the Society of Arts for an allegorical bas-relief. He was a successful competitor for the Beckford monument, erected in the Guildhall. There is also a monument by him to Dr. Thomas Wilson, in St. Stephen's, Walbrook. But neither of these works say much for his ability. He died in York Place, New Road, January 21, 1809.

MOORE, JAMES, engraver. Practised about the middle of the 18th century, and was in 1763 a member of the Free Society of Artists. There are by him a portrait of Whitfield, after Jenkins, 'The Four Quarters of the World,' 'Joseph and Potiphar's Wife,' etc.

MOORE, SAMUEL, amateur. Was employed in the Custom House in the reign of Queen Anne, and as an amateur drew and etched several laborious works, among them 'The Coronation Procession of William and Mary;' and some medleys, imitating paintings, drawings, prints, and other objects grouped together. He engraved some of the plates for a series of 'Costumes à la Mode.' His work was coarse and heavy in manner. He practised about 1715.

MORIER, DAVID, portrait and animal painter. Born at Berne about 1705; he came to England in 1743, and was introduced to the Duke of Cumberland, who settled upon him a pension of 200l. a year. He painted portraits, horses, dogs, and battle-pieces, and met with great encouragement, both George I. and George II. sitting to him. He was in the Fleet Prison in 1769, without hope of release. He died in January 1770, and was buried in St. James's, Clerkenwell, at the expense of the Incorporated Society of Artists, of which he was a member.

MORISON, DOUGLAS, water-colour painter. Was pupil of Mr. Frederick Tayler, and was admitted an associate exhibitor of the Water-Colour Society in

1843. He died young in 1846 or 1847. He is known by some views of Haddon Hall, which he published.

MORLAND, H., *portrait painter.* Bromley catalogues portraits painted by an artist of this name in the reign of William III.

MORLAND, GEORGE HENRY, *subject painter.* Born the beginning of the 18th century. He lived on the south side of St. James's Square, painted genre subjects, and found encouragement. He was assisted, in 1760, by an advance of money by the Society of Artists. Many of his works are engraved, among them — 'The Pretty Ballad Singer,' by Watson, 1769 ; 'The Fair Nun unmasked,' 1769 ; 'The Oyster Woman,' by Philip Dawe. He died some time after 1789.

MORLAND, HENRY ROBERT, *portrait painter.* Son and pupil of the above. He painted portraits both in oil and crayons, chiefly the latter. He also scraped in mezzo-tint, and was a picture-cleaner and picture-dealer ; but with all these means of living he became bankrupt. He was a man of unsettled habits, frequently changing his residence. His chief works were in crayons. He left numerous drawings, which are usually signed, and though his works aimed no higher than the mere domestic incidents of life, they are not without merit. He exhibited in 1772-74 and 1776 at the Free Society, in the latter year no less than 26 works, and was from 1771 to 1793 an exhibitor of portraits and domestic subjects at the Academy. He painted a portrait of George III., which was engraved by Houston ; a portrait of Garrick as 'Richard III.,' which is in the Garrick Club ; and at Lord Mansfield's, Caenwood, are portraits in oil by him, called the two beautiful Miss Gunnings, but are more probably from his own daughters. They are both, as was his manner, employed, the one in washing, the other ironing ; carefully drawn, and laboriously finished, expressive but cold, thin, and starved in colour. They are published among Carington Bowles' by no means select series of prints as 'Lady's Maid ironing' and 'Lady's Maid soaping linen.' Many of his later works shew much greater power, and there are some fine mezzo-tints after him. At the latter part of his life, he dwelt in Stephen Street, Rathbone Place, where he died, November 30, 1797, aged 85. MARIA MORLAND, his wife, was an exhibitor at the Academy in 1785-86.

› MORLAND, GEORGE, *animal and subject painter.* Son of the above. Was born in the Haymarket, June 26, 1763. He very early showed a talent for drawing. He was carefully, even strictly brought up, receiving the elements of a fair education, and in art his dawning abilities were most assiduously cultivated and encouraged by his father. In 1779 the name of 'Master George Morland' first appears as an honorary exhibitor of sketches at the Royal Academy. He exhibited at the Associated Society of Artists' Exhibition as soon as 1775. He was very early admitted to the Academy Schools, where he studied during several years. Copying also from the masters of the Dutch and Flemish Schools, he made great progress. He continued to exhibit occasionally at the Academy, but as he became conscious of his own powers, he rebelled against the restraints of home, and shortly broke entirely loose. His innate dislike to work was soon apparent. He gave himself up to idle folly and extravagance, and fell into the hands of a picture-dealer, in whose house he boarded. After a time he escaped from this bondage, went to Margate, where he found employment in painting miniatures, and from thence to France, where he might have earned a subsistence, but reckless and unable to settle to any continuous occupation, he returned to his idle companions.

Soon after he went to live at Kensal Green, where he painted his 'Idle and Industrious Mechanic,' which were engraved and published and had a large sale. Upon this success he married, in 1786, the sister of his friend, William Ward, the mezzotint engraver, and again living quietly for a while he improved in his art ; but his handsome young wife losing her first child, and a long illness succeeding, he was tempted from his home, and allured by his love of company and passionate fondness for music, again fell into idle and unprofitable connections, and became confirmed in habits of intemperance and dissipation, from which he never after was able to disentangle himself. Painting from hand to mouth, surrounded by a class of unprincipled men, who made a traffic of his art, the victim of chicanery and fraud, hunted from place to place by his creditors, and always at hide-and-seek, his art was debased and degraded. Yet in 1791-93 and 1794 he sent some pictures to the Academy, and struggled for a time to give some completeness to his works ; but a rapid pencil was required to meet his constantly recurring wants, and he was fast exhausting his memory, on which he relied, and his powers.

His toil was nevertheless excessive. He seldom left his painting-room, and his complaints of the slave-like labour to which he was subjected are truly touching. Between 1800 and 1804 he painted for his brother alone, who was a dealer in his works, no less than 192 pictures, and probably as many more for other persons. Such was his life. His excesses increased. Taking his meals by his easel, drinking strong liquors all day long, surrounded by dogs, pigs,

birds, and other animals, living in constant dread of a prison, in November 1799 he was arrested, and taking a house within the rules, it became a rendezvous for all his profligate companions. He was intoxicated frequently, lay the night through on the floor, and the ruin of his health and character was complete. In 1802 he was released under the Insolvent Act, but was broken-hearted, downcast, harassed by diseased fears, and his sight and intellect both impaired. In this state he was soon a prisoner again for a publican's score, and overwhelmed with misfortune and despair, died in a spunging-house in Eyre Street, Cold-Bath Fields, on October 29, 1804. His neglected, wronged wife died three days after, and both were buried together in the new ground attached to St. James's Chapel, Hampstead Road.

His works were founded upon the everyday life about him, and were over and over again repeated, his boon companions frequently his models. His pictures, hastily conceived, were painted with little thought or previous study. They display little mind or invention, yet, easily understood by all, they were popular, and he enjoyed a reputation in his day which has not been maintained. In his colour the greys and ochres predominate; his landscape is wanting in atmosphere; his painting slight, and frequently slovenly. He was largely assisted by his pupils, and his works have been the prey of many copyists. There is a spirited etching by him of 'A Fox with a Pullet.' His life was written, with critical observations on his works, by J. Hassell, 1804; by his friend, G. Dawe, 1807; by Blagdon, with list of the possessors of his principal pictures, and 20 large tinted illustrations, 1806; and in the 'Memoirs of a Picture,' by William Collins, 1805.

MORLEY, FRANCES, Countess, *amateur*. Daughter of Thomas Talbot, Esq. Married, in 1809, to the first Earl of Morley. She made many good copies from the old masters, which decorate the drawing-room and other apartments at Saltram. Died December 7, 1857.

MORRIS, ROBERT, *architect*. Practised in the early part of the 18th century. He built Wimbledon House for Lord Spencer, a well-balanced, neat elevation, published in Wolfe and Gandon's work; a small mansion for Mr. T. Wyndham, on the Thames, at Hammersmith, of a simple and pleasing elevation; and the Duke of Argyll's seat at Coome Bank, Kent. He published, 1728, 'An Essay in Defence of Ancient Architecture;' 1734, 'Lectures on Architecture;' 1754, 'Rural Architecture.'

MORRIS, THOMAS, *engraver*. Born about 1750. Was the pupil of Woollett, and much employed by Alderman Boydell. He died towards the end of the century.

298

Among other works, he engraved two large-sized street views, after Marlow—'View of St. Paul's' and 'View of the Monument,' 1795, both boldly executed and crowded with figures; 'Skiddaw,' after De Loutherbourg; 'Landscape and River,' after R. Wilson; 'Hawking and Fox Hunting,' after Gilpin; 'La Femme rusée,' after Collet.

MORRISON, Sir RICHARD, Knt., *architect*. Was the son of an architect at Cork, and originally intended for the Church, but became a pupil of Gandon, the well-known architect of Dublin. He then had a civil appointment in the Ordnance, which he held only a short time, when, taking up the practice of his profession, as an architect, he obtained considerable employment. He built the Clinical Hospital at Dublin, and several of the county court-houses. He acquired a good property, and was knighted by the Lord Lieutenant of Ireland in 1841. Died at Dublin, aged 82, October 31, 1849.

MORTEN, THOMAS, *subject painter*. Was born at Uxbridge in 1836. He studied at Mr. Leigh's art school, and was largely employed in designing for the illustration of periodical and other works. His designs for an edition of 'Gulliver's Travels' showed much invention and humour. He exhibited at the Royal Academy, in 1863, 'Conquered, but not Subdued;' and in 1866, his last work, 'Pleading for the Prisoner,' which was of much promise. But greatly embarrassed in his affairs, he unhappily committed suicide, September 23, 1866.

MORTIMER, JOHN HAMILTON, A.R.A., *history painter*. Born in 1741, at Eastbourne, where his father owned a mill, and afterwards held the office of collector of customs. He imbibed a love of art from his uncle, who was a painter of some ability, and was sent to London, and placed for three years under Hudson, studying at the same time in the Duke of Richmond's Gallery, and later at the St. Martin's Lane Academy. He is also said to have studied under Edge Pine, and Reynolds. With such teaching he acquired a good knowledge of the figure, and obtained several premiums from the Society of Arts for his drawings from the antique. In 1763 he gained the Society's first premium, and in 1764, in competition with Romney, the award of 100 guineas for his 'St. Paul preaching to the Britons.'

He was a member of the Incorporated Society of Artists, and exhibited with them occasionally from 1763 to 1773. In the latter year he was vice-president of the Society, and was looked upon as of much promise, though he did not gain employment. He disliked portraiture, and was not happy in his likenesses. His portrait, however, painted by himself, is in the National

Portrait Gallery. He lived in the neighbourhood of Covent Garden, made acquaintance with the wits of the day, was fond of company and sports, and a great cricketer, a fascinating and dangerous companion, he became extravagant and dissipated. His strong frame and handsome person were shattered by his excesses, and his progress in art no longer justified the early expectations entertained of him. But in 1775 he married, and was happily able to abandon his vicious habits. Quitting the temptations of his London life, he went to reside at Aylesbury, and while there painted 'The Progress of Vice' and 'The Progress of Virtue,' and a few portraits ; also a ceiling at Brocket Hall, for Lord Melbourne.

With restored health and vigour his enthusiasm for his art returned. He exhibited at the Academy for the first time in 1778, contributing a small whole-length family group, a subject from Spenser, and some landscapes, and was elected an associate of the Academy in the November of that year. He returned to London in the same month, and resided in Norfolk Street, Strand. Here, after an illness of only 12 days, he died of fever, February 4, 1779, in his 38th year. He was buried at High Wycombe, where his picture of 'St. Paul,' which gained the Society of Arts' premium, is the altar-piece of the parish church. Eight works by him were exhibited, as, it is said, he intended, at the Academy in 1779—they comprised 'The Battle of Agincourt,' 'Vortigern and Rowena,' a small landscape, and some washed drawings.

Mortimer possessed an unbridled imagination. He loved to paint the grotesque and horrible—banditti and monsters. His attempts at character from Shakespeare, though praised at the time, are extravagant and unreal. He was not successful as a colourist. He devoted his time to trifles, and is better known by his drawings than his pictures ; they possess much spirit and are good in composition. He etched many of his own designs, of which 11 large plates were published in 1768 and nine in 1778, but many more were finely etched by Blyth. Val. Green mezzo-tinted a portrait of him by himself. Ryland engraved his 'Battle of Agincourt.' He designed the 'Elevation of the Brazen Serpent' for the great window at Salisbury Cathedral, and made the cartoons for the stained glass at Brasenose College, Oxford. He designed also for Bell's 'Theatre,' Bell's 'Poets,' and other publications.

MORTON, ANDREW, *portrait painter*. Born at Newcastle-on-Tyne, July 25, 1802. He was a student in the schools of the Royal Academy, gained a silver medal in the life school in 1821, and the same year exhibited a portrait, his first contribution. From that time he was a constant exhibitor of portraits, with occasionally a portrait-group. He was of some name in his art, which did not extend beyond portraiture, and had many sitters of distinction. He was assisted by the Fitz-Clarence family, and there is by him a good portrait of William IV. in the gallery of Greenwich Hospital. He died August 1, 1845.

MOSER, GEORGE MICHAEL, R.A., *enameller and modeller*. Was born in 1704, the son of a sculptor at St. Gall, and came to England at an early age. Soon attracting notice by his ability as a chaser, he was employed by an eminent cabinet-maker as a chaser for the brass-work with which the furniture of that day was decorated. He also distinguished himself as a carver and enameller, and found employment in the decoration of trinkets in the manner then in vogue. He painted in enamel, for the watch of George III., the portraits of his two eldest sons. He was also an excellent medallist and designed the King's Great Seal.

He was for many years a member of the St. Martin's Lane Academy, and was elected the treasurer and manager, and was also, 1766, a member of the Incorporated Society of Artists. He was one of the most active of the founders of the Royal Academy, and became the first keeper, an office for which his knowledge of the figure made him well qualified. In 1769 and 1770 he exhibited some chasings and medals, his only contributions to the Academy. He had high merits as an artist, excelling not only as a chaser but as a medallist, and he painted in enamel with great beauty and taste. He died in his apartments at the Royal Academy, January 23, 1783, aged 78, and was buried at St. Paul's, Covent Garden. His large collection of works of art were sold by auction by Mr. Langford in the same year.

MOSER, MARY, R.A. (afterwards Mrs. LLOYD), *flower painter*. Was the only child of the above. She showed an early inclination to art, and gained the Society of Arts' premiums for her drawings in 1758 and the following year. She exhibited at the Spring Gardens' Rooms in 1761 and 1762, and distinguished herself by the admirable way in which, with great taste, she painted flowers, well composed, sweetly coloured, and most carefully finished. She was elected a member of the Royal Academy on its foundation in 1768, and was, from its first exhibition up to 1790, a constant contributor, except in the years 1786 and 1787. Her works were chiefly flowers, with an occasional portrait or classic subject. In 1789 she exhibited 'Atalanta and Hippomenes ;' in 1790, 'Proserpine gathering Flowers ;' in 1792, a landscape, and her name next appears in 1798 as Mary Lloyd. In that year, and in 1800 and 1802,

299

Mortimer Thos-Painter

her last contribution, she exhibited a classic or historic work. Queen Charlotte employed her to paint a room at Frogmore, where her work still exists, for which she received above 900l., and her Majesty for many years showed a friendly interest in her. She was very near-sighted, an amiable, clever, lively woman, and is charged with a passionate flirtation with Fuseli, R.A. After many years' practice in her profession, she married Captain Hugh Lloyd, and then painted as an amateur. She was left a widow, and died in Upper Thornhaugh Street, Bedford Square, May 2, 1819, and was buried at Kensington.

MOSER, HANS JACOB. Was the brother of the foregoing George Michael Moser. He came to England at the age of 9 years, and practised here as an artist, towards the middle of the 18th century, with some success.

MOSER, JOSEPH, enameller. Born in Greek Street, Soho, in June 1748, son of the above Hans Jacob Moser. He was intended for a painter, and studied art during 15 years. He was a constant exhibitor at the Academy from 1774 to 1782, chiefly of enamel heads from the antique for jewellery, with an occasional portrait in enamel, and, after a lapse of four years, exhibited for the last time in 1787. Then marrying, he was enabled to lay down his palette and retire into the country. Later in life he was appointed a police magistrate, and sat at the old Queen Square Court, and afterwards at Worship Street.

MOSES, HENRY, engraver. He commenced practice early in the 19th century, and passed a long life in the pursuit of his art, in which he attained great skill and accuracy, and was one of the engravers attached to the British Museum. Among his chief works, which were mostly in outline, are 'The Gallery of Pictures painted by Benjamin West,' 1811; a 'Collection of antique Vases,' 1814; 'Picturesque Views of Ramsgate,' 1817; 'Vases from Sir H. Englefield's Collection,' 1819-20; and in parts, 'Sketches of Shipping,' drawn and etched by himself, 1825, followed by the 'Marine Sketch-book.' There are also engravings by him after Barry, R.A.; Northcote, R.A.; Opie, R.A.; Retsch, and others. He died at Cowly, Middlesex, February 28, 1870, in his 89th year.

MOSLEY, CHARLES, engraver. Practised in London about the middle of the 18th century. He was chiefly engaged on portraits, and employed by the booksellers. But he both designed and engraved some political caricatures, 1745. He assisted Hogarth in engraving 'The Gate of Calais.' There is a fine plate by him after Vandyck's 'Charles I. on Horseback,' and an engraving of the shooting of three High-

landers on the parade in the Tower 1743. He died about 1770.

MOSNIER, JEAN LAURENT, portrait painter. Was born in France, and became painter to Louis XVI. and member of the academy in Paris. He fled to this country on the Revolution, settled here as a portrait painter, and met with encouragement, many distinguished persons sitting to him. He exhibited at the Royal Academy from 1792 to 1795, and was at that time living in London.

MOSS, WILLIAM, architectural draftsman. He was a student of the Royal Academy, and exhibited there from 1775 to 1782. In 1778 he received the Academy gold medal for his design for a church in the Corinthian order. He did not exhibit after 1782, in which year he contributed a design for a cathedral, a work of great merit. He painted some landscapes, and both drew and etched. Two views of Somerset House by him were aqua-tinted by F. Jukes.

MOSSMAN, WILLIAM, sculptor. He was a Scotch artist, and coming to London, was for some time employed by Sir Francis Chantrey, R.A. He practised for a time in London, and afterwards both in Glasgow and Edinburgh. He died 1851.

MOSSMAN, GEORGE, sculptor. He was younger brother of the above, and was born in Edinburgh. He removed to Glasgow, and studied in the art school there. Afterwards he came to London and entered the Academy Schools, gaining the medal in the life school. In 1846, while in London, he exhibited at the Academy 'The Guardian Angel forsaking Paradise,' a basso-relievo, and 'Prince Charles after Culloden.' His health failing in London, he returned to Glasgow, and assisted in his brother's studio. His chief work was a life-size figure of 'Hope.' He died at Glasgow, in 1863, aged 40.

MOSSOP, WILLIAM, medallist. He was born in Dublin in 1751, and early in life found employment in cutting stamps for the linen manufacture. Attempting better things, he produced in 1784 a medal of Ryder, the comedian, which gained him employment on works of a higher class. He died of apoplexy, in 1804, aged 53.

MOSSOP, WILLIAM STEPHEN, R.H.A., medallist. Son of the above. Was born in 1788, educated in Dublin, and at the age of 14 years was admitted to the art schools of the Dublin Society. He was the private pupil of Francis West, and had at the same time the assistance of Edward Smith. Before completing his 17th year he produced his first medal, a work of much promise. He made his designs in wax, always larger than his intended medal, and first undraped. From these he commenced his die in metal. He had attained great purity

Mottram. *Engraver (16*

of taste, and about 1820 he began a series of Irish medals, of which he finished six— Usher, Swift, Charlemont, Sheridan, Grattan, Moore. On the visit of George IV. to Ireland he published a medal, the reverse a figure of Hibernia, and though finely executed, it did not remunerate him. He was a partisan, and party stood in his way. He soon after began a medal of 'Hercules slaying the Hydra,' whose heads represented those of three prominent political agitators in Dublin; but the work never got beyond the model. He died in the early part of 1827, aged 39.

MOUNTAGUE, WILLIAM, *architect and surveyor.* He was a pupil of George Dance, R.A., and for many years his chief assistant. In 1812 he was appointed surveyor to the Improvement Committee, and was charged with the formation of the Pavement, Finsbury, and also with the erection of the Debtors' Prison in Whitecross Street. He had continued Mr. Dance's assistant, and on his resignation of the office of 'clerk of City's works,' he succeeded him in 1816. He was also one of the district surveyors of the City, and had besides an extensive private practice. He died April 12, 1843, aged 70, and was buried in the Bunhill-fields Burial-ground. His employment was more that of surveyor than architect. Among his chief works, in addition to the above, are the Guildhall Courts of Law, 1821; Farringdon Market, 1824; the library, Guildhall, 1825, since removed; the committee-rooms and lobbies, Guildhall, 1841.

MOUNTSTEPHEN, E. G., *wax modeller.* Was born in the county of Meath. He came to London about 1781, and settling in the Metropolis, commenced practice as a portrait modeller in wax, and arrived at great excellence. He was an exhibitor at the Royal Academy from 1782 to 1791, in 1789 exhibiting a very fine head of the Duke of Orleans. He afterwards went to the Continent, where he died.

MÜLLER, WILLIAM JAMES, *landscape and figure painter.* Born at Bristol in 1812. His father, a German clergyman, was the curator of the Bristol Museum, and published some scientific works. He was an apt scholar, and had a taste for botany and natural history. He was intended for an engineer, but gave early indications of a genius for drawing and adopted art. He received his first instructions in art from J. B. Pyne, a fellow-townsman, but he soon turned to nature as his guide. He exhibited at the Royal Academy, for the first time in 1833, 'The Destruction of Old London Bridge, Morning.' In 1833-34 he visited Germany, Switzerland, and Italy, and returning to Bristol, he commenced his professional career there, without finding much encouragement. In 1836 he exhibited both at the Royal Academy and in the Suffolk Street Gallery; at the former his 'Peasants on the Rhine waiting for the Ferry Boat,' and at the latter he continued to exhibit in the two following years. In 1838 he visited Greece and Egypt, and again returned to Bristol. About the end of 1839 he came to reside in London, and his works soon found purchasers. He sent his pictures again to the exhibitions, and exhibited yearly at the Academy till his death.

On the Government expedition to Lycia in 1841, he asked and obtained permission to join it, and that he might freely follow his own art, he defrayed his own expenses. He made a valuable collection of sketches, from which his 'Burial-ground, Smyrna,' exhibited at the Academy, 1844, and his 'Tent Scene, Xanthus,' were painted. His merits were now fully recognised. He received many commissions, but he was unequal to the task. His heart was diseased; he was greatly reduced in strength by a continued hæmorrhage from the nose; he returned to Bristol, seeking rest and advice, and though he continued to paint occasionally, he gradually succumbed to his disease, and died there September 8, 1845. His manner was original. He painted in a simple and broad style, rich and glittering in colour; his figures were characteristic and well introduced, and his Eastern landscapes well studied and true to nature, yet his art somewhat approached to scene painting. He published, in 1841, 'Picturesque Sketches of the Reign of Francis I.' At a three days' sale of his works at Christie's, in May 1846, they realised 4600l. A memoir of his life by N. N. Soley was published in 1875.

MÜLLER, JOHN SEBASTIAN, *engraver.* Was born in 1720. He engraved Hayman's designs for Milton's 'Paradise Lost,' and was living in 1760.

MULLINS, GEORGE, *landscape painter.* He was born in Ireland, and studied in the Dublin Schools under James Manning. He found employment in a manufactory at Waterford, where he painted snuff-boxes and trays in imitation of the Birmingham ware. He came to London, where he practised landscape painting for several years. His works are spoken of as excelling in tone and colour, and showing much painter-like feeling. He is stated to have died in Dublin about 1771, but it seems probable he was living in London several years later.

* MULREADY, WILLIAM, R.A., *subject painter.* Was born at Ennis, Co. Clare, April 30, 1786. His father was a master leather-breeches maker, and soon after the birth of his son removed to Dublin with his family, and carried on his business there for two or three years, and then came to London, and resided in Compton Street

301

Soho. Here the son was put to school, and was afterwards placed under a Romish priest, and gained some knowledge of Latin. He had early showed an aptitude for drawing, and at the age of 15 was admitted to the schools of the Royal Academy. In 1807 he illustrated a child's penny book— 'The Butterfly's Ball; or, The Grasshopper's Feast,' which was so popular that it was followed in the same year by 'The Lion's Masquerade,' 'The Peacock at Home,' and 'The Lioness's Ball;' and in the following year by 'The Elephant's Ball,' 'The Lobster's Voyage to the Brazils,' 'The Cat's Concert,' 'The Fishes' Grand Gala,' 'Madame Grimalkin's Party,' 'The Jackdaw at Home,' 'The Lion's Parliament,' 'The Water-king's Lévee;' and in 1809 by 'Think before you Speak,' which concluded the interesting little series.

These works show what were some of his early employments in art, which it is well known were very various. He drew portraits, taught drawing, which indeed he continued to do all his life, and assisted in some panorama painting. In 1803 he exhibited his first picture, 'The Crypt in Kirkstall Abbey,' at the Royal Academy, followed in 1806 by some views in York city; in 1807, 'Old Caspar,' his first figure subject, at the British Institution. In 1808 he exhibited some old houses in Lambeth, and 'The Battle' at the Academy. Before this time, when he was only 18 years of age, and was literally earning his daily bread, he had married, but early in life separated from his wife. His first works were landscape, but he soon found the true bent of his genius, and studying devotedly the Dutch masters, his progress was unusually rapid. His first important work was 'The Carpenter's Shop,' exhibited in 1809 at the British Institution, a quiet scene of everyday life, with no other story. In 1811 he exhibited 'The Barber's Shop' — a loutish boy brought to the village barber to be shorn of his unkempt locks; and still showing marked improvement— with more attempt at character and expression — continuing to make boys the foundation of his subject, he painted, in 1813, 'Boys Fishing;' in 1815, 'Idle Boys,' which secured him his election as associate of the Academy in that year, and in 1816, 'His Fight interrupted,' the big bully of the school vanquished by a little hero, over whom he had attempted to tyrannise. This work added to his growing reputation, and he was in 1817 elected a full member of the Academy.

He was now the father of four boys; he had gained the full honours of his profession, and also, with the favour of the public, confidence in his own powers, and from this time a gradual change took place in his art, and he became more original in his

302

manner. He painted 'The Village Buffoon,' 'The Dog with two Minds,' and another popular work, 'The Wolf and the Lamb,' exhibited 1820. Continuing in this course, his 'Interior of an English Cottage,' 1828, was a work of high finish and great art merit. His 'Seven Ages' had more of subject and design than is usual with him, and was followed by his 'Giving a Bite,' 1838; 'The Sonnet,' 1839, and 'First Love;' and in 1838, 'All the World's a Stage,' in which works the peculiarities and power of his art are fully displayed. In 1840 his illustrations on wood to an edition of the 'Vicar of Wakefield' were published, and from these graceful designs he painted some of his most perfect pictures — 'The Whistonian Controversy,' 'Burchell and Sophia,' and 'The Wedding Gown.' In 1848 a fine collection of his pictures and drawings was exhibited at the Society of Arts, intended as the first of a series of the works of our eminent living artists. At Mr. Thornhill Baring's suggestion he designed the first postage envelope in 1840.

His life was passed in constant study. He said, when examined by the Royal Academy Commission, 'I have, from the first moment I became a visitor in the life school, drawn there as if I were drawing for the prize;' and to this his chalk studies, which are inimitable for their drawing and exquisite finish, are a witness, and a proof of his remarkable powers. His choice of subject was feeble, but if on this ground his works lack the interest of those of some of his contemporaries, they will always possess a charm to the lover of art from his beautifully minute execution, the brilliant harmony of his colour, and the extreme completeness of every part of his work. In all these he has left a great example to the students of the English school. His life was a solitary one, but was devoted to the last to his art. His last evening was spent at the Academy; on the following morning, July 7, 1863, he was no more. He was buried in the Kensal Green Cemetery, where his friends raised a monument to his memory. The nation is rich in his works by the bequests of Sheepshanks and Vernon, now at the South Kensington Museum. William Godwin wrote a book entitled 'The Looking-glass Life of a Genius or Painter,' which contained the incidents of this painter's life, and was illustrated by some of his earliest works, drawn when he was three and four years old.

MULVANY, THOMAS JAMES, R.H.A., *landscape painter*. He was born in Ireland, and practised there early in the 19th century. He contributed to the Dublin Exhibition in 1809; was a strenuous advocate for the grant of a charter of incor-

poration to the artists of Ireland, and one of the members of that body when incorporated in 1823, and became the keeper of the Institution in 1841. His works were well esteemed in Dublin, but he does not appear to have exhibited in London. He edited the 'Life of James Gandon, Architect,' and died, about 1845-46, before the entire completion of this work.

MULVANY, GEORGE F., R.H.A., *subject painter*. Son of the foregoing. He was born in Dublin in 1809. He studied in the schools of the academy there, and afterwards in Italy. In 1832 he was elected an associate of the Royal Hibernian Academy, and succeeded as keeper on his father's death. He was greatly instrumental in the foundation of the National Gallery in Dublin, of which he afterwards became the director. He sent to the Royal Academy, London, in 1836, an 'Infant Bacchus;' and in 1839, 'Various Attractions, a Scene in the Louvre.' Among his works may be mentioned his 'White Man cast upon the Red Man's Shore,' 'First Love,' 'The Peasant's Grave.' He died in Dublin, February 6, 1869.

MUNN, PAUL SANDBY, *water-colour painter*. His name first appears as an exhibitor at the Royal Academy, in 1798, of views in the Isle of Wight. He was then living at Greenwich, and continued to exhibit Welsh and other views up to 1805, when he became an associate exhibitor of the Water-Colour Society; and from that time to 1813 exhibited with that body views, chiefly in the North of England, and once again, in 1815, when the Society was open to the whole profession. His works, partaking of the early manner, are clever, but weak. Some of them have been engraved. He died at Margate, February 11, 1845, aged 72. JAMES MUNN, probably a relative, exhibited with both the Incorporated and the Free Society landscape drawings, 1767-73.

MUNRO, ALEXANDER, *sculptor*. He was born in 1825, in Inverness, where he early made himself known by his abilities, and with a friendly introduction he came to London in 1848, and was employed on the stone carving for the Houses of Parliament. He first exhibited at the Royal Academy, in 1849, some busts; and continuing to exhibit from that time, his chief work was portrait sculpture, busts, medallions, and occasionally a group. In 1852 he exhibited 'Paolo and Francesca,' a marble group; and in 1853, a portrait-group of children, which was greatly praised. For the houses of Parliament he executed a statue of Queen Mary; for Birmingham, a colossal statue of Watt; and a nymph, serving as a fountain, in Berkeley Square, is by him. For many years his constitution, which was always weak, was quietly failing,

and without giving up his London studio, he resided much at Cannes, where he had built himself a studio, and died there on January 1, 1871. Of true genius and feeling, his works are graceful and spirited, but are sketchy in their execution.

MÜNTZ, J. H., *landscape painter*. He was much employed by Lord Orford. He exhibited at Spring Gardens, in 1762, a landscape painted in encaustic; and published, 1760, a small volume describing the process, which he claimed as his invention. But neither his process nor his drawings, of which there were several in the Strawberry Hill collection, had much merit. He exhibited in 1763 for the last time. Little is known of him, but he is said to have married a servant of Lord Orford's, and to have left his lordship abruptly.

MURPHY, D. B., *miniature painter*. An artist of some note, who lived in Dublin at the end of the 18th century, and who subsequently held the appointment of painter in ordinary to the Princess Charlotte. By her orders he copied Lely's 'Windsor Beauties' (now at the South Kensington Museum), which were afterwards engraved from his copies. From 1800 to 1827 he was an occasional exhibitor, at the Royal Academy, of miniatures on ivory and in enamel, but they were not of a high class. He was the father of Mrs. Jameson, the well-known writer on art.

MURPHY, G., *portrait painter*. There is by him in the National Portrait Gallery a portrait of Plunket, archbishop of Armagh, who was executed 1681. Bromley catalogues portraits by him painted about that time.

MURPHY, JOHN, *engraver and draftsman*. Born in Ireland about 1748. He practised in London, both in the dot manner and in mezzo-tint, and had the reputation of an able artist. Towards the end of the century he executed a number of plates in mezzo-tint, good impressions of which are prized by collectors. He engraved after the old masters, also after Northcote, and some portraits after Reynolds and Romney. In 1787 he finished a plate of 'The Royal Family,' after Stothard, R.A. His works are well drawn, light and shade good, general effect of his best plates brilliant.

MURPHY, JAMES CAVANAGH, *architect*. Was born at Blackrock, near Cork, and was originally a bricklayer. He showed a talent for drawing, and made his way to Dublin, and afterwards to Portugal, and later held some diplomatic office from that country to Spain. He pursued his art study in Spain, and published two works on the buildings, arts, and antiquities of that kingdom, 1789-90. He also made plans, elevations, and sections of the Portuguese church and monastery of Batalha, which he published in London, 1792-96. He died

in London, September 12, 1814. His 'Arabian Antiquities of Spain' were published 1813, 'History of the Mahometan Empire in Spain,' 1816. He also published 'Travels in Portugal,' 1795; and a 'General View of the State of Portugal,' 1798.

∴ MURRAY, John, *portrait painter*. In the 'Gentleman's Magazine' there is an obituary record of an artist of this name, as 'of Southampton Row, a famous face painter, worth 40,000*l.*; died June 1, 1735.'

MURRAY, R., *portrait and subject painter*. Practised in London about the middle of the 18th century. He painted portraits, genre, and history. There is a mezzo-tint by J. Watson of 'The Enchantress' after him.

MURRAY, James, *architect*. Was born at Armagh, December 9, 1831. He was articled to an architect at Liverpool in 1845, and on the completion of his articles he practised in that town. Later, he came to London, and was associated in some works with Welby Pugin. Afterwards he settled at Coventry, where he died in 1862. He built churches at Warwick, Bolton, Sunderland, Newcastle, Birmingham; some provincial justice-rooms, and other works of this character.

' MURRAY, Thomas, *portrait painter*. Was born in Scotland in 1666, and came to London at an early age. Studied under Riley. He was remarkable for his good looks and elegance of manner, and following his master, he had great success in portraiture. There are portraits of King William and Queen Mary by him at the Fishmongers' Hall; of Sir Hans Sloane, at the College of Physicians; of Halley, the astronomer, at the Royal Society; and many of his works at Oxford; also his portrait, by himself, in the Florence Gallery. Many of his portraits were engraved by the best contemporary artists. He had accumulated property, and died in 1724, aged 58. His portraits are poor and timid in drawing, in a low but not agreeable tone of colour, and were reputed good likenesses; but they do not rank high in art merit.

MUSS, Charles, *enamel and glass painter*. Born 1779. Was the son of Boniface Musso, an Italian artist, who followed his profession at Newcastle-on-Tyne, and was an exhibitor at the Spring Gardens' Rooms. He was employed in Mr. Collins's well-known glass works, near Temple Bar, and struggled through many difficulties to eminence in his art. He painted several large enamels for George III., and was appointed enamel painter to George IV. 'His Holy Family,' after Parmegiano, is an enamel of unusual size, and one of his best works. He was in 1802 an exhibitor at the Academy of two miniature portraits,

304

and the following year of a 'Psyche,' and then did not exhibit again till 1817, from which year he was chiefly a contributor of miniature enamels after the old masters, but a few from the life. His last contribution was 'Duncan Gray,' after Wilkie, R.A., in 1823. The stained-glass window at St. Bride's, Fleet Street—a copy of Rubens's 'Descent from the Cross'—is by him. Thirty-three original designs from Gay's 'Fables,' drawn and etched by him, were published in 1825. He died in 1824. His early works are dirty in the shadows and defective in drawing; but he overcame these defects, and his later works are well coloured.

MYLNE, John, *architect*. Was the King's principal master mason in Scotland, 1648. The steeple of St. George's Church, Edinburgh, is by him.

MYLNE, Robert, *architect*. Was the King's master mason in Scotland, 1671. He made some additions to Holyrood Palace, and built several other edifices.

MYLNE, Robert, *architect and engineer*. Was born January 4, 1733-4, at Edinburgh, where his father, a descendant of the above, practised as an architect, and was one of the city magistrates. With a desire to improve in his profession he visited Paris, and from thence went to Rome, where he studied five years; and in 1758 gained the first prize for architecture in the academy of St. Luke. He afterwards went to Naples and Sicily, and on his road homeward saw Florence, Bologna, Venice, and the Lombard cities. On his arrival in London he was a competitor for the erection of Blackfriar's Bridge, and his designs, which were distinguished by the first employment of the elliptical arch, were, after much contention, accepted. This work, the first stone of which was laid in 1761, was completed in 1765, for the estimated sum of 153,000*l.* He was appointed the surveyor of St. Paul's Cathedral and of the extensive works of the New River Company; and was for 15 years clerk of the works to Greenwich Hospital. He built the assembly rooms at St. James's, known as Almack's, and many private residences; but notwithstanding his numerous employments, did not amass property. He died May 5, 1811, and was buried in St. Paul's Cathedral. He married in 1770 the daughter of Mr. Home, the surgeon, and left four daughters, and one son who succeeded him as surveyor to the New River Company.

MYNDE, J., *landscape painter*. He practised about the middle of the 18th century, chiefly in London, and was employed by the booksellers. He lived to a good age, and was but an inferior artist.

• MYTENS, Daniel, *portrait painter*. Was born at the Hague about 1590, and ·

was a pupil of Rubens. He came to this country early, but the date is not known. He, however, lived in St. Martin's Lane from 1622 to 1634. On the accession of Charles I., he was in 1625 appointed one of his Majesty's painters. On the arrival of Vandyck, and his appointment to be the principal painter, he wished to retire, but the King kindly solicited him to remain, and he stayed some time longer. None of his known works in this country are dated later than 1630. He returned to Holland. The time of his death is uncertain, and mistakes have arisen from a confusion of facts between him and his son, who was a painter, and bore the same Christian name. Many of Mytens's portraits exist in the Royal, Knowle, Bodleian, and other collections in this country. They are noble works, fine in tone and colour, bearing the impress of truth; with good backgrounds, usually landscape.

N

NAISH, WILLIAM, *miniature painter.* He was born at Axbridge, Somersetshire, and practised his art in London, where he had many sitters; including some of distinction. He was a constant exhibitor of his miniatures at the Royal Academy from 1783 to 1800, in which latter year he died. His brother, JOHN NAISH, was also an artist.

NASH, EDWARD, *miniature painter.* Born 1778. He was, from 1811 to 1820, an occasional exhibitor at the Royal Academy. He afterwards went to India, where he made some money by the practice of his profession, and returning to England, died here in 1821.

NASH, FREDERICK, *water-colour painter.* He was born in 1782, in Lambeth, where his father was a builder, and aspiring to be an artist, was placed under Malton, and was occasionally employed as a draftsman by Sir R. Smirke, R.A. He first exhibited in 1800, at the Academy, 'The North Entrance to Westminster Abbey,' and continued an occasional contributor up to 1847. In 1808 he was elected a member of the Water-Colour Society, and was soon after appointed draftsman to the Society of Antiquaries. On the change in the constitution of the Water-Colour Society in 1813 he was one of the seceders; but he contributed to their Exhibition in 1817 and 1820, and in 1824 was re-elected a member. His art consisted in the pictorial treatment of architecture, with the introduction of groups of figures. His chief exhibited works were views of Paris and Versailles, and in 1824-25 he was engaged in the drawings for a work on the French palaces. Continuing to exhibit till his death, his best works were French, their inspiration being in the architecture of the French cities. Later he made drawings in Switzerland, Normandy, and on the Moselle and the Rhine. Some of his works produced prices unusually high at the time. He retired to Brighton in 1834, and the pictures he afterwards exhibited were found in the scenery and inci-

dents of that neighbourhood. He died at Brighton, December 5, 1856. Among his published works are 12 views for 'The Illustrations of London,' 1810; the illustrations for Ackerman's 'History of Westminster Abbey and its Monuments ;' and for the 'History of the University of Oxford,' 1814; the series of drawings for a work known as 'Nash's Paris,' commenced in 1819, followed, in 1824, by his 'Environs of Paris.'

NASH, JOHN, *architect.* Was of Welsh extraction, and born in London in 1752. He was a pupil of Sir Charles Taylor. Commencing about 1795, he designed and erected some important cottage and villa residences, and several large mansions. He made alterations at Corsham House, Wilts, and at Bulstrode. He was an exhibitor at the Royal Academy from 1797 to 1814, after which year his contributions ceased. He was one of the architects attached to the Board of Works, and was employed on the important improvement in the metropolis, which carried Regent Street through a mass of poor buildings to the Regent's Park, which was formed at the same time; and he designed the dwellings and shops in this important thoroughfare, with the church of All Souls; also York Terrace, and Sussex Terrace; but with a great opportunity, which rarely happens, he produced nothing great. He was the private architect of George IV., and high in the royal favour; and for the king he designed Buckingham Palace, though it was not completed by him or after his designs, with the Marble Arch, since removed to Cumberland Gate; and he was engaged in the decoration of the Palace at Brighton. He also built the church of St. Mary, Haggerstone, and a new church at Shoreditch. His architecture is mean and wanting in character; marked only by its absence of invention. He made a large fortune, chiefly by his undertakings as a speculative builder. He was the butt of the critics and

caricaturists of the day. He died at his seat, East Cowes Castle, Isle of Wight, a mansion he had built for himself, May 13, 1835, in his 83rd year. He published, in 1825, ' Illustrations of the Palace at Brighton.' His collections of books, prints, and drawings were sold by auction.

NASMYTH, ALEXANDER, *landscape painter*. Born at Edinburgh in 1758, and educated there. . He came early in life to London, and commenced.art as the pupil of Allan Ramsay. He then visited Italy, where he studied during several years both historical and landscape painting ; but his inclination led him imperceptibly to landscape, and he filled his folio with elaborate drawings of the picturesque scenery of the country. On his return he settled in Edinburgh and commenced practice as a portrait painter. He had many distinguished men as his sitters ; but was more successful in his landscapes, and eventually abandoned portraiture. He was an occasional exhibitor of Scotch landscape scenery at the Royal Academy, London, between 1813 and 1826. Assisted by his family, he painted the stock scenery for the theatre at Glasgow. He devoted also much of his time to teaching, and adopted landscape gardening as a profitable part of his profession. His landscapes are carefully coloured and finished, but are timid and wanting in the true characteristics of art and genius. He published, in 1822, 16 views of places described by the author of Waverley. He was a member of the original Society of Scottish Artists, and an Associate of the Royal Institution. The Society of Arts possess a large ' River Scene ' by him. He died at York Place, Edinburgh, April 10, 1840, aged 82.

NASMYTH, PATRICK, *landscape painter*. Son of the foregoing. Was born in Edinburgh, January 7, 1787. Christened Peter, he persisted in calling himself Patrick, and is known by that name. He had an early love of nature, and played truant to wander in sunny fields, and attempt to sketch from the surrounding scenery. An early injury compelled him to learn the use of his left hand in painting, and an illness resulted in deafness. He came to London at the age of 20, and his talents were soon appreciated. In 1809 he exhibited his first picture at the Royal Academy, and was from that time an occasional exhibitor up to 1830. He became a member of the Society of British Artists on its foundation in 1824, and was an exhibitor till his death. His first exhibited works were chiefly from Scotch scenery ; his latter works from the domestic scenery of the English counties. In his art he imitated the Dutch school, painting our lane scenes, hedgerows, village-suburbs, and commons, and chosing the dwarfed oak in preference to other trees.

306

His manner has a tendency to meanness, his foliage is over-detailed, his work black in the shadows. Adopting a low tone, his skies looked brilliant. He painted English nature in her simplest moods, without any attempt at the poetry of art, yet with great force and truth. His loss of hearing threw him too much on his own resources, and in his solitude he was prone to indulge in excess. His constitution became undermined, and catching cold in sketching, when scarcely recovered from influenza, his weak frame gave way. He died at Lambeth, where he had for some time lodged, August 17, 1831, during a thunder storm which, at his own request, he had been raised in his bed to contemplate. He was buried at St. Mary's Church, and the Scottish artists in London placed a gravestone over him.

NASON, R., *portrait painter*. He accompanied Charles II. to England in 1660, and practised in the latter half of the 17th century. He painted a portrait of Charles II., which is engraved by Van Dalen, and some other portraits, which are exquisite in finish.

NATTER, LAWRENCE, *gem engraver*. Born at Biberach, Suabia. Studied in Italy, and afterwards resided several years in England. In 1743 he was in Denmark, and in 1744 he went to Holland to make a medal for the Prince of Orange. He published in London, in 1755, a treatise comparing the antique with the modern method of engraving precious stones. He held the office of engraver to the Mint, and was a fellow of the Royal Society and the Society of Antiquaries. He died December 27, 1763, at St. Petersburg, whither he had gone the preceding year on the invitation of the empress. There is a medal of Sir Robert Walpole by him.

NATTES, JOHN CLAUDE, *water-colour painter*. Was born in England about 1765, and was a pupil of Hugh Dawes. An early draftsman of the water-colour school, his works were mostly connected with topography, on which his art was founded. Between 1797 and 1800 he travelled in Scotland, making the drawings which he published in 1804 under the title of ' Scotia Depicta.' In 1802 he published ' Hibernia Depicta ;' in 1805, ' Select views of Bath, Bristol, Malvern, Cheltenham, and Weymouth ;' and in 1806, ' Bath Illustrated.' He was one of the foundation members of the Water-Colour Society in 1804, but was expelled in 1807 for having exhibited, in his own name, drawings not by his own hand, to increase his share of the profits of the exhibition. At the Academy he was an exhibitor from 1782 to 1804, and from 1807 to 1814, when he exhibited for the last time. His early contributions were almost exclusively views in Italy, but later Scotch and English. He drew in a loose

style, and his works are in the tinted manner, weak and poor.

NEAGLE, JOHN, *engraver*. Was born in London about 1760. Some accounts call him an Irish artist. He produced a considerable number of works; among them 'The Royal Procession to St. Paul's,' 1789. For the Shakespeare Gallery scenes from 'The Comedy of Errors' and 'Love's Labour Lost,' after Wheatley, R.A., and two subjects from the first part of 'Henry IV.,' after Smirke, R.A.; also the illustrations for Murphy's 'Arabic Antiquities of Spain,' 1816. He practised in the line manner. His works were greatly esteemed, and he took high rank among the engravers of his day.

NEALE, JOHN PRESTON, *water-colour draftsman*. Was born in 1771, and began life as a clerk in the Post-office. He early attached himself to topographic art, and appears to have been the son of a painter of insects, who exhibited at the Academy at the end of the 18th century. He painted a few works in oil, but his chief works are in water-colours, drawn in with a pen and tinted. To give greater truth to his buildings he studied architecture. He was, commencing in 1801, a contributor from time to time to the Academy exhibitions, and in 1817–18 to the Water-Colour Society. He made the elaborate and artistic drawings for 'The History and Antiquities of the Abbey Church at Westminster,' published 1818–23. He travelled through Great Britain, and made the drawings for the 'Views of the most interesting Collegiate and Parochial Churches,' published 1824–25; and also made the drawings for two series of 'Views of the Seats of the Nobility and Gentry of the United Kingdom'—the first series published 1822–24, the second 1829; and drew and designed for many other publications. He died near Ipswich, November 14, 1847.

NEALE, THOMAS, *engraver*. Practised in London towards the middle of the 17th century. He is said to have been a pupil of Hollar, and worked in his manner. He engraved the 24 plates of Holbein's 'Dance of Death,' published in 1657; some of Barlow's 'Birds,' 1659; and is assumed to have been employed upon the plates for the eighth edition of Ogilvy's edition of 'Æsop.'

NEELE, SAMUEL JOHN, *engraver*. Was employed on antiquarian illustrations and engineers' plans, but chiefly as a map and writing engraver. He amassed a fortune by his profession. Died in 1824, aged 66.

NELSON, JOHN, *sculptor*. Was known in Shropshire and the neighbouring counties for his skill as a statuary. Sir Rowland Hill's statue, on the column to his memory in Hawkstone Park, and the statue of Sir R. Montgomery, in Shrewsbury Castle, are by him. He died at Shrewsbury, April 17, 1812, aged 86.

NELSON, JOHN HENRY, *sculptor*. He is believed to have been born in Ireland. Resided some time in Dublin. Executed a fine statue of 'Venus Attiring,' which he exhibited at Manchester in 1847. He died there December 26, 1847, aged 47, leaving a widow and four children without provision.

NESBITT, CHARLTON, *wood-engraver*. Born in 1775 at Swalwell, Durham. He was, at the age of 14, apprenticed to Beilby and Bewick, and was one of their first pupils. He gained the Society of Arts' premium for his view of the church of St. Nicholas, Newcastle, which was executed on no less than 12 distinct blocks. He engraved a few of the tail-pieces for the 'British Birds' during his apprenticeship; and, except two, all the tail-pieces to the poems by Goldsmith and Parnell, published 1795. On the completion of his apprenticeship he engraved a large cut (15 in. by 12 in.), from a drawing by his fellow-pupil Johnson, and was again rewarded by the Society of Arts' premium. About 1799 he came to London, where he settled, and found full employment. He engraved many of Thurston's designs; also, for a history of England, published by Scholey; and for the 'Religious Emblems,' published by Ackerman, 1808. In 1815 he retired to his native village, where he continued till 1830, and though he did not abandon his art, his works were comparatively few. In that year he returned for a time to London. He died at Brompton, while on a visit to the Metropolis, November 11, 1838, aged 64. Among his best works are the 'Illustrations of Hudibras,' 'Sir Egerton Brydges Works,' an edition of Shakespeare, and Northcote's 'Fables.' He attained a broad, clever style, his textures were variously and truly rendered, and great brilliancy of effect preserved. His figures well drawn and simply treated.

NEVE, CORNELIUS, *portrait painter*. Practised in the time of Charles I. Several of his works, though not of much excellence, have survived. There was a group of himself, his wife and children at Petworth.

NEWCOURT, RICHARD, *topographical draftsman*. He practised in the middle of the 17th century. Several views of old Religious Houses by him are engraved for Dugdale's 'Monasticon Anglicanum,' by Hollar.

NEWENHAM, FREDERICK, *portrait painter*. He was an occasional exhibitor of portraits at the Royal Academy, with sometimes a domestic subject, from 1844 to 1855. He painted a portrait of the Queen for the Junior United Service Club, and exhibited, in 1845, 'The Mother's Letter;' in 1849, a Spanish subject; in 1855, 'The Toilette.' He died March 21, 1859, aged 52.

NEWMAN, JOHN, *architect*. The Roman Catholic Chapel in Moorfields,

commenced in 1817, is by him. From that time to 1838, in which year he sent a design for the Roman Catholic Church proposed to be erected in St. George's Fields, he was an occasional exhibitor at the Royal Academy. He died at Paris, January 3, 1859, aged 72.

NEWTON, FRANCIS MILNER, R.A., *portrait painter*. Born in London in 1720. He was pupil of Marcus Tuscher, and a member of the St. Martin's Lane Academy. He acted, in 1755, as secretary to the Artist's Committee, to found an academy; afterwards he was secretary to the Incorporated Society of Artists, and on the foundation of the Royal Academy was the first secretary. He was a very indifferent artist, but had many sitters, and exhibited his portraits at the Academy from 1769 to 1774. He resigned his office of secretary to the Academy in 1788, when his powers were declining. Soon after a large fortune was left to him by an acquaintance, who disapproving of the marriage of his only son, disinherited him. To this estate near Taunton he retired, and died there, August 14, 1794. He held for some time the office of 'Muster Master' for England, and generally wore the Windsor uniform.

NEWTON, GILBERT STUART, R.A., *subject painter*. Was born at Halifax, Nova Scotia, September 2, 1795, the son of a British officer who was driven from Boston when that city was occupied by the troops under General Washington. He was the nephew of Gilbert Stuart, who was distinguished in America as a portrait painter, and after his father's death his mother returned with him, in 1803, to Charleston, near Boston, where he was placed with a merchant and intended for a commercial life, but art prevailed. He had some little art instruction from his uncle, but did not long agree with him, yet was soon spoken of as a lad of much promise. In 1817 he visited Italy, where he remained some months, and then went to Paris. Here he met with Leslie, afterwards R.A., and came with him to England by Brussels and Antwerp, arriving in London the same year.

He was admitted a student of the Royal Academy, and though fond of society, was diligent in his studies, and soon made himself known. In 1821 he exhibited at the British Institution his small head called 'The Forsaken,' with 'Lovers' Quarrels,' and 'The Importunate Author.' He also at this time painted some portraits, but his subject pictures were so eminently successful that he was led to continue them, and was a regular exhibitor at the Royal Academy. He contributed, in 1823, 'Don Quixote in his Study;' in 1824, 'Monsr. de Pourceaugnac;' in 1826, 'Capt. Macheath upbraided by Polly and Lucy;' and in 1828, the 'Vicar of Wakefield recon-

ciling his Wife to Olivia,' a work of touching interest and beauty, and was the same year elected an associate of the Academy. This was succeeded by his finest works. In 1830, 'Yorick and the Grisette,' 'Shylock and Jessica,' 'Abbot Boniface;' and in 1831, 'Portia and Bassanio,' with 'Cordelia and the Physician.' These great works secured his election in 1832 as Royal Academician.

The same year he visited America, where he married, and came back to England with his wife within the twelvemonth. During his stay in America he had shown some slight signs of insanity, which unhappily increased after his return. His last exhibited work was in 1833, 'Abelard in his Study;' but he painted no picture of importance after his election as academician. His mind became seriously affected, confirmed insanity ensued, and he was confined in a private lunatic asylum in Chelsea, where his life was terminated by rapid consumption on August 5, 1835. He was buried in Wimbledon churchyard. His widow and son returned to America shortly after his death, and she soon afterwards married again. Dunlap, his American biographer, says, 'That he congratulated himself upon being born a subject of the King of Great Britain, and that on one occasion at New York, at a large dinner-party, he got up and disclaimed being a citizen of the United States.'

His works are marked by a refined sense of colour and a great feeling for female beauty, with a pure sweetness of expression and character, but they are wanting in drawing and executive power. His subjects are well chosen; his story, whether quiet humour or pathos predominate, is simple and well told. His pictures are very few in number, but are always agreeable and full of interest, and the chief of them are well known from their engravings.

NEWTON, JAMES, *engraver*. Was the son of EDWARD NEWTON, an engraver, of whom there is no record, and was born in London in 1743. He practised in London in the latter part of the 18th century chiefly in portrait, but there are landscapes by him after Zuccarelli and Claude, and some subjects after Cipriani and Reinagle.

NEWTON, WILLIAM, *architect*. Brother to the above James Newton. Was clerk of the works of Greenwich Hospital, and designed some of the additional buildings. In 1766 he was a member of the Incorporated Society of Artists, and in 1776 and 1780 was an exhibitor at the Royal Academy. He published 'The Architecture of Vitruvius,' 1772, and superintended the publication of the third volume of Stuart's 'Antiquities of Athens.' Died at Sidford, Devon, in July, 1790.

NEWTON, Sir WILLIAM JOHN, Knt., *miniature painter*. Was born in London

1785, and was the son of the above James Newton. He practised miniature painting with success, after exhibiting at the Academy in 18J8, and from that year continuing a large contributor. His art was popular, and he had many distinguished sitters. He was appointed miniature painter to Queen Adelaide, and in 1837 received the honour of knighthood. He died in London, January 22, 1869. He was a weak draftsman, his works graceless, and wanting in composition and taste. He tried some groups of miniatures of a large size on a plan of his own for uniting several pieces of ivory.

NEWTON, RICHARD, *caricaturist and miniature painter.* He gave promise of ability, but his works were chiefly convivial and licentious. He died in London at the early age of 21, December 9, 1798. The 'Blue Devils,' 1795, drawn and etched by him, is a clever design.

NEWTON, Mrs. MARY, *amateur.* She was the daughter of Mr. Joseph Severn, her Majesty's Consul at Rome, who is well known as an accomplished artist. She married Mr. Charles J. Newton, of the British Museum, and her early taste for art was assisted by Mr. Richmond, R. A. She drew the figure accurately, received several commissions from the Queen, and drew portraits in crayons and water-colours. She exhibited at the Royal Academy in 1855, 'Chess;' in 1856, 'Summer and Winter;' in 1864, 'Letty;' and in 1865, three portraits. She died of measles, January 2, 1866, aged 33.

NICHOLLS, SUTTON, *engraver.* Practised in London early in the 18th century. He was chiefly employed upon plates for booksellers. Some slight etchings of shells and other objects are among his best works. He engraved the views in London for Stowe's 'Survey,' and published in 1725, 'Prospects of the Most Considerable Buildings about London,' both drawn and engraved by himself.

NICHOLS, JOSEPH, *topographical painter.* Painted, in 1738, 'A View of Stocks' Market,' in the City, since removed; and a companion picture, 'A View of the Fountain in the Temple,' both of which were engraved. In the first some well-painted figures were introduced, and the work was for some time attributed to Hogarth. Of the painter nothing is now known.

NICHOLSON, FRANCIS, *water-colour painter.* Was born at Pickering, Yorkshire, where his family possessed a small property, November 14, 1753. He showed an early disposition to the arts, and had some lessons from an artist at Scarborough. After two visits to London, he settled at Whitby in 1783, married there, and was employed in painting portraits of horses,

dogs, and dead game, and was also engaged in teaching. In 1789 he exhibited for the first time at the Academy. He left Whitby in 1792, and resided for a time at Knaresborough, then at Ripon, and from thence, approaching the Metropolis, at Weybridge, and finally came to London, where he established himself as an artist. He was one of the founders of the Water-Colour Society in 1804, and continued a member and exhibitor up to 1815. His subjects, frequently waterfalls or rushing streams, were found in Wales and the hilly country of the north of England, and in Scotland. He became distinguished in the new art, though he never attained excellence. Later he devoted much of his time to lithography, and made above 800 drawings upon the stone, and had much influence in the advancement of the art. About 1822 he published a work on 'The Practice of Drawing and Painting Landscape from Nature.' He discovered a process of treating the high lights in water-colours, which consisted in securing them with a composition, not soluble in water, but which might be readily removed with a highly rectified spirit, leaving the lights pure. Having acquired a competency, he gave up the practice of his own art, and amused himself by experiments, painting in various oil vehicles, sometimes, unfortunately, upon the best of his own drawings in his possession, and continued to the end of his long life in these occupations. He was a man of various attainments, and much practical knowledge. He died in London, March 6, 1844, aged 90. His collection of pictures, drawings and sketches were sold at Christie's in the same year.

NICHOLSON, ALFRED, *water-colour painter.* Son of the above Francis Nicholson. Was born in Yorkshire, and early in life entered the Royal Navy, and saw some service on the coasts of Holland and Portugal. After a few years he left the Navy, and commenced his career as an artist. He visited Ireland in 1813, resided there three or four years, and made a large collection of sketches elaborately finished. About 1818 he settled permanently in London, and was almost exclusively employed as a teacher of drawing. In 1821 he made an excursion through North Wales and a part of Ireland, adding largely to his collection of sketches, and in the following summer visited Guernsey, Jersey, and Yorkshire, assiduously pursuing his art. His drawings combine much graceful finish with force and general effect. His works are usually of a small size. He died in London, November 23, 1833, aged 45, having suffered during the last three or four years of his life from a painful illness. He left a widow and two infant children.

NICHOLSON, ISAAC, *wood-engraver.*

Was born at Melmerby, in Cumberland. Was apprenticed to Bewick, and approaches nearer to him in style than any of his other pupils. He was clever and ambitious. He engraved the illustrations for Flower's 'Heraldic Visitation of the County of Durham,' Sharp's 'History of the Rebellion;' also, among others, for a History of England, Watts's Hymns, 'Robinson Crusoe.' He died October 18, 1848, aged 59.

NICHOLSON, PETER, architect. Was the son of a stonemason, and was born at Preston Kirk, East Lothian, July 20, 1765. He was taken from the parish school at 12 years of age to assist his father, but was afterwards apprenticed to a cabinet-maker, and then worked as a journeyman in Edinburgh and London. He commenced teaching in an evening school in Soho, and, abandoning journey-work, published in 1792, 'The Carpenter's New Guide,' for which he himself engraved the plates. Arising out of his teaching, he next published, 'The Student's Instructor,' 'The Joiner's Assistant,' and 'The Principles of Architecture,' a serial publication commenced in 1794, and completed 1809. He returned to Scotland in 1800, and settled in Glasgow, where he gained employment as an architect. His chief works are a wooden bridge over the Clyde, and some modern residences, which gave a new character to the city buildings. He afterwards practised for a time at Carlisle, and was appointed architect to the county, then, after two years, returned again to London, and resumed his literary labour. He published at this time his 'Architectural Dictionary,' 'Mechanical Exercises,' 'The Builder,' 'The Workman's New Director,' with some other works of a scientific character, and in 1827 commenced the publication of his 'School of Architecture and Engineering,' of which only five out of the twelve numbers proposed were issued. This work failed, and disappointed by the failure and the loss which it entailed, he removed in 1829 to Morpeth, and in 1832 to Newcastle-upon-Tyne, where he was chiefly occupied in teaching; but with all his labours he was poor, and in old age, and struggling with difficulties, a subscription was raised for him in the town, and in 1835 a small pension was granted to him from the privy purse. In 1841 he removed to Carlisle, and died there June 18, 1844. His son, MICHAEL ANGELO NICHOLSON, who died in 1842, was the author of the 'Carpenter and Joiner's Companion.'

NICHOLSON, OTHO, architect. Practised in the reign of James I. The old conduit at Carfax, Oxford, is a singular structure, was by him, and bore his initials. It was removed in 1787 to Nuneham Park, and is engraved, forming the plate to the Oxford Almanack, 1833.

310

NICHOLSON, THOMAS HENRY, wood-engraver and modeller. He was at the commencement of his career chiefly employed on book illustrations, and was known by his very clever drawings of the horse. These gained him the notice of Count d'Orsay, in whose studio at Gore House he for some years found employment. He assisted in modelling the small equestrian statuettes, for which the Count gained some reputation. On the breaking up of the establishment at Gore House in 1848, he returned to his wood engraving; but of a shy and retired disposition, he did not enjoy the credit which his works deserved. He died at Portland, Hants, 1870.

NICHOLSON, JAMES, glass stainer. Lived in Southwark in the 16th century, and was much employed. He was one of the four contractors for the 18 painted windows in the upper storey of King's College Chapel, Cambridge, in the reign of Henry VIII.

NICHOLSON, WILLIAM, R.S.A., portrait painter. He was born at Newcastle-on-Tyne, 1784, and sent from thence, in 1813, two portraits, his first contribution to the Academy Exhibition, followed in 1816 by a portrait of W. Bewick. In 1820 he was settled in Edinburgh, where he practised as a portrait painter, and sent an occasional portrait to the Academy Exhibition in London. His best works were his water-colour portraits, which were esteemed for their faithful resemblance and true art merits. He was one of the promoters and founders of the Royal Scottish Academy, to which his most mature works were contributed, was active in securing the assistance of the most influential of his brother artists, and became himself the secretary, thus successfully opposing the lay directors of the Royal Institution, where the Scottish artists had previously exhibited. He etched and published a series of portraits with short biographical notices, and engraved some of his own works with much painter-like feeling. He died at Edinburgh, after a short illness, August 16, 1844, in his 60th year.

NICHOLSON, WILLIAM ADAMS, architect. Was born in Southwark, and was pupil to J. B. Papworth. In 1827 he settled at Lincoln, and was much employed. He built several mansions and churches in the neighbourhood, and enjoyed some local reputation. Died at Boston, April 8, 1853, aged 49.

NIXON, JOHN, amateur. Towards the middle of the 18th century he was noted for his humorous sketches and caricatures. He died in 1818.

NIXON, SAMUEL, sculptor. Was employed on works of a decorative class, and in portrait sculpture. He was an exhibitor at the Royal Academy from 1824 to

1846, contributing some works of high aim —'The Reconciliation of Adam and Eve,' 1828; 'The Birth of Venus,' 1830. His later works were chiefly portrait sculpture. The sculptural decorations for the Goldsmith's Hall, especially the groups of the Four Seasons at the foot of the grand staircase, are by him, and are gracefully and finely carved, as is also the statue of John Carpenter, at the City of London School; and his chief work the granite statue of William IV., erected by the City Corporation in Cannon Street. He died at Kennington, August 2, 1854, aged 51.

NIXON, JAMES, A.R.A., *miniature painter.* Born about 1741. He was a member of the Incorporated Society of Artists, and was one of the first students of the Royal Academy. He first exhibited at the Academy in 1772, and was elected associate in 1778. His works were chiefly miniatures, in which he attained much excellence, sometimes portraits of actresses and others in character, with occasionally a portrait in oil, and a few historical subjects. He also designed some illustrations for books. He held the appointment of limner to the Prince Regent, and of miniature painter to the Duchess of York. Died at Tiverton, May 9, 1812, aged 71. Some of his works were engraved.

NIXON, JOHN, *engraver.* Born 1706. His best works are small portraits executed in a very neat style, the faces finished in the dot manner; among them the Prince of Wales, Duke of Cumberland, Lord Granville.

NOBLE, GEORGE, *engraver.* He was employed by Boydell, and enjoyed much reputation at the beginning of the 19th century. His chief works are for the Shakespeare Gallery, and are after Wheatley, Westall, Smirke, and Tresham. He also engraved some of the illustrations after R. Cook, R.A., for Goldsmith's Miscellaneous Works. His brother, S. NOBLE, was employed on some of the same works.

NOBLE, MATTHEW, *sculptor.* Was born at Harkness, near Scarborough, in 1818, and was a pupil of Francis. He first exhibited at the Royal Academy in 1845, when he contributed two busts, one that of the 'Archbishop of York.' His best known public works are, 'Her Majesty the Queen at St. Thomas's Hospital,' 'Lord Derby in Parliament Square,' and 'Sir John Franklin in Waterloo Place.' He was a regular exhibitor at the Royal Academy Exhibitions. His talents were not of a rare order, but he had the art of judiciously availing himself of professional assistance. He died at Kensington June 23, 1876, aged 58.

NOBLE, WILLIAM BONNEAU, *landscape painter.* Was the son of a bookseller, and born September 13, 1780. He commenced life as a teacher of drawing, and exhibited at the Academy, in 1809, three Welsh views which were of some promise; but disappointed by the rejection, in 1811, of some works sent for exhibition on which he had spent much labour, though his landscapes were exhibited in 1811, and suffering at the same time from a disappointment in love, he fell into despondency and habits of reckless irregularity, and in November 1825 made a desperate attempt on his life. He died at Somers' Town, September 14, 1831. He left behind him a long poem in manuscript, called 'The Artist.'

NODDER, R. P., *flower and animal painter.* He found his employment chiefly as a painter of natural history, and held the appointment of botanic painter to George III. From 1786 to 1820 he was an occasional exhibitor at the Royal Academy. His contributions comprised flowers, and portraits of horses and dogs.

NOLLEKENS, JOSEPH FRANCIS, called 'Old Nollekens,' *portrait painter.* Was the son of a painter who had resided some time in England, but was born at Antwerp, June 10, 1702. He came to London in May 1733, and studied under Peter Tillemans. He painted landscape, figure and conversation subjects, particularly children, and copied after Watteau and Paulo Pannini. He was employed on some decorative works at Stowe by Lord Cobham, and was also employed by Lord Tylney. He was a Roman Catholic, and is said to have been so much alarmed by the Rebellion in 1745, that he could not rally, and died in St. Anne's parish, Soho, January 21, 1748, leaving a widow with a large family, but not without some provision. He was buried at Paddington Church. A number of his paintings for Lord Tylney were long preserved at Wanstead House, but were sold by auction, with the rest of the furniture, in 1822. They were chiefly landscapes with figures, and realised good prices—one of them, a 'Conversazione,' fetching 127*l.* At Windsor there is a small and very clever little portrait-group by him of Frederick Prince of Wales and sisters, the character and expression very true and good, the group well composed, and gaily but agreeably coloured.

⁎NOLLEKENS, JOSEPH, R.A., *sculptor.* Son of the foregoing. Was born in Dean Street, Soho, August 11, 1737. His mother, a French woman, soon after his father's death married a modeller named Williams, who was employed in the Chelsea Porcelain Works, and went with her husband to Flanders. Her son's education was neglected, but he early set to work to fit himself for an artist, and for a short time studied in Shipley's school. At thirteen he was employed by Scheemakers, and it is said that the drudgery of his tasks, the little prospect before him, and his natural disposition, led

him into dissipation, but that he was afterwards able to resume habits of temperance and industry. In 1759 and in 1760 he gained the premiums of the Society of Arts, and he had at that time by his industry saved the means of getting to Rome, where he worked hard to maintain and improve himself. In 1761 he was again successful and received a premium of 50 guineas from the Society of Arts for a group in marble, and further, the gold medal of the Roman Academy. He executed some busts and some good groups, sending home to the Free Society's Exhibition 'Two Victors in the Panathenian Games,' 1766, and some busts in 1770, and returned to London in that year with a purse which he had saved, and soon afterwards marrying a lady with a handsome portion, he speedily acquired employment and celebrity.

On his return he was a constant exhibitor at the Royal Academy. His contributions consisted largely of busts, but he no less exhibited classic groups, repetitions of Diana, Juno, Venus, Adonis, Cupid, Mercury, and other classic divinities. As a restorer of antique marbles he was much and advantageously employed, and he also speculated very profitably in; such restorations on his own account. In 1771 he was elected an associate, and the following year a full member, of the Academy. He was patronised by George III., with whom he was in much favour. His bust of Fox made a great impression upon the public. Pitt's bust had equal notoriety. Of the former he is said to have sold 100, and of the latter 150 repetitions, at 100 guineas each. To this profitable branch of his art he chiefly devoted himself and gradually raised his price to 150 guineas. He, however, occasionally produced a group. His ' Cupid and Psyche,' ' Bacchus,' ' Arria and Pætus,' and several Venuses—among them his ' Venus with the Sandal,' esteemed his best work. There are also some fine monumental groups by him. His monument, in Westminster Abbey, of the three captains who fell in Rodney's action, 1782 ; Mrs. Howard, of Corby Castle, and his statue of Pitt at Cambridge, for which he was paid 3000 guineas, are of great merit ; but his chief excellence is in his busts, which, if wanting in vigour, are marked by great simplicity and truth.

He carefully imitated nature. His likenesses were good, distinguished by exact finish, and an absence of manner, but his gods and goddesses wanted individuality and freshness. He worked with the most persevering industry till February 1819, when he suffered from a sudden paralytic attack, but partially recovering, he amused himself in his studio for about two years, when increasing infirmities rendered him

312

incapable of any further labour. He died April 23, 1823, and was buried in Paddington churchyard. Eccentric and singular in his habits, shrewd in his dealings, given to petty economies, he had amassed a large property, and being without heirs, left 6000l. to his assistants and servants, and above 200,000l. between four of his friends. His life—' Nollekens and his Times '—was written by John T. Smith, one of his executors, who was for many years keeper of the prints in the British Museum — a gossiping book full of interest, but mixed with many petty domestic affairs which a more tender biographer would hardly have recorded : also by Allan Cunningham, in his 'British Painters, Sculptors, and Architects.'

NORDEN, JOHN, *engraver*. Supposed to have been born in Wiltshire in 1546. He was educated at Oxford, and took there the degree of Master of Arts in 1573. He resided at Hendon, Middlesex, and was patronised by Lord Burleigh and his son the Earl of Salisbury, and was, in 1614, Surveyor of the King's Lands. His principal work as an engraver was his 'Speculum Britanniæ,' a description of Middlesex and Herts, with a frontispiece and maps. He also engraved, in 1609, a view of London, introducing the Lord Mayor's show. He died about 1626.

NORDEN, FREDERICK LUDWIG, *topographical draftsman*. Born in 1708, at Glückstadt, in Denmark, he was brought up to the sea, and became a ship's captain. He was employed by Christian VI. to travel in Egypt and Nubia, and he took the opportunity to make drawings of the interesting scenery and remains of antiquity, and on his return they were engraved. He afterwards came to England and published, etched by his own hand, ' Ruins and Colossal Statues at Thebes.' He died here in 1742.

NORGATE, EDWARD, *limner*. Was born at Cambridge. Son of the Master of Bennet College. He had a talent for limning and heraldry, came to London to pursue this branch of art, and was intimate with the best painters of the time. He gained the notice of the Earl of Arundel, who, in 1633, appointed him Windsor Herald, and afterwards illuminator of the Royal Patents. His works of this class showed exquisite taste and finish. His initial letters, grouped portraits, and borders of appropriate designs, were deemed unrivalled. In 1640 he held the office of Clerk of the Signet and attended the King to Scotland. He was deprived of his office before the execution of Charles I. Fuller states that he died at the Herald's College, December 23, 1650, and was buried in the adjacent Church of St. Bennet ; but Dallaway says that his work, ' Miniature, or the

Art of Limning,' in his own handwriting, is dated July 8, 1654.

NORRIS,—*engraver.* Was living in 1750. Engraved from his own drawings, architectural monuments and ruins.

NORRIS, JOHN, *architect.* He practised early in the 18th century. Rebuilt Lord Stamford and Warrington's seat in Cheshire, 1730.

, NORTHCOTE, JAMES, R.A., *historical an1 portrait painter.* Descended from a respectable Devonshire family, claiming an ancient pedigree, he was the son of a watchmaker at Plymouth, where he was born, October 22, 1746. Though he showed an early attachment to art, his prudent father bound him his own apprentice, and he served his full time to the trade. During these long seven years his spare hours were spent in drawing, and on their termination he devoted himself to art, and commencing portrait painting, gained some notice in his own town ; and then, at the age of 25, in May 1771, he came to London furnished with an introduction to Sir Joshua Reynolds. The kind president not only admitted his young townsman to his studio, but to his house, and he continued with him for five years, picking up such knowledge as he could. He also became a student at the Academy, and between the two must have gained the technical power he most needed ; but his progress was laborious and slow. In 1775 he left Reynolds with mutual regret, and returning to Devonshire, soon made a little purse by portrait painting.

In March 1777 he set out alone for Italy, not knowing any language but his own, and travelled by Lyons and Genoa to Rome, where he spent the greater part of his time in copying, occasionally on commission, and in the study of the old masters, especially Titian. He returned home by way of Flanders at the end of three years, arriving in London in May 1780, and again had recourse to portraiture, which he tried for a time in his native county, and then settled in London. From the first his desire had been to paint subject pictures, and in 1783 he exhibited some works of a domestic class, one of which was engraved for Boydell and had much success. This induced him to continue, meeting at the same time, however, good encouragement as a portrait painter. But his impulses led him to a higher aim, and for this the opportunity was afforded, which he earnestly seized, when the great scheme of the Shakespeare Gallery was started.

He produced, in 1786, his first truly historic work—' The Young Princes murdered in the Tower,' and was in the same year elected an associate of the Royal Academy ; in the spring of the next year a full member. His success was followed by the ' Burial of the Princes in the Tower,' and his great

work, the ' Death of Wat Tyler,' for the Corporation of London. In the succeeding years he continued to work for Boydell's gallery, but did not abandon portraits, and he commenced another series, the career of two servant girls, a moral composition in ten pictures—' The Diligent Servant and the Dissipated,' a female version of Hogarth's ' Idle and Industrious Prentice.' The work was published in 1796, and though successful, yet, from the absence of character and humour, the plainness of the coarsely told incidents, and the omission of all the minor graces, it did not approach the work of his great prototype. He was successful as a painter of animals. He introduced them well into his pictures, and painted some subjects of animals—' The Dog and Heron,' ' The Tiger and Crocodile,' ' The Lion Hunt,' with others, and his fondness for animals seems to have been an inducement to commence his ' Fables,' published in 1828, in which they are conspicuous. In 1825 the directors of the British Institution purchased for 150 guineas his ' Entombment of our Saviour,' and presented the picture to Chelsea new church ; and in 1827, his ' Christ's Agony in the Garden,' which they presented to Hanover Chapel, Regent Street.

He was a man of marked natural abilities. Entering art late in life, unprepared by his general education, he showed great energy and industry in conquering the difficulties of his position. He was observant in all that related to his art, reflective by habit, and able to express clearly his ideas both orally and with his pen. His first literary attempts were printed in ' The Artist,' a periodical commenced in 1807. In 1813 he published his ' Life of Sir Joshua Reynolds,' to which his intimacy with Reynolds and his knowledge of art gave a peculiar character and value. He had great conversational powers, and in 1866 his conversations, written by Hazlitt, who was his constant visitor, appeared in the ' New Monthly Magazine.' They were followed by his ' Fables,' many of which were written as well as illustrated by himself. His last work was his ' Life of Titian,' published in 1830. He lived for nearly 50 years at 39 Argyll Street, where his sister kept his house, and there he died on July 13, 1831, in his 86th year, having amassed a fortune by his profession.

His compositions were faulty and unstudied. His light and shade conventional, and frequently untrue. His processes of painting careless. Yet his groups are often happily conceived, bold and vigorous, free from affectation, and, largely circulated by engraving, became popular. He fairly takes rank with the eminent men of his day, who were following the same art. In manner he was eccentric, and is charged with an

habitual cynicism, which hardly belongs to him. He was prudent in his habits, benevolent to those who asked his help, and courteous to the young painter who sought his advice.

NORTON, CHRISTOPHER, *engraver.* Studied at St. Martin's Lane Academy. In 1760 he was at Rome, and the same year gained a premium at the Society of Arts. He practised in the second half of the 18th century, and engraved after Vandevelde, 'The Tempest,' and also after Pillement, Canot, and others.

NUGENT, THOMAS, *engraver.* Born in Drogheda. He studied his art in Dublin, and about the end of the 18th century practised in London, sometimes in imitation of chalk drawings, excelling in portrait.

NUNEHAM, SIMON HARCOURT, Viscount (afterwards second Earl Harcourt), *amateur etcher.* There are by him some landscape views, dated about 1760, among them several after Paul Sandby. He exhibited some etchings at the Spring Gardens' Rooms in 1763, and the same year published four views of the 'Ruins at Stanton Harcourt,' drawn and etched by himself. Walpole speaks of them in extravagant terms for which there is little warrant. He died April 20, 1809.

NUTTER, WILLIAM, *draftsman and engraver.* Born in 1754. Was the pupil of I. Smith. He practised in the dot manner, and finished a number of plates after Westall, Morland, Bigg, Paye, and Wheatley, with portraits after Hoppner, S. Shelley, and Russell. He resided in Somers Town, and died March 14, 1802, aged 48, and was buried at St. John Baptist, Kentish Town.

NUTTING, JOSEPH, *engraver.* Practised in London at the beginning of the 17th century, and probably commenced engraving about the time of the Restoration. He was chiefly employed on book illustrations. Some of his best works are his small portraits, among them one, on a plate with five others, from the life of Dr. Monk, Bishop of Hereford, who died in 1661; but their chief value arises from their rarity. They are weak in line, and laboured in manner.

O

OAKLEY, OCTAVIUS, *water-colour painter.* Born in April, 1800. He began his artist life as a portrait painter in watercolours, and resided at Leamington, where he had a considerable practice, and in Derby, and while living there in 1826 and 1827, sent portraits to the Academy exhibitions. He also made occasional studies of rustic subjects, and was reputed for his gipsy groups, in which he depicted the character of the race with great truth. In 1842 he came to reside in London, and was elected an associate, and in 1845 a member of the Water-Colour Society. Latterly he painted picturesque scenery, introducing figures with much ability. He was an occasional contributor of a portrait to the Academy exhibitions up to 1860. He died at Bayswater, March 1, 1867. His works were fairly drawn and truthful, but feeble both in colour and light and shade.

OAKMAN, JOHN, *wood-engraver.* Was born at Hendon, Middlesex, and towards the middle of the 18th century was apprenticed to a map engraver. He afterwards cut the illustrations on wood for many children's books with some ability. But he fell into intemperate habits, and then joining two of his boon companions, opened a shop in the Haymarket for the sale of humorous prints. This failing, he turned song and ballad writer, and wrote some cheap novels, in one of which, 'The Life of Ben Brass,' he described some of the scenes of his early career. His last novel, 'William Williams, the African Prince,' had a good sale. He died in distress, December 1793.

OCKS, ——, *medallist.* He was one of the engravers of the Mint in the reign of George I. He died in 1749.

OCKS, RALPH, *medallist.* For many years he was one of the engravers of the Royal Mint. He died at Battersea in 1788, aged 84.

O'CONNOR, JAMES A., *landscape painter.* Was born in 1793, at Dublin, where his father practised as an engraver, and brought him up to the same profession, which he left early in life for the easel, and gained some proficiency as a landscape painter in oil. In 1813 he made his way with his friend Danby to try his fortune in London, but his means were soon exhausted; he walked back disappointed to Bristol and got from thence to Dublin. After many years of hard labour and neglect, he left Ireland early in 1822, and came to reside in London, and in that and the three following years was an exhibitor, chiefly of Irish views, at the Royal Academy. During this time his works found some purchasers in the sale rooms, and by the intervention

of the dealers; but the prices which he received left him poor, and in May 1826 he went over to Brussels, where he remained about twelve months, made many sketches, and was unfortunately the victim of a swindling transaction, by which he was a great sufferer. From 1827 to 1832 he continued in London, and then visited Paris, sending some pictures he painted there to London, where they realised fair prices. From Paris he went into Rhenish Prussia, where an illusory introduction and the loss of a letter with remittances was the cause of much difficulty. In November 1833 he returned to London, and from that time to 1839 he continued to labour, yet with small remuneration, at his easel, and was an occasional exhibitor at the Academy and at Suffolk Street. But his health began to fail. His income, which had at the best been irregular and uncertain, now fell off, embarrassment was added to illness, and after a life which had been one long struggle, he died at Brompton, January 7, 1841, in his 49th year. He left a widow, for whom an appeal for assistance was made in the 'Art Journal,' in 1845. His landscapes are boldly painted, show great feeling, and are good in tone and colour, but rather green.

O'DOHERTY, W. J., *sculptor.* Was born in Dublin in 1835, and studied in the schools of the Dublin Society, and afterwards under Kirke, R.H.A. In 1854 he came to London, and in 1862 exhibited at the Academy 'Alethe,' a marble statuette; and the two following years some busts, which were not without promise. About 1865 he set out for Rome, to complete there his design for 'The Martyr,' and was lost sight of till his death was announced as having taken place in February 1867, at the Maison de Charité, in Berlin. He had probably been taken ill, and, unknown, was removed to that institution.

OGBORNE, John, *engraver.* Born in London, about 1725. He was a pupil of Bartolozzi, and practised in the dot manner, engraving many works, chiefly after Smirke, J. Boydell, Stothard, Hamilton, Westall, Angelica Kauffman, Lely, and also, after his own designs, 'Music' and 'History.' Two or three of his plates were for the 'Shakespeare Gallery;' and there is a good engraving by him after Sir Francis Bourgeois, 'Children at their Mother's Grave.' His engravings possess much power, and are well drawn. In his latter plates, by introducing line, he produced more variety of texture. He died about 1795. He was assisted by Mary Ogborne on some of his plates.

O'KEEFE, Daniel, *miniature painter.* See KEEFE, Daniel. He died at Brompton, June 22, 1787.

O'KEEFE, John, *miniature painter.*

Brother of the above. Was born in Dublin, in 1748. He studied at the Dublin Academy, and for a time in London, under Hudson, and there are some humorous designs by him. He afterwards went upon the stage, and performed low comedy in London and Dublin with success, and left the arts. He was the author of several popular dramatic pieces. He died at Southampton in 1833, in his 86th year. There is a portrait of him by Lawranson in the National Portrait Gallery.

OKEY, Samuel, *engraver.* He was awarded premiums at the Society of Arts in 1765–67. He practised towards the end of the 18th century, working in mezzo-tint. There is a plate by him after Sir J. Reynolds; also after Pine, and others.

• OLIVER, Isaac, *miniature painter.* Was born in 1556. Lord Orford says he could find no account of his family, and he is supposed by some to have been of French extraction, but Nichols, in his 'History of Leicestershire,' quotes an authority which relates that he was said to be of a family holding lands in East Norton. It seems also that he was a relative of John Oliver, master-mason to James I. He was a pupil of Hilliard, and also studied under Zucchero, and attained great excellence in miniature art. That he was highly appreciated is shown by his having received 40l. for four miniatures, a considerable sum at that time. He painted Queen Elizabeth, Mary Queen of Scots, Prince Henry, Ben Jonson, a full-length of Sir Philip Sidney, and many other persons of distinction. He sometimes worked in oil, but his portraits in this medium are flat and minutely finished, though full of character. He painted in oil the portraits of himself, his wife, and his children. He drew well with the pen, and made some historical designs of small size, which evince much power. He died at his house in Blackfriars in 1617 (some accounts give a later date), and was buried in the church of St. Anne's there. His monument and bust, erected by his son, were destroyed in the Great Fire. He wrote a treatise on limning. His drawings are usually signed 'Olivier;' his miniatures with the monogram Φ.

• OLIVER, Peter, *miniature painter.* Eldest son of the foregoing. Born in London in 1601. He was the pupil of his father, and surpassed him in excellence, often painting with him on the same miniature. Many fine portraits by him are cherished in old family collections. He was also distinguished for his miniature copies in water-colours of the historical works of the great masters. He etched some subjects of the same class. He died, as appears by the probate of his will, in 1660, aged 59, and was buried near his father.

OLIVER, John, *glass painter.* He was

315

born in London, in 1616, and was the nephew and pupil of the above Peter Oliver, and a descendant of John Oliver, the master-mason to James I. He practised as a glass painter during a long life. He was appointed the city surveyor, and was one of the three surveyors for regulating the plan of rebuilding London after the fire of 1666, and became possessed of a great part of the MSS. designs of Inigo Jones. The armorial bearings of the Percies, in the great window of the chapel at Petworth House, are by him ; and so is also the window at Christ Church, Oxford, representing the delivery of St. Peter from prison, and is inscribed, 'J. Oliver, ætat. suæ 84, anno 1700; pinxit deditque.' He died the following year. From the discouragement of glass painting during the Commonwealth, his long life had rendered him almost the sole depository of the art.

OLIVER, ISAAC, *engraver.* Son of the above John Oliver. There are mezzo-tint portraits by him of James II. and of Lord Chief Justice Jefferys, with some etchings, but these works are also attributed to his father.

OLIVER, ARCHER JAMES, A.R.A., *portrait painter.* Was born in 1774, and was admitted a student at the Royal Academy in 1793, and in 1803 elected an associate. He had for a time a large and fashionable practice, and from 1800 to 1820 was a large contributor of portrait works to the Academy exhibitions. His practice soon after falling off, he was appointed curator to the painting school, but his health failing, he was chiefly supported from the Academy funds. He continued to contribute to the exhibitions till his death, in 1842, but his latter works were mostly small pieces of still-life, fruit, nuts, and an occasional sketch.

OLIVER, SAMUEL EUCLID, *portrait modeller.* He practised in wax, and exhibited at the first opening of the Royal Academy in 1769, but his name does not appear subsequently.

OLIVER, WILLIAM, *water-colour painter.* He was a member of the New Water-Colour Society. His works were chiefly views of foreign scenery, and were slight and unfinished. He painted a few works in oil. Died November 2, 1853, aged 48.

OMER, ROWLAND, *topographical draftsman.* He was born in Ireland. He practised about the middle of the 18th century, and drew many of the buildings in Ireland, especially in Dublin, which were engraved by Mayell and others.

O NEAL, JEFFREY HAMET, *landscape painter.* Born in Ireland. Practised in London during many years. He painted landscapes, birds, flowers, small conversation pieces, with sometimes a miniature, and contributed for several years to the

Spring Gardens' Exhibition. He lived up to the end of the 18th century.

O'NEILL, HUGH, *architectural draftsman.* Born in Bloomsbury, April 20, 1784, the son of an architect who built part of Portland Place. He was one of the young artists who found a friend in Dr. Monro, who gave him access to his collections. He had a good knowledge of perspective. He spent his early days chiefly in Oxford, but was well known in Edinburgh, Bath, and Bristol. In these cities he taught drawing, and made many carefully-finished drawings, and above 500 sketches of the architectural antiquities of Bristol alone. He died in that city April 7, 1824. Some of his sketches of the ruins of Christ Church, Oxford, were published 1809 ; and 50 of his 'Sketches of Antiquities in Bristol' were published in etching, by J. Skelton, F.S.A., 1826.

OPIE, JOHN, R.A., *historical and portrait painter.* Was born at St. Agnes, near Truro, in May, 1761, the son of the village carpenter, a respectable man, who intended him to continue the family trade. He gave early proofs of a strong understanding, and an attachment to drawing, which was secretly encouraged by his mother, and though at first checked by his father, he was at length allowed to follow. He soon made sufficient progress to get employment travelling about the neighbourhood as a portrait painter, and at Truro attracted the notice of Dr. Wolcott (Peter Pindar), who befriended him, and about 1780 brought him to London, on an arrangement to divide the profits of his work, and introduced him as 'The Cornish Wonder.'

'The Cornish boy in the tin mines bred,
Whose native genius like his diamonds shone
In secret, till chance gave him to the sun.'

Opie's compact with Dr. Wolcott soon came to an end, and in December 1782 he married his first wife, the daughter of a respectable citizen, who proved unfaithful, and he obtained a divorce in 1796. His first works exhibited in London, commencing in 1782, were studies of heads and portraits, and in 1786 he added three subject pictures, 'The Assassination of James I. of Scotland,' 'A Sleeping Nymph,' and 'Cupid Stealing a Kiss.' In the next year he exhibited his great work, 'The Murder of David Rizzio.' His progress had been marked and rapid. He was at once, 1787, elected an associate, and in the following spring, 1788, a full member of the Academy. How fully he was employed in portraiture at this time appears from the fact that in the following seven years he exhibited at the Academy 20 pictures, all of which were portraits. But from 1796, without abandoning portraiture, he exhibited many subject pictures, and was engaged in Boydell's

great series of Shakespeare illustrations, to which he contributed five pictures, increasing in power in the progress of the work. On their completion he had again to rely more on portraiture for his chief means of support; and availing himself of some introductions at Norwich, he met there the clever Amelia Alderson, who became his second wife, and in her memoir of him tells of the painful struggles, and the perseverance with which he strove to gain a competence; and that, stimulated to efforts beyond his strength, taking no rest, a disease affecting the brain ensued. He died April 9, 1807, and was buried with some pomp in St. Paul's Cathedral.

He was a man of great natural intellectual powers, and early devoted himself to supply the defects of his education. Literary men, highly qualified to judge, were greatly impressed with his knowledge and power of thinking and expressing himself in conversation. His first work was a 'Memoir of Reynolds,' in Watkin's edition of Pilkington. He then published a letter on the 'Cultivation of the Arts of Design in England.' He delivered four lectures on Art at the Royal Institution, and on his election in 1805 as Professor of Painting at the Royal Academy he lectured on design, invention, chiaro-scuro, and colour. These four lectures were published after his death, with a memoir, by his widow, who enjoyed a high literary reputation. As an artist his works prove his great genius and original powers. His 'David Rizzio' is full of vigour and freshness, though coarse and slovenly in execution, and marred by many faults. Later his compositions were more simple, his light and shade better understood, and his works have a vigorous and manly strength which contrasts with the feeble inanities of many of his contemporaries. He had no feeling for female beauty. His forte was the grand and terrible.

OPIE, or OPPEY, *portrait painter*. He was born in Cornwall, and of humble origin, but is believed not to have been any connexion of the foregoing John Opie. He was self-taught. He exhibited with the Incorporated Society of Artists in 1780, and is described 'Master Oppey, Penryn —a boy's head, an instance of genius, not having seen a picture.' His work was stated at the time to have been good both for colour and expression, and he attracted some notice, but he died young in Marylebone, November 25, 1785.

ORAM, WILLIAM, called 'Old Oram,' *landscape painter*. Was educated as an architect, but took to landscape painting, and practised in the manner of Wootton, towards the middle of the 18th century. In those sterile days he was of some distinction. Sir Edward Walpole had several of his drawings and paintings, and by his influence he was appointed Surveyor of the Board of Works, and, in 1748, Master Carpenter of all his Majesty's Works. He was much employed in the decoration of halls, staircases, and the panels over chimney pieces, as was then the fashion.

ORAM, EDWARD, *landscape painter*. Son of the above. He was an assistant to De Loutherbourg, and practised in London in the last half of the 18th century. He designed a triumphal arch (which was engraved) for the coronation of George III., and the scenery for the Well-close Square Theatre. In 1766 he exhibited with the Incorporated Society of Artists, and for the first time at the Academy in 1775, and then and in succeeding years contributed small landscapes, views, and morning and evening effects up to 1790, and again in 1798-99, after which his name no longer appears in the catalogues. He published, in 1810, 'Precepts and Practice on the Art of Colouring in Landscape Painting,' with plates.

ORCHYERDE, WILLIAM, *architect*. Was the architect of the extensive buildings of Magdalen College, Oxford, 1473-1485, under the direction of Bishop Waynfleet, the founder.

ORDE, THOMAS, *amateur*. Born in 1746. When an undergraduate at Cambridge he etched some caricatures—'A Cambridge Concert,' and some Cambridge characters. He also etched some family portraits. There is a burlesque of Voltaire by him signed 'T. O., fecit. 1772.' He assumed the name of Powlett in addition to Orde in 1795. He was secretary to the Duke of Rutland when Lord Lieutenant of Ireland, and was created Baron Bolton in 1797. He died July 30, 1807, in his 61st year.

OREWELL, JOHN, *medallist*. He held the office of graver to the Royal Mint from the 10th to the 19th, Henry VI.

ORME, DANIEL, *engraver and miniature painter*. Practised in London about the end of the 18th century. Commencing in 1797, he exhibited many miniature portraits, with one or two in oil, at the Academy, his last contribution being in 1801. He engraved in the dot manner portraits of the chief heroes of the time, with some battle-pieces, and from a picture painted by himself, 'Alexander the Great and Thais.'

OSBORN, JOHN, *portrait painter*. An English artist of the 17th century, who practised at Amsterdam. There is a portrait by him of Frederick Prince of Orange.

OTTLEY, WILLIAM YOUNG, *amateur*. Born at Thatcham near Newbury, August 6, 1771. Son of an officer in the Guards. From his love of art he became a pupil of Cuitt, studied in the Academy Schools,

317

and in 1794 was pursuing the study of art in Rome. But he is best known as a writer on art, who illustrated his works by his own etchings. He published in 1816 'An Inquiry into the Origin and Early History of Engraving upon Copper and on Wood;' in 1818, 'The British Gallery of Pictures,' twenty selected engravings from the Stafford Gallery; in 1823, 'The Italian School of Design,' with etchings by himself; in 1825, 'Etchings by himself after the Paintings and Sculpture of the Florentine School;' in 1826, 'Fac-similes of Rare Etchings by Celebrated Painters of the Italian, German, and Flemish Schools.' Some vigorous pencil and tinted drawings by him, dated 1804, show much mastery of drawing and imagination. He was an honorary exhibitor at the Royal Academy on one occasion only, in 1823, of a spirited but unfinished drawing, 'The Battle of the Angels,' and was in 1833 appointed keeper of the prints in the British Museum. He died May 26, 1836.

OWEN, SAMUEL, water-colour painter. Born 1768. His name first appears as the exhibitor of a sea view at the Academy in 1794, followed in 1797 by the 'British and Spanish Fleets,' commanded by Sir John Jervis, and by marine subjects in 1799 and 1807. He was a member of the short-lived Society of 'Associated Artists in Water-Colours,' founded in 1808. He chiefly drew marine subjects. His works are carefully coloured and finished, and have much merit. He made the 83 drawings illustrating Bernard Cooke's 'The Thames,' which have great pictorial interest, the shipping correctly drawn, and well introduced. He had long left off the practice of his art, and died at Sunbury, December 8, 1857.

OWEN, The Rev. EDWARD PRYCE, M.A., amateur. He was born in March, 1788, and, a clergyman of the Church of England, made himself known as a painter and etcher. He published, in 1820, 'The Ancient Buildings in Shrewsbury,' and in 1852, 50 etchings of rustic scenery, views in Shrewsbury, cattle, figures, &c. He died at Cheltenham, July 15, 1863.

OWEN, WILLIAM, R.A., portrait painter. Was the son of a bookseller at Ludlow, where he was born in 1769. He was educated at the grammar school of the town, and gave early indications of his genius by sketching the scenery of its environs. In 1786 he came to London, and was admitted a student of the Academy in 1791. He was at the same time a pupil of Catton, R.A. In the following year he first exhibited, sending a portrait, and a home remembrance, a 'View of Ludford Bridge,' but his inclination was to rustic subjects, and we find him exhibiting, 'The Blind Beggar of Bethnal Green,' 'The Village Schoolmistress,' 'The Fortune-teller,' and works of this class. His true art was, however, portraiture, and in this his power increased with the number of his sitters, of whom he had a distinguished list. He was at the height of his practice in 1804, and was in that year elected an associate, and in 1806 a full member of the Academy.

In 1810 he was appointed portrait painter to the Prince of Wales, and in 1813 principal portrait painter to the Prince as Prince Regent. The appointment did not add much to his income, which had now reached 3000l. a year. He had for some time resided in Pimlico, and had a studio in Leicester Square, but in 1818 he removed to Bruton Street and united the two. Soon after his health failed; an affection of the spine ensued, and he was confined for several years to his room, and in the latter years unable to work. He died suddenly on February 11, 1825, from the effect of laudanum, taken through the mistake of a chemist's assistant. To his natural genius he added unwearied diligence. His drawing was superficial, his painting not without power, his colour, with a tendency to be hot and monotonous, was good, his landscape backgrounds showed feeling and taste, and the truth and character of his portraits made him popular, more especially in his male portraits; but the reputation of his own day is not sustained in ours, and he only holds a good place in the second rank. Some of his subject pictures were engraved and were very popular.

P

PAAS, CORNELIUS, engraver. Born in Germany. Came early in life to London, where he practised nearly 40 years. He was appointed engraver to George III. Died in Holborn, January 8, 1806, aged 65.

PACK, CHRISTOPHER, portrait painter. Was born at Norwich in 1750, the son of a Norwich merchant of an old family. He

was engaged there in trade and amused himself by painting. His affairs suffering a reverse, he sought his support from the practice of art. He gained an introduction to Sir Joshua Reynolds, and in 1781 made some good copies from his works. But his health failed, and he returned to Norwich, where he practised as a portrait painter,

318

and then went to Liverpool, in 1787 returning to London. He then went, on an invitation, to Dublin, where he was successful as a portrait painter, and afterwards returned to London about 1796, exhibiting at the Academy in that year, and continuing to practice with some repute; but he does not appear again as an exhibitor.

PÁDUA, JOHN OF, *architect.* *See* THORPE, JOHN.

PAEST, HENRY, *portrait painter and copyist.* He practised in the reign of Charles II., and found employment under Barlow and Henry Stone. There is a copy of Lucca Giordano's 'Cyclops' by him, which was in the royal collection at St. James's Palace.

PAINE, JAMES, *architect.* Was a student in the St. Martin's Lane Academy, and attained the power of drawing both the figure and ornament well, and was the designer of the ornament for his own works. He was a member of the Artists' Committee appointed 1755 to plan the establishment of a Royal Academy. In 1765 he built an exhibition room for the Society of Arts, and about the same time rebuilt Salisbury Street, Strand. He erected several fine mansions, among his earliest, Nostell Priory, Yorkshire, simple but heavy in character; also Wardour Castle, Wilts, Worksop Notts, Thorndon Hall Essex, and the mansion at Whitehall known as Dover House. He was clerk of the works at Greenwich Hospital, and was appointed architect to the King, but his office was one of those abolished by Mr. Burke's act. He was an influential member of the Incorporated Society of Artists in 1765, afterwards president, and for several years exhibited his designs with the Society, but his presidency was the cause of great recrimination and ill-will. He exhibited in 1781 at the Royal Academy his design for a national monument to the Earl of Chatham. He published in 1775, 'Plans of Doncaster;' and in 1783, his 'Plans and Elevations of Noblemen's and other Houses,' with 176 plates. He lived in a spacious house which he had built for himself in St. Martin's Lane, and then removed to the neighbourhood of Chertsey, where he had a fine collection of drawings, and in 1783 was high sheriff for Surrey. He retired to France and died there in 1789, in his 73rd year. There is now a good portrait of him and his son in University Gallery, Oxford. His daughter married Tilly Kettle, the painter.

PAINE, JAMES, *water-colour draftsman.* Son of the above. Was a member of the St. Martin's Lane Academy, and exhibited stained drawings at the Spring Gardens' Exhibitions, 1761-64-70.

PALMER, Sir JAMES, *amateur.* Was a favourite in the household of Charles I.

and Deputy Chancellor of the Order of the Garter. He copied several of the pictures in the Royal collection; among them, Titian's 'Tarquin and Lucretia.' These copies were probably 'limnings.' He is also said to have painted a 'Feast of Bacchus.' He was an agent for the purchase of some pictures for the King.

PAPWORTH, GEORGE, R.H.A., *architect.* He was born in London about 1781, and was first employed in the office of an elder brother. In 1804 he went to Northampton, and in 1806 to Dublin, where he settled. He was for some time engaged to superintend the manufacture of stone tubes for piping, and made some inventions, which were profitable to him; and from 1812-18 was employed as an architect and arbitrator. His reputation increased, and he erected several public buildings; among them the King's Bridge, a novel, light iron structure, over the Liffey. In 1831 he was elected a member of the Royal Hibernian Academy. In 1851 he built the Museum of Irish Industry at Dublin. Died there March 14, 1855.

PAPWORTH, JOHN BUONAROTTI, *architect.* Elder brother of the foregoing George Papworth. He was an exhibitor at the Academy from 1816-41, chiefly of architectural designs. About 1823 he was appointed architect to the King of Wurtemburg, for whom he designed a palace; and on the establishment of the Government School of Design in 1837, he was appointed the director, and he fitted up and arranged the schools. He also made designs for furniture, and was occasionally employed in the embellishment of gardens. Was a vice-president of the Royal Institute of British Architects. He published an essay on 'The Dry Rot in Timber,' 1803; 'Hints on Ornamental Gardening,' 1834; 'Hints on Rural Architecture.' After 50 years' practice he retired to St. Neots, where he died June 16, 1847.

PAPWORTH, JOHN THOMAS, R.H.A., *architect.* Eldest son of the above, was born in 1813, and was professor of Architecture in the Royal Dublin Society, and secretary to the Institute of Irish Architects. He died prematurely in Paris, in October 1841, aged 27.

PAPWORTH, JOHN WOODY, *architect.* Son of the foregoing J. Buonarotti Papworth, was born in Marylebone, March 4, 1820, and at the age of 16 entered his father's office. On the opening of the new Government School of Design he filled for twelve months the office of secretary to the Council. In 1839 he was admitted to study in the schools of the Royal Academy, and from that time for many years exhibited his architectural designs at the Academy; among them, a design for the *façade* of the Cathedral of Santa Maria at

319

Florence, and for improving the approach to Westminster Abbey. He also made many designs for art manufactures, and wrote several suggestions and papers connected with art. He died July 6, 1870.

PAPWORTH, EDGAR GEORGE, *sculptor.* Nephew of J. Buonarotti Papworth, and a pupil of Bucley's. He was a student of the Royal Academy, and first exhibited there in 1832. In the following year he gained the Academy gold medal for his group, 'Leucothea presenting the Scarf to Ulysses,' and in 1834 was elected to the travelling studentship. In 1836 he sent from Rome to the Academy exhibition a 'Psyche.' In 1838 he had returned, and that year exhibited a 'Flora' and a head of 'Psyche.' Soon after he married a daughter of Bailey, R.A., in whose studio he was employed. He continued to exhibit chiefly busts, statuettes, and sketch designs. In 1856 he sent a marble figure, 'The Moabitish Maiden,' a commission from Prince Albert; in 1859 his last works, 'The Young Emigrant' and 'The Bride.' He died in 1860.

PARISET, D. P., *engraver.* Was born at Lyons in 1740. He was a pupil of Demarteau, the inventor of the chalk manner. He came to England in 1769, and etched for Ryland, and afterwards worked for Bartolozzi. He engraved a series of plates of the drawings of the great masters, and portraits of English artists after Peter Falconet.

PARK, THOMAS, *amateur engraver.* Was born about 1750, and practised in mezzo-tint. He engraved 'Mrs. Jordan as the Comic Muse,' after Hoppner, 1786; 'Holman and Miss Brunton as Romeo and Juliet,' after Browne; and also after Reynolds, Beechey, Paye, and others.

PARK, PATRICK, R.S.A., *sculptor.* Was born at Glasgow in 1809. In the earlier part of his career he studied in Italy. In 1840 he came to live in London, and then was first an exhibitor at the Academy. In 1841 he contributed a 'Warrior;' in 1843, 'Hector,' a colossal statue, sending also an occasional bust; in 1850 he sent busts for exhibition from Edinburgh; in 1853 and the two next years from Manchester. He excelled as a bust modeller, his works embodying character and tenderness. He was elected a member of the Royal Scottish Academy in 1850. He died in the prime of life at Warrington, August 18, 1855.

PARKE, ROBERT, *architect.* Practised in Dublin, and between 1787–94 made considerable additions to the exterior of the Irish House of Commons, adding a fine Ionic portico to the western entrance.

PARKE, HENRY, *architect.* Was originally intended for the bar and received a good classical and mathematical education. He then became the pupil of Sir John Soane,

320

and travelled to complete his studies, visiting Italy and Egypt. He brought home many original measured drawings of the monuments of these countries. In 1830 he exhibited at the Academy an 'Interior of a Sepulchral Chamber,' a clever work, and in 1831 an excellent drawing of the 'Temples in the Island of Philœ.' He painted both in oil and water-colours, and made some elaborately finished views, which were powerful both in effect and colour, and some naval drawings of much ability. A large collection of his drawings is deposited in the Institute of British Architects. He was engaged by his brother architects to design the medal which they presented to Sir John Soane. He died May 5, 1835, aged about 45. Many of his works were sold by auction at Sotheby's in May 1836.

PARKER, FREDERICK, *wood-engraver.* Son of Mr. John Parker, the publisher. Was of much promise. Died young, December 16, 1847.

PARKER, JAMES, *engraver.* Born 1750. Pupil of Basire. He joined William Blake in a print shop in 1784, but on some disagreement quitted him three years after. He was chiefly employed in the illustration of books, and his plates were greatly esteemed. He engraved, after Stothard, for the 'Vicar of Wakefield,' 1792, and 'Falconer's Shipwreck,' 1795. He also engraved after Flaxman, Smirke, Northcote, and for Boydell's 'Shakespeare.' He worked chiefly in the line manner, was neat and careful in his execution, but wanting in power. He was one of the founders and a governor of the Society of Engravers. He died suddenly May 26, 1805, and was buried at St. Clement's Lanes, burial-ground.

PARKER, JOHN, *history and portrait painter.* Born about 1730. He went to Rome to study, resided there several years, and painted an altar-piece for the Church of St. Gregorio, Monte Celio; about 1762 he returned to England, and in the following year exhibited with the Free Society of Artists, of which he was a member, 'The Assassination of Rizzio,' and his own portrait. He died soon after at Paddington, it is said, in 1765.

PARKER, JOHN, *landscape painter.* Studied in the Duke of Richmond's gallery, and received some instructions from the Smiths of Chichester. In 1765–66 he exhibited landscapes and flowers with the Free Society. He went to Rome, where he was about 1768. He had returned to England in 1770, and then in the following year exhibited landscapes at the Academy. In 1776 he exhibited, for the last time, three small landscapes, introducing subjects from classic story.

PARKES, DAVID, *amateur.* Born at Hales Owen, Shropshire, February 21, 1763. He was educated in the village school, and

afterwards was a schoolmaster at Shrewsbury. He sketched in water-colours the churches and antiquities of the county with much knowledge and correctness, and was for many years a well-known contributor of drawings and antiquarian papers to the 'Gentleman's Magazine.' He died at Shrewsbury, May 8, 1833.

PARKES, JAMES, *draftsman*. Son of the above. Practised as a drawing-master at Shrewsbury. He etched 12 views of monastic and other remains in Shropshire, which were published in 1829. Died March 31, 1828, aged 34.

PARKINSON, THOMAS, *portrait and subject painter*. He practised in the last quarter of the 18th century, and painted portraits and theatrical groups. He exhibited at the Academy, in 1775, a good group from 'She Stoops to Conquer,' in the manner of Zoffany (mezzo-tinted by R. Laurie), followed by a scene from 'Cymon,' 1775, a scene from the 'Duenna,' 1776. He was thenceforth chiefly employed in portraiture, continuing an exhibitor up to 1789.

PARMENTIER, JAMES, *history and portrait painter*. Born in France, 1658. Was the nephew and pupil of Sebastian Bourdon. He came to England in 1676 and was employed by La Fosse to assist in his works at Montague House. William III. sent him to Holland to ornament his palace at Loo. But he quarrelled with the surveyor, and on his return, not finding employment in London, he went into Yorkshire, where he lived several years, painting portraits and some historical works, an altar-piece at Hull, and another at St. Peter's Church, Leeds. The staircase at Worksop is by him, and at Painters' Hall, London, is his picture of 'Diana and Endymion.' On the death of old Laguerre in 1721, he hoped to find more encouragement, and then settled in London, where he died, in indifferent circumstances, December 2, 1730, and was buried at St. Paul's, Covent Garden.

PARR, REMI, *engraver*. Born at Rochester in 1723. Learnt the rudiments of his art in London, and then studied on the continent. He engraved portraits and book plates; horses after Seymour, Wootton, and Tillemans, and many humorous plates, with several works of an architectural character; 'Views of the remarkable Buildings in Florence,' 1750 ; 'Views of St. Paul's;' 'View of London from under the Arch of Westminster Bridge,' 1757, and a 'South-east View from the Bridge.'

PARRIS, EDMUND THOMAS, *portrait and history painter*. Was born June 4, 1793, and first exhibited at the Royal Academy in 1816. He painted the gigantic panorama of London at the Coliseum, in the Regent's Park, which occupied him from 1825 to 1829, and which was afterwards removed to New York. He was appointed historical painter to Queen Adelaide in 1838. He painted a portrait of Queen Victoria, and in 1839 her Coronation, from both of which engravings have been published. In 1843 he took a prize for his cartoon of 'Joseph of Arimathea converting the Jews,' at the competitive exhibition at Guildhall. From 1853 to 1856 he was employed in restoring the pictures of Sir James Thornhill in the dome of St. Paul's Cathedral, a work of great labour and difficulty. He died November 9, 1873.

PARRY, WILLIAM, A.R.A., *portrait painter*. He was born in London, 1742. Son of the celebrated blind harper. Studied at St. Martin's Lane Academy and the Duke of Richmond's gallery. He gained premiums at the Society of Arts in 1760, and was one of the first students in the Royal Academy schools. He also became a pupil of Sir Joshua Reynolds, and making good use of his advantages, was looked upon as of considerable promise. In 1766 he was a member of the Incorporated Society of Artists. By the assistance of Sir W. W. Wynne he went in 1770 to Italy, and returned to London in 1775, when he married. In the following year he exhibited full and half-length portraits at the Royal Academy, and was elected an associate. He continued to exhibit portraits in 1777-78 and 1779, but did not meet with the employment he hoped, and, involved in annoyances by the imprudence of his wife's brother, he retired to Wales, where his wife dying, twelve months after he revisited Rome. He was again, and for the last time, an exhibitor at the Academy in 1788. He had acquired a small fortune with his wife, and finding sufficient employment, remained at Rome till his health failing he set off home, and arrived in London only in time to die, February 13, 1791. He etched a benefit ticket for his blind father, whose likeness it bears.

PARS, WILLIAM, A.R.A., *portrait painter*. Was the son of a chaser, and born in London in 1742. He studied in the St. Martin's Lane School, and also in the Duke of Richmond's gallery. He exhibited at the Society of Artists in 1761, a portrait and miniatures, and was in 1763 a member of the Free Society of Artists, and in the following year obtained the Society of Arts' medal for a historical painting. He was, in June of the same year, selected by the Dilettanti Society to accompany as draftsman Dr. Chandler and Mr. Revett to Greece, and was absent till November, 1766. On his return he accompanied Lord Palmerston to the Continent, and made drawings at Rome, but chiefly in Switzerland and the Tyrol. In 1770 he was elected an associate of the Royal Academy, and in 1774 was chosen by the Dilettanti Society

to complete his studies at Rome on their student's pension, and started in the summer of 1775, remaining there till the autumn of 1782, when he died of fever. He was a constant exhibitor at the Academy from its establishment, chiefly of small whole-length portraits, with some life-size; and of drawings, stained views of temples in Asia Minor and Greece, his last contribution being sent from Rome in 1776. Woollett engraved the Mer de Glace and four other Swiss views after him, Sandby several of his views in aqua-tint, and William Byrne a selection of his Greek drawings for the Dilettanti Society.

PARS, HENRY, *draftsman and chaser.* Was the elder brother of the above. He was brought up to his father's business as a chaser. On the falling off of this trade, he was employed, about 1763, to manage the St. Martin's Lane School, which was thence called Pars' School, and in connexion with which his name became well known. In this employment he continued till his death, in his 73rd year, May 7, 1806. His brother, ALBERT PARS, was a successful modeller in wax.

PARSONS, FRANCIS, *portrait painter.* Student in the St. Martin's Lane Academy. He exhibited with the artists at Spring Gardens' Rooms, in 1763, a portrait of one of the Indian Chiefs then in London, and of Miss Davis as Madge in 'Love in a Village.' He was a member of the Incorporated Society of Artists, 1766, but had not much success as a painter, and for many years kept a shop as picture-dealer and cleaner. McArdell engraved his Indian chiefs, and Dunkarton a portrait by him of Brindley, the engineer.

PARSON, WILLIAM, *amateur.* Born in London, 1736. Was the son of a builder in Bow Lane, and was educated at St. Paul's School. At 14 he was apprenticed to an architect, and took several premiums at the Society of Arts. On the completion of his apprenticeship, he went on the stage, and became a very popular comic actor, but he never entirely relinquished his art. He painted architectural subjects, landscapes, and fruit pieces, the latter his best productions. He died February 3, 1795.

PARTRIDGE, JOHN, *portrait painter.* He was born February 28, 1790. Little can be traced of his early career. In 1815 he appears as an exhibitor at the Royal Academy, sending portraits in that year, and in 1817-18-19, and from that time was a regular contributor to the exhibitions. He sent on one of two occasions only a subject picture—in 1830, 'Titania, Puck, and Bottom;' in 1836, 'Sketch of a Sketching Society, the Critical Moment.' In 1843 he exhibited two portraits, the Queen and Prince Albert, both of which were engraved; and in 1845 he was appointed portrait

322

Parsey. a - painter

painter extraordinary to her Majesty and the Prince. In 1846 he exhibited for the last time, sending portraits of Lord and Lady Beauvale. His portraits were carefully drawn and painted, his likeness good, and his portrait of the Queen was popular. He for 30 years occupied an excellent position as a portrait painter, and made a property by his art; but he did not attain to the first rank. He was a member of the Sketching Club. He died November 25, 1872, in his 83rd year.

PASSE (or DE PASSE), CRISPIN, *engraver.* There is great uncertainty both as to the place and time of his birth. He is generally stated to have been born at Utrecht, or Arneminden, about 1560. He was a man of letters, and early studied art. He was invited to Paris to teach drawing, and from thence came to England, where he executed numerous works, both portraits and subjects from his own designs and after various masters. He drew the figure well, and the extremities with much knowledge. He worked entirely with the graver, in a fine clear style, but hard. His portraits, many of which he drew from the life, are his best works. Among his English portraits are Queen Elizabeth in a sumptuous dress; James I., Henry Prince of Wales, and his brother Charles, the Count Palatine and Elizabeth his wife. Vertue supposes he left England before 1635, as none of his works dated here are after that year. He published in four languages a book on the art of painting and drawing. He also illustrated with sixty plates, in folio, 'Instruction du Roi en l'Exercise de monter à Cheval.'

PASSE (or DE PASSE), CRISPIN, *engraver.* Eldest son and pupil of the above. There are a few plates by his hand; but so little is known of him—not even the fact that he practised his art in England—that his place in this work is questionable.

PASSE (or DE PASSE), MAGDALEN, *engraver.* Daughter of the elder Crispin. Was born at Utrecht, 1583. She practised about 1620 in the same manner as the rest of her family, using the gravér only, and in a neat literal style. There is a portrait by her of Catherine Duchess of Buckingham, some plates after classic pictures, and landscapes. She worked in Germany and Denmark as well as in this country.

PASSE (or DE PASSE), SIMON, *engraver.* Born at Utrecht, 1591. Son of the elder Crispin, with whom he is supposed to have come to England. His earliest work here is dated 1613. He engraved the portraits of many distinguished persons, among them a whole-length of Queen Elizabeth; several portraits of James I.; his Queen on horseback, with a view of Windsor, dated 1617; Prince Henry; Villiers Duke of Buckingham, 1617; Carr Earl of Somerset

and his Countess. He practised in England about ten years, and then went to Copenhagen in the service of the King of Denmark, and died there soon after 1644.

PASSE (or DE PASSE), WILLIAM, *engraver.* Was the eldest son of Crispin. Born at Utrecht, about 1590. Some of his best works are dated London, and were executed between 1620–27. His works are very numerous, some of them from the life, and are rare and much esteemed. He engraved James I., with his family; the Bohemian family, signed 'Will. Pass, fecit ad vivum figurator, 1621;' Frances Duchess of Richmond and Lennox, 1625, with many others.

PASTORINI, BENEDICT, *engraver.* An Italian, who practised in London in the latter part of the 18th century. He had some instruction from Bartolozzi and engraved in his manner. He worked after Angelica Kauffman, Rigaud, and others. He was one of the governors of the Society of Engravers, founded 1803.

PASTORINI, J., *miniature painter.* He was an occasional exhibitor at the Royal Academy from 1812 to 1826, and died in Newman Street, August 3, 1839, aged 66.

PATCH, COZENS, *subject painter.* There is at Petworth a painting in the Hogarth manner, and of the same period, by an artist of this name.

PATCH, THOMAS, *engraver and painter.* He went to Italy with Sir Joshua Reynolds, and is supposed to have died there some time after 1772. He engraved a series of caricatures, dated 1768–70; 26 folio plates after the frescoes of Masaccio; Ghiberti's Baptistery Gates; Studies from Fra Bartolommeo, 1771; two landscapes after Poussin. He also painted some landscapes and figures, and there is a large plate of Florence, well drawn and etched, by him. In the Royal Collection at Hampton Court there are two pictures by this artist.

PATON, DAVID, *portrait painter.* Practised in Scotland about the middle of the 18th century. He painted miniatures in black and white, drew many small portraits, and copied likenesses from pictures, finishing the draperies and accessories with great minuteness. His portraits are simple and pleasing, and he had for his sitters persons of distinction. Some of his portraits are engraved. Robert White engraved his portrait of Sir James Dalrymple of Stair, president of the Court of Session.

PATON, RICHARD, *marine painter.* He is said to have been born in a low sphere of life, and was found a poor boy on Tower Hill by Admiral Sir Richard Knowles, who took him to sea. How he gained a knowledge of art is unknown. He painted the Lord Mayor's Show by water, the figures by Wheatley, a picture which is now in the Guildhall. He exhibited, 1762–68, with the Incorporated Society of Artists, of which he was a vice-president, but after a very angry correspondence, resigned his membership in 1771. In 1774 he finished a set of views, the figures by Mortimer, of Count Orloff's victory over the Turks. He also painted four excellent views of the dockyards, broad and rich in colour, in one a ship on fire, the effect cleverly managed. These four works are now at Hampton Court Palace. From 1776 to 1780 he was a large contributor to the exhibitions at the Royal Academy. His works were engraved by Woollett, Fittler, Canot, and others, and there are three marine views etched by himself. He held for many years an office in the Excise, and rose to be the general accountant, but of early habits, he managed to continue his art. He died in Wardour Street, Soho, after a long and painful illness, March 7, 1791, aged 74.

PATTEN, GEORGE, A.R.A., *portrait and history painter.* Born June 29, 1801. He was of a family of artists, and entering the schools of the Academy in 1816, studied first as a miniature painter, and practised that art till 1830. He then painted life-size portraits in oil, and some subject pictures. In 1837 he went to Italy, and visited the chief art cities, and was elected an associate of the Academy in the same year. In 1840 he visited Germany, and painted there the portrait of Prince Albert, who subsequently appointed him his portrait-painter in ordinary. He painted many full-length portraits for presentation to different institutions, and a number of classical, with two or three scriptural, subjects. He was a large contributor to the exhibitions of the Academy from 1819 to his death. Though he had been a diligent and laborious student, and had acquired great power as a painter, he failed to attain that excellence which would have gained him the membership of the Academy. He had resided the latter part of his life at Ross, in Herefordshire, but returned to the neighbourhood of the metropolis, where he died, March 11, 1865.

PAUL, J. S., *engraver.* Practised in mezzo-tint in the latter half of the 18th century. There is a portrait by him of Mrs. Barry, the actress, after Kettle, some portraits after Reynolds, and a 'Conversation' after Jan Steen. His works possess much ability.

PAUL, ROBERT, *engraver.* Studied at the Glasgow Academy and practised in that city, of which there are several views slightly etched by him, and a north view of the Cathedral Church, dated 1762.

PAXTON, JOHN, *portrait and history painter.* He is believed to have been instructed in Foulis' Academy, at Glasgow. He was a member of the Incorporated Society of Artists, 1766, and sent from

Rome to their exhibition in that year, 'Samson in Distress,' and in London, in 1772 and 1773, was also a contributor. To the first exhibition of the Royal Academy, 1769, he sent a small whole-length portrait, a boy in the character of Cupid, and a girl playing on a musical instrument. His portraits were well painted and finished, and gained him a reputation. He afterwards went to the East Indies, and died in Bombay, in 1780.

* PAYE, RICHARD MORTON, *subject painter.* Was born at Botley, in Kent, and first employed in London as a chaser. He was soon distinguished by the fine sculpturesque manner of his classic and allegorical groups. He also occasionally practised painting. His easel pictures were carefully finished, his light and shade excellent, but his painting woolly. His subjects were chiefly domestic and familiar, for his feelings were now roused by family cares, and he for a time enjoyed some popularity. But few of his works are known. His 'Miraculous Increase of the Widow's Oil,' in which he introduced his wife and some of his children, is said to have been sold as a Velasquez, and another picture by him as a Wright of Derby. In 1773 he exhibited at the Royal Academy both portraits in oil and wax models, and the same in the following year. He was a contributor in 1783 to the exhibition of the Incorporated Society and of the Free Society. In 1787 some emblematical designs by him were published in the 'Artists' Repository.'

When Dr. Wolcott quarrelled with Opie he took up Paye, lodged him in his house, and praised and flattered him, but the connexion was soon dissolved. He painted a loutish stupid lad, said to be a natural son of the doctor, which he exhibited at the Academy in 1785, as 'Portrait of a Sulky Boy.' This was supposed one cause of quarrel; and he satirised the doctor in a sketch as a bear seated at an easel. His employment was precarious. He tried modelling, oil painting, miniature painting, and engraving to procure a subsistence. Shy and diffident in his habits, he did not mix with his brother artists, or in any other society. He was soon known to be in difficulties. His powers began to fail. He suffered from rheumatic fever, followed by an attack which paralysed his right hand, and, stimulated by necessity, he learned to work with his left; but embarrassed by poverty and neglect, he fell into obscurity. He did not exhibit after 1802, and was lost sight of by his friends. The date of his death even is unknown, but it has been traced with tolerable accuracy to have happened in December 1821. Many of his pictures were engraved by J. Young, who befriended him. Val.

324

Green engraved, in 1783, his, 'Child of Sorrow,' and two or three others; and he himself engraved, after his own pictures, 'Puss in Durance,' and 'No Dance, no Supper.'

PAYE, Miss, *miniature painter.* Lived for several years with the above, and was probably his daughter. She was an exhibitor at the Royal Academy, commencing in 1798, and among her works were the portraits of many persons of rank. She exhibited in 1800, 'L'Allegro;' 1801, 'Cupid;' 1803, 'Sylvia;' 1805, 'Mrs. Siddons,' with many others, but ceased to exhibit in 1807.

PAYNE, JOHN, *engraver.* Was a pupil of Simon de Passe. His chief works are frontispieces, book-plates, and portraits; but he also engraved landscapes, animals, birds, fruit, and flowers. He is reputed to have been the first English artist who practised line engraving. Evelyn commends his portraits, and also a very large plate by him of Phineas Pett's 'Royal Sovereign.' Walpole says he was an idle genius, who neglected the fame and fortune which his talent would have secured him, and died in indigence, before the age of 40, shortly before 1648. A plate by him is dated 'London, 1620.' His works are prized by collectors.

PAYNE, WILLIAM, *water-colour painter.* He originally held a civil appointment in the engineers' department at Plymouth, and, having a love of art, pursued it himself, and, self-taught, struck out a new style. He resided at Plymouth in 1786, and in that year sent to the Academy exhibition some views of the neighbouring scenery. He had great dexterity of hand, working with the brush, almost excluding outline. His colour was brilliant, his style marked by vivid effects of sunshine and light and shade produced by the opposition of warm colours and grey aërial tints. He exhibited at the Spring Gardens' Rooms in 1776 and in 1790, when he came to reside in London, and was soon the fashionable teacher of the day. But he was seduced further and further from nature by his great facility, and fell into a mere mannerist. He was, in 1809, elected an associate exhibitor of the Water-Colour Society, but appears to have withdrawn in 1813, with other seceders, when a change was made in the constitution of the society. Sir Joshua Reynolds spoke in high terms of some small drawings made by him of the slate quarries at Plympton.

PEACHAM, HENRY, *amateur.* Born at South Mimms, near St. Albans. Studied at Trinity College, Cambridge, and took the degree of M.A. He was for a time a teacher at the Free School at Wymondham, Norfolk, and then became tutor to the children of Lord Arundel, and accompanied

him to the Low Countries. Afterwards he visited Italy. He was distinguished for his attainments in music, painting, and engraving, and was deemed both a scholar and an artist. He took likenesses, and engraved a portrait after Holbein. He published 'The Complete Gentleman,' 1634, which, among other matters, gives instruction for drawing and painting, and was much studied by the younger gentry of that age, though it does not seem probable that they would gain much art knowledge from it. He also published 'The Gentleman's Exercise, or An Exquisite Practice as well for Drawing all manner of Beasts in their true Portraiture; as also the making of Colours for Limning, Painting, Tricking and Blazoning of Coats of Arms, 1630.' He is supposed to have died about 1650.

PEACKE, EDWARD, } engravers. Prac-
PEACKE, ROBERT, } tised about the middle of the 17th century, working together. There are by them several plates of friezes and architectural ornaments.

PEACKE, WILLIAM, engraver and painter. There are some portraits by an artist of this name, who practised in the reign of James I.

PEAK, JAMES, engraver and draftsman. Was born about 1730, and brought up in London. He was employed by Alderman Boydell, and engraved landscapes after Claude, R. Wilson, the Smiths of Chichester, Pillement, and others. There are also several spirited painter-like etchings by him. His numerous works are much esteemed. He died about 1782.

* PEAKE, Sir ROBERT, Knt., painter and engraver. He was brought up as an engraver, and, as was common at that day, was also a printseller. He was a good draftsman, and painted portraits in miniature. He painted for King James, in 1612, three portraits, for which he was paid 20l.; and he engraved the portrait—supposed from his own drawing—of Charles I., with his family. In the revolutionary war he took the royal side, and held a commission as lieutenant-colonel under the brave Marquess of Winchester. He was present at the siege of Basing House, and was made a prisoner. He was knighted by Charles at Oxford, in March 1645. He died in 1667, aged about 75, and was buried in St. Sepulchre's, London. Faithorne and Dobson were his pupils.

PEARCE, WILLIAM, portrait painter. Born in London, about the middle of the 18th century, and at its close exhibited one or two portraits at the Academy. He also painted some rustic subjects, and C. Turner engraved 'The Milkmaid' after him.

PEARCE, Sir EDWARD LOVETT, architect. He held the office of 'engineer and surveyor-general' in Dublin, and, in 1729,

designed and commenced the Parliament House, a noble piece of architecture, though the design has been attributed to Castells. He also designed the theatre in Aungier Street, a fine work. He died in 1733, and was buried in the old churchyard of Donnybrook, near Dublin.

PEARSON, JAMES, glass painter. Was born in Dublin. Learnt his art in Italy. In 1776 he completed the window at Brazenose College, Oxford, of 'Christ and the Four Evangelists,' after the designs by Mortimer; and also executed after that artist, 'The Raising of the Brazen Serpent in the Wilderness,' for the great window at Salisbury Cathedral. He also painted some designs after Barry, R.A. The altar-window in Aldersgate Church, London, is by him. He married a daughter of Paterson, the well-known book auctioneer. He died in 1805.

PEARSON, EGLINGTON MARGARET, glass painter. Daughter of Samuel Paterson, the bibliopolist auctioneer, and originator of the noted Darien Scheme. She married the foregoing James Pearson, and assisted him in his paintings. She was much reputed for her work, especially her copies after the cartoons of Raphael. Of these she made two sets, and commenced a third in 1821, but her close application brought on a complaint which ended in her death on February 14, 1823.

PEARSON, Mrs. CHARLES, portrait painter. Her maiden name was Dutton. She married early in life Mr. Pearson, the city solicitor, and later, member of Parliament. She exhibited portraits at the Royal Academy from 1821 to 1837, sending in the years 1836-37 a portrait of the Lord Mayor, and exhibited once more in 1842, again a portrait of the Lord Mayor. She died April 15, 1871, aged 72.

PEART (or PAERT), HENRY, copyist and portrait painter. Pupil of Barlow, and afterwards of Henry Stone. He was an indifferent artist, chiefly employed as a copyist, and copied most of the historical pictures in the royal collections. He died in 1697 or 1698. A portrait by him of a Morocco ambassador, 1682, was engraved.

PEART, CHARLES, sculptor. His original practice was as a modeller in wax. He obtained the Royal Academy gold medal in 1782, for his group of 'Hercules and Omphale,' and from that time was an occasional exhibitor at the Academy of a classic work in plaster. In 1784, 'Prometheus ;' 1787, 'Neptune and Amphitrite ;' but his chief practice appears to have been small portraits in wax. He was an exhibitor from 1778 to 1797.

PEAT, T., portrait painter. He practised in the latter half of the 18th century, and was an imitator of Reynolds, but his practice was chiefly as a painter in miniature, sometimes in enamel. He exhibited

325

at the Academy from 1791 to 1805. Miss M. PEAT, his sister, painted miniature, and was an exhibitor in 1796–97.

PECKITT, WILLIAM (known as 'Peckitt of York '), *glass painter.* Was born in April 1731, at Hursthwaite, in the North Riding, and was a pupil of Price. He was inferior to his predecessors in the art, but, a good chemist, he attained great brilliancy of colour. He commenced glass-painting in York in 1751. Between 1765–77 he completed the windows of the north side of New College Chapel, with apocryphal portraits. In 1767 he put up at Oriel College, 'The Presentation of Christ in the Temple,' from the design of Dr. Wall, a physician, who amused himself by painting. In the library at Trinity College, Cambridge, he painted from an allegorical design by Cipriani, a window, consisting of 140 square feet of glass, for which he was paid 500*l.* There are also some specimens of his work in York Minster and in the City Town Hall. He died at York, October 15, 1795, in his 65th year.

PELHAM, HENRY, *history and miniature painter.* He resided with Copley, R.A., was most probably his pupil, and while under him exhibited at the Academy, in 1777, his first contribution, 'The Finding of Moses,' which was finely engraved by W. Ward in 1787. At the same time, and in the following year, he exhibited some miniatures in enamel and water-colour, after which there is no further trace of his works.

PELHAM, PETER, *engraver.* Born in London about 1684, and practised there early in the following century. There are many fine mezzo-tint plates by him, among them Cromwell after Walker, George I. and George II., and others after Kneller. He died about 1738.

PELHAM, J. C., *portrait painter.* Was the son of the above, and was born about 1721. He practised in London, painting portraits, and occasionally an historical subject.

PELTRO, JOHN, *engraver.* In 1779 he exhibited with the Free Society some engravings after Taverner and others. He found his chief employment in engraving, after the designs of Repton, the miniature views of gentlemen's seats, for the annual 'Polite Repository.' He died at Hendon, August 5, 1808, aged 48.

PEMBROKE, THOMAS, *historical painter.* Born 1702. Was a pupil of Laroon, whose manner he imitated. He painted several pictures for the Earl of Bath, and J. Smith mezzo-tinted after him ' Hagar and Ishmael,' which was published by Boydell. He died in 1730, aged 28.

PEN, JACOB, a *Dutch painter.* A good draftsman and colourist, who came to this country, where only his works are known,

326

and was chiefly employed by Charles II. He died in 1678.

PENLEY, AARON EDWIN, *water-colour painter.* He first appears in 1835 as an exhibitor of portraits in water-colours at the Royal Academy, and continued an occasional contributor up to 1857, sending in 1842 a ' Flower Girl,' and in 1850 a ' Welsh Peasant Girl.' He was elected a member of the new Water-Colour Society (now the Institute) in 1838, and exhibited with them, but feeling his works did not receive in the exhibitions the place due to their merit, he withdrew from the Society in 1856. In 1851 he was appointed professor of drawing at the Addiscombe East India College, and filled that office till the dissolution of the College. He also held, till his death, a similar appointment at the Woolwich Military Academy, and was water-colour painter to William IV. and Queen Adelaide. In 1864 a reward was advertised in one of the London daily papers for any information respecting him, living or dead. What this related to does not appear. His death took place suddenly at Lewisham, January 15, 1870, in his 64th year. His collection and works were sold at Christie's in the following April. He was the author of ' The Elements of Perspective,' 1851 ; ' The English School of Painting in Water-Colours,' 1861 ; and ' Sketching from Nature in Water-Colours,' 1869.

PENNACCHI, GIROLAMO (called Da Trevige), *painter and architect.* He was born at Trevigi in 1508. An imitator of Raphael, he became a good portrait painter, and practised with distinction in several cities in Italy. He then came to England and entered the service of Henry VIII., who employed him chiefly as an architect and engineer. He was killed when serving the king before Boulogne in 1544.

PENNETHORNE, Sir JAMES, Knt., *architect.* He was born at Worcester, in June 1801, and having been educated in that city, he came to London in 1820, and was placed under Augustus Pugin, and afterwards under John Nash. In the autumn of 1824 he visited Italy, and after a careful course of study at Rome, he visited the other great art cities, returning to England at the end of 1826. He was then employed in the office of Mr. Nash, who was at the time largely engaged upon Government works. In 1832 he was himself appointed by the Commissioners of Woods to plan some of the Metropolitan improvements then in contemplation, and for many years was their adviser and executive officer, and in addition to extensive street improvements, he designed Victoria, Kennington, and Battersea Parks. From 1840 his entire services were required by the Government, and in 1843 he visited Ireland to report upon the construction of

Pemberton. C–R
? a dissenting. minister (1840)

the workhouses. In 1845 he commenced the Museum of Economic Geology, a good example of his ability, and its success led to his employment on the Public Record Office, a very important work, which, commenced in 1851, occupied nearly the remainder of his life. Among his other official works were the alteration of the Quadrant, taking away the heavy colonnade ; the addition to the Ordnance Office, Pall Mall, and of a new wing to Somerset House, and the erection of the University of London at the back of Burlington House, his last and best work. Soon after, on some changes made in the Office of Works, he was with little notice removed, in 1870, from an appointment he had so long and with so much distinction held, by the abolition of his office. He received, in 1857, the medal of the Institute of British Architects, and was also presented by the members of his profession with a special medal, in recognition of his talent and services, followed by the honour of knighthood by the Queen on his quitting office. He died at Malden, Surrey, September 1, 1871.

PENNINGTON, JAMES, *china painter.* He was the son of a Liverpool potter, and was apprenticed to Messrs. Wedgwood of Etruria. On the completion of his time he was employed in the Worcester works, when he painted a fine service for the Duke of York, with appropriate naval designs. His son, JOHN PENNINGTON, was apprenticed to Messrs. Wedgwood of Etruria, in 1784, to learn the art of engraving in aqua-tint as applicable to china.

PENNY, EDWARD, R.A., *portrait and subject painter.* Was born at Knutsford, Cheshire, in 1714, and showing an inclination for art, was placed under Hudson, and completed his studies in Rome, where he was some time before 1748. On his return to England he met with much employment, painting small portraits in oil. He also produced some subject pictures, several of which were engraved. Of these, the chief were his 'Death of General Wolfe,' the impressions of which had a great sale ; and 'The Marquis of Granby Relieving a Sick Soldier.' He also designed the illustrations for an edition of 'The Novelists,' which were engraved by R. Houston. He was vice-president of the Chartered Society of Artists, and was one of the foundation members of the Royal Academy, and the first professor of painting, an office which he held till 1783. He was an exhibitor at the first exhibition — his early subjects from Shakespeare and portraits. But his art degenerated into the lesser sentimentalities, and later he fell in with the moral fashion of art at that time. In 1774 he exhibited 'The Profligate Punished,' with its proper pendant, 'The Virtuous Comforted ;' in 1782, his last contribution,

'The Benevolent Physician,' 'The Rapacious Quack,' and 'The Distraint upon a Widow's Cow.' About the same time he married a lady of property, and retired to Chiswick. He died November 15, 1791.

PERIGAL, ARTHUR, *history painter.* Gained the Royal Academy gold medal, 1811, for his historical painting, 'Themistocles taking Refuge at the Court of Admetus.' He had previously exhibited at the Academy, and in 1813 sent 'The Mother's last Embrace of her Infant Moses before placing him in the Ark.' In 1814–15 he did not exhibit. But in 1816 he painted again his subject exhibited in 1813. In 1817 he exhibited a portrait, and in 1821 he was living at Northampton, and exhibited for the last time, 'Going to Market.'

PERRY, FRANCIS, *engraver.* Was born at Abingdon, and brought up to the trade of a hosier. Afterwards he was placed under Vanderbank, the engraver, with whom he learned little, and then under Richardson ; but not making more progress as a painter than as an engraver, he was employed as clerk to a commissary, and going down with him into Staffordshire, he made drawings of Lichfield Cathedral, which he etched, and from this time made many topographical drawings, and resumed engraving. He was employed for the magazines, but could barely earn a livelihood by his industry. There are by him two or three portraits, a series of English silver medals and coins, neatly engraved, and three or four numbers of a gold series, which he had commenced. He died in London, January 3, 1765.

PETER of Colechurch, *architect.* He was the chaplain of St. Mary, Colechurch, and the architect of the old London Bridge. He died in 1205.

* PETERS, The Rev. MATTHEW WILLIAM, R.A., *portrait and history painter.* He was born in the Isle of Wight, but his parents removing to Ireland while he was an infant, he has been supposed to have been born there. His father held an appointment in the Customs at Dublin. He was for a time a pupil of West, the master of the Academy of Design in that city. He gained a premium from the Society of Arts in 1759. Originally intended for the Church, his love of art led him twice to Rome, and he passed some months at Venice in 1773–74. While in Italy he copied the San Gierolomo at Parma, and his copy is over the altar of the church at Saffron Walden. He also copied, in 1782, for the Duke of Rutland, Le Brun's picture in the Carmelite Church at Paris. He painted with success both historical subjects and portraits. He was engaged for Boydell's Gallery, and contributed scenes from 'The Merry Wives of Windsor' and

'Much Ado about Nothing.' There is a full-length portrait by him of George IV. when Prince of Wales in Freemasons' Hall. His works were engraved by Bartolozzi, J. R. Smith, and others. He was in 1771 elected an associate, and in 1777 a full member, of the Academy. He had some years previously entered Exeter College, Oxford, but he continued to paint after he had taken his degree, and in 1783, when he is first described as 'The Reverend' in the catalogue, he exhibited his first sacred subject, 'An Angel carrying the Spirit of a Child to Paradise.' He only exhibited once again, in 1785. He held successively three livings, was a prebendary of Lincoln Cathedral, and chaplain to the Prince Regent. It does not appear whether by conscientious, or what other reasons, he was led in 1790 to resign his Academy honours, and to give up his professional practice, but the few paintings he afterwards produced as an amateur, and did not exhibit, were of a religious class, though some of his early engraved works were not unexceptionable in character. He died at Brasted Place, Kent, March 20, 1814. He married a niece of Dr. Turton, a physician of large practice, the bulk of whose ample fortune went to the painter's second son. He was an object of Peter Pindar's merciless satire.

PETERSON, FREDERIC, enamel painter. He was a pupil of Boit, and practised in London at the beginning of the 18th century. He died in 1729.

PETHER, ABRAHAM, called 'Moonlight Pether,' landscape painter. Was born at Chichester in 1756. He early showed a great genius for music, and then took a turn for painting, and was instructed by George Smith. He soon gained distinction as an artist. He exhibited at the Academy in 1784, a 'Moonlight;' next, in 1785, 'Mount Vesuvius,' and the following year, 'Ship on Fire at Night, in a Gale of Wind,' and continued to exhibit at intervals up to 1811, when he sent his last work, an 'Eruption of Mount Vesuvius.' He chose rural scenes, selecting the beautiful. His colouring was clear and good. He had great power of handling; his distances treated with great truth and sweetness; but he had little idea of light and shade. His favourite subjects were effects of artificial light and moonlight. A picture called the 'Harvest Moon,' was the subject of much contemporary praise. He was an ingenious man, and good mechanic. He made telescopes, microscopes, and lectured on electricity, using instruments of his own making, added to which he was an excellent musician. He was a member of the Incorporated Society of Artists. Died at Southampton, April 13, 1812, aged 56, leaving a widow and nine children.

328

PETHER, SEBASTIAN, landscape painter. He was the eldest son of the foregoing, and painted subjects of the same class. He first exhibited at the Royal Academy in 1814, 'View from Chelsea Bridge,' the 'Destruction of Drury Lane Theatre,' and then only once again till 1826, when it was evident that friendly help was given to him, as he painted on commission for Sir John F. Leicester, Bart., 'A Caravan overtaken by a Sand Storm in the Desert,' and for the Royal Manchester Institution, the 'Destruction of a City by a Volcano;' but these were his last exhibited works. He married very young, and had a large family, whose support was a hard task for his pencil. His only purchasers were the dealers; but the prices he received did not keep his family from the most painful privations, and his talent missed opportunity for success. After a short illness he sank under an inflammatory attack, and died at Battersea, March 18, 1844, aged 54. He was a well-educated man, and gifted with a mechanical talent. A subscription was raised for his destitute family.

PETHER, WILLIAM, mezzo-tint engraver. Was born at Carlisle in 1731, and was cousin of the foregoing Abraham Pether. In 1756 he received a premium from the Society of Arts. He was a member of the Free Society of Artists, 1763. He commenced art as a portrait painter, practising both in oil and in miniature, and occasionally exhibiting miniatures at the Royal Academy from 1781 to 1794; he also painted some tolerable landscapes. But his true art was mezzo-tint, which he studied under Thomas Frye, and soon gained great distinction. His portraits in oil are rare; they are firmly and powerfully painted. His miniatures are spirited works; in mezzo-tint, his works are deservedly prized, well drawn, the expression well maintained, but in treatment rather cold and hard. He drew and mezzo-tinted the portraits of the three Smiths of Chichester, and produced mezzo-tint plates after Rembrandt, Dow, Teniers, Wright of Derby, and others. He died about 1795.

PETHER, THOMAS, wax modeller. He appears to have been a son of Abraham Pether. He exhibited portraits in wax and in crayons with the Free Society of Artists, 1772 to 1775.

PETIT, The Rev. LOUIS JOHN, amateur. Was educated at Cambridge, and took his B.A. degree at Trinity College in 1823. He was an honorary member of the Institute of British Architects, and read some papers at their meetings; a member of the Archæological Institute, and a clever sketcher in water-colours, illustrating many of his antiquarian papers. He also produced some good etchings. He died at Lichfield, December 1, 1868, aged 67. He

wrote 'Illustrations of Church Architecture,' which he illustrated by 200 etchings, 1841 ; 'On the Principles of Gothic Architecture as Applied to Ordinary Parish Churches,' 1846; 'A Description of the Abbey Church, Tewkesbury,' 1848; 'Lectures on Architectural Principles,' and in 1854, 'Lectures on Architectural Studies.'

● PETITOT, JOHN, *enamel miniature painter.* He was born in 1607, in Geneva, where his father practised as a sculptor and architect. Intended for a jeweller, in the practice of that trade, he attained great ability in the use of enamel ; and united with Bordier, who afterwards became his brother-in-law, in its application to miniature painting ; and went with him to Italy, where they improved in their art by the help of the best chemists, and in the study of the works of the great painters. Then coming to England, he was assisted by Sir Theodore Mayerne, the chief physician to Charles I., and the most distinguished chemist of his day, and made great improvements in his scale of colours, and the means of vitrifying them.

By Mayerne, who was his countryman, he was introduced to the King, who gave him employment, assigned him an apartment in Whitehall, and, it is said, knighted him. The time of his arrival is unknown, but about 1640 he produced here some works which are among the finest specimens of his art. The civil war breaking out destroyed his prospects at the English Court, and he went to France ; some accounts say that he attended the royal family to Paris. He was well received by the French king, who gave him a pension, with a residence at the Louvre. But he was a zealous Protestant, and on the revocation of the edict of Nantes, in 1685, then greatly advanced in years, he asked the king's permission to return to Geneva, but as he still continued to practise his art, the king, though pressed by repeated memorials, was unwilling to part with him, and appointed Bossuet to convert him. In this position his anxiety brought on a fever, and, obtaining his liberty, he made his escape to Geneva. Here employment followed him, and so great was the number of his visitors, that he retired to Vevay, where he died suddenly, in 1691. He had 17 children, one of whom became a major-general in the English service, and one only followed his art.

Petitot's enamels excel in all the great qualities of the art, and are unsurpassed in the beauty of their drawing, in refinement of expression, in tender sweetness of colour, and the complete mastery of materials. A large number of them are possessed in this country.

PETITOT, JOHN, *miniature painter.* Son of the foregoing, by whom he was taught the art. He settled in London, and practised with much success. His miniatures are hot in colour, and wanting in the exquisite character and finish of his father's. He died in London, and after his death his family removed to Dublin, where they were settled in 1754. An inscription on the back of one of his miniatures shows him to have been 35 *b 1650* years of age in 1685.

PETRIE, JAMES, *portrait painter.* Was a native of Aberdeen. In the latter part of the 18th century he settled in Dublin, and practised his art there. In the disturbed times which ensued he was a firm loyalist ; but many of the patriot party were his sitters, among them Lord Edward Fitzgerald, Emmet, and Curran.

PETRIE, GEORGE, R.H.A., *landscape painter.* Son of the above. Was born at Dublin, in 1789, and, allowed to follow the bent of his own inclination, he adopted art, studied in the schools of the Dublin Society, and, in his 14th year, gained a silver medal. He early took an interest in antiquarian studies, and in his sketching expeditions made careful notes of antiquarian remains. Up to 1809 his studies had been confined to the counties of Dublin and Wicklow. In 1810 he visited Wales, and in 1813 London, in company with Danby, A.R.A., and O'Connor. In 1816 he was an exhibitor at the Royal Academy, and for the next few years was largely engaged in landscape views, drawn chiefly in monochrome, for the illustration of pictorial works on Ireland. These drawings were careful, and truthfully accurate, showing much poetry of treatment. In 1826 he became an associate of the Royal Hibernian Academy, and was a contributor to their first exhibition, held that year. In 1828 he was elected a full member, and was from that time a constant exhibitor of landscape scenery illustrating the national antiquities. In 1831 he was appointed librarian to the Academy, and the same year visited the Isles of Arran, led both by art and antiquarian tastes.

His literary tastes were indeed developed with his art, and his first essays on antiquarian subjects were contributed to the 'Dublin Examiner' and the 'Dublin Penny Journal' as early as 1816 ; and, with a growing love of Irish antiquities and history, literature gradually superseded art. In 1833 he became connected with the Ordnance Survey of Ireland, which, for the next six years, with little intermission, engaged his whole time and thought. He was placed at the head of a staff whose duty it was to collect every possible information, antiquarian and topographical, and to examine and compare all ancient documents. But this work was suspended in 1839 on a question of cost, and, returning to his easel, he set vigorously to work, and produced

some of his best landscapes. At the same time he was occupied in bringing out his great work, 'On the Ecclesiastical Architecture of Ireland.' In 1845 he visited Scotland. In 1847 the University of Dublin conferred on him the degree of LL.D., and in 1849 he was granted a well-earned pension on the Civil List. He was president of the Royal Hibernian Academy, and in 1859 resigned the office. He died in Dublin, January 17, 1866, and was buried in the Cemetery Mount St. Jerome. His 'Life and Labours in Art and Archæology' was published by Dr. W. Stokes, Dublin, 1868.

PETTIT, JOHN, *engraver and draftsman*. Practised in London, in the dot manner, in the latter part of the 18th century. He engraved a portrait of George Prince of Wales, and 'Yorick and the Grisette,' 1784.

PHELPS, RICHARD, *portrait painter*. He practised in the first half of the 18th century. J. Faber engraved after him a portrait of Bampfield Moore Carew.

PHILIPS, R., *portrait painter*. He was much employed towards the middle of the 18th century, and died in 1741.

PHILIPS, CHARLES, *portrait painter*. He was born in 1708, and was the son of a portrait painter (probably of the foregoing), and painted many persons of distinction, among them the Princess Augusta of Wales and Frederick Prince of Wales. His portraits are usually of a small size. He is also known as a painter of conversation pieces. Earl Cathcart has a work of this class, a family group of Lord and Lady A. Hamilton and children, carefully finished, comprising eight figures, looking like dolls, in a great library, and all evidently posed for the portrait painter; faithful likenesses, no doubt, and well painted, but very poor in composition. It is signed and dated 1731. There is also a portrait by him of Bishop Warburton in the National Portrait Gallery. Several of his portraits are engraved. He died in 1747.

PHILIP, JOHN BIRNIE, *sculptor*. His name first appears in 1858, when he exhibited at the Royal Academy an alto-relievo of 'The Archangel Michael and Satan,' for St. Michael's Church, Cornhill. This was followed by some monumental works, and in 1863 by the reredos for St. George's Chapel, at Windsor, and a recumbent figure of Lady Herbert of Lea. He was at this time engaged upon the Prince Consort's memorial in Hyde Park, and executed 'Geology' a statue, and 'Geometry' a statue; but he will be best remembered by his figures in alto-relievo representing architecture and sculpture, on two sides of the podium of the monument, which gave him a well-earned reputation. He also executed eight statues for the Royal Gallery in the Palace at Westminster, and the

statues in front of the Royal Academy at Burlington House. Probably his only classical work was his 'Narcissus,' exhibited in 1873. He died of bronchitis at Chelsea, March 2, 1875, aged 48, and was buried in the Brompton Cemetery.

PHILLIP, JOHN, R.A., *subject and portrait painter*. Was born at Aberdeen, the son of an old soldier, April 19, 1817. He early showed a great talent for painting and produced a good likeness of his old grandmother. To improve himself he got employment with a house-painter, but was injured by a fall, and soon found his mistake. He then gained the notice of an artist at Aberdeen, who gave him some advice and assistance. He earned a few shillings by painting the portraits of his acquaintance, and with the assistance of a skipper trading to the Thames was enabled to carry out a plan that possessed him, of coming to London to see the exhibition. He was then 17 years of age, and during one week's stay he spent six days at the Academy, and managed also to see the works at the British Institution, and the Elgin marbles at the British Museum. On his return he set resolutely to work upon a group of four figures, which being shown to Lord Panmure, he sent him to London in 1836, placed him under T. M. Joy, and provided him with the means to continue his studies.

During the three following years he studied in London, and painted some portraits. In 1837 he was admitted to the schools of the Royal Academy, and in 1838 and 1839 he exhibited a portrait at the Academy; in 1840 sending his first subject picture, 'Tasso in Disguise, relating his Persecutions to his Sister,' and the same year returned to Aberdeen. There he painted a few portraits, and in 1841 came back to settle in London, but did not exhibit at the Academy till 1847, when he contributed 'Presbyterian Catechising,' and continued to contribute Scotch subjects, his 'Baptism in Scotland,' 1850, giving the first promise of his future excellence. This was followed, in 1851, by 'Scotch Washing,' 'The Spae Wife,' and 'A Sunbeam.' His constitution, always weak, now showed signs of failure, and, advised to try a warmer climate, he determined to visit Spain, and in 1852 did not exhibit.

At Seville, where he spent some months, his health improved, and his art found a new development. Filled with admiration for the works of the Spanish painters, especially Velasquez, and no less so with the picturesque peasantry, their rural customs and celebrations, and the glowing scenery by which they were surrounded; both his art and his subject were thenceforth Spanish, and his future works found their inspiration in Spain, and rivalled the great

master's by whom it was incited, in its power and freshness. In 1853, he exhibited at the Academy, 'Life among the Gypsies at Seville,' and at the British Institution, 'A Spanish Gipsy Mother.' In 1854, at the Academy, 'A Letter-writer of Seville;' the next year, 'El Paseo,' portraits of two sisters, purchased by the Queen, and, returning to a home subject, 'Collecting the Offertory in a Scotch Kirk.' In 1856 he again visited Spain, and that year exhibited 'Agua Fresca' on one of the bridle roads in Spain, 'A Gipsy Water-carrier in Seville,' and two other Spanish scenes. In 1857, 'The Prison-window in Seville,' a favourite picture, and 'Charity,' Seville.

He was elected an associate of the Academy in 1857, and in the following year exhibited several Spanish subjects, and a portrait of the Prince Consort. In 1859 he became a full member of the Academy. In 1860 he made a third journey to Spain, and was represented at the Academy by a picture painted for her Majesty, 'The Marriage of H.R.H. the Princess Royal' —a group of portraits, glowing with brilliant colour; and, continuing Spanish scenes, he in 1863 also exhibited his portrait subject, 'The House of Commons,' and in the next year one of his greatest works, 'La Gloria,' a Spanish wake. In 1865 and 1866, also Spanish subjects, with one or two portraits. In the latter year he went to Rome, which resulted in his two pictures of the 'Lottery,' and then, with relapsed health, his mind reverted to home scenes, and two Scotch subjects were exhibited on the walls of the Academy in that year. But they were his last and were sent by his friends. Before the exhibition he was struck with paralysis, and though favourable accounts were given of him, he died suddenly, about ten days after the attack, at Campden Hill, Kensington, on February 27, 1867, and was buried in Kensal Green Cemetery. He had attained the first rank in art. His subjects were well conceived and full of truthful character—carefully studied, well composed, drawn with great vigour, powerful, and broad in execution and light and shade, and brilliant in harmonious colour. His works have secured him a place among the best painters of the English School. Several of his finest pictures have been engraved in the best manner. His collected works were exhibited at the International Exhibition, 1873.

PHILLIPS, CHARLES, engraver. Was born in 1737, and studied in London. He was employed by Alderman Boydell, about 1765. His best works are in mezzo-tint, but there are some plates by him in the dot manner. He engraved chiefly after the old masters — Parmegiano, Spagnoletto, Rembrandt, Francesco Mola, and others. There is a fine mezzo-tint by him of the daughter of Hone, R.A., powerful and luminous in colour.

*PHILLIPS, THOMAS, R.A., *portrait painter*. Was born of respectable parents at Dudley, in Warwickshire, October 18, 1770. He received a good education, and showing an early love for art, his inclination was encouraged by his parents, who placed him with Mr. Eginton, the well-known glass painter, at Birmingham. At the end of 1790 he came to London to follow art as a profession. He was admitted a student of the Academy, and was for a time employed by Benjamin West, P.R.A., who was then designing the glass windows for St. George's Chapel, Windsor. In 1792, he first appears on the walls of the Academy, his work a 'View of Windsor Castle,' followed next year by an historical attempt, 'The Death of Talbot, Earl of Shrewsbury,' and 'Ruth and her Mother-in-law.' In 1794 he exhibited attempts of the same class, with one portrait. He soon appears to have found the scope of his talent, and from this time to 1804, portraiture was his chief pursuit. In this he was not without good rivals; but he industriously made his way. He removed to George Street, Hanover Square, in the latter year, and was elected an associate, and in 1808 a member of the Royal Academy. His presentation picture, 'Venus and Adonis,' was the last of his creative subjects.

Sitters of eminence now came to him. In 1806 he painted the Prince of Wales, the Marchioness of Stafford, the Stafford family, and Lord Egremont, who was his friend through life. He had established a reputation. His portraits were numerous; they were characterised by simplicity of style and truthful finish, solid, and carefully executed, and he has preserved to us many of the most distinguished in literature and art, among them, perhaps the best portrait of Lord Byron. In 1824 he was elected the Academy Professor of Painting, and visited Italy, in company with his friend Hilton, R.A., to prepare for his new duties. His lectures embraced a history of painting, invention, design, composition, colour, light and shade, and the duty of art as a teacher. These lectures were published in 1832. He wrote several articles connected with the fine arts for Rees' 'Encyclopedia.' He was one of the chief promoters of the General Benevolent Institution. He died April 20, 1845, at his house in George Street, where he had dwelt 41 years. He left two daughters and two sons, one of whom followed successfully his profession.

PHILLIPS, HENRY WYNDHAM, *portrait painter*. Son of the above, and studied his art under his father. He first appears an exhibitor in 1839, and was from that year to 1868 a constant contributor to the

331

Academy exhibitions. His works were almost exclusively portraits; but between 1845 and 1849 he tried some sacred subjects. He was for several years the secretary to the Artists' General Benevolent Institution. He acquired some repute as a portrait painter, but died suddenly, December 5, 1868, aged 48.

PHILLIPS, GILES FIRMAN, *landscape painter.* He painted almost exclusively river scenes, introducing vessels, and these, with hardly any exception, views on the Thames, and in water-colours. He was an exhibitor at the Royal Academy from 1836, when he was residing at Greenwich, to 1858. He published in 1838 'The Theory and Practice of Painting in Water-Colours,' and since, other works connected with his art. He died March 31, 1867, aged 87.

PHILLIPS, S., *engraver.* Practised in London about the end of the 18th century. He engraved 'The Birth of Shakespeare,' after Westall, and 'The Guardian Angel,' after Maria Cosway.

PICART, CHARLES, *engraver and draftsman.* Born about 1780, practised in London. He engraved several dramatic portraits after Clint and Wivell, and some of the illustrations for the 'Description of the Ancient Marbles in the British Museum.' He executed some of the plates for Dr. Dibdin's work and for Lodge's portraits. He died about 1837.

PICKEN, ANDREW, *lithographic draftsman.* Was the son of an author. Born 1815. When of sufficient age he was placed under Louis Haghe to learn the art of lithography. He distinguished himself by his landscape and other illustrations, and in 1835 exhibited at the Academy a 'Tomb in Narbonne Cathedral.' He had long suffered from delicate health from the rupture of a blood vessel, and in 1837 was sent by his physician to Madeira. During a two years' residence in the island, he devoted himself to art, and made a series of drawings which he afterwards published under the title of 'Madeira Illustrated,' a work of great truth and skill. Returning to England in 1840, his failing health compelled a second voyage to Madeira; but his disease gained ground, and he came back to London, where he died June 24, 1845, in his 30th year. His short life had been chiefly devoted to lithography, and his productions maintain a high rank in that art.

PICKERING, HENRY, *portrait painter.* Practised in the first half of the 18th century. His portraits are after the allegorical manner of Kneller. Faber engraved a 'Shepherdess' after him, a portrait of that class.

PICKERSGILL, HENRY WILLIAM, R.A., *portrait painter.* Was born in London, December 3, 1782. He was adopted early in life by a connexion, a Mr. Hall, who sent him to school at Poplar, and intended him for his own business, that of a silk manufacturer. This business having declined in consequence of the French war, he was led to the study of art. He became a pupil of George Arnald, A.R.A., and was admitted as a student of the Royal Academy in 1805. When he first began to paint, he exhibited historical and mythological subjects, but he soon devoted himself to portraiture. He was elected an associate of the Royal Academy in 1822, and a full member in 1826. In 1856 he succeeded J. Uwins, R.A., as Librarian to the Royal Academy, which office he held many years. His portraits are generally satisfactory as likenesses, though they are not very distinguished for their artistic qualities. After the death of T. Phillips, R.A., he became the fashionable portrait painter of the day, and painted likenesses of nearly all the celebrated people of the time. Many of his best portraits are in the college halls of Oxford. His portraits of Wordsworth in the National Portrait Gallery, and of Mr. Vernon in the National Gallery, are good specimens of his style. He also painted a very fair full-length portrait of the 'Duke of Wellington' for General Lord Hill, and many portraits for Sir Robert Peel's collection at Drayton. He exhibited every year at the Royal Academy, portraits and other works, till 1872. He placed himself upon the retired Academicians list in 1873, and died at Barnes, April 21, 1875, aged 93.

PICKERSGILL, HENRY HALL, *subject and portrait painter.* Eldest son of the above. He studied in the Netherlands making careful studies of the old masters, and afterwards visited the art cities of Italy. He first exhibited at the Royal Academy, in 1834, 'The Troubadours;' in 1837, 'Holy Water;' the following year, 'Charity;' and continued to exhibit works of this class. He was then induced to visit St. Petersburg, and on his return, after two years spent there, he exhibited, in 1846, 'Fishermen of Rebatzky on the Neva;' and in 1847, 'A Ferry on the Neva.' Returning to his earlier subjects he exhibited, in 1848, 'The Right of Sanctuary;' in 1851, 'Cupid and Psyche,' and 'The Finding of Moses;' in 1852, 'Romeo and Juliet.' Soon after he found his chief employment as a portrait painter, practising almost exclusively in Manchester and Wolverhampton, and in the adjacent counties, Shropshire and Herefordshire, from 1855 to 1860, exhibiting only portraits. He died January 7, 1861.

PICKFORD, J., *architect.* He built Sandon, in Staffordshire, a mansion of plain, simply-proportioned elevation, about 1770,

332

which is engraved in Woolfe and Gandon's work.

PICOT, VICTOR MARIE, *engraver.* Was born at Abbeville, in 1745, and studied his art in Paris. He was brought to England about 1766 by Wynne Ryland, and about 1770 was living with Ravenet, whose only daughter Angelica, herself a clever artist, he married. About 1773 he kept a print-shop in St. Martin's Lane, about ten years later in the Strand, and afterwards in Chandos Street. In 1766 he was elected a member of the Incorporated Society of Artists. He excelled in the then prevailing dot manner, and engraved after Serres, Barralet, De Loutherbourg, and others. He returned to France in 1790, and died about 1805.

PIDDING, HENRY J., *subject painter.* He chose humorous scenes and subjects from still-life, excelling in his painting of dead fish. He exhibited at the Royal Academy, commencing in 1824, works of this class, and from the same year with the Society of British Artists, of which body he became a member in 1843, and continued an exhibitor till his death. He enjoyed some reputation, and several of his pictures were made popular by engraving. Of these may be named, 'The Fair Penitent,' a 'Negro in the Stocks,' 'The Battle of the Nile Re-fought,' two Greenwich pensioners laying out a diagram of the battle with fragments of tobacco pipes, both of which were engraved by himself. He died at Greenwich, June 13, 1864, aged 67.

PIERCE, EDWARD, *ornamental painter.* He practised in the reign of Charles I., and was noted as a painter of history and landscape. He painted several ceilings and altar-pieces, and was skilled also in architectural design, but his chief works were destroyed by the Great Fire. He was some time engaged by Vandyck as an assistant. After the Restoration he was employed in repairing the injuries done by the Puritans to the altar-pieces in the London churches. He died soon after this time, and was buried at Stamford. He etched a book of designs for friezes, 1640.

PIERCE, EDWARD, *statuary and architect.* Son of the above. Was pupil of Edward Bird. He practised in the latter half of the 17th century, and was some time assistant to Sir Christopher Wren, under whom he built the Church of St. Clement, Strand. He executed the statues of Sir Thomas Gresham and of Edward III. for the Old Royal Exchange, the four dragons at the angles of the pedestal of the monument on Fish Street Hill, the busts of Newton and Wren for the theatre at Oxford, a fine vase for Hampton Court Palace, and, his chief work, a large and pretentious monument to William, Lord Maynard, at Little Easton, Essex. He

died at Surrey Street, Strand, 1698, and was buried in the Savoy.

PIERCE, JOHN. Another son of the foregoing, who was bred a painter, and is said to have attained some eminence, but no traces remain of his art.

PIETERS, JOHN, *history and portrait painter.* Was born at Antwerp, 1667, and studied painting there. Came to England in 1685. Was very poor, and not meeting with the encouragement he had hoped as a history painter, he engaged himself as an assistant to Sir Godfrey Kneller, who employed him upon the draperies and backgrounds of his portraits. In 1712 he left Sir Godfrey and found the same employment with others. He was a good copyist of the works of Rubens, but his chief business was as a repairer. He became drunken and imprudent, and died in London, 1727. He was buried in the churchyard of St. Martin's.

PILKINGTON, Sir WILLIAM, Bart., *amateur.* He was of a very ancient family, and succeeded to his title in 1811. He was a good scholar, a man of taste, and a clever landscape painter. He also showed some skill in architecture, and Butterton Hall, Staffordshire, was built after his designs. He died near Wakefield, September 30, 1830, aged 75.

PILLANS, R., *marine painter.* He practised in the second half of the 18th century, and painted both storm and calm, seashore views with fishermen, harbours, and vessels.

PILLEMENT, JEAN, *landscape and marine painter.* He was born and educated at Lyons. Went to Paris for his improvement, and then to Vienna. After the peace of 1763 he came to London, and enjoyed here a great reputation. Between 1773–80 he was an occasional exhibitor with the Artists' Free Society. He painted landscapes, marines, subject-pictures, and also flowers. His landscapes were greatly in vogue, and he was the fashionable teacher of his day. He worked both in oil and pastelle, but he was best known by his water-colour drawings. He was fond of gay colours and violent effects. His manner was spirited, and his compositions pleasing. Many of his works were engraved in England, Woollett, Mason, Elliot, and others working after him. He advertised the sale of his paintings and drawings in 1773, being, on account of his health, advised to relinquish all business, and retire to Avignon. He styled himself painter to the King of Poland and to Marie Antoinette, Queen of France. He died at Lyons, where he passed his latter days, in 1808, in his 80th year. He was a clever etcher.

PINE, JOHN, *engraver.* Born 1690. He kept a print-shop in St. Martin's Lane,

and was the convivial friend of Hogarth, who painted his portrait, and also introduced him as the friar in his picture of 'Calais Gate,' from which he obtained the nickname of 'Friar Pine.' He became known by his series of engravings, published in 1725, representing the ceremonial of the revival of the Order of the Bath by George I., and established a high reputation by his fine engravings from the House of Lords' tapestry of the 'Destruction of the Spanish Armada.' He designed and engraved an illustrated edition of 'Horace,' the text itself engraved on the plates, and ornamented from gems and ancient bas-reliefs. He also engraved some portraits, an etching of himself, and a mezzo-tint of Garrick. In 1743 he was appointed blue mantle in the Heralds' College, where he went to reside, and died, May 4, 1756. He was one of the committee of artists who, in 1755, attempted to found a Royal Academy.

PINE, Robert Edge, *history and portrait painter*. Born in London, 1742. Son of the above. He early distinguished himself in art. In 1760 he gained the Society of Arts' first premium of 100 guineas for his 'Surrender of Calais,' the figures in which were life-size; and in 1763 he again obtained the Society's first prize for his 'Canute Reproving his Courtiers.' He was a member and occasional exhibitor of portraits at the Spring Gardens' exhibition, 1764–70, and at the Royal Academy, and contributed to that exhibition his last work, 'Lord Rodney in Action on board the Formidable, attended by his Principal Officers.' In 1771 he angrily erased his name from the lists of the Spring Gardens' Incorporated Society, on the ground of an insult by the president. He went to Bath at this time, and practised portrait painting there till 1779. In the early part of 1782 he was in London, and exhibited a collection of his pictures from 'Shakespeare' in the great room at Spring Gardens, but the exhibition was not successful. He was a restless, morbidly-irritable, little man, and about this time went with his family to America, ostensibly to paint the heroes of the Revolution, and Washington, with others, sat to him; but little is known of him there. He died at Philadelphia in 1790. His colour and composition were agreeable, but his drawing feeble. He took several of his historical pictures to America, where they were unfortunately destroyed by fire. His 'Surrender of Calais' was placed in the Town Hall at Newbury. There is a good whole-length portrait of George II. by him at Audley End; and a whole-length of the Duke of Northumberland at Middlesex Hospital. His portrait of Garrick is highly esteemed. Many of his theatrical portraits were engraved by McArdell, Valentine Green, J.

334

Watson, Dickinson, and C. Watson, and were very popular.

PINE, Simon, *miniature painter*. Brother of the foregoing. He resided a few years in London. He practised in Dublin and Connaught, but chiefly at Bath, from whence he sent miniatures to the Spring Gardens' exhibition from 1768 to 1771. He also exhibited at the Royal Academy in 1772, and died in that year.

PINGO, Thomas, *medallist*. Born in Italy, he came to England, and was appointed an engraver to the Royal Mint, ii. George III. In 1763 he was a member of the Free Society of Artists. His best works are dated between 1745 and 1764. There is a good medal of the Pretender by him, executed in 1750. He modelled for Wedgwood, in 1769, the battles of Plassy and Pondicherry. He died in December 1776.

PINGO, Lewis, *medallist*. Son of the above. Was appointed chief engraver to the Royal Mint, xix. George III., and was eminent in his art. He was a member of the Free Society of Artists, 1763. He retired from his office in 1815, and went to reside in Camberwell, where he died, August 26, 1830, aged 87.

PINGO, John, *medallist*. Brother to the above Lewis Pingo. He was appointed assistant engraver to the Mint, xxvii. George III., and in 1768 and 1770 exhibited medals and wax models with the Free Society of Artists.

PINWELL, George John, *water-colour painter*. Was born in London, December 26, 1842, and began his art education at Hatherley's School of Art. He first became known as a book illustrator, and as a draftsman his reputation for brilliant drawing was very early established. Among his most important works were his illustrations for Dalziel's 'Wayside Poems,' 'Vicar of Wakefield,' 1864; '' 'Good Words,' 'Once a Week,' and 'London Society.' He exhibited his first water-colour drawing at the Dudley Gallery in 1865, and from that year his success was continuous. He was elected an associate of the Society of Painters in Water-Colours in 1869, and a full member two years later. He exhibited that year 'The Pied Piper of Hamlin;' in 1872, 'Gilbert à Becket's troth;' in 1874, 'The Beggar's Roost, Tangier, Morocco;' and in 1875, 'We fell out, my Wife and I.' He was elected an honorary member of the Belgian Society of Painters in Water-Colour, and was rapidly becoming one of the foremost men in this branch of art, when he was prematurely cut off at the early age of 33. He died in London, September 8, 1875.

PISTRUCCI, Benedetto, *medallist*. An Italian. Encouraged by an English gentleman, he came to England in 1816.

On his way he was arrested in Paris as a spy and confined many weeks in prison. He was bringing with him some fine engraved gems as specimens of his power, and was compelled to part with them for his support. He alleged that his detention arose from an intrigue to get possession of his gems. He owed his release to his English friends. On his arrival in London he obtained an introduction to the Prince Regent, whose portrait he produced as a cameo on a fine gem. He soon after received commissions for the Royal Mint, and was employed as an assistant on the new silver coinage. On a vacancy in 1817 he was appointed the chief engraver, with a salary of 500*l.* He engraved the dies, using, it is said, the wheel of the gem engraver for the coins of the end of George III.'s and the early part of George IV.'s reign ; and about the same time produced three fine heads of the King, cut in jasper. In 1820 he engraved the Coronation Medal, and in the following year a medal in commemoration of the King's visit to Ireland. He had refused to use the portraits of this sovereign by Sir Thomas Lawrence and Sir Francis Chantrey as his models, and his continued refusal, contrary to the King's wishes, to use Chantrey's bust as his model for the new coinage was, it is said, the chief cause of the discontinuance of his services by the Mint, and of an arrangement by which he was retained as medallist with a reduced salary of 350*l.*

This was the cause of much irritation. He felt his position a false one and expressed his discontent. He was then employed upon a Waterloo Medal, and commenced one on a large scale, but its completion was delayed from time to time and the public were dissatisfied. He was at the same time engaged upon some private medals. On the accession of Queen Victoria he produced the Coronation Medal. It did not, however, please. In 1849 he completed his Waterloo Medal, which he deemed his *chef-d'œuvre.* It was no less than five inches in diameter, and contained altogether 60 figures ; but he confessed his inability to harden it, and no one else ventured upon the responsibility, so the toil of so many years was of no further use than to strike a proof impression on soft metal. His original appointment in the Mint was the subject of much censure, and his conduct in a difficult position left him open to animadversion ; but his abilities as an artist, if not exactly suited to his office, cannot be questioned. He executed some marble busts of a colossal size. He died at Englefield Green, near Windsor, September 16, 1855, aged 73.

PITTS, WILLIAM, *sculptor.* Born 1790. His father, to whom he was apprenticed, was a chaser in silver. He gained a Society of Arts Medal in 1812, and distinguished himself by modelling part of Stothard's 'Wellington Shield,' and afterwards by chasing Flaxman's 'Shield of Achilles.' He also modelled in silver, with great ability, Le Soeur's statue of Charles I. He married at 19, and then, impelled by his genius and his necessities, he set vigorously to work and produced in rapid succession, first exhibiting at the Academy in 1823, 'The Deluge,' a sketch ; 'The Creation of Eve,' 'Samson Killing the Lion,' 'Herod's Cruelty,' 'Cupid under the Mantle of Night,' 'Pandora brought to Epimetheus,' and 'Puck.' In these varied yet truly classic subjects he greatly excelled, and they were admired and appreciated. They brought him also plenty of employment. He made many models of silversmith's work. He executed a large proportion of the bas-reliefs for Buckingham Palace and sculpture for other buildings, besides several monuments.

Among his later works were 'The Shield of Eneas,' exhibited in 1828 ; 'The Pleiades adorning the Night,' 1833 ; 'The Shield of Hercules,' 1834 ; a bas-relief of the Sovereigns of England from the Conquest to William IV., with their several attributes, 1837 ; and a 'Design for the Nelson Memorial,' 1839. He also drew with great facility, and projected a series of outline illustrations of Virgil, two numbers of which were published; a series from Ossian, of which he completed two large plates in mezzo-tint, which are unpublished, and he made many drawings to illustrate Horace and Euripides. In the midst of such active labours a rash engagement, relative to an elaborate and expensive work, is supposed to have preyed upon his mind, and in a fit of depression, from which he suffered much, he took poison and terminated his existence, April 16, 1840. His numerous works had produced him little profit. He had been subject to ill-health, and he left a widow and four children without provision.

PIXELL, Miss MARIA, *landscape painter.* She was probably a pupil of S. Gilpin. She practised both in oil and water-colours, painting views and compositions. From 1796 to 1811 her works occasionally found a place in the Academy exhibitions, and were extravagantly praised by the press in her day.

* PLACE, FRANCIS, *amateur.* Was born in Yorkshire. He was descended from a Durham family, and was articled to a solicitor in London, where he continued till the breaking out of the Plague in 1665, when he left the metropolis, and found an excuse to abandon a profession he disliked. He then amused himself with art. He had some assistance in etching from Hollar, and he painted, etched, tried the new art
335

of mezzo-tint, and drew many local buildings and objects. His drawings are done with the pen, slightly shaded in the foreground with Indian ink or bistre, minute and weak in manner, and chiefly date between 1673 and 1713, signed with his initials only. He etched some animals and insects which were published, and mezzo-tinted some portraits after Vandyck and Kneller. He tried an experimental porcelain manufactory, and some specimens of his work still exist. He resided some time in Dimsdale, Durham. Died at the Manor House, York, 1728.

PLACE, GEORGE, *miniature painter.* Was the son of a fashionable linen-draper in Dublin, and a student in the schools of the Irish Academy. He came to London and practised here with repute for several years, exhibiting at the Academy yearly from 1791 to 1797. Afterwards he went to Yorkshire, where he followed his profession about the end of the century.

PLAYFAIR, WILLIAM HENRY, R.S.A., *architect.* Was born in London, in July 1780, the son of an architect known in his day. He settled in Edinburgh, and in 1829 became one of the foundation members of the Royal Scottish Academy. His works in Edinburgh are in the classic style, in which he excelled. He was the architect of St. Stephen's Church, the Royal Institution, the National Gallery, the Free College, the Surgeons' Hall, and of Donaldson's Hospital, an edifice in the Tudor style. He died in Edinburgh, after a long illness, March 19, 1857.

PLAYFORD, ——, *miniature painter.* He practised in London with some ability in the latter half of the 18th century. Died in Lamb's Conduit Street, October 24, 1780.

PLAYTER, C. G., *engraver.* He practised in the dot manner in the second half of the 18th century, and was employed on the Shakespeare Gallery. He engraved after Rigaud, 'A Scene from the Comedy of Errors;' after Hamilton, R.A., 'Lady Godiva,' and two subjects after Samuel Shelley.

PLIMER, ANDREW, *miniature painter.* He was born at Bridgwater, and first exhibited at the Royal Academy, in 1786, some miniatures in ivory and on enamel, several of them in character. His finish was excellent, his portraits powerful, admirably drawn and expressed. He resided at Exeter, and continued to exhibit up to 1819. He died at Brighton, January 29, 1837, aged 74.

PLIMER, NATHANIEL, *miniature painter.* Brother to the above. Born 1751, at Wellington, Shropshire. He exhibited miniatures at the Academy for the first time in 1787, and from that year was an occasional exhibitor. His works were

336

carefully drawn and finished, but weak in execution, and not agreeable in colour. He died in 1822.

PLOTT, JOHN, *miniature painter.* Born at Winchester in 1732. Commenced life as clerk to an attorney and accountant. Had a taste for painting, came to London in 1756, and was for awhile the pupil of R. Wilson, R.A. and was afterwards with Hone, R.A., whom he assisted in miniature, both enamel and water-colour. On leaving him he practised as a miniature painter, and in 1777 was living in London, and exhibited at the Academy, to which he continued an occasional contributor. Later he went to reside at Winchester, and was elected a member of the City Corporation. He painted a few portraits in oil. He had also acquired a knowledge of natural history, and executed some drawings of natural objects which had great merit. He commenced a history of 'Land Snails,' and had made some of the drawings, which showed great truth and beauty. He died at Stoke, Winchester, October 27, 1803, aged 71.

POCOCK, NICHOLAS, *marine painter.* Born about 1741. He was the son of a Bristol merchant of good family, and when a young man commanded a merchant vessel sailing from Bristol. He had a great taste for drawing and illustrated his journal with sketches which he met with on his voyages. Then cultivating art, and entirely self-taught, he left the sea to adopt art as his profession. He drew portraits, landscapes, and sea pieces, devoting himself chiefly to marine subjects. In 1780 Sir Joshua Reynolds wrote him an encouraging letter criticising his first picture in oil, which had arrived at the Academy too late for exhibition. Continuing to reside at Bristol, he was a constant exhibitor of marine subjects from 1782 to 1789, and at that time removed to London, and continued to exhibit up to 1815. He early attained distinction, and painted the chief naval battles of the war. One of these is in the gallery at Greenwich Hospital, and two others in the Hampton Court Galleries. These latter are large pictures, careful and literal, but lifeless, and wanting the interest and spirit of a battle. He was one of the original members of the Water-Colour society, and from 1805 to 1813, when he resigned his membership, a constant contributor of marines, with an occasional Welsh landscape, to the Society's exhibitions, and continued so up to 1817. He designed the illustrations for an edition of 'Falconer's Shipwreck.' He died at Maidenhead, March 19, 1821, aged 80.

POCOCK, ISAAC, *portrait and history painter.* Was born at Bristol, March 2, 1782, son of the above. He showed great ability for drawing when a child, and was,

in 1798, the pupil of Romney, and afterwards of Sir William Beechey. He exhibited subject pictures and portraits at the Academy in 1800-4 and 5, and was, on a competition, awarded 100*l.* by the Directors of the British Institution in 1807 for his picture of 'The Murder of St. Thomas à Becket.' He painted several historical subjects and portraits. He was a member of the Liverpool Academy in 1812, and exhibited there many designs, both in oil and water-colours. From 1810 to 1819 he was also an occasional exhibitor, chiefly of portraits, at the Royal Academy; but he had before him the prospect of an independent fortune, and he relaxed in his pursuit of art. In 1815 he succeeded to a property left him by his uncle, and soon after retired to Maidenhead, and to the pursuits of a country gentleman added literature in preference to art. He produced several very successful farces and melodramas. 'Yes or No,' a farce; 'Twenty Years Ago,' a melodrama; 'Any Thing New,' 'The Miller and his Men,' and others. He died at Maidenhead, August 23, 1835, in his 54th year. Hayley addressed a sonnet to him:
'Ingenious son of an ingenious sire!
Pocock! with friendly joy I saw thee start
For honour's goal in the career of art.'

POCOCK, W. F., *architect.* He first commenced art as a landscape painter; then, turning to architecture, he was an exhibitor at the Royal Academy from 1799 to 1827 of works, not of importance, which he was executing; but in 1806 he contributed, a larger attempt, a 'Design for a Temple of Fame.' He published 'Modern Finishings for Rooms,' 'Architectural Designs for Rustic Cottages,' &c., 1811.

POLACK, Solomon, *miniature painter.* Was born at the Hague in 1757. He came to England early in life and settled here. He first appeared as an exhibitor at the Royal Academy 1790, and was from that time for above 40 years a constant contributor. He practised for a time in Ireland, towards the end of the century. Died at Chelsea, August 30, 1839. He designed and etched the plates to a Hebrew Bible.

POLLARD, Robert, *engraver.* Was born at Newcastle-on-Tyne, and was apprenticed to a silversmith in that town. He afterwards became a pupil of Richard Wilson. He commenced art as a painter of landscapes and marine subjects, and later practised as an engraver. He worked with the point, etched, aqua-tinted, and produced many plates from his own designs, among these 'The Blind Beggar of Bethnal Green,' and 'Lieut. Moody Rescues Himself from the Americans,' and a hunting piece, 'At Fault.' Also after Serres, Smirke, Wheatley, Paye, and, after Dayes, the elaborate drawing of 'The Trial of

Warren Hastings,' crowded with figures. He was the last surviving member of the Incorporated Society of Artists, and in 1836 he gave over to the Royal Academy the books and papers of the Society. After experiencing great privations and vicissitudes, he died on May 23, 1838, aged 83.

*POND, Arthur, *painter and engraver.* He was born about 1705, and was educated in London. He travelled to Rome with Roubiliac, the sculptor. In his engravings he worked with the needle, and also in the chalk and crayon manners, and produced several plates, in which he admirably imitated, by the means of etching and aqua-tint, the manner of the Poussins, Salvator Rosa, and others. In 1734-5 he published imitations of the Italian masters; and afterwards, in connexion with Knapton, 90 plates after the great painters; also a set of caricatures after the Cavaliere Ghizzi, with some others. He painted several portraits during George II.'s reign, and a portrait of William Duke of Cumberland, which was engraved by Ravenet. McArdell and Grignion also engraved after him, and he engraved some fine plates himself, after Raphael, Parmegiano, Caravaggio. He was elected a Fellow of the Royal Society in 1752, and Fellow of the Society of Antiquaries the same year. He had a house in Queen Street, Lincoln's Inn Fields. He died September 9, 1758. His collection of drawings by the old masters was sold in the following year, and realised 1449*l.*

POPE, Alexander, *amateur.* Born in London, May 22, 1688. The celebrated poet. He was an amateur painter, proud of his attainments in art. He was from a child fond of drawing, was for 18 months the pupil of Jervas, and made considerable progress. He painted and copied portraits and worked hard to excel. He says, in a letter to Gay, dated 1713, after his eyes had been opened to the superior abilities of his friend Jervas, 'I have thrown away three Swifts, each of which was once my vanity, two Lady Bridgewaters, a Duchess of Montague, half-a-dozen Earls and a Knight of the Garter.' Some proof, indeed, that he had tried to succeed. When Jervas went to Ireland we are told that Pope took up his abode in the painter's London house, and as a relaxation drudged away at his easel morning, noon, and night. He designed a fan, the Story of Cephalus and Procris, which was purchased by Sir Joshua Reynolds, and a frontispiece for a small edition of his own 'Essay on Man.' A head of Betterton by him, a copy after Sir Godfrey Kneller, is in the possession of the Earl of Mansfield. He died at Twickenham, May 30, 1744.

POPE, Somerville Stevens, *amateur.* Was the son of a miniature painter in Ireland, under whom, and also under

337

Thomas Roberts, he studied art about the middle of the 18th century. He was chiefly known as a devoted copyist of the works of Vernet. But he became High Sheriff of Dublin, and his practice of art was thenceforth rather as an amateur than professional.

POPE, ALEXANDER, *miniature painter.* Was younger brother of the above. He was born at Cork, and was a student in the Dublin Art School, under West. He practised portrait painting in Cork with success, and occasionally performed on the stage. In 1783 he came to London, and made his appearance in Covent Garden Theatre. He succeeded in tragedy, and was well known for his performance of Othello, Henry the 8th, and other characters. He first exhibited at the Royal Academy in 1790, and was an occasional exhibitor up to 1821. He died in London in 1835.

POPE, Mrs. CLARA MARIA, *flower and miniature painter.* She was a daughter of Jared Leigh (amateur painter), and married at an early age Wheatley, R.A., and exhibited at the Academy, in 1796, a portrait, and for several years after portraits and little domestic subjects, introducing children; in 1804, 'A Ride in a Wheelbarrow.' About this time, having become a widow in 1801, she married the above Alexander Pope. She painted both miniatures and flowers. Her portrait of Madame Catalani became very popular, but she excelled in her flowers, for which she enjoyed a great reputation. She was a frequent exhibitor at the Royal Academy. She died December 24, 1838, at an advanced age. Her portrait was painted by Hamilton, R.A.

PORDEN, WILLIAM, *architect.* He was born at Hull, and was the grandson of Roger Pourden, of York, architect. He showed an early attachment to drawing and poetry, and gaining the notice of Mason, the poet, was introduced by him to James Wyatt, who admitted him into his office, where he studied architecture for some time, and was afterwards the pupil of Samuel P. Cockerell. He then became Secretary to Lord Sheffield, who appointed him paymaster to the 22nd Dragoons, a regiment raised by his lordship in 1770. After the reduction of this regiment he turned again to architecture, and in 1778 exhibited at the Academy designs for a Gothic church, and continued an occasional exhibitor. He was employed by the parish of St. George, Hanover Square, and superintended the fitting of Westminster Abbey for the Handel Festival in 1785-86, and was afterwards appointed by Earl Grosvenor surveyor of his estates in the metropolis. He built the stables at Brighton for the Prince of Wales, and Eaton Hall, Cheshire,

338

for Lord Grosvenor, but was, for some cause, superseded in the latter employment. This preyed upon his spirits, and he died two years after, on September 14, 1822, aged 67. He had a numerous family, all of whom died in infancy except two daughters—the elder married Mr. Kay the architect. The younger, Eleanor Anne, was distinguished by her poetic talent. She published 'Cœur de Leon' in sixteen cantos, with some other poems. She was a great favourite of Flaxman, R.A., who called her his daughter, and became the first wife of Captain Franklin, R.N., the arctic explorer. She died young, in 1825.

* PORTER, Sir ROBERT KERR, Knt., *history painter.* Was born at Durham in 1777. His father, descended from an old Irish family, was surgeon to the 6th Enniskillen Dragoons, and, dying young, left his family in very low circumstances, and his mother then retired with them to Edinburgh. He made early attempts at drawing, which induced his mother to take him to West, P.R.A., by whose advice he entered the schools of the Royal Academy in 1790. He made rapid progress, and commenced art on a large scale. In 1793 he painted 'Moses and Aaron,' an altar-piece, commissioned for Shoreditch Church, and, in 1794, presented 'Christ stilling the Waves' to the Roman Catholic Chapel at Portsea, and, 1798, 'St. John Preaching' to St. John's College, Cambridge. In 1800 he was employed in scene-painting for the Lyceum Theatre, and then undertook, when only 22 years old, to paint 'The Storming of Seringapatam,' 120 feet long, which contained 700 life-size figures, and was completed in ten weeks. This panoramic effect was exhibited in the Theatre, and was followed by two others of nearly equal magnitude: 'The Siege of Acre' and 'The Battle of Agincourt.' It has been said of him that if he was not a great painter he surely painted great pictures, which seems to be the sum of his art merits. At this time he exhibited some easel pictures at the Royal Academy, and of these, in 1801, 'Mr. and Mrs. Harry Johnston as Hamlet and Ophelia.' But he was of a restless as well as a vigorous nature: in 1803 he was appointed a captain in the Westminster Militia, and in 1804 was invited to Russia, where he was appointed historical painter to the Emperor. He was employed in the decoration of the Admiralty Hall, and painted several large pictures. He fell in love with the Princess Schertakoff, but left Russia, travelling through Finland to Sweden, where he was knighted by the King. Here he met General Moore, whom he accompanied to Spain and shared the hardships of the campaign ending with Corunna. He then went again to Russia, where he married his princess, and, com-

pelled to leave the country, arrived in England in 1813, and was knighted by his Sovereign. From 1817 to 1820 he was travelling in the East. While there he was created Knight of the Lion and Sun of Persia, and made many sketches, which are now in the British Museum. In 1826 he was appointed consul at Venezuela, where he resided till 1841, when he returned on leave of absence, and visiting St. Petersburg, he died suddenly of apoplexy on May 4, 1842, aged 65, and was buried in the foreign cemetery there. He was by turns, during his active and adventurous career, artist, soldier, author, and diplomatist. Several of his pictures were engraved. He designed the illustrations for an edition of 'Anacreon,' 1805; published 'Travelling Sketches in Russia and Sweden,' 1808; 'Letters from Portugal and Spain during the March of the Troops under Sir John Moore,' 1809; 'Narrative of the late Campaign in Russia,' 1813; and '.Travels in Georgia, Persia, and Armenia,' 1821-2. His sisters, Jane and Maria, were distinguished as novelists. There is a tablet to the memory of the family in Bristol Cathedral.

POTT, JOHN, *engraver.* He practised in London in the latter half of the 18th century, and engraved after Sir Joshua Reynolds, Tilly Kettle, and others.

POUNCY, B. T., *engraver.* Was the pupil and brother-in-law of Woollett. Began art as an engraver of seals and antiquarian fac-similes, but soon showed great ability in landscape, and in the latter part of the 18th century engraved some fine plates after R. Wilson, Hearne, Farington, and several others. He exhibited some engraved landscapes at the Spring Gardens' Rooms, 1778, and architectural views at the Academy in 1782–89, and good views of English towns. He died in Pratt Street, Lambeth, August 22, 1799.

POWELL, C. M., *marine painter.* He commenced life as a sailor, and, used to the sea and ships, was self-taught in art. He was first able in 1809 to exhibit a painting at the Royal Academy, and continued a regular contributor up to 1820, of marine subjects, calms and storms, in oil colours. His works, which are numerous, were of some promise, but he was an improvident man, and fell into the hands of the dealers. He died May 31, 1824, leaving a widow and eight children in sad distress.

POWELL, JOHN, *portrait painter.* Was an assistant to Sir Joshua Reynolds, and was often employed in copying his pictures in small size in oil, which he did with much fidelity and taste. He exhibited portraits (chiefly small size) at the Academy in 1778, and in two or three subsequent years, contributing for the last time in 1785—unless some enamelled portraits,

on china, exhibited in the same name, between 1812 and 1822 are by him.

POWELL, JOHN, *landscape painter.* Born about 1780. Painted first in oil, views in Wales and parts of England. He exhibited at the Academy in 1797, and several succeeding years, in water-colours, in which his abilities are best shown, and was a candidate, but unsuccessful, for admission to the Water-Colour Society, on its foundation. He was much engaged in teaching, and published some etchings of the different varieties of trees for the use of his pupils. Also eight landscape etchings, of much merit, from the old masters. He continued an exhibitor at the Academy up to 1829.

POWELL, JOSEPH JOHN, *history painter.* Was born of English parents, at Douai, France, in January, 1834. He commenced the study of art there, and continued his studies at Lisle till 1851, when he came to London, and entered the schools of the Royal Academy. He was reserved in his habits, had little assistance from his friends, who could not afford him help, and was subjected to much difficulty and privation; but neither poverty nor ill-health damped his zealous application. At the Academy, in 1852, he gained a silver medal, and the following year two. In 1855 he was the successful competitor for the gold medal, the subject 'The Death of Alcibiades.' His work was of great promise, and he was preparing to compete for the travelling studentship, when he was seized with illness. A month's tour in the Isle of Wight and Guernsey produced an apparent improvement, and with exhausted resources he was returning to his work, when his illness recurred; he lingered a few weeks at Southampton, and died there September 20, 1856.

POWIS, WILLIAM HENRY, *wood-engraver.* Was much esteemed in his art. There are some excellent cuts by him in the 'Illustrations of the Bible,' 1833; and 'Scott's Bible,' 1834. Also in some of the illustrations of the 'Solace of Song.' He was making good progress, but ruined his health by his close and continuous labour, and died in 1836, aged 28.

POWLE, GEORGE, *engraver and draftsman.* Was a pupil of Worlidge, and engraved some portraits in his style, among them Sir Richard Berkeley, Chief Justice of the King's Bench. He exhibited some portraits with the Free Society in 1776. Several views by him of the City of Hereford are engraved by James Ross. He practised about the middle of the 18th century.

PRANKER, ROBERT, *engraver.* Was chiefly employed for the booksellers. He was a member of the Free Society of Artists, 1763, and practised in London in

Zn. Powell. painted Mother Poore. *Poynter Edwd John. R.A. b.1836.*

the latter half of that century. His work was in the line manner, but was only of a mediocre class. He married one of Gerard Vaudergucht's daughters.

PRATT, Sir Roger, Knt., *architect.* He was employed by Charles II. with Mr. Wren (afterwards Sir Christopher Wren) to survey the foundations of old St. Paul's, and he obstinately opposed the plans of restoration proposed by his distinguished colleague. He built Clarendon House, Piccadilly, pulled down in 1683, for Lord Chancellor Hyde, at a cost, it is said, of 40,000*l.* He was knighted by the king for his exertions connected with the rebuilding of London after the Great Fire.

PRATTENT, T., *engraver.* Practised about the end of the 18th century, chiefly upon topographical landscape. There are some good etchings of this class by him in the 'Gentleman's Magazine,' which appear to be from his own drawings.

PRENTIS, Edward, *subject painter.* He resided a time at Monmouth, and painted scenes of domestic life, usually humorous, and not without a moral. 'The Profligate's Return from the Ale-house,' 1829; 'Valentine's Eve,' 1835; 'The Hypocrite,' 1838; 'Morbid Sympathy,' 1843; 'The Folly of Extravagance,' 1850. Several of his works are engraved. He was, in 1823 and 1824, an exhibitor at the Royal Academy, and became one of the early members of the Society of British Artists, where he exhibited from 1829 to 1850. He died in December, 1854, aged 57, leaving a widow and 11 children.

PRESTON, Thomas, *engraver.* He is sometimes styled 'Captain Preston.' He practised, without repute, in the reign of George II. There is a head of Pope by him, and a portrait of Admiral Blake, with ships introduced under it. He died October 29, 1785.

PREWITT, William, *miniature painter.* He was a pupil of Zincke, and practised in London towards the middle of the 18th century. His works are in enamel, brilliant in colour, and possess much merit. There is a good whole-length group by him in the miniature collection at the South Kensington Museum.

PRICE, John, *architect.* He built a mansion for the Duke of Chandos in Marylebone Fields in 1720, and the church of St. George the Martyr, Southwark, 1733-36, and practised for several years in the metropolis.

PRICE, Joshua, *glass painter.* He restored in 1715 Van Linge's windows at Christ Church, Oxford, which were broken by the Puritans. He also painted the Apostles and Prophets in the chapel at Magdalen, and finished the windows at Queen's College.

PRICE, William, *glass painter.* Bro-

ther to the above. Was the pupil of Henry Gyles, of York, and succeeded him. He painted the 'Nativity' after Sir James Thornhill, for Christ Church, Oxford, in 1696; the great east window of Merton College, 1700; and the Life of Christ in six compartments, for the same College, in 1702. He also repaired the windows of the chapel of Queen's College, 1715, and painted the centre window in the chancel. He died in 1722.

PRICE, William, *glass painter.* Son of the above Joshua Price. Was employed on the windows of Westminster Abbey, 1722–35, funds for the work being voted by Parliament. He painted the 'Genealogy of Christ,' for the chapel at Winchester College, and repaired and completed several of the Flemish windows from the designs of Rubens, New College, Oxford. 'The Herbert Family' at Wilton is also by him. Both his colour and his drawing were good, and his ornament superior to any of his predecessors. He enjoyed a great reputation. Died unmarried in Kirby Street, Hatton Garden, July 16, 1765.

PRIEST, Thomas, *landscape painter.* Resided at Chelsea towards the middle of the 18th century, and painted chiefly views on the Thames. He published a set of etchings of Chelsea, Mortlake, and other places on the river's banks, executed in a coarse but spirited manner.

PRITCHETT, J., *architect.* Was born at St. Peter's, near Pembroke, of which parish his father was the clergyman, October 14, 1788. He was articled to Mr. Medland, in Southwark, and while with him, in 1808 and 1809, exhibited designs at the Royal Academy. He was afterwards employed in the Government Barrack Office, and in 1812 commenced practice for himself, the following year removing to York, where he succeeded John Carr, the well-known architect of that county. He gained a wide field of practice in the northern counties. In York city, he was the architect of the Deanery, the New Art Schools, and the Savings Bank. In the county, of the Wakefield Asylum, the Court-house and Gaol at Beverley, and many other works. He died May 23, 1868, in his 80th year.

PROCTOR, Thomas, *sculptor and history painter.* Was born at Settle, in Yorkshire, April 22, 1753. His father, a man in humble circumstances, apprenticed him to a tobacconist in Manchester; but, tired of this occupation, he found his way to London, and gained employment in a merchant's counting-house, which, after some time, he quitted, to devote himself to the study of art, but without losing the friendly assistance of his late masters. He was admitted a student of the Royal Academy in 1777, and, incited by the works

of Barry, he painted a large picture of 'Adam and Eve.' In 1782 he obtained a premium from the Society of Arts; in 1783, the Academy silver medal; and, in 1784, the gold medal for his original painting from 'The Tempest,' and was carried round the quadrangle of Somerset House on the shoulders of his enthusiastic fellow-students, shouting, 'Proctor! Proctor!'

He then tried modelling, and, as a sculptor, claims a high rank among British artists. He first produced his 'Ixion,' which he exhibited at the Academy in 1785; and the work was so warmly praised by the president of the Academy that it was purchased by Sir Abraham Hume, Bt. Thus encouraged, he set earnestly to work upon a larger subject, 'Diomedes Devoured by his Horses,' a noble work, which, exhibited in 1786, attracted great admiration in the Academy, but unfortunately was unsold. It had cost him 12 months' labour. He had spent his small patrimony in the study of his profession, and not having the means to pay for a place where he might deposit his model, he destroyed it in a fit of sad despondency, and abandoned sculpture in despair. His first contributions to the Academy exhibitions, in 1780 and 1783, had been portraits; and in 1789 he again sent a portrait. Then, in 1790, continuing to paint, he exhibited 'Elisha and the Son of the Shunammite' and 'The Restoration of Day after the Fall of Phæton,' a sketch. In 1791, 'Hannah declines to accompany her Husband to the Yearly Sacrifice.' In 1792, 'Pirithous, the Son of Ixion, destroyed by Cerberus,' a group in plaster, and two portraits. Then reverting to painting, in 1793, 'The Final Separation of Jason and Medea,' and three portraits. In 1794, 'Venus approaching the Island of Cyprus.'

The period had now arrived for the Academy to elect a student to send to Rome, and Proctor was chosen. But for the last four years he had exhibited without giving an address, and his very abode was unknown. This was in 1793. The president, West, humanely sought him. He was in a miserable attic in Clare Market, had subsisted day by day on a penny roll with water from a neighbouring pump, but, unable to pay the pittance for his lodging, had wandered about till health quite gave way. The president immediately assisted him, cheered him, told him to prepare for his journey to Italy, and promised him kind introductions. But all too late. The broken-hearted man drooped, his mind was disturbed, and a few days later he was found in his solitary bed, where he had died unheeded. He was in his 41st year, and was buried in Hampstead Churchyard. Professor Westmacott, R.A., exhibited his 'Ixion' and his group of 'Pirithous' at his lecture to the students, and expatiated upon them as the works of true genius.

PROUT, SAMUEL, *water-colour painter.* Was born at Plymouth, September 17, 1783, and educated at the Grammar School of the town, and in art by a drawing-master established there. When a child he had suffered from a sunstroke, and was afterwards weak and ailing. A love of drawing was predominant. Chance threw him in the way of John Britton, who was collecting materials for his 'Beauties of England and Wales,' and the two went together into Cornwall—the young artist's expenses being defrayed in consideration of the service he might render. But his first attempts were very discouraging; he cried over his failures, and after several efforts was compelled to return home. This was in the autumn of 1801. In the following May he sent Mr. Britton some sketches of old buildings, which proved he had made considerable progress; and it was eventually agreed that he should come to reside with him in Clerkenwell for two years, during which time he was employed in copying after the best topographical draftsmen of the day.

In 1805 he returned home, chiefly on account of his ill-health. He had, in the previous year, first exhibited at the Royal Academy, and was, for the next 10 years, an occasional exhibitor; his works chiefly views and coast scenes in Devonshire. In 1812 he came again to the Metropolis, and resided in Stockwell; and, improving in his art, he was, in 1815, an exhibitor, and, in 1820, elected a member of the Water-Colour Society. He at this period found employment as a teacher; and in 1816 Ackermann published in parts his 'Studies,' executed in lithography, followed by 'Progressive Fragments,' 'Rudiments of Landscape,' 'Views in the North and West of England,' with other works calculated to assist in teaching. In 1818 he was induced by increasing weak health to visit the Continent. He seemed naturally to have been led to marine subjects, but his early architectural employment for Mr. Britton had prepared him for the picturesque studies afforded by Havre and Rouen, and determined his future path in art; and he soon became celebrated as the painter of the cathedrals, churches, and market-places of Normandy.

He was gifted with a strong feeling for the picturesque, and did not fail to seize the grand proportions of his buildings, but he was without sufficient knowledge to detail their beautiful tracery, marking only the general features with his broad reed-pen; but in the arrangement of his picture —his groups of living figures, and various accessories sparkling in colour—he was unrivalled. In 1824 he visited Venice, and

341

afterwards other parts of Italy and Germany, making yearly excursions to the Continent, and adding variety to his pictorial art. He published in lithography facsimiles of sketches made in Flanders and Germany, views in France, Switzerland, and Italy; also a series of drawings from antiquarian remains, etched by himself in a simple large manner. He was a frequent sufferer from ill-health during his latter years, but continued a constant contributor to the exhibitions of the Water-Colour Society till the end of his life. He died at Camberwell, February 10, 1852, aged 68.

PROUT, J. SKINNER, *landscape painter*. Was born in Plymouth in 1806, and was the nephew of the above Samuel Prout. He was largely self-taught. He practised in water-colours, and turned his attention to the study of old buildings. He published, in 1838, 'The Antiquities of Chester,' a folio volume with large plates, and 'The Castles and Abbeys of Monmouthshire.' He resided a long time in Bristol, and published a work on 'The Antiquities of Bristol,' the sketches for which were made in company with the painter Müller, with whom he had early formed a friendship. It was in subjects of this character that he delighted, and though he had not the facility and power achieved by his uncle, he had much refinement and delicacy of colour. Early in life he visited Australia, and lived some time in Sydney and Hobart Town, and he afterwards exhibited the sketches he made there at the Crystal Palace. He was elected a member of the Institute of Painters in Water-Colours, and continued to exhibit with the Society until his death, which took place in Camden Town, August 29, 1876.

PRUDDE, JOHN, of Westminster, 'glazier.' Engaged to paint the windows of Beauchamp Chapel, built for the great tomb of the Warwick family, in the reign of Henry VI.

PRYKE, ROBERT, *engraver*. Pupil of Hollar. He practised in the reign of Charles II. Published Pierre le Muet's 'Architecture,' 1675.

PUGH, EDWARD, *miniature painter*. He practised in London, and from 1793 to 1806 was an occasional exhibitor of miniature portraits at the Royal Academy. In 1808 he sent a 'Welsh Landscape.' He made the drawings to illustrate 'Modern London,' published 1805; and for 'Cambria Depicta.' He died at Ruthin, in 1813.

PUGH, CHARLES J., *landscape painter*. He practised chiefly in water-colour, his works only washed or tinted with colour. He exhibited occasionally at the Academy from 1797 to 1803, views in the Isle of Wight and in Wales.

PUGH, HERBERT, *landscape painter*.

Born in Ireland. Came to London about 1758. In 1765 he received a premium at the Society of Arts. He was an early exhibitor and was, in 1766, a member of the Incorporated Society of Artists. There was a large landscape by him in the Lock Hospital. He tried two or three pictures in Hogarth's manner, but they are only mean representations of low scenes. They were poorly engraved by Goldar. He dwelt in the Piazzas, Covent Garden, and was living in 1788, but died shortly after, having shortened his life by his intemperance.

PUGIN, AUGUSTUS, *architectural draftsman*. He was born in France in 1762, and having fought a duel early in life he fled suddenly to this country, in the troubled times of the Revolution. Not being understood at the Post Office, he was placed in great difficulty, for the want of remittances which had been sent to him, until he met with a French artist named Merigot, then in this country, by whom he was assisted both in his art and his pecuniary trials. He had a talent for drawing, and was admitted to study in the schools of the Royal Academy, where, commencing in 1799, he was an occasional exhibitor, contributing chiefly views of Gothic buildings. Soon after his arrival in London, replying to an advertisement, he gained employment in the office of Mr. Nash, the architect of Waterloo Place and Regent Street, in whose service he continued above 20 years. He was, from 1807, an exhibitor at the Water-Colour Society, and was, in 1821, elected a member, but his contributions to the Society's exhibitions were very limited. He sketched in a bold expressive style, and was much employed by Mr. Ackermann upon his publications. He added the architecture and backgrounds to Rowlandson's figures, contributed to that publisher's 'Microcosm of London,' 1808–11, and made a series of drawings for the 'Views in Islington and Pentonville,' 1813; also for the Histories of Westminster Abbey, Oxford, and Cambridge, many of which are finished with great care and accuracy of detail. In 1821 he published his 'Specimens of Gothic Architecture,' a work which was at once appreciated for the accuracy of its details. This was followed by his 'Antiquities of Normandy,' 'Gothic Examples,' 'Ornamental Timber Gables,' and 'Paris and its Environs.' These careful illustrations of early architecture rendered important assistance to students, and laid the foundation of much that has since been achieved in the revival of the Gothic style. He had gained much practical knowledge during his long engagement with Mr. Nash, and was himself occasionally employed as an architect, but the Diorama in the Regent's Park and some country villas are the extent of his executed works. He

also educated several pupils, who have risen to eminence in art. He married an English lady, and long resided in Great Russell Street, Bloomsbury, where he died December 18, 1832.

PUGIN, AUGUSTUS WELBY NORTHMORE, *architect*, only son of the above. Was born in London, March 1, 1812, and was educated under his father. He was taught to draw with readiness and accuracy the grand forms, as well as the minute details, of Gothic architecture, and became an enthusiast for mediæval art. He was by nature restlessly energetic. Before he was 15 years of age he was employed to make designs for furniture and goldsmith's work. He tried scene-painting, and gained a knowledge of the machinery and contrivances which are the accessories of scenic effects, and painted the complete scenery for an opera. Then, his genius taking another turn, he purchased a small vessel and cruised about in the stormy Channel, gathering archæological and natural curiosities on the French and Belgian coasts, and at last was wrecked penniless on the Scotch coast.

He then commenced an extensive enterprise, founding and training an establishment for the manufacture of carved ornaments, and Gothic decoration of every class. He had married in the mean time. His undertaking ended in loss, almost ruin. His young wife died, and with such large experience in life he was a father and a widower, and yet not 20 years of age. Sobered by his sorrows and his trials he turned to architecture, and at once found full employment, and having earned the means, he built himself a large house in his favourite style, married a second time, and set eagerly to work. He visited many of our cathedrals, and his fine taste was disgusted by the neglected decay of some, and the patched-up attempts at restoration in others; and with the assumed conviction that the Romish Church is the only one by which the grand and sublime style of ecclesiastical architecture can be revived, he on that ground quitted the Protestant faith, which was possibly never very strong in him, and entered the Romish Church.

Following this idea on his secession, he published, in 1836, his 'Contrasts,' placing in juxtaposition — most powerfully, but most unfairly it must be added — the finest mediæval examples with the weakest modern attempts in stucco — and both in his illustrations and his letter-press treated the latter with indignant scorn. He was engaged in the erection of several Roman Catholic churches, and the large cathedral in St. George's Fields. He entered enthusiastically into projects for the reform and perfection of his adopted Church, occupied his restless mind with all the adjuncts of

its architecture—painted glass, metal work, and embroidery of all kinds. But even here he met with mortification and disappointment. He was difficult to restrain, and was alternately checked and flattered by the heads of his Church.

He then set about the erection of a church of his own at Ramsgate, which he found consolation in decorating with a zealous love, and piously joined in the daily services, and at times ran out with his vessel into the Channel to meet the storms and waves. He had, too, the charge of a house full of children again motherless, and was busied in battling for his cherished Gothic, and now to all this was added the charge of all the decorative fittings and designs, under Sir Charles Barry, for the Houses of Parliament—a work for which he was peculiarly fitted. Thus, his busy mind crowded with occupation, his time passed till 1851, when he plunged into the great Papal effort to establish a Hierarchy in England with his 'Earnest Address,' which astonished and embarrassed the holders of the newly-assumed dignities. He was denounced as a doubtful believer, and, mortified with grief, careworn with his many labours, the news burst upon his friends that he was in Bethlehem. The circumstances connected with this confinement are unknown; but the generous, broken-hearted man was only released by the efforts of his friends, to expire in his own house. He died at Ramsgate, September 14, 1852.

His chief publications, omitting those of a controversial character, are: 'Gothic Furniture, Style of 15th Century,' 1835; 'Contrasts, a Parallel between the Noble Edifices of the 14th and 15th Centuries and the Present Day,' 1836; 'The True Principles of Christian and Pointed Architecture,' 1841; 'Present State of Ecclesiastical Architecture in England,' 1843; 'Apology for the Revival of Christian Architecture in England,' 1843; 'Glossary of Ecclesiastical Ornament and Costume,' 1844; 'Floriated Ornament,' 1849; 'Treatise on Chancel Screens and Rood Lofts,' 1851. His 'Life,' published 1861, was written by his friend, Benjamin Ferrey, architect.

PUGIN, EDWARD WELBY, *architect*. Son of the above, was born March 11, 1834, and succeeded to his father's business when only seventeen years of age. He devoted himself entirely to the practice of Gothic architecture, and completed his father's unfinished buildings, not only in England and Ireland, but in America and Belgium. His best known works are: St. Michael's Priory, Belmont, near Hereford; the Augustinian Church in Dublin. Scarisbrick Hall, Lancashire; the Granville Hotel, Ramsgate; some large parish

churches in Liverpool, and the Roman Catholic College of St. Cuthbert, Ushaw. He died in London after a brief illness, June 5, 1875, in his 40th year.

PURCELL, RICHARD, *mezzo-tint engraver*. He was born in Ireland about 1736, and studied in Dublin under John Brooks. He for a while practised there, engraving 'Jenny Cameron,' a mere copy of Latham's 'Peg Woffington,' the 'Countess of Berkeley,' 'William at the Siege of Namur,' after Wyck, which is, in fact, a copy after Faber's print; after Rembrandt, 'The Jewish Bride.' He afterwards came to London and engraved the works of Reynolds, Cotes, Ramsay, Frye, and some of the most eminent painters of the time. He was depraved in habit and licentious in manner, and had the character of being one of the wags of the day, and, probably for concealment, adopted the signature, 'C. Corbutt'—but neither the cause nor the time of this change of name are known. He died in London, in a state of great distress, about the year 1765. His engraving showed much ability, but was weak in drawing.

PYE, CHARLES, *engraver*. Born in 1777. He practised at the beginning of the 19th century. There are some plates by him in illustration of Dibdin's 'Bibliographical, Antiquarian, and Picturesque Tour,' 1829.

• PYE, JOHN, *engraver*. Was born at Birmingham, April 22, 1782. He early shewed a talent for drawing, and acquired a good deal of self-taught skill. When about eighteen he left Birmingham, and obtained paid employment under James Heath in London, to whom he apprenticed himself, and worked for him a considerable time. Devoted chiefly to landscape engraving, he engraved about 1811 'Pope's Villa,' after Turner, R.A., the figures by his master. This work gained him much notice, especially from the great landscape painter, who employed him to engrave his 'Temple of Jupiter in Egina.' He was again successful, and from this time his progress was rapid, and his reputation established. He mastered in copper all the gradations by which space is expressed, and colour suggested. He was one of the founders of the Artists' 'Fund,' and was among the foremost opponents of the Constitution and Privileges of the Royal Academy. He lived for a considerable time in Paris, and was elected a corresponding member of the French Institute, which awarded him a medal of honour. He was also hon. member of the Imperial Academy of Arts in St. Petersburgh. Some of his best works are after Turner, but among his other plates should be mentioned 'The Annunciation,' after Claude, a 'Classical Landscape,' after Gasper Poussin,

'Holy Family,' after Michael Angelo, and after Barrett, 'Evening.' He died in London, February 6, 1874, in his 92nd year. He wrote 'The Patronage of British Art,' an historical sketch, 1845, a work full of information connected with artists and the art institutions of his country.

PYE, JOHN, *engraver*. Was born in 1745. He was a pupil of Major, and gained a premium at the Society of Arts in 1758. Commencing in 1780, he was for nine years a constant exhibitor of views in water-colour in the Royal Academy. As an engraver he was employed by Alderman Boydell, and his landscape plates were much esteemed. He worked with the needle, and both in the line and dot manner. He engraved a 'Holy Family,' after Polemberg, 'Tobit and the Angel,' after Karl du Jardin, and after Claude, Watteau, Wootton, Pynaker, and others.

PYE, THOMAS, *historical painter*. He studied in Dublin under the elder West, and was at Rome in 1794 pursuing his studies from the old masters, but no further notice of him can be obtained.

PYLE, ROBERT, *portrait painter*. He practised in London early in the last half of the 18th century, and in 1763 was a member of the Free Society of Artists. He painted allegorical subjects, portraits, and conversation pieces. His art was weak, his figures stiff and poorly composed. The 'Power of Music and Beauty,' by him, was engraved by J. Watson, and his 'The Four Elements,' by C. Spooner. His portrait of Queen Charlotte is also engraved.

PYM, B., *miniature painter*. He practised in London, and found much employment about the end of the 18th century. For some time he was a regular contributor to the Royal Academy Exhibitions, but his name does not appear after 1793.

PYNE, WILLIAM HENRY, *water-colour painter*. Was the son of a leather-seller in Holborn, and born 1769. His early love of drawing induced his father to place him under a clever draftsman, but he disliked his master, and refused to be apprenticed to him. He, however, managed to attain a great facility with his pencil, and showed much taste in the selection of objects for his sketches. He practised only in water-colour. He first appeared as an exhibitor at the Royal Academy in 1790, contributing 'Travelling Comedians,' 'Bartholomew Fair,' and a 'Puppet Show,' and in the succeeding years exhibited chiefly rural subjects up to 1796. In his early works his foregrounds are carefully drawn with the pen and tinted with warm colour, his middle distances put in with grey. In his rural landscapes figures and animals were cleverly introduced. He was one of the original members of the Water-Colour Society 1804, but he resigned in 1809, and

then once more, in 1811, exhibited at the Academy. The first part of 'The Microcosm of London,' published in 1803, and completed in 1806, contained 600 small groups of well-drawn and characteristic figures, and was followed, 1808, by 'The Costume of Great Britain.' He became connected with Mr. Ackermann, the publisher, and suggested many of his undertakings. His 'Royal Palaces' was one of these. The work, in three volumes, comprised Windsor, St. James's, Carlton House, Kensington Palace, Hampton Court, Buckingham House, and Frogmore, but he undertook only the literary part, and the latter part of his life was devoted almost entirely to literature. He wrote 'Wine and Walnuts,' and interesting gossip for the 'Literary Gazette,' remarkable alike for its stories of facts and its painstaking accuracy. The work was afterwards published in two volumes. Then he edited the 'Somerset House Gazette,' a weekly periodical devoted to art and artists, which only existed for two years, though its merits should have ensured it success. He contributed to 'The Library of the Fine Arts,' and to 'Arnold's Magazine of the Fine Arts;' and 'The Greater and Lesser Stars of old Pall Mall,' which appeared in 'Fraser's Magazine,' is by him. He was also the author of 'The Twenty-ninth of May: a Tale of the Restoration.' He was closely connected with the literary and artistic world during the greater part of his life,

was a social and amusing companion, full of clever projects, but wanting in that steadiness and perseverance which lead to wealth. He underwent many sad difficulties, and died at Paddington, after a long and depressing illness, May 29, 1843, aged 74.

PYNE, JAMES BAKER, *landscape painter.* He was born at Bristol in December 5, 1800, and was originally intended for the law, but he early abandoned that study, and, self-taught, under many difficulties struggled to make himself an artist. In 1835 he left Bristol to try his fortune in London, and for the next four years was an exhibitor at the Royal Academy. He was also an exhibitor with the Society of British Artists, and in 1842 was admitted a member of the society, and then on one occasion only was again an exhibitor at the Academy. In 1846 he visited Switzerland, Germany, and Italy, and in 1851 revisited Italy. He was a frequent contributor to the 'Art Journal.' He published 'Windsor and its Environs,' in 1838; 'The English Lake District,' 1853; and 'The Lake Scenery of England,' 1859; and by these picturesque works he was widely known. He died July 29, 1870, aged 70, and was buried in Highgate Cemetery. He chose his subjects, as seen from the banks of rivers, was fond of powerful contrasts both of colour and light and shade, and had a tendency to extravagance in his works, which did not meet with appreciation.

Q

QUELLIN, THOMAS, *statuary.* Was the son of a statuary of great repute at Antwerp. He came to this country in the reign of James II., settled in London, and was well employed. He carved the well-known monument to Mr. Thynne in Westminster Abbey, which is the only work with which his name can be safely identified.

Died in St. Giles's in the last half of the 17th century, aged 33.

QUINTON, GEORGE, *engraver.* He was born at Norwich in 1779, and was first known when keeping sheep in the adjoining county. Self-taught as an engraver, some works of his appear in the 'Gentleman's Magazine' 1796, and some portraits.

Quilley - H = N. at an graver: 1840

R

RADCLYFFE, WILLIAM, *engraver.* Was born at Birmingham, and practised his art there during his life, engraving in the line manner, chiefly landscape. He was much employed for book illustration. 'The Graphic Illustrations of Warwickshire,' published 1829, were engraved by him; also 'Roscoe's Wanderings in North

and South Wales.' Among his last plates were 'Müller's Rest in the Desert,' and Collins's 'Crossing the Sands,' published in the 'Art Journal,' 1847 and 1848. Some works by him, after Turner, R.A., were exhibited at the International Exhibition, 1862. In 1814 he was associated with the founders of the first school of art, in

Birmingham. He died there, December 29, 1855, in his 73rd year.

RADCLYFFE, EDWARD, *engraver.* Son of the above. Was born at Birmingham about 1809, and studied under his father. His principal works were for the 'Art Union,' for which society he etched some plates after David Cox. He was also much employed for the 'Annuals,' and produced some engravings for the 'Art Journal.' He died at Camden Town, in November, 1863.

RADCLYFFE, WILLIAM, *portrait painter.* Brother of the foregoing. He practised with some repute at Birmingham, and afterwards in London, and on one or two occasions was an exhibitor at the Royal Academy, but died young of paralysis, April 11, 1846.

RAEBURN, Sir HENRY, Knt., R.A., *portrait painter.* Was born at Stockbridge, near Edinburgh, March 4, 1756. He was the son of a respectable manufacturer, and at an early age was left an orphan. He gained a good education at Heriot's School, and at fifteen was apprenticed to an eminent goldsmith in Edinburgh. His love of art tempted him to try miniature painting, and his success induced his master to encourage him. He had no instruction, but David Martin, who then held the first rank as portrait painter in Edinburgh, was kind to him, praised his attempts, and lent him some of his own paintings to copy. His miniatures were much admired, and he soon gained so much employment, that he arranged to give up part of his earnings to his master for a portion of his time. He made another step during his apprenticeship—he began to paint in oil, and soon adopted this larger medium in lieu of miniature; on completing his time he took up the profession of a portrait painter. His manner was spirited, and he was successful in impressing on his canvas the character of his sitters. He was rising by the efforts of his own genius, and fortune assisted him, when in his 22nd year, by his marriage with an estimable wife, who possessed some property.

He then came to London, and introduced himself and his works to Sir Joshua Reynolds, who received him kindly, advised him to visit Italy, and offered him introductions and even pecuniary help. The latter was not needed, but he set out for Rome with the president's introductions, and spent two years in study in Italy; on his return, in 1787, he settled in Edinburgh, and gained full employment. Both his art and his society were esteemed. He was surrounded by friends, and painted the most distinguished of his northern countrymen. He paid only short visits to London, and knew little of the art or the artists of the Metropolis. But honours fell thick upon
346

him in his native city. In 1812 he was elected President of the Society of Artists in Scotland; in 1813 an associate of the Royal Academy, London, and the following year an academician. He had been an occasional exhibitor at the Academy from 1798, and from 1810, though still residing in Edinburgh, he was a constant contributor to the Academy exhibitions. He was said to have consulted Sir Thomas Lawrence about settling in London, but he was assuredly well advised to remain where he held undisputed pre-eminence in art, and was surrounded by friends, nor is it at all certain that his peculiar manner of painting would have pleased the fashionable world. On the visit of George IV. to Edinburgh, in 1822, he was knighted, and on a vacancy in the following year was appointed his Majesty's Limner for Scotland. He died at a house he had built for himself in the suburbs of Edinburgh, on July 8, 1823. His life seems to have been one of great prosperity; but it is said that in his mid-career, his affairs were sadly embarrassed, from having incautiously become security for a near relation who was in the West India trade, which swallowed up a little fortune he had acquired by his pencil. This loss he, however, bore with great firmness. He worked at his easel with increased zeal, so that he not only completely re-established his affairs but again secured an independence for himself and his family. His portraits were distinguished by their breadth, and marked by great individuality of character and truthful expression, they were true as portraits, and possess some interest as works of art.

RAILTON, WILLIAM, *architect.* His design for the Nelson Column in Trafalgar Square was the one selected, in competition with many others, on two separate occasions. He died at Brighton, October 13, 1877.

RAIMBACH, ABRAHAM, *engraver.* Born in Cecil Court, St. Martin's Lane, London, 1776, the son of a Swiss who had settled here. He was the pupil of J. Hall, and on the termination of his apprenticeship, entered as a student of the Royal Academy. He found at the same time some employment from the booksellers, and painted a few miniatures, of which, from 1797 to 1805, he was a constant exhibitor at the Academy. But he eventually devoted himself to engraving, and followed the line manner. His drawing was good, his line pure, the expression and character well defined. He engraved after Reynolds, a 'Venus,' and the 'Ugolino.' About 1812 he commenced engraving after Wilkie, and produced 'The Village Politicians,' followed by the 'Rent Day,' 'The Cut Finger,' 'The Parish Beadle,' 'Blind Man's Buff,' 'The Spanish Mother,' and some other of his works. He died at Greenwich, January 17,

1843. His 'Memoirs and Recollections,' edited by his son, were privately printed in the same year.

RALPH, G. KEITH, *portrait painter.* He was an exhibitor of portraits at the Royal Academy from 1778 to 1795, and also of an occasional subject picture. He held the appointment of portrait painter to the Duke of Clarence.

RAMAGE, DAVID, *medallist.* Was one of the Corporation of Moneyers of the Mint, and was engaged by the Corporation in 1649 to produce, with his own hand, specimen coins, in competition with the specimens of Blondeau, who was eventually compelled, by the opposition of the managers to leave England. These specimens, which comprise the half-crown, shilling, and sixpence, are now very rare, and command large prices. A pattern shilling of the Commonwealth sold in 1874 for 17*l.*

RAMBERG, JOHN HENRY, *subject painter and engraver.* Was born at Hanover in 1763, and came early in life to England. He is reputed to have been for a time pupil of Sir Joshua Reynolds and of Bartolozzi, R.A. From 1782 to 1788 he was a contributor to the Academy exhibitions, and in 1789, with the sanction of the King, he drew and engraved the portraits of the princesses. He painted many subjects for book illustration, and was engaged on Boydell's Shakespeare Gallery. He was employed in the decoration of Carlton House. There are some humorous caricatures also by him. He engraved in aqua-tint, and in the chalk manner, and etched. Among his engravings are 20 allegorical subjects after the Princess Elizabeth, then Princess of Hesse Homberg, printed at Hanover, in 1834. He travelled in Italy, France, Holland, and Germany, and is supposed to have died at Hanover, July 1, 1840, but the accounts of him are very conflicting. A clever picture drawn by him of Sir J. Reynolds showing the Prince the paintings in the Royal Academy exhibition, 1784, the room filled with pleasing groups, is well engraved in line.

RAMSAY, ALLAN, *portrait painter.* Son of the author of 'The Gentle Shepherd.' Born 1713, at Edinburgh. Churchill equivocally says,—

'Thence came the Ramsays, name of worthy note,
Of whom one paints as well as t'other wrote.'

His early love of art was encouraged by his father, and when about 20 years of age he visited London, became a member of the St. Martin's Lane Academy, and after studying there some time, he returned to Edinburgh, and from thence set out for Italy in May 1736. He pursued his art at Rome under the best masters, confining himself almost exclusively to portraiture.

On his return he practised chiefly in London, where, in 1758, he had attained great distinction ; but he also practised occasionally in Edinburgh. In 1766 he was Vice-President of the Incorporated Society of Artists. He was introduced to the Prince of Wales, afterwards George III., by Lord Bute, and in 1767 was appointed principal painter to his Majesty. He entirely engrossed the professional business which properly belongs to his office. At this time he was residing in Soho Square, and his painting room was crowded with portraits of the young King in every stage of progress ; and with all the assistance he could procure he could scarcely keep pace with the demands for the Royal portrait. Shortly after his return from a second visit to Rome the Royal Academy was founded, and, without any information on the subject, it seems strange that he did not become a member. In 1775 he made a tour for his health, and again visited Rome. He was at the time at the height of his reputation. His portraits are graceful and easy in pose, possess a calm representation of his sitter, expressive, without affectation of attempted graces, but are deficient in power. He was an agreeable man, of matured literary tastes, a good French, Italian, and Latin scholar, and learnt Greek in his old age. He published some essays on history, politics, and literature, under the title of 'Investigator.' Sir J. Reynolds said 'he was the most sensible man of all the living artists,' and Johnson also praised him, saying, 'You will not find a man in whose conversation there is more instruction, more information, and more elegance.' He paid a fourth visit to Italy, and died on his return at Dover, a few days after landing, August 10, 1784, in his 71st year. He was buried at St. Marylebone Church. He left a son, who attained the rank of general, and a daughter, born in Rome, who married Sir Archibald Campbell.

RAMSAY, JAMES, *portrait painter.* He commenced his art in London, and exhibited for the first time at the Royal Academy in 1803, and practising with success, and having made eminent sitters, he was a regular exhibitor. In 1837 he painted a portrait of Earl Grey for the Town Hall at Newcastle-on-Tyne, and in 1847 he retired to that town, but continued an exhibitor till his death there, June 23, 1854, aged 70. There is a portrait of Thomas Bewick by him in the National Portrait Gallery, and a good portrait of Grattan by him is engraved.

RANDALL, JAMES, *draftsman and painter.* Practised in London about the beginning of the 19th century. He painted, in oil, landscapes, introducing architecture, and made, in water-colour, a series of drawings, which were published in aqua-tint in

1806 'A Collection of Architectural Designs for Mansions, Casinos, Villas, Lodges and Cottages in the Greek, Gothic, and Castle Styles.' He exhibited at the Royal Academy designs of this class from 1798 to 1814.

RANKLEY, ALFRED, *subject painter.* He was born in 1819, and was a student in the schools of the Royal Academy. His name first appears in the Academy Catalogue in 1841, when he exhibited a 'Scene from Macbeth;' next, in 1843, contributing a portrait, and from that time he was a constant exhibitor, seldom sending more than one work and never exceeding two. His paintings were generally domestic subjects, conscientiously finished, and inculcating some healthful thought. Of some of his best works may be mentioned · The Lonely Hearth,' 1857 ; 'The Return of the Prodigal,' 1858 ; 'The Day is Done,' 1860 ; 'The Doctor's Coming,' 1864 ; 'Follow My Leader,' 1867. His last exhibited works were 'Following the Trail,' and 'The Hearth of his Home,' 1870, with 'The Benediction,' 1871. He died at Kensington, December 7, 1872.

RANSOM, THOMAS FRAZER, *engraver.* Born at Sunderland in 1784, he was apprenticed to an engraver at Newcastle. In 1814 he received the Society of Arts' medal for an engraved portrait. In 1818 he entered warmly into the controversy then existing as to the prevention of the forgery of Bank of England notes, and was himself tried for having a forged bank-note in his possession, but was acquitted, the jury believing the note to be genuine. In 1821 he gained the Society of Arts' gold medal for a line engraving, and in 1822 a second gold medal for his engraving from Sir D. Wilkie's 'Duncan Gray.'

RASTELL, JOHN, *wood-engraver, printer, and mathematician.* Was greatly reputed in London in the first half of the 16th century. He was brother-in-law of the celebrated Sir Thomas More. He published, in 1529, with many wood-cuts by his own hand, which have been erroneously attributed to Holbein, 'The Pastime of the People, or the Chronicles of Divers Realmes, and more especially of the Realme of England.' This work was republished by Dibdin in 1811. He died in 1536.

RATHBONE, JOHN, *landscape painter.* Was born in Cheshire in 1750. Self-instructed in art, he acquired some proficiency, and practised both in oil and water-colours. He was the boon companion of George Morland, and of Ibbetson, who painted figures into his landscapes, and some others, birds of the same feather. He exhibited at the Royal Academy from 1785 till his death. His contributions were landscape views, with figures—chiefly lake scenery—with effects of morning and evening ;

storms, wood scenes, with cattle. He died in 1807.

RATTEE, JAMES, *carver.* Born at Funden Hall, Norfolk, and educated at the village school. He was apprenticed to a carpenter, and nourished an inborn love for the beauties of Gothic carving, in which he displayed great skill and ingenuity. He was associated with A. Welby Pugin in restorations at Cambridge, and G. G. Scott at Ely. In 1852 he travelled for the improvement of his health, and to gain knowledge by visiting the great Gothic edifices in Belgium, Cologne, and Hamburgh. On his return, he was entrusted with the sole charge of constructing the reredos at Ely, composed of highly-chased stone and alabaster, and, a martyr to ill-health, he died at Cambridge, from the effects of a cold, March 29, 1855, aged 35. He had shortly before been appointed wood-carver to the Cambridge Camden Society, and had erected some extensive works at Cambridge.

RAVEN, JOHN S., *landscape painter.* Was born in Suffolk, August 21, 1829, and was the son of a clergyman, himself a very clever water-colour painter, as will be seen by some drawings given by him to the South Kensington Museum, and some others exhibited at the Grosvenor Gallery Winter Exhibition in 1877. He studied in no school and under no particular master, though his earlier works shew the influence of the Norwich School. His first exhibited picture was 'Salmsley Church' in 1845, when he was only sixteen years of age. His last contribution to the Royal Academy was 'Barff and Lord's Seat from the slopes of Skiddaw,' in 1877. Among his most important works are 'Midsummer, Moonlight, Dew rising,' 1866 ; 'A Hampshire Homestead,' and 'The Monk's Walk,' 1872 ; 'The Lesser Light to rule the Night,' 1873 ; 'The Heavens declare the Glory of God,' 1875. The Pre-Raphaelite school seems to have had some influence upon his art work, but led him rather to greater realization of details, than to the ignoring of art. His landscapes were not only of a realistic character, but exhibited a high feeling for the poetical and imaginative in nature, and he always subjected his imitation of nature to some preconceived idea of the subject. He was accidentally drowned while bathing. He was painting from a tent on the Sands at Harlech in North Wales, and his wife on going to take him his luncheon, found only his clothes, and was met by some fishermen bearing his lifeless body. This sad event occurred July 14, 1877.

RAVENET, FRANCOIS SIMON, A.E., *engraver.* Was born in Paris in 1706. He was a pupil of Le Bas, and attained considerable reputation. He came to England shortly before 1745, and settled in London, where

his art was highly esteemed. He was employed for a time at the Battersea enamel works, and gained a Society of Arts' premium in 1761, and was in 1766 a member of the Incorporated Society of Artists. He is said to have been invited to this country by Hogarth, to assist in engraving his 'Marriage à la Mode,' the 4th and 5th plates in which series are by him and dated 1745. He became one of his ablest coadjutors. He was also employed by Alderman Boydell, and he executed many plates for the booksellers. His best works were however executed for Boydell, 'Charity after C. Agneri,' 1763 ; 'The Lord of the Vineyard paying his Labourers,' after Rembrandt, 1767 ; 'The Prodigal Son,' after Salvator Rosa, 1767 ; 'George II. on Horseback,' after D. Morier, 1757, and there is a good portrait of himself which he engraved after Zoffany. His engravings are remarkable for imitation of colour, as well as for their brilliancy and careful drawing. He was elected an associate of the Royal Academy in 1770, and exhibited there some proofs of his works. He lived many years at Lambeth Marsh, but removed to the Hampstead Road, nearly opposite to the 'Mother Redcap,' where he died, April 2, 1774, and was buried in St. Pancras' old churchyard.

RAVENET, SIMON, *engraver.* Was born in London about 1755, and was the son of the above, by whom he was instructed in his art. Soon after his father's death he went to Paris, and studied there under Boucher. He then went to Italy, and finally settled at Parma, where he undertook to engrave all the works of Correggio in that city. This labour occupied him from 1779–85, and gained him, on its completion, the distinction of Chevalier. He was living, according to some writers, in 1813.

RAWLE, SAMUEL, *engraver and draftsman.* Practised in London about the beginning of the 19th century. He exhibited a landscape view at the Royal Academy in 1801, and again in 1806. There is an artistic engraving, also drawn by him, of the Middle Temple Hall, in the 'Gentleman's Magazine' for 1798. He engraved some of the illustrations of Murphy's 'Arabian Antiquities of Spain,' published in 1816.

RAWLINS, THOMAS, *gem and die-engraver.* Was born about 1610. He was intended for a goldsmith, and early cut in metal and precious stones heads and coats of arms. Charles I. appointed him first engraver to the Mint in 1648, and he was again employed after the Restoration. The dies for the coinage struck at Oxford are by him, as well as several medals commemorative of the period, and are works combining great spirit with careful details. Evelyn, in his 'Sculptura,' mentions him as excell-

ing in medals and intaglios, and in Flecknoe's 'Miscellanies' there is a poem 'on that excellent *cymilist* or sculptor in gold and precious stones, Thomas Rawlins.' He wrote 'Rebellion, a Tragedy,' with some other pieces for the stage, and 'Calanthe,' a book of poems, 1648. He died 1670.

RAWLINSON, JAMES, *portrait painter.* He was a Derbyshire artist, and was a pupil of Romney. In 1799 he exhibited at the Academy, his only appearance there, 'An Old Woman Knitting.' A portrait by him of Darwin, the poet, is well engraved by Heath. Hayley mentions him in his 'Life of Romney.' He died July 25, 1848, in his 80th year.

READ, CHARLES DAVID, *draftsman.* Born 1790. He was a drawing-master at Salisbury, and produced a number of landscape etchings, which he published in 1840, but they possess little merit. He also painted some landscapes in oil. He died at Kensington, May 25, 1851.

READ, Miss KATHERINE, *portrait painter.* Practised in London, both in oil and crayons, in the early part of George III.'s reign. She lived in the neighbourhood of St. James's, and gained considerable reputation. In 1765–68 she contributed crayon portraits to the Free Society's exhibitions, and was later an exhibitor at the Royal Academy. About 1770 she went to the East Indies, where she stayed some time, but probably not long, as in 1771–72 she exhibited at the Spring Gardens' Rooms. On her return, resuming her practice in London, she painted a portrait of Queen Charlotte, and a group of Prince George and Prince Frederick when children, with a large dog. Valentine Green engraved after her, and Robert Lowry engraved her Elizabeth Duchess of Hamilton. From 1773 to 1776 she exhibited crayon portraits at the Royal Academy. Her best works are in crayons, but her own portrait in oil, still in the possession of her family, is a very clever work. Her portraits are well drawn and grouped, and are marked by their pleasing natural expression. She painted a miniature of Hayley, the poet, when a boy ; and in his poetic epistles he commemorates 'the soft pencil of the graceful Read.' She died, unmarried, in London, December 15, 1778.

READ, NICHOLAS, *sculptor.* Was a pupil of Roubiliac, and after his death occupied his studio and premises in St. Martin's Lane, succeeding also to much of his professional connexion. He showed some early ability, and in 1762–63 gained premiums of the Society of Arts, and in 1764 was awarded the first premium of 150 guineas for a marble statue. He is said to have cut the skeleton figure of death in Mrs. Nightingale's monument, which is remarkable for its excellent tooling, but he

was of a conceited, vain disposition, and an annoyance to his master, whose somewhat exuberant style he exaggerated to an extravagance approaching absurdity. In 1779 he exhibited with the Free Society of Artists a very pretentious design for Lord Chatham's monument. His monument to Rear-Admiral Tyrrell in Westminster Abbey has been called 'the pancake monument.' There are several other monuments by him in the south aisle of the Abbey. His mind, unfortunately, became impaired in the prime of life, and a short time before his death he was totally deprived of reason. He died at his house in St. Martin's Lane, July 11, 1787.

READ, RICHARD, engraver. Was born about 1745. He was a pupil of Caldwall, gained a Society of Arts' premium in 1771, and practised his art in London during the latter part of the century. He worked chiefly in mezzo-tint, but sometimes in the dot manner. He engraved 'The Dutch Lady,' after Rembrandt; 'Moses in the Bulrushes,' after Le Soeur; 'The Queen of Scots,' after Hamilton, R.A., and other works. He died towards the close of the century.

READER, WILLIAM, portrait painter. Was born at Maidstone, the son of a clergyman, and practised his art in the 17th century. Was for a long time in the service of a nobleman. His portrait of Dr. Blow, the musical composer, is engraved in mezzo-tint. He died poor in the Charter House.

READING, BURNET, engraver. He was born at Colchester, and practised in London between 1770-90, working in the dot manner. Some of his works, as was then the fashion, are printed in red. There is by him, 'Charlotte at the Tomb of Werther,' and after Bigg, R.A., 'Lavinia and her Mother.' There is also a portrait of him drawn and etched by himself. He was riding and drawing-master to the Earl of Pomfret at Windsor.

READING, SARAH, engraver. Practised at the same time, and in the same manner as the above. A small oval by her, 'Olivia and Sophia,' is known.

READY, WILLIAM JAMES DURANT, marine painter. Was born in London, May 11, 1823. The son of a clerk in the Customs, he was a self-taught artist. Early in life he took some of his productions to a dealer, who bought them all, and advised him to study the rules of art, and to work directly from nature. Upon the last part of the advice alone he acted. He went to America for four or five years, and on his return again sold his drawings to the same dealer (who subsequently bought nearly all his productions), and with whom he frequently stayed by the sea-side, making also many excursions along the coast. D. Roberts, R.A., thought highly

of his ability, and induced him on one occasion to send two pictures to the Royal Academy. In consequence of their being exhibited, the Inland Revenue sent him an income-tax paper to fill up, which alarmed him so much, that he never again exhibited. He painted both in oil and water-colours, and nearly always finished his work upon the spot. His exertions out-of-doors were fatal to his health: he became very ill at Brighton, and when on his seeming to be somewhat better his brother went down there to remove him to London, he fainted in the carriage, was carried back to his lodgings, and died at Brighton, November 29, 1873. He usually signed his pictures W. F. R., or W. F. Ready.

REBECCA, BIAGIO, A.R.A., history and ornamental painter. Of Italian extraction. He became a student of the Royal Academy in 1769, and an associate in 1771, in which year he exhibited a picture of 'Hagar and Ishmael,' and in the following year, 'A Sacrifice to Minerva.' He contributed some weakly drawn illustrations to Bell's poets. He was principally employed in painting staircases and ceilings with arabesques, and during several succeeding years he does not appear as an exhibitor. He probably became known to the royal family by his employment as a decorator, for it is said that he contributed to their amusement at Windsor by his facetious drawings and professional freaks. He died at his lodgings in Oxford Street, February 22, 1808, aged 73.

REDE, WILLIAM, architect. He was bishop of Chichester in 1369, and deemed the best mathematician of his age. He built the first library at Merton College, and the Castle at Amberley, Sussex. He died 1385.

REDFERN, JAMES F., sculptor. Was born in Derbyshire, and while yet a young village boy showed a talent for art, which was strikingly displayed by his carvings and modellings from the woodcuts of illustrated newspapers. Mr. Beresford Hope, on whose estate he was born, placed him under the tuition of Mr. J. R. Clayton, and the fruit of this pupilage was a fine group, 'Cain killing Abel,' which called forth the warm approval of J. Foley, R.A. His patron also sent him to Paris for six months, where he gained some knowledge of the language and of the work in its ateliers. After this he devoted himself chiefly to works of a Gothic character. He executed a very elaborate reredos for St. Andrew's Church, Wells Street, a series of figures for the west front of Salisbury Cathedral, and some sculptures for Bristol Cathedral, which, owing to an outburst of party spirit, have not been allowed to be placed there. He died at Hampstead, June 13, 1876, aged only 38.

REDMOND, Thomas, *miniature painter*. Was the son of a clergyman at Brecon, and was apprenticed to a house-painter at Bristol. He came to London, studied a short time at the St. Martin's Lane Academy, and improved himself as an artist. In 1763 he was a member of the Free Society of Artists. He then settled at Bath, where he practised his art with success. He exhibited portraits in miniature and in crayons at the Royal Academy from 1775 to 1779. He died at Bath in 1785, aged about 40 years.

REED, Joseph Charles, *landscape painter*. Was born in 1822. He was elected an associate of the Institute of Painters in Water-Colours in 1860, and became a full member about six years later. He sought for subjects for his art in various parts of England, and contributed many landscapes to his Society's exhibitions from Wales, Scotland, and Ireland. He died in London, October 26, 1877.

REED, Robert, *architect*. He was born at Edinburgh, November 8, 1774, and practised in that city, where he designed and erected several important public edifices. Among them St. George's Church in Charlotte Square, the Law Courts and Courts of Justice in Parliament Square, and the Bank of Scotland. He exhibited at the Royal Academy, in London, in 1818-19-20, his designs for several national works. He held the appointment of Queen's architect for Scotland. He died in Edinburgh, March 21, 1856.

REINAGLE, Philip, R.A., *animal and landscape painter*. Was born 1749, and was admitted to the Schools of the Royal Academy in 1769. He was afterwards employed by Ramsay, the court painter, and assisted him in the numerous repetitions of the royal portraits he was commissioned to supply. In 1773 he first exhibited at the Academy, and in that year and up to 1785 his contributions were exclusively portraits. He then tried animal painting with great success, and exhibited some subjects, introducing animals and birds, but from 1794 chiefly landscapes. His hunting pieces, sporting dogs, and dead game were excellent, and in 1787 he was elected an associate of the Academy, but he did not gain his election of Academician till 1812. He had great powers of imitation, and copied the Dutch masters—Ruysdael, Hobbema, Wynants, Wouvermans, and others, with such careful accuracy, that many of his copies pass for fine originals in good collections. He painted birds well, the plumage well coloured, and pencilled with great lightness and truth, and towards the end of the century exhibited some illustrations for Thornton's 'Botany,' continuing an exhibitor up to 1827. His 'Sportsman's Cabinet,' a work comprising all kinds of dogs used for sport, was engraved by Scott, and published 1803. He died at Chelsea, November 27, 1833, aged 84.

REINAGLE, Ramsay Richard, R.A., *portrait and animal painter*. Born March 19, 1775. He was the son of the foregoing. He painted both history and portrait, and also animals and landscapes, but chiefly excelled in the latter, exhibiting at the Academy at a very early age. Some of his early life was passed in Italy, and in 1796 he was studying in Rome, and afterwards in Holland from the Dutch masters. In 1806 he exhibited with the Water-Colour Society some Italian Landscapes, and in 1807 was elected a member of the Society, and continued to exhibit, mostly scenes in Italy, up to 1812, when he was appointed the treasurer, but in the next year he left the Society on the changes which then took place. He had during this time been a regular exhibitor also at the Academy, and in 1814 he was elected an associate and 1823 a full member. In 1848, having purchased a landscape and exhibited it at the Academy as his own, he was, after a full inquiry, called upon to resign his diploma. He did not, however, cease to exhibit at the Academy, sending for the last time two landscapes in 1857, nor did the Academy withhold their assistance from him ; he received till his death a liberal allowance from the Academy funds. He died at Chelsea, November 17, 1862, aged 87.

REINAGLE, George Phillip, *marine painter*. Son of the above, by whom he was instructed in art. Was a successful copyist of the Dutch masters, particularly Backhuysen and William Vandevelde, and probably from them gained his feeling for marine subjects. He first exhibited at the Academy in 1824, and in that and the three following years contributed naval scenes. He accompanied the English Fleet and painted with great success 'The Battle of Navarino,' which, with other subjects connected with the battle, he exhibited in 1829-30-31. He was also with Admiral Napier's fleet in the action with the Portuguese, and exhibited 'Napier's Victory over the Miguelite Fleet,' in 1835, his last contribution to the Academy. He painted both in oil and in watercolours, had a good knowledge of shipping, and was of much promise as a marine painter. He died, prematurely, at Camden Town, December 6, 1835, aged 33.

✦ REISEN, Charles Christian, *medallist*. Was born in the parish of St. Clement's Dane, London, the son of a Norwegian goldsmith who had come to this country and settled in London, 1666, practising as a seal engraver. His genius soon gained him employment, and his great ability becoming known on the Continent he received commissions from Denmark, Germany and

France. He was greatly befriended by the Earl of Oxford. He lived chiefly in the vicinity of Covent Garden, and had also a house at Putney. He was director of Kneller's Academy. He made a large collection of medals, books, and drawings. He died of gout, December 15, 1725, aged about 46, and was buried in the churchyard of St. Paul's, Covent Garden. He left the bulk of a large property which he had amassed to an unmarried sister who kept his house.

REMSDYKE, JOHN, *draftsman.* Was born in Holland. Settled at Bristol, and practised there in the latter half of the 18th century. His chief employment was in drawing natural history. He made many drawings for the publications of Dr. William Hunter; and, with his son, ANDREW REMS-DYKE (who gained a medal at the Society of Arts in 1767), published in London, in 1778, a volume of natural history, the illustrations drawn and etched by himself and his son, from objects in the British Museum. The son, who painted portraits, died at Bath in 1786.

* RENNIE, GEORGE, *sculptor.* He studied in the schools of the Royal Academy, and afterwards pursued his studies in Italy. He executed several groups in marble, some of which have great merit. From 1828 to 1837 he was an exhibitor at the Royal Academy, sending, in the first year, 'A Gleaner' and 'A Grecian Archer;' in 1831, 'Cupid and Psyche;' and a marble group of four figures, in 1837, after which his name disappears.

RENNOLDSON, ——, *engraver.* Practised in mezzo-tint in London, about the middle of the 18th century. 'The Dancing Mistress,' after J. Collet, is by him.

RENTON, JOHN, *portrait painter.* He was, commencing in 1821, an exhibitor of portraits at the Royal Academy, and his works were well esteemed. In 1827 he exhibited 'King Charles setting up his Standard at Nottingham,' a sketch; in 1839 a landscape, and, in 1840, some intaglios, his last contribution.

REPTON, HUMPHREY, *landscape gardener.* Born 1752, at Bury St. Edmunds, where his father possessed a small estate. He received a fair education, and became known to the Rt. Hon. W. Windham, who, on obtaining the appointment of Secretary of State for Ireland, in 1783, took him to Dublin, in the hope of finding some suitable employment for him, which was prevented by the short life of the administration. He was a tolerable draftsman, and between 1788 and 1791 was an honorary exhibitor of some landscape views at the Royal Academy. He also tried landscape gardening — introducing a more natural arrangement — and architecture. Among other gardens and parks laid out by him may be named those at Cobham,

Woburn, and Richmond. He published numerous works, his chief being 'Observations on Landscape Gardening and Architecture,' 1806, and 'Fragments on Landscape Gardening, with some Remarks on Grecian and Gothic Architecture,' 1816. He also maintained a smart disquisition, which was printed, with Uvedale Price and R. Payne Knight, who attacked the professional principles which he adopted. 'The Bee,' an art publication, 1787, is attributed to him. Some of the vignettes of the 'Polite Repository,' a small pocket diary, are also by him. He died near Romford, Essex, March 24, 1818, in his 66th year.

REPTON, JOHN, ADEY, *architect.* Son of the above. He was born at Norwich, March 29, 1775, and was deaf from his infancy. At the age of 14 he became the pupil of Wilkins, the father of the Academician, who was then practising in Norwich. In 1796 he was employed as an assistant to John Nash, with whom he continued four years, and then joined his father. He exhibited drawings and designs at the Academy, commencing in 1798, contributing for the last time in 1805, when he is styled an honorary exhibitor. In 1809 he gained the first premium for a design for the public buildings then proposed to form 'Parliament Square,' Westminster; and, later, the second premium for a design for Bethlehem Hospital. He assisted his father in some of his published works, and after his death was consulted in professional matters. But his deafness proved a great bar to the pursuit of his profession, and he went to reside at Springfield, near Chelmsford. From this comparative retirement he was roused to prepare drawings in competition for the new Houses of Parliament, in 1835. He sent several communications to the Society of Antiquaries, which appear in the Society's publications. He died unmarried, November 26, 1860, in his 86th year.

REPTON, JOHN STANLEY, *architect.* Brother of the above. He was a pupil of Augustus Pugin, and afterwards an assistant to Nash, under whom, in 1816–18, he superintended the alteration of the Italian Opera House; and, in 1819, designed St. Philip's Chapel, Regent Street. He married privately, in 1817, Lady E. Scott, daughter of Lord Chancellor Eldon; and on a reconciliation, soon after, with her family, retired from his profession. He died June 29, 1853.

REVE, THOMAS, '*glazier,*' or *glass painter,* of St. Sepulchre's, London, was one of the four contractors in the reign of Henry VIII. who supplied the 18 painted windows in the upper story of King's College Chapel, Cambridge.

REVELEY, WILLEY, *architect.* Was a

pupil of Sir William Chambers, and in 1781 first appears as a contributor of architectural designs to the Royal Academy exhibition. In 1785 he was in Rome, and from thence sent to the. Academy a design for a theatre. In 1789 he contributed a design for a metropolitan church; and in 1793 exhibited for the last time. He travelled in Greece with Athenian Stuart, and edited the third volume of Stuart's 'Antiquities of Athens.' He made many drawings and studies in Greece, had a good knowledge of classic antiquity, and great professional attainments, added to a high opinion of his profession. But he was eccentric, expressed his opinions sarcastically, and did not succeed to the measure of his abilities. His principal work was the new Church of All Saints, Southampton, in which his design was, however, curbed of its full merits. He submitted to Parliament plans for wet docks on the Thames, which showed great professional ability. He died, after a few hours' illness, in the prime of life, at his house in Oxford Street, July 6, 1799.

• REVETT, Nicholas, *architect*. He was descended from an old county family in Suffolk, where he was born in 1721. He had a fine natural taste, and had gained so much knowledge of art that he determined to follow it as a profession, and went to Italy, in 1742, to pursue his studies. He was practising as a painter in Rome when he formed a friendship with Athenian Stuart, and, in 1748, accompanied him to Naples, and then to Greece, to study the Greek monuments of art, which the Turks seemed bent upon destroying. He arrived at Athens, with Stuart, in 1751, and was occupied there till 1754, measuring and drawing the ancient remains, when he left to pursue his studies in other parts of Greece, and was seized by corsairs, to whom he paid a ransom of 600 dollars, and was able to continue his researches, but under great difficulties, till 1755. He then returned to London, and was occupied with the arrangement of his materials till 1764, when he was induced by the Dilettanti Society to visit Ionia, with Dr. Chandler and William Pars, A.R.A., where for two years he was engaged in drawing the antiquities. His chief architectural work was the Church of Ayott St. Lawrence, Herts, which he designed after the style of the early buildings of Asia Minor. The 'Antiquities of Ionia,' in which he had so large a share, was published, the first part in 1769, the concluding part in 1797. He also published 'Baalbec and Palmyra.' He died in June 1804.

, REYNELL (or RENNELL), Thomas, *portrait painter*. Born 1718, of a good family, near Chudleigh, Devon. He was educated at the Exeter Grammar School,

and, showing some genius for art, was sent to London as the pupil of Hudson. He returned to Exeter, and, with a wife and family, settled, residing there many years. His works found admirers in the neighbourhood, and the Duke of Kingston, attracted by his ability, offered him some assistance to come again to London for his improvement; but he was too indolent to avail himself of this offer; and he then went to Dartmouth, where he lived in great poverty. He was known to have lain idly in bed for a week together, with no other sustenance than a bit of cake and water. He did little in art, and he no sooner received any money for his work than he purchased any stray object that attracted him, though he was at the time in want of both food and clothing. An asylum was at last provided for him by the generosity of a friend. He died at Dartmouth, October 19, 1788. He painted portraits and some few indifferent landscapes. His portrait of Dr. Huxham, M.D., of Plymouth, was mezzo-tinted by Fisher. He had several scientific acquirements. He was a chemist, a musician, and composed some pieces, and he published some poetry. He also invented and constructed a musical instrument for himself.

' REYNOLDS, Sir Joshua, Knt., P.R.A., *portrait painter*. Was born July 16, 1723, at Plympton, where his father, who was in the Church, was master of the Free Grammar School. He was educated under him, but never made much progress in classics. He was intended to be a physician, but a love of art prevailed, and in 1741, at the age of 18, he was sent to London and placed under Hudson, the fashionable painter of the day, with whom he continued three years. He then returned to Plympton, and found employment in painting portraits at a low price. He does not at this time appear to have gone much beyond the common-place manner of his master, and he had a very weak knowledge of drawing, which stood in his way during his whole career; but he had now a great opportunity of improvement. He was induced by Captain, afterwards Lord Keppel, to accompany him in his vessel to the Mediterranean, and landing at Leghorn in 1749, he proceeded at once to Rome, where he studied nearly two years, and afterwards visited Florence, Venice, and the other great art cities of Italy.

The works of Titian, Correggio, Raphael, Michael Angelo, were his favourite study, but he made few copies, filling up his time most probably in portrait painting, on which he must have depended mainly for his support. He returned to London in October 1752, and in 1755 his name appears as a member of the St. Martin's Lane Academy. After a short residence

in St. Martin's Lane, he removed to Great Newport Street, and in 1761 to the west side of Leicester Square, where he bought a house, and added a painting room and gallery. He was, on his return, immediately distinguished, and was soon looked upon as the head of his profession. It must surely have been a cause of mortification, that, on a vacancy in the office of Court painter, he was passed over; but he never was a favourite of the Court, and the king never sat to him but on one occasion, that he might present the royal portrait to the Academy. There must have been some cause for this neglect, but whether from a want of appreciation of his art, or a dislike to the painter, there seems no sufficient explanation.

He was one of the first members of the Incorporated Society, wrote the preface to the catalogue for 1762, and was a regular contributor to its exhibitions up to 1768; and though he had little in common with the Society, he was, up to 1764, a member of the managing committee, and apparently gave such attendance as his engagements would permit. On the foundation of the Royal Academy, the artists unanimously elected him their first president; yet he was only very reluctantly induced to accept the office. To add to its importance the honour of knighthood was conferred upon him. He had arrived at the height of his practice. In the next 15 years he exhibited no less than 147 works: these, though chiefly portraits, included, in 1773, his 'Ugolino,' and 'The Strawberry Girl;' in 1777, 'The Fortune Teller;' in 1779, 'The Nativity.' Two of his pictures, 'The Duke of Clarence,' and 'Philippe Égalité Duc d'Orleans,' were burnt at the fire at Carlton House, June 8, 1824; as, however, there were some remains of each, they were restored in 1874, and are now in Hampton Court Palace.

Up to this time he had, during his long career, continued to paint almost without interruption, when in 1782 he experienced a slight shock of what he feared was paralysis, but he soon recovered from it, and returned at once to his easel. In that year he exhibited 15 works, the next year 10, and in 1784 no less than 16, including the 'Nymph and Cupid,' and his celebrated portrait of Mrs. Siddons. In 1785 again 16, and in each of the two following years 13, and in 1788, 18; so that if, as is generally stated, he looked upon the attack he had suffered as premonitory, he no less set himself greater tasks, and worked harder than ever. But these exertions were followed by a more severe attack in 1789, and, finishing what he was able of the works he had in hand, he exhibited for the last time in 1790, leaving a blank on the walls of the Academy which has not yet been filled.

As a portrait painter Reynolds has in the English school always been placed before all others. He gave an interest and a value to his works beyond the mere portrait, breaking away at once from the stiff air of portraiture, he seized every new action, every true expression that nature offered to him. His children have all the artless graces of childhood, his women are lovely, his men endowed with dignity. Untrammelled by rules of practice he ran a free career, and aiming at beauties beyond the reach of his materials, striving to attain a higher excellence, he used indiscriminately fading colours and fugitive mediums which led to the premature decay of many of his works, and have brought many more into the hands of cruel restorers. His contemporaries eulogised him as a history painter, but in that art he retains no rank in the present day. His conceptions did not rise to history, the form and character of his creations never went beyond his model. Yet in all his works we see great power, luxuriant and glowing colour, excellently treated draperies, and most appropriate and beautiful backgrounds.

He was on terms of intimacy with the most eminent literary men of his time, and maintained an uninterrupted friendship with Dr. Johnson to the end of his life. The doctor said of him, 'I know of no man who has passed through life with more observation than Reynolds;' and again, 'when Reynolds tells me anything, I consider myself as possessed of an idea the more.' He was himself distinguished by his literary abilities. He wrote, 1759–60, three papers for 'The Idler,' No. 76, 'False Criticisms on Painting,' No. 79, 'On the Grand Style in Painting,' No. 82, 'On the True Idea of Beauty;' some annotations to Du Fresnoy's 'Art of Painting,' and his 'Discourses on Painting,' which formed his yearly addresses to the students of the Royal Academy, were not only so admirable in their precepts and art teaching, but of so high literary merit, that he was at the time, though it is now known unjustly, denied the full merit of their authorship. He paid a short visit to Holland and Flanders in 1781, and again in 1783, and published an account of his journey. He had returned from Italy with almost a loss of hearing, but during a long and particularly successful life had enjoyed uninterrupted health. He was of a mild and amiable temper, happy in disposition, and possessing social qualities which made his company desirable. With a careless hospitality he drew round him many of the most distinguished persons of his time, and by his genius in his art, no less than by distinguished abilities and high personal character, he gave a position to the new Academy, and especially to his profession, which it

had never before enjoyed. His name will never be forgotten in the English school.

Following his last sad attack his sight was suddenly affected, and he soon found that he had lost the use of his left eye, and dreading the loss of the other, he sorrowfully determined, what was indeed too apparent, that he could paint no more. He was not, however, without resources. He was surrounded by friends, and able to enjoy their society till the latter part of the year 1791, when some painful symptoms recurring, he sank into despondency. His complaint had now developed itself. After suffering about three months from an enlarged liver, he died, unmarried, at his house in Leicester Fields, on February 23, 1792. His body lay in state at the Royal Academy, and was buried with unusual pomp at St. Paul's Cathedral. He left a good collection of pictures, many paintings of his own finished and unfinished, and about 80,000l., the bulk of which, on the death of his sister Frances, reverted to his niece Miss Palmer, who became, by marriage, Marchioness of Thomond. Farington, R.A., published 'Memoirs of the Life of Sir Joshua Reynolds,' 1819; Malone, an account of his life and writings; Mr. Cotton, in 1858, a list of his portraits; and in 1859, his notes and observations on pictures; and in 1865, Leslie, R.A., and Mr. Tom Taylor, his 'Life and Times.' In 1813 the British Institution had a Reynolds commemoration, and exhibited 113 of his works, but in 1867, no less than 155, including many of his finest, were included in the National Portrait Exhibition of that year.

REYNOLDS, Miss Frances, *amateur.* Born at Plympton, May 10, 1729. Was the youngest surviving sister of Sir Joshua Reynolds, and for many years kept his house in Leicester Fields. She painted miniatures, and found great pleasure in copying her brother's pictures. It has been said that she practised professionally, but it seems more probable only as an amateur; and we learn that the Duke of Marlborough made her a present of a gold snuff-box—not a mode of professional payment—for her copy in miniature of Sir Joshua's painting of the Duke's children. Dr. Johnson wrote of her, in 1758, ' Miss is much employed in miniatures;' and many years later, in 1783, ' I sat for my picture, a three-quarter, painted in oil, to Miss Reynolds, perhaps for the tenth time, and I sat for near three hours with the patience of mortal born to bear. At last she declared it finished, and seems to think it fine !' But he did not think so himself, for he told her it was ' Johnson's grimly ghost.' Yet one of the last occupations of his life was to sit to her. She does not, indeed, seem to have met with much encouragement, for Goldsmith

offended by telling her she loved pictures better than she understood them; and Northcote says, ' Nothing made Sir Joshua so mad as Miss Reynolds' portraits, which were an exact imitation of all his defects. Indeed, she was obliged to keep them out of his way. He said (jestingly) they made everybody else laugh and him cry.' But upon his death she took a large house in Queen Square, Westminster, and here she exhibited her own works, decorating her rooms with them. She died November 1, 1807.

REYNOLDS, Samuel William, *engraver.* Was descended from a family who possessed property in the West Indies, and was born in 1773. He studied in the schools of the Royal Academy, and was a pupil of Hodges, R.A. He commenced art as a painter, and painted in oil many portraits, some genre subjects and landscapes of great merit, contributing his works to the Academy exhibitions from 1797 to 1811. His landscapes were spoken of by his contemporaries as boldly painted and rich in tone and colour. Afterwards he tried engraving, and became distinguished by his fine plates in mezzo-tint, as well as by some excellent works in aquatint, he brought his work on steel to great perfection. He gave some lessons in drawing to the daughters of George III., and engraved a fine mezzo-tint portrait of the king from a small etching which he had made and touched from the life. He engraved many portraits after Reynolds, Dance, Northcote, Jackson, Owen, Dawe, Phillips, and some fine plates after Rembrandt; also some subject pictures after G. Morland, Northcote, and Stephanoff. In 1826 he went to Paris, where he resided some time, and engraved several important works after the French painters, by whom his art was highly esteemed. His engravings are spirited, brilliant, powerful, excellent in expression and drawing, but rather wanting in refinement in the tints. He died in 1835 at Bayswater, and was buried in Paddington churchyard. He brought out in six folio volumes the works of Sir Joshua Reynolds, to whom he believed that his family was collaterally related. They are engraved in a small size in mezzo-tint, and were at that time supposed to comprise all Sir Joshua's known works. His landscapes in oil have many of the characteristics of his great namesake, and have been sought for in Paris on that account. His daughter Elizabeth was an artist. See Elizabeth Walker.

RHODES, John N., *landscape and animal painter.* Was born at Leeds, in 1809, and was the son of Joseph Rhodes, a self-taught painter, who practised nearly half a century in Leeds, and died there in 1854. He was brought up to art under his

father, and painted with much fidelity rustic scenes and groups of cattle. He exhibited in London, and eventually settled there. Attacked by inflammation in the eyes, and suffering generally from weak health, he returned to Leeds, where he died in December 1842, aged 33.

RHODES, RICHARD, *engraver*. Practised in the line manner, in which he excelled. He engraved some of the illustrations of the 'Ancient Terra-cottas in the British Museum,' 1810, and some illustrations of the English poets. In the latter part of his career he was for many years the principal assistant to Charles Heath. He died at Camden Town, November 1, 1838, aged 73.

RICHARDS, JOHN INIGO, R.A., *landscape and scene painter*. He chose as his landscape subjects the ruins of old domestic and ecclesiastical buildings, but was chiefly distinguished as a scene painter. In 1763-65 he exhibited views at the Spring Gardens' Rooms. He succeeded Dall, in 1777, as the principal scene painter at Covent Garden Theatre, and held that engagement for many years. He was one of the foundation members of the Royal Academy, and a contributor of landscapes and figures, from 1769, to the exhibitions. In 1788 he was appointed the secretary to the Academy, and from that time was only an occasional exhibitor. He repaired the cartoon by Leonardo da Vinci, which belongs to the Academy. After suffering many years from ill-health, he died in his apartments at the Academy, December 18, 1810. His scenery for 'The Maid of the Mill' delighted the town, and in 1768 one of the scenes was engraved by Woollett, and had a large sale. Both Hearne and McArdell engraved after him.

RICHARDSON, GEORGE. *architect*. He received a Society of Arts' premium in 1765, and was in full professional practice at the end of the 18th century. He published, in 1794, 'A Complete System of Architecture;' also 'A Supplement to Vitruvius Britannicus,' and 'The New Vitruvius Britannicus: Plans and Elevations of Modern Buildings.' He lived many years in Tichfield Street, became very distressed in his old age, and was often assisted by the generosity of the sculptor Nollekens.

RICHARSON, JONATHAN, *portrait painter*. He was born in 1665, and lost his father when only five years of age. His mother married a second husband, a scrivener, to whom he was articled against his inclination. But, released in the sixth year of his apprenticeship by the death of his father-in-law, he choose art for his profession, and became the pupil of John Riley, with whom he continued four years, and ended by marrying his niece. He

acquired enough of his master's manner to support a solid and lasting reputation, even during the lifetime of Kneller and Dahl; and on their deaths he ranked with Jervas as at the head of the profession. Walpole says of him : ' His men want dignity, his women grace'—which, if true, is redeemed by the honest character and great individuality of his portraits. His heads are well and carefully drawn, and well coloured, and some half-lengths by him may be praised, but hardly his whole-lengths. He etched a few portraits in a slight but spirited manner. He was also distinguished as a writer. Dr. Johnson said of him, 'He is better known by his books than his pictures,' a doubtful compliment for a painter, which, if true in the Doctor's days, is assuredly not in ours. He wrote ' An Essay on the whole Art of Criticism in Relation to Painting,' 1719 ; ' An Argument in behalf of the Science of a Connoisseur,' 1719 ; ' An Account of some Statues, Bas-reliefs in Italy, &c.,' 1722 ; 'Explanatory Notes and Remarks on Milton's Paradise Lost, with the Life of the Author,' 1734. In his writings he was much assisted by the classic attainments of his son, some witless allusions to which in his preface to his ' Notes on Milton,' led to a caricature of both father and son by Hogarth, and to the reply of Prior, when asked by him what title he should give to one of his books, 'The memoirs of yourself and your son Jonathan, with a word or two about painting.' We learn also that he inflicted upon all comers to Old Slaughter's, Button's, and Will's his ' Notes on Milton,' which he persisted in reading to them. He had many years retired from the practice of his profession, when he died suddenly, at his house, in Queen's Square, Bloomsbury, May 28, 1745. His collection was sold by an auction in February, 1747, which lasted 18 days. His drawings produced 2060*l*., his pictures about 700*l*. Hudson, who had married one of his daughters, purchased many of the drawings.

RICHARDSON, JONATHAN, *portrait painter*. Only son of the above. He painted only as an amateur. Living with his father in great harmony, he assisted him in all his pursuits, and shared in his labours. A portrait of Matthew Prior by him is engraved. He died in Queen Square, Bloomsbury, June 6, 1771, aged 77, and was buried in the churchyard of St. George-the-Martyr.

RICHARDSON, THOMAS MILES, *landscape painter*. Was born at Newcastle-on-Tyne, May 15, 1784. His family were well-descended, and possessed property in North Tynedale. He was apprenticed to an engraver in Newcastle, and, on his death, transferred to a cabinet-maker. On the conclusion of his apprenticeship he com-

'Ricci ~narop
Ricci Sebastian

menced business, which he carried on for five years. On the death of his father in 1806 he was appointed to succeed him as master of the St. Andrew's Grammar School, and then first directed his attention, in his spare time, to drawing, and at the end of seven years gave up his school to devote himself wholly to art. He practised both in oil and water-colours. His first picture of any importance was a view of Newcastle from Gateshead Fell, which was purchased by the corporation of that town. This was followed by many landscapes and marine views in the neighbourhood. He was an occasional exhibitor at the Royal Academy from 1814, when he sent a 'View of the Old Fishmarket of Newcastle,' and in 1822 a 'View of Edinburgh Castle from the Grass-Market,' and after a long intermission, from 1841 to 1845, was a yearly exhibitor of river views in the north. He also exhibited at the British Institution, and later at the New Water-Colour Society, of which he was a member. In 1816 he commenced, with a partner, an illustrated work in aqua-tint, of the scenery about Newcastle, but only a few numbers were issued ; and in 1833, in conjunction with his brother, he began a work in mezzo-tint, engraved entirely by himself—' The Castles of the English and Scottish Borders,' but this work was not completed. He died March 7, 1848, leaving a widow and large family. His eldest surviving son is a member of the Old Water-Colour Society. His landscapes were painted in a bold and original manner. He excelled in sunset effects, and enjoyed a good repute in his profession.

RICHARDSON, CHARLES JAMES, *architect*. He was a pupil of Sir John Soane, and first appears as an exhibitor at the Academy in 1837, from which time he continued an occasional contributor. His exhibited works were chiefly of a decorative character, designs for Elizabethan ceilings, and other interior fittings. He built a mansion for the Earl of Harrington in Queen's Road, Kensington, and a group of five houses at Queen's Gate, in that neighbourhood. He was much employed in the literature of his art, and the author of many illustrated works—' Architectural Remains of Elizabeth and James I.,' 1840; ' Studies of Ornamental Design,' 1848 ; 'A Popular Treatise on Warming and Ventilation,' 1856 ; 'The Englishman's House, from a Cottage to a Mansion,' 2nd edition, 1871 ; ' Cottage Architecture,' ' Village Architecture,' ' Old Title Pages,' and some others. He died at Kensington, November 20, 1871, aged 65.

RICHARDSON, EDWARD, *sculptor.* He first appears as an exhibitor at the Royal Academy in 1836, and in that and the following years contributed classic works

of much pretension. Then his contributions were chiefly busts, and in his later years monumental works, mostly in relief. He restored the effigies of the Knights Templars in the Temple Church, and the recumbent effigy of the Earl of Powis, at Welshpool. He was an active member of the London and Middlesex Archæological Society. He died in July, 1869, aged 57.

RICHMOND, THOMAS, *miniature painter.* He was born at Kew in 1771, and was a pupil of George Engleheart, and a student at the St. Martin's Lane Academy. He first exhibited at the Royal Academy in 1795, was well known in his day, and was for many years an occasional exhibitor. His works were well drawn and finished, but formal and stiff in character. He died in London in 1837. Mr. Richmond, R.A., is his son.

RICHTER, CHRISTIAN, *portrait painter.* Was the son of a silversmith at Stockholm, and came to England in 1702. He painted in oil, studying the works of Dahl, but he is best known by his miniatures. Later in life he applied himself to enamel painting, but did not live to attain much proficiency. He died in November 1732, at the age of 50. He had a brother a medallist, several of whose medals, modelled from the life, were produced in silver.

RICHTER, HENRY J., *water-colour painter.* He was of German extraction. He practised in London, and was, as early as 1788, an exhibitor at the Royal Academy of two landscapes, and continued for many years a fitful contributor. In 1813 he was elected a member of the Water-Colour Society, but was a small and uncertain contributor to its exhibitions, and no less uncertain in his connexion with the Society. On the change which took place in its constitution in the year of his election he appears to have resigned his membership. Next year, and up to 1820, he was connected with the Society as an 'exhibitor' only. In 1821 he again became a member, but did not exhibit in that or the following year, and in 1823 he appears in the new class of ' Associate Exhibitors.' In 1826 he is again a member, and in 1828 an associate exhibitor. In 1829, once more elected a member, he continued in that rank, and contributed his works to the exhibitions till his death. He painted exclusively figure subjects, chiefly domestic and well chosen, and popular in character. Some of his subjects are from Shakespeare. ' Christ giving Sight to the Blind,' exhibited at the British Institution in 1813, was purchased by the directors for 500 guineas. His ' School in an Uproar,' ' Tight Shoe,' ' Brute of a Husband,' a work in oil, exhibited at the Academy in 1827, and others of his works, have been engraved. He was

an earnest disciple of Kant, and published, in 1817, with this singular title, 'Daylight, a Recent Discovery in the Art of Painting, with Hints on the Philosophy of the Fine Arts, and on that of the Human Mind, as first dissected by Emanuel Kant.' He died in Marylebone, April 8, 1857, aged 85.

RICKARDS, SAMUEL, *miniature paint-er*. Practised in London at the latter part of the 18th century, and exhibited at the Royal Academy in 1776 and 1777.

RICKMAN, THOMAS, *architect*. Born of an old Sussex family at Maidenhead, June 8, 1776. His father was a surgeon, and he studied for that profession till 1797, when he came to London and was for a time with a chemist. He then completed his surgical studies, and joined his father at Lewes, where he practised medicine for two years. In 1803 he returned to London, and was clerk to a corn factor, and five years later removed to Liverpool, where he was employed by one of the chief brokers; and, having spare time, devoted himself to the study of architecture, minutely examining the characteristics of the Gothic style. After his somewhat erratic course, he seems to have found a vocation suited to his tastes. He began to design monumental and other small works, and became a competitor for some of the many new churches at that time erecting. On one occasion he was successful, and summoned to London to execute his design, he at once abandoned the certainty which he held, to commence the new career which his ability and perseverance had opened to him. He continued, however, to reside in Liverpool, till finding his engagements in many parts of the country increase, he removed to Birmingham and finally settled there. He was attacked by apoplexy in 1834, and from that time his constitution gradually gave way. He died at Birmingham, in January 1841, aged 64. Among his best works may be mentioned the buildings of St. John's College, Cambridge, a good example of Gothic design; the church at Oulton, near Leeds; and Hampton Lucy Church, Warwickshire. He published 'An Answer to the Observations on the Plans for a New Library at Cambridge,' 1831; and 'An Attempt to Discriminate the Styles of Architecture from the Conquest to the Reformation,' 1843.

RIDDEL, JOHN, *marine draftsman*. Practised in the second half of the 18th century. Ant. Walker engraved after him.

RIDLEY, WILLIAM, *engraver*. Practised with some distinction about the close of the 18th century, and was much employed on book illustration. Many of his portraits, well drawn and expressed, appear in the 'Evangelical Magazine.' He died at Addlestone, where he had for many years retired, August 15, 1838, aged 74.

358

• RIGAUD, JOHN FRANCIS, R.A., *history and portrait painter*. Was born at Turin, May 18, 1742, the son of a respectable merchant, and descended from a French Protestant family. He early studied art, was appointed painter to the King of Sweden, and travelled in Italy for his improvement, making some stay at Rome, Bologna, and Parma; and in 1766 was elected a member of the Academy at Bologna. In 1772 he went to Paris and from thence came to London. He was an exhibitor at the Royal Academy for the first time in the same year, was soon distinguished, was elected an associate of the Academy in that year, and in 1784 a full member. His diploma picture of 'Samson,' presented to the Academy, was much esteemed. He found employment both in historical works and in portraiture, continuing to practise and to exhibit yearly in both styles up to 1810. He painted for the Shakespeare, Historic, and Poet's Galleries, and decorated several ceilings, among them the ceiling of the Court Room in the Trinity House, Tower Hill. He also painted in fresco an altar-piece for the Parish Church at Packington, and one for St. Martin Outwich, London. He was found dead in his bed at the house of his patron, Lord Aylesford, at Packington, December 6, 1810. He translated into English Leonardo da Vinci's 'Treatise on Painting,' 1806, and was a contributor to 'The Artist.'

RIGAUD, STEPHEN FRANCIS, *water-colour painter*. He was a student of the Royal Academy, and first appears as an exhibitor in 1797, and for many years was an occasional contributor both of portraits and of subject pictures, sacred and classic. In 1801 he gained the Academy gold medal for his historical painting, 'Clytemnestra Exulting over Agamemnon;' and in 1804 he was one of the foundation members of the Water-Colour Society, and a regular contributor to its exhibitions; his works chiefly of a sacred character. In 1805, 'Satan Discovered in the Bower of Adam and Eve;' in 1806, 'Martha and Mary;' in 1807, 'Sin and Death,' with an occasional subject from the poets. In 1812 he was the treasurer of the society, but on the change in its constitution, in the following year, he was one of the seceders. In 1814 he exhibited a large picture, which he had painted, of the 'Invasion of France in 1813,' with portraits of the Duke of Wellington and his generals. He last exhibited at the Royal Academy in 1815, 'David going forth against Goliath.' But in 1849-50 and 51, he exhibited some classic subjects with the Society of British Artists.

• RILEY, JOHN, *portrait painter*. Was born in Bishopsgate parish, London, 1646, and was the son of the Lancaster Herald, who was also Record Keeper at the Tower.

He was the pupil of Soest and Fuller, and practised his art in London; little noticed till the death of Lely, he then rose into public estimation. He painted the portrait of Charles II., who is said to have discouraged the modest painter when looking at his portrait, by exclaiming, 'Is this like me? Then, odd's fish, I'm an ugly fellow!' James II. and his Queen sat to him, and he was appointed their state painter; and William and Mary were painted by him several times. His art was original, founded on his own observation of nature, his drawing careful, expression natural and pleasing, and his heads and hands well painted. There are several of his portraits in the National Portrait Gallery, a good example of his work at Hampton Court, and his portraits find a place in many old mansions. He died of gout in 1691, aged 45, and was buried in St. Botolph's Church, London. Richardson married a niece of Riley, and inherited many of his pictures and other effects.

RIPLEY, THOMAS, *architect.* Was born in Yorkshire, and came early in life to London. He worked as a carpenter, and also kept a coffee-shop in Wood Street, Cheapside. Improving his means by his industry, he married a servant of Sir Robert Walpole, and by his patronage obtained employment under the Crown, and a seat at the Board of Works, of which department he became the comptroller. He built Houghton Hall for Sir Robert, but chiefly after the plans of Campbell, and afterwards Wolterton; and in 1718 he rebuilt the Custom House, which had been destroyed by fire in 1714. He built also the Admiralty, Whitehall, except the façade, 1726. He died in 1758, and was buried at Hampton, Middlesex. His work was without invention, or taste in design; but was convenient in arrangement, and well constructed. His success was not without remark. He was said to have been raised from a house carpenter to an architect by the patronage of Walpole, and he fell under the ridicule of Pope.

RIPPINGILLE, EDWARD VILLIERS, *subject painter.* Was born at King's Lynn, the son of a farmer, in 1798, and was, as an artist, entirely self-taught. He exhibited his first picture, 'Enlisting,' at the Royal Academy in 1813, a 'Scene in a Gaming House' in 1815, and in 1819 gained public notice by his 'Country Post-Office.' Stimulated by his success, he devoted himself to the representation of rural scenes, illustrating English manners and customs. The inventor of his own subject and story, of his works of this class may be distinguished his 'Recruiting Party,' 'Stage Coach Breakfast,' now a recollection of the past, 'Going to the Fair,' and, about 1834, 'The Progress of Drunkenness,' a series of six pic-

tures. In 1837 he went to Italy, and the following year sent from Rome to the Academy exhibition, 'Father and Son, Calabrian Shepherds.' He appears soon after to have returned to London, and to have been again in Rome, where he made a short stay in 1841. From his first visit his subjects and inspirations were Italian, and it was not till 1846, that, returning to home subjects, he commenced and continued to exhibit English scenes up to 1857.

In 1843 he was a successful competitor in the Cartoon Exhibition, Westminster Hall, gaining one of the prizes. He was also a writer and lecturer on art. In 1824 he commenced a series of lectures on the necessity of art to manufactures, which he delivered at several of the large provincial towns, and at the Royal Institution, London. In 1843 he commenced a monthly periodical, 'The Artists' and Amateurs' Magazine,' but it was not supported, and only existed 12 months. He was also the author of several brigand tales in 'Bentley's Magazine,' 'The Wanderings of a Painter in Italy;' and in the 'Art Journal' 'Personal Recollections of Great Artists.' He sometimes quoted from a poem of his own, 'The Consolation of Hope,' but it does not appear that it was ever printed. He died suddenly April 22, 1859, at the railway station, Swan Village, Staffordshire.

RISING, JOHN, *portrait and subject painter.* Practised in London, and was a contemporary of Reynolds. His portraits are vigorously painted, and his colour good. He exhibited at the Royal Academy from 1785 to 1814, when his name disappears. His works were chiefly portrait, but he occasionally exhibited a domestic subject—'Ballad Singers,' 'Infant Piety,' 'A Match Girl,' 'Girl with Grapes.' W. Ward mezzotinted two plates—'Juvenile Amusement' and 'Juvenile Employments,' painted by J. Rising and J. Reynolds.

RITCHIE, JOHN, *sculptor.* Was born at Musselburgh, near Edinburgh. His father was a brick and tile maker, and amused himself in modelling. In this art the son soon became a proficient, and struggled hard to distinguish himself in his native city. Among the works by him may be mentioned, as one of his best, his statue at Glasgow of Sir Walter Scott. He was a dreamer, and fond of telling his dreams, and he embodied one of them in his fine group in clay, 'The Deluge,' exhibited in Edinburgh, 1822, and at the Royal Academy, London, his only contribution there, in 1840. He for many years assisted his more talented brother, Alexander, and while so employed he received a commission to execute his model of 'The Deluge' in marble. This induced him to make a journey to Rome. He had hardly

reached that city, when he was attacked by fever, and died there towards the close of the year 1850, aged 41.

RITCHIE, ALEXANDER HENDYSIDE, A.R.S.A., *sculptor.* Brother of the foregoing. He was born at Musselburgh, near Edinburgh, in 1804, and of his own genius became a modeller almost from his childhood. He was from 1830, at intervals, an exhibitor at the Royal Academy, London, as well as at the Scottish Academy, and was elected an associate of the latter in 1846. In the following year he was employed upon some of the decorative sculpture for the Houses of Parliament, and from that time was chiefly devoted to architectural sculpture, of which there are examples at Edinburgh, in the Bank of St. Andrew's Square, and the pediment of the Commercial Bank; and at Glasgow in the Duke of Hamilton's monument. His principal works exhibited in London were busts, but in 1857 he sent 'The Scottish Lassie,' a statue in marble. He died early in May 1870.

RITSON, JONATHAN, *wood carver.* Was born at Whitehaven, about 1776, and brought up to his father's trade of a carpenter. He was employed upon the Duke of Norfolk's estate, and attracted the Duke's notice by his able carvings in wood. At the Duke's request he removed to Arundel, and executed the chief of the carvings in the library and Baron's Hall of the Castle. In 1815, on his patron's death, he was employed by the Earl of Egremont in completing the work at Petworth, left unfinished by Gibbons. He showed great ability in combining groups of birds, fruits, and flowers, with much skill and natural lightness. Treated here with too much indulgence, and tempted by an inordinate love of strong beer, he fell into habits of intemperance and sought the lowest company. He died at Petworth, April 9, 1846, aged 69. His portrait by Clint hangs there as a pendant to the portrait of Gibbons.

RIVIERE, WILLIAM, *painter.* Was the son of a drawing-master, and was born in London, October 22, 1806. He became a student of the Royal Academy, and sent his first work for exhibition in 1833, continuing a constant exhibitor for the next ten years, of portraits and other works. He contributed a cartoon of 'A Council of Ancient Britons,' to the Westminster Hall Competition. In 1849 he accepted the appointment of teacher of drawing in Cheltenham College, which he held for ten years. He then settled at Oxford, where he continued to teach till a short time before his death, which took place August 29, 1876.

ROBERT, CHARLES, *engraver.* Born in Edinburgh, in 1806, he was articled to an engraver there, studying also in the Trustees' Academy. His first works were chiefly vignette portraits. He engraved

'The Widow,' after Sir W. Allan; 'The Rush-plaiters,' after Sir G. Harvey; 'The Expected Penny,' after A. Fraser; and also engraved after Noel Paton and Eckford Lauder. About 1850 he was engaged upon the engravings for the London Art Union, for which he produced some good plates. He just lived to complete 'The Battle of Preston Pans,' perhaps his most important work. He died in Edinburgh, September 5, 1872.

ROBERTS, DAVID, R.A., *landscape painter.* Was born at Stockbridge, near Edinburgh, October 2, 1796. His parents, persons in humble life, his father a shoemaker, managed to give him some education, and when at a suitable age, he was apprenticed to a house-decorator in Edinburgh. Here during seven years he learnt the use of the materials of art, and attained a power and readiness of hand; and then tried his skill as scene painter to a company of strolling players at Carlisle, and had occasionally to take his part on the stage. This led to his employment, in 1820, in the scene-room at both the Edinburgh and Glasgow Theatres, and to his engagement at Drury Lane Theatre in 1822. He had, in 1820 and the following year, sent pictures to the Edinburgh Exhibition, and in 1824, having joined the Society of British Artists, he contributed to their exhibition in Suffolk Street. In the same year he strayed to France, and visited the coast towns of Dieppe, Havre, and Rouen; and in the following spring exhibited scenes which were taken from the fine Gothic of these cities; but he continued to hold an engagement at Covent Garden, and did not abandon scene painting.

In 1826, his first work, 'Rouen Cathedral,' appeared on the walls of the Academy. In 1828 he produced a work of another character, 'The Departure of the Israelites out of Egypt,' which he sent to Suffolk Street, and for the next seven years sent his easel pictures to this young society. But gradually withdrawing himself, he resigned his membership in 1836, and growing in reputation sought the honours of the Royal Academy. Of this body he was elected an associate in 1839, and an academician in 1841. He had already, in the pursuit of his art, visited France, Belgium, Germany, Spain, Morocco, and Holland; and seeking more distant scenes, in 1838, Egypt and Syria. For the ten succeeding years his works, with only an occasional exception, were eastern, and he had attained the summit of his reputation, producing his best pictures, and exhibiting almost exclusively at the Royal Academy.

He visited Italy for the first time in 1851, returning by the way of Vienna, and from that year to 1860 his themes were Italian, the decaying temples of Rome and the gran-

Rivers. Chal - Line Engraver

deurs of Venice, Pisa, and Milan, his inspirations. Then, as age crept on and travel tired, he found subjects nearer home, and commenced a fine series of views on the Thames. He had completed six of these views, and was actively engaged upon another when, on the morning of November 25, 1864, he was seized with an apoplectic attack in the street, and died the same evening.

His art was essentially scenic, his subjects picturesque architecture, giving all the splendour and magnificence of the ancient structures, enriched by groups of accessories. His style was formed at the theatre. He had no sympathy with realistic imitation. Broad, simple, and conventional, agreeable in his colour, though not like nature, his pictures charm by their ease and power. He worked both in oil and in water-colour, and his pictures have from first to last a marked equality in excellence. His works were eminently suited for publication. He made for four years drawings for the 'Landscape Annual.' In 1837, he published in lithography, his 'Picturesque Sketches in Spain;' and in 1842 commenced his well-known work 'Sketches in the Holy Land and Syria.' In 1859 his last work appeared, 'Italy, Classical, Historical, and Picturesque.' His paintings are numerous, and by them and his publications he realised a considerable fortune, which he left to an only daughter. He was highly esteemed by his countrymen, and was by them entertained at Edinburgh, in 1842, at a banquet given in his honour. In 1858 he received the freedom of his native city. He was appointed one of the Commissioners for the Great Exhibition of 1851, and is a member of several foreign art academies. His Life by James Ballantine was published in 1866.

ROBERTS, JAMES, *portrait painter.* Was born in Westminster, but brought up in Oxford, where he commenced the practice of his art. He gained a premium at the Society of Arts in 1766, and was an exhibitor at the Royal Academy of three-quarters portraits, and small whole-lengths, commencing in 1773. A group of Lord Charles and Lady Charlotte Spencer, in character, painted by him in 1788, is engraved in mezzo-tint, but it is a poor, stiff composition. A portrait of Sir John Hawkins, in the Music School, Oxford, is by him. He painted some scenery for private theatricals at Blenheim, engravings of which were published, and he was similarly employed at Windsor. Not meeting with sufficient encouragement at Oxford, about 1793 or 1794 he returned to Westminster, where he settled. He was about this time appointed portrait painter to the Duke of Clarence, and continued to exhibit up to 1799. There are some water-colour drawings by him in the British Museum, much laboured but deficient in art.

ROBERTS, JAMES, *engraver.* Son of the above. Was born in Devonshire, in 1725. He practised in landscape. There are by him a set of four plates, 'Fox Hunting,' after Seymour; two small marine views, after Pillement, 1761; four English views, after Barrett, and others after Smith of Chichester. He died in Cold Bath Fields 1799, aged about 74, and was buried in St. Andrew's new burial-ground, Gray's Inn Road.

ROBERTS, HENRY, *engraver.* Towards the middle of the 18th century he kept a print-shop in Hand Court, Drury Lane. He engraved some large landscapes, among them one by T. Smith of Derby, 1743. He published some humorous prints, a drawing-book, &c. Careless in habit, he engraved chiefly such works as would find a quick sale in his shop. He died some time before 1790, aged about 80 years.

ROBERTS, THOMAS, *landscape painter.* Was the son of an architect, and was born at Waterford. He was a pupil of George Mullens, and his works had considerable merit, possessing great freshness, and his foliage, though rather hard, much beauty of pencilling. He practised towards the end of the 18th century. The Duke of Leinster and Lord Powerscourt, who patronized him, possessed many of his best works. His irregularities brought on consumptive symptoms, and he went to Lisbon for the recovery of his health, and died there. His sister was a tolerable painter of landscape, and painted several scenes for the theatre at Waterford.

ROBERTS, THOMAS SOTELLE, R.H.A., *landscape painter.* Younger brother of the above. Was originally articled to James Ivory, the architect. On the completion of his time his tastes led him to landscape painting. He practised for several years in London, and from 1789 to 1811 was an exhibitor, contributing largely at the Royal Academy. He exhibited once more in 1818. His name does not recur again. He was engaged subsequently in making views of the principal cities and towns in Ireland, many of which are engraved. In 1823 he was one of three artists chosen to select 11 others to be the members of the Incorporation of Artists in Dublin, founded in that year, and was himself one of the first members.

ROBERTS, EDWARD JOHN, *engraver.* Was pupil and assistant of Charles Heath, and was much employed upon the 'Annuals' under him. But the occupation in which he most excelled was in etching the engraver's plates; and as he was largely engaged in this manner his name is little known. The plates for Prout's 'Continental Annual,' 1832, were etched in by him; and

also for Bulwer's 'Pilgrims of the Rhine,' after Roberts, R.A.; but some few of the plates for these works were completed by him, and to these his name appears. He died March 22, 1865, aged 68.

ROBERTSON, ANDREW, *miniature painter*. He was the son of a cabinet-maker at Aberdeen, where he was born October 14, 1777. A clever lad, he commenced practice as an artist at the age of 14, and for two years was a pupil of Alexander Nasmyth. When only 16 he was director of the concerts at Aberdeen — at the same time teaching drawing, and painting scenes, portraits, miniatures, and anything that offered. In 1794 he took his M.A. degree at the Aberdeen University. He walked up to London in 1801 to see the exhibition, and soon after was noticed by West, then president of the Academy, who sat to him for his portrait, and during his protracted sittings advised him on its art and complete finish, and induced him to stay in London. He entered the schools of the Academy in the same year, and his miniature of West was exhibited at the Academy in 1803, and was noticed from its original manner and powerful colour. By his abilities he gradually made his way. Through West's kindness he painted the Princesses at Windsor, and passing his life in the practice of his art, had many distinguished sitters, among them, in 1812, the Prince Regent, and at the peace visited France and Italy. He was appointed miniature painter to the Duke of Sussex. In 1808 he was a member and the secretary of the short-lived Associated Artists in Water-Colours. He continued his early love of music, and became distinguished as an amateur violin player; and he was actively engaged in the business of several charitable institutions, to which he devoted much of his time. He had several pupils, who afterwards were distinguished in miniature art, and on his retirement from his profession in 1841, after thirty years' practice, with great reputation, the miniature painters recognised him as the father of their profession and presented him with a piece of plate. He died at Hampstead on December 6, 1845. His miniatures were well finished and carefully drawn, but his powerful masses of pure colour are somewhat opposed to due refinement. An elder brother, ARCHIBALD, went to New York in 1791, to practise portrait painting, and was afterwards followed by another brother, ALEXANDER, a miniature painter and pupil of Shelley.

ROBERTSON, GEORGE, *landscape painter*. Born in London. Was the son of a wine-merchant, and brought up to that business. He early showed an ability for drawing, and studied in Shipley's school, where his drawings, especially of horses, for which he received a Society of Arts' premium in 1761, were much admired. This gained him the notice of Beckford, with whom he travelled in Italy, and studied, chiefly at Rome, during several years. He returned to London about 1770, and though recommended in every way by Beckford, he did not meet with much encouragement, and was induced to make a voyage with him to Jamaica. He painted some views in the island, and, coming back again to England, exhibited them in 1775, with the Incorporated Society of Artists, of which body he was for some time the vice-president. These views were engraved, and created much interest; but he received no better encouragement than before. He had married, and by teaching and drawings which he made for the dealers and engravers, he managed to support his family. His health, always failing, was aggravated by a fall from his horse, when he was happily relieved by a small competency left him by an uncle. He gave up his teaching, took a modest house in Newington Butts, and not surviving long, died there, September 26, 1788, before attaining his 40th year. He painted a few pictures in oil, aiming at the grand style, and his 'St. Martin dividing his Cloak,' is in the Vintners' Hall; but his art was essentially landscape. His compositions were too scenic; his trees, though spirited, were fanciful and exuberant in their forms, yet his works are by no means without merit, and many of them are engraved. He etched some of his own landscapes in a very spirited manner.

ROBERTSON, WALTER, *miniature painter*. Was the son of a jeweller in Dublin, and practised there about the end of the 18th century, holding for many years the first place in miniature art in Ireland. He went from Dublin to America in 1793 with Gilbert C. Stuart, on his return, and was called 'Irish Robertson.' He gained much notice by his miniature copies of Stuart's portraits. He afterwards went to the East Indies, where he died.

ROBERTSON, CHARLES, *miniature painter*. Younger brother of the above. Practised in Dublin about the end of the 18th century, and gained much repute for the extreme neatness of his finish. He came to London about 1806, and in that and several following years exhibited miniatures and miniature groups at the Royal Academy. He excelled in his female portraits. Was a contributor to the Dublin Exhibition in 1809, and a strenuous supporter of the claims of Irish artists for the grant of the charter obtained in 1823.

ROBERTSON, Mrs. J., *miniature painter*. She was a niece of George Saunders the miniature painter, and her art was well known. She was from 1824 an exhibitor at the Royal Academy, sometimes

362

sending a portrait in oil, up to 1844, about which time she went to Russia, where she was elected a member of the Imperial Academy at St. Petersburg.

ROBINEAU, C., *portrait painter.* He practised in Paris and was well known there about the year 1780. At first he drew portraits, but afterwards painted them in oil. In 1806 he was Inspector of the Pupils at the Government Drawing-School in Paris. There are two small full-length portraits in the Royal collections by him, one of George, Prince of Wales, and a portrait, life-size, of Abel the composer.

ROBINS, WILLIAM, *engraver.* Practised in mezzo-tint in the reign of George I. There are special mezzo-tint portraits by him dated about 1730.

ROBINSON, JOHN, *portrait painter.* Born at Bath in 1715. Was a pupil of Vanderbank; made good progress, and became distinguished as a portrait painter. He married a wife with a good fortune, and taking Jervas's house in Cleveland Court, came at once into an extensive practice, yet he was weak and feeble in colour, and his attempts to dress his sitters in Vandyck's costume were in poor taste. He died in 1745, before completing his 30th year. Faber mezzotinted 'The Amorous Beauty' after him.

ROBINSON, PETER FREDERICK, *architect.* Was the pupil of Henry Holland. From 1795 he was a frequent exhibitor at the Academy. In 1816 he travelled in Italy, and on his return sent drawings of Italian architecture to the exhibition, to which he continued to contribute. His chief work was the Egyptian Hall, in Piccadilly, 1811, but he was the author of many professional works: 'Illustrations of Mickleham Church, Surrey,' 1824; 'Rural Cottages,' 1834; 'Designs for Ornamental Villas,' 1836; 'Village Architecture,' 1837; 'Designs for Farm Buildings,' 1837; 'Designs for Gate-Cottages, Lodges, and Park Entrances,' 1837. He went to reside in Boulogne from pecuniary difficulties, and died there in June 1858, aged 82.

ROBINSON, WILLIAM, *architect.* Was secretary to the Board of Works, and from 1746 to 1775 clerk of the works to Greenwich Hospital. In 1767 he rebuilt the west side of the Old Royal Exchange. He was also the architect of the Excise Office in Old Broad Street, a work of much merit, since pulled down, and of the additional west wing to Castle Howard.

ROBINSON, WILLIAM, *portrait painter.* Was born at Leeds in 1799, and was apprenticed to a clock dial enameller. Determined to follow art, he made his way to the Metropolis in 1820, and with some introduction was admitted by Sir Thomas Lawrence to his studio, and became a student of the Academy. In 1823 he was able to return to his native town, and com-

mence practice as a portrait painter, and in that and following years exhibited his portraits at the Academy. He was well received, and painted the portraits of several Yorkshire celebrities. He also painted four whole-lengths for the United Service Club in London. For one of these the Duke of Wellington gave him several sittings; the others were chiefly painted from well-known portraits. He gained a local name and repute. Died at Leeds in August, 1839, aged 39.

ROBINSON, THOMAS, *portrait painter.* He was descended from a good Leicestershire family, and brought up as a portrait painter, he practised in London, living in Golden Square, early in the 18th century. He visited Italy for his improvement in art, made himself master of the language, and was a good musician. He became afflicted by a disorder in the eyes, which ended in a total loss of sight, and was then supported by the musical talents of his daughter, the celebrated Anastasia Robinson, who was secretly married to the Earl of Peterborough, and died in 1755.

ROBINSON, R., *engraver.* He practised in mezzo-tint about the end of the 17th century. There are by him portraits of seven bishops sent to the Tower, each in a small oval.

ROBINSON, THOMAS, *portrait painter.* Was born at Windermere, became the pupil of Romney, and resided with him about 1785. He was invited to Ireland, and after visiting Dublin and the northern part of the country, he settled at Belfast in 1801, where he remained till 1808, patronised by Dr. Percy, Bishop of Dromore, and painting many portraits. A picture of the 'Combat between the King's Troops and the Peasantry at Ballynahinch,' which he painted in 1799, was purchased by the Marquis of Hertford. A large painting of the 'Giant's Causeway' was disposed of by raffle. His 'Military Procession at Belfast in Honour of Lord Nelson,' is in the Harbour Office in that city. His portraits were reputed good, and he had a fair knowledge of art. He was president of the Society of Artists in Dublin. Died there July 27, 1810.

ROBINSON, JOHN HENRY, R.A., *engraver.* He was born at Bolton, Lancashire, in 1796, and was a pupil of James Heath. He engraved some good works for the illustration of books; among them, for Rogers's 'Italy,' and a number of fine portraits. He engraved 'Little Red Riding-Hood,' after Lawrence, P.R.A., 'Napoleon and Pius VII.,' after Wilkie, R.A., and 'The Wolf and the Lamb' for the Artists' Fund, for which it is said to have realised nearly 1000l.; after Leslie, R.A., 'The Mother and Child;' and after Partridge, 'The Queen,' a very carefully

363

Robinson Hugh (1776)

finished portrait. From the old masters he engraved Murillo's 'Flower Girl' and Vandyck's 'Emperor Theodosius Refused Admission to the Church,' with, one of his latest works, Vandyck's fine portrait of the Countess of Bedford. He was one of the engravers who petitioned Parliament, in 1836, on the state of his art, and especially upon the position of engravers in the Royal Academy. In 1856 he was elected an associate engraver of that body, and in 1867 a full member. He had made money by his profession, and late in life he married a lady with some property, and soon after retired to Petworth, where, after a long state of declining health, he died, October 21, 1871. He practised in the line manner, and attained great excellence. He was one of a great school of engravers, of whom he left few his equals.

* ROBSON, GEORGE FENNEL, *water-colour painter*. Was born at Durham in 1790, the son of a wine merchant in that city. He had an early propensity for drawing, which school discipline could not check, and he is said to have haunted the artists who visited the locality, showing the greatest interest in the progress of their work. He got his first instruction from a Mr. Harle, a drawing-master—and the only one—in Durham. He came to London at the age of 16 with only 5l. in his pocket, and in less than 12 months, by the sale of his drawings, was able to return this sum to his father. He was a most persevering student. In 1808 he published a view of his native city, and the profits enabled him to visit the Highlands of Scotland, through which he wandered until he became familiar with their changing aspects, and had laid up a large stock of materials. On his return, he published 'Outlines of the Grampians.' He first exhibited at the Royal Academy in 1807, and continued a contributor till 1813, when, under the altered laws, he was an exhibitor at the Water-Colour Society, and was the following year elected a member. He published, in 1819, his 'Scenery of the Grampian Mountains,' comprising 41 large coloured plates. In 1820 he filled, for that year, the office of president. He was at all times a most zealous member of the society, wrapt up in its success ; a very large contributor to its exhibitions, sending in the 19 years which followed his election no less then 653 pictures. In 1826 Britton published from his drawings 'Picturesque Views of the English Cities.' He attained great reputation in his art. His mountain scenery was treated with much poetry, skill, and power. R. Hills, who lived for some time in the same house, was associated with him in many of his works, painting the animals in the foregrounds, the two artists working together with great skill.

He embarked in excellent health on board a steam-boat to visit his friends in the north, and, being taken seriously ill, was landed at Stockton-on-Tees. Medical aid was procured ; his malady was not stayed ; he was sent home to his house in Golden Square, London, where he died, eight days after being put on shore, September 8, 1833. His last words were, 'I'm poisoned ;' but a *post mortem* examination afforded no satisfactory solution.

ROCHARD, FRANÇOIS, *miniature painter*. Was born in France, 1798, and studied his art for several years in Paris. He first tried some subject pictures, but shortly before 1820 he came to London, following his brother, Simon James Rochard, who had practised miniature art here successfully since 1815, and whom he probably for some time assisted. He had exhibited at the Academy, commencing in 1819 ; but from 1823 appears to have practised on his own account. His art soon became fashionable, he had many sitters of distinction, and continued to practise up to about 1850, when he married, and retired upon his savings to Notting Hill, where he died in 1858. He practised exclusively in water-colours, and was careful in his drawing and finish. Some of his portraits have been engraved. *See* ~~Jean Gregor~~ ~~Fra-S-uil~~

ROCHE, SAMPSON TOWGOOD, *miniature painter*. Practised in Bath in the early part of the 19th century. He sent some miniatures from thence to the Academy exhibition in 1817, the only occasion on which he was an exhibitor. He painted a good miniature, but his practice seems to have been entirely local.

* ROESTRAETEN, PETER, *portrait and still-life painter*. Was born at Haerlem, in 1627, and was the pupil of Frank Hals, whose daughter he married. He came to England in the reign of Charles II., was well received, and practised portraiture, painting many of the nobility ; but that art was almost monopolized by Sir Peter Lely, and he tried still-life, and painted many good subjects in that style, particularly wrought plate, in which he excelled. From an injury he received at the fire of London, he was lame during the rest of his days. He died in James Street, Covent Garden, in 1698, and was buried in the neighbouring church.

ROETTIERS, JOHN, called 'old Rotteer,' *medallist*. Was the son of a goldsmith and banker in Paris, who was supposed to have supplied Charles II. with money during his exile, and was on the Restoration invited by the king to England. He came over accompanied by his family, and was employed in the Mint, superseding Simon, who had made the dies for the Commonwealth coinage. He was an excellent artist, skilled in metal dies as

well as in intaglios in stone. An authentic account of the family appears in the report of a commission appointed in 1697, by William III., 'To inquire into the miscarriages of the offices of the Mint.' The report states that 'old Rotteer and his three sons were brought over by Charles II., and 325*l.* per annum allowed to the father, with the addition of 450*l.* per annum to the three sons—viz. 150*l.* a-piece for their several lives, which hath been constantly paid him that remained here, notwithstanding one of them went several years since to Flanders, and the other fled to France, where he now is in the French King's service.' The report also states that the master of the Mint produced ' an agreement made by him and the younger of the Rotteers, to pay to him the said Rotteer, over and above the said 325*l.* per annum and 450*l.* annuity, the further sum of 800*l.* yearly.' Then speaking of their character, it sets forth that the Rotteers were violent Papists, refused to take the oaths required by law, and were carrying on a treasonable correspondence with France, and receiving a salary from the French King, at the same time they were paid the above salaries. Of the father the report adds : ' That he was still continued in the graver's house in the Tower, though he will not nor ever did own the king, or do anything as a graver since the Revolution, and that the Governor of the Tower had declared him to be a dangerous person to be in the Tower, and that he would remove him if he could.' But it seems he could not bear the close watch kept upon him, and, leaving the Tower, he retired to a house in Red Lion Square. He had, as may be supposed from his large salaries, amassed considerable wealth, and old and infirm, was living on the succession of Queen Anne, and was induced to commence a medal on her accession, but died in 1703, before its completion. He was taken to his grave in the Tower, and was buried there in the church of St. Peter ad Vincula. A memoir of the Roettiers family, by Jacob Henry Burn, was read before the Numismatic Society, and published in 1841.

ROETTIERS, JOHN, } *medallists.*
ROETTIERS, JAMES, } Sons of the
ROETTIERS, NORBERT, } above, and mentioned in the foregoing report. JOHN, who was born in Paris, 1661, came early to this country, worked for his father, and was appointed one of his Majesty's engravers. He died young. JAMES, said to have been born in London in 1663, was employed by his father, and in other ways found much employment. He was also appointed one of his Majesty's engravers. He was hurt by a fall from his horse at Bromley, and died there in 1698. NORBERT was born in 1665, at Antwerp, where

his mother had taken refuge during the plague. He also received the same appointment as his brothers, and continued in the service of the Crown, receiving a large pay, till the Revolution. He is erroneously stated to have made the coronation medal for William and Mary. His art was very poor, and had but little employment. He is believed to have remained in this country till the early part of 1695, when, disturbed by the inquiries made and the reports concerning him, he left his office and went to Paris, where he was employed by Louis XIV. He died in May, 1727.

ROETTIERS, JOSEPH, } *medallists.*
ROETTIERS, PHILIP, } Brothers of 'Old Rotteer.' JOSEPH accompanied him to this country, and was appointed to an office in the Mint, with a handsome salary, and on his successful establishment here was followed by PHILIP, to whom is attributed the King's medal, on the reverse of which the face of the beautiful Mrs. Stuart is engraved as Britannia. Discontented and jealous of the greater favour shown to their nephews, both the brothers left England, Joseph, in 1672, to enter into the service of the King of France ; and Philip, in 1678, went to Flanders, and was employed by the King of Spain.

ROFFE, JOHN, *engraver.* Practised, with some merit, in the early part of the 19th century. He was chiefly engaged upon architectural works, and engraved some of the plates for the description of the marbles in the British Museum, 1812 ; and for Murphy's 'Arabian Antiquities of Spain,' 1816. He died at Upper Holloway, December 14, 1850, aged 81.

ROGERS, PHILIP HUTCHINS, *marine and landscape painter.* Was born at Plymouth in 1794, and educated there. His works, some of which were close imitations of nature, were views in that neighbourhood, and find a place in the collection at Saltram. About 1813 he painted a large picture, 'The Bombardment of Algiers,' which was engraved ; and about 1820 some views on the Spanish coast. He was an occasional exhibitor at the Royal Academy up to 1835. In the latter part of his life he resided on the Continent from motives of economy, and died at Lichtenthal, near Baden Baden, June 25, 1853.

ROGERS, GEORGE, *landscape painter.* Practised only as an amateur. He exhibited at the Spring Gardens' exhibition in 1761 and 1762, and his works were said to possess considerable merit. He resided at the Isle of Wight and married a daughter of Jonathan Tyers, the proprietor of Vauxhall. Died about 1786.

ROGERS, WILLIAM, *engraver.* Was born in London about 1545. Practised in the reign of Elizabeth, of whom there is a

' Rogers Inr. of Liverpool .] Engraver -1790 .

fine engraved portrait by him, and other frontispiece portraits, in a neat formal style, with some ornamental plates for book illustration. He reached considerable perfection in his art, and was probably one of the earliest English artists who was so employed. There is also by him a whole-length portrait of the Emperor Maximilian.

ROGERS, WILLIAM GIBBS, *carver in wood*. Was born at Dover, August 10, 1792, and having very early in life shown great ability in carving and modelling, he was apprenticed to a carver in London. He rose to great distinction in his profession, both from the delicacy of his execution and the beauty of his design. He decorated 'Carlton House,' 'The Pavilion' at Brighton, 'Kensington Palace,' 'St. Anne's Church,' Limehouse, 'St. Michael's,' Cornhill, and 'St. Mary' at Hill. In 1872 the Queen granted him a pension of 50*l.* a year, in reference to the influence he had had on art decoration, especially with regard to the art of wood carving in this country. He died March 21, 1875.

ROGERSON, R., *portrait painter*. Practised about the middle of the 17th century. He painted a room in the Pope's Head Tavern, in 1688, of which Pepys says, 'I do not like it at all, though it be good for such a public place.'

ROGIERS, THEODORE, *ornamentist*. Practised as a chaser in the time of Charles I., and designed and executed several pieces of plate for the King, ornamented with poetic subjects, among them a silver ewer, with the Judgment of Paris, after a design by Rubens. Among the artists drawn by Vandyck is a head of Rogiers.

ROLLES, JOHN, *medallist*. Was chief engraver to the Mint in the reign of George II. He died May 20, 1743.

ROMA, SPIRIDONE, *portrait painter*. Was born in Italy, but came to England and settled here. He exhibited a portrait at the Academy in 1774 and 1775, and in 1777 and 1778, his last contributions, designs in water-colours. Among other works the ceiling at the East India House, now pulled down, was by him. It was, however, a feeble work, and he was best known as a picture-cleaner. He died suddenly in the street, in 1787.

• ROMNEY, GEORGE, *portrait painter*. Was born December 26, 1734, at Dalton-le-Furness, Lancashire, where his father, a man of many occupations and projects, was builder, farmer of a small freehold, and dealer. He was apprenticed to a cabinet-maker and acquired some skill at his trade, and also in wood carving. A clever lad, he showed a taste for music, made himself a fiddle, and learnt to play upon it. He had also an early notion of mechanics, and a love of art. In 1755 he was still in the

366

workshop, but soon after falling in the way of an itinerant artist, an unprincipled fellow, he became his pupil, continuing with him about two years. Suffering from fever he was nursed by a young girl, with whom, in 1756, he contracted a hasty marriage. He soon after left his young wife and rambled about the northern counties, painting portraits at two guineas a head, and small whole-lengths at six guineas. Thus employed he managed to save 100*l.*, and giving 70*l.* to his unoffending wife, who was now burthened with two children, he abandoned his family, to seek his fortune in the Metropolis.

He arrived in London in 1762, and making an attempt at historic art gained a premium at the Society of Arts for his ' Death of General Wolfe.' In 1764 he paid a short visit to France, and in the following year gained a second premium at the Society of Arts for his ' Death of King Edward.' In 1766 he was a member of the Incorporated Society of Artists, and in 1769 was admitted to study at their school. He exhibited with them, 1770, 'Melancholy' and ' Mirth.' In 1771, Mrs. Yates as the ' Tragic Muse,' a whole-length portrait; and in 1772 some portraits. He was also an exhibitor with the Free Society. He rapidly established himself in public favour, and we are told was making 1200*l.* a year by his profession, when he determined to visit Italy, and in March 1773, set off in company with Ozias Humphrey, a brother artist. Arrived at Rome he separated himself from his fellow-traveller and led a recluse life, holding no intercourse with his countrymen studying there. On his way home he made some stay at Venice and Parma, and reaching London in July 1775, he with much nervous anxiety settled himself in a large house in Cavendish Square, and commenced practice as a portrait painter.

Charging 15 guineas for a head life-size, and proportionately for whole and half-lengths, he soon found himself surrounded by sitters, and his labours were attended by such success that in 1785 he received 3635*l.* for his portraits. His prices had then risen· to — full-length, 80 guineas ; half whole-length, 60 guineas ; half-length, 40 guineas ; kit-cat, 30 guineas ; head, 20 guineas. Yet he would have it believed that he disliked portrait painting, for he· wrote to his friend Hayley, the poet, ' This cursed portrait painting, how I am shackled with it ; I am determined to live frugally and cut it short as soon as I can.' He was ambitious of higher attempts, and having been successful at the commencement of his career was desirous to return to historic art. He had made acquaintance with Hayley soon after his return to London, visited him every season at Eartham, in Sussex, where he resided, was praised by

him in florid verse, and incited to paint classic subjects; but he was imperfectly educated in art, could have possessed little anatomical knowledge, and impatient to see his conceptions on the canvas, sadly wanted that perseverance essential to the completion of a great work.

He had become acquainted with Emma Lyon, who sat as a model to painters, and, after many vicissitudes, became notorious as the wife of Sir William Hamilton. Her graceful poses suggested many subjects, and her attractions, to which he was not insensible, lured him to attempts at high art, but the most of them were mere beginnings, not carried further than the hasty sketch of the first idea. When Alderman Boydell at this time (1786) made known his scheme for the 'Shakespeare Gallery,' Romney entered heartily into it, and commenced his picture of 'The Shipwreck' from the 'Tempest.' He painted from his witching model Magdalenes, St. Cecilias, Sapphos, and Bacchantes, but his best finished work is, probably, his 'Infant Shakespeare.' After an uninterrupted career of employment for above 20 years, he retired, in 1798, to Hampstead, where he displayed more whim than taste in the construction and decoration of his house; but soon after, his health declining, he disposed of his house and his collection.

Since abandoning his family he had visited them only once, in the year 1767. He had, we learn, supported them and protected them from poverty—and now, his dream of ambition past, his health and youth gone, he selfishly determined to return to them. His forgiving wife, patient under her protracted wrongs, received him without reproach, and under her affectionate care, having relapsed into the helpless state of infancy, he died at Kendal, November 15, 1802.

Romney was by nature an enthusiast—morbidly shy in his associations—impulsively eloquent and silent by turns—abstemious—easily irritated, timid, full of projects, but conscious of a defective education—associating little with his professional brethren, rather shunning them, while he complained of their neglect, and never exhibiting at the Royal Academy after his return from Italy, he was not eligible to be elected a member of that body. He was highly popular as a portrait painter, dividing for a time the fashion with Sir Joshua Reynolds, yet his reputation, though still high, has hardly been maintained in our day. He was deficient in drawing, his colouring is coarse and heavy, devoid of all the refinement which tint gives—and his portraits want individuality, yet they are pleasing, especially his female portraits, and endowed with great breadth of treatment and originality. His 'Life,' by Hayley, was published in 1809; a 'Memoir,' by his son, the Rev. John Romney, 1830. There is also a memoir of him in the 'European Magazine,' vol. 43, by Richard Cumberland, and a memoir in Cunningham's 'Lives of the Painters.'

ROMNEY, PETER, *portrait painter.* Brother of the foregoing. He practised for a while at Ipswich, and then removed to Cambridge, where he was arrested for debt, and thrown into prison in 1774. Though a clever man, he underwent many difficulties, and depressed by his misfortunes and trials sank into an early grave.

ROMNEY, JOHN, *engraver and draftsman.* He engraved 'Sunday Morning,—the Toilette,' after Farrier, and in 1830 'The Orphan Ballad Singer,' after Gill, also some of Smirke's illustrations to Shakespeare. He was employed on the plates of the ancient marbles in the British Museum, and published some 'Views of Ancient Buildings in Chester,' 1851. He died at Chester, February 1, 1863, aged 77.

ROOKER, EDWARD, *engraver and draftsman.* Was born in London about 1712. He was a pupil of Henry Roberts and a member of the Incorporated Society of Artists. He attained great excellence as an engraver of architecture, and his 'Section of St. Paul's Cathedral,' after a drawing by Gwynn, R.A., the figures by Wale, R.A., has very great merit. The plates for Sir William Chambers' 'Civil Architecture;' several of the plates for Stuart's 'Athens,' and Adams' 'Dioclesian's Palace at Spalatro,' are by him. Many of the headings of the Oxford Almanacks are also by him, as are four views in Italy, six views in London, and twelve views in England. He started a periodical called 'The Copper-plate Magazine,' by which he made a considerable sum of money. He etched in a bold, free style, in conjunction with Paul Sandby, a fine set of illustrations to Tasso's 'Jerusalem.' He had another talent. He played at the Drury Lane Theatre, and was esteemed the best harlequin of his time. He died November 22, 1774.

ROOKER, MICHAEL ANGELO, A.R.A., *water-colour painter and engraver.* Was the son of the foregoing, and was born in London in 1743. Intended for an engraver, he was taught by his father, and studied in the St. Martin's Lane Academy. He also received some instructions in landscape painting from Paul Sandby. In 1769 he was admitted a student of the Royal Academy, and the following year was elected an associate. He attained much excellence as an engraver, and for several years both drew and engraved the headings of the 'Oxford Almanack,' proving himself also an excellent topographical artist. His sight becoming injured, he gave up engraving,

and obtained the appointment of principal scene painter to the Haymarket Theatre, but he continued his work for the Almanack. About 1788 he began his autumn pedestrian tours, choosing the most romantic of the English counties, and made views of the picturesque ruins in Norfolk, Suffolk, Somerset, Warwick, and other places. He had from his admission as a student been a constant exhibitor of his water-colour views at the Academy, and contributed yearly up to his death. His works are drawn with conscientious accuracy, and show a sweet pencil, coupled with a fine taste and finish, which give him rank among our early water-colour painters. His animals and figures are well introduced. He was a well-read man, reserved in manner, shy to show his drawings, and being discharged from his office of scene painter, it is said to reduce the expenses of the establishment, he fell into dejection of spirits, from which he never rallied. He died March 3, 1801, and was laid in the burial-ground of St. Martin-in-the-Fields, in the Kentish Town Road. In the following month his drawings, &c., were sold by Squib, and produced 1240*l*. He contributed some of the illustrations to an edition of Sterne's works, 1772.

ROOM, HENRY, *portrait painter*. Practised chiefly in Birmingham, and enjoyed a reputation there. He was residing in Pentonville in 1826, and exhibited a portrait at the Academy, and in 1827–28 sent portraits from Birmingham for exhibition. In 1830 he came to London, and continued to exhibit his portraits, and while practising here painted 'The Interview of Queen Adelaide with the Madagascar Princes at Windsor,' and 'The Caffre Chief's Examination before the House of Commons' Committee.' Many of his portraits are engraved for the 'Evangelical Magazine.' He did not exhibit at the Academy between 1840–47, but in 1848 sent his last work. He died August 27, 1850, aged 48, and was buried in St. Giles's Churchyard.

ROOS, JOHN, *die engraver*. He succeeded Thomas East, his uncle, as one of the engravers of the Royal Mint, and held that office till the accession of George I.

ROPER, ——, *animal painter*. He was a student at the St. Martin's Lane Academy, and painted sporting pieces, race-horses, dogs, and dead game. He exhibited at the Spring Gardens' exhibition in 1761 and the succeeding years, but did not survive long after. His art powers were not more than sufficed to gratify the gentlemen of the turf and the stable.

ROSE, SUSAN PENELOPE, *miniature painter*. Was a daughter of Gibson, the dwarf, and married a jeweller. She painted in miniature with great freedom, and had several eminent sitters. She died in 1700.

368

aged 48, in Covent Garden, and was buried in the church there.

ROSE, WILLIAM S., *landscape painter*. He practised exclusively in oil, and painted chiefly the rural scenery of the home counties. He was a constant exhibitor from 1853 at the Royal Academy, and exhibited occasionally at the British Institution. To the former he sent, 1853, 'Kentish Heath Scene;' 1857, 'Road to a Farm, Bucks;' 1859, 'Clover Time;' 1863, 'A Rustic Village;' 1866, 'Rough Pastures;' 1870, 'Ashdown Forest;' and in 1873, 'Holiday on the Heath, Summer Day.' After long suffering from illness, he died at Edenbridge, May 25, 1873, in his 63rd year.

ROSENBERG, GEORGE F., *water-colour painter*. He was elected an associate of the Water-Colour Society in 1849, and exhibited from that year landscapes, chiefly mountain scenery, painted with much ability, with usually a fruit or a flower-piece. About 1862 he contributed many Norwegian scenes, and towards the end of his career some good Scotch landscapes. He introduced into his foregrounds watery pools, with their luxuriant sward and weeds. He resided at Bath, where he died September 17, 1869.

ROSLANEY, WELLS, *ornamental painter*. An ingenious designer, who practised in London. He died October 1, 1776. His widow, inconsolable for his loss, starved herself to death.

ROSS, H., *miniature painter*. His father was of a Ross-shire family, and became gardener to the Duke of Marlborough. He exhibited at the Royal Academy from 1809 portraits and portrait groups in miniature.

ROSS, Mrs. MARIA, *portrait painter*. Wife of the above. Practised in London, and also tried history. She was sister to Anker Smith, the engraver. She was an occasional exhibitor at the Academy, commencing in 1811, and contributed portraits in oil. In 1814 'The Adoration of the Shepherds.' Died in Charlotte Street, Fitzroy Square, March 20, 1836, aged 70.

• ROSS, Sir WILLIAM CHARLES, R.A., Knt., *miniature painter*. Was the son of the foregoing, and was born in London, June 3, 1794. He found, as a child, amusement in drawing, and very early evinced great ability. In his boyhood he gained several medals at the Society of Arts, and entering the Academy schools in 1808, his student career was rewarded by five silver medals. In 1809 he first appears as an exhibitor at the Academy, and then, 15 years of age only, contributed 'Mordecai Rewarded,' 'The Judgment of Solomon,' and 'Portrait of a Lady and Child in the Character of Venus and Cupid,' and for several following years, with an exceptional

portrait, his exhibited works were of a classic character. At the age of 20 he became assistant to Andrew Robertson, a distinguished miniature painter, but found time to devote to historic art. In 1821 he gained the Society of Arts' gold medal for his oil painting of 'The Judgment of Brutus,' and in 1825 he exhibited at the Royal Academy a large work in oil, the figures life-size, 'Christ Casting out the Devils from the Maniacs in the Tombs.'

But there was then little encouragement for the grand style, and whatever may have been his predilections for it, he left it to devote himself to miniature. In this he soon established a high reputation, and was surrounded by fashionable sitters. In 1837 the Queen sat to him, and pleased .both by his art and his simple manners, commissioned him to paint her husband and children. He was in the full tide of fortune; in 1838 he was elected an associate of the Royal Academy, and in the following year a full member, and received the honour of knighthood. He painted the King and Queen of the Belgians with the other members of the Saxe-Gotha family. He went to Lisbon to paint the King and Queen of Portugal, with several of their court. Prince Louis Napoleon also sat to him. His miniatures exceed 2200, and include the most distinguished of his country. His work was confined to ivory. He did not attempt enamel. His passion for history was revived by the cartoon competition in 1843, and his 'Angel Raphael Discoursing with Eve,' which he sent in anonymously, was rewarded with a premium of 100l.

In his style the influence of Reynolds was apparent. He was refined and accurate in his drawing, his composition pleasing. The colouring of his flesh excellent, and his draperies and accessories brilliantly and powerfully painted. His resemblance was faithful, the individuality and expression well maintained. Taking the first rank in his art, he lived to see it superseded by the cheap attractions of photography, and on his death-bed lamented 'that it was all up with future miniature painting.' Of amiable manners, true in his friendships, loyal in his art, he passed a peaceful, uneventful, but eminently successful life. In 1857 he suffered an attack of paralysis, from which he never entirely recovered. He died unmarried, January 20, 1860, and was buried at the Highgate Cemetery. An interesting exhibition of his works was made at the Society of Arts in the summer of the same year.

ROSS, F. W. R., *amateur.* Commenced life in the Royal Navy, in which he held the King's Commission. Later, retiring to Topsham, in Devonshire, he made drawings illustrating natural history. For this he had the advantage of scientific knowledge, and he showed great talent in his accurate and skilful finish, and also in colour. He particularly excelled in birds. He died at Topsham, December 25, 1860, aged 68.

ROSS, JAMES, *engraver and draftsman.* Practised in the latter part of the 18th century. He was a pupil of R. Hancock in 1765, and had the reputation of being the best engraver of transfer plates for pottery. There are by him some neatly executed small plates of views in the city of Hereford, after drawings by Powle. Also in illustration of Val. Green's 'City of Worcester,' where he appears to have resided, and numerous plates in a 'History of Tewkesbury.' He died at Worcester, September 16, 1821, aged 76.

ROSSI, JOHN CHARLES FELIX, R.A., *sculptor.* Was born at Nottingham, March 8, 1762. His father, a native of Sienna, practised medicine there and afterwards in Leicestershire. In this county his early years were passed, and he was then placed under an Italian sculptor in London. Upon the completion of his apprenticeship he continued with his master at wages of only 18s. a week, but afterwards found some more profitable employment in Messrs. Coade and Seeley's works. He had entered the schools of the Royal Academy, and in 1781 gained the silver medal, followed in 1784 by the gold medal for his group of 'Venus Conducting Helen to Paris;' and in 1785 was sent to Rome as the travelling student of the Academy. He had made a hard struggle to gain this position, and he made diligent use of his opportunities in Italy, and at Rome executed a Mercury, exhibited at the Academy, and a Britannia, the latter 15 feet high. He returned to London in 1788, was fortunate to obtain employment on works of high art, and was a constant contributor to the Academy exhibitions. In 1798 he was elected an associate of the Academy, and a full member in 1802. His chief works were the memorials in St. Paul's Cathedral, commemorating the heroes of the war; of these, the most important are to the Marquis Cornwallis, Lord Heathfield, and Lord Rodney, and later he was employed in the decoration of Buckingham Palace, and was appointed by George IV. his sculptor in ordinary. He also received several commissions from Lord Egremont. But he made no provision for his latter days, and became a pensioner of the Academy. He died at St. John's Wood, February 21, 1839, in his 77th year, and was buried in St. James's Church, Hampstead Road.

ROSSI, HENRY, *sculptor.* He was one of the foundation members of the Society of British Artists, and exhibited with them in 1824, 'An Equestrian Group of the Duke of Wellington;' and in 1837, 'The Sportsman,'

Rossetti Dante Gabriel—b.18

a sketch for a monument. The terra-cotta ornaments for the interior of St. Pancras' new church are designed by him. His name is omitted from the list of members of the Society in 1844.

ROTH, WILLIAM, *portrait painter.* Practised both in oil and miniature. He exhibited at the Chartered Society in 1768, and about 1770 was at Reading, and painted several portraits there and in the neighbourhood. He died soon after.

ROTHWELL, RICHARD, R.H.A., *portrait painter.* He was born at Athlone in 1800, and in 1815 commenced his studies in Dublin, and practising there, was early elected a member of the Irish Academy. He afterwards came to London, and was employed in the studio of Sir Thomas Lawrence, whose manner he imitated. His early portraits were of much promise. He first exhibited at the Royal Academy in 1830, and again in 1831 and 1832, numbering among his sitters the Duchess of Kent, and other persons of distinction. He then travelled on the Continent, and does not appear again as an exhibitor till 1835, when, with some portraits, he sent a 'Serenade,' and 'Kate Kearney.' From this time he was a yearly exhibitor of his portraits, with an occasional subject picture, up to 1847; but he was unable to maintain the opinion which his first works gained him. In 1848, he went for a time to Dublin, and from thence sent a picture to the exhibition, and for the next two years exhibited without giving his address, but appears to have returned to London. In 1858, he was residing in Leamington, and sent from thence in that year to the exhibition, 'A Remembrance of the Carnival;' and in 1862, 'The Student's Aspiration,' his last exhibited work. He was disappointed and discouraged, and went over to Paris, where he settled in the practice of his profession, and was almost lost sight of. He died at Rome in September, 1868.

ROTHWELL, THOMAS, *engraver.* He was of good repute in his profession. He died at Birmingham, January 16, 1807, aged 65.

ROUBILIAC, LOUIS FRANÇOIS, *sculptor.* Was born in Lyons in 1703; some accounts give an earlier date. He received a fair general education, and was the pupil of Balthazar at Dresden. He is said to have come to England in 1720, but Dussieux, in his 'Artistes Français à l'Etranger,' says he could not have come here in that year, as he was in France in 1730, and gained the second grand medal in sculpture, though the two statements are not absolutely inconsistent. His principal works were, however, executed in England. He was first employed in this country by Thomas Carter, and we are told that he picked up a pocket-book containing a

large sum of money, which introduced him to the owner, Sir Edward Walpole, by whose assistance he obtained better employment under Henry Cheere, and was afterwards enabled to set up for himself in St. Martin's Lane.

He was chiefly employed in monumental works, and some of his best will be found in Westminster Abbey. That to the Duke of Argyll is a fine example—the figure of 'Eloquence,' part of the group, has been much praised, both by Bacon, R.A., and Canova, who deemed it the finest piece of modern art he had seen in this country. Mrs. Nightingale's monument has also been highly esteemed, as well as Sir Isaac Newton's and Handel's; and the monument of the Duke and Duchess of Montagu at Boughton ranks among his finest works. There is also at the British Museum, a noble statue of Shakespeare, executed by him for Garrick; and at the Senate House, Cambridge, statues of George I. and Charles, Duke of Somerset. His art was of a decorative and ornamental character, his finish elaborately careful. Flaxman, R.A., whose own severe art would not lead to an appreciation of Roubiliac's, admitted that he possessed considerable talents; but spoke depreciatingly of him, saying 'his thoughts were conceits, and his compositions epigrams.'

He paid a short visit to Italy in company with Arthur Pond, and stayed only three days in Rome, where he laughed at all the remains of ancient sculpture. Bernini was his model. He was a great enthusiast, and did not lack conceit. Gayfere, the abbey mason, found him one day with folded arms, his eyes fixed upon one of his figures on which he was at work, and, as he approached, the artist said in a whisper, 'Hush, hush! he vill speake presently.' He died from the effects of unskilful bleeding, January 11, 1762, and was buried in the French church, St. Martin's-le-Grand. His funeral was attended by Reynolds and Hogarth. He was so seriously in debt, notwithstanding the large patronage he had enjoyed, that his effects only paid 1s. 6d. in the pound.

ROUQUET, JEAN, *enamel painter.* Born in Geneva, of French extraction. Came to England in the reign of George II., and practised his art in London for nearly 30 years. He imitated Zincke with some success, and was the companion of Hogarth, Garrick, Foote, and the wits of the day. He published in Paris, in 1755, 'L'Etat des Arts en Angleterre,' a work highly laudatory, of which a translation was afterwards published in London. He had returned to Paris, and died there in 1758.

ROUSSEAU, JAMES, *landscape painter.* Was born in Paris, 1626, and was a pupil

of Swanevelt. He went early to Rome, and painted some fine views in the suburbs of that city. He excelled in landscape, introducing classic architecture with great skill. On his return to Paris he was employed by Louis XIV., and was elected a member of the French Academy. He was at the height of his reputation, when on the revocation of the Edict of Nantes, he left Paris to avoid persecution as a Protestant, and took refuge in Holland, from whence he came to England. Here he found employment. He was engaged in the decoration of Montague House; and painted several landscapes and perspective views for Hampton Court Palace. He etched some spirited compositions of landscape with architecture and figures. He could only have practised in England a short time, and died in London in 1694.

ROUW, PETER, *gem engraver and modeller.* From 1795 to 1840 he exhibited his works at the Royal Academy Exhibitions. In 1819 he was appointed ' modeller of gems and cameos to the Prince Regent,' and from that time he called his works ' medallic portraits,' for which he gained a very high reputation, and had the most distinguished sitters — among them the Princess Charlotte. He died at Pentonville, December 9, 1852, aged 81. His father, PETER ROUW, practised the same art, and was an exhibitor at the Academy up to 1777.

ROWBOTHAM, THOMAS LEESON, *water-colour painter.* Was born in Dublin, May 21, 1823, and was the son of Thomas L. Rowbotham of Bath, also an artist. Till twelve years of age he lived at Bristol, where he met many painters who then resided in that city. He studied his profession under his father, and in 1847 made a sketching tour in Wales, followed in the succeeding years by visits to Scotland, Germany, Normandy, and Italy. He was gradually led by his love for sunny effects to paint only marine subjects under Italian skies. He succeeded his father as drawing-master to the Royal Naval School, New Cross, and in 1858 was elected a member of the Institute of Painters in Water-Colours. He was a good musician. His health was never very strong, and he died at Kensington, June 30, 1875, aged 52.

ROWE, EDWARD, *glass-painter.* He did not attain any excellence, and little more than the record of his name can be traced. He died in the Old Bailey, April 2, 1763.

ROWELL, JOHN, *glass-painter.* Was born at High Wycombe, and was originally a plumber at Reading. He was employed to paint some glass for the Earl of Pembroke, the Bishop of Worcester, and for the Duke of Richmond, at Goodwood. The windows of Hambledon Church, Bucks,

are by him. He is said to have succeeded William Price in the art, but it is not stated by whom he was instructed. He painted one or two scripture subjects, but he was chiefly employed upon coats of arms. His processes were uncertain, his glass was imperfectly burnt, and some of his colours fail—but he is known to have discovered a fine red, of which the secret was lost with him. He died at Reading, September 2, 1756.

ROWLANDSON, THOMAS, *caricaturist.* Was born in the Old Jewry, the son of a respectable tradesman, in July, 1756. His talent for drawing was exhibited on the margins of his school books, and he became early in boyhood a student of the Royal Academy. At the age of 16 he was sent to Paris, where he studied drawing for two years, and then, on his return, resumed his place in the Academy schools. He gained a good knowledge of the figure, and combined a rapid power of drawing with much finish. He was thrown upon his own resources before he had attained manhood by the pecuniary embarrassments of his father; but he was liberally assisted by his aunt, a French lady who had married his uncle, to whose indulgence may be attributed some of the careless habits of his early life.

He was fitted, both by his talent and his art education, to have filled a place in the higher ranks of art, and could draw with elegance and grace. In 1775 he exhibited at the Academy, ' Delilah visits Samson in Prison,' and afterwards some portraits; but he was careless and idle, and, receiving 7000*l.*, with other valuable property, under the will of his aunt, he gave himself up to gaming, and soon dissipated above half his fortune. He was known in most of the London gaming-houses, and on one occasion sat uninterruptedly at the gaming-table for 36 hours. Such habits were inconsistent with any studied attempts, and he fell back upon his early talent for caricature, where the execution may be as rapid as the idea. In this manner his works are numerous, drawn chiefly with the reed pen, and slightly tinted, they are full of humour, excelling in a most humorous fancy, rarely political, but touching the manners of society—not always free from vulgarity, nor from too broad a treatment. Too thoughtless to seek employment, he was supplied with subjects by Mr. Ackermann, the publisher, for whom he illustrated the well-known ' Dr. Syntax in Search of the Picturesque,' and ' The Dance of Death ' and ' Dance of Life,' works by which he will be remembered. In the former of these, his designs, contributed from month to month, suggested the subject, and Mr. Combe, without knowing the artist, wrote his humorous poem to them. By his

[See. Gyles].

companions he was dubbed 'Master Rowley,' and though careless of his reputation, he was scrupulously honourable, and his word was always good in all his transactions. He died at his apartments in the Adelphi, after two years' illness, April 22, 1827.

ROWLETT, THOMAS, *draftsman.* Practised in London, about the middle of the 18th century, both as a draftsman and etcher, chiefly in portraiture. There is a portrait of Dobson, the painter, etched by him.

RUBENSTEIN, ——, *drapery and portrait painter.* Born in Germany. He came to England, early in life, and found employment chiefly in the drudgery of drapery painting, but he occasionally painted still-life and portraits. He was a member of the St. Martin's Lane Academy. Died in London about 1763.

• RUNCIMAN, ALEXANDER, *history painter.* Was born in 1736, in Edinburgh, where his father was a builder, and was apprenticed to a coach-painter, under whom he acquired some knowledge of colours. He studied for a time in Foulis's Academy at Glasgow, and is said to have been the pupil of an eminent landscape painter, under whom he made much progress. About 1766 he managed, with his brother, to travel to Rome, where he studied during five years, and painted his large picture, 'Nausicaa at Play with her Maidens,' and sent home, in 1767, a picture which he exhibited that year with the Free Society of Artists. On his return he lodged, in 1772, in Leicester Square, and was an exhibitor at the Royal Academy. In 1773 he settled in Edinburgh, and was fortunate in being appointed the manager to the Trustees' Academy, with a salary of 120*l.* a-year, which gave him the means of applying himself to ambitious works. He decorated the great hall of Pennicuik with a series of subjects from Ossian, and painted several easel pictures, 'The Prodigal Son,' 'Cymon and Iphigenia,' and 'Sigismunda Weeping over the Heart of Tancred,' reputed his best work. An altar-piece for the Episcopal Chapel at the Cowgate, Edinburgh, was his last completed work. He etched several plates in a loose sketchy manner. On October 21, 1785, he fell down in the street, and died suddenly.

• RUNCIMAN, JOHN, *historical painter.* Was brother of the foregoing, born at Edinburgh in 1744, and an artist of much promise. He went with his brother to Rome and died at Naples, where he had gone for the recovery of his health, in 1766. Among his works are 'Judith and Holofernes,' 'Christ and the Disciples at Emmaus,' 'King Lear in the Storm.' He was of much promise, and the Scottish Academy erected a monument to him and his brother at the Canongate Church, Edinburgh.

Barry, R.A., spoke highly of him. A clever picture by him was exhibited at the International Exhibition, 1862. He etched some of his works, and some others are engraved.

RUPERT, The Prince, *amateur.* Was born in 1619, the third son of the Prince Palatine of the Rhine and the Princess Elizabeth, and consequently nephew of Charles I., on whose side he fought during the civil war, but with more courage than prudence. On the termination of the war he retired to Paris, where he sought amusement in the pursuit of art. While in England he was Governor of Windsor Castle, and principally resided in that fortress. He was a mathematician and a chemist, but it is as a mezzo-tintist he finds a place here. He has been credited with the invention of this charming art. He certainly learned the secret early, practised it, and introduced it to the artists of this country by whom it was first employed. There are several known plates by him, some of them marked with his initials and a crown, and some fine impressions, which show considerable art-merit, in the print-room of the British Museum. He also produced some etchings. He died, unmarried, in 1682, having completed his 63rd year.

RUSSEL, THEODORE, *portrait painter.* Was the son of a jeweller at Bruges, and was born in 1614. He was the nephew of Cornelius Jansen, with whom he lived several years, and afterwards with Vandyck, whose pictures he copied, small size. He was much employed in the families of the Earls of Essex and Holland. Some of his works are in the Royal collections. Small whole-lengths by him of Charles II. and James II., removed from Hampton Court, are at Holyrood Palace. They are well drawn, and vigorously painted, but the flesh is black and disagreeable in colour, and the draperies crude.

RUSSEL, ANTONY, *portrait painter.* Son of the foregoing. Said to have been a pupil of Riley, whose manner he imitated, but without much success. Both Vertue and J. Smith engraved after him, the latter his portrait of Dr. Sacheverell. He died in July, 1743, aged above four score years.

RUSSELL, JOHN, R.A., *portrait painter.* Born at Guildford, where his father was a bookseller, in April, 1744. The Society of Arts awarded him a premium in 1759, and he was afterwards pupil of Cotes, R.A., and a student at the St. Martin's Lane Academy. He practised in crayons, but occasionally in oil, and produced some excellent crayon portraits. His early works in crayon were in the manner of his master, but he attained more power, both in colour and effect. His groups are pleasing, well drawn, and the expression natural. In 1768 he first ex-

ubens . Peter . Paul 1577-1640

hibited at the Spring Gardens' Rooms. He greatly excelled in his art, and invented a method of preparing his crayons. Of this process he gave an account, with some valuable instructions, in his 'Elements of Painting with Crayons,' published in 1776. He painted a variety of subjects, and tried history in crayons. Fond of astronomical studies, he invented an apparatus for exhibiting the moon's phenomena, which he patented in 1797. He was elected an associate of the Royal Academy in 1772, and an academician in 1788, and held the appointment of portrait painter in crayons to George III. and to the Prince of Wales. He was a constant and large contributor to the Academy exhibitions, sending between 1789-93 on an average 16 works yearly, comprising portrait groups, conversation pieces, and portraits in character. He visited some of the provincial towns in the pursuit of his profession, and died of typhus fever, in his lodgings at Hull, April 20, 1806, and was buried at Trinity Church in that town. A large number of his portraits are engraved. His crayon portraits are excellent—powerful, brilliant in colour, well grouped and expressed.

RUSSELL, WILLIAM, *portrait painter.* Son of the foregoing. Practised in London. Painted also some genre subjects. He exhibited portraits at the Academy from 1805-1809, after which year his name no longer appears in the catalogue.

RYALL, HENRY THOMAS, *engraver.* Was born at Frome in August, 1811, and was a pupil of S. Reynolds. He made himself known by his works for Lodge's portraits, and was then employed upon some miniatures of the Royal family after Sir William Ross. He also engraved Hayter's 'Coronation of Queen Victoria,' Leslie's 'Christening of the Princess Royal,' and after Wilkie, Landseer, Ansdell, Rosa Bonheur. He held the appointment of historical engraver to the Queen. His manner possessed some originality. He employed a mixture of stipple and line with good effect, and was correct in his drawing and finish. He died at Cookham, Berks, September 14, 1867.

RYDER, THOMAS, *engraver and draftsman.* Born 1746, was a pupil of Basire, and one of the earliest students at the Royal Academy. He was intended for a painter, but took to engraving, and was one of the best engravers of his time. He worked in the dot manner after Opie, West, Shelley, Kauffman, and executed eight of the large plates in the Shakespeare Gallery for Alderman Boydell, which are his best works. Many of his plates are printed in brown, some in colours. He died 1810. His son of the same name also practised as an engraver.

RYLAND, EDWARD, *engraver,* but worked chiefly as a copper-plate printer. He was born in Wales, and coming to London, settled in the Old Bailey, and died there July 26, 1771.

RYLAND, WILLIAM WYNNE, *engraver.* Was born in London in July, 1738, the son of the foregoing, and named after his godfather, Sir Watkin Williams Wynne. He was, about 1752, apprenticed for seven years to Ravenet, then living in Lambeth, and showed great application and ability. On the completion of his apprenticeship, about 1760, he set out to visit the French and Italian schools, in company with Gabriel Smith, and remained on the Continent for several years, improving himself with great assiduity. In Paris he gained a gold medal in the French Academy, and at Rome was received with much consideration. On the accession of George III. he was still abroad, and on his return, soon after, he was, on the refusal of Strange, employed to engrave the fine portraits of the King and Lord Bute, by Ramsay, and the Queen, after Cotes, R.A. These works are examples of a finished style of engraving, the lines shewing great taste, the quality of the lace, fur, and other textures well expressed. They gained him the appointment of engraver to his Majesty, with a salary of 200*l.* a-year, and at once made him a reputation. He also engraved, in the same style, some fine plates after the old masters, and after Angelica Kauffman. In 1766 he was a member of the Incorporated Society of Artists, and exhibited with them in 1767. From 1772 to 1775 he also exhibited at the Royal Academy, his contributions consisting of some drawings after Angelica Kauffman, with small portraits.

In his later manner he adopted the imitation of chalk drawings, which lent itself to a cheaper class of art, and was suitable for colouring and to print with tints, and when combined with line and etching has produced some fine and artistic effects, though it proved eventually injurious to the engraver's art. He afterwards entered into a partnership in a print-shop in Cornhill, and traded largely in engravings, but he formed an illicit connexion with a young female, who involved him in large expenses. He was extravagant, became bankrupt, and had contracted a habit of gaming. He then took on his own account a shop in the Strand, which, though promising success, he gave up, retired to Pimlico, and afterwards removed to Knightsbridge.

While living here he was charged with the forgery of two bills on the East India Company for 7114*l.*, which, with other genuine bills, he deposited with his bankers for an advance of 3000*l.* On the discovery of the forgery, which was most ingeniously executed, and the offer of a large reward

for his apprehension, he fled from justice, and took a poor lodging in Stepney under an assumed name. Here he was discovered by his name in a shoe which he had sent to a cobbler to be mended. Arrested, he attempted suicide by cutting his throat, and taken to Bow Street, he was committed for trial in July, 1783, and after a long investigation, was convicted at the Old Bailey of uttering the forged bills, and sentenced to death. Unavailing efforts were made to save him. He was hanged at Tyburn, August 29 following, the execution being delayed for some time by a violent thunder storm, and was buried at Feltham, Middlesex. In his defence he pleaded that his circumstances placed him above the imputation ; that, in addition to his salary from the King, his business was every year producing him 2000*l.*, and his stock-in-trade was worth 10,000*l.* He died declaring his innocence. He left a widow, for whom, with her six children, a subscription was raised, and she kept a print-shop for many years at the corner of Oxford Street and Berners Street. One of his daughters became a teacher of drawing, and it is said the Princess Elizabeth was one of her pupils.

His works are numerous. He published, in the dot manner, above 200 plates, many of them only small in size, but excelling in their delicate finish and excellent texture. Some of them, printed in coloured inks, have great merit. His works in the line manner, from their great artistic qualities, place him high in the ranks of his profession. A short authentic memoir of him was published in 1784. His brother was, in 1782, convicted of highway robbery, and only reprieved on the morning fixed for his execution.

RYLEY, CHARLES REUBEN, *history painter.* Was born in London about 1752, the son of a private in the Life Guards. He was fond of art. First tried engraving, and received a premium in 1767 from the Society of Arts. Afterwards became a pupil of Mortimer, and in 1778 gained the Royal Academy gold medal for his painting of 'The Sacrifice of Iphigenia.' From 1780, till his death, he was a constant exhibitor at the Academy, but his works were chiefly drawings and sketches, not having any high aim, or giving proof of any sustained effort. He was employed by the Duke of Richmond in the decoration of Goodwood, and was afterwards engaged in the decoration of several other mansions, but he found his chief employment in designing for book illustration and as a teacher of drawing. In early life he was of a Methodistical turn, but he became of irregular and debauched habits, which shortened his life. He died in the New Road, Marylebone, October 1, 1798.

* RYSBRACK, JOHN MICHAEL, *sculptor.* He was born at Antwerp, where his father practised as a landscape painter, June 24, 1693, and studied there under an eminent sculptor. He came to England in 1720. He showed much ability in modelling small figures in clay, and soon found employment on portrait busts, and afterwards was engaged in monumental works of a larger class. For some time he was employed by the architects Gibbs and Kent, but as they shared the profits, he soon abandoned dependence upon them, and for many years some of the most important works were entrusted to him. At Westminster Abbey the monuments of the Duke of Newcastle, Earl Stanhope, Sir Godfrey Kneller, and Mrs. Oldfield, the latter after Kent's design, are by him. Bishop Hough's monument at Worcester, and the bronze equestrian statue of William III. at Bristol, must also be classed among his best works. His principal busts are of Pope, Gibbs, Sir Robert Walpole, the Duke and Duchess of Argyle, the Duchess of Marlborough, Lord Bolingbroke. He retired from his business in January 1766, and sold his models, casts, &c., by auction. He had resided many years in Vere Street, Oxford Street, and died there January 8, 1770. He was buried in Marylebone churchyard. He made a great number of highly finished drawings from historical subjects, as well as designs for sculpture, some of which will be met with in good collections. He was simple in his monumental works, happy in the action of his principal figures, but without much invention. Fuseli says hardly of him, 'He was a mere workman ; too insipid to give pleasure, too dull to offend greatly.'

RYTHER, AUGUSTINE, *engraver.* Practised in London about the close of the 16th century, He engraved the plans of the Spanish Invasion, with cuts of the several exploits and conflicts with the Spanish Fleets, 1590. He also assisted Saxton upon his maps of Yorkshire, which are embellished by views in the margins.

S

SADLER, THOMAS, *portrait and miniature painter.* He was the son of a master in Chancery, who was greatly esteemed by Cromwell, and was educated for the law, but acquired a love of art from his intimacy with Sir P. Lely, and received some instructions from him. He first applied himself as an amateur, and then, reduced by misfortunes, he followed art as his profession, and practised in the reign of Charles II., and up to the time of William III. His heads are well drawn and expressed, not so his hands, simple in colour and low in tone. One of his best works, a portrait of Bunyan, is engraved in mezzo-tint; a good miniature of the Duke of Monmouth by him is also mentioned.

SADLER, WILLIAM, *portrait painter.* Was born in England, the son of a musician, but studied his art in Dublin, and practised there both in oil and miniature, and was an artist of some ability. He also scraped some mezzo-tint portraits. He died in Dublin about the end of the 18th century.

SAILMAKER, ISAAC, *marine painter.* Born 1633, it is said, in England. He was a pupil of George Geldorp, and was much in favour with Cromwell, who employed him to paint the fleet before Mardyke. There is an engraving, dated 1714, of a painting by him of the Confederate fleet under Sir George Rooke engaging the French fleet. He died June 28, 1721.

ST. AUBYN, Miss CATHERINE, *amateur.* There are several etchings by her. 'A young Woman reading,' a copy after Bartolozzi, 1788; 'Dorothy Pentreath,' after Opie, R.A.; 1789; 'Pevensey Castle,' two views, 1797–98. Two drawings by her of St. Michael's Mount are engraved.

SALMON, Mrs., *portrait painter.* She was an English artist, and enjoyed great reputation about 1700-15 for her clever portraits modelled in wax. She also attempted some historical designs in the same material. Her art was continued by her descendants.

SALT, HENRY, *draftsman and traveller.* Was born at Lichfield about 1785, and educated in classics and mathematics at the Grammar School there. He then came to London and commenced the study of art, and in 1802, accompanied Lord Valentia (afterwards Earl Montnorris) to India as draftsman, and after a residence of four years with him in the East, which he traversed from north to south, also visiting Ceylon, he furnished the illustrations for his lordship's 'Travels' published 1809. He was afterwards employed by the Government to carry presents to the King of Abyssinia, and negotiate an alliance with him. On his return in 1809 he published 24 views taken in India, the Red Sea, Abyssinia, and in 1814 the narrative of a second journey to Abyssinia. In 1815 he received the appointment of Consul-General for Egypt, and devoted himself to the study of its antiquities, assisting with all his influence the researches of learned travellers, and particularly of Belzoni. He published in 1814, an 'Account of a Voyage to Abyssinia,' and travels in the interior of that country, in 1809-10; 'Egypt,' a descriptive poem with notes, 1824; 'Essay on Young's and Champollion's Phonetic System of Hieroglyphics,' 1825. His 'Life and Correspondence' was published in 1854. He died on the route from Cairo to Alexandria, August 30, 1827.

SALTER, WILLIAM, *historical and portrait painter.* Was born in 1804, at Honiton in Devonshire. He came to London in 1822, and was a pupil of Northcote for five years. He then went to Florence, where he painted a picture of 'Socrates before the Judges of the Court of Areopagus,' which he exhibited at the Belle Arti; this work gained him great reputation, and he was elected a member of the Academy of Fine Arts at Florence, and a professor of the first-class of history. After remaining in that city for five years, he went to Rome, and subsequently to Parma, where he distinguished himself by his studies from Correggio, and where he was elected a member of the Academy. Returning to England in 1833, he painted a remarkable picture of the annual banquet given by the Duke of Wellington at Apsley House, in commemoration of the Battle of Waterloo, which picture is now in the possession of G. Mackenzie, Esq. He also painted scenes from Shakespeare, and historical events from the lives of the Stuarts. He was a member and Vice-president of the Society of British Artists, and he but rarely exhibited at the Royal Academy. He died in London at West Kensington, December 22, 1875.

SALWAY, N., *engraver.* Practised in mezzo-tint, chiefly portraits. His works are dated about the middle of the 18th century.

SAMUEL, RICHARD, *portrait painter.* He was twice adjudged the gold medal of the Society of Arts for the best original historical drawing, and was a frequent exhibitor at the Royal Academy from 1772 to

375

1779, contributing small whole-lengths, conversation pieces, and portrait heads, with occasionally a subject piece. There is an engraving after him of the 'Nine living Muses of Great Britain'—Mrs. Sheridan, Mrs. Montague, Angelica Kauffman, &c., but it is only a poor affected work. In 1773 the Society of Arts awarded him a premium for an improvement in laying mezzo-tint grounds. He published, in 1786, a short pamphlet 'On the Utility of Drawing and Painting.'

SAMUEL, GEORGE, *landscape painter.* He practised both in oil and water-colours, chiefly the latter. A clever view of the Thames by him, from Rotherhithe Stairs during the frost of 1789, the shipping frozen in and surrounded by groups of figures, was much praised at the time. He made drawings for the illustration of 'Grove Hill,' a poem, published in 1799; and at the beginning of the 19th century had already gained a reputation, and his landscapes were much esteemed. He was a good draftsman and skilful painter. From 1786 to 1823 he was an exhibitor at the Royal Academy, and also exhibited at the British Institution. Soon after the last date he was killed by an old wall falling upon him while he was sketching. F. Jukes engraved after him two views of Windsor.

SANDARS, G., *portrait painter.* Practised in the reign of George II.

SANDARS, THOMAS, *engraver.* Was the son of a painter at Rotterdam, where he was born. He came to London, was a member of the St. Martin's Lane Academy, and exhibited up to 1775. He etched the 'Italian Fisherman,' after Joseph Vernet, and drew and engraved 15 views of market towns in the county of Worcester, 1777–81. He was also a teacher of drawing.

• SANDBY, PAUL, R.A., *water-colour draftsman.* Was descended from an old county family, and was born at Nottingham in 1725. In that town he and his brother, clever young men, kept a school, and, by the help of their borough member, in 1741 gained employment in the military drawing office at the Tower. In 1746, when, on grounds of military policy, it was determined to improve the roads in the Highlands of Scotland, the scene of the memorable campaign of 1745–46, he was engaged as draftsman to the Survey, and made many sketches of the grand scenery which surrounded him. But, tired of the employment, he quitted it in 1752, and went to live with his brother Thomas at Windsor, and in the picturesque architecture of the castle and at Eton he found many subjects for his pencil, completing about 70 drawings. Many of these were purchased by Sir Joseph Banks, and making his acquaintance, he accompanied him to Wales, and drew the chief castles and resi-

dences in the Principality and was then induced by Sir Watkin W. Wynne to continue his stay and his labours.

He was a member of the St. Martin's Lane Academy, and one of those who in 1753 wished to extend and give permanence to art teaching; but the plan was opposed by Hogarth, and the prints which were then published to ridicule 'The Line of Beauty' were attributed to him. He also caricatured Vestris, in the costume of the day, teaching a goose to dance. He contributed largely to the Artists' Exhibitions from 1760 to 1764, was a member of the Incorporated Society of Artists, and, on the institution of the Royal Academy in 1768, was nominated one of the original members. The same year he was appointed the chief drawing-master at the Woolwich Military School, and was also known as a fashionable teacher. He possessed indefatigable industry, and was a constant contributor of his water-colour views to the Royal Academy exhibitions. He published a folio of etchings from the sketches he made when engaged upon the survey in Scotland, and became distinguished in the art, etching with great neatness, skill, and truth. He aqua-tinted and published his Welsh sketches, and was the first English artist who attempted this style of engraving, in which he showed great ability and brought to much perfection in his later publication of 'Views in the Encampments in the Parks,' 1780.

He has been styled the father of the water-colour school. He was certainly among the first who practised in this medium; but his landscapes did not get beyond topography and the mere tinted imitation of nature. His best works are carefully drawn in with the pen, worked up with washes, and finished with colour. Some of his larger works are in body-colour. He introduced freely into his landscape groups of figures by no means ill-drawn, and adding great interest, but he was frequently assisted by others—his brother Thomas and Wheatley, R.A., are mentioned. He was a master of perspective, and drew architecture well, and his views of cities, with their grouped buildings, are gracefully and truthfully executed. Earnest in all that interested his profession, his name is inseparably connected with the art and artists of his day. Age creeping on, he resigned his appointment at Woolwich in 1799, and was succeeded by his son. He died November 9, 1809, in his 84th year, at 4, St. George's Row, Bayswater Road, and was laid in the burial-ground adjoining.

SANDBY, THOMAS, R.A., *architect.* Was brother to the above, and born in Nottingham, 1721. Like his brother, he was employed in the military branch, and was appointed draftsman to the Chief

Engineer in Scotland. He was at Fort William when the Pretender landed in 1745, and was the first to convey intelligence to the Government. This service, added to his professional skill, led to his appointment as draftsman to the Duke of Cumberland, and he followed the Duke in his Flanders campaigns. In 1746 he was made Deputy-Ranger of Windsor Great Park, and planned the large lake known as Virginia Water. He published eight drawings, illustrating his alterations and improvements in the Park. He was one of the committee to found a Royal Academy in 1755, a member of the Incorporated Society 1766, and was nominated one of the members of the Royal Academy established in 1768, and the first Professor of Architecture, and contributed architectural views to the early exhibitions at the Academy. He built the Freemasons' Tavern and Hall in 1775, and designed some of the oak carvings in St. George's Chapel. He held the office of Deputy-Ranger above 50 years, died in the Ranger's House June 25, 1798, and was buried at Old Windsor. He was a clever draftsman, possessing more spirit and artistic feeling than his brother. Many of his drawings are in the Royal Collection at Windsor, and some are possessed by the Soane Museum and the British Museum. His collection of drawings was sold by auction at Sotheby's, in 1799.

SANDERS, JOHN, *portrait painter.* Practised in London, and first appears as an exhibitor at the Academy in 1771, contributing portraits in oil, and subject pictures. He continued to exhibit, sending with portraits a 'St. Sebastian,' in 1772; 'A Jael and Sisera,' in 1773, and later exhibited crayon and water-colour drawings.

SANDERS, JOHN, *portrait painter.* Lived at the same address, and probably the son of the above. Practised the same class of art. He was an exhibitor for the first time at the Royal Academy in 1775, and then sent two small crayon portraits with 'A Foundling Girl,' and 'Jacob and the Angel.' In 1778 he removed to Norwich, and afterwards returned to London, continuing to exhibit occasionally till about 1820.

SANDERS, JOHN, *engraver and draftsman.* Was born in London, about 1750, and formed his art under the influence of Bartolozzi. But he did not work exclusively in that manner, as he produced some plates both in mezzo-tint and in aqua-tint. He went to St. Petersburg, made sketches of the collection of pictures in the 'Hermitage,' and was appointed engraver to the Emperor. He afterwards published his works under the title of 'Galerie de l'Hermitage.' Delatre en-graved after him 'May-day, or the Happy Lovers,' and P. W. Tomkins 'Sir John Falstaff.'

SANDERS, JOHN, *architect.* He was a pupil of Sir John Soane, and a student of the Royal Academy. He contributed designs to the exhibition of 1786–87; and in 1788 gained the Academy gold medal for his design for a church. He held the appointment of architect to the Barrack Department in 1805. He designed the Royal Military Asylum at Chelsea, commenced in 1801, and about 1811, the Royal Military College, built at Bagshot. He continued an occasional exhibitor of his architectural designs at the Academy up to 1821.

SANDERSON, JOHN, *architect.* Practised in London, towards the middle of the 18th century. He built the mansion at Kirtlington Park, Oxfordshire, a good Ionic work, and the Duke of Bedford's seat at Stratton Park, Hants. His designs are engraved in Woolfe and Gandon's work. He is mentioned as the friend of Hogarth.

SANGSTER, SAMUEL, *engraver.* He was a pupil of W. Finden, and was well reputed, practising in the line manner. He was much employed upon the Annuals, and also upon the illustrations for the 'Art Journal.' The 'Gentle Student' and 'The Forsaken,' by Newton, R.A., are good examples of his art. He had for some time retired from practice, and died June 24, 1872, in his 68th year.

SARTORIUS, FRANCIS, *animal painter.* He practised in London during the latter part of the 18th century, and was esteemed for his portraits of horses, to which his art, though he painted some hunting subjects, was almost exclusively confined. He was an exhibitor, both with the Free Society of Artists and the Incorporated Society, from 1772 to 1780, and from 1775 to 1790 at the Royal Academy. He died about 1806. Several of his works have been engraved in mezzo-tint, and some are at Saltram House.

SARTORIUS, JOHN N., *animal painter.* Son of the above. He exhibited works of the same character at the Royal Academy, from 1778 to 1824. Some racing subjects by him are engraved.

● SASS, HENRY, *portrait painter and teacher.* Born in London, April 24, 1788, the son of an artist of no distinction. He studied in the Schools of the Royal Academy, and in 1808 exhibited his first work, 'The Descent of Ulysses into Hell,' followed by portraits and an occasional historical attempt. In 1816 he visited Rome and the chief seats of art in Italy; and exhibited, in 1817, 'Infancy, one of a series to illustrate the Seven Ages of Woman,' which proceeded no further. He

was never able to obtain any notice as an artist, and devoted himself to elementary art teaching preparatory to the Academy Schools, in which he was very successful, many of his pupils becoming distinguished. He did not meanwhile cease to exhibit, and between 1820 and 1838 many portraits by him found a place on the walls of the Academy. He had retired from his school for some time owing to a protracted illness, and died June 21, 1844. He published his 'Journey to Rome and Naples,' and 'The Arts of Painting and Sculpture in England.'

SASSE, RICHARD, *water-colour painter.* Was born in 1774. He was cousin to the above, but added the final *e* to his name. He first exhibited at the Academy in 1791, and continued a large contributor up to 1813. His subjects were landscape, introducing cattle and figures, with occasionally a waterfall, a favourite subject with him. In his practice he attempted to use more colour than the 'tinters' of his day. In 1811 he was appointed teacher to the Princess Charlotte, and afterwards landscape painter to the Prince Regent. On the termination of the War in 1815, he travelled on the Continent, and in 1825 he settled in Paris, where he died, September 7, 1849. He was much patronised, but never attained excellence. His works, though clever and effective in colour, want decision and character. He tried many manners without succeeding in forming one of his own. There are examples of his art in the collection at South Kensington. He published a series of etched sketches from nature in 1810.

SAUNDERS, GEORGE L., *miniature painter.* Was born at Kinghorn, Fifeshire, 1774, and was educated in Edinburgh. He showed a great aptitude for drawing, and was apprenticed to a coach-maker, a man of considerable taste. On leaving him he practised in Edinburgh, principally in painting miniatures, and as a teacher of drawing. He also, early in his career, painted a panorama of the city from the guard-ship in Leith Roads. He was induced by his success, and the advice of his friends, to come to London in 1807, and at once took a distinguished position as a miniature painter, the Princess Charlotte being among his first sitters. About 1812 he tried life-sized portraits in oil, which were for some time commissioned at large prices, but his art friends were more appreciative of his miniatures, and he was piqued and estranged from the general body of the profession. He very rarely exhibited at the Royal Academy; but in 1829 he contributed three miniatures; in 1830, Prince Esterhazy, and some others; in 1831, the Duke of Cumberland and Prince George. He did not then exhibit
378

again till 1838, when he sent Lady Clementina Villiers; and in 1839, his last contribution, the Marchioness of Downshire. He had many distinguished sitters; among them, Lord Byron, whom he painted several times. One of his portraits, 'Lord Byron standing beside his boat,' was engraved by Finden, 1831, and is well known. He died in Marylebone, March 26, 1848.

SAUNDERS, GEORGE, F.R.S., *architect.* Practised in London, and in 1780 built the stone *façade* to the theatre at Birmingham. Was some time architect of the British Museum, and built the Townley Gallery. He held the appointment of Surveyor to the Commissioners of Sewers. He was distinguished as an antiquary, and was the author of 'A Treatise on Theatres,' published 1790, and of 'Observations on the Origin of Gothic Architecture.' He died in 1839, aged 77.

SAUNDERS, JOSEPH, *miniature painter.* He practised in London towards the end of the 18th century, and was well employed. He was an exhibitor at the Academy from 1778 to 1797. His works were principally portraits of ladies. His son, R. SAUNDERS, followed the same profession, and exhibited on a few occasions at the Academy.

SAVAGE, JOHN, *engraver.* Born in London about 1640. He practised his art in the Old Bailey, and was chiefly employed on portraits for the booksellers. He engraved William III. and Queen Mary, Algernon Sydney, Bishop Latimer, and many of the heroes executed before the neighbouring gaol; also some of the plates for Tempest's 'Cries of London,' and for Evelyn's 'Numismata.' He worked chiefly with the graver, but, though careful in execution, he was without taste, and his drawing defective.

SAVAGE, WILLIAM, *painter and engraver.* Was born about 1785, and studied in the schools of the Royal Academy. He made experiments in printing with a succession of wood blocks for decorative works, and published, in 1822, the results of his labours, the illustrations cut by his own hand, 'Practical Hints on Decorative Printing, with Illustrations Engraved on Wood and Printed in Colours by the Type Press.'

SAVAGE, JAMES, *architect.* He was born at Hackney, April 10, 1779. Articled to Mr. D. A. Alexander. He was also, in 1798, admitted to the schools of the Royal Academy, and in 1799 he was first an exhibitor, sending a design for a mansion; and in 1800 a design for a triumphal monument. At the same time, when in his 22nd year only, he was awarded the second premium of 150*l.* for his design for improving the City of Aberdeen. In 1805 his designs were selected for the erection

of Ormond Bridge, over the Liffey, Dublin; and in 1808 for Richmond Bridge, over the same river. In 1815 he was the successful competitor for a three-arch bridge over the Ouse at Tempsford, Bedfordshire. In 1819, in a strong competition for building St. Luke's Church, Chelsea, his designs were selected. The work possesses great merit, notable for its general design, and especially for its fine vaulted roof and excellent construction. His design, in 1823, for London Bridge, and his plan for improving the river Thames, by a southern embankment, though not adopted, were works of much labour and judgment. He was appointed architect to the Society of the Middle Temple in 1830, and erected the Hall, Clock Tower, and other works, and up to this time continued an occasional exhibitor at the Academy. In 1840 he was employed to prepare designs for the restoration of the Temple Church, and had commenced the work, when, from difficulties which arose between the two societies interested, the completion was entrusted to others, but it was finished according to his original intentions. Among his other works the chief were — Trinity Church, Sloane Street; St. James's Church, Bermondsey; Trinity Church, Tettenham Green; St. Mary's Church, Ilford; St. Michael's Church, Burleigh Street, Strand; St. Thomas the Martyr's Church, Brentwood; St. Mary's Church, Speenhamland, near Newbury; St. Mary's Church, Addleston, Surrey. He was one of the active supporters of the plan for restoring and opening to public view the Lady Chapel of St. Saviour's, Southwark; a member of the Surveyors' Club, the Graphic Society, the Institution of Civil Engineers, of the Architectural Society, and for a short time of the Institute of British Architects; but withdrew from a difference of views upon some matters of regulation. He had much practice in arbitration cases, and was successfully employed by the defendant in the case of the Crown v. Peto. He died May 7, 1852, in his 74th year, and was buried at his church in Chelsea. He presented to the Architectural Society, in 1806, an essay on bridge building, and published, in 1836, 'Observations on Style in Architecture,' in reference to the designs proposed for the Houses of Parliament.

SAVILLE, DOROTHEA, portrait painter. Practised in London in the first half of the 17th century. Both Hollar and Thomas Cross engraved after her.

SAXON, JAMES, portrait painter. He was born in Manchester, and practised for a time in London, exhibiting portraits at the Royal Academy in 1795-96. He afterwards went to Edinburgh, where he was practising in 1803, and about 1805 came again to London, and in that and the fol-

lowing years, up to 1817, was an exhibitor of portraits—sometimes of actors in character—at the Academy. He then went to St. Petersburg, where he was for several years successfully employed, and on his return, he lived for a short time in Glasgow. He died in London in the year 1816 or 1817. His characteristic portrait of Sir Walter Scott holding a large dog, with a landscape background, has been engraved, and is well known.

SAXTON, CHRISTOPHER, engraver. He lived near Leeds, and was a domestic servant. Shewing an ability for engraving, he was encouraged by his master to undertake a set of county maps, which, after six years' labour, he completed, mostly with his own hand. They were, some of them, decorated with views, published in 1579. They were the first known in England, and were dedicated to Queen Elizabeth.

SAY, WILLIAM, mezzo-tint engraver. Was born in 1768, at Lakenham, near Norwich, in which neighbourhood his father was land-steward to the proprietors of several estates. He was left an orphan at the age of five years, and was brought up by an aunt, who dissuaded him from an early desire to go to sea. After trying several pursuits, he came up to London at the age of 20, and a love of art, which had been for a time uppermost, induced him to place himself under James Ward, R.A., who was then practising as an engraver. He worked assiduously, and soon made great progress, and his merits gained him full employment. In 1807 he was appointed engraver to the Duke of Gloucester. The greater number of impressions to be taken off steel had brought steel plates largely into use, and about 1820 he engraved the first mezzo-tint which had been successfully produced on steel. He executed no less than 335 plates, with his own hand, many of them historical and portrait works of large-size. The British Museum possess a complete set of his works engraved between 1795-1834. He engraved 16 plates for 'Turner's Liber Studiorum,' several for 'Turner's River Scenery,' 'The Dilettanti Society,' after Sir Joshua Reynolds, and several after Fradelle. He died in Weymouth Street, Portland Place, August 24, 1834.

SAYER, JAMES, caricaturist. Was the son of the master of a trading vessel at Yarmouth, where he was born in August, 1748. He commenced life as an articled clerk in an attorney's office, served his time and practised for a while in Yarmouth, where he became a member of the Borough Council. His father having left him a small fortune, he did not continue to practise in the profession, but following the bent of his inclination, he drew caricatures and wrote songs. There is a political poem by him

379

Sayer. G - Painter

(then called Sayers of Yarmouth), 'The New Games at St. Stephen's Chapel.' Taking the side of Mr. Pitt, who was then in opposition, he came to London about 1780, and produced in 1783 his first work, satirizing the Ministry, and from that time to 1794 published above 100 political caricatures. The success of this led to numerous others, and in the great political struggle which followed the Whig India Bill, he zealously supported Mr. Pitt with his pencil, and his works had an extensive sale and influence, so great that Mr. Fox himself once observed that Sayer's caricatures had done him more harm than all the attacks made upon him in Parliament, or by the press. On succeeding to office Mr. Pitt rewarded him with a post in the Exchequer and he became Marshal of the Court, Receiver of the sixpenny duties, and one of the Cursitors. But while holding these offices he continued occasionally to publish his caricatures. On the death of the Minister in 1806, he wrote 'Elijah's Mantle,' which has been ascribed to Canning. He had not much power of drawing, and his works were weak, his wit coarse, but they will always form a part of the great political contest which was then waged. He died in Curzon Street, May Fair, April 20, 1823, and was buried in the vaults of St. Andrew's Church, Holborn.

SCANDRETT, THOMAS, *architectural draftsman.* He was born at Worcester in 1797. He first appears as an exhibitor of two portraits at the Academy in 1825, and from that time, at long intervals, sent an architectural drawing. He died in 1870.

SCHARF, GEORGE, *miniature and subject painter.* Born in Germany. He practised in London in the first half of the 19th century He painted 'The Parliament at Westminster,' which was engraved in 1820, and 'The Lord Mayor's Feast,' of which a lithograph was published, and was an occasional exhibitor at the Academy. But he is principally known as one of the earlier lithographic draftsmen. He died November 11, 1860, aged 72.

SCHEEMAKERS, PETER, *sculptor.* Was born at Antwerp in 1691, studied there, and early in life made his way to Denmark, where he worked as a journeyman ; and from thence, supported by his love of art, travelled on foot to Rome, selling his shirt for his subsistence when near the end of his weary journey. He remained in Italy only a short time, and starting again on foot, came to England. In 1728, he returned to Rome, where he studied two or three years, gaining a reputation by his small models from the Antique. In 1735, he came again to England, and establishing himself in St. Martin's Lane, settled here in the practice of his profession, He soon found considerable employment, was encouraged by

the Court, and shared the patronage of the time with Roubiliac and Rysbrack. He excelled in busts, three of which by him are in Westminster Abbey, where there is also, carved by him, a monument to Shakespeare, after Kent's design ; and a good monument to Dr. Chamberlain, one to Dr. Mead, in the Temple Church ; a Statue of Edward VI. in bronze, at Guy's Hospital ; and many statues in the gardens at Stowe. His models, pictures and marbles, were sold by auction by Langford in 1756 ; and, some remaining, in the following year. In 1769 he retired to Antwerp, where he soon afterwards died.

SCHEEMAKERS, THOMAS, *sculptor.* He was the son of the foregoing, and succeeded him in his business. He exhibited busts and bassi-relievi with the Free Society of Artists in 1765 and 1768, and commencing in 1782, he was an occasional exhibitor of models for monumental figures, with sometimes a medallion portrait, or a bust at the Royal Academy. He died July 15, 1808, aged 68, and was buried in St. Pancras' old churchyard.

SCHETKY, JOHN ALEXANDER, *amateur.* Born in Edinburgh in 1785, and descended from an old Transylvanian family. He was educated in that City for the medical profession, and at the same time studied drawing in the Trustees' School. He served with much distinction as surgeon to the Portuguese forces, under Lord Beresford, and on the termination of the war in 1814, he resumed his art studies in Edinburgh ; and in 1816-17 exhibited some scenes in Portugal at the Water-Colour Society. In 1821, he also exhibited at the Academy some works of the same class, and in 1825, his brother exhibited there two paintings of frigate actions, painted in conjunction with him. In 1819, he was called into active service. He was ordered to Ceylon, and afterwards exchanged with a brother officer for Sierra Leone, his object being to follow Mungo Park's route of exploration. He died at Cape Coast Castle, September 5, 1824. Some of the illustrations to Sir Walter Scott's 'Provincial Antiquities' are by him. His landscapes and marines showed great ability, and he was a clever linguist.

SCHETKY, JOHN CHRISTIAN, *marine painter.* Elder brother of the above. He was born in Edinburgh, August 11, 1778, and was educated at the High School, where he made many enduring friendships. He studied art for a while under Alexander Nasmyth, and at the age of 17 was able to gain a livelihood by teaching scene painting, &c. In 1801 he visited the Continent, and walked from Paris to Rome ; on his return, he was induced to take up his residence in Oxford as an art teacher. In 1808 he was appointed Professor of Drawing at the

380

Scannell. Edith (1890) — *Schalken Godfrey Juleh 1843·17*

Royal Military College, then at Marlow, and afterwards at the Royal Naval College, Portsmouth, where he continued for 25 years, and on the dissolution of that institution, was appointed to the East India College, at Addiscombe, from which he retired in 1855. In 1813–14 he spent his summer holidays in the Peninsular, with his brother Alexander, then with the British Army. He first appears as an exhibitor at the Royal Academy in 1805, and occasionally, with some long intervals, was an exhibitor up to 1872. At the Westminster Hall competition in 1847 he exhibited 'The Battle of la Hogue,' a painting of large size, in oil. He held the appointment of marine painter to George IV., William IV., and Queen Victoria. He published in 1867 his 'Veterans of the Sea,' followed by 'A Cruise on the Scotch Waters.' His 'Rescue of a Spanish Man-of-War' is in the United Service Club. He died January 28, 1874, in the Regent's Park, London, in his 96th year.

SCHIAVONETTI, Lewis, *engraver.* Was the son of a stationer in humble circumstances at Bassano, where he was born, April 1, 1765. He had an early taste for drawing, and was placed under Giulio Colini. He became acquainted with an indifferent engraver named Testolini, and made for him some imitations of Bartolozzi's works, which Testolini passing off as his own, made the means of an introduction to Bartolozzi, who was then in London and in great repute. This was followed by an invitation, which, from interested motives, he managed to get extended to Schiavonetti, who came to this country in 1790. The true character of Testolini was soon discovered, but Bartolozzi induced Schiavonetti to join him, and took him into his house in Sloane Square, where he continued for a time. Schiavonetti improved under his friend's instructions, and then was enabled to be independent in the practice of his art.

He executed several plates of subjects connected with the French Revolution, which, though got up in haste, showed much merit, and were profitable to the publishers. Then employed on works of a higher class, he produced a 'Mater Dolorosa,' after Vandyck; a portrait of Vandyck in the character of Paris; Michael Angelo's Cartoon of the 'Surprise of the Soldiers on the Banks of the Arno;' etchings from Blake's illustrations of Blair's 'Grave;' De Loutherbourg's 'Landing of the British Troops in Egypt;' and he left unfinished the plate of Stothard's 'Canterbury Pilgrims,' of which he had only completed the etching and some of the principal figures. He was largely engaged in works for book illustration. He died at Brompton, June 7, 1810, and was buried in Paddington churchyard. He was eminent for his power both in the line and the dot manner. The force, clearness, and freedom of his line are admirable. His dot manner was equally clever, and he was reputed in both as well for correct expression and drawing as for his careful finish and correct imitation of the master.

SCHIAVONETTI, Niccolo, *engraver.* Was born at Bassano, the younger brother of the foregoing, with whom he came to England in 1790. He chiefly worked in conjunction with his brother, and after his death was employed some time upon his incomplete plate of the 'Canterbury Pilgrims,' which was eventually finished by Heath. He engraved in his brother's manner, but did not approach him in excellence. Died at Hammersmith, April 23, 1813, aged 42.

SCHMUTZ, Johann Rudolph, *portrait painter.* Was born at Regensberg, Switzerland, and was a pupil of Mathias Fuessly. He first attempted historical subjects, but not succeeding, tried portraiture. When Kneller was at the height of his reputation he came to England, and imitating his manner, had many sitters. Both J. Smith and Vertue engraved after him. He died in London in 1715.

SCHNEBBELIE, Jacob C., *topographical draftsman.* Was born August 30, 1760, in Duke's Court, St. Martin's-in-the-Fields. His father, a native of Zurich and a lieutenant in the Dutch Navy, quitted that service and settled at Rochester as a confectioner. He followed his father's business, first at Canterbury, then at Hammersmith, but having acquired some knowledge of drawing under Paul Sandby, he left his shop and commenced teaching drawing. He was afterwards appointed draftsman to the Society of Antiquaries, and made drawings for Morris's 'Monastic Remains,' 'The Gentleman's Magazine,' and the early numbers of 'The Antiquaries' Museum.' He was chiefly employed on antiquarian and topographical subjects which he drew and etched or aqua-tinted. From 1786 he exhibited at the Royal Academy views of buildings possessing an antiquarian character. He published four views of St. Alban's Abbey, etched by himself. He died in London, of rheumatic fever, February 21, 1792, in his 32nd year. He left a young widow, for whom a subscription was raised.

SCHNEBBELIE, Robert Bremmel, *topographical draftsman.* Was the son of the foregoing. He was a good draftsman. Commencing in 1803, he occasionally exhibited at the Academy a drawing of some old building; but he did not long continue an exhibitor. He was engaged in drawing for the 'Gentleman's Magazine' and other periodicals, and made also the drawings for 'London Illustrata.' He was rather weak in his intellect, capricious in his work, and,

losing his mother, was scarcely able to take care of himself. He was found dead in his lodgings, which were almost destitute of furniture, and it was clear that his death had been hastened by starvation. This happened about 1849.

SCHOLES, JOSEPH JOHN, *architect.* Was born in London in 1798, and was educated in a Roman Catholic School. In 1812 he was articled to Mr. Ireland, and in 1822 he travelled to complete his studies in the Levant, Egypt and Syria, making some careful surveys of the holy places. In 1826 he returned to England and commenced practice. He built St. Peter's Church, Great Yarmouth, his first important work, which was followed by several commissions for Roman Catholic churches. Of these the most elaborate is the Church of the Immaculate Conception in Farm Street, Grosvenor Square. He also built the residence of the Oratory at Brompton. He was honorary secretary and afterwards a vice-president of the Institute of British Architects. He died December 29, 1863.

SCHWANFELDER, CHARLES HENRY, *animal painter.* He was born at Leeds in 1773, and chiefly practised in his native town. He painted animals, landscapes, and, occasionally, portraits. He was appointed painter of animals to George III., and afterwards to the Prince Regent. He exhibited at the Royal Academy in 1809, and was an occasional exhibitor up to 1826. His works were almost exclusively portraits of dogs and horses. He died in 1837.

SCHWEICKHARDT, HEINRICH WILHELM, *landscape painter.* Born at Brandenburgh, supposed of a Dutch family, in 1746. He studied under an Italian, and practised some time in Holland, where he held the appointment of Director of the Academy at the Hague, and produced many good works. In consequence of the disturbances in Holland he came to London in 1786, and settled here. He painted landscapes, marine subjects, and later a few portraits, and was an exhibitor at the Royal Academy from the time of his arrival. He died in Belgrave Place, Pimlico, July 8, 1797. He published in London several etchings, among them ' Eight Etchings of Animals,' dedicated to Benjamin West, P.R.A.

SCORE, W., *portrait painter.* He was a native of Devonshire, and about 1778 became a pupil of Sir Joshua Reynolds, and yearly, from 1781 to 1794, with one exception, was an exhibitor of portraits at the Royal Academy.

SCOTIN, LOUIS GERARD, *engraver.* Born in Paris about 1690, he practised up to the middle of the 18th century. He was brought over to this country soon after 1733 to assist in the engravings for a translation of Picart's 'Religious Ceremonies.'

He engraved, in 1745, two of the original plates of Hogarth's ' Marriage à la Mode,' also several plates after Frank Hayman, one of whose boon companions he was.

SCOTT, EDMUND, *engraver.* Born in London, about 1746. Was a pupil of Bartolozzi, and worked in the dot manner. He excelled in this style, was much employed, and was appointed engraver to the Duke of York. He engraved the Prince of Wales, after a portrait drawn by himself, and several subjects after George Morland, Stothard, Ramberg. He died about 1810.

SCOTT, JOHN, *engraver.* Was born, March 12, 1774, at Newcastle-on-Tyne, where his father worked in a brewery, and was apprenticed to a tallow-chandler in that town. Towards the end of his term he began to show an attachment to drawing, which he practised in his leisure hours. He was first employed to engrave the profile portraits for Angus's ' History of the French Revolution,' published 1796, and gaining confidence, he came to London and was assisted by Pollard, a fellow-townsman, who was then practising as an engraver, and who gave him such gratuitous instruction as enabled him to gain employment. After working some time for his master he produced his ' Breaking Cover,' and ' The Death of the Fox,' which, by their ability, gained him the Society of Arts' gold medal, and made him known to the publishers. Afterwards he was engaged upon ' The Fine Arts of the English School,' 1812 ; Britton's ' Cathedral Antiquities,' 1820 ; ' The Sportsman's Cabinet,' ' A series of Horses and Dogs,' and Daniel's ' Rural Sports.' He particularly distinguished himself as an engraver of animals. Their character and action was well rendered, and the character of their fur or skin seized with great truth. He suffered a paralytic stroke in 1821, and fell into difficulties, but a subscription was raised for him, and he was for a while enabled to resume his work ; but he again fell ill and eventually lost his reason. He died at Chelsea, early in March 1828, aged 54.

♦ SCOTT, SAMUEL, *marine painter.* He is said to have been born in London about 1710, but little information exists of his early life. He was one of the boon companions of Hogarth and his friends, and one of the jovial water-party to Gravesend in 1732. He drew well, and his works were well coloured. He was one of the early draftsmen in water colours, but his chief works are in oil. He gained a great reputation for his sea-pieces, and for his topographical views, which are filled with groups of figures, well drawn and painted ; but his works are not much esteemed in the present day. He exhibited at the Spring Gardens' Rooms in 1761, and in 1771 at the Royal Academy, ' A View of the Tower of London on the King's Birthday.' He was then living

382.

Scott James Met Engraver —

at Bath, where he had retired after a long practice in the Metropolis, and there, in Walcot Street, he died of gout, which had long harassed him, October 12, 1772, leaving an only daughter. His collection of drawings, prints, &c., was sold by Messrs. Langford, at the Piazza, Covent Garden, in January 1773.

SCOTT, ROBERT, *engraver*. Was born November 13, 1771, at Lanark, where his father was a skinner and glover. He early showed some ability in drawing with his pen, and was apprenticed in 1787 to Alexander Robertson, an engraver at Edinburgh, who was employed upon the views of old buildings, which then appeared in the 'Scot's Magazine.' He also studied in the Trustees' Academy. He engraved a series of views round Edinburgh, and the plates for Dr. Anderson's 'Bee,' with many other works. His engravings were careful and well-finished, and he gained the reputation of the first engraver of his day in Scotland. He brought up several pupils who became distinguished. He died in January 1841.

• SCOTT, DAVID, R.S.A., *history painter*. Son of the above. Was born in Edinburgh, October 10 or 12, 1806, and was educated at the High School in that city. He early turned to art, and both designed and engraved for book illustration ; and he engraved, after Stothard, R.A., a series of designs for Thomson's 'Scottish Melodies.' He then devoted himself to painting, and attempting the grand style, produced, in 1828, 'The Hopes of Early Genius Dispelled by Death.' In 1830 he was elected an associate of the Scottish Academy, and in 1832 he was enabled to visit Italy, where he made sketches or remembrances of the fine works of art in the chief cities. In Rome he continued more than 12 months, including in his studies there anatomy and painting : and from thence he sent home a large picture, 'Family Discord, the Household Gods Destroyed.' Returning with exhausted funds, he settled in Edinburgh in 1834. In the following year he exhibited at the Scottish Academy, and continuing to exhibit there sacred and classic subjects, was elected a member of the Academy. In 1838 and again in 1841, his pictures were selected for prizes by the Committee for Promoting the Fine Arts in Scotland. He sent in competition designs to the two first exhibitions in Westminster Hall, but his works were unnoticed.

He was from his boyhood of a sad temperament, and was distressed by his want of success, and failure in gaining public appreciation; but by his great power in drawing and indefatigable application, he completed many large pictures. His great picture, 'Vasco de Gama,' is now in the Board-room at the Trinity House at Leith ; the 'Alchymical Adept Lecturing,' is in the possession of Sir J. Gibson-Craig; the 'Dead Rising,' in the collection of Mr. Leathart, of Newcastle. His pictures, grandly and poetically conceived, were wanting in that finish, colour, and taste which could alone render them saleable. A disappointed man, of dreamy and misanthropic habits, some of his sad thoughts are embodied in his fragmentary poetry, of which he left many examples. He published a series of outlines which he called 'Monograms of Man,' and 25 etched illustrations to Coleridge's 'Ancient Mariner,' which were not more successful than his paintings. He also contributed to 'Blackwood's Magazine' a series of papers on the characteristics of the great masters. He died in Edinburgh, March 5, 1849, aged 42. An affectionate memoir of him was published by his brother, a well-known writer on art and also an artist, in 1850.

SCOTT, Sir GEORGE GILBERT, R.A., Knt., *architect*. Was born in 1811, at Gawcott in Buckinghamshire, of which place his father (the son of the author of the 'Commentary on the Bible') was the incumbent. While yet quite young, he began to study and draw from Gothic churches, and this led his father to place him in an architect's office, where he learnt the practical part of his profession, but little of the particular style congenial to his own inclinations. However, when he entered into practice for himself, he devoted himself entirely to Gothic architecture. In 1841, when in partnership with Mr. Moffatt, he designed the 'Martyr's Memorial' at Oxford ; and in 1842, after the church of St. Nicholas, Hamburg, had been destroyed by fire, his designs for a new building were those chosen, in a competition open to all Europe. The spire of this church, while those of Cologne remain unfinished, is the highest in the world. Some years later he was again selected to erect the Senate House, and the Hotel de Ville in the same city. In 1848 he designed the Cathedral Church at St. John's, Newfoundland, which is not yet completed. He was largely engaged upon the restoration of many English Cathedrals, those of Ely, Hereford, Ripon, Gloucester, Chester, St. David's, St. Asaph's, Bangor, Salisbury, Exeter, Peterborough, Worcester, Rochester, and Oxford, having been placed under his care, and at the time of his death he had just entered upon the restoration of St. Alban's. Besides this, he re-arranged the interior of Durham Cathedral; in conjunction with Mr. Slater he reconstructed the central tower and spire of Chichester Cathedral, and also superintended several improvements in the abbey church of Westminster. He built many new churches in various parts of England, and restored many old ones; his

383.

last new church in the Metropolis was that of St. Mary Abbot's, Kensington, which remained unfinished at his death. But he undertook many secular buildings besides these. He was, in conjunction with Sir Digby Wyatt, the architect of the New India Office, and he also built the New Foreign Office, and the Home and Colonial Offices. He restored Exeter, Merton, and New Colleges at Oxford, and carried on extensive alterations to St. John's College, Cambridge. He designed the New Midland Railway Station at St. Pancras, the Town Hall at Preston, and a great number of private residences in all parts of the country. He was also appointed by the Queen to be architect to the National Memorial to the Prince Consort erected in Hyde Park. He was elected an associate of the Royal Academy in 1852, and a full member in 1860, and received besides this honour of knighthood. He was the author of several works upon his own branch of art, such as 'Remarks on Secular and Domestic Architecture,' published in 1850; 'Gleanings from 'Westminster Abbey,' 1862; and 'Conservation of Ancient Architectural Monuments,' 1864. He was Professor of Architecture at the Academy, and founded the Architectural Museum, now in Westminster. While we owe much to him from the impetus he gave to Gothic architecture in this country, his works are rather marked by their clinging to precedent than by any great originality of conception. He died almost suddenly, from heart disease, in South Kensington, London, March 27, 1878, aged 67.

SCOTT, WILLIAM, *water-colour painter.* He resided all his life at Brighton, and painted the home scenery and cottages of Sussex and Surrey, seldom straying beyond. In 1811 he was elected an associate exhibitor of the Water-Colour Society, and continued a contributor to the Society's exhibitions to 1850. He published, in 1812, six 'Etchings on Stone,' to imitate drawings in black and white.

SCOTT, Miss, *water-colour painter.* Daughter of the foregoing, who practised at Brighton. She was elected a member of the Water-Colour Society in 1823, and was yearly an exhibitor of flowers and fruit up to 1834, when she married a Mr. Brooksbank, and in that name continued to exhibit up to 1839.

SCOUGAL, ——, *portrait painter.* A Scotch artist, who practised with much repute in Scotland in the reign of Charles II. He was a pupil of Sir Peter Lely, and in his manner painted many of his Scottish ladies. But the accounts of him are obscure and conflicting.

SCOUGAL, GEORGE, *portrait painter.* He was the son of the foregoing, and brought up to art, but was inferior to his father. He practised for many years after the Revolution, and standing almost alone in Scotland was much employed. Yet his portraits were stiff in manner, careless in finish, and incorrect in likeness.

SCOULAR, WILLIAM, *sculptor.* He studied in the Trustees' Academy, Edinburgh, and in London, where he first exhibited a bust, in 1815, and in 1817 gained the Academy gold medal for an alto-relievo of 'The Judgment of Paris.' He continued to exhibit busts, wax portraits, and occasionally a classic group, and in 1825 was sent to Rome with the Academy travelling studentship. He sent from thence to the Academy exhibition, in 1826, 'Adam and Eve bewailing the Death of Abel,' and was the same year appointed sculptor in ordinary to the Duke and Duchess of Clarence. From that time till 1834 he did not exhibit. He had purchased the business of Sarti, a well-known Italian modeller, but this not succeeding he appears again as an exhibitor, contributing busts; in 1838, 'Paris and Helen,' a marble statue of 'Sir Walter Scott,' and continued to exhibit, sending several groups in marble, up to 1846.

SCOULER, JAMES, *miniature painter.* He received a Society of Arts' premium for a drawing in 1755, and was then about 14 years of age. Exhibited with the Society of Artists in 1761–62, and was a member of the Free Society 1763. On the foundation of the Royal Academy he was a constant exhibitor of miniatures with that body up to the year 1787, and occasionally contributed a work in crayons or a group.

SCRIVEN, EDWARD, *engraver.* Was born at Alcester, near Stratford-upon-Avon, in 1775. He showed a strong disposition for art, and became a pupil of Robert Thew, living with him during seven or eight years, at Northall, in Hertfordshire. He appears then to have come to London, where he was employed on some of the principal works of the day. He engraved for the Dilettanti Society, the 'Shakespeare Gallery,' and the 'Fine Arts of the English School,' and was employed generally by the publishers. A series of portraits, chiefly after Sir Peter Lely, and West's studies of heads for his 'Christ Rejected,' are by him. He held the appointment of engraver to the Prince of Wales. His works are chiefly in the dot manner, in which he attained great excellence, but some of his later productions are in the line manner. They show great taste, and are clever representations of the peculiar art of the painter. He was a useful member of his profession, giving much of his time to promote its interests, and was the founder and secretary of the Artists' Fund. He died August 23, 1841,

Scriven - a - painter 17 -

leaving a widow and five children, and was buried at the Kensal Green Cemetery.

SCROPE, WILLIAM (of Castle Coombe, Esq.), *amateur*. He painted, with some ability, landscape scenery, and early in the 19th century was an occasional exhibitor at the Royal Academy. In 1801 he contributed 'A Scene from Schiller's Robbers.' In 1807 a subject from 'The Lay of the Last Minstrel'; in 1811, 'View of Melton Bridge;' and in 1834, at the British Institution, a carefully painted picture of the decayed convent of St. Vivaldo, Tuscany. He published, in 1808, 'The Landscape Scenery of Scotland,' engraved from his own drawings. He died July 20, 1852, aged 81.

SCROUDOMOFF, GABRIEL, *engraver*. Was born in Russia, and was a pensioner of the Empress Catherine. He came to this country, where he resided from about 1774 to 1782, and engraved a great many plates, among them a portrait of De Loutherbourg's beautiful wife.

SEATON, CHRISTOPHER, *gem-engraver*. He was a pupil of Reisen, and practised in London about the middle of the 18th century. He was a contributor to the first exhibitions held in the Metropolis, and was a director of the Incorporated Society of Artists, 1765. He died October 6, 1768.

SEATON, JOHN THOMAS, *portrait painter*. Son of the foregoing. He was a pupil of Frank Hayman, studied in the St. Martin's Lane Academy; and was also a member of the Incorporated Society of Artists. He exhibited half-length portraits at the Royal Academy in 1774. He was practising in Edinburgh about 1780, and was in high repute, which his works merited. He was living in 1806.

SEDDON, THOMAS, *landscape painter*. He was born in London, the son of an eminent cabinet-maker, August 28, 1821, and was intended for his father's business, but he could not overcome his dislike to it; and having a taste for art, which he wished to follow, he was sent to Paris in 1841 to study design. On his return he became the designer for his father's works and superintended their execution. In 1848 he gained a prize offered by the Society of Arts for an ornamental design, and aspiring to the practice of art he diligently studied the figure. In 1849 he spent some time in Wales sketching the scenery, and in 1850 made an excursion to Paris and Fontainebleau, and after a severe illness again visited Wales in 1851. In 1852 he exhibited his first work, 'Penelope,' at the Academy, but subsequently turning to landscape, exhibited in 1853, and again in 1854, a 'View in Brittany.' In these two years he was travelling in the East, where he painted some most careful and elaborately finished sketches and studies, which he brought home with him and exhibited two of them at the Academy in 1856. Setting out again for the East he was attacked with diarrhœa and died, after a few days' illness, November 23, 1856, at Cairo, where he was buried. His friends purchased and presented to the National Gallery, his 'Jerusalem and the Valley of Jehosaphat,' a work which affords a good notion of his conscientious and painstaking art. His collected works were exhibited at the Society of Arts in 1857. His brother published a memoir of him in 1859.

SEDGWICK, WILLIAM, *engraver*. Was born in London, 1748, and practised there in the dot manner, to which, under the influence of Bartolozzi, he devoted himself. There are plates by him after Angelica Kauffman, E. Penny, R.A., and others. He died about 1800.

* SEEMAN (sometimes spelt ZEEMAN), ENOCH, *portrait painter*. Born 1694. Was the son of Isaac Seeman, a portrait painter at Dantzig, who brought him when young to London. Here he painted many portraits in a minute, careful manner, some of which are engraved by Faber, G. Bartch, and others. He died suddenly in 1744.

SEEMAN, ISAAC, *portrait painter*. Brother of the foregoing. Practised his art in London, where he died April 4, 1751. He left a son who followed his profession.

SEEMAN, PAUL, *portrait painter*. Was the son of the above Enoch, and practised portrait painting here. Some subjects from still-life are also attributed to him.

SEGAR, WILLIAM, } Two English portrait painters who
SEGAR, FRANCIS, } trait painters who practised in London in the 16th century. They are spoken of in 'The Wit's Commonwealth,' London, 1598. Maclow spells the name 'Seagar.'

SÉGUIER, WILLIAM, *topographical landscape painter*. Was born in London in 1771, eldest son of David Séguier, well known as a picture-dealer in the time of Sir Joshua Reynolds. He studied under George Morland, and for some time followed the profession of an artist, and painted some interesting views in and around the Metropolis. 'Covent Garden Theatre when on fire;' 'the Church of St. Paul, Covent Garden, on fire;' 'a view of Seven Dials.' They are painted in a neat but free hand, which recalls the manner of his master, are pleasing in colour, and filled with groups of figures well introduced. Later in life he devoted himself to picture-restoring. His professional skill, taste, and knowledge of art, gained him several important appointments. George IV. appointed him keeper of the royal pictures. He was also the first director of the National Gallery, and superintendent of the

Segantini - G. ['1895].

British Institution. He died at Brighton, November 5, 1843.

SÉGUIER, JOHN, *topographical landscape painter.* Younger brother of the foregoing. He was born in London in 1785. He commenced his studies as an artist in the schools of the Royal Academy, where he gained a silver medal in 1812, and from that time up to 1822 was an exhibitor at the Academy. He painted local views, some of which in the neighbourhood of Paddington and Marylebone became of considerable topographical interest. Among his best pictures may be mentioned two of Oxford Market, two of Mr. Watson Taylor's House in Cavendish Square, and a view of Kew Bridge. He succeeded his brother as superintendent of the British Institution. He died in London in 1856.

SELDEN, ——, *wood-carver.* Was a pupil and assistant of Grinling Gibbons, and lost his life at Petworth, in saving from the flames a fine vase carved by his master, in imitation of the antique.

SENEX, JOHN, *engraver.* The London almanacs from 1717 to 1727 (except the year 1723) are engraved by him. He died in 1741.

SERRES, DOMINIC, R.A., *marine painter.* Was born in 1722 at Auch, in Gascony, and was educated in the public school there. He is said to have been nephew of the Archbishop of Rheims. His parents designed him for the Church, but this being repugnant to him, he ran away from his native town, and made his way on foot into Spain. He then went on board a vessel bound for South America as a common sailor, and passing through the ordinary gradations as a seaman, became master of a vessel trading to the Havannah, where, during the war of 1752, he was taken prisoner by a British frigate, and brought to this country. Released on parole, he resided for a time in Northamptonshire. He was in great difficulties, and, having had some instruction in drawing, he tried to earn a living as an artist. His sea experiences led him to marine subjects, and by unremitting exertions, and some kind assistance from Brooking, he made his way, married, and determined to settle in England. This seems the most reliable of the several accounts of his early career.

The naval wars of the period did not fail to provide subjects for his pencil, and his works became popular. In 1765 he was a member of the Incorporated Society of Artists, and exhibited with them in that and the following year. On the establishment of the Royal Academy in 1768, he was chosen one of the foundation members. His name appears as a constant exhibitor, contributing, up to the year of his death, marine-pieces, illustrating the naval exploits and victories of the day. In 1792 he

386

was appointed librarian to the Academy. For this office he was well qualified. He spoke English with fluency, was a good Latin and Italian scholar, and was tolerably versed in French, Spanish, and Portuguese. He was also appointed marine painter to George III., but he did not long hold these offices. He died November 6, 1793, and was buried at St. Marylebone old Church. There are several large sea-pieces by him in the gallery at Greenwich Hospital, and at Hampton Court Palace. They are weak in execution, and want purity in colour, and some of them, from his manner of painting, sadly have decayed. He left two sons, both artists; the eldest was distinguished as a marine painter — the younger was only known as a teacher of drawing. His daughters, Miss J. Serres, and Miss E. A. Serres, were honorary exhibitors at the end of the century.

SERRES, JOHN THOMAS, *marine painter.* Eldest son of the foregoing. He was born in December 1759, and, brought up under the eye of his father, naturally imbibed a taste for art. Having attained manhood, he looked to teaching for his future support, and was drawing-master to a Marine School then at Chelsea. But he soon appears as an exhibitor at the Royal Academy, sending in 1780 two water-colour views and a painting of 'Sir George Rodney engaging the Spanish Squadron;' and continuing an exhibitor of landscape and marine views. He had saved the means of visiting Italy, and was preparing to start when he was introduced to Miss Olive Wilmot, the daughter of a house-painter of Warwick, and the niece of the Rev. J. Wilmot, vicar of Barton, in that county. He fell at once in love and became engaged to her, but in 1790 he started on his projected tour, made a short stay in Paris, visited Lyons, Marseilles, Genoa, Pisa, Florence, and Rome, where he passed five months, sending a picture to the Academy, and then proceeded to Naples. He had spent little more than one of the three years which he proposed, when a letter from Miss Wilmot hurried him home, and, notwithstanding the opinions of his friends, he was married to her on September 1, 1792.

On the death of his father in 1793, he succeeded to the office of marine painter to the King, and was also appointed marine draftsman to the Admiralty, and in the execution of his duties in the latter office was frequently employed during the war to make sketches, for the assistance of the Admiralty, of the harbours on the enemy's coasts. For this a vessel was appointed for his service, and he was paid 100l. a month while on actual duty. He also contributed regularly to the Academy exhibitions, chiefly shipping and marine subjects. But the intrigues, depravity, violence, and ex-

travagance of his wife, who called herself Princess of Cumberland, and founded large claims upon this assumption, ruined him. She even forged bills in his name. From all this a deed of separation in 1803 did not relieve him, and in 1808 he went to Edinburgh to avoid the persecutions to which he was subjected, and to hide himself as well as the nature of his occupation would permit, and for the next seven years withheld his pictures from the Royal Academy. It was, however, of no avail ; he was soon arrested and thrown into prison, and the same round of persecutions continued, till at last, impatience of his misery hurried him to attempt suicide, which was happily frustrated.

Notwithstanding such difficulties, he had, from his Government employment and other sources, saved some money, and he embarked 2000l. in the speculation for building the Cobourg Theatre, to which he was to have been appointed the scene-painter, but the speculation failed, difficulties increased, and he was compelled to take advantage of the Insolvent Act. He had smiled only at his wife's great pretensions, but they lost him the royal favour, which he could never regain. He exhibited at the Academy in 1817, and once more in 1819. Teaching now became his chief occupation and support. Desponding, labouring early and late, his health failed, his mental suffering aggravated a tumour ; he was moved into the rules of the King's Bench, but the removal hurried on his death, which took place on December 28, 1825. He was buried beside his father in Marylebone churchyard. In his will he declared that his wife had 'assumed the name and title of the Princess of Cumberland without the least foundation whatever for a claim to royal birth.' He translated and published in 1801, 'The Little Sea-torch,' a guide for coasting-ships, with a large number of aqua-tinted and coloured views, very literally but artistically treated ; and in 1805 his 'Liber Nauticus,' or instructor in the art of marine drawing. An exculpatory memoir of him was published by 'A Friend' in 1826.

SERRES, OLIVE, *amateur.* Wife of the foregoing. Born in 1772. She was an honorary exhibitor of a landscape at the Royal Academy in 1794, and also exhibited landscapes yearly from 1804 to 1808, and at the British Institution in 1806. In 1807 she styled herself 'landscape painter to the Prince of Wales,' but that title is omitted in the following year. Her claim to be the daughter of Henry Frederick Duke of Cumberland was brought before the House of Commons in 1822. She died November 21, 1834. Her daughter (Mrs. Lavinia Janetta Horton Ryves), who did not disclaim her mother's high pretensions, died December 7, 1871.

SERRES, DOMINIC, M., *water-colour draftsman.* Younger son of D. Serres, R.A. He was a teacher of drawing, and on his brother leaving England in 1790 he gained part of his connexion. He exhibited landscape views at the Academy from 1783 to 1787, and supported himself for many years by his art, but at last fell into hopeless despondency and lost his employment. He then became dependent upon his brother, but died after a few years.

SEYMOUR, JAMES, *animal painter.* Was born in London in 1702, the only son of a banker, who was fond of art, drew himself, and was intimate with Lely and other artists. He excelled in sketching horses with the pen, showing great spirit and character, but he was a weak colourist, and, too idle to apply himself, he never attained excellence beyond the mere sketch. Few of his finished works are known. He died June 30, 1752. R. Houston engraved after him 12 plates of race-horses ; and Thomas Burford some hunting-pieces and hunters.

SEYMOUR, EDWARD, *portrait painter.* Was a formal imitator of Kneller. He died in January, 1757, and was buried in the churchyard at Twickenham.

SEYMOUR, Colonel, *amateur.* Painted some good miniature portraits in the reign of Queen Anne.

SEYMOUR, ROBERT, *caricaturist.* Born in the Metropolis about 1800. He was apprenticed to a pattern-drawer in Spitalfields. On the completion of his time he painted in oil, and in 1822 exhibited at the Royal Academy, a subject from Tasso, followed by others of some pretence, and some portraits and miniatures. But his true talent was soon developed, and he was fully employed in drawing on wood for book illustration ; his works being almost exclusively of a humorous character. In 1830 'The Odd Volume' was published with his designs. In 1832–34, 'The Comic Magazine ;' and 1831–36 the 'Figaro in London.' He was also an etcher. In 1827, he etched the illustrations for 'Vagaries in Quest of the Wild and Wonderful ;' and in 1835 the 36 illustrations to 'The Book of Christmas.' Shortly after he proposed a series of designs of sporting life, introducing the members of a Cockney Club, which he claimed to have been the origin of the 'Pickwick Papers,' by Charles Dickens, a claim which involved him in some controversy. At the same time he was attacked with much virulence by the Editor of 'Figaro,' with which publication he had been so intimately connected. He was harassed by the many claims upon his pencil, and these added troubles were probably too much for him. He became subject to fits of despondency, and on April 20, 1836, committed suicide.

S H A A, EDMUND, *die-engraver.* Was graver to the Mints of London and Calais 2nd Edward IV.

SHAA, JOHN, *die-engraver.* Was graver of the coining irons of gold and silver within England and Calais 1st Richard III.

SHACKLETON, JOHN, *portrait painter.* Succeeded Kent, as principal painter to George II., in April 1749, with a salary of 200*l.* He was one of the Artist Committee of 1755, appointed to establish a Royal Academy. In 1766 he exhibited portraits with the Free Society. There are by him portraits of George II. and his Queen in Fishmongers' Hall, and a portrait of the King at the Foundling Hospital. He died March 16, 1767.

SHALDERS, GEORGE, *water-colour painter.* His name first appears as an exhibitor at the Royal Academy in 1848. He was then living at Portsmouth, and was an occasional exhibitor of views in Surrey and Hants, and in 1858 and 1859 of Irish scenery. In 1863 he was elected an associate, and in 1865 a member, of the Institute of Water-Colour Painters, and from that time contributed to their exhibitions, landscapes, in which he skilfully introduced cattle, especially sheep. Absorbed in his art, and compelled by his necessities to exert himself above his strength, he was struck with paralysis, and died, after a few days' illness, January 27, 1873, aged 47. His artist friends raised a subscription for his three motherless children, and a collection of sketches and pictures they had made with the same object was sold at Christie's in 1874.

SHARP, WILLIAM, *engraver.* Was the son of a gun-maker in the Minories, and was born there January 29, 1749. He received a premium from the Society of Arts, and was apprenticed to Barak Longmate, an engraver on plate, and after his apprenticeship continued to work for him till he married, and set up for himself as a writing engraver. He continued this business for some time with good encouragement, till aspiring to something better than card-plates and door-plates, he made a drawing from Hector, the old lion in the Tower, which he engraved on a small quarto plate, and exposed for sale in his window. About 1782 he quitted his shop and went to reside in a private house at Vauxhall, and then commenced the higher branch of his art. He engraved from the old masters, executed some plates for the 'Novelists' Magazine' after Stothard, and about the same time completed the plate of West's 'Landing of Charles II.,' which Woollett had left unfinished at his death. He also engraved some of the illustrations for 'Captain Cook's Voyages,' and Benwell's 'Children in the Wood.' His success in his profession, and some money left him by

his brother, enabled him to remove to a better house in Charles Street, Middlesex Hospital. From thence he removed to Tichfield Street, and then, quitting the Metropolis, to Acton, and finally to Chiswick.

Among his finest works are—after Guido, 'The Doctors of the Church disputing' and 'Ecce Homo;' after West, P.R.A., 'King Lear in the Storm' and 'The Witch of Endor;' after Trumball, 'The Sortie from Gibraltar;' after Copley, 'The Destruction of the Floating Batteries at Gibraltar;' and after Sir Joshua Reynolds, the portrait of John Hunter and two plates of 'The Holy Family,' one of which, to the great discredit of Bartolozzi, was converted by him into the dotted style, but happily not before 100 impressions had been taken off. Sharp's style of engraving is masterly and entirely original; the half-tints of his best works rich and full; the play of his lines marked by taste and genius; the colour and character of the master excellently rendered. His works are known throughout Europe, and though he received pressing invitations from the continent, he never left his own country. He was elected honorary member of the Imperial Academy at Vienna, and of the Royal Academy at Munich. But at home he espoused the cause of the engravers, who stood aloof from our Academy, of which, by his own choice, he never became a member.

He held very peculiar opinions. In his young days he was a republican, dabbled in the politics of Tom Paine and Horne Tooke, and so loudly expressed his opinions, that he was examined on treasonable charges before the Privy Council; but in his frank, jolly manners the Council soon saw that there was no danger to the State from the poor deluded artist, who is said to have pulled out his subscription list for a work he was publishing, and asked the Council to add their names. Though a staunch believer in the Scriptures, he was by turns a convert to the opinions of the self-styled prophets Brothers, Wright, and Bryan, and under a portrait of the former, with the title of 'Prince of the Hebrews,' he engraved, 'Fully believing this to be the man whom God has appointed, I engrave his likeness.—William Sharp, 1795.' Having heard of Joanna Southcott, he suddenly set off to Exeter, where she was gaining her living as a charwoman, sought her out and brought her to London, where he maintained her at his own expense for a long time, and expressed the firmest faith in her divine mission.

After a short residence at Chiswick, he died there, of dropsy on the chest, July 25, 1824, aged 75, and was buried in the parish churchyard. His credulity may account for his dying poor, though industrious and successful in his art.

Shade G. Invt Engraver 10 =
Sharp. W. Lithographer : 1830

SHARP, "MICHAEL W., *portrait and subject painter.* He was born in London. Was a pupil of Sir William Beechey, and studied in the schools of the Royal Academy. In 1801 he appears as an exhibitor, and for several years contributed portraits and portrait groups, with an occasional subject picture to the Academy exhibitions. He was also an exhibitor at the British Institution, and in 1809 was awarded a premium of fifty guineas. After about 1818 he confined himself to the latter class of art, but painted some subjects, into which he introduced portraits. In 1820, he exhibited 'Sunday Morning;' in 1823, 'The Shakespeare Jubilee,' with portraits of the principal Covent Garden performers; in 1825, 'The Barber Politician;' in 1828, 'The Sailor's Wedding;' and in 1836, his only other contribution, 'Taming the Shrew.' He died at Boulogne, in 1840. His art, which had a tendency to vulgarity, was well known by his engraved works: 'Sunday Morning,' 'The Sailor's Wedding,' 'Beeswing,' 'The Black Draught,' 'The Last Pinch,' 'Spoilt Child,' and others. He was a member of the Sketching Society.

SHARP, JOHN, *engraver.* Though his labours tended to advance his art, he never rose to much eminence. He died in 1768, and was buried at Chigwell, Essex.

SHARPE, EDMUND, M.A., F.R.I.B.A., *architect.* Was born at Knutsford, October 1809, and educated at St. John's College, Cambridge. He afterwards studied architecture for three years in France and Germany. On his return home he settled in Lancashire, and after some time withdrew from the practice of his profession to inform himself as to the history and principles of the art. He was one of the few systematic students of Gothic architecture, and the author of several works upon this branch of art, such as 'Architectural Parallels,' 'Rise and Progress of Decorated Window Tracery,' 'Seven periods of Gothic Architecture,' and 'Christian Architecture.' He died at Milan, May 8, 1877, in his 68th year.

SHARPE, JOHN, *medallist.* He held the office of graver to the Royal Mint, 1st Henry VIII.

• SHARPE, LOUISA (afterwards Mrs. Seyffarth), *water-colour painter.* Her name first appears in 1817 as an exhibitor of portrait drawings at the Royal Academy, and she continued an occasional exhibitor up to 1829, in which year she was elected a member of the Water-Colour Society. She then painted domestic subjects, and her art was much appreciated. Among her first contributions to the Society's exhibitions were 'The Wedding,' 'Juliet,' 'Brunetta,' from Addison, 1832; 'The Good Offer,' 1835; 'Constancy' and 'Inconstancy,' 1840; 'The Alarm in the Night,' 1841; and in 1842, 'The Fortune Teller.' In

1834 she married Dr. W. Seyffarth, of Dresden, and resided in that city till her death there, January 28, 1843.

SHARPE, Miss ELIZA, *water-colour painter.* Eldest sister of the above. She was an occasional exhibitor of portraits at the Royal Academy, from 1817 to 1829; and in the latter year she was elected a member of the Water-Colour Society. She was never a large contributor to the Society's exhibitions, seldom sending a second picture in the year. Her subjects were chiefly domestic, or some incident from the poets. In 1850 she was placed on the list of 'Honorary Members,' and in 1861 classed with the 'Associate Members,' and was an occasional exhibitor till her name was removed in 1870. In her last days she found some employment as a copyist in the Galleries of the South Kensington Museum. She died in Chelsea, June 11, 1874, aged 78 years.

SHARPLES, Mrs., *portrait painter.* She was the widow of an artist who practised with much repute in America, and painted the portraits of many eminent men of the time of the Rebellion. She resided some time at Bath; and was in London about 1807, and in that year exhibited at the Royal Academy miniatures of General Washington and Dr. Priestly, now in the National Portrait Gallery. She afterwards practised at Bristol, where she settled, and after a residence of some years, died, well advanced in years, in March 1849. Left alone in the world she bequeathed all her property to establish a Bristol Academy of Art, and erect an edifice to be devoted solely to artists; her legacy, with a previous donation, amounting to 4662l., was the means of founding a permanent art institution.

SHARPLES, Miss ROLINDA, *portrait painter.* Daughter of the above. She practised her art in Bristol. She exhibited at the Royal Academy in 1820; and in 1823 sent 'Rainham Ferry,' with portraits; and at the Suffolk Street Gallery, in 1832, 'The Trial of the Bristol Rioters,' an elaborate work, filled with small portraits. She was an honorary member of the Society. She died February 10, 1838, and left several of her father's portraits to the Bristol Society of Arts, which afterwards formed part of the institution to which her mother's property was bequeathed. Her brother, JAMES SHAPLES, was a portrait painter, and an exhibitor at the Royal Academy. He died at Bristol in 1839.

SHAW, WILLIAM, *architect.* He held the office of Master of the Works at Holyrood Palace, where there is a portrait of him. He died in 1602.

SHAW, JAMES, *animal painter.* Lived in Mortimer Street, Cavendish Square, where he built a room suitable for horses,

389

which he chiefly painted. He exhibited with the Society of Artists, 1761, 'Brood Mares,' and 'A Stallion,' and contributed to the first exhibition at the Royal Academy. He died about 1772.

SHAW, JAMES, *portrait painter.* Born at Wolverhampton. Was a pupil of Penny, R.A. He lived for some time in Charlotte Street, Rathbone Place, and practised as a portrait painter. He exhibited at the Royal Academy in 1776 and 1784, but did not attain celebrity. Died shortly after the latter year.

SHAW, JOHN, F.R.S., *architect.* He had considerable practice, and built the new Hall at Christ's Hospital, 1829, the new Church of St. Dunstan, near Temple Bar, and other important edifices. He was a member of the Royal Institute of British Architects. Died from a sudden affection of the heart July 30, 1832, aged 56.

SHAW, HENRY, F.S.A., *architectural draftsman.* Born in London, July 4, 1800. He developed an early taste for drawing, and found congenial employment in assisting John Britton in his 'Cathedral Antiquities of Great Britain.' The illustrations for Wells Cathedral, part of this great work, published in 1824, are chiefly by his hand; and he was also largely engaged upon the illustrations for Gloucester Cathedral, published in 1828. The following year he published a work of his own, drawn and engraved by himself, 'The Antiquities of Luton Chapel,' and then commenced his unrivalled series of illuminated works, the industrious labours of a long life. He published, in 1832, 'A Series of Details of Gothic Architecture,' followed by 'Illuminated Ornaments,' 'Specimens of Ancient Furniture,' 'Ancient Plate and Furniture,' 'Dresses and Decorations of the Middle Ages,' 1839; 'The Encyclopædia of Ornament,' 1842; 'Alphabets, Numerals, and Devices of the Middle Ages,' 1845; 'Decorative Arts of the Middle Ages,' 1851; 'The Handbook of Mediæval Alphabets,' 'Arms of the Colleges of Oxford,' 1855; 'Ornamental Tile Pavements,' 1858; with several other works of analogous character. The examples for these were selected with great knowledge and taste from the purest and best specimens; but the labour of 40 years met with no other reward than the gratification found in a cherished pursuit. He died June 12, 1873, aged 73.

⚬ SHEE, Sir MARTIN ARCHER, P.R.A., *portrait painter.* Was descended from an old Connaught family, and was born December 20, 1769, at Dublin, where his father, a well-educated man, was a merchant. In his boyhood he shewed a fondness for art, and was placed in the Dublin School of Design. His father dying soon after, he was taken in charge by a married aunt, whose partiality for him caused some words

with her husband, which, coming to his ears, he suddenly left the house penniless. He was able to find some employment in portrait painting, and continuing to work hard at his studies, he gained, in 1787, the chief medal in the Dublin School. In June, 1788, he came to London, and bringing a kind introduction from Burke as ' his little relative' to Reynolds, he was advised by him to enter the schools of the Royal Academy, which he did in 1790, though he thought himself beyond such instruction. He most earnestly employed his time and opportunities. He had, in 1789, exhibited two heads, and was employed both by Boydell and Macklin to make reduced copies of pictures for engraving, but though he does not appear to have found remuneration for his labours, he refused his aunt's help, and practised great self-denial.

In 1791 he exhibited his first whole-length at the Academy, and struggling on, he quietly gained a name and place in art. His earliest works were theatrical portraits. Lewis (an excellent full-length now in the National Gallery), Stephen Kemble, Pope, Fawcett, and others were painted by him in character. At this time he attempted an historical work, which, he says, cost him at intervals three years' thought and toil. His subject was 'The Daughter of Jephthah lamenting with her Companions,' exhibited in 1794. In 1798 he completed a large equestrian portrait, which added to his reputation, and in the following year was elected an associate, and in 1800 a full member, of the Academy. He then made a tour on the continent with Samuel Rogers the poet. Though his true art and occupation was in portraiture, he painted some subject works, but they did not add much to his reputation. These were 'Lavinia,' 'Belisarius,' his presentation picture, 'Prospero and Miranda.' Meanwhile he had established his reputation and his position. In 1796 he took a large house in Golden Square, and married, and in 1798 removed to Cavendish Square, where he painted a portrait of the Duke of Clarence, which was engraved.

His genius was not, however, confined to his pencil. Early in his career he had contributed a series of criticisms to a daily journal, and in 1805 gained a literary reputation by his 'Rhymes on Art,' of which he wrote a continuation in 1809 under the title of 'Elements of Art.' After several lesser literary works, chiefly connected with art and its interest, he wrote 'Alasco, a Tragedy,' which was withdrawn from the stage in consequence of some excisions insisted upon by the licenser of plays, but was printed in 1823, with, an angry preface appealing to the public, and, though coldly received, the copyright is said to have brought him 500*l.* In 1829 he published

anonymously 'Old Court,' a novel in three volumes, which attracted little attention.

He had gained the esteem of the public and of his profession. A man of many talents, good breeding, gentlemanly manner, of business habits, an orator able to express himself well on all occasions, he was, on a vacancy in 1830, elected to the office of president of the Academy, and received the honour of knighthood. He did not, however, receive the same lucrative commissions which had been enjoyed by his predecessors, while his office and ostensible position entailed much expense and a great devotion of his time. His presidency had also fallen in troubled times. He had to maintain, against much opposition, the privileges the Academy had so long enjoyed in the possession of their rooms at Somerset House, and shewed great judgment and ability in the defence of the Academy and of the interests of art, in the widest sense, in his examination before a Parliamentary committee in 1836, most successfully replying to the attacks of the assailants of the Academy.

Among his later works he painted, in 1834-35, the portraits of William IV. and Queen Adelaide, which are now at Windsor Castle ; and in 1842 a portrait of Queen Victoria for the Royal Academy. In 1845 an illness, from which he had some time suffered, increased, and he tendered the resignation of his office of president. But on the unanimous solicitation of the Academy he withdrew it, and at the same time accepted a yearly allowance of 300l. voted to him, to assist him duly to maintain the office, which had much encroached on his means ; and to this, 200l. a year was added from the pension list by the Queen, with reversion to his daughters. His health, however, gradually declined, and his death, accelerated by the sudden death of his wife, took place at Brighton, August 19, 1850. He was of the Roman Catholic faith, and was, at his own request, buried in the Brighton Cemetery. His life was published in 1860 by one of his sons.

In his early portraits he shewed much ability, clever, easy action, good drawing and individuality of character, but with a tendency to redness in his flesh tints, which increased in his later works. As he advanced in art, he departed from the sharper and more forcible execution which marked his first portraits, and fell into a method of giving the flesh a soft, unnatural smoothness—an over-laboured appearance—and did not fulfil in his later the promise of his earlier years. He was, however, a zealous supporter of the interests of the art and artists of his country, and will be always remembered with sincere respect.

SHELLEY, SAMUEL, miniature painter. He was born in Whitechapel, about 1750. He gained a Society of Arts' premium in 1770, and was in a great measure self-instructed in art, copying much from Reynolds, upon whom he is reputed to have found his style. He first appears as an exhibitor at the Royal Academy in 1774, when he was living in Whitechapel, and was for several years a constant contributor. He worked hard to improve his art, and raised himself to celebrity. He was distinguished for his miniatures, especially of females, they display great finish, taste and elegance, are often treated allegorically and powerfully coloured, though a grey tone predominates. He was one of the original members of the Water-Colour Society, which was planned and founded in his house, and at the first exhibition in 1805, it will give some idea of his art to say that he exhibited, together with miniature portraits, 'Psyche,' 'Nymphs feeding Pegasus,' 'Cupid turned Watchman,' Love's Complaint to Time,' 'Cupid solicits New Wings,' and some other ; and in the three following years was a large contributor of works of the same character. He made some designs, which are defective in drawing, for book illustration, and engraved some of his own works ; and J. R. Smith, Caroline Watson, Bartolozzi and Ryder engraved after him. He died in George Street, Hanover Square, December 22, 1808.

SHENTON, HENRY CHAWNER, engraver. Was born at Winchester in 1803, and was a pupil of Charles Warren, whose daughter he married. He practised in the line manner, produced a number of fine works, and was greatly distinguished. Among his more important works are 'The Stray Kitten,' after Collins, R.A.; 'The Loan of a Bite,' Mulready, R.A. ; 'Country Cousins,' Redgrave, R.A. ; some good plates for Finden's Gallery of British Art, and the Annuals ; and an excellent engraving after Cross of 'Richard Cœur de Lion,' for the Art Union. He died suddenly in Camden Town, September 15, 1866, but had not, owing to the failure of his sight, practised his profession for some time previous to his death.

SHENTON, HENRY CHAWNER, sculptor. Was the eldest son of the foregoing, and the nephew of Luke Clennell. He was a pupil of Behnes, and in his 18th year was admitted a student of the Royal Academy. He studied for a time in Rome, and completed three very ambitious groups. At the Westminster Hall Competition he contributed a colossal group of the 'Burial of the Princes in the Tower,' and to the Royal Academy in 1843, his 'Christ and Mary.' He also modelled a statue of Archbishop Cranner, and was engaged upon a model of the Crucifixion, the act of nailing Christ to the Cross, when he died, after a few days' illness, February 7, 1846. His son, WILLIAM

KERNOT SHENTON, born in June, 1836, was also a sculptor. His ability was only moderate. He died in 1877.

SHEPHARD, WILLIAM, *portrait painter*. Practised in the reign of Charles II. There is by him a good portrait of Thomas Killigrew, the jester, with his dog, well introduced, in the possession of Sir J. Buller East, Bart. It is brilliant in colour, well but freely drawn, and an original composition. This portrait, and another by him, are well engraved by Faithorne. Little is known of him. Walpole says he retired to Yorkshire, where he died. Francis Barlow was his pupil.

SHEPHEARD, GEORGE, *water-colour painter*. He was of a family long known in Herefordshire. He commenced the study of art in the schools of the Royal Academy, and from 1811 to 1830 was an occasional contributor to the Academy exhibitions. He painted chiefly the landscape scenery of Surrey and Sussex, with one or two subject pictures.

SHEPHEARD, GEORGE WALLWYN, *water-colour painter*. Eldest son of the above. He was born in 1804, and was originally intended for the law, but was led to the study of art ; and travelled, sketch-book in hand, through France, Germany, and Italy, in 1838, while staying in Florence, married an Italian lady. From 1830 to 1851 he was an exhibitor of landscape views and studies at the Royal Academy. He died in 1852. His brother, LEWIS H. SHEPHEARD, also an artist, published in 1873, 16 of his sketches, in pencil and sepia, reproduced by the autotype process.

SHEPHERD, GEORGE, *engraver*. Was born about 1760. He practised his art during many years in London. Engraved 'Lady Hamilton's Attitudes,' in 15 plates ; 'The Fleecy Charge,' after G. Morland, and many portraits, which he etched and finished in mezzo-tint.

SHEPHERD, ROBERT, *engraver*. Supposed to have been a pupil of David Loggan, from whose drawings he sometimes engraved. He practised at the commencement of the latter half of the 17th century. His best works are portraits. He made a reduced, but poor, copy of 'Alexander's Battles,' from the engravings of Gerard Audran. His works were in the line manner, laboured and careful.

SHEPHERD, GEORGE SIDNEY, *water-colour painter*. He was from about 1821 an exhibitor at the Royal Academy, contributing chiefly views in Devonshire. Later he exhibited views of Metropolitan buildings—in 1830, 'Old Covent Garden Market ;' in 1831, 'The Zoological Gardens ;' in 1835, 'Old London Bridge.' He was in 1833 elected a member of the New Society of Painters in Water-Colours, and was from

.392

time to time an exhibitor up to 1860, when his name disappears. His drawings were well-coloured, and possessed much artistic merit.

SHERIDAN, J., *portrait painter*. Was born in the county of Kilkenny. He studied in the Dublin Academy, but came to London to practice before he had qualified himself for success by sufficient study, and from 1785 to 1789 exhibited a portrait yearly at the Royal Academy. With such help as his friends could give him he struggled hard to succeed, but borne down by his late troubles, he died in London in 1790.

SHERIFF, WILLIAM CRAIG, *subject painter*. He was born near Haddington, October 26, 1786, and studied in the Trustees' Academy, Edinburgh. He was deemed of great promise, and had commenced a clever picture of 'The Escape of Queen Mary at Lochleven,' when he was seized with rapid decline, and, just living to complete his work, died March 17, 1805, at the early age of 19. His work was engraved by W. H. Lizars.

SHERLOCK, WILLIAM, *portrait painter and engraver*. Was born about 1738, at Dublin, the son of a prize-fighter. In 1759 he was a student in the St. Martin's Lane Academy, London, and the same year gained a premium at the Society of Arts. He was afterwards a pupil of Le Bas in Paris. He exhibited portraits, small whole-lengths, and miniatures, painted both in oil and in water-colours, with the Incorporated Society of Artists (of which body he was one of the Directors), from 1764 to 1777, and at the Royal Academy from 1802 to 1806. His principal engraved works are the portrait heads for Smollett's History of England, but there are also some landscapes engraved by him. There was another artist of the same family and the same name who exhibited miniatures at the Academy in 1803.

SHERLOCK, WILLIAM P., *topographical draftsman*. He was born about 1780, and was an occasional exhibitor of views at the Royal Academy, chiefly architectural, from 1796 to 1810, and drew many of the illustrations for Dickinson's 'Antiquities of Nottinghamshire,' 1801-6 ; and published, 1811, 24 soft-ground etchings after drawings by Girtin, Payne, Powell, and others ; he also engraved in the stipple manner some copies of small size of some rare portrait plates. He was a great imitator of the landscapes of Richard Wilson, R.A., and many of his works have been sold as originals by this master.

SHERRIFF, CHARLES, *miniature painter*. He practised in Edinburgh, and came to London in 1773, first exhibited at the Royal Academy in 1771, and continued to contribute his miniature portraits and groups for several years, attaining a high

rank among the miniature painters of his day. Mrs. Siddons spoke of him in her correspondence in 1785 'as more successful in her portrait than any miniature painter she had sat to.' He was deaf and dumb, and in 1796, and up to 1800, was living at Bath. He is believed to have afterwards visited India to follow his profession there.

SHERWIN, WILLIAM, *engraver.* Was born at Wellington, Shropshire, about 1650, the son of a clergyman. He engraved portraits, many of them from his own drawings. His earliest work is dated 1670, and he continued to practice till 1711, and died within three or four years after. He was one of the early mezzo-tintists, and left a few indifferent plates in that manner, not reaching any excellence in either branch of his art. He is said to have had the office of engraver to the King conferred upon him by patent, a very unusual distinction.

SHERWIN, JOHN KEYSE, *engraver and history painter.* Was born at Eastdean, in Sussex, the son of a labourer, and was himself, as a lad, employed as a wood-cutter on the estate of Mr. Mitford, near Petworth. Showing a great imitative power of drawing, he gained a medal at the Society of Arts in 1769, and was then sent to London and placed under John Astley, and after some time under Bartolozzi, with whom he served three years. He was admitted a student in the Royal Academy, and, after gaining a silver medal, carried off, in 1772, the gold medal for his original painting of 'Coriolanus taking Leave of his Family.' His name from this time appears in the Academy as an exhibitor of drawings in chalk, some of which attracted much notice, and his genius soon raised him from very limited means to comparative affluence, and rendered him careless and indolent. He was rapid and slight in his manner, of great assurance, and tempted by his vanity to try works above his power. His 'Deserted Village,' into which the portraits of his family are introduced, and 'Siege of Gibraltar,' were very poor performances; but his 'Installation of the Knights of St. Patrick,' fifty or sixty feet long, so far as it was carried, was an absolute failure.

It is as an engraver that he will rank high among our artists. His line was good, the treatment well studied, and his textures well rendered. His 'Christ bearing the Cross,' after Murillo; 'Christ appearing to Mary Magdalen,' and some of his portraits, possess very great merits; while his engravings from his own works are meagre in style and mannered. Of this, his 'Finding of Moses,' in which the portraits of the Princess Royal and of several ladies of rank who sat to him are introduced, is an example; while, as his own composition, it is devoid of all historic character and feeling. In addition to his works after the old

masters, he engraved after Gainsborough, Edge Pine, Dance, and Angelica Kauffman. He also made some water-colour drawings. He held the appointment of engraver to George III. and the Prince of Wales.

His talent and his speculations should have turned to his advantage, but he had no prudence, and he so ill-used the gifts of fortune, that he ruined his constitution, disgusted his friends, and so embarrassed his circumstances, that he took refuge in the house of a print-seller on Cornhill, afraid to appear abroad, and forced to the drudgery of daily labour. Broken in health and fortune, he died, forlorn and comfortless, in a poor lodging at a public-house in Oxford Street, on September 24, 1790, aged 39.

SHIELS, WILLIAM, R.S.A., *animal and subject painter.* Was a native of Berwickshire, and practised in Edinburgh. He was a member of the Scottish Academy, and was an occasional exhibitor at the Royal Academy in London. In 1813 he sent 'The Gipsies' and 'A Friendly Visit;' in 1814, 'A Courtship;' and was not again a contributor till 1851, when he exhibited 'The Interior of a Scotch Fisherman's Cottage;' and in the following year, 'Preparing for a Visitor.' But he was best known as an animal painter. He died August 27, 1857, aged 72.

SHIERCLIFFE, EDWARD, *miniature painter.* He practised at Bristol about the latter part of the 18th century. His works were delicately and well finished. He was living in 1776.

● SHIPLEY, WILLIAM, *portrait and landscape painter.* Was originally a drawing-master at Northampton, and afterwards in London. He studied portrait painting under C. Philips, and there is a mezzo-tint by Faber of a painting with the name of Shipley as the painter. But he is better known as the founder of the St. Martin's Lane Academy, known as 'Shipley's School,' where the best artists of a whole generation studied. He also planned and originated the Society of Arts. He died at Manchester, in December, 1803, aged 89. He was brother to Dr. Jonathan Shipley, Bishop of St. Asaph.

SHIPLEY, Miss GEORGINA, *amateur.* Was daughter of the Bishop of St. Asaph, and niece of the foregoing. Miss Burney, writing to a friend, says of her, in 1782, 'She is very much accomplished, and her fame for painting and for scholarship I know you are well acquainted with;' but she describes her as full of herself, eager for notice and conceited. She was an honorary exhibitor at the Royal Academy in 1781: 'Portrait of a Lady and Two Children.' In Hare's Memorial of a 'Quiet Life,' it says of her, 'Her extraordinary artistic talents were cultivated under the eye of

SHI

SIE

Sir J. Reynolds, who, when they were in London, was almost a daily visitor at her father's house.' She married Francis Hare Naylor, who inherited the old mansion and estate at Hurstmonceux. She lived many years abroad, devoted to the education of her children, who afterwards became distinguished in literature. She died in 1806.

SHIPSTER, Robert, *engraver.* Was a pupil of Bartolozzi. He engraved for Macklin's Bible West's 'Witch of Endor,' a very creditable work in the line manner, tolerably drawn, but wanting in power.

SHORT, R., *draftsman and painter.* Practised in the middle of the 18th century, painting military scenes and shipping. Boydell published twelve plates of naval engagements between French and Spanish vessels engraved after him by Caroline Watson.

SHUTE, John, *painter and architect.* Born at Collumpton, Devon. He is reported to have practised before Hilliard, and brought miniature limnings in books to rare perfection. He was patronised by the Duke of Northumberland, and was sent by him to Italy, in 1550, to improve himself in architecture, and at Rome he studied under the best architects. Died September 25, 1563. He published, in 1563, 'The First and Chief Groundes of Architecture,' with illustrations on wood, and styles himself 'painter and architecte.' He is mentioned also by Heydock in his translation of 'Lomazzo on Painting,' published 1598.

SHUTER, Thomas, *portrait painter.* Practised early in the 18th century. There is a full-length portrait by him at Westwood Park, Droitwich, signed and dated 1725. It is in the semi-Roman style of that time, and is reputed to have more of pretence than merit.

SIBELIUS, M., *engraver.* Born at Amsterdam. He practised after the manner of Houbraken, and came to this country, where he was much employed by Sir Joseph Banks, and was eminently truthful in his botanical illustrations. He died in Lisle Street, Leicester Square, February 11, 1785.

SIBSON, Thomas, *subject painter.* Was born in Cumberland, the son of a yeoman, in March, 1817. He was sent to Manchester to commence life in an uncle's counting-house, but, preferring the uncertainty of an artist's career, he came to London in 1838, and issued an etched work called 'Scenes in Life,' which was extravagant in design and drawing, and had no success. After some other attempts he went to Edinburgh, where he found some employment as a book designer. In 1842 he made his way to Munich to study, and worked for a short time under Kaulbach, but his health suffered, and he returned to England. He proposed to winter in Italy, but died at Malta, November 28, 1844.

394

SIDDONS, Mrs. Sarah, *amateur.* Born July 14, 1755. The eminent tragic actress. She had much taste as a modeller. She exhibited a bust of Adam from the 'Paradise Lost' at the Royal Academy in 1802. At the Garrick Club there is a bust by her of herself, and another of her brother. Died June 8, 1831.

SIEVIER, Robert William, *engraver and sculptor.* He was born in London, July 24, 1794, and showed a precocious talent for drawing. In 1812 he was awarded the Society of Arts' silver medal for a pen and ink drawing; and, designed for an engraver, he was placed as a pupil with John Young, and subsequently with Edward Scriven, and was, in 1818, admitted a student of the Royal Academy. He early practised as an engraver, and produced many good works, chiefly in the dot manner—a portrait of Lord Ellenborough, after Lawrence, P.R.A.; Lady Jane Grey, after Holbein, 1822; Mr. Coutts, after Beechey, R.A.; 'The Importunate Author,' after Newton, R.A., and several plates after Etty, R.A. He had at the same time practised modelling for his improvement in the figure, and had also studied anatomy under Mr. Brookes, the well-known anatomical lecturer.

His last works as an engraver precede 1823, and his studies and tastes then led him gradually to sculpture. His first attempt was a bust of his father; in 1824 Lord Chancellor Eldon sat to him, and rapidly improving, his great facility of seizing the likeness and characteristic expression of his sitters led many persons of distinction to his studio. He exhibited several of his busts at the Royal Academy. In 1842 the Prince Consort, and the late King of Prussia, both sat to him. Among his works were also the busts of the Persian Ambassador and Lord Brougham, from whom, to save him the time of sitting, he took a plaster mask of the face; the Earl and Countess of Sheffield, with several other eminent persons. In the Soane Museum there is a bust by him of Lawrence, P.R.A. But his art was not limited to busts. He executed in alto relievo a fine colossal figure of Christ; the monument to the chapel at Windsor to the Earl of Harcourt, the pedestal representing in alto relievo four of his military achievements; a statue of Dr. Jenner in Gloucester Cathedral; 'Affection,' a group exhibited at the Academy in 1828; and in 1829, a 'Girl with a Lamb;' also 'Musidora;' a 'Sleeping Bacchante;' a 'Boy with a Tortoise.' There is also by him a statue of Charles Dibdin at Greenwich Hospital; a fine monument to St. John Long in the Kensal Green Cemetery; a statue of Sir William Curtis at the Foundling Hospital; and some good monumental tablets introducing

figures at St. John's Church, Upper Holloway.

Of an active inventive mind, he had succeeded in two very separate branches of art, when his thoughts were turned into a new direction. He was well versed in subjects of a scientific character, and had established a spacious laboratory with valuable apparatus ; and distinguished also by his manners and power of conversation, he was, in 1840, elected a Fellow of the Royal Society. In his latter career, absorbed in scientific and mechanical pursuits, to the neglect of art, he built a large manufactory for the production of elastic fabrics, made great improvements in the manufacture of carpets, was associated with the original India-rubber works, and rendered good early service in electric telegraphy. He resided many years at Henrietta Street, Cavendish Square, where he had built a studio, and had also a house at Upper Holloway, where his manufacturing inventions were carried on. He died April 28, 1865, and was buried in the Kensal Green Cemetery.

SILLETT, JAMES, *miniature and flower painter.* Was born at Norwich in 1764, and commenced life as an ornamental and herald painter. He then came to London, and from 1787 to 1790 studied at the Royal Academy. He was an exhibitor in 1796, and continued to exhibit occasionally for nearly 40 years. He chiefly excelled in miniature, but he painted still-life, fruit and flowers both in oil and water-colours, and was also for a time employed in the scene room of both Drury Lane and Covent Garden Theatres. About 1804 he went to King's Lynn, and while there drew the views for Richards's 'History of Lynn.' In 1810 he returned to settle in Norwich as a painter of still-life, and died there May 6, 1840.

SIMMONS, JOHN, *portrait painter.* Born at Nailsea, Somersetshire, about 1715. He was well known both as a painter of history and portraits. The altar-piece at All Saints', Bristol, and at St. John's, Devizes, are by him. He was an exhibitor of portraits at the Royal Academy in 1769–72-76. Many of his portraits are engraved. He carried on the business of a house and ship-painter at Bristol, and died there January 18, 1780.

SIMON, JEAN, *engraver.* Born in Normandy, 1675. He was of an artist family, who belonged to the Protestant Church at Charenton, near Paris, where he studied his art, and engraved some good plates in the line manner. A refugee, he came to London, and settled. He tried mezzo-tint, made some improvement in the method of working, and produced some good plates, which have also the merit of a correct imitation of the originals. On Kneller's disagreement with John Smith, Simon was

employed by him to mezzo-tint his portraits, which he did with much success ; and also worked after Dahl, Hoare, Thomas Murray, Van Loo, and others. He engraved several historical subjects after the old masters, including some from the cartoons. He died in London about 1755. His collection of prints was sold by auction, November 3, 1761.

SIMON, PETER J., *engraver.* Born some time before 1750. He practised his art in London for many years, following the dot manner. He was early engaged upon Worlidge's 'Antique Gems,' published 1768, and engraved many of the plates for Boydell's 'Shakespeare Gallery,' and other works after the principal contemporary artists of the English school. He died about 1810.

SIMON, THOMAS, *medallist.* Was born in Guernsey. His genius led him to art, and he became a pupil of Briot, a French artist, who was employed by Charles I., both in the English and Scotch mints. Simon assisted him in the latter, in 1633, upon dies both for medals and the coinage. In the same year he engraved the seal for the high admiral, on which a ship in full sail formed part of the composition. In 1646 he succeeded Briot as chief medallist at the London Mint, and engraved many medals for Charles I., and afterwards, for Cromwell, who appointed him chief engraver. The Great Seal, and the dies for crowns, half-crowns, and shillings during the Commonwealth are by him, and many of his best works were executed at that time. On the Restoration he was thrown into prison, and there executed a fine crown-piece of Charles II., on the margin of which he engraved a petition to the king. This fine work gained him not only his liberty, but his office of chief medallist. An impression of this celebrated coin, known as 'The Petition Crown,' was sold by auction, in 1832, for 225*l.* ; his fifty-shilling piece of Oliver Cromwell, in 1874, for 43*l.* He was compelled to give place to the brothers Roettiers, in 1663, but he was certainly employed in the following year, and is supposed by Vertue and others to have died, some say of the plague, about 1665, it seems probable, at his official house in the Tower. Samuel Pegge, in a letter to the 'Gentleman's Magazine,' Vol. 58, supposes him to have been living in 1674, and says that, 'in his latter days he used to stroll about from place to place, in a long coat, with a long staff, and a long beard,' a statement which appears rather to belong to his brother Abraham, the facts of whose life have in other instances been confounded with his. He was a great artist ; he drew well ; his reliefs are low and broad ; his manner of treating the hair beautiful, and rarely excelled by any other medallist.

395

Vertue drew and engraved his 'Medals, Coins, and Great Seals,' 1753.

SIMON, ABRAHAM, *medallist and modeller.* Elder brother of the foregoing, to whom he was some time an assistant. He was born in Yorkshire, and intended for the church, but turned to art. He practised in the reign of Charles II., and excelled in his portrait models in wax. He went to Sweden, on the invitation of the Court, and accompanied Queen Christina to Paris, from whence he went to Holland, and returned to England. He modelled, in wax, Charles II.'s portrait for the medal of the proposed order of the Royal Oak. The king was greatly pleased with his work, and presented him with 100 guineas, and the Duke of York then sat to him, and asking the price of his work, was told that the king had paid 100 guineas for the same. The duke thought that 40 guineas would be enough, to which Simon replied, by squeezing the soft model into a shapeless lump, highly offending the Duke. It is said this proud temper marred his prospects. He lost the Court favour, and with that his employment; became slovenly and careless, eccentric and cynical, wearing a long beard, and died in obscurity soon after the Revolution. He had continued to wear the dress which prevailed in Charles I.'s reign. There is a portrait of him engraved by Blooteling.

SIMONS (or SYMONDS), RUDOLPH, *architect.* Practised in London about the middle of the 16th century, and was considered one of the most skilful architects of his day. Among his works are Emmanuel College and Sidney Sussex College (1596-8). In the master's house at the latter there is a fine portrait of him. He made also some additions to Trinity College.

SIMPSON, ARCHIBALD, *architect.* Was born at Aberdeen, and educated at the Marischal College. He was placed under an architect in London, and then visited Italy to complete his studies. On his return he settled at Aberdeen, and had an extensive practice. He erected several public buildings—the Church at Elgin, a bridge across the Spey, and some fine mansions in Aberdeenshire and the adjacent counties. He also built part of Gordon Castle. He died at Aberdeen in 1847, in his 59th year.

SIMPSON, FRANCIS, *amateur.* Filled the offices of alderman and mayor of Stamford, and was known by his skill as a draftsman. He made many drawings in water-colours, and published from his drawings a volume of Baptismal Fonts and the West Front of Croyland Abbey. He died at Stamford, July 29, 1861, aged 65.

SIMPSON, JOHN, *portrait painter*. He was born in London, in 1782, and studied in the schools of the Royal Aca-
396

demy. For many years he was an assistant to Sir Thomas Lawrence, and from 1807 was an exhibitor, and later a large contributor of portraits to the Academy. In 1834 he went to Lisbon, and was appointed painter to the Queen of Portugal. His art was confined to portraiture. He exhibited for the last time in 1845, and died in Carlisle House, Soho, in 1847. He drew the head and hands carefully, but his work, though not without character, is weak. He painted William IV. and some other distinguished persons.

SIMPSON, PHILIP, *portrait painter.* Son of the foregoing. He studied in the schools of the Royal Academy, and was brought up to art. He painted in 1824, 'I will fight,' which was exhibited at Suffolk Street, was engraved, and is now in the South Kensington Museum. His chief subject pictures exhibited at the Academy were, 'The Young Piper,' 1829; 'Boys with a Monkey,' 1830; and in 1836, 'Girl and Boy with a Parrot,' his last contribution. His brother, CHARLES SIMPSON, who died young, in 1848, was also brought up as an artist, and was an exhibitor on one or two occasions at the Academy.

SIMPSON, JOSEPH, *engraver.* Practised in the reign of Queen Anne. He began life as an engraver on plate, and gaining some knowledge at the Artists' Drawing Academy, he was employed by Tillemans on a plate of his picture of New-market, which helped to make him known in a better rank of art. He also engraved after Wootton and Wyke, and his works are chiefly hunting subjects. There is also by him a series of six mezzo-tints, after Monamy and Vandevelde, printed in green, and some plates after his own designs.

SIMPSON, JOSEPH, *engraver.* Son of the foregoing. He was brought up to his father's profession. He completed a good plate of a 'Holy Family,' after Filippo Lauri, in 1728; and a portrait of Charles I., on a white horse, after Vandyck, 1731, and was deemed of much promise, but he died young, in 1736.

SIMPSON, MATTHEW, *painter.* Was drawing-master to the children of Charles I., and afterwards went to Sweden. There is a miniature by him of Charles I., signed M. S.

SIMPSON, WILLIAM, *engraver.* Practised towards the middle of the 17th century, and was chiefly employed by the booksellers. He engraved the plates for an edition of 'Quarles' Emblems.'

SIMSON, GEORGE, R.S.A., *portrait painter.* Born at Dundee in 1791. Brought up a printer, he did not attempt art till his 30th year. He was early elected a member of the Scottish Academy, and was for many years a contributor to the exhibitions, sending portraits, with sometimes a

subject picture, or a landscape. He died, in Edinburgh in 1862.

SIMSON, WILLIAM, R.S.A., *portrait and subject painter*. Brother of the above. Was born at Dundee in 1800, and studied at the Trustees' Academy, Edinburgh. He commenced with small coast scenes, and for the first ten years of his career he painted pictures sketched on the sands of Leith and the shores of Fife, which found a ready sale. In 1829 he made a higher effort, and painted 'The Twelfth of August,' followed by 'Highland Deer Stalkers,' and 'Sportsmen Regaling.' In 1830 he was chosen a member of the newly-founded Royal Scottish Academy, and then for three or four years tried portrait painting, and was, by his savings, enabled to visit Italy for his improvement. Returning in 1838 he settled in London, and exhibited his 'Camaldolese Monk,' and 'Cimabue and Giotto,' and the next year, at the British Institution, his 'Dutch Family,' and at the Academy 'Columbus and his Child at the Convent of Santa Maria di Rabida,' which gained him much notice; but his subsequent works did not maintain the expectation which these pictures had raised. He fell into ill-health, and died in Sloane Street, August 29, 1847. His works showed much vigour, powerful in colour and light and shade.

SIMSON, DAVID, R.S.A., *landscape painter*. Was born at Dundee, and was the youngest of the three brothers who all distinguished themselves in art. He was a member of the Royal Scottish Academy, and died in Edinburgh, March 29, 1874.

SINGLETON, JOSEPH, *miniature painter*. First appears as an exhibitor at the Royal Academy in 1773, and continued to contribute up to 1784. He exhibited portraits, and also, in miniature, 'A Holy Family,' a 'Little Bacchus.'

SINGLETON, WILLIAM, *miniature painter*. He practised in London, and was, from 1779 to 1791, an occasional exhibitor of miniature portraits at the Royal Academy.

SINGLETON, HENRY, *history painter*. Was born in London, October 19, 1766, and his father dying while he was a child, he was assisted by his uncle, the above William Singleton, with whom he resided for many years at the commencement of his career. He showed early indications of genius, exhibited at the Spring Gardens' exhibitions as 'Master H. Singleton, aged ten years,' 'a Soldier Returned to his Family,' drawn with the pen, and gained admission to the schools of the Royal Academy. At the age of 18 he gained the first silver medal, and, in 1788, for his original painting from Dryden's 'Ode,' the gold medal. In 1793 he painted, on commission, a portrait group of the Royal Academicians assembled in Council, an important work, now in the possession of the Academy. He occasionally painted portraits. He first exhibited at the Academy in 1784, and contributed constantly to his death. He put his name down for election as associate for the first time in 1807, and, indignant at his rejection, did not again become a candidate. He was largely employed as an illustrator of books, for which he was well suited, by his fertile pencil and ready invention. Towards the end of his life he completed a series of small-sized pictures from Shakespeare. He lived in Charles Street, St. James', was in easy circumstances, and of moderate, industrious habits. He died at the house of a friend, in Kensington Gore, September 15, 1839, and was buried in the vaults of St. Martin's Church. His works were mannered, but showed great talent and refinement. There are engravings after him by Gillbank, J. Daniel, Scott, A. Cardon, and many others. Miss SARAH M. SINGLETON, apparently his sister, resided with him for some time, and was, from about 1790 to 1820, an exhibitor of miniature portraits at the Academy.

SISSON, ——, *portrait painter*. Born in Ireland, where he practised both in oil and miniature. Mr. Burke mentions having sat to him for a miniature. He died some time before 1774.

SKELTON, WILLIAM, *engraver*. Descended from an old Cumberland family. He was born in London, June 14, 1763, and was for some time pupil to James Basire, sen., and afterwards to William Sharp. He also studied in the schools of the Royal Academy. He distinguished himself by his engraving in the line manner and early found employment. He was engaged on the specimens of ancient sculpture for the British Museum, and by the Dilettanti Society, for which he executed some of his best works. He also engraved in the dot manner for Boydell's 'Shakespeare.' Later he engraved and published on his own account a series of royal portraits of the family of George III., which was very popular and had a large sale. From this work and his other labours he realised a competence, and retired to Ebury Street, Pimlico, where he died August 13, 1848, leaving an only daughter, who had lived with him for half a century. He was buried in Brompton cemetery.

SKELTON, JOSEPH, *engraver*. Younger brother of the above. He studied in London, engraved for 'Cantabrigia Depicta,' published 1809, and for 'Oxonia Illustrata,' 'Pietas Oxoniensis,' and 'The Antiquities of Oxfordshire.' He also engraved a series of 154 etchings of the collection of armour at Goodrich Court, 1823. He went to France for a time, and was employed in engraving the collection at the Versailles

Gallery then publishing in Paris. He afterwards published himself, ' Le Château d'Eu Illustré.'

SKILLINGTON, ——, *architect*. He practised in the 16th century, and built Kenilworth, in 1575, for the Earl of Leicester.

SKILLMAN, WILLIAM, *engraver*. Practised in the reign of Charles II. There is an engraving by him of the façade of Albemarle House, and of the Banqueting House, Whitehall.

SKIPPE, JOHN, *amateur*. He was a native of Ledbury, Herefordshire. He published, between 1770 and 1812, several chiaroscuro wood engravings, after drawings by Parmigiano, Correggio, Raphael, and other masters of the Italian School. They were printed with three or four blocks, and were the first which had been attempted in this manner since John B. Jackson's work in 1754, to which they were much superior. He sketched with much vigour in bistre landscape compositions and sacred subjects; his figures were fairly drawn, and well composed.

SKIRVING, ARCHIBALD, *miniature painter*. He was born in Haddingtonshire in 1749, and studied at Rome in 1794. He practised some time in London, confining himself to miniatures in water-colour and crayon portraits. His miniatures are excellent for their drawing, colour, and admirable expression. He possessed great taste, was ingenious, eccentric, and aspired to wit. He died in 1819.

SLATER, JOSEPH, *landscape painter*. Practised in the reign of George II. Painted landscapes, introducing architecture and figures. He executed some ornamental ceilings, and other works in fresco at Stowe and Mereworth.

SLATER, J. W., *miniature painter*. He went early in life to Ireland, and practised in Dublin, where his works were well esteemed, about 1770. He then came to London, and in 1786–87 was an exhibitor at the Royal Academy. He was a good miniaturist.

SLATER, T., *engraver*. Practised in the reign of Charles I. There is a portrait head by him, but little is known of his works.

SLATER, WILLIAM, *architect*. He was brought up to his profession under an architect of some local repute, and distinguished himself by his many church restorations in Northamptonshire — the fine early Saxon churches at Kingsthorpe, Brixworth, Scaldwell, Pitsford, Burton Latimer, Cransley, and Higham Ferrers. He was also employed in Scotland and in Ireland, and repaired the old mansion of Holdenby. He died about the end of 1872, and was buried at Hazelbeach, where his family had possessed considerable landed property.
398

SLAUGHTER,¡ STEPHEN, *portrait painter*. He was some time in Ireland; practised there between 1730–40, and his works are frequently met with in the old mansions. He was appointed keeper of the King's pictures in succession to Parry Walton's son. He retired to Kensington, and died there May 15, 1765. His portraits possessed some merit for colour, but were black and heavy in the shadows. His sister had some repute for her drawings.

SLEAP, JOSEPH AXE, *water-colour painter*. Was born in London, May 30, 1808. His drawings prove him to have been an artist of some ability, but he does not appear to have exhibited his works at any of the London Galleries; nor does he seem to have succeeded in a pecuniary sense, for on his death, October 16, 1859, his widow was left in distress.

SLOANE, MICHAEL, *engraver*. Was a pupil of Bartolozzi, and practised up to the beginning of the 19th century, working in the dot manner. He engraved Correggio's celebrated ' Notte;' 'The Christening,' after Wheatley, R.A., and other works.

SMALLWOOD, WILLIAM FROME, *architectural draftsman*. Was born June 24, 1806, the son of a hotel-keeper in Covent Garden. He was a pupil of Cottingham; was several times on the continent, and made a number of clever sketches, some of which he exhibited at the Royal Academy, and at the Suffolk Street exhibition. Many of his drawings were engraved for the ' Penny Magazine.' He died of brain fever April 22, 1834.

SMART, JOHN, *miniature painter*. He was born about 1740, and in 1755 received a premium for a head in chalk from the Society of Arts. He was a pupil of Daniel Dodd, and a fellow-student with Cosway in the St. Martin's Lane drawing school. He was a member of the Incorporated Society of Artists, exhibited with them miniature and crayon portraits at the Spring Gardens' Rooms in 1762–63–64, and occasionally to 1783, and became one of the Society's vice-presidents. He went about this time to Ipswich, from whence he sent to the exhibition of the Royal Academy miniatures, and occasionally an oil portrait, up to 1788. In that year he went to Madras, and afterwards, it is believed, to Calcutta and Lucknow, and met with great encouragement and success. He remained about five years in India, and on his return, was an occasional exhibitor at the Academy till his death. His miniatures usually bear the signature 'J. S.' They are well drawn, and distinguished by great delicacy, both of minute finish and colour, and are highly esteemed. He died in Russell Place, Fitzroy Square, May 1, 1811, in his 70th year. His son, JOHN SMART, exhibited miniatures at the Aca-

Sleigh. Wm Morrell = Painter

demy in 1800 and 1808; died at Madras in 1809. Another son, also an artist, committed suicide in 1856.

SMART, SAMUEL PAUL, *miniature painter.* He resided in the east of London, and from 1769 to 1787 was a constant exhibitor of miniature portraits at the Royal Academy.

SMIBERT, JOHN, *portrait painter.* Was born in Edinburgh in 1684, and served an apprenticeship to a house-painter there. On its completion he came to London to better his fortune, and for his subsistence worked as a coach-painter, at the same time copying pictures for the dealers, and improving himself in drawing. He studied a time in Sir James Thornhill's Academy, and then managed to visit Italy, where he spent three years copying the portraits of Titian, Rubens, and Vandyck. On his return, he practised for some time in his native city, and was intimate with Allan Ramsay, the poet. He afterwards settled in London as a portrait painter, and found employment. In 1728 he was tempted to join in Bishop Berkeley's philanthropic scheme to establish a universal college of science and art, and engaging himself as a professor, he set sail for the Bermudas, but this failing, he left the Bishop at Rhode Island, and settled at Boston. There he married a lady of considerable fortune, and continued the practice of his art, exercising great influence on the young American artists. He died at Boston in March, 1751, leaving two children, one of whom, NATHANIEL, followed his profession, but died young.

SMIRKE, ROBERT, R.A., *subject painter.* Was born at Wigton, near Carlisle, in 1752, of a family supposed of foreign descent, who removed there from the West Riding of Yorkshire. His father, a clever man, who soon after died, brought him to London in 1766, when 13 years old, to develop a talent which he manifested for art, and apprenticed him to a herald painter. He was a member of the Incorporated Society of Artists, and in 1772 entered the Royal Academy schools, and exhibited in 1786, for the first time at the Academy, his subjects 'Narcissus' and 'Sabrina,' and in 1791 'The Widow,' a humorous subject. He was elected the same year an associate of the Academy, and in 1793 an academician, presenting for his diploma picture 'Don Quixote and Sancho.' He also entered into the plan of the Shakespeare Gallery, for which he painted 'Katherine and Petruchio,' 'Juliet and her Nurse,' 'Prince Harry and Falstaff,' and some others. At the same period he exhibited at the Academy pictures, usually of a small size, from our poets, chiefly from Thomson. In 1804 he was elected the keeper of the Royal Academy, but he was

known to have expressed strong and revolutionary opinions, and the King refused to sanction his appointment.

He continued to paint subjects of domestic nature, in which a quiet humour chiefly predominated; and in his later years was devoted to 'Don Quixote,' 'Gil Blas,' 'Shakespeare,' and the 'Arabian Nights.' He was also much employed in the illustration of books, for which his art was peculiarly adapted. He died in Osnaburgh Street, Regent's Park, January 5, 1845, in his 93rd year. His works are numerous, marked by a graceful, quiet humour, well drawn, cleverly painted, and always pleasing. He was modest in his opinion of his own works, impatient of the judgment of amateur critics, and was the author of a Catalogue Raisonné of the annual exhibition at the British Institution, 1815, in which he satirised the titled directors.

SMIRKE, Sir ROBERT, Knt., R.A., *architect.* Was the second son of the foregoing, and was born in London, October 1, 1780. He was educated at Apsley School, Bedfordshire. At 15 he began to study architecture, and in 1796 was a pupil of Sir John Soane, but for one year only, and at the same time was admitted a student in the Royal Academy. In 1799, having previously gained a silver medal, he was awarded the gold medal for the best architectural design for a National Gallery for Painting. In 1801 he visited Holland, and in September 1802 set out on his travels through France, Italy, Sicily, Greece, vigorously pursuing his professional studies, and returned through Germany to England in January, 1805. His reputation did not leave him in want of employment. He was engaged on the erection of Lowther Castle, for Lord Lonsdale, a fine specimen of domestic architecture, and was, in 1807, appointed architect to the Royal Mint, and erected the present new structure on Tower Hill. He was also engaged to rebuild Covent Garden Theatre, destroyed by fire, which he completed in 1809, within 12 months of its destruction. He was elected an associate of the Academy in 1808, and in 1811 to full membership. Continuing to find full employment on large public works, he erected, 1823-29, the General Post Office, and at the same time, 1823-47, his most imposing work, the British Museum; also the College of Physicians, Trafalgar Square; King's College, forming the east wing of Somerset House; the Carlton Club, afterwards altered by his brother; the Union Club, the Oxford and Cambridge Club, his most decorative design, and some other works. His style was classic. He chiefly employed the Ionic order, and his buildings, though grand and imposing in their proportions, were frequently heavy.

He seldom tried Gothic, yet in that style he built the Temple Library, and superintended the restoration of York minster after the fire of 1829. He was for several years one of the architects of the Board of Works, and on the abolition of that office in 1831 he received the honour of knighthood. In 1845 he relinquished further employment, and soon after his office of treasurer to the Royal Academy, which he had held for 30 years, and in 1850 retired to Cheltenham. This was followed, in 1859, to make way for younger men, by the surrender of his diploma as Royal Academician. After so long and prosperous a career, during which he left such important marks of his ability in the Metropolis, he died at Cheltenham, April 18, 1867. He published 'Specimens of Continental Architecture.'

SMIRKE, RICHARD, *antiquarian draftsman.* Was born in 1778, and was the elder brother of the above. Like him he was brought up to art, studied in the Royal Academy Schools, and in the same year, 1799, gained the gold medal, in his case for painting, the subject being 'Samson and Delilah.' But he was led from high art to the study of antiquities, particularly of early costume, and was much employed as their draftsman by the Society of Antiquaries. His works were distinguished by great accuracy and truthfulness. The fac-simile copies of the ancient paintings in St. Stephen's Chapel, Westminster, were made for the Society by him. He had much scientific knowledge, particularly in chemistry, and he made several useful discoveries in the qualities of colours. He died May 5, 1815, in his 37th year.

SMIRKE, SYDNEY, R.A., F.R.I.B.A., *architect.* Was born in London in 1798, son of Robert Smirke, R.A., and younger brother of Sir Robert Smirke, in whose office he began his professional career. He gained the gold medal of the Royal Academy in 1819, and the travelling studentship in 1825, going that same year to Italy. He was elected an associate of the Academy in 1847, and a full member in 1859. He was also appointed Professor of Architecture, and on the death of Mr. Hardwick, Treasurer of the Royal Academy. In connexion with his brother he designed the University Club in 1835, and jointly with Mr. Basevi, the Conservative Club in 1844. In 1847 he restored the 'Temple Church,' and published an account of this interesting building, entitled, 'Architecture of the Temple Church.' He was architect to the Hospitals of Bethlehem and Bridewell, and Surveyor General of the Duchy of Lancaster. He built Paper buildings, and partially restored Lichfield Cathedral and York minster. In 1846 he succeeded his brother as architect to the 400

British Museum, and constructed the large Reading-room. On the removal of the Royal Academy to Burlington House, he erected the schools and exhibition rooms, and added a storey to the original building. He retired to Tunbridge Wells, and died there, December 3, 1877.

SMITH, ANKER, A.R.A., *engraver.* Was the son of a silk merchant in Cheapside, where he was born in 1759, and educated at the Merchant Taylors' School. He was articled to his uncle, an eminent conveyancer; but showing great ability in copying engravings with his pen, his uncle was induced to cancel his indentures and transfer him to James Taylor, an engraver, from whom he soon learnt the mechanical part of his art, and then became assistant to James Heath. Some time after he was employed on the plates for Bell's 'Poets' and other illustrated works of the same kind. He commenced his art in the dot manner, and in this style executed 10 fine plates for Boydell's 'Shakespeare,' and was also employed on the 'Ancient Marbles' and the 'Ancient Terra Cottas,' published by the British Museum. Later he practised in the line manner, and produced another series of plates of great excellence, among them 'The Holy Family,' after Da Vinci; 'A Magdalen,' after Correggio; and 'Sophonisba,' after Titian. He was elected an associate engraver of the Royal Academy in 1797, and died June 23, 1819.

SMITH, FREDERICK WILLIAM, *sculptor.* Was the son of the above, and was born in Pimlico. He studied in the schools of the Royal Academy, and was a pupil and assistant to Sir F. Chantrey. In 1819 and 1820 he exhibited some busts at the Academy, and in 1821 he gained the gold medal for his group 'Hæmon and Antigone,' but failed in his competition for the travelling studentship. In 1824 he exhibited a group from the 'Murder of the Innocents,' with some busts; in 1825 'Ajax,' and in 1827 a 'Nymph and Cupid.' He exhibited for the last time in 1828. In his busts of Allan Cunningham, Chantrey, and Brunel, the character was well expressed, and he was of much promise; but his health failed, and he died young, at Shrewsbury, January 18, 1835.

SMITH, HERBERT LUTHER, *portrait and subject painter.* Born 1811. He was the younger brother of the above, and a student at the Royal Academy. After exhibiting portraits in 1831 and 1832, he exhibited a subject of 'Bonner Requiring the Removal of Cranmer's Bible from the Churches.' He continued to exhibit portraits, sending, also, in 1834, 'Non Angli sed Angeli;' in 1835, 'Christ Raising the Sick of the Palsy;' in 1838, 'Leonidas;' in 1845, 'Jonah's Impatience Reproved;' in 1846, 'Abraham and Isaac.' These were

his principal works, though he afterwards exhibited. He was, in the latter part of his life, employed by the Queen as a copyist. He died March 13, 1870.

SMITH, BENJAMIN, *engraver*. Was a pupil of Bartolozzi, and practised in the dot manner. He gained an early reputation, which he hardly merited, and was employed by Boydell on the Shakespeare Gallery. He engraved after West, Rigaud, Copley, Romney, and the prominent artists of his day. His pupils were largely employed on his plates. He died in Judd Place, London, in 1833.

* SMITH, CHARLES, *portrait painter*. He was a native of the Orkneys, and nephew of the well-known Caleb Whitefoord. He studied his art in London. In 1789 he exhibited a portrait group at the Academy; in 1791 portraits of two young ladies dancing; in 1792 the infant Shakespeare nursed between Tragedy and Comedy. In 1793 he resided in Edinburgh, and exhibited a 'Nymph' and an 'Infant Bacchus,' and the same year went to India, where he was appointed painter to the Great Mogul. In 1796 he had returned to London, and exhibited an 'Andromeda,' and in 1797 'Cymon and Iphigenia,' and some other works, his last contributions. He wrote a musical entertainment, in two acts, 'A Trip to Bengal,' published in 1802. Died at Leith, December 19, 1824, aged 75. There is a small portrait of him, etched by himself, and two mezzo-tint engravings of him from a portrait painted by himself.

SMITH, CHARLES HARRIOT, *architect*. Was born in London, February 1, 1792, the son of a respectable stone-mason, and was employed in that business, devoting himself, after the ordinary hours of work, to drawing and modelling, his chief employment being in stone-carving. He soon met with encouragement, and, gaining admission to the schools of the Royal Academy, he applied himself to the study of architecture, both classic and Gothic, and in 1817 he gained the Academy gold medal for his 'Design for a Royal Academy.' Of studious habits, he became an archæologist, and acquired a knowledge of geology, mineralogy, and chemistry. He was appointed a member of the Royal Commission to determine the best quarry to supply the stone for building the new Houses of Parliament; and was in 1855 elected a member of the Royal Institute of British Architects. He exhibited at the Academy designs in architecture, models, and portrait busts; was a lecturer, and wrote an essay on linear and aërial perspective in Arnold's 'Library of the Fine Arts.' He died October 21, 1864.

SMITH, CHARLES JOHN, F.S.A., *engraver*. Was born in 1803 at Chelsea, where his father practised as a surgeon. At the age of 16 he was apprenticed to Charles Pye, the engraver. On the expiration of his term, he was chiefly employed in the illustration of topographical and antiquarian works—Cartwright's 'Rape of Bramber,' Stothard's 'Sepulchral Effigies,' Dibdin's 'English Tour,' and publications of the same class. He engraved also a series of 'Autographs of Royal, Noble, and Illustrious Persons;' and had proceeded as far as the sixth number of a work, 'Historical and Literary Curiosities'; when, in apparently perfect health, he was attacked by paralysis, and died November 23, 1838.

SMITH, COLVIN, R.S.A., *portrait painter*. Was born at Brechin in 1795, where his father was a merchant. He was sent to London to learn his art, and entered the schools of the Royal Academy. He also drew in Nolleken's studio, where Gibson was a fellow-pupil. Subsequently he visited Italy. He returned to Scotland about 1827 and settled in Edinburgh; his first exhibited work there being the portrait of the Chief Commissioner of the Royal Institution. Two years afterwards he joined the Royal Scottish Academy. He executed many portraits, one of Sir Walter Scott was so successful that he repeated it more than twenty times. He last exhibited in 1871, and died July 21, 1875.

SMITH, EDWARD, *engraver*. Finished some good plates in the line manner; 'Puck,' after Sir J. Reynolds; 'The Piper,' and 'Guess my Name,' after Wilkie. He was engaged on Finden's Royal Gallery, and engraved 'The Contadini Family Prisoners with Banditti,' after Sir Charles Eastlake.

SMITH, EDWARD, *sculptor*. Was born of a respectable family in the county of Meath, 1746, and was apprenticed to Verpyle, an inferior artist, who at that time had good employment in Dublin. His first public work was the statue of Dr. Lucas, in the Royal Exchange, Dublin, 1772, an extraordinary production for so young a man. From this time to 1802 he was little noticed. Few exhibitions were in the interval held in Dublin, and from size and other considerations his works were unsuited to exhibition, for he was chiefly employed on chimney-pieces, tablets, and ornamental designs. On the arrival of Gandon, the architect, in Dublin, he fully appreciated and employed him. He modelled 12 designs representing the rivers of Ireland, to decorate the Dublin Custom House. He designed for the noble portico of the Four Courts — 'Clemency,' 'Justice,' 'Moses,' 'Mercy,' and 'Minerva,' works of incontestable merit, and some large emblematic figures in bas-relief for the interior of the dome. Also, two caryatide figures and two groups in bas-relief for the King's Inn. These works were all executed for Gandon, as were also the corbel ornaments, the heads for the key-stones, and the admirable groups

of cherubs' heads for the ceiling ornaments of the Castle Chapel. He had for some years received a large income, but had saved nothing, and he was glad to accept, with a salary of 100l. a year, the office of master of the School of Sculpture, which the Dublin Society established in 1806, and to hold the office till his death, when he was succeeded by his son, JOHN SMITH. He was born, studied, and lived only in Ireland, and died there towards the end of 1812. Vigorous, original, and inventive, he was eminently distinguished as an Irish artist, and both father and son were remarkable alike for their genius and their misfortunes.

SMITH, FRANCIS, architect. He practised at Warwick and in the neighbouring counties in the first quarter of the 18th century. He is said to have rebuilt Warwick Church. He built some good mansions which had the character of being convenient and handsome, but were marked by great sameness. He died in 1730. There is a portrait of him by Winstanley.

SMITH, FRANCIS, landscape painter. Said to have been born in Italy. Painted landscape, and some small domestic subjects. He travelled in the East with Lord Baltimore and made drawings. Exhibited at the Royal Academy in 1770 a picture of Constantinople, and in 1772 some views in Naples, and in 1773 some sketches on the Thames, his last contribution. Some of his drawings of the ceremonies of the Turkish Court were engraved. He died in London some time before 1780, supposed in 1779.

SMITH, FREDERICK COKE, water-colour painter. He was born June 26, 1820, travelled largely in the pursuit of his art, and attained a very rapid but unfinished manner of execution. He went to Turkey, and in 1835-36 finished a number of sketches at Constantinople, which were lithographed by J. F. Lewis in 1837, and afterwards went to Canada, and published his sketches made in that colony. He died May 13, 1839.

SMITH, GABRIEL, engraver. Was born in London in 1724, and studied the elements of his art there. He then went to Paris for his improvement, and on his return commenced practice in the dot manner. His best works were executed for Alderman Boydell, and were engraved after Tintoretto, Snyders, Salvator Rosa. He travelled on the Continent for his improvement, accompanied by Ryland, and in the latter part of his life was employed by him, and etched for him almost exclusively in the chalk manner. He died in London in 1783, with the reputation of an able artist.

SMITH, GEORGE, architect. He practised in the City, and built St. Paul's School 1823, and many other buildings in London. He was architect to the Mercers' Company, and built for the Company, 1825,

Whittington's College, near Highgate. He was an occasional exhibitor at the Royal Academy, sending, in 1827, with other works, a design for Tottenham Church, and in 1829 a design for the London Corn Exchange. He died in 1869, aged 87.

SMITH, GEORGE, architect. Was born in 1793, and was an assistant of W. Burn, of Edinburgh, who offered to take him into partnership, which offer he declined. He was architect to the Improvement Scheme of Edinburgh of fifty years ago, and constructed the fine thoroughfare which begins with Castle Terrace and ends with the George IV. Bridge. He also designed the Normal School, which was held up by the Privy Council Committee on Education as the best model of its day. He was the author of a work on cottage architecture, a prize essay of the Highland Society, and he gave many courses of lectures on Architecture at the Society of Arts. He died in Edinburgh, October 1877, aged 84, and was buried in the Warriston Cemetery.

SMITH, GEORGE, history painter. Was born in London in 1802. He was brought up as an upholsterer, but having a great talent for art, on coming of age he turned to it as a profession. He entered the schools of the Academy, subsisted by the sale of his drawings and by teaching, and in 1829 gained the gold medal for his original painting, 'Venus Entreating Vulcan to Forge Arms for Æneas;' and the following year he was sent to Rome as the travelling student of the Academy. He returned home at the end of 1833, and resumed the practice of his profession, but he met with little encouragement, his health failed, and he died from rupture of a blood vessel, October 15, 1838. He was of much promise, a good colourist, a vigorous draftsman and painter. There is a painting by him in the South Kensington Museum.

SMITH, GEORGE, landscape painter (known as 'Smith of Chichester'). His father was a baker, and afterwards a cooper in the South of England, but also exercised the functions of a general Baptist minister. He was born in Chichester in 1714, and, with his brothers, studied art in the surrounding scenery, chiefly painting rural subjects, and compositions of a pastoral class. His works were pleasing, well coloured, with a tendency to blackness, but mere imitations of Claude and Poussin. In his day they were lauded beyond their merits, fashion placed him in the front rank, poets apostrophised him, and the Society of Arts awarded him in 1760 their first premium in competition with Richard Wilson. His name lives in the works of Woollett, Elliot, Peak, and others, whom it was his fortune to have as the engravers of his works. Jointly with his brother

John he published 53 small plates, which they had etched and engraved from their landscapes. And Vivares and others engraved after them a collection of 'Select Views in England and Wales.' In 1763 he was a member of the Free Society of Artists. He was a good musician, an excellent violoncello player, and frequently performed at the Chichester concerts. He was also gifted with some poetic taste, and published in 1770 six pastorals and two pastoral songs, of which in 1811 his three daughters published a second edition. He died September 17, 1776.

SMITH, JOHN, *landscape painter.* Younger brother of the foregoing. Was born in 1717. He also painted landscape, but was inferior to his brother. He was a member of the Free Society of Artists. Died at Chichester, July 29, 1764.

SMITH, WILLIAM, *portrait and landscape painter.* Elder brother of the two foregoing. Was born in Guildford in 1707. He devoted himself chiefly to portraiture, but later he tried landscape, and afterwards fruit and flowers. He was a member of the Free Society of Artists. He died at Shopwich, near Chichester, October 4, 1764.

SMITH, J. CATTERSON, P.R.H.A., *portrait painter.* He was born in England, and studied in the schools of the Royal Academy. In 1838–40 he exhibited there one or two portraits, and about ten years later went to Ireland. He first settled in Kerry, and then removing to Dublin, he painted some subject pictures, afterwards settling down as a portrait painter. He was elected a member of the Royal Hibernian Academy, and later the President, and had many sitters in the Irish Metropolis. His portrait of the Queen is in the Dublin Mansion House, of Daniel O'Connell in the City Hall, and of several successive Lords-Lieutenant in the castle. He died in Dublin, May 31, 1872, aged 65.

SMITH, JACOB, *engraver.* Practised about 1730. Among other works, he engraved on one plate portraits of Sir Isaac Newton and Sir Hans Sloane, executed in one continuous spiral line, commencing in the centre, and running to the extremities of the plate.

SMITH, JAMES, *architect.* Practised in Scotland about the end of the 17th century, and was esteemed the most experienced architect of his day in that kingdom. He designed and executed, 1692, Melvin House, which is engraved in Campbell's 'Vitruvius Britannicus.'

SMITH, JAMES, *sculptor.* Was a student in the Royal Academy, and in 1797 gained the gold medal for his group, 'Venus wounded by Diomed.' He was also a successful competitor for the monument in Guildhall to Lord Viscount Nelson,

which he executed in 1808. He was employed by Flaxman, R.A., and assisted Mrs. Damer in many of her works. He died in Upper Norton Street, April 28, 1815, in his 44th year.

SMITH, JOHN, *mezzo-tint engraver.* Was born at Daventry, in 1652, and was the son of an engraver. He is said to have served his time under one Tillet, and was afterwards a pupil of Beckett, from whom he learnt the new process of mezzo-tint, in the technical process of which he was further assisted by Vandervaart. His early works attracted the attention of Sir G. Kneller, who took him into his house, employed him in engraving his works, and instructed him in their correct imitation. Here he made great improvement in his art, engraved the chief of Kneller's works, and was esteemed the first engraver of his day, but some time before Kneller's death they disagreed and he left him. He is commonly said to have died in London in 1719, but it has been shown that he was one of the mourners at Kneller's funeral in 1723, and he is supposed to have lived till after 1727, as a portrait by him of George II. bears that date. It has, however, now been ascertained that he died January 17, 1742, at Northampton. There is a tablet to his memory in St. Peter's Church there. His works are very numerous, above 500 have been catalogued. They are chiefly portraits, but he also produced some very fine plates after Correggio, Titian, Paul Veronese, and Maratti. His works united great power with sweetness, finish, and freedom, and are very highly prized by collectors. His portrait, by Kneller, is in the National Gallery.

SMITH, JOHN (known as 'Warwick Smith'), *water-colour painter.* Was born at Irthington, Cumberland, July 26, 1749, and was educated at St. Bees. He was one of the early draftsmen in water-colours; and following Sandby, he advanced the art, giving greater force and colour to his works. He accompanied Lord Warwick to Italy, and hence his designation. Some of his Italian sketches are dated between 1786 and 1795, the earliest mere tinted drawings in the manner of the time, the latter enriched by local colour boldly used. His works are elegant in composition, and have a pleasing freshness of manner. He joined the Water-Colour Society in 1807, continued a member when a large secession took place in 1813, and was President of the Society in 1816. He died in Middlesex Place, Marylebone Road, March 22, 1831, and was buried in the vault under St. George's Chapel, Uxbridge Road.

SMITH, J. JOHN, *landscape painter.* Was born in London about 1775, and was educated to art. He painted views introducing figures and animals, and also

some sea-pieces. He was an exhibitor at the Royal Academy 1813-19-21; in the latter year a view of Lisbon, taken on the spot. There are eight views of villages, well-etched plates, by him.

SMITH, JOHN ORRIN, *wood-engraver.* Was born at Colchester in 1799. He was educated as an architect, but on coming to London he made some successful attempts at wood-engraving, and in 1824 placed himself under William Harvey. His first works of importance were the illustrations to Seeley's Bible, and some spirited heads, after Kenny Meadows. In 1835 he commenced the illustrations for a French edition of 'Paul and Virginia,' which were very successful, and in the same year was engaged upon 'The Solace of Song.' Following this, he engraved the designs for 'The Illustrated Shakespeare,' by Kenny Meadows; also for La Fontaine's 'Fables,' Béranger's 'Songs,' and other works of the same character. He died from apoplexy, caused by the shock of a shower-bath, October 15, 1843.

SMITH, JOSEPH CLARENDON, *water-colour painter.* He was born in 1778, in London, where his father was a builder. Left without provision, he was sent to sea, and after serving about three years he was admitted to the mathematical school of Christ's Hospital to improve himself in navigation. But he showed a desire to try art and was placed under an engraver, with whom he worked with credit, but not upon plates that bear his name. Some of his best works on copper will, however, be found in Weld's 'Topography of Killarney.' After a time he appears to have quitted engraving, in which he was little known and ill-rewarded, to try painting in water-colour. He exhibited some views of churches at the Royal Academy, in 1806-1807. His subjects were chiefly of a topographical character. The undercroft of Canterbury Cathedral, 1807; Henry VII.'s Chapel; Waltham Cross, 1809; the Saxon town of Bury St. Edmund's; and St. Augustine's Gateway, Canterbury. He worked zealously at his new art, but he was suffering from a pulmonary attack and went to Madeira. He died on his passage home in August 1810.

SMITH, NATHANIEL, *modeller.* Was a student in the St. Martin's Lane School, and in 1755 became the pupil of Roubilliac. He gained several premiums at the Society of Arts, the first in 1759, and later was employed for many years as the principal assistant to Nollekens, R.A. He carved the River Gods at Somerset House, after the designs of Cipriani, R.A. Some of his drawings were published in his son's 'Antiquities of London.' He is described on a good portrait etching as 'Sculptor and Printseller.'

404

SMITH, JOHN THOMAS (called 'Antiquity Smith'), *topographical draftsman.* Son of the foregoing. Was born in a hackney coach, June 23, 1766. His great-uncle was Admiral Smith, known as 'Tom of Ten Thousand.' He entered the Schools of the Royal Academy, and was placed under Keyse Sherwin, the engraver, but he left him at the end of three years, and sought an engagement on the stage. This failing, he practised for many years as a drawing-master, residing at Edmonton. In 1798 he was an unsuccessful candidate for the appointment of drawing-master at Christ's Hospital. For a time also he practised as a portrait painter. He was a clever draftsman and a tolerable engraver, and his antiquarian feeling led him at last to topography. He was employed in drawings of that class, and his name is largely connected with recollections of the Metropolis.

His publications are numerous. In 1791, 'The Antiquities of London and its Environs;' in 1797, 'Remarks on Rural Scenery,' with 20 etchings of cottages from nature; in 1807, 'The Antiquities of Westminster;' between 1810-15, 'The Ancient Topography of London,' 'The Streets of London,' 1815, drawn and etched by himself. In 1816 he was appointed keeper of the prints in the British Museum, an office he held till his death; but it did not interrupt his busy literary pursuits, for he produced, in 1817, 'Vagabondana,' with 60 portraits drawn and etched by himself from the life, of noted mendicants in the Metropolis. He will, however, be best known to the public by his 'Nollekens and his Times,' published in 1828, which, descending to the meanest domestic incidents of his friend's life, was attributed to disappointment from no mention in his will. He died in University Street, Tottenham Court Road, March 8, 1833, in his 67th year, and was buried in St. George's burial-ground, Bayswater Road. His 'Book for a Rainy Day' was published after his death. His drawings in water-colour shew great power in that art. His etchings are truthful and clever. His imitations of Rembrandt and the Dutch landscape painters very close.

SMITH, TOM, *engraver.* Pupil of Charles Grignon. He executed some plates with C. White; but, thoughtless and good-natured, he cared little for his art, and being left a property of 300*l*. a-year, he was dubbed 'Squire Smith.' He died young, of fever, in 1785, and was buried at Clerkenwell Church.

SMITH, THOMAS, *landscape painter,* known as 'Smith of Derby,' where he was born and chiefly resided. He was a self-taught painter, and acquired a respectable eminence by his own industry. He painted views of Chatsworth, dated 1744, Dovedale, the Peak, and other picturesque parts

of the county; and also in Yorkshire, Westmoreland, and other northern counties. He was one of the first artists who depicted the beautiful scenery of England. A collection of 40 plates from his Derbyshire views, engraved by Vivares and others, was published by Boydell in 1760. He died at the Hot Wells, Bristol, September 12, 1767.

SMITH, THOMAS COREGGIO, *miniature painter.* Was the eldest son of ' Smith of Derby,' and was educated by him as a painter, but from want of ability or of application, succeeded no further than to become a bad miniature painter, and by this, aided by a small patrimony, he contrived to live. From 1785 to 1788 he exhibited at the Academy small portrait drawings and miniatures. He died at Uttoxeter, somewhat beyond the middle age.

SMITH, JOHN RAPHAEL, *painter and mezzo-tint engraver.* Born 1752. Younger brother of the above. Commenced life as the apprentice to a linen-draper at Derby. He then for a time served as a shopman in London, and occupied his leisure, to increase his means, by painting miniatures. Making some progress in art, he tried engraving, and produced a print, called ' The Public Ledger open to all Parties,' which had so great a sale, that he was induced to turn engraver. He soon distinguished himself by his works in mezzo-tint, and in 1778 was residing in Bateman's Buildings, Soho, in the full practice of his art. He produced about that time his plate of ' Edwin,' after Wright, and of ' Mercury inventing the Lyre,' after Barry, both works of much skill. He afterwards engraved many of Reynolds's works with great success, and a full comprehension and rendering of his manner. These works were very popular, and he was appointed engraver to the Prince of Wales. He formed an extensive connexion as a publisher and dealer in prints, and should have realised an independence; but he was a man of pleasure, fond of company, which led to dissipation, became a sportsman, or rather sporting-man, an adept in field sports, pugilism, and the stage, and a good judge in all such matters. He was a boon friend of George Morland, and one of his best speculations was his 'Morland Gallery.'

He drew in black and red chalk with great spirit, and having gained the first rank as an engraver, was ambitious to distinguish himself as a painter, and drew with great ability small whole-length portraits in crayons, and subject pictures, and from 1779 to 1790 was an exhibitor at the Academy, contributing, in 1782, a group of the Duke and Duchess of Gloucester and their children. His subject pictures were of the class then fashionable, ' The Widow's Tale,' ' The Unsuspecting Maid,' ' The

Moralist,' ' Inattention,' and such like. When the print trade fell off, he devoted himself exclusively to this, and, becoming itinerant, visited professionally York, Sheffield, Doncaster, and other towns. His portraits of Mr. Fox, the Duke of Bedford, Sir Francis Burdett, and Horne Tooke are proofs of his ability. His latter portraits are slight and hasty, a manner suited to his disposition, and their number was incalculable. He could finish one in an hour, but he was lost to his higher art. His mezzo-tints were tender, charming in drawing and expression, and full of colour. The last three years of his life were spent at Doncaster, where he died suddenly, of asthma, on March 2, 1812, in his 60th year, and was buried in Doncaster Churchyard. Possessed of art talents in an eminent degree, he was liberal, communicative, and an able critic and adviser. He was also gifted with great conversational powers and varied information. Chantrey, R.A., whom in early years he had encouraged in Sheffield, modelled a most characteristic bust of him. His son, J. R. SMITH, was for several years at the beginning of the 19th century, an exhibitor of works of the same class as his father's.

SMITH, Miss EMMA, *water-colour painter.* Daughter of the foregoing. Born about 1787. Had a talent for drawing. She exhibited at the Royal Academy in 1805 ' Hector taking leave of Andromache,' and in 1806 joined the Society of Associated Artists in Water-Colours, during its brief existence.

SMITH, SAMUEL, *engraver.* Was born in London about 1745. He practised landscape, using both the etching-needle and the graver. He completed some good plates— ' The Finding of Moses,' after Zuccarelli, 1788. He also engaged in some plates in conjunction with other artists; and in the ' Niobe,' after Wilson, R.A., by Sharp, the landscape is by him, 1803.

SMITHSON, ROBERT, *architect.* He is supposed to have been the pupil and successor of John Thorp. He built several fine mansions and was architect to the Earls of Newcastle, for whom he built part of Welbeck. He died October 15, 1614, aged 79, and was buried at Wollaton, Notts.

SMITHSON, HUNTINGDON, *architect.* He was the architect of Bolsover Castle, and when it was proposed to rebuild this immense pile, which he commenced in 1613, he was sent to Italy by the Earl of Newcastle to collect materials for the improvement of his work. He built the famed riding-house there in 1623, and the stables in 1625. He died December 27, 1648.

SMITHSON, JOHN, *architect.* Son of Huntingdon Smithson; was well reputed as an architect. He died in 1678.

Smith - Will^m painter ?1830

SMITZ, GASPAR (called 'Magdalen Smith'), *subject and portrait painter*. Born in Flanders. He came to England soon after the Restoration to follow his profession, and was induced to visit Ireland, where he settled. He studied for a time in Rome. He painted miniature portraits in oil, and attained much repute for their colour, life-like nature, and resemblance. He was, however, best known by his Magdalens, which were well drawn, and finished in a chaste, clever style, but painted from a woman he kept and called his wife. He usually introduced a delicately finished thistle in the foreground. There is a Magdalen by him in Painters' Hall, dated 1662. He was also a clever flower-painter. He had high prices for his works, and was fully employed, yet his extravagance kept him always in difficulties, and he died in Dublin, in great distress, in 1707.

SMYTH, JOHN TALFOURD, *engraver*. Was born in Edinburgh, and was a zealous student in the Trustees' Academy there. In 1835 he determined to follow the profession of an engraver, but his master dying in the first year of his pupilage, he was his own teacher, and soon gave proofs of his ability. In 1838 he removed to Glasgow, where he worked on plates which produced him money, without advancing his art, and he was induced to return to Edinburgh, and there gained employment of a higher class. He engraved 'John Knox Dispensing the Sacrament,' from Wilkie's unfinished picture: Mulready's 'School,' from the Vernon collection; Sir William Allan's 'Tartar Robbers Dividing their Spoil.' He was engaged upon other works of this class, when he died after a short illness, from an attack on the brain, May 18, 1851, aged 32.

SNELLING, MATTHEW, *portrait and miniature painter*. Practised in the reign of Charles II. He painted chiefly female heads, but was not of much repute. A portrait of Charles I. by him, dated 1647, was exhibited at Kensington Museum in the Loan Collection, 1862, and there is a passable portrait by him at the College of Physicians.

• SOANE, Sir JOHN, Knt., R.A., *architect*. Was the son of a bricklayer, in humble circumstances, and was born near Reading, September 10, 1752. He was educated at Reading, and showing a love of art, was first employed as an errand boy, and then admitted to assist in the office of George Dance, the architect. Subsequently he was employed for a time in Henry Holland's office, where he acquired a practical knowledge of the profession, remaining with him till 1766. Meanwhile he studied in the schools of the Royal Academy. In 1772 he obtained a silver medal, and in 1776 the gold medal for his 'Design for a Triumphal

Bridge,' and was then elected the travelling student. He travelled for three years in Italy, diligently engaged in study, returning in the summer of 1780. He was tempted to return at that time by an offer of employment from the capricious Hervey, Earl of Bristol, which he did not realize; but entering into competition for public works he made himself known, and in 1788 gained the appointment of architect and surveyor to the Bank of England, which laid the foundation of his fortune. He had married in 1788, and through his wife, who died in 1815, he eventually received a considerable property.

Success waited upon him. In 1791 he was appointed clerk of the works at St. James's Palace, the Houses of Parliament, and other public buildings; in 1795 architect to the Department of Woods and Forests. Then professional honours came. He was in that year elected an associate, and in 1802 a full member, of the Academy, in 1806 Professor of Architecture. In 1807 he was appointed clerk of the works to Chelsea Hospital, and erected the new infirmaries, and about the same time the new Picture Galleries at Dulwich College. On a commission from the Treasury he made designs, in 1820, for the New Law Courts, in the following year for a Royal Palace on Constitution Hill. The former was carried out, only after long contention, to be afterwards altered; the latter was never proceeded with, to his great chagrin, and probably the public loss. Buckingham Palace was patched up instead. In 1831 he was knighted, and in 1836 completed the State Paper Office, his last work.

He had been fortunate in holding the first professional appointments, had amassed a fortune, built a house for himself in Lincoln's Inn Fields, and made it a storehouse of art-treasures; but he was not without his share of the world's troubles. Of two sons, one died young, the other lived to be a constant irritation and annoyance, and his obstinate temper found a consolation in disinheriting his only surviving child. Arrived at 80 years of age, his sight failed, and in 1833 he resigned all his appointments and professional engagements. He had long contemplated leaving his collections, with his house, to the nation, for the benefit of his profession, and he lived to see his intentions carried out under the sanction of a private Act of Parliament. He died at his house in Lincoln's Inn Fields, now 'The Soane Museum,' January 20, 1837, aged 84. He was buried in the ground belonging to St. Giles-in-the-Fields, adjoining the Old Church, St. Pancras.

His art was founded on the Greek, its proportions pleasing, its masses broad and simple, the arrangements well considered and convenient to their intended uses, but

the style was marked by mannerism, especially in the ornamentation. The buildings at the Bank, the exterior of which he re-built, are usually pointed to as his best and most pretentious work. He did not live to feel the annoyance which must have been suffered by the alteration of the Law Courts, the destruction of his fine façade to the public offices in Whitehall, and the entire demolition of his State Paper Office, an erection of great perfection and merit, both in its elevation, interior arrangement, and fittings. He published, in 1778, 'Designs in Architecture;' in 1788, 'Plans, Elevations, and Sections of Buildings erect-ed in Norfolk, Suffolk, Yorkshire,' &c.; in 1793, 'Sketches in Architecture;' in 1827, 'Designs for Public and Private Buildings.' He also published a statement respecting the new Law Courts and the Privy Council Office, and in his latter days amused him-self by preparing an account of his house and museum.

SOEST, GERARD (sometimes spelt ZOEST), *portrait painter*. Was born in Westphalia about 1637. He learnt his art in his native country, and came to London with an established reputation about 1656, and was soon appreciated. His portraits were well-coloured, simple, and natural, and those of small size were much esteemed. His draperies were frequently satin painted in imitation of Terburgh's manner, which he afterwards enlarged by the study of Vandyck. His male portraits were the best. There is a good whole-length by him of Lord Mayor Sheldon at Drapers' Hall, and a head of Dr. John Wallis at the Royal Society. He is commonly said to have died in 1681, aged 44 years, but in Mr. Beale's Pocket-book, well known to anti-quaries, there is a note, 'February 11, 1680-1; Mr. Soest, the painter, died. Mr. Flessiere, the frame-maker, said he believed he was near 80 years old.'

SOLDI, ANDREA, *portrait and history painter*. He was born in Florence, and, after a visit to the Holy Land, he came to England about 1735, and was then about thirty years of age. A good draftsman, and surpassing many of his contemporaries, he found good employment as a portrait painter; but he was extravagant, lost his patronage, and fell into misfortunes. He was a member of the Incorporated Society of Artists in 1766, but did not long survive this date.

SOLOMON, ABRAHAM, *subject painter*. Was born in London in 1824, of a respect-able, but not wealthy, Jewish family. At the age of 13, he was placed in a drawing-school in Bloomsbury, and the same year was awarded a medal at the Society of Arts. In 1839 he was admitted a student of the Royal Academy. In 1843 he exhibited there his first picture, a subject from Crabbe;

in 1847 a story from the 'Vicar of Wake-field;' and continuing a yearly exhibitor, sent in 1857 'Waiting for the Verdict,' a picture which made him known. In 1862 he exhibited his last work, 'The Lost Found.' He was suffering from disease of the heart, and, in the hope of relief, visited the south of France, and died at Biarritz, December 19, 1862.

SOLY, ARTHUR, *engraver*. Was a pupil of Robert White, and engraved for him. He practised in the reign of Charles II., and there are some good heads by him; among them a portrait of Richard Baxter, dated 1683. A portrait of him, by his master, was engraved in the same year. He died about 1695.

SOMERVILLE, ANDREW, R.S.A., *sub-ject painter*. He was born, it is believed, in Edinburgh. Educated in the Trustees' Academy, he practised in that city, and was in 1833 elected a member of the Royal Scottish Academy. He died in the same year, when about only 30 years of age. His 'Flowers of the Forest,' and 'The Bride of Yarrow,' may be mentioned among his successful works.

SONMANS, WILLIAM. Practised in London in the first half of the 18th century, chiefly in making drawings of natural his-tory. The drawings for the illustration of Morrison's 'Historia Plantarum,' 1715, are by him.

SOUNES, WILLIAM HENRY, *art teacher*. Was born in London in 1830. He received his art education in the Government School of Design, Somerset House. In 1855 he was appointed modelling-master at the Birmingham School of Art, and subse-quently became head-master of the Sheffield School. He died at Sheffield in 1873.

SOWERBY, JAMES, *draftsman and engraver*. Was well known by his many drawings for the illustration of botanical works. Of these the chief are Smith's 'Icones Pictæ Plantarum Rariorum,' 1790; Smith's 'Gleanings of Botany,' 'Specimens of the Botany of New Holland,' 1793; Shaw's 'Zoology of New Holland.' He was also the publisher himself of 'The Florist's Delight,' 1791, an easy introduction to drawing flowers; 'English Botany,' 1790; coloured figures of British fungi, 1796. He resided some of the latter part of his life in Paris. Died October 25, 1822, in his 66th year.

SOYER, Madame, *subject painter*. (*See* JONES, EMMA.)

SPACKMAN, ISAAC, *still-life painter*. Was known as a painter of animals, princi-pally birds. He practised about the middle of the 18th century. Died at Islington, January 7, 1771.

SPANG, MICHAEL HENRY, *modeller*. Was a native of Denmark. He exhibited busts and models in wax with the Society

Soe (or Zoen) Jean van - 1658-770

of Artists in 1761, and carved the figures in the pediment of Lord Spencer's house, St. James's Park—a very respectable work—and the decorations on the screen of the Admiralty. He drew the figure well, and with great anatomical truth. He died shortly before 1767. His widow was relieved by the Artists' Society.

SPANGLER, ——, *modeller*. He was brought from London, and was employed at the Derby China works about 1798, where he gained a great reputation, and was considered the best modeller of the figure in biscuit and in finish, equal to any modeller of his time.

SPENCE, WILLIAM, *sculptor*. Was born at Chester, and at an early age placed under a wood-carver and teacher of drawing at Liverpool. He was fortunate in making the acquaintance of John Gibson, R. A., the eminent sculptor, who assisted him to employment, and he soon distinguished himself as a draftsman and modeller. He was appointed professor of drawing in the Antique School of the Liverpool Academy, and regularly contributed to its exhibitions, and in 1843 and 1844 sent some Scripture subjects and busts to the Royal Academy. But he was admitted a partner into a Liverpool house, and, withdrawing himself from his profession, was successful in business. He died at Liverpool, July 6, 1849, aged 56.

SPENCE, BENJAMIN EDWARD, *sculptor*. Son of the foregoing. He was born at Liverpool in 1822. At the age of 16 he modelled a very successful bust of Mr. Roscoe, and later a group, which was awarded a prize at the Manchester exhibition. He then went to Rome, where he was assisted by John Gibson, R.A., and became the pupil of R. T. Wyatt, and soon made up his mind to settle there in the practice of his profession. Some of his first works were not sent to this country, but from 1849 he occasionally sent a work from Rome to be exhibited at the Royal Academy. In 185), 'Ophelia ;' in 1856, 'Venus and Cupid ;' in 1861, 'Hippolytus ;' and in 1867, 'The Parting of Hector and Andromache.' In 1862 he was a contributor to the International Exhibition. He did not attain much eminence. His works had little originality in their conception, but were not without elegance and feeling. He died at Leghorn, October 21, 1866.

SPENCER, GERVASE or JARVIS, *miniature painter*. Was a gentleman's servant. He had a talent for art, and amused himself by drawing. He made such a successful copy of a miniature of one of his master's family that he was encouraged and assisted by him to try art ; and he studied with so much perseverance as to become the fashionable painter of his day. He practised towards the middle of the 18th century both on ivory and in enamel. He exhibited

with the Society of Artists in 1762 some portraits in enamel, and some fine miniatures in that material bearing the initials ' G. S.', seem properly attributable to him. His portrait was painted by Reynolds, from which he etched a good plate, to which the name of George Spencer has been erroneously added. Some slight portrait etchings by him in the print-room at the British Museum evince a refined power of drawing. He died October 30, 1763.

SPENCER, LAVINIA, Countess, *amateur*. Daughter of the Earl of Lucan, married in 1781 the second Earl Spencer. Between 1780–90 she made some good original drawings, several of which were engraved. Gillray engraved in the dot manner 'The Orphan,' by her, and Bartolozzi her 'New Shoes.' She died June 8, 1831.

SPICER, ——, *engraver*. Practised in mezzo-tint in the latter half of the 18th century. There are by him, after Reynolds, plates of Kitty Fisher, Lady Stafford, and some others.

SPICER, HENRY, *miniature painter*. He was born at Reepham, Norfolk, and was the pupil of Gervase Spencer. He first appears as a contributor of miniatures to the exhibitions of the Incorporated Society of Artists in 1766, and was their secretary in 1773, continuing to exhibit yearly with them up to 1783. At the Royal Academy he first exhibited in 1774, and in 1795 contributed the portrait of the Prince of Wales, who appointed him his portrait painter in enamel. In 1776 he went to Dublin and painted the portraits of many of the most eminent persons in Ireland. For 20 years he continued an exhibitor at the Academy, practising both in enamel and on ivory, and attained much excellence in his art ; his works were powerful and the likeness strongly impressed. He died in Great Newport Street, June 8, 1804, aged 61.

SPILLER, JOHN, *sculptor*. Was born in 1763, and was a pupil of Bacon, studying also in the schools of the Royal Academy. The statue of King Charles, which stood in the centre of the piazza of the Royal Exchange, before the fire in 1838, was his work. He was an occasional exhibitor at the Academy, commencing in 1778. He contributed wax models and portraits. In 1785 'Venus Introducing Helen to Paris,' a group ; and in 1792, when he exhibited for the last time, designs for two churches. The elder D'Israeli says of him, 'the energy of his labour and the strong excitement of his feelings had made fatal inroads upon his constitution, and he only lived to finish his statue of Charles.' He died 1794.

* SPILSBURY, F. B., *amateur*. Was surgeon to H.M.'s ship 'Le Tigre,' and was in the campaign in Syria and Palestine, 1796, where he made many sketches of

views and costume. He published 'A Series of Picturesque Scenery in the Holy Land and Syria,' and also 'A Voyage to the Western Coast of Africa,' 1805, illustrated by his own sketches of the natives, but they are rudely drawn and without character. He also painted several pictures in oil.

SPILSBURY, JOHN, mezzo-tint engraver. Born in 1730, he gained a premium from the Society of Arts for a mezzo-tint in 1761 and 1763, and scraped a great number of small plates and portraits after Reynolds and others; also, after Rubens, the heads of two monks reading from the same book. He designed and engraved *ad vivum;* and in this manner there is a mezzo-tint portrait of the Prince of Wales, dated 1757; and a second, dated 1764; and in the same year portraits of the King and the Queen; also a portrait as large as life, dated 1766, of Arthur Pond's sister, the lady mentioned in the 'Idler,' who rode 1000 miles in 1000 hours. He also engraved in the dot manner ' A Collection of Gems' and some Nonconformists' portraits. In 1770-71-73 he exhibited at the Spring Gardens' Rooms, and was from 1776 to 1784 an exhibitor of portraits at the Royal Academy, and in 1777 contributed two scriptural subjects. About 1782 he was drawing-master at Harrow. His work was good and careful, but rather bleak and hard. He kept a shop in Russell Court, Covent Garden, and styled himself engraver, and map and print-seller. He died about 1795.

SPILSBURY, Miss MARIA, portrait and subject painter. Daughter of the above. Born in London in 1777. She showed a taste for art, to which she devoted herself. Her best works are peasants and children. She painted ' The Seven Churches of Glendalough,' with a fair in the foreground—and ' Holyeve.' Her attempts of a higher class were not successful. In 1792 she was an honorary exhibitor at the Academy, and in 1807 exhibited eight works, which were much praised. Several of her works are engraved, and she herself engraved one, ' A Shepherd's Family.' Many of her works are in Ireland. She was noted for her musical abilities. She married Mr. John Taylor, and died about ten years after in Ireland.

SPOFFORTH, ROBERT, engraver. Practised in London towards the end of the 18th century. He was chiefly employed on portrait frontispieces for book illustration.

SPOONER, CHARLES, mezzo-tint engraver. Was born in the county of Wexford, and apprenticed in Dublin to John Brooks. On the invitation of McArdell he came to London when about 23 years of age. He practised in mezzo-tint, and produced several excellent plates after Reynolds, Cotes, Miss Benwell, Chatelaine,

Rembrandt, Schalken, and Teniers. His best works are dated between 1752-61. He died in London, December 5, 1767, aged about 50, and was buried beside his fellow-pupil and friend, McArdell, at Hampstead. His life was shortened by his habits of roystering intemperance.

SPRY, WILLIAM, flower painter. He practised in London with much ability, painting both in oil and water-colours. From 1834 to 1847 he was an exhibitor at the Royal Academy, and in the last year contributed a miniature group of flowers in oil.

SPYERS, JAMES, landscape painter. Practised in London in the second half of the 18th century, principally painting landscape views. Six views of Hampton Court by him were engraved by J. Jukes, and six views of country mansions were mezzo-tinted by G. Wills.

STACKHOUSE, J., flower painter. He practised in London towards the end of the 18th century, and painted flowers and fruit.

STADLER, JOSEPH CONSTANTINE, engraver. He was a native of Germany. He came to England, and practised in London 1780-1812. He engraved views chiefly in aqua-tint. After De Loutherbourg he engraved ' The Fire of London,' ' The Defeat of the Spanish Armada,' and ' Six Views of the Picturesque Scenery of Great Britain.' After Farington, R.A., he etched for Alderman Boydell views of London Bridge, Westminster Bridge, Blackfriar's Bridge, Somerset Place, Adelphi; also numerous views illustrating Coombe's ' History of the River Thames,' published 1794.

STAEVARTS, PALAMEDES, portrait painter. Born 1607 in London, where he practised his art, and died in 1638. Pontens engraved Mary Countess of Warwick after him.

STAINES, ROBERT, engraver. He was born in London, October 21, 1805, and was a pupil of J. C. Edwards, line-engraver, but finished his term of apprenticeship with the Findens, and was afterwards employed by them. He engraved for the ' Literary Souvenir,' the ' Friendship's Offering,' and the ' Art Journal.' He died October 3, 1849.

STAINIER, R., engraver. Practised in London, in the dot manner, in the latter part of the 18th century. He was chiefly employed on portraits. He engraved 'Cleopatra,' after Wheatley, R.A., 1788; ' Lindor and Clara,' by the same artist.

STANFIELD, WILLIAM CLARKSON, R.A., marine painter. Was born at Sunderland, of Irish parentage, in 1794. His ?1790 father was the author of an ' Essay on Biography,' and esteemed a writer of some reputation. As a boy he chose the marine

service, went to sea, and gained some experience, perfecting himself as a seaman. Fond of sketching ships and marine subjects, he formed a taste for art, and while afloat painted the scenery for a play got up by the crew. His talent was first noticed while serving as clerk on board a king's ship, and his desire was, when an opportunity offered, to try art as a profession. So when temporarily disabled by a fall, and discharged from the navy, he was able to gratify his wishes by an engagement about 1818 to paint the scenery for the old Royalty, a sailors' theatre in Wellclose Square. Improving in his capacity for this art, he was afterwards engaged at the Cobourg Theatre, where his labours and promptitude were unremitting, and his success soon led him to a higher field. He got an engagement at Drury Lane Theatre, and painted there scenery equal to any which had been known on the London stage, effecting great improvements in the art.

Continuing in this profession for several years, he produced at the same time some small marine views, and his reputation grew as a marine painter. He first exhibited in 1823 with the Society of British Artists, founded in that year, of which he became a member, and also at the British Institution. In 1827 he exhibited at the Academy, and encouraged by the success of his easel pictures and a premium of 50 guineas awarded to him at the British Institution, he abandoned scene-painting about 1829, and the following year made his first tour on the continent. Having resigned his connexion with the Society of British Artists, he in 1831 exhibited at the Academy, and was in the following year elected an associate, and in the same year was commissioned by William IV. to paint 'The Opening of New London Bridge,' and 'Portsmouth Harbour,' works which he exhibited at the Academy in 1832, followed in 1833–34–35 by some Italian scenes, chiefly Venetian. He was at the same time much engaged in illustrations for 'The Picturesque Annual.' In 1835 he was elected a full member of the Academy, and in 1836 he exhibited 'The Battle of Trafalgar,' a large work painted on commission for the United Service Club.

He had been much impressed by the scenery of Italy, and spent the greater part of 1839 there, and in the four following years his contributions to the Academy were chiefly Italian, and from that time indeed, the scenery of Italy, with views off the Dutch coasts, formed the subjects of his best works. In 1847 he exhibited a notable work, 'The French Troops fording the Magra in 1796;' in 1854, 'The "Victory," bearing the body of Nelson, towed into Gibraltar;' in 1857, 'The Wrecked

Spanish Armada;' in 1860, 'Vesuvius and the Bay of Naples;' in 1864, 'War' and 'Peace.' These are among his most esteemed works. He exhibited for the last time in 1867.

For some time he had been in a declining state of health, and on May 18, 1867, he died at Hampstead, where he had for many years resided. He was buried in St. Mary's Roman Catholic Cemetery at Kensal Green. He was a master of his art; his knowledge of seamanship gave a truth to the grandeur of his marine subjects, and his training in the scene-loft a picturesque beauty to his landscape views. But his art was too scenic, and the influence of stage effects prevailed to the last. He was for many years an influential member of the Sketching Society.

Among his works should be mentioned a series of ten pictures of large size, painted for the banqueting room at Bowood, and a second series for Trentham Hall. He also painted a number of views of coast scenery for Heath's 'Annual,' and published a collection of lithographic views on the Rhine, Moselle, Meuse, &c. The Royal Academy included in their exhibition of the old masters in 1870 a large collection of his works, but it did not tend to maintain the very high reputation which he had enjoyed in his lifetime.

STANFIELD, GEORGE CLARKSON, landscape and marine painter. Son of the above. Was born at Buckingham Street, Strand, London, May 1, 1828. He learnt the first principles of his art under his father, and was also a student of the Royal Academy. He first exhibited in the year 1844, and was from thenceforward a contributor to each year's annual gathering at the Academy without interruption down to 1876. He painted principally continental landscapes, being marine subjects and the scenery of towns. His art was similar in kind to that of his father, and did not present any striking originality. He died of disease of liver, at Hampstead, March 27, 1878, in his 50th year.

STANLEY, CALEB ROBERT, landscape painter. Born about 1790. He practised in London, and studied for a time in Italy, where he made many sketches. He painted in oil, and produced a few works in watercolours, introducing figures and architecture. He exhibited at the Royal Academy from 1820 to 1863 landscapes in oil, and at the commencement of his career on a few occasions landscapes, both in oil and watercolours, with the Society of British Artists. His execution was good but mannered. He died in London, February 13, 1868.

STANLEY, MONTAGUE, A.R.S.A., landscape painter. Born at Dundee, in January 1809. He was taken by his parents to New York, where he lost his

father. His mother marrying again, they removed to Halifax, and thence to Jamaica. A precocious child, he was engaged when eight years old, to play the part of 'Ariel,' which led to his becoming an actor. When about ten years old, he returned with his mother, again a widow, to England, and continued his theatrical career, chiefly in Edinburgh, where he became a favourite, till 1808. Then having previously studied landscape painting, he left the stage, partly from conscientious scruples, to follow art. His pictures were greatly esteemed and fetched good prices; he was rising in the profession, and had been elected an associate of the Royal Scottish Academy, when he was attacked by consumption, and died in the Isle of Bute, May 5, 1844. His sketches and other works were accidentally destroyed by fire on the rail on their way to auction at Edinburgh.

STANNARD, JOSEPH, *landscape and marine painter.* He was born September 13, 1797, at Norwich, where, with a taste for art, he managed to gain instruction from Robert Ladbrooke, and was assisted to visit and study in the Dutch galleries. He practised in his native city, was a member of the Norwich Society and a contributor to the Society's exhibition in 1811, and to the exhibition of the Society of British Artists in 1824. He painted a large picture, 'The Annual Water Frolic at Thorpe,' introducing portraits. His works are chiefly coast and river scènes, with some portraits, for which he enjoyed a local repute. He was a good etcher, and published a set of etchings of much promise. He died young in 1830.

STANTON, EDWARD, *sculptor.* Practised in London in the latter part of the 16th century. He erected a fine monument in the Church at Stratford-upon-Avon, and three good monuments of the Lytton family at Knebworth Church, 1704–10.

STANTON, THOMAS, *landscape painter.* Was born about 1750, and practised his art in London. He painted views and landscapes introducing architecture. S. Middiman engraved after him a large plate of Stonyhurst College.

STARK, WILLIAM, *architect.* He practised with great repute in Edinburgh and Glasgow about the beginning of the 19th century. He died at Edinburgh, in October 1813.

• STARK, JAMES, *landscape painter.* Was the son of a well-to-do dyer at Norwich, and was born there in 1794. He showed an early love of art, and in 1811 was articled to John Crome for three years, and the same year he contributed five landscapes in oil to the exhibition of the Norwich Society, and was elected a member. In 1817 he came to London and entered

the schools of the Royal Academy, and in that and the two following years he exhibited with the Water-Colour Society. About the same time he also became an exhibitor at the British Institution, where his works found purchasers, and the Governors awarded him a premium of 50l. But he was compelled by a painful affliction, the nature of which is not told, to return to his family at Norwich, where he remained about 12 years, and during that time married. Continuing in the practice of his art, he commenced, in 1827, a publication on 'The Scenery of the Rivers of Norfolk,' but when completed in 1834, notwithstanding its great merit and interest, it produced no adequate reward. He exhibited at Suffolk Street from 1824 to 1839, and at the Royal Academy from 1831 to 1859. He was not a constant contributor to either exhibition, but he frequently sent his works to the British Institution. In 1830 he came again to the Metropolis, and lived near the Thames, in Beaufort Row, Chelsea, and after 10 years' residence there, following the stream, he went to Windsor, and then after some years he returned to London, for the greater advantages of educating his son in art. He died March 24, 1859, in the 60th year of his age. His art owed much to his master, Crome, but it was original and purely English, the local character and incidents well preserved, yet wanting in richness and force, its simple and unobtrusive truth failed to wake enthusiasm.

STAYLER, ALEN, *illuminator.* He practised as an illuminator and miniaturist in the reign of Henry III., and illustrated the books of the Abbey of St. Alban's.

STAYNER, J., *engraver.* Practised in London in the latter part of the 18th century. There are two plates by him of humorous subjects, after Collet, and some other works in mezzo-tint.

STEEL, AARON, *ornamentist.* He was employed in Messrs. Wedgwood's manufactory, commencing in 1785, and acquired great skill in drawing the figures on their fine Etruscan vases. He died in 1845.

STEELE, EDWARD, nicknamed 'Count Steele,' *portrait painter.* Was born at Egremont, Cumberland, about 1730, and brought up to art. He studied for a time in Paris, and practised at York and in the Northern counties, painting portraits at four guineas each, which were by no means without merit, his works being correctly drawn and painted in a free, broad manner. Sterne was one of his sitters. He was eccentric and unprincipled, and ran away with a young lady, his pupil, assisted in this affair by Romney, who was then studying under him. His collection of pictures, prints, and drawings were sold by auction in 1759.

• STEENWYCK, HENRY, *painter of*

interiors. Was born in Flanders about 1589, the son of a painter of great reputation, under whom he studied his art. Vandyck encouraged him to come to England, employed him occasionally to paint architectural backgrounds to his pictures, and introduced him to Charles I. His usual subjects were the interiors of churches and other large edifices, which, in his latter works were more luminous and less dark than his earlier pictures. He died in London.

STEEVENS, RICHARD, *sculptor, painter, and medallist.* Born in the Netherlands. He came to this country and practised here in the reign of Elizabeth, with much distinction. The tomb of the Earl of Sussex, Lord Chamberlain to the Queen, at Boreham, Suffolk, was erected after his design, and the figures are by his own hand. He painted a full-length portrait of the Queen in a dress embroidered with sea-monsters, and one of Mary Queen of Scots. It is said that his portraits were attributed to Holbein; but they have little claim to this, and are wanting in his power and finish. Some of his medals are engraved in Evelyn's 'Discourse on English Medals.'

STENNETT, WILLIAM, *amateur.* Was a merchant at Boston, Lincoln, who had antiquarian tastes, and was a good draftsman. A drawing of Boston Church by him was engraved in 1715; and one of Walpole Church in 1734. He made drawings of other churches in Lincolnshire, and styled himself 'Delineator.' He died in poor circumstances at Boston. about 1762.

STEPHANOFF, FILETER N., *portrait painter.* Born in Russia. Came to London and settled here. Exhibited at the Royal Academy in 1778, and about the same time exhibited some stained drawings, views, with the Free Society. He painted portraits, but was chiefly employed on decorations for ceilings, and was for a time engaged in painting scenes for the circus in St. George's Fields. He produced some landscapes in India ink, slightly tinted, or, as it was then called, 'stained.' He committed suicide some time before 1790.

STEPHANOFF, GERTRUDE, *flower painter.* Wife of the above. Painted flowers, fruit, and still life with great finish and skill. She exhibited at the Royal Academy in 1783 and 1805, and was a teacher of drawing. Died at Brompton, January 7, 1808. Her daughter, Miss M. G. STEPHANOFF, was a flower painter and also an exhibitor.

STEPHANOFF, FRANCIS PHILIP, *subject painter.* Son of the above. Born in 1788 at Brompton. He commenced art at the age of 16, and was, from 1810 to 1845, a constant exhibitor at the Academy. His best works are, 'Poor Relations,' 'The

412

Reconciliation,' 'The Trial of Algernon Sydney.' He painted both in oil and water-colours, and from 1815 to 1820 was a contributor to the Water-Colour Exhibition, sending, among some other works, some drawings for Pyne's 'Royal Residences.' He gained a premium of 100*l.* at the Westminster Hall competition. Many of his works are engraved. He died at West Hannam, Gloucestershire, May 15, 1860. He furnished most of the costume portraits for the Garter-King-at-Arms' sumptuous work, 'The Coronation of George IV.,' and produced a fine series of historical drawings in water-colours, 'The Field of the Cloth of Gold.' His works were not of a high class, but were popular.

STEVENS, ALFRED, *sculptor and decorator.* Was born at Blandford in 1817. He was a short time at the Royal Academy schools, and at 16 went to Italy to prosecute his studies, where he was much impressed by the works of Michael Angelo. For a time, he assisted Thorwaldsen, who thought highly of his powers and gave him many commissions. He came back to England in 1826, and was principally engaged in decorative works in sculpture, painting, and metal. The finest specimen of his house-decoration is, perhaps, Mr. Holford's mansion in Park Lane, London. In 1850 he went to live at Sheffield, and his influence on the local metal manufactures there was very marked, and he also became connected with its School of Art. The small lions on the iron posts in front of the British Museum are by him; and he made a design for one of the Mosaic spandrels under the dome of St. Paul's. He received from Government a commission to execute the National Monument to the Duke of Wellington, in St. Paul's Cathedral, which after causing him sad trouble and vexation he left unfinished at his death. Still, it is probable, that two groups from it, 'Valour Triumphing over Cowardice,' and 'Truth Plucking out the Tongue of Falsehood,' will achieve for him a lasting reputation. He died at Haverstock Hill, London, May 1, 1875. Godfrey Sykes was his pupil.

STEVENS, ALEXANDER, *architect.* He is best known by works which are of an engineering character. His bridge over the Liffey at Dublin, the docks and works on the Grand Canal, Ireland, and the aqueduct over the Lune, at Lancaster. He died at a very advanced age at Lancaster, January 20, 1796. He was noted as a clever draftsman. He executed many works in the north of England and in Scotland.

STEVENS, D., *portrait painter.* Practised in the time of George I. A portrait of that king by him is engraved by J. Faber.

STEVENS, EDWARD, A.R.A., *architect.*

Pupil of Sir William Chambers. In 1762 he gained a premium at the Society of Arts. He was a member of the Incorporated Society of Artists, 1764, and was one of the early exhibitors at the Royal Academy, commencing in 1770 with designs for the Dublin Royal Exchange, followed by designs for mansions, a sepulchral church, &c. He was elected an associate of the Royal Academy in 1770, and died at Rome in 1775.

STEVENS, Francis, water-colour painter. Little is known of the career of this artist. He was born November 21, 1781. In 1804 he was first an exhibitor at the Royal Academy, and then received some instruction from Paul S. Munn. In 1806 he joined the Water-Colour Society, and in 1808 was one of the founders of the well-known Sketching Society. In 1810 he appears as a member of the Norwich Society of Artists, and having given up his membership of the Water-Colour Society, he exhibited in 1813 three oil landscapes at the Royal Academy, and in 1819-1822 was also an exhibitor of works in oil and water-colours; and was living at Exeter. Since then the trace of him is lost. Probably he was a native of that city, as he was sometimes designated 'Stevens of Exeter.' He had great merit. His drawings are well composed and drawn, and richly coloured; his figures well introduced. He etched the drawings for Ackerman's Farm-houses and Cottages, 1815.

STEVENS, John, R.S.A., subject painter. He was born at Ayr, N.B., about 1793. He came to London to study, and in 1815 was admitted to the schools of the Royal Academy. He then returned to his native town, where he practised portrait painting, but after a while went to Italy. He passed the greater part of his life in Rome. In 1831 he exhibited at the Royal Academy, 'Pilgrims at their Devotions in an Italian Convent.' Advanced in age, the shock of a railway accident in France was the proximate cause of his death, which took place in Edinburgh, June 1, 1867.

STEVENS, John, landscape painter. Born in Holland. He came to this country and painted small landscapes of a second-rate-class. Died in London, 1722.

STEVENS, John, engraver. Practised in London about the middle of the 18th century. He engraved with C. Grignon a series of English views.

STEVENS, Thomas, modeller. Was employed upon the magnificent tomb of the Warwick family, time of Henry VI., in Warwick Church. The principal figure and the small figures which occupy the niches are in copper richly gilt, and are attributed to him. They are exceedingly well executed.

STEVENSON, Thomas, landscape

painter. Was a pupil of Robert Aggas, and practised towards the end of the 17th century. He painted landscape in oil, introducing architecture and figures in distemper, but was little more than a second-rate scene painter. He made the designs for the pageant of the jubilee of the Goldsmiths' Company in the mayoralty of Sir Robert Vyner. He also painted portraits, one or two of which were engraved.

• STEWARDSON, Thomas, portrait painter. Was born at Kendal, of Quaker parentage. He served a short apprenticeship to a painter there, and then came to London, and was a pupil of Romney. Early in the century he commenced portrait painting in Leadenhall Street, and in 1804 was first an exhibitor at the Royal Academy. Soon attracting notice by his ability, he moved westward and was well employed. He attempted some subject pictures, and exhibited at the Academy, in 1818, 'The Indian Serpent Charmer,' and in the following year 'Aladdin.' He painted George III. and his Queen. Many of his portraits are engraved. He was appointed portrait painter to Queen Caroline. Died at his lodgings in Pall Mall, August 28, 1859, aged 78.

STEWART, Anthony, miniature painter. Was born at Crieff, Perthshire, in 1773. Showing a taste for art, he was placed under Alexander Nasmyth, in Edinburgh, and studied as a landscape painter. He made many sketches and drawings of Scotch scenery, which display great feeling and merit; but at an early period of his life he turned to miniature, which he adopted as his profession, and, after practising for a time in Scotland, came to London, where he established himself. He painted a miniature of the Princess Charlotte, and afterwards the first miniature of the Princess Victoria, who sat to him for several years in succession. Greatly excelling in the portraits of children, he devoted himself for the last 15 years of his practice almost exclusively to them. He was a man of superior education, a good judge of art, and made a fine collection of etchings and engravings. His miniatures were well drawn and coloured, and pleasing, in expression. He died in London in December 1846, and was buried in Norwood Cemetery. His daughters, Margaret and Grace Campbell, excelled as miniature painters, and the latter was an occasional exhibitor at the Academy between 1843 and 1848.

STEWART, George, architect. Built the large mansion in Earlstoke Park, Wilts, 1786-91. He exhibited some architectural designs at the Royal Academy in the latter year.

STEWART, James, portrait painter. Was appointed Serjeant-Painter to George III. in 1764 He painted for Alderman

Boydell portraits of all the artists employed on the Shakespeare Gallery, but the work did not possess much merit.

STEWART, JAMES, R.S.A., *engraver.* Was born in Edinburgh in 1791, and apprenticed there in 1804 to a line-engraver. He was also a student in the Trustees' Academy. His first engraved work of any importance was 'Tartar Robbers dividing their Spoil,' after Allan, R.A. This was followed by 'The Circassian Captives,' after the same painter. In these works he proved himself, by his refined yet vigorous manner, an accomplished line-engraver; and, continuing to engrave after Allen, R.A., he produced 'The Murder of Archbishop Sharp,' and 'Mary signing her Abdication.' He was next employed upon some of the lesser works of Wilkie, R.A., and then upon his 'Penny Wedding,' in which he successfully imitated the painter's manner. About this time some disappointment in his art, added to the cares of a large family, led him to emigrate, and in 1833 he arrived with them at Algoa Bay, where he invested his savings in the purchase of a farm; but the Caffre insurrection breaking out in the following year, his farm was destroyed, and, compelled to fly with his family, they with great difficulty reached the settlement at Somerset. He then again fell back upon his art, and by painting portraits and teaching he saved sufficient to purchase another property, on which he resided for many years, and became a magistrate of the settlements and a member of the legislature. He died in the colony in May 1863.

STOKER, BARTHOLOMEW, *portrait painter.* Born in Ireland, the son of an upholsterer in Dublin, and worked at that trade while studying in the Dublin art schools. He afterwards practised portraiture in crayons with great success in that city and the neighbourhood. He died, of decline, in Dublin, 1788.

STONE, EDWARD, *architect.* He was appointed clerk of the works to the Corporation of London in 1477, and was the first who held that office, which he filled only for one year.

● STONE, NICHOLAS, *sculptor and architect.* Born at Woodbury, near Exeter, in 1586. Worked some time in London, and on the termination of his apprenticeship went to Holland, and was employed at Amsterdam by Peter van Keyser, the architect of the city, whose daughter he married. He returned to London, and found full employment, chiefly in monuments, which he erected to many persons of distinction. In 1616 he was sent to Edinburgh, to decorate the Royal Chapel with sculpture; and in 1619 was employed on the ornamental work at the Banqueting House, Whitehall. He built the chapel in the Charter House to the memory of Thomas

Sutton, 1615; the front of St. Mary's at Oxford; and executed several works at Windsor Castle, to which edifice he was appointed by Charles I., in 1626, his master-mason and architect. He recorded as among his chief works — Lord Ormond's tomb, Kilkenny; Lord Northampton's, at Dover Castle; the Earl of Bedford's; the poet Spenser's, in Westminster Abbey; and Sir Edmund Bacon's, at Redgrave. His works of architectural monuments were so numerous, that he seems to have monopolised this class of the art of his day. He had three sons, Henry, Nicholas, and John, who all attained excellence as artists. He died August 24, 1647, aged 61, and was buried in the old church of St. Martin's-in-the-Fields.

● STONE, HENRY (known as 'Old Stone'), *painter and statuary.* Was the elder son of the foregoing. Passed many years of his life in Holland, France, and Italy; continued in the latter country four years, and while at Rome received some instruction from Bernini, returning to England in May 1642. He at first practised as a sculptor, and on his father's death carried on his business in conjunction with his brother John; but his time was chiefly given to painting. His portraits are careful and earnest in expression and finish. He copied Titian and other Italian masters, and his copies of Vandyck have fetched large prices as originals. He wrote a work on the art of painting. Died in London, August 24, 1653, the last survivor of his family, who were all buried in the same grave, with the inscription, 'Four rare stones are gone, the father and three sons.'

STONE, NICHOLAS, *sculptor.* Second son of the above Nicholas Stone. Studied his art in Italy. He reached Rome in October 1638, was admitted to the studio of Bernini, and made some good studies from the antique in terra cotta. He also copied several fine works, among them Bernini's 'Apollo and Daphne.' He was a good draftsman, and made drawings and sketches of the Italian buildings. Lady Berkeley's monument in alto-relievo at Cranford is by him. He returned to England in 1642, and died September 17, 1647. He was buried in the same grave with his father.

STONE, JOHN, *modeller.* Third son of Nicholas Stone, senr., was educated at Oxford, and intended for the Church, but became the pupil of Thomas Cross, the engraver. He joined the Royal army during the civil war, and on the final defeat of the King, he fled, and after many adventures, reached France, where he is supposed to have subsisted as he best could for several years. On his return to England, he devoted himself to art, and, in conjunction with his brother Henry, carried on his late father's

414

business, but little is known of his works. He published, anonymously, 'Enchiridion,' a book on fortification, with small engravings by himself ; and one of the plates in Dugdale's 'History of Warwickshire' is by him. He died, probably early, in 1653.

STONE, FRANK, A.R.A., *subject painter*. Was born at Manchester, where his father was a cotton spinner, August 22, 1800. He was brought up to his father's business, and was not attracted to art till his 24th year. Then, setting to work, he studied diligently, and making good progress, he came to London in 1831. He was elected, in 1837, an associate exhibitor of the Water-Colour Society, and produced works of sentiment, finished with much taste and prettiness. In 1837 he began to exhibit at the Academy, and tried the higher medium of oil, and in 1841 was awarded a premium of 50 guineas at the British Institution. In 1843 he was elected a member of the Water-Colour Society, and exhibited that year, and up to 1846, with the Society. In 1847 he resigned his membership. His oil pictures had meanwhile a great popularity. 'The Last Appeal,' 'Checkmate,' and 'Mated,' 'The Course of True Love,' and others, were engraved, and known in every part of the kingdom. He was elected an associate of the Academy in 1851. His works were assuming a higher character both in subject and treatment. His 'Gardener's Daughter,' and some French subjects painted at Boulogne, showed improvement, when he died suddenly, in London, of disease of the heart, November 18, 1859, and was buried in Highgate Cemetery.

STOOP, DIRCK or PETER, *painter of battle-pieces*. Was born in Holland about 1612. Practised some time in Portugal, and came from thence to England with Queen Catherine in 1662. He painted battle and hunting-pieces, and views of the seaports, but he is best known as an etcher of much spirit. Among his etchings, there are seven views of Lisbon dedicated to the Queen, and eight large plates representing the 'Procession of Queen Catherine from Portsmouth to Hampton Court on her Arrival in England ;' also several plates to Ogilvy's '.Æsop,' after Barlow. He died in England about 1686. Other accounts say he returned to Holland in 1678, and died there in that year.

STOPPELAER, HERBERT, *portrait painter*. Was born in Dublin, and made his way to London with Thomas Frye. He tried many means to gain a living. He painted portraits, and exhibited with the Society of Artists in 1761-62. Designed many of the humorous subjects published in his day by Bowles, and was an actor, dramatic writer, and singer. With Charles Dibdin he planned the Patagonian

Theatre, over the Exeter Change ; the proscenium six feet wide, and the actors ten inches high; and while Dibdin wrote the pieces and the music, he painted the scenes and spoke for the puppets. He was engaged by manager Rich, and played the doctor in 'Harlequin Skeleton,' but he appears to have done better in art ; for on a proposal to renew his engagement, he answered, 'Sir, I thank you for the *fever* you intended me, but have a violent cold and hoarseness upon me this twelve months, which continued above six months, and is not yet gone, and I am apprehensive it will return. I can but just keep my head above water by painting, therefore do not care to engage in the playhouse any more.' He died in 1772.

STOPPELAER, MICHAEL, *portrait painter*. Brother to the above, was born in Ireland, and practised portrait painting. A portrait by him of Joe Miller, painted in 1738, is engraved. He also had dramatic tastes, was famed as a comic singer, and performed low characters with much originality.

STORER, JAMES, *draftsman and engraver*. He lived chiefly at Cambridge, and devoted himself to the ancient architecture of Great Britain, which he both drew and engraved with great detail and accuracy, and had very considerable merit as an engraver. He published 'The Rural Walks of Cowper in a Series of Views near Olney,' 1803. He made the illustrations for 'The Antiquities of the Inns of Court and Chancery,' 1804; for 'Select Views of London and its Environs,' 1805; and in the same year for 'Views in North Britain,' illustrative of the works of Burns; with a work of the same character illustrating the works of Bloomfield; and in 1807-11 for the 'Antiquarian and Topographical Cabinet.' In 1812 he published 'A Description of Fonthill Abbey,' with views. In 1814 he commenced his 'History and Antiquities of British Cathedrals,' an accurate and excellent work, which was followed by 'An Elucidation of the Principles of Gothic Architecture.' He resided the latter part of his life in the Metropolis, where he died December 23, 1853, aged 72, and was buried at St. James's Chapel, Pentonville.

STORER, HENRY SARGANT, *draftsman and engraver*. Son of the foregoing, and associated with his father in his chief works. He resided many years at Cambridge, and drew and engraved views of King's College, Trinity College, and other edifices at Cambridge. He died in the prime of life, January 8, 1837, and was buried at St. James's Chapel, Pentonville.

● STOTHARD, THOMAS, R.A., *subject painter*. Was born at the 'Black Horse,' Long Acre, a house kept by his father, August 17, 1755, and being a delicate child

was, when five years old, sent to an uncle at Acomb, near York, where he grew strong, and gained some instruction at a village school, and afterwards at a school near Tadcaster. At the age of 13 he returned to his parents in London, and then went to a school at Ilford. In 1770 his father died, leaving him 1200*l*., and having shown an aptitude for drawing, he was apprenticed to a pattern draftsman for brocaded silks in Spitalfields, and occupied his leisure by designs from the poets. Some of these falling under the notice of the proprietor of the 'Novelists' Magazine,' he employed him to make a few designs, and though he did not then receive further employment, his thoughts were turned in that direction, and when, from a change in the silk trade and the death of his master, he was released a year before the completion of his apprenticeship, he at once devoted himself to art.

His first designs engraved were for an edition of 'Ossian,' and for 'Bell's Poets,' and the talent they displayed led to his employment on a series of designs for the 'Novelists' Magazine.' These subjects were well suited to his tender, simple tastes, and their truth and grace at once established a reputation. He was at first paid half a guinea each, which was soon raised to one guinea. Of these illustrations, the eleven illustrating 'Peregrine Pickle,' published in 1781, are admirable, the characters excellent, having all the flavour of Smollett. They were followed by some graceful designs for Richardson's 'Clarissa,' and 'Sir Charles Grandison,' full of a sweet imagery, which has rarely been surpassed. He afterwards designed from Shakespeare and Cervantes, illustrated 'Pilgrim's Progress,' in 1788, followed by 'Robinson Crusoe,' and in 1798, 'The Rape of the Lock,' in which tenderness and grace are combined with allegory.

The foregoing designs were exclusively for book illustration, and were usually drawn and washed in with India ink, sometimes sweetly coloured, but he painted many pictures in oil. He had entered the schools of the Royal Academy in 1777, and was a contributor to its exhibition. Commencing in 1778, his exhibited works were chiefly his book designs, which after his election as an associate in 1791 were chiefly in oil, with occasionally a work of more importance; but his contributions, though continued till his death, did not often exceed one each year. His last work of note was his 'Venus Attended by the Graces,' in 1824. He was elected a full member in 1794, and in 1810 was appointed the librarian. Among his oil pictures were his works for Boydell's Shakespeare Gallery, 'The Canterbury Pilgrims,' and 'The Dunmow Flitch.' Also, the great staircase at Burleigh, on which he was employed during 416

the summer months for four successive years; and the staircase of the Advocates' Library in Edinburgh. He was engaged likewise in designing for goldsmiths' work; and his Wellington Shield, modelled in silver, is a noble example of his talent.

He had been an industrious worker during a long life, and his designs have been estimated at 4000; above half that number have been engraved. Their elegance and grace gave a charm to book illustration, in which he stands unrivalled. But his oil paintings are not equal to his drawings; they are crude and defective in tone. Female beauty and purity are conspicuous in his works, but, wanting individuality, they are too much of one conventional type. His art did not, however, reach the sacred or historical. His conceptions were not of the severe character such subjects demand, and his works of this class are wanting in elevation of character and expression. He had married early and had a large family. He lived in Newman Street from 1794 till his death, April 27, 1834. He was buried in Bunhill Fields' ground. His life, with personal reminiscences, was published in 1851 by Mrs. Bray, the widow of his son Charles Alfred.

STOTHARD, CHARLES ALFRED, *antiquarian draftsman.* Son of the foregoing. Was born July 5, 1786. He early showed a taste for drawing, and was admitted a student of the Royal Academy. He started in art with an attempt in the grand style, and in 1810 painted the murder of Richard II. in Pomfret Castle, but did not meet with encouragement; and having made some drawings of the old monuments at Burleigh, while his father was engaged there, he turned his attention to the illustration of our national antiquities, and in 1811 published the first number of 'The Sepulchral Effigies.' He was painstaking and accurate, and soon established a name as an antiquarian draftsman, and from this time till 1815 travelled in England, often taking long journeys on foot, in pursuit of antique monuments. He was associated with Lysons in his 'Magna Britannia,' and was elected historical draftsman to the Society of Antiquaries. In 1816 he was employed by the Society to make drawings of the Bayeaux Tapestry, and while in Normandy made several antiquarian researches, and discovered the tombs of the Plantagenets, the existence of which had been doubted. He had completed nine (out of twelve) numbers of his 'Sepulchral Effigies,' having etched 127 of the plates with his own hand, and had commenced the collection of materials to illustrate the age of Elizabeth, when he met his untimely death. He went into Devonshire to make drawings and notes for the 'Magna Britannia,' and while tracing

a church window at Beer Ferrers, he fell, and was found dead on the floor, May 28, 1821. His widow, who published a memoir of him in 1823, afterwards married the clergyman of the church.

STOTHARD, HENRY, *sculptor.* Was the brother of the foregoing, and the third son of Thomas Stothard, R.A. He was a pupil of Flaxman, R.A., and was admitted to the Schools of the Academy, where he gained the first medal in the antique school. He suffered an attack of apoplexy, and after being for 20 years unable to follow his profession, obtained admission to the Charter House in 1840, and died in that institution, February 26, 1847, aged 56.

STOTHARD, ALFRED JOSEPH, *medallist.* Was the sixth son of Thomas Stothard, R.A. His works are well known. He reproduced Chantrey's bust of Sir Walter Scott, and medallions of Lord Byron and Mr. Canning. Also a good medallion portrait of George IV. He exhibited portrait medals at the Academy, for many years, commencing in 1825. He died October 6, 1864, aged 71.

STOW, JAMES, *engraver.* Was born near Maidstone, about 1770, the son of a Kentish labourer. He showed such an early ability for art, that the gentry of the neighbourhood raised a subscription and apprenticed him to Woollett, on whose death he was transferred to William Sharp, with whom, after completing his apprenticeship, he continued for some time as assistant. He worked in the line manner, and was employed upon some of the best works of his time. For Boydell's 'Shakespeare,' between 1795-1801, he engraved eight plates. For Du Roveray's 'Homer,' 1806, 12 plates. He also engraved some portraits, in which he excelled, and some good landscapes, among them Gainsborough's 'Boy at the Stile.' But he did not realise his early promise; his exaggerated talent had not aided him, he became irregular in his habits, then embarrassed in his circumstances, and on his death left a family in indigent circumstances. Among his latter works his plates for 'Londina Illustrata,' 1811-23, are very inferior.

STRANGE, Sir ROBERT, Knt., *engraver.* Was born at Pomona, Orkney, July 26, 1721, of an ancient Fifeshire family, who had settled there. He was classically educated at Kirkwall and intended for the law, but showing some talent for drawing, was apprenticed to Richard Cooper, an engraver, then practising in Edinburgh. He first began business himself as an engraver in that city, and held a respectable position there when, on the breaking out of the Civil War, it was occupied by the Young Pretender and his troops in 1745. He joined the Jacobite side, and was appointed engraver to Prince

Charles, a half-length portrait of whom, bearing the initials 'C. P. R. and R. Strange, sculp.,' gained him a great reputation. There exist several portraits in pencil by him at this time of the Prince and his adherents, which, though weakly drawn, have the character of truthful individuality. He is reputed to have fought in the ranks at Culloden, and after the loss of the battle to have escaped to Paris. Here he studied under Le Bas, and in 1751 returned to London, where he established himself, and was recognised as an engraver of great eminence.

On the accession of George III. he was invited to engrave the full-length portraits of the King and his prime minister Lord Bute, by Ramsay, and gave great offence, which probably his previous career increased, by refusing this commission; and he thought it well to carry out at once a wish he had long entertained, of visiting Italy. Here he studied with great diligence at the principal cities, chiefly at Rome and Bologna, and produced some of his finest works. He also spent several years in Paris, where, as in Italy, his works were held in very high estimation. He engraved some of the finest pictures by Guido, Domenichino, Titian, Raphael, Correggio, Vandyck, and other masters, and was elected member of the Academies of Rome, Florence, Bologna, Parma, and Paris. In several of the highest qualities of his art he is unsurpassed. His tender flowing line gives a peculiar delicacy and transparency to his flesh, and his works are excellent in power, drawing, and character—qualities which he had attained by his practice of making the most careful studies in red chalk.

He was a member of the Incorporated Society of Artists, 1766. He resented the laws of the Royal Academy, which did not allow the election of engravers, thought himself excluded by petty intrigues, and was a bitter opponent of that body. In 1775 he published an attack upon them, under the title of 'An Enquiry into the Rise and Progress of the Royal Academy of Arts at London,' to which he prefixed a letter, complaining that Lord Bute had shown his resentment by engaging an emissary to learn the works of the great masters which he intended to engrave in Italy, and then employing Bartolozzi to engrave these very pictures from drawings dishonourably obtained in the King's name. It does not appear when he returned to London, but he did not regain the Court favour till 1787, when he engraved, after West, the apotheosis of the three children of the King, who died in their infancy, and in the same year received the honour of knighthood. He had been long in a declining state of health, and died at his house in Great Queen Street, Lincoln's

Inn Fields, July 5, 1792. He was buried in St. Paul's Churchyard, Covent Garden. At Sir Mark Sykes's sale in 1824, his works fetched high prices, and 51l. was paid for a proof of his Charles I., after Vandyck. His wife was of an old Jacobite family, and it is told of her that, when aged and bedridden, some one in her presence speaking of Prince Charles as 'The Pretender,' she started up and exclaimed, 'The Pretender be d——d to you!' The 'Memoirs of Sir Robert Strange and Andrew Lumisden,' the brother of this lady, were published in 1855.

• STREATER, ROBERT, *history painter.* Was born in Covent Garden in 1624, the son of a painter, and was a pupil of Du Moulin, said to have been celebrated in his day. He painted history, portraits, landscape, and still-life. Charles II. appointed him his Serjeant-Painter. He painted several ceilings at Whitehall, which were destroyed at the fire; 'Moses and Aaron,' for St. Michael's, Cornhill; the Chapel at All Souls' College, Oxford, and a large ceiling at the theatre there, deemed his best work; the flying Amorini on it are good, and though a pretentious attempt, it is not without merit. He painted scenes for the King's masques, and etched the Battle of Naseby and several architectural plates. Pepys describes him 'as an excellent painter of perspective and landscape,' and says 'he had great popularity during his life.' He was attacked by illness, and the King sent to Paris for an eminent physician to attend him, but he arrived too late. He died in 1680. It appears that his son succeeded him as Serjeant-Painter, and died in 1711.

STREETES, GWILLIM, *portrait painter.* Was an English artist, and was painter to Edward VI. in 1551. Strype records that the King paid him 50 marks for two pictures of the King, and a third of Henry Howard, Earl of Surrey, who was beheaded in 1546-7.

STRINGER, DANIEL, *portrait painter.* He was a student of the Royal Academy about 1770, and obtained the power of drawing with great beauty and spirit, and was also a good colourist. He produced some admirable heads, and made some sketches which showed great comic power. But he sacrificed his great talent to the company of country squires and the love of Cheshire ale, and the admirers of his art lost sight of him.

STRINGER, E., *topographical draftsman.* Practised in the last quarter of the 18th century. Was a member of the Liverpool Academy, and contributed to their exhibitions. Some of his works, which have no art merit, were engraved for the 'Gentleman's Magazine' about 1785.

418

STROEHLING, P. H., *portrait painter.* He was a Russian subject, and was educated at the expense of the Emperor, finishing his studies in Italy. He came to this country about 1804, and in that and the two following years was an exhibitor at the Royal Academy. He does not again appear as an exhibitor till 1819, and from that year till 1826 sent his works to the Academy. His portraits are chiefly in oil, but he also painted some good miniatures, and had many distinguished sitters.

• STRUTT, JOSEPH, *painter and engraver.* Was born at Springfield, Essex, October 27, 1749, and was the son of a miller who possessed some property. His mother, who had been many years a widow, apprenticed him, at the age of 14, to the unfortunate W. Wynne Ryland. In 1769 he was admitted to the schools of the Royal Academy, and having gained a silver medal, he was, in 1770, awarded the gold medal for his historical painting of 'Æneas stopped by Creusa.' An introduction at this time to the Library of the British Museum turned his attention to literature, which divided his thoughts with art, and in 1773 he published his 'Regal and Ecclesiastical Antiquities of England;' in 1774 the first volume of what he called his great work, 'The Manners and Customs of the English,' followed by the remaining two volumes in 1775 and 1776. His art was the handmaid to his antiquarian tastes. He made his drawings, engraved his plates, and wrote his letter-press commentary. In 1775 the first volume of his 'Chronicle of England' appeared, and the second in the following year; but it did not receive sufficient encouragement to induce its continuance.

At this time he was greatly afflicted by the death of his wife, followed by the death of his mother, and it is not till 1785 that he again appears. In that and the following year he published his 'Dictionary of Engravers,' in the second volume of which he was assisted by the elder Bacon, the sculptor. He suffered from asthma, and in 1790 he retired to Bramfield, near Hertford, where he resided five years, and engraved the greater part of the plates for 'Pilgrim's Progress.' But he returned to London, where alone he could find materials to gratify him in his studies, and began to collect materials for his work, 'The Dresses and Manners of the English,' which he published in 1796-9. To this, in 1801, he added his last work, 'The Sports and Pastimes of the English.' He had commenced a work to illustrate the usages of the 15th century, styled 'Queen Hoo Hall,' which he laid aside to undertake a new edition of his 'Manners and Customs,' but death put an end to his industrious labours.

He died in Charles Street, Hatton Garden, October 16, 1802, and was buried in St. Andrew's Church. As an artist he painted only five or six historical works. His drawings, however, both in chalk and body colour, are numerous and carefully executed. His engravings are in the dot and the chalk manner, very tender and spirited, well drawn and expressive. In addition to the 'Pilgrim's Progress' there are some landscapes after Claude, and some plates after Le Soeur, Cipriani, and Stothard. But by his antiquarian labours his name will always be remembered.

STRUTT, JACOB GEORGE, *landscape painter.* He studied his art in London, and first appears as an exhibitor of portraits at the Royal Academy in 1822 and 1823. In the following year, and up to 1831, his exhibited works were exclusively forest scenes. Soon after he went to Lausanne, and after residing there some time went to Rome. He sent from thence, in 1845, 'The Ancient Forum,' and in 1851, 'Tasso's Oak, Rome,' and the same year returned to London. He exhibited an 'Italian Scene' in 1852, his last contribution to the Academy. He published, 1823–25, 'Sylva Britannica,' drawn and etched by himself; also 'Deliciæ Sylvarum.'

STUART, JAMES (known as 'Athenian Stuart'), *architect.* Born of humble parents, (his father a Scotch mariner, in Creed Lane,) London, in 1713. He evinced an early talent for drawing, and a power of attaining knowledge. By painting fans for Goupy, a famous maker, who kept a shop in the Strand, he materially assisted to support his widowed mother and her young family, and found means also to improve himself. He became a correct draftsman, geometrician, mathematician, and to these attainments he added Latin and Greek. These studies led him to architecture. He was of a robust constitution, and gifted with great courage and perseverance. When almost in penury he conceived the idea of visiting Rome and Athens, but he delayed his journey till he could make some provision for his mother, with a young brother and sister. On their fortunate employment, and his mother's death, he started, with an almost empty pocket, in 1741, for Rome on foot, travelling through Holland and France, but of necessity stopping at Paris and other places to earn money for the prosecution of his journey.

At Rome he met with Nicholas Revett, with whom his name is indissolubly connected, and remained with him there for six or seven years, closely employed in the study of painting, and during this time they conceived the plan which they jointly made known in 1748, of publishing an authentic description of Athens. With this purpose they left Rome in March 1750,

but did not reach Athens till the following March. Stuart had, while on the Continent, made himself a master of the art of fortification, and voluntarily served at this time a campaign as chief engineer, in the army of the Queen of Hungary. Then, returning to Athens, he applied himself closely to the study of Athenian architecture, making exact measurements and drawings. In 1753 he left Athens, accompanied by Revett, and visited Thessalonica, Smyrna, and the Islands of the Archipelago, and returned to London with his companion early in the year 1755, after a laborious expedition of five years. In 1762 he published, in conjunction with Revett, the first volume of the 'Antiquities of Athens,' a work which will form a memorial of his accuracy, skill, and perseverance. The second volume, which he had completed, was published after his death, in 1789. The drawings were nearly completed for the third and concluding volume, which was published in 1795, edited by Reveley. From 1771 to 1783 he exhibited with the Free Society of Artists, contributing views in water-colours of the 'Ancient Buildings in Athens,' 'Views of Athens,' 'Grecian Antiquities,' and designs, which were modelled by Thomas Scheemakers, 'Cupid Unveiling Modesty,' 'Judgment of Paris,' 'The Story of Cyrus,' and some others. In 1780 he was President of the Society.

He practised as an architect, erected several fine mansions in London, was appointed surveyor to Greenwich Hospital, and rebuilt the chapel, after its destruction by fire. His drawings were chiefly made in body colour. He was twice married, first about 1760, to his housekeeper, a good woman, by whom he had one son; and a second time, about 1781, to a young lady by whom he had four children. He died, in Leicester Square, February 2, 1788, and was buried in the vaults of the church of St. Martin-in-the-Fields. He left a considerable fortune, amassed entirely by his own industry. In addition to the acquirements already mentioned, he was skilful in engraving and carving, and distinguished by his general antiquarian knowledge.

● STUBBS, GEORGE, A.R.A., *animal painter.* Was born in 1724, at Liverpool, where his father practised as a surgeon. Little more is known of his early life than that he was an earnest anatomical student, and about 1754 visited Italy, extending his journey as far as Rome. It is probable that he studied there for a time, as Barry, R.A., twice mentions him in his letters from Rome, and speaks in terms of high praise of some works he was painting. On his return he settled in London, soon became known as a painter and anatomist, devoting himself largely to the dissection of animals. He was patronised as a horse-

painter by all who delighted in art. He was a member of the Incorporated Society of Artists, and in 1773 their President. In 1766 he published his ' Anatomy of the Horse,' a work on which he had been long engaged, and had drawn and etched, from dissections made by himself, the 18 plates with which it was illustrated. In 1780 he was elected an associate of the Royal Academy, and the following year an academician; but he declined to present a painting by himself to the Academy, in pursuance of the rule, and preferred to remain an associate.

In painting the portraits of horses, he aspired to something more than the mere lay-figure treatment which had hitherto prevailed, and aimed at showing the animal's form in variety of motion, and also grouped and in combination with the higher animals. Of this class are his ' Horse frightened at a Lion,' and ' Lion killing a Horse.' He also painted tigers and other wild animals with great ability. He was fortunate that engravers of such distinction as Woollett, Earlom, and Val. Green spread the fame of his works. His ' Fall of Phaëton,' which he is said to have repeated four times, is always mentioned as one of his best works, but it does not maintain its reputation. He had been long engaged on an anatomical work, comparing the human structure with that of the tiger and other animals, but he only lived to complete three out of the intended six parts. He tried some enamels of large size on iron plates, and in 1782 exhibited the portrait of a dog and of an artist in that material. He died in Upper Somerset Street, Portman Square, July 10, 1806. He had resided there for 40 years, and during that time had been a strict water-drinker, yet he lived to enjoy 82 years of vigorous life.

STUBBS, GEORGE TOWNLEY, engraver. Son of the foregoing. Was born in London about 1756, and learnt his art under his father, many of whose works he engraved in mezzo-tint. He also engraved after others, and some of his works are in the dot manner and printed in colours. He exhibited with the Incorporated Society in 1775-76 mezzo-tints and stained drawings. He died in 1815.

STUBLEY, P., portrait painter. Practised in London about 1730. His portraits are very well drawn and composed. There is a good engraved portrait of Peter Monamy, the marine painter, after him, and some other portraits engraved by J. Faber.

STUMP, JOHN S., miniature painter. He was a student in the schools of the Royal Academy, where he was for many years and up to 1845 a constant contributor to the exhibitions. He contributed miniature portraits, many of them theatrical portraits in character, and one or two classic
420

subjects also in miniature. He also exhibited subjects of the same class, from 1824 to 1845, with the Society of British Artists; and in his early career contributed some landscape scenes and portraits to the Water-Colour Society. There are likewise a few oil portraits by his hand, and some Swiss landscape scenes. He held a high place as a miniature painter, his work being marked by great tone and breadth. He was a member of the Sketching Society. He died in 1863.

STURT, JOHN, engraver. Born in London, April 6th, 1658. Was apprenticed, at the age of 17, to Robert White. His works had not much art merit. He engraved the Lord's Prayer within the compass of a silver penny, filled the curls of a royal wig with pious praises, and some other like feats; but his chief work was his Common Prayer Book, published by subscription in 1717, which was engraved in two columns on silver plates, with borders round each plate, initial letters, and small histories at the top. The work is of large octavo size, and contains 166 pages, besides 22 which comprise title, dedication, preface, portraits of George I., and of the Prince and Princess of Wales, &c. He afterwards engraved, in the same manner, a Companion to the Altar, and some other works, among which deserves notice Anderson's Scotch Records, which he left unfinished. He grew aged and poor, refused a place in the Charter House which was offered to him, and died in August 1730. Faithorne drew his portrait, which was engraved by W. Humphreys.

SULLIVAN, LUKE, engraver. Was born 1705, Co. Louth, Ireland, and is reputed to have been the son of one of the Duke of Beaufort's grooms, and to have found his first employment in the stable. He came early in life to London, about 1750, and was a pupil of Thomas Major, the engraver. He is chiefly known as an engraver, and was an assistant to Hogarth. He engraved his ' Paul before Felix,' in which picture the face of the angel was drawn from him; and the ' March to Finchley,' an excellent work. He painted in water-colour some architectural and landscape views, and engraved himself his ' View in the Park,' with a group of figures, 1751; and also a series of six seats — Cleveden, Esher, Wilton, Ditchley, and Woburn, 1759. He also excelled highly in miniatures, especially of females, and from 1764 to 1770 was an exhibitor, chiefly of miniatures, with the Incorporated Society, of which he was a member and director. He was of dissipated habits, passing his time in brothels and taverns, and died at the ' White Bear,' Piccadilly, early in 1771.

SUMMERFIELD, JOHN, engraver. Was the favourite pupil of Bartolozzi, R.A.,

and was early distinguished by his talent. He executed, in 1800, a fine plate of 'Rubens and his Wife going to Market,' for which he received the Society of Arts' gold medal, and some other excellent works; but to so low an ebb was the art then reduced, that he is said to have suffered from actual want. He died in Buckinghamshire in March 1817.

SUNMAN (or SONMAN), WILLEM, *portrait painter.* Was born in Holland, came to England in the reign of Charles II., and was much employed after the death of Lely, but was jealous of the rising ability and favour of John Riley, and retired to Oxford. Here he was employed by the University, and painted the series of large apocryphal pictures of the founders of colleges now in the Picture Gallery, works which do not give a high idea of his abilities. But there is by him a good portrait at Wadham of an old female servant of that college. Some of his portraits are engraved. He died in 1707, in Gerrard Street, Soho.

SUTCLIFFE, THOMAS, *water-colour painter.* He was born in Yorkshire, and during his art career lived at Headingly, near Leeds. He first exhibited in London at the Royal Academy, in 1856, 'A Study in Harewood Park,' and was soon after admitted an associate of the Institute of Painters in Water-Colours, and exhibited landscape views with that Society up to his death in December 1871.

SUTHERLAND, THOMAS, *engraver.* Was born about 1785, and practised his art in London. He is chiefly known by his plates in aqua-tint, some of which are printed in colours. Among his works are the Peacock Tavern, Islington, from whence the northern mails started; some hunting subjects, and views of Dover and Calais.

SUTHIS, WILLIAM, *architect.* He was a citizen of London, and held the office of Master Mason and Architect of Windsor Castle, on the reign of Charles I. He died October 5, 1625, and was buried at Lambeth.

SUTTON, JOHN, *modeller and carver.* Was employed upon the famous tomb of the Earl of Warwick. Temp. Richard the Second.

SUTTON, BAPTIST, *glass painter.* Painted two windows for the Church of St. Leonard, Shoreditch, some time prior to 1634.

SWAINE, FRANCIS, *marine painter.* He was a member of the Free Society of Artists 1763, and was an exhibitor with them and the Incorporated Society till his death. He gained the Society of Arts' medal in 1764, and again in 1765, for his marine views. He painted marine moonlights, sea-fights, and was an imitator of the Dutch masters. There are two small

sea-pieces by him at Hampton-Court, but they do not support the reputation he enjoyed in his lifetime. He resided many years in Stretton Ground, Westminster, and removed to Chelsea, where he died in 1782. Two of his works are engraved by Canot. MONAMY SWAINE, probably his son, was also a painter, and an exhibitor of marine subjects.

SWAINE, JOHN, *engraver.* Born at Stanwell, Middlesex, was a pupil of Jacob Schnebbelie, and on his death, in 1791, was transferred to Barak Langmate, a writing engraver, and then to his son. He was chiefly employed on works of an antiquarian character, and was painstaking and accurate, but feeble. He executed very clever facsimile imitations of old engraved portraits. He died in Dean Street, Soho, November 25, 1860, aged 85. His son, JOHN BARAK SWAINE, who was brought up as an engraver, and was of some promise, died prematurely in 1828, aged 23.

SWAN, ABRAHAM, *architect.* Practised in London in the middle of the 18th century, and published, in 1757, 'A Collection of Designs in Architecture.'

SWIFT, JOHN WARKUP, *marine painter.* He was brought up at Hull in the midst of shipping, and was for several years a sailor. He first became scene painter to an amateur dramatic club, and improving in art, he settled in practice at Newcastle-on-Tyne, and became well known in the north of England. He painted, in 1863, 'The Channel Fleet running into Sunderland,' and 'Shields Harbour,' both large works. He also painted a few landscapes. Some of his works were produced in chromo-lithography. He died suddenly, at Newcastle-on-Tyne, May 7, 1869, aged 54.

⚫ SYBRECHT, JOHN, *landscape painter.* Born at Antwerp in 1625. He came to England, and was employed during four years in the decoration of Cliefden House, and afterwards at Newstead and Chatsworth. He painted in the decorative manner of Du Jardin and Berghem. He died in London in 1703, and was buried at St. James's Church, Piccadilly.

SYKES, ——, *portrait painter.* He was one of the artists consulted, in 1727, on the value of Thornhill's paintings at Greenwich Hospital. He died in Lincoln's Inn Fields shortly before 1733, and his collection of pictures was sold in June of that year. He was considered of some eminence in his day.

SYKES, GODFREY, *ornamental modeller.* Was born at Malton, and was successively student, pupil-teacher, and master of the Sheffield School of Art. He was afterwards employed at the South Kensington Museum, and united with Captain Fowke, R.E., in the decoration of the new Museum buildings and the arcades of the

conservatory in the Horticultural Gardens. The columns for the lecture theatre at the Museum are examples of his taste and genius. His style was distinctly formed, and showed great fertility of invention, controlled by sound principles. After a long illness, he died at Brompton, February 28, 1866, in his 41st year.

SYME, PATRICK, R.S.A., *flower-painter*. He was born September 17, 1774, in Edinburgh, where he was educated, and at an early age followed the profession of his elder brother, succeeding, on his death in 1803, to his practice as a teacher of drawing. He was a regular contributor from 1810 to 1816 to the exhibitions of the Society of Associated Artists. He died at Dollar, N. B., in July, 1845. He was a man of several attainments—a botanist, entomologist, had made collections of shells and insects, and some of his natural history drawings were deemed his best works. He was also a writer of poetry and fiction. His ' Treatise on British Song Birds' was published in 1823. He also published an

edition of Werner's ' Nomenclature of Colours.'

SYME, JOHN, R.S.A., *portrait painter*. Nephew of the above. He was born in 1795 in Edinburgh, where he studied in the Trustees' Academy, and afterwards practised. He was a pupil of Sir Henry Raeburn, and on his death, completed his unfinished works, and was successful as a portrait painter. He was one of the foundation members of the Royal Scottish Academy, and took an active share in its management. His portrait, painted by himself, is in the Academy Gallery. He died in Edinburgh in 1861, after a severe illness, which had for several years prevented the exercise of his profession.

SYMONDS, SYMON, *glass-painter*. Lived in St. Margaret's parish, Westminster, and, conjointly with Francis Williamson, contracted for the painted windows of the upper story of King's College, Cambridge, 18th Henry VIII., of ' Orient Colours and Imagery of the Story of the Old Law and of the New Law.'

T

TACONET, CHARLES, *sculptor*. Studied in the schools of the Royal Academy. In 1790 he exhibited 'The Death of Milo,' and ' Venus Instructing Cupid in Archery,' and in the same year he gained the Academy gold medal for his model of ' Samson.' In 1791 he exhibited a design for a portrait medal, and in 1792, 'Atlas,' after which there is no further trace of his art.

TAGG, THOMAS, *etcher*. Was well known for the great taste of his etchings. His name does not appear as an exhibitor. He chiefly forwarded plates for engravers. He suffered for some months from epileptic fits, probably aggravated by poverty, and was in great pecuniary want. His artist friends raised a subscription for him, but only in time to provide for his funeral and pay the debts contracted during his illness. He died at Kennington, in November, 1809.

TALFOURD, FIELD, *portrait painter*. Born at Reading in 1815. He first exhibited at the Royal Academy in 1845, and from that year was an occasional contributor chiefly of portraits. From 1865 he sometimes exhibited a landscape, and his last works sent to the Academy in 1873 were two Welsh landscapes. His portraits were frequently drawn in crayons. He died in Sloane Square, after a short illness, in March 1874. He was the younger brother of Mr. Justice Talfourd.

TALLEMACHE, WILLIAM, *sculptor*. He studied in the schools of the Royal

Academy, and in 1805 gained the gold medal for his group, ' Chaining Prometheus to the Rock.' He does not appear to have followed up this success. He only appears again as an exhibitor of small models, to be cast in bronze, on two occasions, in 1812 a ' Model of the King ; ' and 1814 a ' Bacchus ' and an ' Ariadne.'

TALMAN, WILLIAM, *architect*. Was born at West Lavington, Wilts, where he had an estate. He was Comptroller of the Works to William III., and was employed on many considerable buildings. In 1671 he built Thoresby House, Nottinghamshire, which was burnt down ; in 1681, Chatsworth, Derbyshire ; in 1698, Dynham House, Gloucestershire ; and later, Swallowfield, in Berkshire.

• TALMAN, JOHN, *amateur*. Son of the foregoing. He went to Rome with Kent to study, in 1710, and passed much of his time in Italy, where he made numerous drawings of the churches and public edifices, some of which are sketched with the pen and others tinted in water-colours. A few of these drawings are possessed by the Society of Antiquaries.

TANNER, JOHN SIGISMUND, *medallist*. Was a native of Saxe-Gotha, and came to England about 1733. He was first employed in the domestic service of Frederick Prince of Wales, and showing a taste for carving and chasing, he obtained some appointment in the Royal Mint, and by his ability rose to

be chief engraver in 1740. He executed medals of the Prince and Princess of Orange, the large family medal of George I., his Queen, and their children, and a medal of Sir Isaac Newton. After nearly 40 years' service in the Mint he retired. He died in Edward Street, Cavendish Square, March 16, 1775.

TANNOCK, JAMES, *portrait painter.* Was born about 1780, at Kilmarnock, where his father, to whose trade he was apprenticed, was a shoemaker. He was so bent upon painting that he was at last allowed his own way, and getting employment as a house-painter, he tried portraiture with sufficient success to gain notice in his own town. He then went to Glasgow and had some practice there, and was, from 1806 to 1809, at Greenock, where he painted chiefly miniatures, but some few oil portraits also, and again for a time resided at Glasgow, where his art was much esteemed. About 1813 he came to London, and lived for many years in Newman Street. His portraits possessed some merit, and from 1813 to 1841 he exhibited, with little intermission, at the Royal Academy. From about 1820 to 1830 his son, W. TANNOCK, was also an exhibitor of portraits.

TASSAERT, J. PHILIP, *portrait and drapery painter.* Was born at Antwerp, and came to England when very young. He was some time with Hudson the portrait painter, probably as his assistant. He was, in 1769, elected a member of the Incorporated Society of Artists, and in 1775 a president of the Society, exhibiting with them for several years landscapes and subject pictures. On one or two occasions he sent a small whole-length portrait to the Academy. His works were frequently pasticcios and copies, and he can hardly be classed as an original painter. He was also known as a picture-cleaner and dealer. He issued, in 1777, a plan for 'A Most Noble and General Exhibition of Arts and Sciences,' which was partly to be formed of works on loan. He died in Soho, October 6, 1803.

TASSIE, JAMES, *gem-engraver and modeller.* He was born near Glasgow, of humble parents, in 1735, and was brought up as a country stonemason. Going into Glasgow on the occasion of a fair he saw the Foulis collection of pictures, and was struck with the desire to be an artist ; and removing into Glasgow, where he got employment at his trade for his support, he obtained admission to Foulis' Academy, where he acquired a power of drawing and modelling. He exhibited at the Royal Academy, in London, in 1769, two modelled portraits, and continued an exhibitor up to 1791. He then went to Dublin to seek employment, and his talent made him known there to Dr. Quin, who was engaged in making pastes in imitation of precious stones, and, taking him into his confidence, he showed him his processes, and to this art he devoted himself, imitating some of the most precious relics of antiquity in gems and coins. In 1766 he came to London to prepare and sell his pastes, but, diffident to excess, he struggled long under difficulties, from which he slowly emerged, and gained a competence by the perfection of his art, his imitations being so fine as to be sold for originals. He executed about 15,000 for the Empress of Russia. He collected materials of great art value, increasing his stock of casts and pastes to 20,000 impressions. He was an excellent artist, a man of taste, judgment, and research, and executed many likenesses, possessing great accuracy, of men eminent in his day. He died in Leicester Square, 1799, and was succeeded by his nephew, WILLIAM TASSIE, who was the fortunate winner, in 1805, of the Shakespeare Gallery, erected in Pall Mall, the great prize in Alderman Boydell's lottery, and died at Kensington, in 1860.

TATE, W. CHRISTOPHER, *sculptor.* Was born at Newcastle-on-Tyne, where he was apprenticed to a marble-mason, and afterwards worked for a sculptor. Leaving him, and struggling hard to establish himself as an artist, he produced a 'Dead Christ,' and a statue of 'Blind Willie,' by which he is known. He then tried bust-modelling. Several persons of influence sat to him, and he exhibited at the Academy in 1828–29–33, but not afterwards. Later he produced a 'Judgment of Paris,' a well-designed group, and a 'Musidora.' His health failing, he made a voyage to the Mediterranean, but his disease making rapid progress, he returned, and died, on his way home, in London, March 28, 1841, aged 29, leaving a widow and two children without any provision. There are many monumental tombs by him in the neighbourhood of his native town.

TATE, WILLIAM, *portrait painter.* He was a pupil of 'Wright of Derby,' and practised with some reputation at Liverpool in 1776 ; then, for a short time, in London, at Manchester in 1787, and later, at Bath. He exhibited portraits, with one or two attempts at subject pictures, at the Royal Academy, between 1776 and 1802. He died at Bath, June 2, 1806.

TATHAM, CHARLES HEATHCOTE, *architect.* Studied his art in Italy. Was several years at Rome and Bologna, and was elected a member of the academies of those cities. He exhibited at the Royal Academy, commencing in 1797, designs and ornamental works, and was early in his career well employed, chiefly on works of a decorative character. He published 'Etchings from the Best Examples of Ancient Ornamental Architecture, drawn from the Ori-

ginals at Rome,' 1799, and a second volume in 1803; 'Etchings representing Fragments of Grecian and Roman Architectural Ornaments,' 1806; and the same year, 'Designs for Ornamental Plate.' In 1811, his own complete works, 'The Gallery at Castle Howard,' and 'The Gallery at Brocklesby.' He also wrote the letter-press for Carey's 'Ancient Cathedrals,' and for some other publications. He was warden of Norfolk College, Greenwich. Died April 10, 1842, in his 72nd year.

TAVERNER, JEREMIAH, *portrait painter*. Practised early in the first half of the 18th century. There is a portrait by him, mezzo-tinted by J. Smith. He was the author of several plays.

TAVERNER, WILLIAM, *amateur*. Was born in 1703. He was the son of a proctor in Doctors' Commons, and grandson of the above, and followed the profession of a proctor, devoting his leisure to art. His drawings are chiefly in body colour, imitating the Italian masters, mostly woody scenes, and, though clever, do not by any means maintain the great reputation which he enjoyed in his own day. He was the author of two plays, 'The Maid the Mistress,' 1732, and 'The Artful Husband,' 1735. He died October 20, 1772.

TAYLOR, ALEXANDER, *miniature painter*. Exhibited at the Royal Academy, for the first time, in 1776, and continued an occasional exhibitor till 1796.

TAYLOR, CHARLES, *engraver*. Was born in London in 1748, and became the pupil of Bartolozzi. He engraved a number of plates after Angelica Kauffman.

TAYLOR, EDWARD CLOUGH, *amateur*. He was educated at Trinity College, and took his M.A. degree in 1814. He lived at Kirkham Abbey, Yorkshire, and was distinguished as a clever etcher. Died May 14, 1851, aged 65.

TAYLOR, ISAAC, *draftsman and engraver*. Was born at Worcester, December 13, 1730, the son of a brass founder, and in connexion with this business he learnt to draw ornaments and the figure, and did a little engraving on plates and cards. He came to London in 1752, walking by side of the waggon, and with an empty pocket. By good fortune he obtained some employment with a silversmith. He then married, and went to Brentwood, where he tried land-surveying, but found it more advantageous to return to London and resume his work as an engraver. He had engraved plates for the 'Gentleman's Magazine,' and he now found employment of this nature, gradually gaining notice. Between 1766-70 he exhibited several engravings for books, engraved after his own designs. He also drew and engraved the plates for an edition of 'Sir Charles Grandison,' which were highly esteemed. His

424

style was finished, his execution good, and he possessed talents which should have given him a wider reputation. He died at Edmonton, October 17, 1807, aged 77, having for many years retired from the practice of his profession. He was Secretary to the Incorporated Society of Artists from 1774 to the collapse of the Society.

TAYLOR, ISAAC, *engraver and draftsman*. Son of the above. Was born in London about 1750, and was a pupil of Bartolozzi. He is chiefly known by his engraved works for Boydell's Shakespeare Gallery, 'Rizzio,' after Opie, 1791; 'Henry VIII.'s first sight of Anne Boleyn,' after Stothard, and 'Falstaff frightened by supposed Demons,' after Smirke. He also made the designs for Boydell's 'Illustrations of the Holy Bible,' many of which were engraved by his father. About 1786 he retired to Suffolk, and afterwards became minister of an Independent congregation, at Colchester and at Ongar, at which latter place he died December 11, 1829. His daughters, Jane and Ann Taylor, were well known by their 'Original Poems.'

TAYLOR, JAMES, *designer and engraver*. Was younger brother of the first ISAAC TAYLOR. He was employed for many years as a china-painter at Worcester, and then came to London and worked as an assistant to his brother. He died in Coldbath Fields, December 21, 1797, aged 52. He was the master of ANKER SMITH, A.E.

TAYLOR, JOHN, *portrait painter*. Nephew of the water-poet. He practised at Oxford in the middle of the 17th century. His portrait, painted by himself, is in the Bodleian Library, and also two portraits of 'The Water-Poet,' painted in 1655.

TAYLOR, JOHN, *landscape painter*. Was born at Bath about 1745. Studied in London with much reputation. He painted marine landscapes with figures and cattle. Goupy and Lerpinière engraved after him, and he was himself an etcher. He died at Bath, November 8, 1806.

TAYLOR, JOHN (known as 'Old Taylor'), *portrait painter*. Was born in Bishopgate in 1739, the son of one of the principal officers of the customs. He was a pupil of Frank Hayman and a student of the St. Martin's Lane Academy. In 1766 he was a member of the Incorporated Society of Artists. For some years he devoted himself to portrait drawings in pencil, which he finished with great minuteness, but did not attain excellence. Commencing in 1779 he was an occasional exhibitor for above 20 years at the Academy, sending domestic scenes, but more frequently portraits in miniature and drawn in pencil. Later he took up teaching as more profitable, adend ma a small competence, invest-

ing his earnings in the long annuities expiring in 1840. It was just sufficient for his unusually long life. He died in Cirencester Place, November 21, 1838, in his 99th year. He was a man of cheerful humour, full of never-failing reminiscences of art and artists.

TAYLOR, Sir ROBERT, Knt., *architect.* Was the son of a stone-mason, who made a good deal of money, but spent it. He was the pupil of Henry Cheere, and managed to travel to Rome for his improvement. He worked at the commencement of his life as a statuary. General Guest's monument, near the north door of Westminster Abbey, is one of his best works. The bas-relief in the tympanum of the pediment of the Mansion House portico is also by him. He afterwards relinquished statuary and confined himself to architecture. He made some important additions to the Duke of Grafton's house in Piccadilly, Lord Howe's in Hertfordshire, and Lord Radnor's in Wiltshire. His chief buildings are Ely House, Dover Street; Gorhambury, Hertfordshire; Hevingham Hall, Essex; and Stone Buildings, Lincoln's Inn. He was appointed architect to the Bank of England, the Admiralty, Greenwich Hospital, and the Foundling Hospital, and held several other offices. He filled the office of sheriff in 1783, and was then knighted. He was of very active habits, rose very early, and made his journeys by night. He died September 27, 1788, aged 74, and was buried at St. Martin's-in-the-Fields. He left a fortune of 180,000l., which he had accumulated during an active practice of 40 years.

TAYLOR, SIMON, *botanical draftsman.* Was educated at Shipley's Drawing School, and in 1756 was awarded a medal by the Society of Arts. About 1760 he was engaged by Lord Bute to make botanical drawings, for which he had given proof of early ability, and continued in his employ for many years. He painted on vellum in water-colours, in a very accurate and masterly manner. He was afterwards engaged in the same manner by Dr. Fothergill. His works are very numerous. His usual price for a drawing was three guineas. Lord Bute's collection was sold by auction in 1794 by Leigh and Sotheby. Dr. Fothergill's was purchased by the Empress of Russia. He died about 1798.

TAYLOR, THOMAS, *engraver.* Practised about the middle of the 18th century. Was employed by Alderman Boydell, and engraved Henry VIII., after Opie, for the Shakespeare Gallery. Also engraved after Salvator Rosa and Van Harp, and some allegorical designs by Gwynn.

TAYLOR, THOMAS, *engraver and print-seller.* He practised in London, 1680–1720.

TAYLOR, WILLIAM B. SARSFIELD, *landscape painter.* Was the son of a map-engraver at Dublin. He commenced life in the Commissariat Service, and was present at the siege of St. Sebastian. He afterwards tried art, but without much success, and is better known by his writings. He was an exhibitor at the Royal Academy from 1820 to 1847. Commencing with landscapes, he contributed some military scenes, and some marine subjects among his later works. His publications are—' A Description of Trinity College, Dublin,' with illustrations from his own drawings; 'A Translation of Merimée's Practice of Painting;' 'A History of the Fine Arts in Great Britain and Ireland;' and 'A History of the Practice of Fresco Painting.' He also wrote on the penitentiary system of the United States, and was an art critic. In the latter part of his life he was curator of the St. Martin's Lane Model Academy. He died December 23, 1850, aged 69.

TAYLOR, WILLIAM DEAN, *engraver.* He was born in 1794. He practised in the line manner, and his art was well esteemed. Among his works are 'Acis and Galatea,' after R. Cook, R.A., and a portrait of the Duke of Wellington, after Lawrence, P.R.A. He died suddenly in 1857.

TAYLOR, ZACHARY, *statuary.* Was one of Charles I.'s 'surveyors and carvers,' and was employed in carving the marble enrichments of the great doors of old St. Paul's, when restored by Inigo Jones.

TELBIN, WILLIAM, *scene painter.* He attained great reputation by his scenery painting, and his drop-scene for the 'Overland Route' at Drury Lane Theatre was much applauded. He was a member of the Institute of Water-Colour Painters from 1839 till his death, yet never a large contributor to their exhibitions. He exhibited at the Royal Academy in 1859, and on two occasions at the Institute of British Artists. He was for several years an invalid, and never recovered the depression caused by the sudden loss of his son, in an Alpine avalanche. He died December 25, 1873, in his 61st year.

TEMPEST, PIERCE, *engraver and print-seller.* Received some instructions from Hollar, and assisted him in his works. He engraved James II. and his Queen, but is best known by the 'Cryes and Habits of London,' engraved in 50 plates after old Laroon, and commonly called 'Tempest's Cries,' published 1688. He practised 1670–1705. Died 1717, and was buried at St. Paul's, Covent Garden.

TEMPLE, W. W., *wood-engraver.* Was apprenticed to Bewick, and engraved for his 'British Birds,' the rough-legged falcon, pigmy sand-piper, red sand-piper, and the eared grebe. On the completion

425

of his apprenticeship he abandoned art and became a draper and silk-mercer.

TEMPLE, GEORGE, *architect.* Designed and erected Temple Bridge, Dublin, 1752, and was much reputed in his profession. He published, late in life, a treatise, valuable at that time, on 'Building in Water.'

TEMPLETOWN, Viscountess, *amateur.* Born Lady Mary Montagu, she married Viscount Templetown in 1796. Fond of art, she designed some groups, which were executed by Messrs. Wedgwood. There is by her a clever drawing in Indian ink, a wood scene, in the South Kensington Museum. She died October 4, 1824.

TENNANT, JOHN F., *landscape painter.* He was born at Camberwell, in September 1796, and commenced life in a merchant's office, but he early turned to art, and in 1820 exhibited some landscapes at the Royal Academy, introducing figures and cattle. On the foundation of the Society of British Artists he was a large contributor to their first exhibitions, and in 1842 was admitted a member. He lived some time in North Wales, afterwards in Devonshire, and later at Hendon. His landscapes were picturesque in their character and treatment. He exhibited occasionally at the Academy up to 1847, and for many years later with his own Society. He died in 1872.

TERASSON, H., *engraver.* Practised in London in the early part of the 18th century. He engraved some plates of insects, and there is a view of the Banqueting House, Whitehall, drawn and engraved by him in 1713.

TERNOUTH, J., *sculptor.* He was from 1819 to 1849 an exhibitor at the Royal Academy. His works were almost exclusively portrait busts, and he had some distinguished sitters. He exhibited one or two monumental works, and in 1847 a 'Musidora,' his only work of a poetic character. He died in 1848 or early in 1849.

TERRY, G., *mezzo-tint engraver.* Was a member of the St. Martin's Lane Academy, and was chiefly employed in engraving portraits about the last quarter of the 18th century.

THACKER, ROBERT, *engraver.* Practised in the reign of Charles II., and styled himself engraver to the King. There is by him a large engraved plate of Salisbury Cathedral, in four sheets.

THACKERAY, WILLIAM MAKEPEACE, *amateur.* He was born at Calcutta in 1811. His father was of a good Yorkshire family, and was in the Civil Service of the East India Company. He was educated at the Charter House, and went to Cambridge, but did not take a degree. Un-
426

decided for a while in his tastes between literature and art, he spent some time on the continent, chiefly with a view to the study of the latter; but his early sketches gave little indication of ability, and his great literary genius soon showed the true bent of his talent. His 'Vanity Fair,' 1846, followed by 'The Newcomes,' 'Pendennis,' 1849, and 'Esmond,' 1852, placed him in the first rank of the literary men of his day. For some of his early works, his papers in 'Punch,' his 'Irish Sketch-Books,' and also his contributions to the 'Cornhill Magazine,' which he established in 1860, he designed many of the illustrations on the wood, but they were crude, poorly drawn, and had little pretensions to art. He died, suddenly, at Kensington, December 24, 1863, and was buried at the Kensal Green Cemetery.

THEAKSTONE, JOSEPH, *sculptor.* Was born of respectable parents at York, and was a pupil of the elder Bacon. He afterwards assisted him, was then employed for several years by Flaxman, and for a time by Baily. He exhibited occasionally at the Royal Academy, from 1817 to 1837, his contributions not rising higher than a bust or a monumental design; but for the last 24 years of his life he found constant employment in Chantrey's studio, chiefly upon the draperies, in which he had attained great skill and dexterity. He showed much judgment, and used his chisel with great cleverness. He died in Pimlico, April 14, 1842, aged 69.

THEED, WILLIAM, R.A., *sculptor.* Was born in 1764, and commenced art as a student in the Royal Academy Schools in 1786. He first practised as a painter of classic subjects and portraits, sending to the exhibition in 1793 a 'Venus and Cupids.' He then went to pursue his studies in Rome, where he remained several years; married at Naples a French lady, and returned to England some time in 1794. In 1798 he again exhibited some paintings, and in 1799, 'Nessus and Dejanira,' a model, and soon after began to design and model for the Messrs. Wedgwood, the potters, in whose employment he continued for several years, and was then employed in designs for goldsmiths' work by Messrs. Rundell & Bridges, with whom he remained, receiving a handsome fixed salary, about 14 years. During this time he continued to exhibit a work occasionally at the Academy; in 1800, 'Cephalus and Aurora,' a painting; in 1806, 'Thetis with the Arms of Achilles,' a wax model; in 1811, three classic models, and was in that year elected an associate of the Royal Academy, and in 1813 a member. He continued an exhibitor of models, comprising a large figure of Mercury, a life-size group, and a Thetis, in

bronze. His last designs were of a monumental character. He died in 1817. His son has become eminent in his father's profession.

THEW, ROBERT, *engraver*. Born in 1758, at Patrington, Holdernesse, where his father kept a village inn. He was apprenticed to a cooper, and served his time, and was a private in the Northumberland Militia during the war. Though without education, he had much natural ability. In 1783 he settled in Hull, and engraved shop-bills, cards, &c., and then a plan of Hull, and, advancing in his attempts, the head of a well-known puppet showman. Later he engraved a good plate after Gerard Dow, and through it gained an introduction to Alderman Boydell, who gave him employment. He practised in the dot manner, and engraved no less than 19 of the large plates for the Shakespeare Gallery, which are finished with great delicacy and character. A plate by him, after Westall, of Cardinal Wolsey entering Leicester Abbey is one of his best works. He held the appointment of engraver to the Prince of Wales. He died at Stevenage, Herts, in August 1802.

THIRTLE, JOHN, *water-colour painter.* He was born in Norwich in 1774, the son of a shoemaker. He first practised as a miniature painter, and then began business as a frame-maker, carver and gilder, at Norwich. Was a member of the Norwich Society, with which he exhibited, and practised at Norwich in the beginning of the 19th century. He exhibited at the Royal Academy in 1808, but only on this occasion. His drawings were good, well-coloured examples of pure water-colour art. He married the sister-in-law of J. Sell Cotman. He did not leave his native city, and died there September 29, 1839, and was buried in the Rosary Cemetery.

THOM, JOHN, *subject painter.* Was born in Edinburgh about 1783, and studied the elements of his art there. Later he came to London, where he met with encouragement. His 'Young Recruit' was engraved by A. Duncan in 1825.

THOM, JAMES, *sculptor.* Was born in Ayrshire in 1799, and found his first employment, obscure and unfriended, as a stone-cutter. Uneducated, he produced in stone some clever natural groups, which attracted the notice of his own countrymen, and induced him to try his fortune in London. Here he found employment, and his 'Tam O'Shanter' and 'Old Mortality' were produced in plaster, sold throughout the country, and made him famous. He entrusted these two groups to an agent to exhibit in America, and, never receiving any returns, he crossed the Atlantic to look after his property, and was induced to remain. He settled at Newark, where in exploring for stone for his own purposes, he discovered a valuable quarry. He reproduced from this stone his two favourite groups and a statue of Burns, and several commissioned groups for the decoration of pleasure-grounds. He made a profitable contract for the stone-work and for much of the decorative stone-carving for Trinity Church, New York, and was enabled to purchase a farm on the line of the Erie Railroad, and to build himself a house. He appears then to have abandoned his profession. He died of consumption, in his lodgings at New York, April 17, 1850, aged 51. He left a widow and two children.

THOMAS, MATTHEW EDWARD, *architect.* Was a student of the Royal Academy, and in 1815 gained the gold medal for his design for a palace. This he exhibited the following year, and then travelled in Italy, and was elected a member of the Academy at Florence and of St. Luke at Rome. On his return, he exhibited at the Academy in 1820–21–22, and his name then disappears. The works contributed in these three latter exhibitions were architectural drawings, not designs.

THOMAS, JOHN, *sculptor.* Was of a Welsh family, and was born in 1813 at Chalford, Gloucestershire. He came to London to undertake part of the decorative sculpture of the new Houses of Parliament. From 1838 to 1862 he was a constant exhibitor at the Academy. His contributions were chiefly busts, on which he appears to have been well employed, with an occasional design of a monumental character. The pediment and figures in front of the Great Western hotel are by him, as also are the allegorical bas-reliefs of London, Liverpool, Manchester, and other cities, at the Euston Square station. He designed the new works at the head of the Serpentine river, and the great majolica fountain (now in the Horticural Gardens) for the International Exhibition in 1862. Of his works of higher pretension are a 'Musidora,' in marble ; 'Lady Godiva,' 'Una and the Lion.' He suffered from overwork and anxiety, and died at Maida Hill, April 9, 1862, aged 49.

THOMAS, JOHN EVAN, *sculptor.* Was born in Wales, and came to London, where he studied under Sir Francis Chantrey. He was from 1835 an exhibitor at the Royal Academy. His works were chiefly, and for many years exclusively, busts, but he executed several statues in marble and bronze, and some portrait statuettes. Among his statues may be mentioned a colossal bronze figure of the 'Marquis of Bute,' at Cardiff, 'The Duke of Wellington,' at Brecon, and 'Prince Albert,' on the Castle Hill, Tenby. He only exhibited·

at the Academy on two occasions after 1857. He retired from London and resided in Breconshire, in which county he filled the office of Sheriff. He died at a somewhat advanced age in October 1873.

THOMAS, WILLIAM, architect. Practised in London in the second half of the 18th century. He was from 1780 to 1794 an occasional exhibitor at the Academy of architectural designs, but they were not of an important character. He published, 1783, 'Original Designs in Architecture,' 27 plates, comprising villas, temples, grottos, tombs, &c. He was a member of the celebrated Artists' Club.

THOMAS, GEORGE HOUSMAN, portrait and subject painter. He was born in London, December 17, 1824. He was apprenticed to a wood-engraver, and commenced practising that art in Paris, and then designed on the wood. From thence he went to America to illustrate a New York newspaper, and while there, staying about two years, he designed the notes for the States' bank. He returned to Europe on the ground of ill-health, and visited Italy, was in Rome when that city was besieged by the French, and sent many sketches of the events of the siege to the 'Illustrated London News.' Settling in London, he was employed upon that paper. He first exhibited at the British Institution, but was a frequent exhibitor at the Academy, commencing in 1854. He was fortunate in gaining the patronage of the Queen, and painted for her Majesty 'The Marriage of the Prince of Wales at Windsor,' 'The Marriage of the Princess Alice at Osborne,' 'The Princess Royal doing Homage as Crown Princess at the Coronation f the King of Prussia,' 'The Distribution of the Victoria Medals by the Queen,' and several others. He also painted ' Rotten Row,' 1862 ; 'Soldiers' Ball, Camp at Boulogne.' He died at Boulogne, July 21, 1868, aged 44. In the following year his collected works, several of which are engraved, were exhibited in Bond Street. His sketches and studies were sold at Christie's in July, 1872. His works were pleasing, gay in colour, and correctly drawn, but he did not attain to a higher feeling in art.

THOMPSON, WILLIAM JOHN, R.S.A., portrait painter. He was born at Savannah, Georgia, 1771, the son of a Scotch American loyalist, and was brought to England when a child. As a lad he was compelled to labour for his support, when, finding his way up to London, he attached himself to art, and tried portraiture. In 1808 he joined the Associated Artists in Water-Colours. Gaining employment he improved, and practised in London till 1812, when he removed to Edinburgh, where he settled. In 1829 he was elected a member of the Royal Scottish Academy. His works were life-like and

428

spirited, and for many years he enjoyed a reputation. He painted some fine portraits in miniature. He died in Edinburgh, March 24, 1845, aged 74.

THOMPSON, CHARLES, engraver. Practised in London early in the 19th century. He engraved several plates for the almanacs, and the illustrations for ' Ædes Althorpianæ,' 1822.

THOMPSON, E. W., portrait painter. Had a considerable practice. Resided many years in Paris, where he was well known and employed. He sent five portraits from Paris to the Academy in 1832, and the following year, when he had returned to London, and again in 1840, but only on those occasions was a contributor. He died at Lincoln, December 27, 1847, aged 77.

THOMPSON, JOHN, portrait painter, known in his day as 'Thompson, the City painter.' Practised in London, 1590-1610, and was a member of the Painters' Company, in Little Trinity Lane, where there is his own portrait, and several others by his hand.

THOMPSON, THOMAS, glass-painter, of Coventry. Painted the great east window of York Minster in the reign of Henry IV.

THOMPSON, WILLIAM (nicknamed ' Blarney'), portrait painter. Was born in Dublin. Learned his art in London, where he practised. He exhibited whole and half-length portraits with the Society of Artists, in 1761, and continued to exhibit with that Society till 1767. He was a man of education, possessed of a specious address. His portraits were esteemed for their likeness, but his art was feeble, and marrying a wife with a fortune, he relinquished his profession, in which he wanted the ability and the industry to succeed. On her death he married a second time, and again a lady possessing a fortune. Yet he got into difficulties, and into the King's Bench prison, and made some stir by noisily asserting the illegality of confinement for debt. He was for some time secretary to the Incorporated Society of Artists. He founded a school of oratory, held at the noted Mrs. Cornely's, in Soho Square, which was open to both sexes, and at which he was the moderator, an office in which he acquitted himself with more success than reputation. He published ' An Enquiry into the Elementary Principles of Beauty in the Works of Nature and Art.' He survived till the early part of 1800, when he died suddenly in London. Two of his portraits were engraved in mezzo-tint.

THOMPSON, JOHN, wood-engraver. Was born in Manchester, May 25, 1785, and was a pupil of the elder Branston. He attained great distinction in his art. His works are marked by correct drawing and

true artistic feeling; his manner excellent and purely original, free from the mechanical treatment so often shown on wood. Some of his best works are after the designs of Thurston, whose illustrations he engraved for the works issuing from the Chiswick Press, 'The London Theatre,' 1814–1818; Fairfax's 'Tasso;' and in 1818, Butler's 'Hudibras.' He was then engaged by the Bank of England to produce a note which, from its art, it would be impracticable to imitate, and about the same period was much employed by the French publishers. Then followed his illustrations to the 'Blind Beggar's Daughter of Bethnal Green,' 1832; Gray's 'Elegy,' 1832; Shakespeare's Works, 1836; 'The Arabian Nights,' 1841; 'The Vicar of Wakefield,' after Mulready, 1843; the chief of the illustrations to Yarrell's works on natural history, and many fine works after Stothard. He was employed by the Government, in 1839, to engrave, in relief, on gun metal, Mulready's design for the postage envelope; and in 1852, to engrave, in relief, on steel, the figure of Britannia which is still printed on the Bank of England notes. He was, from September 1852 to July 1859, the director of the Female School of Engraving at the South Kensington Museum, and in 1853 delivered a very instructive course of lectures to the students. He presented to the library of that Institution his collection of wood-engravings. In 1855 he received the Grand Medal of Honour at the Paris Exhibition. He died at Kensington, February 20, 1866, aged 81, and was buried at Kensal Green.

THOMPSON, CHARLES, wood-engraver. Brother of the foregoing. Was born in London, in 1791, and was the pupil of Bewick and of Branston. The demands from Paris for wood-engravings by our artists induced him, in 1816, to visit that capital, and meeting with considerable encouragement he settled there, and was held in much estimation. He introduced the practice of engraving on the end of the wood, then unknown on the Continent. He founded a reputation by his contributions to many illustrated works published in Paris, and in 1824 was decorated with the gold medal, and on his death the French Government granted his widow a pension. The chief publications on which he was engaged were 'L'Histoire de l'ancien et du nouveau Testament,' 1835; 'Fables de la Fontaine,' 1836; Thierry's 'Conquête de l'Angleterre,' 'Corinne,' 1841. He died May 19, 1843, at Bourg-la-Reine, near Paris.

THOMPSON, CHARLES THURSTON, wood-engraver. Was the son of the above John Thompson, and was born at Peckham, July 28, 1816. He was brought up to his father's profession, and followed it for some years, attaining great excellence. His works illustrate many of Messrs. Van Voorst's and Messrs. Longman's publications. He was a man of great taste and judgment, and took a prominent share in the arrangement of the Great Exhibition of 1851. After this, having undertaken the superintendence of the works of the photographers, he became attached to that art, which was rapidly developing its powers. In the following year he was employed by the Exhibition Commissioners to superintend the photographic printing which was done at Versailles, and from that time devoted himself to this new art. He was then engaged by the Science and Art Department, and in their employ made several visits to Paris, Spain, and Portugal to photograph objects of interest. During his residence in the two latter countries his health was much shaken, and an old attack returning, he died at Paris, after a short illness, January 22, 1868, in his 52nd year. He was buried at Kensal Green.

THOMPSON, GEORGE, architect. Practised in Scotland towards the middle of the 17th century. He was employed on the building of the King's College, at Aberdeen.

THOMPSON, THOMAS CLEMENT, R.H.A., portrait painter. He was an exhibitor at Dublin in 1809, and was a zealous advocate for the Charter granted to the artists in 1823, and one of the foundation members of the Royal Hibernian Academy then established. He had, however, a considerable practice as a portrait painter in London. He was first an exhibitor at the Royal Academy in 1817, and was then residing in Dublin, but the following year he settled in London, and was from that time a large contributor to the Academy Exhibitions, exclusively of portraits, exhibiting for the last time in 1842.

THOMPSON, JAMES ROBERT, architectural draftsman. He appears to have been first engaged in making drawings for John Britton's publications, and was from 1808 an occasional exhibitor at the Royal Academy, his contributions consisting of landscapes and architectural designs. In 1818 he sent five scenes representing the mode of hunting and capturing elephants in Ceylon; in 1822 a 'Design for a Temple of Peace,' and in 1830, when he last exhibited, his finished sketch designs for the new London Bridge.

• THOMSON, HENRY, R.A., historical painter. Was the son of a purser in the Navy, and was born in London, July 31, 1773. He was educated at a school at Bishops Waltham, where he continued nearly nine years. In 1787 he went with his father to Paris, and on the breaking

out of the Revolution, returned to London. Choosing art for his profession, he became the pupil of Opie, R. A., and in 1790 entered the schools of the Royal Academy. In 1793 his father took him again to the Continent for the completion of his studies, and he visited Parma, Bologna, Florence, Rome, and Naples, occupied by the art of these cities till 1798, when, still accompanied by his father, he went to Venice, and after a few months' residence there, to Vienna and Dresden, and in 1799 journeyed homewards by Berlin and Hamburg. On his return, the artists were busy upon Boydell's Shakespeare Gallery, and he contributed 'Perdita,' and one or two subjects from the ' Tempest.' In 1800 he exhibited a classic subject at the Academy, followed by some domestic scenes and portraits, and was, in 1801, elected an associate of the Academy. In 1804 he exhibited ' Mercy Interceding for a Fallen Warrior,' and some portraits, and continued to exhibit portraits and subject pictures ; in 1815, ' Cupid Disarmed ;' in 1820, ' Christ Raising Jairus' Daughter ;' in 1822, ' Miranda's First Sight of Ferdinand ; ' and in 1825, ' Juliet,' his last, and probably his best, work. In the same year he was appointed keeper of the Royal Academy, but resigned the office at the end of two years from severe illness and suffering, and retired to Portsea, where, his health rallying, he was able to amuse himself in sketching the marine and landscape views of the neighbourhood. He died at Portsea, April 6, 1843, and was buried in Portsmouth churchyard.

THOMSON, The Rev. JOHN, Hon., R.S.A., *amateur landscape painter.* Known as ' Thomson of Duddingston,' was the son of the minister of Dailly, in Ayrshire, and was born there September 1, 1778. He was brought up to the Church, and succeeded his father in 1800, removing to Duddingston, near Edinburgh, on his nomination to the church of that parish in 1805. He was an excellent scholar, a man of great taste, showed an early talent for art, and, assisted by Alexander Nasmyth, made great progress. He painted mountain and lake scenery with great breadth and truth, and was distinguished by an amount of artistic power seldom attained by amateurs. He first exhibited in 1808, and continued an exhibitor to his death, but rarely except in Edinburgh. He was appointed an honorary member of the Royal Scottish Academy, having refused to join that and other art institutions on account of the clerical profession to which he belonged. Died at Duddingston Manse, October 20, 1840, aged 62.

THOMSON, JAMES, *engraver.* Was born at Mitford, Northumberland, the son of a clergyman of the Established Church. Showing an early attachment to drawing,

430

he was apprenticed to an engraver in London, and embarking at Shields for the Metropolis, he was nine weeks at sea, and supposed to have been lost. He disliked his master, and the style of his art, and after assisting him at the close of his apprenticeship for two years, set up for himself. His best known works are ' The Three Nieces of the Duke of Wellington,' after Sir Thomas Lawrence ; the equestrian portrait of ' The Queen, attended by Lord Melbourne,' after Sir F. Grant, P. R.A. ; ' The Bishop of London,' after G. Richmond, R.A. ; and ' Prince Albert,' after Sir William Ross, R. A. He engraved also many of the plates for Lodge's Portraits, the Townley Marbles, and other works. He died in Albany Street, Regent's Park, September 27, 1850, aged 61.

THOMSON, PATON, *engraver.* Was born about 1750. He practised in London, and produced some good works, chiefly portraits. He engraved a portrait of Edward Jerningham, 1794 ; and 'John Anderson my Joe,' after David Allan, 1799.

THORNBURY, WALTER J., *art critic.* Was brought up as an artist, and studied his profession at Leigh's School of Art, but took to literary pursuits, and became an author. He died June 11, 1876.

‡ THORNHILL, Sir JAMES, Knt., *historical painter.* He was born in 1676, at Melcombe Regis, of an old county family, whose property his father had dissipated. Compelled to seek some profession, following his own tastes he came to London, and was placed by his uncle, the celebrated Dr. Sydenham, under Thomas Highmore. Little is known of his early art career, but he is reputed to have soon made great progress. He was patronised by Queen Anne, who commissioned him to paint the interior of the Dome of St. Paul's, and appointed him her Serjeant-Painter. Other work of the same character followed. He painted the Great Hall at Blenheim ; the saloon and hall of the mansion at Moor Park, of which he was the architect ; the Princesses' apartments at Hampton Court ; the hall and staircase at Easton Neston ; the Chapel at Wimpole ; and the Great Hall at Greenwich, on which he was engaged from 1708 to 1727. About 1715 he made a tour through Holland, Flanders, and France, and had then acquired the means of purchasing some good pictures. He made careful copies of the cartoons at Hampton Court, now in the possession of the Royal Academy, upon which he was occupied for three years. He painted the altar-piece at All Souls and at Queen's College, Oxford. In May 1720 he was knighted by George I., and was the first native painter who received that distinction. He had the singular satisfaction to re-purchase his family estates, and was elected to represent Mel-

Thornburn Rob^t Painter on Ivor
6-1818-d

combe Regis in the first Parliament of the King's reign. He proposed to found a Royal Academy for Art, and on failing to gain the assistance of the Government, he opened a private academy in his own house in 1724, which he maintained during his life-time. He had amassed considerable property, yet many statements are made of the inadequate pay which he received for his public works. By some intrigue he was removed from his office, and, suffering in his latter days from the gout, he retired from his professional practice, and died at the mansion he had erected on his property near Weymouth, May 13, 1734. His daughter was clandestinely married by the painter, Hogarth, who said, 'he was the greatest history painter this country ever produced,' an eulogium which will certainly not find an echo now. His works were chiefly allegorical, and though they show great invention and genius, do not rise above the character of decorative art. He left a collection of pictures and some etchings, by his own hand, in a loose, bold manner.

THORNHILL, JOHN, marine painter. Only son of the foregoing. Painted sea-pieces and landscapes, excelling in the former. Succeeded his father as Serjeant-Painter to George II.; resigned the office, 1757.

THORNTHWAITE, J., engraver. Born in London about 1740. Practised in London both in mezzo-tint and as an etcher. There are several portraits by him. He engraved for Bell's 'Shakespeare,' in 1787, and for the 'Booksellers' British Theatre.'

THORNTON, JOHN, glass-painter, of Coventry. Painted the fine east window in York Cathedral, about 1338, and some of the west windows, and his works show him to have been eminently skilled.

THORPE, JOHN, architect. Practised in the reigns of Elizabeth and James I. He designed Holdenby, for Sir Christopher Hatton, 1580; Longleat, 1597; and the great mansions of Burleigh, Wollaton, Hatfield, 1611; Longfield Castle, 1612; Buckhurst, and Holland House, 1607; Audley End, completed 1616; and is reputed the architect of old Somerset House, London. He resided some time in Paris, and was employed there. He is by some supposed to be the individual called 'John of Padua,' who was employed by Henry VIII. A book containing 280 original manuscript plans and elevations by him, formerly in the possession of the Earl of Warwick, is now in the Soane Museum.

THURSTON, JOHN, wood-engraver and designer. Born at Scarborough in 1774. He was originally a copper-plate engraver, and assisted James Heath on some of his plates. Later he both designed and engraved on wood for book illustration, finally

devoting himself exclusively to designing, Among his works of this class are— 'Religious Emblems,' 1808; 'Shakespeare's Works,' published by Whittingham, 1814; Somerville's 'Rural Sports,' 1818; Falconer's 'Shipwreck,' 1817. He was for a time the principal artist in London who had any repute as a designer on the wood, and contributed largely to the formation of the modern school of wood-engraving. His compositions were slight and pleasing, mostly for the Chiswick Press, and very numerous. He made some clever designs in water-colour, chiefly in Indian ink and tinted, and was in 1806 a Fellow and exhibitor of the Water-Colour Society. Died at Holloway, in 1822, aged 48.

THYNNE, JOHN, architect. Practised with great reputation in the reign of Henry VIII.

TIDEY, HENRY F., water-colour painter. He was born at Worthing, where his father kept an academy, January 7, 1815. He was fond of drawing. as a boy, and in 1839 he first appears as an exhibitor of portraits in water-colours at the Royal Academy. He painted many groups of children, in which he was successful, and met with good encouragement, continuing a constant exhibitor. In 1858 he was elected an associate, and the next year a full member of the Institute of Painters in Water-Colours, and exhibited with that body many fine drawings painted to a large scale. In 1859, 'The Feast of Roses,' purchased by the Queen; in 1861, 'Dar Thule,' from Ossian; in 1863, 'Christ Blessing little Children'—the children portraits; in the same year at the Royal Academy, where he did not cease to exhibit, 'Saxon Captives at Rome.' His last works were, 'Sardanapalus,' 1870; and, 'The Flowers of the Forest,' 1871. He was a good draftsman and an industrious and clever artist, devoted to art profession. He died July 21, 1872.

TILLEMANS, PETER, landscape and animal painter. Was born at Antwerp, the son of a diamond cutter, in 1684, and was the pupil of a landscape painter. He came to England in 1708, and was employed by a dealer in copying, particularly after Teniers. He painted some seaports, but chiefly landscapes, introducing horses and dogs, hunting-pieces, races; and when he became known he was employed to paint views of country mansions, introducing portraits of the owners, with their horses and dogs. His works were carefully composed and painted, the animals excellent in action and treatment, the portraits characteristic. He was much employed by William, fourth Lord Byron, who became his pupil. He painted a good picture of Chatsworth, for the Duke of Devonshire, and a very large picture, now in the possession of Earl Manvers, of the second

431

Thornycroft. Hamo A.R.A. (1881

Duke of Kingston and a shooting party, with mounted attendants, the dogs in the foreground forming the most prominent objects, and an extensive view of the park and mansion, the whole admirably finished in a low tone and quietly coloured. It is signed and dated 1725. He united with Joseph Goupy in painting a set of scenes for the opera. He made nearly 500 drawings for Bridge's ' History of Northamptonshire,' many of them dated 1719. They are in Indian ink, in a slight, masterly manner. He was paid one guinea per day while so employed, and had the run of his employer's house. He suffered for many years from asthma, and died at Norton in Suffolk, where he had some time resided, December 5, 1734, and was buried in the churchyard of Stow Langtoft. He was painting a horse on the day of his death.

TILSON, Henry, *portrait painter.* Was born in Yorkshire in 1659, and was a grandson of the Bishop of Elphin. He was a pupil of Lely, soon after whose death he went to Italy, in company with Dahl, studied there during seven years, copying the works of the best masters, and was at Rome in 1687. On his return to England he painted portraits, both in oil and crayons, and was rising in reputation, when he shot himself from disappointment in love, in 1695, at the age of 36. There are many portraits by him in the reign of William III., and several have been engraved, but his works are stiff in manner and heavy in colour, appearing overwrought.

TIMBRELL, HENRY, *sculptor.* Was born at Dublin in 1806, and studied there, under John Smith. In 1831 he came to London, and assisted Baily, R.A., who employed him occasionally for several years. He was at the same time a student in the Royal Academy, and exhibited, in 1832, 'Phaëton;' in 1833, 'Satan in Search of the Earth;' in 1834, 'Sorrow,' a monumental group. In 1835 he gained the gold medal for his group of ' Mezentius tying the Living to the Dead.' In 1843 he was elected to the travelling studentship, and went to Italy, and that year sent to the exhibition, ' Hercules and Lycas.' In the second year of his residence in Rome he completed a fine life-size group, ' Instruction,' but was wrecked in the vessel bringing it to this country, and almost totally destroyed. He was engaged upon two figures commissioned for the new Houses of Parliament, and a life-size statue of the Queen, in marble, when he was attacked by inflammatory fever, and ended a life of much promise, at Rome, on April 10, 1849. His brother, JAMES C. TIMBRELL, who exhibited some domestic subjects, died at Portsmouth, January 5, 1850, aged 39.

TINNEY, JOHN, *engraver and print-*
432

seller. Practised in London about 1740–50, and for a time in Paris. He worked in mezzo-tint and also with the graver, and is now best known as the master of three distinguished pupils, William Woollett, Anthony Walker, and John Browne, A.E., who were apprenticed to him. He died in 1761. There are eight views by him of Kensington and Hampton Court, after Anthony Highmore. He wrote a small book on Anatomy for artists.

TITE, Sir WILLIAM, Knt., C.B., F.S.A., F.R.S., *architect.* He was born in 1802, the son of a London merchant, and was the pupil of Mr. Laing, architect of the Custom House. He was first employed in superintending the rebuilding of St. Dunstan's-in-the-East, and was soon after actively engaged in the competitions of the day—in 1819 for the new Church of St. Luke, Chelsea; in 1822 for the rebuilding of London Bridge; in 1825 for the restoration of St. Saviour's Church, Southwark; and the new National Scotch Church in Regent's Square, Gray's Inn Road, and in the latter was the successful competitor and the architect of the building. He was then much employed upon railway buildings, on the London and South-Western Line, the Blackwall Line, the Caledonian and Scottish Central Line. He was the architect of the Woking Cemetery. He built, in conjunction with Professor Cockerell, the London and Westminster Bank at Lothbury, and in 1841 he was chosen, on competition, the architect for the erection of the Royal Exchange, his great work upon which his reputation will rest. In 1854 he exhibited at the Royal Academy, a composition from the works of Inigo Jones. He was in early life unusually fortunate, and his success attended a long career. He amassed a considerable fortune, was popular in his profession, and generous in assisting those less fortunate. Of active habits, he was in 1855 elected member for Bath, and represented that city till his death. He was the president of the Architectural Society, a member of the Institute of British Architects, and a fellow of the Royal Society, and the Society of Antiquaries. He received a bachelor knighthood in 1869, to which was afterwards added the Companionship of the Bath. He died at Torquay, after a short illness, April ˙20, 1873. His personal property was sworn under 400,000*l.*

TOBIN, J., *engraver.* Practised about the commencement of the last quarter of the 18th century. He etched several small landscapes after H. Grimm, and engraved after Both, Ostane, and others. There are also some tinted impressions by him.

TOLMIE, JAMES, *ornamental carver.* He designed and executed some good ornamental sculpture. His work may be

seen on the exterior of the Whitehall Club, the Inns of Court Hotel, and the Prince Consort's Mausoleum at Frogmore. He died at Lambeth, in December 1866.

TOMKINS, WILLIAM, A.R.A., *landscape painter.* Was born in London about 1730. His father and uncle were both artists, but their works are unknown. He was a member of the Free Society of Artists, and afterwards of the Incorporated Society. In 1763 he obtained the Society of Arts' premium for landscape. He made copies after Claude, Hobbema, and several of the Dutch painters, and painted many landscapes and views of gentlemen's seats in the West of England, and on a commission from the Earl of Fife he painted some views of his mansion in Scotland. He was an exhibitor at the Academy from 1769 till his death. His contributions were chiefly views, with sometimes a bird and dead game. He was elected an associate of the Academy in 1771. Some of his works are in Lord Morley's collection at Saltram. Six views of Windsor Castle by him are engraved. He died in Queen Anne Street East, January 1, 1792, leaving four sons, two of whom practised art.

• TOMKINS, PELTRO WILLIAM, *engraver.* Son of the foregoing. Was born in London in 1760, and was a pupil of Bartolozzi. Following the manner of his master he engraved in the dot manner, and soon established a reputation. He was appointed engraver to Queen Charlotte in 1793. He executed many good plates for the work—'Original Designs of the most Celebrated Masters of the Bolognese, Roman, Florentine, and Venetian Schools,' 1812; also, 'Tresham's Gallery of Pictures,' 1814; the 'Marquis of Stafford's Collection,' 1818; 'Illustrations of Modern Scripture,' 1832. He also engraved after Angelica Kauffman, and other artists of his time. After his own designs he engraved 'Innocent Play,' 'Love and Hope,' and some others. He died April 22, 1840.

TOMKINS, CHARLES, *painter and engraver.* Eldest son of W. Tomkins, A.R.A. Was born in London about 1750, and educated there. He was awarded in 1776 a premium by the Society of Arts for a view on Milbank. He painted landscapes, chiefly landscape views, which he exhibited at the Academy, and many of which he engraved. He engraved with Jukes, Cleveley's 'Floating Batteries before Gibraltar,' 1782; and in 1796 produced 'A Tour in the Isle of Wight,' illustrated by 80 views, drawn and engraved by himself. He also drew and engraved a large coloured print of the 'Review in Hyde Park, 1799,' with views of the houses in Park Lane; 'Views of Reading Abbey and the Churches originally connected with it,' 1805; and in the

same year 'Illustrations of Petrarch's Sonnets.'

TOMLINSON, J., *engraver.* Studied his art in London, where he originally practised, and made a good income. He was invited to Paris and was employed there for a time, but fell into bad habits and extreme degradation, and in a fit of intoxication threw himself into the Seine in 1824 and was drowned. He engraved chiefly views.

• TOMPSON, RICHARD, *mezzo-tint engraver.* Practised in London in the latter part of the 17th century, and engraved after Lely and Kneller. His works are powerful, the textures good, but the drawing and light and shade want refinement. A good print of Nell Gwynne and her two sons bears his name. He kept both a printing office and a shop, and it has been questioned how far the excellent prints, which bear his name, are by his hand; but in his time the artist and the dealer were frequently one. He died in 1693. His portrait, painted by Soest, was engraved by F. Place.

TOMS, WILLIAM HENRY, *engraver.* Born about 1700, practised in London, chiefly engraving topographical and architectural subjects. There are, however, some book-plates and some portraits by him. He engraved R. West's 'Perspective Views of all the Ancient Churches in London,' 1736–39; a number of views of gentlemen's seats; a series of 12 plates of shipping; and in 1747 English views, after Chatelaine. He died about 1750. Alderman Boydell's love of art is said to have been aroused by a plate of his, and he became his apprentice.

TOMS, PETER, R.A., *portrait painter.* Was the son of the foregoing. Became a pupil of Hudson, and practised portraiture, but his chief excellence was as a drapery painter, and he was employed on draperies by Reynolds, Cotes, and sometimes by West. On the appointment of the Duke of Northumberland as Lord-Lieutenant of Ireland, in 1763, he went in his suite as portrait painter, but did not meet with success. He returned to London, and was in 1768 nominated one of the foundation members of the Royal Academy. At that time he was almost wholly employed by Cotes, on whose death he became melancholy, it is said intemperate, and committed suicide towards the end of 1776. During the whole time he was a member he only exhibited four works. He was fastidious, and would spend two or three hours in arranging the folds of a robe; but when once settled, would paint it with great spirit and correctness. His price for the draperies, hands, and accessories of a full-length portrait was 20 guineas, for a three-quarter three guineas. He was the last of the drapery painters. He held the appointment of pursuivant at the Heralds' College.

F F 433

Tombleson. W. Engraver - ?1825

TOOKEY, JAMES, *engraver.* He practised about the beginning of the 19th century. The animals in Church's 'Cabinet of Quadrupeds' are engraved by him after Ibbetson. He also engraved some of the plates in Bell's 'British Theatre.' His works are chiefly in the line manner, slight and weak in execution.

TOPHAM, FRANCIS WILLIAM, *water-colour painter.* Was born in Leeds, April 15, 1808, and as an artist was self-taught. When a boy he had a great wish to become a painter, but his father knowing nothing of art, apprenticed him to a writing-engraver. He came to London at the age of 21, and practised for some years engraving from pictures. After attaining considerable success in this art, he deserted it entirely for painting. He was first a member of the Institute of Painters in Water-Colour; but quitting this body in 1847, was immediately elected into the older Society, of which he became a full member in the next year, and his most important works have been exhibited there. He drew his subjects from Ireland, Scotland, Spain, and Italy. Some of the best known are—'The Spinning Wheel,' 'The Whiskey Still,' 'Card Players,' 'The Letter Writer,' 'Eve of the Festa,' 'Venetian Well,' 'Barnaby Rudge,' etc. He died at Cordova, in Spain, March 31, 1877, aged 69.

TOREL, WILLIAM, *sculptor.* Descended from an English family named in the records from the days of Edward the Confessor. He finished the figure of a King for Henry III.'s tomb in Westminster Abbey, and executed in 1291 three effigies of Eleanor, Queen of Edward I., one for Westminster, one for Blackfriar's Monastery, the third to be placed over her viscera in Lincoln Cathedral. The first remains in good preservation, and is a proof by its idealised style and fine execution of the advanced state of art in England at that time.

TOROND, ——, *engraver.* Practised towards the middle of the 18th century. Little is known of him beyond the statement that he was classed among the humorous draftsmen of his day.

TOTO, ANTHONY, *portrait painter and architect.* An Italian artist who came to this country about 1531, in the reign of Henry VIII., who appointed him his Serjeant-Painter. He was naturalised in 1543, and practised in England 20 years. His works are all lost or unknown.

TOUSSAINT, AUGUSTUS, *miniature painter.* Was the son of an eminent jeweller in Denmark Street, Soho. In 1766 he gained a premium at the Society of Arts. He was apprenticed to Nixon, A.R.A., and practised his art in London for some time. He exhibited at the Royal Academy from 1775 to 1788 miniatures both on ivory and in enamel. But on succeeding to the property amassed by his father he retired to Lymington, where he died between 1790 and 1800, and was buried in the churchyard there.

TOWNE, FRANCIS, *landscape painter.* He was probably a pupil of William Pars, gained a premium at the Society of Arts in 1759, and was in 1762 a member of the Free Society of Artists, where he exhibited, and at the Spring Gardens' Rooms in 1769. In 1775 he exhibited some water-colour views at the Royal Academy, and in 1779, when he was residing at Exeter, a 'View on the Exe,' and some others. He appears to have visited Italy, as, from the above date to 1794, he exhibited views in that country and Switzerland. He then settled in London, and continued an exhibitor at the Academy up to 1810. His works were well esteemed in his day. He died in London, July 7, 1816, in his 77th year.

TOWNE, CHARLES, *landscape and cattle painter.* He first appears as an exhibitor of the portraits of animals at the Royal Academy, commencing in 1795, and later of landscape, introducing cattle and sheep. He continued an exhibitor up to 1812. About this time he went to reside at Liverpool, where he practised, and was in 1813 vice-president of the Liverpool Academy. His works were carefully studied and finished, but were tame, and sadly wanting both in originality and the freshness of nature. He is believed to have died, at an advanced age, about the year 1850. He painted some works in water-colours, and was in 1809 a candidate for admission to the Water-Colour Society.

TOWNLEY, CHARLES, *engraver and painter.* Son of the Rev. J. Townley, Head-Master of the Merchant Taylors' School. Was born in London in 1746, and after studying there some time went to Italy for his improvement, and pursued his studies for several years in Rome and Florence. He was first known as a miniature painter, but he also produced many portraits both in crayons and in oil. He exhibited chalk portraits with the Free Society 1782. He copied many portraits of the Italian painters, and engraved them both in mezzo-tint and in the dot manner. About 1776 he practised in Berlin, and was appointed engraver to the King of Prussia. In 1789 he went to Hamburgh, and later he returned to England, and then produced some excellent mezzo-tint plates after Reynolds, Romney, Hoppner, Opie, Dance, and Cosway, and a plate of 'Bull's fighting,' after Stubbs.

TOWNSHEND, GEORGE, Marquis, *amateur.* He was born February 28, 1824, and was created a marquis in 1787. He had a great reputation for his humorous burlesques, some of which he is said to

434

Torrentius John 1589-1640 Dutch
Townshend Lady Amateur Paintress

have etched himself. His caricature of the Duchess of Queensberry, and of a celebrated Irish physician are mentioned as full of clever humour. He was in 1767 Lord-Lieutenant of Ireland, and said himself that he had caricatured every officer of his staff. He died September 14, 1807.

TRACY, ——, *antiquarian draftsman.* Was chiefly engaged upon the antiquities of the county of Kent. Was living at Brompton, near Chatham, in 1792. He made the drawings for Thorpe's 'Antiquities.'

TRAIES, WILLIAM, *landscape painter.* He was born at Crediton in 1789, and practised his art at Exeter, where he gained a local reputation. In 1820, and on one subsequent occasion, he was an exhibitor at the Royal Academy. He drew the illustrations for a work on natural history, by Dr. Neal. He died at Exeter, April 23, 1872.

TRENCH, HENRY, *historical painter.* Was born in Ireland. Towards the commencement of the 18th century he went to Italy, where he studied for several years, and gained a medal in the Academy of St. Luke at Rome. He came to England, and professed historical painting, but, meeting with no encouragement, returned to Italy, and for two years continued his studies. In 1725 he came again to England, and died in London the following year. He was buried at Paddington.

• TRESHAM, HENRY, R.A., *history painter.* Was born in Dublin about 1756, some accounts say 1749, and, showing an early taste for art, was placed in the Dublin School, under West. After exhibiting some attempts at Dublin, he came to London in 1775, and found employment in drawing small portraits. He was then invited by Lord Cawdor to travel with him in Italy, and continued for fourteen years on the continent, chiefly at Rome, where he studied zealously from the antique. He returned to England in 1789, having made himself a good draftsman and attained much knowledge and skill in matters of art and taste. He was also a member of the Academies of Rome and Bologna. He exhibited at the Academy in that year, and in 1791 sent an 'Adam and Eve,' 'Phryne,' and a subject from St. Luke. These works confirmed his continental reputation, and he was in the latter year elected an associate of the Royal Academy. He was chiefly employed on the illustrated publications of the time, eschewing portraiture, but he added to his income by dealing in art. He is said to have bought of a servant of Mr. Thomas Hope a number of Etruscan vases, the refuse of a collection purchased by his master, who gave them to him, and to have afterwards sold one moiety of the collection for 800*l.*, and

for the remainder, with some additions, to have received from Lord Carlisle an annuity of 300*l.* With some dealers he opened a gallery of the works of the old masters for sale. In 1795 and 1796 he exhibited historical subjects, and in 1799, 'Christ and Nicodemus,' and was elected a member of the Royal Academy, and in 1807 professor of painting, an office which he resigned in 1809 from failing health, and afterwards only exhibited again on two occasions. He contributed three paintings to Boydell's Shakespeare Gallery. His drawings in pen and ink and in black chalk are his best productions. He made some designs in water-colour. He was generally an accomplished man and a writer. He published at Rome in 1784, 'Le Avventure di Saffo,' 18 designs of no merit produced by himself in a rude kind of etching mezzo-tint; and, after his return to England, 'The Sea-sick Minstrel; or, Maritime Sorrows,' a poem, 1799; 'Rome at the close of the Nineteenth Century,' 1796; 'Britannicus to Buonaparte, an Heroic Epistle,' 1803; and he edited for Messrs. Longmans, contributing the descriptive letter-press, 'Engravings from the Works of the Ancient Masters in the British Collections,' a costly work. His health became visibly impaired after his return from Italy, and for several years before his death he was reduced to a state of great feebleness and infirmity. He died in Bond Street, June 17, 1814.

TREVETT, ROBERT, *draftsman and engraver.* Practised at the beginning of the 18th century. He painted architecture, and planned, with Vertue, in 1710, a work on St. Paul's Cathedral, for which he made several drawings of the interior and the exterior; some of which were engraved, but the work was not completed. His last engraving was an extensive view of London, on several sheets, from the tower of St. Mary Overy, but he died in 1723, and left it unfinished. He was master of the Paper-stainers' Company.

TREVINGARD, ANNA, *subject painter.* Practised in London in the second half of the 18th century. She painted a romantic class of subjects. Some of her works were engraved.

TROLLOPE, ROBERT, *architect.* Built Capheaton, near Newcastle-on-Tyne, 1659, and also the old exchange at Newcastle. Buried at Gateshead, December 11, 1686.

TROTTER, S. C., *portrait painter.* Native of Ireland. Drew, in 1782, a portrait of Dr. Johnson, which was engraved in 1784. The doctor said, when he saw the drawing, 'Well, thou art an ugly fellow, but like the original.' There are by him three other portraits of the doctor, which were engraved; one of them, a whole-length, in the dress he wore in the Hebrides.

TROTTER, THOMAS, *engraver.* Was

born in London, the son of a clergyman, and was apprenticed to a calico-printer. Having some talent for drawing, he tried engraving, and soon produced some excellent portraits. He received some instruction from Blake, who was his fellow-engraver, and finished a plate or two after Stothard, R.A. In 1785 he exhibited a chalk drawing of Dr. Johnson from the life. Being unable to work as an engraver by an accidental injury to his sight, he found employment as a draftsman, making drawings of churches and monuments for antiquarian publications. He died February 14, 1803, and was buried in the graveyard of the new chapel, Broadway, Westminster.

TROUGHTON, THOMAS, *draftsman and painter*. He undertook a voyage to Africa, and was shipwrecked on the coast of Morocco, where from 1747 to 1780 he was detained in slavery, and suffered great hardships. He published some account of his sufferings. Died 1797.

TRUCHY, L., *engraver*. Was born in Paris, 1731. Practised his art in London. He worked for Alderman Boydell. Engraved a village dance after Teniers, and 12 plates after Highmore, in illustration of 'Pamela.' He died in London, 1764.

TUCKER, NATHANIEL, *portrait painter*. Practised in London about 1740-60. His works are engraved by J. Faber and some others.

TUER, HERBERT, *portrait painter*. His father and grandfather were in the Church. His mother was niece to George Herbert, the poet. He withdrew to Holland after the execution of Charles I., and applying himself to art, made good progress in portrait painting, but his works are almost unknown in England. One or two of his portraits are engraved. He is believed to have died at Utrecht some time before 1680.

TULL, N., *landscape painter*. Was the schoolmaster at Queen Elizabeth's school in Tooley Street, Borough. Painted for his amusement close rural scenes, lanes, and cottages; drew in black and white chalk, on coloured paper. There are also some portraits attributed to him. He exhibited landscapes with the Society of Artists in 1761. Vivares and Elliot engraved after him a set of six plates. He died in 1762.

TURNER, CHARLES A. E., *engraver*. Was born at Woodstock in 1773, and entered the schools of the Royal Academy in 1795. On commencing his art, he was influenced by the manner of Bartolozzi, and was employed by Alderman Boydell. He produced some dot engravings of very high merit, and then used the needle and aqua-tint with great success. In this manner he engraved the early numbers of Turner, R.A.'s 'Liber Studiorum,' and his fine painting of 'The Wreck,' imitating

with much truth this great master's brilliant lights and reflections, and the depth and clearness of his shadows. In 1828 he was elected an associate engraver of the Royal Academy. He engraved some fine portraits after Lawrence, P.R.A., Jackson, Shee; 'The Beggars,' after Owen; Reynolds's large group of 'The Marlborough Family,' with many other important works. His latest and best works are in mezzotint, with the needle partially employed. He was a great artist, admirably translating his original picture, and excelling in every style he used. He died in Warren Street, Fitzroy Square, August 1, 1857, aged 83, and was buried in the Highgate Cemetery.

TURNER, DAVID, *draftsman and engraver*. Was, in 1790, the pupil of John Jones, engraver in London. He devoted himself to painting landscape and architectural views. He exhibited, about the end of the 18th century, views on the Thames—Lambeth from Millbank, Somerset House, Temple Gardens, St. Paul's from Westminster Bridge, contributing for the last time in 1801. These works were small, carefully finished, usually in oil, but weak, showing little art power. He was also an etcher, and there are some etchings by him of the castles, monuments, and abbeys in Scotland, a view of Peterborough Cathedral, and of St. Ouen at Rouen.

TURNER, JAMES, *portrait painter*. Practised 1745-90. Exhibited miniatures with the Society of Artists in 1761. Some of his portraits are engraved.

• TURNER, JOSEPH MALLORD WILLIAM, R.A., *landscape painter*. Was born April 23, 1775, the son of a hairdresser of small means in Maiden Lane, Covent Garden. Had the rudiments of an ordinary education. His love of art was developed early, since he was admitted to the schools of the Royal Academy in 1789. He had previously contributed to the exhibition, and the following year sent a 'View of Lambeth Palace.' He was well grounded in perspective under Thomas Malton, and was for a short time in the office of Mr. Hardwick, the architect of the St. Catherine's Docks. He studied, with Girtin and others, in the friendly house of Dr. Monro, coloured prints, put in architects' backgrounds, gave some lessons, and by these means, and the sale of his sketches, managed to support himself. Then gaining some notice, and continuing to improve in his art, he made excursions into the Midland counties, Wales, and the South Coast, Yorkshire, and the lakes, and sketching views for the topographical publications at that time in vogue, but continued to foster that love of rivers and river scenery which first attracted him on the picturesque Thames.

His art was founded on a diligent study of

nature, though he owes some obligations to John R. Cozens, who was one of his fellow-students at Dr. Monro's. His sketches, and indeed many of his early exhibited pictures, were in water-colours, very rarely in oil, and were all views. Some of these studies are, however, merely pencil outlines, faithful, firm, and well drawn, full of truth and detail of every kind, while those in water-colour, including every sort of subject, are varied in like manner from mere washes of tint, truly beautiful and effective, to bits of foreground, and objects more minutely rendered, but all sparkling in the freshness of nature. Of such studies, which are innumerable, many are now displayed on the National Gallery walls at South Kensington. By them the true genius of the painter was nourished, and in 1793 he exhibited in oil, 'The Rising Squall,' in which the poetry of nature was attempted. In 1796, among other works, a subject picture, 'Fishermen at Sea,' and the next year 'Moonlight,' followed by paintings in which all the changing phases of nature were attempted.

These works gained him admission to the Royal Academy. He was elected an associate in 1799, and then eschewing altogether the topographical imitation of landscape for a more noble art, he looked beyond the mere details to a larger treatment of nature, seizing all the poetry of sunshine, and the mists of morn and eve, with the grandeur of storm and the glow of sunset. Yet he does not appear to have at once established a new art for himself. In some of his earlier works the influence of the great masters of the Dutch school is apparent, as in his noble picture of 'The Shipwreck,' 1805, now in the National Gallery; then Poussin attracted him, and later Claude, with whom he especially desired to be placed in rivalry, bequeathing two of his finest works to the National Gallery on the condition that they should be hung between two of the most esteemed works of that master. In 1802 he was elected a member of the Academy, and about that time visited Scotland, and afterwards France, Switzerland, Italy, and the Rhine. In the succeeding years he produced some of his finest pictures, enlarging his range of subjects—his 'Jason,' 'The Tenth Plague of Egypt,' 'The Blacksmith's Shop,' 'The Unpaid Bill.' In 1807 he was appointed the professor of perspective. From this time his works included some of his most expressive marine subjects—'The Wreck of the Minotaur,' 'The Shipwreck,' 'The Gale,' and some others. His 'Apollo and Python' followed in 1811; 'Dido and Æneus,' 1814; 'Crossing the Brook,' 1815; 'The Decline of Carthage,' 1817; 'Richmond Hill,' 1819.

About 1820 a great change was manifest in his method of painting. In his first manner dark predominated with a very limited portion of light, and he painted solidly throughout with a vigorous and full brush; now he adopted a principle of light with a small proportion of dark, used a light ground, and by scumbling obtained infinitely delicate gradations, using the purest orange, blue, purple, and other powerful colours, and in this manner he produced his 'Bay of Baiæ,' and in 1829, one of his most beautiful and poetic works, 'Ulysses Deriding Polyphemus,' in which, while in no way gaudy, it seems impossible to surpass the power of colour which he has attained, or the terrible beauty in which he has clothed his poetic conception, a work almost without a parallel in art.

Such was his art in oil, but he was no less eminent in water-colours. He soon found the heaviness which resulted from laying in the gradations of light and dark with grey, and afterwards representing the hue of each object by tinting it with colour, and proceeded to treat the whole surface of his picture as colour, using at once the pigments by which it might be represented, and by delicate hatchings achieving wonderful qualities of broken hues, air tints, and atmosphere. Thus he mastered the whole mystery of the art, and while others excelled in one particular phase of nature, for which they were distinguished, his art compassed all they did collectively, and more than equalled each in what he most excelled.

Turner's art was appreciated in his early career, and he amassed a large property, of which a considerable portion arose from the engravings from his works, for which he was able to make close bargains with the publishers, and to retain an interest. He commenced in 1808 his 'Liber Studiorum,' a work of the highest artistic merit, of great and now of rare value. This led to his employment as an illustrator of books, and his 'Southern Coast Scenery,' 'England and Wales,' 'Rivers of France,' and 'Rogers' Italy,' are great examples of his genius and taste. Several of his finest pictures have also been produced by our best engravers in line or mezzo-tint.

A genius of the highest class, endowed with great refinement in art, he had none of the personal characteristics which we associate with such gifts. Clumsy in figure, common in manner, slovenly in dress, he led a retired life without companionship even in art. Taciturn and reserved, he was no less a jovial associate at the occasional meetings of his professional brethren, and full of jokes which it was difficult to comprehend. Full also of art knowledge, which he was ready to communicate, but which his manner made a riddle to understand, but well worth the thought to construe. At the

437

age of 25 he had been able to establish himself in a house in Harley Street. Thence he removed to Hammersmith, and following his favourite Thames, he took a small house at Twickenham, where he lived for several years, having at the latter part of the time a house also in Queen Anne Street, Marylebone. Thrifty, shrewd in his dealings, of untiring industry, he was making money fast, and unsocial, without any inducements to expense, it accumulated. He has been called avaricious, and seeking only his own glorification in his wealth. But he devoted it to art, which had been his only pursuit and happiness in life.

He had long been accustomed to absent himself at intervals, and without having been missed, his friends learnt suddenly that the great painter was lying dead at a small cottage on the banks of the Thames, just above Battersea Bridge. In this house he had been accustomed to lodge occasionally, and had formed a connexion, under the assumed name of BROOKS, with the female who kept it. Here his last illness seized him, and here he died on December 19, 1851. His body was conveyed to his house in Queen Anne Street, and was buried in the crypt of St. Paul's Cathedral. By his will, after leaving some small annuities to his relations, he gave the bulk of his property, sworn as under 140,000*l.*, for the benefit of art and artists ; but his will, drawn by himself, was so unskilfully framed and so vague, that after four years' litigation, by the advice of the Lord Chancellor, a compromise was arranged. The Royal Academy received 20,000*l.*, his pictures and drawings were assigned to the National Gallery, his real estate to the heir-at-law, and his large collection of prints, with other property, to the next of kin. The Academy set aside the sum adjudged to them as ' The Turner Fund,' for the relief of distressed artists, not members of their body, and to perpetuate his memory founded a ' Turner' gold medal to be awarded biennially in competition for the best landscape painting.

TURNER, WILLIAM (known as ' Turner of Oxford'), *water-colour painter.* Was born at Blackbourton, Oxfordshire, November 12, 1789. Losing his father at an early age, he was brought up by an uncle, who, observing his love for drawing, sent him to London and apprenticed him to John Varley, with whom he made fair progress. After leaving Varley, he settled at Oxford, where he was chiefly employed as a teacher, finding pupils among the members of the university and the neighbouring families. He first exhibited in 1808, and in 1809 was elected a member of the Water-Colour Society. Residing during his whole career in Oxford, many of his subjects were found in that city and its suburbs. But he also painted the moor and down scenery of

England, introducing groups of sheep and cattle, as well as the mountain scenery of Wales and Scotland. He was a close and industrious student of nature, indefatigable in his work ; his drawings, possessing many good qualites, carefully coloured and finished, are yet deficient in composition and art treatment, and his works failed to gain popularity. He married in 1824, and was for 54 years an exhibitor of his works. He died, childless, August 7, 1862, in his 73rd year, and was buried at Shipton-on-Cherwell, near Woodstock. His numerous drawings and sketches were sold by auction in March 1863.

TURNERELLI, PETER, *sculptor.* Was born the latter end of 1774 at Belfast. His father was an Italian modeller, and resided many years in Dublin ; his mother a native of that city. He was intended for the priesthood, but a love of art prevailed. He came to London at the age of 18, was placed with M. Chenu, an able artist, and admitted a student of the Royal Academy. His works early attracted notice and employment. He was engaged to teach the Princess of Wales, and also many of the nobility, modelling in wax, and he exhibited the infant Princess Charlotte in wax, which was much admired. In 1810 George III. sat to him for his bust, and the work was so popular that he made no less than 80 copies of it in marble. He was appointed sculptor to the Queen, and also to the Princess of Wales. Some of the most distinguished men of the day were his sitters, and in 1813, when he visited the continent, Louis XVIII. sat to him for his bust. He executed several monumental works : Sir John Moore, in Canterbury Cathedral ; Admiral Sir John Hope, in Westminster Abbey ; and Burns at his plough, for the Dumfries monument. He died, after a few hours' illness, in Newman Street, March 20, 1839, leaving a wife and family in great destitution. He had the reputation of being a charming amateur singer.

TWEEDIE, WILLIAM MENZIES, *portrait painter.* Was born in Glasgow in 1826, and was the son of a naval officer in Her Majesty's service. He was himself intended for the Navy, but shewed such talent for portraiture when only six years old, that his father was persuaded to allow him to study art instead. He entered the Edinburgh Academy at 16 and remained there four years, gaining during his studentship the prize for the best copy of Etty's picture of ' The Combat.' At twenty years of age he came to London and became a student of the Royal Academy, and afterwards studied for three years in Paris, under Couture the painter. His first exhibited picture was a half-length portrait in oil, which was hung at the Royal Scottish Academy when he was only 17 years of age. From 1858,

when his portrait of Mr. Graves, M.P., was exhibited, his contributions were sometimes accepted and sometimes rejected by the Royal Academy, down to 1874, when he contributed portraits of Gathorne Hardy, M.P., and his son. In the following years his pictures were refused, which caused him to fall into ill health, and he died of grief March 19, 1878.

TYLER, WILLIAM, R.A., *sculptor and architect.* He exhibited some busts with the Society of Artists in 1761, and was one of the Directors named in the Charter when granted, 1765. On the foundation of the Royal Academy in 1768 he was nominated a member, and was trustee and auditor, taking an active interest in the young institution. To the earlier exhibitions he contributed busts and monumental designs, but later he is described as an architect, and from 1780 exhibited architectural designs. In 1786 he designed the Freemasons' Tavern, to which, ten years afterwards, Thomas Sandby added the large hall. He exhibited for the last time in 1787, and died in Caroline Street, Bedford Square, Septem-

ber 6, 1801, never having attained distinction either as a sculptor or as an architect.

TYSON, MICHAEL, *amateur.* Was a fellow of Bennet College, Cambridge, and both painted and etched for his amusement. He practised about 1770. Of the etchings by him there is a portrait of Archbishop Parker, copied from a print by R. Hogenburg, said to be one of the earliest engravings produced in England; from an illuminated manuscript, a portrait of Sir William Paulet, and of Jane Shore, from the portrait at King's College, Cambridge.

TYTLER, GEORGE, *lithographic draftsman.* He travelled in Italy about 1820, and published several lithographic views which he had made there. He also compiled from his sketches a pictorial alphabet, of which a lithographic impression was sold, and it was then produced on copper. He also published in lithography a large panoramic view of Edinburgh. He died in Clement's Lane, Strand, in great destitution, October 30, 1859, aged 62. He held the appointment of draftsman to the Duke of Gloucester.

U

UNDERWOOD, RICHARD THOMAS, *water-colour painter.* He was a man of scientific attainments, and, possessed of an independence, can hardly be said to have followed art as a profession. He was one of the group of artists who studied at Dr. Monro's, and exhibited some of his drawings at Cooke's exhibition in Soho Square. He died at Auteuil, near Paris, in 1836.

UNWIN, R., *enamel painter.* He was distinguished by his skill and taste in enamelling watches, jewelry, &c. He exhibited at the Royal Academy from 1705 to 1801, and the last time in 1812, contributing miniature portraits, designs, subjects from the poets, and landscapes.

UWINS, THOMAS, R.A., *subject painter.* Was born at Pentonville February 24, 1782, and was educated at a day-school in the neighbourhood. He was apprenticed to an engraver in 1797, but, ambitious to become a painter, quitted him at the age of 16, and was admitted a student of the Royal Academy. He began to draw portraits, and about 1808 was engaged in book illustration. He illustrated 'Robinson Crusoe,' 'Young's Night Thoughts,' and many other works, but chiefly by a frontispiece and vignette only for each. He also drew for Ackermann's 'Repository.' In 1808 he was admitted an associate of the Water-Colour

Society, and in the following year a full member, and was in 1813, for a short time, secretary to the Society. His contributions to the Society's exhibitions were chiefly of a rustic character, introducing children. In 1810, 'The Little Housewife;' in 1811, 'Children returning from School;' 1812, 'Higler's Boy going to Market;' 1813, 'Girl decorating her Head with Hops,' with one or two subjects of a higher class. In 1814, his health failing, he went to reside in the south of France, where he made many sketches and studies, but designing for booksellers formed his chief employment up to 1817.

At this time he was subjected to some pecuniary difficulties from the default of a person for whom he had been surety, and in 1818 he resigned suddenly his membership in the Water-Colour Society, and devoted himself to the drudgery of art till he honourably discharged his obligations. He settled for a time in Edinburgh, and was successful in portraiture, chiefly drawn in chalk. In 1824 he went to Italy, and during seven years' study there visited Florence, Rome, Naples, and the other art cities, returning in 1831 with the materials he had gathered. Hitherto his art had been chiefly in water-colour. His works had not been seen in the London exhibitions

439

for several years, and now, approaching his 50th year, he was prepared to commence a fresh career with a new art. His inspirations hitherto had been purely English, now they were of Italy.

He exhibited his works in oil at the Royal Academy, and at once established a reputation by his Italian scenes, 'The Tarantella,' and 'The Saint Manufactory.' In 1833 he was elected an associate of the Academy, and, growing in public favour, in 1838 academician. Further honours waited upon his later days. In 1844 he was appointed librarian of the Royal Academy, and in 1845 surveyor of the Queen's pictures, followed, in 1847, by the appointment of keeper of the National Gallery. Then, his health failing, he resigned the two latter offices, in 1855, and retired to Staines, where he died, aged 75, August 25, 1857, and was buried. His art is well represented in our national collection by his 'Vintage in the Claret Vineyards, south of France,' and 'Le Chapeau de Brigand,' both of which have been finely engraved; and also in the Sheepshanks collection at South Kensington by his 'Italian Mother teaching her Child the Tarantella,' with some other of his works. His widow published, in two volumes, in 1858, 'Recollections of Thomas Uwins, R.A.'

V

VANASSEN, BENEDICTUS ANTONIO, *designer and engraver*. Practised towards the end of the 18th century as a designer for books, but in a poor weak manner. He exhibited occasionally at the Royal Academy from 1790 to 1803, and there is a full-length portrait of Belzoni the traveller, 1804, which is engraved by him. He drew and etched 'Emblematic Devices;' 48 plates published 1810. He also engraved Mortimer, the painter, after a pen and ink drawing, 1810, and three nymphs and an infant sacrificing to Pomona and Ceres, a good work in the dot manner. He died in London about 1817.

VAN BELKAMP, JOHN, *copyist*. Was a Dutch artist; came to England early in Charles I.'s reign, and was employed under Vanderdoort to make copies of the King's pictures. The copy of Holbein's large picture, the original of which was burnt in the fire at Whitehall, containing a full-length of Henry VII. and Henry VIII., is by him; also the portraits of several remarkable persons of the reigns of Henry VIII., Elizabeth, James I., and Charles I., the originals of which were dispersed. By a vote of the House of Commons in 1649, he was appointed one of the Trustees for the sale of Charles I.'s goods. He died in this country, and R. Symonds notes in 1653 that he is said to be lately dead.

VAN BLECK, PETER, *mezzo-tint engraver*. Born in Flanders; came to England in 1723. His works are neatly finished, and have much merit. He engraved several theatrical portraits, and some portraits both drawn and engraved by himself, and among them his own portrait, dated 1735, and those of two then renowned players in the 'Alchemist.' He died July 20, 1764.

VANBRONDEBURGH, GILBERT, *die-*
440

engraver. Was appointed graver to the Royal Mint, 9th Henry V., and the appointment was continued in the reign of Henry VI., when his office was defined as 'Sculptor of the dies of gold and silver within the Tower of London,' where the Mint was then established.

* VANBRUGH, Sir JOHN, Knt., *architect and dramatist*. He was the grandson of a Protestant refugee, whose family had long been merchants of repute in Flanders, and had fled to England. His father settled in Chester, and is said to have acquired wealth there as a sugar baker, and to have married a daughter of Sir Dudley Carleton. Several of his brothers and sisters were born in Chester. With regard to him, however, the accounts are very conflicting; but it seems most probable that his father, who held the office of Controller to the Treasury, settling in London, he was born in the parish of St. Stephen, Walbrook, in the year 1666. Young Vanbrugh was the second of eight sons, and of a very lively disposition. He received a liberal education, which he finished in France, and then commenced his career with an ensign's commission in the army, which he did not hold long. When about nineteen years of age he went again to France, where he remained for several years. He cultivated a taste for the drama, and wrote 'The Relapse,' which was acted with great success in 1697, and was followed by 'The Provoked Wife,' played in Lincoln's Inn Fields' Theatre in 1698, and 'The Confederacy,' comedies which Walpole erroneously said would endure as long as his, the author's, edifices. About this time he must have studied architecture, but under what circumstances he was led to the study does not appear. His talent in this direction must have been

Vaillant · Warner
Valentine W--painter ? 1850

unexpected, for Swift, one of the satirists of the day, referring to him, wrote:—

> 'We may expect to see next year
> A mouse-trap man chief engineer.'

Nevertheless in 1702 he was employed on his first great work, and began Castle Howard, a noble Corinthian edifice, which so pleased his employer, the Earl of Carlisle, that he appointed his architect Deputy Earl Marshall and Clarenceux King at Arms, thus placing him above all the Heralds, and notwithstanding their remonstrances, and his own want of knowledge of the duties of the office, he held it till his death. His reputation established, on the completion of this work he commenced a succession of noble mansions. He built Eastbury, in Dorsetshire, since taken down; King's Weston, near Bristol; Easton Weston, Northamptonshire; Duncombe Park, Grimsthorpe; Seaton Delaval, Blenheim, his great work for which, though Parliament voted the building, they refused to provide the money, and several others. He also was the main promoter and architect of a fine theatre erected in the Haymarket, and on its completion in 1706 he became the Manager, and produced 'The Confederacy,' a play full of humour; but the speculation failed, and he soon after quitted all connexion with the stage. On the accession of George I. in 1714, he was knighted, and was appointed Surveyor of Greenwich Hospital in 1716. Ten years later he died at Whitehall on the 26th of March, 1726, and was buried in the family vault, at St. Stephen's, Walbrook. He left one son, who was killed at the battle of Fontenoy. His widow died at the age of 90, in 1776. Some unfriendly wit wrote his epitaph:

> 'Lie heavy on him, Earth, for he
> Laid many a heavy load on thee.'

A partizan himself, he had to bear, which we are told he did with much superiority, the attacks of party, and the sarcasms of Swift and Pope. Opinions upon his art were much divided. Walpole speaks very disparagingly of him; says he wanted all idea of proportion; that his style was of no age or country; that he had no imagination; that he undertook vast designs, and composed littleness. But Sir Joshua Reynolds tells us that there is in his works a greater display of imagination than we shall perhaps find in any other; that he had originality of invention, and great skill in composition; and such is now the prevailing opinion. His works, with many faults, impress us by their grandeur. His style, though founded on the classic, was not subservient to its rules; but aimed rather at the picturesqueness of the Gothic. His plays, of which he wrote altogether twelve, abounding in wit and satire, are too immodest to retain their place on the stage of our day.

VANDERBANK, PETER, *engraver.* Of Dutch extraction, he was born in Paris in 1649, and was a pupil of De Poilly. He came to England about 1674, and soon gained a name for the laboured finish of his work, chiefly portrait heads, some of which are of unusually large size. In the absence of higher qualities he had a good knowledge of the mechanical part of his art; but he was unappreciated and underpaid. He married the sister of a gentleman of good landed property, at Bradfield, in Hertfordshire, and when reduced and in difficulties, found an asylum in his house. He engraved many portraits of historical interest, of such are the heads for Kennet's 'History of England;' also some of Verrio's paintings at Windsor. He is supposed to have been connected with the manufacture of tapestry. He died and was buried at Bradfield in 1697. He left three sons, one of whom, of the same Christian name, was brought up to his profession. His widow sold his plates to a well-known print-seller, who made a large profit by them.

VANDERBANK, JOHN, *portrait painter.* Son of the above, was born in England towards the close of the 17th century, and studied his art here. He was much employed in the reign of Anne and of George I., was a bold and masterly draftsman, and painted a good likeness, but, with great facility of execution, was too careless and extravagant to be successful. There is a portrait of Newton by him at the Royal Society, and at Hampton Court a large group of figures, crowded together with little attempt at composition, or light and shade. He was known as a caricaturist. He designed the illustrations for a translation of 'Don Quixote' by Lord Carteret, who thought him superior to Hogarth. He headed the rebel party who seceded from Sir James Thornhill's academy, and established himself a drawing academy, to which, introducing the living model, he gave a short existence. He had a brother who practised as an artist. He died of consumption in Holles Street, Cavendish Square, December 23, 1739, aged about 45, and was buried at Marylebone Church.

VANDERBORCHT, HENRY, *flower painter.* Was born at Brussels in 1583, the son of a painter of the same name. He was sent to Italy by the Earl of Arundel, in whose service he continued till the Earl's death. He was then employed by the Prince of Wales, afterwards Charles II., and lived in London many years. He chiefly excelled in flowers and fruit, but there are some etchings by him—a 'Virgin and Child,' after Parmigiano, dated London,

1637; a 'Dead Christ,' an 'Apollo,' and a 'Cupid.' He returned to Antwerp, and died there in 1660, aged 77. His portrait was engraved by Hollar.

• VANDERDORT, ABRAHAM, *modeller.* Was born in Holland, and was employed by the Emperor Rudolphus. He then came to England, and was appointed keeper of Prince Henry's medals, an office soon vacated by the Prince's death in 1612. On the accession of Charles I., he was at once engaged in his service, with a salary of 40*l.* a-year; and in 1625 he was appointed by patent to make designs for his Majesty's coins, and was paid an additional 40*l.* a-year. By a second patent in the same year he was appointed keeper of the King's pictures; and the King's favour, in the exercise of the Royal prerogative, was further shown by the recommendation of him by letter, in the way of marriage, to Louysa Cole, relict of James Cole, no doubt a wealthy widow. He compiled careful catalogues and lists of the King's collections, which still exist, comprising the paintings, medals, and other works of art and vertu. A miniature, by Gibson, of 'The Parable of the Lost Sheep,' was given into his special charge by the King, and was so carefully laid by that, when asked for by the King, he could not find it, and hanged himself in despair, but it was afterwards found and restored by his executors.

VANDER-EYDEN, JOHN, *portrait painter.* Studied his art at Brussels, came to England, and found employment as an assistant to Sir Peter Lely, chiefly in drapery painting. He afterwards practised in Northamptonshire, where he married. He died about 1697, and was buried at Stapleford, in Leicestershire.

VANDERGUCHT, MICHAEL, *engraver.* Was born at Antwerp in 1660, came to this country, and was the pupil of David Loggan. He engraved many anatomical figures; and for the illustration of Clarendon's 'History of England.' There is also a portrait of Mr. Savage, esteemed his best work, and a large print of the Royal Navy. He was much afflicted with gout, and died October 16, 1725, aged 65. He was buried at St. Giles's Church.

VANDERGUCHT, GERARD, *engraver.* Born in London, he was a son of the foregoing, and a pupil of Louis Cheron. He began life in the practice of his profession, and his name will be found to many small book plates. He then traded as a dealer in works of art, paintings, prints, busts, and curiosities. He was the founder of the Art Gallery in Lower Brook Street. He died March 18, 1776, aged 80, and his stock-in-trade, comprising a large collection of engravings, was sold in the following year. He was the father of 30 children. The

'Four Seasons,' after Coypel, are by him, and he was employed by Sir Hans Sloane.

VANDERGUCHT, JOHN, *engraver.* Was another son of the above Michael, and was born in London in 1697. He learned his art from his father, and studied in the Painters' Drawing Academy. He chiefly practised etching, sometimes using the graver with the point. He engraved the plates for Cheselden's 'Osteology,' and was largely employed on the plates, from Thornhill's designs under the dome of St. Paul's. He assisted Hogarth on several of his early plates, and was himself a caricaturist and humourous designer. He died in 1776, aged 79.

VANDERGUCHT, BENJAMIN, *portrait painter.* Was the only son of the above John Vandergucht. He studied at the St. Martin's Lane Academy, and on the foundation of the Royal Academy, was one of the first students admitted. His early works were of much promise. He exhibited at the Free Society in 1770, and at the Royal Academy, in 1774, a good half-length portrait of Woodward, the performer, which he presented to the Lock Hospital; in 1779, a portrait of Garrick, followed by portraits of several other performers, which were engraved in mezzo-tint. He also exhibited 'A Scene in the Register Office,' and some scenes from popular plays, but he ceased to exhibit in 1786, and quitting art, turned picture-cleaner and picture-dealer. He possessed a collection of pictures to which he admitted the public on the payment of 1*s.* He was drowned, near Mortlake, in crossing the Thames from Chiswick, September 21, 1794. His collection was sold by Christie in 1796. He gave an 'Entombment,' by G. Seghers, to the Church at Mortlake.

VANDERHAGEN, JOHANN, *marine painter.* Was born at the Hague, and completed his studies there. He afterwards came to London, where he met with encouragement, but settled in Ireland, and for several years practised in Dublin and some of the other towns. He shewed much ability in his art, but was eccentric and idle, and in his latter days only worked when he had spent his last shilling. He was relieved by the Artists' Society in 1768, and died in Dublin soon afterwards. 'A Sea Storm' by him is engraved by Watson.

VANDERMYN, HERMAN, *portrait and history painter.* Was the son of a clergyman, and was born at Amsterdam in 1684. Intended for the Church, he received a good education, but a love of art prevailed, and he was placed under a flower-painter, and excelled in that branch of art. He then tried historical subjects. In 1716 he visited Munich and Antwerp, and in 1718 Paris, from whence, or as some accounts say, from Antwerp, he came to London, in

1719, in great difficulties. Here he was engaged in painting the portraits of several of the nobility, which, with the draperies and accessories, he finished with extreme minuteness, and was patronized both by the Court and the City. Among his sitters were Frederick, Prince of Wales, the Prince of Orange, and the Duke and Duchess of Chandos. He received 500*l*. for repairing the paintings at Burleigh, and demanded large prices for his portraits, but he had married imprudently, was extravagant, and in constant difficulties, to avoid which he returned to Holland in 1736, but came back to England shortly before his death, which happened in London in 1741, leaving eight children, some of them brought up as painters. He painted 'A Jupiter and Danae,' 'Peter Denying Christ,' and other historical works, which were highly esteemed in his day.

VANDERMYN, AGATHA, *flower painter*. Was the sister of the above, and came with him to London. In 1763 she was a member of the Free Society of Artists. She painted still life, fruit, flowers, and game.

VANDERMYN, FRANK, *portrait painter*. Was the son of the foregoing Herman, and practised in London, where he became distinguished in his art. He was in 1763 a member of the Free Society of Artists. He constantly indulged in his pipe while painting, by which he lost many sitters, and there is a mezzo-tint from a portrait of him, painted by himself, lettered 'The Smoker.' He died in Moorfields, August 20, 1783, aged 68. His wife practised as a flower and fruit-painter, and exhibited her works.

VANDERMYN, ROBERT, *portrait painter*. Was born in London, 1724, and practised about the middle of the century, painting portraits and many landscapes, fruit and flower pieces.

VANDERVAART, JOHN, *painter and engraver*. Was born at Haarlem, in 1647, and came to England in 1674. Here he became the pupil of Old Wyck, but did not confine himself to his master's art. For some time he painted portraits and still life, and for the latter gained much reputation. Afterwards he painted draperies for Wissing, and then, selling his collection, in 1713 he turned picture-repairer, and found that more profitable than painting. Later he assisted John Smith on his mezzo-tint plates, and mezzo-tinted some of his own works, several of which are also engraved by others, and there is a well-known mezzo-tint by him of Charles II., after Wissing. He built a house for himself in Covent Garden, near which place he lived about fifty years. He died of fever, unmarried, in 1721, and was buried in St. Paul's, the parish church.

• VANDEVELDE, WILLIAM (distinguished as 'Old Vandevelde'), *marine painter*. Was born at Leyden, in 1610, and commenced life as a sailor, but he must have shown an early ability for drawing, as his art was known by the time he was 20 years of age, and his great technical knowledge of shipping is due to the early part of his career. His talent recommended him to the notice of the States of Holland, and he was granted a small vessel to be present with the fleet, and witnessed, in 1665–66, the great sea-fights, not without exposure to imminent danger, between the Duke of York and Admiral Opdam, and between Admiral Monk and Admiral De Ruyter. Charles II., who had known him in Holland, invited him to England, and he arrived here in 1675. The King at once took him into his service, 'to make draughts of sea-fights,' with a salary of 100*l*., which was continued by James II. He was a rapid and able draftsman, and painted chiefly in black and white, and dated all his later works. There is a series of 12 naval battles and sea-ports, by him, in the Hampton Court collection. He died at his house, in Greenwich, and was buried in St. James's Church, Piccadilly, where there is this tablet to his memory—'Mr. William Vandevelde, senior, late painter of sea-fights to their Majesties King Charles II. and King James. Dyed 1693.' His art had little connexion with the English school, and his chief claim to insertion in this work is the appointments he held under two sovereigns.

• VANDEVELDE, WILLIAM, the younger, *marine painter*. Was the son of the foregoing, and was born at Amsterdam, in 1633. He studied under his father, and afterwards under Simon de Vlieger, an eminent Dutch marine painter, and soon surpassing all his contemporaries, rose to great excellence ; correct in the graceful form of his vessels and their rigging, delicate and yet spirited in his finish, admirable in the introduction of his numerous figures, depicting with equal skill the calm, the breeze, and the storm, his works had risen to great estimation in his own country, when he was induced to follow his father to England, and joined him in his house at Greenwich, where he chiefly resided. The King received him with great favour, and by a warrant of the 26th of his reign (1674), granted him a salary of 100*l*. for putting the drafts of his father into colours for the King's particular use. He was also largely employed by the nobility, but it is probable that many of the fine works by him in our collections were painted before his arrival here. His sea-pieces are very numerous, and are now very highly prized, recent sales showing, in several instances, an increase of value tenfold, within a few years. He was

gifted with a very rapid power of sketching, and the number of his drawings, often very slight, is incredible; about 8000 were known to have been sold by auction between 1778 and 1780. His finished drawings have kept pace in price with his pictures, and at a sale at Amsterdam, in 1833, several very large sums were realised. He died at Tavistock Row, Covent Garden, April 6, 1707, aged 74, and was buried at St. James's Church, Piccadilly.

VANDEVELDE, CORNELIUS, *marine painter.* Was the son of the foregoing, and practised in London at the beginning of the 18th century. He made some good copies of his father's works, but is only remembered as a copyist.

● VAN DIEST, ADRIAN, *landscape painter.* He was born at the Hague, in 1655, the son of a marine painter, and was his father's pupil. He came to England at the age of 17, and found employment as a landscape painter, but occasionally painted portraits. He was employed for several years by Lord Bath, and drew several views and ruins in the West of England. His works are of unequal merit, as his narrow circumstances and the necessities of his family compelled him to work for low prices. He decorated the wainscot in old houses with slight landscapes and mountainous backgrounds. His best works are luminous, well coloured, and finished. Sir Peter Lely possessed seven of his landscapes. He painted his own portrait, the right hand holding a landscape. He died in London, of an attack of gout, in 1704, and was buried at the church of St. Martin-in-the-Fields. There are several sets of landscapes etched by him in a slight but masterly manner. He left a son, who practised as a portrait painter.

● VANDYCK, Sir ANTHONY, Knt., *portrait and history painter.* Was born at Antwerp, March 22, 1599, the only son of a wealthy merchant in that city. He first studied art under Henry Van Balen, a clever painter, and then, attracted by the works of Rubens, he entered his studio in 1615, became his favourite pupil, and his assistant in many of his great pictures, continuing four years with him. By Rubens' advice he visited Italy, and presenting his master with a portrait of his wife Helena Forman and two other of his own works, in return for the present of a horse by Rubens, he set off for Venice in 1621 to study the masterpieces of Titian. From thence he went to Genoa and Rome, where he stayed some time, lived in much luxury, and painted the portraits of several distinguished men, among them, Cardinal Bentivoglio, for whom he also painted some historical subjects; but he refused to join in the carousals of the artists, who became the severe critics of his works, and he returned

to Genoa, where he was received in the most flattering manner, and found full employment. On an invitation from Palermo he visited that city, and painted the portraits of the Prince of Savoy, the Viceroy, and some other persons of eminence. Then, on an outbreak of the plague, he left Palermo, and afterwards returned, in 1626, to his native city.

The reputation he had gained in Italy had preceded him, and the citizens of Antwerp were ready to welcome him. He was employed to paint St. Augustine for the church of the Augustines, and the picture increased his fame. He was overwhelmed with commissions for the public edifices of Antwerp, Brussels, Mechlin, and Ghent. He painted, in grisaille of small size, the portraits of the eminent artists of his time, which have been many times engraved, and he etched several with his own hand. But his success gave rise to jealousy. His old fellow-pupils depreciated his works; the canons of the cathedral church of Courtrai, among others, abused the pictures they had commissioned him to paint, and he readily accepted an invitation from Frederick Prince of Orange to visit the Hague, where he painted the portrait of the Prince and the principal personages of his court. He is believed to have been a short time in England in the spring of 1621. In 1629 he was induced to come here again by the encouragement given to the arts by Charles I., and lodged with his friend Geldorp, a painter; but, failing to gain the King's notice, he went away chagrined, and this reaching the ears of the King he sought his return.

In 1632 he was specially invited by the Earl of Arundel, at the command of the King, who showed him the greatest favour and immediately employed him. He was knighted the same year, and soon after appointed painter to his Majesty, with an annuity for life of 200*l.* The King, his Queen, and their children sat to him repeatedly, and we are indebted to him for the most complete historic portraiture of his time. He was indefatigable in his labours, and his works will be found in most of the mansions of England's old families. He married Maria Ruthven, daughter of Dr. Ruthven, a physician, and grand-daughter of the unfortunate Earl Gowrie, whose great personal beauty was her only dower. Soon after his marriage he took his wife on a visit to his family at Antwerp, and thence to Paris. It is supposed that he was anxious to have been employed upon the decoration of the Louvre, but he was disappointed, and, returning to England, he proposed to paint the history and procession of the Order of the Garter on the walls of the Banqueting House, Whitehall, of which Rubens had decorated the ceiling. For this

444

he prepared sketches, and submitted them to the King, but the work was probably postponed by the state of the royal finances, and the signs of approaching troubles.

He was fond of pleasure, and of expensive habits. His luxurious and sedentary life induced gout, and injured his fortunes, which he sought to repair in the pursuit of alchemy, then a prevalent folly. He had on settling in London, lodged among the King's painters at Blackfriars, and there he died, cut off, in the vigour of his life, December 9, 1641, and was buried in St. Paul's Cathedral. He left an only daughter, who married a gentleman named Stepney, and her grandson was the poet Stepney. His peculiar genius is displayed in his portraits, particularly of females. Refined, elegant, exquisite in taste and colour, his art is almost unrivalled. His hands are noted for their beauty, his heads unconstrained and full of life and truth ; the action, simplicity and dignity of his figures and grace of his draperies are unsurpassed. His historical pictures, though partaking of the fine qualities of his portraits, do not equal them in merit. His ordinary prices were, for a half-length, 40l., a whole-length, 60l. It is said that he named an extravagant sum, 8000l., for the proposed decorations for the Banqueting House ; but the King was well able to make a bargain with him, as appears by a document in the State Paper Office, in which the King has made large deductions from his charges for portraits painted. Mr. Carpenter, of the British Museum, published, in 1844, a ' Memoir of Sir Anthony Vandyck.'

VANDYKE, PETER, *portrait painter.* Born in 1729. He was a descendant of the great Vandyck. He was invited over from Holland by Sir Joshua Reynolds to assist him, particularly in his draperies, and remained with him for many years. He afterwards settled at Bristol, where he practised as a portrait painter, and was reputed for his likenesses. He exhibited with the Incorporated Society of Artists in 1762, a ' Diana,' an historical subject, and a portrait ; and in 1764 ' Portraits of a Lady and Child in the Character of the Madonna.' At the Free Society in 1767 he exhibited three whole-lengths and three other portraits. There are portraits by him of the poets Coleridge and Southey, in the National Portrait Gallery. A portrait of Samuel Taylor Coleridge, 1795, is engraved, as is also a view with many figures introduced.

VAN GAELEN, ALEXANDER, *battle-painter.* Practised in Holland, where he was in repute as a painter of battle pieces and animals. He followed the Court of William III. to England, and was employed by the King to paint the Battle of the Boyne on a large scale. Settling in London, Queen Anne commissioned him to paint

her Majesty in her state coach drawn by eight horses, and accompanied by her Horse Guards. He was also commissioned by a nobleman to paint three of Charles I.'s battles.

VAN GELDER, P. M., *sculptor.* Was a student of the Royal Academy, and in 1771 gained the gold medal for a bas relief of ' The Choice of Hercules,' but there is no trace of his further career.

VAN HAECKEN, ALEXANDER, *engraver.* Was born in the Netherlands in 1701, and coming to England settled in London, where he practised in mezzo-tint. There are many fine works by his hand, chiefly portraits ; among them George II. and his Queen, after Amiconi. Works by him are dated down to 1754.

VAN HAECKEN (or VANAKEN), JOSEPH, *portrait painter.* Was born at Antwerp, where he studied his profession. He came to England in the reign of George II., and found full employment with our face painters, many of whose art did not extend beyond the head of their sitter. He added the figure with the background, and though worthy of better things, he found it to his interest to confine himself to this branch of the art. The stage coach brought him canvasses to complete from the most remote parts of England, and two painters agreed to pay him 800 guineas a year, to work only for them. His draperies were in excellent taste, natural, and extremely well painted, not unfrequently the best part of the portrait. He died in London, July 4, 1749, aged about 50. Hogarth, who knew how essential his art was to the portrait painters, caricatured them, following his coffin in procession as mourners. He left a brother who was employed in the same professional work.

VAN HOVE, FREDERICK HENRY, *engraver.* He was born at Haarlem about 1625. He came to London, where he settled, and was much employed by the booksellers on portrait frontispieces between 1648–1692. There are portraits of many eminent Englishmen of that date engraved by him. He was found murdered, October 17, 1698.

VAN LEMPUT, REMY, *copyist.* He was born at Antwerp, and was known as an able copyist of the works of Vandyck. He came to this country where he was chiefly employed in copying, but there are some portraits by him. He purchased at King Charles's sale the fine Vandyck portrait of the King on horseback, and was compelled to give it up. He died in November 1675, and was buried in the churchyard at Covent Garden. His daughter was known as an artist ; she married the brother of Robert Streater the painter.

VAN LINGE, BERNARD, *glass painter.* He was a Fleming, and came to England

in James I.'s reign, and gained a great reputation by his art. Probably his earliest work in this country is at Wadham College, Oxford, 1622. Among other paintings by him is the chapel at Wroxton, 1632; the seven windows at Lincoln College, Oxford, 1629–31, are generally attributed to him. Some writers, without questioning that these works are by him, doubt whether he ever came to this country.

VAN LINGE, ABRAHAM, *glass painter.* Supposed to have been the son of the foregoing. He painted many fine windows in this country. At Christ Church, Oxford, 1640; Balliol College, 1637; Hatfield, Wroxton, Queen's College, 1635; University College, Lincoln's Inn Chapel, 1641; Peterhouse, Cambridge.

VAN LOO, JOHN BAPTISTE, *portrait painter.* Was born at Aix in Provence, in 1684, and at a very early age obtained considerable reputation in art, and painted altar-pieces for the churches in Toulon, Aix, etc. This led to his going to Turin, where he painted portraits of the grand ducal family. The Prince of Carignan sent him to Rome, where he studied under B. Luti, and restored Giulio Romano's picture of the 'Loves of the Gods.' Later he went to France, where he restored Primaticcio's pictures at Fontainebleau. In 1737 he came to England and painted a portrait of McSwiney the actor, which obtained him great employment. Walpole states that he soon bore away the chief business of London from every other painter. His likenesses were strong but not flattering, and his heads forcible in colouring. His work was laborious, though he only demanded five sittings from each person. His portraits are largely engraved. He etched one plate representing 'Diana discovering Endymion in a Forest.' He returned to Paris in 1742, but soon retired to Aix, where he died in 1746, aged 62.

VAN NOST, JOHN, *sculptor.* Was born in Piccadilly, where his father made statues in lead for the decoration of gardens. About 1750 he went to Dublin, where he settled and was much esteemed. The equestrian statue of William III. on College Green, is by him; also, the equestrian statue of George II., on St. Stephen's Green, and many statues and ornamental works about the castle. He was appointed statuary to the King. About 1780 he returned to London, but went back to Cork on the invitation of the Corporation, and erected in that city a statue of the Mayor. He died in Dublin, in 1780.

• VANSOMER, PAUL, *portrait painter.* Was born at Antwerp in 1576. Practised for some while in Amsterdam. Then came to England. The time of his arrival is not known, but it was certainly before 1606. He settled here, painted James I. with his

Queen, and many of the nobility and other persons of distinction. His portraits possess many fine qualities, grand, dignified, and characteristic, particularly in his male portraits, powerful in light and shade, and quiet in tone and colour, excellent in his landscape back-grounds and in general pictorial treatment. There are many noble examples of his art in the royal and other collections. He died in London, aged about 45, and was buried at the church of St. Martin-in-the-Fields, January 5, 1621.

VANSOMER, PAUL, *engraver.* Born at Amsterdam, 1649, he resided some time in Paris, and then came to London, where he settled and was one of the first artists who practised in mezzo-tint. He also etched and engraved, but without attaining excellence in either manner. He executed a plate of the Duke of Bavaria and his secretary in 1670, before his arrival in England, and many other portraits. There are also many historical engravings by him. 'Tobit Burying the Dead,' 'Moses Found in the Bulrushes,' 'The Baptism of Christ,' 'The Adoration of the Shepherds,' from a design by himself; 'A Drawing Book,' and some other works. His works are dated as late as 1690. He died in London, 1694.

VANSON (or 'Vanzoon'), FRANCIS JOHN, *still-life and flower painter.* Was born at Antwerp about 1650, and studied art under his father, who was a flower painter. He came early to England, settled here, and marrying the niece (some accounts say the daughter) of Robert Streater, he succeeded to much of his practice. He painted still-life, fruit, flowers, china, rich silks, and tissues, imitating them from the objects with great fidelity and truth, rich in colour, and picturesquely composed. Into some of his works he introduced rare botanical plants studied at the Physic Garden in Chelsea. He lived chiefly in Long Acre, and died in St. Alban's Street in 1700.

VAN VIANEN, CHRISTIAN, *modeller and chaser.* He practised in the reign of Charles I., and was distinguished by the beauty of his designs and workmanship in silver plate. His works were treasured in the Royal Collection and in the households of several of our nobility. That he practised in this country is vouched for by his initials, 'C. V., Lond.'

VANVOERST, ROBERT, *engraver.* Was born at Arnheim, Holland, about the end of the 16th century, and came to England early in life. He engraved the portraits of many distinguished Englishmen, chiefly after Vandyck, Mirevelt, and Honthorst, particularly the fine portrait of Charles and his Queen, by Vandyck; Elizabeth of Bohemia, after Honthorst; and his own portrait, by Vandyck. He used the graver almost exclusively, and his plates are neatly

and carefully finished. Vanderdoort, in his Catalogue, styles him 'The King's Engraver.' His last known work is dated 1635, but he is believed to have lived till 1669.

VARDY, JOHN, *architect.* Was a pupil of Kent. He was a member of the Incorporated Society of Artists, and was the architect of several fine mansions. He built the Horse Guards, it is said, after a design by Kent, 1753. He exhibited at Spring Gardens, in 1761, 'A Design for a Building for the Dilettanti Society,' 'A Design for the British Museum, prepared by order of the trustees, 1754'; 'A Design for a Royal Palace fronting the Park,' 1748, on the spot where the Horse Guards was afterwards placed, and 'A Design for the North Front of St. James's Palace;' 'Earl Spencer's House,' looking into St. James's Park, and, in 1762, 'Uxbridge House, Burlington Gardens,' now a branch of the Bank of England. He held the office of Clerk of the Works at Kensington Palace. He died in 1765.

VARLEY, JOHN, *water-colour painter.* His father, a native of Epworth, Lincolnshire, settled for a time in Yorkshire, where he married, but his circumstances not proving prosperous he came to London, and his son was born at Hackney, August 17, 1778. The father became tutor to Lord Stanhope's son, and was a man of very scientific attainments. He discouraged the taste of his son, John Varley, for art, and he was sent on liking to a silversmith, with the intention to apprentice him to that trade; but his father dying, he managed to free himself from the engagement, and found some employment with a portrait painter, and when about 16 years of age, with an architectural draftsman, and in his spare hours sketched everything that came in his way. He was taken on a tour by his master to sketch the principal buildings in the towns they visited, and in 1798 he exhibited his first work, a 'View of Peterborough Cathedral.' In the next year he made a tour in North Wales, and here he found the true field for the exercise of his art. He made numerous studies, revisited Wales in 1800, and again in 1802, and afterwards the northern counties of England. Meanwhile he was one of the class of young painters that met continually at the house of Dr. Monro, and had profited by association in their studies.

He had exhibited his works at the Royal Academy up to 1804, when he became one of the foundation members of the Water-Colour Society, and thenceforth contributed to its exhibitions alone, sending no less than 42 works, almost entirely Welsh subjects, to the Society's first exhibition, and continuing to contribute so largely that he exhibited 344 drawings in the first eight

years, so that it is no wonder there are so many slight and inferior works by his hand.

Many of his subjects at this period are from the banks of the Thames, and, evidently painted on the spot, possess greater individuality and truth than his more aspiring compositions. But he had married in 1803; a family had now to be cared for, and he was obliged to work for the dealers, and at their prices; and from this resulted weak and common-place work. He continued a member of the Water-Colour Society, when a large secession took place in 1813, and clung to it during its several changes and vicissitudes, constantly contributing to its exhibitions. All his latter works were chiefly compositions, mountains and lake scenery, produced from a stored memory, but not possessing the qualities of the works of his middle period.

Part of his income arose from teaching, and he had several pupils, who became eminent in art. Some of his lady pupils, and some who came to purchase his drawing, had another object. He was an enthusiastic astrologer, and they enticed him to cast their nativities. He was in some degree a sincere believer in his power, and many strange coincidences are told in respect to his predictions. A man of a liberal and genial character, he was full of clever conversation on many topics, and amusing on all. As artist, teacher, and astrologer, he managed at one period of his life to make a good income; but in the latter part he fell into difficulties, not from any extravagance or indolence, but rather from mismanagement and neglect of his household affairs. He had suffered from an affection of the kidneys, and sitting down to some sketch that allured him he had a relapse, was unable to reach his home, and died in a friend's house on the 17th November, 1842.

His landscapes have great breadth and simplicity, his tints are beautifully laid with a full and free pencil, his colour fresh, pure and simple, and no body colour is used in his best works. He was rather mannered, but a great master of the rules of composition, which he applied with true genius. His foliage is large and massive rather than imitative. He usually painted common sunlight and summer foliage, seldom autumnal tints, and rarely sunsets or other effects. He was happy in the introduction of figures. He published some strange books, for he had not mastered the art of writing. A treatise on 'Zodiacal Physiognomy,' 1828; 'Observations on Colouring and Sketching from Nature,' 1830; and a 'Practical Treatise on Perspective.' His eldest son, ALBERT FLEETWOOD VARLEY, a water-colour painter, and teacher in good practice, died at Brompton, July 27, 1876, aged 72.

VARLEY, WILLIAM FLEETWOOD, *water-colour painter*. Was younger brother of the above, and commenced art under his instructions. He exhibited views at the Royal Academy in 1804 and 1805, and regularly from 1809 to 1817. About 1810 he taught drawing in Cornwall, and afterwards at Bath and at Oxford, at which latter city, by the thoughtless frolics of a party of the students, he was nearly burnt to death. His nerves suffered a shock from which he never recovered, and he experienced great distress. In his latter days he was sheltered in the house of his son-in-law. He died at Ramsgate, February 2, 1856, aged 71 years.

VARLEY, CORNELIUS, *water-colour painter*. Brother of the two foregoing. He was born at Hackney, November 21, 1781, and on the death of his father, when he was only ten years of age, was taken charge of by his uncle, a manufacturer of philosophical instruments and apparatus, under whom he gained a knowledge of mechanics, optics, and chemistry. He remained with his uncle till about his 20th year, and was engaged in many ingenious inventions and experiments, but left him about 1800, owing to some family disagreement, and joining his elder brother, John Varley, he set himself to study art. Making several visits to Wales, he sketched direct from nature, and was soon engaged in teaching. He first appears as an exhibitor of 'A Wood Scene, a Composition,' at the Royal Academy in 1803, and in the following year was one of the artists who met and founded the Water-Colour Society, of which he was one of the first members, and from its formation a constant contributor to its exhibitions. He was also a member of the Sketching Society. In 1808 he extended his sketching excursions to Ireland. Among his chief works were, in 1809, 'A Mountain Pastoral;' 1811, 'Evening,' 'The Sleeping Shepherd;' and 'Palemon and Lavinia;' 1815, 'View of Ardfort, Ireland,' and the same year he was appointed Treasurer of the Society; in 1816 he exhibited 'Evening in Wales;' 1819, 'Ruins of Troy;' 1820, 'The Vale of Tempé;' and in 1821, on changes which then took place, he resigned his membership. His works were few, chiefly of a classical character, introducing architecture and groups of figures, compositions carefully and elaborately finished. He had, while a member of the Water-Colour Society, occasionally sent a picture to the Academy exhibition, and he now exhibited his principal works there, seldom more than one, and usually a landscape composition. He exhibited for the last time in 1859. He was a man of many attainments, and, active in scientific pursuits, was a frequenter of the Royal Institution, and took to the

last an earnest interest in the proceedings of the Society of Arts, of which he was the oldest member. His practice in art was carried on without abandoning scientific pursuits. He made various improvements in the camera lucida, the camera obscura, the microscope, for which he received the Society of Arts' Isis gold medal; and he invented the graphic telescope, for which he also received a medal at the Exhibition of 1851. He was the last survivor of the founders of the Water-Colour Society. In the enjoyment of his faculties to the end, he died at Highbury, October 2, 1873, in his 92nd year. He published 'Etchings of Boats and other Craft on the river Thames.'

VASLET, LEWIS, *miniature painter*. Practised at York about 1770, and from 1775 to 1782 at Bath, and was an occasional exhibitor at the Royal Academy, contributing for the last time in the latter year.

VAUGHAN, ROBERT, *engraver*. He practised about the middle of the 17th century, and engraved the portraits of some eminent men, but his works do not possess much merit. He also engraved for Dugdale's 'Warwickshire,' Morton's 'Ordinal,' and for Ashmole's 'Theatrum Chemicum.' During the Protectorate he appended so offensive an inscription to a portrait of Charles II., that proceedings were taken against him after the Restoration. His latest known work is dated in 1655. He died about 1667.

VAUGHAN, WILLIAM, *engraver*. Practised in the last half of the 17th century, and was chiefly employed upon frontispieces for the booksellers. He engraved after Barlow, 'A small Book of such Beasts as are most useful for Drawing, Graving, Arms Painting, and Chasing,' 1664; and three plates for a small folio pamphlet, 'The Sufferings of Sir William Dick, of Braid.'

VENDRAMINI, JOHN, *engraver*. Was born near Bassano in 1769. Pursued the study of his art there till the age of 19, when he came to England, and, settling in London, completed his studies under Bartolozzi, with whom he remained till his master left England, when he succeeded to his house at North End, Fulham. In 1802 he married an English lady, and in 1805 he made a journey to St. Petersburgh and Moscow, and during a stay of two years in Russia was greatly esteemed, and was patronised by the Emperor, who made every effort to induce him to stay, and, his passport being refused, he escaped from the country in disguise. On reaching England he resumed the practice of his profession, and worked with great diligence on works of a high class. The chief of these are, 'The Vision of St. Catherine,' by Paul

Veronese; 'St. Sebastian,' by Spagnoletto; 'Leda,' by Da Vinci; and 'The Raising of Lazarus,' after the Sebastian del Piombo, now in the National Gallery. He died in Regent Street, February 8, 1839.

VERELST, SIMON, *portrait and flower-painter.* Was born at Antwerp in 1664, and distinguished himself there by his flower and fruit pieces. He came to England in the reign of Charles II., and then took to portrait painting, surrounding his portraits with flowers and fruit. His portraits in this manner became popular. They were, as well as the flowers, painted with extreme delicacy and finish, and he received large prices for them. Many anecdotes are told of his immoderate vanity, which Walpole says led to his confinement as a madman. He called himself 'The God of Flowers,' and did not recover his reason till towards the close of his life. In 1683 he was living in Jermyn Street, St. James's; he died in Suffolk Street in 1710.

VERELST, HERMAN, *flower-painter.* Was the elder brother of the above. He practised for some years in Vienna, where he enjoyed a reputation as a flower-painter. He sometimes attempted history painting. About 1683 he came to England, where he settled, and continued to paint the same subjects. He died about 1700, and was buried at the Church of St. Andrew, Holborn. His works are engraved by Becket, Faber, Smith, and others.

VERELST, MARIA, *portrait painter.* Daughter of the above and his pupil. Born in 1680. She painted small delicately finished portraits in oil, and some historical subjects. She was mistress of several languages, a great proficient in music, and a very accomplished woman.

VERELST, CORNELIUS, *portrait painter.* Son of the above Herman. Was born at Vienna in 1667, and accompanied his father to England, where he practised portraiture in oil with some repute. He died March 7, 1734.

VERELST, WILLIAM, *portrait painter.* Son of the above. Practised, in London, portraiture in oil, and was esteemed in his day. There is a good portrait of Smollett by him, dated 1756, solidly and carefully painted. He died unmarried soon after that date.

VERGAZON, HENRY, *landscape and portrait painter.* He was a native of Holland, where he practised as landscape painter. In the reign of William III. he came to England and settled here. He painted portraits of a small size, but was chiefly employed by Sir Godfrey Kneller in painting the back-grounds of his portraits.

VERNON, THOMAS, *engraver.* He was born in Staffordshire about 1824, and studied his art both in Paris and in England. He practised in the pure line manner, and maintained a high reputation, excelling in his figures. Among his chief works are 'The Madonna and Child,' after Raphael; 'The Virgin and Child,' after Dyce, R.A.; 'The Princess Helena,' and 'The Lady Constance Grosvenor,' after Winterhalter; 'Olivia Unveiling,' after C. R. Leslie, R.A.; 'The First-born,' after Cope, R.A.; and 'Christ Healing the Sick,' after Murillo, probably his finest work. His art was finished and elaborate, and falling in times when engraving of a high class met with little appreciation, found only a poor remuneration. He died January 22, 1872.

VERPYLE, SIMON, *sculptor.* Was born in England, and was a pupil of Scheemaker. Towards the end of the 18th century he was invited to Dublin by the Earl of Charlemont, and for some time, and about 1764, found full employment and practised there. He was considered a clever bust-modeller, but his art did not extend beyond this. He practised for many years in Dublin, and died there. His widow was relieved by the Artists' Society.

VERRIO, ANTONIO, *history painter.* Was born at Naples in 1634. After making some progress in his art he visited France, and settled at Toulouse, where he met with employment, and painted an altar-piece for the church of the Carmelites. He came to England in 1671, on the invitation of Charles II., who purposed to re-establish the tapestry manufacture at Mortlake, which had been interrupted by the civil war; but seeing some painting which he had executed for Lord Arlington, the King preferred to employ him in the decoration of Windsor Castle, where he was engaged for several years in painting the principal chambers. Most of the ceilings are by him; the Chapel, and one side of St. George's Hall. For these works he was paid nearly 7000*l.* He held also the place of master gardener, had a lodging assigned him in St. James's Park, and lived sumptuously. He was continued in his employment at Windsor by James II., and there is in the great hall of Christ's Hospital a painting ninety feet long of the Governors, accompanied by the officers and children, in large life-size groups, returning thanks to that monarch for the grant of the Hospital Charter—a work of great pretension and power. On the Revolution we are told he refused to paint for William III. and was for some time employed at Burleigh by Lord Exeter, and afterwards at Chatsworth. He was then induced to work for the King, and painted his well-known work, the great staircase at Hampton Court. His sight failing, Queen Anne granted him a pension of 200*l.* a year, and soon after he died at Hampton Court, June 17, 1707. His works

have been smartly criticised by Pope and others, whose ridicule is not unwarranted by many absurdities; but injustice has no less been done to the painter and his merits, and the great fitness of his art as a decorator overlooked. His great facility, the easy pose of his figures, the fresh and decorative look of his surface, are qualities which might well make him popular in his own day, and demand recognition in ours.

VERTUE, ROBERT, *statuary*. Was employed as master mason in the erection of Henry VII.'s Chapel, at Westminster.

VERTUE, GEORGE, F.S.A., *engraver*. Was born of respectable parents in the parish of St. Martin, London, 1684. At thirteen he was apprenticed to an engraver of arms on plate; but after between three and four years, his master failing, he returned to his friends, and devoted himself to study drawing. He then entered into an engagement with Michael Vandergucht for three years, which he prolonged to seven; and afterwards in 1709 began to work for himself, studying closely not only to improve in his art, but also to acquire the French, Italian, and Dutch languages, and to cultivate a love of music. He was one of the first members of the Academy (called Kneller's Academy) founded in 1711, in Great Queen Street, Lincoln's Inn Fields, for the study of the human figure, and drew there for several years. His works were beginning to attract attention, when, on a commission from Lord Somers, he engraved a fine plate of Archbishop Tillotson, which at once gave him a reputation, and on the accession of George I., he engraved a portrait of him, which had a very considerable sale and was followed by the portraits of the Prince and Princess.

As early as 1713 he commenced his researches into the lives of our artists, and his collection of whatever might assist in his contemplated history of the arts in England. He also practised in watercolours, copying antiquities and relics, and sometimes attempting portraits; and acquiring a love of antiquarian research, became a member of the Society of Antiquaries, and was in 1717 appointed Engraver to the Society. He was full of employment. He visited the principal galleries and the old mansions of the nobility, as well as the Universities, in search of English portraits, and, taking great care for their proper identification, he engraved a great number of them. He also made sketches and notes of statues, busts, tombs, and art memorials of every kind. He engraved the Oxford Almanacs from 1723 till his death. In 1730 he completed his twelve heads of the poets, followed by a series of heads of Charles I. and the loyal sufferers in his cause, and the illustrations to Rapin's 'History of England.' Altogether
450

he is said to have engraved above 500 portraits alone. Some of his works show much merit; but truth and correctness were preferred by him to art, and his manner is laboured and dry.

His literary works are held in much esteem. His reputation stands higher as an antiquarian than as an artist. He published ' On Holbein and Gerrard's Pictures,' 1740; ' Medals, Coins, Great Seals, Impressions from the Elaborate Works of Thomas Simon,' 1753; ' Catalogue and Description of King Charles the First's Capital Collection of Pictures, Limnings, Statues, &c.,' 1757; ' Catalogue of the Collection of Pictures belonging to King James II., to which is added a Catalogue of the Pictures and Drawings in the Closet of Queen Caroline;' ' Catalogue of the Curious Collection of Pictures of George Villars, Duke of Buckingham;' ' Description of the Works of that Ingenious Delineator and Engraver, W. Hollar,' 1745, second edition 1759. He died July 24, 1756, as he had lived, a strict Roman Catholic, and was buried in the Cloisters of Westminster Abbey, where there is a tablet to his memory. His prints, drawings, and books, were sold by auction in March, 1757. His pictures, models, limnings, casts, coins, and medals, in the May following. After his death his large collection of notes and memoranda were purchased by Horace Walpole, and formed the material for his 'Anecdotes of Painting in England.'

VERTUE, JAMES, *portrait painter*. Was the brother of the foregoing. He practised as a portrait painter and draftsman at Bath, and died there about 1765. His drawings were sold by auction in London in 1766. His brother George engraved, after a drawing by him, ' The Interior of the Abbey Church at Bath.'

VICKERS, ALFRED, *landscape painter*. Was born at St. Mary Newington, September 10, 1786. He was early devoted to art, and was self-taught. He painted small pictures from English scenery with great facility, which were truthful and pleasing, but did not reach to higher excellence. He was a frequent exhibitor at the Royal Academy from 1813-59, and the other exhibitions. He died in 1868, aged 82.

VICKERS, ALFRED GOMERSAL, *subject and marine painter*. Son of the above. Was born in Lambeth, April 21, 1810. He commenced art with little instruction, except such as he may have received from his father. He painted both in oil and in water-colours, and was a constant exhibitor at the British Institution, and from 1827, till his death, at the Royal Academy, and at Suffolk Street. In 1833 he was employed to visit Russia to make sketches for publication, and made some excellent drawings, which were published in the

Annuals. He died when beginning to make himself known, January 12, 1837. His works were sold in the following February at Messrs. Christie's.

VILLIERS, FRANÇOIS HUET, *miniature painter.* Born in Paris. Son of an animal painter. He took refuge in this country on the breaking out of the French Revolution, and settled here in the practice of his art. He painted chiefly portraits, but also landscapes and animals, and was, in 1808, a member of the Associated Artists in Water-Colours. His portraits were in miniature, on ivory, and in chalk and oil. He made some drawings of Westminster Abbey, which were published, as was also his Drawing Book for cattle and trees. He held the appointment of painter to the King of France, and was appointed miniature painter to the Duchess of York, and was a constant exhibitor at the Academy from 1804 to 1813, contributing miniatures —some of them on marble—animals, and studies from nature. He was a respectable artist, his portraits well finished, and effective in colour, but stiff and graceless. He found good employment in his versatile practice. He died in Great Marlborough Street, July 28, 1813, aged 41, and was buried in St. Pancras old churchyard.

VINCENT, W., *engraver.* Practised in London towards the end of the 17th century. Engraved mezzo-tint portrait heads and history, and some plates after his own drawings. His works are much esteemed.

VINCENT, GEORGE, *landscape and marine painter.* Was born at Norwich in June 1796, and was educated in the grammar school of that city. He was a pupil of old Crome, and his name first appears as a contributor to the Norwich exhibition in 1811. The next year he sent two pictures, and in 1814 no less than 15, and the same year, and up to 1823, was an occasional exhibitor at the Royal Academy, sending also one or two works to the Water-Colour Exhibition. In 1817, and the following year, he was an exhibitor in London at the British Institution, and then, leaving Norwich, he settled in London in 1819. In 1820, when the Society's exhibitions were open to others than members, he exhibited with the Water-Colour Society, 'London from the Surrey Side of Waterloo Bridge,' a fine work in oil; and in 1824, on the foundation of the Suffolk Street Gallery, exhibited there, and continued to do so up to 1830, after which his name does not appear. On a commission from Mr. Carpenter, of the British Museum, he painted his best work, 'A View of Greenwich Hospital,' which was exhibited at the International Exhibition in 1862. He had married and fitted up a good house in Kentish Town, but he fell into bad habits, followed by debts and difficulties; his pictures were to be seen in dealers' windows, and became more slight and less studied; he was lost sight of, and the date of his death is uncertain, but it is supposed that it occurred about 1831. His 'Greenwich Hospital' gives him high rank as an artist. The hospital is seen from the river at full tide, crowded with craft and shipping, the sun in the picture obscured by the vessels, and the light dispersed, the sky pearly and luminous. In his latter pictures he painted subjects as seen under the sun, using large masses of greyish shadow, tipped and fringed with the solar rays. He did not frequently introduce trees or foliage as his principal objects. He had powers, which show he might have rivalled the great landscape painters of his day.

VIOLET, PIERRE, *miniature painter.* Was a native of France, where he attained much reputation, and was miniature painter to Louis XVI. and Marie Antoinette. On their execution, in 1793, he came to London, and settled here in the practice of his art. He exhibited occasionally at the Royal Academy; among other works, a portrait of the Prince of Wales, and continued an exhibitor up to 1819. He also gave lessons in water-colour drawing. A likeness of Bartolozzi by him is engraved. He wrote an introduction to miniature painting. He died in London, in his 71st year, December 9, 1819.

VISPRÉ, VICTOR, *miniature painter.* Was born in France. Towards the end of the 18th century he was residing in Dublin, in the practice of his art. He sent from thence to the Spring Gardens' exhibitions, 1770–78, small life portraits. He also executed small crayon portraits, among which may be mentioned those of Garrick and his wife. His brother, FRANCIS ZAVERIUS VISPRÉ, practised in Dublin at the same time, painting fruit pieces in oil and on glass, and also exhibited at the Spring Gardens' Rooms.

VIVARES, FRANCIS, *landscape engraver and draftsman.* Was born near Montpelier, France, July 11, 1709, and contrary to his will, was apprenticed to a tailor. He was, however, fond of drawing, and practised it. He etched some landscapes, which he finished with the graver, and early in life—it does not appear on what inducement—he came to London, arriving here at the age of 18. He attracted the notice of Chatelain, who befriended him, and took him as his pupil. He studied, with such help, both drawing and engraving, soon made his way to distinction, and became the founder of a school of landscape engravers. In 1766 he was a member of the Incorporated Society of Artists. His line is good, his light and shade well preserved, and his figures well drawn. He published 'A New Book of Shields.' He engraved

Vincent. a. P. 3 (1807)

some fine plates after Gaspar Poussin, Gainsborough, Vanderneer, Smith of Derby, and the Smiths of Chichester ; and especially Claude, whose works he rendered with great truth and ability. His landscape works are very numerous. The spirited character of his foliage, and the richness of his foregrounds, were the admiration of Woollett. He drew with the pen in a very spirited manner. He died in Great Newport Street, where he had lived 30 years, November 26, 1780, and was buried in Paddington churchyard. He had married thrice. and had 31 children.

VIVARES, Thomas, engraver and draftsman. Son of the foregoing, he was born in London about 1735. In 1761 he gained a Society of Arts' premium. He practised as an engraver, but he was also a teacher of drawing, and in 1783-87 exhibited some moonlight scenes at the Royal Academy, but his works are little known. Several of the architectural plates to the works of R. and J. Adam, published in 1773, are engraved by him, and there is a set of six landscape views near London which are both drawn and engraved by him.

VOGELSANG, Isaac, landscape and cattle painter. Was born at Amsterdam in 1688, and studied his art there. Practised in London in the time of George I. ; then visited Ireland, and was much employed there. He painted landscapes, animals, battle-pieces, and occasionally accessories and draperies for the portrait painters. From thence he went to Scotland, but not succeeding, he returned to London, where he settled, and died June 1, 1753.

VON HOLST, Theodore, historical painter. Was of a Livonian family, and born in London, where his father was a musical teacher, September 3, 1810. He showed an early talent for drawing, and was admitted a student of the Royal Academy, where he gained the notice of Fuseli, and of Sir Thomas Lawrence, who purchased some of his drawings. As he advanced in art, he was led aside by the promptings of his wild genius, and chose subjects of wild, gloomy romance, which were unsuited to the English taste ; and he frequently visited Germany, nourishing a love for German art. He exhibited at the Royal Academy in 1829 'Students Watching the Clock of Eternity ;' in 1833, 'Pleasure a Vision ;' in 1834, 'A Seducer,' and 'The Treasure-Seeker ;' and occasionally a portrait, sending his last contribution in 1843. His principal works are 'The Drinking Scene in Faust,' 'The appearance of the Ghost to Lord Lyttelton,' 'The Raising of Jairus' Daughter,' which is engraved, and for which the Directors of the British Institution awarded him a donation of 50 guineas. He was disappointed in his art, resolutely re-

sisted advice, and following his own bent, wasted his real powers. He died after a short illness in Percy Street, Bedford Square, February 14, 1844, aged 33. He illustrated an edition of Shelley's ' Frankenstein.'

VORSTERMAN, Luke, engraver. Was born at Antwerp in 1580, and commenced life as a student of painting in the atelier of Rubens. He afterwards devoted himself to engraving. In the reign of Charles I. he came to England, and resided here from 1623 to 1631. He engraved several fine pictures in the King's collection for the Earl of Arundel, and made some drawings and painted some small pictures while in England, among them a portrait of Prince Henry. His last-known work is dated 1656, though this has been attributed to his son, whose Christian name was the same.

VULLIAMY, Lewis, architect. His father was celebrated as a clock-maker, and the firm had for above 130 years held the appointment of clock-makers to the Crown. He was brought up for an architect, was articled to Mr., afterwards Sir Robert, Smirke, and was admitted to the schools of the Royal Academy. In 1813, he gained the Academy gold medal for his design for ' A Nobleman's Country Mansion,' and was in 1818 elected to the Academy travelling studentship, and passed several years of study on the continent, chiefly in Italy, and also visited Greece and Asia Minor. In 1822 he exhibited at the Academy ' A Design for the Court of a Palace ;' in 1823, the ' Portion of a Design for a Bridge ;' in 1824, ' Examples of Ancient Architecture, Greek, Italian,' &c., and settling in London, he soon established an extensive professional connexion. He did not again exhibit till 1830, when he sent the ' Front of the Law Institution,' then erecting in Chancery Lane ; in 1831, ' The Designs for a Church' he was building at Highgate ; in 1833, ' The Elevation of a Church in Woburn Square ;' and in 1837-38, the front and other portions of the Royal Institution, his last exhibited works. During a practice of nearly half-a-century he was the architect of several fine mansions, and altered and enlarged several others. Among his works of this class, Dorchester House, Park Lane, and Westonbirt, Tetbury, should be mentioned. He built no less than 28 new churches, of which St. Barnabas, Kensington, is a good example, and so is, among his later works, the London and Westminster Bank. But he may well rest his reputation upon his last work—Mr. Holford's noble mansion in Park Lane—conspicuous by the classic proportion and taste of its design—the fine entrance hall and staircase, and the excellent adaptation of the building to its site. He died at his residence, Clapham Common,

January 4. 1871. He published in 1826, with coloured plates, 'Ornamental Sculpture in Architecture, from the Originals in Greece, Asia Minor, and Italy.' 'The Builder,' in 1871, published a complete list of his numerous executed works.

W

WADDINGTON, S., *landscape painter*. He painted some good landscapes in a classic style, and was of some promise, but died at the age of 22 in 1758.

WAGEMAN, THOMAS CHARLES, *portrait painter*. He first exhibited at the Academy in 1813, and continued a contributor of portrait drawings in water-colour, with sometimes a miniature, up to 1848. He exhibited many portraits of eminent actors in character. He was appointed portrait painter to the King of Holland. Died June 20, 1863, aged 76.

WAGGONER, ——, *landscape painter*. There is a view of the Fire of London by a painter of this name in Painters' Hall, London, and a painting of the same subject, like in many of its details, at the Society of Antiquaries, supposed by the same hand. The effect of the conflagration is well represented, but the painting has generally no artistic merit. The latter picture is engraved by Mazell, for Pennant's 'London.'

WAINWRIGHT, THOMAS GRIFFITH, *subject painter*. He claimed a good Welsh descent, and was educated under Dr. Burney. From 1820 to 1823 he was a contributor, under the name of 'Janus Weathercock,' of some humorously flippant, impertinent art-criticisms to the 'London Magazine,' and in 1821, exhibited at the Royal Academy, 'A Romance from Undine,' followed in 1822 by 'Paris in the Chamber of Helen;' in 1824, by 'The Milkmaid's Song,' and in 1825, when he last exhibited, by a 'Scene from der Freischutz,' and a 'Sketch from la Gerusalemme Liberata.' He was then living in Great Marlborough Street, and was well received in artistic and literary society, and afterwards lodged with the widow of an officer at Mortlake, one of whose daughters he clandestinely married. In 1830 he insured the life of his wife's sister, for a short period, within which she died suddenly. The Insurance Office successfully disputed his claim, and the dark suspicion that strychnine, then little known, had been used, clung to him. He wandered about for a while in France; but, returning to England in 1836, he was at once apprehended on the charge of forging his wife's and her trustees' signatures to the transfer of 5200*l.* stock; and, pleading guilty at the Old Bailey, was transported to Van Diemen's land. In 1854 he was admitted to the General Hospital at Hobart Town, where he remained several years, and when discharged he recurred to his own profession. But known, his character surrounded with the gravest suspicion, he was disliked and shunned, and is said to have again attempted poisoning. After seven years he petitioned for a 'Ticket of Leave,' which was refused by the Governor. He died in the Hobart Town Hospital, of apoplexy, about 1852. He had some art reputation in his day, but the traces of his works are lost. Sir Edward Lytton told the story of his crimes in 'Lucretia,' a novel, and Mr. Justice Talfourd, in his 'Memorials of Charles Lamb.'

WAIT, ROBERT, *portrait painter*. Was born in Scotland, and was a pupil of the younger Scougall, and had some instruction from Kneller. He was much employed as a portrait painter from 1708 to 1722, and later painted still life. He died in 1732.

WAKEFIELD, WILLIAM, *architect*. Practised in the reign of George I. He erected, in 1713, the Mansion at Duncombe Park, Yorkshire, a grand pile in the Doric order, which has been attributed to Vanbrugh; and in 1723, Rookby Park, in the same county; also Atherton Hall, Lancashire, a work of much pretension and merit. He gave the design for 'Helmsley, once proud Buckingham's delight.' His works are engraved in Campbell's 'Vitruvius Britannicus.'

WALDRE, VINCENT, *history painter*. He was a native of Vicenza, and having painted some ceilings at Stowe, on the invitation of the Marquis of Buckingham, who was then Lord-Lieutenant of Ireland (1787-90), he went to Dublin, and was employed to decorate Saint Patrick's Hall, with three large paintings, the subjects from Irish history. He afterwards produced some easel pictures. Later he was appointed architect to the Board of Works, but has left no edifice by which he can be remembered. He married an English lady, and settling in Dublin, died there, aged 72.

WALE, SAMUEL, R.A., *history painter*. Was born in London (some accounts say Yarmouth), and was apprenticed to a silver plate engraver. He studied drawing at the St. Martin's Lane Academy, and had some assistance from Frank Hayman, whose

manner he imitated. He practised painting, and executed several ceilings; but his chief employment was as an illustrator of books. His designs were chiefly made with the pen and tinted with Indian ink, and are many of them from English history, but they are weak and spiritless, wanting both in drawing and in light and shade. He was one of the foundation members of the Royal Academy, and first lecturer on perspective, of which he was a master, and also professed a knowledge of architecture. He lived in the same house with John Gwynne, R.A., the architect, and assisted him both in the artistic and literary part of his publications. There is an engraving from a joint drawing by them of the 'Interior of St. Paul's Cathedral,' decorated according to Sir C. Wren's original intention. He painted some signs, and one of 'Shakespeare' was of some notoriety. On the death of Richard Wilson he was appointed librarian to the Academy. He was an exhibitor at the Academy from 1769 to 1778, contributing sacred and historic subjects, but chiefly tinted designs only. In the latter year he was placed upon the Academy Pension Fund, and was the first member who participated in its benefits. He died February 6, 1786, in Little Court, Leicester Square. There are works by him in Bethlehem Hospital, St. Thomas's Hospital, Christ's Hospital, and the Foundling Hospital, at the latter a small landscape, good in colour and light in shade, with figures well introduced. There are also some slight etchings by him. The illustrations for 'London and its Environs Described,' 1761, are by him, as are also those for an edition of Izaak Walton's 'Angler.'

WALES, JAMES, *landscape painter.* Was born of respectable parents, at Peterhead, in 1748, and was educated at the Marischal College, Aberdeen. Choosing landscape, his love of art was fostered by travel. He went to the East Indies in 1791, and devoted himself to make drawings of the ancient architecture and sculpture. Twenty-four of his drawings of the Temple of Ellora are engraved by Thomas Daniell, R.A., in his work on 'Hindoo Excavations,' 1803. He also made drawings of the Temple of Elephanta, and in 1788 and 1789 was an exhibitor of portraits at the Royal Academy. He died in 1796, at Salsette, on the coast of Malabar, where he had gone to make drawings. He painted some good portraits of the Indian Princes and their ministers.

WALKER, ANTHONY, *engraver and draftsman.* Was born at Salisbury in 1726. Other accounts say Thirsk, and that his father was a hatter. After gaining some knowledge of his art he came to London, placed himself under John Tinney, and was admitted a member of the St. Martin's Lane Academy. He engraved the figures in his fellow-pupil Woollett's 'Niobe.' He was for some time employed on frontispieces and vignettes for book illustrations, which he both designed and engraved. In 1754 he published five excellent plates, after his own designs, from 'Romeo and Juliet,' and was then noticed and employed by Alderman Boydell, for whom he engraved after Pietro di Cortona, Holbein, Rembrandt, Chatelaine, Woollett, and others. He exhibited his 'Angel,' after Rembrandt, at the Spring Gardens' Rooms, 1765. He died at the early age of 39, near Kensington, May 9, 1765, leaving a promise of much excellence, and was buried in Kensington churchyard.

WALKER, WILLIAM, *engraver.* Brother of the above, and one of a family of 10 children, all of whom were remarkable for their love of drawing. He was born at Thirsk, in November 1729, and served his apprenticeship to a dyer. When his time was out he came to London, bent upon following art, and was taught by his brother, whom he for some time assisted. He was employed for nearly 30 years upon the illustrations of the publications of the day, and also engraved some good plates for Alderman Boydell. Early in life he discovered the valuable art of re-biting, and Woollett, who occasionally used the process, when successful, was wont to exclaim, 'Thank you, William Walker.' Unable to overcome the loss of his daughter, he died in Rosoman Street, Clerkenwell, February 18, 1793.

WALKER, JOHN, *engraver.* Son of the foregoing. Practised in London in the second half of the 18th century, and finished many of his father's plates. He engraved views in England, Ireland, and Scotland, which were published, 1794-96, in a serial called 'The New Copper-Plate Magazine.'

WALKER, FREDERICK, A.R.A., *subject painter.* Was born in Marylebone in 1840. His father and his grandfather were both lovers of art. He began his art career by drawing at the British Museum, and at 16 was placed for 18 months with an architect named Baker. From him he returned to the British Museum, and studied at the same time at Leigh's evening classes, while he entered soon after the schools of the Royal Academy. He had already begun to draw on wood; and to improve himself in this art, he placed himself with a wood-engraver, and remained with him three years, drawing three days a-week. An introduction to Thackeray led to his illustrating for the 'Cornhill Magazine,' and he also worked for 'Sunday at Home,' 'Good Words,' 'Once a Week,' and other periodicals. The last books he

illustrated were Miss Thackeray's novels. He was elected an associate of the Society of Painters in Water-Colours in 1864, and a full member in 1866, and was the only Englishman who took a medal for water-colour in the Paris International Exhibition of 1867. Among his finest works in this medium are 'Philip in Church,' 'The Fairy,' 'The Fishmonger's Shop,' etc. His first oil picture in the Royal Academy was 'The Lost Path,' exhibited in 1863—followed by 'The Bathers,' in 1864; 'The Vagrants,' 1868; 'The Old Gate,' 1869; 'The Plough,' 1870; and 'The Harbour of Refuge,' 1872. His last work sent to the Exhibition was 'The Right of Way.' He became an associate of the Royal Academy in 1871, and was the first painter elected into the academical body while still a member of the Water-Colour Society. His early death deprived English landscape art of a follower whose genius was throughout strikingly original. His works are marked by a method of their own, the drawing, colour, and execution, alike peculiar to himself. They are at once refined and pathetic in sentiment, and novel in their conception of nature and her effects. His figures have at the same time the true feeling of rustic life with the grace of line of the antique. His subjects were chiefly chosen from the events, novels, etc., of his day, and as such will be interesting to future times as characteristic of the date at which he lived. He died at St. Fillan's, Perthshire, of consumption, June 5, 1875, aged 34, and was buried at Cookham-on-the-Thames, a place he had loved in life. His brother artists erected a tablet to his memory in Cookham Church.

WALKER, JAMES, *engraver*. Was born in 1748, the son of a captain in the merchant service, and at the age of 15 became the pupil of Valentine Green. He practised in the mezzo-tint manner, and on finishing his apprenticeship he engraved after Penny, Romney, Northcote, and other contemporaries, and in 1784 went to St. Petersburgh, on the appointment of engraver to the Empress of Russia, where he resided for 17 years, and engraved the portraits of the Imperial family, and many plates from the old masters, which were his own property. In 1802 he returned to England with a pension, but unfortunately his valuable plates were lost by the ship's foundering off Yarmouth. He died in London about 1808.

WALKER, GEORGE, *landscape painter*. Practised in the second half of the 18th century, and painted many English views which were engraved by Byrne. He died about 1795.

WALKER, HUMPHREY, *sculptor and founder*. He practised in the reign of Henry VII., and was employed, with others,

about 1512, in the decoration of that King's Chapel at Westminster Abbey.

• WALKER, ROBERT, *portrait painter*. Was contemporary with Vandyck, and studied his works, but founded a manner of his own, more severe in style and colour, aiming at great truth and character. During the Commonwealth his works were greatly esteemed by the Republican party, and he painted the Protector and the principal officers of his army, and is known as 'Cromwell's Portrait Painter.' There is a fine portrait of him, by his own hand, at Hampton Court; another in the University Galleries, Oxford. He had for some time an apartment in Arundel House, in the Strand, and died there about 1660, but under an engraved portrait by Lombart, he is stated to have died in 1658. His portraits were vigorous, truthful, and expressive, and full of character, possessing many of the highest qualities.

WALKER, J. RAWSON, *landscape painter*. He practised at Nottingham, where his works were well known and esteemed. He introduced, with some skill, figures and architecture into his landscapes. He exhibited at the Academy, in 1817, 'The Feast of Eleusis at Athens,' and in 1819 some landscape compositions. A view of Nottingham by him is engraved.

WALKER, THOMAS LARKINS, *architect*. Was the son of Adam Walker, M.D., and a pupil of Augustus Pugin. He published the history and antiquities of the Vicars' Close Wells; of the Manor House and Church of Great Chatfield, Wilts; of the Manor House of South Wraxhall and the church of St. Peter at Bildestone, Wilts; these works forming the first three parts of 'Examples of Gothic Architecture,' a series which went no further. He then removed from London to Nuneaton, and afterwards to Leicester, and finally, it is supposed from some unfortunate speculations, was induced to try to better his fortune in China. He died at Hong Kong, October 10, 1860.

WALKER, WILLIAM, *water-colour painter*. Was born at Hackney, July 8, 1780, and was a pupil of Robert Smirke, R.A. In 1803 he went to Greece to draw the architectural remains and monuments, and on his return, published 'Six picturesque Views of Greece.' In 1808 he was a member of the short-lived Society of Associated Artists in Water-Colours, and in 1813 was admitted as an exhibitor of the Water-Colour Society, and was a regular contributor to its exhibitions. When the Society was reconstituted in 1821, he was elected an associate exhibitor. His works were chiefly views on the shores of the Mediterranean, with some marine subjects, and he also tried some works with figures. He continued to contribute to the Society's

exhibitions, but did not rise out of the rank of associate. From 1824 to 1834 he exhibited chiefly pictures in oil at the Royal Academy, principally scenes in the East. In 1836 his last exhibited work, 'Athenian Soldiers,' appeared at the Water-Colour Society. He lived mostly in the neighbourhood of London, but died at Sawbridgeworth, September 2, 1868.

WALKER, WILLIAM, *historical engraver.* Was born in Mid Lothian, in 1793, and studied his art under Mitchell, at Edinburgh. In 1816 he came to London, and under T. Woolnoth learnt stipple engraving, carrying this manner to great excellence. He afterwards took some lessons in mezzo-tint from Lupton. In 1819 he returned to Scotland, and engraved some fine portraits after Sir H. Raeburn, and in 1826 a portrait of Sir Walter Scott by the same artist, which he had commissioned him to paint, followed by a portrait of the artist himself. These works were in the stipple manner, of which they are admirable examples. He also commissioned Sir Thomas Lawrence to paint a portrait of Lord Brougham, from which he completed an engraving in 1831. In 1832 he came again to London, where he settled, and engraved many portraits and some historical works. 'The Passing of the Reform Bill,' 'The Reformers presenting their protest at the Diet of Spires,' after Cattermole, 1847; 'Caxton Presenting his Proof Sheet,' after Maclise; 'The Aberdeen Cabinet,' 1857. His last work was 'The Distinguished Men of Science living in Great Britain in 1807.' He was always the publisher of his own works. He died of paralysis, in Margaret Street, Cavendish Square, September 7, 1867, and was buried in Brompton Cemetery.

WALKER, ELIZABETH, *miniature painter.* Wife of the above, and second daughter of S. W. Reynolds, the mezzo-tint engraver. Was born in London in 1800. She began to learn engraving when only 14 years of age, under Lupton, and executed many plates, amongst which was a portrait of herself by Opie. She then began drawing and painting on ivory, and, after some lessons from Clint, A.R.A., followed miniature painting as a profession, and was appointed miniature painter to William IV. She exhibited her portraits for many years running at the Royal Academy. A full-length portrait in oil which she executed of Lord Devon, is now placed in the hall of Christ Church, Oxford. She married, in 1829, William Walker, the engraver, and afforded her husband much assistance in his profession, while not ceasing to work at her own branch of it. She died November 29, 1876, at Margaret Street, Cavendish Square.

WALL, JOHN, M.D., *amateur.* Born
456

at Powick, Worcestershire, 1708. He was educated at Oxford, and became eminent as a physician practising at Worcester. His chemical experiments largely contributed to the establishment of the manufacture of china in that city. He showed also a talent for painting, and a window, 'Christ's Agony in the Garden,' was executed after his design; as also the chapel window of the Bishop's Palace at Hartlebury. He died at Worcester, July 12, 1783.

WALLACE, WILLIAM, *portrait painter.* He was a native of Falkirk, and from about 1820 to 1833 practised in Edinburgh, removing in the latter year to Glasgow, where his art was well esteemed. He died July 8, 1866, aged 65.

WALLER, J., *portrait painter.* He practised about the end of the 17th century. Bernard Lens engraved a portrait by him of John Lord Cutts, surrounded by Mars, Minerva, and Apollo.

WALLIS, JOSHUA, *water-colour painter.* He practised for many years in London, but does not appear to have been a member of any of the art societies. His works were low in tone, well, though perhaps too highly, finished, and represented effects of light, such as sunsets on the snow. They had much merit, but he failed to attain any reputation. He exhibited some of his works at the Royal Academy about 1820. He died at Walworth, February 16, 1862, aged 72.

WALLIS, JOHN WILLIAM, *landscape painter.* Was born in Scotland about 1765. He travelled in Italy, and was at Rome in 1802, when no other English artist was residing there. In 1812 he travelled in Germany, and painted a fine view of the Castle of Heidelberg, which was highly esteemed, but he painted little afterwards. He began to deal in pictures, and finally abandoned painting. From Holland, Belgium, and more especially from Spain, many highly-prized works were introduced into England by his active agency.

WALMISLEY, FREDERICK, *genre and portrait painter.* Was a student of the Royal Academy, and a pupil of H. P. Briggs, R.A. Early in life he became paralysed in the lower limbs. His works were very mannered from want of power to study. He died December 25, 1875, aged 60. He was an occasional exhibitor at the Royal Academy and the Institute of British Artists.

WALMSLEY, THOMAS, *landscape painter.* Born in Dublin in 1763. He came to London, and studied under Columba, then principal scene-painter at the opera-house. Returning to Dublin, he painted scenery for the Crow Street Theatre. He exhibited a Welsh view at the Spring Gardens' Rooms in 1790, and from that year to 1795

he lived in London, and exhibited Welsh Lake scenes at the Royal Academy. About 1795 he published 'Picturesque Views in Wales,' and 'Views on the Lake of Killarney,' engraved by Jukes. He painted, chiefly in body-colour, some small landscapes of merit. His works were remarkable for the great luminousness of his skies. He retired to Bath in ill-health, and died there in 1805.

WALTERS, JOHN, *architect*. Built a good Gothic chapel on the London Hospital estate, the Auction Mart near the Bank of England, and the parish church of St. Paul, Shadwell. He died at Brighton, October 4, 1821, aged 39.

WALTERS, EDWARD, *architect*. He was born in London, where his father practised as an architect, and was early in life left an orphan. He was for a time employed in Mr. Lewis Vulliamy's office, and was then engaged by Sir John Rennie to superintend the erection of a small-arms' factory at Constantinople. On his return he settled at Manchester, and after a while he succeeded in establishing himself in practice. He erected there the Free Trade Hall, the Cavendish Street Chapel and Schools, the Bank in Mosley Street, and other works, including some fine Warehouses, which will maintain his name in that city. He died at Brighton, in his 64th year, January 24, 1872.

WALTON, NICHOLAS, *architect*. Was 'Master Carpenter and Engineer of the King's Works for the Art of Carpentry' in the reign of Richard II. The magnificent timber roof of Westminster Hall and of Eltham Hall are attributed to him.

WALTON, HENRY, *portrait painter*. Was born about 1720. His portraits, usually of small size, are tolerably drawn, and tenderly painted, with some attempt at expression. He also painted domestic incidents, in which he introduced portraits, and exhibited some subjects of this class at the Royal Academy in 1777-78 and 1779. He was an active member of the Society of Artists. Died about 1795. Several of his works have been engraved.

WALTON, PARRY, *still-life painter*. Was a pupil of Robert Walker, and painted still-life, but never attained to any distinction as an artist. He is better remembered as a picture-repairer, and for his knowledge of the works of the masters, particularly of the Italian School. He was keeper of the pictures to James II., and repaired several of the pictures in the Royal collection. He also restored Rubens's Ceiling at Whitehall Chapel, for which he was paid 212*l.* He lived in Lincoln's Inn Fields, and died there about 1700. His son succeeded him in his employment, but was only known as a copyist.

WALTON, JAMES TROUT, *landscape*

painter. He was born at York, and practised his art in that City. From 1852 to 1863 he was an occasional exhibitor at the Royal Academy, contributing views in oil, chiefly Scotch, with figures introduced. He died at York, October 17, 1867.

WARD, FRANCIS SWAIN, *landscape painter*. Was born in London about 1750, and studied his art there. In 1769 he was elected a member of the Free Society of Artists. He travelled in England and Wales, and made sketches and drawings of the ancient castles and mansions, from which he painted pictures both in oil and water-colours. Later he entered the service of the East India Company, and went to Calcutta, and there are numerous drawings by him of the Indian pagodas, tombs and ruins. He died about 1805.

WARD, WILLIAM, A.E., *mezzo-tint engraver*. Born in London in 1766. He was apprenticed to J. R. Smith, and on completing his time, was engaged to assist his master, who placed his own name on Ward's plates, on which there was little of his work, a practice not then unusual. In 1795 his name first appears as an exhibitor at the Academy. In that and several following years he contributed 'A Portrait of a Lady.' He was eminently skilled in his profession, and in 1814 was elected Associate Engraver of the Academy, and from that time was an exhibitor of an engraving till his death. His works are very artist-like, full of spirit and truth, excellent in the feeling of colour, the flesh tints tender without weakness, light and shade powerful. He was of a quiet and domestic turn, of serious habits and feelings, and early withdrew from some jovial companions with whom he had become connected, diligently following his art. He married a sister of George Morland, many of whose works he engraved. He died very suddenly at Mornington Place, on the 1st December, 1826. He held the appointment of mezzo-tint engraver to the Prince Regent and the Duke of York.

• WARD, JAMES, R.A., *animal painter and engraver*. He was born in Thames Street, London, October 23, 1769, and very early commenced the study of engraving under his elder brother, William, serving with him (if we except a few months with John R. Smith) an apprenticeship of nine years, and studying anatomy under Brooks. He soon distinguished himself by the artistic character of his mezzo-tint engravings, that of 'Cornelius' after Rembrandt, and that of 'Mrs. Billington' after Sir J. Reynolds having rarely been surpassed. Having in 1792 and 93 exhibited some clever rustic pictures, he was appointed in 1794 'Painter and mezzo-tint engraver to the Prince of Wales.' Among his early paintings was his 'Bull-bait,' a work of great ability, full of figures cleverly grouped,

Ward. Edw^d matthew -b-1816

457

fine in colour, and full of animation and character, which, though the talk of the day, was purchased by a dealer for 40*l.* He continued a large contributor to the Academy exhibitions ; commencing with domestic subjects, he soon introduced animals, and became distinguished as a cattle-painter. About the end of the century he painted some fine cows and bulls, and his great picture of 'The Bull,' recently purchased for the National Gallery, for 1500*l.*, was a work of this date. He was elected an Associate of the Academy in 1807, and a full member in 1811. In 1817 he gained the premium offered by the Directors of the British Institution for an 'Allegory of the Battle of Waterloo,' and was commissioned by the Directors to paint a large picture from his sketch for 1000*l.* ; but the picture was a failure, the subject being unsuited to his art. In 1822 he painted 'The Boa Serpent seizing a Horse,' the horse being a portrait of Adonis, a favourite charger belonging to George III.: and he was for several years chiefly employed as a painter of favourite horses. In his latter days he painted many subjects very miscellaneous in character. His works are very numerous. He retired about 1830 to Cheshunt, and continuing an exhibitor at the Academy up to 1855, he died November 23, 1859, in his 91st year.

WARD, WILLIAM JAMES, *mezzo-tint engraver.* Son of the foregoing William Ward, and of an artist race, his talent was early developed. At the age of twelve years he gained a medal at the Society of Arts for a drawing after Raphael, and under the teaching of his father, soon excelled in his art. He engraved many portraits in a highly effective manner, combining great depth with richness of colour, and was most successful in his rendering of Reynolds's works. He became insane, arising, it was said, from an imprudent use of the cold bath, and died 1st March, 1840, aged about 40.

WARD, MARTIN T., *animal painter.* Brother of the above, with whom he sometimes lived. He studied under Landseer, and first exhibited at the Academy in 1820, and in that year and 1822–24–25 contributed portraits of dogs and horses. His name appears once more in 1830, when he sent two pictures of animals to the Institute of British Artists. From this time he is lost sight of, but about 1840 he was leading a most eccentric life in Yorkshire, where his works were well known. Two or three years later he took up his residence in York, and till his death was never known to have left that city. He died February 13, 1874. He had kept his room for several days, and was found insensible on the floor in a scene of great wretchedness and squalor.

WARD, The Rev. SAMUEL, *caricaturist.* He was celebrated as a teacher at Ipswich in

the reign of James II., and no less as a caricaturist. He designed a print published in 1621, 'Spayne and Rome Defeated,' representing the Pope in Council and the Gunpowder Plot. On the complaint of the Spanish Ambassador, he was imprisoned by the Court of Star Chamber. On his release he returned to Ipswich, and confined himself to the ornamentation of his published sermons, and his 'Woe to Drunkards,' 1635, on the title-page to which are two designs. Later he fell into the iron grasp of Bishop Wren and Archbishop Laud. He died in 1639.

WARE, SAMUEL, *architect.* He practised in London, and enjoyed some reputation. He exhibited some designs at the Academy in 1807. In 1811 he was one of the competitors for the erection of Bethlehem Hospital. The Burlington Arcade, erected in 1819, is his best known work. He published a 'Treatise on the Properties of Arches.'

WARE, ISAAC, *architect.* Was originally a chimney-sweeper's boy, and one day chalking the side of a house, he attracted the notice of a gentleman, who befriended and educated him, and sent him to Italy to pursue his studies, but it is said, the stain of his original calling was not obliterated on his return. He was the architect of Chesterfield House, finished in 1749 ; of the mansion at Wrotham Park, Middlesex ; and of a part of Bloomsbury Square. He was a member of the Artist Committee formed in 1755 to plan a Royal Academy, and one of the Surveyors of the Board of Works. He edited an edition of 'Palladio,' a 'Complete Body of Architecture, with some Unpublished Designs of Inigo Jones,' and 'Plans, Elevations, and Sections of Houghton, Norfolk.' He amassed considerable property, resided in Bloomsbury Square, and built himself a country house at Westbourne. He was a constant visitor at old Slaughter's coffee house, and the associate of the wits who met there. He died 1766.

WARING, JOHN BURLEY, *architect.* Was born at Lyme Regis, June 29, 1823, and was the son of a captain in the navy. He was sent to a school at Bristol in 1833, and in 1840 was apprenticed to an architect in London, and was a student at the Royal Academy. Partly on the ground of weak health he went to Italy, where he visited the chief cities, making many studies and sketches. On his return he became assistant as draftsman to many eminent architects, for which he was well qualified by his studies of the figure in Paris. He also visited Spain. It is, however, by his published works that he is chiefly known ; such as, in 1850, 'Architectural Art in Italy and Spain,' 'Designs for Civic Architecture ;' 1857, 'The Art Treasures of the United Kingdom ;' 1858, 'The Arts connected with Architecture in Central Italy ;' 1862, 'Mas-

terpieces of Industrial Art and Ancient Sculpture,' ' Ceramic Art in Remote Ages,' etc. He was engaged in the superintendence of the Manchester Art Treasures Exhibition, 1857, and the Exhibition of Works of Art at Leeds, 1868. He died March 23, 1875.

WARREN, JOHN, *architect*. Was the builder of St. Mary's Church, Cambridge, where he is buried, and there was a tablet to his memory against the east wall of the chancel, now removed to the vestry, which records that ' with the church his own life finished,' December 17, 1608.

‣ WARREN, ALFRED WILLIAM, *engraver*. He practised in London about the middle of this century, working both in line and in mezzo-tint. He engraved ' The New Coat,' after Wilkie ; some portraits of the British poets, and for the illustration of Pope's ' Essay on Man ' ; ' The Arabian Nights,' after Smirke ; and Coxe's ' Social Day.'

‣ WARREN, CHARLES, *engraver*. He was born in London, June 4, 1767, and married when about 18 years of age ; but little is known of his early career. In 1802 he emerged from the difficulties attending upon a large young family, and, employed chiefly on book illustrations, became distinguished for works of that class and largely known. In his youth he had been employed in engraving on metal for calico-printing, and was able to perfect the process of engraving on steel plates attempted by Raimbach, and was awarded a gold medal by the Society of Arts. But he did not seek to secure the advantage to himself by a patent. He illustrated an early edition of the ' English Poets,' and engraved two plates from the Boydell Shakespeare. He lived in Gray's Inn Road, and was improvident and fond of society. He died suddenly in Wandsworth, April 21, 1823, and was buried in the vaults of St. Sepulchre's church, Old Bailey.

WATKINS, JOSEPH, R.H.A., *sculptor*. He was late in commencing the study of his art. He practised in Dublin : was of much promise, and was elected a member of the Royal Hibernian Academy in 1869. He exhibited a bust at the Royal Academy, London, in each of the years 1867, 1868, and 1870, and died in Dublin at the close of the year 1871, aged 33.

WATSON, WILLIAM, *portrait painter*. He practised in Dublin, painting both in oil and crayons. He was known as an admirable flute-player. His wife painted flowers and fruit.

WATSON, JAMES, *mezzo-tint engraver*. Was born in Ireland in 1740, and was brother of the above, and equally distinguished in his art. He engraved many fine portraits after Vandyck, Reynolds, Gainsborough, Romney, and also some fine his-

torical and subject plates. He exhibited some mezzo-tints at the Spring Gardens' Rooms in 1775. His works are full of colour, powerful, the flesh tenderly expressed. He resided many years in Little Queen Street, near Portland Chapel. He died in 1790.

WATSON, CAROLINE, *engraver*. Daughter of the above James Watson. Born in London about 1760. She made many drawings of celebrated paintings, which she afterwards engraved, working both in mezzo-tint and in the dot manner. She also engraved some good portraits. Her works are well drawn and expressed, and possess great merit. She was appointed engraver to Queen Caroline in 1785. She engraved Correggio's ' Marriage of St. Catherine,' and Reynold's ' Death of Cardinal Beaufort.' She died in Pimlico, June 10, 1814, in her 54th year, and was buried in St. Marylebone Church, where there is a tablet to her memory with some lines by Hayley. She was singularly modest and retired in her habits, and was highly esteemed.

WATSON, THOMAS, *engraver*. Was born in London, 1743, and was apprenticed to an engraver on plate. He gave early proofs of talent, practising in the dot manner, but his later and best works are in mezzo-tint. In this manner he engraved the ' Windsor Beauties,' after Kneller, many fine portraits after Reynolds, which constitute his most esteemed works, and also after West, Nathaniel Dance, and others. He exhibited at the Spring Gardens' Rooms in 1775 and several following years. For a while he kept a print shop in Bond Street with W. Dickenson. Some fine plates after Rembrandt and Correggio by him are greatly valued. He died in 1781, at Bristol, and was buried there.

WATSON, JOHN BURGESS, *architect*. Practised in London with some repute, and was a good draftsman. He built the Gothic church at Staines in 1820. He was a member of the Institute of British Architects. Died in 1847.

WATSON, JOHN, *portrait painter*. Was born in Scotland in 1685, and studied in the Trustees' Academy, Edinburgh. He emigrated to New Jersey in 1715, and is said to have been the first painter who settled in America, and, though a very indifferent painter, to have amassed a property by the practice of his art. He paid one visit to his native country, and took back with him a collection of pictures. He died in America, August 22, 1768.

WATSON, MUSGRAVE LEWTHWAITE, *sculptor*. Was born at Hawkesdale, near Carlisle, 1804, the son of a small independent yeoman. At the age of 17 he was articled to a solicitor at Carlisle; but he

did not take to the law, and after two years quitted it, and coming up to London in 1824, he made himself known to Flaxman, R.A., by whose advice he entered the schools of the Royal Academy. He articled himself to R. W. Sievier, the sculptor, for a short time, and then, following the advice of Flaxman, went to Italy in 1825 on an allowance made by his father, and studied during two years in Rome. He returned to London in 1828, having seen the principal works in Italy, and setting up a studio, completed a small figure of Sigismunda, and two small statuettes of Chaucer and Spencer; but coming to the end of his money, he obtained employment as a modeller to Chantrey, R.A. This engagement he threw up on the refusal of his application for an increase of pay, and was then employed by Bailey, R.A., and afterwards by Behnes, and, gaining strength, he determined to work on his own account. On the death of Chantrey, he was employed to complete for New College, Oxford, the colossal statues of Lords Eldon and Stowell, for which Chantrey has left slight sketches, but he was only able to finish the plaster models. He executed the model for one of the bas-reliefs of the 'Battle of St. Vincent' for the pedestal of the Nelson Column in Trafalgar Square. His chief other works were a Hebe and Iris at Bowood, a monument to Dr. Cameron, the statue of Queen Elizabeth in the Royal Exchange, a bas-relief in the Hall of Commerce, Threadneedle Street, and a monument to his friend, Allan Cunningham. He had suffered for some years from heart complaint, and died just as he was rising into reputation, October 28, 1847. His 'Life and Works' was published by Dr. Lonsdale in 1866.

WATSON, SAMUEL, *carver and sculptor*. Was born at Heanor, Derbyshire, in December 1663. He was employed on the works at Chatsworth, and executed some of the fine carvings commonly attributed to Grinling Gibbons. The dead game over the chimney-piece in the great chamber is by his hand, and for this and other decorations in the same chamber in lime-tree wood, all completed in 1693, he was paid 133*l*. 7*s*. The trophy containing the celebrated pen over the door in the south-west corner room is likewise his work. He also executed the arms in the pediment of the west front in 1704; the stone carvings in the north front, finished in 1707; and other of the decorations, both in wood and stone. Walpole says that Gibbons had several disciples and workmen, and that Watson chiefly assisted him at Chatsworth, where the carved boys, and many of the other ornaments in the chapel, were executed by him; but it seems clear, from his having made his own bill for the above works,
460

that he executed them on his own account. He died at Heanor, March 31, 1715.

WATSON, GEORGE, P.R.S.A., *portrait painter*. Was born in 1767, at Overmains, Berwickshire, where his father possessed some property. After receiving some elementary instructions from Alexander Nasmyth, he came to London at the age of 18, and painted in Sir Joshua Reynolds's studio for about two years. He afterwards settled in Edinburgh, where he was extensively employed, and was long the contemporary of Sir H. Raeburn, with whom he maintained an honourable rivalry. From 1808–12 he presided over the Associated Artists of Scotland, and at that time sent some portraits to the Royal Academy exhibition in London. On the foundation of the Royal Scottish Academy in 1830, he was elected the president, and held that office till his death, at Edinburgh, August 24, 1837.

WATSON, WILLIAM SMELLIE, R.S.A., *portrait painter*. Son of the above, was born at Edinburgh in 1796. He studied under his father, and at the Trustees' School in Edinburgh. In 1815 he came to London, and entered as a student at the Royal Academy, where he continued five years. He was also nearly a year with Wilkie, and, it is said, helped him while he was painting 'The Penny Wedding,' and other pictures. When he returned to Edinburgh to settle, he practised as a portrait painter. He was one of the original members of the Royal Scottish Academy, and a constant contributor to its exhibitions. He died in November 1874.

WATT, JAMES HENRY, *engraver*. Was born in London, 1799, and at 16 became a pupil of Charles Heath, but by his careful study developed a manner of his own, and was greatly distinguished as a line-engraver. He always worked upon copper. His art is marked by great decision, dexterity, and taste, is brilliant and finished, and evinces great art power. Among his best works are Stothard's 'Procession of the Flitch of Bacon,' Eastlake's 'Christ Blessing Little Children,' and Landseer's 'Highland Drovers.' Suffering from illness, added to domestic affliction, he died in June 1867, aged 68.

WATTS, WALTER HENRY, *miniature painter*. He was, in 1808, a member of the short-lived Society of Associated Artists in Water-Colours, and was from that year to 1830 an exhibitor of miniatures at the Royal Academy, sometimes painting a subject in oil. But he gained a name as a miniature painter.

WATTS, JOHN, *landscape painter*. Born about 1770, he practised his art in London. He drew views in Scotland and Wales, and painted several subjects in oil.

His works attracted some attention in his day.

WATTS, JOHN, *engraver.* He practised in London about 1760–80, working in the mezzo-tint manner. 'Vandyck in the character of "Tearus,"' 1778, is a powerful work by him.

WATTS, WILLIAM, *engraver.* Was born early in the year 1752, in the neighbourhood of Moorfields, where his father was a master silk-weaver. He got his education in art under Paul Sandby and Edward Rooker, and on the death of the latter, he continued the 'Copper-plate Magazine,' commenced by him. This also suggested to him a work of his own, 'The Seats of the Nobility and Gentry,' which he began in 1779, and finished in 1786. Up to this time he resided at Kemp's Row, Chelsea, but now selling his furniture and his art collection, in which there were some rare drawings and prints, he travelled in Italy, reaching Naples in September, 1786. After about a year's absence he returned, and then lived at Sunbury. In 1789 he went to Carmarthen, the following year to the Hot-wells, Bristol, and in 1791 to Bath, where he spent two years, and brought out his 12 views of that city, which are fine specimens of line-engraving. At this time he became an enthusiast in the events of the French Revolution, and went to Paris. He had inherited property from his father, a large portion of which, with his own earnings, he invested in the French funds, and the whole was eventually confiscated, though a remnant was recovered at the Peace in 1815. On this loss he was compelled to return to the active practice of his profession, and published, in 1800, his 'Select Views of London,' and between 1801–1805 completed his last work, 60 views for Sir R. Ainslie's 'Turkey and Palestine,' and then retired from his profession. He lived a short time at Mill Hill, Hendon, and in 1814, purchasing a small property at Cobham, in Surrey, he settled there, and died December 7, 1851, aged 99. He was a good French and Italian scholar, and a well read man. Though in his latter years deprived of sight, he enjoyed good health.

WATTS, JANE, *amateur.* She was the daughter of Mr. Waldie, a Scotch clergyman, and married Captain Watts, R.N. Possessing a talent for drawing, she painted landscapes in oil, and exhibited on one or two occasions at the Royal Academy and the British Institution. She had also literary tastes, and published 'A Panoramic Sketch of the Field of Waterloo,' 'Sketches of Italy,' 'Continental Adventures,' 'Rome in the Nineteenth Century.' She died July 6, 1826, in her 34th year.

WATTS, SIMON, *wood-engraver.* He practised in London about the middle of the 18th century. There are two or three large woodcuts by him, dated 1736, and some small circular portraits of painters freely engraved. A portrait of Queen Elizabeth, 1773, and of Dudley Earl of Leicester, 1775, with some other works, are also attributed to him.

WEBB, DUNCAN, *engraver.* Attained great repute as an engraver of animals, especially of horses and dogs. He fell down in the street and expired suddenly in the prime of life in 1832, leaving a widow with a large family in distressed circumstances.

WEBB, WESTFIELD, *portrait painter.* He exhibited, in 1762, the whole-length portrait of a celebrated female singer, and continued to exhibit for the following ten years not only portraits, but landscapes and flowers, but in none of his works was shown any art of an enduring character. He resided in St. Martin's Lane, then the resort of painters, and died soon after 1772.

WEBBE, JOHN, *architect.* Was of a Somersetshire family and was born in London in 1611. He was the nephew of Inigo Jones, and married his only daughter. He was also his pupil and assistant. From the designs of his master he built Amesbury, Wilts, and from his own designs Wilton House, after the fire, 1648; Gunnersbury House, 1663; Ramsbury Manor House, Wilts; Horse-heath, Cambridgeshire, 1669, a handsome and commodious structure; the large houses in Queen Street, Lincoln's Inn Fields, and the north-west quadrangle of Greenwich Hospital. In 1656 he designed and painted the scenery for the siege of Rhodes. His works do not evince much originality. He died in 1672, at Butleigh, in Somersetshire, his native place, aged 61. He published Inigo Jones's 'Treatise on Stonehenge,' and a vindication of it against Dr. Charlton; also an essay to prove that the Chinese is an original language.

WEBBER, JOHN, R.A., *landscape painter.* Was born in London in 1752, the son of a Swiss sculptor, whose name, WEBER, he Anglicized. His father, who executed some monumental works in this country, sent him to Paris, where he studied five years, and then, returning to his family in London, in 1775 he became a student of the Royal Academy. By the influence of Dr. Solander he was appointed, in 1776, draftsman to Captain Cook's third and last voyage, and on his return, in 1780, he superintended the engraving of the drawings he had made for the Admiralty; and also etched, aqua-tinted, and coloured a series of views of the principal places he had visited. There he published on his own account, and they were very popular. In 1784-5 and 1786 he exhibited views taken on his voyage. He then travelled in

England, Wales, and Scotland, and afterwards, in 1787, in Italy, France, and Switzerland, and made numerous drawings, some of which were the subjects of his oil pictures. He had been elected an associate of the Royal Academy in 1785, and in 1791 was made a full member. His last exhibited works were views of England. He died at his lodgings in Oxford Street, May 29, 1793. His drawings are careful and accurate, but weak, his figures incorrect. His colouring thin and green, and his works wanting in light and shade. The illustrations of his voyage are his best works. His drawing of the death of Captain Cook, of which he was an eye-witness, was engraved by Byrne and Bartolozzi.

WEBBER, HENRY, *sculptor*. Was a student in the Royal Academy, and in 1776 gained the Academy gold medal for his group, 'The Judgment of Midas.' He had exhibited some wax models in the preceding year, and in 1779 exhibited a 'Bacchus and Ariadne,' a basso-relievo, after which his name disappears.

• WEBSTER, JOSEPH SAMUEL, *portrait painter*. Practised in London in the reign of George II. There is a portrait by him in the hall of the Drapers' Company, and several mezzo-tints from his portraits, by McArdell and J. Watson. He also painted some ideal figures. He died in London, July 6, 1796.

WEBSTER, MOSES, *water-colour painter*. Born in 1792, in the town of Derby, he was apprenticed at the china works there, and soon excelled in flower-painting on porcelain. When out of his time he continued for a while in his employment at the works, and was then engaged for four years at the china works in the city of Worcester, and afterwards went to London, where for some time he found employment; but returned to Derby and to his painting in the china works. He was well skilled also as a flower-painter on paper, and noted for his finished execution. In 1818 he exhibited some flowers with the Water-Colour Society. About 1827 he commenced teaching as a profession and found many pupils in Derby and Nottingham. He drew several views in these counties, which he published. He also painted some landscape in oil. Advancing in years, he was admitted into the Liversege alms-houses, where he died October 20, 1870.

WEBSTER, SIMON, *water-colour painter*. He was, in 1766, a member of the Incorporated Society of Artists, which, in 1769, voted him a sum of money in consideration of his losses by a fire. He practised in the early part of the present century. He drew landscapes, and was one of the artists who etched for the clever work published by Ackerman—' Views of Cottages and Farmhouses in England,' 1817–19.

WEBSTER, G., *marine painter*. He was an occasional exhibitor of marine subjects at the Royal Academy from 1799 to 1826. He practised in oil, but painted a few works in water-colours. He went on a sketching tour in Wales with Varley in 1802. His works are not without merit. In 1801 he exhibited a 'View on the Gold Coast, Africa; taken on the Spot, 1799;' in 1807, 'Shipping, a Fresh Breeze;' and in 1825, 'The Battle of Trafalgar.'

WEBSTER, THOMAS, *architect*. Born in the Orkneys, February 11, 1772. He was brought up as an architect, and from his tastes became much connected with the school of water-colour painters; and from his acquired proficiency was elected an honorary member of the Sketching Society. He built the lecture theatre of the Royal Institution, which is reputed for its acoustic properties and fitness. He was a man of several scientific attainments. He died in London, December 26, 1844, aged 72.

WEDGWOOD, JOHN TAYLOR, *engraver*. Practised in London, and was engaged on the plates to illustrate the marbles in the British Museum, 1812. There are also by him, in the line manner, some good historical plates, and portraits of Scott, Byron, Bernadin St. Pierre, and others. He died at Clapham, March 6, 1856, aged 73.

WEEKES, HENRY, R.A., *sculptor*. Was born at Canterbury in 1807. He began his art career with Behnes, to whom he was articled by his father for five years. He entered the schools of the Royal Academy in 1823, and later engaged himself as an assistant to Chantrey, with whom he remained till his death, succeeding to many of his commissions, and occupying his studio till his own death. He was elected an associate of the Royal Academy in 1857 and a full member in 1863. Among his principal works are, a bust of her Majesty, the first that was taken after her accession to the throne; monuments to Shelley and Mary Woolstoncraft at Christ Church, Bournemouth; statues of Dr. Goodall at Eton; Lord Bacon at Trinity College, Cambridge; the Duke of Wellington; John Hunter for the Museum of the College of Surgeons; three statues for the Martyr's Memorial at Oxford; and one of the groups for the Albert Memorial in Hyde Park; besides numerous busts, among which those of Dean Buckland, Sir G. C. Lewis, Lord Truro, etc., should be mentioned. He also executed a statue of Charles II. for the House of Lords. He was professor of sculpture for several years at the Royal Academy, and was awarded a gold medal by the Society of Arts for the best treatise on the Fine Art Section of the Great Exhibition in 1851. He did not excel in the figure, but was a good portrait sculptor,

Webster Tho⁴ - R.A. b 1800

some of his busts having great merit. He died in Pimlico, May 28, 1877, in his 71st year.

WEHNERT, Edward Henry, *water-colour painter.* Was the son of German parents, who settled in London. His father carried on a large business as a tailor. He was sent to Germany for his education, and was a student at Göttingen. He returned to England at the end of four years, and began the study of art. He first exhibited at Suffolk Street and the British Institution, and then passed two years in Paris, where he acquired a good knowledge of drawing, and, after staying some time in Jersey, came back to London in 1837; and he joined the New Society of Painters in Water-Colours in the same year, and was a constant and important contributor to its exhibitions. In 1845 he was a competitor in the Cartoon Exhibition at Westminster Hall. About 1858 he went to Italy, but his studies were impeded by ill health. He brought home few sketches. His works were usually subject pictures of large size, well finished, the figures carefully drawn, but the colour unpleasant, and the light and shade weak, and were generally marked by a German feeling and character. He died unmarried in Kentish Town, September 15, 1878, aged 54. An exhibition of his collected works was made in the gallery of the Institute of Water-Colour Painters in the following spring.

WELLER, J., *portrait painter.* There is in the British Museum a portrait of this artist *se ipse pinxit,* correctly and carefully drawn in chalk, and dated 1718, ætat. 30.

WELLS, William Frederick, *water-colour painter.* He was born in London in 1762. At the age of 12 years he became a pupil of Barralet, and under his teaching his first efforts were chiefly in pencil or crayon. It does not appear when he first tried water-colours, but he was among the first who practised the new art. He exhibited at the Royal Academy in 1795, contributing Scotch views, and the following year Penmaen Mawr, North Wales. He visited the continent, and in 1804 extended his travels to Norway and Sweden, and made numerous sketches, some of which on his return he painted in oil. In 1804 he was one of the original founders of the Water-Colour Society, and in 1806 the president, and thenceforth he practised chiefly in that medium. He exhibited with the Society up to 1812, contributing with some Welsh scenery some views in Norway, and also some views in Oxford and Cambridge. For many years he was a successful teacher in the Metropolis, and had several distinguished pupils. He was one of the professors of drawing at Addiscombe College, an office which he filled for nearly 30 years, and until his death in 1836.

Several of his drawings have been published in aqua-tint. His daughter, who died in 1872, was an occasional exhibitor.

WELLS, Joanna Mary, *subject painter.* Her maiden name was Boyce. She had a natural taste for art, and at the age of 18 commenced its study as a profession, and in 1855 exhibited her first work— 'Elgiva,' a head, at the Royal Academy. She then studied for a time at Paris, and in 1857 spent a year in Italy, and, while at Rome, was married to Mr. Wells, since R.A. Returning to London in the following spring, she exhibited at the Academy 'Peep Bo!' 'The Heather Gatherer,' and 'La Veneziana,' works of much promise; but she unhappily died in childbed in her 30th year, July 15, 1861.

WELLS, Thomas, *medallist.* Was born in London about 1770. He cut a few good likenesses in steel, and also practised as a portrait modeller in wax, exhibiting at the Royal Academy between 1786 and 1791.

• WEST, Benjamin, P.R.A., *history and portrait painter.* Was born October 10, 1738, in Chester County, Pennsylvania, where his father, descended from an old Quaker family of Long Crendon, Buckinghamshire, had emigrated in 1715. He seems to have been born an artist. Gathering as he could his own materials, where none could be purchased, he drew, when only seven years old, a likeness of his baby sister in her cradle, and earned the fond kisses of his surprised mother. His bent was so decided that, when 16 years of age, his Quaker relatives consented to his following art—a profession at least doubtful with their sect—and he began to paint portraits, first in his own neighbourhood, and then in New York. Meeting with encouragement in his art, and assisted by his friends, he determined to visit Europe, and in 1760, when in his 22nd year, he embarked for Leghorn to study art in Italy. Arrived in Rome, the young painter from the New World was an object of curiosity and interest, and though dazzled by his reception, was no less impressed by the elevated art of the Capitol, as well as of Florence and Bologna, which he afterwards visited, spending three years studying in Italy. He then came to London, arriving in the summer of 1763, provided with good introductions, and preceded by a reputation. In the following year he exhibited a portrait in the great room at Spring Gardens, and, settling down in his art with the intention of remaining in England, he married a young American lady, to whom he had been engaged in Philadelphia, and who was conducted to London by her father. In 1765 he was chosen a member and one of the directors of the Incorporated Society of Artists, and sent his first historical picture—the 'Orestes and Pylades' (now in the National Gallery)

—to their exhibition in 1766, with 'The Continence of Scipio,' and received several commissions. He painted 'Agrippina with the Ashes of Germanicus' for the Archbishop of York, who was so much pleased with it that he introduced him to George III., who gave him a commission to paint 'The Departure of Regulus from Rome,' the commencement of a long course of Royal patronage and favour. In 1768 he was one of four artists who submitted to the King the plan for a Royal Academy, which received His Majesty's sanction, and he became one of the first members.

In 1772 the King appointed him his historical painter, and employed him upon a large series of pictures at Windsor Castle illustrative of English history, and upon the portraits of himself, his Queen, and the Royal Family, both singly and in groups. In 1790 he was appointed Surveyor of the Royal Pictures, and in 1792 he was elected, on the death of Reynolds, President of the Royal Academy, but declined the proffered honour of knighthood. On some difference as to the power of the Council, and some fancied coldness on their part, he resigned the presidentship, but at the next annual election, 1805, he was re-elected, it is said unanimously, with the exception of one vote for Mrs. Lloyd, then an Academician, and that Fuseli, being taxed with giving this vote, said: 'Well, suppose I did, she is qualified, and is not one old woman as good as another?' an instance certainly of his little appreciation of West.

Among his works at this period were several sacred subjects, but his most popular pictures were his 'Death of Wolfe,' 'Penn's Treaty with the Indians,' and 'The Battle of La Hogue,' in the former of which, abandoning classic costume, he had the courage to adopt the modern and appropriate dress, and by his success to establish that mode of treating heroic subjects of our own time. During 33 years he painted for the King, and had received from his gracious patron 34,187l., and his employment only terminated with the illness which led to his sovereign's death. He then painted several large sacred pictures, 'Christ Healing the Sick,' now in the National Gallery, for which he received 3000 guineas; 'Christ Rejected,' exhibited in 1814; and 'Death on the Pale Horse,' 1817. But his long career was drawing to a close, and he died in Newman Street on the 11th March, 1820, in his 82nd year, and was buried with great ceremony in St. Paul's Cathedral.

The greater part of the pictures which remained in his possession on his death were sold by auction by Robins, in May, 1829. They amounted to 181 in number, and realised 19,137 guineas. His 'Death on the Pale Horse' fetched 2000 guineas; 'Christ Rejected,' for which it is said he

had been offered 8000l., only 3000 guineas; but when the class of subjects is considered, these are really high prices, which would not at this time even be realised, though they are no doubt less than would have been attained when he was in the height of his career. His large picture of 'The Annunciation' was sold by auction in 1840. It had for some years been placed in Marylebone Church, and at the sale the Vestry's minute was read, ordering West's price of 800l. to be paid to him for it. After a considerable time 10l. was bid, and the picture was really sold for that price. It is indeed difficult to account for the high position which he held in art in his own day as compared with ours. It cannot be attributed wholly to Royal patronage, for it was loudly expressed by his brother artists, and echoed by the press and the public. Sir Thomas Lawrence in his annual address, 1823, said: 'Mr. West produced a series of compositions from sacred and profane history, profoundly studied and executed with the most facile power, which not only were superior to any former productions of English art, but far surpassing contemporary merit on the continent, were unequalled at any period below the schools of the Caracci;' and Sir Martin Shee, when examined before a Committee of the House of Commons in 1835, characterised Mr. West almost in the same words as 'the greatest historical painter, I have no hesitation in saying, since the days of the Caracci.' But coming down to later times, Mr. Haydon, assuredly no friend of academicians, wrote of him in 1829: 'In drawing and form his style was beggarly, skinny, and mean. His light and shade was scattered, his colour brick-dust, his impression unsympathetical, and his women without beauty or heart.' The public, too, showed no interest in his works. Three years after his death the exhibition of his collected labours was totally neglected and deserted. Exalted to a high pinnacle in his lifetime, he has since been unjustly depreciated. His aim was at least high. He attempted great works, deemed no subject, even the most sacred, above his powers, and we owe to him the abandonment of classic costume in the treatment of modern events. Yet it must be admitted that his compositions are more studied than natural, the action is often conventional, and his works fail to sustain his great aims. His figures want individuality; his manner is flat, painty, and his textures all alike; his backgrounds are devoid of contrasts; his colour hot and wanting in variety of tint. During his long and laborious life he painted above 400 works, besides numerous sketches. 'The Progress of Genius,' memoirs of his early life and studies, by John Galt, was published in 1816. His works were engraved

by some of the greatest artists of our school, James Heath, Sharpe, Woollett, and Hall.

WEST, RAPHAEL LAMAR, *history painter*. Eldest son of the above. Was born in England in 1769. He was a student in the Academy and a good draftsman, but did not apply himself earnestly to art. Leslie, R.A., said 'he had more talent than industry.' He painted 'Orlando and Oliver' for the Shakespeare Gallery, and in 1800 visited America, but meeting with no encouragement, he was glad to return in 1802. He drew the figure with anatomical correctness, and in a masterly style. His daughter was often painted by the President, and she sat to Leslie for Anne Page, in the picture which he painted of 'The Dinner at Page's House.' He inherited, with his brother, the property left by President West. He died at Bushey Heath, May 22, 1850.

WEST, ROBERT, *topographical drafts-man*. He drew perspective views of all the ancient churches and other buildings in London and Westminster, which were published 1736-39.

WEST, CHARLES, *engraver*. Born about 1750 in London. He engraved many plates in the dot manner, and also used the needle with the graver. He engraved 'The Silver Age,' after Henry Walton, 1787, 'A Circassian Lady,' and 'Diana with her Dogs.'

WEST, ROBERT, *history painter*. Was the son of an alderman of Waterford, and was sent early in life to Paris, where he studied under Van Loo, and gained the first medal in the French Academy. He was greatly distinguished as a draftsman, and was for nearly 20 years master of the Dublin Society's Schools, but in consequence of mental infirmity, his place was filled by Ennis, one of his pupils, on whose death in 1770 he was again appointed, but died a few weeks after his appointment.

WEST, FRANCIS ROBERT, *history painter*, son of the above. He studied in Paris under Boucher and Van Loo, and acquired a great academic power of drawing. In 1770 he succeeded his father as master of the Dublin Society's Schools, and held that office till his death. Remarkable for the accuracy of his drawing, he trained several artists who attained great distinction, and some of his own chalk drawings from the life were esteemed master-pieces. He exhibited in London with the Free Society of Artists, 1774, 'The Adoration of the Shepherds,' a drawing. He did not paint much in oil, and showed little power as a colourist, but he took a high rank in the Irish school. He died in Dublin, January 24, 1809, aged 60.

WEST, ROBERT LUCIUS, R.H.A., *history painter*. Was the son and grandson of the foregoing. In 1808 he exhibited at the Academy in London, 'A Subject from

Gray's Elegy.' In 1809 he succeeded his father as Master of the National Academy of Design, and on the incorporation of the Royal Hibernian Academy in 1823, he was chosen one of the first members.

WEST, SAMUEL, *portrait and subject painter*. Born in Cork, he came early to London, and soon gained some repute. From 1840 he was an exhibitor at the Royal Academy, chiefly of portraits and portrait groups of children, in which he excelled. In 1841 he sent for exhibition 'Cardinal Wolsey leaving London after his Disgrace,' and the following year, 'Charles I. instructed in Drawing by Rubens.' He exhibited portraits, his last contributions in 1866 and 1867. In the latter part of his career he excelled as a copyist of the old master in water-colours.

WEST, WILLIAM, *landscape painter*. Was a native of Bristol, where he practised the greater part of his life. He first exhibited at the Royal Academy in 1845, sending 'The Israelites passing through the Wilderness preceded by the Pillar of Light,' afterwards some Welsh and Norwegian scenery. In his early career he painted many views in Norway. Later he found his subjects in the rocky coast of Devonshire and the hill scenery of Wales. His works were close imitations of nature, with little attempt at art. He was in 1851 elected a member of the Society of British Artists, and was a large contributor to the Society's exhibitions. In the last few years of his life he resided at Chelsea, where he died in January 1861, in the 60th year of his age.

WESTALL, RICHARD, R.A., *subject painter*. Was of a Norwich family, and was born at Hertford in 1765, and apprenticed to an engraver on silver in London in 1779. But he had abilities for higher work, and, studying to improve himself after the hours of labour, he exhibited in 1784 a portrait in chalk at the Royal Academy, and was in 1785 admitted to the Academy schools, and the following year, on the completion of his apprenticeship, commencing his career as an artist, he joined Lawrence, a fellow-student, and the future President, in a house in Soho Square. He exhibited largely designs for book-illustration, with occasionally a few portraits, and first attracted notice by his designs in water-colour, in which medium he executed some well-finished historical subjects : 'Esau seeking Isaac's Blessing,' 'Mary Queen of Scots going to her Execution,' 'Sappho,' rich and full of colour, and of great beauty in execution. His art had naturally led him to book-illustration, in which he found his true place, and gained much employment ; but he exhibited pictures in oil, chiefly domestic or rural subjects, his largest contributions being, however, his designs in

water-colours, which were very numerous. In 1814 he made an exhibition of his paintings and drawings at his gallery, 54, Upper Charlotte Street, Fitzroy Square.

He made a series of designs for an edition of Milton, for Alderman Boydell, and painted five subjects for the Shakespeare Gallery. His illustrations for the Bible and Prayer-Book were suited to the public taste, and were very popular. He designed also for the 'History of England.' Crabbe's 'Tales,' Moore's 'Loves of the Angels,' 'The Arabian Nights' Entertainments,' and numerous other publications, and by these works he made money and acquired a competence. In 1813 the directors of the British Institution purchased for 450 guineas his 'Elijah restoring the Widow's Son to Life.' His large pictures in oil did not, however, find purchasers, and are now little known. One, his 'Christ crowned with Thorns,' is placed over the altar at All Souls, Langham Place. In 1792 he was elected an associate, and in 1794, a full member of the Royal Academy. Later in his career he engaged in some unfortunate speculations in pictures by the old masters. The artist-dealer was led into improvident purchases, ending in pecuniary embarrassment. His means were dissipated, and he became the pensioner of the Academy. His last employment was in giving drawing lessons to the Princess Victoria. He died December 4, 1836, aged 71.

He will be best known as a book-illustrator and painter in water-colours, and claims to be ranked among the founders of the new art. His works are marked with great sameness and prettiness, both in colour and design, and are effeminate and wanting in character. He succeeded best in subjects admitting a decorative treatment. Some of his little rural scenes are among his best works. He painted some good small whole-length portraits in water-colours. He published in 1808 a volume of poems with his own illustrations, 'A Day in Spring.'

• WESTALL, WILLIAM, A.R.A., landscape painter, brother to the above, was born at Hertford, October 12, 1781. He studied under his brother and in the schools of the Royal Academy. He had a great talent for drawing, and at the age of 19 was selected for appointment in 1801 as draftsman to Captain Flinder's Voyage of Australian Discovery. After nearly two years' employment in this duty, he was wrecked on the north coast, was picked up by a ship bound for China; here he remained several months, visited the interior of the country, and made many interesting sketches. From thence he secured a passage to India, and on landing at Bombay made an excursion into the neighbouring mountains of the Mahratta country, and

to the excavated temples of Kurlee and Elephanta. He returned to England after about four years' absence. Finding his services were not immediately required in connexion with the publication of Captain Flinder's voyage, he set off for Madeira, where by great exertions he made a number of sketches, which were all lost, and he was nearly drowned, by the upsetting of the boat on leaving the island. But he prosecuted his journey to the West India Islands, and was so charmed with the scenery that in 1805 he again visited Madeira, and made a large collection of drawings, and on his return to England painted many views of foreign scenery. From 1805 he was a frequent contributor to the Academy exhibitions.

In 1810 he was engaged upon the drawings to illustrate his Australian voyage, and he painted several pictures on commissions from the Admiralty, some of which were exhibited at the Royal Academy in 1812. His works had hitherto been chiefly in water-colours, and in 1811 he was admitted an associate exhibitor of the Water-Colour Society, and in the following year a member, but appears to have resigned, as the same year he was elected an associate of the Royal Academy. He exhibited some landscapes in oil, but they were not much esteemed. His principal employment was upon illustrated publications, mostly landscape views, which he rendered with great fidelity and skill. The chief of these works are 'Views of Scenery in Madeira, the Cape, China, and India,' 1811; 'Views of the Yorkshire Caves,' 1818; 'Britannia Delineata,' and, jointly with Samuel Owen, 'A Picturesque Tour on the River Thames.' He died from the effects of an accident, at North Bank, St. John's Wood, January 22, 1850, aged 68.

WESTMACOTT, Sir RICHARD, Knt., R.A., sculptor. Was the son of a statuary in Mount Street, Grosvenor Square, and was born in London in 1775. Brought up with his father, he imbibed an early taste for art, and was sent to Italy in his 18th year, arriving at Rome in January, 1793. He was furnished with good introductions, made rapid progress, and gained the gold medal for sculpture in the Academy of St. Luke, and removing to Florence, the premium of the first class in sculpture in the Academy there. He afterwards received the Pope's medal at Rome. In 1797 Italy was alarmed by the advance of the French army upon Rome, and he travelled homewards by Bologna to Venice, crossed the Adriatic to visit the German galleries, and reached London at the close of the year. He first exhibited at the Academy in 1797, and from that year exhibited monumental figures and groups, with an occasional bust. Steadily pursuing his art, his first im-

portant work was his statue of Addison for Westminster Abbey in 1806, followed by statues, for the same edifice, of Pitt, Fox, and Percival. In 1820 he exhibited his first classic group, 'Hero and Leander;' followed in 1822 by a 'Psyche,' and in 1827 by 'Cupid made Prisoner.' He executed several statues for Saint Paul's, erected by the State to the memory of the officers engaged in the French revolutionary war, among them those of Sir Ralph Abercrombie and Lord Collingwood. Of his other works, should be distinguished his statue of Lord Erskine, for Lincoln's Inn; Lord Nelson, for the Liverpool Exchange; and his Monumental group to Warren Hastings. Among his latest works were the large ornamental group for the pediment of the British Museum portico; his 'Euphrosyne,' a classic group in marble, exhibited in 1837, followed by two monumental works, the last exhibited in 1839. He was elected an associate of the Royal Academy in 1805, and an academician in 1815. In 1827 he was appointed Professor of Sculpture, and in 1837 received the honour of knighthood. He died in South Audley Street, September 1, 1856, aged 81. He will be remembered by his many public works. Remarkable for his bold and powerful hand, his figures, if not attaining a high degree of refinement, are never wanting in grandeur of proportions and solidity. He was well versed in Greek art, which he had made his study.

● WESTMACOTT, RICHARD, R.A., *sculptor.* Born in London in 1779. He was the son of the foregoing. His early desire was to be brought up for the Bar, but yielding to his father's wishes, he entered his studio, and soon showed a talent for art. In 1818 he was admitted to the schools of the Royal Academy, and two years later was sent by his father to pursue his studies in Italy, where he continued till 1826. The following year, he first appears as an exhibitor at the Academy, sending a simple, graceful statue in marble, of a 'Girl with a Bird,' followed in 1829 by 'The Reaper,' both of these works showing the result of careful study. They were followed by a succession of his best works, groups in marble. In 1830, 'The Guardian Angel,' part of a monument; in 1831, 'Venus carrying off Ascanius;' in 1832, 'The Cymbal Player;' in 1833, 'Narcissus.' These were succeeded by some works in alto-relievo, in which art he excelled. In 1834, 'The Pilgrim' and 'Hope;' in 1837, 'Mercury presenting Pandora to Prometheus,' and 'Wickliffe Preaching;' in 1838, 'Venus instructing Cupid,' with 'Paolo and Francesca.' In this latter year he was elected an associate of the Royal Academy, and in 1849 a full member. In 1857, he was elected Professor of Sculpture.

Of his remaining works, his 'Memorial Angel,' 1841, statue of Archbishop Howley in Canterbury Cathedral, and the sculpture for the pediment of the Royal Exchange, must be mentioned. After 1840, his chief works were busts, on which he was largely employed, and monumental sculpture, but he did not exhibit after 1855, and retired from his profession, withdrawing from the Royal Academy about a year before his death, which occurred at Kensington, on April 19, 1872. He was well known as a writer and lecturer on art. He published 'The Handbook of Ancient and Modern Sculpture,' 1864; a pamphlet 'On Colouring Statues;' and contributed some articles to 'The Encyclopedia Metropolitana,' 'The English Encyclopedia,' and 'The Penny Cyclopedia.'

WHEATLEY, FRANCIS, R.A., *portrait and landscape painter.* Was born in 1747, in Wild Court, Covent Garden, the son of a master tailor, who placed him under an able teacher of drawing. He afterwards studied in Shipley's school, and at the Royal Academy, and by his early ability carried off several of the Society of Arts' premiums. He was employed in the decoration of Vauxhall, and assisted Mortimer in the ceiling at Brocket Hall, and by perseverance and the strength of his natural abilities, attained considerable skill as a painter. In early life he made many theatrical acquaintances, and was led into extravagance and debt. At this time he became acquainted with Mrs. Gresse, the wife of the water-colour painter, and compelled to leave London to avoid his creditors, she fled with him to Dublin. Here he met with much encouragement as a portrait painter, and painted many small whole-lengths, and the Irish House of Commons, with portraits of the members, some of the first of whom he is said to have rubbed out to give place to others, who like them, but later, had subscribed for the engraving. The work, which was eventually disposed of by a raffle in Dublin, was then unfinished. He had introduced his companion as his wife, and when the deception was found out he was obliged to leave Dublin, and then returned to London.

He first exhibited at the Royal Academy in 1771, commencing with portraits, and afterwards sending some rustic and genre subjects, both in oil and water-colour. On his return he painted a large picture of the riots in London in 1780, which was unfortunately burnt, but is well known by Heath's fine engraving. He also contributed some good pictures, both to the Shakespeare Gallery and Macklin's Poets' Gallery. He at the same time painted portraits, and his large picture, still in the possession of the family, of 'The Second Duke of Newcastle and a Shooting Party,' the principal figures

on horseback, with keepers, dogs, and dead game, in a fine wooded background, is an example of his great ability. For subjects of this class, and for rural subjects generally, he became very popular. He painted chiefly in oil, and in a masterly manner, but he also painted many subjects in watercolours, which are mostly drawn with the pen, the shadows washed in with Indian ink, and the whole slightly tinted. His landscapes showed great taste, his figures were well introduced, but his rustics, especially his females, were meretricious and unreal. The popularity of his works is evidenced by the number engraved. There is a mezzo-tint by him, and an etching dated 1785. He was elected an associate of the Royal Academy in 1790, and an academician in 1791, and soon after became a pensioner of the Academy. Among his last works were his 'Cries of London.' A martyr to the gout. arising from early irregularities, he died from one of its attacks, June 28, 1801, aged 54 years, leaving, with four children, a widow who afterwards married again. *See* POPE, Mrs.

WHESSELL, JOHN, *engraver*. Practised in London towards the end of the 18th century, and engraved after Serres, Stothard, Gainsborough, Singleton, and others.

WHETTON, THOMAS, *architect*. Was a pupil of Sir William Chambers, and was admitted to the schools of the Royal Academy, where he gained the silver medal for an architectural drawing; and afterwards, in 1774, the gold medal for an original architectural design. Some of his early designs showed great taste and merit. He continued to exhibit at the Academy up to 1786, but he was allured from his profession by inheriting an ample property. For many years he resided chiefly at Sunning Hill, Berks, and died there on July 18, 1836, in his 83rd year.

WHICHELO, JOHN M., *water-colour painter*. He chiefly painted marine subjects, and the coasts, harbours, and dockyards of England. He exhibited at the Royal Academy in 1816–17 and 1818, and was at that time marine and landscape painter to the Prince Regent. In 1823 he was elected an 'associate exhibitor' of the Water-Colour Society, and was from that time to 1865 a constant contributor to the Society's exhibitions, sending in 1827 'Portsmouth Naval Arsenal;' in 1831 'Rotterdam Boats passing Dort in a Fresh Breeze;' and later some views on the Rhine and the Scheldt. His last works were chiefly from English scenery. He was also engaged in teaching. He died in September, 1865, and his drawings and art property were sold at Christie's in April 1866.

WHITAKER, GEORGE, *water-colour*

468

painter. His works are chiefly known in Devonshire, where he mostly resided. He died at Dartmouth, September 16, 1874, aged 40.

WHITCOMBE, THOMAS, *marine painter*. Born about 1760. He practised in London, painting sea-pieces, sea-fights, storms, and the ports and harbours of Great Britain, confining himself to marine subjects. His vessels were well and accurately drawn, and his subjects of a high class. He was a constant exhibitor from 1783, when he sent 'The Destruction by Night of the Spanish Batteries at Gibraltar,' to 1824. He died soon after 1824.

WHITE, CHARLES, *flower painter*. Practised soon after the middle of the 18th century. He died at Chelsea, January 9, 1780.

● WHITE, ROBERT, *engraver and draftsman*. Was born in London in 1645, and was the pupil of David Loggan. Among his early works are some title-pages and landscapes, with architecture. But he became distinguished by his portraits, which he engraved on the copper from the life, and was exceeded by none in this class of art. He was no less celebrated for his portraits drawn in pencil on vellum, which for their accuracy of likeness, correct drawing, and finish, were highly prized. He is described as possessing 'a wonderful power to take the air of a face.' There are also some few plates in mezzo-tint scraped by him. In 1674 he engraved the first Oxford Almanac. Many of the portraits in Sandford's 'Curious Coronation of James II.' are supposed to be by his hand. The heads of Sir Godfrey Kneller and his brother are engraved from drawings by him, and Sir Godfrey painted his portrait in return. His works were very numerous. Vertue collected the names of no less than 275 portraits by him, all of which are the prizes of the antiquary and the art-collector, by whom they are greedily sought even at extravagant prices. It is said that when he completed a plate he was in the habit of taking off two or three impressions, which he threw into a closet, where they lay in heaps. After forty years' labour he had saved between 4000*l.* and 5000*l.*; yet by some misfortune or waste he became poor. He resided in Bloomsbury Market, and died in indigent circumstances in 1704.

WHITE, GEORGE, *engraver and painter*. Was born about 1671, and was the son and pupil of the foregoing. He began art as a portrait painter, practising both in oil and in miniature, but his chief works are as an engraver. After the death of his father he finished the plates left incomplete by him; and afterwards practised chiefly in mezzo-tint, introducing a method of his own, by etching the outlines of his plate to attain greater precision. He engraved after Lely, Kneller (whom he

is said to have so teased with proofs that he was forbidden his house), Vanderbank, Thornhill, and after some of his own works. His mezzo-tint impressions are still much esteemed. His last known plate is dated 1731, but there is a small clever chalk portrait of Martha Blount by him, dated 1732. He is supposed to have died about 1734.

WHITE, CHARLES, engraver. Was born in London, in 1751, and was a pupil of Robert Pranker. He commenced his art as a line-engraver, but later adopted the dot manner. Of convivial thoughtless habits, he was one of the class known in that day as 'Social Artists,' and is remembered by some humorous designs, among them 'A Masquerade at the Pantheon,' 1773. He married one of Gerard Vandergucht's daughters. He engraved 'Ruins of Rome,' some plates in stipple for Bell's Poets, and some botanical plates with other subjects from natural history; but he did not gain employment on any works of importance, and was only beginning to give proof of his power to attain some distinction, when he died of fever in Pimlico, August 28, 1785, aged 34.

WHITE, CHARLES WILLIAM, engraver. Was born about 1740, and was taught by George White. He produced many plates in mezzo-tint, and engraved after Bunbury, Stothard, R.A., W. Pether, Cosway, R.A.

WHITE, HENRY, wood-engraver. He was apprenticed in London to James Lee, on whose death, in 1804, he went to Newcastle and served the remainder of his time with Bewick. He then returned to London, where he practised with great reputation. He engraved the clever illustrations for Hone's 'House that Jack Built,' 'Matrimonial Ladder,' and for many of the illustrated works of that period.

WHITE, THOMAS, architect and sculptor. Was born in Worcester, and was articled to a statuary in Piccadilly, London. He gained the notice of Sir Christopher Wren, whom he accompanied on his visit to the Continent in 1665, when he assisted the great architect in his measurements. Wren wished to retain his services on his return, but he preferred to settle at Worcester, where he had some property. The statue of Queen Anne, and some busts in the Guildhall of that city, are by him. He built the Church of St. Nicholas, 1730–32, and it is said some other churches in Worcester, where he died about 1738.

WHITE, THOMAS, engraver. Was born in London, and practised at the beginning of the second half of the 18th century. He was chiefly employed by Ryland, whom he assisted in his plates. He excelled in architecture, and engraved the chief part of the plates for Woolfe and Gandon's continuation of the 'Vitruvius Britannicus.' He died in London about 1775.

WHITTAKER, J., landscape painter.

Was born in the North (probably at Manchester), and was originally an engraver; but saving a little money, he went to study landscape art at Llanwrst, in North Wales, where he lived for a time, existing by the casual sale of his water-colour sketches. Receiving a commission for a picture in oil from Mr. Douglas Pennant, for which he was promised the, for him, large sum of 100l., his success had a bad effect upon him, leading him into habits of intemperance. He was elected an associate of the Society of Painters in Water-Colours in 1861, and a full member in 1864. He was accidentally drowned at Bettws-y-Coed, September 9, 1876.

WHITWELL, T. STEDMAN, architect. He practised early in the present century, and erected some county buildings, occasionally exhibiting at the Royal Academy from 1807. In 1811 he contributed his designs for St. Mary's Hall, Coventry; in 1820, when he was residing at Birmingham, for the new Library which he built in that town. His practice extending to London, he rebuilt, in 1828, the old Royalty Theatre in Whitechapel, then named the Brunswick Theatre, which fell down three days after it was opened. He had till this event been held in good repute, but it appears to have marred his professional career. He made a large collection of notes and sketches for a book to be called 'Architectural Absurdities,' but the work was never published and he was lost sight of in art.

WHOOD, ISAAC, portrait painter. He resided in Lincoln's Inn Fields, and in the second quarter of the 18th century had a considerable practice. His portraits are painted in oil, drawn in red and black chalk, chiefly in profile, and in black lead, but they are weak, without power or expression. In Lambeth Palace there is a portrait by him of Archbishop Wake, painted in 1736. He was esteemed a good copyist, and was for many years employed by John Duke of Bedford to copy, for his new mansion at Woburn, the portraits of any collateral relatives of the family that could be met with. He made some designs in 1743 to illustrate 'Hudibras.' Some of his portraits are engraved. At the latter part of his life he was reduced in circumstances by defending proceedings in Chancery against him for the recovery of an estate. He was a noted humorist. He died in Bloomsbury Square, February 24, 1752, aged 63.

WICKSTEAD, PHILIP, portrait painter. Born in London, he was a pupil of Zoffany, and was distinguished by his small whole-length portraits. In 1763 he gained a premium from the Society of Arts. He was at Rome in 1773, and found much employment in portraiture, and making acquaintance there with Mr. Beckford, he accompanied him to Jamaica, and practised

his art for a considerable time in that island. He then speculated as a planter but was unsuccessful. His losses led him to drinking and shortened his life. He died some time before 1790.

WICKSTEED, JAMES, *engraver.* Practised in London in the second half of the 18th century, working in the dot manner. He exhibited at the Academy some impressions and some small portrait casts, 1779–82. He died July 11, 1791, aged 73.

● WIGHTWICK, GEORGE, *architect.* He was born at Albrighton, August 26, 1802, was brought up as an architect, and in pursuit of his art went to Italy in 1828. In that year he exhibited at the Academy his only contribution, a drawing of Giotto's Tower, Florence. On his return, he commenced practice at Plymouth, from which he retired in 1850, without leaving any executed work with which his name may be associated. He will be best remembered by his professional writings ; among them, ‘Sketches by a Travelling Architect,’ in the Library of the Fine Arts, 1832 ; ‘The Life of an Architect,’ in ‘Fraser's Magazine;’ ‘The Palace of Architecture,’ ‘Hints to Young Architects,’ 1847 ; ‘The Principles and Practice of Architectural Design,’ 1853 ; ‘On Gothic Architecture,’ and ‘Roman Antiquities.’ He also wrote two tragedies, some novels, and poems. He died at Portishead, July 9, 1872. He bequeathed to the Institute of British Architects a large collection of drawings of his principal architectural works.

WIGSTEAD, H., *subject painter.* Practised in London towards the end of the 18th century, painting popular subjects and drawing satirical designs. He exhibited at the Royal Academy from 1784 to 1788. His ‘Country Vicar's Fire-side’ was engraved in 1785. He etched a plate of two Jews, old clothes men, called ‘Traffic,’ and Rowlandson etched, in 1786, a clever drawing by him of the costume and manners of the day, hardly a caricature. His works were popular in his day. He died in Greek Street, Soho, November 13, 1793.

WILD, CHARLES, *water-colour painter.* Was born in London in 1781. He early devoted himself to architecture, and made a number of architectural views, his practice being chiefly as an architectural draftsman. He exhibited some works of this class in 1804, and the following years, at the Royal Academy. He became, in 1809, an associate exhibitor of the Water-Colour Society, and was, in 1821, elected a member of the Society, and afterwards filled, successively, the office of treasurer and of secretary. He was from the first a constant contributor to the Society's exhibitions. His early works were almost exclusively of our English cathedrals, with

some designs for Pyne's ‘Royal Residences.’ Soon after 1821 he commenced exhibiting his elaborate drawings of the great religious edifices of France and the Low Countries. He published, in 1813, his Chester Cathedral and Lichfield Cathedral ; 1819, his Lincoln Cathedral ; and in the same year Canterbury and York Cathedrals ; Worcester Cathedral followed in 1823. He travelled in Germany, France, and Belgium, and made numerous drawings in their chief towns of the churches and public buildings, and afterwards published his ‘Foreign Cathedrals;’ and in 1833 etched outlines from sketches made in Belgium, Germany, and France. In 1837 his last work was published, ‘Select Examples of Architectural Grandeur in Belgium, Germany, and France.’ His architecture was beautifully drawn, his subject pictorially treated ; his effect always sweet and tender, with suppressed tone and colour. He was afflicted from 1827 by the loss of sight. He died in Albemarle Street, Piccadilly, August 4, 1835.

WILDER, JAMES, *landscape painter.* He was born in New Street, Covent Garden, in 1724, and, educated as an artist, painted landscapes, introducing figures. Afterwards, under Mr. Walton, the keeper of the King's pictures, he gained much repute as a picture-restorer. But he quitted art for the stage, and appeared at Covent Garden Theatre in 1749, and then performed at Drury Lane and in Dublin. He wrote ‘The Gentleman Gardener,’ an opera, produced in 1751. In 1788 he obtained an official appointment at Somerset House, and then left the stage.

●WILKIE, Sir DAVID, Knt., R.A., *subject painter.* Was born at Cults, in Fifeshire, of which place his father was the minister, on November 18, 1785. Early accounts of him speak of his very precocious scribblings and his artist power of observing. With his years his love of drawing increased so much that though the whole family had wished he should be a minister, his father was convinced he must be a painter, and placed him in the Trustees' Academy at Edinburgh, in 1799. Here he studied during four years under John Graham, was a diligent student, readily felt the character of the figure he was at work upon, and became a tolerable draftsman. In 1804 he returned for a while to his home, and, struck by the incidents of a fair in the adjoining village, where he had found his early schooling, he painted his first picture, ‘Pitlessie Fair.’ This work of small size, full of subject and of figures, speaks well for the amount of technical skill he had attained, and for the air of local truth, gained by the direct study of nature, but is red and rank, and gives no proof of his future excellence in colour.

Wildman – Painter

He also painted among his friends a few small portraits and miniatures.

His ambition was then aroused. He had sold his 'Pitlessie Fair,' for 25l., and probably added to this sum by his portraits ; and, determining to try his fortune in London, he started from Leith by sea in May, 1805. On his arrival, his first object was to secure admission to the schools of the Royal Academy. He added to his means by selling for 6l. a small picture of 'The Recruit.' While continuing zealously his Academy studies, he completed for the next year's exhibition his 'Village Politicians,' and, stimulated by its sale, and the interest which it excited on the Academy walls, he set to work on 'The Blind Fiddler,' a commission for 50l., and now in the National Gallery. He then painted, also on commission, his 'King Alfred in the Herdsman's Cottage,' which did not add to his growing reputation. But, returning to a more congenial subject, he produced his characteristic picture of 'The Rent Day,' sold for 300 guineas, and in 1809 was elected an associate of the Academy.

He had just completed his 24th year, and was already famed in art when he began his 'Village Festival,' also in the National Gallery. This picture was studied with great care, and, both in execution and the treatment of his subject, evinces a very marked improvement; the groups are well composed, and the varied characters true to nature. It was not completed in time for the Academy exhibition of 1811, and though only weakly represented, the reputation he had already earned gained him his election as academician in that year. In 1812 he made an exhibition of 29 of his own works and sketches in Pall Mall, when his 'Village Festival' was first shown to the public ; but his exhibition did not succeed—he did not realise his expenses. In weak health, and with his new honours, he now paid a visit to his family, and in 1814 made his first visit to the continent, passing five or six weeks in France in the study of the collections of art in the Louvre, then so rich. On his return he produced his 'Distraining for Rent,' followed by the 'Penny Wedding' in 1819, and in 1820 the 'Reading the Will,' which greatly added to his reputation. In 1822 he completed in time for the exhibition his 'Reading the Gazette of the Battle of Waterloo,' a commission from the Duke of Wellington, a work almost historical, and the attraction of the year; and the next year, for George IV., 'The Parish Beadle,' in which his early art and manner culminated.

On the King's royal progress to Edinburgh, Wilkie went to the Scots' capital to find a subject in connexion with the event,

and the office of King's Limner for Scotland falling vacant at the time, he was appointed to it. He proposed to paint 'The Entrance of the King,' and his Majesty, approving the choice, sat to him—but the attendant courtly sitters troubled him sadly, many incongruities presented themselves, and the work proceeded but slowly. Meanwhile domestic troubles and anxieties gathered round him, and weighed sorely on his sensitive mind; added to these, about 1825, he lost a considerable sum which he had invested in some speculation connected with a publishing house. Under these trials his health again failed, and he sought its restoration in foreign travel and an entire cessation of his art labours. He set out in 1825 for Paris, and, joined there by a cousin, travelled on to Italy. At Florence his painter friends, Hilton and Phillips, were added to the party, and by easy journeys they made their way to Rome. His health had somewhat improved, but the fever of admiration excited by the great works at Rome, added to further accounts of pecuniary losses, again threw him back. He visited Naples, Bologna, and Venice. and from thence went to Germany, seeing Dresden, Prague, and Vienna, and then returning to spend the winter in Italy, and, slowly recovering in health, he again took up his palette.

He had altered his style by the study of the old masters, and painted in a larger, bolder manner ; he sought to make his pictures more effective, and to attain greater rapidity of execution. Having arrived at Geneva on his way home, he changed his mind after a short stay there, determining to see Spain. He arrived at Madrid in October 1827, painted several pictures, and made many sketches and studies, returning to London in the spring of 1828, highly satisfied with his visit. His enthusiastic study of Velasquez confirmed him in his new manner, and the pictures painted in Madrid and on his return seem to have been completed at once. They are fine in general effect and tone, and have a Spanish air about them. Of these we may mention 'The Guerilla Council of War,' 'The Guerilla Taking Leave of his Confessor,' 'The Maid of Saragossa,' and 'The Confessional.' When these pictures were exhibited, the public lamented his early art and the class of domestic stories, all his own, on which his fame is founded. But, though startled by the sudden change, many beauties will be found in his latter works, which, too, give him claims to historic art.

In 1830 he completed his 'Entry of the King into Holyrood,' but it added nothing to his reputation. The same year the President of the Academy died, and many thought that Lawrence would be succeeded

by Wilkie; yet, although the King appointed him his painter-in-ordinary, he was not elected to the presidency by his brother academicians, and, overcoming his disappointment, he resumed his 'John Knox Preaching,' which he had long had on the easel, determining to make it a fine work. At the same time he was busy upon some full-length portraits, among them the King, in Highland costume, and in 1833, 'The Duke of Sussex,' in the same costume; but his portraits, while pleasing, failed to give the mental characteristics or the best expressions of his sitters. He retained his household appointment on the accession of William IV., from whom, in 1836, he received the honour of knighthood; and on the accession of Queen Victoria, still retaining his post in the household, he was commissioned by her Majesty to paint her first council, a work of great interest, but hurriedly conceived and finished.

With many commissions and much uncompleted work in hand, he suddenly determined, in 1840, to make a voyage to the East, to seek new fields of art in the localities of the sacred narrative, that his countrymen and the art of the time might reap some benefit from his journey. Travelling through Germany to Vienna, he took a steamer down the Danube, and reached Constantinople in October, 1840, and after some delay in that capital, setting out by Smyrna and Beyrout, arrived at Jerusalem by the end of February. He was deeply impressed with all he saw, and made many sketches of the scenes and incidents which surrounded him. On his return, while at Alexandria, he commenced a portrait of the Pasha. He had been about ten months absent, and, though he had enjoyed good health, began to long for home. He left Alexandria apparently well. At Malta he was imprudent in eating some fruit, and an attack of some complaint in the stomach recurred in the night. He was fast sinking when the vessel left the harbour, and died within an hour, on June 1, 1841,—the same evening his body was committed to the deep.

Wilkie's truly original art will always hold a high place in the English school. His early pictures of domestic story and sentiment, his own inventions, full of incidents, quietly both humorous and pathetic, will always interest and please, while their art and finish, founded on the Dutch school, will no less satisfy the artist and connoisseur. His later works, painted after the study of Italian and Spanish art, and approaching the manner of those schools, are of higher aim, and depict interests and feelings which are allied to history, and in both styles he was great. Had he survived his eastern travel, he
472

would most probably have painted not only Oriental, but Scriptural subjects, but it is doubtful if he would have added to the fame which was founded on his early subjects. Of these, the chief were engraved in line by Raimbach and Burnet, and greatly extended the knowledge of his art. In 1842, 130 of his works were exhibited with the collection of the old masters at the British Institution. His life, by his friend Allan Cunningham, was published in 1843, and his artist friends placed his statue, by S. Joseph, in the vestibule of the National Gallery.

WILKIN, CHARLES, engraver. Practised in London towards the end of the 18th century. In 1771 he was awarded a premium by the Society of Arts. He engraved in the dot manner, with much power, some fine portraits after Reynolds, Beechey, and others. He died from the effects of an accident, May 28, 1814.

WILKIN, FRANK W., portrait painter. Son of the foregoing. Began art very early in life as a miniature painter, and found employment in making water-colour copies of the old masters, which were very truthfully rendered. While so engaged he received a commission to paint in oil on a very large scale 'The Battle of Hastings,' for Battle Abbey, for 2000 guineas. He completed this work, which he exhibited at Spring Gardens in 1820. It was looked upon as a great effort, but it was weakly painted, spiritless, and the figures without motion. He afterwards devoted himself to portraiture in chalk, and was extensively employed, exhibiting at the Academy occasionally from 1820 to 1841. He died in September 1842.

WILKIN, HENRY, portrait painter. Brother of the above, practised his art for some time in London, and in the latter part of his life at Brighton. His portraits were chiefly in crayons, and were correctly drawn, and from 1830 he was a large contributor to the Academy exhibitions. He also painted some well-finished pictures in water-colours, and was an occasional lecturer on art. He died suddenly at Brighton, July 29, 1852, aged 61.

WILKINS, ROBERT, marine painter. He was born about 1740, and practised his art in London in the latter part of the 18th century. In 1765 he received a Society of Arts' premium of 30 guineas, and from that year exhibited with the Free Society of Artists up to 1778, and at the Royal Academy from 1772 to 1779. His works comprised naval actions, ships on fire, and moonlight scenes. In 1772 he exhibited at the Academy, 'The City, Mole, and Fortifications of Algiers;' in 1777, 'A Storm—Mackerel Fishing;' in 1779, 'A Naval Engagement.' He died about 1790.

WILKINS, WILLIAM, R.A., *architect.* He was born August 31st, 1778, at Norwich, where his father was successful as a builder, and was educated at the Free Grammar School there. On the removal of his father to Cambridge, he matriculated at Gonville and Caius College, in 1796, and graduated as Sixth Wrangler in 1800, and next year, gaining a travelling fellowship, he visited Italy and Greece, and cultivated a taste and knowledge of their architecture. On his return, his connexion with the University led to his appointment as architect of Downing College, and his employment on several of the University buildings. In 1808 he erected the Nelson Column at Dublin, and in 1817 a memorial column to the same hero at Yarmouth, and was rising to acknowledged reputation as an architect. In 1820 he appears as an exhibitor at the Royal Academy, sending, in that year a design for the new buildings, Cambridge, comprising the additions to King's College and the Fitzwilliam Museum, and in 1823, an elevation of the quadrangle for Corpus Christi. In 1825 he was elected an associate, and in 1826 a full member, of the Academy, and in the latter year he was associated with Gandy Deering in building the University Club in Pall Mall East, and in connexion with him designed and exhibited at the Academy a design for a commemoration Waterloo Tower 280 feet high.

He excelled in the purity and harmony of his Grecian designs, and in 1828 he was employed to erect the University College in Gower Street. He only completed the centre, the wings remaining unfinished; but his portico, the main feature of his design, was greatly admired for its classic taste. His next important work was the National Gallery, Trafalgar Square, completed in 1838. In this he had to contend with more than one difficulty. He had to introduce the portico from Carlton House, and was cramped by an alteration in the allotted space and by conditions imposed by the Government; and this work has not ceased to be the subject of hostile criticism. He afterwards rebuilt St. George's Hospital, and again had to contend with alterations imposed by the assertion of neighbouring rights. He was appointed architect to the East India Company, and built in the Grecian style the Company's college at Haileybury; and commenced in the same style Downing College, Cambridge, which he did not live to complete.

He was an unsuccessful competitor in 1836 in the designs for the Houses of Parliament; and afterwards, in a pamphlet, 'An Apology for the Design of the New Houses of Parliament,' marked 'Phil-Archimedes,' severely criticised the decision of the Commissioners and the designs of his competitors. He was an accomplished scholar, and had early in his career published his 'Magna Græcia,' and was known as a writer on subjects connected with his profession. He published his 'Civil Architecture of Vitruvius' in 1813, and in 1816, 'Atheniensia, or Remarks on the Buildings and Antiquities of Athens.' In 1831, a letter to the Prime Minister, on 'The Patronage of the Arts by the Government;' in 1837, the first, and only part, of his 'Prolusiones Architectonicæ.' The same year he was appointed Professor of Architecture at the Academy, but he never delivered any lectures. He had suffered for some time from gout, and died at Cambridge on August 31, 1839, on the 61st anniversary of his birth. He was buried in the chapel of Corpus Christi College, which he had erected.

WILKINSON, The Rev. JOSEPH, *amateur.* Forty-eight landscape views by him in Cumberland, Westmoreland, and Lancashire, were published by Ackermann, in 1810. His drawings were very weak and unfinished.

WILKINSON, ——, *engraver.* Practised in London towards the end of the 18th century. He engraved chiefly portraits, but the 'Loss of the Halsewell, East Indiaman,' after Northcote, has been powerfully scraped by him in mezzo-tint.

WILLES, WILLIAM, *landscape painter.* He was born at Cork, of a respectable family, and, early devoted to study, was a man of many attainments. He painted landscapes, introducing figures, and was from 1820 an exhibitor at the Royal Academy. In 1824 he sent 'A Serenade;' in 1826, 'A River Scene, a View of London,' introducing groups of figures; in 1829, 'A Midsummer Night's Dream,' and landscape views of Killarney. About 1830 he came to reside in London, and in 1857, when he exhibited for the last time, 'Excelsior,' he was at Reading. 'The Mock Funeral' is spoken of as one of his best works.

WILLIAMS, EDWARD, *engraver.* Practised in London in the last half of the 18th century. There are several groups by him after Rowlandson, and a plate after Wigstead. He was one of Hogarth's boon companions.

WILLIAMS, EDWARD, *landscape painter.* Son of the above. Was born in Lambeth in 1782, and was the pupil of his maternal uncle, James Ward, R.A., and was afterwards apprenticed to a carver and gilder; but meeting with some success in his attempts in miniature and landscape painting, he turned to the latter, and was successful in moonlight scenes, his favourite subjects, and in 1814 and 1816 exhibited at the Royal Academy. Later in life he painted the scenery of the Thames. There

473

is a moonlight by him in the National Gallery. He died at Barnes, June 24, 1855, leaving six sons who followed the arts, three of whom changed their names to preserve identity in their art.

WILLIAMS, Hugh William (called 'Grecian Williams'), *water-colour painter.* Was born in 1773 in Wales, where he claimed an ancient descent. He early settled in Edinburgh, and Scotland became his adopted country. He was in 1807 a candidate for admission into the Water-Colour Society, and in 1808 joined the new Society of Painters in Water-Colours, which that year started into a brief existence. Many of his early topographical views are engraved in the 'Scot's Magazine.' After gaining a reputation in Edinburgh, where he was a great favourite, he travelled several years in Greece and Italy, and on his return in 1818 published 'Travels in Italy, Greece, and the Ionian Islands,' 1820, and in numbers completed, in 1822, his 'Views in Greece.' In 1822 he exhibited in Edinburgh a collection of his sketches and drawings in these countries. He married a lady of good family and fortune, and died June 23, 1849. His drawings possessed great breadth, with rich and harmonious colouring; his trees well drawn, his masses of foliage simple. There is an account of his gallery in 'Peter's Letters.'

WILLIAMS, James Francis, R.S.A., *landscape painter.* Was born in Perthshire, and, it is believed, came to London at an early age, and was connected with the stage, both as a scene-painter and actor. About 1810 he returned to Edinburgh to paint scenes for the Edinburgh Theatre. After a time he left the theatre, settled in Edinburgh as a landscape-painter, and was much employed as a teacher. On the foundation of the Royal Scottish Academy in 1830 he was chosen one of the members, and in 1840 was elected to the office of Treasurer. In 1823, and some subsequent years, he contributed some Scotch landscape scenes to the Royal Academy. He died at Glasgow October 31, 1846, aged 61.

WILLIAMS, John (known as 'Anthony Pasquin'), *engraver.* Studied in the schools of the Royal Academy, and was apprenticed to learn engraving, to Matthew Darby, the well-known caricaturist. If as an artist he is unknown, his caustic art-criticism has given him a name. He wrote a 'Liberal Critique on the Exhibition for 1794,' 'Memoirs of the Academicians, being an Attempt to Improve the Taste of the Realm,' and 'An Authentic History of the Artists of Ireland.' He emigrated to America, and died at Brooklyn in 1818.

WILLIAMS, John Michael, *portrait painter.* Is reputed to have been a pupil

474

of Jonathan Richardson, and practised in London with much reputation about the middle of the 18th century. His works were much admired in his day, but appear slight in drawing and weak, yet are not without an air of fashion. His portraits have been engraved by McArdell, C. Corbutt, and F. Faber. He exhibited at the rooms of the Incorporated Society in the Strand in 1761. He resided in Scotland Yard, and is supposed to have died about 1780.

WILLIAMS, J. T., *gem-engraver.* Born in the latter part of the 18th century. Was brought up as a sculptor. He made several copies from the antique, and some statuettes and bas-reliefs; and afterwards engraved some gems, both cameos and intaglios, and upon these his reputation rests.

* WILLIAMS, Roger (or Robert), *mezzo-tint engraver.* Was born in Wales, and practised in the reign of Queen Anne. He is said to have been a pupil of Theodore Freres, who was brought to this country in 1687 by Sir Peter Lely, and remained here only a short time. He distinguished himself in his art, and his portraits after Vandyck, Kneller, Wissing, and others are finely executed. His leg was accidentally injured and he suffered amputation, which he survived many years.

WILLIAMS, Solomon, R.H.A., *history and portrait painter.* Was born in Dublin and studied in the Dublin Academy. He exhibited a portrait in wax at the Royal Academy in 1782, and afterwards some oil portraits. He then visited Italy, making some stay at Rome, and Bologna, where he was admitted a member of the Academy. He sent from thence, for exhibition in London, in 1792, a portrait group; in 1796, some domestic subjects and portraits. He brought home some good copies after Titian. He practised for a time in Dublin, but towards the end of the century he was in London, and in 1804 and 1807 was a contributor of some classic subjects to the Academy exhibition. In 1823 he was engaged on a large painting, 'The Trial of Algernon Sydney.' He was one of the foundation members of the Royal Hibernian Academy. He died August 2, 1824.

WILLIAMS, Samuel, *wood-engraver.* Was born at Colchester, of poor but respectable parents, February 23, 1788, and was apprenticed there to a house-painter. After teaching himself to etch, he tried wood-engraving, and on the completion of his apprenticeship had made sufficient progress to trust to that art for his livelihood. He was first employed to engrave the illustrations to a work on natural history, and his success did not fail to gain him other engagements; his great ability is evidenced

by his work in the chief publications of his day. He designed as well as engraved the illustrations for an edition of 'Robinson Crusoe,' 1822. Some good examples of his work are in Hone's 'Every-day Book,' 1825. He was skilful in rural scenery. He painted a few pictures in miniature and in oil colours, and was an exhibitor at the Royal Academy. Died, September 19, 1853, in his 65th year.

WILLIAMS, T. H., *water-colour painter*. Practised at Plymouth about the middle of the 18th century. He exhibited at the Academy between 1801-14 some views in Wales and Devonshire, and published in 1804 'Picturesque Excursions in Devonshire and Cornwall,' for which he drew and etched the plates; also 'The Environs of Exeter,' and 'A Tour in the Isle of Wight,' illustrated in the same manner.

WILLIAMS, WILLIAM, *subject and portrait painter*. He was awarded a premium by the Society of Arts in 1758, and practised in London in the second half of the 18th century, and from 1770 was an exhibitor at the Royal Academy. He sent landscapes, with figures, portraits; in 1778, 'The Good Samaritan,' 'Trinculo and Caliban,' and did not exhibit again till 1787, when he contributed 'Banditti Sleeping,' and some rustic scenes; in the following year, with some portraits, 'Venus attended by the Graces,' and in 1792 exhibited for the last time. Some subjects from Shakespeare by him were engraved by Val. Green, and his 'Marriage' and 'Gallantry' by Jukes.

WILLIAMSON, FRANCIS (of Southwark), *glazier*. 'He contracted jointly with Simon Symonds, 18th Henry VIII., to glaze four windows in the upper story of King's College Chapel, Cambridge, curiously and sufficiently of orient colours and imagery of the story of "The Old Law and the New Law," after the manner and goodness in every point of the King's new chapel at Westminster.'

WILLIAMSON, PETER, *engraver*. Practised in London in the reign of Charles II. and engraved some small plates of the incidents of the King's concealment. He also engraved portraits of the King, and Queen Catherine, and of some of the nobility. He was for some time employed by David Loggan, and appears to have been also engaged as a printseller.

WILLIAMSON, JOHN, *portrait painter*. Practised for above thirty years, and was respectable in that branch of art, and had many eminent sitters. He died at Liverpool in 1818, aged 67.

WILLIS, BROWN, *antiquarian draftsman*. Was born at Blandford, in Dorsetshire, in 1682. He was in 1738 a member of the St. Martin's Lane Drawing Academy, and obtained some notice as an artist. He died in 1760.

WILLISON, GEORGE, *portrait painter*. A native of Scotland. After studying some time in Rome, he settled in the practice of his profession in London, and in 1771 resided in Greek Street, Soho. He exhibited some whole-length portraits at the Royal Academy in that and the following year. His works were flat and thin, but not badly coloured. Not meeting with encouragement he went to the East Indies, and acquired a fortune of 15,000*l*., upon which he returned to Edinburgh, where he settled, and died in 1797. He acquired his great wealth, chiefly in jewels, left him by a person in India, whom he possessed sufficient knowledge of physic to cure of an afflicting wound of long standing. His portraits are engraved by Valentine Green and James Watson.

WILLMORE, JAMES TIBBITTS, A.E., *line-engraver*. Was born at Erdington, near Handsworth, Staffordshire, where his father was an extensive manufacturer, September 15, 1800, and was articled for seven years to Wm. Radclyffe, an engraver, at Birmingham. He came to London in 1823, upon the expiration of his apprenticeship, and for three years was employed in Charles Heath's studio, and then commenced his own career, producing many fine works. In 1843 he was elected an associate engraver of the Royal Academy, and was for the first time an exhibitor, contributing 'Ancient Italy,' a fine work after Turner, R.A., and the following year 'A View of London from St. Bride's Church,' apparently from a drawing by himself, and he was an occasional exhibitor of works after J. J. Chalon, R.A., Leitch, Stanfield, R.A., E. Landseer, R.A., and particularly Turner, R.A., from whose works, so difficult to render, he produced many plates of great delicacy and excellence. Latterly his health became very precarious, and he was unable to pursue his labours. He died, aged 62, March 12, 1863, and was buried in Highgate Cemetery.

WILLS, The Rev. JAMES, *portrait painter*. Practised towards the middle of the 18th century. He exhibited in 1760 with the Society of Artists 'Liberality and Modesty,' and the following year 'St. Peter returning from Prison,' a sketch. He contributed to the Foundling Hospital a large painting, 'Suffer little Children to Come unto Me.' He did not meet with much success in art, and having received a liberal education, he took orders, and was for many years curate, and afterwards vicar, of Canons, Middlesex. He was also for a short time chaplain to the chartered Society of Artists, with a salary of 30*l*. a year. He died in the latter part of 1777. Some of his portraits are engraved. He

published in 1754 a dry translation of Du Fresnoy's 'Art of Painting.'

WILLSON, Thomas, *architect*. Studied in the schools of the Royal Academy, and in 1801 gained the gold medal for his design for a 'National Edifice.' In the same year he exhibited at the Academy 'The Palace of Dido;' in 1804 'Entrance Front, Bank of Ireland,' and does not appear again till 1814, when he exhibited 'West Elevation for a Royal Palace, designed for an Illustrious Personage,' and in the following two years 'A National Mausoleum, to commemorate British Naval and Military Heroism,' with a section of his design. In 1819 he designed a 'Wellington Pillar;' in 1824 a 'Marine Villa for Cape Town;' and in 1831 'The Pyramid Cemetery for the Metropolis,' and from that time there are no traces of him.

WILLSON, Edward James, *architect*. He was born at Lincoln, where his father was a respectable builder, June 21, 1787. He held the appointment of county architect, but his reputation rests only upon his writings in connexion with the works on mediæval Gothic architecture, by John Britton and Augustus Pugin. He died in Lincoln, September 8, 1854.

WILSON, Andrew, *landscape painter*. Was born in Edinburgh in 1780, of a respectable family of Jacobite opinions, and at an early age was a pupil of Alexander Nasmyth. In his 17th year he came to London and studied at the Royal Academy, but after a short time started for Italy, and with some difficulty landed at Leghorn, making his way to Rome, and subsequently Naples, where he became acquainted with two well-known collectors, and studying the great works of the Italian masters, gained a knowledge of the distinctive characters of their art. He returned to London in 1803, but was soon after induced to re-visit Italy, for the purpose of purchasing works of the old masters, a task of some hazard, owing to the recurrence of the war. He arrived at Genoa in 1803, and, under the protection of the American consul, made that capital his chief residence, and was successful in purchasing 54 pictures, many of them of a high character. He came back through Germany, reaching home in 1806, and, devoting himself to landscape in water-colours, was in 1808 a member of the short-lived Society of Artists in Water-colours, and a frequent exhibitor at the Royal Academy. In 1808 he married, and soon after obtained an appointment as one of the teachers of drawing in the Royal Military College at Sandhurst, but resigned this office in 1818, and returned to Edinburgh as master of the Trustees' School. Here he brought up several pupils who attained distinction, and was a constant exhibitor to the Edinburgh

exhibitions, sending also some works to the Royal Academy in London. He made the collection of engravings for the trustees of the Royal Institution, which is now shown in their galleries. But his restless attachment to Italy and a small accession of fortune led him again to that country, for which, with his wife and family, he set off in 1826, and living alternately at Rome, Florence, and Genoa, passed there the next twenty years. During this time he painted many fine pictures, only a few of which found their way to our exhibitions; was much consulted by the buyers of works of art, and made many good purchases himself. In 1847, anxious to re-visit his native country, he left Genoa for London, and after a few months' residence went to Edinburgh, and here, whilst preparing to return to his family in Italy, he was struck with paralysis, and died on November 27, 1848. His compositions, mostly Italian, were pleasing; simply painted, without the use of body colour. They were carefully finished; his distances tender, and the whole work marked by much refinement.

WILSON, Benjamin, *portrait painter*. Was born in 1721, at Leeds, where his father ranked as one of the first clothiers, but afterwards fell into decay. He came to London early in life, was for some years in a very poor condition, and then gaining employment as a clerk, found means to pursue a love of art. He is said not to have received any instruction, but appears to have had some help from Hudson. By his perseverance and ability, he made himself known in art, and became the friend of Hogarth, Hudson, Lambert, and others of the leading painters. In the spring of 1748, he went to Ireland, to paint some commissioned portraits, and found employment there till 1750, when he returned to London, and established himself in Great Queen Street, Lincoln's Inn Fields. Here he painted many eminent persons, became fashionable, and is reputed to have made 1500*l.* a year by his art. Zoffany assisted him as his drapery painter. At the same time, he applied himself to science, and in 1746, and 1750, published treatises on electricity. He contrived and exhibited a large electrical apparatus, and in 1756 he was elected F.R.S., and printed his 'Experiments and Observations on Electricity.' He had also studied chemistry. He was versatile in his talents. He took part in a private theatre, and was both manager and prompter, and by this means he became known to the Duke of York, who appointed him about 1773, painter to the Board of Ordnance, reputed to have been a lucrative office. In 1760, and 1761, he exhibited portraits in the Spring Gardens' Rooms. He succeeded Hogarth as sergeant painter, and in 1776 had the honour of exhibiting

to the King and Queen, whose favour he enjoyed, his picture of ' Belshazzar's Feast.' He etched with great ability, and was a copier of Rembrandt, after whom he is said to have produced a landscape, which took in Hudson, who was a great connoisseur and collector. A caricature etching by him, at the time of the American Stamp Act, called 'The Repeal,' and sold at sixpence, is said to have produced him 300*l*. Several of his works were engraved, 'Garrick, as Hamlet,' by McArdell ; ' Garrick, as King Lear;' 'Lady Stanhope, as the Fair Penitent, in some amateur theatricals,' by Basire, and other portraits. He married at the age of fifty, and had seven children, one of whom became well known as General Sir Robert Wilson. He died in Bloomsbury, June 6, 1788. He had been a speculator on the Stock Exchange, and was, about 1766, a defaulter ; but, to the surprise of his friends, he left a very handsome property.

WILSON, CHARLES, *architect.* Commenced his studies in 1827, in the office of Mr. David Hamilton of Glasgow, and two or three years after the termination of his apprenticeship set up in business for himself, practising both in the Classic and Gothic styles. One of his early works was the Lunatic Asylum at Glasgow, commenced in 1842. He afterwards erected many public buildings in Scotland, and|was the President of the Glasgow Architectural Association. He died 1862 or 1863.

WILSON, JAMES, *engraver and draftsman.* Born about 1735. Practised in London. There are some good works by him in mezzo-tint, several of them after Sir Joshua Reynolds. He died about 1780.

WILSON, JOHN H., R.S.A., *landscape and marine painter.* Born in Ayr Borough, August 13, 1774. Apprenticed to a house-decorator in Edinburgh, and, on the completion of his term, having received some instruction from Alexander Nasmyth, he went to Montrose, where he passed two years in painting and in teaching drawing. About 1798 he came to London, and was employed as a scene-painter at Astley's. In 1807 he was for the first time an exhibitor at the Royal Academy, and again in 1809, and both his pictures found a purchaser. In 1810 he married. In 1813 he exhibited at the British Institution and was a constant contributor from that time for many years, his sketch of the Battle of Trafalgar, in 1826, gaining in competition one of the premiums of 100 guineas offered by the directors. He was a foundation member of the Society of British Artists, established in 1824, and one of its most constant supporters and exhibitors. Though settled in London he was a regular exhibitor at the Royal Scottish Academy, and was elected one of its honorary members.

During the latter years of his life he resided at Folkestone, with the sea, which he loved to study, ever before him, and there he died on April 29, 1855, having continued to paint till the last. His pictures are bold and free—the sea in all its moods, the vessels that traverse it and the craft which haunt its shores, he rendered with truth and spirit, and his works—if wanting in refinement of execution—are strong in their reality to nature.

● WILSON, RICHARD, R.A., *landscape painter.* Was born August 1, 1714, at Pinegas, in Montgomeryshire, where his father, who was afterwards collated to Mold, in Flintshire, then held a small living. His mother was connected with the family of the Lord Chancellor Camden. He received an excellent classical education from his father, and in 1729, having shown some early taste, was sent to London, assisted by Sir George Wynne, Bt., a relation of his mother, and placed under Thomas Wright, a portrait painter of small ability, with whom he continued six years. He then commenced portrait painting on his own account, and after several years practice, must have obtained some power, even were the great art qualities, which he afterwards displayed, unrecognised. He must also have been of some reputation, as he was employed in 1749 to paint the full-length portraits of the Prince of Wales and the Duke of York, and his ability in this branch of art is attested by the works which are known, and of which there are examples at the Garrick Club and in several private collections.

He had, with the desire which belongs to the artist, looked forward to visit Italy, and having managed to save the means, he set out in the year last mentioned for Venice. Hitherto his practice had been in portraiture, but here the true bent of his genius was disclosed. Zuccarelli, then a fashionable landscape painter, admired a landscape which he had painted and advised him to follow that art. After a stay of about twelve months at Venice, where he made acquaintance with Mr. Locke, of Norbury, he visited with him several of the Italian cities, painting for him some sketches and landscapes, and continued his journey to Rome. Here he remained some while, and meeting with little employment and being in difficulties, probably devoted his time to landscape, and here Vernet, the celebrated French artist, seeing one of his landscapes, exchanged for it a picture of his own, counselled him to continue that art, and recommended him to his own friends. After having spent nearly six years in Italy, chiefly in Rome, he travelled to Naples with Lord Dartmouth, for whom he painted some fine landscapes, and in 1755 made his way home.

In 1758 he was living in the Piazzas, Covent Garden ; he had now changed his art ; he was a landscape painter. It is related that his return excited some interest among his brother artists, but that his art was unappreciated either by them or by the public ; the artists indeed advised him that his manner was not suited to the English taste, and the critics, to whom it was new, did not understand and depreciated it, while they lauded the meretricious productions of his contemporaries. Thomas Sandby, R.A., who had favour at Court, with better judgment recommended him to the Duke of Cumberland, for whom he painted the ' Niobe,' one of his great works, which he exhibited in the Adelphi with the Society of Artists, of which he was a member, in 1760. It is said, however, that he lost the Court patronage. Having afterwards painted a landscape of Sion House for the King, Lord Bute, by whom it was to have been submitted, remarking that sixty guineas, the price he named, was too high, he angrily replied that if the King could not pay that sum at once, he would take it by instalments, and thus cut short his hope of Royal favour. This unfortunate explosion of temper, if a fact, did not stand in his way upon the foundation of the Royal Academy by the King, in 1768, for he was then nominated one of the first members, and was a constant contributor to the exhibitions up to 1780. In 1770 he sent 'Cicero and his Two Friends at his Villa at Arpinium ;' in 1771, 'Wynnstay' and 'Crow Castle,' two large landscapes painted for Sir W. W. Wynn ; in 1774, 'Cader Idris,' 'The Cataract of Niagara,' and others ; in 1775, 'The Passage of the Alps at Mont Cenis,' and 'The Lake of Nemi ;' in 1776, 'Sion House ;' in 1778, 'View in Windsor Great Park ;' in 1779, 'Apollo and the Seasons,' and 'View of St. James's Park ;' in 1780, when he exhibited for the last time, 'Tabley Park.' He repeated many of his favourite works, some of them several times

But only a few of these fine pictures found purchasers, even the dealers declaring that those they bought remained on their hands, and from time to time, descending in the scale, he changed his abode to suit his diminished means. His temper, naturally quick, was embittered by his trials. He lived in a poor lodging in Tottenham Court Road, wanting employment, and one day, in tone of indignant despair, asked Barry, R.A., if he knew any one mad enough to employ a landscape painter, to whom he could recommend him, as he had literally nothing to do. He was no less a man of high spirit and gentlemanly feeling, of classic tastes, an elegant scholar, and when not suffering from a morbid depression of spirits, for which there

478

were only too many sad causes, he was of courteous address and brilliant in his conversation. He also possessed great knowledge and critical judgment of art. Yet while neglected by fortune, he did not give up the struggle, and continued to paint, thinking himself happy to obtain even the mean sum of 15 guineas for a three-quarters landscape. So he managed to live till, in his declining powers, he became, on a vacancy in 1776, the Librarian to the Royal Academy, and the small salary attached to that office, for which he was well fitted, greatly increased his narrow means. It is pleasant to add that he unexpectedly became possessed of a small property near Llanberis on the death of his brother, and that retiring there he passed a short time in comfort and peace, and then died suddenly, in May 1782. He was buried on the 15th of that month in the churchyard of St. Mary-at-Mold.

His art possesses some of the highest qualities in the reach of the landscape painter. Purely classic and noble in his conceptions, he gave a new aim to the English school. Strong in his impressions of Nature's truths, vigorously and powerfully painted, grandly poetic in tone and colour, yet broadly and simply treated, his works will secure him an imperishable name in the English school. Peter Pindar, who spared him in his caustic criticism, truly prophesied — 'But, honest Wilson, never mind, immortal praises thou shalt find.' Yet the poet deferred the realisation until the painter had been dead one hundred years. Did he find any compensation during years of neglect and suffering in the confident hope we learn he entertained, that posterity would do him justice ?

An exhibition of the works of deceased British artists, at the British Institution, in 1814, included 85 of his works. Our National Gallery possesses two fine examples of his art, and he has been made widely known by engraving, and is fortunate in the engravers employed on his works, among whom Woollett, William Sharp, Byrne, Canot, Rooker, Earlom, and Middiman, are distinguished. He made many studies, which are in the hands of collectors, executed in black and white on a grey Roman paper. His life, by Wright, was published in 1824 ; and Cunningham, falling upon that work for his chief facts, has written a memoir of him in his 'British Painters.'

WILSON, WILLIAM CHARLES, engraver. Born about 1750. There are many early plates by him in mezzo-tint. He was employed by Boydell upon his Shakespeare Gallery, and engraved after Smirke, Westall, West, P.R.A., and Pillement.

WILSON, Sir WILLIAM, architect. He

was knighted in 1681, and practised in the reign of William III.; but little is known of his works. He is said to have designed the colossal figure of Charles II. on the west front of Lichfield Cathedral. He rebuilt the spire of Warwick Church. Died about 1702.

* WILTON, JOSEPH, R.A., *sculptor.* Was born in London July 16, 1722, and was educated at Hoddesdon, Herts. His father, originally a workman, was a manufacturer of architectural ornaments in plaster, employing many men. He studied mathematics and geometry for the profession of an engineer, but afterwards determined to follow sculpture as his profession. He was placed under Delvaux, who had formerly resided in London, at Nivelles, in Brabant, and in 1744 went to Paris, where he studied in the Academy under Pigalle. In October, 1747, he left that city, and travelled in Italy, studying several years in Rome and Florence, and in the former city, in 1750, gained the Jubilee Gold Medal, given by the Pope. He afterwards visited Naples, and the interesting localities in the neighbourhood, and from 1751 till May 1755, when he returned to London, he was fully employed in Florence upon copies and commissions.

On his home journey he was accompanied by Sir William Chambers, and Cipriani, R.A. He had enjoyed opportunities of study which other English sculptors had not known. In 1758 he was selected to teach modelling in the Duke of Richmond's Gallery, and was about the same time appointed State coach carver to the King, and modelled the ornaments for the Coronation State coach. On the institution of the Royal Academy, he was nominated one of the foundation members. In 1773 he completed his monument to General Wolfe in Westminster Abbey, his first public work. This was followed by monuments to Admiral Holmes, the Earl and Countess of Monteath, Pulteney Earl of Bath, and a series of fine busts, including Bacon, Newton, Cromwell, Chatham, and Swift. He also executed some fine mantelpieces. His contributions to the Academy exhibitions were very limited. In 1769, and several following years, he only sent a bust. In 1773 a small model of Mutius Scævola before Porsenna. In 1781 and 1783 he each year exhibited a monumental figure, and was not again an exhibitor.

His father had left him an independence. He had added to this considerably by his professional gains, and after a career of nearly thirty years, he sold his premises and materials by auction. Retiring from the active pursuit of his art, he accepted the office of Keeper to the Academy in 1790, an office which he filled with much zeal till his death. Living in much luxury, he

entertained many distinguished friends, among whom were some of the most eminent artists and dilettanti, including Dr. Johnson. His daughter, who is always mentioned as possessed of remarkable beauty, married Sir Robert Chambers, Chief-Justice in India. She presented to the Academy a bust in plaster by Roubiliac of her father. He died November 25, 1803, in his 81st year. His works are skilfully executed and coldly correct—sometimes graceful. His groups are crowded in their composition, yet not without grandeur of conception.

WINDHAM, JOSEPH, *amateur.* Was born at Twickenham, August 21, 1739, and educated at Eton and Christ's College, Cambridge, and was an eminent classic scholar, learned in the history of art and architecture. He travelled in France, Italy, Istria, and Switzerland, and, a good draftsman, he made many sketches of scenery, architecture, and ancient remains; and at Rome measured some of the ruins with great accuracy. Many of his plans and sections are engraved in Cameron's work on the Roman baths. He wrote the greater part of the letterpress of the 2nd Volume of the 'Ionian Antiquities,' published by the Dilettanti Society. He died September 21, 1810.

WINGFIELD, J. D., *landscape and figure painter.* His name first appears in the catalogues of the Royal Academy as an exhibitor of portraits in 1835–36. But he afterwards painted interiors, and garden and park scenes, introducing figures in costume; and he exhibited works of this class up to 1872. He died in the spring of that year, and his works, with numerous copies from the old masters, were sold by Messrs. Christie in the following July.

WINSTANLEY, HENRY, *architect.* He was of Littlebury, Essex, and had by several inventions shown the germs of genius. He travelled in Italy early in life, and his name first appears in 1694 as clerk of the works at Audley Inn, then a royal palace, and as filling the same office at Newmarket in 1700. Evelyn mentions having, on a visit to Chelsea in 1696, 'seen those ingenious water-works invented by Mr. Winstanley, architect of the Eddystone Lighthouse, wherein were some things very surprising and extraordinary.' Here he also exhibited the model of his lighthouse at a charge of sixpence each person. This erection, which was chiefly of wood, was commenced in 1696 and completed in four years. He was so confident of its security, that he is reputed to have expressed a wish to be left in it during a storm. Anyhow this so happened. He was superintending some repairs, making under his inspection, and perished together with his workmen and his work in the great

storm on November 26, 1703, which swept the whole away. He etched some views of Audley Inn 1688, which, though now rare, have little art-merit, and dedicated them to James II.

* WINSTANLEY, HAMLET, *engraver*. Son of the above. Was intended for a painter and was a pupil of Sir Godfrey Kneller. He painted several portraits, among them the Bishop of Chester, and a group of himself and his wife, which are engraved by Faber. His portraits are correct in drawing, but weak in expression and colour. Having travelled in Italy, on his return he gave himself up chiefly to engraving. He etched 25 of the family portraits and pictures of the Derby family, and published under the title of 'The Knowsley Gallery,' his etchings from Lord Derby's pictures; also, a set of prints from Thornhill's paintings in the dome of St. Paul's Cathedral, and several others. He died, aged 61, in May 1761, and was buried at Warrington, Lancashire.

WINSTON, CHARLES, *amateur*. Was born in 1814 at Farningham, Kent, where his father, the Rev. B. A. Sandford, was the vicar. On succeeding to some property he took the name of Winston. He graduated at Oxford, and was in 1814 called to the bar, and practised on the Home Circuit. But with the law he cultivated a love of glass-painting, and acquiring great accuracy of drawing, he made many copies of ancient glass, rendering the character and colour with great skill. He was also distinguished for his knowledge of stained glass. He published in 1847 an 'Inquiry into the difference of Style observable in Ancient Glass-Painting,' and in 1849 'An Introduction to the Study of Painted Glass,' and he contributed several papers to the Journal of the Archæological Society. His published works were illustrated by drawings made by himself, and on his death, October 3, 1864, he left to the nation a large collection of drawings of stained glass.

* WISSING, WILLIAM, *portrait painter*. Born at Amsterdam, 1656. Studied at the Hague both portrait and history. After leaving his master there he went to Paris, and shortly after, about 1680, came to England. He was at first employed by Lely and imitated his manner, and on his death succeeded to much patronage and was the fashionable rival of Kneller. He painted the portraits of the Royal family and several of the Duke of Monmouth, and was much employed by the Court. James II. appointed him his principal painter, and sent him to Holland to paint the portraits of William and Mary, then Prince and Princess of Orange. On his return he went to Burleigh and painted the sixth Earl of Exeter, and soon after, dying there, September 10, 1687, in his 32nd year, he was

buried by the Earl at St. Martin's Church, Stamford, where there is a tablet to his memory. His death was attributed to envy, and he was suspected of having been poisoned, but without any sufficient grounds. Several of his works are well engraved in mezzo-tint, among them a fine portrait of himself, *ipse pinxit*, by John Smith. His portraits were solidly and carefully painted, pleasing in character, rather gay in colour, and not undeserving the reputation he enjoyed. It is said that he would take by the hand a pale-faced sitter and dance her about the room to heighten her colour and improve her looks.

WITHERINGTON, WILLIAM FREDERICK, R.A., *landscape painter*. Was born in Goswell Street, London, May 26, 1785, and brought up to a business, but cherishing an early love of drawing he tried to improve himself, and when in his twentieth year gained admission to the schools of the Royal Academy, but while an attentive student he did not for a considerable time abandon his business pursuits. In 1811 he first exhibited his 'Tintern Abbey' at the British Institution, and the same year also exhibited at the Academy. His early works were landscapes with figures, but he afterwards tried more purely figure subjects of a rural character, and his health failing he lived more in the country, and for several years painted landscapes. In 1835 he exhibited 'A Hop-garden,' one of his best works, which forms part of the Sheepshanks' Gift to the South Kensington Museum. There are also two landscapes by him in the Vernon Collection. He gained his election as associate of the Academy in 1830, and as full member in 1840, and at this time painted much of the scenery of Devon and the Welsh Lakes. His landscapes were entirely English, introducing all the rural accessories of English scenery; careful, pleasing, full of incident, with the figures well introduced, his works yet fail to reach an art that would give him a high rank as a landscape painter. He died April 10, 1865, aged 79.

WITHERS, EDWARD, *china-painter*. About 1774 he was the first painter of flowers at the old Derby Works, but his employment there failing, he went to Staffordshire, yet met with no better success. Then quitting his own art, he found employment in the Japan trade in Birmingham. Next he went to London, where he suffered much distress. Flower-painting being in request at the Derby Works, he was sought out and sent for, but he had lost his early skill. He fell into great difficulties, which were attributed to his own misconduct, and on his death he was buried by the contributions of his fellow-workmen.

WIVELL, ABRAHAM, *portrait painter.* Was born in Marylebone, July 9, 1786. His father was a tradesman at Launceston, who, failing in business, came to London, and died soon after, leaving a widow and four children in penury. After many difficulties and some little teaching by his mother, he learnt shoemaking at the Marylebone School of Industry, and was eventually apprenticed, in 1799, and served his time with a peruke-maker and hair-dresser. Setting up on his own account, he placed in his window beside his wigs some miniatures in water-colours which he had attempted, and was advised to apply himself to art, but he had married and was afraid to give up his trade. An opportunity, however, arrived; he sketched the likenesses of the Cato Street Conspirators, and his success gained him notice and some commissions for theatrical portraits; following up this, he sketched with great readiness and ability the portraits of the principal persons engaged at the Trial of Queen Caroline, which he published. He had saved some money in these undertakings, and was induced to publish 'An Inquiry into the History of the Shakespeare Portraits,' but the work was a failure and entailed great loss upon him; and he was relieved from much difficulty by an annuity of 100*l.* a year left him by an uncle. At this time he was engaged in inventing fire-escapes, and when the Society for the Protection of Life from Fire was established in 1836 he was appointed their superintendent with a pay of 100*l.* a year. But upon some difference he threw up this employment and went to reside at Birmingham, where in 1847 he resumed his art career, and was engaged to take the portraits of the railway celebrities for the 'Railway Record.' This was his last work. He died at Birmingham, March 29, 1849. He exhibited at the Academy in 1822 and in 1830, a portrait in oil. But his art was confined to a carefully-drawn miniature portrait in black-lead, in which the likeness was well preserved.

WODEWARD, WILLIAM, *medallist.* Held the office of Graver to the Royal Mints of Dover and Calais 32nd Henry VI.

WOGAN, THOMAS, *miniature painter.* He studied in the Dublin Academy, and practised both in that city and in London, enjoying a contemporary reputation. He was an exhibitor at the Royal Academy in 1776–77–78, and was then residing in London. He died in Dublin, 1780.

WOLCOTT, The Rev. JOHN, M.D. (known as 'Peter Pindar'), *amateur.* Was born at Dadbrook, Devonshire, in 1737, of respectable parents, and educated at the Grammar School at Kingsbridge, a neighbouring town, where he acquired a knowledge of Latin and Greek, and was a

tolerable classic. He then went to France, and stayed about a year to complete his studies, and on his return was app enticed to his uncle, a surgeon and apothecary at Fowey. On the expiration of his apprenticeship he came to London, where he studied his profession, obtained his M.D. degree from a Northern University, and in 1767 went to the West Indies as Physician to Sir William Trelawney, a distant relative, who was appointed Governor of Jamaica. He next appears as Physician to the Forces in Ireland, but the post does not seem to have been profitable, and he afterwards took holy orders, in the expectation of obtaining a good living which he had in view in Jamaica, but in this he was disappointed. It is said there is no proof of his having been admitted to orders, but it appears that he was ordained both deacon and priest by the Bishop of London. On his return to England, he settled in Cornwall, and becoming acquainted with Opie, afterwards so distinguished as a painter, brought him to London in 1780 on condition of sharing the profits of his professional labours, and pushed him into notice, but the pair soon separated. The arrangement was one-sided and, moreover, the young painter was too honest in his opinion : 'I tell'ee, ye can't paint, stick to the pen;' which was an affront to the doctor's art attempts. He then took into his house on the same conditions, and the same result, Paye, a young artist of great genius and great misfortunes. Wolcott had written political satires upon the Court of George III., and he now turned his attacks upon the Academy, and published his criticisms, vulgarly abusive rather then critical, upon the exhibitions of 1782–83–85–86, under the title of 'Lyric Odes to the Royal Academicians.' These were followed in 1788 by 'The Bee, or the Exhibition exhibited in a new light,' and in 1797 by 'The Royal Academy, or a Touchstone to the present Exhibition.' He was fond of art, possessed a small collection of pictures, painted with some ability as an amateur, and made some fair sketches of the scenery of his native country. Six picturesque views from paintings by Peter Pindar, Esq., in aqua-tint, by Alken, were published in 1797. In the decline of his life he became blind, and died at Somer's Town, after a lingering illness, January 13, 1819, in his 81st year, and was buried at St. Paul's, Covent Garden. His poetical works with a memoir had been published in Dublin in 1789.

WOLSTENHOLME, D., *animal painter.* He lived for several years during his early career at Cheshunt. He first exhibited at the Academy in 1804, sending 'Fox Hunting;' in 1805, 'The Epping Forest Hunt;' in 1807, 'The Golden Lane Brewery.' These works were followed by

portraits of favourite horses and dogs. In 1824 he exhibited 'The Interior of the Riding School of the Light Horse Volunteers,' introducing portraits; in 1846, a work of some pretension, 'The Progress of Queen Elizabeth with her Retinue to Hatfield;' and in 1849, 'A Morning Shooting,' his last work exhibited at the Academy. Bromley, A.E., engraved after him 'Portraits of Three Dogs.'

WOLSTENHOLME, D., junr., *animal painter.* He was born about 1800, son of the above, and followed the same branch of art, painting chiefly the portraits of favourite animals. He first exhibited in 1818, and in 1822 sent 'Truman and Hanbury's Brewhouse,' with portraits of their horses and men; in 1825, 'Terriers Ferretting Rabbits,' with portraits. He exhibited for the last time in 1828.

WOOD, JOHN, *engraver.* He is supposed to have been a pupil of Chatelain. He was employed by Boydell, for whom he engraved several of the plates in a set of landscapes published in 1747. He engraved after Salvator Rosa, Gaspar Poussin, Claude, Rembrandt, and Richard Wilson. 'A View of London from Greenwich,' by him, after Tillemans, is dated 1774. He died about 1780. His works possess considerable merit, and are executed with much care and finish.

WOOD, JOHN GEORGE, *water-colour draftsman.* He was the author of several works on art but had little claim to artistic power. From 1798 he was an exhibitor at the Royal Academy, chiefly of Welsh views. He exhibited for the last time in 1811. He published, in 1792, 'Plans for Labourers' Cottages;' in 1793, 'Six Views in the Neighbourhood of Llangollen,' from his own drawings; in 1804, 'Lectures on Perspective,' which he had delivered; in 1813, 'The Principal Rivers of Wales,' illustrated; in 1814, 'The Principles and Practice of Sketching Landscape from Nature.' He died in 1838, and his drawings were sold by auction at Sotheby's in that year.

WOOD, JOHN (of Bath), *architect.* He appears to have settled in Bath in 1727, and in that year he have built there Chandos House, a fine mansion. He became the architect of the city. He built Queen Square, and several fine edifices, and much improved the street architecture by combining several houses in one façade. He was also the architect of the Bristol Exchange, Buckland Manor House, Berks, an original attempt of some merit; and Stanlinch, Wilts. He published 'The Origin of Building,' 1741; 'A Description of the Bristol Exchange,' 1745; 'Description of Bath' (two editions), 1749. He died at Bath, after a long illness, in May 1754, in his 50th year. He was a Justice of the Peace for the county of Somerset.

WOOD, JOHN, *history painter.* He was born in London, June 29, 1801, and was the son of an artist, who found his chief employment in teaching. He was fond of drawing, and was early admitted into Mr. Sass's Academy, and in 1819 he entered the schools of the Royal Academy. He was, in 1824, living in Whitechapel, and that year, with two portraits, exhibited his 'Archangel Michael Contending with Satan,' his first contribution to the Academy. In 1825 he gained the gold medal for his 'Joseph Expounding the Dreams of the Chief Butler and Baker,' which he exhibited the following year with his 'Psyche, wafted by Zephyrs.' He next exhibited some portrait groups with, in 1829, 'Comus and the Lady,' and in 1833, 'Cupid and Psyche.' These works earned him a great reputation, and sanguine hopes were expressed as to his future career. In 1834 he gained, in competition, an important commission for the altar-piece for St. James's Church, Bermondsey. In 1836 he was awarded, at Manchester, the prize for his 'Elizabeth in the Tower,' and shortly after a premium of 1000*l*., also in competition, for a painting of 'The Baptism of our Saviour.' But it was already apparent that he was unable to maintain the reputation he had achieved by his first successes. He painted portraits, and continued at his easel, and later in his career Scripture subjects, but his art degenerated with his failing health, and he was never able to regain his early reputation. He died April 19, 1870.

WOOD, PHILIP, *carver in wood.* He was born at Sudbury in Suffolk, and, early left an orphan, was brought up by a retired London merchant named Haybittle, whose house he ornamented with many quaint carvings. Having fallen in love with his patron's daughter, he came in 1689 to London, hoping to improve his fortunes; but, unable to get work from having no recommendations, he employed his spare time in gazing at the rebuilding of St. Paul's. Here Wren noticed him, and asked him what he could carve. Overcome with confusion, he answered stammeringly, 'Troughs.' 'Troughs,' said Wren, smiling, 'then carve me a sow and pigs, and bring it me this day week.' Accepting this commission, he re-appeared with the carving, when Wren at once engaged him, saying, 'Young man, I fear I did you some injustice.' He married his patron's daughter, and assumed the name of Haybittle, which is found appended to various receipts in payment of carving work done for the Cathedral.

WOOD, WILLIAM, *modeller.* He was employed in the Messrs. Wedgwood's manufactory about the end of the last century, and was distinguished for his great

ability, and the beauty and finish of his work.

WOOD, WILLIAM, *miniature painter.* Practised in London, and was distinguished for his correct drawing, taste, and harmony of colour. From 1791 he exhibited at the Royal Academy, miniatures, with occasionally a portrait drawing, contributing for the last time in 1807. He promoted the establishment, in 1808, of the short-lived Society of Associated Artists in Water-Colours, and was the Society's president. He published, 1808, 'An Essay on National and Sepulchral Monuments.' Fond of the study of nature, he planned the laying out of parks and grounds, and made many sketches from nature of great merit. He improved the stability of colours on ivory. Died at his house in Golden Square, November 15, 1809, aged 41.

WOODCOCK, ROBERT, *marine painter.* He was born of a good family, and, having a genius for painting, resigned an office under the Government to devote himself to art. He began to study in 1723, and, copying in oil after Vandevelde, he acquired a technical knowledge, and adopting art as his profession, made great progress, confining himself to marine subjects. He had also a talent for music, and was not only a good performer, but composed some pieces, which were published. He died of gout, in his 37th year, April 10, 1728, and was buried at Chelsea.

WOODFIELD, CHARLES, *topographical landscape painter.* Was a pupil of Isaac Fuller. He painted topographical subjects, buildings, antiquities, and views. He was idle and often wanted necessaries, but lived to the age of 75 years, dying in 1724.

WOODFORDE, SAMUEL, R.A., *history painter.* Born in 1764, at Castle Cary, Somersetshire, of a respectable family, long settled in that county. Was well educated, and, seized with an early passion for drawing, he was sent up to London, and in 1782 admitted a student in the schools of the Academy, where he by diligence obtained a power of drawing. In 1785 he was assisted to visit Italy. Residing some time in Rome, he was persevering in his studies, but being of a slow nature, his hard work was not rewarded by much progress. After seeing Florence and other of the art cities, and tarrying to study the works of the great colourists at Venice, he made his way back to England in 1791. He had sent some works from Rome for exhibition at the Academy, and he now exhibited some Roman landscapes, followed by, in 1793, 'Caractacus before Claudius,' some portraits, and classic subjects. He was then employed by Boydell on the Shakespeare Gallery, and painted the forest scene from 'Titus Andronicus,' which was engraved by Anker Smith. He also painted some por-

traits, and gaining rank in his profession, was popular as a painter of compositions, usually a few figures, from the lighter class of subjects, poetry and tales. These he painted with some grace, but little power, and only occasionally finding a purchaser, was obliged to depend upon portraiture, in which he was less qualified to succeed. In 1800 he was elected an associate, and then exhibited 'Charles I. in the Hands of his Army, has an Interview with his Children,' engraved by W. Sharp. In 1807 he became a full member of the Academy. He managed by economy to secure an independence, and in the spring of 1815 married, and shortly afterwards set off again for Italy, probably with the intention to settle there, but was taken ill between Bologna and Ferrara, and died of inflammatory fever at the latter city, after a few days' illness, July 27, 1817, in his 54th year. Among his principal works are, 'Calypso lamenting the Departure of Ulysses,' 1810; 'Diana and her Nymphs,' 1814. His works possess the correctness of drawing and composition due to his laborious studies, but the genius to become more than a respectable artist was not given to him. His colouring was good, and in this respect his water-colour drawings are in advance of his contemporaries.

WOODHOUSE, JOHN THOMAS, M.D., *amateur.* He was senior Fellow of Gonville and Caius College, Cambridge, and though he took his degree in medicine, he never practised. He was chiefly occupied in painting portraits, in which, as an amateur, he greatly excelled, painting the likenesses of his many friends and distinguished contemporaries. He died at his college, March 20, 1845, aged 65.

WOODING, T., *line-engraver.* Practised towards the end of the 18th century, and produced works of some merit. William Bromley, A.E., was his pupil.

WOODMAN, RICHARD, *engraver.* Born in London, he practised there in the latter part of the 18th century, in the dot manner. His last works are dated about 1810. Among his best works are, 'The Choice of Penelope,' after Riley, and 'Children at Play,' after Poussin.

WOODMAN, RICHARD, *engraver and draftsman.* Was the son of the above, born in London, July 1, 1784, and was placed under Meadows, a stipple engraver. After leaving him, he was employed to colour, which he did with great ability, the engraved imitations of William Westall's drawings. In 1808 he was engaged by Wedgwood to superintend the engraving department of his works, but he soon relinquished that employment, and returning to London, he undertook the engraving of some large hunting and sporting plates, and afterwards engraved for Knight's 'Por-

trait Gallery.' He also possessed much ability as a miniature painter and water-colour draftsman, and in the latter part of his life, seldom using his graver, he produced some water-colour drawings of much refinement and finish. He died December 15, 1859. His plate after Rubens' 'Judgment of Paris' is considered his best work.

WOODS, Joseph, *architect.* Was born at Stoke Newington, August 24, 1776, the son of well-to-do Quaker parents. He was a pupil of Mr. Alexander, and practised for a time on his own account; but, possessed of sufficient means, he indulged his tastes in a long residence on the Continent. In 1806 he was the first President of the London Architectural Society, then founded, and in 1813-15 was an exhibitor at the Royal Academy, sending, in 1814, 'A Design for a Palace and Public Buildings,' intended to be erected on the Thames bank. He was the editor of the fourth volume of Stuart's 'Athens.' In 1828 he published 'Letters of an Architect from France, Italy, and Greece.' A good draftsman, he amused himself by making drawings from his early sketches. He was also a member of several scientific societies, and in 1850 published his 'Tourists' Flora,' a botanical work. He died at Southover, Lewes, January 9, 1864.

WOODSTREET, Godfrey, } gold-
WOODSTREET, B., } smiths,
who practised in the reign of Richard II., and executed the statues of Richard, and Anne his Queen, which have been engraved by Gough, in his 'Monumental Antiquities.'

WOODWARD, Benjamin, *architect.* Practised some time in Dublin. He built the new building in Trinity College, the new Museum at Oxford, and the offices of the Crown Insurance Company, at Bridge Street, Blackfriars. He sent in competition designs for the public offices in Downing Street. To recruit his health he went on the Continent, and died on the threshold of his intended tour, at Lyons, May 15, 1861. He was of much promise, and for some time was the partner of Sir Thomas Deane, in conjunction with whom he executed several works. He treated the Italianised Gothic with great simplicity and beauty.

WOODWARD, George M., *caricaturist.* His earliest attempts appeared in 1792. Rowlandson engraved after him, in 1797, 'Cupid's Magic Lanthorn.' In the following year he published, with numerous illustrations, 'Eccentric Excursions in England.' He caricatured Mrs. Billington under the title of 'The Musical Mania for 1802.' In 1807 he commenced a 'Caricature Magazine,' and in 1808 published by subscription his 'Comic Works in Prose and Poetry,' a very poor performance. He had much reputation as a caricaturist, but seems to have been of strange and unsettled habits. He was taken very unwell in a hackney coach, and penniless, was driven to the Brown Bear public-house, in Bow Street, where he had occasionally slept, but was otherwise unknown. A doctor was procured; he was suffering from dropsy, and surviving only a short time, he died in November 1809, and was buried by the humane landlord.

WOODWARD, Thomas, *animal painter.* Was born at Pershore, Worcestershire, in 1801, and was a pupil of Abraham Cooper, R.A. He made early progress, and at the age of fifteen years exhibited a picture at the British Institution, and became from that time a constant exhibitor both there and at the Royal Academy. At the latter he was a constant exhibitor from 1822 to 1852. In 1823 he sent 'Turks with their Chargers;' in 1829, 'The Chariot Race;' in 1831, 'A Horse Pursued by Wolves;' in 1841, 'A Detachment of Cromwell's Cavalry Surprised in a Mountain Pass;' in 1845, 'A Welsh Shepherdess and her Dogs;' and in 1851, 'Mazeppa,' his last contribution. He was also an occasional exhibitor at Suffolk Street. He likewise painted 'The Battle of Worcester,' and several other large-sized pictures, and many portraits of animals. His 'Tempting Present,' a very cleverly composed work, has been well engraved. His landscape backgrounds had great merit. He died of consumption, at Worcester, in November 1852.

WOOLASTON, J., *portrait painter.* Was born in London about 1672. He was happy in his likenesses, which were tolerably drawn, low in colour, and rather black. There are two portraits by him of Britton, the musical small-coal man (one dated 1703), both of which are engraved. He was himself musical, and performed at Britton's concerts. He died an aged man in the Charter House.

WOOLASTON, John, *portrait painter.* He painted a portrait of Whitfield, which was engraved by Faber, 1742, and Vertue also engraved after him. He went to America in 1772, and found full employment for his art in Virginia and Maryland.

WOOLFE, John, *architect.* He was born at Kildare, where his family were held in much consideration. He was appointed Architect to the Board of Works. He built Lord Shrewsbury's house at Heythorpe, and for Mr. Alderman Beckford Fonthill House, one of the finest residences in the West of England, and, in conjunction with Gandon, published in 1767 the fourth volume, and in 1771 the fifth volume, of the 'Vitruvius Britannicus,' commenced by Campbell.

WOOLLETT, William, *engraver.* Was

434

born at Maidstone, August 15, 1735. His family came originally from Holland; his father was a watchmaker. He began to draw when quite young, and his friends at Maidstone subscribed to apprentice him to Tinney, an engraver; and of some of his works during his apprenticeship he was both designer and engraver. He was a member of the St. Martin's Lane Academy, and early distinguished himself. His art was his constant study, his aim to produce a fine work rather than to seek commercial success. He was employed by Alderman Boydell, and his 'Niobe,' after Wilson, R.A., and 'Death of General Wolfe,' after West, P.R.A., were the first English engravings that gained notice on the Continent, while Hogarth's were not understood out of England. For the former of these he received 150l. (the original agreement was 100l.), and the prints were originally sold for 5s. each. A fine proof has since been sold for 50l. His 'Battle of La Hogue' is one of his finest works; but he succeeded no less in landscape, excelling in all the varying manners of sky, foliage, and foreground, and especially in the tender transparency of water, when seen in motion.

In 1766 he was a member of the Incorporated Society of Artists, and for several years secretary to the Society. He held the appointment of engraver to the king. His works embraced a wide field of subject. His manner, uniting the needle with the graver, was rich and varied in execution and peculiarly his own. He gave every variety of texture, particularly the delicate softness of flesh in the most perfect manner. His works gave a high character to the English school. He lived many years in Green Street, Leicester Fields, and then removed to Charlotte Street, Rathbone Place, where he was wont to celebrate the completion of a plate, by firing a cannon from the roof of his house. He died in Upper Brook Street, Rathbone Place, May 23, 1785, from the effects of a neglected injury received while playing at Dutch pins several years before. He was buried in the churchyard of St. Pancras-in-the-Fields, and his friends placed a tablet to his memory in the cloisters of Westminster Abbey. His widow and two daughters were left in such narrow circumstances, that in 1814 a subscription was raised for them, and in 1843 his daughter, then 73 years old, was a candidate for a pension from the National Benevolent Institution.

WOOLNOTH, Thomas, *engraver.* Born in 1785. He engraved many theatrical portraits, 'The Infant Saviour' after Correggio, and the portrait of Gevartius after Vandyck. He was living in 1836.

WOOTTON, John, *animal painter.* Was a pupil of John Wyck. He first made himself known at Newmarket, where he drew the favourite racehorses, and became distinguished as a painter of horses and dogs, receiving large prices for his works. Later he tried landscape, and introduced hunting scenes. His works, usually on a large scale, decorate the halls of several old mansions, Longleat, Dytchley, Althorp, Blenheim, with some in the royal collection. His sight failing, he sold his collections of drawings and paintings in 1761, and died in January 1765, at a house in Cavendish Square, which he had built and decorated with his paintings. His horses are painted with great spirit and truth, his landscapes are coarse in manner, but his art is associated with many English recollections. He designed several illustrations, which have much humour, for the first edition of Gay's 'Fables,' published 1727.

• WORLIDGE, Thomas, *portrait painter and etcher.* Born in 1700. He practised in the reign of George II. and first painted at Bath, drawing with pencil on vellum or in Indian ink, portraits of a miniature size. He afterwards tried portraits in oil, and then removed to London, but not succeeding he applied himself to drawing and etching. He was a good draftsman, and etching with much ability in the manner of Rembrandt, was tolerably successful. He drew and etched a large plate of the Oxford Commemoration, 1761, full of figures, some of them portraits, freely but slightly etched, yet not wanting in drawing or spirit. After his death in 1768, a selection of his drawings from antique gems was published, comprising 182 plates, a work by which he is best known. He also etched many heads, and was distinguished by his use of dry point. His style was designated as the scritch scratch manner. In 1766 he exhibited whole-length and three-quarters portraits with the Free Society. He married a young wife, the daughter of a toy-man at Bath. She was gifted with great beauty, and able to assist him in his art, and became celebrated by her skill in worsted work. He appears to have been one of those who 'take no care for the morrow.' We are told that when in want of a dinner in his early days, he luckily found half a guinea, and then instead of disposing of it for some beef steaks and a pair of shoes, as his wife wished, he chose a feast of some early green peas. Later in life, when his etchings had become fashionable and he was better off, he resided chiefly at Bath, but he died September 23, 1766, at Hammersmith, was buried in the church there, where a tablet is erected to his memory.

WORNUM, Ralph Nicholson, *artist and writer upon art.* Was born at Thornton, near Durham, in 1812. He was originally intended for the bar, but in 1834 turned to art as a profession, and studied for five years in Munich, Dresden, Rome, and Paris.

He settled in London, wishing to become a portrait painter, in 1840, and in the first Westminster Hall competition his work was selected for 'Praise.' In 1846 he began his catalogue of the National Gallery, and was in the same year appointed keeper of that institution, and from this time devoted himself to illustrating by his pen the history and practice of art; though he had already published his 'Epochs of Painting,' and held the office of Lecturer in the Government Schools of Design. He died of nervous exhaustion of the brain in London, December 15, 1877.·

WORSDALE, JAMES, *portrait painter.* Was a pupil, and reputed to be a natural son, of Sir Godfrey Kneller, who dismissed him for secretly marrying his wife's niece. But he managed to gain many patrons, and was appointed master-painter to the Board of Ordnance. He painted a large whole-length portrait of George II., which he presented to the Corporation of Yarmouth. He designed some humorous subjects not over delicate, which were published by Bowles. But he had also a reputation as a player, and was a singer and a mimic, and for some time belonged to a provincial company of players at Chester. He wrote a 'Cure for a Scold,' 'The Assembly,' a farce in which he played admirably a principal character, 'The Queen of Spain,' and 'The Extravagant Justice.' He died in London June 13, 1767, aged 75 years, and was buried at St. Paul's, Covent Garden. He wrote his own epitaph, which was placed on his tombstone :—

'Eager to get, but not to keep the pelf,
A friend to all mankind, except himself.'

His son, who succeeded him in the office of Painter to the Board of Ordnance, died in 1779.

WORTHINGTON, WILLIAM HENRY, *engraver.* He was born about 1795, and practised his art in London. He worked in the line manner, and engraved some of the illustrations of the marbles in the British Museum, 'The Cottar's Saturday Night,' and 'Children brought to Church,' with other works after Stothard, R.A., also the portraits of the sovereigns of England, for Pickering's 'History of England,' 1826. His works were chiefly in the line manner.

WOUTERS, FRANCIS, *landscape and figure painter.* He was born at Brabant in 1614, and was brought up in the school of Rubens, but chiefly painted landscapes, introducing small undraped figures. He came to England with the Emperor, Ferdinand II., in 1637, and his works pleasing the Court, he was appointed painter to the Prince of Wales, afterwards Charles II. On the misfortunes which befell the Royal family he retired to Antwerp, where he was accidentally shot in 1659.

486

WRAY, ROBERT BATEMAN, *gem-engraver.* He enjoyed a reputation about 1770, and exhibited some wax impressions from his works at the Royal Academy. He was chiefly employed in engraving seals.

WREN, Sir CHRISTOPHER, Knt., *architect.* He was born at East Knoyle, Wilts, October 20, 1632. His father, descended from an ancient family in Durham, was Rector of Knoyle, chaplain to Charles I., and Dean of Windsor. Small and weakly in constitution, when only 13 years old he invented an astronomical instrument, and in the following year patented an instrument for writing with two pens, thus producing two fac-simile copies. He was educated at Westminster School, under Dr. Busby; was B.A. of Wadham College in 1650, and was in 1653 elected a fellow of All Souls', Oxford, where in the same year he took his M.A. degree. He was early distinguished by his mathematical attainments and numerous inventions, and was, in 1657, elected Professor of Astronomy at Gresham College, in 1659 Savilian Professor of Astronomy at Oxford, and in 1661 had the degree of D.C.L. conferred upon him.

Up to this time it does not appear that he had made any study of architecture, yet he must have no less acquired much knowledge and skill in matters connected with that art. His reputation stood high among men of science and scholars. He had powerful friends, and in 1661 he was appointed Assistant-Surveyor-General, but for fully two years he remained unemployed, and when, in 1663, he at last received a commission for his first public work, a survey of the mole, fortifications, citadel, and port of Tangiers, the employment appeared to have arisen from an intrigue to remove him from Court, and he declined the office. He was, however, at this time appointed under a Great Seal Commission, dated in 1663, to prepare plans for the complete restoration of Old St. Paul's, which showed, from an original faulty construction, alarming symptoms of decay; and with a view to gain experience with reference to this great work, he visited Paris in 1665, studied there some time, and made numerous useful drawings, remarking, indeed, that he should almost bring home all France on paper.

The question of repairing the old cathedral, which had been long debated, was, indeed, settled by the Great Fire in 1666, but not finally then, nor till after vexatious delays and warnings of danger had stopped all further attempts to repair. He was then empowered to destroy the massive walls of the old building, a work of great labour and skill, and to lay the foundations for his own design; but the business proceeded so slowly that it was not till 1675 that he received an approval

of his plans, with full authority to proceed. He made the most careful arrangements for his great work, appointing officers for the several special duties of overlooking and paying the men, measuring and checking the materials used, and buying and paying for them, and he diligently himself directed and superintended the whole, and made the drawings for all the details and every part of the work, attending in person, carefully watching the work to its completion with never-failing solicitude, during 35 years, and for all this he was paid 200*l.* a year.

While occupied with this great work, he was ordered by the King to survey the whole of the burnt city, and to make designs for its reconstruction. He made practical plans, founded on sufficient data in respect to expense and other particulars. His designs included spacious, arterial streets, quays on the Thames bank, the decorative rebuilding of the churches, with fine squares and public buildings, and the removal to the environs of graveyards and noxious trades. But petty interests and prejudices prevailed, or London would have risen from its ruins one of the most magnificent and beautiful of known cities.

In 1667 he commenced the Royal Exchange, and in the following year he succeeded to the office of surveyor-general, to which he had been appointed in reversion. The new theatre at Oxford followed, and Temple Bar in 1670; the Monument in 1671. He also built the Library at Trinity College, Cambridge, the Ashmolean Library, the Palace at Winchester, the College of Physicians, the Royal Hospital at Chelsea, made large alterations to Hampton Court Palace, built Greenwich Hospital, Marlborough House, St. James's, the western towers of Westminster Abbey, and above 50 parish churches, all of them noted for their construction and suitable convenience, and many of them conspicuous for their beauty; of these latter may be specially mentioned St. Mary-le-Bow, St. Stephen, Walbrook, St. Magnus, London Bridge, St. Bride, Fleet Street. A complete list of his works will be found in the *Parentalia.* Many of his most interesting designs are possessed by All Souls' College, Oxford.

He was knighted by Charles II. in 1673. At the age of 86 he was removed from the office of surveyor-general by Geo. I., after 50 years' service, to make way for William Benson, who was notoriously incompetent. During the short remainder of his life he was taken once a year, we are told, to St. Paul's, and the sight of the great work which he had been spared to complete revived faculties almost dormant with age. He died February 25, 1723, aged 91, and has found his proper rest in St. Paul's. He had filled the office of president of the Royal Society, had sat in two parliaments, and had been twice married. He made many discoveries in science, and was the first in this country who experimented upon the new art of mezzo-tint. As an architect his genius eclipsed all others, and during his long professional life he was without a rival. Yet the critics have not left him scatheless. Walpole, whose Strawberry Hill Gothic gives us little faith in his architectural judgment, speaks of Wren's want of taste, his false taste, and of his palace at Winchester as the ugliest building in the island. His works are, however, the greatest ornaments of our Metropolis. His knowledge of geometry and mathematics gave him great constructive skill, which his genius has employed in designs of surpassing magnificence, grandeur, and beauty, marked by refined taste and invention. His St. Paul's remains the most distinguished architectural object in our Metropolis; his palace at Greenwich the greatest ornament of the Thames.

WRIGHT, Mrs. PATIENCE (sometimes called Mehetable and Sybilla), *modeller in wax.* She was born of Quaker parents, at Bordentown, New Jersey, U.S., in 1725. Her maiden name was Lovell. She married in 1748, and became a widow in 1769. She early showed an aptitude for modelling, using dough or any material that fell in her way, and before 1772 had made herself known by her small portraits modelled in wax. She then, with her three children, came to this country, seeking a wider field in the English Metropolis, where her great ability was soon recognised, and she was much employed. In 1778 she made an exhibition of her works, among which were portraits of the King and Queen, the Duke of Cumberland, and many eminent persons, and also the story of Judith and Holofernes. A full-length by her in wax of Lord Chatham stood in Westminster Abbey. She had an ardent feeling of country, and had gained the acquaintance of many eminent men of the day. She was called a spy, and during the war was charged with giving political information to Dr. Franklin, then the American minister at Paris, and in 1781 she went to France, where she was made much of by those holding her opinions. She was again in London, to which she never lost her attachment, in August, 1785. She died March 23, 1786. Her younger daughter, whose face often appears in the works of West, P.R.A., married Hoppner, R.A. Her son, JOSEPH WRIGHT, who was born in America in 1756, was assisted in art by West and Hoppner, practised for a time in London, exhibiting at the Academy in 1780 'Mrs. Wright modelling in Wax,' and afterwards in Paris, and then returned to America, where he died, of yellow fever, in 1793.

487

WRIGHT, RICHARD, *marine painter*. He appears to have been designated 'Wright of the Isle of Man.' He was born at Liverpool in 1735, and was brought up as a ship and house-painter. In 1764, and again in 1766 and 1768, he gained the Society of Art's premiums for his sea views. He was a member of the Incorporated Society of Artists, and a man of rough manners and warm temper. He took an active lead among the discontented members of that body. He was a contributor to their exhibitions from 1765 to 1770, sending, among others, 'A Storm, with a Shipwreck,' 'Sunset, a fresh Breeze,' 'A fresh Gale,' 'River, with Boats, &c., Moonlight.' He died about 1775. There is a painting by him at Hampton Court of 'The Vessel bringing Queen Charlotte to England in a Storm, with the Royal Convoy.' His 'British Fishery,' which has been much lauded, was engraved by Woollett, but was quite unworthy of the engraver. Both his wife and daughter painted.

* WRIGHT, JOSEPH, A.R.A. (known as 'Wright of Derby'), *subject, landscape, and portrait painter*. Was born September 3, 1734, at Derby, where his father was the town clerk. He had some mechanical bent, but, taking to art, he came to London in 1751, and studied under Hudson, and afterwards under Mortimer. On the completion of his pupilage he returned to Derby, and was well employed as a portrait painter. In 1765 he sent two candle-light pictures to the Exhibition of the Incorporated Society of Artists, of whose body he was a member, and in the following year two pictures of the same class, with 'The Orrery,' and became known as a painter of subjects under artificial light. In 1773 he married, and took the opportunity to visit Rome and other parts of Italy, returning in 1775. He then went to Bath, but not meeting with much encouragement there, he found his way back, in 1777, to his native town, where he finally settled. He had made many sketches in Italy. While at Naples he saw an eruption of Vesuvius, and studied the effects of the flames, and also the varied effects of light in the caves at Capri and the grotto at Pansilippo, effects which often recur in his cottages on fire, moonlights, cavern scenes, and sunsets, which formed the staple of his art, and gained him reputation and patronage, and from 1778 he was an exhibitor of subjects of this class at the Royal Academy. On the foundation of the Academy he had entered as a student, and in 1781 he was elected an associate ; his election as a full member followed in 1784. But we are told that, annoyed by another having been elected before him, he retired altogether from the Academy. The facts, however, do not bear out this statement, and it ap-

pears more probable that the nervous, irritable, ailing painter, settled quietly so far from the Metropolis, was afraid of the duties and responsibilities which his membership would entail. In 1785 he made an exhibition of his works at the great room in Spring Gardens, but did not withhold his works from the Academy, and from 1788 to 1794 sent his pictures to their exhibitions. One of his best works, 'An Experiment with the Air-pump,' is in the National Gallery. He died at Derby, August 29, 1797. Several of his works are engraved.

WRIGHT, ANDREW, *sergeant-painter* to Henry VIII. Practised in Southwark in the early part of his reign, but never attained to any repute. He had an allowance of 10*l*. a-year.

WRIGHT, JOHN MASSEY, *water-colour painter*. Was born at Pentonville, in 1773, the son of an organ-builder, and was brought up to that business, but did not get on ; and loving art, at the age of 16 he was introduced to Stothard, R.A., and, influenced by his works, made some attempts to design from Shakespeare. Living in Lambeth Walk, he became acquainted with the scene-painter at Astley's Theatre, and afterwards with Roberts, R.A., Stanfield, R.A., and Barker, the panorama-painter, by whom he was for some time employed, and then entered into an engagement with him for seven years. His skill and readiness in drawing the figure were of great value to him, and he was engaged to assist in the scene-loft of His Majesty's Theatre, where his weekly pay was at once raised from three to five guineas. From 1808 he was an exhibitor, chiefly in oil, at the Royal Academy. In 1812, of 'The Living Shame ;' in 1815, of 'Don Quixote Fed by the High-born Damsels ;' in 1817, 'Claiming the Flitch of Bacon ;' in 1818, his last contribution, 'The Flitch of Bacon.' In 1824, he was elected a member of the Water-Colour Society, and then devoted himself to that art, and was a constant exhibitor (in the latter part of his membership, however, rarely exceeding one work), and a large and successful designer for book-illustration. He died May 13, 1866, in his 93rd year, and, after an industrious life, it is hard to say, in straitened circumstances.

WRIGHT, JOHN, *miniature painter*. Practised in the latter part of the 18th century, in Gerard Street, Soho, and afterwards in Burlington Gardens. His likenesses were correct and agreeable in manner, and his art was well esteemed. He exhibited miniatures at the Royal Academy from 1795, almost without intermission, to 1819, soon after which time he unhappily committed suicide.

WRIGHT, JOHN WILLIAM, *water-colour painter*, son of the above. Was born in

London in 1802. Showed an early ability for art, and was placed under Phillips, R.A. In 1831 he was elected an associate of the Water-Colour Society, and in 1842 a member, and was appointed the secretary in 1845. He was a constant contributor to the Society's exhibition, sending subjects chiefly of a domestic class. In 1835, ' Sunday Evening' and ' Cornish Villagers ; ' in 1839, ' Little Red Riding Hood ; ' in 1842, ' A Family of Primitive Christians Reading the Bible' and the 'Orphan ;' in 1845, ' The Despatch.' He was of weakly constitution and succumbed to an attack of influenza, January 14, 1848. His works were sold at Christie's the following March. His labours had not enabled him to do more than modestly provide for the daily wants of his family, and he left a widow and two children without provision.

WRIGHT, Inigo. *engraver.* Was born in London about 1740, and practised in mezzo-tint. He engraved eight country scenes after Morland, and also after Frank Hals, 1771, and F. Laurie.

WRIGHT, Joseph Michael, *portrait painter.* Was born in Scotland and was a pupil of Jamesone. He came to England at the age of 16 or 17, and soon gained reputation and employment. Afterwards he went to Italy, where he lived for some time, and in 1648 was elected a member of the Academy of St. Luke, at Florence. He painted many persons of distinction, and his portraits are well known. They are correctly and carefully drawn and finished. The hands are good, the colour very gay and pleasing, and the expression and character well maintained. Among them may be mentioned his ' Prince Rupert,' 1662, a life-size portrait, strangely costumed in armour, with a large French perruque ; ' Thomas Hobbes, at the Age of 81,' also the Judges, painted for the Corporation of London, which it is said Lely refused to paint unless they would sit at his studio, and that the commission of 60*l.* each was on their refusal transferred to Wright. There is also at Hampton Court a good characteristic full-length portrait by him of Lacy the actor in three characters, 1675. Two similar works, ' A Highland Laird,' and ' An Irish Tory,' have been much praised. In 1686 he accompanied Roger Palmer, Earl of Castlemaine, as steward of his household to Italy, and published a pompous account of the Earl's fruitless embassy. On his return he was mortified to find that Kneller had established a pre-eminence which he had before with much difficulty maintained. He died about the year 1700, in James Street, Covent Garden, and is buried in the adjacent church. He gave himself many designations. While at Rome he assumed the name of ' Michael Ritus,' and is so classed in the catalogue of the Ro-

man Academy. At the back of a portrait he has called himself ' Jos. Wick Wrilps Londonensis, Pictor Caroli 2 Regis,' and at times signed himself ' Scotus ' or ' Anglus.' He is, no doubt, the 'one Wright,' whom Pepys mentions rather contemptuously. But he deserved much higher consideration. His works possess great merit. His nephew, of the same name, was educated at Rome and afterwards settled in Ireland, where he made a large income as a portrait painter. His fine collection of gems and coins was after his death purchased by Sir Hans Sloane.

WRIGHT, Stephen, *architect.* Practised in the latter half of the 18th century, and held the office of Master Mason of the King's works. He designed ' The King's Lodge' in Richmond Park, an edifice engraved in Woolfe and Gandon's work ; and in 1767, built Clumber for the Duke of Newcastle.

WRIGHT, Thomas, *portrait painter.* Practised in London early in the 18th century, and was the master of Wilson, R.A. Little is known of him, and he is spoken of as of very slender abilities ; but a portrait, in the Bodleian Library, ascribed to him, entitles him to more favourable mention.

WRIGHT, Thomas, *engraver and portrait painter.* Was born at Birmingham, March 2, 1792. He was brought to London by his parents when a child, and before 14 years of age, was apprenticed to Meyer, the engraver. At the close of his apprenticeship, he joined a fellow-pupil, Fry, in the completion of engravings etched by Fry, whose name was affixed to them. After four years he left Fry, and engraved portraits, for which he had a peculiar talent. ' The Princess Charlotte and Prince Leopold in a Box at the Theatre,' and some other works by George Dawe, R.A., are engraved by him. He afterwards began to take portraits both in oil and in miniature ; and in 1822, went to St. Petersburg, to engrave ' The Military Gallery,' painted by Dawe, and the portraits of ' The Royal Family.' He returned to England in 1826, engaged to engrave ' The Beauties of Charles II.,' and found full employment. In 1830 he returned to St. Petersburg to arrange the affairs of George Dawe, who was his brother-in-law, and, with the patronage of the Court, was induced to continue there for 15 years. He painted the portraits of the ' Royal Family,' and of many of the nobility, and brought out there ' Les Contemporains Russes,' a series of portraits drawn and engraved by himself. He made in Russia a good copy of ' The Infant Hercules,' by Reynolds, and on his return to England, issued proposals to publish an engraving of it. But he was then almost forgotten in art, and owing to his long illness, the plate remained unfinished. He

489

died in George Street, Hanover Square, March 30, 1849. He was a member of the Academies of St. Petersburg, Stockholm, and Florence.

WYAT, ENOCH, *sculptor.* He practised in the reign of Charles I., during the Commonwealth, and in the reign of Charles II. He carved two figures for the water-stairs at Somerset House, and a statue of 'Jupiter,' and modelled a very large figure to form part of Inigo Jones's restorations of Old St. Paul's, but it was never used. In the Puritan times he altered and draped the statues by John of Bologna and Le Soeur, which had been thrust out into Whitehall Gardens, and were considered 'heathenish and profane.'

WYATT, JAMES, R.A., *architect.* Was born August 3, 1748, at Burton Constable, Staffordshire, where his father was a farmer and dealer in timber. He received the common education of a small country town, and evincing an early taste for drawing and architecture, was fortunate in attracting the notice of Lord Bagot, who, when nominated on an embassy to Italy, took young Wyatt, then only 14 years of age, with him that he might study architecture in Rome. Here he spent three or four years, and then went to Venice, and studied for two years under Vincentini. In 1766 he returned to England, and in 1770 his merit was acknowledged by his election as an associate of the Royal Academy. He, with great skill, adapted the Old Pantheon, in Oxford Street, for dramatic performances ; and becoming the place of fashionable resort, it at once gave him a reputation and established him in his profession. So widely was his name known, that an offer was made him to settle in Russia, as the architect of the great Catherine.

But he already ranked foremost in his profession at home, and was employed as the architect of several fine mansions. His works had hitherto been in the classic style, in which he was educated, but his genius led him to assist in the revival of the Gothic, and he employed draftsmen to make drawings of our ancient monastic and baronial structures. His first work in this style was a mansion at Lee, near Canterbury; and he was, in 1778, employed in making additions to some of the Colleges in Oxford. He was, at the same time, employed on the Observatory and Library at Oriel, and made some alterations at Baliol. He was also engaged in the restorations at Salisbury and Lincoln Cathedrals, and his Gothic works were as popular as his classic. But the archæologists accuse him loudly of reckless adaptations and demolitions, and not without just cause. Yet it must be remembered that Gothic architecture was little understood in his time.

Prosperous in his art, enjoying the chief
490

practice in his profession, he was in 1785 elected a full member of the Academy, and was for many years a contributor to their exhibitions. On the death of Sir William Chambers, in 1796, he was appointed Surveyor-General to the Board of Works, followed by appointments to several other public offices. At this time he erected Fonthill Abbey for Mr. Beckford, son of the Alderman, and the Royal Military Academy at Woolwich. By virtue of his office, he was employed on works at the House of Lords, and at Windsor Castle. He commenced a Gothic Palace at Kew, for George III., since pulled down. During a misunderstanding between West, P.R.A, and the Council of the Academy—upon the express wish of the King—he temporarily filled the office of President. In 1805 he built for Mr. Codrington a mansion at Doddington, finished in 1808, at a cost of 120,000*l.*, and commenced Ashridge for the Earl of Bridgewater. He designed the front of White's Club in St. James's Street. On his way from Bath to London he was overturned in his carriage, near Marlborough, and died instantly, September 5, 1813. For nearly 48 years he was at the head of a lucrative profession ; during a considerable part of that time he enjoyed the Royal favour. He had great means of amassing wealth, but he wanted prudence. At an early age he reached the summit of his reputation and practice. He found riches too easily gained to rate them at their worth, and he left little more than his reputation to his family. A widow and four sons survived him.

WYATT, SAMUEL, *architect.* Elder brother of the above ; studied his art in Italy, and brought home a rich portfolio of sketches on his return. He practised in the Roman style. He built Hooton Hall, the mansion at Tatton Park, and completed Kedleston, for Lord Scarsdale. In 1795 he finished the Trinity House on Tower Hill, which introduced him to other works. He was appointed architect to the Bank of England, and Clerk of the Works to Chelsea Hospital. He died at Chelsea, February 8, 1807, and was buried there.

WYATT, BENJAMIN DEAN, *architect.* Eldest son of the foregoing James Wyatt, R.A. He was born in London in 1775, and was educated at Westminster and Christ Church, Oxford, where he continued till 1797. He was then pupil, and for a time assistant, to his father, and afterwards visited some of the chief capitals in Europe. Returning in 1802, he became private secretary to Sir Arthur Wellesley, and was with him in this capacity in Ireland and in India. Then returning to his profession, he gained employment as an architect. He commenced the rebuilding

of Drury Lane Theatre, in 1811. He built the mansion in St. James's Park for the Duke of York, now Sutherland House, Apsley House for the Duke of Wellington, 1829, Holdernesse House and Wynyard, Durham, for the Marquis of Londonderry, Crockford's Club House, St. James's Street, the York Column, 1830–33. He retired from his profession, and died in Camden Town about 1848–50. His brother, PHILIP WYATT, who died in 1836, was connected with him in some of his most important works.

WYATT, MATTHEW COTES, *sculptor.* He was the third son of James Wyatt, R.A.; born in 1777, was educated at Eton, and studied his art in the schools of the Royal Academy. At the age of 19 he was employed, under the patronage of George III., at Windsor Castle. His first public work was the Nelson memorial on the Exchange at Liverpool. He first exhibited at the Royal Academy in 1804, sending some portraits in oil in that year, and in 1808 and 1810. In 1811 he exhibited a bust of the King, and the following year a 'Descent from the Cross,' a painting, but he exhibited only on one or two further occasions. He suggested, and was commissioned to execute, the cenotaph to the memory of Princess Charlotte, in St. George's Chapel, Windsor. The St. George and the Dragon in the hall is also by him. He erected the equestrian statue of the Duke of Wellington, which has been placed over the entrance to the Green Park, at Hyde Park Corner, and for which a subscription of 30,000l. was raised; and the equestrian statue of George III. at Pall Mall East; also a monument to the Duchess of Rutland, at Belvoir Castle. He died in the Harrow Road, Paddington, January 3, 1862, in his 84th year, and was buried in Highgate Cemetery.

WYATT, WILLIAM LEWIS, *architect.* Was second son of Benjamin D. Wyatt, and grandson of James Wyatt, R.A., and for some time his pupil. He was architect to the Crown and the Board of Ordnance. He practised on his own account in Shropshire and Cheshire, and was fully employed. But, possessing an independence, he preferred quiet, and, relinquishing all professional employment, retired early in life to the Isle of Wight, where he died February 14, 1853, in his 76th year.

WYATT, RICHARD JAMES, *sculptor.* Was born of a collateral branch of the Wyatt family, in Oxford Street, May 3, 1795. He studied in the schools of the Royal Academy, and was then placed under Rossi, R.A., for seven years. Canova, when in this country in 1821, was pleased with him and invited him to Rome, offering him the use of his studio. This induced him, after studying a short time in Paris, to go on to Rome, where he arrived in

1822, and from 1831 to his death regularly sent his works from thence to the exhibitions of the Royal Academy. He was at first employed by Gibson, R.A., but after a few years he commenced on his own account, and finally settled in Rome as his adopted city. Of unusually retired habits, his whole thought and happiness centered on his art, and indefatigably studious, his career was eminently successful. Rarely attempting the heroic, he was unrivalled in his own class of subjects. His 'Flora,' 'Nymphs,' and 'Penelope,' are in the royal collection, and with his 'Ino and the Infant Bacchus,' 'Musidora,' 'Shepherd Boy protecting his Sister from the Storm,' may be mentioned as his best and most characteristic works. At the exhibition of 1851 one of the first class gold medals was, after his death, adjudged to his exhibited works. He died unmarried at Rome, where he had worked for 30 years, of apoplexy, May 28, 1850, and was buried in the English cemetery there. He had never visited England except for a few months in 1841. He attained great purity and finish; his compositions were marked by their harmony and beauty of line, combined with great truth and nature. He had a strong feeling for the beauty of the female figure, in which he excelled.

WYATT, Sir MATTHEW DIGBY, Knt., *architect.* Was born near Devizes in 1820, and was the youngest son of the late Mr. Matthew Wyatt, the police magistrate of Lambeth. He was educated at Devizes, and afterwards entered the office of his elder brother, Mr. Thomas Henry Wyatt, architect. In 1836 he obtained a prize from the Architectural Society for an essay. Proceeding to the Continent in 1845, he employed his facile pencil in studying the buildings and antiquities of Italy, France, and Germany, and on his return published his sketches in facsimile. Later he joined the Society of Arts, and aided much in promoting the first International Exhibition; and when a royal commission was appointed to carry the idea into execution, Wyatt, with five others, was placed on an executive committee to carry on the work. After the close of the Exhibition he published the result of his observation in 'The Industrial Arts of the Nineteenth Century,' a work combining an appreciation of the beautiful with much technical knowledge. He aided Sir M. Isambard Brunel in the structural forms of the Great Western Railway Station, and on the removal of the Crystal Palace to Sydenham, was heartily occupied in its success. In company with Mr. Owen Jones, he travelled on the Continent and purchased for the Company a fine collection of architectural casts. In 1855, being a juror of the Paris Exhibition, he received from the Emperor of the French

the cross of the Legion of Honour. In conjunction with his brother he obtained the first position in a competition for a model barracks. He was also much employed by the India Office, and was joined with Sir Gilbert Scott in the erection of the India Office at Whitehall. He was also busily employed in erecting and altering many mansions for private persons, among others, that of Lady Marian Alford, at Knightsbridge. In 1855 he became Secretary to the Royal Institute of British Architects, a post which he held until May 1859. In 1866 he received the gold medal given by her Majesty, the highest professional honour, and in 1869 was knighted by the Queen, while he was the same year chosen Slade Professor of the University of Cambridge. His literary works connected with architecture and the arts added, perhaps, more to his reputation than did the buildings which he designed and erected. Urbane in manner and of cultivated taste, his society was much sought by his friends. His health gave way in 1875, and after a protracted illness he died at his house, Dimlands Castle, Cowbridge, May 24, 1877.

WYATT, HENRY, *portrait and subject painter.* Was born at Thickbroom near Lichfield, September 17, 1794. Losing his father when only three years of age, he went to live with Francis Eginton, the well-known glass-painter at Birmingham, who was his guardian. Here acquiring a fondness for art, he came to London in 1811 to study, and in the following year was admitted to the Academy schools. In 1815 he worked without pay in Sir Thomas Lawrence's studio for one year, and continued for a while with a salary of 30*l.* a-year. About the end of 1817 he returned to Birmingham, where he found employment in portrait painting, and was from that time an occasional exhibitor at the Royal Academy. In 1819 he removed to Liverpool, and then to Manchester, where he continued till 1825, and then came to London, and was a constant exhibitor at the Academy and the British Institution. At the end of 1834, his health failing, he went to reside in Leamington. In 1837 he hoped to return to London, but went first to Manchester to paint some portraits, for which he had accepted commissions, and early in the following April he had an attack of paralysis, from which he never recovered. He died February 27, 1840, at Prestwich, near Manchester, and was buried there. He was a clever painter, his colour good, and his subjects pleasingly treated. His 'Fair Forester' and 'Proffered Kiss' were engraved by Doo, R.A. His 'Juliet,' 'Chapeau Noir,' 'Gentle Reader,' 'The Romance,' 'Clara Mowbray,' Mars and Venus,' were popular works.
492

WYATT, THOMAS, *portrait painter.* Younger brother of the above. Studied in the schools of the Academy, and practising portrait painting, accompanied his brother to Birmingham, Liverpool, and finally Manchester, where for a time he tried photography, but without success. He then settled near Lichfield, his native place, and resumed portraiture, but again with little encouragement, and attacked by paralysis, he died, after five years' dependence upon his friends, July 7, 1859. His works are well known and esteemed at Birmingham, where he was secretary to the Midland Society of Artists, and in the neighbouring counties.

WYATVILLE, Sir JEFFERY, Knt., R.A., *architect.* Was born August 3, 1766, at Burton-on-Trent, where his father, Joseph Wyatt, practised as a surveyor, and was educated at the free school in that town. He had an early passion to go to sea, and was rigged out to join the 'Royal George,' but was disappointed by her unfortunate loss at Spithead. In 1783 he made another attempt to leave an irksome life at home and seek his fortune. He came to London, and, finding no opportunity of entering the Navy, he was kindly received by his uncle, Samuel Wyatt, the architect, who took him into his office for seven years—on the completion of which, having gained a good knowledge of the routine of the profession, he was employed by another uncle, James Wyatt, R.A., who had already greatly distinguished himself, and under him made a special study of Gothic and old English architecture. He also became known, through his uncle, to the Prince Regent and to many persons of distinction.

Not immediately finding employment as an architect, he joined in business with an eminent builder, and engaged in extensive government and other contracts. In this business he continued till 1824, when after an interval of 25 years, during which he had only incidentally done any work of a professional character, he was to his great surprise summoned to Windsor by George IV., and received his instructions relative to some proposed extensive alterations of the Castle. He had during his career designed several public and private buildings, including some large works at Wynnstay, and had exhibited at the Academy since 1794, and in 1798 sent a design which attracted much notice, called 'Priam's Palace,' but it was not till 1823 that he was elected an associate of the Academy, nor a full member till 1826. Parliament voted 300,000*l.* for the improvements to be made at Windsor. Wyatt and three other architects were asked to make designs, and, his being selected by the commissioners appointed to advise as to the appro-

priation of the large sum granted, he commenced his works at the Castle in 1824, the King laying the first stone of the gateway forming the principal entrance to the quadrangle, and on this occasion he assumed by Royal license the name of 'Wyatville,' to distinguish himself from other architects of the name of Wyatt then living. The affectation of the thing, and the satisfied vanity of the architect, gave occasion to the squib :—

'Let George, whose restlessness leaves
 nothing quiet,
Change if he will the good old name of
 Wyatt ;
But let us hope that their united skill
Will not make Windsor Castle—Wyatville.'

To the works at the Castle he devoted his whole time. They proceeded rapidly ; in December 1828, the King's private apartments were completed, and on taking possession, his Majesty conferred upon his architect the honour of knighthood. The completion of these extensive works, which involved an outlay of above 700,000l., occupied the remainder of his life, during the last five years of which he suffered from asthma, but his mind retained its vigour. He died at his house in Brook Street, Grosvenor Square, February 10, 1840. His body was removed to his apartments in the Wykeham Tower, Windsor, and on the 17th was buried in St. George's Chapel. An only daughter survived him.

His fame will rest upon his great works at the Castle, England's only palace ; but during the last 20 years of his life he made extensive additions to Chatsworth, designed lodges and other buildings in Windsor Park, added a new front to Sidney Sussex College, Cambridge, and made some alterations to the Queen Dowager's residence at Bushy Park. He was of honest, independent manners, and never failed to express and support his opinions manfully, whether to his Prince or his equals.

• WYCK, THOMAS (sometimes called 'Van Wyck'), *marine and subject painter.* He was born in 1616 at Haarlem, studied there under his father, and practised painting seaports, shipping, and subjects introducing small figures. He then passed some time in Italy, and designed and etched 21 views of the Mediterranean ports. He came to England at the Restoration, and meeting with encouragement, settled here. He painted a long view of London and the Thames, drawn from the Southwark side, and a view of the parade in St. James's Park, with Charles II. and his court walking, both of which were at Burlington House, Piccadilly ; also several views of the Fire of London, and many interiors of laboratories, then the fashion with Charles

and his nobility. He died in England in 1682.

‡ WYCK, JOHN (also spelt Wyke), *battle-painter.* Son of the above. Was born at Haarlem in 1640, studied art under his father, and came with him to England. His works were usually of a small size. He excelled in battle and hunting pieces ; his horses were spirited and well painted. There are also some landscapes by him, and several views in Scotland and Jersey, pleasing in composition and colour ; and there are on a larger scale his 'Battle of the Boyne' and 'Siege of Namur,' engraved by Faber, with some others, introducing portraits. He made the drawings for a 'Book on Hunting and Hawking.' He married in England, and residing in London and the suburban villages, died at Mortlake in 1702. Several of his works are in the royal and other collections.

WYKEHAM, WILLIAM, Bishop of Winchester, *architect.* He was born in Hampshire in 1324, and is believed to have received what at that time would be considered a good, but not an university education, and entered the Church. Early in life he gained the favour of Edward III. and entered into his service, and from that time his rise at Court was rapid. It is vaguely stated that he was led to the study of geometry and architecture, of which he must have had some competent knowledge, as he was appointed in 1356 surveyor of the King's works at the castle and park of Windsor, and by his advice the greater part of the old edifice was razed, and a royal palace of great magnificence designed by him was erected, of which the round tower is now the only part left. In 1359 he was constituted warden and surveyor of the King's castles at Windsor, Leeds, Dover, and some others, several of which he restored.

In 1360 he first appears to have received preferment in the Church. He was appointed to the Collegiate Church of St. Martin's-le-Grand, London, and during the three years he held this living, he built on his own plans, the cloisters, chapter-house, and the body of the church. Promotion soon followed ; in 1366 he was elected Bishop of Winchester, and in 1368 was appointed to the high office of Chancellor of England. But his good fortune and zealous desire to reform abuses in the Church raised him up many enemies, who in the latter days of the King's reign prevailed against him ; he was impeached, deprived of all his temporalities, and banished from the Court. On the accession of Richard II. he was declared wholly innocent of the charges made against him, pardoned, and restored to his employments.

He then commenced Winchester College, Oxford, now called New College, of which

he was both the founder and architect, 1380-86, and this was followed by St. Mary's College, Winchester. When in his 70th year, he began his great work, the restoration of his own cathedral, which it is said, with the assistance of William Wynford, he completed after ten years. He died September 27, 1404. His works would prove him to have been one of our greatest architects, and they are attributed to him by undisputed tradition. His large educational foundations were established by his own munificence. His life by Bishop Lowth was published in 1758.

WYNDE, Captain WILLIAM, *architect.* Was born at Bergen-op-Zoom, held a commission in the Dutch army, and was a learned and ingenious man. He is said to have been a pupil of Gerbier, and also to have studied under Webb, and to have been executor to Inigo Jones. He designed Cliefden, burnt down 1795; Newcastle House, Lincoln's Inn Fields, now tenanted by the Society for Promoting Christian Knowledge; Buckingham House, St. James's Park, 1703, not a portion of which probably now remains; Coombe Abbey, for Lord Craven, for whom he also finished Hempstead Marshal, planned by Gerbier, and destroyed by fire 1718. Several of his designs for these mansions were included in a sale of his son's effects, 1741.

WYNFORD, WILLIAM, *architect.* He is the reputed builder of the nave of Winchester Cathedral, 1394, and is said to have assisted Bishop Wykeham in his other architectural works.

WYON, THOMAS, *medallist.* Was born in 1792 at Birmingham. He was educated in London, and was apprenticed to his father, who was engraver of his Majesty's seals. He entered the Royal Academy schools, where he gained the silver medal both in the antique and the life school; also the premiums of the Society of Arts, and engraved for that body the head of Isis, used as their prize medal. He also executed several medals and tokens which gained him notice, and eventually led to his appointment, in 1811, as Probationary Engraver to the Royal Mint. Soon after, he engraved his medal to commemorate the Peace, which at once proved his powers and established his reputation. Commissions followed rapidly, and his Manchester Pitt medal—'Pitt arousing the Genius of Britain,' which comprised 13 figures—raised him to the front rank in his profession, and in 1815 he received the appointment of Chief Engraver to the Mint. In the midst of his success his health was the subject of much solicitude to his friends. He was visibly declining, and sent by his medical advisers to Hastings, he died there, September 22, 1817, in his 25th year. Had he lived, he promised to equal the greatest of his predecessors. A memoir of him, with a list of his chief works, will be found in the 'Gentleman's Magazine,' for February, 1818.

WYON, BENJAMIN, *seal-engraver.* Was born in London, January 9, 1802, younger brother of the above, under whom he studied. He succeeded his father as engraver of his Majesty's seals, and engraved the great seal of William IV. He was a frequent contributor to the exhibitions at the Royal Academy. He died November 21, 1858.

WYON, JOSEPH SHEPHERD, *medallist and seal-engraver.* Son of the above, was born in 1836. He was a student of the Royal Academy, and obtained two silver medals. His first work of importance was a medal of James Watt. He subsequently engraved the great seal of England now in use, a medal commemorating the passage of the Princess of Wales through London, for the Corporation, and the great seal of Canada. He was appointed chief engraver of her Majesty's seals on the death of his father in 1858, and received from the Sultan the Order of the Medjie. He died at Winchester, August 12, 1873.

WYON, WILLIAM, R.A., *medallist.* Was born in 1795, at Birmingham, where his grandfather, of German origin, was a silver engraver, and his father, to whom he was apprenticed in 1809, a die-sinker. He was cousin to the two above-mentioned artists, and moved by the success of Thomas Wyon, he came up to London, and applying himself to the study of Flaxman's works, gained the Society of Arts' gold medal for his copy of the head of Ceres. This success was followed by the award of a second gold medal by the Society for his original group of 'Victory in a Marine Car drawn by Tritons.' In 1816 he settled in London as assistant to his uncle, Thomas Wyon, in engraving the public seals, and in the following year entered the schools of the Royal Academy. At the same time he gained, in open competition, on the award of Sir Thomas Lawrence, the appointment of second engraver to the Royal Mint, thus becoming the assistant to his cousin Thomas.

On the early death of the latter, Signor Pistrucci succeeded to the chief office, and Wyon, holding the office of assistant under many official rivalries and difficulties, claimed to have executed the principal part of the work. In 1822 Signor Pistrucci's services were discontinued, but he continued to receive the salary till 1828, when the chief's salary was divided between the two officers, in order to get rid of the jealousies which existed, and Wyon then took the title of Chief Engraver, to which his labours had so long entitled him. He soon after gained Academy honours. He

was elected in 1831 an associate, and in 1838 a full member, of the Royal Academy. In 1833, with the permission of the Government, he went to Lisbon, and prepared the dies for the Portuguese coinage, and afterwards executed similar commissions for other countries. His coins include those of the latter years of George IV., the coins of William IV., and the early coins of Queen Victoria. He also made several pattern dies of coins, which were not adopted.

He produced many fine medals—the war medals for the Peninsular victories, Trafalgar, and the Indian medals for Jellahabad and Cabul. His medals for the learned and scientific societies include the Geographical, Geological, Royal Academy, Art Union, Royal Institution, and Glasgow University. The Coronation medal of William IV. is also by him, and one of his latest is the medal for the Great Exhibition of 1851. In these works, though he usually designed the reverse himself, he in some instances worked after the design of Flaxman, R.A., Howard, R.A., or Stothard, R.A. His coins are simple in their designs, the heads, though idealised, maintain the likeness, and are well executed. His medals are conceived in a classic spirit, and tastefully finished. He died at Brighton on October 29, 1851. A list of his works exceeding 200 in number, with a memoir of him, was printed for private circulation in 1837 by his friend Mr. Nicholas Carlisle.

Y

YATES, THOMAS, Lieut., R.N., *amateur.* He was the great nephew of Richard Yates, the well-known comedian. In 1782 he entered the Navy. He engraved and published from his own drawings a set of 'Celebrated Naval Actions.' On some dispute about the possession of a house left him by his uncle, he was shot, and died three days after, August 29, 1796. His widow was the beautiful Mrs. Yates, who played at Covent Garden Theatre, and was celebrated in the character of the Grecian Daughter.

YEATES, NICHOLAS, *engraver.* He practised in the reign of Charles II. There are portraits by him dated 1669 and 1682, but they are of little merit.

YENN, JOHN, R.A., *architect.* Was a pupil of Sir William Chambers, and studied in the schools of the Royal Academy. In 1771 he gained the Academy gold medal for his design for 'A Nobleman's Villa.' He continued for some time as an assistant to Sir W. Chambers, and then entered into practice for himself. He was a frequent contributor to the Academy exhibitions, his designs being chiefly domestic architecture, in which he found his principal employment. In 1774 he was elected an associate of the Academy, and in 1791 a full member. He filled the office of Treasurer from 1796 to 1820. In 1803 he was one of the five members of Council who were suspended, on a question as to their authority, by the General Assembly, and was replaced on an appeal to the King. He died at an advanced age, March 1, 1821.

YEO, RICHARD, R.A., *medallist and sculptor.* He was appointed one of the engravers to the Royal Mint in 1749, and afterwards principal engraver. His name appears as a member of the Artists' Committee appointed in 1755 to plan the establishment of a Royal Academy, and in 1760 he was a member and exhibitor of the Incorporated Society of Artists, and one of the governing body. On the establishment of the Royal Academy, he was one of the foundation members, and a contributor to the two first exhibitions, sending in 1770 a proof impression of his five-guinea piece. He died December 3, 1779.

YEOMAN, ——, *medallist.* He was one of the engravers of the Mint in the reign of George II.

YOUNG, JOHN, *engraver.* Practised with great ability in mezzo-tint in the reign of George II., who appointed him his engraver. There is a fine engraving by him of Hannah Snell, dated 1723.

YOUNG, JOHN, *engraver.* Born in 1755. He was a pupil of J. R. Smith, and was, in 1789, appointed mezzo-tint engraver to the Prince of Wales. In 1794 he exhibited some portraits in mezzo-tint at the Academy. He engraved after Sir William Beechey, Hoare, R.A., Hoppner, R.A., G. H. Morland, R. M. Paye, Zoffany, R.A., West, P.R.A.; also a prize-fight, after Mortimer, A.R.A., one of his best works; a series of 31 small portraits of the sovereigns of Turkey; and, in outline, in 1820 the Grosvenor Gallery, in 1826 the Stafford Gallery, and later the Angerstein Gallery. At the latter part of his life he was hon. secretary to the Artists' Benevolent Fund, and keeper to the British Institution. He died in London, March 7, 1825.

YOUNG, TOBIAS, *landscape painter.*
495

He lived some time at Southampton, where he enjoyed a local reputation. He painted the scenery for Lord Barrymore's private theatre at Wargrave. In 1816 and 1817 he exhibited at the Royal Academy 'A Landscape in the New Forest.' 'The Judgment of Solomon,' in the Town Hall at Southampton, is by him. He died December 1, 1824.

Z

ZEITTER, JOHN, *landscape painter.* Was born on the Continent, but was long naturalised in England. He painted chiefly Hungarian and Polish scenery, and for many years exhibited with the Society of British Artists, of which he was elected a member in 1841. His works were mostly in oil and of the most sketchy character. He seemed without the power to finish. He died in Kentish Town, in June 1862. His widow was assisted from the Artists' Benevolent Fund.

ZIEGLER, HENRY BRYAN, *landscape painter.* He received some instruction from John Varley, and in 1814 first appears as an exhibitor at the Royal Academy, and continued to exhibit landscape views and compositions, introducing rustic figures. From 1828 he was for many years an exhibitor at the Institute of British Artists, and at the British Institution. About 1857 he returned to Ludlow, where he died, August 15, 1874, aged 76.

• **ZINCKE, CHRISTIAN FREDERICK,** *miniature painter.* He was the son of a goldsmith at Dresden, and was born there in 1684. He came to England in 1706 and studied for a while under Boit. Soon found full employment and had for many years more commissions than he could well execute, though he raised his price from 20 to 30 guineas. He was especially patronised by George II. and his Queen; the Prince of Wales appointed him his Cabinet Painter, and several of his portraits of the Royal Family remain in the Royal collection. He practised in enamel; his works possess great delicacy of finish and beauty, drawn and coloured with exquisite refinement, they possess the additional charm of characteristic likeness. They fetched great prices at the Strawberry Hill sale, and notwithstanding their large number, continue to be highly prized. In 1737 he made a short visit to his own country. He lived for several years in Tavistock Row, Covent Garden, and when in 1746 his eye-sight failed him, he had amassed a good property, and, retiring to South Lambeth, left off practice. He was twice married, and had children by both wives. Died, March 24, 1767.
496

ZINCKE, PAUL FRANCIS, *portrait painter.* Was grandson of the above and practised his art in London with some ability, but he was always in need. He was a noted copyist, and made many copies of a portrait of Shakespeare and sold them as the original. He also exercised the same skill upon portraits of Milton and Nell Gwynn. He lived in Windmill Street in great poverty, and was well known as 'Old Zincke.' He died in 1830, at a very advanced age.

ZOEST (or ZOUST), GERARD, *portrait painter. See* SOEST.

ZOFFANY, JOHANN, R.A., *portrait and subject painter.* He was born at Frankfort-on-the-Maine, in 1733. His father, descended from a Bohemian family, was architect to the Prince of Tours and Taxis, and he was brought up by that prince till the age of 13, when he was led by his love of art to run away from his friends and found his way to Rome to study painting. Upon his father discovering his intentions he obtained a recommendation to one of the Cardinals, who befriended him, and placed him under the care of the Convent of the Buon' Fratelli. He continued in Italy nearly 12 years and visited the chief cities, then returned to Germany for a short time, from whence he came to England in 1758. He was at first in great difficulties. He painted the ornamental faces of Dutch clocks, and then was employed to assist Benjamin Wilson, the portrait painter. But a portrait of Garrick in character attracted the notice of Lord Bute, who introduced him to the Royal Family, and his fortunes then improved.

He was a member of St. Martin's Lane Academy, and in 1762, when he exhibited a portrait of Garrick, a member of the Incorporated Society of Artists. In 1769 he was nominated a member of the Royal Academy, and was in the enjoyment of a good practice, having just completed a portrait group of the Royal Family, when he engaged to accompany Sir Joseph Banks in Captain Cook's voyage round the world; but, dissatisfied with the cabin he was to paint in, he suddenly

gave up the enterprise. By this engagement he had disappointed and displeased many of his friends, giving up their commissions, and leaving his work unfinished, and pressed by his embarrassments, notwithstanding the patronage he met with, he determined to visit Italy again. He left England in 1772, was assisted by a present of 300*l.*, and took with him an introduction from George III. to the Grand Duke of Tuscany. While at Florence he painted the interior of the picture-gallery, which was afterwards purchased by the king. He also received a commission from the Empress Maria Theresa to paint the Royal Family of Tuscany, and went to Vienna in 1778 to present his work to the empress, when he was created a Baron of the Austrian Empire. On his way home he painted the Court Chapel at Coblentz. While in Italy he was elected a member of the Academies of Bologna, Tuscany, and Parma, and met with great patronage.

He returned to England, after an absence of seven years, in 1779, and resumed his profession, exhibiting at the Academy his ' Florence Gallery ' and some portraits, portrait groups, and conversation pieces. He was actively employed when, in 1783, he suddenly determined to go to India—his friend and colleague, Paul Sandby, R.A., said, ' anticipating to roll in gold-dust.' Here again his good fortune accompanied him. He travelled far into the country and received many lucrative commissions. At Lucknow, where he stayed several years, he painted in 1786 the celebrated ' Cock-fight,' his ' Embassy of Hyder-Beck Calcutta,' containing 100 figures, and his ' Tiger Hunt ; ' also many portraits. In 1790 he returned to his family in England. He had already sent home large remittances ; but with a heavier purse he returned with weakened faculties, which, though he continued to paint, declined so rapidly as to leave little trace of his former powers. He died at Strand-on-the-Green, November 11, 1810, and was buried in the neighbouring churchyard at Kew. He was twice married. His first marriage, to the niece of a priest at Coblentz, was unfortunate. By his second wife, a lady whom he married in England, he left four daughters. His early works were grey and hard in colour, and though also rather stiff in drawing, were full of character. Later his colour improved, and was rich and agreeable, with a fine deep tone. Several portrait groups by him are in the Royal collections, and the College of Physicians possesses his interesting work, 'Dr. W. Hunter, M.D., delivering an Anatomical Lecture before the Members of the Royal Academy,' which contains portraits of the members. His dramatic portrait groups were greatly esteemed, and were popularised by the en-

gravings of Dixon, Finlayson, and Haid. His Indian groups and some of the Royal portraits were finely produced in mezzo-tint by Earlom.

ZUCCARELLI, FRANCESCO, R.A., *landscape painter.* Was born in 1702, at Pitigliano, near Florence, and studied his art in that capital. He then went to Venice, and for a while was lured to history painting. After staying some time in Venice, and visiting Germany, Holland, and France, on the recommendation of the British Consul, he came to London, and during a stay of five years was employed as scene-painter at the Opera House, and also painted some views on the Thames, and some subjects from Shakespeare, and returned to Venice, where he painted some of his best landscapes, but finding that he had become known and admired in England by the engravings from his works, he came a second time to London, in 1752, and at once met with encouragement. His works became the fashion, and the many which will still be found in our mansions and in the Royal collection prove how largely he was patronised. He was a member of the Incorporated Society of Artists, and on the establishment of the Royal Academy, 1768, he was nominated one of the foundation members, and in the three following years was a contributor to its exhibitions. He retired to Florence in 1773, and invested his savings on the security of one of the monasteries in that city, which being soon after suppressed, he was left in indigence, and compelled to resume his art. He died in Florence in 1788. William Byrne, Woollett, Mayor, Vivares, and Bartolozzi engraved after him. There are some early etchings by him after the old masters. His art was scenic and unreal, marked by an unnatural prettiness, insipid, and made up of oft-repeated parts.

ZUCCHERO, FREDERIGO, *portrait painter.* Was born at St. Angelo, in Vado, in 1543, yet several various dates are given. Was employed by Pope Gregory XIII. and, quarrelling with his officers, he fled to France, where he was engaged in designing tapestry for the Cardinal de Lorraine. In 1574 he came to England. He painted Queen Elizabeth, Sir Nicholas Bacon, Howard Earl of Nottingham, Sir Francis Walsingham, and other distinguished persons of her court. He remained several years in England, and then, offended with our religion, having made peace with the Pope, he returned to Rome. The date of his death is usually stated as 1609. There is great uncertainty in the identification of his art, and his claim to insertion in this work is, at the least, questionable.

ZUCCHI, ANTONIO, A.R.A., *landscape and decorative painter.* He was born at Venice in 1726, and painted some his-

torical subjects in oil, while in Italy. He travelled in Italy with the Brothers Adam, made for them a number of water-colour drawings, and was brought by them to London, and decorated several of their buildings. He painted ceilings at Buckingham House (now pulled down), Osterley Park, Caen Wood, and Luton, and decorated a gallery for the Duke of Northumberland. He painted also easel pictures; and in 1770 he was elected an associate of the Academy, and was an exhibitor only on three or four occasions, of views—ruins of ancient temples and works of that class. Several of his works are engraved. In 1781 he married Angelica Kauffman. In the same year he went with her to Rome, where he resided till his death in December 1795.

ZUCCHI, GUISEPPI, *engraver*. Brother of the above. Practised for several years in London, and engraved many of the works of Angelica Kauffman.

SUPPLEMENT.

The recent and lamented death of Sir F. Grant has necessitated the insertion of the following supplementary notice :—

GRANT, Sir FRANCIS, P.R.A., *portrait-painter*. Was born in Edinburgh in 1803, and was the fourth son of Mr. Francis Grant of Kilgraston, Perthshire. He was educated at Harrow School, and for a time studied law, but his tastes led him to prefer art, and having spent his patrimony he resolved to take to it as a profession, and his love of field sports gave it its first direction. In 1834 he became an exhibitor at the Royal Academy, and early made himself a reputation by his picture of 'The Meet of Her Majesty's Staghounds,' painted for Lord Chesterfield, exhibited both in London and Paris, and 'The Melton Hunt,' purchased by the Duke of Wellington. In these works the figures are of a small size, yet as portraits they are excellent and characteristic, while the animals are well drawn, and the landscape backgrounds, though treated with great truthfulness of detail, yet in good keeping with the figures. In 1842 he was elected an associate of the Royal Academy, and began to devote himself more especially to life-sized portraits in oil, painting many of the beautiful women, and most of the distinguished men, of his time. Among these portraits, as of marked excellence, may be named those of 'The Marchioness of Waterford,' 'Lady Rodney,' 'Mrs. Beauclerk,' the painter's own daughter, 'Mrs. Markham,' 'Lord Macaulay,' 'Lord Derby,' 'Mr. Disraeli,' 'Lord Russell,' 'Lord Hardinge,' and that of 'General Sir Hope Grant,' his distinguished brother playing the violoncello. In 1851, on the occasion of four vacancies (an unusual occurrence), he was elected a full member of the Academy; and in 1866, on the death of Sir Charles Eastlake, and on Sir Edwin Landseer's declining the distinction, he was chosen President and received the honour of knighthood. The University of Oxford conferred on him the honorary degree of D.C.L. in 1870. He continued to practise his profession to the last, though amid much suffering in his later years, and exhibited five pictures in the Academy Exhibition of 1878. He died rather suddenly on Saturday, October 5, 1878, at Melton Mowbray, and was buried in the Cemetery there on the following Saturday, his family having decided to decline the offer of a public funeral in St. Paul's, where his brother members desired to inter him. He was twice married, was of a kindly nature and handsome person, and perhaps more fitted for the duties of the office he held by his natural qualities than by his artistic ones. He succeeded better in his female portraits, than in giving the sterner characteristics of men, but his surest fame will rest with those hunting scenes, which he loved and depicted so well.

THE END.

CLAY AND TAYLOR, PRINTERS, BUNGAY.

Lightning Source UK Ltd.
Milton Keynes UK
UKHW021843161222
414070UK00005B/161